VENICE

ART & ARCHITECTURE

EDITED BY
GIANDOMENICO ROMANELLI

VENICE
ART AND ARCHITECTURE

PHOTOGRAPHS BY
PIERO CODATO
MASSIMO VENCHIERUTTI

h.f.ullmann

FRONT COVER:
Basilica of San Marco, western facade.
Photo: © Piero Codato and Massimo Venchierutti/Cameraphoto-Arte

BACK COVER:
Justice triptych (detail), Jacobello del Fiore, 1421.
Venice, Galleria dell'Accademia.
Photo: © Piero Codato and Massimo Venchierutti/Cameraphoto-Arte

COVER DESIGN:
Simone Sticker

The captions and the text of the explanatory boxes were written by the Magnus Edizioni editorial staff
with the exception of the text on Antonio Rizzo.

Original title: *Venezia: l'arte nei secoli*
© 1997 by Magnus Edizioni, Udine
ISBN of the original edition: 88-7057-145-9

© 2005 for the one-volume English edition:
Tandem Verlag GmbH
h.f.ullmann is an imprint of Tandem Verlag GmbH

© 2007 for this edition: Tandem Verlag GmbH
h.f.ullmann is an imprint of Tandem Verlag GmbH
Special edition

Layout: Gilberto Brun
Design: Peter Feierabend
Translation from Italian: Janet Angelini, Elizabeth Clegg,
Emma French, Gareth Thomas
Editor: Sharon Herson
Contributing editor: Shayne Mitchell
Typesetting: Goodfellow and Egan, Cambridge
Project coordinator: Kristina Meier
Assistant: Stephan Küffner

This one-volume edition produced by Cambridge Publishing Management Ltd
Index by Indexing Specialists (UK) Ltd

Printed in China
ISBN 978-3-8331-3622-1

10 9 8 7 6 5 4 3 2
X IX VIII VII VI V IV III II I
www.ullmann-publishing.com

Contents

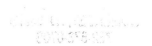

Venetia Before Venice: From Grado to San Marco

A Common Heritage Between the Italian Hinterland and the Venetian Region During the Dark Ages

If we are to understand the beginnings of the art of Venice, or rather of Venetic art, we must pay a visit to Grado where around the "Patriarchs' Square" we will see works of architecture, sculpture, and mosaic which at one and the same time are majestic and humble, the product of a refined culture fashioned by modest hands. They provide a clear illustration of the unique transitional phase in the second half of the sixth century, a period of a harrowing but clear-cut transition between three ages: that of Rome, already disappeared, that of Ravenna, in decline, and that of Venice, about to start. The group of buildings in Grado includes S. Eufemia with its baptistery (see pp. 7, 8), and S. Maria delle Grazie, rebuilt and restored by Bishop Elias (571–586) (see p. 8). Looking at the plan of the basilica we see side-chapels that are part of the priests' chambers as well as a presbytery with a *pergula*, or elevated balcony, both important features in the development of the Early Christian basilica. In S. Eufemia, on the other hand, the apses are polygonal on the outside, a vocabulary of the Ravenna type that is new to the Aquileia area. In S. Maria delle Grazie the internal apse flanked by seats (*synthronon*) marks the high point of a local tradition with a long future.

Inside the churches, the most ambitious parts confirm that it had become obligatory to reuse classical fragments. There are numerous simple or composite Corinthian capitals decorated with drilled fleshy acanthus leaves or scalloped acanthus motifs, dating from between the fourth and the sixth centuries. There are also Egyptian capitals, dosserets reused as capitals, drilled basket capitals from the sixth century, and even Ionic capitals from the first century. On the other hand, two kinds of decoration used for the plutei, or marble panels, were produced locally. One, imbued with a naturalism not lacking in painterly taste despite the intrinsic flatness of its vocabulary, takes the form of blossoming shoots, bunches of fruit, and birds. The second kind of local decoration draws inspiration from more abstract symbolic themes such as the *chrismon* that was used for anointing, crosses, the *kantharos*, or drinking cup, peacocks, birds, and borders. In this type of

decoration the design sometimes assumes negative weight. Finally, with regard to pavements, the late classical tradition of Aquileia was maintained through the creation of geometric and plant-shaped patterns whereas the great figurative repertory was cast aside (see p. 10). This period is also marked by impoverishment with regard to the colors used in mosaics.

The great political, economic, and cultural crisis of the early Middle Ages was long and tormented. As in Grado, the artistic situation in the Byzantine province of Venetia was inherited, not planned. There is

ABOVE:
Pluteus with peacocks and vase, mid-6th century. Grado, basilica of S. Eufemia.

BELOW:
Fragment of pluteus with hunting scene, 6th century. Grado, basilica of S. Eufemia.

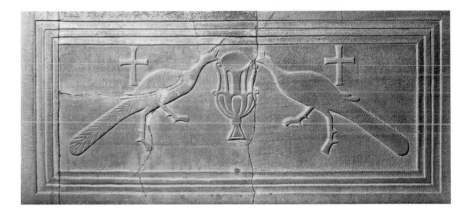

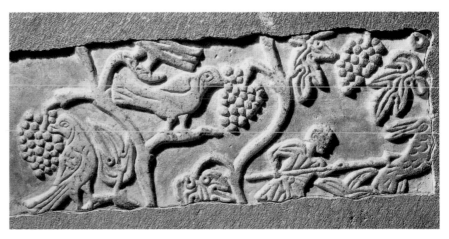

Interior of the three-aisled apseless basilica of S. Maria delle Grazie in Grado, rebuilt in the time of Bishop Elias.

OPPOSITE:
Interior toward the chancel and the great semicircular apse of the basilica of S. Eufemia in Grado. The church was consecrated in 579 AD by Bishop Elias who built it on the foundations of another basilica, probably constructed about a century earlier.

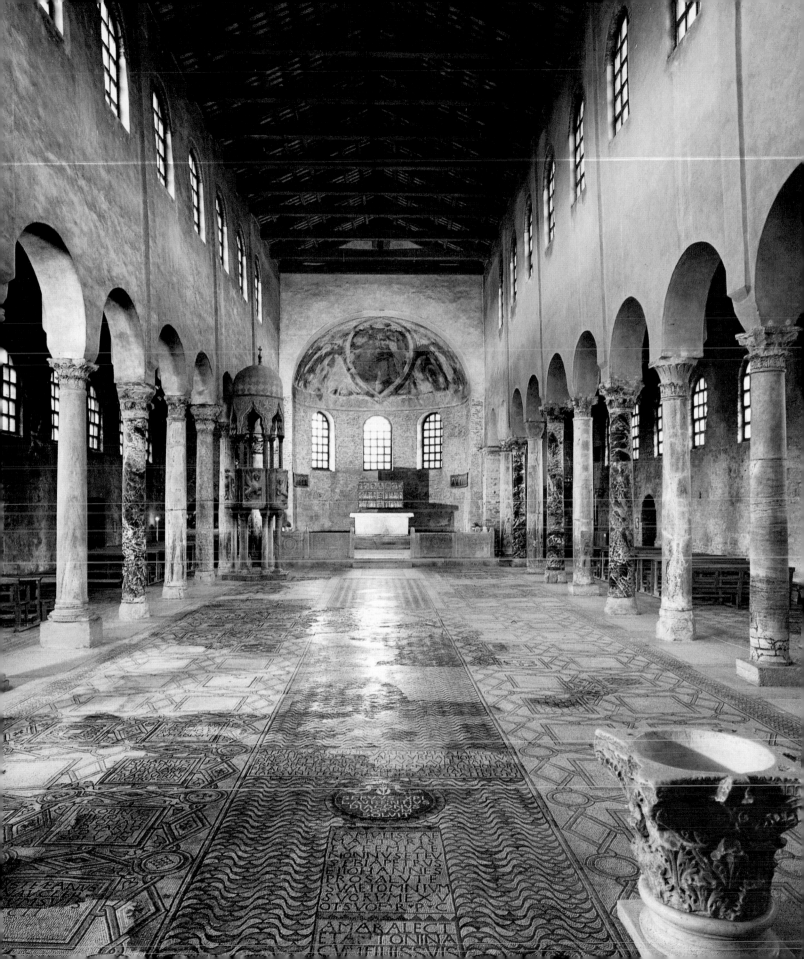

no doubt, however, that its roots go back to the Late Imperial taste of Roman tradition. On the one hand it closed the Constantinian period; on the other it introduced a more sober and subdued application of traditional models of provincial life associated with the Venetic cultural world.

There are scarcely any noteworthy artistic works of the sixth century in the Venetia that Pliny defined as lying between Chioggia and the Sile estuary, nor in the maritime area close to it. Certainly there is nothing that can be compared to the abundance in Grado (or indeed Concordia and Padua) in the same decades. Nevertheless, amid the first sparks of life in an area that was to become known by the phrase "a Deo conservata Venetiarum provintia [the province of the Venices preserved by God]" are elements that can be interpreted as a continuation of that culture.

By the second half of the sixth century the area covered by the remains of the new, expanded Roman territory had broken up and was fragmented. It was defended against the Lombards by the exarchate of Ravenna and organized by Byzantine officials and tribunes sent by landowning families which held economic, military, and judicial sway. New settlements had been formed as people migrated to the region from its hinterland, sometimes only temporarily. Probably as early as the fifth century a network of centers was developing, and the new religion was able both to underpin these spiritually and to provide organizational arrangements.

Albeit with difficulty, we can identify places in the darkest centuries—the seventh and eighth—which were later to play an important role. Firstly, there is the site of an eighth-century private chapel which in 819 the Particiaco, a ducal family, donated to the monastery of S. Ilario in what is now the port of Marghera (see p. 17). In the nineteenth century a few fragments of crudely inscribed funeral slabs were found there (see p. 15). In Venice herself we have for some time been aware of a number of walls and foundations that can definitely be ascribed to early Byzantine military engineering. Further excavation may reveal new finds and increase the significance of these remains. Recent excavation work in the church of S. Pietro di Castello unearthed dwellings, wooden floors, and embankments which can probably be dated to around 610–41 thanks to a gold coin of Heraclius found there. In 1961 excavations in Torcello brought to light a glass furnace and shore protection works, while we also have a mosaic pavement of the eighth to ninth centuries belonging to an episcopal church founded in 639. In Ammiana the buildings of the twelfth-century monastery and the church of S. Lorenzo, dating from the seventh to the eighth century, were constructed over a Byzantine

castle which in turn had been built over various layers of settlements dating back to the first century after Christ. Excavations in Equilo (Jesolo) have revealed an interesting variety of types of church. In a palimpsest of the episcopal area, it was discovered between 1963 and 1966 that the mosaic pavement of the church of S. Maria, which dates from the beginning of the seventh century, lies over an earlier church of the fifth century. There are also numerous fragments of architectural sculpture from between the seventh and tenth centuries. Not far away, excavation of the small monastery of S. Mauro revealed a beautiful almost intact tenth-century ribbon pluteus. In Cittanova, the oldest Byzantine military command position after the Oderzo line of defense was abandoned, finds from casual excavations in 1953–54 have unfortunately been scattered. But the excavations managed to define the structures that made up the quarter of the exiled Oderzo bishopric (seventh- to eighth-century church and baptistery).

Architectural Sculpture

In this context we can consider a number of sections of plutei that as early as the eleventh century were reused in the new basilica of S. Marco. Their inclusion among works of the sixth to eighth centuries would certainly have enriched a program which seems to have been lacking with respect to sculpture. On the other hand, it is very difficult to claim for local workshops of that time most of the plutei (fifty or so, the majority intact) which were used in the women's galleries and on facades, not to mention many other small fragments in S. Marco. What we have are slabs with symbolic decoration (*chrismon* between clipeus shields, crosses, candelabra, alba-

rellos [pottery jars], peacocks). Their formal excellence, evidence from measurements, and comparisons with similar examples from the northern Adriatic area make it almost certain that they are late works imported from Constantinople or the East, or from Ravenna, even Grado (see p. 17). The culture they express was definitely not inspired by the taste of local patrons, nor could local craftsmen of the seventh and eighth centuries have produced such work. Similarly, we cannot link Venetian production to some of the Ravenna-style sarcophagus fronts with niches between small columns with conches and triangular pediments. The same applies to the plant volutes and fleshy acanthus leaves that were clearly made in the East and, finally, to the later slabs (tenth century) with interlace between clipeus shields, rhombi, and rectangles of outstanding geometric quality. There are obvious local copies of this type of original imported work, but they date from the second half of the eleventh century (sometimes even later) and were clearly made by craftsmen working on commissions from the Contarini, Selvo, and Falier doges.

Far from being a Roman—or indeed a Byzantine—island in a sea of barbarity, Venetic artistic culture of the seventh to tenth centuries rather appears an integral part of Italic culture. Even in the darkest period of the seventh century it never ceased to play its role as the Early Christian heir. Its rich repertory was laden with symbolism inherited from the period in the sixth century of greatest (and most expressive) spiritual clarity. This is also reflected in the paler colors used in the backgrounds of the mosaic pavements (Grado), and in the smooth abstraction of translucent slabs (Ravenna), which almost deny the very substance they are made of or even sublimate their material substance. There are very few other

Architrave of *pergula* [elevated balcony], 8th to 9th century. In its use of classical motifs, it brings to mind the sculpture of the early Byzantine period. Grado, Lapidario.

OPPOSITE:
Pavement with motif of crosses and circles in the form of serrate leaves, in the right-hand aisle of the oldest part of the basilica of S. Maria delle Grazie in Grado, mid-5th century (above)

Detail of pavement in the basilica of S. Eufemia in Grado, second half of the 6th century (below)

BELOW AND OPPOSITE:
Three plutei in Aurisino and Carso limestone decorated with interlace circles, possibly early 9th century.

Italic remains that are such clear heirs to the proto-Byzantine manner linked to the ideological and political climate of the forty years of Justinian's rule. This is echoed in works produced by craftsmen from, or influenced by, Ravenna, and found as far away as the Istrian coast (Parenzo and Pola, modern Poreč and Pula). This inheritance cannot be separated from its Late Roman origins, common to all Italic territory. It shone through the ethnic strand and taste of the barbarian conquerors and dominated them. The light that characterizes the jewels and the linear tension that fills the geometric plant- and animal-shaped ornament of Lombard fibulas and clasps (and those of other invading peoples) were to be taken up by Italic craftsmen. Their intention in doing so was not to borrow the iconographic vocabulary of Germanic animalism of the I, II, and III styles, but rather to fuse the techniques of traditional, fairly cultured, sculpture with those used in this type of metallic art, for example the positive-negative effect of relief carving.

For this reason, the works produced by Venetian stonemasons are unlikely to be very different from those produced elsewhere in the Italian peninsula. There is a substantial number of marble and stone

well-heads (see p. 16), sarcophagi, and transennas [screens, grills], often made from older objects produced in Roman times (and therefore originally from river trade with the mainland). This enables us to see that sculpture and carving were commonly used to meet the needs of day-to-day life. That this life was increasingly less provisional in nature can be inferred from the fact that it was no longer only church ornament that was in demand.

It is clear that there are not many remains that can be dated with relative certainty to the eighth century. If we leave aside a host of fragments, we are left with a dozen sarcophagi (from S. Ilario (see p. 15), S. Marco, S. Angelo, Murano (see p. 16), Lio Maggiore, and Equilo), a few pieces of church ornament (S. Marco, Torcello, Caorle, Grado), a handful of plutei (Venice, Murano (see pp. 12, 14, 15), Torcello), about a dozen transennas (Venice, Concordia, Grado), a few capitals or dosserets, and a scattering of fragments from friezes, pilasters, and series of arches (Torcello, Caorle).

The sarcophagi immediately reveal a wide variety of cultural trends. Some can be linked to symbolic use (crosses on a neutral background) (see p. 16) whereas others, borrowed from Late Imperial culture, are typified by divisions into arches resting on small columns, with or without crosses. Elsewhere this is accompanied by frequent asymmetry and wonderful creations using spiral shoots, interlace, intersecting circles, skeins, and the clipeus shield with fleurons, not to mention crude representations of the mystic lamb and the dove. There are two more fragments connected with this, bearing inscriptions about a certain *Bonellus* and *Antoninus tribunus* [Antonius, tribune] and his wife Agnella. The rough animal design, the asymmetry of the layout, the flatness of the relief, the dearth of inscriptions, and the absence of ordered compositional schemes all combine to provide a distinct picture of what must have been the typical and older way of Italic funerary celebration at the time.

Among items of church ornament we should recall a pluteus in the Mascoli Chapel, some fragments from Torcello (trabeated friezes which may come from a ciborium, or tabernacle), and some of the oldest pieces found in Jesolo (plutei, pilasters, slabs, and transennas) and in Caorle. They are all from the same context in its most restrained phase at the start of the ninth century. In particular, the Torcello friezes tie in with the perhaps slightly later ones in S. Maria delle Grazie in Grado and with a Venetian ciborium arch now in Berlin.

Even the rare fragments of *pergula*, common in Grado, Istria, and Dalmatia, belong to this art (see p. 11). There is a piece in the Venice archaeological

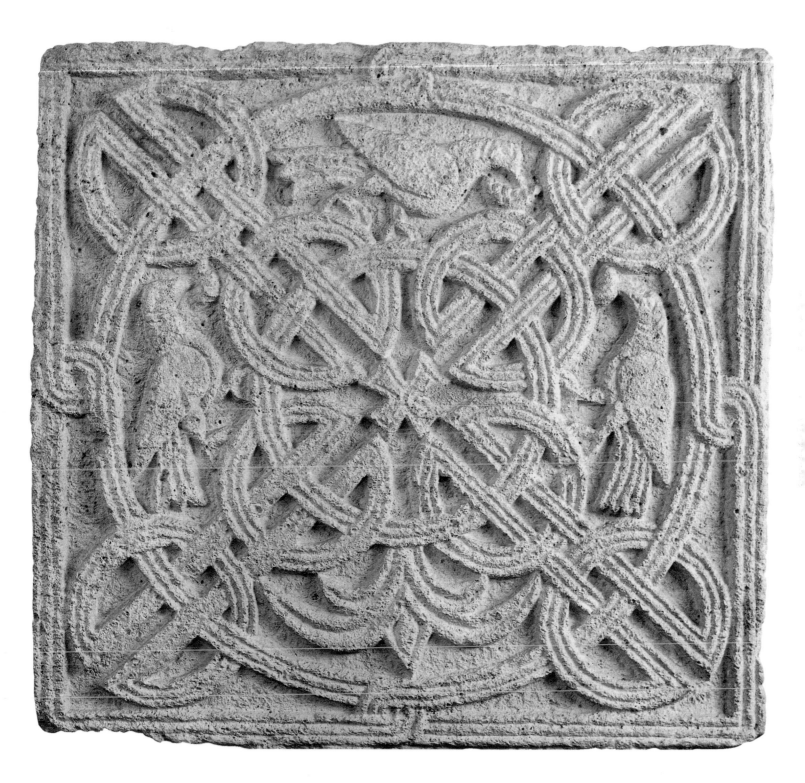

Plutei in Greek marble with a cross inscribed within a small arch, 9th century. Venice, Museo Archeologico.

tary techniques, the stone slab was pierced to give it false depth as well as a separate design element, namely light.

On the basis of the remains mentioned here, it is certainly not easy to find a Byzantine-style culture in the *Venetiarum provintia* of this time. Nor is it easy to maintain that there was a clash (or even a contrast) of two rival cultures. What emerges from the lost Italic world of the seventh and eighth centuries is reaffirmed with even greater force, otherwise incomprehensible, at the start of the ninth century. And we are not talking of a time when the Frankish rulers Obelerius and Beatus were ruling in Rivoalto, rather of the moment when the Particiaco dynasty was set up, in other words when Byzantium was in control.

There is now a substantial collection of remains, fairly consistent for the ninth century but less so for the tenth: at least fifteen well-heads, thirty or so plutei, a few sarcophagi, uprights, small pillars and architraves, and a handful of capitals as well as numerous other fragments. The vocabulary remains pretty much the same as in preceding centuries but across Italy it reaches a formalization of style and organizational rationality. Motifs are ordered and selected and in general the language attains a level of dignity within the context of the Carolingian Renaissance. This overwhelming cultural movement can also be seen in what is by now called the *ducatus Venetiarum*. In Venetian imitations of Carolingian

museum with a small interlace arch, a cross in the tympanum, and a caulcole cornice on the pediment. The Torcello museum has an identical piece and a third was recently found in the Torcello area. Together they prove that the Venetic *pergula* of the early Middle Ages was composed of an architrave supported by small columns on slender pilasters between plutei. It formed an arch that splendidly crowned the central entrance to the presbytery.

Well-heads (see p. 16) provide the most striking negative relief culture, in particular the marble cube from S. Tomà on which large and small crosses are lost amid herringbone patterns (perhaps originally representing heavenly palm trees) obsessively repeated in thickly woven designs. Another well-head (Torcello) is decorated with extended crosses contained within a border. Finally, some examples of Venetian transennas seem to be fully part of the Italic climate of the day. They are variously in marble, stone, and terracotta and can probably be dated to the close of the eighth century: Ponte della Frescada in S. Tomà, Calle del Traghetto in S. Barnaba, a church transenna now in the Archaeological Museum, one that has been incorporated into a monumental tomb in the crypt of S. Marco, with a replica on show in the Palaeo-Christian Museum in Aquileia, and others. These are part of the stubborn continuation of Early Christian sculpture into the fifth and sixth centuries and are found throughout Italy. Using fairly elemen-

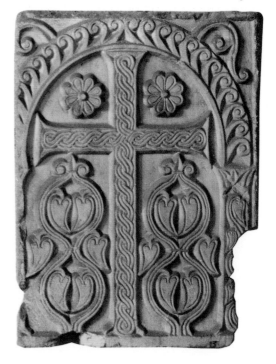

art the animalistic presence is rigorously excluded. But at the same time animal- and plant-shaped ribbon motifs of Germanic inspiration can be found in local art of the eighth century, as can be seen on a frieze in Caorle cathedral.

Later on, the material used is clearer, allowing long strips of burnished background to show through. It concentrates the previous variety of plant shapes into a small number of leaf and flower motifs and standardizes the geometric designs and interlace, while the three-wicker band becomes ever more ribbon-like. This takes on values and style that are classical in meaning. The Venetian region came close to rivalling the most beautiful imported slabs produced in Constantinople and imitated in S. Marco. By now all residual foliage is banished from the interlace, which nevertheless remains tightly knit and closely resembles Islamic decoration. A fragment in Berlin moves in this direction, as do various fragments from Torcello (two of which were reused as the side panels of thrones), two plutei from S. Marco (one in the northern ambo and a similar one in the women's galleries), fragments in the Diocesan Museum, a complete pluteus in the Archaeological Museum, one incorporated into the apse in SS. Maria e Donato on Murano, and, finally, another in the water gate to the Ca' d'Oro. The outstanding item in this group is a slab in the Diocesan Museum which still shows ample evidence of plant-shaped motifs as well as incorporating a central figure of a lion. This period possesses greater compositional clarity and tends to use simple geometric shapes (circle, square, rectangle, and rhombus) which weave together theological and Platonic symbolism. The more formal and courtly Venetian sculpture is in turn freed from its original links to the Italic context, a prelude to growing imitation of the art of Constantinople.

In Venice even interlace decoration—which had never disappeared—is now used to produce striking examples of formal rigor. Among these are the three large plutei from the women's galleries in S. Marco which were reused in reverse during the eleventh century. Here we have countless three-strand bands weaving in and out of each other and of a web of loops and circles, a single element repeated until it creates an infinite tangle. These are the most perfect examples of many which frequently betray the original simple early classical plait. Other instances include sarcophagi, from S. Ilario (Donatus), Murano (Johannes Masserdalus and a recent discovery), Ammiana (Johi Vyllari), and Castello (Vitales et Paulina), two well-heads (one in Venice, the other in Berlin), and numerous fragments in marble, stone, and terracotta from the collections in S. Marco, the Archaeological Museum, Murano, and Torcello. Nor

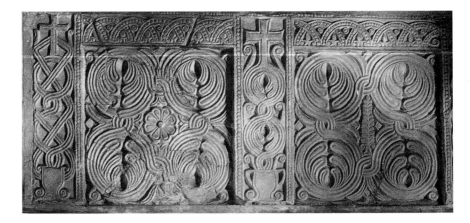

should we forget that in the nineteenth century there was a large pluteus like those in S. Marco in the Dal Zotto collection. There is also the wonderful Murano pluteus, as well as the one already mentioned from S. Mauro in Equilo, and a pair of well-heads from Venice and Mira, not forgetting the Caorle cathedral transennas and other architectural sculpture. Finally, there are many pieces in Grado, and scattered across the mainland from Aquileia to Ravenna. They all prove once more that on both sides of the border there was a common vocabulary and function.

With regard to well-heads, the motif of arches mounted on columns with crosses and other symbols appears to be finely matched to the circular form, becoming more common. The vocabulary shifts from full-bodied flatness to thread-like relief and to pure draughtsmanship in at least a dozen pieces. Three of these are Venetian and can be found in the Archaeological Museum, three in the Ongania catalogue are from Venice or S. Erasmo, one Venetian piece was published by Cattaneo, some are in private Venetian courtyards, and others have found their

9th-century pluteus in the church of SS. Maria e Donato, Murano.

9th-century sarcophagus, originally in S. Ilario. Venice, Museo Archeologico.

Well-head, its splendid decoration enhanced by recent cleaning. Museo Correr, courtyard.

9th-century sarcophagus in the church of SS. Maria e Donato, Murano.

skill from classicizing foliage and spiral plant volutes contained by astragals. On the right the upright contains various decorative motifs from the eighth century associated with geometric interweaving crosses and segments.

Despite the lack of adequate chronological reference-points, it is only when we reach the tenth century that we can clearly see any Venetian imitation of fashions from Constantinople at a time distinguished by the rebirth of the Macedonian dynasty. This can be seen fully in Venice in the work on S. Marco initiated by the Contarini doges.

Another sign of the progressively widening gap—never to broaden into a gulf—with the culture of the hinterland is the Venetian echoes of Byzantine geometrical ribbon plutei which generally feature patterns woven with Constantinian shields. Some of the slabs in S. Marco (chapel of the Crucifix, Baptistery, the large Manin arch), a pluteus reused in the Torcello basilica in the presbytery, and a few other fragments all constitute imitations of imported Byzantine plutei (one is attached to the wall of the Treasury (see p. 17), another is in the votive chapel in the crypt of S. Marco, and a third, originally from Codevigo, is in Padua). Stars, suns, fleurons, and whirls reflect each other between soft bands of garlands in which traces of the old three-wicker motif spread until they reach the thread where they create ambivalent positive and negative effects in the relief. In contrast to what was happening in the pre-Romanesque hinterland, between the tenth and the eleventh centuries Venice saw the growing importance of proportional clarity. This meant that the newly exuberant use of plant shapes took on dimensions of elegant correspondence and symmetry. Furthermore, the taste for contrast between light and shade in carving is connected to a general trend in

way abroad. The motif closely follows the artistic development of church plutei, from those of great expositional polish and clarity in S. Fosca and Torcello Museum to those in the Baptistery of S. Marco and in the walls of S. Donato in Murano, and the pair that was ruined and walled in at Torcello. There are also those of the Archaeological and Diocesan Museums, which include a couple of fragments from S. Ilario, one from Cittanova (now in Oderzo), two slabs from the portico of the Ca' d'Oro, and others besides. The interlace and symbolic strands therefore coexist with, or come from, the same vocabulary. Proof of this is the composite portal of S. Maria Assunta on Torcello, where an architrave clearly of the Contarini school at S. Marco (second half of the eleventh century) is supported on the left by an upright (ninth-century), composed with unusual

decorative and representational effects which led to the introduction of drill work and encouraged the (probably ancient) use of colored paste as a filler.

With regard to the difficult subject of the production of capitals, there is a lack of material. What appears most clearly is that workshops in Grado, Torcello, Murano, and Rivoalto all reworked capitals from the classical and late classical periods. There are occasional examples of new work from Torcello. In one instance we have a classical imitation where the acanthus leaf is pared down to a kind of herringbone motif. The plaited face of another capital has six heads while another displays half-fleurons beneath small arches. There are three dosserets where the interlace assumes forms as summary as any found in barbarian taste. On the basis of this new work we can surmise that local craftsmen were closely involved with what was going on in the plastic arts throughout the Italian peninsula. Only after strong signals from Constantinople during the tenth and eleventh centuries did distinct change take place. This can be seen from some broken capitals from S. Maria in Equilo, which seek to repeat the Corinthian order. From just before or just after the year 1000 we have another capital in Torcello Museum, decorated with plant-shaped motifs, caulcoles, and fleurons skilfully pierced with a drill to give an overall refined effect. Immediately following this, a series of important buildings use a wide range of new classicizing capitals, all of which were skilfully designed and produced locally.

Compared to the amount of plastic art produced, remains of wallpainting and pavements in the Venetian region from the Dark Ages up to the year 1000 are few and far between. After the isolated episode of the churches founded by Bishop Elias in Grado, the next mosaic pavement is found in Equilo, in the early seventh-century church described above. We can see from a few well-ordered strips that the tessellated pavement was coherently designed and decoratively composed. It seems to cover the full range of the Early Christian repertory, with peltast shields, fleurons, scalloped leaves, wheels, checkerboards, plaits, various geometrical shapes, and inscriptions about patrons. With regard to color, too, it seems close to the pavements in Grado. Many of the tesserae are fairly bright, varying from red to pink and green as well as gray, black, and white and there are more subdued and paler shades too. There is no doubt that this pavement still belongs to late classical culture and stands apart from all later work. Nevertheless, it can also be regarded as the earliest surviving artistic work from the Venetic territory between Cittanova and Malamocco and as the link between the culture of mainland Venetia and that of the Byzantine province.

On the other hand, we can see striking similarities of subject and treatment with Italic culture in other important mosaic pavements from the early decades of the ninth century. The floors in question are tessellated pavements on the lower levels of S. Ilario. We can see how overuse had rendered the successful classical technique of geometric and decorative divisions barren; here it is replaced by a wafer-thin grille laid over a background of white tesserae surrounding the figures. A single row of black tesserae plays the same part in the overall design as the ribbon plait. In it there are four-petaled flowers, symbols, and animals, including a Pegasus, a peacock, and the griffin of classical mythology. The way they are shown fre-

Pluteus from Constantinople, 10th century, incorporated in the south facade of the Treasury of the basilica of S. Marco next to the porphyry Tetrarchs.

Fragment of mosaic pavement originally in S. Ilario, 9th century. Museo Correr, courtyard.

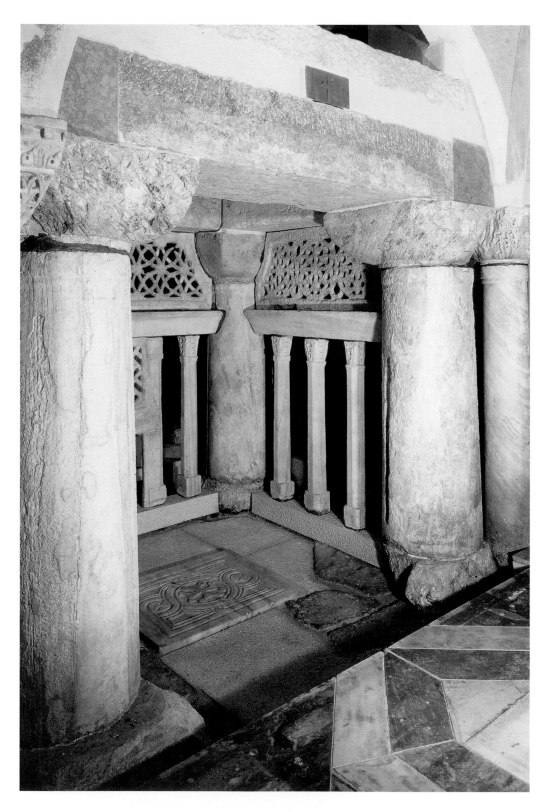

Sacellum in the crypt of the basilica of
S. Marco.

quently has heraldic overtones, a theme continued later in Veneto-Byzantine paterae, or cups, of the Romanesque period. The naivete of the design and the relative roughness of the way the pavements were laid give these mosaics much in common with those of late Lombard Italy. They also appear to share the cultural sensitivity found in the hinterland in a Benedictine monastery which was probably authorized by Agnello Particiaco, head of the dynasty installed by the Byzantines on their return.

The motif used in S. Ilario is also found in a mosaic pavement which now lies some 22–27 cm under the present *opus sectile* [mosaic or paving of thin slabs of coloured marble cut in geometrical shapes] pavement of S. Maria Assunta on Torcello.

The Earliest Churches: S. Teodoro and S. Marco

The lack of surviving pavements makes us understand that from the architectural point of view too it is still difficult to establish the character of general Venetic culture in the Dark Ages. According to contemporary chronicles, many churches were erected in places where the second wave of immigrants settled when they left the outlying centers of Rivoalto territory in the ninth and tenth centuries. These may have been preceded by a few foundations described as "de parè, zoè de ligname [constructed in wood]" in the seventh and eighth centuries. This points to the first stable transfer of populations from the hinterland.

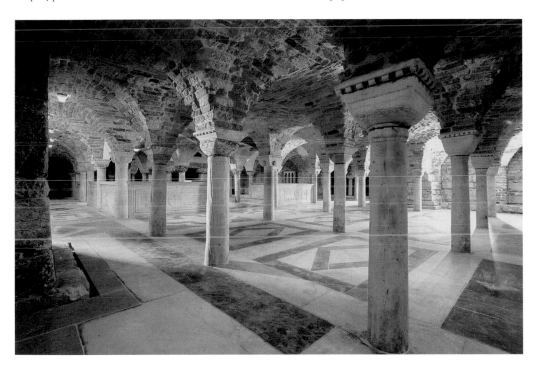

Even the older pavement does not mark the original 639 AD level, but was probably laid during works commissioned by Deusdedit II (864–867). The remains can be viewed only through two small hatches but are sufficient to attribute style and date.

Another fragment shows a clipeus shield (reworked in modern times) between leafy plant volutes. This, in S. Pietro di Castello, probably part of the original church built by Bishop Orso Particiaco, son of Agnello (830–840), reveals the refined elegance of the way plant volutes had evolved, striving toward purely abstract decoration.

In general, the first type of church appears to have had an inscribed apse, for example S. Maria and S. Mauro in Equilo and the baptistery of S. Pietro di Castello—in which we think Sts. Sergius and Bacchus were found—and probably also S. Pietro in Cittanova. We are looking at a model with three small aisles, always built on a modest scale. In some cases it may originally have been a single undivided space. Examples of these undivided spaces can still be found in the eleventh and twelfth centuries in S. Leonardo at Fossa Mala and S. Marco on Torcello. This ties in with some fifth-century foundations in Grado and in Dalmatia. The simplicity of these

Crypt of the basilica of S. Marco, occupying the space beneath the chancel and side-chapels. In 1094 the body of St. Mark was buried here. The saint's remains are now in the high altar of the Contarinian basilica.

buildings, which have tiny apses and presbytery *pergulas,* sometimes no more than simple covered porches, appears to carry on the Aquileia tradition with its dislike of free apses. They also continue the tradition of the early churches in Grado, where inside the simple rectangle of the building functional areas are clearly distinguished and liturgical areas arranged in a curved structure. These buildings date from the beginning of the seventh century through to the eighth and ninth.

Recent excavation work on the earliest foundations of S. Lorenzo in Venice is still proving difficult to interpret (the plan was possibly a basilica with three apses). The same applies to the remains found in S. Giovanni Evangelista on Torcello (three free apses, believed to be very ancient). These remains were later reused for a crypt in 1009 to house the relics of St. Barbara given to the church by Doge Pietro Orseolo II. The Particiaco dynasty, on the other hand, commissioned S. Teodoro and S. Marco, ascribed respectively to Agnello Particiaco (814–19) and to his sons Giustiniano and Giovanni (829–36).

At S. Teodoro we have a central layout based on an inscribed Greek cross. This was common in the east during the seventh century (compare the church of the Dormition in Nicaea, S. Nicola in Mira, the church of the Virgin in Hakh, and several Armenian churches). According to chronicles, it was an Armenian named Narsis who was inspired to invent this layout. We must not forget that P. and G. Saccardo and R. Cattaneo demonstrated over a hundred years ago that the structures of the northern chapels in the transept of S. Marco contain the surviving parts of the original building. This confirms the chronicles of the day, according to which the new S. Marco, built in 1063–94, incorporated the ancient S. Teodoro. As far as any remains of the earlier S. Marco are concerned, clear iconographical clues that would not otherwise have been present at the start of the ninth century lead us to the outer walls of the crypt, walls that were covered by the building commissioned by the Particiaco doges. This seems to be backed up by recent restoration work in the crypt, and is also largely borne out by structural analysis (see pp. 17, 19). The two foundations, similar in size, were laid right next to each other close to the imposing living quarters of a Byzantine castle which crucially dates from the age of Heraclius (first half of the seventh century); the settlement was to become the site of the future Palazzo Ducale.

From these two foundations we can see how the politics and culture of Venetian patrons were evolving at the start of the ninth century. The church of S. Teodoro was dedicated to the martyr who was patron saint of the Byzantine army (for which the

founder excluded the use of "Italie vel Francorum usalia"). The church is therefore a clear expression of the military command at the time when peace had been negotiated with the Carolingian empire. On the other hand, S. Marco, dedicated to an Evangelist and disciple of St. Peter, can be seen as urging allegiance to Rome and the West; it was a way of stating independence through a building. The church itself was conceived along the same lines as other churches dedicated to martyrs, a practice widespread in the eighth and ninth centuries and after on the shores of the Adriatic, from Zara [Zadar] to Nona, Pola [Pula] to Rovigno, and Sesto al Règhena to Belluno.

Both S. Teodoro and S. Marco had domes although they were not conceived as twin basilicas. They probably served different functions, although both were palace chapels and the cult associated with the two martyrs-cum-patron-saints probably lasted a long time. This is demonstrated by the fact that as late as the twelfth and thirteenth centuries reworked classical sculpture was used for the two columns dedicated to *Marco e Todero* in the Piazzetta. But while the church of S. Teodoro had a Byzantine narthex, or vestibule, of which traces still remain in the Mascoli Chapel in the present basilica of S. Marco, the original S. Marco was

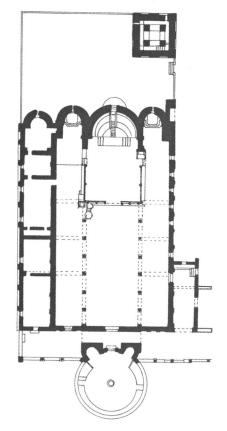

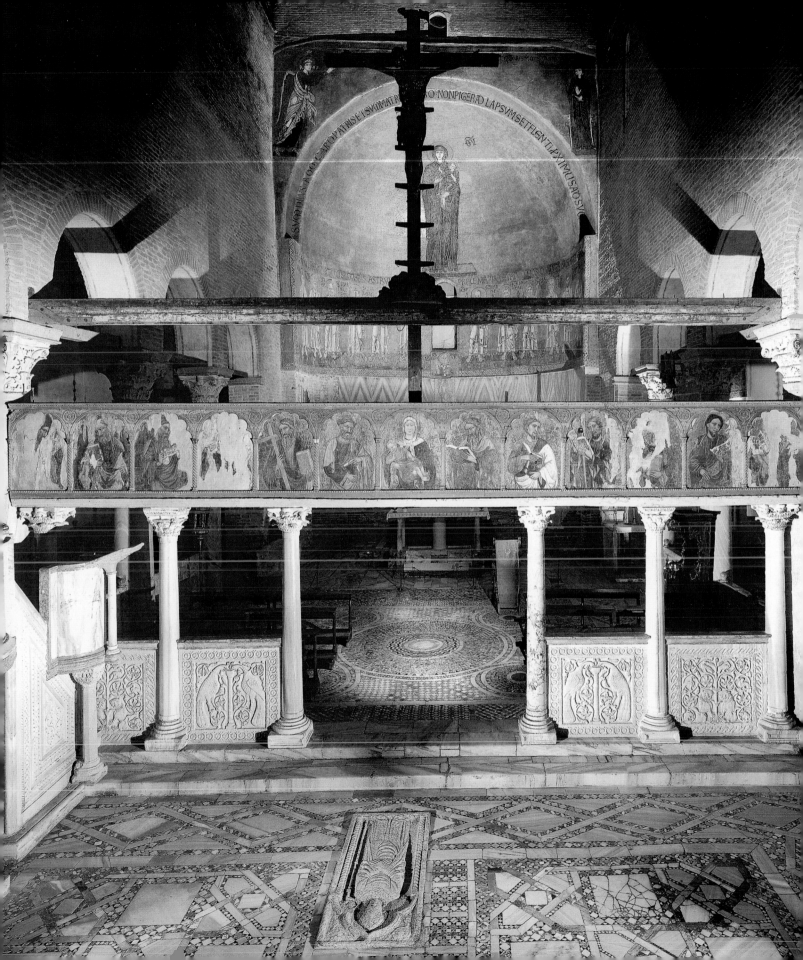

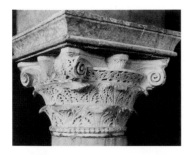

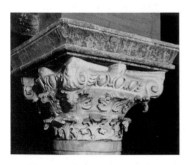

Corinthian capitals with thorny acanthus leaves in the cathedral of S. Maria Assunta on Torcello.

built with a Carolingian-style atrium (*Westwerk*). The walls and substantial vault pillars from this atrium now lie below floor level in the middle of the basilica. Finally, the dedication of S. Marco is confirmed by the still standing votive chapel dedicated to the Evangelist's relics. According to the chronicles, this was conceived as a copy of the tomb of Jesus in the Church of the Holy Sepulcher in Jerusalem. Again according to the chronicles, the *cuba,* or cupola, of S. Teodoro was painted with a memorial inscription dedicated to the "Olivolense doge and bishop," that is to say a doge and bishop from Castello. It is these clear traces of different cults, cultures, and functions that bring us back to what was going on in the politics of Rivoalto in the ninth century. The art of Venice took its first uncertain and hesitant steps torn between two empires. It is little wonder that its forms were conditioned by both East and West.

Venetian Art in the Northern Area of the Duchy After the Year 1000

The cathedral of S. Maria on Torcello, enlarged by Bishop Orso Orseolo, beginning in 1008, by the addition of apses and a pseudo-crypt, and decorated with frescoes in the new chancel, opens a period of innovation in the history of the architecture of the Venetian lagoon. The measurements of the general reconstruction by Deusdedit II (864–867), sufficient for an episcopal church second only to that of Grado in the entire duchy, which had already introduced an unusual dimension to the Venetian way of working, provide us with significant elements of proportional and symbolic characterisation. A relationship of the golden section between the length (108.1 Venetian feet) and width (66.7 ft), and the height (54 ft) and width (33.3 ft) of the nave, and between the external height of the central apse (40 ft) and the right-hand apse (24 ft) recall numerological research which is both architectural and cultural, and is later seen consistently in the great churches of Caorle, Equilo, and Murano (see p. 20). Moreover, the curving additions to the apse, whose simple pilaster relief increases to the complex three-dimensional Romanesque arches and galleries of the churches of Caorle, S. Nicolò di Lido, S. Marco, Equilo, S. Fosca on Torcello, and Murano, brought profound innovation into the upper Adriatic tradition of Aquileia and Grado, and also made it possible to adopt the exterior polygonal form of Ravenna (see S. Marco, S. Zaccaria, S. Maria in Equilo, and S. Fosca on

Interior of the cathedral of S. Maria Assunta of Torcello, looking toward the chancel and iconostasis.

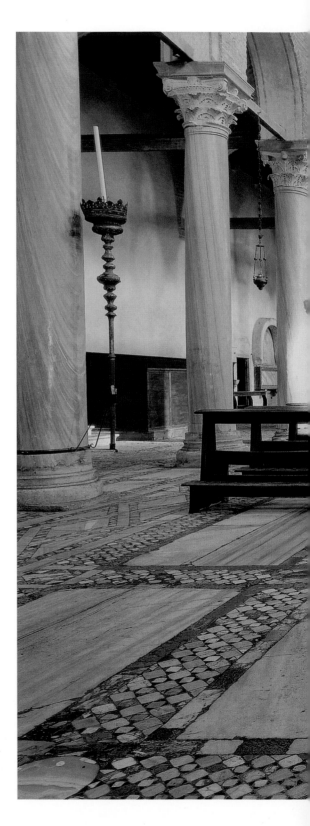

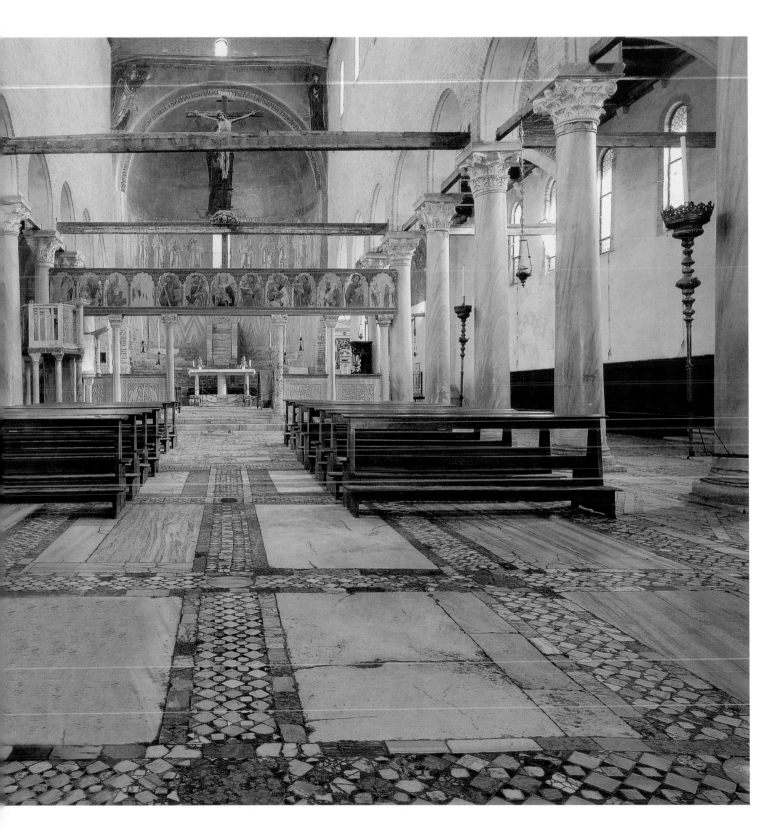

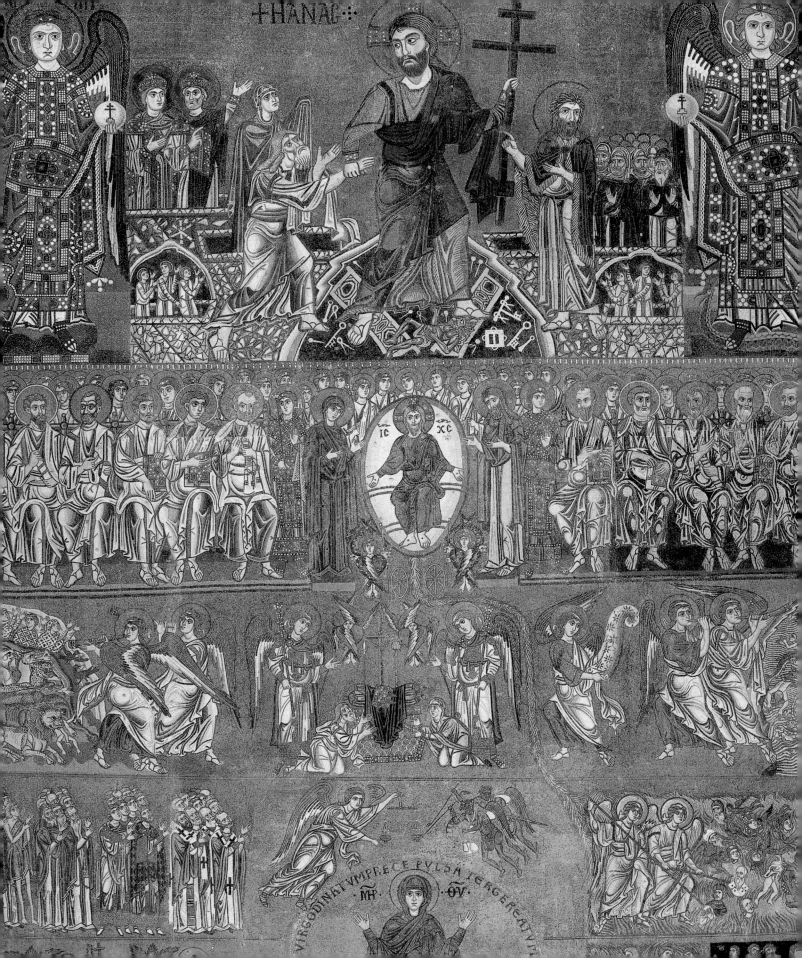

+HANAC

IC XC

VIRGO DINAT VMPP ECE PVLSA TER GE REATV M

MP ΘV

Torcello). Finally, the decisive preference for the three-aisled basilica and its classical measurements and relationships involved significant interest in the function of the capitals. The choice in S. Maria on Torcello of Corinthian capitals of high quality, partly taken from buildings of the classical era, placed on precious columns, reveal right from the first years after 1000 a mature comparison with that of a classical revival. This is confirmed by some capitals placed in Torcello cathedral after the earthquake of 1117, a proud comparison with those of ancient times (see pp. 22–23).

These structural characteristics, however, are less apparent when visiting the great silent nave, immersed today in the solitude of the lagoon, in which one is impressed more by the chromatic effects than by the mosaics, floors, and splendid oriental marble decoration which contrast with the bare poverty of the walls (see p. 20). In three places of high psychological and cultural significance (the curve, the vault, and the triumphal chancel arch, the facings and counterfacade of the right-hand chapel), the extraordinary chromatic design of the Hodegetria Virgin, the Apostles and the Annunciation, the Pantocrator with the four Fathers of the Western Church, the triumph of the lamb of God, and a Last Judgment of exceptional iconographic completeness (see p. 24) all offer for the first time in the West the majestic pictorial and theological force of the Byzantine wall mosaics of the Comnene age. The most recent investigations, conducted with the help of many archival documents and direct contact with the mosaics (unfortunately compromised by clumsy restoration, even by the fraudulent replacement of original fragments), make it possible to recognise that the majority of the existing mosaics were conceived between the mid and late eleventh century solely by Byzantine craftsmen close to the earlier decoration of S. Luca in Focide (first half of the eleventh century), that is, close to a Greek monastic tradition that was far from the courtly art of Constantinople. However, partial or total refacing in the area of the chancel, as well as some parts of the Judgment on the west wall, were carried out toward the end of the following century by Greek and Venetian master craftsmen who were decorating S. Marco, in particular the central dome of the Ascension (see p. 43). This is confirmed by the materials used and the distinctive stylistic features (Andreescu). This new task of restructuring, necessary because of the damage caused by the earthquake of 1117, seems to be evident also in differences in the mural structures of the central apse, and in the presence of new imitation capitals which can be attributed to the workyard of S. Marco. With this restoration, some of the decoration takes on a more

elegant wealth of figure movement (see the angel of the Annunciation), while others (the Hodegetria Virgin in the apse) form a totally successful part of the series begun in the vault of SS. Maria e Donato on Murano. Here, with the loss of the Annunciation, placed, as at Torcello, in the triumphal arch, the praying figure appears in the dominating linear style of drapery as an astonished figure adhering to the style of the Emmanuel dome of S. Marco, while in the portrayal at Torcello an expression of sovereign serenity dominates, and mature physical composure is imprinted on the organic arrangement of the robes, similar to that of the figure of the Ascension dome in S. Marco.

The pavement, too, in mosaic with round wheel shapes and large slabs of Greek marble, has particular compositional rigor, with no concessions to animal or phytomorphic figures, thus contributing

Imitation Corinthian capital in the church of SS. Maria e Donato, Murano.

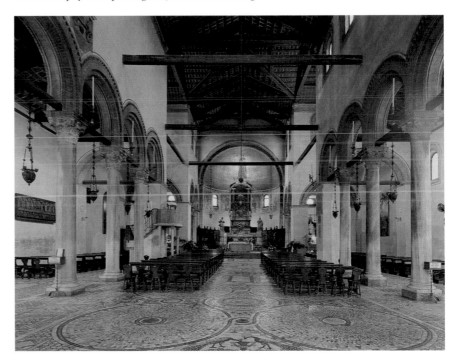

with fresh stylistic homogeneity to the light of the interior space. Those pavements, introduced into Italy (Montecassino, 1071) by the *ars musiaria et quadrataria* [mosaic and stonecutting skill] of master craftsmen from Constantinople, generated in Venice, starting with S. Marco, an extraordinary series of marble coverings capable of controlling the sparkling of a thousand colors in primary geometric shapes—square, triangle, circle—of Platonic significance. As well as Torcello we should recall Murano and

Interior of the three-aisled church of SS. Maria e Donato, Murano, with a wooden ceiling *a carena di nave* [ship's keel]. The dedication of the church derives from the relics of St. Donatus, brought to the church from the island of Cephalonia off Greece on board the galley of Doge Domenico Michiel (1118–1130).

OPPOSITE:
Last Judgment, 11th–12th-century mosaic which covers the entire west wall of the cathedral of S. Maria Assunta of Torcello.

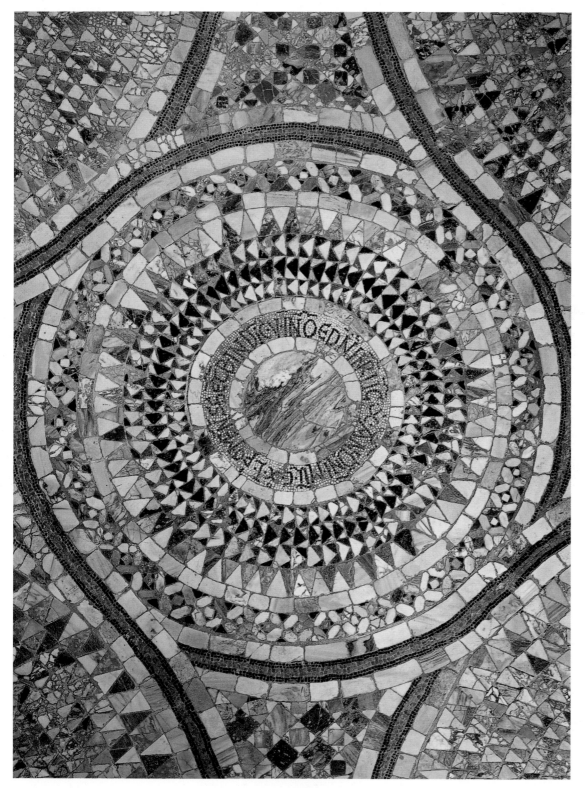

Detail of pavement in mosaic and *opus sectile* [paving of thin slabs of coloured marble cut in geometric shapes] in the church of SS. Maria e Donato on Murano. The inscription refers to the reconstruction of the church: "AN[NO] D[OMI]NI MIL[LESIMO] C[ENTESIMO] CL P[RIM]O MENS[E] SE[P]T[EM]B[RI] INDIC[IONE] V. I[N] NO[MIN]E D[OMI]NI N[OST]RI I[ESU] C[HRISTI] [In the year of the Lord 1141, month of September, fifth indiction. In the name of Our Lord Jesus Christ]".

OPPOSITE:
Detail of pavement in mosaic and *opus sectile* with peacocks drinking from a vase. SS. Maria e Donato, Murano.

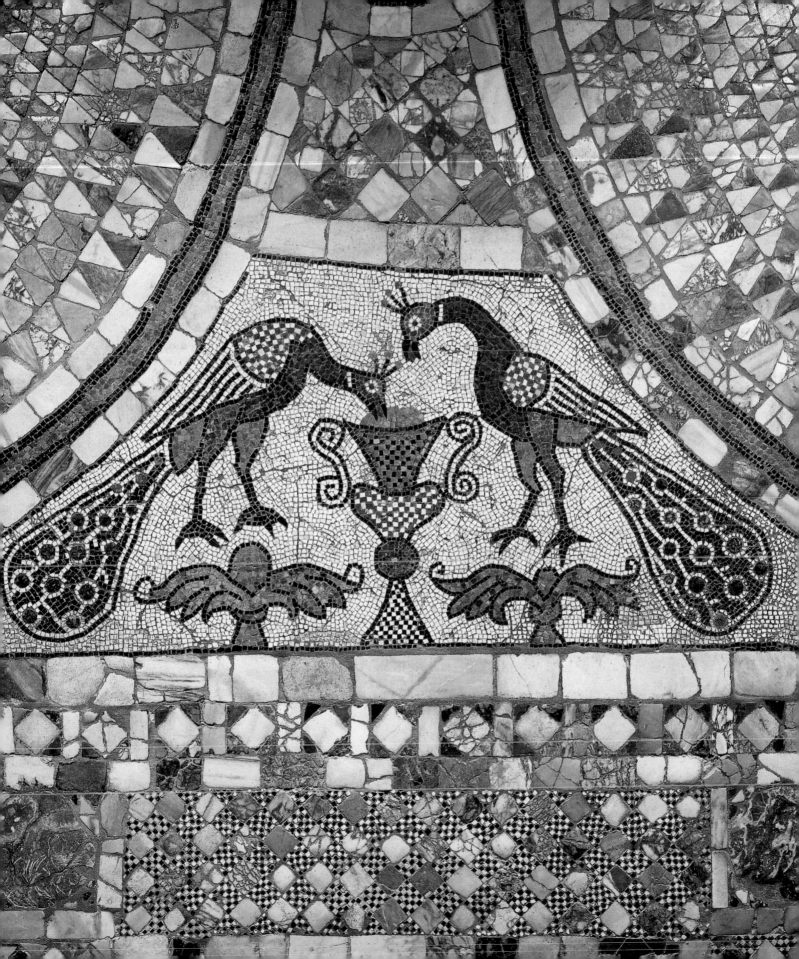

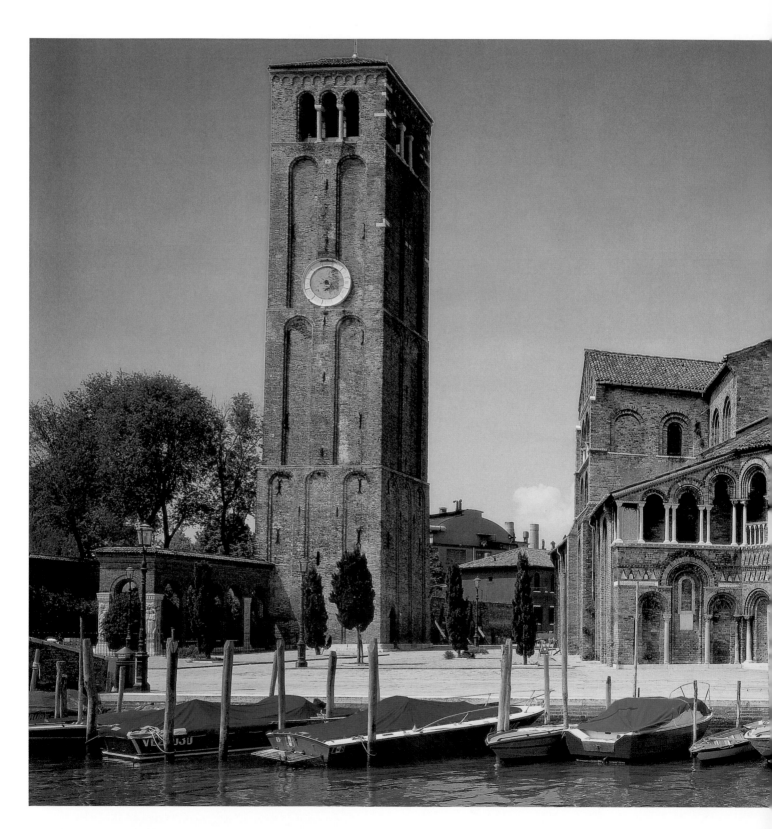

Plan of the Latin cross church of SS. Maria e Donato, Murano.

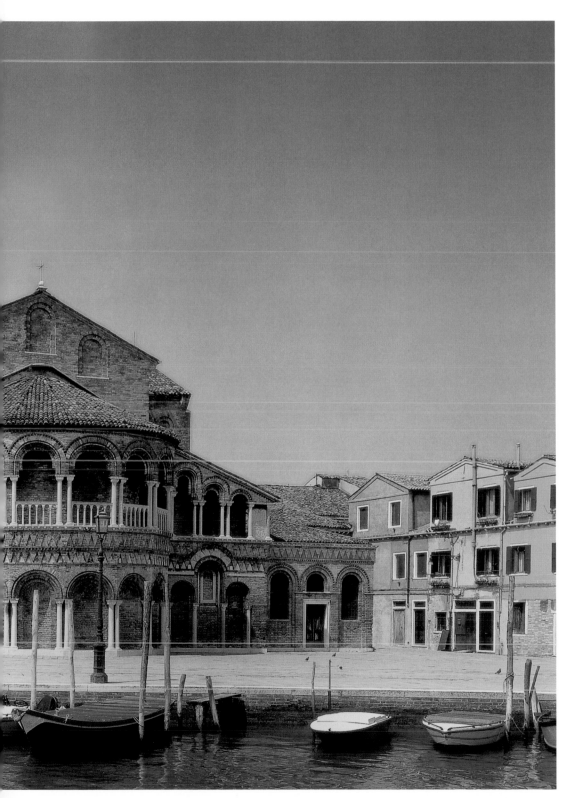

An impressive row of arches characterizes the apse of the church of SS. Maria e Donato on Murano. One of the oldest buildings in the Venetian lagoon, it was erected around the 7th century and reconstructed after the year 1000. The apse is on the canal, the main waterway along which in time the urban structure of Murano grew.

OVERLEAF:
The powerful articulated apse of S. Fosca on Torcello. The church is recorded between 1010 and 1020 even if its present appearance places it between the 11th and 12th centuries.

ON PAGE 31:
Corinthian capitals with abacus in red Verona marble. S. Fosca, Torcello.

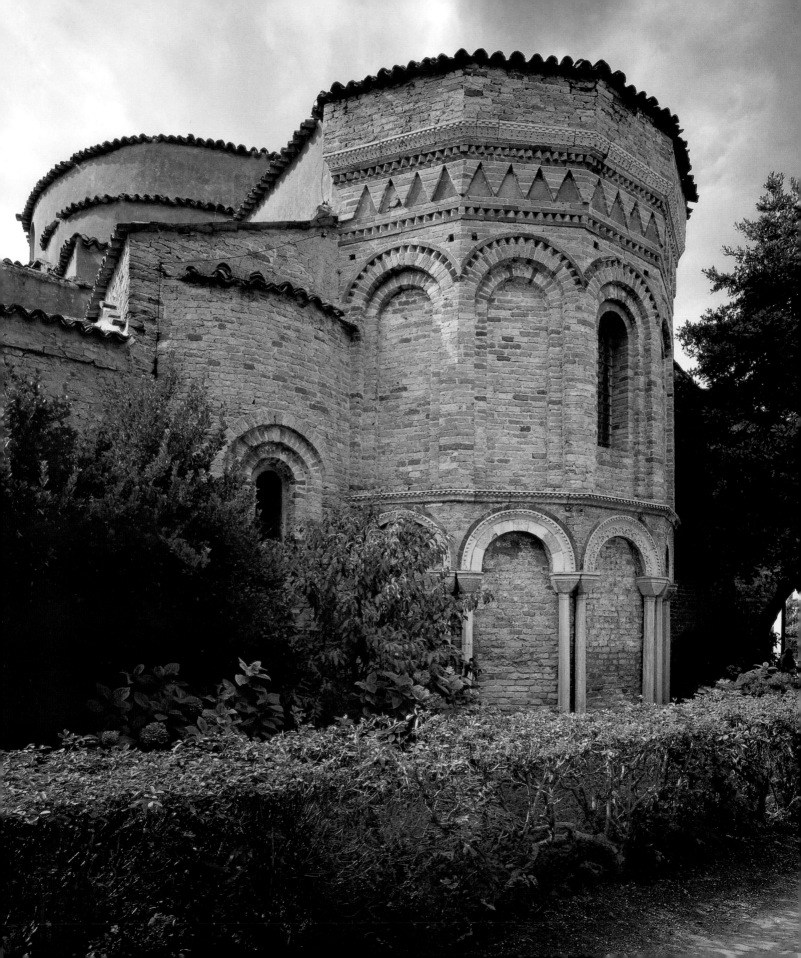

Equilo, and in Venice S. Salvador, S. Zaccaria, S. Lorenzo, and S. Martino, although already well into the fifteenth century Marco Cornaro regretted the dozens of churches "lavorade et salizado de musaico" [decorated and paved with mosaic] which had disappeared in the northern area of the duchy.

Despite its differences in quality, the decoration on the walls, floors, and furnishings of the episcopal church of S. Stefano in Caorle—traditionally dated 1038—are remarkably similar to those of Torcello in type and structure. For the rest, only the remains of S. Maria Maggiore in Equilo (before and after 1117) suggest the hypothesis that other cathedrals, from S. Pietro di Castello (after 1120) to S. Maria in Chioggia (probably twelfth-century), competed with each other in the building of walls the age of the last 'equal' contest between the dioceses of the duchy (Murano too, immediately after the completion of the reconstructed church with the dedication of SS. Maria e Donato in 1141 registered its—thwarted— episcopal ambitions). However, the impression is clear that over a hundred years or so a radical cultural renewal of the whole of Venetian society, an original maturing of the taste of its ecclesiastical patrons, and the refinement of the technical skills of craftsmen all left their mark on the entry of the archaic little Venices into the new duchy in the age of civic and commercial expansion.

The search for innovation in architecture is seen in the superb apse of SS. Maria e Donato in Murano, with forms and characters capable of transforming a rudimentary Romanesque building to the highest level, expressing the dawning Venetian taste for colored surfaces (see p. 29). With this must be seen the delicate minor translation of the nave of S. Fosca on Torcello, with its pure Greek flavor, and the subtle plastic form of the high apse of S. Maria of Equilo, original in its internal distributive solution of the whole head of the cross. Even the bell towers that rise ever higher next to the churches, constructed with unequal materials and shapes, symbolize the highest point of sought-for prestige, aimed outward, and sure protection of the first urban groupings. In contrast to the massive bell tower of Aquileia (see p. 33), erected in hard sandstone by the Germanic, and hostile, Patriarch Poppo (1019–31), round towers imitating those of the territory of Ravenna, sometimes refined with loggia tracery and the use of Istrian stone, and built in warm brick, were built in Caorle (see p. 32), Tessera, and San Secondo. The high Pomposa bell-tower of Deusdedit (1063), rich with pilasters, bows, and reliefs in terracotta, is copied more solidly in Torcello, Murano, Equilo, and S. Marco, and in a great number of small Rivoaltine bell towers.

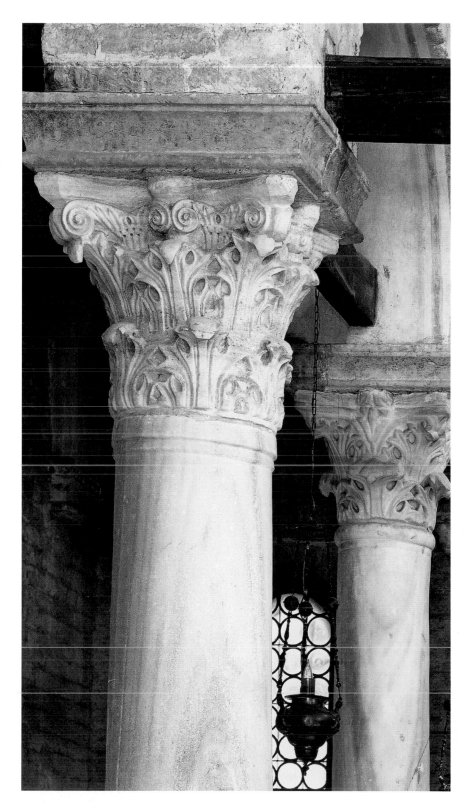

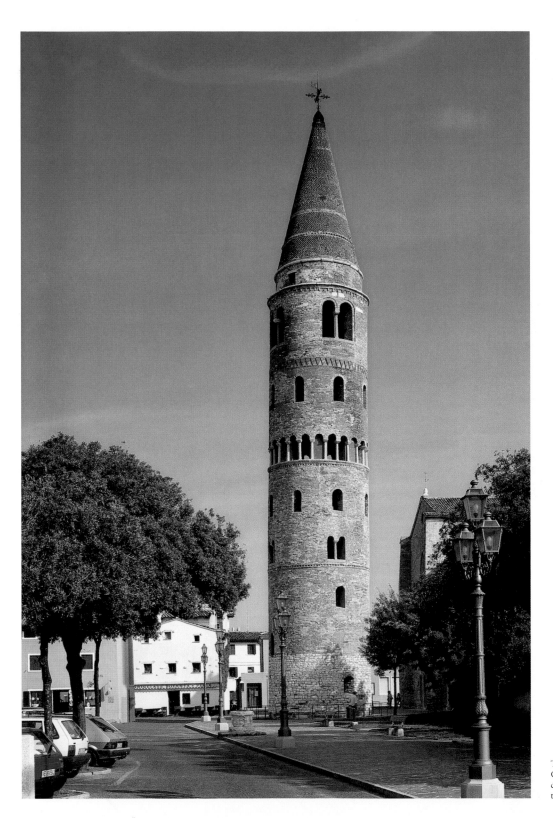

Typical circular bell tower of the cathedral of
Caorle. Dating from the first half of the 11th
century, it recalls the bell towers of the
territories of the exarchate of Ravenna.

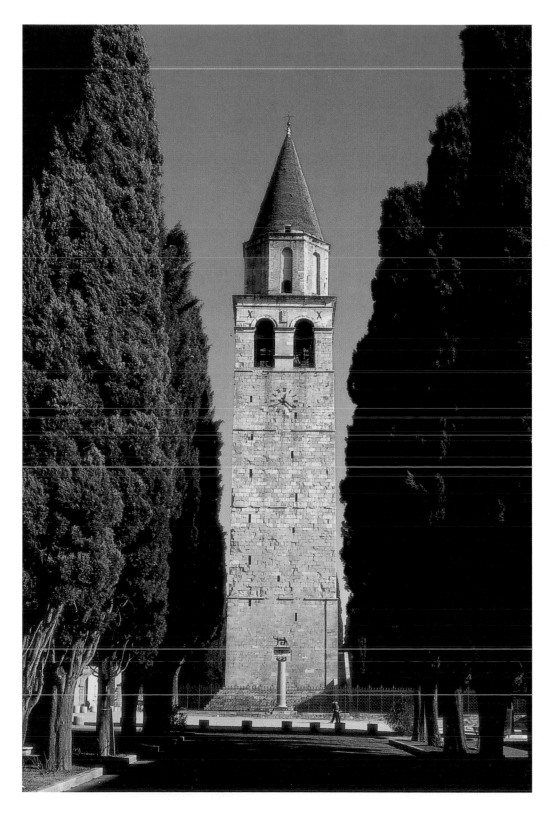

Framed by ancient cypresses, the square bell tower of the basilica of Aquileia. Under the leadership of Poppo, a noble of Carinthian origin and minister to Emperor Conrad II, Aquileia enjoyed an artistic Renaissance.

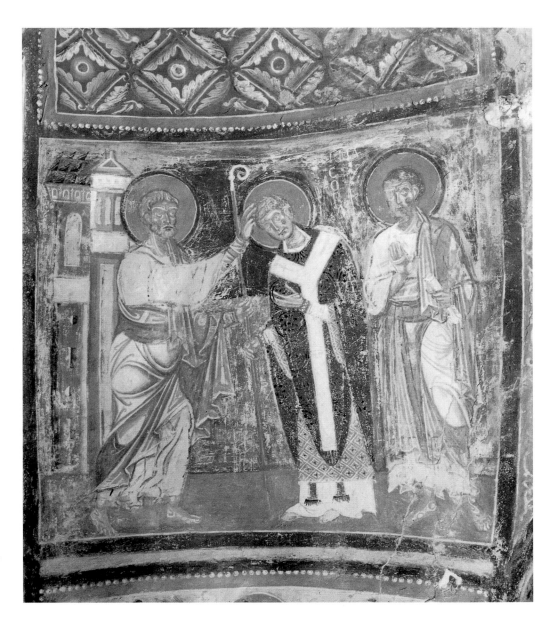

St. Peter Consecrates St. Hermagoras Bishop in the Presence of St. Mark, fresco, c. 1180. Aquileia, crypt of the basilica. The most interesting Romanesque frescoes in the entire Venetian region are here. The stories of the preaching of St. Mark at Aquileia and of the apostolate of St. Hermagoras were intended to glorify Aquileia.

In sculpture, the capital, an elaboration in the eleventh century in the Venetian area and all along the upper Adriatic coast, a perfect reflowering of the innumerable variations on the Corinthian of the fourth and fifth centuries, appears once more, perhaps for the first time consistently, in the great Aquileia series in the basilica of Poppo, where the acanthus leaf seems to be transformed into a palmetto, as shown by Buchwald. But the series he proposed (Aquileia, examples in Padua, Caorle, S. Nicolò di Lido, S. Giusto in Trieste, and S. Lorenzo in Pasenatico in Istria) can be further enriched with the examples—not externally dated, unfortu-

nately—of S. Eufemia on the Giudecca, S. Giovanni Decollato and S. Barnaba in Venice, Chioggia, and Istro-Dalmatian examples in three churches in Arbe (S. Maria Maggiore, S. Giovanni, S. Pietro in Valle), S. Michele in Cherso [Kres], and S. Maria Maggiore in Zara [Zadar], dated to the second half of the eleventh century. The spread of this model, which finds its most formalised creative development in the capitals of the nave of the Contarinian basilica of S. Marco, in those (of identical origin) of S. Giacomo di Rialto, and, finally, in those (post-1117) of S. Maria Assunta on Torcello, and those of SS. Maria e Donato on Murano

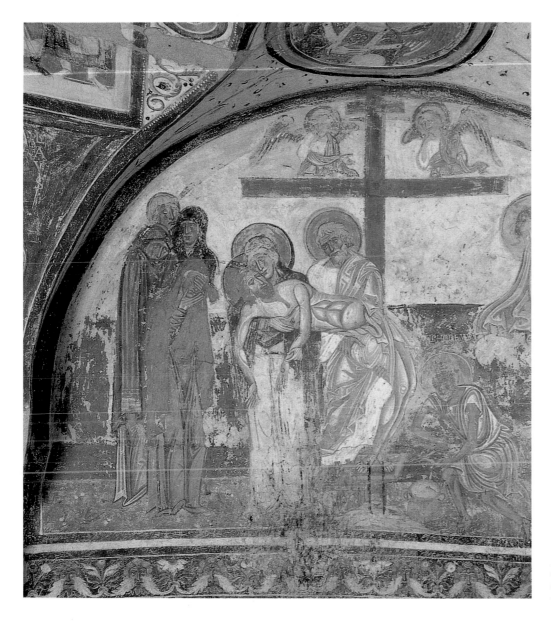

(where they are often embellished with a niello-decorated dosseret with delicate palmetto designs) is included among the upper Adriatic innovations accepted by Venice, with her own particular capacity for creative elaboration.

Unfortunately the few traces of fresco painting which can be dated to the eleventh and twelfth centuries do not assist in recreating a consistent panorama. The list is short: in the Torcello apse fragments of saints and of walls painted to represent *opus sectile* and *velum* [curtains], in the portico of S. Nicolò di Lido a lost group of Apostles in the Garden of Gethsemane, in the Baptistery of S. Marco a large fragment of the Virgin with angels and Apostles, at Murano a few traces of *velum*, at Equilo a lost fragment of *velum* with a griffin, in S. Lorenzo a fragment of drapery on a pilaster. The finds in Torcello, S. Marco (see p. 37), and S. Lorenzo, surely of monastic-Byzantine inspiration, are tied to the mosaic fragments of the Ursiana cathedral (Basilica in Ravenna (1112), and to the frescoes in the crypt of the basilica in Aquileia (see pp. 34, 35) where the *Deposition* is closely linked to the mosaic of the same subject in S. Marco. The *velum* at Equilo seems to be

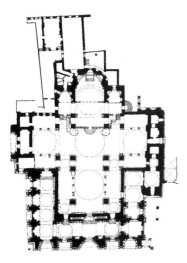

inspired rather by Romanesque iconography and taste, close to the frescoes of the sacellum at Summaga, while the lost *Garden of Gethsemane* of S. Nicolò would seem to be linked to the Benedictine manner of south Germanic influence, which in many ways also approaches the frescoes at the baptistery in Concordia.

If, with its exceptional works, Torcello represents the last attempt to preserve the now declining hegemony of the northern part of the Duchy, it is in S. Marco that the new power of the Rivoalto is found, able to impose, both within and without, a superior level of religious, artistic, political, and civic greatness.

The Building Yard of San Marco: From Architecture to Mosaic

In the sixteenth century Stefano Magno wrote: "It is a matter of record that since a sum of money was available, it was proposed that it be spent either to make that church or to make war; it was decided to make the church." This note may seem too cold in its calculation of a "business" investment, but it gives a psychological explanation for the astonishing leap—in scale, planning, and finance—implicit in the decision made by Doge Domenico Contarini to rebuild S. Marco, embracing S. Teodoro and reconstructing the chapel of 829 as the crypt of the new basilica. It seems clear that in Venice the politico-religious ideology of the period intended wholeheartedly to play the St. Mark card in the face of the two empires, Byzantine and Carolingian. The transformation of

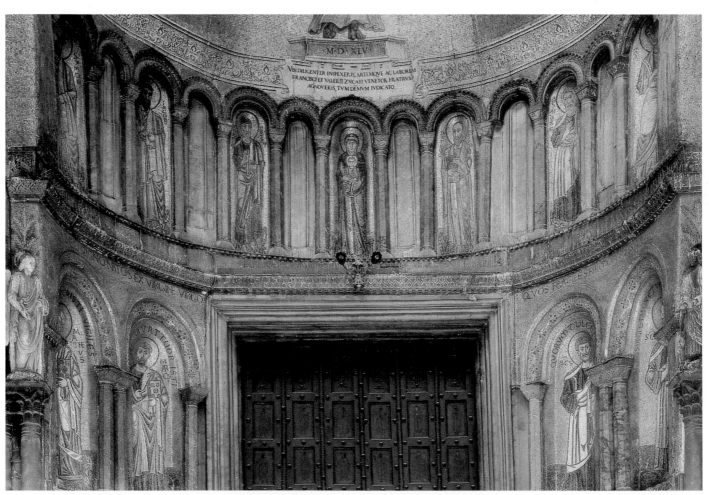

the chapel into a crypt did not completely obscure its shape recalling the church of the Holy Sepulchre, which was guaranteed at least by the Evangelist's shrine, but the city conceived a new and unsurpassable model, "an ingenious construction, like the one built in honor of the twelve Apostles in Constantinople," summoning the best architects from Constantinople to build "a superb temple, both unique and rare" (Bernardo Giustinian). The plan of S. Marco itself was decisive in transforming Rivoalto into Venice.

Even with the historian Procopius's lively description, we know little of the great Justinian basilica of the Holy Apostles in Constantinople except for the essential characteristics of its free cross shape and its domes. The basilica was demolished by the Turks in 1469. However, the new *similitudo* [likeness] sought in S. Marco by the Venetians must be understood in the symbolic and allusive ways typical of the medieval way of thinking. Moreover, the adaptations imposed by the preservation of the pre-existing buildings, all of great interest, must be considered, part of S. Teodoro and the first S. Marco as well as military constructions.

Thus a great Byzantine project with typical Late Romanesque architectural characteristics came into being in the building yard of Doge Domenico Contarini. On top of the solid base of the chapel of 829 rose a Greek conception with Roman structures and Venetian workmanship: a complex of giant pillars holding up five domes, fenestrated at the base, which crown four arms of the cross and the central area where they meet (see pp. 36, 39). The multiplication of the grandiose module of this pillar-arch-pendentive-dome system turned out to be decisive in obtaining a central cosmological-theological spacious-ness that reflects the oriental philosophical tradition, but, apart from the head of the cross formed on the chapel which had become a crypt, did not prevent the nave from having a rhythm analogous to those of the naves of Western basilicas, which give more importance to the longitudinal axis, in the Latin manner. More than demonstrating consistency with the expressive vocabulary of the late Macedonian architecture known to us, S. Marco brings to mind the great buildings of sixth-century Constantinople, S. Sofia and S. Irene, as well as recalling, because of its otherwise inexplicable formal homogeneity, the lost basilica of the Holy Apostles.

Nevertheless, S. Marco, consecrated in 1094, underwent numerous modifications over the first four centuries of its history. On the outside, an imposing structure of vaulted and dome-shaped atria (the narthex) and of chapels (the Zen Chapel and the Baptistery) gradually hid the greater part of the original facade, composing on the structural level pendi-

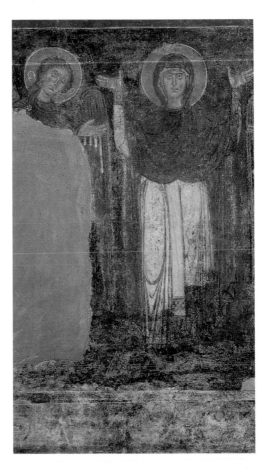

OPPOSITE:
Plan of the basilica of S. Marco.

Evangelists (on second level, in niches) and *Virgin Flanked by Apostles*, mosaic, basilica of S. Marco, main (western) doorway. These are among the oldest mosaics in the basilica.

Virgin Praying Between Two Angels, fresco, basilica of S. Marco, Baptistery. This may, according to some historians, be all that is left of a much larger fresco depicting the Ascension.

Detail of mosaic pavement, basilica of S. Marco, south transept.

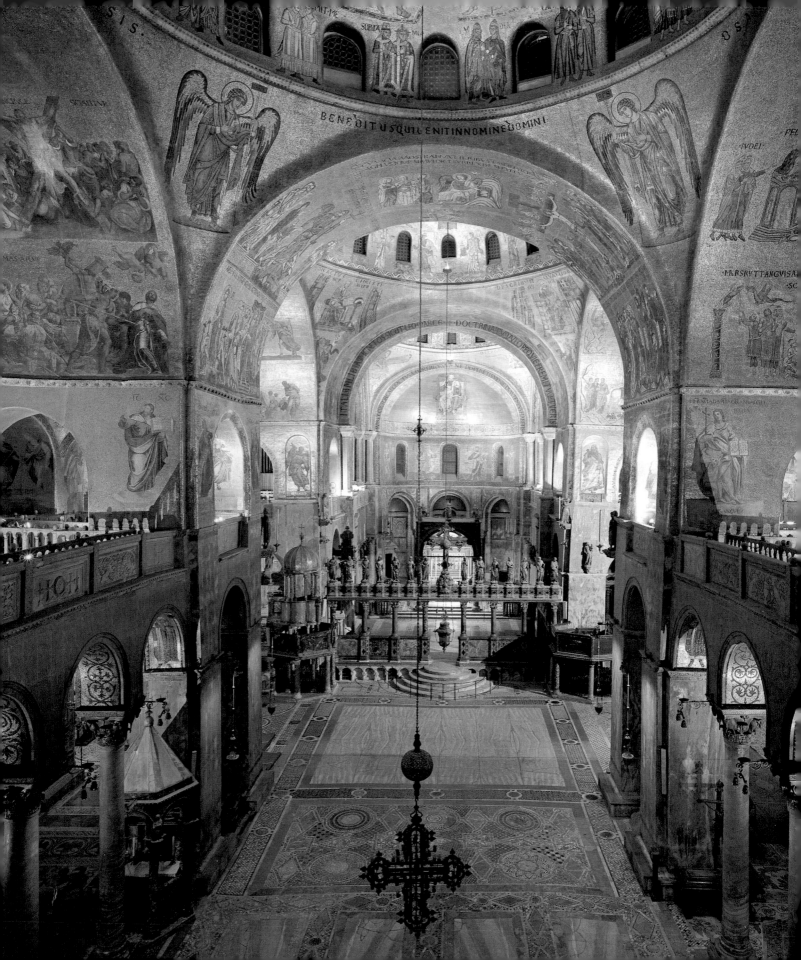

ments, modifications, removals, and closings-off, and adding marble and mosaic facing, a wealth of sculpture, and huge wooden extensions to the outer domes to the point that the final result could not have been imagined at the beginning (see p. 39). Only the exterior of the apse has maintained its original appearance, where the different components that formed it through two architectural orders can be read: a lower circle of the apse that recalls Late Roman art from the polygonal styles of Ravenna, an upper circle made up of niches of an outside gallery in upper Adriatic Romanesque. On the three facades that have been reworked, the brickwork and niches have been hidden for ever by the marble panels and porphyry and marble columns provided by the Sack of Constantinople in 1204.

Even the interior underwent significant change. The women's galleries were mostly demolished or reduced to narrow walkways after the earthquake of 1222 and the fire of 1231. The great series of windows of the external wall had already been closed in the twelfth and thirteenth centuries in order to allow the construction of the vast mosaics and the advance of the northern narthex and the southern chapels, seriously reducing light in peripheral areas. Perhaps a similar reason was behind the demolition of the central dome of the western narthex (the so-called "well"). Certainly the great Gothic rose window was opened on the southern wall of the transept to solve the problem of illumination. Even the wonderful gilding of all the interiors, starting from a height of nine meters (thirty Roman feet) from the floor, was extended far more than had been planned and allowed for in the original design, canceling the articulation of walls and architectural niches prepared for the hierarchical orders of effigies of saints and feasts of the liturgical cycle. The result is unique, a decorated uniformity comparable to the basilicas of the East, in which are kept distinct, both for function and for decoration, the *pars terrestris*, the earthly, lowest part, and the *pars coelestis*, the heavenly, highest part, of that representation of the cosmos that they are intended to express. Furthermore, in the great sea of gold in S. Marco can still be made out five marble cornices that run at different heights along the whole fabric, residual signs of the original levels decided by Contarini's architects: a first frieze, at a height of 20 Roman feet, crosses the body of pillars and walls at the height of the pulvins; a second, at a height of 30 feet, indicates the floor of the women's galleries; a third, at 34 feet, is indicated by the handrail of their plutei; a fourth, at 48 feet, marks the profile of the arches all over the building and the base of the vault in the apse; finally, at a height of 72 feet, a fifth frieze constitutes the circum-

ference of the base of the tambours that hold up the domes, which reach 90 feet and 96 feet at the top of the central dome. But the *pars coelestis*, or, better, *aurea* [golden], takes up a preponderant section of this gradual occupation of space, leaving to the reflecting marbles in precious symmetry of the *pars terrestris* less than a third of the total height of the wall. Moreover, by submerging the entire upper space, the gold in S. Marco floods each element of

Plutei of different styles and periods. Basilica of S. Marco, women's galleries.

OPPOSITE:
Interior view of the basilica of S. Marco toward the iconostasis and chancel. In the center foreground, the arch of the Passion.

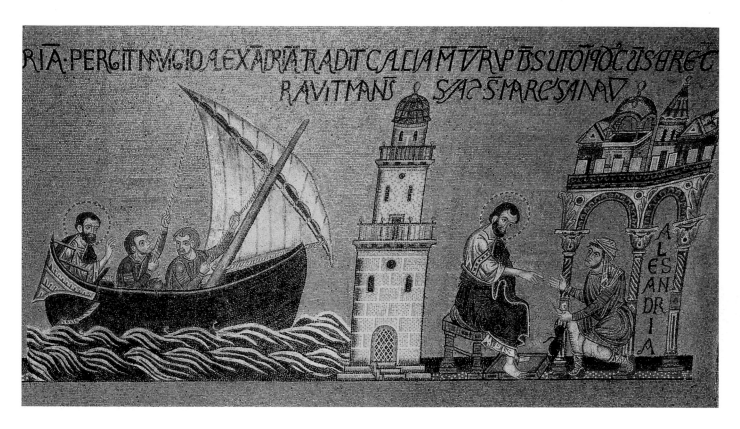

RIA·PERGITNAVGIOALEXADRIARADITCALIAMTDRVPBSVTOTPOCISBREC RAVITMANS SAPSIMARESANAD

Arrival of St. Mark the Evangelist in Alexandria, mosaic, vault of the Zen Chapel in the basilica of S. Marco. Detail from the 12th-century cycle of the story of St. Mark.

nature and hierarchy of the story of salvation with a dazzling wave of heavenly light, thus distancing itself from neo-platonic as well as Byzantine concepts of cosmological theology.

That this was not the original intention is demonstrated by those buildings immediately following it which are at least partly inspired by the Contarinian building yard. One is the large church of S. Maria Maggiore in Equilo, begun perhaps at the end of the eleventh century and finished after 1117. This church takes a good part of its design from S. Marco and imitates many of its architectural details. Another is the new church of SS. Maria e Donato on Murano, completed in 1141, which develops the suggestion of the outer apse of S. Marco, thus producing a flexion of extraordinary originality in the late and uncertain context of Venetian Romanesque architecture (see p. 29). Finally, S. Fosca on Torcello recalls the Greek churches of the eleventh to twelfth centuries and renders the same architectural language in a poor but elegant combination of stone and brick (see p. 29).

In these three outstanding buildings there is no decorative excess: only a few fragments of frescoes have been found at Equilo and none in S. Fosca, while the surviving praying Virgin in the golden vault in SS. Maria e Donato in Murano shows closer links

to the theology of the delegated spaces that make Torcello cathedral so extraordinary.

Instead, the development of the gilt decoration of S. Marco is a statement of the city's desire for hegemony in the second half of the twelfth century, particularly the imperialist glorification that arose from the Sack of Constantinople in 1204. In these decades the doges, Sebastiano (1172–1178) and Pietro Ziani (1205–1229), were exceptional men from extremely rich families. Piero by then was "Lord of a Quarter and a Half-Quarter of the Roman Empire." The marbles and gold of S. Marco expressed an imperial dream.

Halfway through the twelfth century, there were few mosaic surfaces in S. Marco: the Virgin with the Apostles and Evangelists over the front portal (probably surmounted by a Pantocrator), the great figures of the apse (Pantocrator, redone in 1506, and the patron saints), the eastern dome (Emmanuel among the Prophets), and possibly the western dome (Pentecost with the Apostles) (see p. 44), the first stories of St. Mark in the chapels of St. Peter and St. Clement, the stories of the life of Christ of the great southern arch from the temptation in the wilderness to the washing of the feet. It is clear that there was an intention to present in the basilica the essential

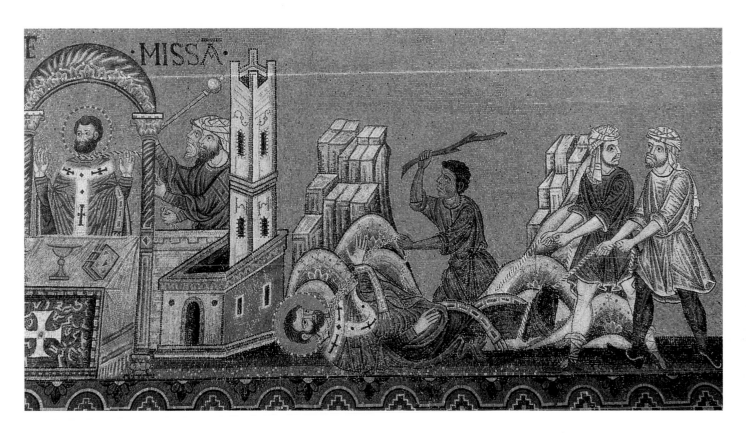

themes of Eastern iconography alongside some local themes, in particular those referring to St. Mark, but it is certain that work was not yet being done on the full gilding of the interior.

The mosaic decoration of the twelfth and thirteenth centuries altered profoundly the original iconographical orientation because it provided for a Western-style narrative rather than a theological synthesis in the Byzantine manner. The divinity, for example, is represented in three domes (Ascension, and Pentecost) (see pp. 42, 43, 44) and in the apse (the Pantocrator), thus investing the basilica lengthwise with themes that mature Byzantine tradition reserved for holy days (Ascension and Pentecost), and certainly would not have placed on domes. In this can be seen the desire to show in narrative form what in eleventh-century Byzantine art is represented as a vision of heavenly dogma, purely for contemplation. This narrative approach seems to be confirmed by the tendency, typical of the artists of S. Marco, to multiply the themes of the holy days. Far from being consolidated in the twelve events preferred by Byzantine tradition, these are presented as "stories," not compressed into units of time or space, in which the succession of events is given priority (as in the "little stories" of icons, altarpieces, and polyptychs of

Western late medieval), not exempt from notations of *sermo humilis* [humble language]. All these can be seen in the *Temptation in the Wilderness*, set out into the three temptations of the Devil.

Given this conception, the great expansion of the repeated stories of the cycle of St. Mark within the context of the mosaic (and non-mosaic) decoration of the basilica dedicated to him appears fully justified. The story of St. Mark and Venice is progressively tied together in a myth which extends from the historical terrain of the theft of St. Mark's relics to the canonical one of ecclesiastical jurisdiction, the constitutional one of political independence, and, finally, that of the providential foundation of the Venetian State. Between the beginning of the twelfth century and the end of the thirteenth, it coincides with the periods of decoration of the basilica. From the first series of stories about the apostolate, martyrdom, and removal of St. Mark's body (*translatio*), narrated in the choirstalls of the chapels, to the second telling of the *translatio*, extended over the lunettes of the facade, and then the third series, which in the south transept represents the miraculous events of the apparition (*apparitio*) in two parts (see p. 44), and, finally, the fourth, which on the vault of the present Zen Chapel (see pp. 40, 41) extends the

Martyrdom of St. Mark in Alexandria, mosaic, vault of the Zen Chapel in the basilica of S. Marco. The cycle of the life of St. Mark covers the entire vault.

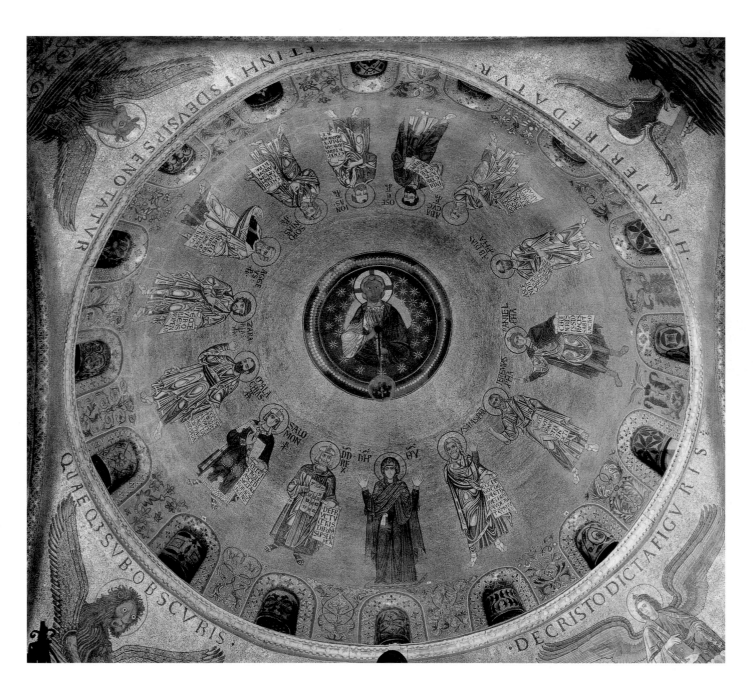

Christ in a Starry Heaven Surrounded by the Virgin and Thirteen Prophets, mosaic. Basilica of S. Marco, Emmanuel dome.

myth with the prophecy of the angel who identified the *vaticinatio* [prophecy] of St. Mark with the destiny [*praedestinatio*] of Venice.

The four series of mosaics in the basilica in which St. Mark's history is recounted are referred to as the birth of the myth of St. Mark (mythogenesis of St. Mark); they represent an event in the process of being formed rather than a sacred story already canonically defined. They express clearly the psychological and political translation that the ducal patrons effected on the iconographical material that the craftsmen had to carry out, defining even the smallest details of those extraordinary accounts in which the story of the patron saint is identified, both temporally and spatially, with the history of the *patria* [motherland]. It is difficult to

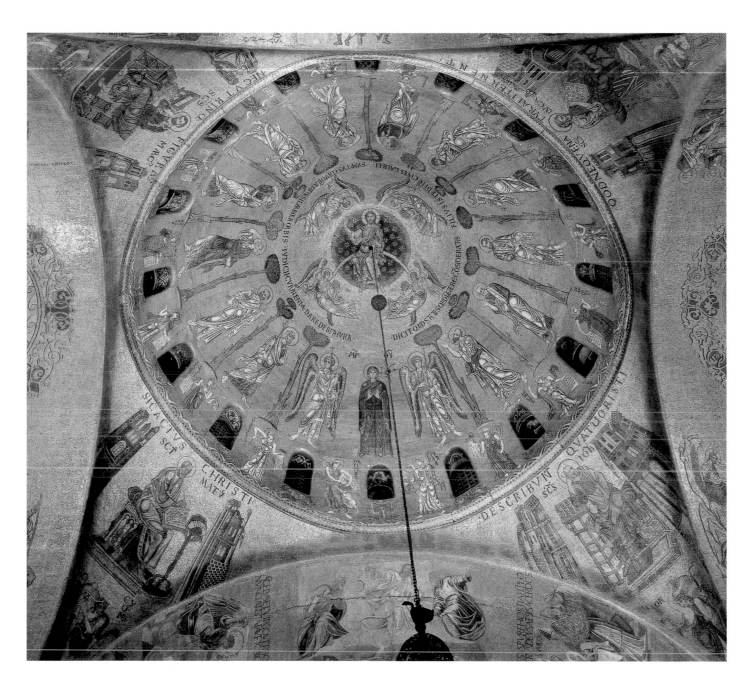

imagine a national epic with more intense popular participation.

As there are no signed medieval works in S. Marco, the names, education, and origins of those who made them are not known for certain. A few external or indirect sources have given us possible names of a Marcus Indriomeni [Greek] *magister musilei* [master in mosaic] (1153), a Teophane (another probable Greek) in about 1200, and local craftsmen such as a Bon[us] Johannis *pictor* [painter], documented between 1185 and 1212, and a Marinus *pictor*, known in 1227. However, the works of several generations of artists which have been preserved, providing an exceptional array of mosaic texts even if it is not intact, have made it possible for many scholars to attempt difficult but

Ascension, mosaic. Christ, surrounded by angels, ascends to heaven, the Virgin, two archangels, and the Apostles around him.

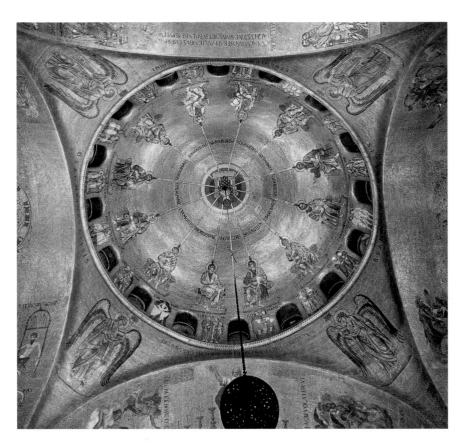

Pentecost, mosaic. The Holy Spirit descends to the Apostles in the form of flames. Basilica of S. Marco, Pentecost dome.

figures were redone after the earthquake, probably after a few decades. The first phase, and this only, of the dome is certainly linked to the preceding works, and must still refer to Greek workmanship of the end of the eleventh century.

The St. Mark cycles of the chapels of St. Peter and St. Clement, the Christological stories of the great southern arch of the central cupola (*Temptation, Entry into Jerusalem, Last Supper,* and *Washing of the Feet*), and the stories of Jesus (childhood and miracles) and of the Virgin found in the transept, as well as the northern and southern domes, later bring together different phases, ways, and attempts by local artists for at least fifty years in the middle of the century.

In the cycles of St. Mark in particular there is a juxtaposition of standard figures, reshaped, adapted, and placed in simple settings with a modest language of physical transparency against a pervasive gold background that Gombosi rightly called "the transparent or pen-and-ink drawing style." The use of miniatures or specific models drawn up in the East and recognisable by their expert elaboration is part of this phase. However, the stories of St. John the Evangelist adapted in the northern dome and structured in a repetitive way display early signs of iconography even if this is a first attempt to set a continuous narrative in the central space of a dome, unknown to Byzantine art of the time.

Perhaps between 1160 and 1180 the decoration of the domes of the nave was taken up again with the reintegration of the eastern one (Emmanuel and Prophets) and the execution of the western one (Pentecost). In this ambitious endeavor, the hand of Eastern master craftsmen is again evident, as already noted in Torcello. Local energies were exercised in new and more profitable apprenticeship. These Prophets and Apostles retain the immobility peculiar to middle Byzantine models. But it is in the Ascension dome, following immediately afterward, that the first astonishing result of the autonomous creativity of the new phase of collaboration between Greek masters and Venetian mosaicists is apparent. It was a local group that was now stable, though perhaps still ethnically mixed, that worked for a few years up to the completion of the great arch of the Passion and the great mosaic of the *Agony in the Garden* (see p. 45). The style is close to that of St. Panteleimon of Nerezi (1165), but Western iconographic and stylistic elements (above all the figures of Virtue and of the Beatitudes in the lower drum) are present in the dome with accents of Late Romanesque, even proto-Gothic (Bettini), expressionist elements, which blend to produce an exceptional result, with a background of late Comnene mannerism, depicting the syncre-

not unproductive readings, datings, cultural interpretations, and stylistic qualifications over the last one hundred years (Cattaneo, Tikkanen, Saccardo, Gombosi, and Bettini), which are brilliantly crowned by the great work of Otto Demus.

The first mosaics, on the portal and the apse, were certainly executed by oriental craftsmen (though they were not very up-to-date) who can be linked to the artists of the older Apostles in the apse of Torcello. They reveal a stylistic evolution (the figure of St. Mark), while also approaching the fragments preserved in the cathedral of Ravenna, dated 1112, even though these are culturally very different (see p. 37). Of about the same date, or, more likely, the beginning of the twelfth century, is a small fragmentary *Deposition* found in 1954, in the unusual place of the chancel of the basilica, which has innovative iconography and the stylistic character of the proto-Comnene period. The mosaics made after the fire of 1106 and earthquake of 1117 are different. The oldest surviving part of the eastern dome (the Prophets Jeremiah, Abadiah, and Abacuc, and part of Daniel) can be dated to after the fire of 1106 but before the earthquake of 1117, while all the other

tistic characteristics of the first great Venetian pictorial art. The schema, which looks ahead to the Macedonian period (S. Sofia in Thessaloniki), permits the inventive expression of dramatic experience in a mannerist fashion together with the standard representation of the dominating figures of the ascending Christ and praying Virgin. The figures provide a whirling human panorama in an axial paradigm of salvation in the frame of an earthly and heavenly setting that is not marred by the gold background.

To the same mosaic workshop should be attributed the scenes—of great compositional skill and color—of the masterly arch of the Passion. Here a narrative figurative composition tends to overtake the mannerist modules of the central dome, accentuating them to the point of making them rigid. The virtuosity of certain figures (doubting Thomas, betraying Judas), together with the overlapping of bodies and the use of strong, even brutal colors, results in intensely emotional relations between figures in the urgency of the situations, an increasingly dramatic context which transforms the "feasts" into "stories." In these representations, especially in the Good Friday Eve, characters speak directly to the faithful through the words of the New Testament, written on scrolls, affirming, in short, a style of historical reconstruction that recalls late medieval mystery plays.

The principal artists of the arch of the Passion were also responsible for the great mosaics of the *Agony in the Garden*, dated to the end of the century, which can be considered the greatest achievement of Italian art of the time. Tastes and styles from the most exquisite Western miniatures emerge here alongside sophisticated late Comnene characteristics and obvious archaic elements. But what really distinguishes this particular endeavor is the narrative continuum: the story takes place at night in a corner, both bitter and sweet, of the mountain where the drama of acceptance occurs in an escalation of divine anguish and human slumber. If the conversation between Jesus and St. Peter still shows repetitious figuration, the superlative depiction of the group of sleeping Apostles is a composition of exceptional daring.

Above later works by this workshop (portrayals of Prophets with the Virgin and the Emmanuel) and by another group which continues the manner of the local "transparent style" (stories of the Apostles' preaching and martyrdom), in the narthex, another ambitious cycle of high-level thirteenth-century Venetian mosaic art can be seen. This is the work of a workshop active in original formal and narrative skill, recognisable for about fifty years.

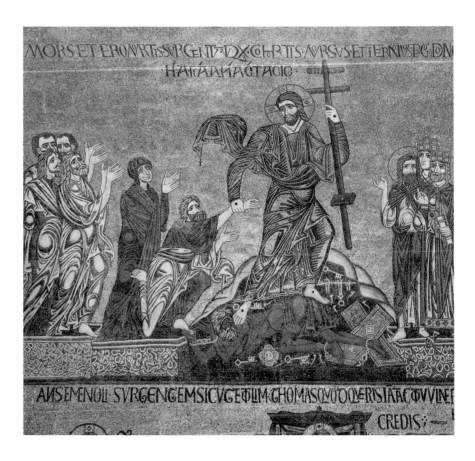

Leaving behind the theological-contemplative fabric of Byzantine basilicas of the Macedonian and Comnene periods and the same composite programme of the basilica interiors, the decoration of the six domes, pendentives, lunettes, and great arches of the narthex of S. Marco tells a single rigorous narrative based on the Old Testament, from the creation of the world to the crossing of the Red Sea by the Jews, realistic narratives of sin and divine intervention, an imposing and imaginative complex of 137 scenes. From Tikkanen to Demus and Weitzmann, research has identified the probable models as the stories from Genesis in the Cotton Bible (pre-Justinian of the fifth and sixth centuries) and the stories from Exodus in a manuscript of the late thirteenth century, proto-Palaoeologan. The transposition of these stories from vellum to curved space posed exceptional problems for the craftsmen that Byzantine mosaic art had never had to face, given that the generally small domes and the vaults of apses were rigorously reserved for the Divinity and for the Virgin and Child. The artists faced two contradictions, that of representing historical events in narrative form in a place reserved for theological contemplation, and

The Anastasis vault between the Ascension and Pentecost dome, known also as the arch of the Passion. Basilica of S. Marco. The risen Christ, grasping the cross in his left hand and trampling the Devil, draws Adam from his tomb, followed by a beseeching Eve and other figures from the Old Testament.

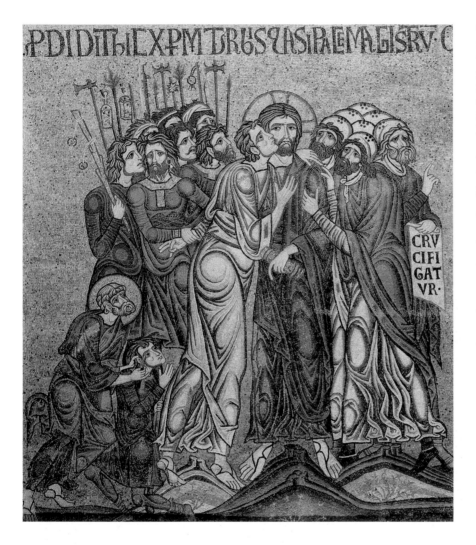

PDIDIThI CXPM TRUS QIS PAE MAGIS RV C

CRV CIFI GAT VR·

Betrayal of Christ, mosaic in the arch of the
Passion in the basilica of S. Marco. The cycle
of the Passion, Ascension, and Agony in the
Garden are the most impressive 12th-century
works in the basilica.

OPPOSITE:
Creation and *Adam and Eve* mosaics. Basilica
of S. Marco, atrium, Genesis dome.

The Genesis dome is a masterpiece in the new
S. Marco manner: here the creative progression of
the days of the origins, marked by the numerical
progression of the angels, is based not only on imagi-
native illustrative ideas but also on the stylistic and
chromatic accents in which it is achieved, an original
interpretation of Romanesque and Western style (see
p. 46).

The second narrative mode can be seen in the story
of Abraham in the second dome, a continuum of
separate scenes distinguished by the repeated appear-
ance of the protagonist, as in the dome of St. John.
The fundamental convention that emerges is that of a
continuous narrative style in a circle of a single
strip in which few indispensable supporting scenic
elements appear, while the stylistic characters of the
figurative compositions of the stories of Genesis,
Noah (see p. 48), and the Tower of Babel are
retained. The first cycle of Joseph, in the third dome,
belongs to this phase, but here the distinctions of
time and place of the narrative are entrusted to the
insertion of recurring spatial elements, and to the
groupings of figures around the protagonists while
the supernatural vanishes, leaving space even for the
illusory phantom of dream representations. At the
top of the vault, progressing beyond the flat star
design of the first dome and the radiant central medal-
lion of the second, the cosmic symbolism marks a
further geometric-decorative development, which in
the last domes generates rose windows of Romanesque
and Gothic taste, full of floral representations of
Islamicizing virtuosity.

Finally, in the northern narthex, a third style
appears, that of the cycles of Joseph in the fourth and
fifth domes and of Moses in the sixth. Here are inde-
pendent scenes, distinguished by the figure of the
protagonist and by different architectural and land-
scape backgrounds (of classical type, Romanesque
form, and some Gothic influence), explained in
appropriate captions (which are no longer confined
to the margins of the representation, as in the prece-
ding domes, but are placed freely in the scenes so as
to become an integral part of them).

This second part of the cycle marks a solution of
continuity, determined by a long pause halfway
through the century during which it is believed that
the craftsmen of the narthex worked elsewhere,
including on the dome of the church of S. Salvador.
When work was taken up again, around 1260, the
art of the S. Marco craftsmen had matured yet more.
The new, more cosmopolitan cultural context shows
the influence of mercantile experience and the exalta-
tion of political and military "imperial" enterprises
in the East (which married well with the story of
Joseph in Egypt). The wealth of colour and of

that of fusing the single autonomous illustrations
available into a narrative continuum. The solution
finally reached through innovations transferred from
dome to dome, starting from c. 1220–30, seems to be
totally original, dependent neither on early Western
false solutions (Lambach, eleventh-twelfth century;
crypt at Anagni, mid-thirteenth century), nor from
the endonarthex of St. Saviour in Chora (Kariye
Camii) in Constantinople (early fourteenth century).

In the complete cycle of the narthex of San Marco,
three growing ways of depicting a narrative can be
recognized, up to the acquisition of a final clear icon-
ographic and stylistic maturity. The first can be seen
in the narrative of the creation of the world in the
first dome, presented in vignettes against a gold
background in a trapezoid section of a circle on three
concentric crowns around a cosmic representation.

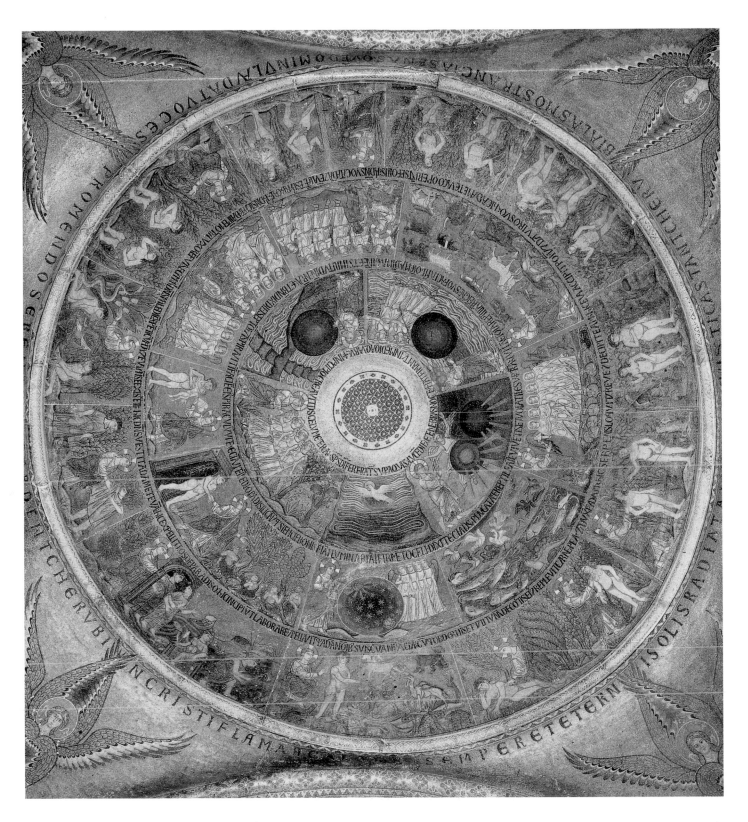

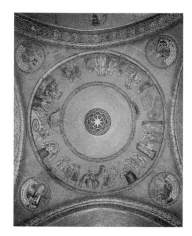

Story of Joseph, mosaic. Basilica of S. Marco, atrium.

Opposite:
Interior of the basilica of San Marco, view from west towards presbytery showing the Emanuel dome, the Ascension and the Pentecost dome.

Drunkenness of Noah, mosaic, detail. Basilica of S. Marco, atrium.

compositional linearism evolve in evident figurative plasticity, with classical stylistic features of rhetorical flavor. The figures, now larger, compete to reduce the gold background and, with the enlarging of the scenographic structures, form autonomous units within the narrative process, at times of longer duration, at times in instant succession, which upsets the rhythm of the story with literary landscapes and dramatic compression—leaps in time, changes of subject, insertion of dreams, semiotic intentions qualifying the narrative knowledge reached. In the dome of the stories of Moses, finally, the wealth of background elements and scenic furnishing is completed by a process of naturalisation that informs the whole changing scenery—buildings, mountains, domestic scenes, deserts—which appear not only to be really happening and lived, but unique and passing through time in the creative variety of functional qualifications.

From the high point of these achievements, the stories of the cycle of the narthex, the largest and most complex of the pre-Giottesque thirteenth century, present to us, at the level of popular history, the mature Venetian version of the vindication of Antiquity and the repossession of the Orient, two motifs common to much of thirteenth-century Italian civilization but experienced in Venice, especially after 1204, in an almost obsessive way.

The gradual narrative construction, religious-historical and politico-historical which we have called the formation of the myth of St. Mark (mythogenesis of St. Mark) was being completed. First of all, the four arcades on the sides of the facade which for decades had been gradually covered by slabs, capitals, and marble columns from the East, provided, a little after the middle of the century, a place of honor for the narrative of the story of the translation of the relics of St. Mark from Alexandria to Venice (of the original unfortunately only the last scene, the triumphal entry into S. Marco, survives). Immediately afterward, the western wall of the southern transept was decorated with two great "historical" scenes reproducing in the division of the basilica the miracle of the Apparition. Finally, the barrel vault of the south entrance of the narthex, open onto the sea door (now the Zen Chapel), received a new story of the travels of St. Mark, in which the prophecy of the angel to St. Mark as he sailed on the lagoon finds a place, representing the divine predestination of the city. What remains of these cycles today, sometimes badly restored, attests to a process of historiographic meaning that gradually matured over more than a century in the mosaic decoration of the basilica. The thirteenth century, an exceptionally harmonious artistic period for the S. Marco mosaics, was defined by Demus as a first Renaissance but the culture of that generation of artists was rapidly lost, if it is true that the workshop of the narthex left no legacy.

The long analysis of the medieval mosaics of S. Marco up to the end of the thirteenth century has had to be extended well beyond the chronological limits set for this chapter.

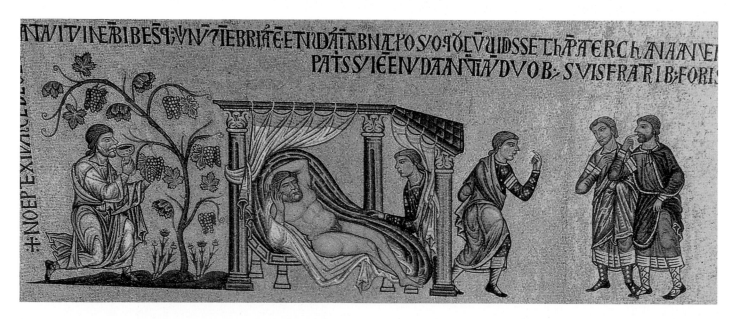

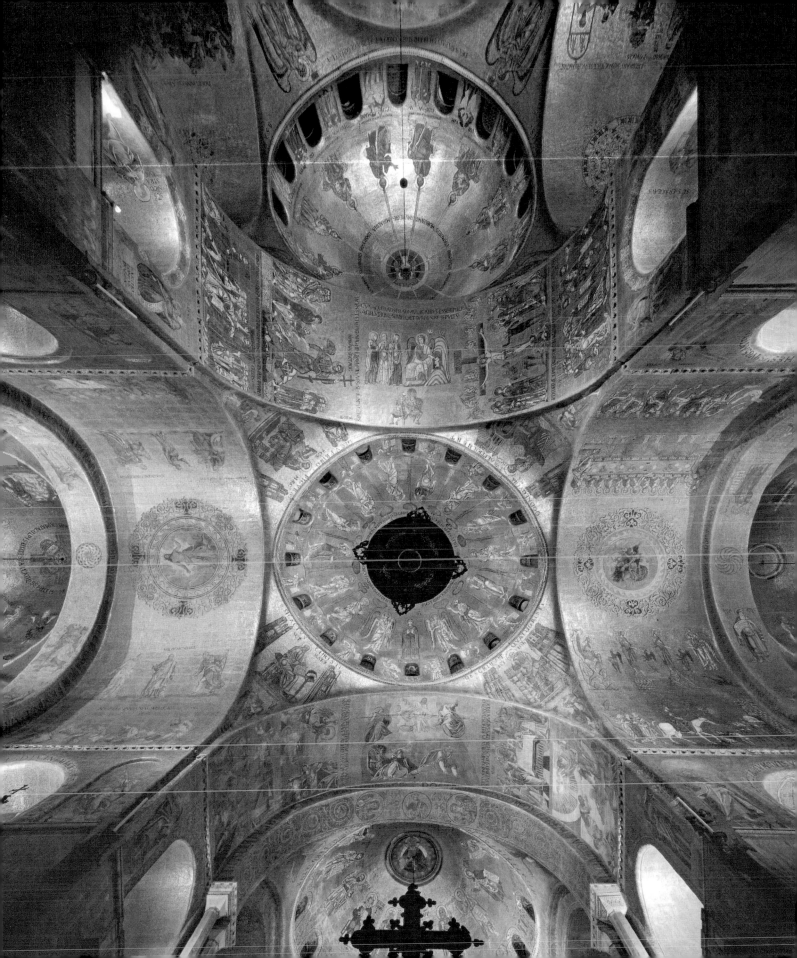

Byzantine "Continuity" and Western Romanesque
Secular Architecture

Virtually nothing is known of residential architecture in Venice before the twelfth century. In the early Middle Ages dwellings were made of perishable materials—wood, reeds, thatch, and the like. Whatever imprint they left in the soil is covered by the modern city. Written descriptions, for their part, are few, and the exact meaning of the technical terms they use is often uncertain. In short, we lack the archaeological evidence and unambiguous written testimony that are required to reconstruct the appearance of Venetian houses before the city's inhabitants began to build regularly in brick and stone.

Throughout Western Europe, masonry construc-tion became common again in ordinary, residential architecture after the millennium. Although masonry was widely used during antiquity, it became an elite material during the early Middle Ages, reserved for the buildings of the privileged clergy and nobility—churches, monasteries, and noble residences. With the advent of the millennium, however, as commerce and industry revived and the merchant classes in trading cities such as Venice prospered, the newly rich began to imitate the building style of the privi-leged, spreading masonry construction down the social ladder. Practical considerations also favored this development. As rising birthrates and massive

Ca' Lion-Morosini. The courtyard connects the palace with the Grand Canal. The living quarters were on the first floor, accessible via external stairs. Supplies, firewood, and equipment for the outfitting and maintenance of boats were kept on the ground floor. A cistern under the courtyard collected rainwater which was reached by a well.

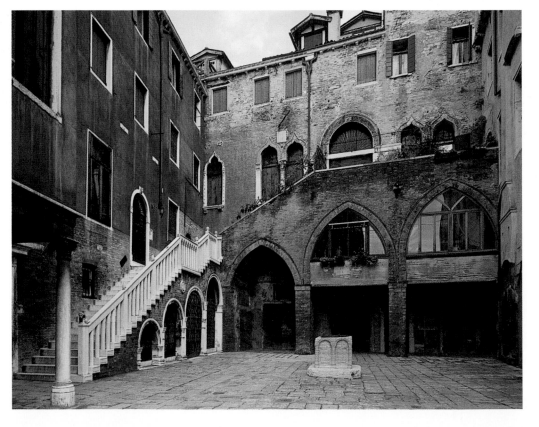

immigration from the countryside made cities throughout Western Europe grow swiftly larger and denser, ever more frequent and ever more ruinous fires began to consume whole urban districts at a time. In Venice alone there were two such fires in 1106, and one in 1117, 1120, 1149, and 1167. Masonry construction began to recommend itself as a means of keeping such disasters at bay.

The earliest remnants of residential architecture in Venice, then, are masonry structures of the later twelfth century, put up for their own use by the wealthier members of society. Remains of masonry buildings destined for less moneyed occupants, such as workers and small merchants, are at least a hundred years later. Nowadays one would call the former palaces and the latter houses. Medieval Venetians called them, respectively, great houses and houses: *domus magnae* or *maiores*, and plain *domus*; if a palace was the family's chief residence, it was called a *domus magna* or *maior a statio*.

Only fragments survive from the very earliest structures, but by cumulating elements observed in different sites and described unequivocally in early deeds, one can form a mental picture of the various building types represented by the known remains. As much as possible, buildings were situated so as to have access on one side to the city's streets and on the other to its waterways. Title documents regularly specify and guarantee land and water access, as well as the right to discharge wastes into a waterway. Since the waterways, in turn, were flushed twice a day by the tide, Venice was a relatively clean and healthy city compared with her sisters on the mainland.

Palaces ("Great Houses")

Great Houses, or Palaces, normally had a landing stage on the water side, for the exclusive use of the owner and the tenants of his rental flats and houses, if such there were. The palace proper normally possessed a ground floor and a first floor; often there was a mezzanine in between them and an attic floor above; occasionally there was a second residential floor. Plans were of three types.

One type, well established throughout Western Europe, was a rectangular structure. Its dominant space was a large hall that occupied most of the first floor. Private chambers lay at one end of the hall. Beneath these spaces, on the ground floor, were service rooms, in some instances collected behind an open portico. If there was a mezzanine floor, such a portico would rise for two storeys, and the mezzanine rooms would lie behind it too. (Initially a hall

was termed a *sala* at Venice, as elsewhere in Europe, but later it came to be called a *porticus*, just like a ground-floor portico, which can mislead the unwary reader of medieval descriptions.) The long side of the structure was its front, and it faced onto a private courtyard with handsomely framed windows for the first-floor hall and with its portico, if there was one, downstairs. An exterior stair in the court gave access to the hall and upstairs rooms.

The two earliest Venetian examples of such buildings are sited with their long sides parallel to an adjacent waterway and set back some distance from it. Entrance court and the emphasized facade toward the court lie on the landward side. How the rear facade, toward the waterway, was treated is not known, because in both cases it was covered over later with new constructions erected in the open space between the original palace and the water.

One of the two buildings is the oldest part, that is, the landward-facing hall and annexed rooms, of the Fondaco dei Turchi, off the Grand Canal near S. Giacomo dell'Orio (see pp. 52, 53). Judging by the Romanesque proportions and outlines of its portico, this part of the building was put up at the end of the twelfth century. Serving originally as a *domus magna*

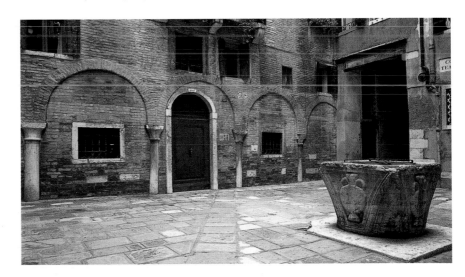

a statio, not a *fondaco*, or trading station, the palace belonged, at the turn of the thirteenth to the fourteenth century, to a family of recently arrived, successful traders from an Adriatic port in the Romagna, the Da Pesaro.

The other is the nucleus, likewise the landward-facing portion, of a palace on the Grand Canal near S. Moisè, owned in the thirteenth century by another trading family, the Barozzi, who had moved to

Courtyard of the Teatro Vecchio near S. Cassiano, also known as the Teatro Vecchio or Michiel. The theater, founded in 1580, was one of the earliest in Venice; its walls preserve a 13th-century Romanesque portico.

Fondaco dei Turchi. Plan (above), elevation (below, right), and cross section (below, left) of the landward facade c. 1600. The remaining part is shown in solid black on the plan.

Venice from Torcello a hundred years before. (The only visual record shows it, unfortunately, from the side toward the Grand Canal, which was built later.)

Neither structure exists any more. Most of the Fondaco dei Turchi was demolished in the nineteenth century, leaving only the outermost part of a Duecento addition that extended the building to the edge of the Grand Canal. The Barozzi palace for its part was rebuilt so radically during early modern times that only some of its foundations and wall masses survive and all articulating members have disappeared. Yet, early plans of the former and early views and descriptions of the latter allow one to reconstruct their layout in the form just described.

As a building type, this kind of palace can be traced back to Carolingian times; it had been slowly spreading on the Western European mainland throughout the Middle Ages. Built first for secular and ecclesiastical princes, it was soon imitated by the greater nobility, then by lesser lords. By the twelfth century it was being built on a reduced scale by urban patricians and rich merchants both in northern Europe and in mainland Italy, where the communes also imitated it for their town halls. In Venice a few such buildings were still built in the Duecento and Trecento, although by then other, more specifically Venetian, types had come to overshadow it. Those still standing are, in fact, very late examples: Ca' Lion-Morosini, of the later thirteenth century (see p. 50), on the Grand Canal near S. Giovanni Crisostomo, and two buildings of the early fourteenth century nearby, in Corte Seconda del Milion, often, but wrongly, said to have belonged to the family of Marco Polo (see p. 54).

The two buildings on Corte del Milion (examples of the hall palace without portico) face a shared inland courtyard, leaving much ground between themselves and the nearest waterway, just like the original parts of the Fondaco del Turchi and Ca'

Barozzi. Ca' Lion-Morosini, on the other hand, faces a courtyard that ends directly on the Grand Canal (see p. 50). Facing a palace toward the water became common practice during the thirteenth century, when courtyards also began to be located at the back so that the building could be moved forward to the water's edge. Even palaces that had originally faced landward, like the Fondaco dei Turchi and Ca' Barozzi, were now extended in the direction of the Grand Canal and given new show facades on the canal side, attaining the appearance by which they are best known. The new preference for waterfront siting must reflect a combination of urban and social changes during the twelfth and thirteenth centuries, chief among which were the rising value of choice sites along the city's waterways, the increasing ability to finance and engineer the embankment of shores, and the growing importance of citywide social relations and political institutions, at the expense of local neighborhood links.

A second palace type found in Venice during the later twelfth century seems a development of the first. In it, the fabric of a hall palace has been turned by ninety degrees so that the long side now runs at right angles, rather than parallel, to the principal adjacent waterway. The earliest known examples are reduced to mere fragments today: only their (walled-up) porticoes survive, while their interior layout has been completely effaced by repeated rebuilding. They are located in the Corte del Fontego (off the Rio di S. Pantaleon near Campo S. Margherita), in the Corte del Teatro Vecchio (off the Grand Canal near S. Cassiano; see p. 51), and on Calle del Rimedio (off the Rio del Palazzo near S. Giovanni in Olio). A later example, of the 1260s or after, also on Calle del Rimedio, is far better preserved and allows one to understand the plan of such an edifice as a whole.

The origins of this particular palace type are uncertain. It is significant, however, that in Verona—the city from which Venice imported building materials and ornamental motifs, and presumably also masons—there are similarly planned, Late Romanesque palaces that are similarly sited with respect to the streets which they adjoin.

Finally, a third palace type that appears at the same time as the other two presents an altogether different layout. Its long axis is also perpendicular to the principal adjacent waterway, but the structure is divided internally into three rows of spaces, whereas the types just examined have at most two. The dominant spaces on the ground and first floors—porticus and *sala*—are here flanked by a row of rooms on either side. As a result, they have to go without, respectively, the monumental arcade and handsome windows that characterized them in the other build-

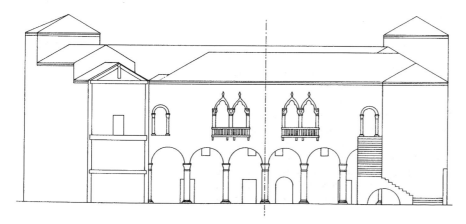

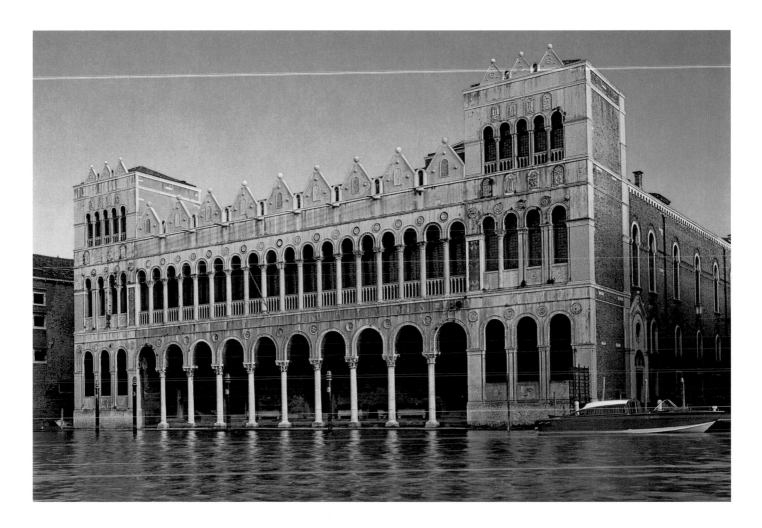

ings. Those features now appear on the end of the structure toward the water, which has become the show facade. At this end, the central row widens downstairs and upstairs to embrace most, or all, of the building's width, assuming the shape of the letter "T." The wide end, that is, the cross-bar of the "T," is expressed on the exterior by an arcade or serried ranks of windows (on which more below). At the opposite, landward end lies the traditional courtyard with its outside stairway leading to the first floor.

The earliest known example of this particular type is Ca' Barzizza, on the Grand Canal near S. Silvestro, the lower two floors of which are still clothed in late-twelfth-century forms (the top three floors were added later). It has been extensively rebuilt within and on the west side of its façade. A better preserved, albeit later, example of the type is Ca' Farsetti (the present-day city hall of Venice), on the Grand Canal near S. Luca, erected shortly before 1208–9 for

Renier Dandolo, son of the famous doge Enrico Dandolo (see pp. 55, 58, 59). Here too, only the lower storeys—ground, mezzanine, and first floors—belong to the original palace; the other two are additions.

A direct model for this particular palace type is hard to find. Modern historians of architecture have tended to consider it a survival or revival of a particular form of Late Antique villa, the facade of which is formed by an open portico between two solid blocks. Such villas, it has been argued, must have been known to medieval Venetians from now-destroyed Roman examples or from Byzantine palaces (likewise now destroyed) that were in turn derived from them. Unfortunately, these villas are not found in Italy, but only in Africa and northern and eastern Europe, and their interior layout in no way resembles the three rows of spaces found in the Venetian palaces. In fact, no buildings similar to the palaces in plan or eleva-

Fondaco dei Turchi, facade on the Grand Canal. This grandiose Veneto-Romanesque building dates from the 12th–13th century. Acquired in 1381 by the Republic, it was granted to the dukes of Ferrara. After various transactions, it became, between 1621 and 1838, the warehouse and seat of the Turkish community. Bought in 1858 by the Commune, the building underwent restoration in the 1860s which hardly altered its structure and facade. Today it houses the Museum of Natural History.

tion have ever come to light in northern Italy or Istanbul. It is true that archaeologists have claimed to have unearthed two edifices similar in elevation at least, one near Forlì in the Romagna in Italy, the other in Istanbul. But in both cases the published reconstructions, which complete whatever was missing from the excavated foundations and supply hypothetical elevations, are based, as the archaeologists freely admit, on the model of Venetian palaces. Thus, the seeming similarity proves nothing but the power of circular reasoning.

Every single one of these three-row palaces has been extended at the rear. As a result, the original rear courtyard and exterior stairs (always mentioned in early descriptions) have been lost, and the buildings' original depth is unknown. They may have been relatively shallow when built, so that the narrower rear part of the central main space may have been no deeper than a chamber at the end of the main room of a conventional hall palace. Leaving such a chamber open to the hall would have created the continuous, T-shaped space that one finds in the three-aisled palaces. Indeed, there are examples of the latter in which the cross-bar of the "T" occupies the whole front of the building, and the stem is small in size and corridor-like in proportion (compare the early-thirteenth-century Ca' Donà della Madonetta) (see p. 56), as if the wider and dominant part formed a proper room and the rest was no more than a passageway. In short, the third of the Venetian palace types may have developed out of the first two.

At all events, it is this particular palace plan that became the most successful in Venice. Plans and elevations of Venetian late medieval and early modern palaces are almost universally descended from the three-row plan, while the other two types died out. Turned end on toward the water, provided with open space at the back rather than at the front or side, possessed of an internal link between the waterfront and courtyard in the form of its continuous central aisle, the three-row palace used a minimum of valuable waterfront while developing a great amount of usable space and retaining direct communication with the water from even the rearmost part of the site. At the same time, with its floor beams straddling the aisles, a palace of this type was supported chiefly by its four longitudinal walls; the front and rear facades carried little other than themselves. It was therefore an unusually flexible structure that could absorb a great amount of differential subsidence—an unavoidable hazard in Venice given the unremitting but uneven subsidence of the city's subsoil. Indeed, the building type is so well adapted to Venetian conditions that it is very unlikely to have been copied from some undiscovered prototype. It

must have been developed locally, as a rearrangement of the characteristic elements of mainland palaces into a pattern particularly suitable for the peculiar situation and way of life of Venice.

A late-twelfth-century date for the earliest examples of all three Venetian palace types is suggested by the style of their stone trim. Arcades and window frames use plain round arches, marked by either a flat stone archivolt with heavy torus moldings for borders, or an inhabited scroll between torus moldings. Arcade columns and window columns use classically profiled bases and simple, vase-shaped capitals with a torus at the neck. Moldings are based on classical profiles too. The stone is marble of Aurisina and Verona, respectively a hard white limestone and usually the so-called *broccatello* of a yellowish or reddish cast. These forms and material had been hallmarks of Veronese Romanesque architecture since the late eleventh century.

At the beginning of the Duecento some of these motifs began to undergo change. Round-headed arches in arcades and window frames were now given a stilted outline. Borders of billet molding and colored marble facings were applied to the archivolts of the more ambitious buildings; a few palaces were even faced entirely with stone. Cornices began to be carved with palmettes and spiny acanthus. All of these were motifs long established in the Byzantine East, and in keeping with this change, original or imitation Byzantine capitals, usually Corinthian, began to be used alongside the simpler vase-shaped ones. The new, byzantinizing impulse was probably inspired by the Venetian conquest of Constantinople in 1204. Ca' Farsetti, built shortly before 1208–9, as mentioned, is already marked by Byzantine detail.

In the light of the Byzantine fashion of the early Duecento, writers have long been wont to call the entire pre-Gothic phase of Venetian secular architecture "Veneto-Byzantine." Recently, a scholar has suggested that it should be called instead "Romanesque-Byzantine," since its beginnings were inspired by Romanesque models at Verona. Wiser, I think, would be to drop the term "Byzantine" altogether. It implies a more pervasive and profound relationship with Greek models than ever obtained during the whole life of the style. Thus, by the mid-thirteenth century a new embellishment, faintly Gothic in appearance but probably Islamic in origin, was added to the superficial "byzantinisms" introduced some fifty years before. Builders began to place an ogee atop the stilted arches and window frames, initially at the extrados, then at both extrados and intrados (compare Ca' da Mosto and Ca' Lion-Morosini) (see p. 57). Other things changed little. A hard, white Istrian limestone began to be used for stone trim, but the limestone of

Ca' Farsetti. The lower storeys of this elegant facade date from the early 13th century. The photograph was taken in the early 20th century.

Aurisina and Veronese *broccatello* remained the favorite materials far into the Duecento. The vase-shaped capital of Verona continued in use even longer, into the Trecento. Changes in fenestration schemes and floor plans were relatively slight. Thus, the existence of lateral rooms at the front of the building, to either side of the central T-shaped space, came to be expressed on the exterior by separating the windows of one and the other (compare the later thirteenth-century Ca' da Mosto and Ca' Falier) (see pp. 60, 61). One or both ends of the cross-bar of the "T" might be eliminated, to make way for side rooms that were larger (see the first and second floors of the later thirteenth-century Ca' Falier). A small court might be introduced on the building's side, to give extra light to its interior (compare the Ca' Donà della Madonetta).

It is only with the turn from the thirteenth to the fourteenth century, however, that variations on the basic three-aisled plan and on the shape of the central space began to multiply and become increasingly inventive. Exterior articulation and detailing began to be modified too, adopting a completely consistent Gothic vocabulary of ogival arches, trilobe window frames, and heavy vegetative capitals and moldings. Istrian limestone now supplanted the other stones almost entirely. This is the point at which one can justly speak of a new phase in Venetian secular architecture—the Gothic phase. What went before, however, during the late twelfth and the entire thir-

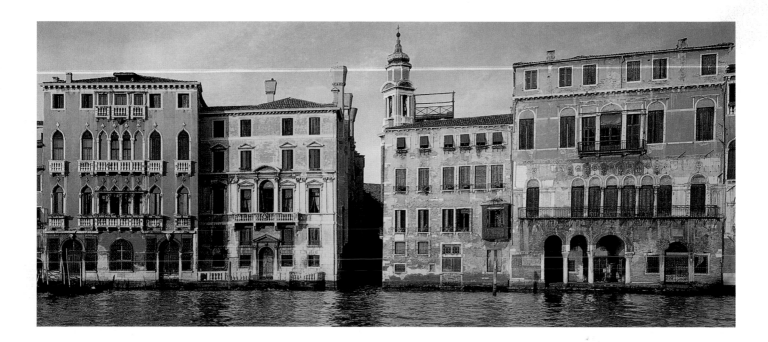

teenth century, was Romanesque at heart, enriched briefly and superficially with a succession of non-Western borrowings; it was never a true marriage between a Venetian or a Romanesque style, on the one hand, and the Byzantine style, on the other.

There are no records from this early that allow us to determine how the different rooms in the Romanesque palaces were used. At a later time, some of the ground-floor rooms (and mezzanine rooms, if there were any) were rented as dwellings to members of less wealthy classes. Other rooms served as storage for provisions, firewood, and boating equipment. Although it has become a habit among Italian scholars to assume that palace owners stored their trading stock on the ground floor, there is no evidence whatever from the twelfth or thirteenth centuries that business goods were kept at home. Instead, traders owned or rented storage rooms—called *magazeni* or *volte*—preferably near the central market area of the city, Rialto.

The main upper floor was where the owners lived. Its hall served as the central room of the palace, where the family ate, received, and entertained. Often one of the lesser rooms served as kitchen; the rest were bed-sitting rooms for individual family members. Latrines were sometimes outside, in the courtyard, and sometimes built inside, at least on the owner's floor, discharging through drains within the walls that led through sewers to a nearby waterway. Drinking water was gathered from roofs and paved courtyards and led into cisterns, whence it could be

drawn from wells in the court, or, occasionally, in the downstairs hall.

Only the fronts of these buildings were elaborately finished with carved stone members. Arcades are the principal feature of the ground floor, and multiple windows of the first floor. Down to the mid-thirteenth century, the arcades and rows of windows might extend over the full width of the building, as they did, for instance, on both floors of Ca' Barozzi, and as they do on the first floors of Ca' Farsetti and Ca' Donà della Madonetta. Alternatively, they might be centered in the facade and be flanked by pairs of single windows on left and right, as on the ground floors of Ca' Farsetti and Palazzo Corner-Loredan (see pp. 58–59) and the first floors of Ca' da Mosto, and Ca' Falier. In the latter case, the arrangement expressed the interior layout, namely the existence of chambers adjoining the front of the hall on left and right.

A continuous open loggia supported by a small order of its own might crown the facade, or ornamental cresting framed by towerlike projections at the facade's corners, or just cresting by itself. Attic loggias were a common feature of Romanesque palaces throughout Italy, although very few are left today. (Later owners generally had them walled up in order to gain additional enclosed living space in their houses.) In Venice many still existed in 1500, whereas today only the restored loggia of Ca' Donà della Madonetta survives.

Towerlike projections above the roof were not as

Ca' da Mosto, on the Grand Canal (on the right of photograph). Its two lower storeys, typical of the Veneto-Romanesque style of the 12th–13th centuries, have exquisite sculptural decoration of paterae, tiles, and friezes. The building, constructed as both residence and warehouse for the merchants and clients of the da Mosto family, Venetian patricians since 1292, was enlarged only in the 17th century with the addition of the third floor and mezzanine. Born here was Alvise da Mosto, in 1465 the first European to circumnavigate Cape Verde in West Africa, and who discovered the Canaries. From the 16th to the 17th century, the building housed the White Lion Hotel.

OPPOSITE:
Ca' Donà della Madonetta. This Late Romanesque residence and warehouse still preserves elements of its original structure,

ON THE FOLLOWING PAGES:
Palazzo Corner-Loredan (left) and Ca' Farsetti (right). The two neighboring buildings, both dating from the beginning of the 13th century, have in their lower storeys characteristic Veneto-Romanesque facades. The upper storeys were addded in the 14th century. Together they now house the city hall of Venice.

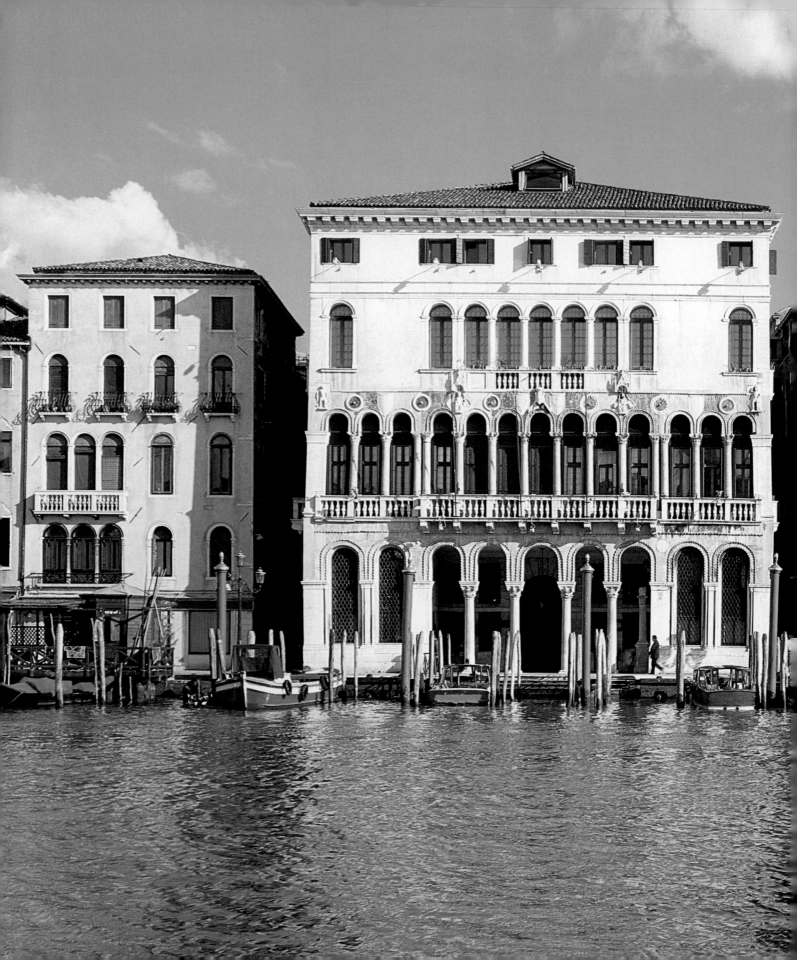

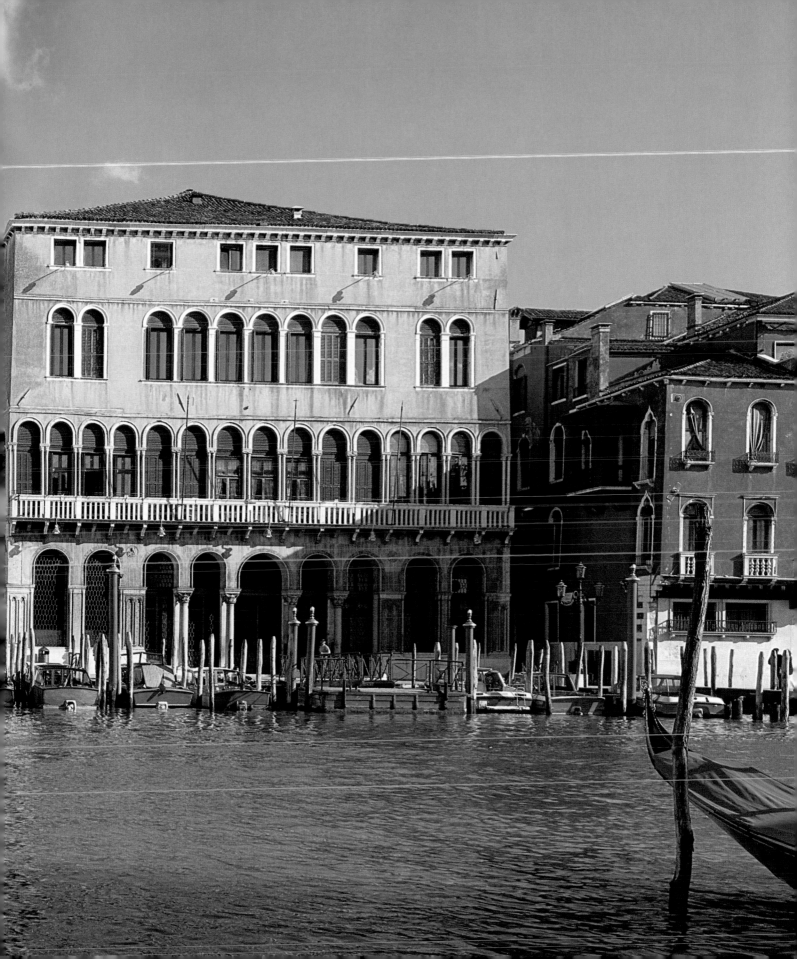

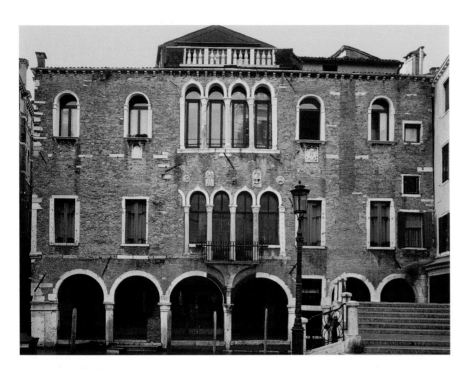

Ca' Falier, facade on Rio dei SS. Apostoli.
Veneto-Romanesque, 12th century.

sported it, as did the newer, waterside portion of the Fondaco dei Turchi. Whether it was inspired by Byzantine or Islamic models is difficult to say.

Still another ornamental feature encountered on facades are small reliefs, either round or shovel-shaped, termed paterae and *formelle* respectively. With religious symbols like those commonly found in Byzantine reliefs, and stylized animals of the kind appearing in Western ivory counters for draughts, they provided stony accents animating wall surfaces. In the Grand Canal elevation of the Fondaco dei Turchi, for instance, paterae were placed in the arcade spandrels and *formelle* at each end of the frieze and in each crest.

The palaces' imposing show facades are the earliest instances since antiquity of public display in private residential architecture. They were the basis of the even larger and more richly articulated facades of Venetian Gothic palaces, while the latter, translated by the first architects of the Italian Renaissance into a vocabulary of classical forms, set the standards of scale, monumentality, and clarity of articulation that obtained in Western palace architecture until the nineteenth century.

Ordinary Houses

Less prosperous Venetians lived in *case* [houses] rather than palazzi [palaces], either owned or rented. The earliest remains of houses are masonry structures dating from the turn of the thirteenth to the fourteenth century. Documents prove, however, that houses built of permanent materials existed as far back as the first half of the twelfth century. Although it is not always clear whether a given text concerns a small single-family house, a large multi-family complex, or a single unit inside such a complex, a sufficient number of documents offers the descriptive clues needed to determine which is meant. (Venetian usage made no distinction among the three, calling them all *domus* [house] or, in the vernacular, *casa*.) Precise texts such as these make it clear that both the separate single-family house and the larger housing complex were established building types when masonry construction was introduced into Venice. Yet, for reasons that are not clear, no single-family houses from the Romanesque period have come down to us, only fragments of housing complexes, and these from a moment at the borderline between the Late Romanesque and Early Gothic styles.

There are remains of three similar housing complexes, two located between the Salizzada di S. Lio and the Rio del Piombo, one between Ruga Giuffa and Rio di S. Severo. In each case the original

common but must have existed in some number, if only to judge by the appellations *dalle torri* and *dalle due torri*, used in early documents to identify particular buildings and places. A pair of towers marked the back of the oldest portion of Ca' Barozzi; another pair topped the Grand Canal extension of the Fondaco dei Turchi. (Demolished in the seventeenth century, they were reconstructed in the nineteenth, when that part of the building was restored.) These features were probably understood as an emblem of status. Erecting towers and crenellation had been a right reserved during the early Middle Ages to the Emperor and those who had been licensed by him to do so. Soon the privilege passed to his agents and clients, and then, with the spread of feudalism, it was asserted, rightfully or not, by ever widening circles of secular and ecclesiastical lords. After the turn of the millennium, petty lords and wealthy city dwellers also began to flaunt these architectural emblems of elite status, and solitary towers and towered residences began to be built in ever increasing numbers in Western Europe, especially in cities. The towerlike excrescences on Venetian palaces should be understood as a local reflection of this pan-European phenomenon.

Ornamental cresting crowned numerous buildings in Venice, as can be established from early views and written sources. Both the older, landward portion and the newer, waterside portion of Ca' Barozzi

development consisted of a pair of housing blocks abutting with one of their short sides on a public street and with the other on a waterway. Between them, connecting the street and canal, extended a narrow *calle* [alley]. A great arch spanned the calle at the street end, linking the blocks on either side and signaling the calle's status as a private right of way (see p. 111). (An idea of how developments like this looked is given by the well-known, although much later, Calle del Paradiso, also off the Salizzada di S. Lio. Being a thoroughfare, the calle here is lined with shops and spanned by arches at both ends.)

An approximate date for all three complexes can be established from the shape of the few original window frames still in situ (stilted arches with an ogee on top) and that of the arch over the calle (plain round in the case of the complexes off the Salizzada di S. Lio, ogival in the case of that off Ruga Giuffa). Each of the blocks is a three-storey structure. Each contained shops on the ground floor at the end toward the public street, as remains of original piers attest. The remainder of the layout is unknown because the rest of these structures, along the calle in the middle, has been totally rebuilt. But some of the original fenestration is still visible on the exterior of the complex off Ruga Giuffa, and this allows one to make some inferences by comparison with similar complexes from the fourteenth and fifteenth centuries. Thus, on the ground floor toward the calle in the middle, these blocks exhibit a series of unadorned rectangular doors and short sequences of small, plain square windows. In later complexes, each door and sequence of windows pertains to a stairway and a set of service rooms (storerooms for provisions, firewood, and boating equipment and, sometimes, a kitchen) connected with one of the apartments above. Presumably that was their function in the complex off Ruga Giuffa too.

Upstairs, on the first and second floors, there are triple windows that alternate with sequences of single windows, quite a few of them still sporting late-thirteenth-century window frames. In later housing blocks, multiple windows express what was a general family room, serving the same functions for the inhabitants as did a hall in an owner-occupied palace, while single windows express chambers. When there are two registers of such windows, as there are in the complex off Ruga Giuffa, one on the first floor, the other on the second, they betoken the existence of separate apartments on each floor, one above the other, each with its own stairs, street entrance, and ground-floor service rooms.

The documents make clear that complexes such as this were built by both private owners and charitable groups. In the case of the latter—religious confraternities, guilds, hospitals for the sick and aged—the houses might be let *gratis* or at reduced rates to particularly deserving members or private persons, or might be rented out at market rates in order to endow the group's activities with a secure and regular income. For private owners, rental housing was simple investment property and might be built in the grounds of the owner's palace as well as along the city's inner streets.

In the next century still other forms of housing blocks were developed: apartments arranged around a court rather than along a calle; single blocks of apartments, facing onto a public street and lacking their own calle or court; blocks in which from two to half a dozen or more dwellings stood side by side, separated by party walls like a Georgian terrace in Britain. Blocks became taller and interior layouts became more complex and ingenious. Exteriors were now dressed with Gothic details, so that these particular variants of the housing complex may be accounted the products of the next phase of Venetian architecture. Yet their basis was the Romanesque housing block, just as the basis for the increasingly grand and ingeniously laid-out Gothic palaces had been the Romanesque palace.

In time housing blocks spread throughout the city, rising on almost every street, filling the interstices between monumental palaces and the single-occupancy houses which one knows were built from early on, but which survive only from later times. Since the types of rooms required in a typical Venetian palace, house, or flat hardly changed over the centuries, patterns of fenestration did not change either. Single and multiple windows at many different levels and of many different styles and sizes, but arranged always in rhythmic alternation, came to repeat themselves over and over again, welding together streetfronts and waterfronts and impressing an extraordinary unity of pattern upon the Venetian cityscape. Only inner Paris achieves the same effect, albeit by imposition on its architecture of a common syntax of a different sort. In Italy, in any case, Venice's appearance is unique, marked by a kind of wholeness which none of the mainland cities can rival.

Juergen Schulz

Ca' Falier. Reconstructed plans of the *piano nobile* and the second, residential floor.

Byzantine Heritage, Classicism, and the Contribution of the West in the Thirteenth and Fourteenth Centuries

The Beginning of the Thirteenth Century:
The Byzantine Influence

Discovery of the Body of St. Mark, enamel panel from the Pala d'Oro in the basilica of S. Marco.

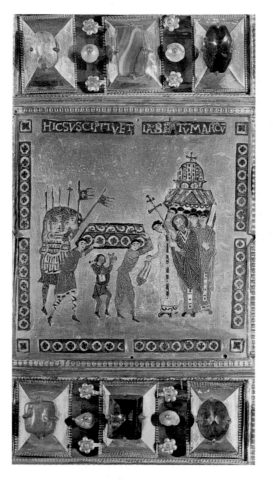

just a few of the Late Antique works which passed to the new imperial center.

Of particular interest are the enamels, which represent six of the twelve Byzantine holy days and the Archangel Michael (see p. 63). The Venetians appropriated these, breaking up the group of which they were part. The Byzantine holy days were in fact twelve and not six, and the image of St. Michael was certainly not positioned in the middle of them. Furthermore, the placing of the six enamels does not correspond to the sequence of the scenes, as is shown by the fact that the *Crucifixion* follows the *Descent into Limbo*, instead of preceding it. Some of the scenes on the large enamels were already depicted in the earlier form of the altarpiece, which was executed in the early twelfth century, and constitute an unnecessary duplication. This inconsistency suggests that the Pala, with the addition of the enamels looted in Constantinople during the Crusade, acquired in the eyes of the Venetians the value of a precious "imperial" object, rather than a liturgical one. Removed from the basilica of the Pantocrator, the burial place of the emperors, the enamels were meant to add splendor to the temple in which were preserved the remains of St. Mark, symbol of the Venetian State. While the dates on which the other treasures from Constantinople arrived in Venice are uncertain, these enamels must have arrived very early if they were placed in the new, upper part of the Pala during the year 1209, while Pietro Ziani was doge. It was the arrival of the crusaders that really opened Venice to the Western world as well.

In reality, Venice had already long assumed the role of political mediator in Europe, and for a longer time still, the city had also acted as a cultural magnet between the European West and the East. Halfway through the eleventh century, while Byzantine master craftsmen created the mosaics of the cathedral in Torcello, evidence of a Western presence in other

OPPOSITE:
Archangel Michael, large enamel at the center of the upper register of the Pala d'Oro in the basilica of S. Marco.

The Fourth Crusade, with the sack of Constantinople in 1204, brought to Venice a rich haul of Byzantine works of art. The four horses of S. Marco, the tetrarchs in porphyry, and the enamels on the upper part of the Pala d'Oro (see p. 64) are

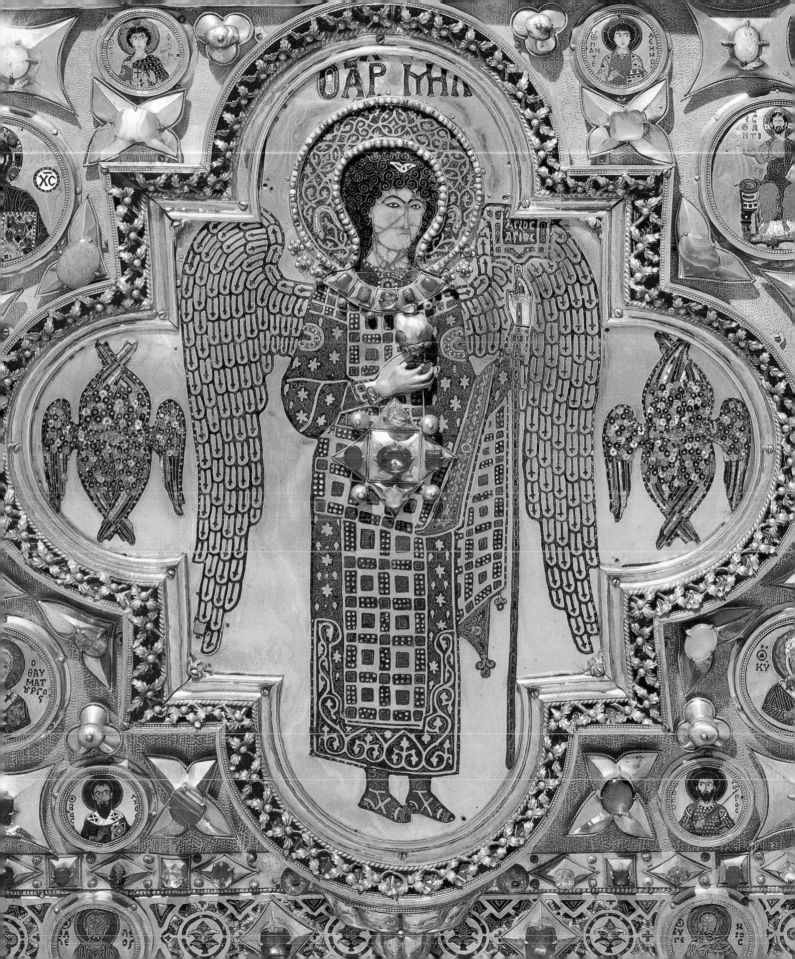

The Pala d'Oro, made up of gems and enamels set in gold, behind the main altar in the basilica of S. Marco.

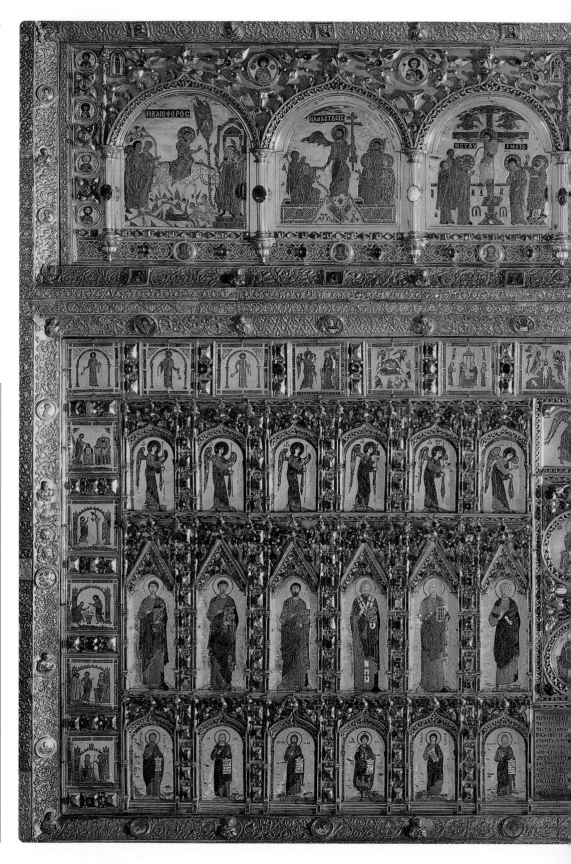

The Pala d'Oro

A masterpiece of Venetian Gothic goldsmith's art, this extraordinary assemblage contains pieces by many artists and was constructed partly out of the spoils of the Fourth Crusade. The first altarpiece, commissioned from Constantinople in 976 by Doge Pietro Orseolo I underwent many modifications, most notably the embellishments commissioned by Doge Ordelaffo Falier in 1105 and, in 1209, by Doge Pietro Ziani, responsible for the addition in the upper register of the seven great enamel inlays, almost certainly brought to Venice in 1204 from the monastery of the Pantocrator. The present appearance of the Pala d'Oro, however, dates from 1342, when, on the orders of the future Doge Andrea Dandolo, the Venetian goldsmith Giovanni Paolo Boninsegna created a great Gothic structure in gilded silver, enriched with Byzantine enamels and hundreds of precious stones, which acts as an architectural framework to hold the finely painted enamels of the Archangel Michael and saints and Apostles. The magnificent frame holds 27 small enamel panels, the work of Greek artists in Venice during the 14th century; according to an inventory from the end of the 18th century, the altarpiece was set with 1,300 pearls, 400 garnets, 300 sapphires, 300 emeralds, 90 amethysts, 15 rubies, and various other stones. Given its immense value, the Pala d'Oro was displayed to the public only on feast days and was otherwise covered by another work of art, a large panel painting known as the Pala feriale, or weekday altarpiece, by Paolo Veneziano.

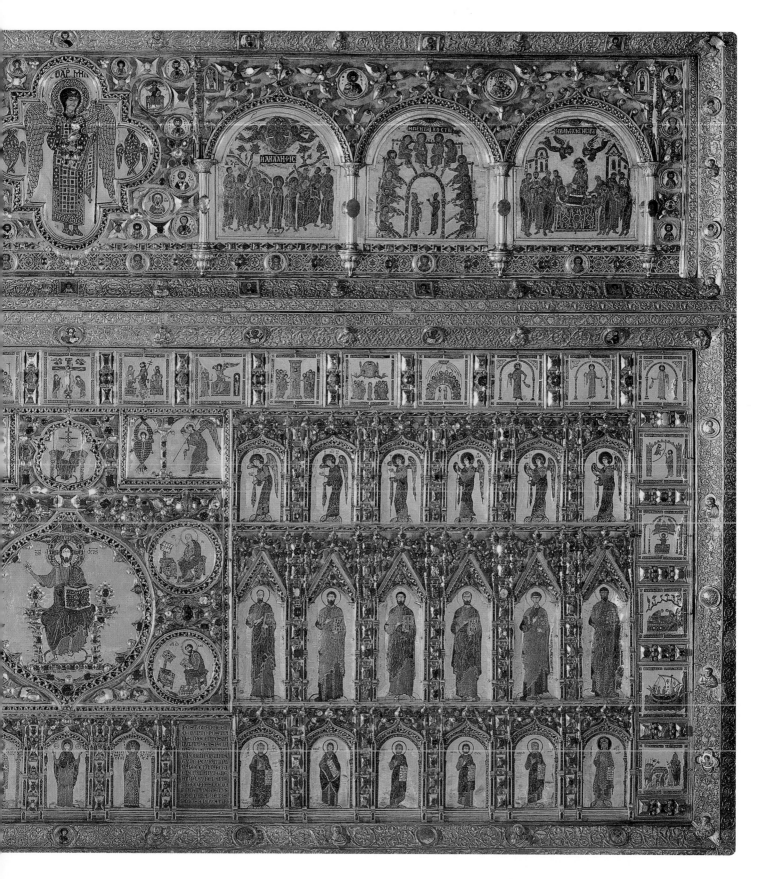

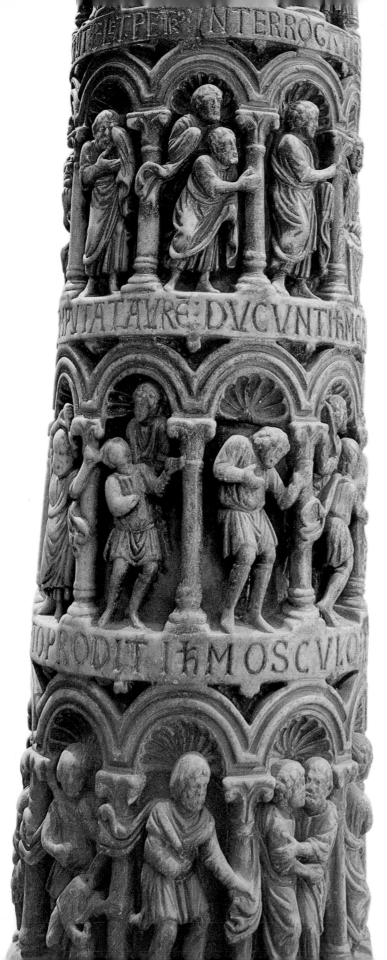

fields of figurative art—miniatures, for instance—is present before, and independent of, the arrival of the crusaders. For example, the passionaries, three illuminated codices executed for the basilica of S. Marco and now in the Biblioteca Marciana, cast light on the relations between Venetian cultural circles and those of the Veneto and the Po valley. The most interesting part is comprised of the thirteenth-century additions to the third passionary. The miniatures follow the Romanesque pattern but are interpreted with an elegance that recalls the precious style of some of the early-thirteenth-century mosaics in S. Marco. It is the work of the same artist who illuminated the commentary on the Gospel according to St. Mark, also preserved in the Biblioteca Marciana, who was active around 1230. The basic structure of the composition of the miniatures derives from Western typologies, while the particular use of brilliant and precious colors recalls Byzantine culture of the period of the Comnenus emperors.

Classicism: The Early Christian Revival

For Venice, the conquest of Constantinople was a moment of great political and military power that manifested itself in the exhibiting, mainly in the church of the State, the basilica of S. Marco, of a large portion of the rich spoils. The mere exhibition of these spoils, however, through which Venice demonstrated her desire figuratively to take the place of the old imperial capital, was not sufficient for her glorification. Reference had to be made to her classical roots. The various neoclassical schools of our history have always had a sense of glorification. Recognizing one's own classical roots means in fact to justify one's own power in the name of links with the antique past. For the Venice of the thirteenth century, antique or classical meant Early Christian.

Above the main altar in S. Marco is a ciborium supported by four columns of decorated alabaster (see p. 67). The niches on the columns represent scenes, like the descent into limbo, not used in Early Christian art but only in medieval. This conflicts with the hypothesis that the four columns are Early Christian work of the fifth century. For other scenes, like *Joachim and Anna* and the *Nativity*, there is no reason from the iconographic point of view not to date them to the thirteenth century.

A careful examination of the way the scenes were realized by the artists who carried out the work suggests that there was a desire to imitate the Antique, in other words, to make a false statement in order to glorify St. Mark in the name of the Antique

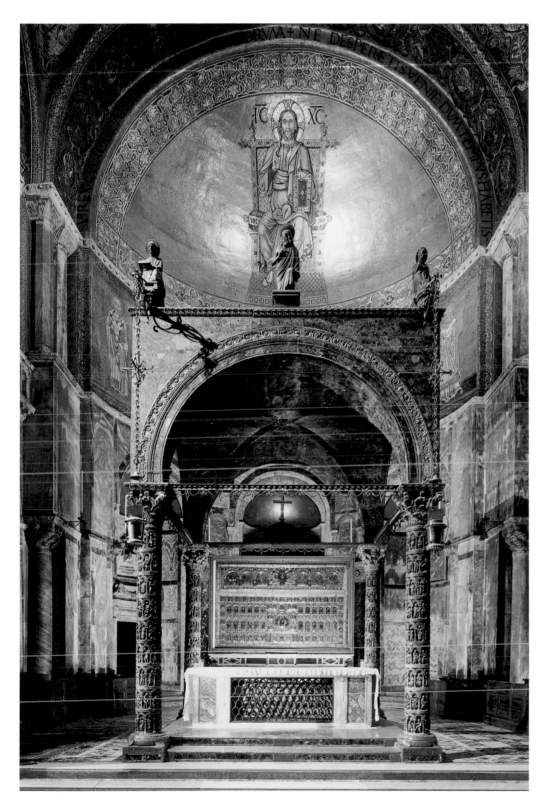

Ciborium over the main altar of the basilica of S. Marco, supported by four columns of oriental alabaster, sculpted with sacred stories inspired by the New Testament. Dated to the beginning of the 13th century.

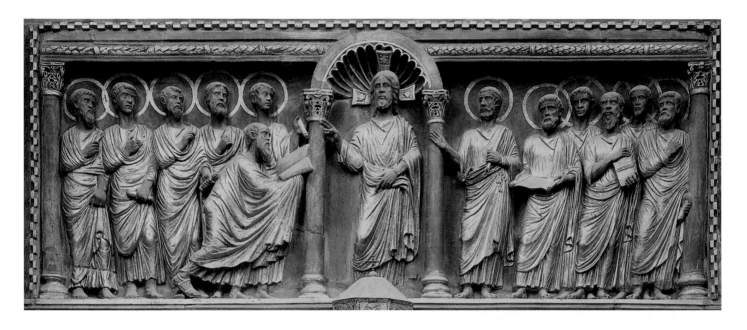

tradition. The occasion could have been the restoration of the Pala d'Oro in 1209. If this were so, it would be the only thirteenth-century work in the whole ciborium, including the statues of Christ and the four seated Evangelists in the upper part of the ciborium itself. That this is the only thirteenth-century work does not, of course, mean that it is the work of a single artist. The four columns are not of the same quality, indeed, the two front columns are more refined than the two at the back. A workshop will have been involved here, not just a single sculptor. The five statues placed on top of the ciborium may well be from the same workshop as the columns, even if there is less evidence of an intention to falsify the style. The sculpted panels that are now inserted into the wall of the reliquary chapel in the treasury of S. Marco can be included in the same ambience of Early Christian revival. The first represents the delivery of the law, that is, Christ giving his new law to the apostles through St. Peter and St. Paul. Here the figure of Christ projects from the niche in which he is sculpted, in a style close to the one used in the columns of the ciborium. But compared with the scenes on the columns, the lines here are more deeply incised, a sure sign not of Early Christian work, but rather of thirteenth-century craftsmanship. The *Christ in the Clipeus Supported by Angels*, the theme of the other panel, is an Early Christian motif that was widely used in both mosaic and sculpture, and is therefore a clear example of the revival in question.

Western Influence: The Main Portal of the Basilica of San Marco

Among all the doors of S. Marco the central one of the atrium is distinguished by its originality; it is splayed with more arches, three of which are decorated with sculptures (see pp. 70–71). The facade of the basilica had gradually been changing over a long period of time in a slow but radical process. The elegant brickwork of the Contarini period had gradually disappeared under marble facings, mosaics, and columns. In the thirteenth century, great cupolas were built on top of those of the Contarini period, which can be seen from the inside, fully covered by mosaics (see p. 73). These great external cupolas increase the volume of the basilica only as seen from the outside. Thus, a continuous process of enrichment and, above all, of expansion of the outside of the basilica was taking place because, due to the extension of the piazza to its present dimensions, the viewing point had become considerably more distant. The original Contarini basilica, on the other hand, had been viewed from much nearer because the piazza in front of it had been closed off at a few meters' distance, to the west of the bell tower.

In the thirteenth century, construction of the main door of the atrium, with the execution of the sculptures of three of the arches, provided a fundamental addition to the structure of the facade. Although a nineteenth-century mosaic now occupies the higher portion between the second and third arches, the original appearance can be recovered from the painting by

Gentile Bellini, the *Procession in Piazza San Marco*. In the space where the mosaic is now located there was a representation of the Parousia, that is, the second coming of Christ, the Last Judgment.

The two sculptural cycles of the first arch may represent the struggle between good and evil, while those of the second show the months of the year and signs of the zodiac, and also, on the facade, the Virtues and the Beatitudes. Finally, the sculptures of the third arch represent Venetian trades in the intrados and prophets on the facade. Other interpretations, however, have been made of these sculptures, linking them to the political situation or to a liturgy that provided for the appearance of the doge in the loggia above, between the four horses brought from Constantinople.

The typology of the portal is similar to that of the Gothic cathedrals of the Ile-de-France, even if the connection between sculpture and mosaic has been documented only in Venice. Compared with French portals of the twelfth and thirteenth centuries, the portal at S. Marco has no columnar statues; instead there are simple columns, often in porphyry.

Alongside typically Western characteristics, references to Venetian models, deriving from the mosaics in the basilica, are found in many details of the sculpted decoration of the main portal. The portrayal of the Virtues and the Beatitudes, for example, derives iconographically from the Virtues at the base of the central cupola, that of the Ascension. To take another example, the models for some of the trades may derive from the atrium: the sawyers from the builders of Noah's Ark and the bricklayers from the workmen laboring on the Tower of Babel. It should be added that these sculptures were originally painted.

If opinions differ regarding the symbolic significance of the portal decoration and whether or not a single iconographic program existed, the situation is equally complex with respect to stylistic interpretations and hypotheses about chronology.

It may be necessary to reduce the period of execution from fifty years to ten. This is because it seems unlikely that a workyard that would have occupied the entire main entrance to the basilica could have been kept open for as long as half a century. If the models for some of the sculptural decorations were the mosaics in the atrium, the work of the sculptors cannot have preceded the third decade of the thirteenth century; on the other hand, the description of Martin da Canal in *Les estoires de Venise* [The history of Venice] persuades us to place the final execution in 1268.

Stylistic examination reveals an attitude that is constantly seen in the Venetian Middle Ages. The orderly programming of the French masters of the twelfth and thirteenth centuries, above all those working in the Ile-de-France, was rejected in Venice, in the name of a pragmatism that manifested itself as a need for "open" work.

In the underside of the first arch, the human and animal figures are very rough, as is also the vegetal cluster in which the figures are arranged. They are decorations that could have been carried out by backward-looking Venetian masters following in the tracks of sculptors of the Contarini period, now more than a century distant. The figures of the intrados of the second arch, that of the months of the year and the zodiac, seem to have come from a workshop that followed in the footsteps of the one that had worked on the face of the first arch. From a common background emerge the individual symbolic figures which have precise iconographic echoes in the mosaic Virtues of the Ascension cupola inside the basilica. In the intrados of the third arch are the scenes of the trades, the most celebrated of the whole ornamental complex of the portal of S. Marco. In these scenes, there is a superimposition of several levels, all filled with representations of people moving, working, or joining together in groups, often created with figures which, in the multilevel high relief, are almost in the round, especially those in the front, who are often glimpsed from the side or from behind, as, for example, in the scene of the sawyers. Such methods of composition have caused some scholars to see knowledge of the work of Nicola and Giovanni Pisano in the decorations of the intrados of this arch. Finally, on the face of the last arch, are the prophets.

November, detail of the intrados of the second arch of the main portal of the basilica of S. Marco, where the twelve months of the year are represented, 13th-century.

Stylized lion of red marble, Zen Chapel, basilica of S. Marco. It probably supported the prothyrum of the *da mar* portal, the southern entrance (now closed) to the basilica, before being moved to its present site.

Basilica of San Marco, western facade. The facade culminates in Gothic "tabernacles."

The Basilica of S. Marco

The basilica was built over the foundations of the church erected in 829 by Doge Giovanni Partecipazio to house the remains of St. Mark. These, according to tradition, were stolen from Alexandria in Egypt by two merchants from Torcello and Malamocco. The plan of the building was probably that of an aisleless basilica, although the possibility of a Greek-cross plan cannot be completely excluded. The mid-11th century reconstruction undertaken under Doge Domenico Contarini gave the basilica its definitive form. It should be noted that the church was closely associated with the image of the State and was the Palazzo's main chapel; in fact, S. Marco became the city's cathedral only in 1807, when the Patriarchate—which until then had been confined to the outlying island of S. Pietro di Castello—finally took possession of the basilica. Beyond the works ordered by Contarini, the central nucleus was gradually enlarged by the addition of the narthex, whose southern side was enclosed during the 14th century in order to create the baptistery and in the 16th century to form the Zen Chapel. The facade, originally covered with terracotta and sparsely decorated with marble, was transformed between the 11th and 15th centuries taking on its current magnificent appearance; its oriental cupolas, combined with the Gothic "tabernacles," make the church unique in Western civilization. It is in perfect harmony with the splendid complex of the Palazzo Ducale, the two buildings constituting the fulcrum of the city's religious and civic life.

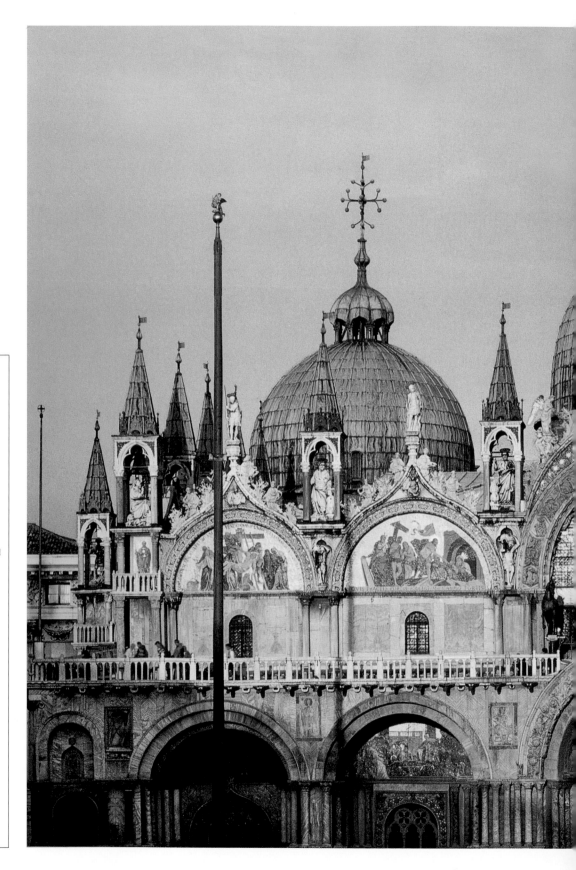

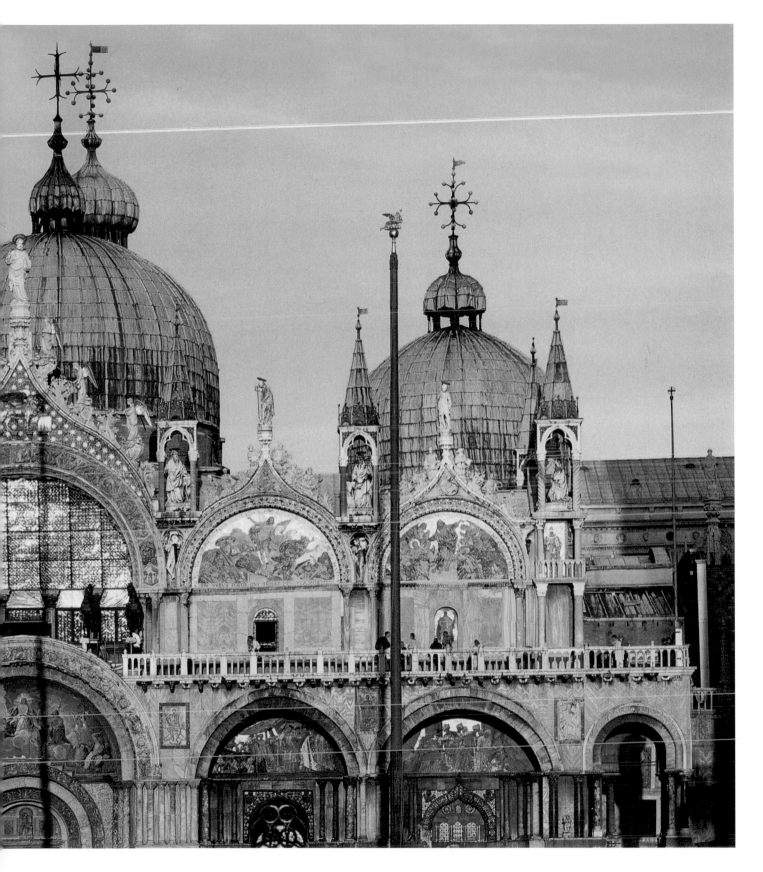

Basilica of S. Marco, northern facade, facing the Piazzetta dei Leoncini.

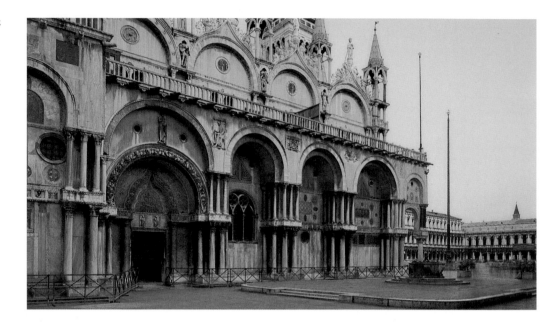

St. Mark the Evangelist, relief on the northern facade of the basilica of S. Marco, 13th century.

The stylistic differences suggest that the individual undersides and faces of the arches must have been executed by different workshops. The first decoration, that is, the one on the first underside, can be attributed to a Venetian workshop whose principal master, even if backward-looking, was certainly not lacking in figurative skill. The other five decorative groups are more difficult to attribute.

One could hypothesize that a "new" portal using French models had been planned in the context of refacing the whole facade of S. Marco; such models would have been well known to the Venetians who by now were receptive to international influence, either through drawings or through the arrival from France of master craftsmen who would have introduced the "new" Gothic style. The Venetian tradition and the "new" thus came into contact, creating a singular and inimitable figurative culture which, in a completely original way, interpreted different stylistic experiences—adopting them, transforming them, and developing them in this "open" work, realizing them in a unified typological project, which was then updated continually during its execution. It is possible to guess at the existence of a single patron who, remarkably sensitive to what was happening in the West, was in a position to make different experiences converge on this singular monument, joining them in a unified discourse. In this sense the main portal of the atrium of S. Marco can also seem a typically Venetian "open work."

Apart from those engaged in the workyard of the main portal of the atrium of S. Marco, other Western sculptors were also working in Venice during the same period. It is enough to think of the sculptural group, the *Adoration of the Magi* (now in the Patriarcal Seminary), previously in the portal of the church of SS. Filippo e Giacomo but probably originating in S. Marco: its author has been identified with the so-called Master of the Months of Ferrara. *Joseph's Dream* (the image that others have identified as *St. Mark's Dream*), in the lunette above the main entrance to the basilica of S. Marco, could have formed part of the same group.

The entrance to the basilica which is second in importance after the main atrium entrance, was the so-called *porta da mar* [door towards the sea], the one that opened onto the quay and toward the Palazzo Ducale in the present-day Zen Chapel, south of the atrium. This *da mar* entrance, which had a clear political significance, was closed in the sixteenth century. According to recent hypotheses, this entrance would have been distinguished by the presence of a two-storyed vestibule, in accordance with traditional Western Romanesque typology. This prothyrum would have been supported by stylized lions, two of which could be those found today in the Zen Chapel (see p. 69). They are two lions in red marble, of remarkable expressive strength, whose style is close to that of the Master of Joseph's Dream. If this supposition is accepted, a possible first phase of Po valley Romanesque influence would have to be given consideration. At approximately the same time, the building of the main entrance of the atrium was started, based on French Gothic models. Such an

innovation may have brought about the suspension of the work on the prothyrum of the *da mar* entrance, which was already being built but was not yet completed; in fact one of the lions is clearly unfinished. This decision may have been caused by an awareness that the choice of typology for the *da mar* door now seemed to have been overtaken by the new style of the central entrance.

An Islamic Contribution and A New Byzantinism

The main portal is certainly the most significant and notable addition in the context of the facade of S. Marco in the thirteenth century. Together with this must be recalled other contributions of diverse cultural origins, less consistent but interesting nevertheless in order to understand the Venetian Duecento, which was so articulated and complex. The two portals at the extremes of the facade, the real door of St. Alipius toward the north and the one that is unopened except for a window toward the south, both have a bent arch like the entrance to the basilica

from the north side and like, in the interior, the door of the treasury. Such arches are proof of a further influence on the thirteenth-century fabric of the basilica of S. Marco, that of Islam.

The Venetians could have chosen such arches because they were typical of the land where the body of St. Mark had been buried before it was secretly removed and brought to Venice. But perhaps, more simply, they just wanted to add something new to their basilica. There is nothing strange in their being inspired by Islamic culture which, like Venetian, had remained immune to barbarian influence and was also of Late Antique origin, and, at least in part, Byzantine.

On the outside of the basilica of S. Marco there are two other decorative complexes of sculpture which have been attributed to the workshop of a single person, the so-called Master of Hercules. On the north side of the basilica (see p. 72) are statues (originally five) representing Christ and the four Evangelists; on the west facade, between the arches, there are six reliefs, two with labors of Hercules and four with the Praying Virgin, Archangel Gabriel, St. Demetrius, and St. George. It is very probable that

Hercules and the Erymanthian Boar

St. George, Master of Hercules relief on the western facade of the basilica of S. Marco.

ON THE FOLLOWING PAGES:
Translation of the Body of St. Mark, detail of the portal of St. Alipius in the main facade of the basilica of S. Marco. The oldest mosaic on the facade, it offers a rare depiction of the basilica in the 13th century, with the original hemispherical cupolas following Byzantine custom over which the present cupolas with their bronze revetment were later built, intended to create a more dashing and

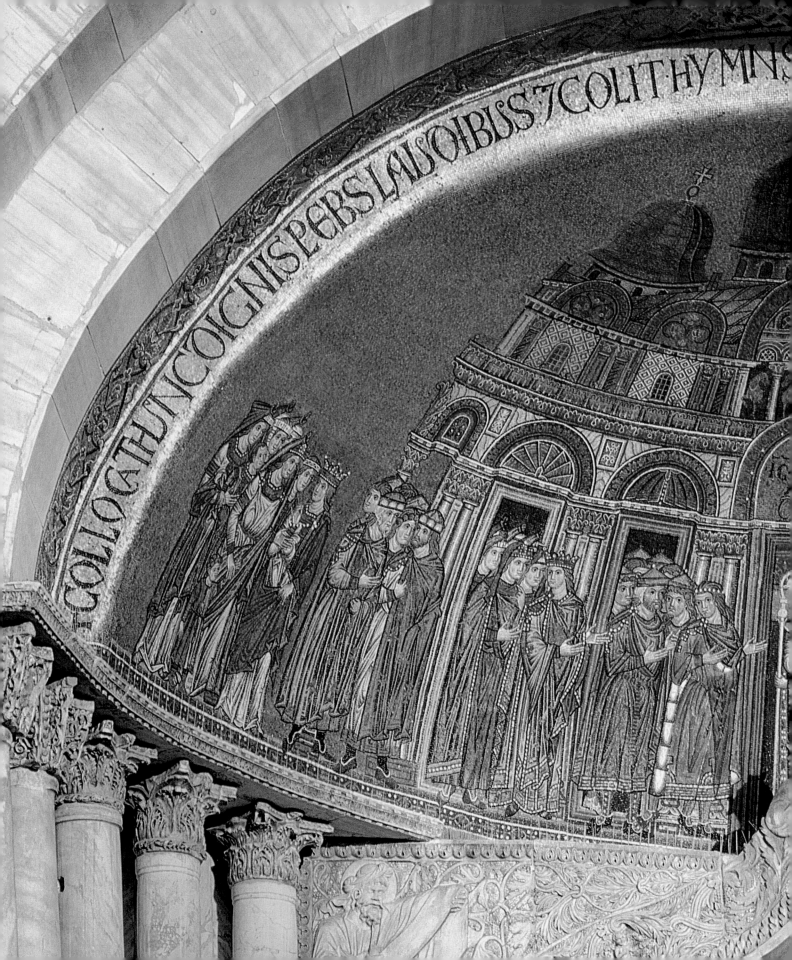

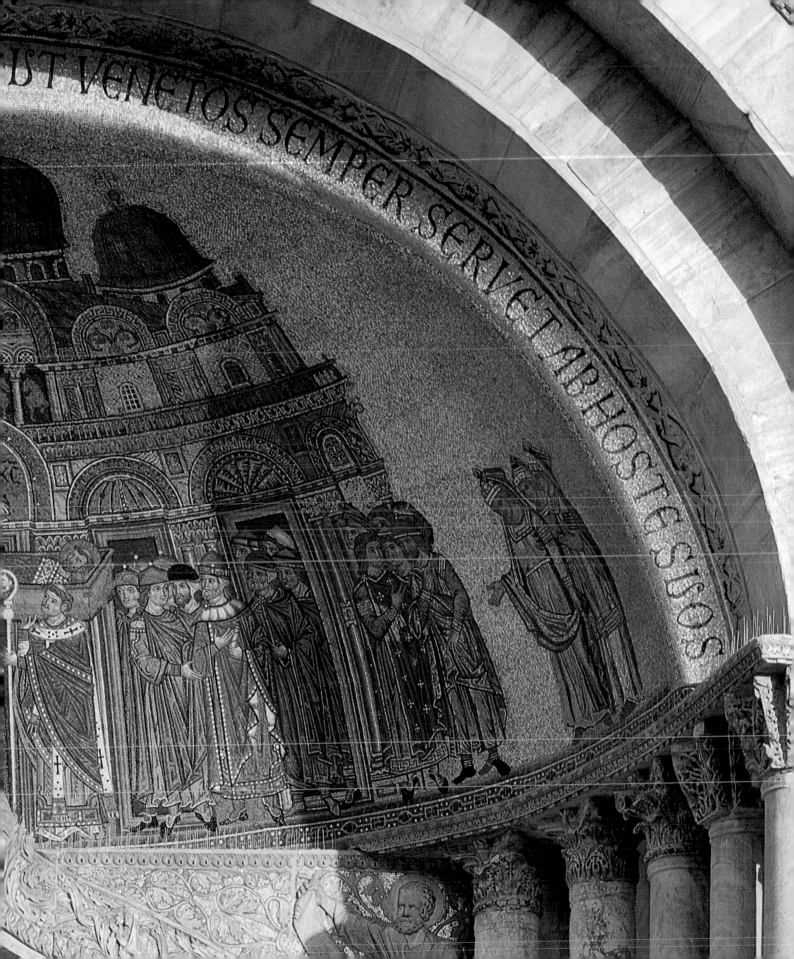

the first group, on the north side, was not placed originally as it is now. The name Master of Hercules derives from the relief of *Hercules with the Hydra of Lerna and the Hind of Cyrene* on the facade of the basilica (toward the south): Hercules, nude, with a cloth knotted on his right shoulder, stamps on the monster with its many heads and bears on his shoulders the hind with golden horns (these are two of the Labors of Hercules, united in a single scene). It is a rather low relief, the work perhaps of a Venetian master who interpreted freely the much more classical *Hercules with the Erymanthian Boar* (see p. 73, bottom left), which is at the opposite end of the facade, toward the north. This could be a Late Antique work, perhaps Byzantine, of the beginning of the fifth century, or even a tenth-century imitation of the antique. A similar relationship seems to exist between the two marble sculptures at the side of the main portal representing St. Demetrius and St. George. The *St. Demetrius* certainly cannot be considered a Latin (that is, Western) work: the saint, in armor, is seated, and grasps his sword, pulling it out of its sheath which is placed on his knees. The saint's position, the refined decoration of the "antique" breastplate, his monumental calm and simultaneous hint at movement bring to mind work by Greek artists of the end of the twelfth or the beginning of the thirteenth century. The relief with St. George (see p. 73, bottom right) is an exact copy of the *St. Demetrius*, both in the overall composition and also in the smallest details, but it is a cold and flat repetition of a model that seems to be of full figurative inspiration. Perhaps one should not speak of a poor copy of a prototype, but rather of a "translation" into Venetian language of the Byzantine model, guessing that the author of the relief of *St. George* is the Master of Hercules. He would have been a specialist in translating Byzantine models into Venetian.

The other two statues on the facade represent the Praying Virgin and the Archangel Gabriel. The first of these definitely had a Byzantine example as its model, in the antique tradition but certainly still well known in Venice in the thirteenth century. In this case too, the Byzantine model, which may have been in the late Comnenus style, would have been translated into Venetian.

All six images signify "protection" or "defense" of the basilica, that is, of the Venetian State of which the building was the symbol. Beside the portal, thus defending the place of access to the basilica, are the images of two warrior saints, bearing arms and at rest but ready to intervene in its defense. At the end are two images of Hercules, considered invincible in the classical era and then accepted with an equal amount of significance in the sense of moral strength by Christian culture. Hercules, having become a Christian model, is also placed to defend the basilica. Finally, there is the Praying Virgin, who could certainly not be absent from the context of the basilica's facade. In one of his homilies, Photius, patriarch of Constantinople in the ninth century, refers to the image of the Virgin in the great imperial palace of Constantinople in the following words: "The Praying Virgin, with her arms raised for our salvation, to obtain happiness for the Emperor and victory over his enemies." So the Praying Virgin could not be omitted from the "protectors" of the basilica. Her equivalent is the Archangel Gabriel. In general, the archangels are also the protectors of power, but this function is usually attributed to Michael. In this case, however, the situation is iconographically ambiguous. Gabriel is the archangel of the Annunciation, and it is therefore he who is the pendant of Mary, even if here she is not represented as the Virgin Annunciate.

Thus, of these six panels, two (*Hercules and the Erymanthian Boar* and *St. Demetrius*) seem to be Byzantine, three (*Hercules with the Hydra and the Hind, St. George,* and the *Praying Virgin*) could be by the Master of Hercules, and, finally, one (*Archangel Gabriel*) is by a master who could be defined as "Gothic."

In addition to these images on the facade, the panels on the north side of the basilica must also be remembered: Christ and the four Evangelists. The figure of Christ is presented frontally, while those of the Evangelists are in three-quarter view. A comparison of the faces of these figures with those of the *Hercules with the Hydra and the Hind* and the *Evangelists Luke and Matthew* proves the common paternity of these works. In conclusion, the Master of Hercules seems to have been an artist linked to Byzantine forms, which he was probably obliged to follow because he had to complete several series of religious works already present in Venice, perhaps part of the famous spoils of the Fourth Crusade. He translated the Byzantine models in an original way, overturning the figurative structure he had to copy. His ability to *translate* seems to have been both his gift and his limitation. He invented formulas, which he sometimes repeated too insistently, and obtained remarkable visual effects, but he did not invent a new and original language. He must have been active in the years around 1240.

The Venetian cultural environment in the thirteenth century was truly international. In this century Venice was enriched by the most diverse external experiences, appropriating them and in some cases actually executing them, never through rigid, long-

term projects, but almost on a day-to-day basis. The relationship, in the Venetian cultural context, between the figurative world of Constantinople and that of the West is evident in the works already cited. In a way, they are examples, in themselves varied, of the interpretation of elements that on some occasions seem linked more or less explicitly to the Byzantine world and at other times to the variegated and complex influence of the West. It is perhaps relevant to mention here another landmark in the pictorial, or rather miniaturistic, culture of Venice: the Bible produced for S. Marco, now in the Biblioteca Marciana. The first letter of the *Incipit* [opening words] of the Book of Genesis, created on gold leaf, has a shape that recalls French and English types, while the quatrefoil medallions, within which are represented the seven days of creation are connected to the late Romanesque and Gothic tradition. Thus, onto the underlying Byzantine style new contributions of Western origin were grafted.

Regarding the international status of Venice, a further example can be cited, taken this time not from works of art, but from written texts. Between 1267 and 1275, Martin da Canal wrote *Les Estoires de Venise*. The choice of the French language was probably aimed at having the glorified history of the Venetian duchy reach out beyond the confines of the city. And in her use of this language, Venice, in fact, was no exception with respect to the cultural world of northern Italy. In fact, this international opening up of thirteenth-century Venice, in other ways and for other purposes, is evident in the great voyages to reach other markets: suffice it to mention Marco Polo and to recall that his work too was written in French.

Founding New Churches and Rebuilding Old Ones

In the history of thirteenth-century architecture, the two mendicant orders which then had just been founded, the Franciscans and Dominicans or Preachers, have a place of considerable note. Their religious seats were located in buildings that already existed, and in an urban context. Whereas Benedictine monks occupied spaces that were far from the "world," the mendicant orders were founded to carry out their activities among the people.

Doge Jacopo Tiepolo donated land for building the church dedicated to SS. Giovanni e Paolo (in Venetian this name becomes S. Zanipolo) in 1234, but the Dominicans must have been in Venice since at least 1226 as a document of that year mentions a Brother Martino, prior of the Preacher Friars of

Venice; subsequently, in a papal document of 1229, there is reference to a prior of the church of S. Martino of the same order. The text of the act of donation refers to a piece of marshland which was certainly easily flooded by the waters of the lagoon. The new building was presumably begun only after reclamation work had been carried out on the land. In 1246, a papal bull promised indulgences to those who offered to make financial contributions toward the building of the church, and in 1268, Doge Ranieri Zeno left 1,000 lire in his will for the building of the portal and the bell tower. It can be estimated, therefore, that the church was completed within the last decades of the thirteenth century. The present Venetian church of S. Zanipolo certainly does not date from the thirteenth century, except in its most basic foundations. Its superstructure can be considered to date from the fourteenth century. It is interesting to observe how, right from the third decade of the thirteenth century, that is to say, shortly after the arrival of the Dominicans in Venice, a doge took action to have a permanent center built for the community, thereby demonstrating the interest of the political powers of the day in providing an establishment of great prestige. Equally prestigious was the church of the other mendicant order, the church of S. Maria Gloriosa dei Frari, which was topographically distant, as tended to happen in all cities, from the Dominican building.

The *Legenda Major* of St. Bonaventura records that St. Francis, while he was crossing the marshes of Venice with another friar, encountered a large flock of birds that sang so loudly that the two friars could not hear themselves recite the hours. St. Francis ordered the birds to keep quiet until he and his fellow friar had finished saying their prayers. The miracle is mentioned, little more than a century later, in the *Chronica brevis* of Andrea Dandolo. It is said to have happened when St. Francis was returning from a journey to the Orient, around 1220. According to tradition, in 1231 the patrician Jacopo Michiel, after listening to a sermon preached in S. Marco della Vigna, where Franciscan friars were residing (later, it was here that S. Francesco della Vigna was built, in the Castello district), had a dream, which resulted in his invitation to the friars to settle on an island of his, where vines were grown; this island was donated to the Order of Friars Minor (the Franciscans) in 1233, and the small monastery of S. Francesco del Deserto was erected there.

Assuming that the tradition is true, the hermitage of S. Francesco del Deserto is not however the first foundation of the Friars Minor in the lagoon. Their presence is documented in the will of a certain Achillea Signolo (or Singnolo) in which, in 1227, 10

Virgin Annunciate, 14th-century statue in the church of S. Giacomo dell'Orio.

lire were left to the Franciscans of Venice. Tradition says that it was while Jacopo Tiepolo was doge that a plot of "vacant" swampy land—needing therefore to be reclaimed—was granted for the building of a church and monastery. We do not possess the original donation document or a copy, but the original cannot be earlier than 1229, the first year of Jacopo Tiepolo's period of office. The foundation of the new Franciscan settlement in the area of S. Maria Gloriosa dei Frari may date from 1231.

In 1234 Giovanni Badoer donated to the Franciscans a plot of "vacant" land and a house adjoining the land and church of the same Order. The first document that gives evidence for the name of S. Maria Gloriosa dates from 1236: so by this time a Franciscan church dedicated to the Virgin already existed, but nothing at all is known of its structure, either in documentary or archaeological form. In 1249 Pope Innocent IV promulgated a bull by which he granted indulgences to whoever contributed to the construction of a new church for the friars which was to be dedicated to S. Maria Gloriosa. The first stone was laid a year later, in 1250. Subsequent papal bulls granted other indulgences to those who made financial contributions to the building of the edifice. The church, completed probably before the end of the century, remained standing until the construction, started in 1330, of the present. From fourteenth-century documents, we know that the second church, approximately fifty meters long, had three apses and probably an aisleless nave with transept. Thus it was built in accordance with "Franciscan" typology, on the model of the upper church of Assisi, and it was oriented in the opposite direction from the present one.

In a discussion of thirteenth-century Venetian art, it must not be overlooked that in two areas distant from each other, there were two important monastic churches which, in the following century, would also have an urban function of considerable importance and would be witness for centuries to commissions of enormous artistic prestige. To draw up a profile of religious architecture of the thirteenth century, reference must be made to other churches besides the foundations of the mendicant orders, some of which, even if restored and modified in later times, still reveal thirteenth-century characteristics.

The church of S. Giacomo dell'Orio, for example, is an ancient foundation dating back, perhaps, to the end of the tenth century, which was completely rebuilt in the first half of the thirteenth century (the date handed down by Corner was 1225). Subsequent alterations, from the fourteenth to the seventeenth century, changed its appearance, with additions and modifications, but some parts, like the central apse, show clear thirteenth-century characteristics.

Another church, which perhaps preceded the rebuilding of S. Giacomo dell'Orio, is S. Nicolò dei Mendicoli. This building too underwent various phases of rebuilding and additions. Recent restoration has identified the foundations of a late medieval building that could refer to defense works rather than to a church. S. Nicolò dei Mendicoli is at the end of the Dorsoduro district, at the far western limit of the city, at one of the nearest points to the coast; it cannot be excluded, therefore, that here, in the Byzantine period, a sort of *castrum* [fort] was built for defense. This church—like S. Giacomo dell'Orio and other twelfth-century churches starting with the basilica of SS. Maria e Donato on Murano—seems to have been divided into a nave and aisles with a single central apse and with a transept. This edifice, if it is to be dated, as seems probable, to the end of the twelfth century, can be considered a typological forerunner of the church of S. Giacomo dell'Orio, which was built in the first half of the thirteenth century.

The typology of churches divided into an aisled nave with transepts can be considered a generic derivation from S. Marco, with substantial simplifications, above all with regard to the roofing system. The structure of the walls, in contrast, seems not specifically related to S. Marco, but appears nonetheless to be modeled on a method from the Contarini period.

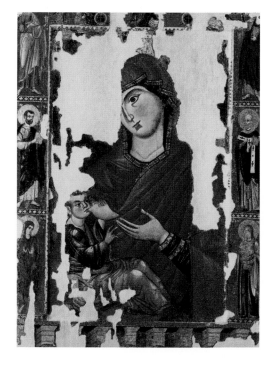

Madonna Suckling the Child, in Venetian vernacular known as the *Madona de la late*, panel, 13th–14th century. Venice, Museo di S. Marco.

S. *Helena*, 13th-century frescoed lunette in the church of S. Giovanni Decollato, showing St. Helena within a triumphal arch; below, the heads of Sts. John, Peter, Thomas, and Martius.

The Pictorial Culture of the Second Half of the Thirteenth Century

A splendid codex in the Biblioteca Capitolare of Padua is the epistolary by Giovanni da Gaibana, a beneficed priest in the cathedral; probably illuminated by a Venetian in 1259, it signals a harmonious synthesis of Byzantine and Western cultures. The first seems evident especially in the traditional way of setting out the whole page. The second is shown in the execution of the initials, with plays of vegetal ornament that recall typologies of Po valley and Venetian regional provenance to which reference was made earlier when we considered some of the details in the great Bible of S. Marco. Here we are in the presence of a cultural process similar to that observed with respect to the Master of Hercules, but with results that are certainly more refined and give their author the merit of having created an original figurative language. In fact, the style of the Master of the Epistolary of Giovanni da Gaibana seems to have been more widespread in Padua (the churches of S. Sofia and S. Benedetto) than in Venice, but here, too, there are certainly still echoes in both mosaics and miniatures: there are some mosaics in the style of the northern arm of the atrium of S. Marco, and also some miniatures in rock crystal, a "specialty" typical of Venice.

If the Master of the Epistolary was a refined artist who was absorbed in his research and worked in a Byzantine and late Romanesque-Gothic cultural context, at a distance from him of perhaps a few decades there was working in Venice a painter, a fresco artist, who, taking over some of his formulas, brought new inspiration to the interpretation of figurative space: this was the painter of the frescoes in the Venetian church of S. Giovanni Decollato (in Venetian S. Zan Degolà or S. Zandegolà). Discovered by Michelangelo Muraro in 1945, the wall paintings were taken down and, after journeys to different places, recently returned to their original home, the left-hand apse in the chapel of the Crucifix. On the triumphal arch was an Annunciation, now placed inside the chapel on the left wall, while on the right wall the fresco of *St. Helena* has been put back. It represents a sort of loggia under a triumphal arch, a scene delimited at its base by a small cornice in perspective. Below this are the heads of four saints, John, Peter, Thomas, and Martius, on the vault are the Emmanuel and the symbols of the Evangelists. What strikes the eye immediately is the new sense of figurative space, which brings to mind a post-Giottesque painter and thus a date within the first decades of the fourteenth century. But Giotto's space is quite different: partly in Assisi, but especially in Padua, his space became existential; in other words, it gave indications not only of place, but also of space in which the figures stand. This does not happen in the cycle of San Giovanni Decollato. It does not mean, however, that the master who created the

St. John the Baptist, icon, 14th century. Venice, Museo Corror.

latter cycle is not a great artist; in fact, he showed a new spatial sensitivity in the representation of architecture, even if it was different from Giotto's. Similarly, no relationship can be seen with Giotto in the definition of the single figures, whose typology is still linked to the Byzantine tradition and, indeed, that particular Byzantinism which was not exempt from Western influences, typical of Venetian culture of the thirteenth century. The author of the S. Giovanni Decollato cycle, therefore, seems to have been a Venetian linked to his late-thirteenth-century cultural milieu but who, in the name of a new classicism, tended to bring innovation to his sense of space, borrowing from antique models: the balcony on which St. Helena appears is a sort of Roman triumphal arch with three barrel vaults, seen from a three-quarter angle, with a bold three-dimensional effect. This is an authentic revival of the antique, and it is in this key that an "antique" perhaps known directly in Rome—where new spatial experiences were being developed at the end of the thirteenth century—should be viewed and interpreted.

An indication of date may come from a comparison with the Annunciation mosaic of the ciborium of the cathedral of Parenzo (Poreč in Istria, now Croatia), traditionally attributed to Venetian master craftsmen and dated 1277. The compositional shape is similar, but the rendering of space in the ciborium of Parenzo is very schematic, seeming to be almost

stiff compared to the complexity of the background of the *Annunciation* of S. Giovanni Decollato. Its originality places this master in a unique position. The works that are usually dated to the end of the thirteenth century do not have much in common with the classical rendering of the S. Giovanni Decollato cycle. It is enough to consider, for example, the paintings on the casket of the Blessed Juliana in the Corror museum. The wooden chest, made to contain the uncorrupted remains of the Blessed Juliana of Collalto in the last decade of the century, has a number of decorative elements, the most interesting of which is the painting on the inside of the lid. Represented here are St. Biagio and St. Cathaldus and, in smaller dimensions, the Blessed Juliana in a Benedictine habit (see p. 82). Western characteristics have been recognized here by all the scholars who have studied this work, which is certainly not of great stylistic value but interesting as a measure of the taste originating from certain aspects of the great Bible of S. Marco, as well as from the epistolary of Giovanni da Gaibana.

Also of Western origin (Umbria-Tuscany), though executed perhaps by a Venetian master, the crucifix of S. Maria Gloriosa dei Frari is the most sensational discovery of thirteenth-century painting on wood of recent years (see p. 81). In 1992, to commemorate the fifth centenary of the consecration of the church, it was decided to carry out a radical restoration of the crucifix of the chapter. The results of the restor-

Casket of the Blessed Juliana, painted wood, intended to hold the remains of the Blessed Juliana of Collalto, datable around the end of the 13th century. Venice, Museo Corror.

ation were both exceptional and unforeseen: underneath the nineteenth-century repainting was discovered a crucifix in tempera, attributed to the thirteenth century. Some parts of the work were missing: the whole of the right side of the body of Christ extends beyond the wood of the cross and we have to imagine that the body was painted in a setting that was broader than just that of the cross. A double inscription runs right along the horizontal bar: "In cruce monstravit quantum te gratis amavit" [On the cross he showed how much he freely loved you] and "Pro mundi vita suam crucifixit ita" [For the life of the world, so did he crucify his own]. This is a type derived from central Italy and, in view of the particular devotion of St. Francis for the crucified Christ, it is not difficult to hypothesize that the Friars Minor were the carriers of this type to Venice. It is a type, therefore, that can be defined as originally Umbro-Tuscan and one that was made known by the Franciscans.

The prestigious painting on wood of the *Madonna Suckling the Child* (in Venetian, *Madona de la late*), which is in the museum of S. Marco, was previously in the atrium of the basilica and subsequently (by the sixteenth century) in the chapel of S. Teodoro (see p. 78, bottom right). The Virgin is represented in the act of suckling her son. On each of the long vertical sides of the frame of this icon three saints are represented, while on the lower side is a cornice in perspective—a foreign element in this type of icon, in the traditional sense of the term. The principal scene brings to mind Pisan influence, but the saints on the frame are certainly not Pisan. It could be the work of a Venetian master at the very end of the thirteenth century, who, in the international climate of Venice, would have come into contact with Pisan prototypes. These he could have used in his depiction of the *Madonna Suckling the Child*, managing to soften the strong linear tension of icons in the Pisan tradition into more delicate volumes, while, for the pictures of the saints, being without models of that type, he borrowed from forms that were more common in the Venetian tradition. There is, however, another compositional element that must be considered: the base of the icon is painted with brackets seen in perspective. It is an innovative choice for this type of icon. A similar structure, of different dimensions, can be seen in the decorations at the base of the balcony on which the figure of St. Helena is placed in S. Giovanni Decollato.

In 1261, Venice was forced to give up her attempt to occupy Constantinople when the Byzantine emperors returned with the Palaeologan dynasty. The relationship between Venice and the empire does not suggest immediate cultural links with Constantinople, thus

Crucifix painted on wood, a masterpiece of 13th-century Venetian painting. S Maria Gloriosa dei Frari.

the Byzantinism of the late thirteenth century could have been independent of the imperial capital. Ties with the Palaeologan capital, nevertheless, would be evident in the late Trecento.

The Fourteenth Century

The new century, the fourteenth, opens at Padua with a monument exceptional for its qualitative importance and its innovative power in the context of Western painting: Giotto, between 1303 and 1305, was commissioned by Enrico Scrovegni to fresco the Arena Chapel. It is the most explicit example of the renewal that Cennino Cennini described as follows: "Giotto changed the art of painting from Greek to Latin, and introduced the modern." Such a renewal does not seem to have taken place in Venice. The city still looked to the oriental world (the "Greek"), neglecting the neighboring West (the "modern" of Giotto at Padua). Until a few decades ago, only very few works were known that showed some knowledge of generally post-Giottesque, Western culture: one of these was the double Deposition in the chapel of the Most Holy Sacrament in the church of SS. Apostoli. It is a double Deposition because in the upper part is represented the *Deposition from the Cross* and underneath, the *Deposition into the Sepulcher*. The first scene is fairly legible and seems to hint at Giottesque influence. The second is very damaged and almost illegible. The little that can be seen seems to connect it to Giottesque forms, but certainly not in the

St. *Cathaldus*, detail of the interior of the lid of the *Casket of the Blessed Juliana*. Venice, Museo Correr.

overall composition if one compares the analogous scene in the Scrovegni commission at Padua, where the superimposition of levels is an almost unheard-of boldness. In the fresco at SS. Apostoli, everything is simplified as much as possible. Only in the composition of several figures do Giottesque models emerge. Finally, the frame with brackets viewed in perspective, which was no novelty for Venice, has been seen in the *St Helena* in S. Giovanni Decollato and the *Madonna Suckling the Child*.

A few years ago some frescoes were discovered and some miniatures studied that make it possible to review in more depth the cultural situation in the field of painting in the first half of the Trecento in Venice. The coherence of the Giottesque language had a significance that was radically different from Venetian taste, which perhaps seemed incapable of understanding and absorbing the profound revolutionary import of the great painter's example. Nevertheless, some echoes of Giottesque influence in Venice, either directly or indirectly, are today fairly well documented, even around S. Marco.

In the first half of the fourteenth century, the basilica of S. Marco commissioned a new series of antiphonaries. According to tradition, these antiphonaries were executed in 1318. Unfortunately, a large number of the miniatures with representations of scenes from the life of Christ, like the Pentecost, have been stolen or removed. Nevertheless, even in its fragmentary state, it shows precise reference to scenes from Giotto's cycle in the Scrovegni Chapel. All the illuminated initial letters are still there: against a blue background, the individual letters are painted with rich decoration in brilliant colors which make the compositions even more rich, with their refined play of vegetal ornament.

Another work that seems to refer to Giottesque prototypes is the fresco on the vault of the Foscari passageway that leads to the door of the south transept of the basilica of S. Marco from the courtyard of the Palazzo Ducale. It is a small cycle of scenes from the life of Christ, badly damaged and fragmentary: the Annunciation, Nativity, Crucifixion, and Deposition into the Sepulcher. The fragments are almost illegible, but this small and little-known cycle is in the tradition of Giotto, probably painted in the first decades of the century.

In the neighboring church of S. Nicolò, which today is part of the Canonica, is a fresco of the Crucifixion, discovered less than twenty years ago. In a better state of conservation than the small cycle in S. Marco, it represents Christ on the cross between the Virgin and St. John and two pairs of saints (of whom one is clearly St. Peter). Two angels above the cross complete the scene. The work of two different

hands has been noted here, one responsible for the five central figures and the other for the two pairs of saints at the edge of the composition. The first master may have been linked to the pictorial tradition of Rimini, while the second has been recognized as more closely connected to the Byzantine cultural phase called the Palaeologan Renaissance. This *Crucifixion* in some ways is the symbol of a crucial moment in Venetian pictorial culture of the fourteenth century: the ambivalence between East and West which, according to some interpretive suggestions, would signal the environment into which the painter Paolo Veneziano was born.

Some scholars have seen a glimpse of Giottesque or Rimini influence in works attributed to the young Paolo Veneziano. An example is provided by the dossal of the Blessed Bembo at Dignano (Vodnjan) in Istria, now Croatia. This work, dated 1321, reveals an artist of great ability, certainly sensitive to Paduan or, more generally, Po valley pictorial culture of the first decades of the fourteenth century. The little scenes that describe episodes in the life of the Blessed Bembo are often set in three-dimensional spaces, similar to models of Giottesque origin. Those who attribute this work to the young Paolo have to admit to a "Western" phase with respect to a succeeding phase which has been documented as Palaeologan Byzantine. The discussion about Paolo, however, will be taken up again a little later: at this point it is important to show how Venice did not remain entirely insensitive to Giottesque lessons, even if she seemed to submit to, rather than to accept, the teaching of Giotto, whose spatial rigor could probably not yet be understood. And in fact, it would be the more linear post-Giotto "Gothic" that found its ideal setting in Venice, becoming an integral part of her figurative language.

The Bembo dossal to some extent is one example that defines the difficult and debated relationship between Western and Eastern culture. To clarify the fundamental significance of these two cultures, it is enough to think of two examples as models: in the Western world, the decoration of the Scrovegni Chapel; in the Byzantine, the decoration of the basilica of the Holy Saviour in Chora, Constantinople, a clear symbol of the Palaeologan Renaissance.

In 1333, Paolo Veneziano completed (with signature and date) the polyptych of the *Dormition of the Virgin* executed for the church of S. Lorenzo in Vicenza and now in the Museo Civico there. The basic shape and modality of the painting connect this work to the Palaeologan Byzantine world. In 1345, together with his sons Luca and Giovanni, Paolo executed a work for the basilica of S. Marco, the cover of the Pala d'Oro, commonly called the *Pala*

Madonna and Child with Patrons, Paolo Veneziano, forced lunette from the tomb of Doge Francesco Dandolo in the church of the Frari. Dandolo is represented as St. Francis, and his wife, Elisabetta Contarini, as St. Elizabeth.

feriale [weekday altarpiece] (see p. 84). If, in 1345, he already had two sons who were painters, it is logical to think that twelve years earlier, in 1333, he can by no means have been a painter just starting his first works. Some scholars have hypothesized activity prior to 1333 in which Paolo could have mastered a Western visual language, as would seem to be proved by those who accept the attribution to him of the Bembo dossal (1321), mentioned earlier.

The *Dormition* at Vicenza is without doubt a work of Palaeologan influence, but it must also be said that even though the typological organization of the composition refers to Byzantine prototypes, elements of Gothic taste, rather than Byzantine, appear in it. This work is a personal and original translation by Paolo which shows sensitivity to Palaeologan experience (to the extent that some scholars have suggested that he visited Constantinople), but it also demonstrates—through a delicate linearism that recalls the interpretive subtleties of pictorial Gothic—an ability to render this experience as post-Giottesque. Master Paolo accepted a commission from the ducal court when, in 1339, he was given the task of decorating the lunette of the tomb of Francesco Dandolo in the church of the Frari: in the center are the Virgin and Child, at whose feet kneel the two patrons, Doge Francesco Dandolo, presented by St. Francis, and his wife Elisabetta Contarini, presented by St. Elizabeth. The bodies of the two accompanying saints follow the curving line of the lunette, bending toward the Virgin who, in the center, dominates the scene. There is a perfect equilibrium between the volume of the three larger figures, the Virgin with Child and the two accompanying saints, and that of the ducal couple; a perfectly balanced composition of elegant rhythms, constructed of gentle figures with faces colored in warm tones. The composition does not neglect the smallest details, for example the shoe with its golden spur poking out from under the doge's red cloak. A gold banner with a pattern of flowers, held up by angels, is superimposed behind the figure of the Virgin on the gold background of the composition.

In 1345, Paolo created with his sons Luca and Giovanni the dated and signed *Pala feriale*, the cover for the Pala d'Oro which was shown to the public only on religious festivals (see pp. 84–87). The work, commissioned by Andrea Dandolo, was in two registers: the upper with seven sections containing the figures of St. George, St. Mark, the Virgin, a Pietà, St. John the Evangelist, St. Peter, and St. Nicholas; and the lower with seven scenes from the life of St. Mark. Among these is the scene of the *Miraculous Intervention by St. Mark on the Occasion of the Translation of His Body to Venice from Alexandria*; almost as if it were the principal scene of the story of St. Mark, it is this one that bears the names of Paolo and his sons. It is interesting to note that while the protagonist of the scene is, of course, St. Mark, appearing to the sailors who were frightened by the storm, what strikes the eye immediately is the representation of nature—the rocks, and the wind that fills the sails—in conformity with a compositional style that is more Gothic than Byzantine.

The polyptych executed for the Venetian church of S. Chiara is dated toward the end of the activity of Paolo Veneziano. He died between 1358, the date of his last certain work, the *Coronation of the Virgin*, and 1362, the year in which Marco is documented as the son of the *quondam* [late] Master Paolo. The *Coronation of the Virgin* is a dazzling splendor of gold and precious vestments, with a chorus of angel musicians in the upper part of the central panel. It is one of the examples in which the visual language of the last phase of Paolo's activity has matured in the Gothic sense. He transformed a religious theme, the Coronation of the Virgin, into a sumptuous scene that seems to belong to the courtly world. The other panels of this polyptych, which show neither the same compositional sense nor the delicacy of colors of the central part, are probably to be attributed to his school.

With Paolo Veneziano the great moment of difficult synthesis between the Palaeologan Renaissance and the world of the Gothic is reached: following in his footsteps, Venetian painting moved toward the Late Gothic but in fact never reached the highly refined qualities of this master.

Andrea Dandolo

Andrea Dandolo was an extremely cultivated man and an important patron in the world of art. A friend of Petrarch, he was a man of letters, a lawyer, and a historian, as is shown by his two chronicles, the *Chronica brevis* and the *Chronica extensa*. His political career was precocious: at twenty-two he became procurator of S. Marco and at thirty-seven (in 1343), he became doge. First as procurator and subsequently as doge, he dedicated himself to the ducal basilica. His most significant initiative, heavy with symbolic import, was the reconstruction of the Pala d'Oro. Created first in 1105 by Doge Ordelaffo Falier, it was modified with additions by Doge Pietro Ziani in 1209. In the years immediately preceding 1345, Andrea Dandolo decided to reconstruct it, and in fact, the version of the Pala as it is seen today is, in its basic lines, the one he ordered. This is known thanks to an inscription cut into two golden tablets that form part of the lower section of the Pala. This inscription is placed between the figures of the Virgin, Doge Ordelaffo Falier, and Empress Irene of Constantinople. As has been stressed recently, the composition of this group is not original: the figure of the doge was once that of Emperor Alexis I

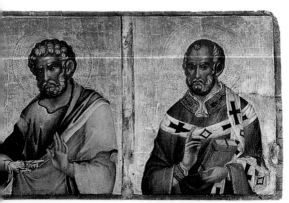

Comnenus, husband of Irene. It was probably Andrea Dandolo who had the head of the imperial image replaced by that of Ordelaffo Falier, with the addition of the explanatory note of the doge's name. This act had a precise political meaning: Andrea Dandolo wanted to glorify the State whose representative he was, with the theory of the "prince," the instrument of his people's happiness, modeled on Constantine. But after Constantine, all other princes of East and West had failed: "Then occurred the *translatio imperii* [imperial transfer] and the *princeps* [ruler] of Venice, leader in Europe and master of Romania, appeared with the new Constantine, or rather as the one whose fullest jurisdiction all Venetians and non-Venetians, ecclesiastical and lay, in their own interest, had to recognize." If this really was Dandolo's belief, it explains clearly why he wanted to cancel the imperial figure of Alexis Comnenus and replace it with the image of the doge who was the first patron of the Pala d'Oro. However, Dandolo's intervention in this work went well beyond the transformation of the imperial image into a ducal one: it was a complete restructuring. In fact, all the enamels of the first and second versions of the Pala were used to create an absolutely new one. This probably meant moving some of the enamel groups

which previously had a unified iconographic and compositional logic of their own. In the center of the largest area was placed Christ Pantocrator with the symbols of the Evangelists; immediately above was the empty throne, waiting for the Second Coming of Christ. This central quadrangle is enclosed by processions of angels, Apostles, and prophets, while in the upper part are the six Byzantine holy days with the figure of the Archangel Michael in the center.

Thus, it is the framework of the Pala that is completely changed, with a figurative setting that is decisively Gothic. It is not only a question of the external frame which delimits the two parts, the upper (originally mobile) and the lower, but it is also the structure into which the individual enamels were placed: a great Gothic scaffolding, with two types of arches, arranged on a series of pilasters, laden throughout with precious stones—in all the interstices between the registers, between the tympana of the procession of apostles, and between the arches of the great panels of the upper zone of the Pala itself. The precious stones are mounted on gilded supports of geometric or vegetal form, on which they are set in frames which themselves become decorative motifs. This framework, covered as much as possible with precious stones and substances, conferred a new aspect on the Pala, in which the Byzantine enamels are placed, as already noted, like the stained-glass windows in a French Gothic church. The Gothic linearism of the cathedral is softened in the brilliance of the colors of the precious stones and in the dazzle of the gold. The very inconsistency that arises from the dual presence of two completely different visual languages—the Gothic of the framework and the Byzantine of the enamels—becomes the reason for the sublime and poetic original of the abstract light, all drenched with the gold that reflects it. A light, then, that is atonal and cold unites the whole composition, creating a work of incomparable value which only a great and wealthy doge could invent as a demonstration of the power of the Venetian prince, in the place that was the symbol of that power itself, the tomb of St. Mark. The whole complex of the Pala d'Oro was completed in 1345 with the *Pala feriale*, the weekday altarpiece, the work of Paolo Veneziano and his sons Luca and Giovanni.

Of the mosaics of S. Marco, only the two illuminated cycles commissioned by Dandolo can be mentioned here, one in the Baptistery and the other in the chapel of S. Isidoro. In the Baptistery, Dandolo himself was buried, in a monument with lines from Petrarch as an epitaph; he was the last doge to be buried in the basilica of S. Marco. The chapel of S. Isidoro was built after the Black Death of 1348, almost as a defense against other such terrible epide-

Pala feriale, Paolo Veneziano. So called because it served to cover the Pala d'Oro on ordinary weekdays. In the center, the dead Christ surrounded by St. George, St. Mark, and the Virgin on the left, and St. John the Evangelist, St. Peter, and St. Nicholas on the right. The lower register shows stories from the life of St. Mark, the miraculous discovery of the saint's body, and its translation to Venice. The altarpiece is signed and dated 22 April 1345. Venice, Museo Marciano.

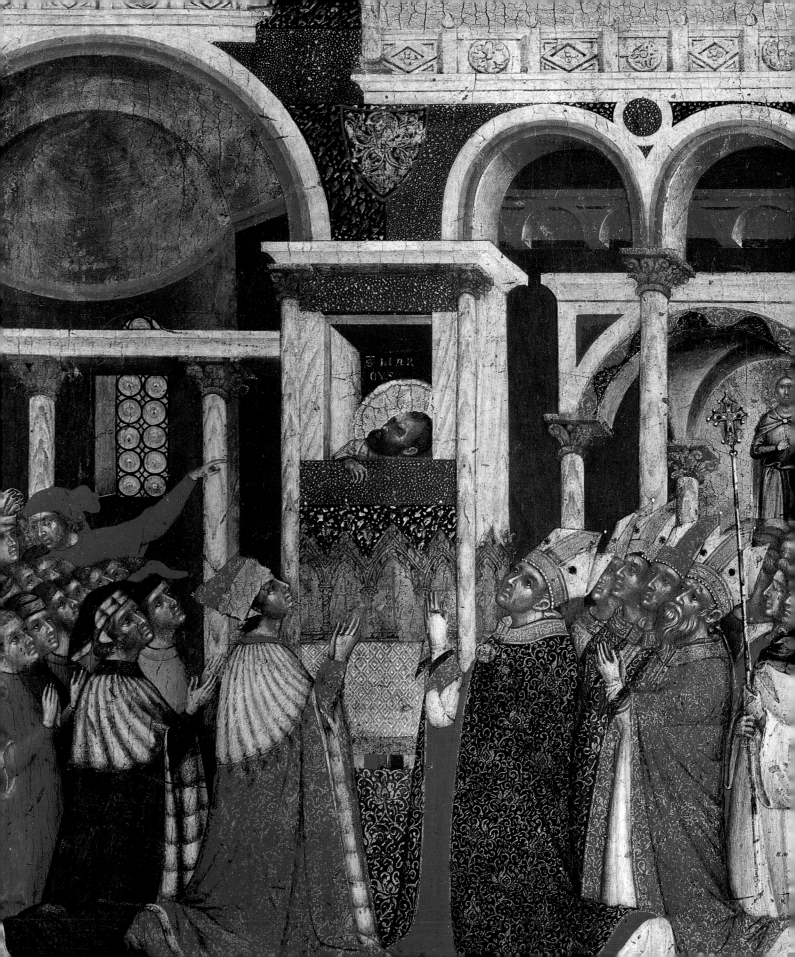

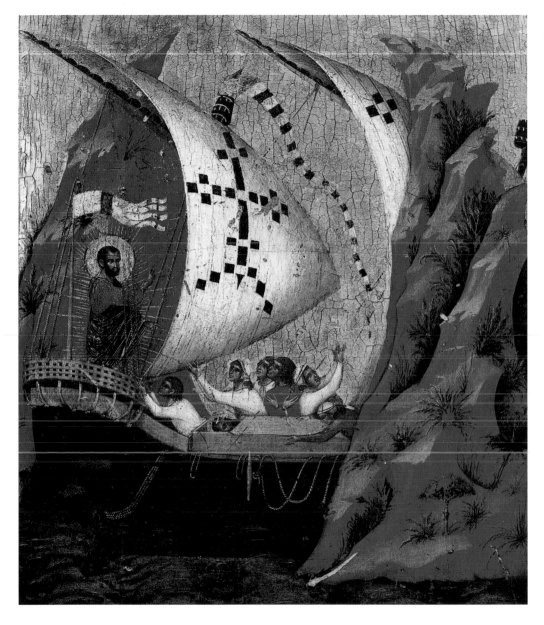

OPPOSITE:
Miraculous Discovery of the Body of St. Mark, Paolo Veneziano, section of the lower register of the *Pala feriale*, 1345, Museo Marciano.

Translation of the Body of St. Mark, Paolo Veneziano. Section of the lower register of the *Pala feriale*, 1345, Museo Marciano.

mics, and its decoration was finished in 1354, the year after Andrea Dandolo's death. Dandolo was the patron too, about halfway through the fourteenth century, of the important work carried out in the Palazzo Ducale, where the chief architect was Filippo Calendario.

Even in moments of great public tragedies like the Black Death, the figure of Doge Andrea Dandolo seemed able to overcome difficult and dramatic events with an eye to the interests of ducal power and its most visible manifestation: all his commissions, in the various modes of expression, have in common a flavor of his sense of power. They are cultural "episodes," meant to demonstrate this power as *'preclarus honore'* [most illustrious honor], as it was defined in the inscription of the Pala d'Oro, the symbol of that ducal power which was a Late Antique inheritance: art, for him, had to be the glorification of all this.

Giovanni Lorenzoni

The Triumph of Gothic Culture

Civic and Religious Architecture in Gothic Venice

The refinement of domestic life appears to have been far advanced in Venice from her earliest days, and the remains of her Gothic palaces are, at this day, the most delightful residences in the city, having undergone no change in external form . . . the traveller . . . can still stand upon the marble balcony in the soft summer air, and feel its smooth surface warm from the noontide as he leans on it in the twilight; he can still see the strong sweep of the unruined traceries drawn on the deep serenity of the starry sky, and watch the fantastic shadows of the clustered arches shorten in the moonlight on the chequered floor.

John Ruskin, *Stones of Venice*, vol. II, 1853

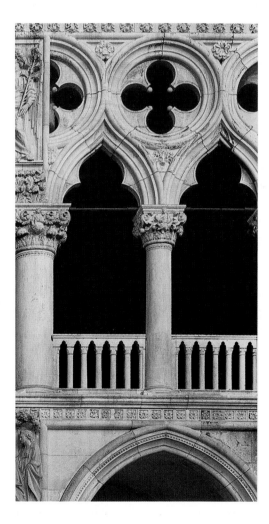

Characteristic ogive and quatrefoil motif typically used in loggias and windows of Venetian Gothic buildings.

It was Ruskin's acute visual sensibilities that opened his eyes to the beauties of Venetian Gothic, at a time when the academic classicism of Selva and Cicognara still governed the study of architecture in Venice. Ruskin's passionate defense of the city's Gothic buildings, then regarded as unfashionable relics within the Venetian townscape, laid the basis for the study of the subject since that time and ensured a concern for their preservation. Ruskin sought to give scholarly rigor to his studies by attempting to chart the chronological development of the style within its historical context. He wrote forcefully, but also with tenderness, his words almost caressing the details he describes. Prevailing neoclassical dogma had no appeal for Ruskin. His antipathy toward industrial technology blinded him to the scientific achievements of the Renaissance, and his strictly Protestant upbringing made him suspicious of the "pagan" roots of classicism. In Gothic architecture, by contrast, he found evidence of the spontaneous imagination of the stonecutter, whose love of naturalistic detail sanctified the work by reflecting the perfection of God the creator.

For the *Stones of Venice,* Ruskin wrote his famous essay on "The Nature of Gothic" in which he described not only the physical elements which defined Gothicness, but also the "characteristic or moral elements of Gothic." This discourse developed ideas he had already formulated in his *Seven Lamps of Architecture* of 1848—the reference to the Revelation of St. John in the title anticipating the language and tone of the pulpit in the book's content. In the *Stones of Venice* Ruskin pursued this moralizing justification of the Gothic style. For him its essential quality was represented in the deeper values behind the physical reality, categorized (in order of importance) as Savageness, Changefulness, Naturalism, Grotesqueness, Rigidity, and Redundance.

In Savageness Ruskin saw a quality of undisciplined ruggedness, a "magnificence of sturdy power," which he considered superior to the obedient correctness of polite classicism. Changefulness described the variety of ornament in Gothic architecture, which Ruskin attributed to the freedom of invention afforded to the medieval craftsman. Grotesqueness referred to the quality of humor and mischief which enliven the style. By Naturalism Ruskin intended the imitation of natural forms—especially plants—in decorative details, which brought the craftsman closer to divine truth. The term Rigidity is perhaps the least easily interpreted: Ruskin admired "*active* rigidity: the peculiar energy which gives tension to movement, and stiffness to resistance," that is to say, the strength and resilience of the Gothic structural system. And finally Redundance: "the uncalculating bestowal of the wealth of its labour." Here Ruskin alluded to the sacrifice of the laborer: "the richness of the work is, paradoxical as the statement may appear, a part of its humility."

Meanwhile his penetrating powers of observation led him to study and record the visual presence of Venetian Gothic architecture, both in words and in numerous drawings and watercolors, some of which were engraved for use in the book. Ruskin depicted the city's Gothic legacy with unprecedented acuity— even the meticulous realism of Canaletto had depicted Gothic buildings less for their own intrinsic merits than to give authenticity to a controlled and classical vision of the city, and Cicognara's surveys had corrected irregularities to give discipline to the city's medieval heritage.

According to Ruskin, certain physical characteristics, such as pointed arches, vaulted roofs, flying buttresses, gables, and grotesque sculpture, could identify a building as Gothic, though these were no more than visual manifestations of the underlying abstraction: "Every building of the Gothic period differs in some important respect from every other;

and many include features which, if they occurred in other buildings, would not be considered Gothic at all." The difficulty with Venetian secular Gothic, as he realized, was that here the style was not a structural system. A Gothic palace had pointed-arched windows and portals, but no vaulting or buttresses. The structure of a Venetian house or palace was independent of the mode of decoration, depending as it did on flexibility. Facade walls were merely screens

across the end of the brick spine walls which ran along the length of the building, tied together by wooden beams at every level. Since the structural role of the facade was limited to supporting the front slope of the hipped roof, it could be punctured almost at will in any decorative style—only the position of the chimney flues constrained the distribution of apertures.

Two typical Venetian Gothic motifs from John Ruskin's *Stones of Venice.*

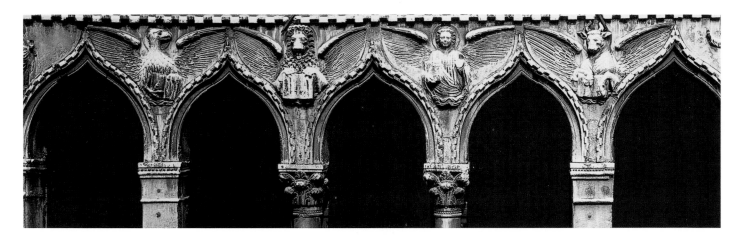

Palazzo Agnusdio, detail of windows. The spandrels contain the symbols of the four Evangelists: the angel of St. Matthew, lion of St. Mark, ox of St. Luke, and eagle of St. John.

Ironically, considering this freedom of design, the Gothic brought a new emphasis on the wall surface to the Venetian palace facade, as Ruskin observed:

We have seen that the wrecks of the Byzantine palaces consisted merely of upper and lower arcades surrounding cortiles. . . . But a great change takes place in the Gothic period. These long arcades break, as it were, into pieces, and coagulate into central and lateral windows, and small arched doors, pierced in great surfaces of brick wall.

Instead of the dark voids of the Byzantine waterfront porticoes, whose colonnades seem like stilts planted in the lagoon mud, the wall surface becomes a flat plane on which to project the image of the owner, just as the rippling reflections of the water play on its surface. The effect is not one of enclosure, but rather one of insubstantiality. Every framing line seems to be fragmented with tiny pockets of shadow—whether it be the dogtooth cresting of the Istrian stone gutters, the twisted rope moldings of the corners, or the delicately dentilled window margins. The polychromy in the juxtaposition of the blue-green water, the rough red brick, and the crisp precision of the white stone is enhanced by the play of these different textures. Abandoning the architectonic rigor of the Byzantine superimposed arcades, the facade becomes a delicate veil mediating between private and public space. By day the hard black voids of the windows would have been softened by the glistening mosaic of light reflecting on their tiny round panes of glass, now mostly replaced by plate glass. By night the palace appears as if in a photographic negative, the wall becoming the void, and the interior rooms revealed as semipublic spaces by the Murano glass chandeliers illuminating their decorated ceiling beams.

The Evolution of Venetian Secular Gothic

The Gothic style in Venice coincided with the period of greatest political power and trading success in the history of the Republic. The first Gothic motifs appeared in the thirteenth century, in the aftermath of the Fourth Crusade of 1204. Venice's opportunistic diversion of the fleet to sack Constantinople had finally demonstrated her supremacy over her former sovereign power, encouraging the growth of an independent cultural identity. It was not until after the shock of the war of the League of Cambrai in the early years of the Cinquecento that Venetian architecture finally shed the last vestiges of the Gothic.

Ruskin analyzed the evolution of Venetian Gothic architecture, classifying it according to a series of six "orders" or stages of development. These were not generic in the same sense as the classical orders, but they enabled the subject to be classified in the way that a British Victorian naturalist might classify fossils or species. In 1817 Thomas Rickman had already provided the study of English medieval architecture with a similar series of stages, from Norman to Perpendicular. Ruskin's sequence was substantiated by considerable historical research, and although in reality the transitions between one order and another proceeded more erratically than his model would suggest, the broad evolutionary outline is one that is still accepted and used today.

The first order was characterized by the Veneto-Byzantine stilted arch, visible today in buildings such as the two neighboring palaces of Ca' Loredan and Ca' Farsetti. Gradually this rounded arch was transformed into a pointed arch, first by a pointed inflection on the extrados, and later by a parallel peaking of the intrados. Both these stages may be seen in the thirteenth-century Palazzo Vitturi on Campo

S. Maria Formosa, where the mezzanine windows are pointed on the extrados alone, and those of the *piano nobile* are fully Gothic. In Ruskin's fourth order, the ogee arch is doubled to form a "waist" in its profile. The fifth is a combination of the third and fourth orders, and the sixth is the same with the addition of a crowning finial. The most problematic stage in the sequence occurs in the fourth and fifth orders, which are both to be found in works of similar date, often combined together in the same building.

The Palazzo Ducale

The fifth of the six orders had already been reached in the Bacino facade of the Palazzo Ducale, begun in 1340. This fact is testimony not to the inadequacy of Ruskin's scheme, but rather, to the extraordinary sophistication of the design at that date, and to its pervasive influence on the homes of the Venetian nobility for over a century. The previous communal palace dated back to the reign of Doge Sebastiano Ziani (1172–78). Ziani was a fabulously wealthy merchant who, according to Renaissance mythology, had rebuilt the whole of Piazza San Marco. Juergen Schulz has recently shown that only the Palazzo Ducale was begun under him, the other structures in the Piazza dating from the dogate of his son Pietro Ziani (1225–28). At that time the building and maintenance of the Palazzo Ducale was still the personal financial responsibility of the doge, so it is not

Palazzo Pisani-Moretta on the Grand Canal, detail of quatrefoil windows.

Palazzo Vitturi in Campo S. Maria Formosa. Facade with fully Gothic arched windows on the *piano nobile*.

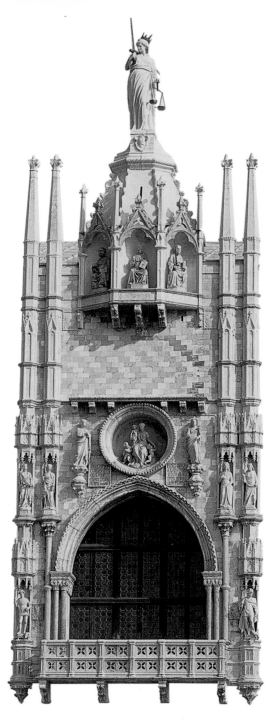

Palazzo Ducale, south facade balcony, designed by Pierpaolo and Jacobello Dalle Masegne, 1400–1404.

north. The Palace of Justice overlooked the Piazzetta, and along the south front facing the Bacino stood the Palazzo Comunale. Above its ground-floor portico ran an arcaded loggia on the first floor, with two stilted arches over each lower arch. The principal chamber where the Great Council assembled was on the ground floor at the eastern end of the south front, flanking the ancient tower which still occupied the corner beside the Ponte della Paglia.

As early as 1296 a proposal to expand the Sala del Maggior Consiglio into adjoining rooms was considered. But it was the Serrata del Maggior Consiglio [restriction of the Great Council] in the following year that provoked the need to reconstruct the Palazzo Comunale, for membership in the Council now became the automatic privilege of those male nobles whose families were listed in the *Libro d'Oro* compiled at that time. Consequently, the numbers of nobles eligible for representation rose rapidly from about 400 to 1,200 within a few decades. Not only was the chamber too small, but its ground-floor location lacked both decorum and security. The position of the cistern prevented expansion into the courtyard. The decision taken in 1340 was therefore to rebuild the entire south wing, incorporating the old tower on the corner and elevating the Sala del Maggior Consiglio to the top of the new building. By 1343–44 construction was advancing rapidly—the date 1344 is inscribed on the penultimate capital of the ground-floor columns near the corner of the Piazzetta. The Black Death of 1348 provoked an inevitable interruption, and although the building of the new Sala was largely complete, work proceeded erratically from that time. It was not until 1365 that Guariento was called in to execute his fresco of the *Coronation of the Virgin* for the end wall of the chamber. The previous Sala del Maggior Consiglio seems to have continued in intermittent use until 1423, incorporated into the ground floor of the new wing.

Despite the ravages of the two fires of 1574 and 1577, which led to the loss of the traceries from the windows of the Sala, as well as the interior decoration, the south wing of the Palazzo Ducale preserves its original external appearance (see pp. 94–95). The only major change has been the insertion of the *finestrone* [large window] by the Masegne brothers in 1404. The spacing of the window openings suggests that this central axis was probably planned at the outset. Martindale has recently pointed out that the north-south axis which it created was already implicit in 1366 in the line of ducal portraits which started at that point. Francesco Sansovino mentions that the doge's throne stood in the center of the north side of the Sala, opposite the Masegne window,

surprising that rebuilding should take place when a wealthy doge was in office.

No view of Ziani's palace survives, but given the deliberate emulation of the *fora* of Constantinople in the whole scheme, it probably resembled the other Veneto-Byzantine buildings around the piazza, visible in the views of Gentile Bellini, Jacopo de' Barbari, and Bastiani. The palace was divided into three main parts around a central courtyard, beneath which was a huge cistern in which to store rainwater from the roofs. The ducal residence lay on the east side, adjoining the palatine chapel of S. Marco to the

though for more formal occasions the dais beneath Guariento's *Paradise* was surely preferred.

The name of the designer of the new wing is unknown. Filippo Calendario, the *proto* [protomagister, master builder, or master of works] executed for his part in the Falier conspiracy in 1355, has been claimed as the author, but no document names a specific *proto* until 1361 when Pietro Basegio's name appears in the documents. By this time Basegio himself had died, and his sons were acting on his behalf. No design role can be ascribed to either Calendario or Basegio with any certainty.

The elusive authorship of the Bacino frontage of the Palazzo Ducale should not blind us to the subtlety of the design and its rich semiotic content. In the first place, we must remember that the decision to rebuild the Bacino frontage was taken in 1340—the same year as that for the erection of the Public Granaries [*Granai Pubblici*] on the opposite flank of this remarkable frontage. Unlike most medieval cities, Venice could be entered at her heart, and the balancing role of the two massive Gothic structures of comparable bulk in this ceremonial backdrop must not be forgotten. The Granaries were demolished in the Napoleonic period, but their appearance is known from earlier views such as Jacopo de' Barbari's of 1500. The first major Venetian conquests on the mainland had been achieved in the previous year, with the acquisition of the territories of Treviso and Bassano in 1339. The Granaries were needed to store their yield of grain, in the interests of greater self-sufficiency. Both security and national pride led to their city-center location, and the massive brick warehouses with their rooftop crenellations and Gothic arches provided the basic elements of the theme that the Palazzo Ducale was to embellish with such virtuosity.

Following a few preliminary revisions, the final project for the new Palazzo Comunale seems to have been formulated by 1343, the year of the election of Doge Andrea Dandolo. This cultivated doge—friend of Petrarch and, according to Francesco Sansovino, the first Venetian nobleman to receive a doctorate—was an ambitious patron of the arts. He was responsible for two chapels in S. Marco, namely the Baptistery and the chapel of S. Isidoro, as well as the remodeling of the Pala d'Oro, thereby embracing the ducal chapel in a triangle of personal interventions. He also made zealous efforts to recover his family property at S. Luca. It is not inconceivable that he, like Sebastiano Ziani before him, took a personal interest in the reconstruction of the Palazzo Comunale.

Let us consider, first of all, the basic structural components of the new Bacino wing. The Veneto-Byzantine formula of two first-floor arches over

Archangel Michael, with sword drawn, carved in high relief on the corner of the Palazzo Ducale toward the Piazzetta.

every bay of the lower arcade was retained, though reinterpreted in the Gothic style, then prevalent across Europe. The doubling of the first-floor arches had a structural justification in the way that the weight was distributed. The vaults on the ground floor transmitted the load to the great columns, whereas the instability of the Venetian terrain did not permit an upper tier to be vaulted in stone. Here, instead, the beamed wooden ceiling spread the weight more evenly; this is reflected in the closer spacing of the columns. The section reveals, too, how the load was distributed more evenly across the site from front to back, using the walls of the rooms behind the porticoes to provide additional support.

We do not know how the great Sala del Maggior Consiglio, which occupies the full width of the upper half of the building along three-quarters of its length, was originally roofed. The great fire of 1577 completely destroyed its woodwork, and the present trussing system postdates this conflagration. The

ON THE FOLLOWING PAGES:
The Palazzo Ducale in all its splendor, seen from the Bacino di S. Marco.

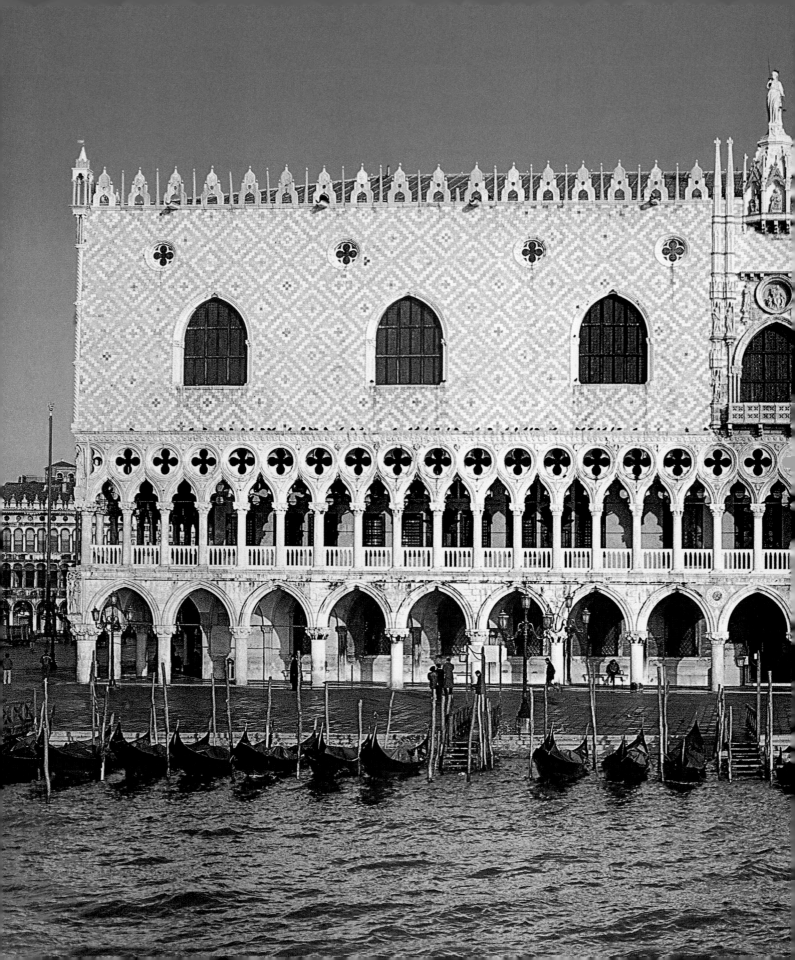

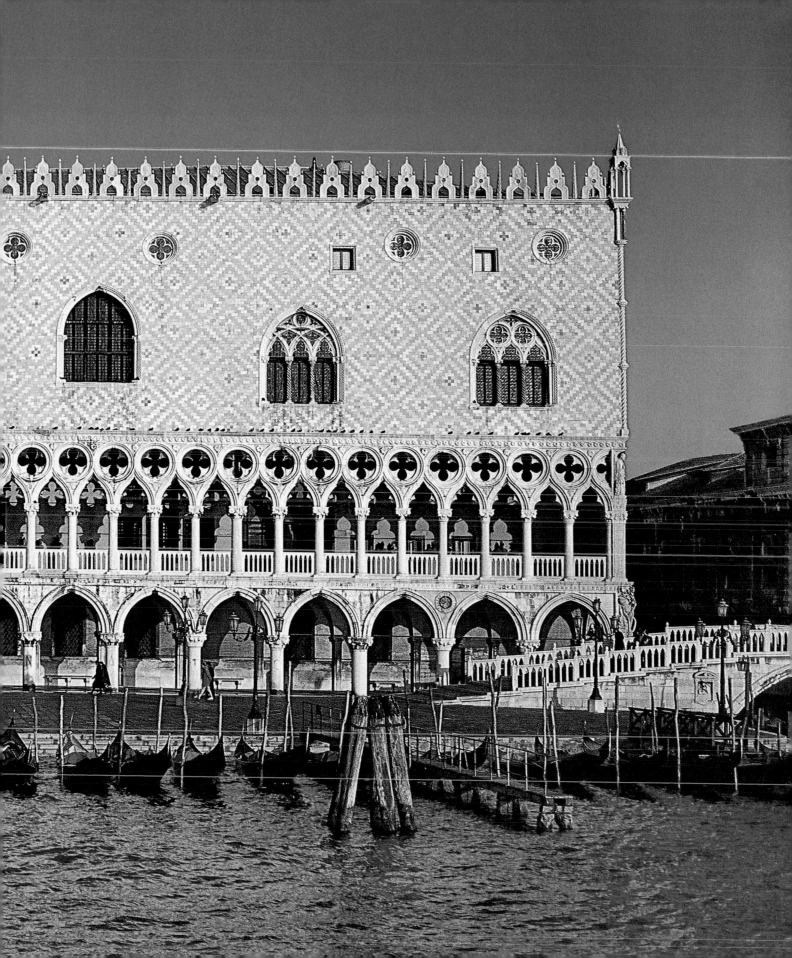

roofing of the Sala was the most brilliant structural achievement of the design, for no single beam could span its width. It has been suggested that the roof was originally vaulted with a wooden ceiling *a carena di nave* [ship's keel ceiling]. Considering the expertise in shipbuilding technology in the city, and given the existence of similar ceilings in local churches as well as in the Palazzo della Ragione in Padua, this is not inconceivable. Such a notion must, however, have been quickly abandoned because the remains of Guariento's *Paradise* of 1365–66 suggest a flat ceiling with corbelled margins, like that still visible in the former Sala del Capitolo of the Scuola della Carità, to be discussed later. Such a ceiling had to be suspended from a complex system of internal trussing and tie beams within the roof space, similar to the post-fire roof structure still visible today, in order to prevent outward thrust on the wall head. The existence of such a construction is confirmed by a restoration document of 1496, when the cornice was indeed found to be leaning outward in an alarming manner. Despite this, Ruskin notes that in the earthquake of 1511, which severely damaged the Campanile and caused statues to fall from S. Marco, only one stone lily fell from the Palazzo Ducale.

The layout of the building underwent some modifications during the genesis of the design between 1340 and 1343, but as executed, its carefully calculated proportions suggest that a complete model was carried through consistently. In its simplest terms the Bacino wing of the palace can be regarded as three cubes placed in a line, for its depth and height are virtually identical, and the length of 200 Venetian feet is the same dimension tripled. As Diruf observed, the height is divided into four tiers, with each arcade level occupying one of the lower quarters. As mentioned, the great Sala del Maggior Consiglio occupies the top half of the building's height, along three-quarters of its length, but its internal dimensions are reduced to approximately 2:1 by the wall thickness. Indeed, this may have been a deliberate adjustment to harmonize the proportions of this great ceremonial room, for Palladio criticized the excessive thickness of the upper walls when he reported on the structure after the 1577 fire. The entrance to the courtyard falls in the center of the seventeen-bay arcade, with the passage walls inside deviating slightly from the perpendicular in order to align the entrance with the side entrance to S. Marco at the far end of the courtyard.

Even the details of the facade arcades show careful attention to proportion. The height of the great columns on the ground floor, including the capitals, is exactly half the height of this storey up to its cornice. The upper columns are the same height, this

time excluding their capitals, and again this is half the height of the storey. The three "knots" on the rope moldings, which outline the angles of the upper half, appear to mark out the equivalent four subdivisions on the upper storey, though the actual distances are not accurately measured out to allow for perspective distortion. Early views of Venice such as those of Reuwich and Barbari show the Palazzo Ducale as much higher in proportion to its width than in reality. This may be either an attempt to enhance its importance or due to the effect of height gained by viewing the massive building at close range from the Riva in front.

The Palazzo Ducale as a Symbol of the Identity of the Nobility

Compared with other communal palaces of its time elsewhere in Europe, such as the Palazzo della Signoria in Florence, the Palazzo Ducale has a distinct identity of its own. The structure is open and unfortified, with its courtyard open to the public for everyday activities such as card-playing or water-drawing. Such openness asserted the confidence of the ruling oligarchy in its right to govern wisely and unchallenged; and so it remained for exactly seven centuries, from the time of the Serrata until the fall of the Republic.

To convey the image of wise government, the Republic turned to the biblical precedent of Solomon, whose palace lay alongside his temple, exactly as the Palazzo Ducale flanked S. Marco. Like the Palazzo Ducale, Solomon's seat, as described in the first book of Kings, chapter 7, consisted of three parts linked by arcades: the Hall of the Forest of Lebanon, the Hall of Judgment, and Solomon's own residence (like that of the doge, "in a court, set back from the colonnade"). All these buildings were made of heavy blocks of stone, with dressed stone above, arranged in three tiers. Like the Bacino wing of the Palazzo Ducale, the House of the Forest of Lebanon was about 3:1 in its length:height ratio, with a wooden roof over three rows of window frames. Its dimensions in plan were 2:1 ("a hundred cubits long, fifty broad"), like the proportions of the Sala del Maggior Consiglio.

The decision to build an extension based on the same design along the Piazzetta frontage to accommodate the Palace of Justice was taken in 1422: "With regard to our Palace of Justice, it should be erected in a decorous and convenient form, corresponding to the highly revered stage of our new Palace." Thus the Palazzo Ducale completed its Solomonic imagery with its own Hall of Judgment, which according to the biblical text was similar in design to the rest of the palace. The sculptural group

Palazzo Ducale. View of the ground-level portico overlooking the Bacino, seen from the Ponte della Paglia. On the left, the relief depicting the *Drunkenness of Noah* by Filippo Calendario.

of the *Judgment of Solomon* on the corner facing S. Marco confirmed the connection. The link was reinforced by the presence of the two colossal columns in the Piazzetta, which served as a reminder of the two huge bronze pillars erected for Solomon by Hiram of Tyre.

Since the time of the Crusades, the Dome of the Rock in Jerusalem had been believed to be the Temple of Solomon—erroneously, of course, since it is in reality an early Islamic monument completed in 692. The Al Aqsa mosque, which stood alongside it in the same precinct, was similarly believed to be the Palace of Solomon. The Palazzo Ducale does not closely resemble the Al Aqsa mosque itself, but it does have a recognizable affinity with images of this building in early maps and views, especially that in Marin Sanudo the Elder's *Liber secretorum fidelium crucis* [Book of the mysteries of the faithful to the cross] of about 1320. This version shares the rooftop cresting, tiny corner pinnacles and small windows above larger ground-floor arches. At a time when visual images were transported verbally, or perhaps through small, informal sketches, the distillation of this Jerusalem monument, so rich in significance, seems to have provided the basic elements of the Palazzo Ducale design.

As if to underline the biblical allusion, the elevation is rich in Middle Eastern motifs. As Ruskin remarked, "The Ducal Palace of Venice contains the three elements in exactly equal proportions: the Roman, Lombard, and Arab. It is the central building of the world." One of the most obviously Islamic motifs is the rooftop cresting, a variation on types found on North African Mamluk mosques, as well as in the much older Syrian desert palaces of the Umayyad caliphs, both of which could have been seen by Venetian merchants in the course of their trading activities. Either source could have seemed

OPPOSITE:
Archangel Gabriel, on the northwest corner
of the Palazzo Ducale.

apt, the one the ancient palace of a powerful ruler in the Holy Land, the other having Alexandrian connotations that were appropriate to S. Marco. The lozenge pattern in the tilework decorating the uppermost walls of the Bacino facade is a Seljuk motif, originally, in Iran and eastern Turkey, carried out in brickwork, but later, by the mid-fourteenth century, commonly executed in colored tiles. The double ogee arch, which appears in Venice for the first time in this building, seems to have an Islamic origin: it may be seen, for example, in ceramic models of *mihrab* niches. Such objects, being portable, were one of the most efficient ways to transport Islamic architectural motifs at a time when masons and builders traveled little.

Certainly the diaphanous, shimmering, two-dimensional character of the Bacino facade of the Palazzo Ducale gives an impression of exotic Orientalism that must have been intentional. In this context we must also remember that the Venetian nobility, whose identity was enshrined in the Palazzo Ducale, was neither a feudal aristocracy nor a gild-based burgher class, but rather an elite of mercantile entrepreneurs whose commercial horizons extended far into the Islamic world. Venetian fourteenth-century trade routes to the East were now officially sanctioned by the escorting convoys of State galleys; and the Republic had *fondachi*, or trading posts, in the main ports of the Levant from Constantinople to Alexandria. By 1324 there was even a Venetian consul in Tabriz. Throughout the Middle Ages the Republic aroused papal wrath for trading with "the Infidel"—significantly, such disputes reached their bitterest point in the mid-fourteenth century. Travelers returning from the Orient to Venice would have seen in the Palazzo Ducale not only vague reminiscences of exotic light and color and delicate traceried ornament, but also specific allusions to the cultures with which the Republic had strongest trading links: Mamluk Egypt, Syria, and Persia. The penultimate capital on the Piazzetta side of this phase of the building (beneath the tondo relief of *Justice)* is decorated with portraits of all the eastern nationalities with which the Republic traded.

Debra Pincus has recently identified in the patronage of Doge Andrea Dandolo (1343–54) a balance between the Aristotelian humanism of his Paduan education and the poetry and eloquence of Petrarch's circle, "intrigued by large and compelling visions of history." Considering that his dogate was punctuated not only by the loss of half the population of the city in the Black Death, but also by war and famine, it is thus all the more remarkable that these years also saw the transformation of the imagery of the city center. Dandolo ruled through the

vital early stages of the construction of the new wing of the Palazzo Ducale which reveals those very qualities of order and poetry in delicate equilibrium.

The Palazzo Ducale under Doge Foscari

The decision to extend the Bacino elevation along the Piazzetta frontage to house the Palace of Justice in 1422 has already been mentioned. It was in the following year that Doge Francesco Foscari was elected, and the erection of the Palace of Justice took place during his dogate. Foscari's reign, which lasted until his disgrace and death in 1457, was to be an epic period in the history of the Republic (see p. 102). This was a time of increasing wealth, power, and confidence, the Republic's huge territorial acquisitions on the *terraferma* being finally ratified by the Peace of Lodi in 1454.

The Palace of Justice extends from the medallion of *Justice* on the Piazzetta facade as far as the corner beside S. Marco. Its most dramatic characteristic is its spacious open loggias which occupy the whole of the first-floor level, with quadrupled columns bearing opulent leafy capitals on the *cortile* side. These loggias may have served a judicial function, for in 1494 Canon Pietro Casola reported court hearings being held semipublicly in the arcades of the palace.

It was under Doge Foscari that the Palazzo Ducale acquired its flamboyant ceremonial entrance known as the Porta della Carta, which was begun by the Venetian stonemasons Giovanni and Bartolomeo Bon in 1438 (see p. 100). By this time Giovanni was probably nearly seventy years old, and the fact that his son Bartolomeo signed the portal "OPS BARTO-LOMEI" [the work of Bartolomeo] implies that the younger man was not only the chief mason but also the designer. The Porta della Carta has a simple and effective iconographic program, with the statue of *Justice* at the apex acting as the culmination of the Solomonic imagery. Four other virtues—*Fortitude, Temperance, Charity,* and *Prudence*—occupy the niches on either side (see p. 101), a bust of *St. Mark* occupies the roundel in the tympanum, and a portrait of Doge Foscari, removed in the Napoleonic period and now replaced by a replica, kneels before the lion of St. Mark over the door. Around the portal, little lion's heads alternate with inlaid panels of colored marble. The window traceries are as ornate as any to be seen in Venice, embroidering the theme of the nearby loggia by dividing and subdividing every element. The shape of the crowning gable is to be found on portals from Naples to Ragusa (now Dubrovnik) in this period, reminding us of the movement of masons around Italy and across the Adriatic. The mischievous *putti* playing among the crockets which sprout from the gable add a further degree of

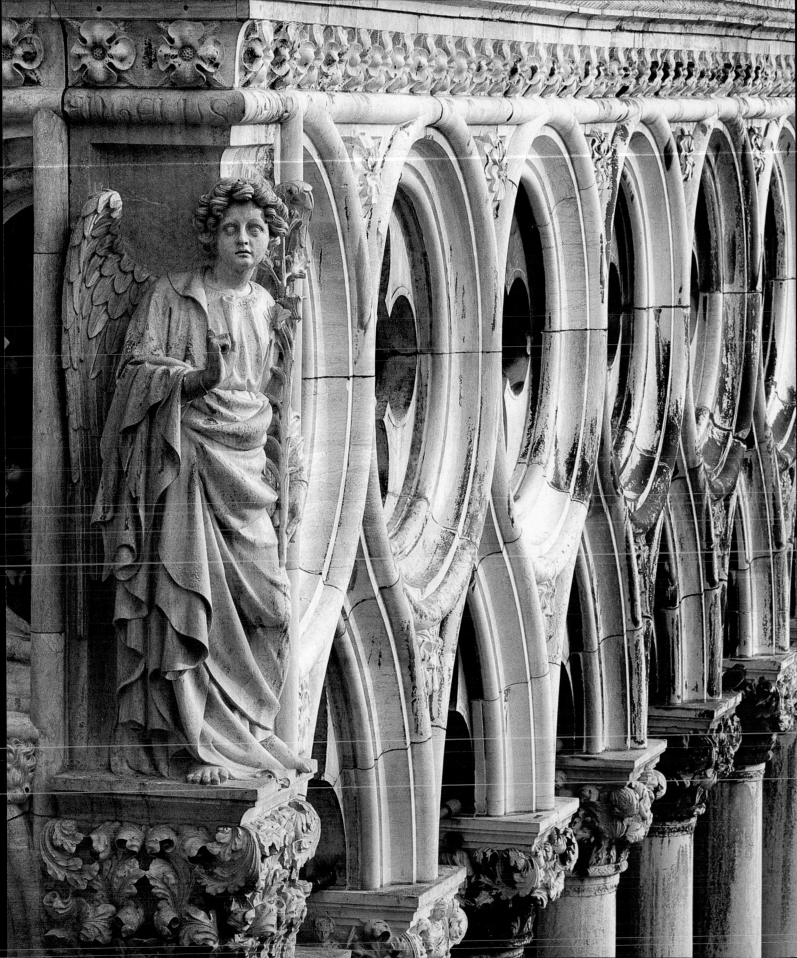

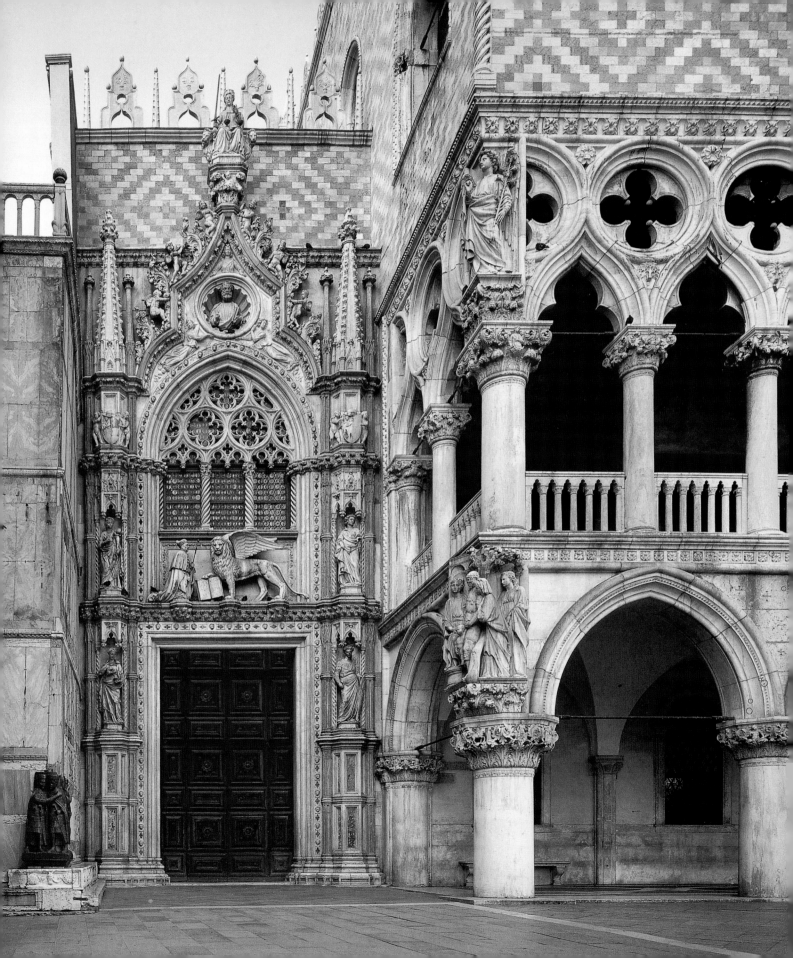

OPPOSITE:
Porta della Carta, the grand entrance to the
Palazzo Ducale designed after 1438 by
Bartolomeo Bon.

Two of the four Virtues (*Fortitude*,
Temperance, *Prudence*, and *Charity*) flanking
the Porta della Carta.

The origins of the family of Francesco Foscari,
doge from 15 April 1423 to 23 October 1457,
from a 15th-century manuscript in the
Biblioteca Marciana, and the doge's coat of
arms.

sculptural virtuosity. To judge by Gentile Bellini's painting of the *Procession in Piazza San Marco* of 1496, the marble polychromy of the whole portal was once richly painted and gilded (confirming Casola's comment on the "great display of gold" in 1494).

The Arco Foscari on the inner face of the portal, begun in 1440–45, creates a deep tunnel-like entrance which does not seem to have been originally intended when the Porta della Carta was first commissioned in 1438 (see p. 103). It seems that the excuse for building this inner structure was to conceal and reinforce the huge buttresses that were required to support the walls of S. Marco. Nevertheless, though produced by the same workshop, the project for the Arco Foscari turned into a display of a very different kind. With its architectonic weight and rounded arches, the inner arch departs radically from the insubstantial two-dimensional decorative and chromatic richness of the outer portal. The fact that open-air ducal ceremonial in the Piazza was known as *andar in trionfo* [to go in triumph] accounts for its overtly triumphal imagery, as if to remind the doge and his entourage of the meaning of their processions as they filed out of the palace. The classical precedent of the triumphal arch was the obvious point of reference. The Porta della Carta, on the other hand, acted like a rich Gothic picture frame to surround the figure of the doge as he made his exit through the doorway.

Patrician Palaces: Form and Function

With the construction of the Palazzo Ducale, the Venetian nobility—its membership newly defined by the Serrata of 1297—acquired a potent image of class identity. By the late fourteenth century, in examples such as the Palazzo Priuli at S. Severo, private families began to appropriate motifs from the Palazzo Ducale in their own homes. Rope moldings, ogee arches with quatrefoils clasped in their uppermost curves, even Moorish-style crenellations began to appear in Venetian merchant's palaces. The most conspicuous examples were also the most ambitious—the lavishly decorated Ca' d'Oro, begun in 1424, and the huge Ca' Foscari, begun in 1452 for Doge Francesco Foscari.

The double ogee arch, in particular, became a distinctive mark of nobility. Facade windows were framed by rectangular panels, with delicately serrated edges like postage stamps, inlaid with marble paterae and reliefs, so that they seemed like huge badges of rank attached to the facade and pierced to allow a view into the privileged life within. The enclosing of an arch within a rectangle in itself recalled a familiar Islamic theme, seen for instance on the ceramic *mihrab*-niche panels already mentioned.

The Palazzo Soranzo at S. Polo, for example, shows how not only individual windows, but also groups of windows on the principal living storeys were framed in rectangles to dignify these levels. The windows of ground-floor rooms used for storage, mezzanine levels for office space, and attic rooms for servants and lesser family members were of simpler design and usually rectangular.

Francesco Sansovino remarked on the legibility of Venetian facades: any viewer familiar with the Venetian lifestyle knew at once where the internal *salone* lay, even in the daytime when it was not illuminated, because of the denser fenestration at that point. Similarly, the facade explained which was the principal *piano nobile*—for instance, that of Ca' Foscari is lofted up to the second floor, where it is indicated on the facade by a relief of playful *putti* bearing coats of arms (see p. 106).

By the Quattrocento the basic design formula of the Venetian nobleman's palace had been established, but it was nevertheless a formula that offered enormous flexibility. In the Veneto-Byzantine period some larger palaces such as that of the Pesaro family, later the Fondaco dei Turchi, had been arranged around a central courtyard like a true *fondaco* (the type of residential trading post prevalent across the Mediterranean world). Others were L-shaped, with a tripartite facade, the central part of which stretched back to become an open *portego* between the longer side wing and the rear *cortile*. In either case the facade was normally arcaded across both the main living storeys.

As already observed, the arrival of the Gothic style in the Duecento and Trecento saw a tendency to abandon waterfront arcades in favor of a more continuous two-dimensional facade wall. The waterfront entrance became a large portal leading directly into the long *androne* [passageway], stretching from front to back of the building, giving access to storerooms for merchandise and family supplies on either side. Diruf's recent claim that by the fifteenth century merchandise was no longer stored in family palaces is not substantiated by the documentary evidence. As late as the Cinquecento, active merchant families such as the Corner and the Dolfin still stored goods in their own homes; and indeed, it is the dual use of the Venetian *casa fondaco* [residence/warehouse], for both business and domestic purposes, that makes its typology distinctive and its representational language so eloquent. The use of orientalizing ogee-arched traceries was not a vague memory of a former trading use, but rather the identity of a class of *active* merchants who spent their formative years aboard ship or in eastern Mediterranean ports, and whose tastes were formed in the exotic world of the Levant.

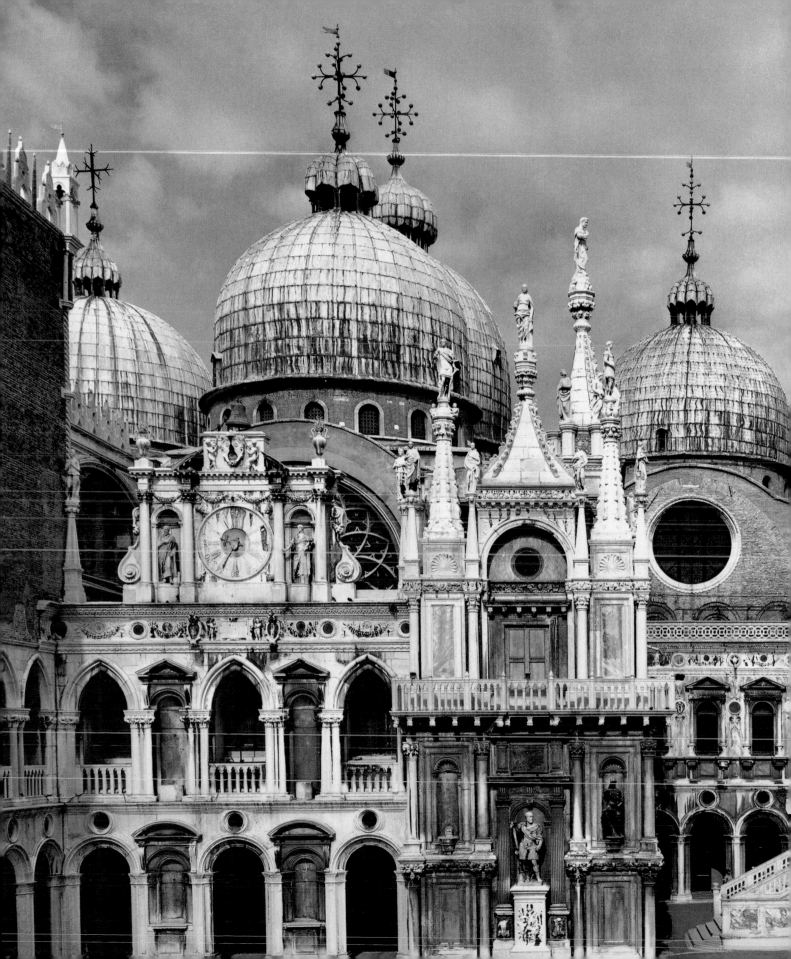

Palazzo Soranzo on Campo S. Polo, detail of windows, 15th century.

By the Gothic period, the more compact nature of the urban fabric meant that as much of the site as possible had to be made habitable. Palaces tended to have long narrow plots, especially on costly high-prestige sites on the Grand Canal. The earlier L-shaped layout therefore became transformed into a deep tripartite plan, with its four structural spine walls penetrating the whole building from front to back. The main *salone* on each main living storey, lit by multilight windows at either end, lay above the central *androne*. The *salone* was now itself often called the *portego*—either as a reminiscence of the formerly half-open character of the ground-floor central axis, or because of the multilight windows. Several types of Gothic plan have been identified, according to the form of the *salone,* which might be transformed into a C- or L-shape to allow design variations in the interior without compromising the regular tripartite arrangement of the facade. Thus, for instance, in the plans of Ca' Foscari and the two adjoining palaces of the Giustinian family, we see the L-shaped *salone* widening out at the front of the building. The Ca' d'Oro, too, had an L-shaped *salone,* for the *piano nobile* loggia was originally glazed (as one can see in Ruskin's evocative water-color). The bipartite character of the facade effectively disguises the more conventional layout of the interior.

We know little about the authorship of Venice's Gothic palaces, but the surviving ledgers of the Ca' d'Oro offer a wealth of documentation about this one particular palace, however atypical it may be (see p. 107). Richard Goy's recent scrutiny of the records has clarified the building history, which began in 1421. He has shown that the facade was built after the rest of the palace, a procedure made possible by the nonstructural role of the Venetian palace facade. Its construction, not begun until 1429, had to await the driving of new pile foundations, a fact which suggests a realignment of the frontage. The stone-work was carved in different workshops: the ornate traceries, elaborating the theme of the Palazzo Ducale, were carved by the Milanese mason Matteo Raverti, whose youthful training in the workyard of Milan cathedral must have equipped him well for such intricacy; meanwhile the workshop of Giovanni and Bartolomeo Bon carved most of the architectural ornament. The design procedure was eclectic, drawing freely on both secular and religious prototypes. The patron, Marin Contarini, would instruct his craftsmen to copy elements from other familiar buildings, a method also revealed in Goy's analysis of the building accounts of the church of the Carità. Contarini's passionate involvement in every detail of the compilation of this remarkable visual "anthology"

is evident, while his meticulous records also reveal his paternalistic concern for the welfare of his crafts-men. The Ca' d'Oro was famous not only for the opulence and delicacy of the stonecarving, but also for the fact that it was originally richly painted, not only with marbling but also with copious amounts of ultramarine and gold, the palette later used in the decoration of the Porta della Carta and, at the end of the century, the Torre dell'Orologio. Blue and gold were the colors of desert mosques and Gothic polyp-tychs alike—not only were they the most expensive pigments, but also the colors of the heavens. How better to display Contarini's place in the *Libro d'oro* of the Venetian nobility?

The function of the *salone,* or *portego,* was in part practical and in part ceremonial. This room was unheated, and in winter it would have served as a sheltered place to take exercise—especially for women whose world outside the home was largely confined by the boundaries of the parish, to judge by the bene-ficiaries mentioned in their wills. The formal recep-tion of less familiar visitors and business callers took place in the *portego,* and only intimate guests were received into the *camere.* The *portego,* though sparsely furnished, was the place for the display of arms and trophies, as well as family portraits. This was the room that provided the setting for ceremonial occa-sions such as wedding feasts and parties. The visual qualities of such a room depended not only on the huge expanse of window at either end (made possible at an early date by the cheapness of the local glass), but also on the delicacy of the traceries which filtered the occupants' view of their city. The highly polished *terrazzo* floors reflected light from these huge windows up to the ceilings, themselves often richly decorated. As Ruskin observed, the sunlight projected the ornate patterns of the window traceries onto the shiny floor, where the polished marble fragments of the *terrazzo* surface glistened like the glass mosaics of S. Marco. Taking the air on the projecting balconies or leaning over the balustrades between the windows, the nobleman or woman could watch waterborne processions and regattas, at the same time becoming part of the spectacle, observed and admired by those in the boats below or in the palaces opposite.

Toward the end of the Gothic period, modifica-tions to the traditional ogee-arched fenestration were introduced to give the family a more memorable identity, both inside and outside. Such embellish-ments can be seen in palaces such as the Palazzo Pisani-Moretta on the Grand Canal, with its quatre-foil windows rolling along the rippling crests of the overlapping arches, instead of nestling securely between them. Pendant traceries inserted into windows of Ruskin's sixth "order," like those on the

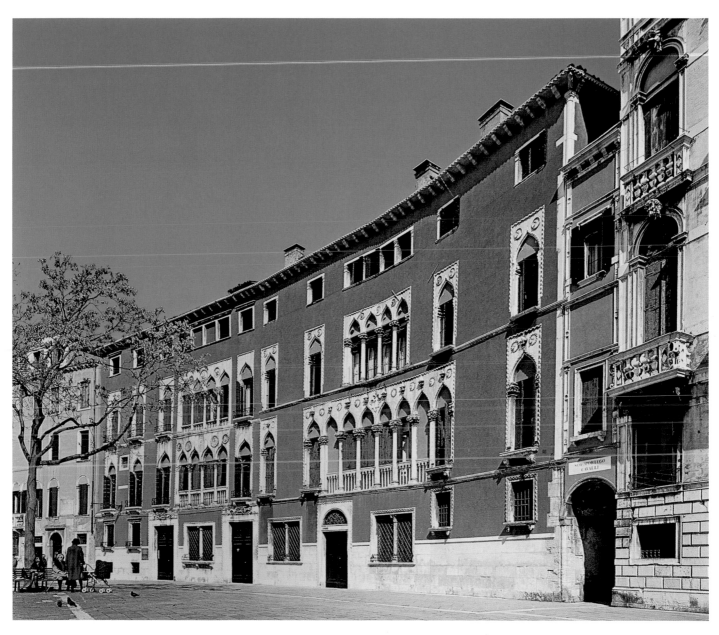

side windows of the Ca' d'Oro, gave added virtuosity. Traceries might even be transferred from the windows to the balconies, as seen in the delightful little Ca' Contarini-Fasan, traditionally known as the "House of Desdemona," dating from about 1475 (see p. 109). Since Giambattista Cinthio, author of the original version of the Othello story was not born until 1504, the Desdemona connection seems improbable, but the fact that the palace held such romantic associations in the Venetian mind is in itself indicative of the theatrical role of balconies to frame the semipublic appearances of noble ladies at their windows.

Suites of living rooms on either side of the *portego* were not only themselves interconnected, but were also each linked to the main *salone*. Maximum flexibility of use could thus be achieved by closing or opening doors to create separate private apartments, with subtle gradations of privacy from one room to the next. Inventories give some clues as to the use of individual rooms and confirm that our present-day distinction between living and sleeping was absent.

Palazzo Soranzo complex in Campo S. Polo. An important example of Venetian Gothic architecture

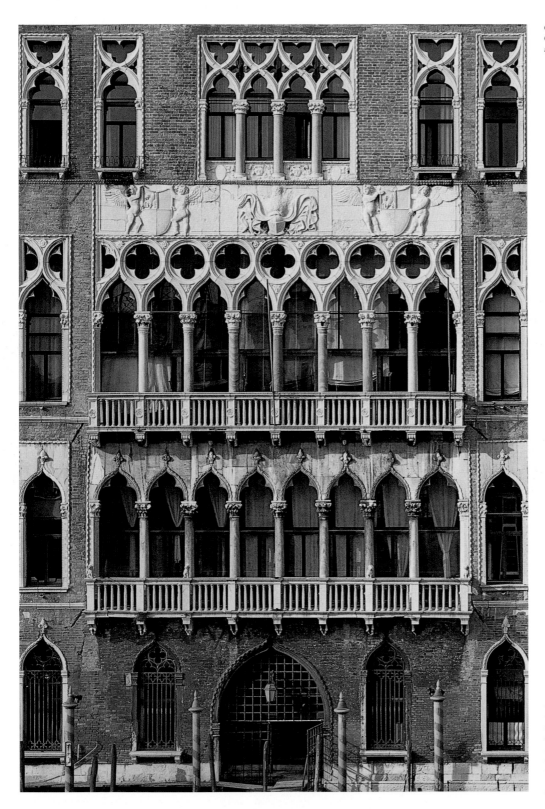

Ca' Foscari, detail of the facade on the Grand Canal, with Gothic windows and the Foscari arms suported by shield-bearing angels.

OPPOSITE:
Ca' d'Oro, facade on the Grand Canal. The most elegant Venetian edifice of the Gothic era, it was built between 1422 and 1440 by Matteo Raverti and Bartolomeo Bon. It was acquired at the end of the 19th century by Giorgio Franchetti who, after having restored it, donated it to the State, along with his superb art collection.

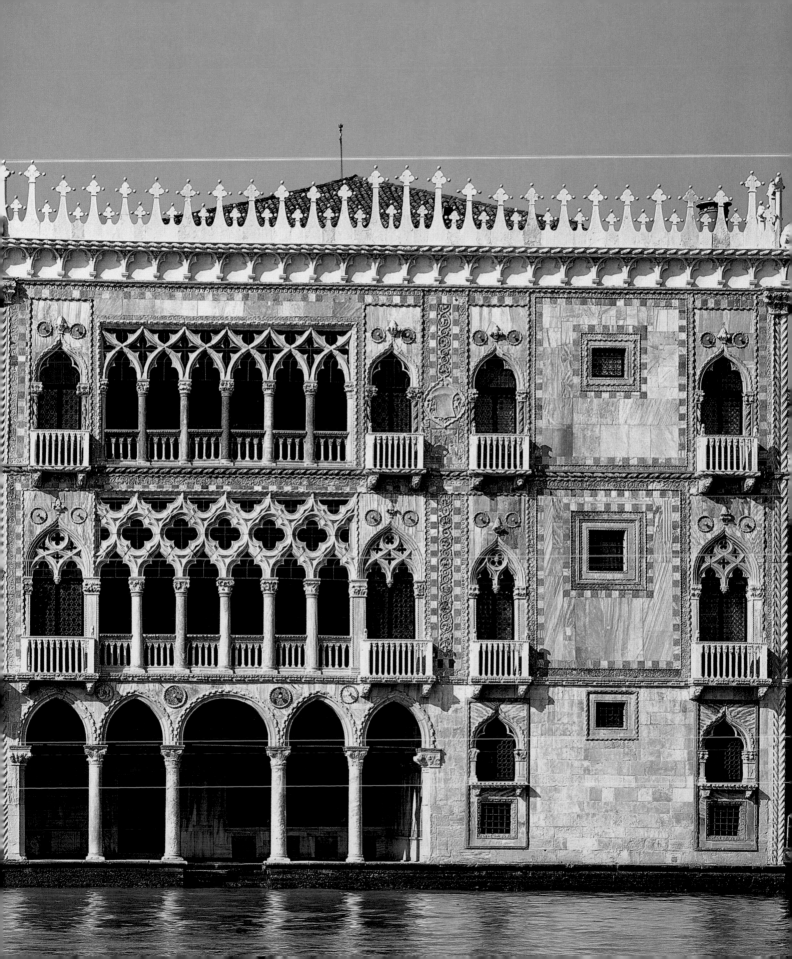

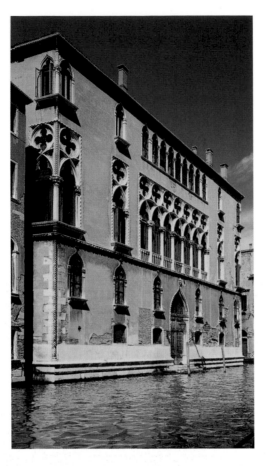

OPPOSITE:
Ca' Contarini-Fasan, facade on the Grand
Canal. Built around 1475 and known also as
the "House of Desdemona," it is decorated
with graceful traceried balconies.

Palazzo Giovannelli at S. Fosca. The facade as
it is today and as it was, in a 19th-century
print.

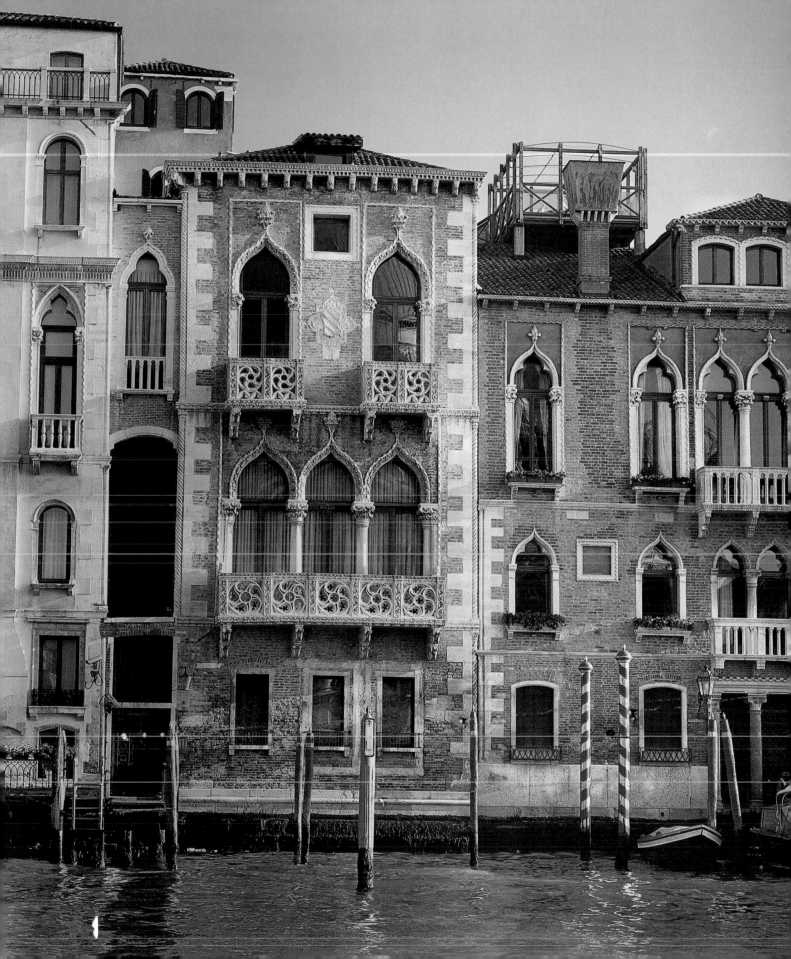

OPPOSITE:
Entrance to the Calle del Paradiso. Of
particular interest is the detail of the Gothic
arch surmounted by a pinnacle within which is
a quatrefoil opening, above the Ponte del
Paradiso; within the arch itself is a
representation of the Virgin with two donors
at her feet, flanked by the coats of arms of the
Foscari and Mocenigo families.

Individual rooms were distinguished by vague terms such as *camerin*, *camera*, and *cameron*. Kitchens could be on the *piano nobile* or in the courtyard, but their position seems to have been flexible and somewhat ad hoc. The medieval Palazzo Tiepolo at the Misericordia, for example, still lacked a decent kitchen in the eighteenth century. Inventories are silent about bathrooms and latrines, which did not form part of the design of a palace, the inhabitants presumably relying on commodes and portable bathtubs.

The Venetian *portego* was not the only area of the

palaces had more than one courtyard, some very small, others of huge size. Large courtyards were usually to be found toward the rear of the site, while smaller light-wells could be situated in any part of the plan. Where there was no *rio* or *calle* alongside the palace to admit light, it was unavoidable that the suite of rooms on that side would be interrupted, since every room had to have fresh air and illumination.

As well as admitting light, the courtyard was also the site of the cistern, in which water from the rooftops was collected, filtered through sand, and stored to provide a supply of fresh water. The larger the

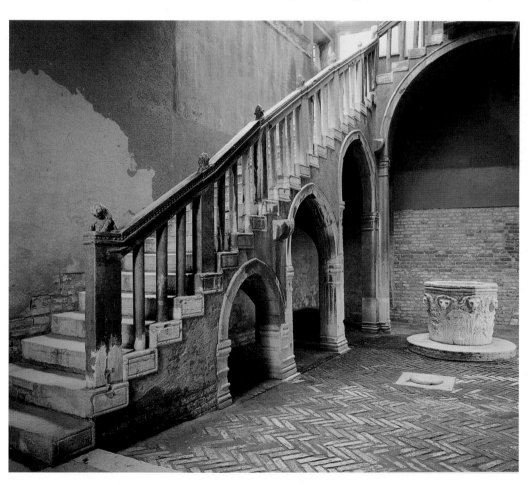

Ca' Goldoni-Centani. Courtyard with external staircase and wellhead.

Gothic palace endowed with distinctive qualities of space and luminosity. The same characteristics can be observed in the courtyards, which acquired a theatricality echoed in the Quattrocento in the elaborate architectural compositions found in Jacopo Bellini's sketchbooks. In a Gothic palace the courtyard was the lung of the house, allowing light and air to penetrate into the dense mass of building. Larger

cistern, the better the water supply, although the catchment area of the rooftops was also crucial. Cisterns had to be sealed effectively to prevent penetration of brackish, polluted water from the canals. As in the case of pile foundations, the cost and labor of moving a cistern was so prohibitive that its position could exert strong constraints on the remodeling of a palace. The position of the cistern meant that no

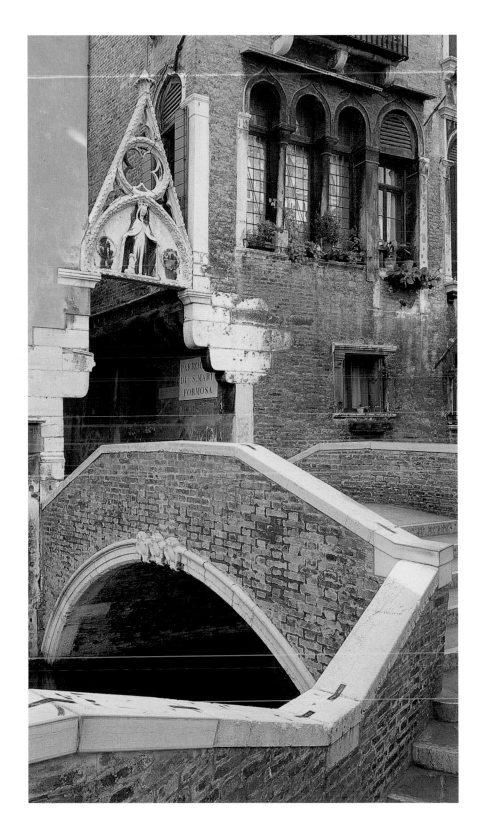

heavy structures, or even garden flowerbeds or tubs, could be placed there. Instead the *cortile* was embellished by the *vera da pozzo*, an ornately carved block of Istrian stone or marble, surmounted by an iron superstructure from which to suspend a pail. The typical Gothic *vera da pozzo* took the form of a huge Corinthianesque capital, emulating the colossal scale of antique fragments. The presence of naturalistic plant forms on the wellhead compensated for the lack of real planting. The *pozzo* also served as a mark of family identity through the carving of heraldic panels on its sides.

In addition, the courtyard was the place for the principal staircase, which until the mid-sixteenth century was normally placed outside the house to save internal space. It would, however, be insensitive to claim a purely utilitarian role for the staircase, which also served to dignify the act of entry into the palace. Indeed, in the case of a palace such as Ca' Foscari, where the *piano nobile* lay on the second floor, the external staircase rose through a full two storeys, by ascending two sides of the great courtyard at the rear. The staircase had to be accessible from both land and water entrances, and preferably visible from both these points of arrival too, to enhance the ceremonial possibilities of the ascent. This can be clearly seen at Ca' Goldoni-Centani, where each of the two ramps of the staircase faces a point of entry, exposing to both doorways its graceful balustrade and Gothic arches. The flood of light into the courtyard from above makes the staircase appear like stage scenery, whether framed by the portal from the narrow *calle* or seen through the tunnel-like darkness of the *androne*.

Although the Grand Canal became the most prominent location for grand patrician palaces, it is noteworthy that in Venice the residences of the nobility were scattered all over the city. A particular branch of a noble family became known by the name of the parish where that family's palace was situated. Some parishes, such as those around the Arsenal, had a greater concentration of popular housing, but there was no exclusive, fashionable quarter, and the stability of the nobility depended to some extent on its physical penetration of the whole city. Because of the system of inheritance, whereby all the sons shared the estate in equal parts, palace design needed great flexibility to allow for subdivision or expansion. Palaces might have self-contained apartments for two brothers, one on each *piano nobile,* or one on either side of the central *portego*. A palace such as the Palazzo van Axel was arranged for dual-family use, with separate entrances and courtyards. Portions of a house—apartments, rooms, or storerooms— could be let out to tenants, and some palaces on

public streets or *campi* even had shops beneath. Additional levels could be added to the top of a palace to create more space, and it is not uncommon to see progressively later styles as one moves upward through the storeys.

Vernacular Architecture

We have seen that the Gothic forms of the Palazzo Ducale provided the basic elements of the Venetian patriciate's architectural identity, and that a standardized palace typology evolved in parallel to the language in which it was articulated. Noble residences were not called palaces, however; they were merely *case*, abbreviated to *Ca'*. In inventories and property transactions a palace was known simply as a *casa da stazio*. The only true palazzo was the Palazzo Ducale, just as the only piazza was the one at S. Marco—the others were merely *campi*. Any resident with adequate wealth, whether a noble or a citizen, could own or occupy a *casa da stazio* and it is not clear that the ranks of these two separate classes were distinguished by their homes, as they were by their dress. Tintoretto's house, for example, has the decorative features of a Gothic *casa da stazio*, though it is a small, bipartite version of the standard tripartite plan. It could be argued that this contraction of the *casa-fondaco* type was more readily associated with *cittadini* (citizens) than with patricians. The early Renaissance Ca' Dario, for example, built by Giovanni Dario, a distinguished citizen-diplomat, has a bipartite plan, though its materials are as lavish as those of any nobleman's house. Dario felt sufficiently embarrassed by the extravagance of his marble-encrusted house to inscribe the facade with a pious dedication to the beauty of the city. It is as if the pretensions of the *cittadini* were circumscribed by tradition, if not by law.

In his detailed study of vernacular architecture in Venice, Richard Goy attempted to show that smaller residences derived their forms and plan from the patrician *casa fondaco*. The relationship between citizen and noble architecture is not a simple one: after all, the Ca' d'Oro, emphatically *signorile* in expression, nevertheless displays a feigned bipartite elevation. Interestingly, Goy's study of the lagoon villages reveals a distinct middle-class identity emerging in the smaller town houses, with their solid, two-storey elevations and rooftop gabled dormer in the center of the roofline.

Artisan's houses were even simpler, with a ground-floor workshop surmounted by a small living apartment. These were often built by a wealthy landowner as a unified property development, with the entrance

into the street or court marked by an arch or portal identifying the owner. A picturesque example is the Calle del Paradiso, the entrance to which bears a relief of the Virgin with the arms of the Mocenigo and Foscari families (see p. 111).

Urban Form

By the end of the Quattrocento, the seventy parishes of Venice, once an archipelago with *velme* [marshy islands], *piscine* [pools of water], and swamps, had become a compact landmass, fishlike in shape (though not in reality as dolphinlike as Jacopo de' Barbari's view suggested), divided by the sinuous curve of the Grand Canal and penetrated by two independent transport networks: waterways and streets. It was only when continuous stretches of *salizzade* [paved streets] first made land transport effective in the thirteenth century that a streetscape evolved. The first examples of urban houses designed to be approached by land are the houses of the Duecento which still survive on the Salizzada S. Lio. These have biforate windows overlooking the street, shops beneath, and huge arches spanning the passageway into the rear of the site.

It was during this period that the banks of the Grand Canal were straightened and reinforced. We have seen that the frontage of the Ca' d'Oro was probably extended forward. Barbari's map shows clearly that many of the Veneto-Byzantine houses which still survived at that time were set back from the present position of the canal frontage. State controls regulating the encroachment of private property onto public streets and waterways had been implemented consistently since the Duecento. If, however, a proposal for reclamation led to an improvement in the alignment or flow of a waterway, this was encouraged. Some parts of the city, such as the northern margins of Cannaregio, were systematically and artificially reclaimed in regulated lots to form long parallel canals which contrasted markedly with the "organic" cellular texture of most of the city.

The labyrinthine character of Venice was not seriously modified as the city grew and coalesced, partly because of the lack of horse-drawn overland transport and partly because the dense matrix offered analogies with the great ports of the East that enhanced the city's imagery as a fabulous emporium. Here one could find gardens hidden behind walls topped by Moorish cresting, market stalls laden with oriental textiles and exotic-smelling spices, long ground-floor halls flanked by benches like a Fatimid palace, and surfaces embellished with reliefs or pierced by delicate traceries. The experience of visiting Venice at the end of the Gothic period must have evoked the *Arabian Nights* or the *Travels of Marco Polo*. As the Milanese visitor Canon Pietro Casola remarked in 1494, "I declare that it is impossible to tell or write fully of the beauty, the magnificence or the wealth of the city of Venice . . . it will be incredible to anyone who has not seen the city."

The Scuole

The *scuole* [confraternities] of Venice constitute one of the most distinctive of the city's building types. It was during the Gothic period that the typology evolved—and, as in the case of palace-building, the basic formula survived the stylistic transformations of succeeding centuries. There were two principal kinds of *scuola* in medieval Venice: the *scuola grande*, or great citizens' confraternity, and the simpler version known as the *scuola piccola*. *Scuole piccole* were of three principal varieties: the artisans' guild (the headquarters of a particular trade or craft), the guild for foreign residents (such as Greeks, Albanians, or Dalmatians), and the devotional confraternity (whose members were dedicated to the veneration of a particular saint or cult). The buildings of the *scuole piccole* were smaller, simpler versions of the *scuole grandi*, some even having no premises other than an altar in a church. All the *scuole grandi* and most of the *scuole piccole* were situated near, or attached to, a church or monastery, alluding to their transitional status between religious and secular culture.

Few *scuola* buildings survive from the medieval period. The best-preserved Gothic *scuola piccola* is the Scuola dei Calegheri, facing the parish church in the Campo di S. Tomà (see p. 114). Although the upper windows have been modified and later shops have been inserted into the facade, the structure still reveals the standard design formula: a large meeting room at first-floor level, raised above a ground-floor hall to enhance its dignity. The roof pitch normally runs from front to back with gabled ends, giving a semi-ecclesiastical air, though some *scuole piccole* have hipped roofs. The most notable feature of the Scuola dei Calegheri is its fine Gothic portal dated 1478, with a relief depicting *St. Mark Healing the Cobbler Anianus*.

The *scuole grandi* of Venice were among her most enduring and powerful institutions. They had been founded with an ostensibly devotional purpose, as flagellant confraternities, in the wake of the ascetic flagellant movement founded by a Perugian hermit in about 1260. Three of the *scuole grandi*, S. Giovanni Evangelista, S. Marco, and the Carità, are known to have been founded at this time, and recent research suggests that the Scuola della Misericordia too may date back to the same years. The *scuole grandi* soon acquired an important semipolitical role as the

St. Mark Healing the Cobbler Anianus, detail of a panel from the Arte dei Calegheri [shoemakers' gild], 1478. Venice, Museo Correr.

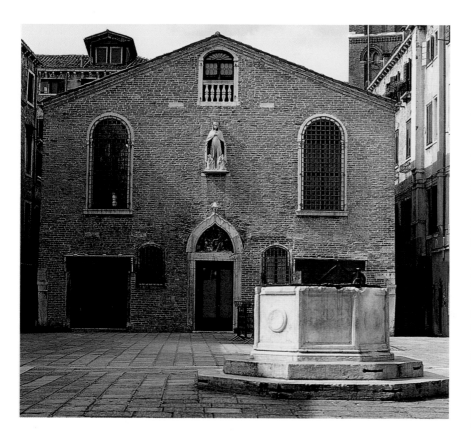

Facade of the former Scuola dei Calegheri, in the Campo di S. Tomà, the best-preserved Gothic *scuola piccola* in Venice.

sixteen officials, reelected annually by the whole membership, or capitolo, supervised the day-to-day activities of the *scuola*. The extra upstairs room was not easily accommodated within the simple structure of the two superimposed halls. Since the *sala del capitolo,* the main upper hall, had to accommodate the whole confraternity (numbering up to about 500 members), there was no desire to reduce the size or dignity of this room by partitioning off a portion for the *albergo*. Various ingenious solutions were devised to resolve this difficulty, usually incorporating the *albergo* into the adjoining monastic buildings.

The character of a medieval *scuola grande* is still perceptible in the former Scuola della Carità, now part of the Gallerie dell'Accademia. The facade and staircase date from the late eighteenth and early nineteenth centuries, but the first room in the gallery preserves what was originally the *sala del capitolo* of the Scuola, completed in 1343. Its splendid gilded ceiling was begun in 1461, under the auspices of the guardian grande of the time, Ulisse Aliotto, whose name is punningly commemorated in the eight-winged (*ali otto*) *putti* on the ceiling. The *albergo*, erected in 1384 and enlarged in 1422–44, was in the adjoining room on the northeast corner, now the last room in the gallery's sequence, which still preserves its paneling and benches, as well as the original gilded ceiling and Titian's *Presentation of the Virgin* of 1534–38.

The early decades of the Trecento were boom years in Venice. This was the period in which the new Palazzo Ducale was begun, not to mention the great mendicant churches of the Frari and SS. Giovanni e Paolo, to be considered below. The Scuola di S. Giovanni Evangelista moved into its present seat in 1340, and we have already seen that the Carità's building was opened in 1343, the year of the start of work on the Palazzo Ducale. The Scuola della Misericordia's great Gothic building dates back to 1310; it was enlarged in 1327 and again in 1365. As elsewhere, the Black Death of 1348 must have caused a drastic interruption. The *albergo*, over the abbey cloister, was begun in 1434, and the facade of the main building remodeled in 1441. The elaborate facade windows, with their finials and pendant traceries, recall the ornate decoration of the Ca' d'Oro and the Porta della Carta, both executed in the same years. The corridor through the ground floor of the building along the canal bank was pierced in 1504–6 to give access to the almshouses. This is the building that best preserves the appearance of a Gothic *scuola grande*, despite the loss of the great facade relief of the *Madonna della Misericordia,* by Giovanni and Bartolomeo Bon, now in the Victoria and Albert Museum in London. The gabled facade

organs of self-government for the prosperous citizen class. Though the Council of Ten had ultimate control over the activities of the *scuole grandi,* the nobility and clergy were not allowed to take part in their internal administration.

The *scuole grandi* gained their income from entry fees and from charitable donations by individual benefactors. In part, their funds were used for charitable acts, to help those members who had fallen on hard times. Such benefits included the payment of dowries or funeral expenses, the distribution of food and clothing, and the provision of hospital or almshouse accommodation. The rest of their funds were used for ceremonial purposes, to purchase processional banners and candlesticks, and, especially, to erect and decorate their premises. Intense competition grew up between the *scuole grandi* to outdo each other in the splendor of their buildings and works of art.

In its simplest terms the *scuola grande* was a larger version of the *scuola piccola:* a barnlike rectangular structure with two halls one above the other, linked by a staircase. The main exception was that an additional smaller meeting room, known as the *albergo,* was needed on the *piano nobile* for the meetings of the governing body, the Banca. This committee of

with its Gothic pinnacles conveys a semireligious character, echoed in the reliefs of kneeling *confratelli* [brethren] on the wellhead in the *campo* in front. The doorway leads into a simple staircase hall with a coffered ceiling decorated with *scuola* emblems. The huge *sala del capitolo* upstairs was so spacious and well lit that it was later used by Tintoretto to paint his great canvas of *Paradise* for the Sala del Maggior Consiglio. The decoration of the ceiling of this *sala*, executed in 1453–65, has not survived. The huge building was vacated when the Scuola moved into new premises designed by Jacopo Sansovino in 1589, but as late as 1581 Francesco Sansovino remarked that "the old building is very memorable; the Sala is as long and broad as any other in the city, with a fine, much esteemed *albergo*."

We have already considered whether the citizen class could be identified by the style of their houses, and concluded that the boundary line between noble and citizen imagery was a fluid one. One could, however, claim with some justification that the *scuole grandi* represented the visual identity of the citizen class more forcefully, being a building type unique to this social group. The *scuole grandi* offered to the citizens not only a degree of self-government and social welfare, but also a prominent role in public ceremonial. The whole membership joined in all the major ducal processions, accompanied by their musicians and bearing their relics and regalia. The buildings became the focus of their patronage of the arts, and the intense competition that developed between them also reflected their social pride. While stylistic details struck a fine balance between the secular and religious traditions, the distinct typology made the buildings immediately recognizable as symbols of the citizen class. *Scuola* arms and reliefs of hooded *confratelli* constantly reminded viewers of the nature of the patronage. The fact that Sansovino's scheme for the new Scuola della Misericordia would later attract so few donations may be largely due to the fact that its imagery was that of the ruling oligarchy rather than a representation of citizen taste and values.

Ecclesiastical Buildings

Whereas the trading connections of the Venetian nobility were with the eastern Mediterranean and northern Europe, the patronage of the religious orders created channels for cultural exchange with the rest of Italy and Western Europe. In contrast to the city's parish churches and nunneries, over which the State retained control, the male religious houses were branches of international monastic networks with their headquarters outside Venice. The oldest form of

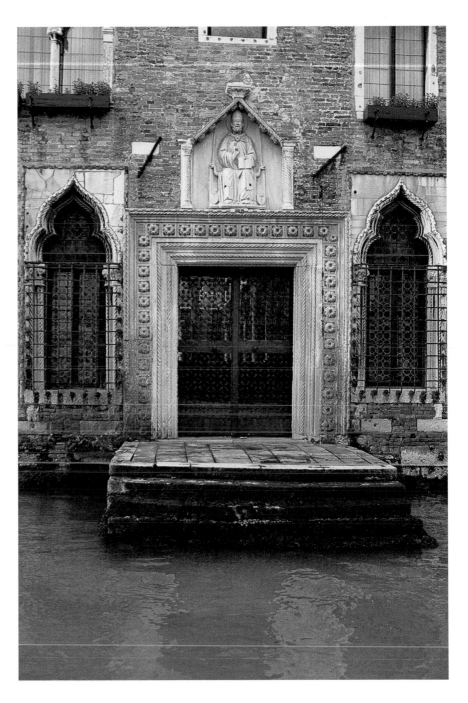

Western monasticism was the Benedictine order, whose rule was laid down in 529. Benedictine houses were originally rural foundations, the monks seeking salvation through prayer, study, and labor in the fields. As the centuries progressed, they acquired enormous wealth (especially in land), deep learning, and influential courtly connections throughout

Monastery church of S. Gregorio, water entrance to the cloister from the Grand Canal. The 14th-century portal is surmounted by an aedicula with an enthroned St. Benedict.

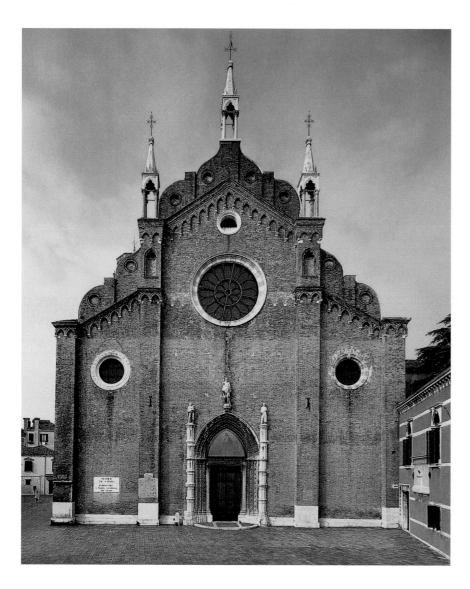

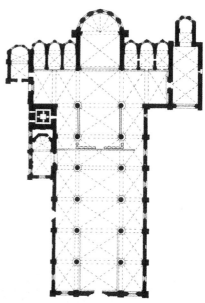

S. Maria facade, plan, and interior. The church was built in the first half of the 14th century by the Franciscan order.
The view of the interior (opposite) offers a view toward the presbytery. At the back, Titian's *Assumption* altarpiece, seen through the choir arch; the marble facing by Pietro Lombardo was finished in 1475.

Europe. The original vows of St. Benedict—poverty, chastity, and obedience—began to seem remote in the face of the growing power and affluence of the order.

The principal Benedictine house in the Veneto was that of S. Giustina in Padua, but from an early date the islands of the lagoon housed many smaller monasteries. The principal Benedictine seat in Venice was that of S. Giorgio Maggiore, whose Gothic buildings and *orti* [gardens] appear prominently in the foreground of Jacopo de' Barbari's view of Venice of 1500. The later reconstruction of the church and monastic buildings planned by Palladio has obscured all traces of the medieval monastery; and even its early Quattrocento library designed by Michelozzo has since been replaced by Longhena's great reading

room. But the close connections with the State remained, symbolized by the island's conspicuous visual relationship with Piazza S. Marco and affirmed each year by the ducal *andata* on the feast of St. Stephen.

Fortunately, a little altered Benedictine monastery survives in Venice, at S. Gregorio, beside the later church of the Salute (see p. 115). Benedictines from the abbey of S. Ilario on the landward edge of the lagoon settled here in 1160. The monastery church, its traceried windows copied in 1458 from the nearby newly built church of the Carità, is now used as the main laboratory for the restoration of paintings. The pretty Gothic cloister dates from 1342, the same period as the start of the Bacino wing of the Palazzo Ducale. Its ornate water entrance on the Grand Canal has a rectangular portal richly decorated with rosettes and rope moldings and surmounted by a relief of St. Benedict. The double-ogee arched windows set in rectangular panels on either side reflect current developments in palace architecture. Windows of this type are rarely found in ecclesiastical architecture of this time in Venice, as we shall see, and such secular identity seems to affirm the wealth, high social standing, and political influence of the Benedictines.

It was in reaction against such Benedictine extravagance that reform movements began to take root in Venice from the early years of the thirteenth century. Unlike the earlier reforming orders in the countryside, such as the Cistercians and the Cluniacs, these new orders, known as the mendicant friars, were established in urban sites to minister to the growing numbers of sick and needy in the towns. In Venice, as

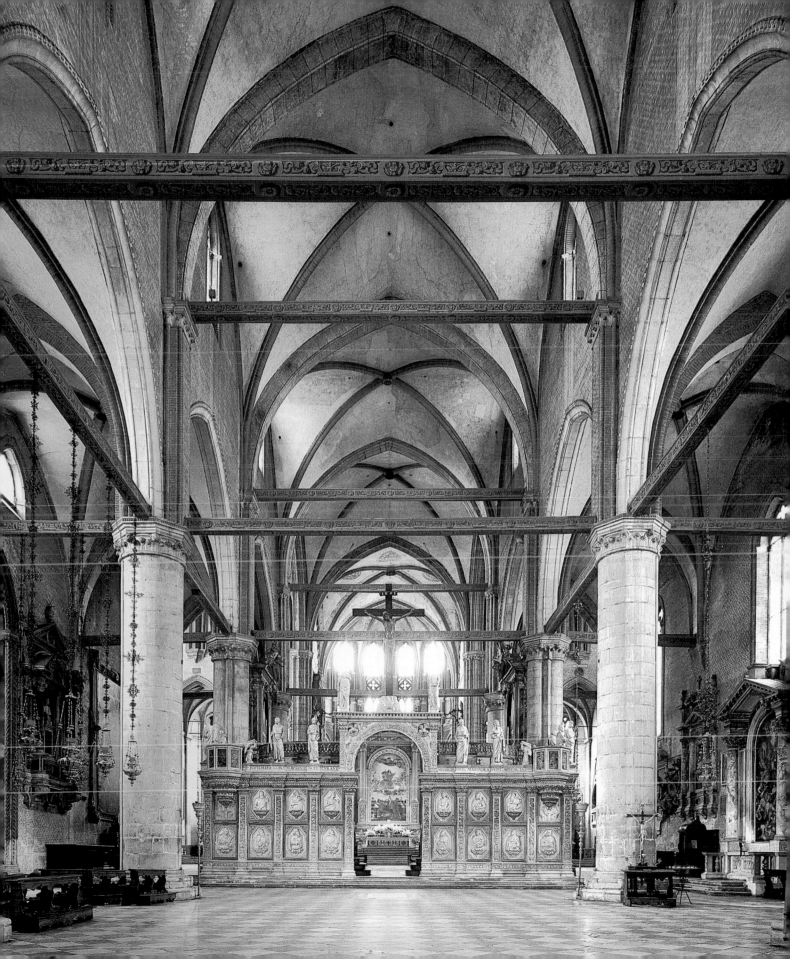

elsewhere in Europe, the new friaries were established around the peripheries of the already densely built-up urban nucleus, where cheaper land was available for large churches and open-air preaching. Mendicant friars abandoned the Benedictine ideal of self-sufficiency, thereby releasing time hitherto spent on farming for good works in the city. Funds were to be raised, instead, by begging, hence the name occupy separate cells rather than sleeping in communal dormitories. This factor, combined with the growing numbers of brothers, resulted in the proliferation of cloisters in order to expand the living accommodation. Jacopo de' Barbari's view of 1500 clearly shows the large areas around the margins of the city occupied by mendicant churches and their multiple cloisters.

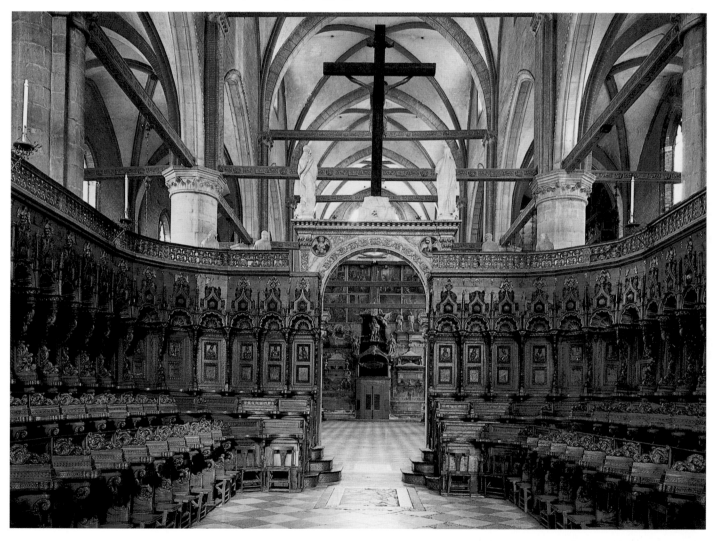

S. Maria Gloriosa dei Frari, choir of the friars, view toward the entrance wall.

"mendicant." The aim was not only to save one's own soul, but also to try to ensure the salvation of others. Thus the repeated recitation of the hours through day and night was relaxed to allow more time for study and charity. Silence and retreat were sacrificed in favor of work in the community. To allow themselves privacy for study and the preparation of sermons, the mendicant friars began to

The principal mendicant orders in Venice were the Franciscans, or Frati Minori, founded by St. Francis of Assisi in 1210, and the Dominicans, or Frati Predicatori, approved in 1216; but friaries were established, too, by other orders, such as the Carmelites, Servites, and Augustinians. As their numbers and resources grew, new churches were begun, particularly in the boom years before the

Black Death, and as will become clear, these became the main channel of influence of the simple ecclesiastical Gothic style of mainland Italy into Venice.

The church that best preserves its original internal arrangement is the great Franciscan church of S. Maria Gloriosa dei Frari, center of the Conventual branch of the order in Venice (see pp. 116–119). (The alternative, more ascetic "Spiritual" branch was soon suppressed, and later reformed branches such as the Observants and the Capuchins occupied separate friaries.) The church of the Frari was begun in about 1330, replacing the earlier, smaller church begun in 1250, which stood on the site of the nave of the present one, orientated in the opposite direction. The present orientation, with the high altar at the southwest, a liturgical anomaly, enabled the new church to face toward Campo S. Polo, the Rialto, and the city center. It also allowed the earlier church to remain in use during the rebuilding. Given the size of the great church, it is not surprising that its construction took more than a century. The tall campanile, second only to that of S. Marco, was completed in 1396. The presbytery, choir, and transepts must have been erected by the first decades of the Quattrocento, when the monument to the condottiere Paolo Savelli, who died in 1405, was placed in the right transept. The nave was built last, after the demolition of the previous church. The high altar was dedicated in 1469, just after the installation of the ornate wooden choir stalls with their Gothic canopies embellished with perspective intarsia scenes. By the time that the stone pulpitum was completed by Pietro Lombardo in 1475, the Gothic style had already been superseded by an elegant early Renaissance classicism, but it is a testimony to the authority of the overall conception that the artistic unity of the Frari is in no way compromised. Indeed, Titian's famous *Assumption,* executed in 1516–18 for the high altar, provides the final unifying element in this dramatic artistic ensemble. The completed church was finally consecrated in 1492.

It is important to consider the use of the different parts of the building in order to understand its architectural configuration. The choir was a secluded space for the brothers' private worship, intimately connected to the high altar, and occupying the intermediate zone between the lay congregation in the nave and the spiritual climax at the high altar. Easily accessible from the friary alongside, the wooden choir stalls offered warmth in winter, and during the recitation of the mass the public would hear sacred voices rising from a mysterious source to accompany the Virgin's ascent and coronation in Titian's picture. A flood of heavenly light emanated from the expanse of tall Gothic windows in the main apse, providing the backdrop to Titian's celestial vision of the Virgin in glory. The illumination at the (liturgical) "east" end—though in reality it was the afternoon sun that flooded in—must have been even more striking before the later enlargement of the clerestory openings into Palladian-style thermal windows made the nave brighter.

To anyone aware of Franciscan tradition, the church of the Frari would have seemed familiar, for its plan is similar to those of the upper church at Assisi and the main Franciscan church in Florence, S. Croce. This point is important, for it demonstrates how the order's international administrative structure enabled new architectural ideas to be imported into Venice. The centralized Veneto-Byzantine Greek-

S. Maria Gloriosa dei Frari. Three of the 124 wooden choir stalls, richly decorated with perspective intarsia scenes by Marco Cozzi.

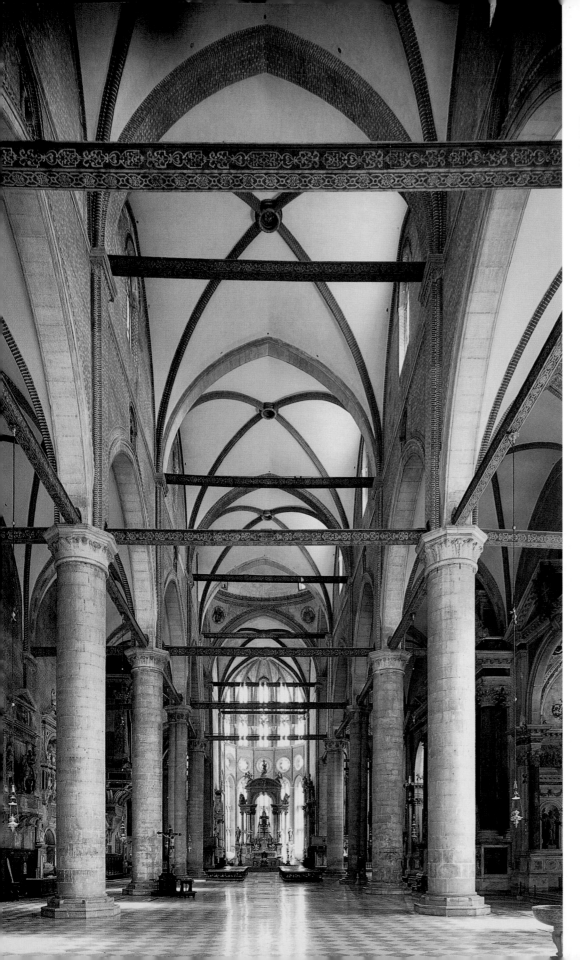

SS. Giovanni e Paolo, interior. This church, the largest in Venice and a stunning example of Venetian Gothic architecture, eventually became the burial place of most of the famous people in the history of the Republic.

OPPOSITE:
S. Stefano, interior. The splendid ceiling is constructed *a carena di nave*.

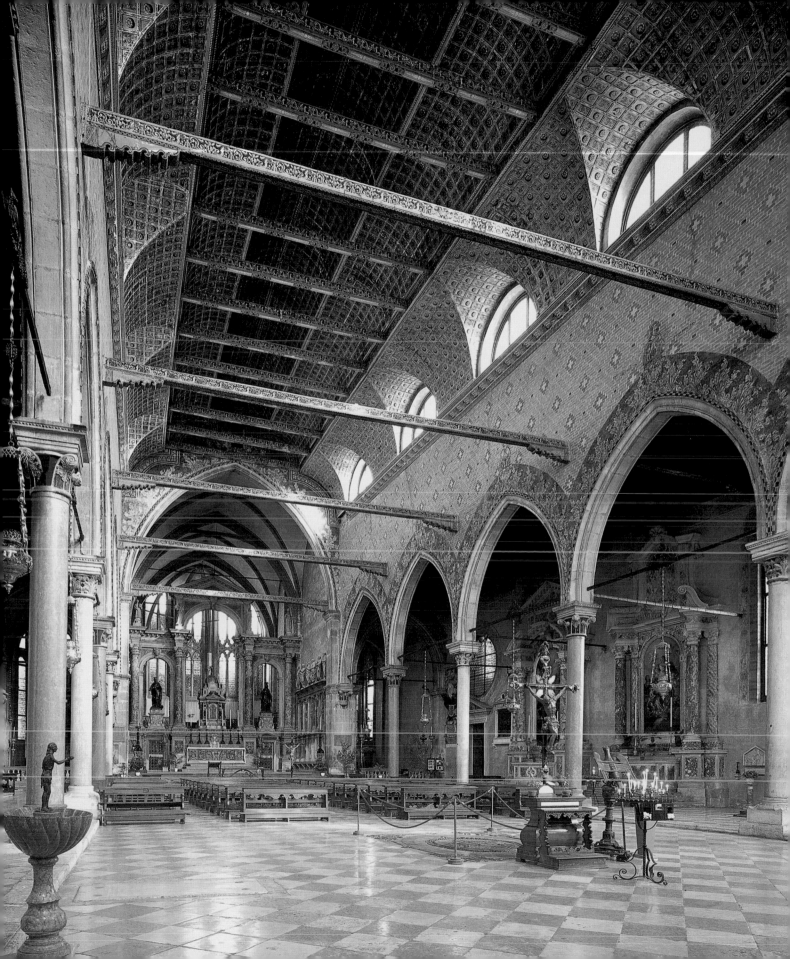

cross plan had been suitable for parish worship, with its emphasis on local family occasions such as baptisms, marriages, and funerals, but it was ill adapted to the needs of the mendicant friars. The great preaching churches which were springing up on the margins of every major Italian town in the Trecento adopted a simple Gothic style executed in brick, with spacious naves and side aisles, single column shafts bearing pointed arches, and plain

S. Giovanni in Bragora in Campo Bandiera e Moro. Simple brick facade.

external pilaster-buttresses to support the vaulted roofs. At the Frari the traceries of the "east" end employ quatrefoils and lozenge motifs, but ogee arches are absent—except where justified by secular links, as in the entrance portal to the Corner family chapel. This is not the orientalizing Gothic of the Palazzo Ducale, but rather the vocabulary of late medieval church builders throughout Europe.

Yet the Frari gives a distinctly Venetian impression, with its warm polychromy in red and white, echoed in the fiery palette of Titian's *Assumption*. The space is crisscrossed with tie beams to sustain the vaults on the unstable terrain. The east end, with its protruding polygonal apses, recalls the tradition of the lagoon's Byzantine-style basilicas. The pulpitum, bearing not only, as the name suggests, the two pulpits at either end, but also the two organs, is gilded and covered with reliefs of saintly images like a Byzantine iconostasis. Tombs and monuments to

rich and famous Venetians affirm the close relationship between the Franciscans and the State. The chapels at the east end, all richly embellished with works of art, were patronized either by wealthy nobles, such as Federico Corner (the richest man of his time, according to tax records), or by other Italian nationalities—the Florentines and the Milanese. The facade is crowned by swelling lobes which seem to have been added to give a more Venetian character to the severe cornices with their cusped machicolations, or *modioni*.

Rona Goffen has pointed out how the church of the Frari and the great Dominican church of SS. Giovanni e Paolo are situated almost equidistant from the Rialto, on opposite sides of the Grand Canal, just as in Florence the churches of S. Croce and S. Maria Novella lie at a similar distance from the Duomo in opposite directions. Both orders enjoyed a close relationship with the State, manifested in SS. Giovanni e Paolo by the array of splendid tomb monuments in honor of celebrated Venetians. Both the Franciscan cult of the Immaculate Conception and the Dominican cult of the Rosary were given official support by the Republic. It seems that the State recognized the importance of the charitable works and religious ministry provided by the friars in the maintenance of social harmony within the city.

The church of SS. Giovanni e Paolo seems more somber and imposing than the Frari, partly because the clerestory windows have not been enlarged, partly because of the removal of the friars' choir in 1682, which made the vastness of the space even more apparent, and partly due to the solemnity afforded by its role as a pantheon to Venetian doges and military heroes (see p. 120). Like St. Francis, who visited the Venetian lagoon in 1220, St. Dominic is also believed to have come to the city, in 1217. There he supposedly founded a small oratory on the northern margins of the city, soon replaced by a larger church begun in 1246 on a nearby site donated by Doge Jacopo Tiepolo. As at the Frari, the community soon outgrew its thirteenth-century building, and the present huge church was begun in 1333. An inscription dated 1368 between the north transept and the nave suggests that the eastern end and crossing were complete by this time, although Dellwing has proposed that the whole structure was laid out at the outset. The whole church was consecrated in 1430; the great bulbous dome over the crossing may have been added later in the century, perhaps to underline the close links with the State by reference to the ducal church of S. Marco; it appears in Jacopo de' Barbari's view of 1500.

Just as the Frari resembles its Florentine sister church of S. Croce in general layout, so, too, SS.

Giovanni e Paolo recalls the plan of the Florentine Dominican church of S. Maria Novella, except that, here too, the eastern chapels and presbytery are all apsed. The plan is composed of a series of square bays: five in the nave and one each in the domed crossing, the chancel, and the two transepts. The side chapels are half the width of this bay unit. Such classical harmony, later to be adopted in Florence by Brunelleschi at S. Lorenzo but relatively unusual in Gothic churches, adds to the effect of grandeur because of the wide spacing of the nave piers and the lucid proportions.

On the exterior, simple pilaster buttresses like those of the Frari separate the tall lancet windows, while once again a huge rose window pierces the facade. Three crowning pinnacles and the cusped corbelling beneath the cornice, also reminiscent of the Frari, enliven the roofline. Like S. Maria Novella,

as well as the Dominican church of the Eremitani in Padua, the facade is indented with deep Gothic niches to house tombs. In 1459 an elaborate new doorway was begun in the workshop of Bartolomeo Bon, using marble columns brought from Torcello, but after the cornice was carved in 1463 the project was abandoned, and the unfinished state of the brickwork has distracted attention from the superb quality of the stonecarving on this portal.

Campo S. Stefano no longer seems a peripheral site, but before the construction of the Accademia bridge in 1854 its location in the lower meander of the Grand Canal would have seemed more remote. Here stands the third of the city's most splendid mendicant churches, that of S. Stefano, "among the first to be commemorated in the city," according to Francesco Sansovino, who dated the church to 1325 (see p. 121). As at SS. Giovanni e Paolo, the choir at

Church of the Madonna dell'Orto. A magnificent brick facade, interesting because it documents the passage from the Romanesque to the Gothic to the Renaissance style, evident especially in the richly ornamented portal.

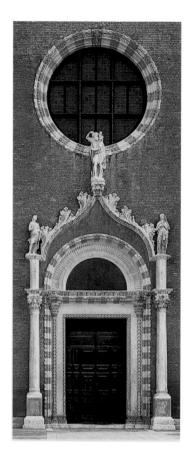

Church of the Madonna dell'Orto, central portal. On octagonal pedestals at the sides of the portal, the Archangel Gabriel and the Virgin Annunciate; on the cornice, at the apex of the arch, St. Christopher.

the head of the nave was removed in the seventeenth century, when the stalls were transferred to the chancel, behind a new high altar. Originally, as at the Frari, the stalls were faced by a marble pulpitum topped by statues of saints, now dismembered and rearranged around the presbytery. Nevertheless the church retains its artistic unity, thanks to the warmth and richness of its red and white tonality. Here the columns are not heavy cylindrical shafts like those of the Frari and SS. Giovanni e Paolo, but slender marble columns alternating in red and white. Such slim columns could not have supported a masonry vault, and instead, the nave is roofed by a lighter wooden ceiling *a carena di nave*. Here, too, a flood of light from the insubstantial traceries of the apse glorifies the east end, but the drama has once again been reduced by the increased illumination in the nave caused by the later insertion of thermal windows. Not only is the woodwork of the ceiling and tie beams lovingly decorated, but the walls were embellished in the fifteenth century with a lozenge-pattern like that of the Palazzo Ducale and with flickering crockets around the nave arches reminiscent of S. Marco.

We have seen in S. Stefano the happy union between the simple mendicant style and the later painted decoration evoking the richness of the city center. Such complex blending of architectural identity can be seen, too, at the Madonna dell'Orto, begun for the Frati Umiliati in 1399 (see pp. 123–125). The simple, aisled Gothic interior is in the Mendicant tradition, though as at S. Stefano the columns are slender shafts of precious oriental marble, requiring a light roof structure, here a flat wooden coffered ceiling reinforced by tie beams. The broad Gothic arches of the nave are echoed in the fifteenth-century cloister alongside the church. The facade is remarkable for the high quality of its sculptural decoration, seen, for instance, in the row of Apostles filling the niches that crown the lateral sections. The aisles are lit by large Gothic windows, richly embellished with tracery and surrounded by bands of red and white marble, like the central *rosone*. The rose window was so admired by the Augustinian canons of the Carità that they asked Bartolomeo Bon to repeat the design on their own church, rebuilt between 1441 and 1454. The portal of the Madonna dell'Orto was commissioned from the workshop of Bartolomeo Bon in 1460, the year after (and doubtless in emulation of) the doorway of SS. Giovanni e Paolo. This entrance, with its striking porphyry lunette, fluid crocket decoration, and finely carved ornament, was financed by the wealthy merchants' guild, the Scuola di S. Cristoforo dei Mercanti, based in the church. Both Bartolomeo Bon and his father Giovanni were members of this *scuola*,

and their workshop at S. Marziale was nearby.

Although the functions of parish churches remained completely distinct from those of the friaries, by the beginning of the Quattrocento the Gothic style was so pervasive, both within Venice and elsewhere, that even parish churches in need of rebuilding were erected in it. An example is the parish church of S. Giovanni in Bragora, which probably dates from the 1470s (see p. 122). Its facade and interior preserve the basic articulation of a smaller mendicant church such as the Madonna dell'Orto in a much simplified form, and with notable differences. The addition of side portals helps not only to bring the church into closer contact with the parish *campo* outside, but may also have allowed easier access for visitors wishing to see the church's precious relics. The lobed profile sets the church firmly in the tradition of the upper Adriatic, a reminder of the local roots of the parish community.

The Napoleonic reorganization of the ecclesiastical structure of Venice obscured the once distinct identity of the great friaries and the parish churches. In the early nineteenth century, many mendicant churches were demolished or put to secular use, and others were converted for parish worship. Their large size and lack of intimacy makes them poorly suited to parish needs—in their original role their horizons were not parochial, but rather citywide and even international. Their impact on Venetian visual culture can hardly be overestimated. Not only did they infuse the city's orientalizing Gothic tradition with a clearer, more architectonic form of the style, but they also became the focus for acts of patronage from individuals as well as the friars themselves. Their social and religious role in the city complemented that of the parish churches, a zone of mediation between the populus and the State consolidating harmony and stability in the outer margins of the city.

Conclusion

We have observed the development of the Gothic style through three centuries of Venetian architecture, from the first tentative appearance of the pointed arch in palaces of the Duecento until its last flourishes in the Quattrocento. From the middle of the fifteenth century, the Gothic overlapped with early Renaissance classicism. These constituted two alternative modes of expression, often coexisting harmoniously within the same building, and it was not until the Cinquecento that Roman classicism acquired the support of the printed treatise which assured its ultimate victory. In the Quattrocento, the same masters could work in either style with equal

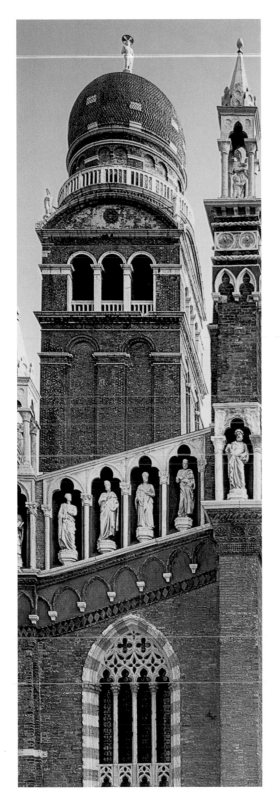

facility and invention: for example, Giovanni and Bartolomeo Bon were responsible for both the ornate Gothic Porta della Carta and the classicizing Arco Foscari on its inside face; and they worked simultaneously on the staggeringly innovative Ca' del Duca and the (by then) conventional Gothic church of the Carità. As Ruskin realized, it was the Gothic style that allowed the greatest display of sculptural virtuosity from the stonemason. Not only native artists such as Giovanni and Bartolomeo Bon, but also sculptors and stonecarvers attracted to Venice from outside, ensured the vitality of the Gothic through continual invention and technical virtuosity. Florid Gothic embellishments—crockets, pinnacles, and statuary—were applied even to the most "classical" monument of the city center, S. Marco itself. The broad repertoire of decorative expression allowed subtle semiotic nuances, ranging from class identity to religious affiliation. The huge amount of construction in the Trecento and Quattrocento created the urban form that is still largely unchanged today and also evolved the typologies that endured until the fall of the Republic.

The finely tuned resonances and artistic merits of the city's Gothic legacy were not forgotten quickly. Francesco Sansovino was generous in his praise of the finest Gothic buildings, from Ca' Foscari to S. Stefano. Significantly, both he and Vasari attribute to his father, Jacopo Sansovino, a remarkable restoration of the Gothic Palazzo Tiepolo at the Misericordia, renewing the substructures while the family continued to live, undisturbed, upstairs. According to Vasari, Michelozzo, too, had astounded Venice with his brilliant restoration of an old palace at S. Barnaba, supposedly carried out during a furtive overnight visit. Just what these Tuscan architects were able to do that had eluded the skills of expert Venetian *proti* remains a mystery— the stories are surely exaggerated by an element of Tuscan pride. The real importance of such fables in the present context is that they testify to the need to preserve an enduring local tradition in the face of the radical *renovatio* of the Cinquecento: to assert the historical roots of the Republic and its noble families. When the Palazzo Ducale was severely damaged by fire in 1577, Palladio recommended its replacement by a classical building, but he had underestimated the value of the Gothic palace as an icon of Venice's political and commercial supremacy.

Deborah Howard

Church of the Madonna dell'Orto, detail of the lateral frieze with statues of Apostles. The bell tower is in the background.

Venetian Figurative Sculpture: 1300–1450

The Beginnings

In the early part of the fourteenth century, Venetian sculptors were still firmly tied to traditional formulas. This may have been one of the reasons why more demanding patrons, such as Enrico Scrovegni in Padua or Bartolomeo Ravachaulo, rector of S. Simeone, preferred to commission sculptors from other towns. One example of this is the Virgin and two angels carved by Giovanni Pisano for the Scrovegni Chapel in Padua. Then, in Venice itself, there is the recumbent figure from the dismembered tomb of St. Simeon, carved in about 1318 by Marco Romano. Romano's artistic training was gained in the circle of Giovanni Pisano, and he was probably working in Siena before 1318. The drapery of St. Simeon's clothes is ample but simple in shape, the clasped hands still seem full of life, the waves of his flowing beard and the hair curling on his forehead frame a powerful and angular head. The pathos of this portrait of a prophet is enhanced by his half-open mouth and his nearly closed eyes.

It is likely that there were originally other sculptures, both figures and reliefs, on St. Simeon's tomb. From very early on, these were studied and zealously copied by local sculptors. This explains why many Venetian works before 1340, which tend to be of only minor importance, reveal Tuscan influence. Some of these works were then exported to the mainland.

In contrast to these sometimes ordinary efforts, the works of the Master of the Statues of Enrico Scrovegni stand out; they too were probably done in Venice. He has been credited with the recumbent figure of Bishop Castellano Salomone (d. 1322) on his tomb in Treviso Cathedral and with two statues of Enrico Scrovegni, the recumbent one on his sarcophagus behind the altar in the Scrovegni Chapel (see p. 127) and the standing one currently in the sacristy. These effigies have enormous vitality with details expressed in a concise formal language; the drapery especially tells us that this sculptor had also studied the tomb of St. Simeon. The standing figure of Scrovegni was probably devised for an early version, later abandoned, of the sepulchral monument dating from 1320. The figure itself still provides us with a strikingly realistic, albeit sober, characterization of the patron which is underlined by the richness of the polychrome effect. The effigy on the tomb, dating from 1336, reveals instead a growing interest in physiognomical detail.

Filippo de Santi is one of the few sculptors of those years whose name we know. His major work is the tomb of the Blessed Odoric of Pordenone, a famous traveler of his day who ventured as far as China. The tomb is now housed in the church of S. Maria del Carmine in Udine. It was commissioned by the patriarch Pagano della Torre and his chamberlain Corrado Bernardiggi. In 1332 Filippo, whom a document names as "the author of the tomb of the Blessed Odoric," received his fee, and shortly afterward additional money was provided to transport the pieces from Aquileia, where they had been shipped from Venice, on to Udine. After the tomb arrived, three well-known people were invited to decide if Blessed Odoric's tomb was "more noble" than that of the Aquileia Virgins. The document in question not only shows that continual attempts were made to

Recumbent Figure of St. Simeon, Marco Romano, c. 1318. The artist carved only the figure of the saint on this tomb in the church of S. Simeone Grande.

surpass neighbors in terms of quality works of art, but also reveals that the wording of the contract, now lost, apparently indicated that the sculptor was to model his work on the Aquileia tomb. The choice of the people to act as judges was a little odd. None of them was a sculptor able to assess the quality of the materials used or any technical shortcomings in the way the work was carried out, as might be expected in such a case. Rather, they were people who had nothing to do with the craft at all and whose artistic judgment was based upon criteria that could prove difficult to sustain should there be a disagreement.

Filippo de Santi had developed his style in Venice and had made a close study of the tomb of St. Simeon, which at the time was among the richest in figures. More than anything else, the effigy of the Blessed Odoric, beard flowing and borne to the tomb on a pall, closely resembles Marco Romano's masterpiece.

Andriolo de Santi

The first work that documentary sources attribute to Andriolo is the portal for S. Lorenzo in Vicenza, carried out between 1342 and 1344. These and later sources place the sculptor in Venice. He may have moved to Padua for a short time in 1364 but soon returned to Venice, where he died between 1372 and 1375.

On the doorway Andriolo portrays the patron, Nan de Marano, kneeling in front of the Virgin, thus choosing a type of representation already traditional on funerary monuments on the back of sarcophagi. St. Lawrence, the patron saint of the church, is interceding on de Marano's behalf. The figure of St. Anthony is shown alongside the Virgin. Even while he was overseeing work on the portal the artist often returned to his native city. So there is little doubt that he will have taken a keen and close interest in an addition to the southeastern corner of the Palazzo Ducale: a sculpture depicting a scene from the life of Noah. This was the masterpiece of Filippo Calendario who was also the architect of the palace. Andriolo and Filippo Calendario shared an interest in the meaningful language of gesture. Andriolo made use of this in his portrait of St. Lawrence, who seems to intercede and point at the same time. In this language, faces have ample and rounded forms, strongly volumetric. The tremendous difference between the *St. Lawrence* and the portrait of the recumbent Scrovegni, which had been finished only a few years earlier, makes the frequent attribution of the Scrovegni figure to Andriolo difficult to believe. The clothes draped on his figures seem to be in thick,

heavy fabrics which fall in soft folds. Nevertheless, in certain places, especially in the saint's left arm, the sculptor is trying to reveal the shape of the body even beneath this heavy drapery.

In Venice we saw very similar effects used in slightly earlier work, generally of a more modest quality. We cannot rule out the idea that their anonymous authors were influenced by Andriolo's early work, especially since an "Andriolus taiapietra"

[Andriolus stonecutter] is mentioned in Venetian sources as early as 1328. Moreover, all of Andriolo's later work is found outside Venice. In the city itself, only reflections of his style—rather numerous—remain. Nevertheless, sources from 1340 to 1355 suggest that, excluding the workshop of Calendario, Andriolo ran the most important workshop in Venice, and his work must therefore be included even in a short history of Venetian sculpture.

A lucky find of abundant and detailed documents relating to the portal of S. Lorenzo provides a glimpse of how workshops managed to cope with large-scale commissions. Apart from Andriolo, referred to as *protomagister*, all kinds of assistants were on daily wages, including stonecutters from far and wide (some of their native towns are given: Como, Ferrara, Padua, and Venice). The documents rarely tell us exactly what each man did. In 1342 fees were paid to "master Pietro and master Andrea for a leafy frame around the door." This probably refers to reliefs on the door jambs and perhaps also around the tympanum. The prototypes of this motif come from the large arches of the main portal of S. Marco. It is hardly surprising then that the work was recorded in this case, for it was particularly demanding; the hands of the two different craftsmen are discernible. The documents shed no light on the extent to which *protomaestro* Andriolo influenced, perhaps through providing sketches, the way in which his collaborators executed the details. The flat

Recumbent Figure of Enrico Scrovegni, Master of the Statues of Enrico Scrovegni. Padua, Arena Chapel.

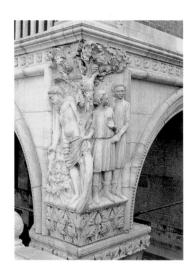

imitation of the tympanum portrait of St. Anthony in another of the same saint on the architrave would seem to suggest that both in the Vicenza portal and in later work, architectural and ornamental features were broadly outlined in the contract but stone-masons were give ample liberty for the figures—even if they did not always make good use of it.

In 1345, not long after finishing the portal, Andriolo was given a commission to build a tomb for a Paduan nobleman, Ubertino da Carrara (d. 1345), and shortly afterward for that of Jacopo da Carrara (d. 1350). The two tombs, which are now in the church of the Eremitani in Padua, were almost identical in structure and faced each other in the presbytery of the church of S. Agostino (destroyed in the nineteenth century). The contract for Jacopo's tomb was drawn up in 1351 and shows that Andriolo, one Alberto, son of Ziliberto, and one Francesco, son of Bonaventura undertook to finish the work within fourteen months. The structure of the tomb recalls a canopy but unfortunately the parts that once connected the canopy to the sarcophagus are no longer legible due to the almost total loss of Guariento's painting which included the portraits of those who commissioned the work. Niches interrupting the upper cornice are a new feature in this sarcophagus, as is a beautiful motif depicting angels who appear to be holding up the bier. A model of the city of Padua at Ubertino's feet shows the center of his power base. The contributions of the different assistants in the figurative decorations are apparent, but attribution of individual parts to one of the three craftsmen mentioned in the contract is possible only for Andriolo, who almost certainly personally carved the wonderfully expressive portraits of both of the deceased. As in the figures on the Vicenza portal, here again Andriolo shows his preference for full forms and deeply curving returns, carved with a certain economy in the detail.

The same style is found in the idealized portrait of Livy above the Porta delle Debite in Padua's Palazzo della Ragione. This was commissioned by the Carrara family in honor of one of the city's most famous sons. Publicly displayed portraits of poets, such as the likeness of Virgil in Mantua, were already found in other cities and had great importance as monuments of civic consciousness.

Andriolo carried out so many other commissions for Paduan patrons as to suggest that he must have started a distinctly Paduan "school." But after his death, the most successful sculptor in Padua, a man called Rainaldino di Francia who originally came from Orvieto, never once turned to Andriolo's work for inspiration.

In the fourteenth century, sculptures were frequently

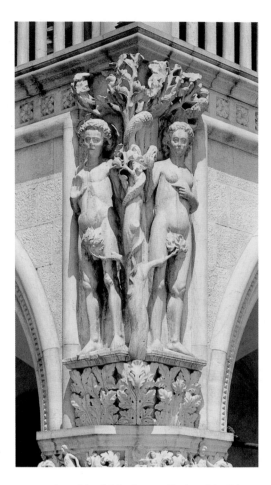

Adam and Eve, Filippo Calendario, relief on the corner of the Palazzo Ducale between the Molo and the Piazzetta.

exported to cities fairly close to Venice; this did not seem to depend on, or indeed be influenced by, the political situation of the day. It seems clear that patrons placing orders from Padua, Treviso, Aquileia, and Udine were either experts or were well advised. In any case, they were fully aware of the distinct superiority of the Venetian workshops. In Venice itself, political reasons dictated that the tomb of the Blessed Jacopo Salomone, who came from a Venetian patrician family (d. 1314), should be given to the town of Forlì and in 1340 a commission to make and ship it was awarded to a Venetian sculptor artistically close to Andriolo. (The tomb is preserved in the Museo Civico at Forlì.)

Andriolo's style had many followers and imitators in Venice until 1380, when the brothers Pierpaolo and Jacobello Dalle Masegne made their appearance on the artistic scene. The countless number of usually low-quality works produced by imitators gave rise to an impression, which has been slow to die out despite all evidence to the contrary, that in the middle years of the fourteenth century Venetian sculpture was

Drunkenness of Noah, Filippo Calendario, detail. On the corner of the Palazzo Ducale toward the Ponte della Paglia.

"Capital of Love," Palazzo Ducale.

Filippo Calendario

The man who dominated Venetian architecture and sculpture in the fourteenth century was and remains Filippo Calendario, architect of the Palazzo Ducale and author of its best ornamental sculpture. Both stylistic criticism and the results of the most recent examination of the construction of the palace itself confirm original data that place the sculptural decoration firmly between 1340, when building work began, and 1355, the year in which Filippo was publicly executed for his part in the Doge Marin Falier conspiracy. The ground floor of the Palazzo was built rapidly, probably between 1340 and 1344. This is confirmed by the date 1344 that a stonecutter carved into one of the capitals. It is likely that Calendario was given a list of subject matter together with the relevant Latin inscriptions drawn up by a specialist whom the authorities would have hired for the purpose. It remains uncertain, however, whether the artist himself decided to feature his own craft within the scheme of figurative work. But it must have been his idea to place almost life-size groups on the corners of the buildings showing *Adam and Eve* and the *Drunkenness of Noah*. Nothing like this had been done before, even outside Venice. The *Noah* group relies partly on expressive gestures to explain the roles of the main characters, even to an inexpert eye. This way of telling the story of Noah is already contained in a thirteenth-century mosaic in the narthex of S. Marco. The bearded head of Noah, who is drunk and no longer master of his movements, reveals a careful study of the recumbent figure of St. Simeon, Marco Romano's masterpiece (1318) in the church of the same name. Noah staggers, spilling wine from his goblet onto the rocky ground. The sculptor delights in the detail of the wooden rigidity of the once-strong body of a man who is now old and whose shoulders have become stiff and narrow. A comparison with the figure of Adam on the other corner shows us an artist who is careful not to waste the means at his disposal for giving character to his subjects, an artist who willingly uses sharp contrast (p. 128, top right). Shem delicately covers up the old man's nakedness and lifts his hand in a gesture of warning, almost protection; by contrast, Ham's sweeping, theatrical gesture directs the viewer's gaze toward his father's scandalous behavior. The contrasting reactions of the two sons are highlighted by the understanding shown in the pure and noble face of one son and the harsh features of the unforgiving son.

In *Adam and Eve*, both turn to face the observer (see p. 128 top right). Eve points her finger directly at Adam, the victim of her seduction, just as he seems to be about to pick the fig (not an apple). Adam's open

conventional and unambitious. It even seems that some of Andriolo's imitators made supplies of stock figures. This can be seen from some of the sepulchral reliefs that were deliberately left unfinished so they could be completed to order, with an angel Gabriel or a saint as needed, but the folds of the drapery and their postures all stayed the same.

face and Eve's frowning visage echo the different reactions and distinct characters of Noah's sons.

Above this group we find the Archangel Michael and an inscription reminding us that the wicked shall be punished and the good protected ("ENSE BONOS TENGO MALORUM CRIMINA PURGO"). Just a few meters away, between two columns, is the place where the gallows used to stand ready for capital punishment. It is probable, therefore, that an inscription with a reference to commutative justice placed in this exact spot in the Palazzo was not due to chance. The fact that the anonymous author of this St. Michael gave him a mild and far from menacing look is doubtless in line with the image of themselves favored by the Republic's judges.

Calendario not only gives a convincing psychological portrayal of the main characters' conflicting feelings, but he even uses drapery to characterize the people he clothes. The "fluttering" cloth that is unfolded to cover Noah and the taut fabric that clothes the "strong and just" shoulders of *Venetia*, who is tucked into the tracery of the western facade of the building, speak to us clearly. This aspect of Calendario's art shows the influence of Giotto's work and makes it obvious that Calendario must have studied the Paduan frescoes closely.

Ruskin, whose keen eye missed nothing, was enchanted by the vines and the fig tree. Certainly the naturalness and the variety of small birds perching on branches, turning round carefully and using their wings to keep their balance have no comparison. Undoubtedly the artist must have studied the wonderful bird-filled foliage of the arches on the main portal of S. Marco. It is also likely that he was familiar with illustrated manuscripts, with their rich subject matter and ornamental motifs similar to those found on his capitals. Perhaps the resemblance to some of the images in Paolino Veneto's manuscripts is not coincidental. In addition, the capitals contain French features that some say can also be seen in the sculptures of the Palazzo Ducale; this is not surprising given the widespread circulation of French manuscripts in that era.

Previous examples of capitals with figurative decoration found in Venice date from the twelfth and perhaps even the thirteenth centuries. We still have a Paduan capital portraying the Virtues which sixteenth-century Paduan connoisseurs thought dated from classical times (Berlin, Staatliche Museen, Stiftung Preussischer Kulturbesitz). Fortunately, many of the capitals were replaced in the nineteenth century by extremely well-made copies. They can be divided into three categories: those with heads, those with an individual figure, and those with groups of figures. In all cases, the figurative scenes are framed by foliage. The capitals are positioned to follow on from one another and present their subject matter in a strict order. This, among other things, underlines the entrance to the Molo and highlights the corners. It is not easy to attribute the capitals to individual sculptors. Very often his assistants managed to reproduce Filippo Calendario's style, and the difference between one man's hand and another's can be seen only from the poorer quality of some of the figures and in the detail on the acanthus leaves. It is very probable that in the workshop there were models for each type of capital and Calendario's assistants would have used these for inspiration as well as to help define their style.

It is possible that capital XXI, *Different Human Races*, was done by a sculptor who had previously worked on the tomb of Rizzardo VI of Camino (d. 1335) in the church of S. Giustina in Vittorio Veneto, where he carved the recumbent figure of the deceased and the four supporting figures. Among the heads on the capitals is a portrait of a Venetian that is reminiscent of the portraits of the master builders which

Stonemason's Capital, from the series of the crafts, Palazzo Ducale.

serve as both decoration and signature in so many buildings on the other side of the Alps. The differences between this capital and capitals XXXI and XXXIV, which can be attributed to Calendario, are marked. Above all, the artist accentuates the linear elements and surface tension of his faces, while his anonymous assistant fashions faces with strong plasticity and eyebrows like knotted rope—quite unlike the style of his master. Similar features can be found in the portraits of Andriolo de Santi. To date, no one

has discovered the meaning of these heads, which lack the captions found on nearly all of the other capitals, even those showing plants and animals. Perhaps they are just portraits of Venetian citizens?

Let us look at capital XVIII which stands on the side facing the Piazzetta (Museo del Palazzo Ducale), next to the large corner capital; it almost acts as a pendant to the *Liberal Arts* capital on the Molo side. It shows the *Quattro Coronati* (martyred Pannonian sculptors) with their pupils: all are intently executing a project and thus give us an idea of the wide range of tasks that a Venetian stonemason was able to tackle. Modern studies of Venetian art separate architecture from figurative and ornamental sculpture which Ruskin examined in such great depth and which has lately been so overlooked. On the contrary, Venetian stonemasons, in particular people like Filippo Calendario, Andriolo de Santi, the Dalle Masegne brothers, and Bartolomeo Bon, designed buildings and then, with the help of their workshops and a whole host of assistants, also took care of the finishing details. So, coming back to look at our capital, the stonemasons are busy shaping columns, architraves, and other architectural features whose preciousness is highlighted by porphyry inlays. A sculptor is working on a figure that looks remarkably like one of Noah's sons. Nevertheless, the total absence of individual features in the physiognomy of the sculptor indicates that this was not a self-portrait of Calendario.

For reasons of space, we will take a look at capital XIII which portrays moments from the life of a couple and has a tragic ending. This does not mean that the other capitals do not deserve equally close examination. We should also trace the long and often complicated iconographic tradition of each subject, especially with reference to illuminated manuscripts, something which so far has been done only for the representation of the month of March ("MARCIUS CORNATOR") on capital XII.

In the first of eight scenes, a young lover stands in front of his beloved's house, a building complete with a crenellated tower of rusticated stonework and an overhanging balcony quite unlike anything found in Venice. With his left hand clasped to his bosom, he declares his love for her, while the young girl coyly lowers her eyes (see p. 130). On the next side, the young girl, wearing a rich and elegant outfit, comes out of the palazzo. The youth now carries a sword in his girdle. She places a crown of flowers on his head, and they both brush against an object which probably could be identified were a thick layer of built-up dirt removed. In the next relief the girl goes back inside while the boy, arms folded, thinks about the effect his words have had. The young woman's atti-

tude and gestures are those of the Virgin in the Annunciation, a subject that was still very common, especially on tombs. The next three scenes are on the back of the capital and are so badly lit that on some days they can hardly be seen at all, a matter not helped by the black layer of grime that covers them. Nonetheless they show the couple tenderly embracing; the man has removed his sword. In the following scene the couple are in bed, holding each other very close. Then, wearing clothes befitting their new status of proud parents, they tenderly hold between them a babe in swaddling clothes. The father looks gently down at the child while the mother looks at her husband. The child grows and the parents bring him up: the next scene shows how both parents help him to stand as he takes his first steps, at the same time a hand placed on his shoulder restrains him a little. It is difficult to conceive of a more concise and meaningful way of illustrating the relationship between parents and a child that is just beginning to take its first steps in the world. The cycle ends tragically with the child's death and the parents' despair.

Calendario was also responsible for the first allegorical depiction of the Republic. His *Venetia*, a large tondo, or circular relief, in the tracery of the west side, contains numerous messages explained by the placard the female figure holds in her left hand: "FORTIS IUSTE TRONO FURIAS MARE SUB PEDE PONO." In her right hand *Venetia* holds aloft the sword that symbolizes power and justice (see p. 133). Beneath her feet, and separated only by a boardwalk, a sea full of fish rises in huge waves. To the right and the left, at *Venetia*'s feet, two small figures represent Anger and Pride. They can be identified by comparing the figures with capital XXVII (Museo dell'Opera), which conveniently shows the same Vices complete with explanatory captions. In his portrayal of Anger, Calendario worked on the same lines as Giotto did in the Scrovegni Chapel, in other words, a person tearing off his clothes in a fit of anger. Pride wears a helmet through which the ears of an ass are poking out. We must ask ourselves whether the choice of an armed person might be a specific reference to known belligerent personalities. This public condemnation of Anger and Pride points directly at the negative qualities that the Venetian ruling class had to strive to avoid. The opposing Virtues, the *rimedia*, were Temperance and Humility. This provided a way of officially promoting a degree of moderation and encouraged individuals to submit to the ideals of the State.

Calendario's *Venetia* has stylistic affinities with the *Virtue* that Andrea Pisano started to work on after 1330 for the bronze door to the Baptistery in Florence which was cast by the Venetian craftsman

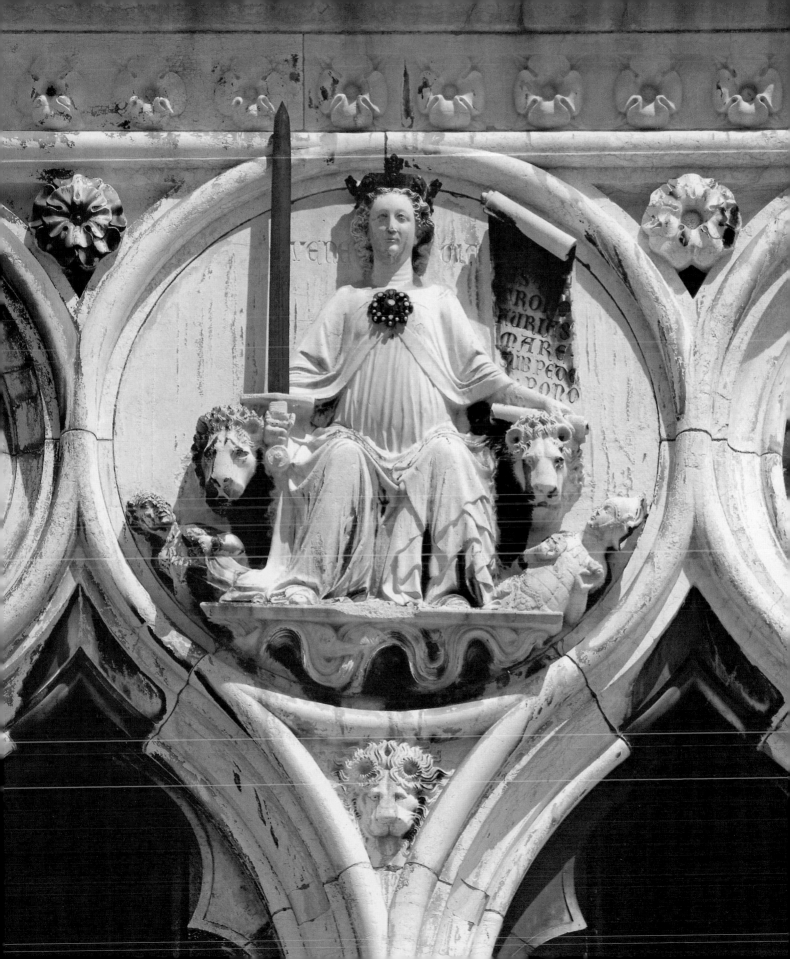

Madonna and Child, Nino Pisano, tomb of Doge Marco Corner in the church of SS. Giovanni e Paolo.

Leonardo d'Avanzo. These affinities would allow us to date the Venetian work, albeit using only criteria of style. Calendario's ability to communicate content through form is clear from *Venetia*'s severe and upright posture, the solid and angular shape of her shoulders, her powerful neck, and her regular but firm face whose original expression must have been even more intense as she probably had eyes of glass.

Once the building was finished, with Calendario's death his shop was broken up and his assistants, who as journeymen had been hired by the day, had to look for jobs elsewhere in Venice or leave the city in search of work. In fact, we find Calendario's style in some of the capitals in Aquileia cathedral, carved around 1370, and in reliefs from the rich tomb of S. Nazaro in Capodistria, now scattered far and wide.

After Calendario's violent death (1355), many sculptures were produced in Venice, especially for funeral monuments, whose figurative structure was inspired by the work of Andriolo de Santi. But none of the surviving work is of sufficiently high artistic merit to deserve mention here. As at the beginning of the century, the most demanding patrons had again to decide whether to accept the modest offerings of local workshops or turn to outside sculptors. The tomb of Doge Marco Corner (d. 1368) in the church of SS. Giovanni e Paolo is a good example of how this situation was handled: apart from the recumbent figure of the deceased, all the sculptures were commissioned in Pisa from Nino Pisano and his shop (see p. 134). They were later used for a tomb designed by Venetian stonemasons while the job of making a recumbent likeness of the dead man was given to a particularly untalented local stonecutter, a phenomenon found quite often in Venice.

The work of foreign sculptors was highly appreciated in Venice. In earlier years, an almost life-sized alabaster figure from England, probably from Nottingham, had been displayed in S. Francesco della Vigna. When it came to making the standing figure for the tomb of the condottiere Vettor Pisani (d. 1380), victor of Chioggia in 1380, it is probable that they called in a Lombard, Bonino da Campione. He had made his name by fashioning sumptuous tombs decorated with many figures for the powerful families of Padua and Verona. But these works were, after all, imported pieces, and for this reason the sculptors who made them did not offer any serious competition to the local stonemasons. It was only in the second half of the fifteenth century that Venetian craftsmen started to worry about the domestic market, and this in turn led to complaints and protests.

Any negative comment on Venetian sculpture in this period should bear in mind that figures were finished in color, a process that could hide shoddy

Madonna and Child, Pierpaolo Dalle Masegne, on the choir screen of the chapel of S. Clemente, basilica of S. Marco.

St. Mark the Apostle, Jacobello Dalle Masegne, on the presbytery choir screen, basilica of S. Marco.

nized and appreciated even outside Venice. Important commissions awarded to them are recorded for funeral monuments, portals, altars, and even entire church facades, including that of Mantua cathedral, with its characteristic rooftop decoration that was imitated several times in Venice. Pierpaolo and Jacobello worked "as joint partners in their father's inheritance," a form of association that made both responsible for every single task. Such an agreement gave the artists fairly substantial benefits and allowed them to carve up the work according to need. Their first job, which has survived only in part, was the tomb of the jurist Giovanni da Legnano and carries the signature of both brothers (the remains of the monument are housed in the Museo Civico, Bologna). On a case by case basis, the brothers had to decide whether to show any signs of artistic differences in jointly executed work or to absorb their individual styles into one. Furthermore, when they were working on their larger commissions, they often used other stonecutters, which really does not help our attempt to pin down attributions.

One of the brothers' early works (the contract dates from 1388) was the high altar of S. Francesco in Bologna. Attributing parts to one brother or the other is complicated above all by the alterations caused by numerous restorations. Nonetheless, Gnudi's research leaves us in no doubt that Pierpaolo did the bulk of the work. The two figures in the sacristy of S. Stefano that are attributed to Jacobello probably date from about the same time. It is likely that they formed part of one of the many medieval altars in this church that were destroyed or scattered in the Baroque period. The *St. John* has much in common with some of the figures seen in Jacobello's iconostasis, while the *St. Anthony* still has strong links with mid-century Venetian work. When they worked on the iconostasis, or choir screen, for S. Marco (1394–97), the brothers shared out the tasks: Jacobello produced the fourteen figures in front of the presbytery and Pierpaolo did the other ten in front of the chapels of St. Peter and St. Clement. The differences in style between the two groups could not be more marked. This allows us to establish what contacts and experience had shaped each brother. Pierpaolo's two *Madonnas* and the figures of female *Saints* are in the style of Nino Pisano, the most successful sculptor in Pisa between 1370 and 1380. The typical smile of Nino's figures was already familiar in Venice from his work on the tomb of Doge Marco Corner (in SS. Giovanni e Paolo). Pierpaolo is so confident using Nino's idiom that we can be almost certain that he had been in Pisa, perhaps even spent a long spell in a workshop there. Jacobello's *Apostles*, by contrast, are influenced by the Lombard sculpture of Bonino da

scalpel work. This is evident from remains of polychrome still found on most Venetian sculptures. Restoration work is continuously turning up new discoveries. One of these was the recently completed restoration of the tomb of Doge Andrea Contarini (d. 1382) in the cloister of S. Stefano. Underneath layers of grime which had completely obscured it, the gilding was still intact and, even more importantly, the colors of the face and hands had been perfectly preserved. For the moment, this is a rare occurrence which helps us to imagine what the effect might have been on other carved pieces when they were softened and finished by paint. It seems that particularly rich and varied polychrome was used on wooden carvings, especially crucifixes, many of which have survived.

Pierpaolo and Jacobello Dalle Masegne

A new chapter in Venetian sculpture started in 1380. By then the brothers Pierpaolo and Jacobello Dalle Masegne would already appear to have been recog-

Detail to left of the central arch of the western facade of the basilica of S. Marco.

Campione and his circle. In fact, the way in which the figures are posed often seems forced, with their arms glued to their body as if swaddled in their clothes. He relies on catching our attention with clever detail, especially the play of the fingers. The faces are full of pathos and remind us of Venetian mosaics of the mid-fourteenth century, those in the Baptistery, for instance. They also bring to mind paintings by the most important artist of the day, Paolo Veneziano, especially his *Pala feriale*, the weekday altarpiece, for the Pala d'Oro in S. Marco. On the other hand, all of Filippo Calendario's lessons seem to be ignored.

We may wonder what part assistants played in carrying out works of this scale. The way things worked in Venice, only subordinate craftsmen could be used, in other words, journeymen who did not have a workshop of their own. As we saw in the capitals of the Palazzo Ducale, once again the differences can be seen more in the quality than the style of the work. There is a silver cross signed by a certain Benato and which, according to the plans, should probably have been far larger. Under this we find a *St. John* which is so poorly done that it is difficult to attribute it to Jacobello. This reveals that the brothers' intention was to supply work that was consistent in style, even at the cost of sacrificing some quality.

Things are different in the sculptures that decorate the balcony of the Sala del Maggior Consiglio, started in 1399 and completed by Pierpaolo in 1404. A number of sculptors, not all of them very good, worked on this at the same time. Pierpaolo himself was responsible for only one of the surviving figures, that of *St. Theodore*. The group featuring the doge which stood in front of the lion of St. Mark was all too readily destroyed by iconoclasts. Pierpaolo's assistant who carved the *Annunciation* was undoubtedly the most talented, and it seems likely that he came from Florence where he had studied an *Annunciation* (now in the Museo dell'Opera del Duomo) in such depth that in Venice he was able to reproduce it almost exactly. This habit of having assistants carve even high-profile pieces was widespread in Venice, and it was clearly tolerated by patrons. It does, however, make attributing the overall design (rather than the execution) of complex works rather difficult. It could well be that when the Dalle Masegne brothers were given a commission to carry out a portal or a tomb, they immediately passed it down the line to someone else to do. We are therefore working on unstable ground, which makes it difficult, for instance, to find arguments to attribute to the Dalle Masegne brothers the funeral monument of Doge Antonio Venier (in SS. Giovanni e Paolo). The monument itself has been heavily reworked over the

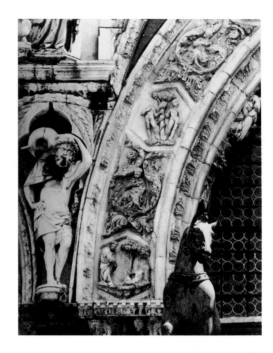

years, but the main reason for attributing it to them is that it may possibly resemble the tomb of Margherita Gonzaga (now in Mantua castle), which the Gonzagas commissioned from Pierpaolo. The recumbent figure, however, was carved by a far less skilled sculptor, perhaps from Pierpaolo's sketch. A kneeling figure of Doge Antonio Venier (Museo Correr) seems to have been carved by Jacobello, but it probably comes from the Palazzo Ducale, and certainly not from the tomb of the doge.

The Rooftop Statuary of San Marco and the Role of Florentine Sculptors in Venice

When Pierpaolo Dalle Masegne died, Venice no longer had a sculpture workshop able to turn out quality work. The countless stonecutters who used the work of Jacobello and Pierpaolo for inspiration were able only to undertake commissions of limited scope. Even the stonemason Giovanni Bon, father of the great Bartolomeo, does not appear to have shone as the author of carved figures.

Work had been underway for some time on the upper tiers of the facade of S. Marco, but when, in 1414, it was ready to be finished with a series of decorative figures, the decision was made to bring in Florentine sculptors. The first to start work were Niccolò di Pietro Lamberti and his son Pietro, along with Giovanni di Martino da Fiesole. Nanni di

Bartolo, known as the Red, only arrived in Venice in 1423. The scanty documentary records do not tell us whether any attempt was made to secure the big names of Florentine sculpture. Lorenzo Ghiberti stayed in Venice for a little while in 1424 but left no documented trace behind him. We do not know how the procurators assigned the work of crowning the three facades of S. Marco, nor who was in overall charge of the design, if indeed a design existed. It is likely that the "tabernacles," erected in 1384, and the overall design were done by a Venetian. In 1414 sources mention a Paolo, probably Paolo di Jacobello Dalle Masegne, who had helped to buy Carrara marble for the building and who was possibly also the author of the figures in the niches on the south side. Small but clearly recognizable differences in the architectural elements of the skyline decoration nonetheless give credence to the idea that contracts for each section were awarded to a number of artists.

The Florentine sculptors who came to Venice worked from their personal memory banks, probably aided by sketchbooks. In the upper arch of the west facade partial copies of a whole range of models found in Florence have been identified. It is possible that Giovanni di Martino da Fiesole carried out part of the work and was in charge. On the underside, the recently restored Prophets are the work of a number of sculptors, none of them outstanding. Despite this, we can pick out expressive hands typical of Donatello and the pathos of his bearded heads. In the poorly executed reliefs on the facade of the upper arch, the creative invention goes back to Andrea Pisano's reliefs on the campanile of the Duomo in Florence.

Attributions to Florentine sculptors of individual figures in the rooftop statuary of S. Marco is helped when we compare them to other signed works they executed in Venice and the Veneto. Pietro di Niccolò Lamberti and Giovanni di Martino da Fiesole signed the tomb of Doge Tommaso Mocenigo (d. 1423) in the church of SS. Giovanni e Paolo. The upper figures and the shape of the niches are similar to the best statues of the Prophets found on the underside of the upper arch in S. Marco. At the same time the figures on the sarcophagus resemble those on the tomb of the jurist Raffaello Fulgosio (d. 1427) in S. Antonio in Padua. This was made in 1429 by Pietro di Niccolò Lamberti with the help of an assistant. But it was Niccolò di Pietro Lamberti who carved the figure of the patron saint at the top of the west facade of S. Marco. The eight amphora-bearers, four on the west side and four on the north, were carved by four different artists. The study of human anatomy here leads to completely different results. Three of the figures on the north side have been attributed,

St. Mark the Evangelist, on the intrados of the central arch framing the large window, basilica of S. Marco.

probably rightly so, to Nanni di Bartolo; the fourth to someone from Campione. Nanni's figures stand out for their relaxed postures, unconstrained musculature, and natural balance of their limbs. The Florentine lesson has been properly learned and convincingly applied. By comparison, the two anonymous sculptors of amphora-bearers on the main facade still appear to be tied to rather stilted traditional forms.

Research has focused especially on the work of the known sculptors who were engaged on the S. Marco project. In order to pick out the work of others we would need to turn to the subtle but not always infallible instrument of stylistic criticism, and analyze the numerous sculptures that have survived elsewhere in Venice and that were presumably the work of Tuscan

ON THE FOLLOWING PAGE:
St. John the Baptist, Donatello, a splendid wood carving for the Florentine Chapel in the church of the Frari, dated 1438.

ON PAGE 139:
Tympanum over the doorway to the Corner Chapel in the church of the Frari, begun in 1422 under the provisions of Federico Corner's will. The marble lunette by the Master of the Mascoli Chapel shows the *Madonna Enthroned Between Two Angels*; at the pinnacle, *St. Mark*.

artists. Such an undertaking would be particularly arduous today since we have often totally lost the original surfaces to corrosion. It is obvious that the series of Apostles on the recently restored facade of S. Maria dell'Orto was largely the work of sculptors who were either from Tuscany or influenced by it.

But the Tuscans engaged on S. Marco and S. Maria dell'Orto were not the only outsiders whose work still survives. It is often difficult to decide whether we are dealing with imported works or if the sculptures were made in situ by itinerant artists. Only later did the stonemasons' guild try to impose strict regulations to slow down imports.

In S. Sofia we have a particularly beautiful statue of the Virgin, slightly under life-size. This comes from André Beauneveu's circle and must have been carved just before 1400. It has been compared to sculptures surviving in Courtrai, Hal, and Arbois. The stone used was not known in Venice, which confirms it was imported. Another, smaller, alabaster figure of the Virgin that is kept in the small sacristy of S. Stefano could have come over the border in the luggage of a Venetian who traveled to Paris in about the year 1420. In Venice, as in other Italian towns, we find groups of the Pietà that were carved on the other side of the Alps: one example is in S. Giovanni in Bragora. It would be fascinating to learn how this excellent sculptor, who was probably from Styria, landed the commission to make four saints for the presbytery in S. Marco. The lifelike wooden crucifix in the church of S. Giorgio, dating from around 1430, is also famous and has been attributed to Hans von Judenburg. Countless carved crucifixes, frequently the work of "German" or "Flemish" artists, have survived in Venice but have sadly never been studied. Nevertheless, it is clear that these imported pieces did not give Venetian sculptors any creative inspiration. Neither were imports from the north limited to sculptures. In 1451 someone called "Peter of Flanders," probably Petrus Christus, was paid a fee to deliver an altarpiece for S. Maria della Carità ("for one *pala* 78 ducats, and for lodgings, boats and other expenses incurred in Venice 100 ducats"). It hardly seems possible that this work of art could have gone unnoticed by Venetian painters.

The most famous imported sculpture is without a doubt the wooden *St. John the Baptist* carved by Donatello in S. Maria dei Frari. Until the signature and date were found during the most recent restoration work ("MCCCCXXXVIII OPUS DONATI DE FLORENTIA" [1438. The work of Donatus of Florence]), the date of the work had been controversial, a clear indication of the limitations of stylistic criticism. Documentary sources tell us that in 1436 the Scuola dei Fiorentini, which was just one of many

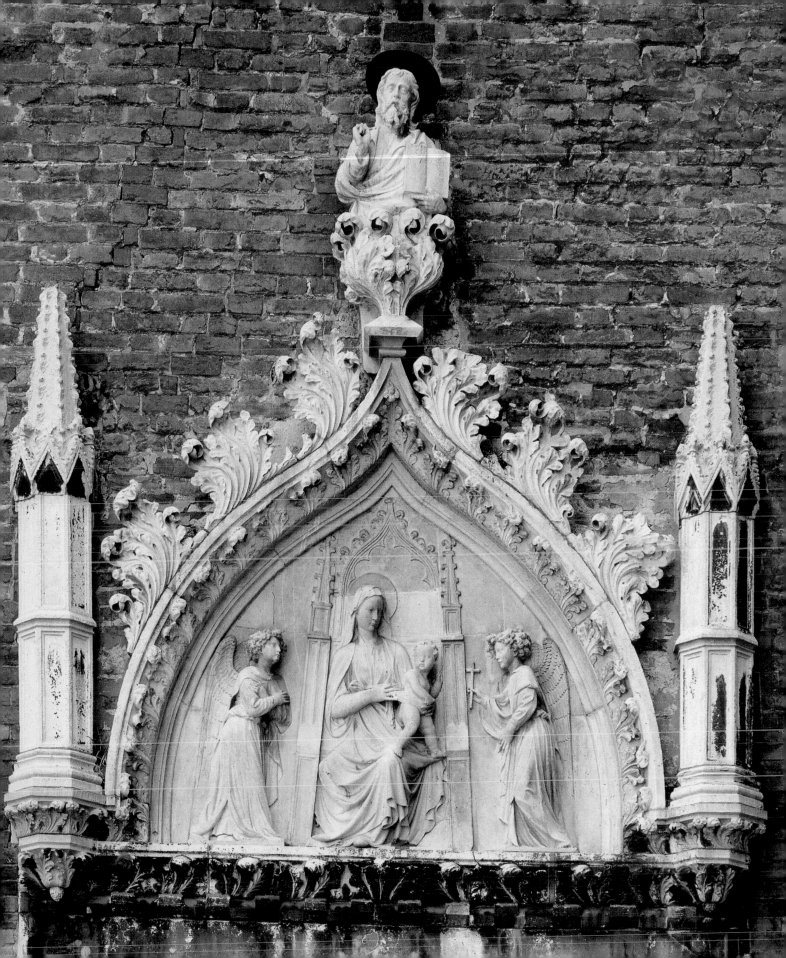

OPPOSITE:
Mascoli Chapel, basilica of S. Marco,
founded in 1430. The mosaics were carried
out by Giambono between 1433 and the mid-
1450s.

foreign community associations in Venice, purchased various properties belonging to the Franciscan monastery and was busy altering them. One of the planned alterations was the construction of an outside stairway and of "a large and magnificent door with a canopy overlooking the *campo* surmounted by the figure of St. John the Baptist with the coat of arms of Florence and the *scuola*. . . ." There appears to be no trace left of either the doorway or the figure of St. John. In the same year the monastery and the *scuola* reached an agreement about installing a "magnificent and beautiful chapel" in S. Maria dei Frari. Seven years later, in 1443, the Council of Ten confirmed the transfer of the chapel from SS. Giovanni e Paolo, where it had been until then, to S. Maria dei Frari. Documents also show that in 1450 a chapel designed by Donatello for a Venetian brotherhood was still not ready and that the artist was refusing to hand over the wax model lest his Venetian colleagues take advantage of a chance to study it. It is very likely that the chapel in question was the Florentine Chapel and that Donatello's design was for the altar destined for the aisle of S. Maria dei Frari. All this shows that Donatello's figure of 1438 was originally destined for the altar in SS. Giovanni e Paolo or for somewhere in the *scuola* itself, and that only later was it moved to S. Maria dei Frari.

Donatello interprets the saint as an ascetic preacher. Even his clothes are stiff, as if they had dried out. This impression is heightened by his raised right hand with its pointing index finger and the inscription "ECCE AGNUS DEI" [Behold the lamb of God] which winds around the scroll that the saint indicates with his left hand. The anonymous author of the polychrome paint and gilding followed the lines of the carving, correcting it in a few places. Oddly, the eyes of St. John do not both look in the same direction. We do not know whether the sculptor was working from a model or if he added this detail to make the Baptist look unusual.

The Master of the Mascoli Chapel Altar in San Marco

Venetian sculptors working in the third decade of the fifteenth century paid little attention to the Tuscan sculptures on the facade of S. Marco. A stronger influence was exerted by the works, few of which have survived, of an anonymous Florentine sculptor who is usually known as the Master of the Mascoli Altar (see p. 45). His inspiration was Lorenzo Ghiberti, or rather Ghiberti's small-scale bronze sculpture. It seems likely that he belonged to the group of people who worked on Ghiberti's first bronze door.

When working on drapery, Ghiberti had made a clear distinction between the monumental figures at Orsanmichele and those portrayed in the reliefs on the doors. The anonymous author of the S. Marco altar clothes his figures of saints in drapery of traditional Gothic style. Faces are carved in a fairly summary fashion; each line is seen as a separate feature and modeled with almost metallic harshness. The hallmark of this sculptor is his clever use of forms from Ghiberti's repertoire, but certainly not his observation of nature. For the figure of the *Madonna*, he followed a type coined by Nino Pisano for the *Madonna* in S. Maria Novella in Florence, merely adapting it to Ghiberti's style.

The same sculptor is credited with a lovely tympanum in the Corner Chapel in S. Maria dei Frari (see p. 137). Here too he used Ghiberti's work as his starting point, especially for the reliefs such as *St. Ambrose* on the first bronze door. That this work did not come from Venice is confirmed by the fact that it was made up of three plates which had to be cut down in order to fit the cornice of the Venetian tympanum.

Commissions awarded in this period often stipulated that the sculptor had to follow a particular model, not necessarily in the modern style. It seems likely that a restraining clause of this type was in the contract for the *Madonna* above the southern pulpit in S. Marco. The statue was probably installed at the same time as the figures "from beyond the mountains" were placed around the walls of the presbytery. This contemporaneity is demonstrated by a comparison of the beautiful corbels on which they all stand which were undoubtedly crafted in the same workshop. The *Madonna* of the Mascoli Chapel altar and the *Madonna* above the pulpit have many details in common. Nonetheless, they are fundamentally different: the sculptor of Venetian training who made the *Madonna* for the pulpit of S. Marco has broken free from the metallic precision of his model and given his figure greater life and a more expressive face.

Bartolomeo Bon

Reconstructions of Bartolomeo Bon's career lead to widely differing conclusions. His masterpiece, the *Judgment of Solomon* in the northwestern corner of the Palazzo Ducale next to the Porta della Carta, has frequently been attributed to other sculptors, perhaps because no one thought it possible that a Venetian could have been responsible for so fine a work. The first record we have of Bartolomeo is in 1427 when he was still working in his father's workshop and was paid for 203 days' work on the well-

Madonna, Bartolomeo Bon, on the altar of the Mascoli Chapel, basilica of S. Marco.

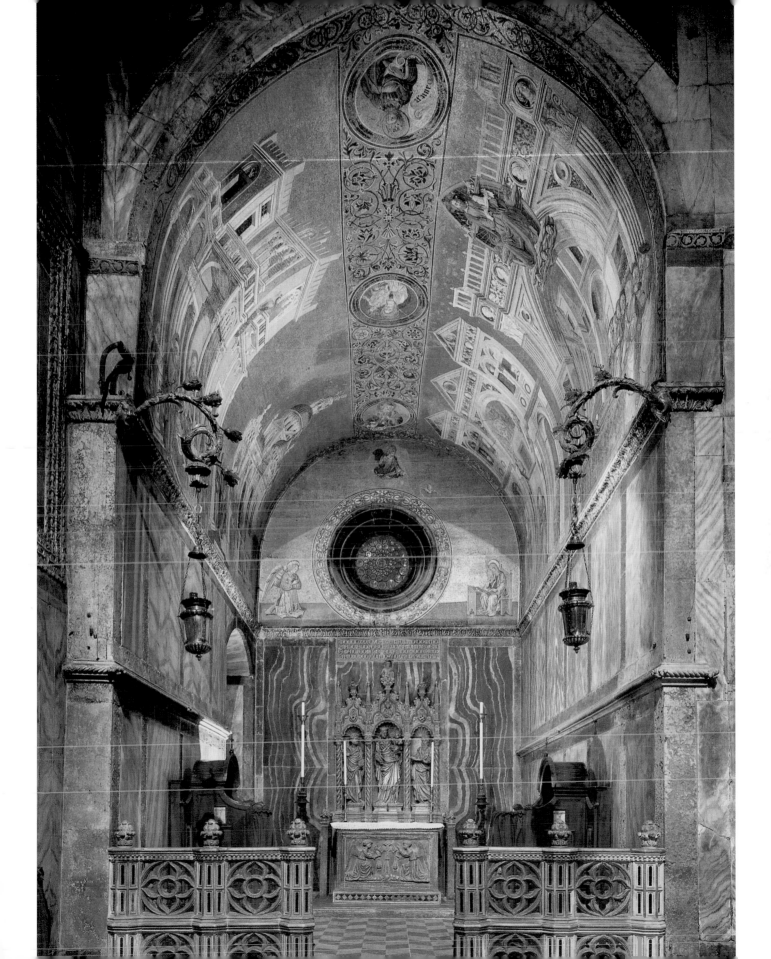

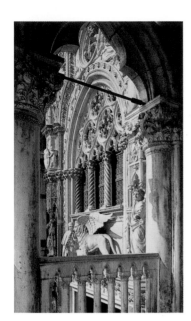

An evocative image of the winged lion of St. Mark on the Porta della Carta, seen from the loggia of the Palazzo Ducale.

OPPOSITE:
Justice, Bartolomeo Bon, part of the statuary crowning the Porta della Carta of the Palazzo Ducale.

head in the Palazzo Contarini, better known as the Ca' d'Oro. Bartolomeo chose a very traditional type, with four heads at the corners and three Virtues on the sides. We can already see the later quality of the artist's work despite the enormous weather damage which, although it may increase the charm of the piece, has destroyed its detail. The extremely lively figure of the child clinging to the figure of Charity brings to mind the child in the *Charity* sculpture in the rooftop decoration of S. Marco. Indeed, traces of that child's physiognomy are also found in the heads at the corners of Bartolomeo's wellhead. In his *Annunciation* (Liebighaus, Frankfurt-am-Main), he was still using tightly pleated drapery with endless folds and borders which he later abandoned in favor of less traditional forms.

No other sculpture can be documented either from written records or from his signature as the personal work of Bartolomeo. Even the highly visible inscription "OPUS BARTOLOMEI" [the work of Bartolomeo] on the architrave of the Porta della Carta in the Palazzo Ducale shows only that he was the author of the architectural design, not that he personally carved the individual figures. Nevertheless, not all of his clients were willing to leave the artist free to decide to whom the work of carving the figures should be given. This is demonstrated by the building contract for S. Maria della Carità in which the clients formally stipulate that Bartolomeo must undertake to carve three statues of saints (now lost) for the facade. No such restrictions are imposed on any other part of the building work even though this too, and most certainly the overall design, was awarded solely to Bartolomeo. It is hardly surprising, therefore, that Bartolomeo passed on even the relief above the portal depicting the *Coronation of the Virgin* (now in the sacristy of S. Maria della Salute) to another sculptor who drew on paintings, mainly the works of Antonio Vivarini, even if he did not actually copy a sketch made for him by a painter. It is clear that patrons rated Bartolomeo's talent highly but at the same time were aware that he did not hesitate to pass on some of the work to stonecutters of little talent.

The Porta della Carta in the Palazzo Ducale (1438–42), so proudly signed by Bartolomeo, demonstrates how difficult it is to try to reconstruct exactly what is really his work. The four Virtues in the niches were given to four different sculptors. On the other hand, the *Justice* which crowns the doorway has almost unanimously been attributed to Bartolomeo himself (see p. 143). There is good reason for this. His interpretation of the personification of Venetian justice is totally different from Calendario's: the look in her eyes emphasizes leniency, not severity, her long hair is worn loose and falls softly over her shoulders,

and beneath a thick and heavy cloak, a flimsy dress intimates the shape of her body. In the regular features of her face and the transparency of her clothing, Bartolomeo draws close to other sculptors who, in their direct confrontation with classical works, were pursuing the same ideals.

Of the group showing Doge Francesco Foscari kneeling before the lion there remains only the life-like face of the doge himself (Museo del Palazzo Ducale). It is possible that Bartolomeo did this relief himself, but it is hard to back up this attribution on the basis of comparisons with the faces of the Madonnas and the allegorical figures. The old doge is shown in profile: the skin is stretched over his head and falls loosely at his neck and cheeks; under his forehead the corners of his deeply sunken eyes and the contour of his nose are heavily wrinkled. Foscari's gaze is tense and his thin lips taut as he looks on the lion of St. Mark, the symbol of the State he had served so assiduously and which, in 1457, sent the old man packing without ceremony.

None of the four Virtues depicted on the Porta is Bartolomeo's work, but two are worthy of comment. The stance of *Temperance* and the power of her gestures set a convincing example and invite us to moderation. The economy of gesture and attitude is reminiscent of the much older work of the Master of the Months on the main portal of S. Marco. The figure of *Fortitude* has been attributed to Antonio Bregno, who would later carve the Virtues for the tomb of Doge Francesco Foscari (d. 1457) in S. Maria dei Frari. The taut, linear flow of the drapery, pleats falling straight down over the hips but wrapped tightly around the torso, provides an understandable and convincing image of strength which is vigilant even in times of peace.

One of the assistants working with Bartolomeo in this period was Giorgio di Sebenico (Šibenik in Croatia), who left Venice in 1441 to take on a sizable workload in his home town, including building its cathedral. It is interesting to examine the work he did there, not least for the light it throws on the repertory of architectural forms he brought back with him from Venice. The figures of *Fortitude* and *Temperance* on the Porta della Carta have been attributed to him on more than one occasion. I believe it is more likely that Giorgio was responsible for some of the heads on the capitals of the loggia on the side next to the courtyard of the Palazzo Ducale. These are very much like the heads on the outside of the apse in Sebenico cathedral.

In 1448 the people of Udine decided to commission a *Madonna* for their loggia comunale. They went to the man who had made and, let us not forget, signed the doorway to the Palazzo Ducale ("qui fecit

Portam Palaciam Venetiis"). Bartolomeo promptly dispatched them the work of a sculptor who had been nowhere near the Porta della Carta.

Officials in charge of building the Palazzo Ducale got tough with Bartolomeo in 1463 and insisted he finally finish a job he had begun some time earlier, including figurative sculpture. In all probability the job in question was the rooftop decoration of the Arco Foscari which had been installed in the courtyard of the Palazzo. As so often in the past, Bartolomeo was working very closely at this time with Pantaleon di Paolo, a sculptor who was highly regarded and thought by some to be as good as Bartolomeo himself. Only one of Pantaleon's works survives: a fine portrait of the scholar Jacopo Della Torre da Forlì (d. 1414), which was presumably made in 1423 (formerly in the church of the Eremitani in Padua and recently placed in storage by the Soprintendenza). Nonetheless, not one of the Arco Foscari figures has been attributed to Bartolomeo Bon or Pantaleon di Paolo, with good reason.

Bartolomeo's reputation always remained fairly high despite his habit, legitimate in those days, of getting others to carry out his commissions for him. In 1461 the architect Benedetto Ferrini was sent by the duke of Milan to recover the "most beautiful" sketch of a palace, the Ca' del Duca on the Grand Canal, started for Marco Cornaro in 1457. Bartolomeo refused to hand it over. The duke's envoy wrote back to Milan that Bartolomeo was "the first and foremost in Venice in his craft of cutting live stone."

When Bartolomeo accepted the commission to carve the *Judgment of Solomon* for the northwest corner of the new west wing of the Palazzo Ducale, started in 1424, he must have realized that he ran the risk of its being compared with Filippo Calendario's *Drunkenness of Noah* and *Adam and Eve* installed at the other two corners of the Palazzo (see p. 144). He also had to use these as his models, at least as far as the size of the figures was concerned. In fact, Bartolomeo absorbed one of the main features of Calendario's work and based his interpretation on the psychology of what the main characters are feeling: Solomon has passed judgment; the terrified mother leans forward, clasping her bosom so hard she can scarcely breathe; the executioner stands next to her, tightly grasping the defenseless child's wrist and raising his sword. At this moment Solomon makes a calm gesture which stops the arm that is ready to strike. Just as Calendario had done in the *Drunkenness of Noah*, here Bartolomeo too uses contrast as a means of expression: the tiny defenseless hand of the child resting in the rough one of the hired ruffian with his determined countenance; the physical proximity of the mother, out of her mind

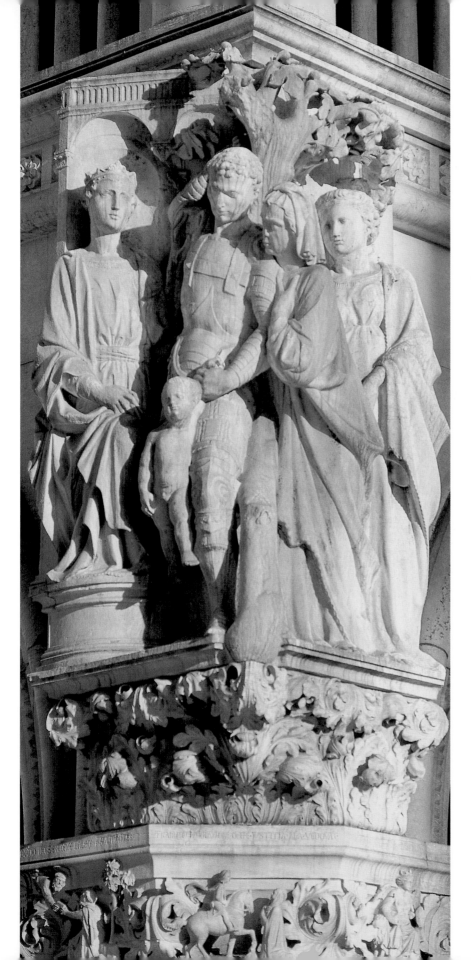

with fear, and the executioner; the noble face of Solomon, who seems to be looking into the distance, next to that of the executioner who is completely engrossed in his atrocious task. None of the other sculptors to whom this group has been attributed ever achieved such insight when interpreting a story.

For convincing reasons, nearly all scholars agree on the attribution to Nanni di Bartolo of a terracotta relief showing the baptism of Christ in the lunette on the tomb of Beato Pacifico (S. Maria dei Frari). This was carved about 1437, but while it imitates some of the figures in Bartolomeo's group it never reaches his level of artistry.

The date of the *Judgment of Solomon* has not been established. Based on what we know of the construction of the west wing of the Palazzo Ducale and the nearby Porta della Carta, it seems probable that it was carried out between 1424 and 1438, the year in which the Porta was erected. Starting from the assumption that Filippo Calendario worked on the building between 1340 and 1344, taking it to the stage where the capitals and the corner groups were in place, and that in 1355 a painting portraying Doge Falier was already on show in the Sala del Maggior Consiglio, we can conclude that the *Judgment of Solomon* cannot be much later than 1430.

Even after this, Bartolomeo continued to interact with Calendario's work. His *Justice* above the Porta della Carta does, however, lack the severity of Calendario's *Venetia*: soft, wavy hair frames an open face, the thin fabric of her clothes shape her body, her heavily woven cloak is gathered in pleats around her legs. Bartolomeo gives us an idealized image of justice as practiced in Venice; the only hint of severity is the sword.

The *Charity* that was installed above the doorway to the Scuola Grande di S. Marco following the fire of 1485 shows how Bartolomeo came up with new allegorical formulas that are full of insight and particularly fascinating. *Charity* holds two very different children in her arms, children who will doubtless have raised a smile from their public. One child, perhaps a girl, is trying to clamber down and is pushing her mother away with her arm. The other is quietly nestling his little head on his sister's shoulder. This way of adding character to the figures echoes the contrasting main characters seen in the *Judgment of Solomon*.

For a long while Bartolomeo was almost a synonym for all Venetian sculpture produced between 1430 and 1460. Later on, the number of works attributed to him was quite rightly thinned out, but no one has managed convincingly to attribute the works which, in a manner of speaking, have thus been orphaned. One of these is the beautiful relief in

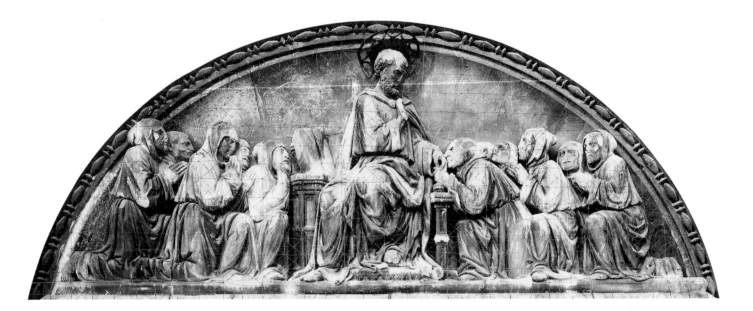

the lunette over the main portal of the Scuola Grande di S. Marco (see p. 145). It shows the goldsmith Geoffredo da Brazzo, who was head of the *scuola*, praying to the patron saint alongside nine members of the brotherhood. In the history of the *scuole*, such devotional images already had a long tradition, going back at least to the middle of the fourteenth century; there are numerous examples of surviving original work or Grevembroch's drawings. The patron saint of a *scuola* had always been depicted standing, surrounded by kneeling brothers; before this relief, only the figure of the Madonna had been shown, sitting on a throne. The anonymous sculptor of this tympanum gave each of the brothers individual features and gestures. The only bare-headed figure is Geoffredo da Brazzo, who is leaning forward to brush his lips against the saint's left hand. His own expressive hands and profiled bald head convey an image of intense devotion. We do not know when this relief was carved or the location for which it was commissioned. It certainly did not come from the main portal to the *scuola* before the fire destroyed it in 1485. The way the saint is clothed makes it unlikely that it dates from before 1450. This is borne out by a comparison with Antonio Bregno's sculpture for the Foscari tomb in S. Maria dei Frari.

Not long before this, Bartolomeo Bon had been commissioned to carve a large relief which was, until the middle of the nineteenth century, over the doorway to the (old) Scuola della Misericordia. As so often happened, Bartolomeo had passed this on to one of his assistants (Victoria and Albert Museum, London). Given the rich variety of the brothers' postures and gestures, we cannot rule out that Bartolomeo actually did the sketch for this work himself.

The reliefs of the *scuole* and the images of the investiture of the doges found on coins and sculpture have points in common. The heads of the members of the *scuole*, like the doges, are shown in a devotional posture before their patron saint. Because he is surrounded by brothers, the head is always seen as part of the institution in question, while the doge, as "first among equals," represents the Republic by himself. The author of the beautiful relief of the Scuola Grande di S. Marco has made the head's devotion to St. Mark the central theme of the work, introducing new touches including the physical proximity of the two main characters. These touches were as dear to Bartolomeo Bon as they were to the anonymous author of the portrait of Vettor Capello in the lunette of the portal in S. Elena. The relief was originally installed in the portal of the new entrance to the Scuola Grande courtyard in the church of S. Giovanni Evangelista and was carved in 1480 by an assistant of Pietro Lombardo (Berlin, Staatliche Museen, Stiftung Preussischer Kulturbesitz). What it demonstrates, however, is that such expressive intensity failed to become widespread. Bartolomeo has also left us other works that document his artistic journey: an intense study of the works of the Master of the Mascoli Altar; then, separated only by time, his study of Calendario's work; and his cautious approach using classical forms. In later life it appears that Bartolomeo spent most if not all of his time on architecture. Works such as the Ca' del Duca on the Grand Canal, the portal to SS. Giovanni e Paolo, and part of the Arco Foscari make him the founder of a specifically Venetian school of Renaissance architecture.

Wolfgang Wolters

Adoration of St. Mark, relief in the lunette of the main portal of the Scuola Grande di S. Marco.

OPPOSITE:
Judgment of Solomon, Bartolomeo Bon, sculptural group on the corner of the Palazzo Ducale opposite the Porta della Carta.

Painting in Fourteenth-Century Venice

From the Thirteenth to the Fourteenth Century

At the beginning of the fourteenth century a new trend was starting to emerge in the figurative arts in Venice, at the time still under the influence of Byzantine tradition. A few artists were beginning to pick up some of the innovations already found in Italian painting but were applying them mechanically to a Byzantine background that remained substantially unchanged. Alongside this, there was another

Crucifix painted on wood by a Venetian painter of the first half of the 14th century. Venice, Museo dell'Istituto Ellenico.

OPPOSITE:
St. Donatus, central section of large wooden polychrome and gilded altarpiece, dated 1310; a collaborative work executed by a group of artists from several workshops. Murano, church of SS. Maria e Donato.

trend that firmly resisted new ideas and remained loyal to more orthodox iconography. This can be seen in the *Virgin and Child* in the *Accademia*. In contrast, Italian and, more specifically Pisan, influence explains some of the detail on the *Casket of the Blessed Juliana of Collalto*, which dates from about 1290 (see p. 80), and in the *Madonna Suckling the Infant Jesus* (in the Museo Marciano) (see p. 78).

Even the few surviving frescoes seem to reveal the same two trends: on the one hand, a realistic "Romanesque" conception; on the other, a more markedly Byzantine approach. In the first category are the badly damaged frescoes in the Orlandini Chapel in the church of the SS. Apostoli, with the *Deposition from the Cross* (see p. 146) and *Deposition into the Sepulcher*. The date of these works is very uncertain, with estimates varying from the end of the thirteenth century to the end of the fourteenth. Their strongly popular spirit is the same that characterizes the surviving but barely legible fresco fragments of the life of Christ recently discovered in the *andito Foscari*. In the second category are the wall paintings found in 1945 in the chapel to the left of the presbytery of S. Giovanni Decollato. The *St. Helena*, heads of the *Four Saints*, and *Annunciation* have been compared to the frescoes in the church of the Holy Trinity at Sopoćani in Serbia and are among the masterpieces of Byzantine painting of the second half of the thirteenth century (see p. 79).

This Byzantine figurative culture was not without followers in Venice, if the Master of Caorle, who is documented in 1374, can be considered a late example. It is quite likely that this culture traveled from the Serbian and Macedonian hinterland through the Venetian ports on the other side of the Adriatic and thence on to Venice itself. Although a different visual effect is created by the different materials and techniques used, nonetheless there are stylistic similarities between the *St. Helena* and the *St. Donatus* altarpiece in the church of SS. Maria e Donato on the island of Murano, the first dated work in the history of Venetian art (see p. 147). It was executed in 1310 by artists from various shops all working together to produce what today we would call a "mixed technique" piece in which painting plays a marginal role.

The central figure, carved and painted, is of imposing grandeur reminiscent of that of the *Blessed*

Leo Bembo, the central figure in the altar front, which has also been attributed as an early work of Paolo Veneziano; dated 1321, it is now in the church of S. Biagio in Dignano in Istria. If the *St. Donatus* altarpiece is unique, it is not, however, the only collaborative work that has survived. This type of cooperation between workshops was common and reached its height with the three-dimensional painted crosses which Venice produced in quantity. They were nearly always of superb quality, and it is possible that workshops outside Venice were involved, introducing artistic influences other than those of the painter himself. This is the case with a Tuscan-style crucifix recently discovered in the Frari and with a crucifix moved from S. Samuele to S. Stefano and attributed to Paolo Veneziano. There are many other documented instances of these in other parts of Italy: the crucifix in S. Maria in Trivio in Rome and that in the church of S. Domenico in Ragusa (Dubrovnik) are both Venetian, the latter also in the style of Paolo (Veneziano).

One of the most monumental of these crucifixes, even though its lower lobe is damaged, is in the Museo dell'Istituto Ellenico (see p. 146). The way in which the Virgin and St. John hold their hands to their cheeks to signify sorrow is typically Byzantine. The crucifix bears close similarities to a fresco in the priest's house of the church of S. Nicolò dei Mendicoli which has quite correctly been classed as a Byzantine work. Together, these show the merging of those two trends that seemed so divergent in the SS. Apostoli frescoes on the one side and those of S. Giovanni Decollato on the other. The highest quality example of the emerging trend, a synthesis of innovation and Byzantine tradition, is the Kress *Coronation of the Virgin*, dating from 1324. Here a strong Byzantine undercurrent is tempered by a decidedly Western concept of space similar to that in the mosaic *Crucifixion* in the Baptistery of S. Marco or in the other Venetian crucifix on panel, in S. Marcuola. These works, especially the Kress *Coronation* and the Museo Ellenico crucifix, allow us to pinpoint the cultural matrix of all of Paolo Veneziano's work. It is not by accident that both works have been ascribed to him, even though it is more likely that they were by his immediate precursor; they are probably the work of the master of Master Paolo. This could well have been his elder brother Marco or even his father Martino.

The new current, with its "strictly conformist" iconography and "Balkan gloominess" survived intact well beyond the middle of the century. These are indeed the specific characteristics found in the *Dormition of the Virgin* in S. Pantalon, a work that cannot be attributed to Paolo but rather to a workshop active around the middle of the century (see p. 148).

Paolo Veneziano

Paolo became the official painter of the Republic. In 1339–40 he painted a portrait of Doge Francesco Dandolo for a lunette in the church of S. Maria dei Frari. In 1345, when Andrea Dandolo was doge, Paolo and his sons Luca and Giovanni produced the cover for the Pala d'Oro. In January two years later he was paid for an altarpiece, now lost, for the church of S. Nicolò inside the Palazzo Ducale. He may be the same Paolo who was commissioned by the Signoria to gild and paint the processional throne used on the feast day of the Marys and to do maintenance work on it.

For some critics, Paolo grafts Gothic figurative culture onto a Byzantine stock. By the turn of the century this figurative culture had already arrived in the Veneto region thanks to Giotto. This means that for his day Paolo was modern: in other words, he was a painter with Western taste and culture. But his technique is not Western since he continued to employ the more sophisticated methods used in the Byzantine techniques in which he was trained. For other critics, however, Paolo is still completely rooted in Byzantine tradition even though he takes on board stylistic elements, forms, and figurative hints from contemporary mainland painting.

Those favoring the former interpretation will underline all the "Gothic" features found in Venetian painting from the earliest years of the fourteenth century (for example, the Bembo altar front, or the Kress *Coronation*). Those who prefer the latter interpretation will obviously cling to the fact that not all Paolo's work contains "Western" features. But the language of Gothic art does not necessarily clash with that of Constantinople. Where Gothic is expressed with graceful suppleness by means of technical precision and refined linearism, which are also found in Byzantine art, the clash is avoided. Suffice it to look at the mosaics in the church of the Holy Saviour in Chora or those of Fethiye Cami in Istanbul which certainly provided the highest expression of the art of the Palaeologan court.

When inserted into a Byzantine context already disposed to receive them, Gothic elements refine shapes, soften physiognomies that would otherwise remain stereotypical, and dilute the degree of repetitiveness imposed by a "modular system." In short, in Paolo's activity, documented from 1333 (polyptych of the *Dormition of the Virgin* in Vicenza) to 1358 (*Coronation of the Virgin*, Frick Collection, New York), it seems that the transition was made from an art still tied to Byzantine modulism to a more markedly Gothic style with a certain continuity; it is certainly true that Paolo's later works are much more Gothic than his early ones. If we take

into account work other than painting, by the middle of the fourteenth century Venetian figurative culture was already "courtly" in the broad sense. Nonetheless it had no reason to turn its back on the way in which it conceived and executed its painting, no reason to give up such a rich inheritance as that of the mosaics in S. Marco.

With regard to the construction of figures, techniques and compositional methods, these mosaics were indeed used as a model by the "modern" mosaic artists who decorated the basilica in the thirteenth century. Later on, Giotto could not avoid being part of this culture, which he may have modified but did not replace overnight. Giotto could only achieve that instantly in those places where there were no existing traditions, no "school," just devout or poor monks and clerics, small-time artisans with no gild to unite them who painted everyday objects or filled empty space on the walls without any ambition, as Dante said, to "lead the field" with an art that did not yet exist.

If Giotto was the first real painter not only in Tuscany but also in the whole of the Po valley, he was not the first in Venice where, if anything, it was the refinement of Sienese art that formed a bridge between the stiff, formal Byzantine world and the courtly, mannered Gothic one.

Perhaps this is the perspective we should use to interpret Paolo Veneziano, the greatest of the fourteenth-century Venetian painters. He knew as much as anyone how to "renew himself" by drawing directly from the best of antique painting with its refined, unreal colors, like precious enamels, which characterized the court of Constantinople. He knew that Venice could not bear to feel left behind. He was drawn by the fascination of neo-Hellenism with all its early freshness, and he combined this with the Gothic innovations that began to influence Venetian art at the beginning of the fourteenth century.

We have no idea if, for him, it was more noble to be Greek than Italian. Perhaps we can guess that perhaps, in some way, it was. Nevertheless, his language relates to the "Latin." Petrarch, who set great store on Latin culture, preferred Simone Martini's painting even to Giotto's and must have therefore viewed the Sienese master as a "Latin." Petrarch appreciated Simone's characteristic refined and formal elegance, his Byzantine sensibility which lingered almost to his last works. These attributes were not, therefore, "Greek." Nor indeed could the people of Siena, who bore Duccio's *Maestà* [Christ in majesty] in procession into the cathedral, have felt that the painting they were carrying was old-fashioned or "Greek." As far as they were concerned, it spoke to them in Latin. It was later, starting in the

OPPOSITE:
Presentation at the Temple and *Dormition of the Virgin*, mid-14th-century workshop panel. Now housed in the church of S. Pantalon.

St. Clare polyptych, Paolo Veneziano. Venice,
Gallerie dell'Accademia.

Renaissance, that historiographers gave the label *alla maniera greca* [in the Greek manner] to all painting earlier than, or, in Siena, contemporary with, Giotto. But those writing when the painter was still alive viewed things very differently. True, it was Giotto who "transposed the art of painting from Greek to Latin," but the contemporary commentator Cennino Cennini, often overlooked, said that he "reduced it to modern terms." To sum up, for those writing history in his own day, Giotto did not speak in Latin, but in the vernacular. It is precisely this use of the vernacular that gave the learned and aristocratic Petrarch cause for reserve.

The same refined aristocratic elements are also found in Paolo. It is probable therefore that to his contemporaries, even to Petrarch, he appeared less "Greek," or Byzantine, than we think today. He was attracted to a type of noble form that could not be separated from its noble subject. In other words, he looked not only toward the ideals of the Palaeologan court, but also to those of the court of Doge Andrea Dandolo, the person responsible for commissioning the *Pala feriale*.

Paolo's special greatness lies precisely in this fusion, neither a juxtaposition nor a layering but rather a synthesis of cultures. We know that he was active in the period of the Dandolo doges, Francesco (1329–39) and Andrea (1343–54), whose offices were briefly separated by Andrea's brother-in-law Bartolomeo Gradenigo (1339–42). It was under the Dandolo that Venice appears to have shifted to a full-blown signoria. Through a process of institutional evolution, this form of government had already taken over from free city councils in other cities, especially those of northern and central Italy. Andrea gave shape to the modernization of the palace begun by his predecessor. He was a learned man, a friend of Petrarch, and it was with him that the "myth of Venice" was born. The court, in the prehumanist sense of that term, gravitated around him, as the "count of virtue." It is no coincidence that halfway through the fourteenth century, when the papacy had already been in Avignon for several decades, it was Venice that, in Italy, emerged as the most important center for the spread of Provencal and French culture. While this culture became a reference point across Europe for sculpture, it attained one of its noblest and most refined achievements in illuminated miniatures, almost exclusively the territory of learned and literate men. Just as the 1340s were drawing to a close, the greatest undertaking in the history of Venetian sculptural-figurative art of that century was beginning, the highest expression of Gothic forms that already were essentially courtly—the sculpted decoration of the capitals in the Palazzo Ducale.

Toward the end of the 1330s, after the death of Doge Francesco Dandolo, Paolo produced the lunette for his funeral monument in the church of the Frari. This is perhaps the work where Byzantine influence comes under greatest pressure from the drive toward figurative renewal. The Virgin's hips slide forward in a typically Gothic *hanchement* which contrasts with the movement of the child. The precious drapery, a regular feature in Paolo's portrayals of the Virgin, has no equivalent in Byzantine art and seems cautiously to allude to a space where the image of a throne would have been all too obvious. The figures of the main characters have a dignity and intensity absent from the *maniera greca*. The "Greek manner," however, can still be clearly discerned in the faces, classically Byzantine, of the angels holding the curtain, in the typology of the Virgin, "both powerful idol and solemn matron," and in the use of modular forms, which rule out the possibility that there are any portraits of real people (as can be seen from the fact that there are two identical St. Elizabeths).

It is the continued presence of this Byzantine influence that gives rise to debate over the date of the *Virgin and Child* in the Canossian (Daughters of Charity) convent of S. Alvise. It does seem reasonable, however, to include it in a series that runs from the Crespi *Madonna* of 1340 almost up to the *Madonna di Carpineta* of 1347.

We do not know when the two Chioggia polyptychs were used as a support for a late Renaissance altar. One is undoubtedly from Paolo Veneziano's school while what remains of the other, that is to say, the central panel with the *Virgin* and two side panels with *St. Peter and St. John the Baptist* and *St. Paul and St. John the Evangelist*, are by Paolo himself, possibly with some help from his workshop.

In any case, as far as art in the fourteenth century is concerned, the master used his pupils in the same way as he used the tools of his trade. Each pupil carried out his orders and instructions to the letter, convinced that such obedience would in turn permit him to grasp all the secrets of the master's art. Giving responsibility to the workshop, therefore, did not mean settling for lower quality because standards were guaranteed by the authority and personal involvement of the master himself. Venetian painting and Paolo's workshop were all ruled by the working methods imposed by the gilds of the day. This is why it is so difficult, if not downright impossible, to tell the master's work from that of his apprentices. Icons, for instance, were effectively produced by a production line: one person painted faces, another drapery, the third did the decoration, a fourth gilded the backgrounds, and so on. If the *Pala feriale* is signed by

Paolo and his sons Luca and Giovanni, is it not also possible that the monumental *St. Clare* polyptych in the Accademia could have been done by Paolo's workshop (see pp. 150–151)? Here Paolo was able to use Gothic solutions not just in his treatment of figures or folds of drapery, but also in the adoption of Western iconographic motifs, such as the halo over the Virgin's head and the cloth that the angels hold over her shoulders. Paolo substitutes a Gothic polyptych with trilobe arches for the traditional forms of the curtain (*antependium*) and icon with lateral scenes. What strikes us above all about the central panel is the "worldly" pomp that makes use of affectations which are not exclusively Eastern—or at least they are neither antithetical to nor ignorant of courtly art.

On the other hand, in the side panels of the same polyptych which depict events from the lives of St. Francis and Christ, the artist was unable to bring the two artistic tendencies together. Paradoxically, here his half-digested Giottesque language makes him less "modern." Although the Giottesque narration may look like a timid step forward, against a backdrop of improbable and old-fashioned landscapes this new scenic space is stiff with traditional formulaic rules, clearly seen in the *Last Supper*, and *Resurrection*, and in the stories from saints' lives in the upper section.

The Mosaics in the Baptistery and in the Chapel of San Isidoro

During Andrea Dandolo's dogate, attention focused on a radical reconstruction and mosaic decoration of the Baptistery in S. Marco, which was definitely finished before the death of Dandolo, the last doge to be buried there.

The mosaic artists of Venice were kept busily at work throughout the fourteenth century. In 1301 we find them in Florence, attracted by the Arte dei Calimala; in 1308 they were back in Venice, at work on the church of S. Barnaba; in 1319 they were in the church of S. Nicolò inside the Palazzo Ducale. Venetian workers were called to Prague between 1370 and 1372 to add the Last Judgment to the decoration on the Golden Porch of St. Vitus' cathedral. Around 1382 they were commissioned to execute the lunette over Andrea Morosini's tomb in SS. Giovanni e Paolo.

The highly complex cycles of work on which Dandolo spent huge sums of money (and which can now hardly be made out at all owing to heavy-handed nineteenth-century restoration work) fill all three rooms of the Baptistery. They may have been

the product of several creative artists who produced the cartoons for the mosaics. If scenes such as the *Dance of Salome*, *Banquet of Herod*, and *Beheading and Burial of St. John the Baptist* reflect the kind of modern culture that Paolo represented in Venice, other scenes make us think that different workshops must also have been involved. The problem of attribution is complicated by the fact that two masters, the *imaginarius* [designer] and a *tessellarius* [mosaicist], both played a part. It was the latter's job to turn

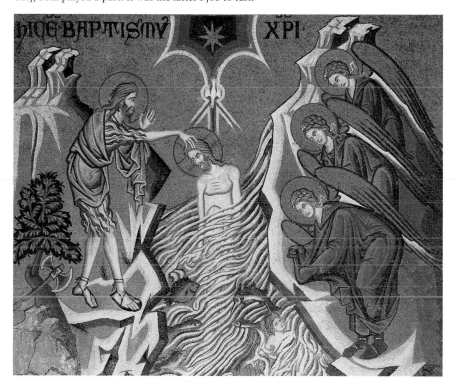

the images provided by the former into mosaic. Each brought with him his own tradition and culture. By the very nature of the material used, the finished product was more striking and longer lasting than the images shown in the sketch. Even if we assume that there was only one *imaginarius*, a number of *tessellarii* would still have had to translate his images, "painting" them with small stones and pieces of glass, interpreting their given theme with images that were not merely mechanical translations. This contrasts with what was to happen two centuries later when their craft was reduced to little more than the mechanical rendition of a painter's ideas.

The mosaics in the chapel of St. Isidore are equally, if not more, interesting. We learn from the mosaic inscription above the altar that they were

Baptism of Christ, Master of the Baptism of Christ, mosaic in the Baptistery of S. Marco.

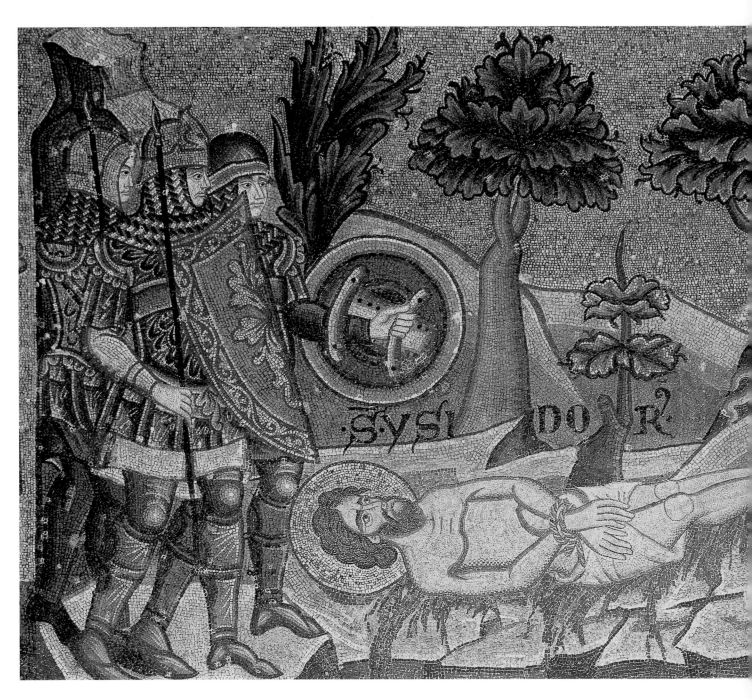

Martyrdom of St. Isidore, mosaic from the chapel of S. Isidoro, basilica of S. Marco.

started when Andrea Dandolo was doge and Giovanni Dolfin was among the procurators of S. Marco. This dates them to after 25 April 1350, when Dolfin was elected to office. The whole building, including the decorations, was finished in "ANNO MCCCLI MENSE IULII DIE X" [On the tenth day of the month of July in the year 1351]. The mosaics

from this work, which have survived almost intact, are close in style to those in the Baptistery, in particular the scene of the Baptism of Christ (see p. 153). In some of the scenes, however, the physiognomies have far greater realistic vigor and express emotions absent from the Baptistery figures. Here the faces are full of dramatic, often tragic, tension, underlining an

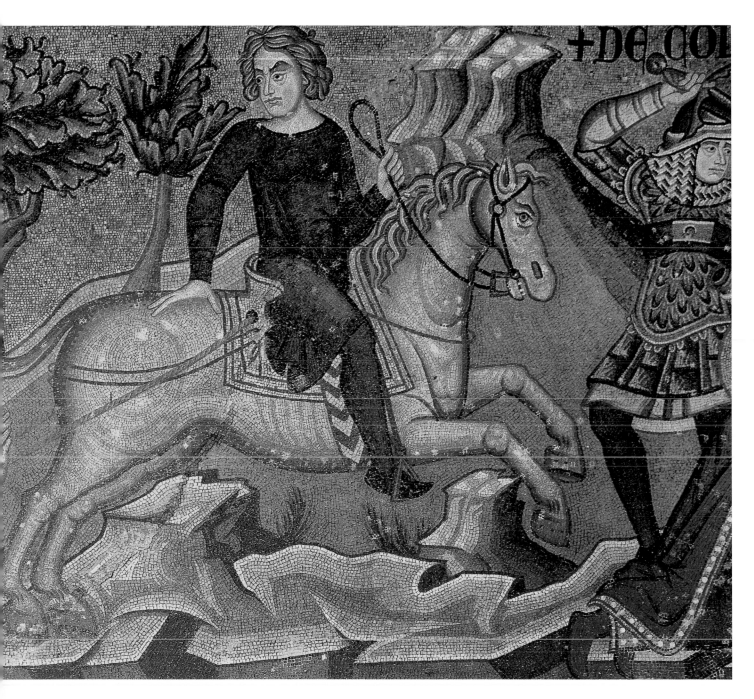

enormous range of feelings. Their gestures, which are sharp and dry, are set off by fantastical, unreal, and fairytale landscapes that are meticulously described as in chivalrous poems.

Perhaps the recent end of the plague, with all that must have implied for the collective imagination, conjured up images of the divine punishment of sin.

Its repercussion in art was an accentuation, through the very choice of images represented, of all that is tragic in the human condition. Perhaps it was necessary to inject new blood into the workshops and yards. As the old masters died they were replaced by new artists who were more up to date in the way they interpreted a culture which until then had only really

been mastered by miniaturists or sculptors, in particular those who at this time were employed in the building work on the Palazzo Ducale. The new iconographies also stemmed from contacts with other art forms and artistic experiences about which we do not have sufficient archival material. These included statues, jewelry, goldwork, and tapestries. Some of these would have originated north of the Alps, but we can assume that they found their way to Venice because we catch echoes and reflections of them in the work of Venetian artists. In fact, the way stories are unfolded along the walls is reminiscent of the color choices and techniques used in tapestry where blues and dark greens predominate. Similarly we find echoes of the *horror vacui* [abhorrence of emptiness] that drives artists in all genres to fill their scenes with images.

The forms these masters give to their figures are still true to tradition: drama, psychological tension, human anatomy, and the landscapes shown are all expressed in the Byzantine language, the only language in which Venice's most ancient art, mosaic, could be expressed. Nowhere else, perhaps, can we so clearly see the dichotomy between what the artist is trying to show and the manner in which he shows it.

Guariento

Venetian painting could only make a true leap in quality by experimenting with new or renewed techniques, principally fresco, which in Padua, no longer a foreign city, had since the early years of the century proved its ability to construct a new language and at the same time bypassed culturally backward Venetian fresco painters, such as, for example, those who worked on the Orlandini Chapel.

The experience of Giotto at the Arena Chapel, with its contribution of new techniques, led to the creation of a flourishing school in Padua with Giusto and Guariento. By the middle of the century Guariento was already at work on the fresco decoration of the tombs carved by Andriolo de Santi for Ubertino and Jacopo da Carrara (1351) in S. Agostino, and Carrara went on to do the same in the palace and chapel, perhaps after Jacopino, Jacopo's younger brother, had taken power.

By the start of the 1360s, Guariento was in Venice where he painted the now lost lunette over the tomb of Doge Dolfin as well as the frame that surrounded it; a few figures still survive on the left-hand wall of the presbytery in SS. Giovanni e Paolo, to one side of the Vendramin tomb which replaced the Dolfin tomb. A few years later, when Marco Corner was doge (1365–68), Guariento painted the most ambi-

Coronation of the Virgin, or *Paradise*, Guariento, two fragments of an ambitious fresco painted c. 1365–68 for the Sala del Maggior Consiglio in the Palazzo Ducale. The work was almost completely destroyed by fire in 1577.

tious fresco yet to be done in the city: the *Coronation of the Virgin*, also known as *Paradise*, was the work most admired by contemporaries. It was in the Sala del Maggior Consiglio and covered the entire area now occupied by Tintoretto's imposing canvas of the same subject. The fresco was damaged beyond repair by fires in 1576 and 1577, and until the beginning of this century it was believed lost. Although the edges are badly damaged, what remains, in fact, is the drawing, so altered as to seem almost like a photographic negative. The fresco is currently being restored, and it will be a great achievement even if we get nothing more than a general idea of how this enormous pictorial undertaking might have looked before the fire, at a time when, according to Savonarola, "on Ascension Day . . . so over-

whelming a number of citizens congregated to enjoy and admire such a divine creation that the chamber was scarcely sufficient to hold them. . . ."

There was a profusion of colors in the figures, of gold and silver in the haloes and scrolls which announce that the whole of the Christian heaven is here. Saints, beatified souls, angelic hosts, Prophets, and patriarchs are ranked in rows around the central figure; from a distance these rows appear to run off from a rhythmic scansion of Gothic arches, arches

that delineate a specific environment, recalling those actual arches that had only just been built as part of the portico in the Palazzo Ducale. In the center there is a grandiose, complex construction of precious marble tracery, almost like lacework. More than a throne, this construction seems to aspire to be the very apse of a basilica. Here, high on a pedestal overflowing with figures, niches, and slender columns, sit the Virgin and Christ. At the sides, two additional constructions, fantastical in conception, simultaneously imposing and airy, conclude, in space as well as in content, the first truly Gothic poem in the history of Venetian art. And it is completely Gothic: the aristocratic detachment of the figures together with the individual definition of their faces, the fascinating angels with their assorted expressions, and even the articulation of the spaces with the minute description of precious architectural forms. This particular attention to architecture and sculpture, the two arts practiced by Andriolo de Santi, who worked so often with Guariento, has a very specific meaning in the way in which the artist defines physiognomies. It proves the degree to which he was able to keep himself current by looking to other forms of expression, borrowing ideas that would prove essential if Venetian painting were to move on toward the future.

It is hard to say why a painter who was not from Venice should have been commissioned to carry out such a high-profile task, one of such great official importance: "Marcus Cornarius dux et miles fecit fieri hoc opus" [Marco Corner, doge and soldier, had this work made] read a now lost inscription. Perhaps Corner, who certainly gave Guariento other commissions in the Palazzo (the *Battle of Spoleto* and the *Arrival of Alexander III in Venice*), played a more important part than the scanty documents suggest in directing such innovative decision-making. Perhaps the presence of Petrarch in Venice from 1362 also swayed the choice. Then again, perhaps there was no one from Venice herself technically able to take on such a huge and complex commission using a technique other than mosaic, which was traditionally reserved for religious buildings. And finally, perhaps the time was ripe for the Signoria to demonstrate, through hiring a foreign painter, that it was wedded to its political choice of conquering the mainland and, in particular, of controlling Padua and the Carrara dominions.

Whatever the reasons, the fact remains that with Guariento, Giotto's painting arrived in Venice. For the first time the figurative culture of the Republic speaks in neither Greek nor Latin but in the vernacular. If this was not the vernacular of Dante, it was that of Petrarch. If the choice had been on Guariento,

Deposition from the Cross, fresco in the Orlandini Chapel, SS. Apostoli.

it was because he was the least traumatic of possible choices from Paduan circles. Especially during the 1350s, as a painter Guariento had used iconographic and compositional themes from Venice, perhaps even from Paolo Veneziano's own work. We can see them in the severity and fixed neo-Byzantine quality of his faces, in his propensity toward an elaborate overemphasis on decoration, very clear in the *Angels* now in the Museo Civico but is also evident in his work in the Carrara Chapel in Padua. But on the other hand, it was precisely the Gothic refinement that runs throughout his work and his "formal courtly reserve" which make him the painter who, although "always and fundamentally Giottesque," was also the least foreign, the most understandable to the Venetians and their way of seeing painting. For all these reasons, during the last three decades of the century Guariento was a catalyst. Among those who followed on from him, perhaps the highest note was struck by an unknown fresco artist who was more mature, more "modern" than Guariento himself. This artist created a magical world which was little more than a mutilated sinopia but which recent restoration has revealed once more: it provided the background to the tomb of Michele Morosini in SS. Giovanni e Paolo. This monument to a doge who reigned for only four months was the most ambitious of the whole fourteenth century. It provides the most individual and meaningful example of how, with varying degrees of success, different techniques compete to produce a unique work in which architecture, sculpture, fresco, and mosaic all blend together. Thanks to the work of the better or best of the two or more sculptors who carried out the plastic elements, here we have a work which is open to the "modern manner" while still clinging to substantially

Byzantine ideas in the work of the sensitive mosaic artist. But there is also here a timid acknowledgment of expressive realism which is the hallmark of artists at work in Venice at the close of this century. To sum up, this is the precursor of the magical architecture painted by Pisanello or Giambono. This fresco artist takes up and enriches Guariento's theme of Paradise, reminding us of Altichiero since his Gothic language reaches a similar level of maturity.

Lorenzo Veneziano

The more traditional current not only managed to live alongside the new ways, but did not even seem to perceive the need to change. It continues along the path laid out by Paolo Veneziano. But there was one exception. It must, in fact, have been in Paolo's shop that Lorenzo was a pupil, taking on board the master's most modern and innovative ways. Between 1357 and 1359 Lorenzo was commissioned by Domenico Lion to carry out the monumental polyptych that used to be in S. Antonio di Castello. Although this is his first known work, we must assume that a commission for such an important altar, which was being carved by a certain Master Zanino, would not have been awarded to an artist who was not already established. Scipione Maffei of Verona recorded that he owned one of Lorenzo's panel paintings, the subject of which is unknown, dating from 1356, and there are two other works in Verona which are definitely by Lorenzo: a monumental *Stations of the Cross*, today in S. Zeno, and a fresco, now detached, showing the *Madonna of Humility with St. Dominic and St. Peter the Martyr* in S. Anastasia. We can assume that these works predate the commission for the Lion polyptych and that Lorenzo had spent some time at the court of Cangrande II della Scala when Verona seemed particularly interested in Venetian figurative culture. In Verona he would also have been able to update his own work through contact with the new trends coming in from the Venetian hinterland and the rest of the Po valley. It would have been easier to achieve this here than in Venice which was still dominated by Paolo. Nor can we rule out suggestions that he was influenced from beyond the Alps, in particular by the *dolce stile* [sweet style] of Bohemia. The Lion polyptych already foreshadows the grandiose architecture of the Dalle Masegne altars. The ambiguity between Gothic and Byzantine that we find in Paolo's work is here resolved in favor of the former. Every element of the polyptych—from the tiny saints who decorate the walls and the pilasters that appear more suited to the facade of a Gothic church than to a frame to the

Monumental double-tiered polyptych painted for Domenico Lion, Lorenzo Veneziano, formerly in S. Antonio di Castello and now in the Gallerie dell'Accademia. Completed between 1357 and 1359, the work exhibits Gothic elements which outweigh the Byzantine influence of Paolo Veneziano.

central figures painted against the background of a space which the base of the throne seems to want to define—vibrates with a sense of courtly grace and gentleness. The painting's beauty is enhanced by the light, gemlike colors with rich nuances used for the splendid drapery that falls in elegant folds over supple bodies of courtly beauty, like that of St. Mary Magdalene.

Like Paolo, from time to time Lorenzo also faltered. This is apparent in the *Enthroned Virgin* in Padua's Museo Civico. The work dates from 1361 and almost seems a sweet Bohemian Virgin expressed in Venetian.

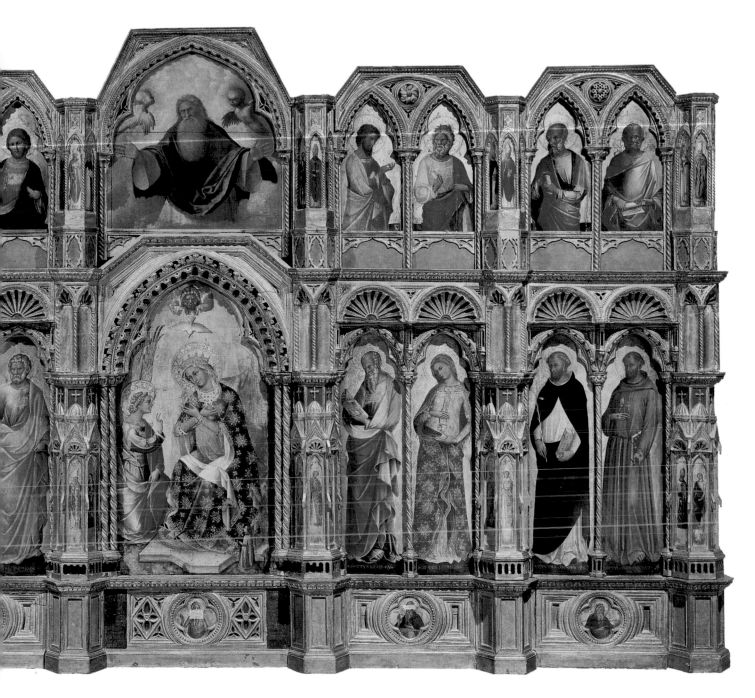

In contrast, in 1366 Lorenzo seems to be searching for a compromise with his former master's language in the *Proti* polyptych in the cathedral of Vicenza. This is especially true in the most important, central section where the saintliness of the figures portrayed seems to repress the artist's desire for freedom of expression. It must be said, however, that Lorenzo may have been inhibited by his theme, the dormition of the Virgin, since Paolo had treated it thirty years earlier in another Vicenza church. Nevertheless the work does have exquisitely Gothic features in some of the saints who are portrayed as warriors, although

they look better suited to amorous combat than soldierly battle; iconographic tradition required that they not be depicted differently.

In the dismembered polyptych with St. Peter, dated 1370, the central panel (in the Museo Correr) is set out in the monumental manner and uses space in a neo-Giottesque fashion, perhaps borrowed from Giusto; this contrasts with the sprightly narrative style, reminiscent of Giovanni da Bologna, found in the *Scenes from the Life of St. Peter* on the predella panels, now in Berlin. Less than a year later the *Annunciation* polyptych shows a flowering meadow

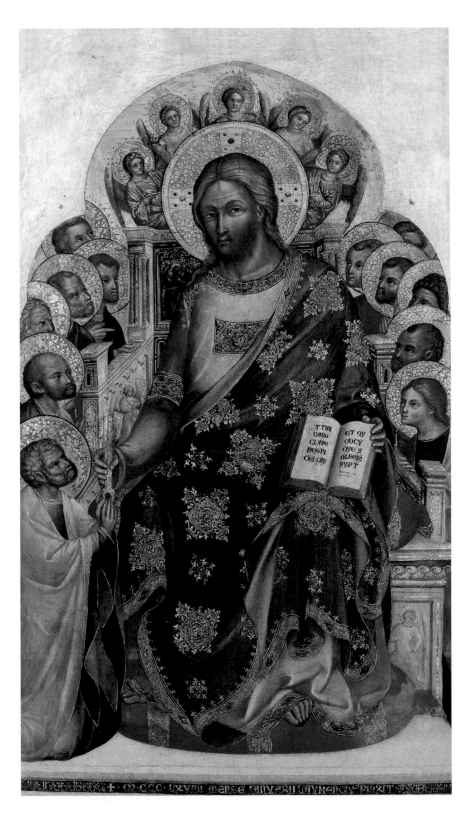

at the feet of the saints and the Virgin and, for the first time in Venice, we have the truly courtly theme of the walled garden, the *hortus conclusus*.

Lorenzo's style has a truly elegant rhythmical cadence and accentuates the value of contour and gold-painted backgrounds. Gold remains, in effect, the only tangible memory of that way of painting from a past which in Lorenzo seems remote.

Renewing the Tradition

At first Lorenzo's art did not find much of a following among his contemporaries or immediate successors. Perhaps this was because he often worked away from Venice and none of his colleagues was able to develop his ideas, despite the stimulating presence of Guariento. In this connection, the case of Jacobello di Bonomo is typical. In his polyptych in S. Arcangelo di Romagna, he handles his figures with a solid, archaic plasticity and formal austerity which makes him the champion of the conservatism that runs through Paolo's shop, judging by the only work we possess by his son Marco, the *Madonna of Humility*.

The *Coronation of the Virgin* in the Accademia is stiff and rigid (see p. 161). Dating from 1375, it is signed by Catarino, a painter who followed rather haphazardly in Paolo's steps. He was unable to reconcile his archaic, formal Byzantine training with the figurative proposals put forward by Lorenzo. In Catarino they merely lead to an empty over-emphasis on decoration which becomes an end in itself. He often worked with another painter called Donato, and they signed various panel paintings together. Catarino always signed second, making us think that he was subordinate to his colleague. The panel painting of the *Coronation of the Virgin* in the Querini-Stampalia Gallery is signed by Donato together with Catarino and dated 1372, that is, immediately after Guariento finished his huge fresco on the same subject for the Palazzo Ducale. The archaisms in the painting lend elegance to the composition, with its rhythmical upward movement, giving an aristocratic felicity to the color which is far removed from the rather plebeian effect achieved by Catarino's cruder but better documented colleague.

Far more convincing and "modern" (by now this term has acquired a specific meaning in Venice) is Nicoletto Semitecolo who tried to tread a path somewhere between Paolo Veneziano and Lorenzo. His main tools were his palette and his adherence to the more expressive "mainland" current. These provided him with the means to introduce substantially new ideas into an otherwise static environment.

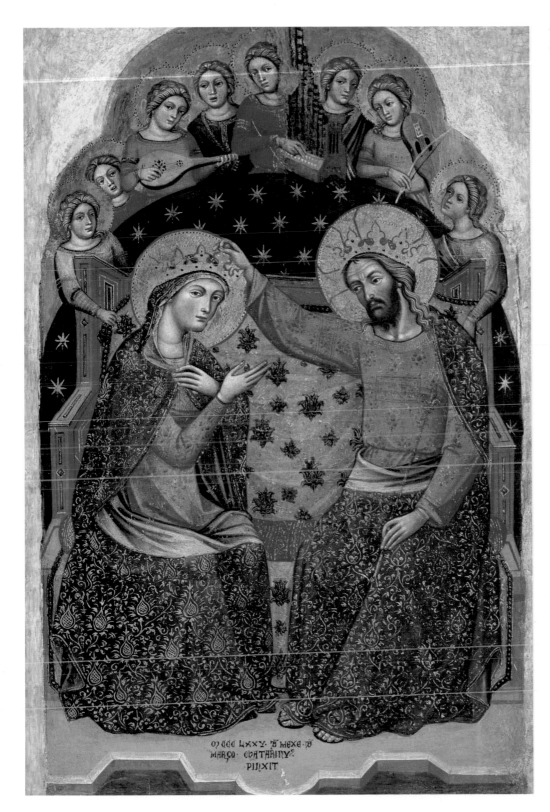

Coronation of the Virgin, Catarino 1375.
Venice, Gallerie dell'Accademia. A rare work
by this artist.

Semitecolo's only certain surviving work dates from 1367, a reliquary which has since been dismantled. It showed scenes from the life of St. Sebastian, the Trinity, the Madonna of Humility, and St. Sebastian and St. Daniel. These are now housed in the sacristy of the canons of the Padua cathedral, a city in which he lived for some time and where he may have worked with Guariento. He seems to express himself in a Gothic language with strong realistic accents. The best example of this is a panel painting that recently appeared at auction, *Dead Christ Between the Virgin and St. John*, originally from the same reliquary. Eight round frescoes showing the symbols of the Evangelists and the doctors of the Church, which have unfortunately been ruined by bad restoration work, come from a more complex cycle that Sansovino wrote about. They were executed in 1370 for the chapel of the Holy Face at the Servi (the present Istituto Canal) and are the only surviving trace of this painter's work in Venice.

Giovanni da Bologna reinterpreted Lorenzo's work. Giovanni is recorded at work in Venice from at least 1377 to 1389 and, as far as we can see, he was culturally Venetian. This belief is fostered by the *Madonna of Humility* polyptych in the Accademia. Later on, however, Giovanni's activity seems to show less interest in decorative elements of Venetian origin and moves toward more markedly plastic forms. This development is in line with trends in painting on the mainland at the end of the century.

Another painter influenced by Lorenzo is Stefano Plebanus (perhaps a parishioner and not the parish priest or the canon) of S. Agnese. His art ranges from the *Enthroned Virgin* of 1369, in the Correr Museum, to the *Coronation of the Virgin* of 1381, in the Accademia, and the refined *Virgin and Child* central panel of the high altar in the chapel of S. Tarasio in S. Zaccaria (see p. 164). With regard to this last work, the expression *sacra conversazione* between a solicitous and sweet mother and an attentive and affectionate child proves its appropriateness. At the sides of the throne "armrests" are formed by two small mock-sculpture angels (clearly he learned this lesson from Guariento who was using the same device in Padua in the 1350s). This is the first time mock sculpture appears in the history of Venetian art, and it is something that would later be taken up by Nicolò di Pietro. Apart from the two saints at the sides, Stefano is also credited with the three panels that may have belonged to the original polyptych (now lost). If the central panel, with its *Holy Martyr*, is reminiscent of Lorenzo's late work, the two side panels are even more so, thanks to the expressive gestures of the small figures who act out the scenes from the life of St. Thomas à Becket with the same

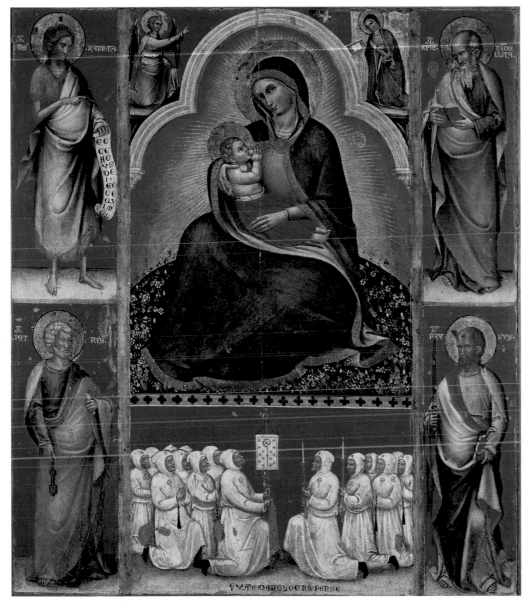

*Madonna and Child with Saints and the
Brethren of the Scuola di S. Giovanni
Evangelista*, Giovanni da Bologna, panel
painting. Venice, Gallerie dell'Accademia.

vivacity—almost elegant miniatures—that Lorenzo had used to narrate the scenes from the life of St. Peter.

It seems precisely from a miniaturist workshop that the unknown artist emerged who painted the *Coronation of the Virgin* (Accademia), of such popular and ingenuous taste. The history of art is also made up of these lesser masters, and we must not overlook them. Their production is seen in countless examples of portable altars of varying size, nearly always for private use, which allow us to glimpse the trends and see the preferences of a larger

and less official body of patrons who also commissioned artists in their day (see p. 171).

Towards the Quattrocento

The last Venetian painters of the fourteenth century point us back toward Padua, the city that Guariento came from. The only signed work we know of by Jacobello Alberegno, the *Crucifixion* triptych in the Accademia, must be placed in the context of Giotto's influence. In its style and iconography the

Virgin and Child with Saints, polyptych on
the high altar of the chapel of S. Tarasio,
church of S. Zaccaria.

Predella panels of the polyptych on the high altar of the chapel of S. Tarasio, church of S. Zaccaria.

Apocalypse polyptych (Accademia) makes specific and precise reference to the Florentine painter Giusto, specifically to his frescoes in the Baptistery of Padua cathedral (see pp. 166, 167). The affinity is so strong that the work has even been attributed to Giusto. If, as seems almost certain, the work must really be ascribed to the Venetian Jacobello Alberegno, it shows how much even conservative Venetian circles had opened up to the figurative culture of the mainland. This can be seen even better in a painter such as Nicolò di Pietro who in 1394 signed and dated the Belgarzone altarpiece (Accademia). The son of a painter called Pietro whose work we do not know, Nicolò must have been familiar with the Bologna since not only had this already been documented in Venice in the last decades of the fourteenth century but altar painters in Venice were receptive. Ten years after the Belgarzone altarpiece, Nicolò signed the Verrucchio crucifix together with a carver called Caterino Moranzone. There can be little doubt that he paid attention to the master carvers with whom he worked so closely. Within the limits of the formal suggestions of the times, this type of attention paid by a painter to sculpture could have been the source of the naturalism that we find in the *Apostles* in the Barberini Gallery in Rome which foreshadow Masaccio in the way they fit in between niches that seem too narrow.

International Gothic

By the start of the fifteenth century Venetian figurative language had been softened by the delicate stylistic elements that Paolo Veneziano had introduced. With Guariento, Lorenzo, and their succes-

sors it was then increasingly free of Veneto-Byzantine iconography. It was coming into line with the pictorial culture of International Gothic, one of the most intense and fascinating chapters in the history of European art. The term itself is admittedly artificial and generic. It is nonetheless useful in defining that common language which in the painting of the age is characterized by naturalism in the way even the smallest details are treated. These details are carefully observed and rendered with a voluptuous sensibility through the imaginative flow of a linear rhythm that evokes an unreal, fairytale world. As far as Italy in general and Padua in particular were concerned, the courtly environment was on the whole synonymous with a signoria, or government by a lord or prince. The court provided the ideal place for this type of art to flourish, and Venice, despite her idiosyncratic form of government, proved to be a center no less valid than the others.

On 1 December 1400 Michele Steno was elected doge. History has perhaps concentrated too much on his military undertakings and political successes to pay sufficient attention to those aspects of his culture and personality that made him the ideal successor to Andrea Dandolo. He was someone who could pick up the inheritance of finishing the palace renovation that had been started half a century earlier and had continued under Marco Corner. Steno was a cultivated, refined man who was sustained by a high opinion of himself and of the dignity invested in him. Perhaps it was not a coincidence that just four days before he was elected doge, the Senate approved a resolution which stipulated that in official audiences the title *Dominus* [Lord], which used to be given to the doge should be replaced by *Missier* [Master]. It also ruled that the doge, like all other citizens, would be subject to taxation.

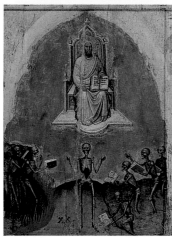

Apocalypse polyptych, Jacobello Alberegno, four panel paintings. Venice, Gallerie dell'Accademia. Above: *Whore of Babylon* and *Last Judgment*; opposite: *Harvest of the World* and *Four Horsemen of the Apocalypse*.

A series of events favorable to the Venetian Republic occurred during Steno's time in office. On 3 September 1402 the fifty-year-old Gian Galeazzo Visconti of Milan died suddenly at Melegnano. This, and the subsequent vacuum of power within Galeazzo's dominions, led first to the Carrara family conquering Verona, which had been a Milanese possession. But then on 22 June 1404 Verona, a stronghold of the della Scala family, capitulated to the Venetians. Precisely five months later, on 22 November, Padua, the last bastion of Carrara crumbling power, was occupied. In a very short space of time Venice expanded her land frontiers into Friuli to the east, around Belluno to the north, and as far as the gates of Brescia to the west. She had become the largest and most feared territorial power in northern Italy without having to give up—indeed using favorable diplomatic agreements to strengthen—her dominion over Istria and Dalmatia.

These are the years in which the "myth of Venice" became a tangible reality. The merchant classes were numerous and widespread and liked to express their taste for splendor, showing off their opulent fabrics, gold, and jewelry in which Eastern influence was clearly discernible. Gilds and religious confraternities vied to outshine each other in displays of riches and power. Public festivals became grandiose affairs that lasted for days and months on end. The festivities marking Doge Steno's inauguration lasted well over a year. There were balls, fairs, and bull fighting. During this time the Compagnia della Calza was founded. After the victory over the Genoese at Zonchio in 1403, so many bonfires were lit on the Piazza that they actually melted the lead between the bricks of the bell tower. On 22 May 1407 the feast of Corpus Christi with its grandiose and fascinating ritual was instigated. Michele Steno's time in office was littered with military victories and diplomatic successes. It seems to have been one long succession of splendid and festive occasions. This continued under the next doge, Tommaso Mocenigo, with the scarlet-clad members of the goldsmiths' gild turning out on horseback in the Piazza to celebrate his succession. The lords of Mantua and Ferrara took part in the tournament that followed.

The rulers of the small but splendid courts of Fabriano, Sanseverino, Camerino, and Urbino had by now gravitated into the orbit of Venice, or were otherwise attracted to it as they had been to Gian Galeazzo Visconti. In this period they enjoyed a privileged position with Venice with regard to the figurative arts. In short, under Doge Steno, Venice not merely became the natural heir to the courts of the Carrara and the della Scala families, but also the reference point for most of the signories of central

and northern Italy, at least as far south as Florence. And from all over Italy and Europe miniaturists, sculptors, and painters converged on Venice. Among them we can think of Michelino from Lombardy, Gentile da Fabriano from the Marches, Pisanello from Tuscany, the Frenchman Giovanni di Francia, or even Zanino di Pietro.

Steno's wish was to finish the palace renovation started half a century earlier when Filippo Calendario had been the great architect and sculptor working on the Palazzo Ducale. Twenty years later Guariento had been the first great painter to work in the Sala del Maggior Consiglio. This was the Sala Nova that between 1400 and 1405 Jacobello and Pierpaolo Dalle Masegne had enriched by adding a large balcony overlooking the Molo. In 1406 Steno, who was known as the *dux stellifer* [star-bearing leader], had its ceiling painted as a star-strewn sky.

On 25 May 1409 the Great Council decided that the State should also pay for all the painted decorations. Apart from the *Paradise*, these were to include at least paintings of historical events and a series of portraits of doges previous. Owing certainly to the meager funds originally voted for the purpose—nonetheless two hundred ducats—two years later another resolution was passed allocating the same amount again. This suggests that the work to be done was far more extensive than can be deduced from the document that stated it was to "repair and adapt the paintings of the Sala Nova."

By 1415 the work must either have already been finished or been nearing completion because a new commission was authorized, this one for a monumental stairway leading up to the chamber. This stairway would replace the previous one which had become too small and narrow for the large number of visitors who wished to admire the "marvelous building noted for the fame of its great beauty and for the excellence of its work."

At last on 30 July 1419 the chamber was solemnly inaugurated with the investiture of Francesco Foscari who succeeded Tommaso Mocenigo. In these years, therefore, all the painted decoration of the Sala Nova, then the largest non-ground floor room in the world, was completed; its magnificence had no equal.

The theme of the painting cycle was drawn from another glorious moment in the city's history. Woven with legendary deeds, it narrated the story of how Pope Alexander III came to Venice to seek protection against Emperor Frederick Barbarossa. It told how the doge helped the pope and showed the subsequent naval victory of the Venetians over the emperor and the capture of his son Otto. It then depicted Frederick's visit to Venice to beg the pope's forgiveness, which was granted. It showed how peace was

made and the pope, emperor, and doge setting off for Rome together. Here, therefore, is an iconographic program designed to bolster the myth of a city which placed herself on the same level as the two greatest powers on earth and surpassed both of them thanks to her intrinsic strength and its military might. These, however, were always shown as part of the pursuit of a peace for which Venice longed and struggled. The figure of the doge represented the surety of this peace.

The documents contain no detailed description of the subjects of these paintings, nor the names of the painters who were to execute them. We know from Bartolomeo Facio (1456) that Gentile da Fabriano painted the scene of the naval battle off Punta Salvore and that Pisanello painted both a storm scene and one in which the emperor's son is begging his father in front of many onlookers, including the future doge Andrea Vendramin. The expressions of the people in the crowd, we are told, were very varied and their postures so realistic that those who saw the painting were inspired with wonder.

It is clear that such a large-scale pictorial undertaking must have involved quite a number of other painters too. They must have been resident in Venice at the time because these scenes were executed as frescoes. The involvement of foreigners like Gentile da Fabriano, already extremely famous, and Pisanello suggests that the most renowned and contemporary painters of the day both from Venice and elsewhere competed for the work. This theory is indeed confirmed by a choice made by the Paduan Guariento who, according to Vasari, actually chose the "Florentine" Antonio Veneziano as a colleague when he began painting the decorations.

There are two sources that tell us about Gentile da Fabriano. An undatable one reports that he was a member of the Scuola di S. Cristoforo at S. Sofia. The other, dated 27 July 1408, reports that he was paid for an altarpiece by Francesco Amadi. Nevertheless, it seems very likely that Gentile's Venetian stay may have started a couple of years earlier, if for no other reason than he already appears to be well-known by the time this was written, as proved by the price he was paid for the commission.

Another prestigious name in Venice in 1410 was Michelino da Besozzo, "the most excellent of all the painters in the world." He provided a recipe for ultramarine blue to Giovanni Alcherio, a tireless traveler and writer from Milan who had settled down in Burgundy in the service of the duke of Berry. That Michelino's presence in Venice was neither isolated nor fortuitous is proved by the fact that a few years later he was engaged by the Corner family to provide miniatures for the epistles of St. Jerome,

which bears the date of 1414 on its frontispiece. Also attributed to him are the frescoes in the lunette of the funeral monuments to Marco and Giovanni Thiene in the church of S. Corona in Vicenza; these establish the length of time Michelino stayed in the Veneto and what he did there. His activity corresponds to the decade between 1405 and 1415, that is, between the year in which he did the frescoes in S. Corona and the execution of the miniatures for the epistles. He may also have been responsible for other works, such as the frescoes of S. Vincenzo di Thiene.

Jacobello del Fiore was already at work in the Palazzo Ducale by January 1412. On 1 May 1415 he finished a commission for a Venetian law court of the *Lion Passant of St. Mark* which was to become the prototype for so many later versions. In 1421 he painted a triptych for the Palazzo Ducale (now in the Accademia), portraying *Justice*. These works convey the image of a court painter of the kind it is easy to believe Paolo Veneziano had been in the days of Francesco and Andrea Dandolo. A perfect ideological and cultural thread does indeed link the Dandolo with Steno and the painters under their protection. These painters were always the most current interpreters of the most modern and vital artistic ideas in a Venice that was in no respect behind the times.

Jacobello was born between 1370 and 1380 and was still in Venice in 1400. He appears to have left for Pesaro the following year where he painted the S. Cassiano polyptych. He may have stayed in the Marches for several years, and it is probable that while he was there he got to know Gentile da Fabriano and suggested that he go to Venice. Documents show that Jacobello himself was back in Venice by 1407 and from there shipped the Montegranaro triptych to Pesaro and perhaps also a crucifix carved by Antonio di Bonvesin for the church of Casteldimezzo. His polyptych of the *Blessed Michelina* was probably carried out in 1409. A will and a whole series of later documents correcting it show that between 1409 and 1411 he must often have been away from Venice but that he returned before 1412, probably to work as a fresco painter in the Palazzo Ducale, but he alternated the work with panel paintings such as the Misericordia polyptych (in the Gallerie dell'Accademia) which may date from 1416. The *Lion Passant* dates from the year before.

Nothing more is known about the painters engaged to work on the Sala Nova. The frescoes themselves deteriorated rapidly. Their restoration turned into a complete reworking when in 1474 the Signoria gave the task to another court painter, Gentile Bellini. And later still, everything was lost, destroyed by fire in the 1576 and 1577 fires which

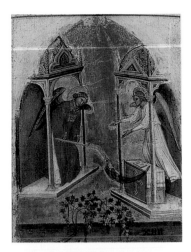

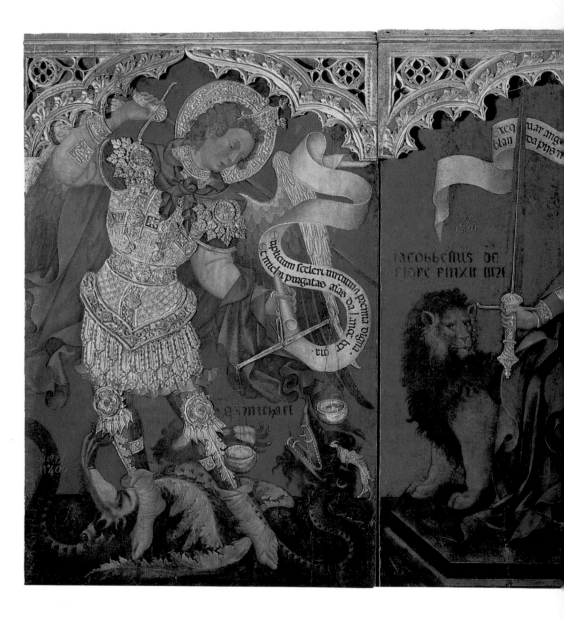

Justice triptych, Jacobello del Fiore. Venice, Gallerie dell'Accademia.

devastated the Palazzo and Sala alike. The presence of Gentile and Pisanello, with the strong probability that Michelino and Jacobello were also involved, is enough in itself to make us think that the decoration of the Sala Nova must have been the grandest, most ambitious, most "modern" pictorial monument in the whole of northern Italy in the opening years of the Quattrocento.

And yet apart from the few recorded works of Jacobello, none of the work of the two other artists, who easily outclassed him, has survived in Venice even though they must also have carried out work for private clients. Indeed, if any trace of the work of these painters in Venice has survived at all, it is only thanks to non-Venetian patrons who commissioned their work and had it sent on to them outside the city. Without a doubt, Michelino's language may have been difficult to understand, but in such a cosmopolitan city he must have received much encouragement. He may have been in Venice when he painted a work that represents the pinnacle of International Gothic, the *Mystical Marriage of St. Catherine* (Siena, Pinacoteca). We must admit, however, that he failed to find a following. This can be seen from the Vicenza frescoes mentioned already and his activity in Venice and the Veneto. His was a culture that was already breathing in Venice before he got there: when Nicolò di Pietro moved toward the miniaturist's art

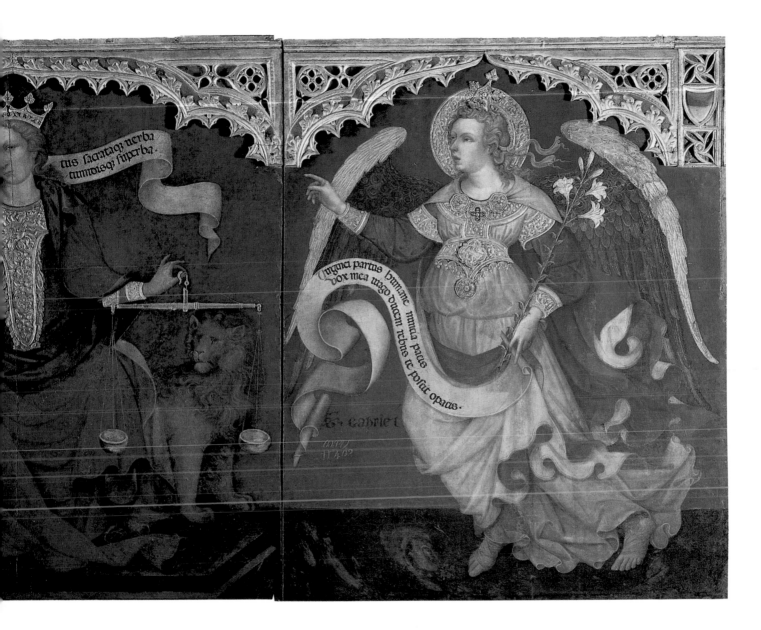

in works such as his small *Virgin and Child* (Cambridge, Mass., Fogg Art Museum), he reveals his attraction for the same kind of world and the same kind of coded, abstract elegance.

The person who was really to play a major part in educating a whole generation of Venetian artists was Gentile da Fabriano. A series of unrelated external facts confirms this. We know that Jacopo Bellini called his firstborn child Gentile in honor of a man whom he considered to be his teacher and master. This was written on the fresco crucifix that he painted in 1436 for the chapel of St. Nicholas in Verona cathedral, which was lost in the middle of the eighteenth century. Furthermore, it is very probable

that when he was in Venice, Gentile was commissioned by Chiavello Chiavelli, the ruler of Fabriano, to paint the Valle Romita polyptych (Milan, Brera). This work is definitely later than 1405 but earlier than 1412 when Chiavelli, who was in Venice at the head of a band of mercenaries, died.

The theme of the *Coronation of the Virgin* is Venetian. The grassy carpet at the feet of the saints is Venetian and goes back to Lorenzo. The starry skies that appear on the arcosolium of the doges' tombs are also Venetian. The earliest are on the tomb of Michele Morosini in SS. Giovanni e Paolo, which dates from the start of the 1280s. While the *dux stellifer*, Michele Steno, was in office, these starry skies

St. Chrysogonos on Horseback, Giambono, in the church of S. Trovaso. The saint is portrayed as a young knight in one of the most fascinating images of International Gothic.

became the leitmotiv of his reign. The first known date that confirms Gentile in Venice is 1408. In that year Francesco Amadi chose him to carry out an altarpiece commission against competition from Nicolò di Pietro. Gentile already enjoyed an uncommon degree of fame and prestige in Venice, the echoes of which were still resonating in Sansovino's day.

Perhaps the most careful and precise interpreter of the International Gothic manner was Zanino di Pietro. He has recently been identified with Giovanni di Francia, son of Pietro Charlier. It is under this name that he appears in Bologna from at least 1389 to 1403, although it is certain that four years later he was back in Venice. It is not possible to say how long he had been living there when, as a *habitator Venexiis* [resident in Venice], he completed a triptych, signed Zanino, for the Franciscan monastery at Fonte Colombo near Rieti with the inclusion of a crucifixion (Rieti Museum). The work must belong to the painter's earliest Venetian period since it shows close affinities with the work that Gentile da Fabriano did in the first decade of the century. On the other hand, Gentile's influence can be more clearly identified in the Torcello iconostasis where it is almost as if Zanino became a slavish imitator of Gentile's aristocratic elegance.

There is no doubt about the determining role on the work of the Venetian painters played by the great Lombard miniaturist who was known by the name of the Maestro di San Michele di Murano. It may be to him, rather than to others who were more specifically painters, that we owe that process of increasing naturalism which from the 1420s onward appears to have become the dominant feature of Venetian painting. There is no other way in which we can explain why those who see the smiles, expressions, and postures portrayed by Pisanello in his fresco in the Palazzo Ducale still react with such admiration. It is precisely along these lines that the unknown master who was responsible for the *Scenes from the Life of St. Benedict* worked. Three of these scenes are preserved in the Uffizi Gallery in Florence and one at the Poldi Pezzoli museum in Milan, one of the most intricate and fascinating junctures in the history of Italian courtly painting.

We are still far from agreeing on the identity of their author even though it is clear that whoever it was must have been a major player in his day. The cultural climate is the same as that which feeds the art of Giambono, who, in the frescoes that surround the Serego tomb, dated 1432, in S. Anastasia in Verona, demonstrates a command that blends sculptural strength with the anxieties of Late Gothic into figures that also possess the aristocratic elegance of a

Pisanello. Giambono may have been born in Treviso and seems to have trained in Venice in the circles of Jacobello, Zanino, and, above all, Gentile da Fabriano and Nicolò di Pietro in whose shop he may have been given his very first jobs. Even Giambono, the artist who best synthesizes the complex situation of Venetian painting in the first half of the fifteenth century, does not come up with coherent solutions. In a way his lack of resolution is perhaps the most intriguing aspect of his art which is often translated into the harmonious synthesis of two apparently antithetical needs. His architecture is ambiguous and irrational. It tells beautiful Gothic fairytales by means of unreal and fantastic buildings in which we are unable to calculate the space. And yet, especially in the mosaics of the Mascoli Chapel in S. Marco, which Giambono started after 1433 and finished some twenty years later, it seems that this language falters. It is as if the same gnawing doubt which in this period was also eating away at Paolo Uccello and Andrea del Castagno in Florence (both of them were to come to Venice when Giambono was still working there) began to undermine his instinct and forced him to listen to the need to make things more believable, to make spaces more habitable. His association with Paolo and his knowledge of what Andrea was doing in Venice must have given even more fuel to this inner rage, which comes out in the way that he treats his figures: the Madonnas, slender ciphered forms, embellished with gold and brocade, holding a child too heavy for them; the statuesque saints of the *St. James* polyptych, lost in reverie; the monumental *St. Chrysogonos on Horseback* in the church of S. Trovaso which exerts a gentle fascination underlined by the standards, flags, and golden background (see p. 170). These are works of the highest level in which the painter still manages to consider the art of Gentile and Pisanello with a formal robustness which, unknown as it was in courtly art, both oppresses and fascinates him. However, in the *Coronation of the Virgin* altarpiece (Accademia), this magical balance seems to have broken. Bodies are robust in size, emphasized by drapery sculpting their shape, faces characterized by intense expressions, combine to make us feel that new times are on the way. They announce the imminent end of a world that still survives in the supporting figures, in the details that are sometimes dealt with in a mawkish fashion, in the colors as bright as jewels and enamels, or in the profusion of gold. It is a world holding fast, but one whose end is near.

Sandro Sponza

Portable altar, late-14th-century. Venice, Museo Correr.

Between Humanism and Renaissance
Architecture Between Humanism and Renaissance

Lion on the left of the Arsenal portal. Tradition has it that the lion, which was looted from Greece and brought to Venice in 1692, used to guard the harbor at Piraeus.

OPPOSITE:
Entrance to the Arsenal, 1460. This entrance to the huge Arsenal complex is thought to be the first Renaissance work in Venice. The central arch is surmounted by the lion of St. Mark; the statue on the tympanum is *Justice* by Girolamo Campagna (1578).

During the eighty years between 1450 and 1530 an extraordinary series of architectural and cultural events took place that were destined to leave a truly deep mark not only on the face of the city, but also on future developments in the very language of Venetian art. Toward the middle of the fifteenth century, the brothers Marco and Andrea Corner, from one of the richest and most powerful families in the Republic, gave the architect Bartolomeo Bon (or Buon) a commission for a palace on the banks of the Grand Canal. Its size and splendor were to eclipse every other private residence in the city and were to introduce to Venice a completely new kind of architectural language. We can only begin to glimpse this marvel from the fragment that was completed of what for Venice would have been a vast structure: this fragment is the large-columned rusticated foundations of the so-called Ca' del Duca (now Palazzo Corner-Spinelli) near S. Angelo (see p. 179).

Almost simultaneously, a new, tradition-breaking monumental entrance was being built for the Arsenal (see p. 173). Even today we do not know who the architect was. It is certain, however, that he drew his inspiration from the Roman triumphal arch in Pola, a Venetian dominion on the other side of the Adriatic.

The unfinished Corner-Spinelli palace and Arsenal entrance are useful examples that show the two points of departure in a sequence of cultural events that plays a major role in Venetian history. These two points mark the start of a season of linguistic experimentation and a search for middle ground between a respect for, and a return to, native architectural tradition, and the use of the antiquarian and moral authority of classical architecture. It would be an unacceptable simplification to put the essential eclecticism of the Ca' del Duca on the same plane as the philologically rigorous idea—however blandly or perhaps naively applied—of the Arsenal entrance. Nevertheless, a number of features and strong reasons of a basically ideological nature push into a single experimental pool two undertakings that on the surface appear to have little in common. Tradition and innovation seem to be fundamental to the whole episode under examination. But, we are entitled to ask ourselves, which tradition? And what kind of innovation? There is no doubt that the concept of tradition was surrounded by wide-ranging cultural references. Indeed, there was room for Rome and for Byzantium, for Aquileia and Ravenna. There was room even for those who wanted to recreate "early" Venetian culture, the culture of her origins. Legend had it that as early as the fifth century it was the Emperor Justinian's celebrated general Narses who had founded the first Venetian churches. Nor did it seem that the late classical exarch tradition or that of Ravenna were opposed to, or out of step with, the character of classical antiquity.

With regard to innovation, Venice felt the pull of Florentine and Lombard lessons, thanks to the

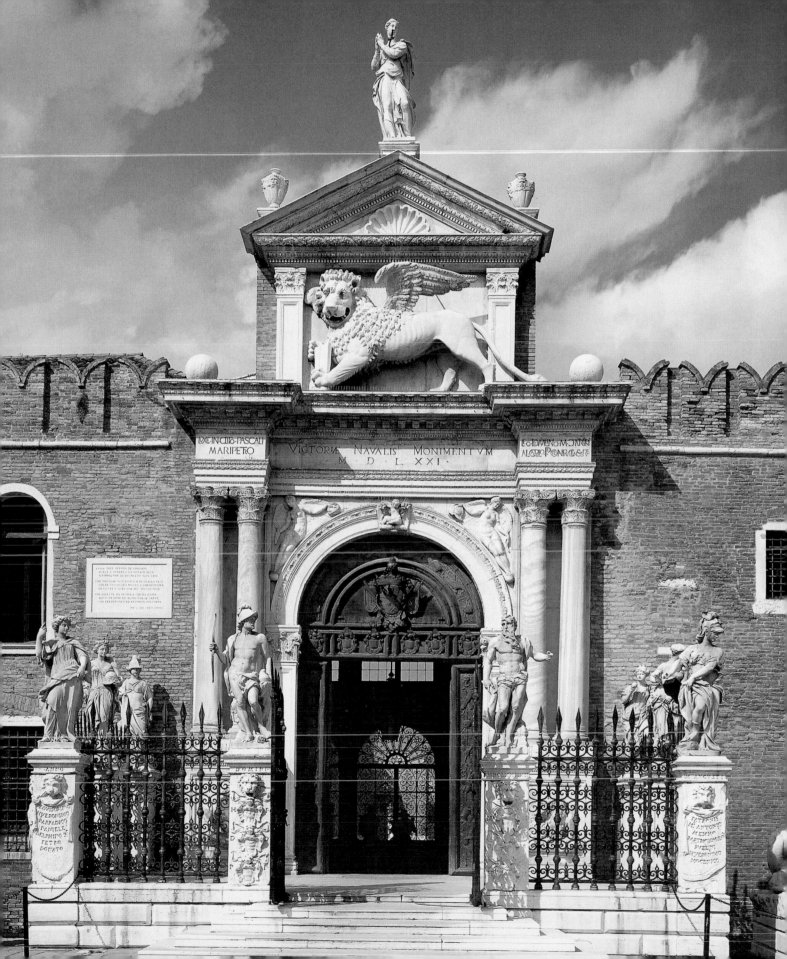

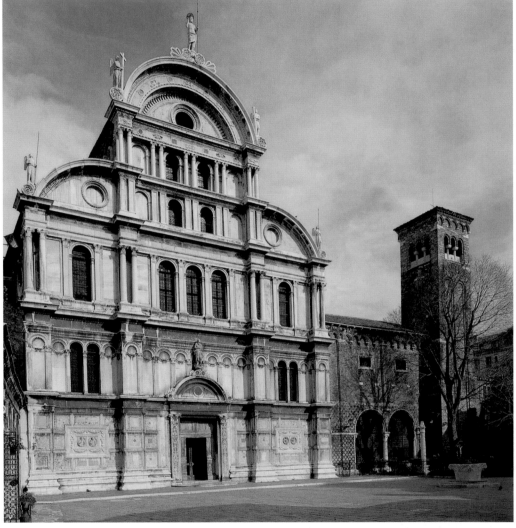

Plan and facade of the church of S. Zaccaria, Mauro Codussi's masterpiece from the second half of the 15th century.

presence in Venice of artists and architects who had been trained and received commissions in Tuscany and Lombardy, and who brought with them the fascination of an architecture that could call on rules and principles as well as practical experience acquired in workshops and building yards. The pull that this exerted was strong, so strong, in fact, that it provided a powerful stimulus projects which unequivocally combined modernity with antiquity, imperial longings with the desire for strength, the celebration of power with its own liturgy, a headlong rush toward the new with the solidity of tried and tested lessons. The specific way that Venetians trod this path is summed up by the existence in the city of one building which, thanks to a miracle of measurable realities and more or less mysterious inclinations, seems to provide the

terms of reference for all of this: the basilica of S. Marco, at once classical and Christian, ancient and modern, steeped in Byzantine models (the church of the Twelve Apostles) and the tradition of Ravenna. It is the resting place of St. Mark and the symbol of the apostolic derivation of power, the political and institutional legitimacy of Venice herself in direct descent from St. Peter to St. Mark, the ideal center for a complex system of cosmology and Christology. The basilica represented the coming together of ancient tradition, consolidated medievalism, and a self-declared will for modernity.

Many of the architectural achievements in the eighty-year period we are looking at must be seen in the intricate texture of such a plan. They may even represent the corollary and proof of it. Nor does it

seem possible to forget that solid political and cultural ambitions lay behind this process. This is highlighted with absolute clarity, albeit in a negative sense, by the sea change accompanying the figure of Jacopo Sansovino which would come about in 1530 when "romanizing" architecture came into favor. Rapidly moving forward by eighty years, we will encounter the start of Jacopo Sansovino's Venetian career when he and many other artists left Rome after the city was sacked by imperial troops in 1527. He brought with him to Venice a whole cultural baggage acquired in the lively environment provided by the building of New St. Peter's. Venice welcomed him with open arms, and before long he became official architect to the patrician classes and to the Republic itself. Sansovino presided over the triumph of Rome in Venetian architectural language. In turn, the language of Rome that he used was a modern reworking of classical architecture. The governing class of the day identified it with its own desire to inherit Rome's spiritual and political heritage.

The eight decades that led up to Sansovino's arrival saw a truly original attempt to give birth to a humanistic and Renaissance architectural language based upon local tradition. To some extent, at least, this was foreshadowed by the episodes outlined above concerning the Corner-Spinelli palace and the Arsenal entrance. An architect from Bergamo, Mauro Codussi, was to prove the most important exponent of the new language, which he elaborated in a varied and mature fashion. But it had other exponents in Pietro Lombardo's family of architects and in Antonio Rizzo and Buora who all used their original talent, often touched with genius, to spread the movement. The last architects of importance to adhere to this language were Antonio Scarpagnino, Giorgio Spavento, and Tullio Lombardo. According to Lionello Puppi's perceptive definition, the fruits of this brief but intense season remain with us like a "squandered inheritance." The ground they gained was to be overshadowed by the good fortune of Sansovino's love of "romanization" and by the classicizing Renaissance's insistence on canons and orders. Nonetheless the experience of these years was to contribute in an effective and thorough-going manner to creating a new and modern face for the city. It should also be said that at least throughout the whole of the fifteenth century, this renewed architectural style had to live alongside the final, triumphant flowering of Gothic architecture: the Arco Foscari and the loggia in the Palazzo Ducale, and palaces like the Foscari, Pisani-Moretta, Justinian-Lolin, and Cavalli. In other words, some of the largest and, architecturally speaking, best palaces in Venice were all designed in the same period as, or

even later than, the Arsenal entrance, at a time when the Lombardo family and Codussi were beginning to make a name for themselves. Borrowings and reciprocal influences are both frequent and intriguing.

It should also be pointed out that other architects and building foremen were also able to compete, with works which to us appear clearly transitional today. Typical of this group is Antonio Gambello, who worked on the master plans of the portal to SS. Giovanni e Paolo and, more importantly, on the apse for the church of S. Zaccaria (see p. 174). Incidentally, some also maintain that he worked on the "triumphal" entrance for the Arsenal, but this argument is not very convincing. All this architecture, is idiosyncratic, which means that it is not always easy to understand. On the one hand, it seems

The busy facade of the Scuola Grande di S. Marco, now a hospital, the work of Mauro Codussi and Pietro Lombardo.

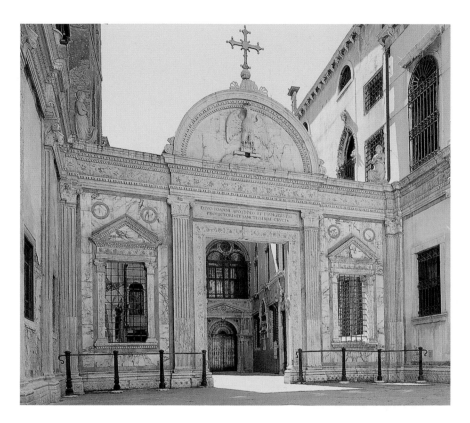

behind the times, on the other, experimental. Furthermore, we should add that it is the fruit of a typically Venetian method: references to things past and invention of things new; things recovered from the past and things placed quite outside their own context, the same principles that guided Bon on the Arco Foscari in the Palazzo Ducale: Gothic words set to a new tune, humanistic architecture chiseled in a Gothic context. Perhaps the most interesting precedent for this type of approach can be found in sketches by Jacopo, the founding father of the Bellini family. Remarkable monumental and courtly settings provide the background for his religious paintings: staircases, palaces, religious buildings once dreamy and eclectic, monumental and light. We could almost use Jacopo's sketchbooks as architectural manuals for the mid-fifteenth century.

It was not just civic architecture that went through a period of renewal thanks to the intense activity among architects and in the workshops at the end of the fifteenth and beginning of the sixteenth centuries. In these years the churches and *scuole* also underwent continuous reconstruction and building programs from scratch. Once again we are witnessing a new interpretation of the characteristics belonging to Venetian tradition, so much so that, especially with respect to Codussi's work, we can with reason

Entrance portal to the small square of S. Giovanni Evangelista, built during the first decades of the 16th century, with the Scuola Grande of the same name, one of the oldest in Venice.

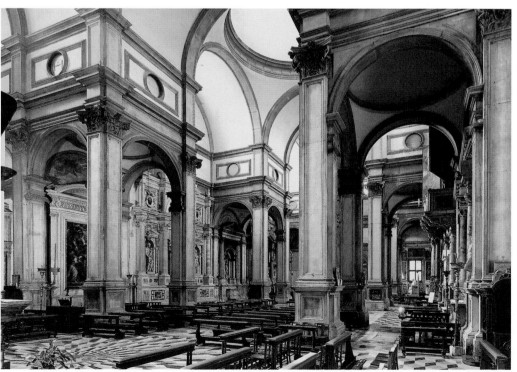

Interior articulation of the church of S. Salvador near the Rialto.

describe it as "Byzantine Renaissance," connected in the broad sense to a renewed and restated rediscovery of the imperial culture of Byzantium. This was the direction in which refined literary and philosophical currents were heading, such as those developed in the learned atmosphere of Venice by the Camaldolite monks. It is also certain that none of this can be detached from political ambitions.

Mauro Codussi came to Venice at the end of the 1460s, at about the same time as Pietro, head of the Solari family (later to become known as Lombardo after their province of origin). We can find them at work, very often side by side, in all the major building sites around the city: from the Scuola of S. Marco and that of S. Giovanni Evangelista to the buildings around Piazza S. Marco. Their architectural languages are often very close, but it would be simplistic to confuse their specific characteristics. Pietro is distinguished by his more decorative style, which contains simple and deliberately archaizing touches. Codussi's approach is decidedly more structural and complex; he must certainly have benefited from knowing and studying Alberti's architecture in Mantua and Rimini. The small church of S. Maria dei Miracoli is emblematic of Pietro Lombardo's work. Compact and self-contained, the building is full of precious marbles and polychrome decoration; a curious series of console capitals support the northern side as it rises from the water. On the other hand, Mauro Codussi's architecture is typified by the perfect, centrally-planned church of S. Giovanni Crisostomo or by the measured, monumental use of space in S. Maria Formosa. If we compare these achievements with Late Gothic religious architecture, we realize that we have reached a turning point. The huge Gothic spaces, red with the bricks of luminous apses, are subdivided into aisles where space is played out in enormous, towering volumes, and where barrel vaults, domes, vaulted ceilings, and pendentives herald orderly compositions of volume and form. Here the first, though still rudimentary, grammar of orders attempts to introduce a law governing proportion and the hierarchical relationship between the parts. Moreover, this is accompanied by the first rules of perspective, which impose order and balance on the sequence of the storeys and the way volumes meet, on the rhythm of full and empty spaces, and on the alternation of wall openings with painted backgrounds. The theme of the domed central plan becomes the testing ground for so many of these architectural ventures which are either Codussi's own work or were by other designers who operated in his circle or in that of the Lombardo family. Thus it became the distinctive feature of that neo-Byzantine revival already alluded

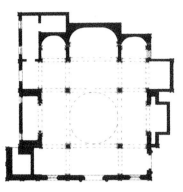

Facade and plan of the centrally-planned church of S. Giovanni Crisostomo, built between 1497 and 1504 by Mauro Codussi.

to. A few years later this art was to find its finest and most successful interpreters in Tullio Lombardo (Pietro's son and successor) and Giorgio Spavento, in the great church of S. Salvador, which was based on a return to the layout of S. Marco.

Mauro Codussi's first work in Venice (from 1468) was the small church of S. Michele in Isola, a commission by the abbot of the Camaldolite monks who lived there. An aisled nave leads up to three chapels with apses, each one topped by a cupola. The established Venetian tradition of dividing the facade into three zones with pilasters corresponding to the nave and aisles inside (one of the most famous churches of this type is S. Giovanni in Bragora), Codussi reworked the whole idea and reinterpreted its features. He raised the middle section of the church facade and framed it in a composite cornice over a pediment which he rested on two slender pillars with Corinthian capitals. The whole of the lower part of the building was clad in smooth rusti-

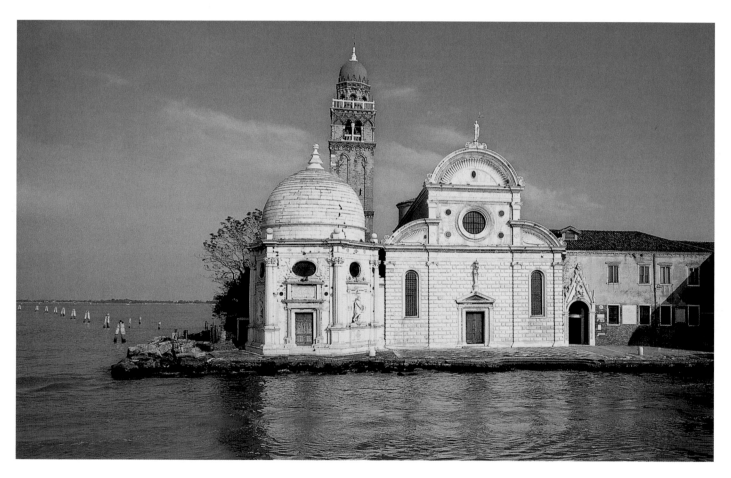

S. Michele in Isola, built from 1468 by Mauro Codussi. On the lagoon side, the church has a simple facade in Istrian stone which stands next to the elegant hexagonal form of the Emiliani Chapel, built about 1530 by Guglielmo Bergamasco.

variety of architectural features and solutions indicate that at this time Mauro was still experimenting, halfway between openly stated uncertainty and the new style, which he had already begun to take on board. This can be seen in his slender columns topped by Ionic capitals with their rich heterodox decoration and twisted motifs as well as in the large arch in the presbytery and the flat coffered ceiling. But what is startling is how Codussi handles the facade of the building. Starting from the well-

cation set off by four narrow pilasters with Ionic capitals. There is no doubt that Codussi got the idea for the rustication in white Istrian stone from the unfinished palazzo on the Grand Canal that Bartolomeo Bon had designed for the Corner brothers. The vague feeling of a triumphal arch that the architect used to transform an architectural form dear to Venetian tradition may have been gleaned from Alberti (most obviously from S. Francesco in Rimini), but it was boosted by the "archaeological"

taste beginning to appear in many Venetian paintings, especially under the influence and guidance of the great Andrea Mantegna.

The Palazzo Corner-Spinelli was also known as the Ca' del Duca Sforza [the Sforza duke's house] because while it was still under construction the two Corner brothers sold it to the duke of Milan, at the end of 1460. The facade was intended to measure more than 50 meters across, and the building's depth was to have been about 55 meters. It would have had two large inner courtyards, which would have broken the enormous block up into wings. Even so, it would have contained an unprecedented number of rooms and salons of unheard-of size. Bartolomeo Bon was so convinced of the importance and novelty of his project that when the sale went through, he refused to hand over his drawings to the duke's architects, insisting that he should be put in charge of the work. Even the unfinished fragment that remains would indicate that it would have been an unusual and revolutionary building. The ground-floor fascia is clad in rusticated and diamond-pointed ashlar. The gigantic shafts of the "free" columns (particularly the corner ones) conjure up a building that would have been bound to become a reference point for all future architecture in Venice. The cultural and political implications of building a palazzo this size for the Corner brothers, whose family was going through a period of unrivaled political and economic power, were in themselves so far-reaching that the Sforza duke decided to scale down the project by finishing it in a less revolutionary manner so as not to upset the Venetians. But compared to the Arco Foscari of less than ten years earlier, Bon here had force-marched the modernization of his own architectural language—albeit at the cost of accentuating the sensation of eclecticism that dominates his work.

If there were architects in transition between the old and new manner, and if buildings are identifiable that are almost emblematic of the way this transition came about, so too there are types of architecture that seem peculiarly suited to this kind of experiment. From this point of view, funerary chapels are definitely of interest. The celebratory, glorifying nature of the chapels, combined with a memory cult either of an individual or a family, permitted, among other things, the introduction of symbols and images dear to classical tradition: triumphal archs, steles, domes, free columns, pilasters, and other features which, by necessity, were accompanied by a respect for the grammar and syntax of the classical orders. It also became almost obligatory to introduce simple proportional ratios, absolute spatiality, and the clean insertion of either the hemispherical spaces of the cupolas or the semicylindrical ones of the vault over

cube-shaped chambers below. Finally, geometrical solutions were applied to spandrels and vaults.

The Gussoni Chapel in S. Lio, Martini and Grimani Chapels in S. Giobbe, Giustiniani Chapel in S. Francesco della Vigna, Zen Chapel in S. Marco (see p. 181) and, above all, the Corner Chapel in SS. Apostoli (see p. 180) are all true tests of this. They are highly evocative and brilliantly inventive in character. The early examples, especially the Gussoni Chapel, still show signs of hesitation (but we must

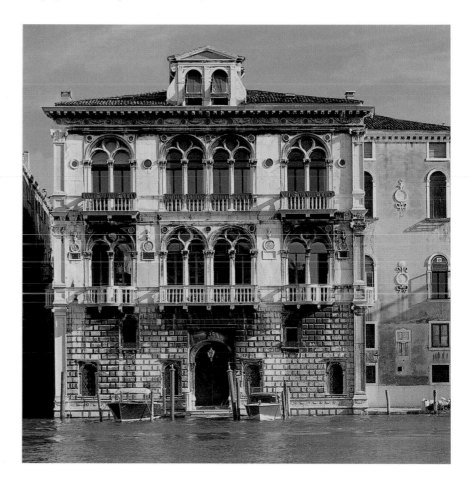

remember that they were employing unusual materials for Venice, such as glazed tiles from Della Robbia's workshop, also used in the Martini Chapel). The later examples, such as the Corner Chapel in SS. Apostoli, are little short of a fully-fledged architectural "manifesto." The architect's name is unknown, although various factors point toward Pietro Lombardo's son Tullio, but the architecture reveals a maturity of concept and faultless familiarity with architectural language of a truly

Facade of the Palazzo Corner-Spinelli (or Ca' del Duca Sforza) on the Grand Canal, one of the masterpieces of the early Venetian Renaissance.

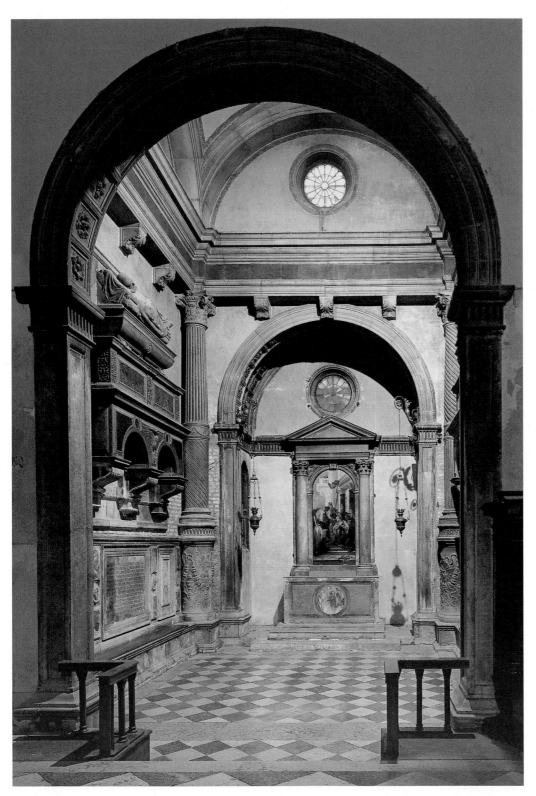

The Corner Chapel in the church of SS.
Apostoli; from the end of the 15th century.

OPPOSITE:
The Zen Chapel, S. Marco, constructed at the
beginning of the 16th century as a funerary
chapel for Cardinal Giovanni Battista Zen. It
was originally open to the Piazzetta where the
portal *da mar* was once the main entrance to
the basilica.

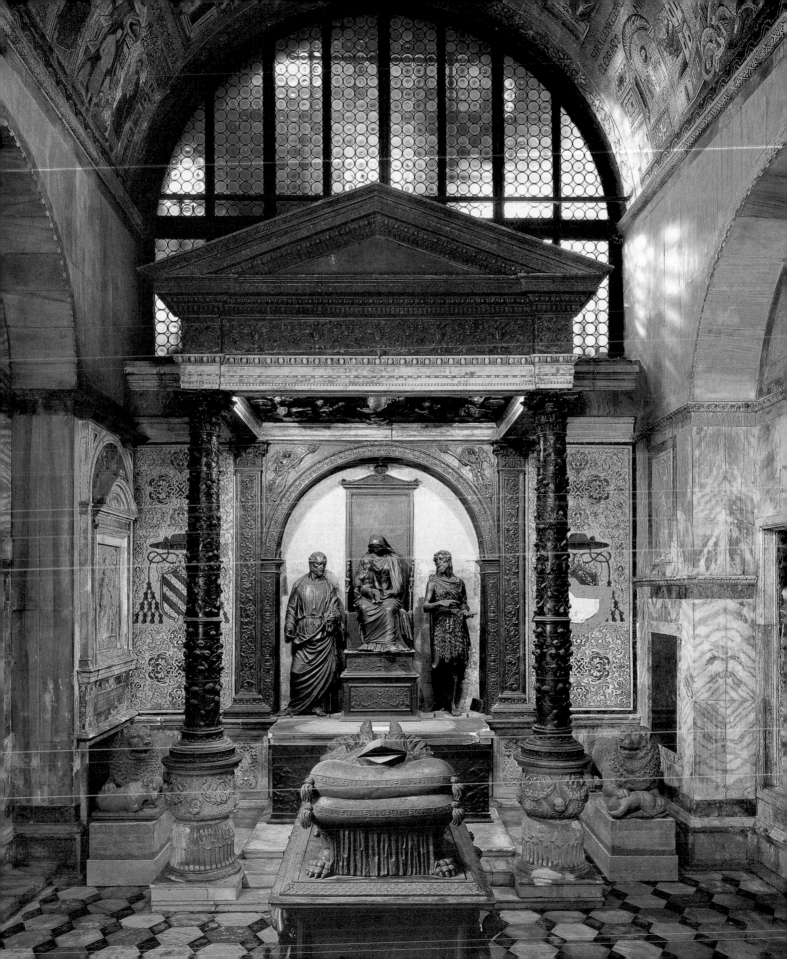

exemplary nature. Space is created inside the chapel by a sequence of three successive volumes. The lowest level is the austere vertical volume of the body of the church itself. Above this, the pendentives create an intermediate space. Finally comes the hemisphere of the dome. Nevertheless the overall effect is one of unity rigorously and tenaciously held together by powerful architectural structures. Here we have tall, angular, fluted columns resting on cylindrical bases worked like Roman altars, pilasters, a large coffered arch with rosettes, exceptionally beautiful entablatures, consoles, capitals, and archivolts. Everything speaks of monumentality and rigor, nothing suggests a concession to picturesque or approximate solutions. There is no doubt that the angular columns bring to mind the type of ciborium or baldachino used in Byzantine traditions nor that the domed ceiling can be read as an homage to the oldest Venetian tradition. The end result, however, is entirely new and fresh.

The most ambitious architectural project taken on by Pietro Lombardo is without doubt the small but exquisite church and sanctuary of S. Maria dei Miracoli (see p. 184), which stands not far away from the huge Gothic mass of SS. Giovanni e Paolo. Pietro's task was conditioned first by the fact that, when he took it on, work was already underway. But he was also limited by the narrow and irregular shape of the site, bounded to the northeast by a canal. The building is small and built in an elongated rectangular shape. Pietro added a domed apse to terminate the presbytery area, which is reached by a steep flight of steps widening at the end into two galleries (this is a layout we will come back to when we look at the marble staircase that Antonio Rizzo built in the Palazzo Ducale, which was inspired by Jacopo Bellini's sketches). What is surprising about S. Maria dei Miracoli is the continuity between interior and exterior. This continuity is underlined by the way the structural division of the building is organized into a double order, on the exterior made visible in an Istrian stone framework, but woven into a tight dialectic by precious marble surfaces. This work has always captured the attention of observers and travelers who are unable to resist the temptation to make comparisons and parallels: S. Marco, Ravenna, imperial Rome, and, above all, Byzantium with its sumptuous polychrome effects and richly decorated buildings. It seems that for Pietro Lombardo the search for antiquity at this stage was, almost paradoxically, more direct and more explicit than it was for Codussi himself. In fact, if Codussi traveled a road on which a "Western" interpretation led to the grammar and syntax of the orders (and, therefore, one colored by the recent experiences of Alberti and

Michelozzo), Pietro arrived at the same destination along the more direct route of evocation and quotation where intention and justification sprang from his reading as well as the real-life experiences that Venetian merchants and travelers had brought, and were still bringing, back from journeys to the Bosporus.

Codussi's architecture, however, appears to be part of the development of a national and classical language in the composite and partly eclectic manner discussed earlier. This is especially true of the way in which it approaches the development of geometric forms for religious buildings, especially those with a central plan based on the inscribed cross. Particularly good examples of this are S. Maria Formosa and S. Giovanni Crisostomo. The play of the domes and their function in the design, the articulation of the spaces around the arms of the cross, the sober use—indeed absence—of ornament, the linguistic sophistication, and, lastly, the dynamic and elastic nature of the structural elements place Codussi's work among the most distinctly new and original to come out of humanism. Nor can we resist the temptation to compare Pietro Lombardo's and Codussi's methods of approaching civic architecture. Pietro gives us the Late Antique preciosity of Giovanni Dario's house (see p. 183), Mauro the terse perspectives of Palazzo Zorzi, or the return to a Ca' del Duca style in his use of rustication for the Lando residence, which also shows the novelty of biforate windows with drop-shaped oculi, already tried out in S. Zaccaria.

Finally, there is the mature, and in many ways disturbing, masterpiece of Palazzo Loredan (now Vendramin-Calergi) (see p. 185, bottom). For the first time in Venice, the facade and the building fabric are treated as separate elements if not actually as opposing parts in the overall design of a palazzo. (This solution was widely taken up by the next generation of architects, mainly by Sansovino and Sanmicheli.) What remained of Gothic building tradition was hidden deep in the heart of the building or kept for the practical way the building was divided and laid out, such as the T-shaped salon (a crozola). The front of the palazzo, on the contrary, was built up by closely interweaving absolute elements of architecture. On the ground-floor level a succession of biforate windows with Corinthian capitals were flanked by pilaster strips; on the upper floors there were fluted or smooth columns. The whole effect was crowned at the top by a powerful trabeated entablature with a frieze of eagles, shields, and unicorns which gives an extraordinary effect of monumentality and elegance. In his guide to Venice, Francesco Sansovino singled it out as the first of the monumental palaces of the new generation, emphasizing

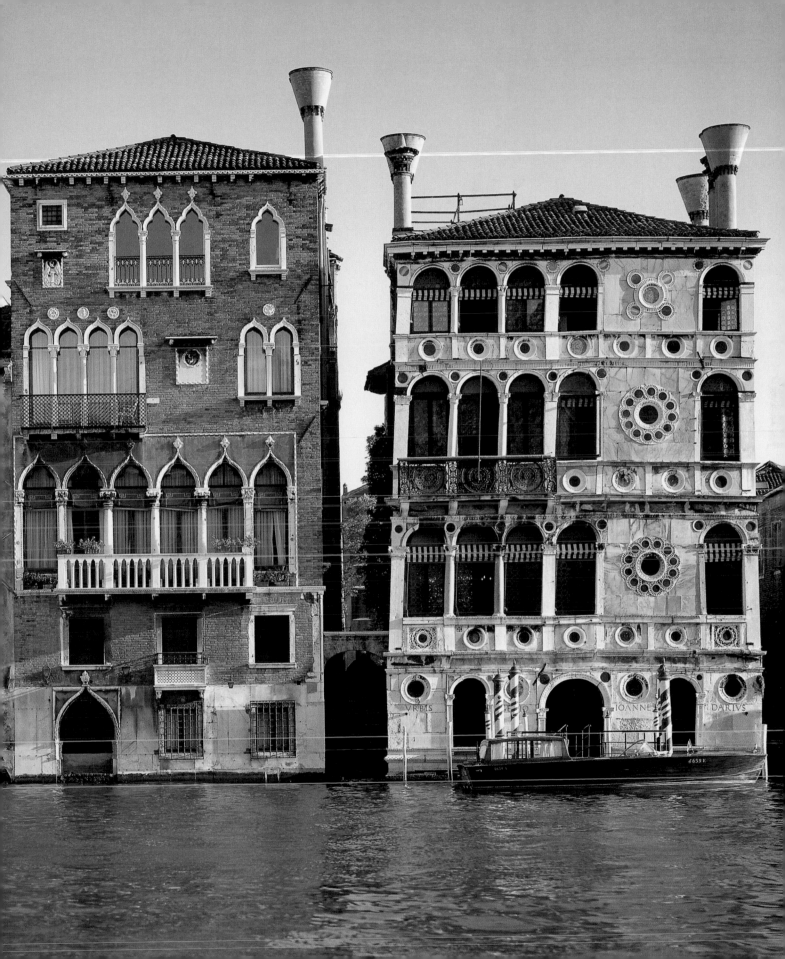

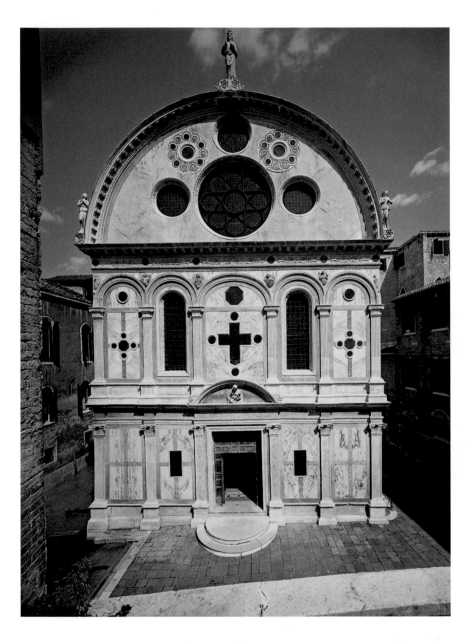

Facade of S. Maria dei Miracoli, designed by Pietro Lombardo who worked on it between 1481 and 1489. One of the masterpieces of the early Renaissance, it makes use of different colored marble slabs, which gives a spectacular chromatic result.

us that educated people of the time commonly believed that this building marked the beginning of a new way of looking at antiquity. This was not a concept that had been handed down by those few who had been able to experience it personally or who had worked on such buildings themselves (in other words, the Venetian parameter of form and ideology), but was rather the proof of a theory that rested for authority upon the superiority of writing, in particular, Vitruvius' own writing.

It also seems clear that the overall result of this specific choice to dismember and reassemble the building into the two dialectic elements—the mass of the building and its facade—led to a surprisingly effective outcome. Thanks to this, we have what in practice is nothing less than a huge, composite triumphal arch making up the entire facade and at the same time acting as the entrance to Andrea Loredan's residence. It is not just the large triple arch at ground level that brings this building to life, but the way the facade is developed and powerfully designed. Its uppermost entablature and corners are eye-catching. Inside the perfectly defined square of the building itself, a system of binary columns containing biforate windows on the outside gives the sensation of a precision piece of triumphal and imperial machinery. The tripartite scansion therefore was one of Codussi's strokes of genius. What the architect did, in fact, was to pick up the subdivision of the facade used in so many Veneto-Byzantine and Gothic palaces, and at the same time poetically and ambiguously twist its meaning by an explicit allusion to a reworking in a classical key. This was undoubtedly a novelty unique in character and degree. The huge Loredan palace (now Palazzo Vendramin-Calergi) was built fairly quickly, starting in 1502 and finishing in 1509. However, in 1504 Codussi died; he never saw his masterpiece completed. The modernity of the palace exemplified the client Andrea Loredan's own cultural choices, which were re-emphasized when Giorgione was called in to do the frescoes on the ground floor. At the time he painted them we know he was also working in the Rialto on the facade of the newly built Fondaco dei Tedeschi [German emporium], designed by Giorgio Spavento.

Codussi's achievement in Palazzo Loredan found only timid heirs. They are visible in the new Scuola Grande di S. Rocco at the Frari. It must be admitted, however, that here a whole variety of architects succeeded one another in planning and supervising the work and that there were also a number of stand-offs with the indecisive and argumentative client. At the same time, it is also apparent that quotations from Codussi and by now out-of-date evocations of the Antique and picturesque pastiches both conditioned

yet again its exceptional features: "[It is] of great size and great height, earlier in time than the others and, almost alone on its block, it appears very noble, since apart from the number of rooms within it, its front is covered in Greek marble, large windows and Corinthian columns." Sansovino did not forget to mention either that the measurements of the building had been devised "in accordance with the doctrines of the ancient Vitruvius." His comments are significant because they clearly show what went into forming late-sixteenth-century sensibility. They show

and limited the effectiveness of the method and syntax used on what otherwise was an unusual richness of means and materials. There are biforate windows with oculi, Roman entablatures, triangular tympanums, aediculae, polychrome insets, and free-standing columns mounted so as to give life to an impressive celebratory setting, to a play of accumulation that betrays, at least in part, the solemn and monumental effectiveness of the huge salons and of the double grand staircase (see pp. 186–187).

And yet in many ways the architecture of the *scuole* (and we should recall that for Sansovino work on the Misericordia was particularly difficult and demanding) marked a decisive step in the evolution of both Codussi and Pietro Lombardo. The Scuola di S. Marco and the Scuola di S. Giovanni Evangelista both bear unequivocal witness to the kind of solutions that were adopted on the exterior and interior and within the very structures of these building complexes: halls, staircases, facades, portals, crownings and gables, vaults and cupolas are all there, as are capitals and painted columns, pilasters and cornices with marble reliefs, ornament and false perspectives (see pp. 175, 176 top).

At the close of the fifteenth century Codussi was busy on an important public commission that would be crucial to some of the architectural choices that would later be made when laying out the whole of Piazza S. Marco. The commission was the Torre dell'Orologio [clock tower], which stands at the entrance to a long commercial street that leads off

Palazzo Zorzi in the S. Severo district, attributed to Mauro Codussi.

from S. Marco and twists its way down to the merchant area of S. Bartolomeo-Rialto (see p. 188). Rather than build a simple bell tower, Codussi once more opted to use the idea of a triumphal arch: this one would have a single supporting arch topped by a square panel containing a clock face and a moving dial with the signs of the zodiac. The two upper orders are smaller in size but still on square bases. The first of these contains an aedicula with the Virgin, the other the lion of St. Mark with Doge Agostino Barbarigo (destroyed). The attic is crowned by a balustrade which supports two bronze Moors who ring the hours. This was the earliest, basic structure of the Torre dell'Orologio. It was, however, immediately enlarged (1499) by the addition of two side wings, giving a total of four symmetrical spans (see p. 189). This modification helped to accentuate the aims set for the tower in terms of perspective and stage setting; it acts as a landmark both in the Piazza itself and for the visual line leading from the Molo [pier] to the start of the Mercerie, the busiest street in Venice, giving the impression of a truly theatrical backdrop.

Siting the clock tower in this exact spot radically modified the overall balance of the Piazza and was the start of a long-term process that led to the reorganization of the whole area. Indeed, the clock tower can be seen as the fulcrum of measures and actions that gradually led to replacing the twelfth-century Ziani buildings as these were reread and reinterpreted in the light of the city's new cultural climate. This process was to get fully underway just a

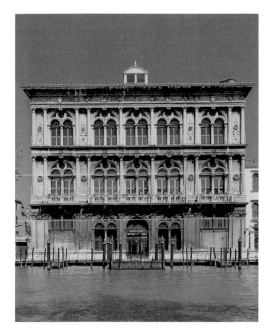

Palazzo Loredan (now Palazzo Vendramin-Calergi) on the Grand Canal, designed by Codussi, and built between 1502 and 1509 for the Loredan family. It passed to the Calergi in 1589 and was later owned by the Grimani, Vendramin, and Berry families. Richard Wagner died here in 1883.

ON THE FOLLOWING PAGES:
The monumental staircase in the Scuola Grande di S. Rocco, designed by Scarpagnino. Two parallel ramps of stairs rise to a landing from which a single double-width ramp continues beneath a barrel-vaulted ceiling punctuated by a small dome.

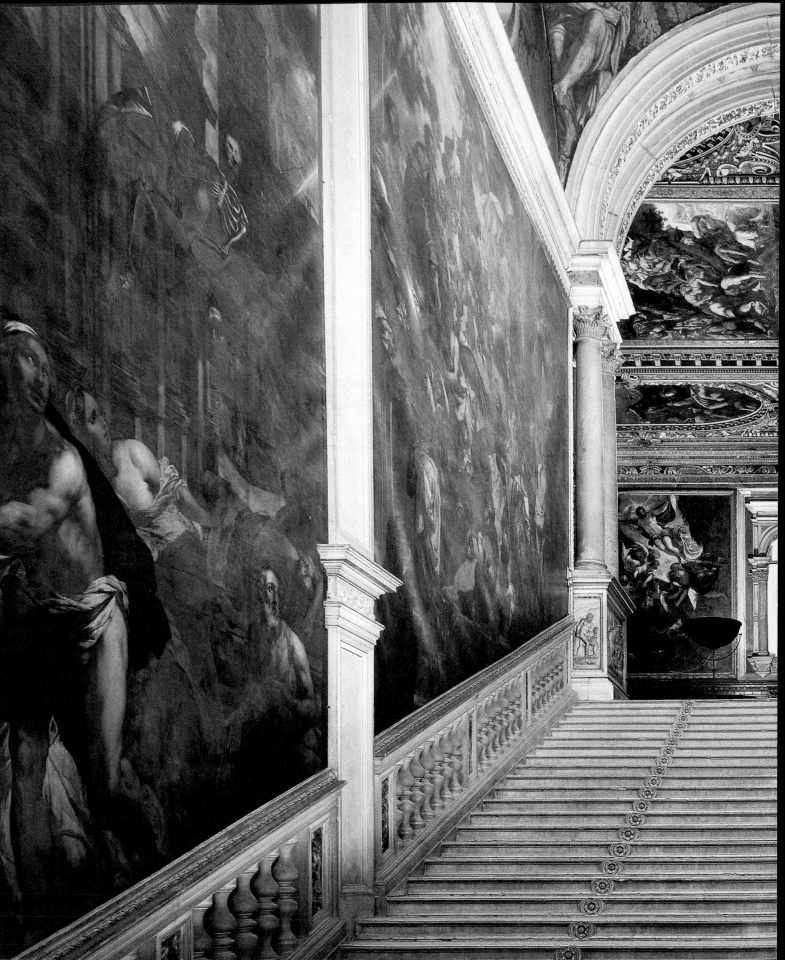

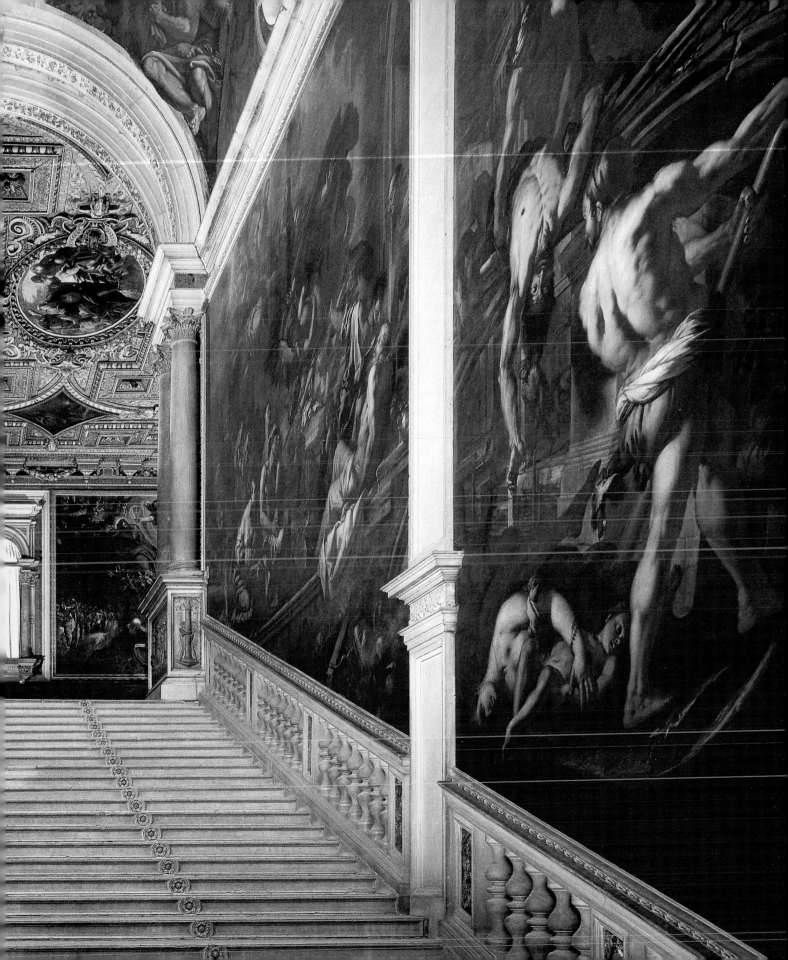

few years later following a fire in the Procuraturie Vecchie on the north side of Piazza S. Marco. The process was only brought to an end in 1532 when Sansovino was appointed the new *proto*, responsible for the fabric of S. Marco, following the plans originally drawn up between 1512 and 1513 by previous *proti* Guglielmo dei Grigi, Maestro Rocco, and Zuan Celestro. Sansovino went as far as rearranging Ziani's vision of the urban plan (Piazza, Mercerie, Procuraturie Vecchie) (see pp. 190–191). The starting point for all of this was Codussi's clock tower. If we bear in mind that in this period architecture was considered an important *trait d'union*, or bond, and also almost a reflection of classical tradition as well as the interpretation and perpetuation of the Antique, we will get a fuller grasp of the scope of the revolution that was wrought on the long-established form of the Piazza in so few years. With the building of the Torre dell'Orologio, the balance thus changed and the modern era of Piazza S. Marco was underway.

We should, however, also take a close look at changes within the very seat of the doge's power, in those buildings away from the Piazza. After the fire of 1483, Antonio Rizzo was commissioned to carry out extensive renovation work on the Palazzo Ducale. The whole of the eastern end of the building was directly affected: a new scheme completely renewed its outer face, even though all the work had to be done within the considerable limitations imposed by the pre-existing layout. So apart from the two facades facing the courtyard and the *rio*, a huge new monumental staircase was designed from scratch to lead up to the loggia. After two colossal statues of Mars and Neptune by Sansovino were placed there, this staircase became known as the Scala dei Giganti, or Giants' Staircase. A brand new design was also introduced for the small space on the other side of the staircase known as the Cortile dei Senatori. Rizzo had to leave Venice in haste after a serious clash with the law at the end of the century, but he had already had time to stamp his work with his own unmistakable personal mark, even compared with Lombardo and Mauro Codussi's achievements in the same period.

There are many reasons why the huge internal facade of the palace seems badly conceived: it is over-laden with ornament, makes no decisive linguistic choice, and is imitative in the way it uses a Gothic portico in an attempt to continue a bygone age. Then it is overworked in relation to the size of the building itself; this in turn makes a clear interpretation of the facade quite difficult. Having said all this, there are also more pleasing aspects to the work. On the portico side are the monumental staircase with two

The Torre dell'Orologio, built between 1496 and 1499 by Mauro Codussi on the end of the Procuratie Vecchie; the upper section with the lion of St. Mark against a starry background was built in 1755 by Giorgio Massari. The two bronze Moors who strike the hours were cast between 1494 and 1497, at the same time as the clock, which shows not only the time but also the phases of the moon and the signs of the zodiac.

galleries and a large arch with three smaller supporting arches. On the other side, the facade overlooking the *rio* is tightly and intelligently played out in terms of horizontal development and the way it exploits the difficult perspectives created by the narrow site which allows only the briefest of views. It is immediately apparent that the diamond rustication on the lower part of this facade has been borrowed from the diamonds on the Ca' del Duca. But this becomes only an extravagant quotation in the way the facade is subsequently developed with a succession of small windows topped by curvilinear tympanums, oculi, powerful string-coursed fascias, round windows, trabeations, precious marble decoration, and so on. But, unlike the facade facing the courtyard, here the architecture succeeds in giving an impression of unity, continuity, and decorum even to something which is, after all, nothing more than the back of a building, albeit the Palazzo Ducale. This fact does not, however, detract from the dignity and preciosity of a unique monument of incomparable quality and splendor which is able to speak a language that fundamentally does not contradict the overall direction of the palace.

What stands out as different is the purpose of the refined ornamental work on the large stairway on the loggia side. Every part of it directly fulfils a requirement to enhance the sumptuous dignity of the doge, to boost the prestige and sacredness of Venice's highest magistrate. It condenses antique quotations and oriental memories, and picks up and copies successive imperial formulations. Alongside memories of Rome and Byzantium, it makes room for the Late Antique and for classical Greek. All this leads to the construction of a liturgy. Never before had the glorification of the doge showed so direct a derivation from Byzantine ritual. The doge is now seen as the legitimate heir to the greatness of the Roman emperors.

From the workyards of Mauro Codussi and Pietro Lombardo, from the Palazzo Ducale and the *scuole grandi*, from the palaces of the Loredan, Lando, and Dario families, spread through the city a language of Venetian architecture destined to divide and melt into more fluent formulas, into more accessible vernaculars. Nonetheless, it still deeply and effectively permeates a new and highly successful era of building in the city. Thus we can say that although in terms of official, grandiloquent architecture for both public and private, religious and lay clients, it was largely overtaken by the rapid rise in fortune of "romanizing" language as practiced by Sansovino and Sanmicheli, Palladio and Scamozzi, nevertheless in the simplified form just described it managed to survive and to prosper as the architectural means most widespread and readily available, most

approachable and workaday. As such it replaced the modular serialism of Gothic building until it ended up translated into a simple and sometimes rudimentary language that everyone felt they could use, from a master of works to all types of patrons. Everyone could identify with it and "speak" through it.

Before the "romanizing" era mentioned above took hold, albeit temporarily, the first generation of architectural renewal reached a point of collective strength that gave birth to a number of remarkable

Torre dell'Orologio today.

architectural achievements. It is not by chance that the most striking buildings of this final moment are clustered around the commercial magnet of the Rialto, with masters such as Giorgio Spavento, Antonio Abbondi, known as Scarpagnino, and Tullio Lombardo.

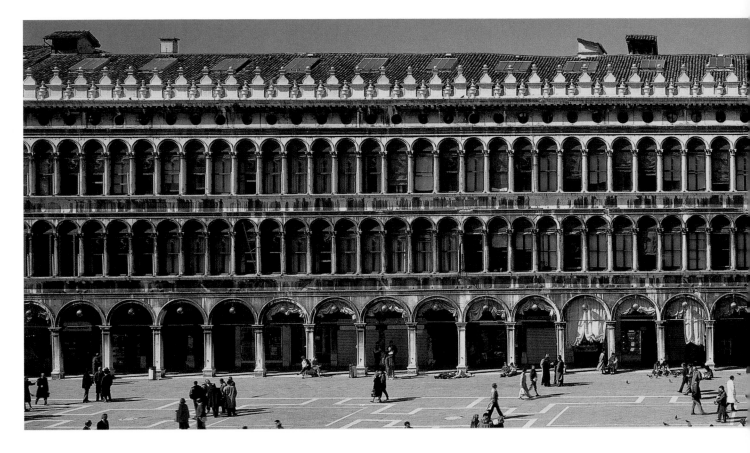

The Procuratie Vecchie on Piazza S. Marco. From the 9th century, Venice provided residences for her nine procurators, the highest magistracy after the doge. The old building consisted of two storeys with arched fronts. In the first years of the 16th century, following a plan by Mauro Codussi, a new structure was begun, which, after a fire in 1506, was completed by Jacopo Sansovino in 1532.

The church of S. Salvador marks the point where the commercial axis of the Mercerie meets the Rialto. As already noted, the Mercerie starts at Codussi's Torre dell'Orologio. It also marks a moment of connection and passage with the Rialto district which, on this side of the still wooden bridge, was centered around the area where German merchants had settled, mainly around their own *fondaco* and their church of S. Bartolomeo. The church of S. Salvador seems unusually large for Venice (see p. 176, bottom). It draws upon Codussi's experience of architectural complexes divided into many sections and executed in a language recalling the Antique. What prevails is the austere dryness of the ornament and the exactness of the proportional ratios, not the sumptuousness of the polychrome or the insets. The church also picks up a whole weight of symbolic meanings, starting from S. Marco. These introduce echoes and quotations even from Jerusalem and Christology. After the death of Giorgio Spavento, Tullio Lombardo took charge of work. His credentials consisted of a philological and antiquarian correctness that only he, as son of Pietro Lombardo, was able to guarantee through his wide

and proven knowledge of texts and sources. The end result is one of outstanding monumentality, distinguished by the complex way it uses space. This is highlighted by the play of arches, cornices, and trabeations. Nothing in Venetian architecture to that date had seemed so cultured and so dynamic, so faithful to its model yet so nonchalant about the way it followed it, so rigorously classical and "new," but still so very Venetian and anchored to tradition.

In 1505 a fire destroyed the Fondaco dei Tedeschi. Giorgio Spavento was among the architects who worked on building the huge new square block. The facades were decorated by an "unlikely" pair, Giorgione and Titian. Conceived as a perfectly functional machine, the Fondaco dei Tedeschi picks up the lesson of the new architecture in a version which stressed absolute essentiality and rigor. This model building even betrays traces of thirteenth-century architecture in its geometrical layout. This is no less than an homage paid to the wisdom of a tradition that had the reputation above all else of being supremely effective: the most telltale sign of this attitude is the fact that the turrets were repositioned from the sides to the front.

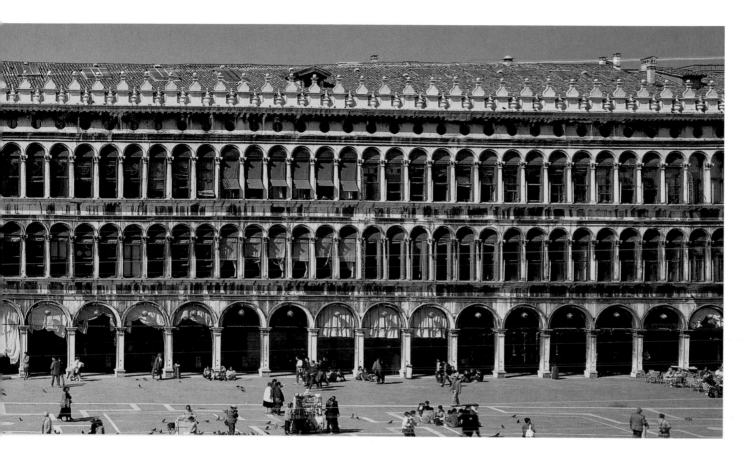

About fifteen years later a building went up opposite the Fondaco that constituted a direct challenge to it. The palazzo in question was to house one of the financial magistracies, the Camerlenghi. In contrast to the Fondaco, the Palazzo dei Camerlenghi is almost picturesque in tone and in its use of the more ornate and precious Lombard-style architecture, almost as if it set out on the far from easy task of conflating diverse fragments from the past.

Still in the Rialto district, it was Scarpagnino who was given the task of reconstructing the commercial buildings on the far side of the bridge after the fire of 1514. Both linguistically and structurally, this operation seems far closer to the contemporaneous rebuilding of the Procuraturie Vecchie on the Piazza which followed the completion of the Torre dell'Orologio. It could be argued that the Palazzo dei Camerlenghi was the last stand of the "ornate" style.

The reconstruction of the buildings of the trading and financial nerve center of the Rialto commercial quarter gave rise to a debate in which utility confronted representation and ideological choices clashed with economic ones. If Fra Giocondo's famous design proposal was based upon Vitruvian principles, the plans that were actually used in the second, more comprehensive stage of rebuilding the Piazza and the Rialto represented the victory of continuity and moderation. They meant that the long colonnade was built which allowed space for shops, banks, offices, and warehouses. In turn, this guaranteed an essence that was so strong and bare that it bordered on anonymity. And yet an unbroken thread links the first steps taken by Codussi, Spavento, even by Tullio Lombardo himself, to these arches, pillars, and columns, string courses and windows up to the edge of the building, to the economy of a building machine that not only did not renege on itself, but indeed aimed amid tensions and setbacks at pushing doggedly forward, without tearing or cutting itself off from the past, along a path toward a cultural adventure that was lived with pride and experienced as a nation.

Giandomenico Romanelli

Venetian Figurative Sculpture:
1460–1530

The 1460s

Bartolomeo Bon, the leading figure of Venetian Gothic sculpture, probably died as early as 1464, but in any case no later than 1467. On his death Venice was deprived of the man who had been its principal sculptor and architect for the last three decades. But even before 1460, when Bartolomeo still enjoyed enormous prestige, other sculptors from totally different traditions had done high-quality work in Venice, preparing the ground for a change in style. This group of sculptures includes the beautiful frames of the enigmatic tondi, or roundels, on the facade of S. Zaccaria. Sources document that payment was made for the work in 1457 to artists whose names, unfortunately, are not mentioned. It is not certain that the sculptors in question were from Donatello's circle in Padua; all we have for the moment is a theory that one of them may have been the same Luca who in 1462–63 was responsible for the wonderful festoon on the portal of SS. Giovanni e Paolo under the supervision of Bartolomeo Bon. Similar figures and festoons can also be found on the doorway of a house in the *campo*, or open space, at S. Maria Formosa. The way in which the artist's steady hand brings the putti to life and foreshortens them is reminiscent of painting technique especially some of Marco Zoppo's drawings.

The bases of the main portal of S. Marco depict children's games and also hold quite a few mysteries of their own. Middeldorf pointed out the great similarity to the reliefs in the "chapel of childhood games" inside the Tempio Malatestiano in Rimini but so far this sharp piece of observation has not been followed up. In view of the large differences in style between the bases and the rest of the portal, which was carved by Giovanni Buora after the 1485 fire, the idea that the bases may have somehow survived the fire is not that abstruse. What is quite certain is that we can find the twin brothers and sisters of these putti born between 1450 and 1460 in the Tempio Malatestiano in Rimini.

From the middle of the nineteenth century, scholars have had considerable difficulty in attrib-

uting countless works that were carved in the 1460s. Contradictory attributions arise partly because the accounts from sixteenth- and eighteenth-century sources can be interpreted in varying ways.

In the eighteenth century Antonio Bregno and his brother Paolo are mentioned as the authors of the funerary monument to Doge Francesco Foscari (d. 1457) in S. Maria dei Frari. The attribution comes from a sketch of the tomb and was probably based on notes, or perhaps a contract, from the Foscari family archives since at that time the name Bregno had not appeared in any historical or artistic writings. The four Cardinal Virtues stand around the tomb; the curtains of the canopy are held aloft by two squires mounted on tall columns; in the center of the traditional Annunciation motif that crowns the tomb we find the figure of Christ and the soul of the departed. Here Venetian traditions, for example, the face of *Fortitude*, which is reminiscent of Bartolomeo Bon's work, are amplified by influences from Andrea Mantegna's Paduan frescoes, such as the "wet look" of the drapery on the figure of Christ.

The outstanding work of this decade is undoubtedly the effigy of the Venetian admiral Vettor Capello, who died in 1467 off Negroponte. The figure is part of a group which at one and the same time forms Capello's funerary monument and the portal to the church of S. Elena. The figure of the saint before whom Capello kneels is one of a fairly homogeneous group of sculptures which Francesco Sansovino's guidebook to Venice (1581) mentions as the work of one Antonio Dentone. The portrait of Capello, however, is quite different. As in Donatello's portrait of the condottiere Gattamelata in Padua, here too armor is used to show the personality of the man who wears it. Great care has been taken to show the old man's stiffness and curved back while at the same time revealing the depth of Capello's faith as he venerates the huge cross that St. Helena originally held in her left hand. It is not possible to attribute these figures, which are of enormous artistic merit, to the young Antonio Rizzo who was just making a name for himself in this period. At this time he was still very much under the influence of Mantegna's

Funerary monument of Doge Francesco Foscari by Paolo and Antonio Bregno in S. Maria Gloriosa dei Frari. Opposite: detail.

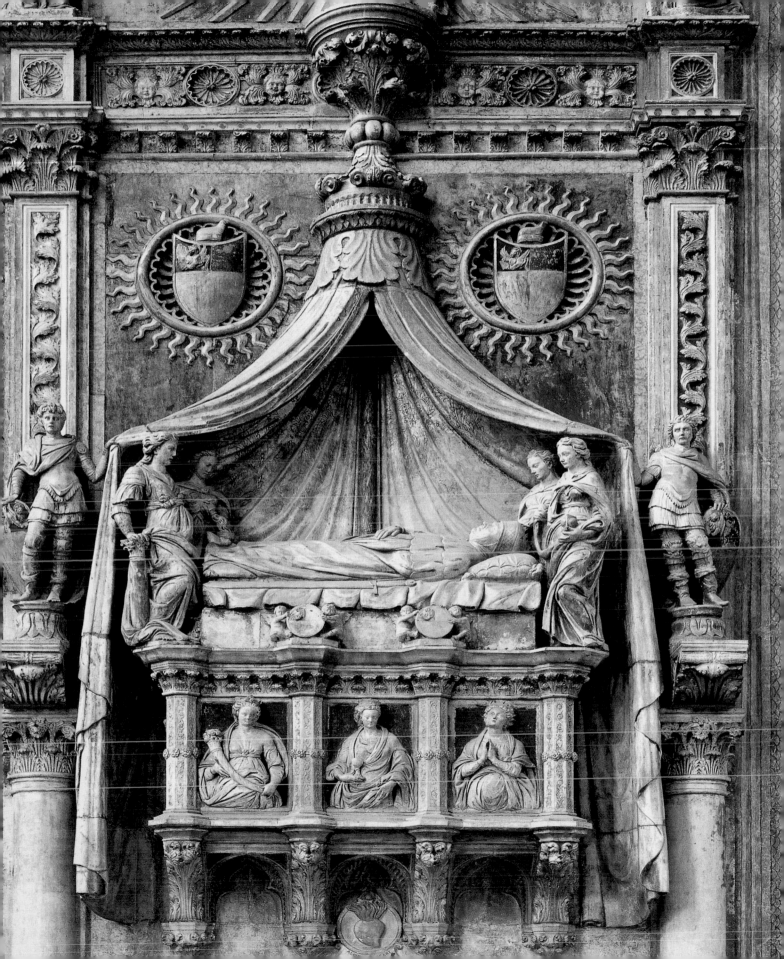

severe style, as can be seen in his figures in the S. Marco altars which were given by Doge Cristoforo Moro.

The S. Elena portal is the first in a rich line of monuments installed in the facades of churches, dedicated originally to the memory of individuals and later extended to include several members of the same family. These figurative epitaphs (the tombs themselves are located inside the church) were one and the same as the church portal or made up part of it. This came about because the parishes and their priests, who enjoyed a great deal of independence, were free to confer the privilege of a public memorial upon the most illustrious members or benefactors of their community.

Current research is almost unanimous in denying that there ever was a sculptor called Antonio Dentone. In my opinion, however, this sweeping dismissal of Sansovino has been made too lightly. Sansovino himself generally stuck to written records rather than working from appearances, and he certainly was not in the habit of attributing work on the basis of stylistic comparison. Apart from the doorway to the church of S. Elena, he had also attributed to the same sculptor the tomb of Orsato Giustiniani (d. 1464) which was finished in 1466 and located in the small church of S. Eufemia; this church was built inside the courtyard of the Carthusian monastery of S. Andrea della Certosa but destroyed in the nineteenth century (some of the Virtues from the tomb are now in the Kress Collection and in that of a Padua bank, the Cassa di Risparmio di Padova). To date, scholars have not collected sufficient evidence to justify attributing these works, which are all very similar, to Antonio Rizzo or Antonio Bregno, but they are happy to write off Sansovino's attribution as a mix-up over names. Nevertheless, it should be said that the Dentone figures, which share a characteristic physiognomy, are closer to Bregno's work than to Rizzo's.

Antonio Rizzo

By commissioning works from Antonio Rizzo and Pietro Lombardo, Doge Cristoforo Moro would appear to have played an important role in establishing new ideas in sculpture. In about 1465 Rizzo was given the job of making three altars for S. Marco which were paid for in 1469. In both architecture and decoration they show that they have completely left traditional Venetian forms behind. Nonetheless, Antonio Rizzo cannot claim to be the precursor in Venice of the study of classical antiquity. Jacopo Bellini had already designed an aedicula in the

ancient manner for an altar, and as early as 1462 a Domenico Fiorentino had framed Bartolomeo Bon's portal to SS. Giovanni e Paolo with a wonderful frieze of foliage in the classical manner. Both the main portal to S. Elena, which was built just after 1467, and Orsato Giustiniani's tomb tend toward classical architecture and decoration. Other major examples of the new style with its echoes of classical antiquity have been destroyed, for instance, the Barco in S. Maria della Carità (1461), the contract for which stipulated that it must be completely *all'antica* [in the classical manner].

Rizzo's altars were also worked on by stone-masons whose training came from the study of works in central Italy. This gives their work coherence, and we can see their intention was to produce something *all'antica*. From 1460 onward, Venetian contracts frequently contain a request that the work should be done as much in the ancient manner as possible. This produced a striking contrast between frames of altars carved *all'antica* and some of the figures which clearly derived no inspiration from classical sculpture. The differences in style and quality between these saints and the superb *Adam and Eve* signed by Antonio Rizzo seem insurmountable and not just at first glance. The couple was originally placed in niches high on the facade of the Arco Foscari, over-looking the east wing of the Palazzo Ducale. The figures were recognized by contemporaries as super-lative works of art; it seems that when working on them Antonio was influenced by Calendario's *Adam and Eve*; where an in-depth study of nature is combined with a masterly psychological interpreta-tion of the characters' feelings. Adam has already tasted the forbidden fruit and, frightened, turns his eyes heavenward as if seeking help. His mouth is open, his right hand clutches his chest as if he is short of breath. Rizzo takes Adam's body from nature without idealizing it. He omits no detail of his orig-inal model. Nothing here recalls the classical works put forward as paradigms at the time by so many patrons and sculptors. What is clear, however, is the close ties with painting, in particular the work of Andrea Mantegna, such as his *St. Sebastian* in the Kunsthistorisches Museum in Vienna or figures from the Ovetari Chapel in the church of the Eremitani in Padua. For *Eve*, Rizzo chose a version of the Medici Venus. Nevertheless, the shape of her body, with its wide hips, narrow shoulders, and muscular arms is far removed from the classical ideal of the female figure. Eve shows no emotion; beneath her lowered lashes her gaze is unwavering, her regular face gives away no feeling. She could be sister to *Charity* on the tomb of Doge Tron. The more you look at this enig-matic and closed face, the more you feel that *Eve* is a

Adam and *Eve*, by Antonio Rizzo, from the Arco Foscari, now in the Museo dell'Opera in the Palazzo Ducale.

Antonio Rizzo

Antonio Rizzo is known to have been in
Venice from 1465, when he created
three altars in S. Marco for Doge
Cristoforo Moro. The style of the
figures is reminiscent of works by
Andrea Mantegna, while the classical
ornamentation harks back to central
Italian models. The life-size figures of
Adam and Eve from the Arco Foscari in
the courtyard of the Palazzo Ducale are
undated. A study from nature links Eve
with the classical Venus, while the figure
of Adam follows nude models. The
funerary monument in the Frari to Doge
Nicolò Tron, created after 1476, is in its
structure reminiscent of Pietro
Lombardi's monument to Doge Pietro
Mocenigo in SS. Giovanni e Paolo, as
well as of funerary monuments to
prominent Romans. The figures of the
Virtues at the Doge's side betray, the
influence of classical models. In 1484
Rizzo assumed responsibility for the
reconstruction of the east wing of the
Palazzo Ducale, destroyed by fire the
previous year. By the terms of the
commission, he was prohibited from
undertaking any further work in a
private capacity. He supervised the
work of numerous stonemasons,
probably from Lombardy. In 1485,
Rizzo was made responsible for the
construction of the Scala dei Giganti in
the courtyard of the Palazzo Ducale.

site the lion of St. Mark which used to be on the
upper part of the eastern facade of the arch. All that
remains of the kneeling figure of the doge is the head
(now in the Museo del Palazzo Ducale) which does
not appear to be Rizzo's work. The squire is wearing
antique, body-molded armor. This leads one to ask
whether Rizzo used a live model or if he sculpted
from the nude body. The sculptor's skill is even more
noticeable if we compare this to the warriors Pietro
Lombardo made for the tomb of Doge Pietro
Mocenigo in 1476 (see pp. 198, 199). The squire's
clothes cling in ridged layers to his body. This brings
to mind the drapery on the *Virtues* of the Foscari
tomb (Antonio Bregno) and in the work of
Mantegna. The squire's young face is framed by
unruly curls, and his lips are creased into a slightly
bitter expression—again reminiscent of Mantegna.

Rizzo's funerary monument for Doge Niccolò
Tron (d. 1473) (see p. 197) was probably conceived
as a reply to Doge Pietro Mocenigo's tomb carved by
Pietro Lombardo just after 1476. For Lombardo this
led to a commission to build the church of S. Maria
dei Miracoli. Both tombs have niches ranged above
each other and inserted in the architectural frame-
work of the monument. This had already been done
in Rome for the tombs of the popes. Pietro
Lombardo had set the standing figure of the doge as
a *miles christanus* [Christian soldier] high upon a
sarcophagus showing scenes of the main events of his
time in office. Rizzo instead places his doge, who
wears the robes of state, at the bottom, standing in
the middle of the monument's complex architecture.
The figure remains higher than the viewer but lower
than the altar, toward which he seems to look. We
can only see the doge's posture and gesture properly
if we look at him obliquely from across the presby-
tery steps. The two allegories next to him are meant
to be viewed from the front.

Right down to its last detail, the sarcophagus
resembles that in the tomb of Orsato Giustiniani
which, according to Francesco Sansovino, was by
Antonio Dentone. It may be that this was a reference
the client wanted and wrote into the contract.
Clearly, the Giustiniani tomb was very famous. So
much so, that at the beginning of the sixteenth
century it was copied for the tomb of Cardinal
Giovanni Battista Zen (see p. 218), as we know from
the contract to build the Zen monument.

To his *Charity* (see p. 197, top right) Rizzo has
given the same body as that of his *Eve*, but her face is
idealized and impassive, more suited to an allegorical
figure. The skill with which he conveys the feeling of
finely pleated fabric revealing the body beneath was
undoubtedly much appreciated by the experts, many
of whom were also collectors of classical works. On

portrait of a model. Although the premise is diffe-
rent, the question is similar to that later posed by
Tullio Lombardo or Simone Bianco's female busts
where we feel that behind the antique idealization we
can see or sense the features of a contemporary
model. It is not hard to see why art historians are so
interested in the splendid figures of *Adam and Eve*.

What has been rather overlooked, though, is
Rizzo's sculpture of a squire, originally on the
southern side of the Arco Foscari where he may have
held Doge Moro's coat of arms. This would have
completed the scene of the doge's investiture, oppo-

Charity, one of the two Virtues which flank the figure of the doge on the funerary monument for Nicolò Tron.

Funerary monument for Doge Nicolò Tron by Antonio Rizzo, in the church of S. Maria Gloriosa dei Frari.

the bust of the other figure, *Caritas-Amor Dei* [Charity-Love of God], the lightweight clothing is seen only where it falls into folds, almost revealing her entire body. It seems likely that Rizzo used an antique prototype for this part of the work. When it came to producing figures *all'antica*, no one else in the Venice of his day was able to reach the level of quality seen in these two *Virtues*. He opened up the whole area that Tullio Lombardo was so soon to cultivate.

The large band of stonemasons who helped Rizzo make the Tron tomb tried to imitate his use of pleats, expressions, and postures but did not quite manage to bring the stone to life as he did. Given the fairly low level of creativity shown in most of the figures these men made, it seems unlikely that the artist influenced their work by providing them with sketches.

After the fire in 1483, Antonio Rizzo was appointed *proto* for the rebuilding work on the Palazzo Ducale. This meant he was prevented from taking on any private work. It does seem, therefore, that he dedicated himself exclusively to the task, even building the staircase intended for the doge's investiture (known later as the Scala dei Giganti, or Giants' Staircase, after two huge statues of Mars and Neptune by Jacopo Sansovino). The best reliefs on the staircase are usually attributed to Rizzo. These are the Victories with their symbolic attributes. He also did the panels on the pillars, some of which are of outstanding beauty.

Apart from Rizzo, there is no doubt that a number of experienced sculptors worked on the staircase, decorating the pillars with trophies and carrying out numerous figurative reliefs on the risers between the steps. The hallmarks of the individual sculptors can mainly be glimpsed in the physiognomy of the figures, although they do appear to have tried to keep their differences to a minimum. Here too it is not clear if Rizzo provided a drawn plan laying down the details that his assistants had to include. The tool of stylistic criticism has come a long way and is frequently used for paintings. To date, this has been very little used in connection with Venetian sculptures as they scarcely ever come up for auction. Owing to the way things were done in Venice, it could happen that expert or even fairly famous stonemasons would all work together in return for a daily wage. In 1496 Pietro Lombardo's client Francesco Gonzaga ran out of patience. In a letter soothing him, Lombardo boasts that he has taken on twenty-five "homeni" [*uomini*, or men] at the same time to work on a chapel and its decoration. Even if he was exaggerating, the fact is that the number of craftsmen working on one job was still far greater than most historians tend to believe. And yet, after

the fire of 1483 in the Palazzo Ducale, it was far from easy to find enough qualified sculptors to work on the new building. The Lombardo stonemasons working on the Palazzo were classified as foreigners, and in order to get them to stay, Rizzo managed in 1486 to have an exception made to the strict gild regulations that limited their activity. The documents relating to the rebuilding of the Palazzo Ducale have survived only in a fairly fragmentary form and mention just a few names without specifying the work they did. The same problem is encountered in other places too: suffice it to mention the decoration of the Palazzo Ducale in Urbino which was carried out at about the same time.

Many attributions we make are cast into doubt by the fact that so many sculptors were able to draw on the motifs and language developed by the most commercially successful among them. If a figure shows the influence of Pietro Lombardo's work, this does not mean that it necessarily came from Lombardo's workshop where he was in the habit of passing on his commissions to a constant flow of new assistants. Therefore, it seems to me that rather than attributing a work to the circle of this or that artist, it would be better to talk, for instance, of a work "close in style to Pietro Lombardo" or, in the phrase so often used in the past, "in the manner of Pietro Lombardo."

Of works close in style to Rizzo, three reliefs in the church of S. Trovaso stand out. These were incorporated in Baroque times into a frontal piece for the altar. The two side reliefs show angels making music. The central panel depicts an interior with a host of angels carrying the *arma Christi*, while an angel in the middle holds the cross. Quite clearly, these reliefs met with the approval of popular taste because they were copied time and time again (copies in Berlin, Staatliche Museert, Stiftung Preussischer Kulturbesitz). Their origin is unclear, and in Venice there are no other surviving examples of reliefs dealing with similar subjects. The theme of the Passion might indicate that they were part of a tabernacle, even though Venetian tabernacles and tabernacle altars do not confirm this.

There is an obvious resemblance between these faces, carved in very low relief, and those on the best pillars of the Scala dei Giganti. The way the figures are foreshortened and ranged in tiers is truly artfully done. This sculptor's inventive richness and narrative zest is unparalleled in Venice. Some of the angels are playing stringed instruments, and one of this group is lost in concentration as he tunes up. Others are singing or tapping timbrels. What is highly unusual is that two of the musician-angels have anything but childish bodies, with chests as well developed as Rizzo's *Adam*. Despite the differences in the shape of

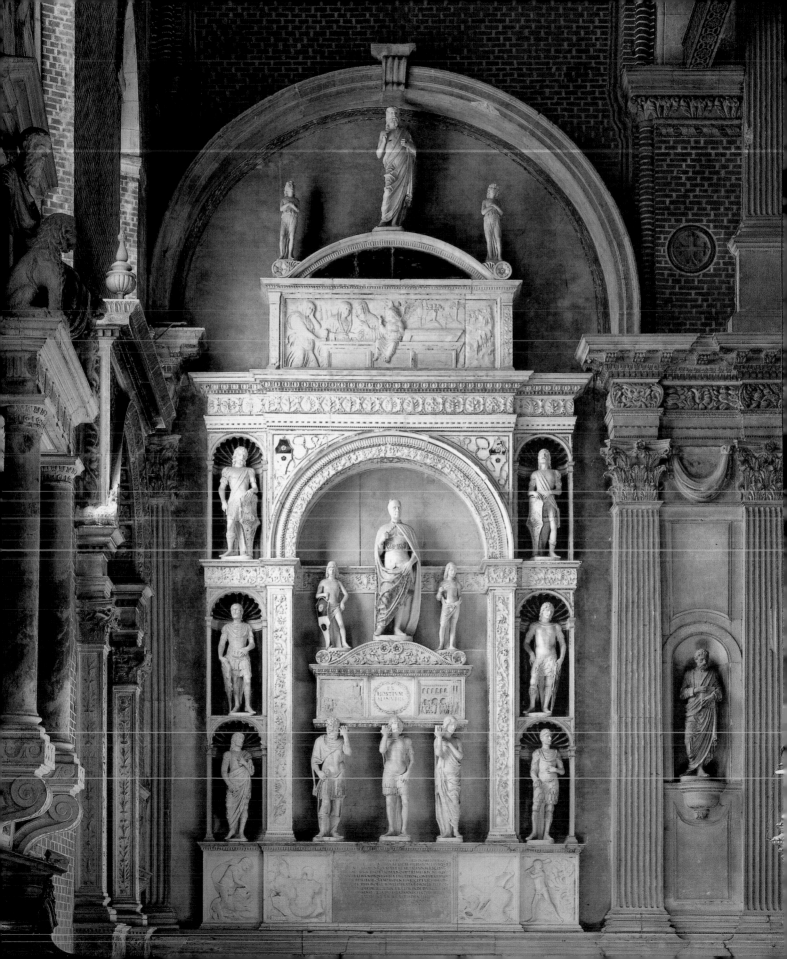

the figures, the composition of these reliefs brings to mind those carved by Tullio Lombardo for the facade of S. Marco, probably toward the end of the 1480s. We can see other faces among the heads of the foreground figures; in the background we can see still more faces that belong to figures who seem less involved in the action. It seems as though the composition of these reliefs is almost a systematic reply to Tullio's *all'antica* scenes. The themes here are the psychology and feelings of the musicians, the harmony of the sounds of the music, the relaxed attitudes of the musicians, and the flow of their robes. Affinities with the best reliefs on the Scala dei Giganti, which are nonetheless not necessarily Rizzo's work, would add weight to the theory that these reliefs could be his late work.

Once Rizzo accepted the position as *proto* on the work for the Palazzo Ducale, he had to close his own shop. In 1481 he complained bitterly about this limitation foisted on him, claiming that the *proto*'s wages were not sufficient to cover all his expenses. This early episode has been linked to rumors which have it that in 1499 Rizzo left Venice hastily for Cesena, taking with him a considerable amount of money intended to pay for work in the Palazzo Ducale. Nevertheless, this does leave us wondering how a *proto* managed to get access to such large sums. Still more questions arise in connection with the tomb of the two Barbarigo doges, Marco and Agostino, in S. Maria della Carità, partly dismantled and partly destroyed in the nineteenth century. The recent discovery of the contract for the tomb shows that in 1492 two sculptors, Giovanni Buora and Bartolomeo di Domenico Duca, who had already worked together on the Scuola Grande di S. Marco, were awarded a commission to carry out the project, for which a drawing already existed. A clause which required the artists to improve on the design does not necessarily mean that it was of poor quality, this was a formula used in contracts at that time. Unfortunately, the document does not tell us who the author of the design was. The names of both Rizzo and Pietro Lombardo have often been mentioned, but we should now also look at Buora and his partner as well.

The contract for the Barbarigo tomb stipulates that "the said craftsmen are not bound to carve any prince but must carve His Serene Highness." Today the kneeling figure of Doge Agostino Barbarigo is tucked away in the sacristy of S. Maria della Salute where it is hardly displayed to best effect. It is, in fact, a masterpiece of concise characterization which encapsulates all the elements of Rizzo's style found in the portrait of Doge Tron. Viewed in profile, as was the sculptor's intention, the doge's thick beard lifts off his chest and the outline of his expressive face forms a unity with the doge's horn. The effigy of this doge, who was still in office at the time, may well have been Rizzo's last work before he left Venice for good, leaving the way clear for the Lombardo who had in any case been present on the scene with their entourage for some time.

The Workshop of Pietro Lombardo and Other Venetian Sculptors of His Time

As early as 1464, even before Antonio Rizzo had carved the altars that Doge Cristoforo Moro commissioned for S. Marco, or Antonio Dentone had made the portal to S. Elena, Pietro Lombardo was busy working in Padua, where he carved the funeral monument (c. 1464–67) for the jurist Antonio Rosselli. It is clear from both the architectural and the figurative elements of his work that he had been influenced by Florentine sculptors. Evidently before coming to Padua by way of Bologna he had carefully studied the Florentine tombs of Leonardo Bruni and Carlo Marsuppini, both in the church of S. Croce.

Documents from 1474 onward confirm Pietro's arrival in Venice. In 1475 the humanist Matteo Collaccio sang the praises of his "statues" in the church of S. Giobbe, without specifying just what kind of statue he meant ("whose statues I much admired yesterday in the church of S. Giobbe"). This gives us immediate problems since there are clear differences in style between the patchy sculptures in the presbytery of S. Giobbe and those of the portal. We cannot rule out that Collaccio merely meant to pay generic homage to the work of the firm of Pietro Lombardo and sons and was just using a conventional formula so often found in panegyrics. We know that around this time equally topical praises of Rizzo's work and that of several Venetian painters were published.

Lombardo's Paduan sculptures, statues, and reliefs alike, are of outstanding quality and only a few of the S. Giobbe sculptures stand up in comparison. Moreover, from 1480 Pietro was in charge of a number of important buildings in Venice as well as in Treviso, where the collapse of the cathedral dome inflicted on him not only a loss of prestige but also considerable economic damage. Construction work on S. Maria dei Miracoli, funeral monuments in Treviso and Venice, a big commission from Ravenna where Pietro did an effigy of Dante for one of the cathedral chapels, and the construction of a chapel in Mantua meant a huge workload which could only be

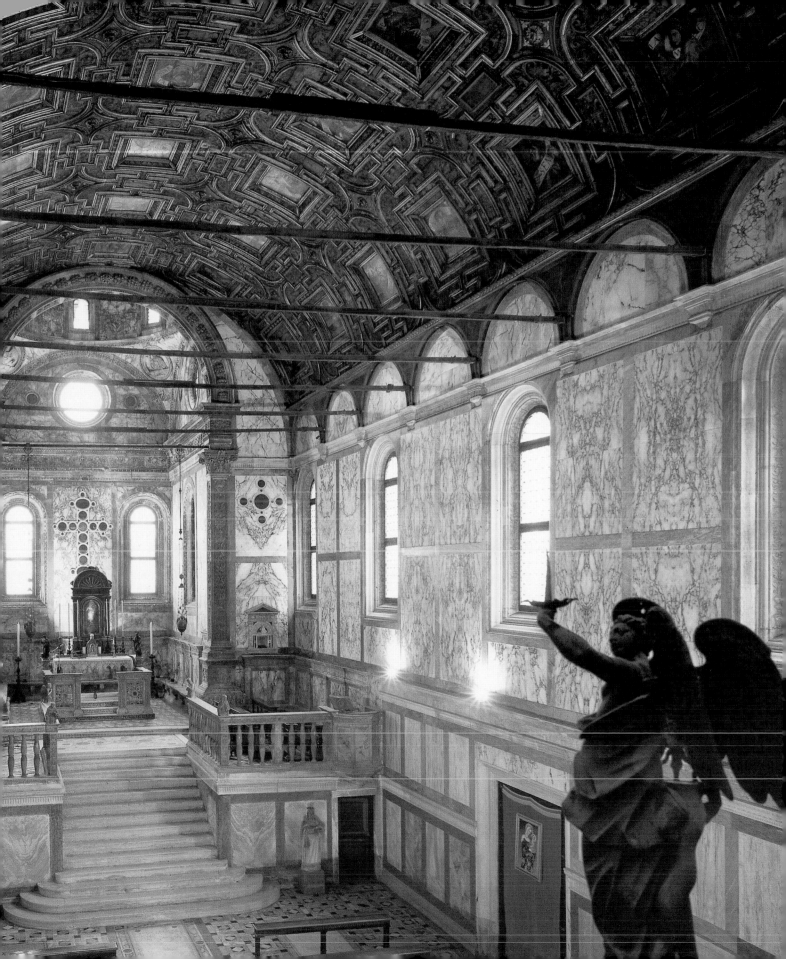

St. Luke and *St. Mark*, two tondi in low relief in the pendentives of the dome of S. Maria dei Miracoli.

handled by having a well-run shop that was able to turn out work of even quality. Perhaps it was less risky delivering work that was mediocre all round than having to justify huge swings in quality.

From the 1480s onward, at the very latest, Pietro was able to count on his sons working with him. Tullio and Antonio worked for many years in their father's workshop, but this does not mean that they were unable to take on work in their own right as well. Given this background, it is not easy for historians to single out the individual work of these very talented sculptors.

Any attempt to separate the work of the head of the firm and his sons from that carried out by their countless assistants is truly difficult, especially in relation to large-scale works done over a short period of time. This is the case with S. Maria dei Miracoli, which was started in 1480 and, with the exception of the wooden vault, was already finished by about 1490 after a change in design. It includes numerous tondi with figurative decorations, portals, and friezes on the outside, as well as richly carved ornamentation on the inside which raise yet to be resolved problems of stylistic criticism. Here too, both the figure sculpture and the ornamental sculpture vary widely in quality, but this does not detract from the overall effect (see pp. 200–203).

The sculptural decoration in S. Maria dei Miracoli is famed primarily for its excellently crafted rich ornamentation. Much less attention has been paid to the figurative sculpture, such as the tondi set in the pendentives of the dome above the choir, which are not easy to examine from a distance, or the statues on the balustrade at the end of the raised presbytery which have more than once been attributed to Antonio. What are well known, though, are the pillar bases in the choir. The cushion motif, which is carved in gray stone, stands out sharply against the white marble and is taken from the niche Donatello made for St. Louis of Toulouse for Orsanmichele in Florence. Andrea Mantegna's works have been mentioned as the probable model for the figurative elements. Even today some of the motifs remain a disturbing mystery in a church dedicated to the Virgin. Around 1485 the nereid and triton motifs were well known and liked in Venice. One of countless examples is their ornamental use in the frontispiece attributed to the Master of the Putti (Treviso, Biblioteca Comunale) in a 1472 edition of Cicero's *Tusculan Disputations.* Another truly surprising motif on the choir pillars is that of an exploding bomb, a reference to an escapade of Federico di Montefeltro, duke of Urbino. All we can imagine as to why this was included is that perhaps the sculptor was unaware of the meaning it had in Urbino and

just thought it was as good an ornamental feature as any other. On the other hand, we cannot believe that the sea nymphs and tritons on the bases follow a specific iconographical order. We find them again in the reliefs on the bronze bases of the flag poles in Piazza S. Marco (1505–6), where they form part of an intricate allegorical scene and, much later on, in Tintoretto's central painting for the Sala del Senato in the Palazzo Ducale. Their only significance in S. Maria dei Miracoli is that they prove how much freedom of choice was left to artists working on the less visible parts of the building.

Pietro obtained the commission to build S. Maria dei Miracoli after his artistic ability had successfully been tested on the tomb of Doge Pietro Mocenigo (d. 1476) in the church of SS. Giovanni e Paolo. At the center of the monument's complex architecture the doge, portrayed as a *miles christianus,* stands erect on his sarcophagus, which is supported by three men. The tomb is decorated with reliefs showing the most important episodes from his dogate. The scenes chosen were the capture of Scutari (1474) and the arrival of Queen Caterina Cornaro in Cyprus, which alluded to the peaceful conquest of the island by the Republic. In this context the inscription "EX HOSTIUM MANUBIIS [captured from the enemy]" adds a particularly triumphal note.

In Venice it was rare for condottieri to be shown standing in armor on their funerary monuments. The first person to receive this great honor was Vettor Pisani who had routed the Genoese in the sea off Chioggia in 1380. The fully armored doge is looking at the high altar, but neither his posture nor his expression are martial. Despite the skill with which they are carved, the faces of Pietro Lombardo's figures seem lifeless: capturing the spirit of his subject was not his strongest point. It was his son Tullio who, about ten years later, set a new trend by including two classical armed warriors in the tomb of Doge Andrea Vendramin. Even if the figures on the Mocenigo tomb are a little stilted, the people who awarded the commission for S. Maria dei Miracoli would have been more interested in the ornamental decoration, some of which is quite superb, and in the unquestionable efficiency of the workshop. The base of the monument shows mythological and allegorical scenes, a totally new idea for the tomb of a doge. We see Hercules killing the hydra and the lion. Felix Faber, a German pilgrim from Ulm who came through Venice in 1490, was so impressed by these images that he dedicated a long passage to them in the travel diary he kept in Latin:

The Dominican church in Venice has the tombs of many doges. Never have I beheld tombs so full of

beauty and pomp. Not even the tombs of the popes in Rome stand up by comparison. The tombs are embedded in the wall above the floor and are completely covered in various marbles and sculptures and decorated in gold and silver more than is proper. There are images of Christ, the Blessed Virgin, the Apostles, martyrs and other saints all according to the wish of the patrons. The sacred images are the main characters, and these are placed in the center, but all around there are figures of pagan gods: Saturn, Janus, Jupiter, Juno, Minerva, Mars, and Hercules with their attributes. To the right of the church entrance I saw the precious tomb of an ordinary doge [Pietro Mocenigo], upon which is carved the image of Hercules fighting. He is portrayed as usual but is wearing the skin of a lion he has killed rather than a cloak. Then there is another image of Hercules wrestling the hydra, a fearful monster which immediately grows seven new heads as soon as one of the old ones is chopped off. And there are also naked warriors, armed with swords and spears, their shields slung around their necks in the place of breastplates, truly pagan idols. Furthermore there are young, naked, winged boys bearing triumphal colors or fighting amongst themselves. Many of these pagan images alternate with those of our redemption, and thus it is that simple souls, believing they are saints, worship Hercules, mistaking him for Samson, and Venus, taking her for Mary Magdalene, and so on. Finally there are also sea monsters, the coats of arms of the deceased, and inscriptions celebrating their achievements.

It is probable that during this period there were many sculptors from Lombardy working in Venice. In 1491 the Venetian stonecutters protested bitterly about this competition which, they said, was ruining them. Forty "Venetians or men from the lands subject to your Lordship" complained to the *provveditori* of the Commune, one of whose tasks was to control the gilds, about the domination of the gild of 126 (!) "outsiders, namely Milanese and those from other foreign parts." One thing they singled out for criticism was that, so we are told, these outsiders refused to take on Venetian apprentices. It would appear, in fact, that in those days solidarity between immigrant sculptors from the same region was especially strong. It is interesting that the complaint was directed only against immigrants from territories outside Venetian control, which at that time extended as far as Bergamo in the west. Later on (1507) they were also blaming stonemasons whose shops took on more than ten boys "who do not do

the work with the due care that is required and sometimes produce work that is not good enough so those who asked for the work must claim damages." Documentary sources show not only that there were at least 166 independent sculptors competing in Venice but also that demand was so strong that it could barely be met. Results were often disappointing. Art historians have always tried to tie the many works that still survive to the few names of the great sculptors that we have, even in cases where there are enormous, indeed often insurmountable, differences not only of style, but above all of quality. The huge success of Pietro Lombardo's workshop meant that many others found it easy to imitate the language he used and made familiar; there were numerous sculptors who were fairly expert but were not "maistri di bottega" or "patron di corte," in other words, they did not have their own shop or yard. They worked as journeymen in other people's workshops, moving around as need be. This means that these workers became familiar with the styles of the main Venetian master-sculptors and had no problem in finding a job anywhere.

If it is often difficult to attribute a work to Pietro Lombardo in person, it is almost impossible to attribute one to his workshop. This term presumes that there was an ongoing working relationship between the artist in charge of the shop and a group of workers. In Venice this was not the norm since many sculptors had the habit, if not the need, to move around regularly from one shop to another. The work produced by the only two stable members of Pietro's workshop, his sons Tullio and Antonio, took on ever greater individuality of style as the years went by.

The tomb of Doge Pasquale Malipiero (d. 1462) in SS. Giovanni e Paolo shows typological affinities to that of Pietro Mocenigo. It too consists of a classically styled funerary chapel in which a sumptuous sarcophagus is installed. The motif on the canopy had already been used on the tombs of two other doges: Tommaso Mocenigo (d. 1423) and Francesco Foscari (d. 1457). Nonetheless, the attribution of this tomb to Pietro cannot be demonstrated either from its ornamentation *all'antica* or from the figures, which contain important stylistic differences compared to those found on the Rosselli tomb in Padua or those on the Mocenigo tomb done by the master himself.

Even the differences between the Mocenigo tomb and that of Doge Niccolò Marcello (d. 1474) in SS. Giovanni e Paolo are clear and, in my opinion, irreconcilable. The latter is conceived in a totally different architectural manner. It has a highly distinctive and detailed figurative style which stands out for its

Detail of a richly carved low relief in the choir of the church of S. Maria dei Miracoli.

graphic elements. This points toward its being the work of a sculptor whose name is unhappily still unknown. In this context we cannot emphasize enough how important it was when the 1492 contract was found that commissioned Giovanni Buora and Bartolomeo di Domenico del Duca to make a tomb for the two Barbarigo doges, Marco and Agostino. The tomb was to go into S. Maria della Carità, and the text of the contract does not rule out the existence of a master plan drawn up by Antonio Rizzo, especially when we bear in mind that at least one of the effigies of the doges was his work. It does, however, almost completely refute the recently suggested attribution of such a plan to Pietro Lombardo. Those who hope to prove an attribution based on the ornamental features come up against another hurdle: he was very frequently in the habit of getting his assistants to do such features. We know from documents that Bartolomeo Bon's portal for SS. Giovanni e Paolo was definitely the work of at least seven stonemasons from different places, each with different artistic experience. I think we can say that the same kind of practice continued into the next generation as well. The ornamental foliage and friezes on Pietro Lombardo's Mocenigo tomb are in widely contrasting styles which are not merely the consequence of how well they were executed.

It appears that Pietro remained in charge of the workshop for many years, but this did not prevent one, or both, his sons from ratifying a contract that had only just been stipulated with their father, nor from taking responsibility for its completion. This happened, for instance, in 1488 when Tullio and Antonio were in charge of making a tomb for Giovanni Zanetti in Treviso based on a contract drawn up with Pietro two years earlier. It is possible that the decision did not merely derive from the well-known heavy load of orders that the shop had, and which would logically mean that the duties and responsibilities for delivering work on time should be divided. We are also tempted to suppose that connoisseur clients had not missed Tullio's extraordinary talent and may have tried to make sure he was bound by contract to work on their job.

With this in mind it is understandable why the tomb of Doge Andrea Vendramin, who died in 1478, (now in SS. Giovanni e Paolo, originally in S. Maria dei Servi), should have been attributed to Tullio and his assistants, even though at the time Tullio was in theory still working in his father's shop. The clients had originally approached Andrea del Verrocchio whose sketch we still have (London, Victoria and Albert Museum). We do not know exactly when Tullio was commissioned to do the Vendramin tomb, but work had already started on it in 1493. If we

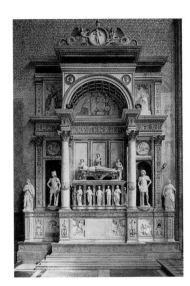

Funerary monument for Doge Andrea Vendramin, by Tullio Lombardo, in SS. Giovanni e Paolo; and detail of classicizing statues.

compare it with the Mocenigo tomb we see huge architectural and sculptural differences, even though it reuses some of the same motifs. Tullio's work here is almost like a criticism of his father's earlier work, even though much of the fame that the Lombardo workshop enjoyed in 1480 derived precisely from that very piece. Watched over by three young men holding candles, the doge rests in a sumptuous cata-

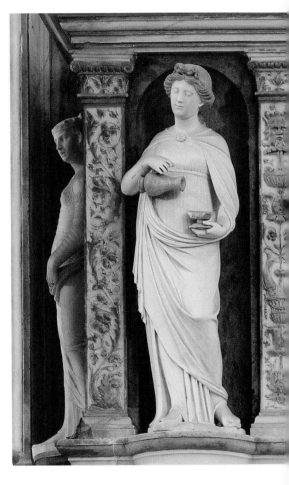

falque beneath a projecting baldachino with a barrel vault. Meyer has described it as "a catafalque turned to stone." The bed itself rests upon a sarcophagus with niches containing the seven Virtues. Originally the two large niches to the sides in black Verona stone were occupied by *Adam* (now in New York, Metropolitan Museum of Art) and *Eve*, and statues of the two grieving men-at-arms were on the side ledges. Two young squires, which were unfortunately damaged during the Second World War (Berlin, Stiftung Preussischer Kulturbesitz), used to stand on the top cornice (see pp. 212, 213). To complete the

monument, the lunette has a votive image of the doge flanked by the two figures of the Annunciation, the Virgin and the Angel Gabriel, which were almost obligatory for funerary monuments.

Here again Tullio did not personally do all the sculptures. *Adam*, which is signed, the two men-at-arms, and the two squires are clearly in his style. A sculptor totally dedicated to classical, toga-clad

thoughtful, almost dreamy, gaze and the very unwarlike posture of the two young men-at-arms, who seem sorrowful at the doge's passing. We would perhaps be taking the easy way out if we were to assume that Tullio went to study in Rome during the 1480s. Nonetheless, such a possibility, and the impact that seeing the best classical works in their own setting would have had, could explain why

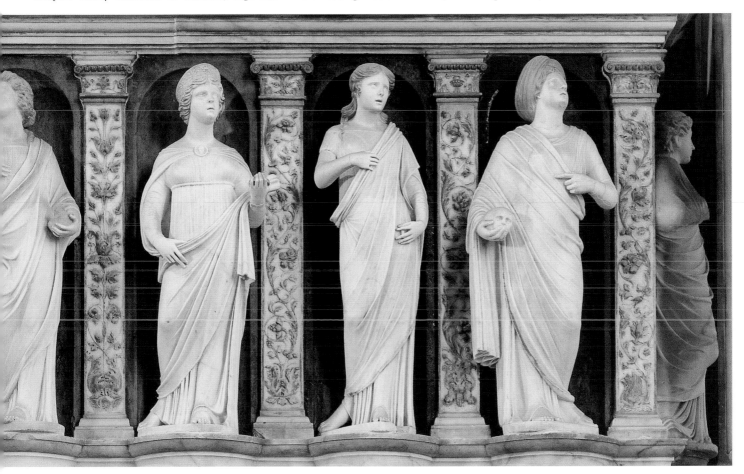

figures carved the *Virtues* on the sarcophagus, while the recumbent figure of the doge and the relief in the lunette are the work of a fairly ordinary sculptor.

Historians have always justifiably underlined the classically influenced style of Tullio's figures because their armor is like that found on countless surviving classical statues of warriors. The effect is heightened because his detailed knowledge of the human body combines with a tendency to idealize human form in the same way that classical statues did. Tullio's interest in capturing feelings can be seen from *Adam's*

Tullio systematically drew on sources of classical antiquity unlike any his father and other Venetian sculptors had used as models for their work.

In Venice there was at least one *Lament at the Death of Christ* with life-size terracotta figures; made for the church of S. Antonio di Castello, the remains are now in Padua, Museo Municipale. Its sculptor was Guido Mazzoni, who was in Venice from 1485, the date of the contract, until 1489. Like Niccolò dell'Arca's very similar sculptures in Emilia, this work demonstrates how imitating nature and conveying strong emotions had been pushed to the

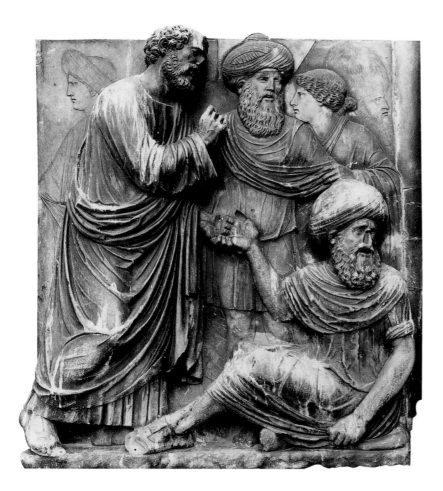

Healing of Anianus, Tullio
Lombardo, low relief on the facade
of the Scuola Grande di S. Marco.

utmost, only to be re-emphasized by naturalistic polychrome painted effects as well. It seems unlikely that Tullio Lombardo could have completely escaped the fascination of so harrowing a scene just because his ideal of classical figures was diametrically opposed to what Mazzoni produced. The flowing hair of the wounded young man and the heart-rending lament of his mother depicted in the first relief in the Cappella dell'Arca in the basilica of S. Antonio in Padua could have been Tullio's reply to Mazzoni's work.

An outstanding example of how Tullio used Roman models is found in the reliefs showing scenes from the life of St. Mark: the *Healing of Anianus*, a cobbler from Alexandria, and his *Baptism*. These date from about 1489 and were commissioned for the facade of the Scuola Grande di S. Marco. With these reliefs Tullio also set out to compete with the painted decoration of facades of Venetian palaces and houses which had become fashionable in the last quarter of the century. The scenes are set against an invented architecture and are designed to be viewed from afar, the only way that the perspective effect could work convincingly. Nevertheless, this does not weaken the cohesion of the building, as so often

happens with *trompe-l'oeil* painting, since the perspectives of porticoes are effectively framed by cornices, like work painted on a facade. The weakness of the link between the figures and the architectural environment against which they are set betrays a fundamental difference of approach compared to the reliefs in the Cappella dell'Arco, started in 1499. This leads us to think that the reliefs on the Scuola Grande could have been installed in a position for which they were not originally conceived.

The two *Miracles of St. Mark* did, however, set a new trend oriented toward Roman reliefs such as the extremely famous ones in the Palazzo dei Conservatori in Rome. Later on, in 1504, Pomponio Gaurico was to write a treatise entitled *De sculptura* [On sculpture] that contains a pregnant description of this style, and was probably inspired by the work of Tullio Lombardo, for whom he is full of praise. Guarico argues that there are different fields in relief: figures in the foreground stand out more (half relief), those in the middle ground stand out less (*contractius*), and those in the background still less (*compressius*). Perhaps Vasari coined his expression "flattened relief" on the basis of his Paduan colleague's terminology.

Borrowings from classical models are not limited to the style of the drapery or the arrangement of figures in receding planes. Typically, in the background we also find two female figures on the left of the relief who are always shown in profile. The tension between these background profiles and the figures of the main characters in the foreground is typical of Roman reliefs such as those already mentioned in the Palazzo dei Conservatori. I am not sure that Tullio's new style, which can be clearly seen from the late 1480s onward, can be explained merely by his knowing the classical works that were already in Venice or in the Veneto. Some parts of Andrea Mantegna's *Triumph of Caesar* (1484–92) (Hampton Court, London) have similarities of style for which we are unable to document any direct connection. The knowledge and understanding of classicism found in Tullio's work is too broad to be based merely on the study of individual pieces, whether actually Antique or *all'antica*, that could then be found locally. We know from writings of the time that painters and sculptors were themselves very often the owners of Antique sculptures which they would study. Marcantonio Michiel tells us that Tullio Lombardo possessed a female torso that he had used as a model more than once. Tullio, and doubtless other sculptors too, used to finish off sometimes even improve on, Antique figures. It would be interesting to be able to take a close look at the *Justitia* [Justice] that was prominently displayed on the Palazzo dei

Dieci Savi in the Rialto just after the fire of 1514 so that we could date it properly.

It was only in 1499 that Tullio finally took the workshop over from his father Pietro when the latter accepted the job as *proto* of the Palazzo Ducale and had to give up all private practice. While Antonio Rizzo had been forced to close down his shop and had complained bitterly about this, Pietro was able to hand his over to his sons who had, in any case, been playing a major role there for some time. In turn, the sons were able to accept lucrative State commissions, such as the sumptuous fireplaces in the rooms of the Palazzo Ducale. They were paid for these in 1505, just before Antonio left Venice to set up in Ferrara.

Tullio's later reliefs, such as the "histories" for the Cappella dell'Arco in Padua, also conformed to Gaurico's "rules." The classical style of the drapery, which allows us to see the contours of the body beneath, proves that he had no intention of deserting a course that had brought him so much success. Pieces that required great craftsmanship played an increasingly important role in his reliefs. Inasmuch as Tullio had opted to be a virtuoso he no longer had to fear any competition. He had already carved and signed the monumental altarpiece with the *Coronation of the Virgin* for the Barnabò Chapel in S. Giovanni Crisostomo, a work so idiosyncratic that attempts to explain its style have led to contradictory results (see pp. 208–209). At the center of a semi-circle, scarcely noticeable as such, of Apostles there, remains space not only for the coronation group but also enough for the two Apostles on either end to lean out of the altar frame; the loss of most of the attributes accentuates the rather monotonous effect of this line of figures tightly draped in their *all'antica* clothes. The composition would appear to be the result of a precise calculation based on linear elements and symmetrical correspondences. Another Venetian relief that we can compare with this is the so-called *Traditio Legis* which is now displayed above the altar in the Treasury of S. Marco. Even today there is disagreement on both the origin of this relief and the date and extent of later reworking. One interpretation dates it to around 1500. It is feasible that Tullio was under pressure from his client to follow this or another similar work. Nevertheless, this most definitely does not mean, as has recently been asserted, that he intended to replace the art of Rome with that of Constantinople and make of it a new paradigm. Sculptors and architects could look to Rome and to medieval traditions for models and inspiration but certainly not to Constantinople which fell to the Turks only in 1453. Once again, here we have the exception that proves the rule. We can see

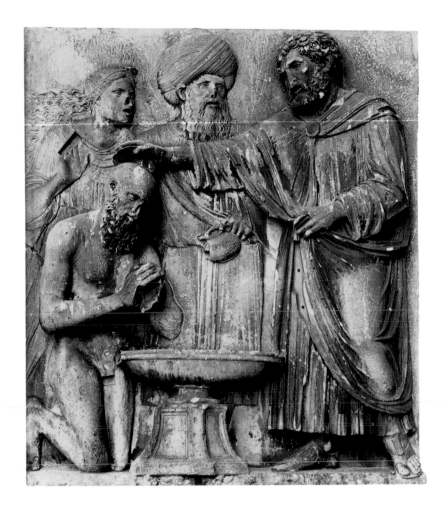

from the stipulations of the contract with Alessandro Leopardi and Antonio Lombardo for the Zen Chapel in S. Marco that the bases of the columns must be in the "Constantinople style." The same contract also makes reference to the candelabras of St. George. These Byzantine candelabras have survived but the column bases do not resemble their style.

At the time in question, sculptors and painters largely followed different routes. While sculptors were not infrequently bound by contract to produce works *all'antica*, it does not appear that Venetian painters were subject to the same kind of restrictions. The composition of the figures in Cima da Conegliano's altarpiece the *Incredulity of St. Thomas* (London, National Gallery), which is signed and dated 1504, reveals that the painter had studied Tullio's relief. Nevertheless, its form is free of antiquarian influence, and it is less calculated in its composition. This freedom from dogmatic constraints illustrates how differently sculptors and painters approached their work at the start of the new century.

Among Tullio's best work we must mention two double portraits in the Ca' d'Oro in Venice and the Kunsthistorisches Museum in Vienna. Made for private viewing, they still leave many questions

Baptism of Anianus, Tullio Lombardo, low relief on the facade of the Scuola Grande di S. Marco.

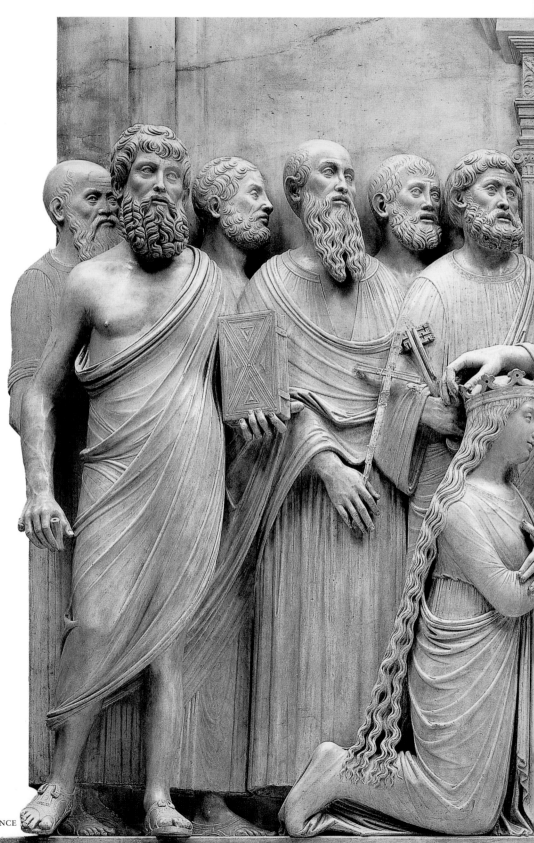

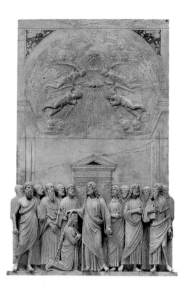

Coronation of the Virgin, Tullio Lombardo,
1500. vast enormous marble altarpiece in the
Barnabò Chapel, S. Giovanni Crisostomo; and
detail of figures.

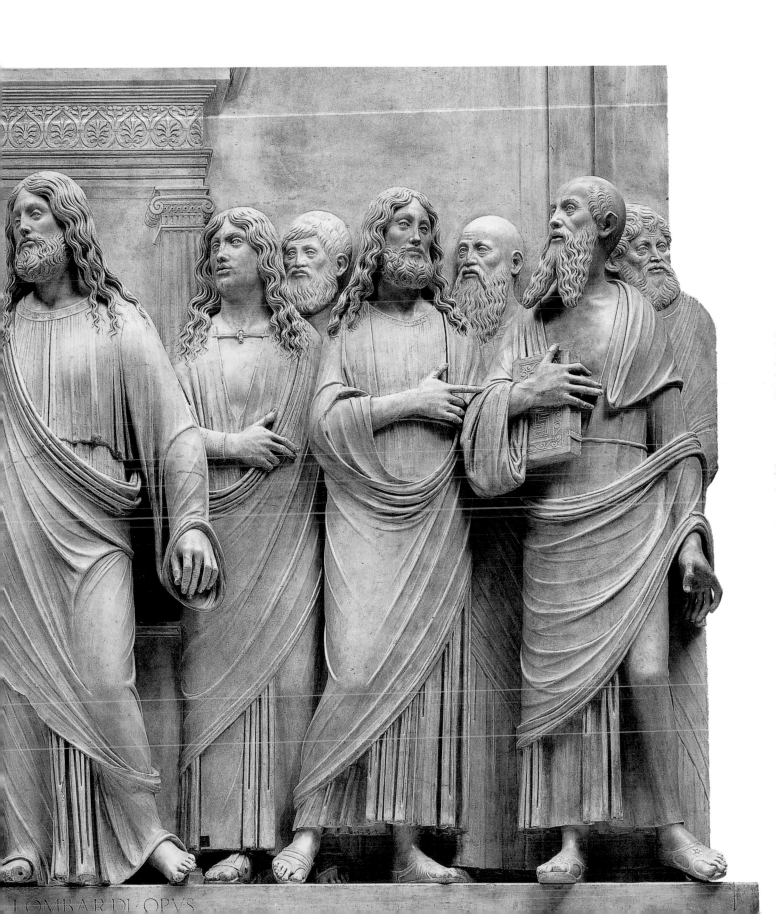

LOMBARDI OPVS

unanswered. It has been suggested that they could be portraits of Venetians shown *all'antica*. It has been pointed out that the hairstyle of the young woman in the Vienna relief was the height of fashion around 1510. As far as the double-portrait genre itself is concerned, many comparisons have been made, especially with paintings from north of the Alps, but also with classical works. Many years earlier, Jacopo Bellini had already sketched the Roman relief on the tomb of Metellia Prima (formerly in Brescia) which was decorated with two busts and was later to be reproduced by Mantegna in his frescoes for the Ovetari Chapel in Padua. The Ca' d'Oro relief (see p. 211) is signed but unfortunately not dated. The two busts, a man and a woman, are carved on different planes, a device which slackens the relationship between the two figures; even their eyes are looking in different directions. The sharp cut of the block and the way the man is carved could suggest that the relief was meant to be put inside a frame, as so often was the case with antique reliefs. As for the woman, in Venice such a low-cut dress could only have been shown on an allegorical figure or in the portrait of a courtesan. This would therefore rule out the idea that the relief portrays members of a Venetian patrician family. The work was probably commissioned by, and intended for, Venetian collectors: next to their antiques, these antique-style reliefs would surely be appreciated, and not just for their great artistic merit. This kind of work would get people talking about Tullio's art and about the possibility that one of the best modern sculptors could succeed in imitating, equaling, and perhaps even surpassing the ancient sculptors. In this context it is appropriate to Pomponio Gaurico who tells us that in Treviso a section of architrave carved by Tullio Lombardo was carried in triumph through the streets of the town.

In the Vienna relief, the figures seem united by a deep bond. They are both looking into the distance but in the same direction, and the current theory that identifies the two figures as Bacchus and Ariadne still seems the most convincing of all those put forward. Tullio Lombardo and his brother Antonio were not the only sculptors who were making busts *all'antica*. It would seem that a Tuscan named Simone Bianco, who started up in Venice no later than 1512 and was probably still working there in 1550, specialized in this area and enjoyed success well beyond the city itself. Christoph Fugger appears to have been one of his admirers and at least one of Simone's works was sent to a French client. Pietro Aretino wrote him letters full of praise which did not fail to mention the accolades he had received from Sansovino and Titian. The fact that Simone signed some of his work

using the Greek alphabet links him to a Giorgio Lascaris who styled himself Pyrgoteles and was the author, among other things, of the Virgin in the lunette in the portal of S. Maria dei Miracoli, a work which shows no trace at all of "Greek" form. Simone's output includes both idealized "classical" busts, such as the bust of a woman in Berlin (Staatliche Museen, Stiftung Preussischer Kulturbesitz) and realistic likenesses of his contemporaries, although it is difficult to establish exactly which ones were meant as portraits. It is possible that high quality Antique-style works were often intended as what our sources describe as works to exchange in order for someone to become the owner of an original classical antique. We must assume that Simone Bianco was one of the group of sculptors who restored classical antiques and did not hesitate to change their appearance by smoothing them down. In this connection we should look at the famous *Portrait of Vitellio* (Venice, Archaeological Museum, Grimani Collection), which some scholars consider a classical work while others believe it a Renaissance piece; studied by celebrated painters such as Titian and Tintoretto, it may be, as Meller suggests, a classical piece reworked by Simone Bianco.

There was not a tremendous number of busts made in Venice in those years, but one that stands out is a portrait of Matteo Eletto (d. 1523), the rector of S. Geminiano (Venice, Ca' d'Oro). Its sculptor, Bartolomeo di Francesco Bergamasco, not only faithfully reproduced each line of the face but also emphasized the serious and resolute nature of a man who played such a vital part in building the church of S. Geminiano, designed by Cristoforo Legname (1505).

According to accounts passed on by Francesco Sansovino (1581), in 1522 Tullio finished carving the tomb of Doge Giovanni Mocenigo, Pietro's brother, who had died of the plague in 1485. Here again it is difficult to attribute the figural sculptures which embody considerable differences in style. Sansovino's attribution could be based on oral tradition, or he may have been aware of the contract. As for the date, Sansovino himself puts it around the time that Tullio took over responsibility for the workshop. This also ties in with the severe architectural style, free of ornamental foliage and rich carved profiles, similar to that of the Bregno tomb in the chapel of the Most Holy Sacrament in Treviso Cathedral.

In a letter of 1526, Tullio, making use of traditional arguments based on comparisons, and especially the long-lasting qualities of marble, defended the supremacy of sculpture over painting, which he thought was too highly valued in Venice. His vehemence is hardly surprising if we remember that, at least as far as altars were concerned, the outlook for

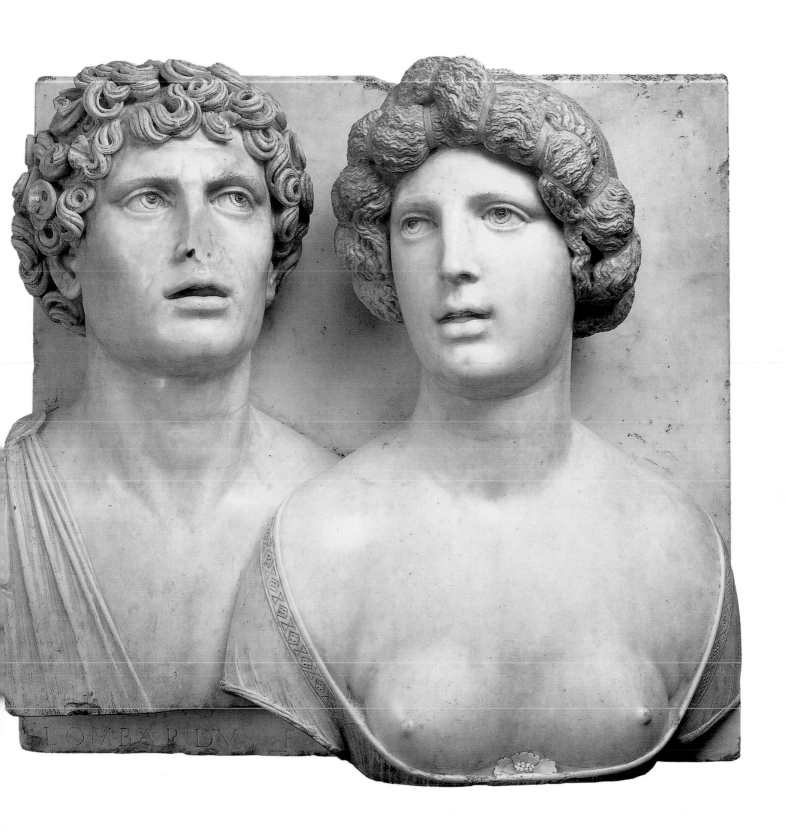

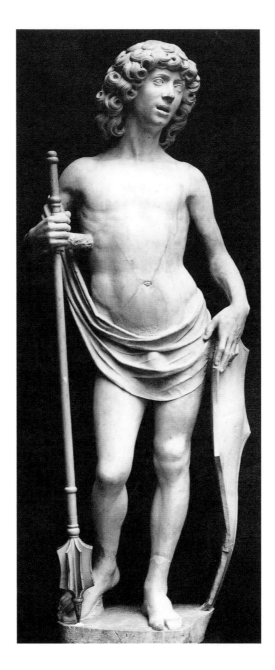

Two Young Shield-bearers, Tullio Lombardo.
Berlin, Staatliche Museen, Stiftung
Preussischer Kulturbesitz,
Skulpturensammlung (prewar photograph).

to Pietro Lombardo's shop, however, is based on features of style that are far too generic. The anonymous sculptor of the altar seems to have based his figure of Christ on that of a young man in a faint that Tullio carved around 1500 for the relief on the Cappella dell'Arca in Padua which shows the miraculous recovery of a boy who had kicked his father.

In those days many people in Venice appreciated sculpture more than painting, but quite clearly it was difficult to find sculptors able to live up to expectations. Even the prestigious Scuola Grande di S. Marco decided in 1498 to commission a marble altar for the Sala Grande which was to be 4.5 meters wide and made up of three reliefs portraying episodes from the life of St. Mark. In the contract drawn up with "Zuane da Trau, [Giovanni from Traù (now Trogir, in Dalmatia]" the architectural backdrops ("large buildings in perspective") are mentioned several times, and a wax model made of them. Moreover, it was probably the clients' intention to differentiate the smooth surfaces of the background by using marbles of different colors, like the black backgrounds on the pulpit Rizzo carved for the same *scuola*, which were destroyed by the fire in 1485. A year and a half later, after seeing the partly finished work, those in charge decided "not to continue with the said work because of the great harm and shame it would bring on the *scuola*." If the Giovanni da Traù mentioned in the contract were indeed Giovanni Dalmata, the artist who made the tomb of the Venetian Pope Paul II (Rome, St. Peters'), it would be hard to understand how he came to fail so disastrously. On the other hand, it does not seem very probable that this sculptor, who earned himself such a bad reputation in Venice, just happened to share the same name as a sculptor whose reputation in other cities was so good. It seems more likely that Giovanni Dalmata fell victim to an intrigue woven by influential local artists, perhaps even by Pietro Lombardo's circle.

After his failure Giovanni Dalmata returned immediately to Traù. Of his Venetian work, we have the bust of Carlo Zeno (1334–1418) (Museo Correr), who was an admiral of the Republic's fleet. The bust could have been commissioned by Cardinal Zen for his own home to commemorate his illustrious forebear. This was probably not an isolated type of commission even though sources more frequently mention painted portraits. The Palazzo Grimani near S. Maria Formosa houses bronze busts of Doge Antonio Grimani and his son, Cardinal Giovanni, mentioned by Sanudo in 1526 when they went on display in conjunction with the doge's *andata* [procession].

sculptors was not too rosy. It should be made plain, however, that in this area good pieces of sculpture were fairly few and far between. The only one worth mentioning is the altarpiece in the Gussoni Chapel in S. Lio, made up of a Pietà in the middle of a semi-circle formed by four figures of saints. The whole layout of the chapel, of which the altarpiece is the central feature, is rich and of very high quality even in its decorative elements. Its traditional attribution

Portraits of Condottieri

Whenever the Republic or the deceased's family wanted to honor the memory of a victorious or outstanding man-of-arms by means of a publicly displayed portrait they chose a funerary monument or an epitaph with sculpture. The only person who was given permission to erect an equestrian statue in a Venetian *campo* was Bartolomeo Colleoni from Bergamo. In return for this a generous and persuasive donation was made. Nevertheless, he did not get his wish that the statue be placed in Piazza S. Marco, scarcely surprising if we remember that even a doge could not be portrayed in a public place unless kneeling. The oldest surviving knight's tomb is that of Paolo Savelli, built just after 1400 in the transept of S. Maria dei Frari (see p. 215). On that occasion, his family made a substantial financial contribution to building the church as well. At about the same time in the church of S. Antonio we find Vettor Pisani, who beat the Genoese at Chioggia, portrayed standing in armor on the sarcophagus beneath a canopy (1380) (now in SS. Giovanni e Paolo).

Of the large number of Renaissance equestrian monuments in Venice, the Colleoni bronze statue stands out not only for its ambition but also for its artistic quality (see p. 216). Verrocchio, who was working in Florence, was commissioned to make the model in 1479. It was brought to Venice in 1481 and exhibited in 1483 together with competing models made by Leopardi and Bellano. Verrocchio's model was cast in 1488 by Leopardi who, according to a widespread custom of the time, signed it. Without a doubt Leopardi was responsible for the design of the beautiful base, a work of which he was so proud that he mentioned it on his own tombstone. The ornamentation on the saddle and the armor are also in a language that is not Verrocchio's. Most of it was probably Leopardi's idea, as was the bronze frieze on the trabeated base, very unusual in style for Venice. The choice of columns for the tall base is reminiscent of an equestrian statue of the Roman Emperor Domitian described by Cesare Cesariano (1521) in his notes on Vitruvius (fol. 59r): "a famous large equestrian statue of the Emperor Domitian in most beautiful marbles, standing on a very large number of columns and, praised by Martial." Before the statue was erected, long discussions, in which even the doge took part, were held in order to decide upon the best location for it. The resulting choice was cleverly made and took into account the main ways into the *campo* and the position of the statue in relation to the church. This meant that the monument itself was displayed to the greatest visual effect. The Republic was wary of the ambitions expressed by this type of monument, but at the same time it was anxious to

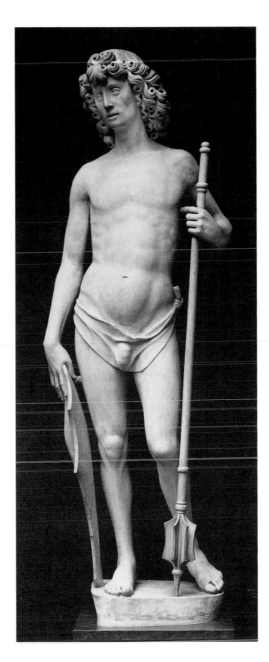

squeeze the best possible propaganda value from statues of its victorious condottieri. For this reason the three monuments erected in the transept of the church of SS. Giovanni e Paolo commemorate condottieri who distinguished themselves in battle against the League of Cambrai allies, and in particular in the battle to retake Padua (1509). The monuments to Niccolò Orsini (see p. 214) and Leonardo da Prato, both on horseback, and the standing statue of

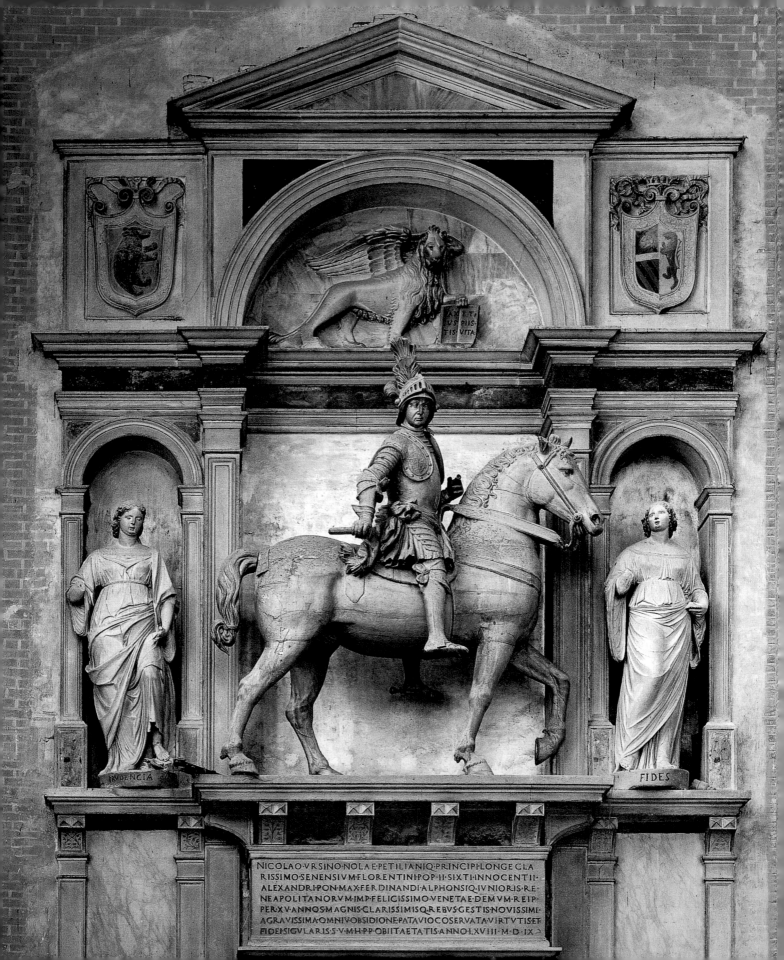

NICOLAO·VRSINO·NOLAE·PETILIANIQ·PRINCIPI·LONGE·CLA
RISSIMO·SENENSIVM·FLORENTINI·POP·II·SIXTI·INNOCENTII
ALEXANDRI·PON·MAX·FERDINANDI·ALPHONSIQ·IVNIORIS·RE
NEAPOLITANORVM·IMP·FELICISSIMO·VENETAE·DEMVM·REIP
PER·XV·ANNOS·MAGNIS·CLARISSIMISQ·REBVS·GESTIS·NOVISSIME
AGRAVISSIMA·OMNIVOBSIDIONE·PATAVIO·COSERVATA·VIRTVTISET
FIDEI·SIGVLARIS·S·V·M·H·P·P·OBIIT·AETATIS·ANNO·LXVIII·M·D·IX·

PRVDENCIA

FIDES

OPPOSITE:
Funerary monument for Niccolò Orsini, count of Pitigliano, with a gilded wood equestrian statue of Orsini, in SS. Giovanni e Paolo.

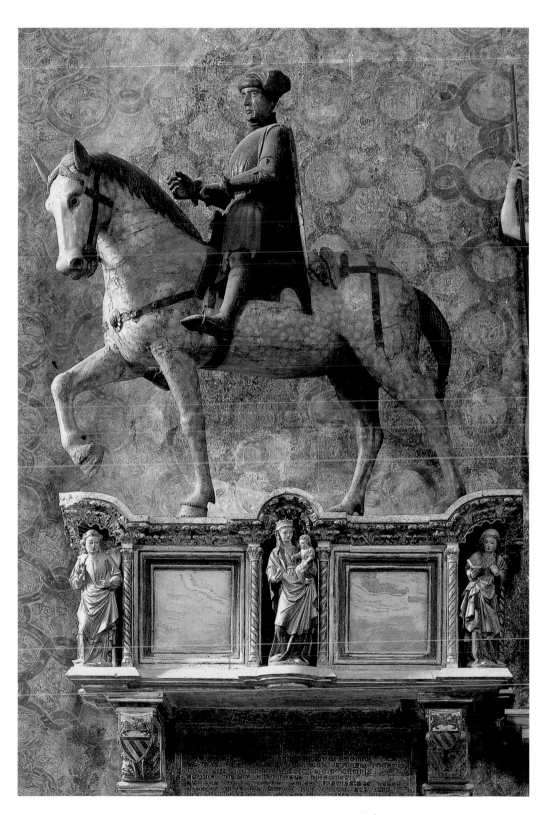

Wooden monument to Paolo Savelli, by Antonio Bregno. Savelli was a Roman patrician who served the Republic as a condottiere and died in 1405. S. Maria Gloriosa dei Frari.

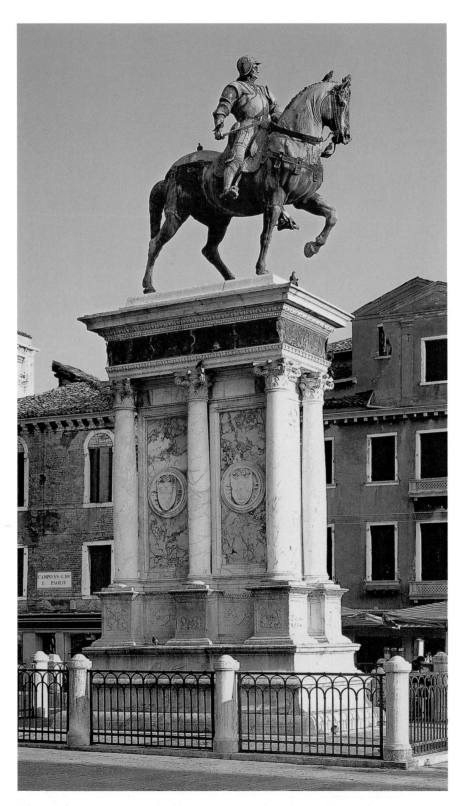

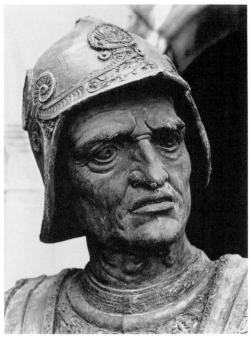

Equestrian monument to the condottiere Bartolomeo Colleoni in Campo SS. Giovanni e Paolo, a masterpiece of Renaissance sculpture, modeled by the Florentine sculptor Andrea Verrocchio and cast in 1494, after his death, by Alessandro Leopardi; above, detail of the face.

OPPOSITE:
Base of the central flagstaff opposite the main facade of the basilica of S. Marco, cast in bronze by Alessandro Leopardi in 1505, with fantastic animals that recall the lion of St. Mark.

Dionigi Naldi, located over the side portal, transform this part of the church into a kind of commemorative shrine to one of the most critical periods in Venetian history. The decision to put up the three monuments at the State's expense was taken by the powerful Council of Ten in 1512 with an educational motive in mind. They were to return to this later when choosing which battles to paint in the Sala del Maggior Consiglio "to inspire others who dedicate their lives to the benefit and comfort of our sovereign state." The riders and their horses are carved from wood and were originally completely gilded. This would have provided a striking contrast between the architectural features, where very little gilding was used, and the golden horsemen.

Free-standing figures had been known from the fourteenth century. What was new were the panegyric inscriptions and the architectural and figurative context in which the figures were set. Vettor Pisani was portrayed on a sarcophagus beneath a canopy. The plastic features of the tomb were completed by frescoes in the background. The reliefs on the tomb of Doge Pietro Mocenigo (d. 1476) commemorate his greatest feats in the spheres of military action and foreign politics. Even those showing the Labors of Hercules are in fact alluding to the prince's own virtues. The tomb of Captain Jacopo Marcello (d. 1484) (S. Maria dei Frari) is decorated with a painted "triumph" which celebrates the dead man's great valor. The portrait of Vettor Capello (d. 1467), which shows him humbly and devotedly kneeling before St. Helena, was not taken up by Venetian sculptors. Clearly a martial stance was usually more in keeping with the deceased's own idea of himself and was probably more satisfying to both family and public expectations. The same can be said of the tombs of Melchiorre Trevisan (died c. 1500) and Benedetto Pesaro (both in S. Maria dei Frari). Like Sansovino's figures on the Scala dei Giganti, the *Mars* (attributed to the Florentine sculptor Baccio di Montelupo) and *Neptune* which flank Pesaro are probably alluding to Venice's ambition of domination of land and sea. The two columns were specifically mentioned by Pesaro in his will, which proves that for the dead man the column was a universally recognized symbol of dignity. Other monumental columns that belong to this sculptural-architectural genre are those on the tomb of Francesco Foscari (d. 1457) in the choir of S. Maria dei Frari.

Bronze Sculpture

We have still not positively identified the authors of many of the large-scale bronzes. As we said,

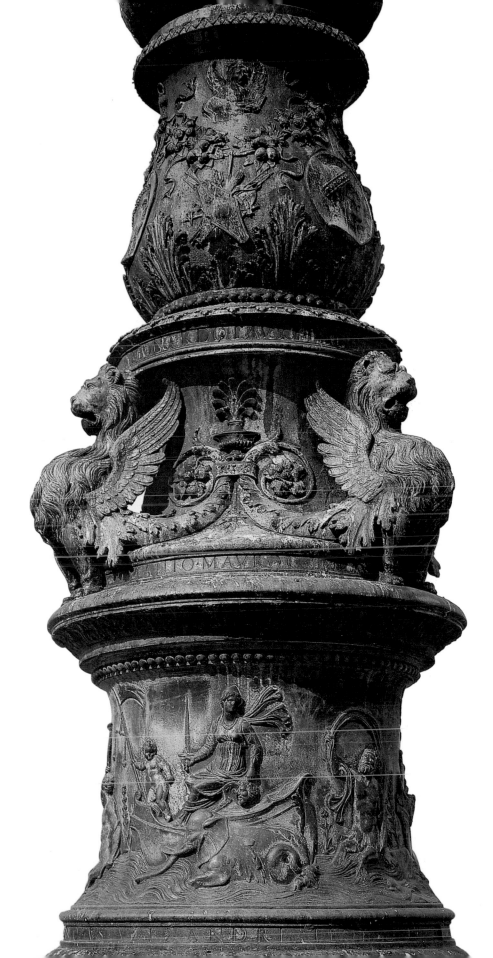

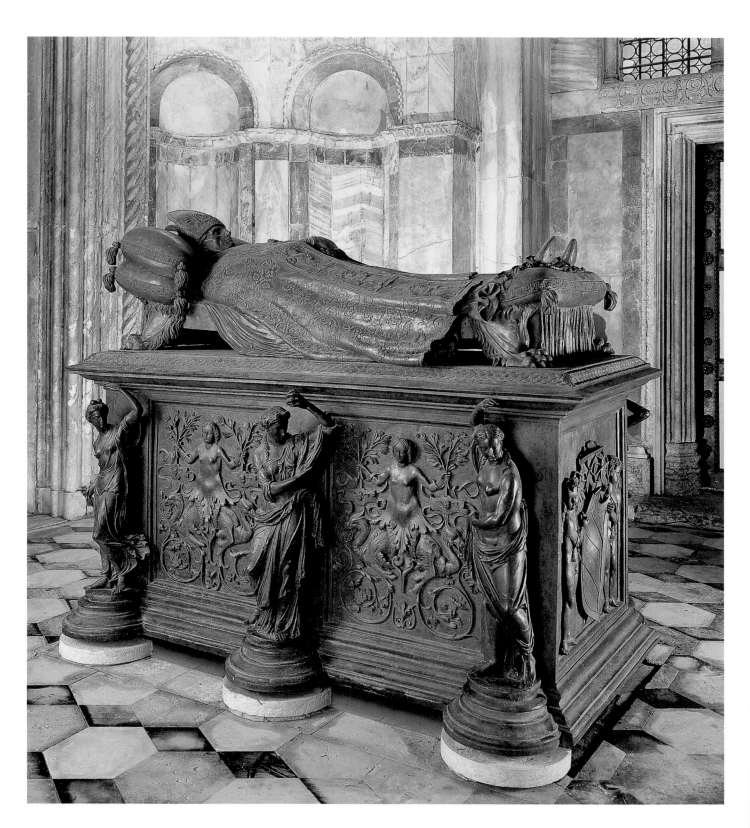

Verrocchio was responsible for the model of the equestrian statue of Colleoni, but the work itself was signed by Alessandro Leopardi who cast it and who very probably modeled the harness, the armor, and the base. We do not know who was the author of a bronze altarpiece given by a doctor, Jacopo Surian, to the church of S. Stefano (1488–93), which also contains a tomb attributed to Giovanni Buora. In 1493 Sanudo listed this altarpiece as one of the outstanding works in the city, probably because in Venice it was still unusual to use such precious material in an altar. Of a sumptuously decorated chapel completed in S. Maria della Carità in about 1493 by the goldsmith Domenico di Pietro, all that remains today is the statue of the *Salvator Mundi*, now housed in the Poldi Pezzoli, museum in Milan. Bronze reliefs from the tomb of the two Barbarigo doges, which was in the same church and later destroyed, are today on exhibition in the Ca' d'Oro.

The artist responsible for the Barbarigo reliefs remains anonymous. Despite the classical way in which the drapery is arranged, the overall style is retrospective. Moreover, in the *Coronation of the Virgin* the figures of the Apostles are loosely counterposed in the manner of Ghiberti but seem quite isolated with regard both to the composition itself and their postures. We find very similar figures in the work of Vittore Carpaccio and his circle, for example, in the *Death of the Virgin* for the Scuola degli Albanesi (Ca' d'Oro).

That paintings could be used as models for reliefs is shown by a *Last Supper*, left in part as a sketch and later used as a tombstone; it finally reappeared in the nineteenth century when restoration work was underway on S. Maria dei Miracoli (Ca' d'Oro). This relief cannot be attributed to Tullio Lombardo because it reveals so much hesitation in the way the model was transposed and because the sculpture possesses more graphic than plastic qualities.

Alessandro Leopardi not only signed the Colleoni statue but also the flagstaffs in Piazza S. Marco. The central one, "facto per Alexandro de Leopardi [made by Alessandro Leopardi]" (Sanudo) was installed in 1505 (see p. 217), the other two in 1506. These bases replaced the older ones, far simpler and in stone, that had been made twenty years earlier in Pietro Lombardo's workshop. Scholarship is almost unanimous in accepting Leopardi's signature, tacitly extending it to cover the design and the casting as well. We know very little about Leopardi's style as an architect and goldsmith since we have so few documentary sources on him. But a lot is revealed by another document: on 19 January 1505 Alessandro Leopardi and his "companion" Antonio Lombardo signed a contract to make an altar and a "sepulcher"

for Cardinal Zen, to be installed in his chapel in S. Marco. Just a year later the procurators replaced Leopardi with other specialists who had experience in casting large bronze pieces. The style of the figures and the individual ornamental motifs on the flagstaffs are so close to some of Antonio Lombardo's work that the models have been attributed to him. Between 1503 and 1505 the Lombardo workshop was the only one equipped to handle a government job of this size, and in the same period it produced the wonderful fireplaces *all'antica* that add to the decorative splendor of the doge's apartments in the Palazzo. Alessandro Leopardi would doubtless have made a few modifications when he was "cleaning up" the cast and would not have hesitated in counting the changes he made to the model as his personal contribution. If we compare the *Abundance* on the middle flagpole, or the children on the southern one, with figures from Antonio's Paduan relief, the similarities are striking. On the other hand, between the ornamentation on the flagstaffs and that on the Colleoni statue base there are irreconcilable differences. These give even greater value, therefore, to the affinities with the wonderful reliefs that Antonio carved in 1506 for the small chamber of the duke of Ferrara (today in St. Petersburg, the Hermitage Museum). The procurators' role in commissioning this elaborate scheme of figurative work is commemorated in large letters on the bases, and it is quite probable that they would have called on the services of specialists. Details of the program were recorded by Pietro Contarini in his *Argo volgar* (published in about 1541): it centered around the figure of Venetia in the guise of Astraea who is carved on the middle flagstaff. The same flagpole also has a portrait of the reigning doge, Leonardo Loredan, in a medallion. This infringement of rules that were clearly defined and generally adhered to—stipulating that the arms and, by extension, the image, of a doge could be displayed only inside the Palazzo Ducale—was quite certainly not part of any written plan. Here the artist, who in my opinion was Antonio Lombardo, seized his opportunity of "smuggling" a tribute to the doge into his work without too openly breaking the rules of the game.

By contrast, another of his projects which was also to have been for the State did not come to fruition: in 1496 there was talk of getting Alessandro Leopardi to cast bronze panels *cum historiis* [with stories] for the Porta della Carta. If indeed the subjects were ever defined, they have not come down to us. In 1518 the Scuola Grande di S. Marco also planned to install a "metal" door in the main portal, but this too was canceled for lack of money.

Bronze group of the *Madonna della Scarpa*, by Antonio Lombardo, flanked by *St. Peter* and *St. John the Baptist* the latter by Paolo Savin. Zen Chapel, S. Marco.

OPPOSITE:
Recumbant tomb statue of Cardinal Giovanni Battista Zen, a work in bronze by Paolo Savin. Zen Chapel, S. Marco.

ON THE FOLLOWING PAGES:
Details of *St. Peter* and the *Virgin and Child* from the bronze group of the *Madonna della Scarpa* in the Zen Chapel, basilica of S. Marco.

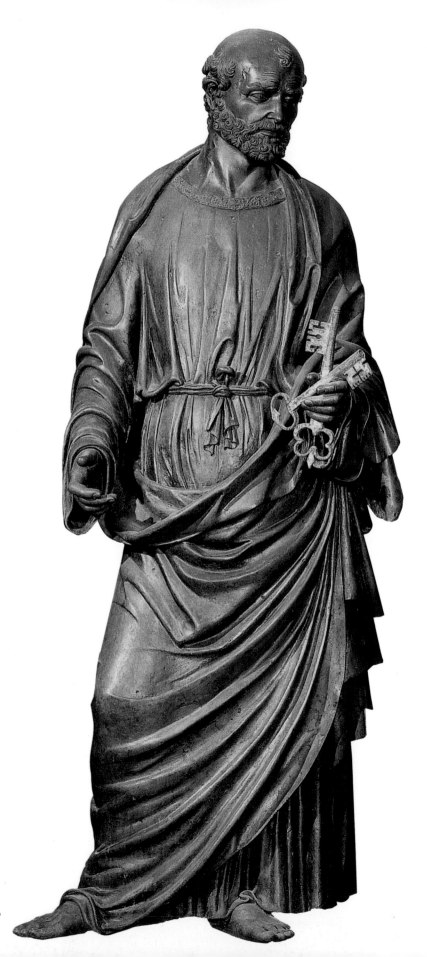

Quite a few interesting facts about Venetian bronzes have fallen into oblivion. Sanudo tells us that the *archa* for Lorenzo Suarez di Figarola, the king of Spain's spokesman who died in 1506, was cast in Venice and shipped to Spain. Justi advanced the opinion that the slab that can be seen in Badajoz may be the work of Alessandro Leopardi, but since then scholars of Venetian art have not bothered with this piece, which is nonetheless of great artistic merit.

But the most complex and best documented project was for the tomb of Cardinal Giovanni Battista Zen. In his will, written in 1501, the Cardinal expressed the ambitious desire for his tomb to be built in the southern transept of S. Marco where today we have the altar that Doge Cristoforo Moro commissioned from Antonio Rizzo. The detailed specifications in the building contract show that the cardinal had been in extremely close contact with the artists advising him. It also shows his appreciation of excellent bronzes. A number of wills left by him all include legacies for altars in this valuable material, one to be erected in a chapel to be built next to the Cappella dell'Arca in the basilica of S. Antonio in Padua and another in a chapel in Vicenza cathedral. Nonetheless, neither these plans, nor another with which he was involved in connection with the church of S. Fatin in Venice, were ever implemented.

When the procurators in charge of S. Marco took the decision to close the southern entrance to the basilica and to transform part of the atrium into a funerary chapel for Cardinal Zen, this led to profound changes and not just of an aesthetic nature. In 1504 the procurators drew up a building contract with Antonio Lombardo and Alessandro Leopardi. The document is so detailed that it enables us to make a graphic reconstruction of the first plan. Antonio Lombardo was the creative director while Leopardi was put in charge of casting the bronzes. Soon afterward the two artists parted company and went their separate ways. When Antonio moved to Ferrara in 1506, the project was handed over to his father Pietro, and only in 1512 was it taken over by his brother Tullio. Alessandro was replaced almost immediately by a casting specialist. From Antonio's hand we have some of the altar figures, including a *Madonna* with a serious expression (see p. 221) and the *Eternal Father* on the canopy. Tullio modified the pretentious plan by introducing classical architectural features as well as correcting several details. As the years went by, several jobs were given out to other sculptors: Bregno carved the figures on the sarcophagus while someone called Paolo Savin, for whom there are no documentary sources, was responsible for the model of St. John, the recumbent

figure of the cardinal (see p. 218), and the altar frontal. It is probable that Savin had already done the models for the bronze "Moors" on the Torre dell'Orologio [clock tower]. Nonetheless his work for the cardinal was not successful, and the fee anticipated for the altar front was considerably cut down. It was not until 1521 that this richest of Venetian Renaissance tombs was finished (see p. 219).

Epilogue

With very few exceptions, the history of Venetian sculpture in the first quarter of the sixteenth century reflects an increasingly provincial outlook, and at the same time an ever-growing isolation compared to what was happening in other artistic centers. On the other hand, the extraordinary flowering of Venetian painting, which was producing a series of works which would prove of fundamental importance to European art right through to the Baroque era, demonstrates that this separateness was not the consequence of the political isolation inflicted on Venice by the League of Cambrai and the painstaking reconquest of her lost territories, an isolation which only ended with the Peace of Bologna in 1530.

Even Tullio Lombardo ended up lacking the strength to renew his work and move forward. In his last documented work, a *Pietà* accompanied by two saints (in Rovigo), his style is scarcely recognizable. His brother Antonio also displayed considerable talent, but he moved to Ferrara in 1506 to work for the Este family. Despite this, at the start of the sixteenth century demand for sculpture in both Venice and the surrounding provinces was as high as ever. Thanks to the large volume of altars, tombs, and chapel decorations being commissioned, Venetian sculpture shops were never going to be short of money, and sometimes their fame spread beyond the city limits. Nevertheless, when Lorenzo Bregno is praised as the "very celebrated sculptor" of the Arca of the basilica S. Antonio in Padua (1520), it is an opinion that can only be justified in the area immediately surrounding Venice.

In recent years there has once again been much serious research carried out into the works of the first decades of the century, and this has brought to light pieces by sculptors little known till now. Of these the best known are Giovanni Antonio Buora from Osteno (c. 1450–1513), the brothers Giambattista (died c. 1513) and Lorenzo Bregno (whose will is dated 1523), Antonio Minello (mentioned for the last time in 1529), Bartolomeo Bergamasco (d. 1527), Simone Bianco, Giovanni Moca, Paolo Stella, and Paolo Savin.

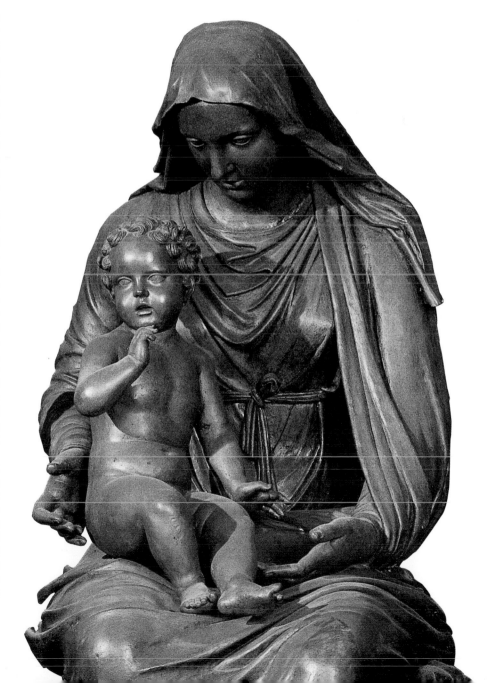

PORTIA·SVM·BRVTI·CONIVX·ET·NATA·CATONIS
QVAM·DEDIT·OPTATAE·FLAMMEA·PRVNA·NECI

Even though they went down different paths, Tullio and Antonio Lombardo had defined the criteria for a fertile relationship with the works and ideals of classical antiquity. Bartolomeo di Francesco Bergamasco's *St. Mary Magdalene* for the altar at the church of Verde della Scala (now in SS. Giovanni e Paolo) had to be "clothed in wide and antique drapery," as shown in the wax model that was submitted. The formula "*all'antica*" is found, among other places, even in the will in which Cardinal Zen left detailed instructions for his sepulchral chapel in S. Marco. The contractual obligation to work in the antique manner did not mean that the artists were invited to study classical works with fresh eyes— apart from anything else most classical works in Venice were in private collections that were hard to see—nor was it an invitation or encouragement to go off on long study tours. There was clearly in existence a repertory of drapery, postures, and expressions on whose classical nature those awarding and receiving the commissions could easily agree. This applied to both the sculptures and the decorative features of architecture that Cardinal Zen described in so much detail in his will and which were probably based on a drawing.

In 1525 someone from Bergamo was asked by his fellow citizens for information about Venetian sculp-tors, and his reply expressed severe judgment. By this he was doubtless intending especially to throw favorable light on Bartolomeo di Francesco, a sculptor from Bergamo working in Venice and known as the author of some works in the church of S. Geminiano, including a portrait of the rector Matteo Eletto, today in the Ca' d'Oro. It is not easy to find fault with his judgment: "I must say that there are a lot of them [sculptors] in Venice, but not many are really up to making a large figure. It's a very different thing making a small figure or a head and making something large and lifelike." Two years later Jacopo Sansovino arrived in Venice. The time was more than ripe for a new beginning.

Wolfgang Wolters

Bronze relief of the *Coronation of the Virgin* from the tomb of the two Barbarigo doges in Santa Maria della Carità, Ca' d'Oro. The artist responsible for the Barbarigo reliefs remains anonymous.

OPPOSITE:
Portia, relief by Giovanni Maria Moca. Venice, Ca' d'Oro.

Painting in Venice: 1450–1515

The work and influence of Andrea Mantegna and Jacopo Bellini

Andrea Mantegna is always said to be the father of Venetian painting, but I would only go so far as to say that he was, at most, its uncle, and certainly not the best of uncles as far as the upbringing of his nephews was concerned. Mantegna, having moved to the court of Mantua as early as 1460, could have had no direct influence on subsequent development in Venetian painting. Those who took him as an example, moreover, inevitably looked to his youthful masterpieces in Padua (the frescoes of the Ovetari Chapel in the church of the Eremitani, 1448–57) and in Verona (the altarpiece of San Zeno, 1557–59), not in Venice. They perhaps continued to look to these examples for some twenty or thirty years, dominated by his model, lulled into lethargy by his exclusively formal style, and conditioned by his authority to the extent of hardly ever looking for any new development.

The father of Venetian painting is, unquestionably, Jacopo Bellini, even though little remains of his painting, and nothing of real importance except his canvases of the 1460s for the Scuola Grande di S. Giovanni Evangelista and the Scuola Grande di S. Marco. Fortunately, we have the extraordinary Paris and London sketchbooks which include at the same time future projects and reference drawings, books

Presentation of the Virgin at the Temple, Jacopo Bellini, from the artist's sketchbook. Paris, Louvre.

Martyrdom of St. Christopher, Andrea Mantegna, detail of fresco. Ovetari Chapel, church of the Eremitani, Padua.

which are both a personal collection and a functional archive. They confirm that, like Mantegna, Jacopo had learned much from Tuscan painters such as Gentile da Fabriano, seen in Venice and perhaps followed in Florence, Paolo Uccello, in Venice between 1425 and 1431, Leon Battista Alberti, whom Jacopo met in Venice and in Ferrara in the 1430s and 1440s, Andrea del Castagno, at work in the chapel of S. Tarasio in 1442, and Donatello, in Padua from 1443 to 1453. Bellini studied the work of these artists, fueling his vocation for storytelling with volume and perspective, a feeling for antiquity, and a fascination with architecture.

Jacopo can be called the father of Venetian art because he established an active and versatile studio in Venice and he taught his craft to his two exceptional sons, Gentile, who was to become a master of narrative art on canvas, and Giovanni who became master of all else. Jacopo took them with him to Padua in 1459–60 to work on the altarpiece (triptych and predella) for the Gattamelata Chapel in the basilica of S. Antonio (Santo) in Padua, and he called on them in the following years to work on the great Venetian triptych of the Carità. Jacopo certainly wanted to involve Mantegna in the studio—and it was maybe for this reason that he gave his daughter Nicolosia as Mantegna's wife—but Andrea preferred the reserved culture of the court to the open culture

St. John the Baptist Preaching, Jacopo Bellini, from the artist's sketchbook. Paris, Louvre.

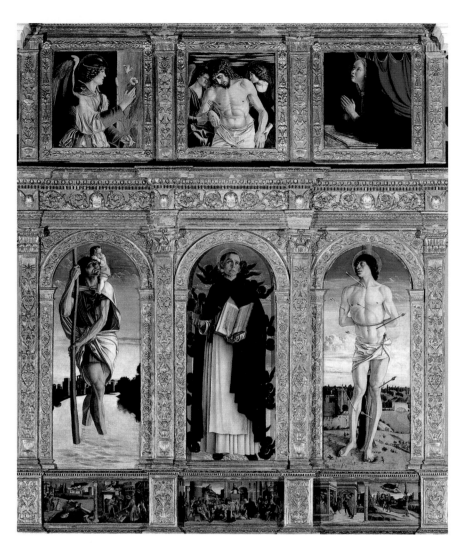

St. Vincent Ferrer polyptych, with *St. Christopher, St. Vincent
Ferrer, and St. Sebastian*, Giovanni Bellini. In the upper section the
Annunciation, Dead Christ Between Two Angels, in the predella,
Miracles of St. Vincent Ferrer. SS. Giovanni e Paolo.

OPPOSITE AND ON THE FOLLOWING PAGES:
St. Christopher Carrying the Infant Jesus, the *Archangel Gabriel*,
and the *Virgin Annunciate*, details from the upper section of the
St. Vincent Ferrer polyptych.

of the city. If he had not, we would have had an even
more exceptional concentration of talent in Bellini's
studio, and for the next stage in Venetian painting,
we would have had, if not a second father, then at
least a brother-in-law.

Giovanni Bellini, 1460–1490

The large polyptych on the second altar to the right
in the church of SS. Giovanni e Paolo portrays St.
Vincent Ferrer in the central section, and flanking
him, St. Christopher and St. Sebastian. Above, the
Archangel Gabriel and the Virgin Annunciate are
depicted to the left and right of a *Pietà* in which
Christ is supported by two angels. Below, three
predella panels depict five miracles of St. Vincent
Ferrer.

Between the Trecento and the Quattrocento, the
Spanish Dominican Vincent Ferrer had established
himself as a figure of great prestige within the order.
From early on, he managed to create around himself
an aura of holiness both among the people and in the
higher echelons of political and ecclesiastical life.
This widespread popularity is reflected in the paint-
ings of the most important moments of his life, taken
from well-informed lives written under the propa-
ganda drive of the Dominican order before and after
St. Vincent's canonization in 1455. The lives describe
the complex personality of an austere friar, scourge
of sinners and infidels, prophet of doom, and
supporter of mortification and abstinence. Yet he
was capable, too, of intervening, often with positive
results, in both the political and dynastic crises of the
Iberian peninsula, and the religious and institutional
disputes which preceded the Reformation.

In his role as preacher St. Vincent crossed Spain,
France, and Italy. Everywhere he went he healed the
sick, exorcised the possessed, and converted and
baptized unbelievers. Contemporary sources record
the mass success of his moving and persuasive prea-
ching, which had as its main ingredients the suffering
of Christ, the flames of hell, the terrors of
the Last Judgment, and the sinister presence of
the Antichrist in the world. From the fall of
Constantinople in 1453, Christianity lived in constant
fear of the continuous advance of the Turks; like a
new and unstoppable barbarian invasion, they seemed
destined to destroy all the acquired certainties of the
West. In these years the Apocalypse took on histori-
cal reality, the Beast and the Antichrist becoming
personified in Sultan Mehmed II. The prophecies of
St. Vincent Ferrer inevitably appeared to frightened
minds as lucid and historical. His image was used not
only as a call to spiritual salvation, but above all as

an example of unshakable tenacity in the struggle with the infidel, a tool to harness political consensus and economic aid in the crusade against Mehmed-Antichrist.

The polyptych was commissioned by the Scuola di S. Vincenzo Ferrer, established in 1450 as a propaganda and lobbying tool for the purposes of canonization and then developed devotion to the saint. The altar, already in existence at the time of the constitution of the *scuola*, was improved and embellished in the following years. The *scuola* archives, which often record and describe the polyptych, make no mention of the name of the artist; it is opportune to recall that it was the content and public function of the image which were important to clients who sought the most effective painter who provided the ultimate guarantee, but without having his name proclaimed on the work for all time.

After much uncertainty, the attribution of the work to Giovanni Bellini finally seems to have gained, if not unanimity, then general acceptance. The best evidence for Bellini's authorship lies, paradoxically, in the work's disparities, which indicate a painter in full phase of experimentation with all known visual languages and all consultable repertoires, already prepared to extract its substance, discard the ephemeral, and catalogue the reusable in a complete dictionary, and then to set out again in new directions. The *St. Sebastian* emphasizes the Paduan and Mantegna manner, but *St. Christopher* hardly portrays them before immediately refuting them, supporting the heavy, albeit fragile, volumes; he is like a wooden statue, with a more modern attention to anatomy and clothing, not to say shrewd tricks like the three-dimensionality of his staff or the sentimental device of the sideways glance toward the plump Christ Child. *St. Vincent Ferrer* appears at first to be a Muranese Dominican image, but not when compared with the *St. Dominic* by Bartolomeo Vivarini who is rather awkward with his weak hands around a heavy book and awkwardly placed flower, and somewhat poorly dressed in his creased habit. St. Dominic is carried on high by the double artifice of the cloud and cherubs, and is ready to justify his elevation, the muscles of his neck tense, his face hollow and deeply lined, the mouth slightly open with ardor, his eyes tender with pity. With St. Vincent, in contrast, the elegant habit has perfect creases and the hands move quickly and with suppleness, one acting as a brazier to the metaphorical flame, the other casually propping up the open book, slightly wrinkling the raised page.

Let us move on to the upper section. The Archangel Gabriel has heavy eyelids and Vivarini ringlets, but the pearls, and the glorious color of the

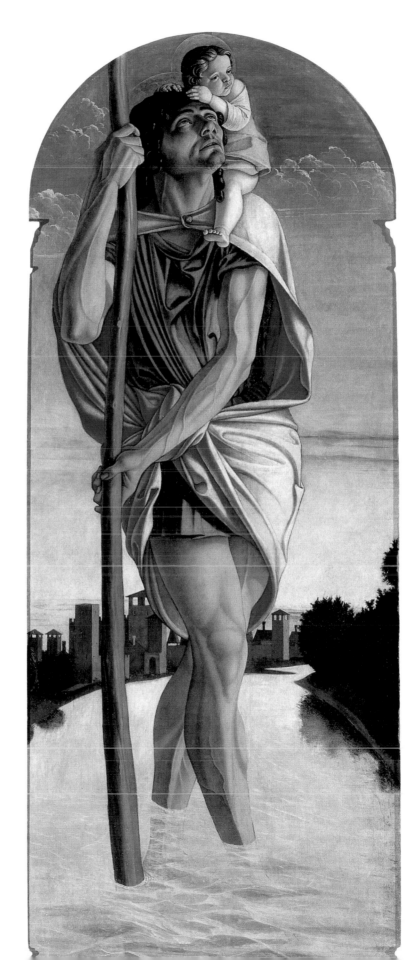

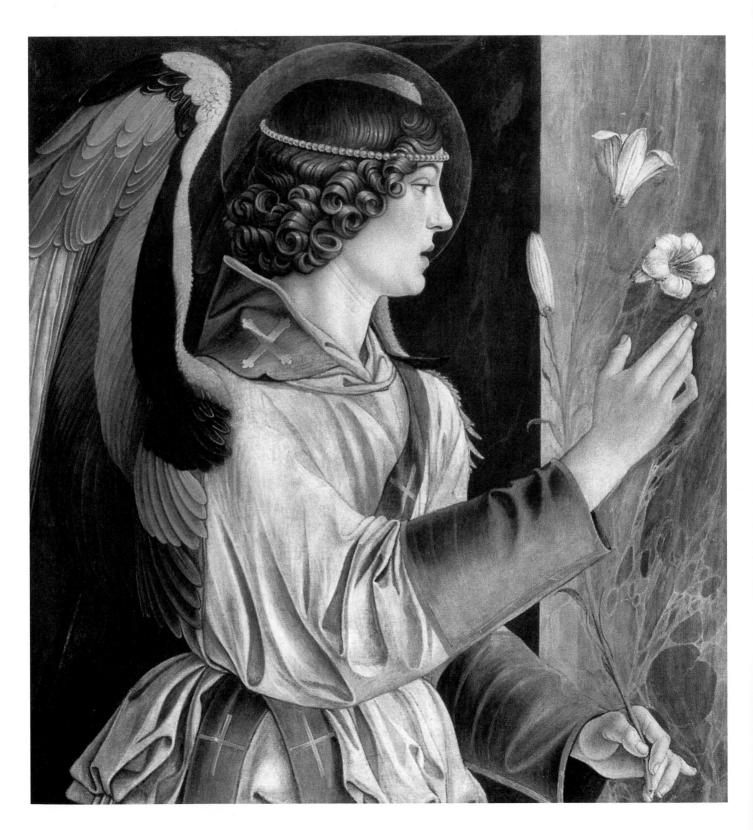

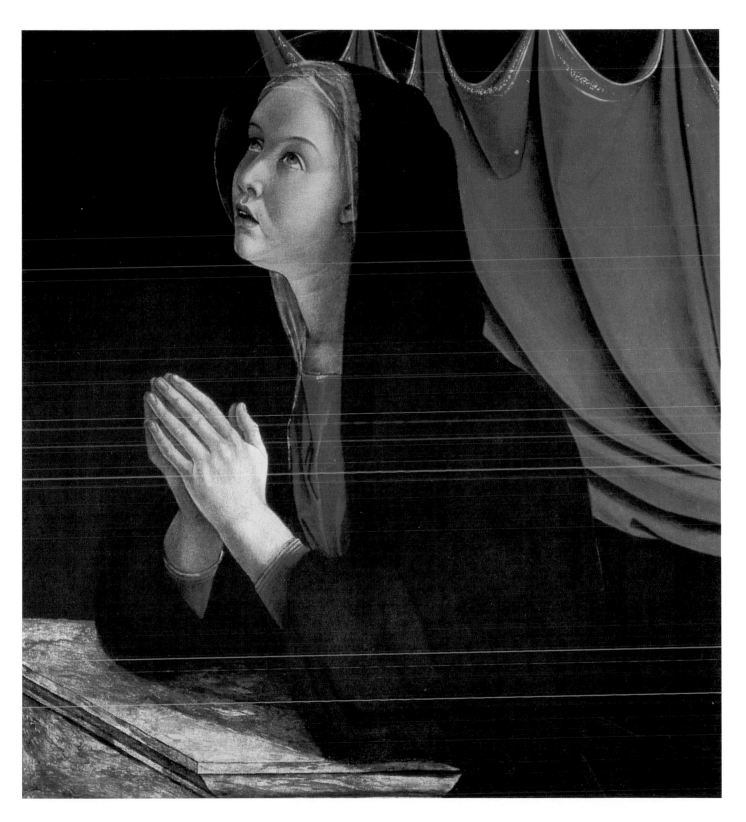

IOANNES
BELLINVS

wings and of the chameleon clothes are completely novel (see p. 228). Then there is the *Pietà*, which is the most old-fashioned section with its explicit sculptural appearance (Christ as a statue, the angels in bas-relief), somewhere between Roman sarcophagi and Donatello. The "newest" compartment is the surprisingly anticipatory image of the plainly dressed Virgin, half serene, half nervous, supported in her emotion by the chair ledge, only two colors revealing its shape against the dark background crossed by the pulled back curtain (see p. 229).

On a date generally agreed around 1465, albeit without documentary support and relying on stylistic evidence, there was only one painter in Venice who had the ability, courage, and almost the effrontery to paint in so varied a style, someone who was busy trying to demonstrate an acquired mastery of all visual languages as well as the possibility of superseding them all through research and invention. That person is Giovanni Bellini, an extraordinary intermediary between the old and new, creator of the old and new in a contemporary style, for the most prestigious and glorious studio of its time, that of his father Jacopo.

The unknown painter of the predella of the altarpiece came from the same studio. The predella represents simple stories of the saint's miracles which are, by comparison, manipulated and modified, summarized, purified, and reduced to their essence: the act of salvation. The artist's choices and modifications point to an understanding of the deeds of St. Vincent Ferrer: they reveal that close to the painter, among the Dominican friars, was a well-informed adviser able to synthesize elements from the oral tradition with elements from the first lives. This painter speaks in fluent, Ferrarese dialect. He seeks the illusion of open, complex spaces but finds it difficult to articulate them, and he populates them with figures that are rigid and stiff in spite of their abundant gestures. He looks for the storyline but finds it difficult to arrange it in a sequence. He is one of those unknown collaborators who operate in the institutionally less important areas of the great works created in the most popular workshops, to which they bring their distinct culture, consistent with their subordinate roles in the procedures of the collective, albeit unequal, organization of the profession.

The Pesaro altarpiece, *Christ Crowning the Virgin Between Sts. Paul, Peter, Jerome, and Francis*, with its stories of all these figures in the predella, the saints on the pillars, and (possibly) the Vatican *Pietà* in the ogee, is perhaps in its entirety not the masterpiece it is always said to be. But the work, whose actual date is the subject of continual debate though it must date from around 1472–74, represents without doubt a

Madonna and Child, Three Musical Angels, and Sts. Francis, John the Baptist, Job, Dominic, Sebastian, and Louis of Toulouse, known as the *St. Job Altarpiece*, Giovanni Bellini, c. 1480. Venice, Gallerie dell'Accademia.

renewed codification of all the traditional and innovative elements of the pictorial knowledge of Giovanni Bellini. It has a large unified section where the master displays the solemn lucidity of his spatial conquest by adapting plastic citations with Flemish means of expression, and minor panels where images and narrative meet, and where (even if it is not talked about much) alongside Giovanni were at least two other painters, one of whom, though unknown, had remarkable talent.

It is arguable that it is after this piece of work, and before 1474–75, that Giovanni Bellini went back to SS. Giovanni e Paolo to paint the great altarpiece of Dominican glories which had among its main subjects St. Catherine of Siena, to whom the altar was dedicated, and St. Thomas Aquinas. We know of this altarpiece, despite its having been destroyed by a fire in 1867, through the Zanotto eighteenth-century prints which reveal a far more complex and modern composition and layout than that of the Pesaro altarpiece. In the Dominican altarpiece are ten saints and three young angels singing around the elevated throne of the Virgin and Child in the ample unified space which is still background.

OPPOSITE: detail of the music-making angels.

Giovanni Bellini

Bellini's early works were inspired
by Mantegna, although he tempered
Mantegna's raw realism with a
greater fluidity of design and
transparency of color. He was the
official painter of the Republic of
Venice from 1483, and had a studio
with many young painters who were
probably responsible, at least in
part, for the numerous Madonnas
and portraits that scholars have
rightly deemed unworthy of the
master himself. Bellini, however, was
responsible for visionary paintings
such as the *Transfiguration* (Naples,
Museo di Capodimonte) and *St.
Francis in the Desert* (New York,
Frick). He followed the changes
occurring in Venetian painting
through the works of Giorgione,
Titian, Sebastiano del Piombo, and
Lorenzo Lotto. Some of these he
assimilated, without suppressing his
own personality.

This was the highly contemporary and striking
model for Antonello da Messina (who at that very
time was setting out from Sicily for Venice), and for
his altarpiece for S. Cassiano, of which only the frag-
ment in Vienna remains, and also the dress rehearsal
for Giovanni Bellini's first real public masterpiece: the
large altarpiece of the church of S. Giobbe [Job] (see
p. 231). The *Madonna and Child, Three Musical
Angels, and Sts. Francis, John the Baptist, Job,
Dominic, Sebastian, and Louis of Toulouse*, long
housed in the Galleria dell'Accademia, was placed on
the second altar on the right in the Frari, probably as
an ex-voto after the plague of 1478, in or around
1480, although the exact year is again the subject of
much discussion. This dedicatee of the church, the
patient Job of the Old Testament, had recently been
required to relinquish part of his privilege, not to
mention the main altar, to a recent important saint,
St. Bernardino da Siena, the famous preacher made
part of Venetian piety at the time of Doge Cristoforo
Moro, patron of the church. The patron, the
members of the Scuola di S. Giobbe, established in
1383, supported by a benefactor who is still uniden-
tified despite his coat of arms appearing on the altar,
were able to console themselves with this extraordi-
nary representation. In the work, a resurrected Job,
showing no wounds or pain, contemplates, at close
range the Christ Child, whose right arm is, unusually,
stretched out toward the praying hands of the old
man. Job witnesses the sight with Sebastian, at peace
perhaps because he is pierced by only two arrows, an
indication to the devout that the danger of plague is
now over.

As always happens, the specific celebratory purposes
of the confraternity had to be adapted to the general
requirements of the context and therefore, in this
case, to the needs of Franciscan culture which
demanded more than Sts. Francis and Louis. The
Virgin, raised on the throne, makes a gesture of
prayer and intercession, "intact flower of virginal
purity," as the Latin inscription on the semidome of
the apse runs. Queen of Heaven, and adorned with
the laurels of chastity, she pronounces the dogma of
the Immaculate Conception, at that time being
fostered under the political drive of the Franciscan
Pope Sixtus IV, against the rigid resistance of the
Dominicans. The presence of St. Dominic in the
altarpiece is therefore provocative: the saint, unable
to understand the Virgin, is forced to absorb himself
in a book that is ostentatiously open, and to study in
order finally to acquire the necessary knowledge.

The painted apse, for the first time wholly unified
and closed, modeled in its totality and its detail on
the ducal chapel in S. Marco, also has political and
civic significance, inseparable from its religious

meaning. The Virgin is the protector of Venice, virgin
both unviolated and inviolable, according to the
ancient and long-revered metaphor. This is perhaps
why the St. Job altarpiece is mentioned by Sabellius
and Sanudo, a significant and exceptional historical
allusion. Together with its theological clarity and
devotional efficacy, both served by a property of
language which magically facilitates the rich and
difficult proportion, it displays rules of symmetry
and contradicts them with improvised asymmetry,
and flaunts solemnity and then mitigates it with infi-
nite variations of characterization, gesture, and
posture, integrating means and messages in the total
abandon and complete legibility of the masterpiece.

In 1488 Giovanni Bellini signed and dated the trip-
tych in S. Maria dei Frari, the *Madonna and Child
and Two Musical Angels Between Sts. Nicholas,
Peter, Mark, and Benedict* (see p. 233). We find
ourselves once again in a Franciscan context, once
again in line with the theological world of the order
and the commemorative motivation of private
clients. Placed in the Pesaro Chapel, where
Franceschina Tron, Pietro Pesaro's wife was buried,
and commissioned by their sons, Nicolò, Marco, and
Benedetto, the triptych depicts the Sts. Nicholas,
Mark, and Benedict, with the Virgin in the splendor
of music and light, while the Latin inscription in the
golden domed vault, taken from the office for the
feast of the Immaculate Conception approved by
Sixtus IV, asks the Virgin's intercession: "O safe
doorway to heaven, guide my mind and life. / All my
actions are entrusted to your protection."

St. Benedict shows the book open at the passage in
Ecclesiastes which at the time provided the concep-
tual basis and scriptural authority for the dogma of
the Immaculate Conception. How much did the
figurative authority of Giovanni Bellini's picture,
with its clear-cut articulation and its enveloping
atmosphere, contribute to its diffusion?

Secondary Figures, Eclectics, and "Foreigners"

Bartolomeo Vivarini was a painter dominated and
conditioned for life by the Mantegna model.
Constrained at the outset to fit in with the estab-
lished practice of his elder brother Antonio's busy
studio, and thus diligently filling in the defined and
neutral spaces of triptychs and polyptychs with
figures, Bartolomeo clung fervently to the modern
Paduan style. He took, presumably with enthusiasm,
to the hard task of adapting it to the typical layout
and construction which were the family studio's

trademark and which guaranteed its continued
success with a clientele which prefered tradition to
innovation. After so much hard work, the rapid
decline of the Mantegna model, coupled with the no
less rapid rise of Bellini's innovations, must have
taken Vivarini by surprise, leaving him without the
mental energy or stimuli to undertake another
complicated process of change and adaptation.
Vivarini kept his conservative Venetian clientele, who
still guaranteed him some highly prestigious commis-
sions, such as the triptych for the Bernardo Chapel in
the Frari (1482). Similar commissions were to be
picked up here and there, first in the Marches, Puglia
and Calabria, then in Bergamo and its environs.

Vivarini hardly ever tried to give movement to his
solid icons, stage anything akin to an action, or let
slip an original gesture or expression. One wonders
how he managed to portray a story, given that in
1467 he was commissioned to paint a canvas for the
Old Testament cycle in the Scuola di S. Marco
(shortly afterward destroyed by fire)? Perhaps the
answer lies in the fact that he received no more
commissions of this kind. What fortunate juncture,
what coming together of favorable conditions led him,
in the triptych of S. Maria Formosa (1473), to the
partial, timid (even compromised), yet crystal-clear,
and largely successful, attempt to portray on the side
panels, around the image of the Madonna of mercy,
two scenes representing everyday, intimate affection,
with hard Paduan outlines finally giving way to
Flemish detail.

Aware of what was happening around him,
conscious of Paduan culture and Vivarini's rework-
ings, and of the Bellini family and Antonello da
Messina, Lazzaro Bastiani never took sides. A
modest colorist, he was nevertheless an attentive and
curious iconographer, a precise and dignified
inventor of compositions, and user of an almost over-
rigorous, therefore schematic perspective. We know
altarpieces, drawings, and devotional paintings by
him, and a valuable example of the rare genre of
votive painting, but he is remembered above all
(perhaps wrongly) for his painting of events. While
his *Story of David*, commissioned by the Scuola di S.
Marco for its Old Testament cycle in 1470, is obvi-
ously lost to us, Bastiani's contributions to the cycle
of the Scuola di S. Gerolamo and the cycle of the
relics of the cross of the Scuola di S. Giovanni
Evangelista survive, proof of his solid craftsmanship
and his quiet inclination for storytelling (see pp.
236–237).

Antonello da Messina, in Venice perhaps as early
as the end of 1474, but certainly there from 1475 to
the summer of 1476, must have received, as far as the
altarpiece genre was concerned, much more from

Madonna of Mercy, triptych with the *Meeting
of Joachim and Anna* and the *Birth of the
Virgin* on the wings, Bartolomeo Vivarini,
1473. S. Maria Formosa.

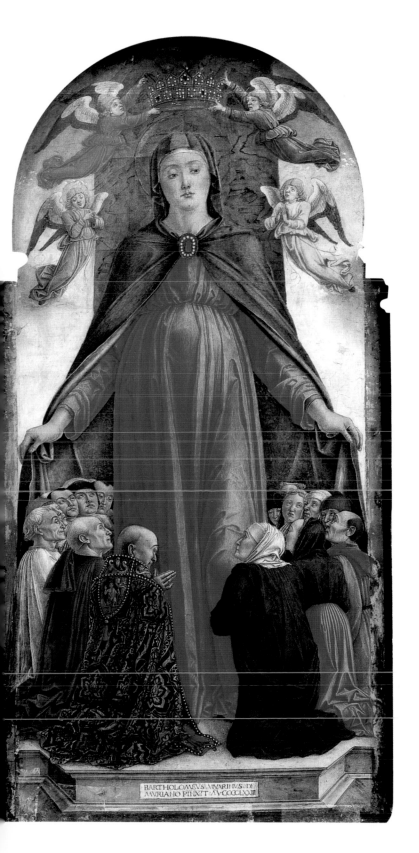

BARTHOLOMEVS·VIVARINVS·DE
MVRIANO·PINXIT·M·CCCCLXXII

Giovanni Bellini than he could have given. Despite accepted accounts, the S. Cassiano altarpiece, from what we can deduce from the fragment in Vienna, is derived almost wholly from Bellini's altarpiece in SS. Giovanni e Paolo, with a few still legible variations of volume and proportion and some perhaps chromatic change, which in any case is no longer decipherable. The importance of Antonello's stay in Venice lies elsewhere. First, he brought Flemish-style paintings with him, producing some locally, sending others from Sicily (like the famous *St. Jerome in his Study*, now in the National Gallery in London, which fifty or so years later, Marcantonio Michiel was to see in Antonio Pasqualino's house). In this way Antonello strengthened with fresh products those Western models that, although already implanted (and fundamental to Giovanni Bellini's cultural development), were nevertheless minor and infrequent. Second, Antonello painted portraits in the "truthful" Flemish style, like the so-called *Condottiere* in the Louvre, not in any way bellicose. Thus he launched a genre that was barely established and had usually been blocked by official standards, and brought along in his wake excellent painters of physiognomy and character, from the mysterious Jacometto Veneziano to the more accessible Alvise Vivarini.

Following the path set by the family studio, but at the same time keeping an eye on the experiments of the Bellini competition, Alvise Vivarini opted as soon as he could for the idealized volumes of Antonello, from which complex brew he distilled many fine pictures. As with his uncle Bartolomeo, one has to ask how he managed to paint stories? All the more so in Alvise's case because, in 1488, not finding himself invited, he put himself forward for the great cycle of the Palazzo Ducale, where Gentile and Giovanni Bellini had already long been at work. He was received into the large workshop, where records show that in 1492 he was earning the same wage as Giovanni Bellini. Despite having not finished one of the three canvases commissioned, he is praised highly by Vasari for his use of perspective, variety of scenery, and number of portraits. It is perhaps in his portraits, like the moment captured in the *Gentleman* (London, National Gallery), of 1497, that Alvise's more up-to-date features can be found, along with an ability to master and develop the style of Antonello da Messina. These features can also be found in the *Christ Resurrected* in S. Giovanni in Bragora of this time, certainly not an absolute masterpiece but a remarkably bold attempt at experimental synthesis not only for its fusion of the Paduan-Muranese line and Antonello-type volume in a Peruginesque pose (Perugino was at this time—and not for the first time—in Venice), for the oddity of

St. Roch and the Angel, Bartolomeo Vivarini. A work noted for its landscape which acts as a backdrop to the lively figures of the saint and the angel, painted on a golden background. S. Eufemia.

the clothes, which fall somewhere between sheets and banners, or for the foreshortening of the figures of the two young soldiers, but especially for the idea of a sorrowful and uncertain Christ, almost taken by surprise at the inexorable solitude of rebirth in that silent dusk, in that sky which was too vast and empty even for him.

Bartolomeo Montagna of Vicenza was in Venice in

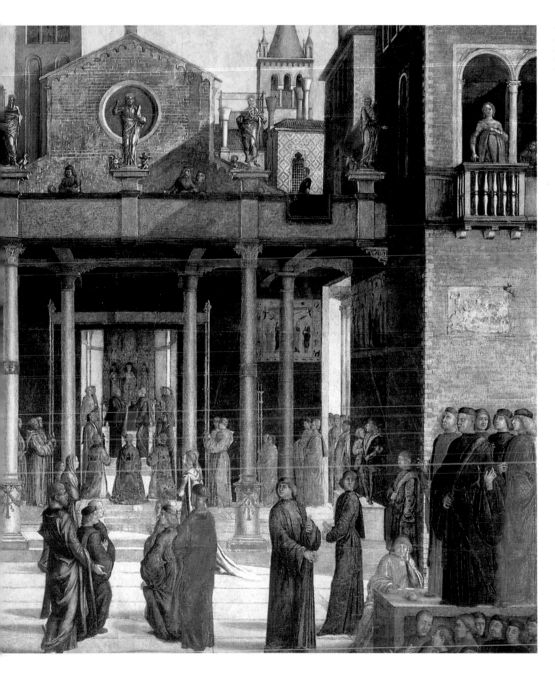

1469 at an early age. He received the commission for two canvases for the (lost) cycle of the Scuola di S. Marco in 1482. For these he must have taken from the work of Giovanni Bellini and Antonello da Messina the simple and evocative language which guaranteed the success of his many luminous and resplendently colored altarpieces that graced altars in Vicenza. Using this clear language, like the best of the Venetian painters, Montagna defined the allegorical stages in the concept of devotion and individual redemption. The altarpiece of the *Madonna Adoring the Child with St. Monica and St. Mary Magdalene*, painted in 1486–87 for the church of S. Bartolomeo (now in Vicenza, Museo Civico), represents its patron Pietra Porto as St. Monica. The patron, having recently lost her husband, felt it apt to

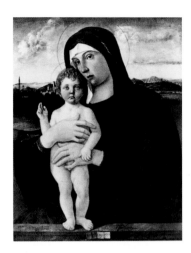

Madonna and Child, known as the *Contarini Madonna*, Giovanni Bellini. Venice, Gallerie dell'Accademia. Among the most harmonious Madonnas of the artist who here introduces, for the first time, a landscape as background.

OPPOSITE:
Madonna of the Small Trees, Giovanni Bellini Venice, Gallerie dell'Accademia. The two small trees flanking the Madonna, which give the work its name, possibly allude to the Song of Songs.

identify herself with the mother of St. Augustine, famous as a virtuous widow, going as far as affirming with her (in Latin on the scroll): "Nothing delights me any more in this life." St. Monica also holds the crucifix, and the whole altarpiece describes Christ's Passion through death and to the Resurrection. The child, whose nakedness betrays his human nature and future human suffering, lies in front of Mary and is worshipped by her, as in a lementation over the dead Christ; he is holding red cherries representing the blood shed in sacrifice as he directs his gaze toward St. Monica's crucifix. Meanwhile, St. Mary Magdalene displays with particular care the jar of perfumed ointment destined for the burial rites. The dead tree on the right is counterpoised on the left by an olive tree with its new green branches, a sign of rebirth. A path leading to the nearby city twists behind the Magdalene: the secluded place of contemplation moves easily, through a simple choice, to the social aspect of devotion.

Devotional Paintings

Devotional paintings are, above all, depictions of the Madonna and child. Of course, it is not a question of an everyday affectionate relationship between mother and child. Superficially simple, the theme of Madonna and child is, in fact, complex; its typological and iconographical details are almost infinite. But the basic meaning still remains the foretelling of the future Passion of Christ. Mother and son are always sorrowful, sometimes anguished; the baby Jesus is usually on a marble "ledge," recalling a sarcophagus and/or altar, and is often in a metaphoric "sleep of death." Sheets and pillows are sometimes white, sometimes black to symbolize mourning, and frequently the child holds coral, the color of blood. The two figures often hold, or have by their side, fruits which symbolize the Passion and redemption, references to the sacrificial role of the son and the co-redeeming place of the mother: Cherries are the color of blood, and Mary's apple is a reference to Eve. A multicolored goldfinch, feeding as it does on thistles, alludes to Christ with his crown of thorns. A book is either closed because destiny is already written and done with, or open so that the painful prediction can be read.

Such typology moreover affirms and demonstrates the human nature of Christ at a time when his divine nature was no longer in doubt but his human nature still provoked much perplexity. The method used to demonstrate this is the exposure of the child's penis, or its partial covering, usually by the Virgin, in such an obvious way as to draw even more attention to it.

The theological purpose of this affirmation lies in the emphasis on the suffering of Christ at the moment of the Passion, a human suffering that would obviously be inconceivable if he had faced his martyrdom solely with his divine nature.

Following a plausible chronology, we can select paintings of the theme from the many by Giovanni Bellini: the *Davis Madonna* (New York, Metropolitan Museum of Art), where Mary has her hands clasped together in adoration of the completely naked child, who sleeps on a white sheet and black pillow; the *Lochis Madonna* (Bergamo, Accademia Carrara), where Mary places her own garment onto the lid of the tomb to cover up, without wholly succeeding, what the child's white nightgown, raised over his hips, has left visible; the *Contarini Madonna* (Venice, Accademia), where the mother does exactly the same thing but with her hand, forgetting however to move her middle finger and straighten her little finger; the *Mond Madonna* (London, National Gallery), with a sarcophagus as unequivocal as ever, white pillow and apple; the *Madonna of the Small Trees* (Venice, Accademia), the child with one foot on top of the other, as they will be on the cross, and the funereal trees (see p. 239).

Among the works of other artists a painting by Bartolomeo Vivarini (Washington, D.C., National Gallery) depicts the anguished child as if trying to defend himself from some malignant outside force and clinging round the neck of his serenely prescient mother. Some examples portray a sublime detachment, like those of Carlo Crivelli (New York, Metropolitan Museum of Art; Bergamo, Accademia Carrara; London, Victoria and Albert Museum; Ancona, Pinacoteca Civica), characterized by the ubiquitous presence of the whole symbolic range of the Passion—altars and pillows, books and goldfinches, red carnations and red coral, apples, cherries, and gourds. A work by Bartolomeo Montagna (London, National Gallery) shows the baby Jesus sitting naked, facing the viewer, astride an enormous closed book placed on top of the altar; both he and his mother hold a large cherry in their fingers. A *Madonna and Child* by Cima da Conegliano (Bologna, Pinacoteca) depicts the child completely naked, his arms crossed on his chest having been crossed, probably by Mary, as she is a prime participant in the process of redemption; another (London, National Gallery) represents a naked Christ, disturbed and a little restless, with a goldfinch in his hand, being propped up by Mary who sits on the sepulcher.

In the narration of the life of Christ, themes and moments that depict or prefigure the Passion also often appear. Represented alongside the Crucifixion

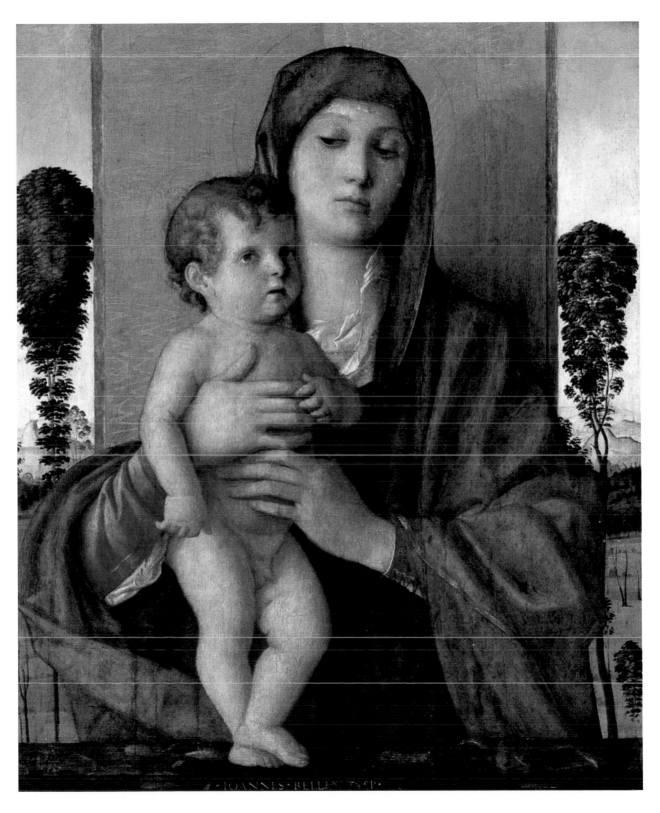

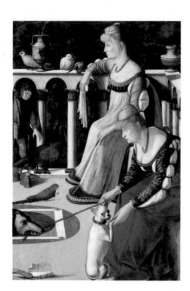

Two Venetian Women, also known as the *Courtesans*, Vittore Carpaccio. Venice, Museo Correr. Opposite: detail.

is the Transfiguration, where Christ informs the Apostles of his sacrifice, or the circumcision, where he sheds for the first time his human-divine blood. But the most important image, which is complementary in its meanings to the Madonna and Child, is the synthetic and antinarrative representation of the dead Christ in the tomb, the upper half of his body showing, either alone or supported by two angels or by the Virgin and St. John. The subject obviously lent itself to sentimental and pathetic expressive emphasis and thus to the devotional experience of compassion and imitation. Giovanni Bellini, who depicted all its iconographic stages, codified its function in his *Pietà* (Milan, Brera) a silent, tragic apparition, where the inscription, from an elegy by Propertius and liberally reworked in a somewhat questionable and twisted Latin, draws a clear parallel between the suffering of the protagonists and that of the painted image. This is not only the painter's powerfully mimetic self-eulogy, but also a premise necessary for the participation of the devout onlooker, engaged in meditation on human-divine suffering.

The masterpiece of devotional painting in the second half of the Quattrocento for its content, thematic originality, and pictorial quality is, without doubt, Giovanni Bellini's *St. Francis in the Desert* (New York, Frick Collection). It was probably painted toward the end of the 1470s, although the exact year is open to debate. It is a profoundly learned picture, based on a rigorous analysis of Old Testament and Franciscan sources, which unites the canonical authority of the *Legenda Maior* of St. Bonaventura with elements of Joachimite spirituality and prophecy, suggesting therefore a knowledgeable and important client. St. Francis, placed physically in the ascetic solitude of the mountains and metaphorically within the general history of monasticism, is connoted, through a rigorous use of symbols, as the new Moses, new Elijah, and new Christ. Like Moses, he is a guide and lawmaker for a chosen people; like Elijah, he lives in the desert and heralds the Messianic age; like Christ, he is marked by the stigmata. The image postulates a renewal that passes, via the practice of contemplation and imitation, through the metaphorical exodus, to the search for the promised land under the spiritual guidance of the Franciscan order.

Vittore Carpaccio: History and Allegory

Carpaccio emerges almost from nowhere c. 1490 with his famous *Two Venetian Women* (Museo Correr). Far from being courtesans, the two women show all the signs of nobility and wealth. Their clothes and their hairstyles are elegant and fashionable, not showy or ostentatious, and their demeanor is suited to the balcony, a place in the noble home of honest rest and leisure. This nobility is denoted by the family crest on the vase on the left of the picture. Apart from the reality represented—the double portrait, clothes, balcony, and crest—the painting is arranged using deliberate symbolic codes, following a consciously mapped-out itinerary that clearly outlines the stereotypical morality for women: chastity for single and widowed women, restraint for married women, modesty and shyness for all, and a discreet vigilance regarding the irrefutable facts of desire, to be converted immediately into virtue. The practice of virtue is made into a pictorial image through two complementary, even interchangeable, codes: those of classical mythology and those of Christian mythology. The models are Venus, for her divine power and expression of love, and the Virgin Mary, for her ability to control and direct the instinct of love within the rules of a society based on motherhood and the family unit.

The younger woman, with a melancholy gaze straight in front of her, is either about to be or recently married: only as such can she wear pearls around her neck and more pearls along the neckline of her dress. The pearls indicate, with the miraculous and luminous transparency of that jewel belonging to Venus (who was conceived by heaven and born from a seashell) and of Mary (a shell who by heaven has conceived the pearl of Christ), chastity, understood as a rigorous observance of marital rules and limitations. The pearl is also a sign of wealth and nobility, albeit devoid of pomp, in observance of the restrictive Venetian sumptuary laws. The same meanings and values are underlined in the woman's elegantly displayed, spotless, and well-pressed handkerchief, socially a sign of high birth, symbolically a sign of purity, and metaphorically a sign of love—a token left by the man departed far away so that the lady can dry her tears. She is sitting between the vase of myrtle or box-tree (both symbols of the Virgin, Venus, and marriage) and the vase with the family crest which now contains only the lower part of the lily. The lily has nothing to do with Venus but is the sign of chastity and the choice of the bride of the Song of Songs, as well as the conventional gift of Gabriel at the Annunciation, a clear and well-known symbol of Mary's purity. The two turtle-doves next to the vase are similarly well-known symbols of chastity, but the fact that there are two indicates a couple united by the unique and eternal bond of matrimony. The orange is the golden fruit of Venus and Mary, and of every bride; the peahen a symbol of conjugal

*Arrival of the English Ambassadors in the
Breton Court*, Vittore Carpaccio, from the
Life of St. Ursula cycle. Venice, Gallerie
dell'Accademia. Opposite: detail.

concord and natural fecundity kept in check by
modesty; and the parrot, able to greet Mary with its
polite *Ave* [Hail], but also able to be a party to
amorous scenes, stands for the opposing poles of
femininity and their meeting in the institution of
marriage.

The older and milder-featured woman in the fore-
ground also has pearls along her neckline but has a
double silver chain round her neck. She is petting a
lapdog and has on a leash the aggressive greyhound.
These two very different types of dog both stand for
loyalty and vigilance. These attributes, apart from
being deeply rooted in popular consciousness, are
well documented in both textual and figurative tradi-
tion. As the older woman closely resembles the
younger one, and is probably her mother, or even her
elder sister, these symbols show her as a chaperone
and companion, the guarantor of matrimonial
probity and family honor. The well-dressed boy who
comes out onto the balcony as a messenger brings
news from the far-off male world.

So where are the distant and much-awaited men?
They are out bird-catching in the lagoon, in the other
half of the original painting, housed for some years
now in the J. Paul Getty Museum in Malibu. The
Getty picture has long been associated with the
Correr picture for the simple reason that the inter-
rupted stem in the vase at the top left-hand corner of
the latter is completed perfectly in the lily that
emerges out of the bottom of the second picture, its

presence against the waters of the lagoon otherwise
inexplicable. Even this early observation has long
been obscured by the inability to understand that the
lagoon is not a view but a vision, not a panorama
seen from the women's balcony, but an allegorical
projection of their thoughts. Now that joint research
carried out between Venice and Malibu has unequiv-
ocally confirmed the pictures' homogeneity, one can
clearly see the meaning behind the unity of the two
"texts": the wives at home by themselves, slightly sad
and bored, their husbands down in their boats,
catching water-birds. However, one should really
talk about a unity of three texts, because on the back
of *Hunting in the Lagoon* there is an astonishing
trompe l'oeil, letters held up by an illusionary ribbon
which in turn is represented as tacked onto the side
frame of a false cabinet. These letters must originally
have borne the names and addresses of their senders
and/or recipients. They also explain the presence of
the messenger boy in the Venetian painting and serve
to fill the suspended time of the distance and the
wait.

The reassembled picture, containing a whole range
of possible references from Pliny and the *Physiologus*,
the Song of Songs, and Marian hymns to Ovid and
Boccaccio, and supported by an exceptional atten-
tion to the detail of custom and behavior, shows that
Carpaccio from his very arrival on the Venetian scene
was not the detached and neutral chronicler tradition
would have us believe, but the shrewd arranger of

invariably allegorical stories. Out of the many painters of the time, he is undoubtedly the most cultured and most open to literature and its illustrations.

Carpaccio's allegorical stories come into their own in the series of canvases he made for the Scuola di S. Orsola depicting the adventures of St. Ursula, the Breton princess promised in marriage to an English prince but killed in Cologne by the Huns while returning from her pilgrimage to Rome. The story comes from the *Golden Legend* by Jacobus da Voragine, a thirteenth-century collection of saints' lives, which was to become a bestseller two centuries later after being printed in Italian.

On the basis of the dates which have fortunately survived on the *cartellini* [labels], it is certain that Carpaccio painted most of the canvases between 1490 and 1495. These depicted the scenes of the journey through to the final massacre and glorious apotheosis. In the following years, Carpaccio added a lengthy prologue of three canvases portraying the comings and goings of the diplomatic missions. For these, there are neither *cartellini* nor archival documents, but there is evidence, as in the famous canvas entitled the *Arrival of the English Ambassadors in the Breton Court* (which is in fact probably the story of their departure), of newly discovered methods of spatial construction and narrative definition. These are apparent through Carpaccio's display of his ability to use perspective, based originally on the work of Jacopo Bellini but continuously developed under the influence of new theories and through working on cycles for the *scuole* and the Palazzo Ducale; through his development of variegated painted architecture, where the expressions of the contemporary avantgarde progressively replace the evocation of the Western and Mediterranean Middle Ages; through his recourse to times, structures, characters, symbols, and instruments for scenic representation; and through his painstaking attention to details of costume and ceremony. The presence in the *Meeting with the Pope* of a portrait of Ermolao Barbaro, author of a book on diplomatic etiquette, is the key to contextual interweaving between the realm of image and the realm of writing, perhaps also to a multiple commission that superimposed over the devotional purposes and modest finances of the *scuola* the celebrative needs and conspicuous wealth of particular Venetian families.

Ceremonial scenes are also represented on the main canvas, the *Meeting and Departure of the Betrothed Couple on Pilgrimage to Rome*, in which a young knight of the garter displays a scroll bearing the initials of the probable patron, Nicolò Loredan, and in the *Meeting With the Pope*, where an imagi-

nary pope is painted against the background of contemporary Rome, with Castel Sant'Angelo and the fields around. Meanwhile the silence of the intimate premonition of the *Dream of St. Ursula* (see p. 244) prepares the way, a rare but effective pause in the sequence of the cycle, for the bloody and violent finale that unexpectedly explodes in the *Martyrdom of the Pilgrims*.

There is no historical, or as we would say today, ethno-anthropological, basis for contemporary obsession with the barbaric ferocity of the Huns. Carpaccio contented himself with depicting a multi-colored troop of men of Germanic-Scandinavian appearance, almost all characterized by long fair hair. However, a viewer of this canvas in the year in which it was made (1493), or in the following years, could not have helped but take the massacre from the timeless legend of St. Ursula and the Huns, and transport it into the present, to the massacres committed by the Turks, who were the new barbarians, the new infidel, and the new persecutors. This superimposition would have been based on contemporary reports, circulated with a mass of illustrative detail, alarmist comment, and propaganda messages, and conscious and unconscious metaphors from both printed books and rumors.

In the canvas of the *Arrival in Cologne*, the Christian ship is already in port, bedecked with flags of the cross while flags depicting three crowns side by side fly in the fields and in the city. In the *Martyrdom* scene the red- and white-tailed ensign with its two series of three crowns rises up majestically in the center of the scene, while the flag with the cross lies abandoned against a mast. The three crowns side by side stand for the "triregnum" [triple kingdom] of Mehmed the Conqueror and his successors, and mark his dominion over the three empires of Asia, Trebizond, and Greece. Giovanni Bellini had put them in the upper corners of his portrait of the Mehmed. The crowned ensigns that face each other from the towers and fly on the field of martyrdom of Cologne are Mehmed's. It is Turks, dressed as Huns, with their blond, colorful, and palpably false appearance, who are covering the field with virgin blood. Even if no one had noticed before, the clue is clearly in evidence in the center of the canvas, just under the fateful standard: the knight on the rearing charger is a Turk, dressed in a tunic and turban, who accompanies this brutal, apocalyptic prelude with blasts on his trumpet.

One of the patrons of this part of the cycle was probably Nicolò di Alvise Loredan, captain of the galleys of Barbary and Alexandria. Nicolò, who died in 1487, came from a branch of a family that could boast an impressive array of successes in the Turkish wars. His father Alvise had been a sea commander, famous for his deeds in Morea; he would also have led the Venetian army fleet on its last great crusade, were it not for the failure to raise a European force. Alvise's first cousin Jacopo was a sea commander in 1453 in an attempt to relieve the besieged city of Constantinople, and again in 1464 and 1467. Jacopo's son Antonio was the heroic and fortunate defender of Scutari during the Turkish siege of 1474. And there were many others, both before and after. The Loredan family had long been the protectors of the brotherhood; following and strengthening the inclinations of Nicolò, it orientated the timeless story of Ursula around the timely celebration of its heroes.

Around the middle of the last decade of the fifteenth century, already busy at work on the *St. Ursula* cycle, Carpaccio still found time to work on the cycle of stories based on the relic of the cross owned by the Scuola of S. Giovanni Evangelista. This enterprise was coordinated and largely carried out by the painter who had perhaps been Carpaccio's master, Gentile Bellini, with the collaboration of two of the other most important representatives of the narrative tradition, Lazzaro Bastiani and Giovanni Mansueti (as well as, initially, a certain "Perusino," who is almost certainly the great Pietro Perugino, and, at the end, Benedetto Diana).

A comparison between the *Healing of the Possessed Man at Rialto* by Carpaccio (see p. 246) and the *Recovery of the Relic at the Bridge of S. Lorenzo* by Gentile Bellini (see p. 247), painted some five or six years later, betrays two different notions of pictorial and political conception. Gentile depicts a perfectly organized spectacle, with a disciplined and attentive public which takes up its assigned places in an orderly fashion, following a precise hierarchy, as if they were the stalls and circle of a modern theater, leaving the privilege of center stage to the miraculous discovery. Carpaccio decentralizes the miracle (the healing of the possessed man through the miraculous properties of the relic), relocating it to the terrace in the top left-hand section, almost unobserved—and indeed unobservable—by the many various and colorful passersby, thereby highlighting the Grand Canal and its gondolas, its bridge and the Rialto palaces and its bustling banks. For Gentile, the miracle is an exceptional event which merits a good set design, precise direction, and a select audience. For Carpaccio, the miracle in Venice, a divinely privileged city, is an everyday event, to record with a participatory and (apparently) neutral eye.

Between 1501 and 1503, Carpaccio painted in rapid succession two canvases of the story of St. George and the dragon for the Scuola Dalmata [*scuola* for Dalmations, dedicated to Sts. George and

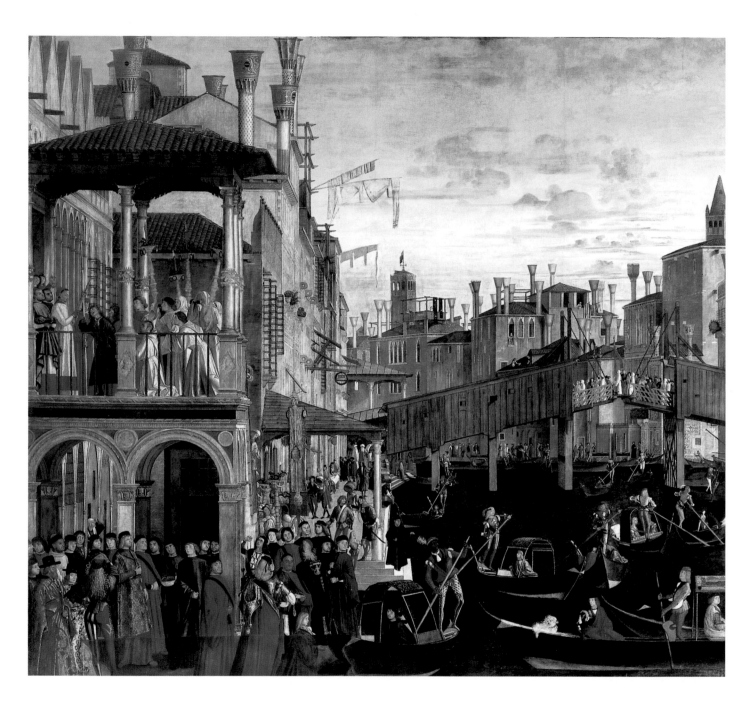

Healing of the Possessed Man at Rialto, Vittore Carpaccio, from the cycle of *Miracles of the Cross*. Venice, Gallerie dell'Accademia. Important for comparison with Bellini's painting of the same subject.

Trifone]. For the same patrons he also painted the canvases of *St. Jerome and the Lion in the Monastery*, the *Funeral of St. Jerome*, and *St. Augustine in His Studio*. Some years later he returned to complete the cycle of St. George with the *Baptism of the Heathen King and Queen* and, in order to gratify the more obscure patron saint, he depicted the youthful St. Tryphon in *St. Tryphon Exorcising the Daughter of the Emperor Gordianus*, which he entrusted largely to a mediocre (and unknown) painter from his studio.

The story of St. George and the dragon, taken essentially from the *Golden Legend*, is told in two parts, on two canvases. Riding his black horse, the

young warrior assails the dragon and wounds it with a well-aimed thrust of his lance (see pp. 248–249). Once the beast is brought back to the city, he deals it the death blow. In the canvas depicting the fight, dead bodies, proof of the devastation carried out by the dragon, and the living creatures that feed off them, are spread all over the battlefield; in between skulls, bones, and torn limbs lie the partially devoured bodies of a young man and woman; lizards, toads, snakes, and vultures roam. The horrors include an extraordinary repertoire of signs and symbols: the dragon is the image of fatal lust, the reptiles its lugubrious and pernicious cortège; the two young people who have been devoured by the dragon

Recovery of the Relic at the Bridge of S. Lorenzo, Gentile Bellini, originally in the Scuola di S. Giovanni Evangelista. Venice, Gallerie dell'Accademia.

St. George Fighting the Dragon, Vittore Carpaccio. Painted for the Scuola Dalmata of St. George and St. Tryphon, this is among the most evocative of the artist's creations, not least for its fantastical background landscape.

should have been able to maintain innocence up to the moment of matrimonial initiation, but instead it has been ripped apart by lust.

The princess is a person on the threshold, in transition. We know she is an African and a pagan, yet she is attired in an almost totally Western fashion, with ringed locks of hair, pearls around neck and a belt around her waist like the most chaste of young women. Indeed, her expression is one of demure absorption, just like the *Virgin Annunciate*, without a trace of fear on her face. She wears her princess's crown, reminiscent of those of virgins and martyrs and has her hands clasped in the traditional gesture

of suffering and awe, reminding one of the gesture of prayer. Behind her rises a lush green hill with two different paths: the nearer, wide one leads to a large church while the far-off, narrow one leads to a fantastic arch of rock over the sea where the narrowest of bridges connects the land to the rock and where two huts, presumably those of hermits, are perched on the precipice. A ship passes behind the arch with its sails billowing in the wind, while another with its sails furled and masts at an angle seems motionless or even drifting. In front of the princess there is the event which sanctions possible change; behind her are the popular Christian signs

and symbols of the variable outcomes of change: the narrow bridge which is the difficult path of contemplation, the steep pathway which leads to the church, and the ship with its full sails on the sea of the world.

Within a cycle, a picture packed with symbols is almost always followed by a picture where the symbols almost disappear completely. It is as if the painter, after having developed his iconography and semiotics with relentless concentration and an immense effort of assembly, organization, and arrangement of information, needs to draw breath in the less strenuous corollary of a calm, narrative complement. This is what happens here, where the dense meaning effort of the *Battle* is followed by the single-minded simplicity of *St. George Kills the Dragon*. One important feature is that St. George, as in the *Golden Legend*, uses the princess's belt to drag the dragon into the city. The blond elegant knight gets ready to finish off the beast, who is trapped, bleeding, curled up, and has a piece of lance sticking out of its head. Despite this, it still provokes fear in the onlookers and restlessness in the horses, especially in the saint's horse. As far as the king, queen, and princess are concerned, the painter leaves us in no doubt that all three are thinking and hoping for

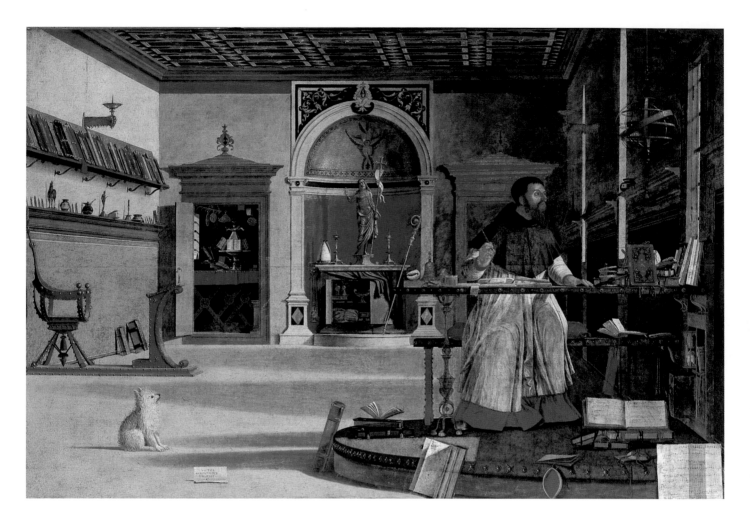

The Vision of St. Augustine, or St. Augustine in His Study, Vittore Carpaccio. Part of the cycle of the life of St. Jerome, this work was painted for the Scuola Dalmata of St. George and St. Tryphon and is especially interesting for its representation of a scholar's study.

the same thing at this moment: the marriage of the princess to the heroic knight who has already, and quite respectably, removed her belt. However, nothing will come of it. The Christian knight is concerned solely with the conversion of the infidel. After having baptized the masses, he will hastily leave for an unknown destination.

While the role of St. George as *miles christianus* [Christian soldier] and crusader knight is amply backed up by textual and figurative tradition, the role of the dragon as a metaphor for the Turkish monster is less well established. The dragon does not stand for the Turks simply as the traditional enemy of the saint, who stands for the Christian knight, but because the association was substantiated by the experience of the Christian soldier in battle. He really did see dragons, because they were depicted on Ottoman flags and because Ottoman cannons were fire-spitting dragons. It was not simply a question of

metaphor, but of real machines of war in which ingenious technology and destructive power went hand in hand with imaginative and terrifying disguise. This is the powerful image which established the recognition and effectiveness of the metaphor in the popular story and in collective consciousness.

The two St. George canvases were probably financed by Paolo Valaresso, who in April 1502 donated to the *scuola* a relic of the saint, given to him by the old patriarch of Jerusalem. As captain of the fort of Corone in Morea, Valaresso had been forced in August 1500 to accept the surrender of the inhabitants to the Turks without a fight, against his own wishes and those of the Venetian minority. As a member of a family of distant, but celebrated, Dalmatian origin, he must have deemed that the *scuola* was the ideal place for celebration and penance of the unfortunate episode. Like all Christian soldiers, he knew that George was the crusader knight victorious

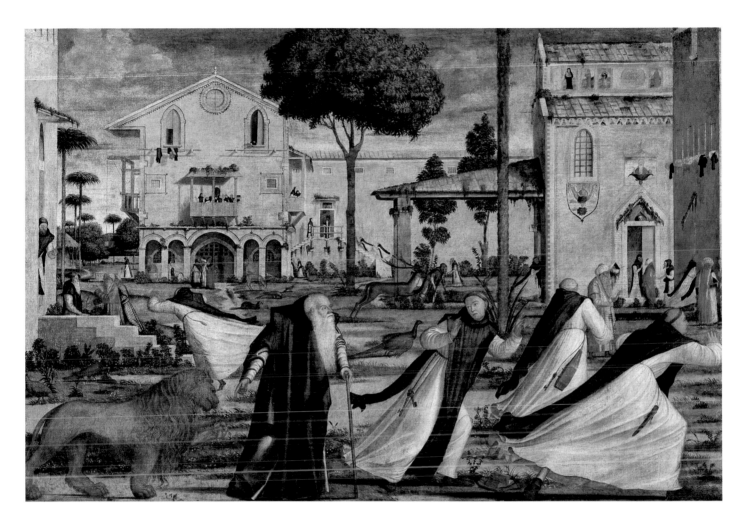

over the infidel, and that the dragon, a frightening and deadly beast which was finally destroyed, stood for the Turk.

The two episodes from the life of St. Jerome also derive from the *Golden Legend*, with some elements based on the *Catalogus sanctorum* [Catalogue of saints] by Pietro de' Natali and on the *Life, Death, and Miracles of the Most Blessed Hieronymus*, another early printed best seller in Italian, available from 1471. When a limping lion approaches the monastery in Bethlehem, the abbot Jerome immediately goes to greet it as a guest, while the other monks flee (see pp. 251, 252). The face of the presumably wild beast is twisted in an expression of pain, and it shows the saint its pincushion-like paw. The risk must be accepted, the unfortunate animal, infected and in pain, needs to be treated, the thorn removed, and the beast healed and tamed. St. Jerome's expression betrays his surprise and disap-

pointment at the sight of the brothers fleeing from the compassionate duties of a good Christian. After imposing his authority and calling them back, once the lion is healed, grateful, and docile, he makes sure that the animal will stay at the monastery. The lion will be on trial, in both senses of the word. He must demonstrate his new peaceful temperament and show his willingness to serve the Christian community, and he will have to face, at some stage, the unjust charge of having devoured the donkey and suffer the punishment, exercising the virtue of patience and trying to set about establishing his innocence. In short, he must provide ample and repeated proof of goodness and stability and of his conversion. He must have succeeded in doing so since he is still there at the funeral of the saint when he raises his head in a roar of pain for the death of his friend (maybe it is a final roar and he dies with Jerome, just as he had lived with him).

St. Jerome Leads the Lion into the Monastery, Vittore Carpaccio, painted for the Scuola Dalmata of St. George and Tryphon. A vivid scene in which the painter seems to revel in representing the surprise of the terrified monks.

The monastery is full of Eastern faces with long beards and unmistakable turbans, dressed in brightly colored garments. It is clear that we are in Bethlehem: but what are these infidels doing in a Christian monastery if not declaring their own willingness to convert? These traditional persecutors of Christians are no longer ferocious animals, they are in fact wounded and hurt, tormented by the thorns of sin, particularly by those of original sin. They must be washed, cured, their wounds healed with holy water, and then, after the necessary tests of patience and humility, they must serve the community of the faithful.

The Venetian victory at Santa Maura in August 1502 brought to an end, for a while, the long hard period of the Turkish wars. If the St. George cycle reflected the military ideology of the conflict, the anxiety of the head-on collision, and the physical elimination of the enemy, then the St. Jerome canvases reflect, albeit more tentatively, the civic ideology of conversion and pacification.

In another canvas, the main character, unlike the old and white-haired abbot, has brown hair and is middle-aged. And despite having scattered around him, amid general disorder, music in sheet and book form, an armillary sphere beside the window, astrolabes in the prayer cell, an hourglass in the cabinet, a small bell and a shell on the table, and a bishop's mitre and crosier in the recess, it took a long time before this Christian humanist was identified as, not St. Jerome, but St. Augustine in his study (see p. 250). St. Augustine, a bishop, had always been represented as an old man, busy in his study of earthly time and musical proportion as a reflection of cosmic time and the harmonic proportions of the celestial spheres, and thus associated with instruments for measuring time and the cosmos. It was St. Augustine who had had the presumption to write a book on the unfathomable mysteries of the Holy Trinity and was then surprised that a child tried to drain the sea with a shell, taking the shell, from that moment, as a symbol of the limitations of the human intellect, in particular his own.

Yet *St. Augustine* is at the same time the finale (one of the possible finales) of the story and of the cycle of St. Jerome, taken from the *Life, Death, and Miracles*: St. Augustine, desiring to write a treatise on the joys of blessed souls and to introduce into his own argument the view of Jerome, about whose death he had not yet learned because it was happening at that very moment, was in the process of writing Jerome a letter when he was surprised by an unnatural and indescribable light. From the light came the voice of Jerome: just like the child with the shell on the seashore, and in similar terms, Augustine was harshly reproached for his intellectual presumption, for having desired to comprehend and to measure the glorious happiness of the blessed, which can be known only directly, after this life, in the experience of eternity.

If we do not waste time counting the books and identifying the bronze statuettes, we may still feel like asking why this perfect and dissonant picture is included within this cycle and within this *scuola*? The narrative reason just outlined, exegetically flawless, cannot make up for the fact that Jerome is absent. This is despite the existence of many other scenes from Jerome's life where the figure of the patron saint could have been brought to the fore. There is, for instance, the scene of St. Jerome himself alone in his study; or, alternatively, that of Jerome the ascetic hermit. The awareness of the presence of St. Jerome in voice and light does not manage to compensate with sufficient abstraction for the very real appearance of a picture entirely structured around the person of St. Augustine, who may have been a great doctor of the Church, but who has no connection with the ancient or recent history of the Dalmatian community. The obligatory choice of an interior setting radically contradicts the usual exterior setting. This canvas is an opulent intruder. There is only one possible explanation: at some stage the clients were "obliged" to include a portrait, and the venerable features of St. Jerome, by now already depicted in the two preceding canvases, proved to be an obstacle. The luminous manifestation of St. Jerome to St. Augustine saved the logic of the cycle only discreetly, but saved the need for the portrait brilliantly.

This explanation is nothing new. It is, in fact, a fairly popular theory that represented as St. Augustine is Bessarion, the Greek cardinal who forty years earlier had contributed to the projected crusade, had given the *scuola* an important indulgence, and had donated to Venice his splendid personal library. In this context his presence would certainly be plausible, but ultimately the theory must be rejected, because the appearance of St. Augustine is nothing like that of Bessarion, well known through a portrait by Gentile Bellini, and because the presumed "seal of Bessarion," that is, the vermilion stamp of the parchment on the dais, does not carry (and never did carry) any trace of the characteristic seal of the cardinal.

We can therefore propose, even without physical similarities, an alternative identification with Bishop Angelo Leonino, apostolic legate in Venice during the time the canvas was made. Leonino, like Augustine, a middle-aged bishop, was suited to the setting of a humanist study, being a doctor of art and medicine.

Funeral of St. Jerome, Vittore Carpaccio, detail. Scuola Dalmata of St. George and St. Tryphon.

OPPOSITE:
St. Jerome Leads the Lion Into the Monastery, Vittore Carpaccio, detail.

In 1502 he conceded Paolo Valaresso the gift of the relic of St. George and conferred an important and remunerative indulgence on the *scuola*. In 1503 he rejected the pressure of the prior of S. Giovanni del Tempio who was set on evicting the brotherhood. Above all, Leonino had been a central figure in the negotiations between the pope and the Republic for their joint expedition against the Turks, which was concluded successfully in 1502. The benefit conceded to the *scuola*, in full keeping with the significance of the pictorial enterprise, wholly oriented on the ideological plane by the emergence of the Ottoman problem, was both solicited and rewarded, with the promise of executing a portrait, the only plausible "contemporary" portrait, with all the political, functional, and instrumental value that such a portrait gives.

Cima da Conegliano, 1490–1500

In the 1490s, with the great series of canvases for the Sala del Maggior Consiglio of the Palazzo Ducale taking up most of his time, Giovanni Bellini had to abandon or turn down altarpiece commissions. The temporary absence of one of the genre's most masterful practitioners left the field open to the competition. There were no more obstacles to hinder the rise of a pictorially knowledgeable artist who, without neglecting other possible experiences and mainly on the strengths of Giovanni Bellini and Antonello da Messina (the S. Giobbe altarpiece by Bellini and the triptych left or sent to the church of S. Giuliano by Antonello da Messina, judging by the surviving *St. Sebastian* in Dresden) (see p. 254), had already developed a clear and consistent style, devoid of any shocks or surprises but with great skill and total decipherability. That artist was Cima da Conegliano.

His *Baptism of Christ* in S. Giovanni in Bragora, of 1493–94 (see p. 255), is constructed with extraordinary iconographic and semiotic lucidity. Baptism marks the beginning of the Christian life, with the death of the old life and the birth of the new, but it also prefigures the end of the Christian life in the identical process of death and resurrection. It can therefore include symbolic references to the Passion of Christ, as a model of equality, a guarantee of redemption, and a promise of rebirth. The intermediate planes of the painting can be "unlocked" using this key: the elm and ash are the trees of the cross and salvation; on the small island behind Christ are a weeping willow and two stunted dead trees upon one of which has perched a small, black bird of prey; beside the Baptist, the usual tree stump, which this

Baptism of Christ in the Jordan, Cima da
Conegliano. Venice, S. Giovanni in Bragora.
An evocative landscape which recalls the
painter's place of birth.

OPPOSITE:
St. Sebastian, Antonello da Messina, with a
background of typical Venetian buildings.
Dresden, Gemäldegalerie.

Madonna and Child and St. Jerome and St. Louis of Toulouse, better known as the *Madonna of the Orange Tree*, Cima da Conegliano, 1487–88. This painting represents one of the most felicitous moments in the career of the artist. Venice, Gallerie dell'Accademia. Opposite: detail.

time has a new shoot growing out of it. The river of baptism inevitably becomes a sacred river, a fountain of life populated with ducks and swans. In the background on the right, beside the water, we can see a hind and a stag, symbols of the Christian soul. Less natural, although generally explicable through the gospel reference to Pharisees and the Sadducees, is the mass presence of Oriental-looking people, three on the boat on the river, two on the opposite bank, and two more high up on the path. On the upland plain a shepherd and his flock are accompanied by a vigilant dog, a detail reminding us of many texts and the vast range of interpretations allegorically assigned to the keeper of the flock, including his poverty, simplicity, and humility, and his role as spiritual guide, as shepherd of the soul, and as priest.

In the *Madonna of the Orange Tree* (Venice, Accademia), painted around 1497–98, Mary is outside, sitting on a natural seat of rock, with the holy child on her lap, under a large orange tree, which is a symbol of a bride's chastity (see p. 257). St. Jerome is with them, dressed in the rags of a hermit and with the penitential stone for beating his chest (see p. 256). St. Louis of Toulouse is also there, and has, in literal homage to his life, put bishop's clothes directly over his Franciscan habit, not forgetting to have them embroidered with the fleur-de-lis. To these appropriate presences in the original context of the Franciscan convent of S. Chiara on Murano

are added the two friars walking down the wooded path and Joseph with his stick and his donkey, a separate presence, but enough to establish an unequivocal reference to the flight into Egypt and to provide an immediate reason (or the perfect excuse) for the unusual outdoor setting of the allegory. The flight, a Christological episode which saves Christ from the premature and unproductive suffering of his innocent contemporaries, is also a Mariological episode, in which Mary, along with Joseph, plays an essential role as far as the process of redemption is concerned. As is explained in the major texts of the Franciscan order, Christ, in order to attain the autonomy of redeemer, must pass through the co-redeeming protection of Mary. This is why, as can be seen in the *Madonna of the Orange Tree*, Mary is the tree and Christ is the shoot.

Beyond the obligatory reference to Isaiah's famous prophecy (Isaiah, chapter 11, verse 1), the common botanical symbolism provides its usual confirmations: the orange tree, principally understood as the tree of chastity, of the bride, and of Mary, has the ancillary meaning of the tree of life, redemption, and paradise. The oak tree, which is generally known for its solidity, and is therefore a symbol of fortitude and patience, is also a symbol of Mary. At the same time it is the tree of the cross, of life, and of salvation. For this reason it is an oft-repeated image in the background of the altarpiece.

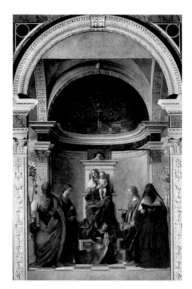

Madonna and Child Enthroned With a Musical Angel and Sts. Peter, Catherine, Lucy, and Jerome, Giovanni Bellini. This magnificent altarpiece, dated 1505, is known as the S. Zaccaria altarpiece. Opposite: detail.

As for the animals, behind St. Louis, in the far right-hand corner sits a dog attentively guarding the sacred meeting, as is his natural prerogative. On the other side of the painting, on the path behind Jerome, is a deer, the recurring symbol of the faithful soul that longs for Christ. There is also a white rabbit, a symbol of vigilance and contemplative solitude. The partridges are to be interpreted through the story that comes from the *Physiologus* through the patristic encyclopedias to the moral bestiaries. Partridges sit on the eggs of other partridges (and generally of other birds) but, when the eggs hatch, the chicks immediately recognize the call of their real mother and go to her. The story is an allegory of the truth, which will sooner or later always be recognized. It is moralized in the invitation to Christians, fleeing the false attentions of the devil, to recognize the voice of Christ and run to the Mother Church.

The city on the hill is a Western, Christian city, with its walls, towers, gardens, churches, and bell towers. Yet around it circulate Oriental-looking figures in turbans. Two of them are halfway up the path, another is straddling the wall, and two more are talking to each other at the entrance to a house a few yards from the main gate. These figures, which are present in the work of Cima and of other artists in scenes which, directly or otherwise, refer to the Passion of Christ, necessarily allude to the mortal danger of the ancient infidel, the Jew. But neither do they preclude a reference, in the context of Venice of the end of the fifteenth century, to the equally mortal danger of the new infidel, the Turk.

The semiotic proof of the organized layout and the iconographic proof of the contextual meanings signal at the same time a symbolic picture of more solid conceptual depth, a more learned and developed theology, and a more general didactic message. They set the reserved and peaceful space of the saints against the indistinct, violent space of the world. The praise of the Christian faith includes a warning about the presence of its opposites. This is why the *Baptism* in S. Giovanni of Bragora shows a number of infidels on the banks of the river where, to their shame, the initiation of Christ takes place. In the *Madonna of the Orange Tree*, they crowd the pathway to the city, obliging the two contemplative saints to close ranks in the consecrated space around the Madonna and child seated on the solid rock of the Church. Cima's solid repertoire, based on comprehensible and meaningful detail and on the principle of the popular and ordered symbolic constellation that takes advantage of the structural innovation constituted by the outdoor setting, results in theological clarity and devotional efficacy.

Giovanni Bellini and Lorenzo Lotto, 1505

In 1505 Giovanni Bellini signed and dated the great altarpiece of the church of S. Zaccaria in Venice, the *Virgin and Child Enthroned With a Musical Angel and Sts. Peter, Catherine, Lucy, and Jerome* (see pp. 258, 259). The altarpiece is dominated by the principle of symmetry. To the sides of the central axis, which follows the perfect perpendicular of the lamp and broadens out gently to include the various couples, Madonna and child, the music-making angel, and Bellini's personal stamp of the *cartellino*, everything, or almost everything, is reproduced in a mirror-image: the partitions and decorations of the architecture, the acanthus volutes and the bold eaglets of the mosaic, even St. Catherine and St. Lucy seem sisters, both carrying a palm and the emblems of their martyrdom, the wheel and the jar with eyes. St. Peter and St. Jerome, lost in thought, equally mirror each other, as do the narrow wooded scenes behind them. But in a context such as this, where identity and symmetry are equivalent to calm and harmony, the mere analogy is already rejected, is already dissonant and thus must conceal significant distinctions.

St. Jerome is immersed in his open book (see p. 259). Behind him are two trees, trembling poplars which have funereal connotations. One of them is covered with leaves, while the other is almost totally bare. The allegorical juxtaposition of the bare tree next to the lush tree corresponds to St. Jerome; it configures itself as his symbol and an element of his definition: as a doctor of the Church, Jerome, with his experience of study, reanimates the dried-up tree of the scriptures, of the ancient tradition entrusted to texts always in danger of obsolescence and criticism. As a cardinal, he transfers that experience to within the ecclesiastical organization. But he gives more importance, however, to reading, even when he is presented with the revelation of Christ in person, with the cycle of the Incarnation, Passion, Death, and Resurrection of Christ, who supersedes contemplation and intellectual rigor.

St. Peter has his usual symbols, keys and a closed book. Behind him there is a fig tree, which has ivy growing up and around it. The logic and symmetry of the composition suggest that the symbolic value of the association of the fig tree with the ivy will be made clear in relation to Peter, and correspondingly, or contrastingly, to Jerome and his poplars. Both the fig tree and the ivy are symbols of the cross. The fig tree readily offers up its sweet, restorative fruit just as the cross offers up Christ, the sweet fruit of Mary's womb, the restoration of grace. The ivy is a deep-

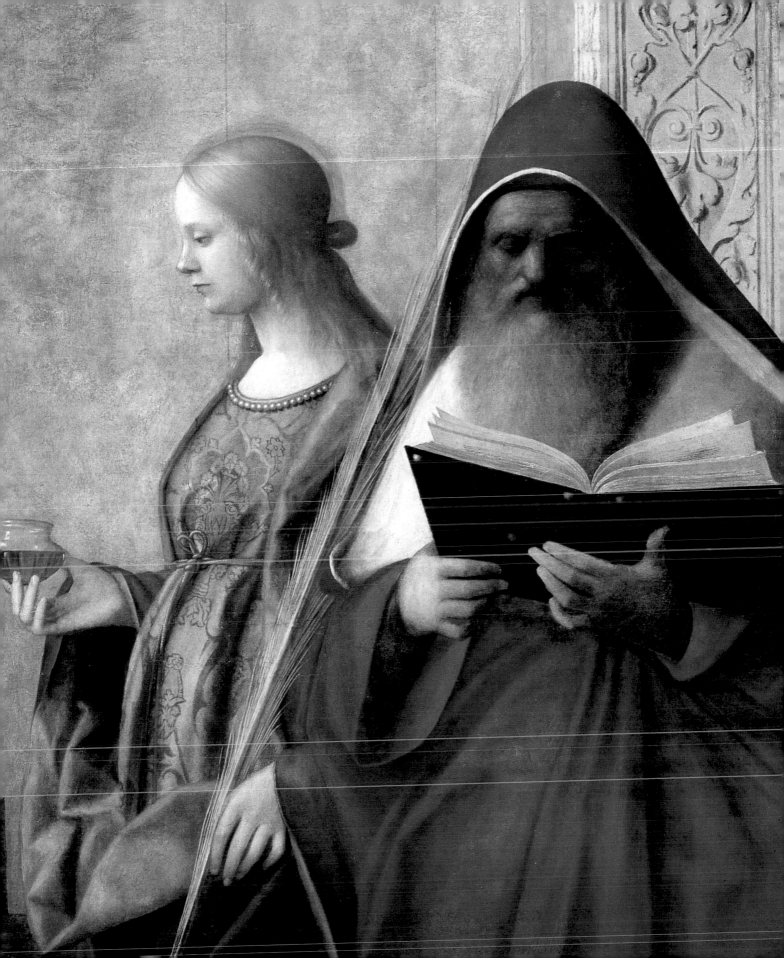

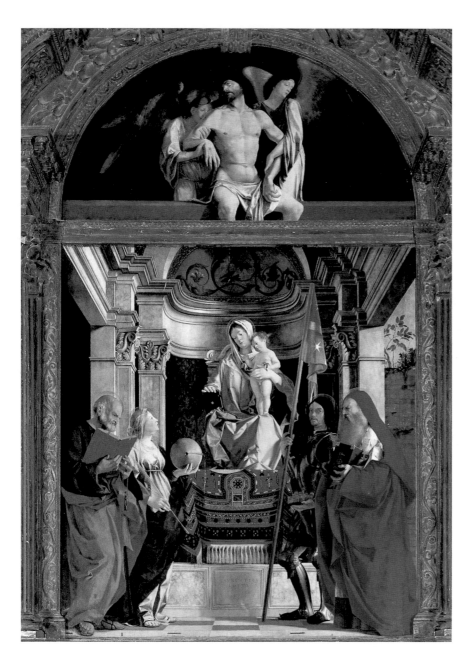

Madonna and Child with Saints, Lorenzo Lotto, painted for the
small church of S. Cristina al Tivarone, near Treviso, 1505–6.
In the upper lunette is a dramatic Pietà.

rooted plant and thus supports whatever it comes
into contact with, just like the cross, which, being
deeply rooted in the truth of the faith, will support all
who put their trust in it. These are the ever-present
references to the role of St. Peter and the role of the
Church, inasmuch as it is teacher and supportive. But
let us not forget the complementary reference to the
Gospel of John, 1 verses 35–51, which tells the story
of the calling of the first Apostles: he who remains
under the fig tree is he who subjects himself to divine
law and understands its wisdom, he who is called by
Christ, the elect.

The Bellini altarpiece confirms Peter's superior role
by the fig tree, symbol of spiritual choice, and by the
ivy, symbol of tenacity and of eternal loyalty to the
mission. The closed book of Peter stands for the codi-
fied and unquestioned wisdom he possesses in virtue of
the very selection that conferred the keys upon him.
Within an altarpiece that excluded over-explicit insis-
tence on the usual Mariological-Christological axis and
on the value of imitation, the patrician monks of S.
Zaccaria wanted from Giovanni Bellini a multiple
eulogy of the Church: a consideration of the good
deeds of St. Jerome, the organized intellectual, and an
unconditional exaltation of the role of St. Peter, the effi-
cient functionary. They also wanted to use the exam-
ples of Sts. Catherine and Lucy, the wise, composed
virgins, for the girls educated in their exclusive establi-
shment. In short, they wanted recognition of the
contemplative tradition and the full affirmation of the
active life—at every level.

According to surviving records, by 1505, or at the
latest by the spring of 1506, Lorenzo Lotto, who at this
time was working in Treviso almost exclusively for
Bishop Bernardo de' Rossi, must have finished the
main section of the altarpiece for the small country
church of S. Cristina, just outside the city, with the
*Madonna and Child Between Sts. Peter, Christine,
Liberale, and Jerome* (see p. 260). A short time after,
the lunette of the *Dead Christ Supported by Two
Angels* was added. The altarpiece as a whole shows a
careful study of the S. Zaccaria altarpiece, corre-
sponding as it does in great detail, almost point by
point, to the statements made in Bellini's masterpiece as
far as its contents and relative functional structures go,
yet with a total inversion of meanings and intentions.

First of all, the symmetry has collapsed. St. Jerome
is bathed in the bright light of the garden, while St.
Peter is enveloped in the darkness beyond the chapel.
St. Christine, in soft, colorful clothes, raises her eyes to
the holy child and holds the palm in one hand and in
the other a smooth stone with a piece of knotted rope,
the instrument of her near-martyrdom. Meanwhile St.
Liberale, wearing shining armor, repeats the gesture in
offering a model of the city of Treviso, but breaks the

symmetry by turning his gaze to the outside and by taking up almost all the space above him with his cumbersome banner. The Madonna and child turn their attention to St. Christine. Every reference to harmony has gone. Not only is the music-making angel missing, but there is no search for a soothing concord: instead it has been lost in a game of highly subtle and acute tensions. It is now St. Jerome who displays the closed book with severe and concentrated determination, while St. Peter scrutinizes the pages of

and almost unmentioned. Christ's Passion, neither a distant memory nor an abstract concept, is the suffering of a martyr, redemption, and a model for imitation. St. Christine, showing the child the symbol of martyrdom and gazing intently on him, reminds him of his analogous, "future" martyrdom. She frightens him: his face shows dismay, his hand makes a gesture of repudiation and defense. Yet everything is preordained, it has all already "come to pass." Christ the child must be aware of this, as he holds the brightly

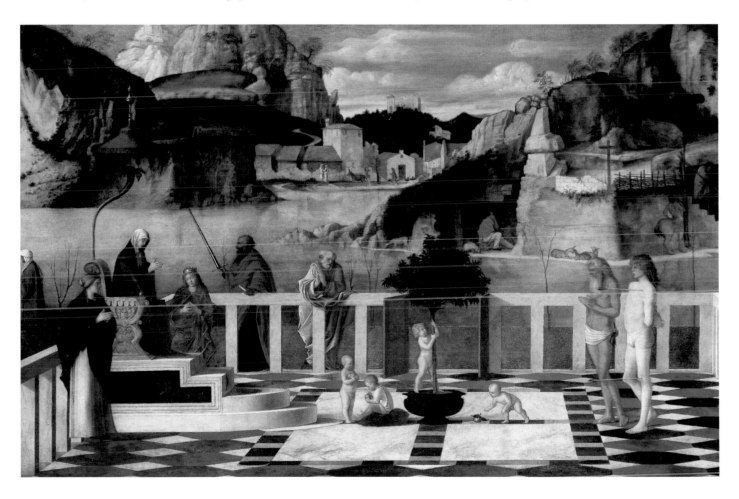

the open book with a worried frown. St. Jerome is the chosen one under the fig tree, bathed in light, while there is pitch darkness behind Peter. So what is the content of St. Jerome's illuminated and illuminating knowledge? The answer is explicit: the large stud in the middle of the binding of the large volume becomes a miniature which houses the figure of Christ of the Passion. But the whole altarpiece insists on this content, which in Bellini is toned down, understated,

colored goldfinch, symbol of martyrdom, tightly in his hand. Mary is certainly aware of it, and she embraces her son in a protective gesture, as if attempting to repel, or at least put off, the terrible event. Meanwhile, however, she can do no more than lower her eyes sadly along a line which, before arriving at St. Christine, passes through another, closed book, another book which no longer holds any mystery. She herself holds the book between her hand and her knees, where a ray

Sacred Allegory, Giovanni Bellini. Florence, Uffizi. A mysterious and compelling work, datable to 1490, the painting is informed by a dreamy spirit of silent contemplation.

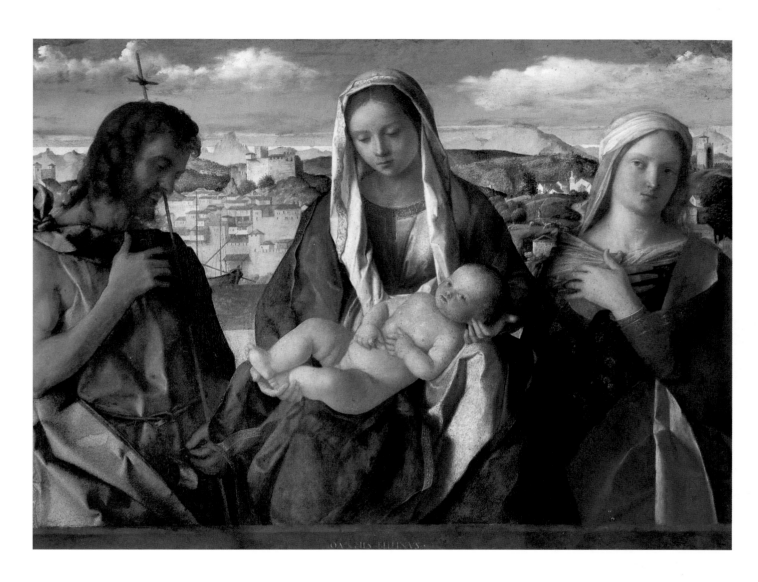

Madonna and Child With St. John the Baptist, and a Female Saint, Giovanni Bellini. Venice, Gallerie dell'Accademia. A painting of the highest quality, this work exemplifies Bellini's spatial experiments realized in the luminous landscape background.

of sunlight has fallen, symbolizing the fire and light of the Word. The lunette with the dead Christ obviously continues the same theme; indeed it is moved illusionistically toward the outside to become the tympanum to the chapel, serving as an introduction to its space and content.

St. Peter, almost an outsider, consumed in a book which he has some difficulty in understanding, but patently still in possession of his keys, is the symbol of a Church imperiled by darkness, a Church which must go back and learn from the difficult pages of a book that has as its contents the unique example of the Passion of Christ. Lotto contrasts the Church of imitation and contemplation with the Church of organization, the active Church exalted by Giovanni Bellini for the noble, Venetians of S. Zaccaria. He

does this for a modest place and an obscure provincial priest who has had himself depicted in the shining armour of the patron, St. Liberale, and who turns his attentions out toward the faithful, to show them devotedly the new model of Christian compassion, and, with a hint of vanity, the tangible result of his teaching and skill.

Three Devotional Madonnas by Giovanni Bellini, 1500–1510

As well as the Madonna and child, half-length figures gradually begin to appear, often Prophets, commentators on the Bible, or imitators of the Passion like St. John the Baptist, St. Jerome, or St.

Francis, but just as often saints of all types, representing individuals, families, patrons of groups, gilds, *scuole*, and cities. The stringent rules that governed public altarpieces became reversed in private devotional pictures, more lax in the myriad of possibilities dictated by individual needs. The *sacra conversazione* (to my mind, an ugly and misleading modern formula—why not replace it once and for all with *Madonna, Child, and Saints . . .* , listing and naming them in such a way as to teach how they can be recognized and explained?) is a simplified allegory for a comprehensive and widespread social function, so much so that it seemed acceptable, indeed sensible, along with the portrait of the client, to insert the principle of reality into it. However, in Giovanni Bellini's devotional paintings, the donor is never there. We are therefore called to imagine the donor before the painting, its first and privileged viewer. The painting becomes a mirror, a visual mechanism in a process of identification which reflects onto the saintly figures the figure, usually unknown, of the client, with their more or less learning, ascetic aspirations, and desire for redemption. Sometimes the client allows themselves to be drawn, metaphorically, into the mirror through simple and lucid semiotic expedients, as in the *Sacred Allegory* (Florence, Uffizi), which opens up the space on the beholder's side, otherwise well cordoned off and officially reserved for the saints. But more often than not the beholder remains apart, reciting a devout spiritual mnemonic, a path of meditation and recognition through places and figures positioned in careful disorder around places and figures that are institutionally central. The landscape that progressively opens up behind and around the characters in the devotional pictures by Bellini and his contemporaries is a vessel for symbols and metaphors, for allusions and references, arranged for and by Christian allegory. The fact that it is a "natural" landscape is certainly not the result of an implausible, anachronistic aesthetic choice, but of a need for ready recognizability and didactic clarity, the result of a concept of religion as daily practice, the subject of objective contemplation. The defining elements of this allegorical landscape are relatively constant and can be reassembled from a thorough examination of sources. First, of course, writing of all kinds, and especially that of a religious nature, with the vast range of patristic interpretations, preaching manuals, new devotional reworkings, and liturgical interventions. Second come the stories of saints in the legendaries, and moral herbaria and bestiaries for the definition of botanical and zoological symbolism. But there was also the popular oral tradition of religion, and

finally, and, above all, the long-established figurative tradition.

In Giovanni Bellini's *Madonna and Child With St. John the Baptist and a Female Saint* (Barbara?) (Venice, Accademia), the sorrowful mother presents to the wise St. John the Baptist, with his usual cross, the holy child, who looks tired, as if he has just woken up, and already has his feet one on top of the other and his hands almost crossed over his stomach. On the other side, the saint, with her beautiful serious face, also has her hands crossed over her breast. The foreshadowing of the Passion is signaled clearly by these gestures, poses, and expressions.

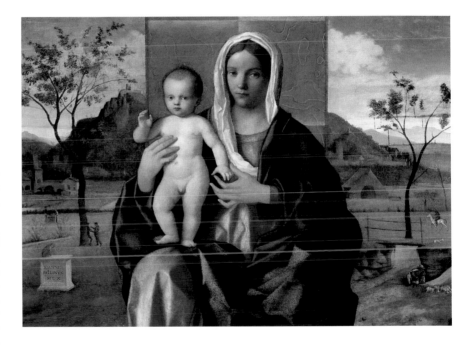

Madonna and Child, Giovanni Bellini, 1510. Milan, Brera. A magnificent example of the artist's mature phase.

Behind the figures, the elements of a charming, "natural" landscape are all lined up. Behind the Baptist is a castle, while between him and Mary a ship is harbored in a calm port. The city is well protected behind its walls, its houses stretching up the hill as far as the impregnable fortress. Between Mary and the female saint are a farmstead, a hardworking shepherd with his flock, and a track which leads up to the town and the church. To the right of the female saint are more houses, trees in bloom, and the large open door of a sturdy bell tower on top of the hill. Above all this, one sees a pale blue mountain range, a golden band of dawning light, and the blue sky with two large white clouds. This apparently "natural" landscape is, in reality, made up wholly of Marian attributes and epithets in a vast (and docu-

mented) repertoire. Mary is symbolized by the solid rock, fortress, tower, and fortified and walled city. She is the sheltered and serene port of sanctuary and salvation, the pleasant and fertile pasture land, the path and door of heaven and the church, the lofty and intact mountain, the resplendent dawn, the bright sky, and the morning cloud. The painting is clearly organized between Christological melancholy in the foreground and Marian consolation in the background. It is the perfect instrument not only for private prayer, but also for devotional mnemonic. It is also an extremely rare example of a single message and of an ordered scheme.

Normally the images are multifaceted, the scheme apparently disordered, and the space in conflict, so much so that in order to clarify the meaning of the elements, one must have a larger comparative analysis of textual sources. This must be carried out, moreover, without ever abandoning the means of organization and arrangement of these elements, singly or wholly, on the printed page since it is this organization, this artful disorder, which determines the course of its reading by tracing the path of devotion.

In the *Madonna of the Meadow* (London, National Gallery), Bellini organized scriptural symbols and structural connections along the lines of contrast, in such a way as to continually oblige the onlooker to exercise a choice. If we place ourselves outside the work, in the place of the client, and let our gaze settle on the work, we encounter first of all the Madonna (large and welcoming) and then the child. Here, there is obviously no conflict—and neither can there be—between them. But we must not underestimate the psychological friction between the "sleep of death" of the child and the behavior of Mary; her gesture is prayerful and protective, her expression melancholic and quietly knowing.

The slightly oblique position of Mary leads us into the subsequent sections of the left-hand side of the picture. Here we may have time to notice that the green meadow has turned into arid land—or perhaps not, because we are also attracted by the unusual scene of the struggle between the positive Christological stork and the negative diabolical serpent. At this point we could shift our gaze along the dry trees up to the eagle, signs of death and resurrection. Or else, saving that climb for later, we could continue deeper into the picture, to encounter cows and a boy lying on the ground with his back against the badly closed picket. His expression is obscured, and he seems to be dressed only in a white shirt. If he really is a shepherd, as one would presume—and as is usually taken to be the case (even if the right clothing and his crook are

missing)—the animals do not seem to be in the best of hands.

The light blue mountains will bring us nearer to the hill in the middle, which rises up behind Mary. Here we find ourselves on the other side, at the sturdily walled and towered city (impregnable Mary, the Church, the City of God: the choice is open). We turn back, finding a more solid and regular fence, more cows, a goat, and a ram (all animals with well-known Christological and Christian meanings). We also come across a strange character, physiognomically neutral, covered from head to toe in white, with a crook or goad in his hand, standing upright and on guard. If he too is a shepherd, as one might assume and as has been taken to be the case, his clothing is again hardly suited to the job and looks more like a friar's habit. If this is the case, then his shepherd duties, which he appears to perform diligently in the painting, will easily find a positive evaluation in Christian allegory. There is still time to make out a well, one of the most common Marian symbols, before going back to the stony ground, distracted in the meantime (if we have not already seen them) by the stork and serpent. Finally, we are back at the sacrificial sleep of the child and the co-redeeming prayer of Mary, after having evaluated the conflicting spiritual and moral alternatives along the way, sharpened our intellect and vision, and matured our choices.

The *Madonna and Child* signed and dated by Giovanni Bellini in 1510 (Milan, Brera) is not so inviting and engaging (see p. 263). Maybe this is because Mary and the child assume, along with the curtain, a certain solemnity and frontality, but, above all, it is because there is no semiotic or iconographic journey to take. The landscape has natural elements like farmsteads and huts even if the usual Marian symbols of walls, towers, and rocks are still in evidence. There is also a well on the left, with figures around it. A little nearer, there are two more small figures, facing the other way and apparently in conversation at the foot of the tree. On the other side is a horseman, devoid of obvious imagery, who is crossing the plain; perhaps he is a hunter. Not only is there no path to follow, but there are no contrasts or choices.

Three symbolic images remain to be examined. Judging by the sadness on the faces of mother and child, however, these images can already be taken to be anything but consolatory.

With no obvious path, we can, for the sake of convenience and clarity, set out from the shepherd and his flock in the lower right-hand section of the picture. Even leaving to one side the two ambivalent characters who play this role in the *Madonna of the*

Meadow, the shepherd is a constant presence, normally attentive and efficient, wearing suitable clothes and carrying a crook. This shepherd, on the other hand, has fallen asleep, and one sheep has already become separated from the flock and is alone and untended on a crag near the bridge. The episode reminds us of various passages from scripture, from the reproaches of Isaiah against bad shepherds to John's parable of the good shepherd, with their vast stock of commentaries and interpretations that confirm the role of spiritual guide allegorically assigned to the humble keeper of the flock, and which emphasize that it is a highly responsible role and can be carried out with either praiseworthy diligence or culpable neglect.

The two other images refer to guile and deceit, to traps as a metaphor for the sacrifice of Christ. On the left is an altar, on which the painter has signaled, with the placing of a name, his own participation in the final meaning of the event and in the mechanism of Passion and redemption. On top of the altar is a small but unmistakable spotted and whiskered leopard (often taken for a monkey). The leopard proverbially carried the "stains" of the sinner who indulges in every type of vice and possesses the guile and ferocity of the infidel and heretic. It is frequently to be found chasing or sinking its teeth into stags or does, gazelles or antelopes, symbols of the vulner-able meekness of Christ and the Christian, as in Carpaccio's *Dead Christ Between Sts. Jerome and Job* (New York, Metropolitan Museum of Art).

More complex, and devoid of precedent or parallels, is the meaning of the final image: the tree on the right, covered with lime, at the top of which is a trapped bird, flapping its wings in an attempt to escape. The scene is an inevitable reminder of Psalms 124, verse 7: "Our soul is escaped as a bird out of the snare of the fowlers; the snare is broken, and we are escaped." It is also a reminder of the substantial exegetic apparatus which explains to us how the trap stands for the ephemeral and illusory sweetness of life, fed with the wiles and perils of the Devil. The bird is the imprudent soul entrapped by worldly pleasures which can never free itself on its own and must therefore hope for the help of someone who will destroy the trap, showing all their liberating power. But in the *Madonna* in the Brera, the bird has not yet found anyone to free it. Indeed, the horseman passing near the tree is possibly the bird-catcher who set the lime in the first place. Liberation is a long way off because redemption is still distant; Christ still has to confront the trap which has been set for him, even if he already knows of, and is expecting, it. He invites

us, with a blessing, to wait with equal faith, offering meanwhile to the devout onlooker a painful meditation on the divine presage and on the diabolical snares of the world.

Giorgione: Myth and Reality

The history of Venetian painting of the first decade of the Cinquecento has been distorted by the belief that Giorgione held sway. According to this version of events, it was Giorgione who introduced all the new developments, he who acted as a mediator for painting from the other side of the Alps as well as from central Italy and who pioneered the "natural" style. As a result, Carpaccio, who was still painting into the 1520s, is relegated to the position of an old-fashioned narrator of fantastic legends, Cima da Conegliano, active up to 1515–16, simply disappears, sharing the same destiny as many other excellent painters in the Bellini mold, while Giovanni Bellini himself, artistically active until 1516, is excepted only because he is said to have adapted his technique to the new, "Giorgionesque" style (an adaptation which all recent restorations have proved to have no basis in reality). Meanwhile, Titian and Sebastiano Luciani (much later called Sebastiano del Piombo) make their appearance only toward the end of the decade and as no less than Giorgione's "creations," his "sons" in art and skill, according to Vasari's description. In this scheme of things, Titian did not exist before 1490, appearing on the scene as an eighteen-year-old boy at the Fondaco dei Tedeschi, and Sebastiano, born in 1485 is regarded as a sort of poor follower, confined to two or three meagre years of Venetian artistic activity before formalizing, with his move to Rome in 1511, his early vocation, and in Venice, in those years, out-of-step with his monumental classicism.

Giorgio da Castelfranco, known as Giorgione, was born in 1477 and died of the plague in October 1510, according to an exchange of letters between Isabella d'Este and one of her servants in Venice. There are very few documents that mention him: payments of 1507–8 for a canvas in the Sala dell'Udienza [audience hall] of the Palazzo Ducale, about which there is no further mention; the dispute at the end of 1508 over the fee for the frescoes of the Fondaco. The Venetian notebook of Marcantonio Michiel is fundamental. Between 1525 and 1543 Michiel mentions the presence of works by Giorgione in the houses of Venetian collectors, thereby assigning a context to his most famous masterpieces: the *Three Philosophers*, *Tempest*, and *Sleeping Venus*.

Madonna and Child with St. Liberale and St. Francis, Giorgione. Castelfranco Veneto, cathedral. On the right: detail of the enthroned Madonna.

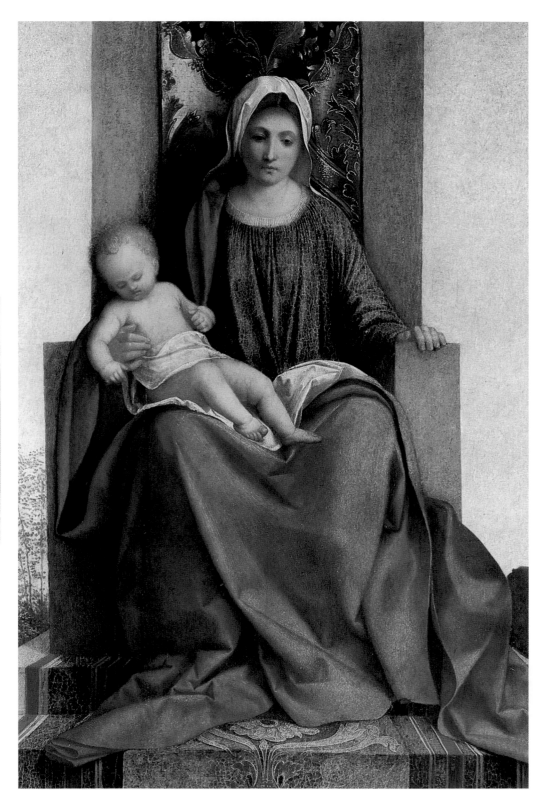

Giorgione probably reached Venice late, around 1503–4. In Castelfranco he left the famous Costanzo altarpiece, too famous a work considering its Umbrian and Emilian influences and the provincial setting which drastically limited its influence, not to mention its obvious old and modern repaintings, always ignored and yet which make the painting almost impossible to judge (see p. 266). He also left a neglected and misunderstood masterpiece, an astrological frieze of a private house, an artistic activity totally consistent with the humanistic culture of Treviso.

In Venice, Giorgione's presence in the studio of Giovanni Bellini, as many claim, following the Vasari line, is implausible. His undoubted Bellini style, greatly reworked and altered, can be better explained in the light of the important inscription behind the so-called *Laura* of Vienna (see p. 267) which describes him, in 1506, as "colleague of Master Vincenzo Catena." The significance of the inscription usually passes under a veil of embarrassed silence, but it is obviously the indication of collaboration, with its ever-present economic laws, within the same workshop. Even in 1506, the role of Giorgione is clearly subordinate to that of Catena, contrary to modern judgment which assigns Master Vincenzo undeserved labels, variously referring to him as "Bellinian," "Giorgionesque," or "Titianesque."

That Giorgione met Leonardo da Vinci in Venice as early as 1500, taking elements of "modernity" from him, is less plausible still. Leonardo stayed in Venice only briefly and had other things to do than contact painters. Above all, Giorgione, until proven otherwise, was not in Venice. The influence of Leonardo on Giorgione is indisputable, but it is partial, late, and second-hand, derived from Giovanni Agostino of Lodi or other Lombard painters known to have been in Venice for some time. Moreover, there is nothing to indicate that Giorgione wanted his own studio, his own school, and his own "creations." Since he was outside the ecclesiastical circuit, the documents from 1507–8 show him more involved in civic commissions, but they come up against the wall of silence in 1509–10, not to mention, it must be said, his early death and that of his works which should have brought him official recognition.

On this occasion I cannot expand on my minority view of Giorgione. Therefore, I will limit myself to reaffirming that, from a comparative analysis of documents and other sources, from research on the secure pieces of the meager oeuvre and on the healthier list of clients, and from the rare iconographical details that can be checked, what emerges is a painter who played a modest and marginal role

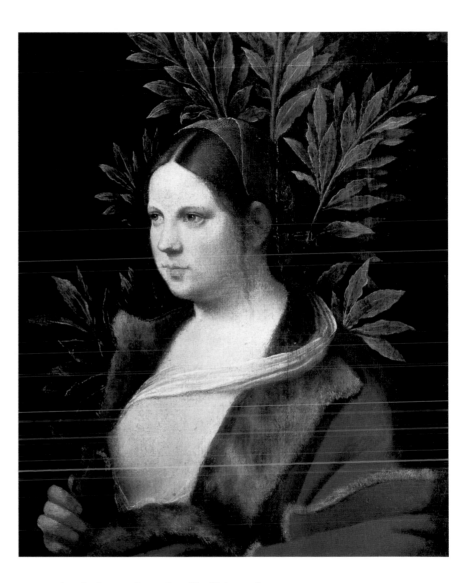

compared to both emerging artists, like Titian and Sebastiano, and established ones, like Bellini, Carpaccio, and Cima. It is a role in total contrast with the forgivable myth-making of the Romantics, the unforgivable overrating by modern scholars, and finally, with the understandable commercial concerns of every age, fed by the lack of sources and sustained by obliging attributions, tendentious restorations, and outrageous fakes.

My view is based on the fact that even taking into account Giorgione's undeniable coloristic quality and atmospheric definition, which make him so popular today, he lacked both continuity and confidence in the construction of figures and therefore the ability to construct narratives, the flexibility to paint *istorie*. He had neither the right political nor cultural

Laura, Giorgione, 1506. Vienna, Kunsthistorisches Museum. Among the most fascinating and mysterious of Renaissance portraits.

Allegory of Venice, Titian (attrib.), Venice, Ca' d'Oro. This is one of the few fragments remaining from the fresco decoration of the Fondaco dei Tedeschi.

connections nor the time to develop them for himself. Faced with the commemorative genres of the historical canvas and the altarpiece, which determined public and private success, in terms of economy of the craft and recognition of the role, Giorgione remained in a private dimension, with his isolated, static figures and his difficult allegories understood only by himself and a few others, characteristics that relegated him to the margins of the mainstream in his own time, and that make him attractive today. Then, as now, however, they only served to add to his incomprehensibility.

The many possible interpretations of his most famous paintings, the *Three Philosophers* and the *Tempest*, which have already been put forward will continue to be debated, and others will undoubtedly be added in the future. The truth behind these paintings will continue to elude us, not because of the complexity of their meaning, but on account of their excessively laconic language and semiotically insuperable reticence. If we are not satisfied with a few miraculous and "modern" atmospheric landscapes, the problem remains how to know whether this reticence is an objective limitation of Giorgione's pictorial abilities, technique, and language, or rather a cultural necessity, prompted perhaps by the caution, or even self-censorship, of his clients concerning the translation into pictures of private, circumscribed, and politically and religiously heterodox themes. This is also the problem of the undeniably Jewish components, which many have recognized in his key works, and which are in any case present—apart from the *Three Philosophers* with its key figure of the wise old Jewish man—in the panels with *Moses* and the *Judgment of Solomon* (both in Florence, Uffizi), in his *Judith* (St. Petersburg, the Hermitage), and in the (possibly) lost *Self-Portrait as David*, an unequivocal declaration of cultural identity.

The obvious success of Giorgione among contemporaries (and near-contemporaries) must have been caused, above all, by his commercially successful production such as his half-length portraits which softened the face in melancholy half-shade or accentuated it with shafts of light, revealing the subjects' character or enriching them with moral body. This is the case with the so-called *Laura* in Vienna, which is certainly not, despite what has previously been believed, Petrarch's Laura. Nor is she a poet or a muse. In fact, it is not even certain she was called Laura at all. The laurel that surrounds her is a well-known sign of chastity and fits well with the wedding veil and her exposed breast, doorway to the heart and soul, a sign of fruitfulness and an offer of love. The breast is not simply naked, but laid bare in that moment by the cautious gesture of pushing to one side the fur-lined robe. The fact that one breast is revealed while the other is covered does not signify an antithesis between sensual pleasure and virtue. It is rather the simultaneous presence of proposed, offered, observed eroticism and moderate, supervised, contained eroticism. Marriage is where these two presences are fused. The young woman is a bride who offers her husband her laurel virginity, fecundity, and modest favors. It would be more instructive to compare this timid young woman, picked out of the dark background by a timid light, with the *Old Woman* (Venice, Accademia), pitilessly placed under a light which shows up her deep wrinkles, missing teeth, frizzy hair, and drained expression. The famous label "COL TEMPO" [with time], which is probably a later addition or simply the result of a didactic afterthought, is totally superfluous. Just this once, Giorgione is neither laconic nor reticent, and he represents, through an image, an awareness of the deterioration of the body and degradation of the mind.

Giorgione and Titian in the Fondaco dei Tedeschi, 1507–1509

The Fondaco dei Tedeschi [German trading house] in Venice was the place where traders from northern Europe could stay and do business. It was owned by the Venetian signoria. After being destroyed by a fire in January 1505, it was rebuilt fairly quickly. The external decoration was completed, as far as Giorgione's involvement went, between 1507 and 1508. In November 1508 Giorgione asked the magistrature for payment of his fee, and the following month a commission called for by Giovanni Bellini and made up of Carpaccio, Lazzaro Bastiani, and Vittore Belliniano estimated the value of the work to be 150 ducats. The *provveditori* decided to reduce this sum to 130, without the consent of Giorgione despite what is claimed. This is all that the documents tell us, and there is no mention of Titian. Dolce talks of Titian at work on the landward facade, as a promising young lad, "while" Giorgione worked on the facade overlooking the Grand Canal. Vasari, however, maintains that Titian worked there as an independent artist "after" Giorgione had completed his job. The frescoes deteriorated fairly rapidly, and the detached parts (to be found today in various Venetian locations, the most important in the Galleria Franchetti of the Ca' d'Oro) are difficult to make out without the aid of Zanetti's eighteenth-century etchings.

Giorgione's decorative program is unfortunately impossible to reconstruct. Vasari could not figure it

out, which only goes to show how little we can rely on him, and on seventeenth- and eighteenth-century descriptions. It was an astrological project (like the frieze of Castelfranco and the *Philosophers*). But it is impossible to say what the subject was on this the canal-side facade that was certainly painted with novel, monumental measure and masterly ornamental efficacy.

Nor is it possible to reconstruct the complete program from the other facade, but the main fresco is indicative of the series. It is attributed to Titian on the evidence of the sources and new research. A sturdy and proud-looking female figure, enthroned on an indistinctly depicted seat, has her foot on a decapitated head and brandishes a sword in her right hand in front of what appears to be, from his military dress, an imperial soldier. By virtue of her crude trophy, the woman is reminiscent of Judith with the head of Holofernes, while her posture and the sword remind us of personifications of Justice and Fortitude. This just and strong woman, chaste and wise like Judith and just as capable of defeating the enemy and free her people, is an allegory of Venice. Venice is the temple of Justice, Prudence, and Fortitude, the inviolable Virgin, ready to raise her sword in defense of the city against a specific and present enemy, a soldier of the Emperor Maximilian, a German like those who live and trade behind the painted wall and who, on their way home, will encounter this image of warning. Between the end of 1508 and the beginning of 1509, the collaboration with Giorgione having ended and the Emperor Maximilian having unambiguously joined the forces united against Venice in the League of Cambrai, the Venetian magistrates of the Fondaco tilted the emphasis of the program toward a clear affirmation of civic virtues supported by divine protection, and assigned it to Titian for its figurative translation.

Altars, Altarpieces, and Contexts Before and After 1510

The *Adoration of the Shepherds with St. Catherine and St. Helena, and Tobias and the Archangel Raphael*, which Cima da Conegliano painted in 1509–10 for the Venetian church of the Carmini under commission from the merchant Giovanni Calvo, is undoubtedly a "modern" painting, certainly not on account of its questionable, and overused, stylistic comparison with Giorgione, but because it displays all the iconographic and semiotic freedom acquired in the first decade of the Cinquecento with the open experiments of the "young" artists and the inexhaustible new additions of the "old" ones (see

pp. 269, 270–271). Cima renounced the popularity of the symbolic domain of the Quattrocento in order to concentrate wholly on allegory. He got rid of the animals (the dog is simply one of Tobias's attributes), gathered the trees together on a spur of rock (a wood of oak trees is, however, full of new shoots), and gives his full attention to the selection of subjects and their relationships.

Giovanni Calvo, while dedicating the altarpiece with St. Catherine to the memory of his wife Caterina, who died in 1508, seems to have been preoccupied, above all, with not following her to the grave (this was the period of the plague), or at least, were the worst to happen, with ensuring his salvation. This is why he managed to include in the picture, otherwise totally incongruously from a narrative point of view and only conceivable in allegorical terms, the figure of Raphael, "medicine of God" and guardian angel. In an extraordinary solution in which Tobias, led by the archangel out of the grotto's semidarkness, is invited by Raphael not to lower his gaze toward the newborn child, but to raise his eyes to the awe-inspiring, spiritual light which that birth has generated. Tobias obediently raises his awestruck eyes and beside the light sees the cross

Adoration of the Shepherds, Cima da Conegliano. Church of the Carmini, Venice. A poetic representation in which the painter evokes his home countryside. On the following pages: detail.

St. John Chrysostom With Sts. John the Evangelist, John the Baptist, Theodore, Catherine, Mary Magdalene, and Lucy, Sebastiano del Piombo, 1510–11. S. Giovanni Crisostomo. A masterpiece from the artist's Venetian period, painted before his departure for Rome.

displayed by St. Helena. This is why Calvo appears in the foreground, humble and contrite, kneeling in front of the holy child and his mother and also in front of Raphael. He is dressed in shepherd's clothes and has his shepherd boy beside him (possibly a moving image of a son he never had or who did not live long). To achieve this, however, he must, apart from tidying himself up and putting on some city shoes, so as not to leave his dignity and identity in doubt, abandon that conceptually and figuratively intermediate dimension between the castle and the city, in which shepherd and shepherd boy normally appear with their dog and flock. One of them, leaning on a tree, plays his pipe, while at his feet the other has dozed off. Both of them have interrupted the tranquillity, awakened and sharpened their attention, and set off on the path that leads to the manger and to the cross.

It was still the "old guard" who dominated the first decade of the Cinquecento, as well as most of the second, trained as they were to unite politics and religion, civic and Christian allegory within the commemorative genre. The first of the "new" artists to emerge was, without doubt, Sebastiano Luciani, who painted with great finesse in the private genres of devotional pictures and portraiture, but also left three exceptionally important examples of public works: first, the large canvas at Kingston Lacy, the *Judgment of Solomon* (1506–7), which celebrated through the classic example of biblical justice the civic virtues of the client, the patrician Andrea Loredan; second, the organ-door paintings with *Sts. Bartholomew, Sebastian, Louis, and Sinibaldo* (1508–9) for the church of S. Bartolomeo at Rialto, the religious seat of the German merchants where Albrecht Dürer had left his *Feast of the Rosary* in 1506; and, finally, the altarpiece of *St. John Chrysostom With Sts. John the Evangelist, John the Baptist, Theodore, Catherine, Mary Magdalene, and Lucy* (1510–11), for the main altar of the church of S. Giovanni Chrysostom (see p. 272). The painter who emerges from these three great works, especially after their recent cleaning, does not match the usual conventional description of one of Giorgione's "creations." Rather, we see a painter of volumes and structures, one who is interested in statues and buildings in terms of antiquarian classicism which, more than other types of painting, could have been infused in him through sculptors and architects working in the "Venetian workshop." This is a painter capable of bringing dignity and humanist decorum to a biblical scene or a grouping of saints. Sebastiano headed for Rome at an early date (1511), anxious about the intense competition in Venice and attracted by the generous purse of the banker Agostino Chigi, but also

St. Mark Enthroned Between Sts. Cosmas and Damian, Roch, and Sebastian, Titian, 1509–10. S. Maria della Salute. A youthful work by Titian, still under the influence of Giorgione.

conscious of his own inclinations and abilities.

The content of the *St. John Chrysostom* altarpiece is both doctrinal and official. The altarpiece, for which a contribution is known to have been made by Caterina Contarini from the London branch of the rich merchant family, her husband Nicolò Morosini, and their son Alvise (all of whom died between 1509 and 1510), was financed with the Contarini and other contributions under the aegis of Ludovico Talenti, the parish priest who was highly involved in the church's reconstruction and decoration. Contrary to popular belief, the unique "sideways" style of the altarpiece is not the result of a mysterious, questionable challenge to the accepted conceits of the time nor is it a flamboyant solution to artificial early Mannerist "difficulty." On the contrary, it is the simplest possible response to a practical problem: how to portray the subject of the altarpiece in the act of writing and make the page of his book visible and legible at the same time. St. John Chrysostom, patriarch of Constantinople in the fourth century, is one of the Fathers of the Greek Church. Inevitably, Sebastiano produced a Westernized image of the scholar at work, wrapped in the vermilion cloak of a doctor of Latin and on the steps of the portico of a Roman basilica. The page of his book is covered with an invented script based loosely on Greek characters, although it also contains real Greek letters picked out in red (the capital T of THEOS, "God," and the word AGION, "of saints or sacred objects", can be distinguished). The patriarch is making notes in a book that has already been written; he is not producing one of his own works but is rather annotating holy scripture. The book symbolizes the divine Word which the holy Fathers pass on through their comment and explanations; it is no coincidence that the main virtue of John Chrysostom (= mouth of gold) was eloquence. The central theme of the altarpiece is the "Word," shown, as required, through "scripture." This interpretation ties in completely with the presence of St. John the Baptist, eloquent prophet and forerunner of the Word. St. John points to the scroll around his cross as he turns his head toward the patriarch's book, thereby emphasizing the holy content the two objects have in common. The presence of St. John ("In the beginning was the Word") enables us to identify the saint behind the book as St. John the Evangelist, despite the fact that he is given no distinguishing characteristics. St. John the Evangelist completes the theme of saints who share the same name and creates a direct link with the book and the Word, primarily as an Evangelist and secondarily as a patron of theologians and writers. St. John Chrysostom's best-known and most important work is a collection of sermons on the Gospel of St. John. John the Evangelist and John the Baptist are linked frequently, not only because they share the same name but also because St. John the Evangelist was a disciple of St. John the Baptist before he became a disciple of Christ. The three St. Johns are accompanied by a harmonious trio of female saints: St. Catherine, St. Mary Magdalene, and St. Lucy—who usually act as an allusion to the three theological virtues, while the warrior saint Theodore, ancient patron of Venice, who significantly reappears in Venetian cults after 1450, is a fitting completion to the revival of the Greco-Byzantine style that Talenti included in all aspects of his reconstruction work in the church.

It was probably Talenti who, becoming involved in an iconographically uncertain commission, dictated the central content of Sebastiano's altarpiece: the progress of the divine Word through the three St. Johns. One might ask if, and to what extent, he might have been able to dictate to Giovanni Bellini, an artist notoriously opposed to accepting orders, some years later. Bellini's altarpiece, *Sts. Jerome, Christopher, and Louis*, signed and dated 1513, was planned to an even lesser extent than that of Sebastiano and was therefore totally open to influence, particularly as the merchant Giorgio Diletti had left a request for the altarpiece in his will twenty years before, and had been dead for ten years. The theological basis to the altarpiece is given (Psalms 13, 2) on the painted inner surface of the frame. Once again a trio of saints standing alone provides the figurative content and, as in Sebastiano's altarpiece, the central figure is also a scholar, St. Jerome. But this is where the cross-references and analogies end: Jerome needed to take the opportunity—the last he would have—to stage a highly topical debate on the classic subject of the clash between the active and the contemplative life.

Bellini portrays the arch of a Byzantine church which opens unexpectedly onto the far-off rock on which St. Jerome is meditating. There is no link between the rock and the narrow space on this side of the balustrade, immediately adjacent to the real space of the church where St. Christopher and St. Louis stand. The saints embody three different models: the humble apostle of the meek (St. Christopher), the institutional involvement of prelate (St. Louis), and the religious contemplation of monk (St. Jerome). St. Christopher and St. Louis, symbols of the active life, are positioned in the real world within the immediate reach of the faithful; St. Jerome, symbol of the contemplative life, is placed in a solitary space outside civic society. The experience of St. Christopher and St. Louis is easy to follow and emulate, but the example of St. Jerome symbolizes

spiritual perfection, reserved for a restricted circle of the elect. The active and contemplative lives both play an essential role in salvation; those whose destiny lies in the active life and the worthy service of their neighbors must be content with their station and not aspire arrogantly to the contemplative life, the privilege of the few. Likewise, those who are destined for the contemplative life and possess the grace of knowledge must not become proud but must place their lives at the service of the Word.

At the time, this issue had become one of topical interest following the astonishing decision of two young patricians, Vincenzo Querini and Tomaso Giustinian, to abandon Venice and its civic life for the community of hermits in Camaldoli. Their correspondence with their Venetian friends, primarily the future cardinal, Gasparo Contarini, is the cultural context in which Bellini's altarpiece must be interpreted. The two deserters defend their choice of the contemplative life and the preeminence of the "spiritual" life, while Gasparo urges them to an active involvement in the world and the preeminence of "society."

One may assume that the merchant Giorgio Diletti intended to identify himself with St. Christopher, the wandering defender of Christianity, and that Ludovico Talenti, the highly committed parish priest of the church, had little difficulty in recognizing himself in the medieval priest who shared his name. Giovanni Bellini, who had often depicted St. Jerome in the isolation of the hermitage and in paintings of private devotion, gives him the exemplary value of the sublime contemplative life which is almost impossible to achieve, an intellectual experience at the edge of human possibility. The old and unsurpassed Bellini brings his long story to a close with this extraordinary painting, both traditional and innovative. The innovations, with the unique devices that mark out the progress of meanings on the revolutionary page, is once more an embellishment of traditionally straightforward discourse, vocabulary, fine iconographical definition, and the highly accurate texture of semiotics which substantiates the programs and illuminates the images.

Titian, like Giorgione, was provincial, if not a "foreigner," and did not take part in the principal religious commissions in Venice in the first years of the century. To see one of Titian's altarpieces one had to venture out in the lagoon to the church on the island of S. Spirito where, between 1509 and 1510, his *St. Mark Enthroned Between Sts. Cosmas and Damian, Roch, and Sebastian* was displayed (see p. 273). (The altarpiece is now on view, somewhat more conveniently, in the church of S. Maria della Salute.)

In terms of the history of painting, this altarpiece is an accurate summary of the tradition of Bellini and also shows a detailed awareness of the new techniques of Sebastiano, evidence that Titian already possessed all the tools he was to need for his rise to fame in the near future. During these years he also demonstrated his skill in the difficult technique of fresco work, from the Fondaco dei Tedeschi to the Padua Scuola of the Santo. Greater emphasis is usually placed, however, on the historical aspect of the altarpiece with its clearly votive purpose of exorcising the plague; the presence of the redeeming saints on the right and the healing saints on the left leave no doubt as to this. In the center, where one would expect to see the Madonna and child, as in many other paintings, sits St. Mark on the highest throne embellished with a cloth of honor, with the traditional book in a particularly prominent position. St. Mark *is* Venice: while retaining the metaphysical protection of St. Roch and St. Sebastian, the altarpiece turns our attention to the real, physical abilities of the rarely depicted Sts. Cosmas and Damian, who are portraits, hinting at the involvement of two specific figures in administering to the afflicted, and with St. Mark in such a prominent position, the care of the afflicted is placed in the hands of Venice the wise, the indisputable task of earthly government, rather than the grace with which the heavenly rulers may intercede. Thus in the altarpiece genre, Titian chooses the short road and direct language of political involvement, while other painters, both old and young, perpetuate the canons of the representative episode and the allegorical convention, of hagiographic celebration and metaphorical reflection.

Carpaccio's Last Works, 1510–1515

Carpaccio, who for some time had been focusing his activities on political involvement, although based, quite naturally, on the models of fifteenth-century allegorical language, did not move from his tried and tested narrative structures and favorite collective commissions. In 1507 he too began work in the Palazzo Ducale. In 1511, his *Consecration of the Deacons* (now in Berlin) opened the cycle of stories of St. Stephen for the *scuola* named after the first martyr. Members of the *scuola* were not wool workers (as is still claimed today) but craftsmen of all types, the outright leaders including the talented Lombard "stonecutters" (members of the *scuola* at this time included Pietro Lombardo, Giovanni Buora, and Manfredo da Bissone). The most important

elements of the cycle, the *Sermon* (Paris, Louvre) and
the *Disputation With the Wise Jews* (Milan, Brera) were
painted in 1514. The cycle was completed several years
later with the large painting of the *Accusation Before
the Sanhedrin* (lost) and the *Stoning of St. Stephen*
(Stuttgart).

In the *Preaching of St. Stephen*, St. Stephen is
portrayed in priestly robes with a rapturous expres-
sion on his face, giving a gesture of faith. He stands
in the place of a missing statue on an intact base
surrounded by fragments of stone. Each member of
his audience is clearly identified by nationality, social
standing, and, in some cases, role and profession, but
most importantly, demonstrates attention and under-
standing, lively interest, and readiness to respond.
This is the figurative equivalent of the *convocatio*,
the spiritual union of Christians from all walks of life
who come together to follow the Word. However, the
woman wrapped in a cloak, who is unable to see or
understand, symbolizes the blindness and ignorance
of the Jewish people, an updated and contextualized
variation on the strong textual and iconographical
tradition of Jerusalem/the Synagogue as a woman—
blind, blindfolded, veiled. In contrast to this aban-
doned Jerusalem, the depletion of the purely physical
congregatio promised by the Synagogue is the
heavenly Jerusalem, the Christian city of the prea-
cher, of the converted, of the pilgrim.

Jerusalem fails to accept the message and inter-

prets it instead as a challenge. The Jewish sages opt
for the *Disputation*. There are not many of them,
barely ten, and their numbers are balanced by the
large group of St. Stephen's followers, the brothers of
the *scuola* who are lined up outside. St. Stephen,
however, does not seem to be in need of support: he is
depicted as an experienced orator, listing his argu-
ments on his fingers and standing above everyone
else, self-confident and so relaxed that he even turns
to attract our attention. The story of St. Stephen has
significant anti-Semitic overtones; while it is natural
that the *scuola* named after St. Stephen should want
to depict the story of its patron, it is also clear that the
polemical, controversial meaning cannot be systemati-
cally removed from the images. But there is also a
significant contextual explanation: years of violent
anti-Semitic propaganda encouraged by the post-
Cambrai crisis, backed up by Franciscan preachers
and Venetian patricians, the start of the process
which led to the creation of the New Ghetto in S.
Gerolamo, decreed by the Senate on 29 March 1516.

The stone is inseparable from St. Stephen; it is a
recurring, unifying symbol of the scriptural written
word and images. Christ is the stone of St. Stephen's
martyrdom, the foundation, structure, and corner-
stone on which the Church was built. St. Stephen
himself is likened to a living, polished, brilliant
stone. At the other extreme of this imagery lie his
persecutors: the Jews are hard, bare sterile stone,
stony and stoners. The stone, constant symbol in the
written story of Stephen, returns in the visual images
certainly not as a coincidence, nor only by mechan-
ical transposition: those commissioning and plan-
ning the images were the stonecutters at the very top
of the *scuola*, for whom stone is an object of work
and of art, a raw material. And, to organize and plan
the story was the painter with the most extensive
and varied knowledge that existed in Venice at that
time. In contrast to the sterile stone of the Jewish
world and the worn-down stone of the pagan world,
here is the solid stone of Christianity which is, of
course, also that of contemporary Venetian architec-
ture: the atrium of the *Consecration* where St. Peter
lays his hands on St. Stephen; the hall of the
Disputation, surrounded by members of the confra-
ternity as St. Stephen smashes the bookish references
of the Jewish sages with the logic of the Word. It is a
"universal history of stone," a reinterpreted story
rather than a rewritten one which freely combines
the Renaissance rock with the Romanesque bell
tower, the triumphal arch with the minaret, without
philology or prototypes (or partial philology and
imaginary prototypes), culminating imaginatively in
the association of the two extraordinary monuments
to the left in the background of the *Disputation*.

Apparition of the Crucifixes of Mount Ararat in the Church of S. Antonio di Castello in Venice, Vittore Carpaccio, detail. Venice, Gallerie dell'Accademia.

This is without doubt the most important commemorative scene for those who commissioned the cycle: the members of the *scuola* are brought together here in the crowd, identified and characterized individually in exceptionally detailed portraits. In this context the two monuments form the chapter on sculpture in our universal history of stone and provide cultural references to the confraternity's overriding concern with a good death and honorable burial, the ideological and material basis of the *scuola*'s statutes. The two monuments in question are funerary: one a pyramid, burial place of the founder, the sovereign, the sage; the other an equestrian monument, burial place of the knight, the condottiere, the hero.

Carpaccio produced a large number of altarpieces at this time, with varying results. The most successful is the *Presentation of Christ at the Temple*, signed and dated 1510, produced for the Sanudo altar in the church of S. Giobbe. Here Carpaccio shows a degree of restraint and produces a solemn, symmetrical scene, suspended and dignified, in which the poses of the music-playing angels are completely detached. The altarpiece is based, inevitably, on Bellini's epic work which dominated the altar opposite, but it is updated accurately to reflect more recently completed monuments.

Carpaccio's most important work in historical and contextual terms is the altarpiece of the *Ten Thousand Martyrs of Mount Ararat*, signed and dated 1515 (Venice, Accademia), which once decorated the altar which Ettore Ottobon, nephew of the prior Francesco, built in memory of the martyrs in the church of S. Antonio di Castello (destroyed under Napoleon). The altarpiece is unique, with a great narrative content based, quite naturally, on history-legend and history-allegory, detailed and complicated, and designed as a vertical painting. Here, the little-known story of the ten thousand Roman soldiers who were converted to Christianity by the intervention of angels and then martyred by their emperor, who had formed an opportune alliance with the pagan kings of the East, commemorates the Turkish wars and the glories of the Ottobon family that commissioned the work. The family is cited in an inscription near the altar: the grandfather of Ettore Ottobon, Antonio, distinguished himself in a courageous raid on the besieged port of Negroponte (1470); his father, Stefano, died in his burning ship in the battle of Zonchio (1499). The altarpiece invests the living hagiography with a series of iconographic and narrative choices, of the whole and in detail, that transpose it through time to contemporary history. Most of the space is given over to mass slaughter in a climate of organized activism, of routine barbarism.

There are thugs dressed mainly in tunics and turbans, interspersed with other knights and turbaned infantrymen who seem to be supervising and monitoring the events; a large band of soldiers is positioned on the right in the background. In contrast to the indefatigable Christian legionnaires is the multicolored open procession of the Roman emperor and his squire, a procession that consists exclusively of kings of the East and their soldiers, the last of whom raises his standard showing a crescent moon, black with menace, war, and mourning.

But the altarpiece is not merely a reminder of the past glories of the Ottobon family. A series of detailed accounts written between 1514 and 1515 (particularly in Sanudo's highly prized *Diari*) refer to the repeated attempts of Emperor Maximilian to secure an agreement with the Ottoman sultan, Selim, in order to attack Venice from both land and sea at once, seize power, and divide up her territories. The altarpiece of the *Ten Thousand Martyrs* was completed during these two years; taking part in the massacre are not only Turkish bandits but also a number of their imperial Roman counterparts; the flag bearing the Roman SPQR flies alongside the standard of the crescent moon. More importantly, the procession of the oriental sultans is opened by the threatening emperor and his squire in German clothes. Carpaccio imagines the Hapsburg Maximilian as the (Roman) emperor and creates the feared Turkish-imperial coalition in his procession. The altarpiece of the *Ten Thousand Martrys*, with its commitment to attention, denunciation, and intervention, seals Vittore Carpaccio's years of craft as an active protagonist inside the history of Venice rather than as a passive witness.

The Year 1516

Giovanni Bellini died in 1516, leaving his last masterpiece, the *Mocking of Noah* (Besancon), to an unknown private collector. Sanudo recognized his mastery, writing that despite his age Bellini *depenzeva per excellentia* [painted superbly]. Cima da Conegliano was to follow shortly after, leaving other altarpieces and polyptychs on the altars of Venice and the provinces and paintings of the Madonna in private homes. For some years after Carpaccio's death, far from Venice, the old allusions remained, as did his son who painted with modest talent. Alvise Vivarini died in 1504 or 1505 before he was able to complete his paintings in the Palazzo Ducale or the altarpiece for the Scuola dei Milanesi at the Frari, the most important of his career. Gentile Bellini followed him in 1507, leaving little hope that his brother

would take up his painting where he had left off. In 1510 Giorgione died before he could keep his (possible) promises.

In 1516 Sebastiano Luciani was in Rome alongside Raphael and Michelangelo. He was to return rarely, and from 1531 to the present day the fastidiously metallic name of Sebastiano del Piombo was to obscure the years and works of "Sebastian Viniziano." Lorenzo Lotto was in Bergamo where he took on the large altarpiece for the church of SS. Stefano e Domenico, now in S. Bartolomeo. Following his extensive experience in Treviso, Lorenzo Lotto worked in the Marches; he was deluded and disappointed by the Roman illusion (1509), returned to the Marches, and settled down in the semi-Venetian, semi-Lombard city for a long period (1513–25) of good fortune, constant work, and masterpieces in many genres. He arrived in Venice full of hope in late 1525 but was soon disappointed and forced to resume his material and cultural wanderings.

So by 1516, Titian was virtually alone or, at least, far from worried by the mediocre craftsmen who had emerged (too late) from the large fifteenth-century workshops. He was already making a name for himself from both works that varied in technique and those with a common political-religious commit-ment, such as the frescoes of the Fondaco dei Tedeschi and those of the Scuola del Santo in Padua, the *Altarpiece of St. Mark*, the large woodcuts of the *Triumph of Christ*, and the *Drowning of Pharaoh in the Red Sea*. He was also attracting attention for portraits with a stunning presence and superb "nonchalance," for "mirrors" of private devotion with a measured emotional content and wide range of landscapes, and for allegories lodged in the humanistic web of literary, philosophical, and musical experiences. It was in 1516 that Titian received the commission for the great altarpiece of the *Assumption*.

Augusto Gentili

Drowning of Pharaoh in the Red Sea, Titian, 1516. Woodcut, Museo Correr.

The Golden Age

Jacopo Sansovino and the Romanization of Venetian Architecture

Introduction

In the Proemio to his *Four Books on Architecture*, with reference to Venice, and to Sansovino's Library in particular, Palladio asserted:

One is beginning to see buildings of merit [in Venice], since Giacomo Sansovino, sculptor and architect of great renown, began for the first time to make known the bella maniera *[beautiful style], as one can see (leaving aside many other fine works of his) in the new building of the Procuratia, which is the richest and most ornate that has probably ever been erected from antiquity to our own day.*

How are we to interpret Palladio's remark? Clearly he wished to present himself as an admirer of the old Florentine *maestro*, who had transformed the appearance of Venice during the last forty years of his life. Sansovino was already eighty-four years old when the *Four Books* were published in 1570, and he died later that same year. Palladio, anticipating the void that would be left after his death, seized this opportunity to present his own professional credentials to the Venetian establishment. But to what extent was his laudatory comment justified? This chapter will attempt to assess the contribution of Jacopo Sansovino to Venetian architecture of the Cinquecento and his role in the propagation of the new Roman image.

Since his first appearance in Venice in flight from the Sack of Rome in 1527, Sansovino had dominated the architectural scene in the city. At the time of his arrival he had little architectural experience. His chief reputation lay in his talent as a sculptor: "He is a great man after Michel Angelo," remarked Lorenzo Lotto in a letter reporting his flight. In Rome he had begun two churches, S. Marcello al Corso and S. Giovanni dei Fiorentini, both of which suffered structural problems and were eventually assigned to his more technically experienced contemporary, Antonio da Sangallo the Younger. His most successful Roman building was the palace for the Florentine banker Giovanni Gaddi, and it was Gaddi who

accompanied him in his flight and initially offered him hospitality in Venice.

Despite his uncertain credentials in technical matters, Sansovino was immediately engaged to restore the domes of S. Marco, which were thought to be on the point of collapse. Vasari records the virtuosity of this restoration in graphic detail: indeed, the records of the Procuratia de Supra confirm that, within two days of Lotto's first report of Sansovino's arrival, the exceptional sum of five hundred ducats was provided for the repair. A year later the procurators were still incurring "maximum expenses." Vasari tells us that Sansovino was recommended for this task by none other than Doge Andrea Gritti himself, "who was a great friend of genius." It is in the context of Gritti's personal agenda for the renewal of Venetian culture that we must examine Sansovino's own architectural contribution.

Andrea Gritti had been elected doge in 1523, the same year as the election of the Medici Pope Clement VII. Although, politically, Gritti's monarchical tendencies were contained by constitutional restrictions on ducal power, he recognized that enlightened patronage of the arts could communicate his personal power and influence both within the city and beyond. The legacy of ancient Rome, both republican and imperial, provided a potent medium for Gritti's *renovatio urbis*. Indeed, he had already begun to foster a conspicuously Roman style in the works he commissioned before Sansovino's arrival. In the years between 1523 and 1527 an unusually close relationship developed, both politically and culturally, between Rome and Venice. It would thus be too simple to suggest that Venice was simply seeking to inherit artistic leadership from Rome in the aftermath of the Sack, although an element of opportunism can surely be detected in the triumphal expression of the Grittian *renovatio* after 1527.

Piazza San Marco as Triumphal Scenery

On the death of Bartolomeo Bon, *proto* to the Procuratia de Supra, it was Gritti who recommended

Andrea Palladio, frontispiece of *Quattro libri dell'architettura [Four books on architecture]*, published in Venice in 1570, the year Palladio was named official architect of Venice. In addition to theoretical ideas, the book contains a treatise on the construction of the city.

Sansovino as his successor. This was the section of the Procuratia de Supra that was responsible for the upkeep of the church of S. Marco as well as most of the other buildings in the Piazza, apart from the Palazzo Ducale. From his Roman years, Jacopo probably already knew two of the Procuratori de Supra, Marcantonio Giustinian and Vettor Grimani, as well as the Venetian cardinal Pietro Bembo. As a former member of the Bramante circle in Rome, where he had studied the antiques of Rome at first hand, the brilliant Florentine sculptor-architect must have seemed the ideal figure to mastermind the *renovatio*. As the designer of a temporary facade for the Florentine Duomo for the visit of Pope Leo X in 1515, he even had direct experience in the creation of triumphal scenery.

On his appointment in 1529, Jacopo was given a house in the newly reconstructed Procuratie Vecchie near the Torre dell'Orologio, overlooking the Piazzetta, with its distant vista of S. Giorgio Maggiore between the two great columns. From his own window he could ponder the potential of this space for articulating the open-air processions which played such a major part in ducal ceremonial. Vasari and Francesco Sansovino tell us that his first action was the removal of the meat and vegetable stalls and latrines from the feet of the giant columns, and the procurators' records confirm this policy. Early views of the Piazzetta, such as those by Jacopo de' Barbari and Lazzaro Bastiani, had implicitly acknowledged the need for removal of the stalls by omitting them altogether. According to Vasari, Sansovino received direct personal encouragement from Doge Gritti, who must have recognized the role of the columns as a symbol of justice, by analogy with the two colossal columns outside the biblical palace of Solomon.

It was, however, the state of the buildings themselves, rather than the cluttered open spaces around them, which most preoccupied the new *proto*, because his job required him to keep these properties in good repair. Opposite the Palazzo Ducale stood a row of five hostelries of ill repute, known as the "Peregrin [Pilgrim]," "Rizza [Flag]," "Caveletto [Pony]," "Luna [Moon]," and "Lion [Lion]," in that order, starting from the Campanile. At the end of the row, facing the Bacino, stood the Beccaria, or meat market. These buildings were Veneto-Byzantine structures dating from the early thirteenth century, with a row of lean-to bakery stalls in front that obscured their ground-floor arcades. They are clearly visible in the view of the Piazzetta attributed to Bastiani, now in the Museo Correr. The south side of the Piazza, where the procurators themselves lived, was of similar age and equally decrepit. The Ospedale Orseolo occupied the east end of this range

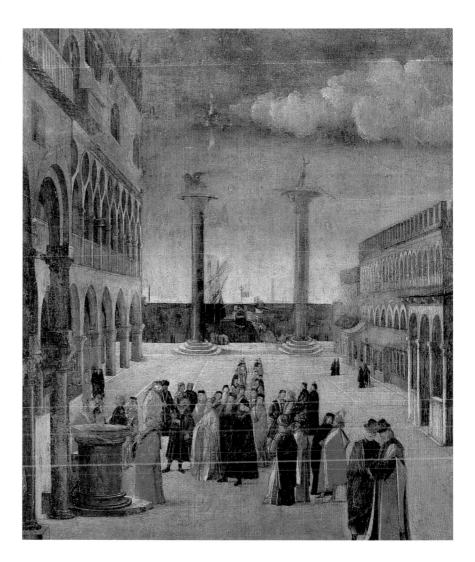

of buildings, which enveloped the Campanile on two sides. The rest of the Campanile was surrounded by money changer's stalls.

The decision to rebuild the north side of Piazza S. Marco after the fire of 1512 had been taken despite the deep crisis induced by the wars of the League of Cambrai. Through this bold resolution, the procurators had already demonstrated their awareness that renewal could be justified as a capital investment because of the reduction in maintenance costs and the increased revenues from the rent of shops and apartments. What was lacking, though, in this new wing, where Sansovino's own house lay, was any statement of *artistic* renewal. The Procuratie Vecchie, erected by Sansovino's predecessor Bartolomeo Bon, and completed by Jacopo himself, closely resembled the facade of the previous Veneto-

View of the Piazzetta, Lazzaro Bastiani. Museo Correr. Interesting for Venetian life and dress in the 15th century; in the background are the two columns with the lion of St. Mark and the statue of St. Theodore, the first patron of the city.

Sebastiano Serlio, drawing showing the facade of a Venetian palazzo that incorporates the Doric and Ionic orders. From *Regole generali di architettura sopra le 5 maniere degli edifici, cioè Thoscano, Dorico, Ionico, Corinthio et Composito, con gli essempi dell'Antiquità, che per la magior parte concordano con la dottrina di Vitruvio [General rules on architecture about the 5 types of buildings, that is: Tuscan, Doric, Ionic, Corinthian, and Composite, with examples from Antiquity, which for the most part correspond to the doctrine of Vitruvius]*, Venice, Francesco Marcolini, 1537.

Byzantine wing, with the addition of an extra storey to augment rental income.

By 1530, however, the Republic had fully recovered, economically and politically, from the traumatic Cambrai wars. Moreover, the cultural context had been transformed by the romanizing policies of the early years of Gritti's dogate. But it was the intellectual revolution made possible by the rise of Venice as a major European center of printing and publishing that most effectively transformed the place of architecture in the culture. In 1511, when building was still severely hampered by the war effort, the illustrated edition of Vitruvius' *Ten Books on Architecture* by the Veronese architect and engineer Fra Giocondo had been published in Venice. This was not only the first Vitruvius edition to be illustrated with woodcut plates, but also the first lucid and accurate transcription of the Latin text with all the Greek words correctly inserted. This book was dedicated to Pope Julius II during a brief period of rapprochement with the papacy during the Cambrai wars.

A casual remark of Alvise Cornaro in his fragmentary treatise on architecture, suggesting that the writings of Alberti and Vitruvius would already be familiar to his readers, underlines the remarkably pervasive interest in architectural theory in the Veneto. Cornaro's favorite architect, Falconetto, had already begun to introduce an *all'antica* style in the Loggia and Odeo Cornaro in Padua. Sebastiano Serlio, who himself, like Sansovino, arrived in Venice in about 1527 from his home town, Bologna, immediately recognized the need for a theoretical base to support the Roman *renovatio*. In 1528 he applied to the Venetian Senate for copyright privileges for a series of engravings of the five orders of architecture. Venice, he remarked, "has a great many rich Temples, as well as public and private buildings, and also mediocre houses." Only nine engravings were published, illustrating the bases, capitals, and friezes of the Doric, Ionic, and Corinthian orders, but the idea began to develop in Serlio's mind. By 1537 he was to have published the first book of his own treatise on architecture, the *Libro quarto* on the orders. The *Libro terzo*, on the antiquities of Rome, followed in 1540, shortly before Serlio left Venice for France.

It would be hard to overestimate the importance of Serlio's treatise for the genesis of the design of Sansovino's buildings in Piazza San Marco. Serlio and Sansovino certainly knew each other well, sharing many friends and acquaintances, such as Aretino, Titian, the publisher Marcolini, and Alvise Cornaro, and both enjoyed the patronage and support of Doge Gritti. Serlio himself built little in Venice: in his 1528 copyright commission he styled himself *professor di Architectura*, an implicit recog-

nition of his role as educator. It was Serlio's visual and theoretical compilation of the five orders that offered to the educated public the key to the understanding of the new Roman style. In his *Libro quarto*, for the first time the five orders were arranged in a hierarchical sequence, as if, Serlio explained, they were the characters in a play. Not only did he anticipate the theatrical role of the new buildings in the Piazza, but he also elucidated the gradations of importance between one building and another.

To walk around the new structures that Sansovino erected in the center of Venice is almost like turning the pages of Serlio's *Libro quarto*. On the west, facing the Bacino, the huge Granai Pubblici [public granaries]—visible in Jacopo de' Barbari's view of 1500 but destroyed in the Napoleonic period—would have marked the point of departure. This structure was lowest in function (warehousing), simplest in materials (brick), and inferior in language (Gothic), and therefore representative of the "mediocrity" that Serlio criticized in his petition of 1528.

After the Bacino frontage and around into the Piazzetta, there followed the Zecca (now the Biblioteca Marciana), begun by Sansovino in 1536 (see pp. 284–285). On the facade, a row of nine shops selling cheese and salami was incorporated into the building, with the silver smelter behind and the gold smelter above. The courtyard at the rear was surrounded by workshops and storerooms. Here the hierarchy begins to unfold. Already the materials are richer (the building is faced in Istrian stone), and the language is *alla romana*, and hence superior to the Gothic, in Serlio's terms. The cheese shops are dignified by the use of simple rustication in the manner of the ancients. The function of the mint itself—merely industrial, yet vital to the economic viability of the State—is enhanced by the choice of a rusticated Doric order which, Serlio explains, is the idiom of the strongest fortress. The finesse of Sansovino's sculptural imagination is evident in the superb quality of the stone carving. Around the shops every alternate stone projects slightly, to give subtle gradations of light and shade. On the *piano nobile*, correct and precisely cut Doric details are juxtaposed with rough-hewn stones as white and shaggy as fleece, and the effect of tension is enhanced by the heavy lintels clutched threateningly over the windows. The third order, in rusticated Ionic, was added in 1538, within Sansovino's lifetime, though probably not to his design, as his employers, the Procuratori de Supra, were engaged in a bitter dispute with the Zecca at this time.

For the site in the Piazzetta that faced the Palazzo Ducale, Sansovino designed a two-storey elevation,

Sebastiano Serlio, drawing of the plan and elevation of a palazzo for a Venetian nobleman. Staatsbibliothek, Munich.

ON THE FOLLOWING PAGES:
Facade of La Zecca on the Bacino di S. Marco. The building, planned by Sansovino to be only two storeys high, was completed with a third level. Today it is the seat of the Biblioteca Marciana, which also occupies the adjacent Libreria Sansoviniana [the so-called Library], built after 1537 and completed by Vincenzo Scamozzi.

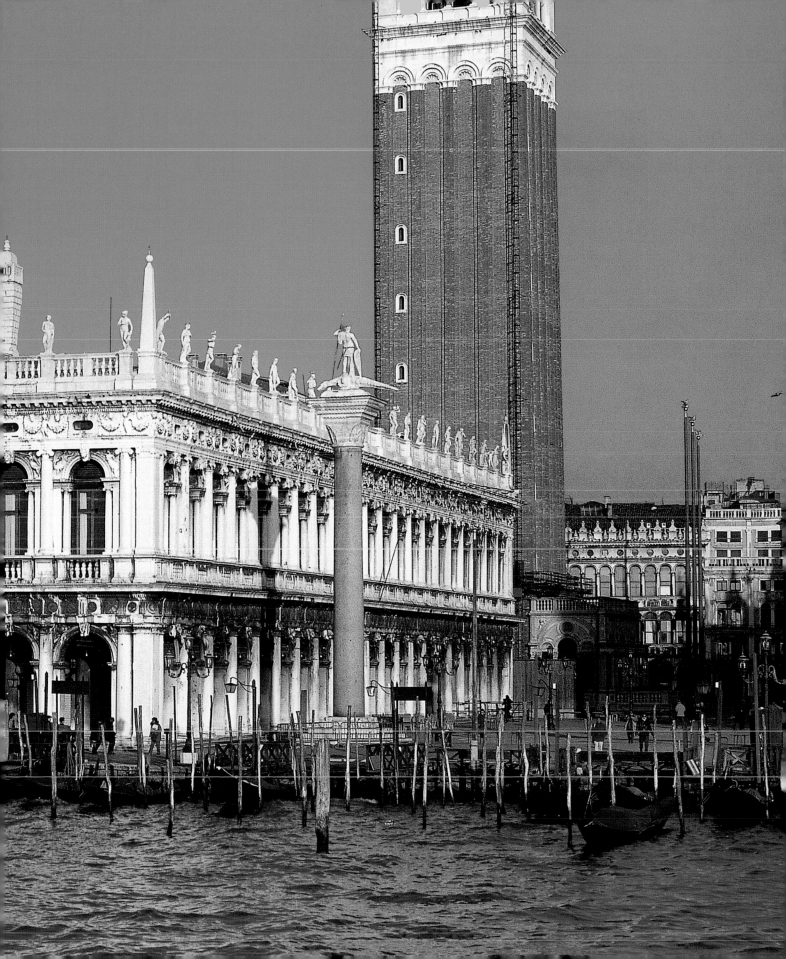

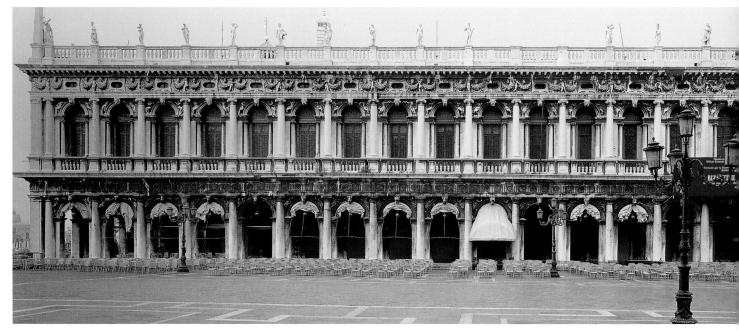

Facade of the Libreria Sansoviniana [the Library], now the Biblioteca Marciana, begun 1537, with its two orders according to the classical canon: a Doric portico and Ionic upper level open almost like a loggia. The sculptural decoration was by Danese Cattaneo, Pietro da Salò, and Tommaso and Girolamo Lombardo. The whole is crowned by a balustraded terrace and statues, some of which are the works of Bartolomeo Ammannati and Alessandro del Vittoria.

intended to extend all around the main Piazza as far as the church of S. Geminiano at the west end. This was the building now known as the Library which was praised so fervently by Palladio in the extract quoted at the beginning of this chapter. Construction was begun at the end nearest the Campanile in 1537, the year after the start of work on the Zecca. The hostelries were demolished and relocated one by one over the next twenty years, although Sansovino—despite enormous efforts in the last decade of his life—never managed to find an alternative site for the Beccaria. The range was finally completed after his death by Scamozzi in 1588–91.

It was only after the start of work on this Piazzetta wing that it was decided to house the Biblioteca

Detail of the facade of the Libreria Sansoviniana, with Doric orders on the ground level.

Marciana, a celebrated collection of Greek and Latin texts, in the part of the building nearest the Campanile. This fact is important because it underlines the role of the new buildings as scenery for the open space outside, rather than simply as a design appropriate to the use of the interior. Certainly, the scholarly function is implicit in the refinement of the orders chosen—a rich Doric order (*dorico delicato*, in Serlio's term) below, surmounted by an even more ornate Ionic storey above—as well as the iconographical erudition of the sculptural ornament. Nevertheless, it is essential to consider the choice of these orders as part of the great crescendo from the Bacino to the entrance of the Palazzo Ducale: the Library is superior to the Zecca in architectural order and cost, as well as function. Serlio illustrates a two-storey Doric-Ionic elevation in his *Libro quarto* which reveals the same basic elements, though without the flickering chiaroscuro of the animated sculptural decoration. Thus the text provides the theme, which Sansovino develops as if providing ornamentation to a musical score.

The design of the Library must have impressed the architecturally informed audience by its abundant references to the buildings of Rome, both ancient and modern. The rich Doric order, for example, is based on that of the Basilica Aemilia, illustrated by Giuliano da Sangallo in his Vatican sketchbook. This ruin also inspired the ingenious corner solution, by which Sansovino succeeded in placing an exact half metope at the end of the Doric frieze, as prescribed

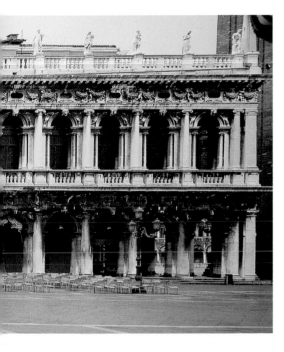

by Vitruvius. Sansovino also followed the Vitruvian recommendation that libraries, like bedrooms, should face the east, to receive good morning light. The reading room falls in the seven bays of the *piano nobile* nearest the Campanile, its rich coffered ceiling embellished with tondi painted by the best Venetian painters of the day (see pp. 288, 289). The significance of the Library entrance in the very center of the 21-bay wing is enhanced by the fact that it lies exactly opposite the medallion of Justice on the Palazzo Ducale. (Tafuri's suggestion that the Library was intended to be only seventeen bays long is proved impossible by the documentation regarding the removal of the Beccaria.)

Finally one reaches the Loggetta, begun by Sansovino at the foot of the Campanile in 1538 as a meeting place for the procurators, to replace the old loggia that had suffered damage by lightning over the centuries. Here the Composite order, the richest of all, represents the climax of the Serlian sequence. Just as the Zecca had combined Rustic and Doric, and the Library Doric and Ionic, so here the Ionic and Corinthian orders are blended into one single order, as the endpoint in this overlapping series. As Serlio explains, the Composite was an order especially suitable for the expression of triumph, and this meaning is explicit, too, in the Loggetta's design, based on three overlapping triumphal arches. The richness of the materials underlines the role of this building as the summit of the hierarchy. Not only were the procurators themselves framed by triumphal arches as

they sat in discussion inside (as Giacomo Franco's engraving illustrates), but the Loggetta also served as the ceremonial backdrop for ducal processions emerging from the Porta della Carta. The diminutive scale of the elements results from a change in plan when the procurators acquired a set of rare oriental marble columns, which were considerably smaller than those originally planned by Sansovino. However, he responded brilliantly to the challenge, adding an attic tier to achieve the necessary height, thereby contriving that from each landing of the Scala dei Giganti in the Palazzo Ducale (the staircase leading to the Porta della Carta) the view of the Loggetta is framed exactly at cornice level.

As Wolfgang Lotz showed, it was Sansovino who determined the freestanding isolation of the Campanile, hitherto hemmed in by buildings on two sides. The earlier configuration is apparent in Gentile Bellini's *Procession in Piazza San Marco*, dated 1496, and confirmed by excavations in the Piazza in 1888–89. In his painting, however, Bellini manipulated the true arrangement of the buildings by moving the whole south side of the Piazza sideways, to reveal the Palazzo Ducale which would otherwise have been hidden behind the Campanile. By separating the Library and the Campanile, Sansovino ensured that the Palazzo Ducale would be visible from any point in the Piazza. This decision not only

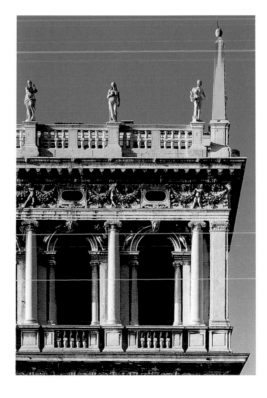

Detail of the facade of the Libreria Sansoviniana, with the Ionic order on the upper level.

Wisdom, Titian, fresco painted c. 1564 for the vestibule ceiling of the Biblioteca Marciana.

Philosopher, Jacopo Tintoretto, detail. This figure forms part of the wall decoration of the *salone* in the Biblioteca Marciana, but was originally located along with all the other wall paintings in the Room of the Philosophers in the Palazzo Ducale.

OPPOSITE:
Biblioteca Marciana, the sumptuous *salone*, designed by Sansovino. On the walls is the series of *Philosophers* by Titian, Veronese, and Andrea Schiavone. The rich ceiling with allegorical scenes is by seven painters chosen by Titian and Sansovino. The tondi with personifications of music and honor are by Paolo Veronese who with these paintings won the golden chain given as a competition prize by the two artists.

allowed a more intimate relationship between the two spaces, but it also enhanced the perspectival subtlety of the layout. It was Codussi in 1486–89 who first exploited the natural irregularity of the two diverging sides of the Piazzetta (seen from the columns) by placing three flagpole bases in front of S. Marco in a similarly diverging pattern. Just as a converging perspective can make a space seem deeper than in reality, so too, if the sides of an apparently regular area diverge, the effect foreshortens the perspective and brings the focal point closer to the viewer. Through his realignment of the buildings, Sansovino repeated this contrivance of diverging sides in the main Piazza, thereby bringing S. Marco closer to the viewer looking from the opposite end of the Piazza, and conversely, enlarging the space when seen from the basilica. Given the ingenuity of this enhancement of the theatrical possibilities of the Piazza, it comes as no surprise that Daniele Barbaro, in the commentary to his Vitruvius edition, referred to Sansovino as *sotilissimo prospettivo* [the most subtle master of perspective].

After he left Venice for France, Serlio published two architectural stage designs in his *Libro secondo*, issued in Paris in 1545, which vividly expound the principles of this remodeling of the center of Venice. The *Scena comica* [comic stage set] was appropriate to "citizens, lawyers, merchants, parasites, and other similar persons;" it was a disorderly mixture of classical and Gothic elements, complete with food shops, a hostelry, a temple, and even a brothel carefully labeled on the plate in the very position of those in the Piazzetta, which must have vividly recalled the chaos of the scene that Gritti and Sansovino had begun to transform. Even the viewpoint, as if seen from a boat approaching the *riva*, encouraged this mental connection. By contrast, the *Scena tragica* [tragic state set] was for the "houses of the nobility, the dukes or great princes, and of the king." This was a decorous, orderly scene, not without variety, but entirely occupied by classical buildings: in this ambience, asserted Serlio, "one may not construct a building lacking in nobility." This equation of nobility with classicism expressed the essence of the Grittian *renovatio*: the center of Venice was the seat of power of the nobility who constituted the ruling oligarchy, and the scenery for public ceremony had to reflect and explain the status and authority of the patriciate. This was the visual embodiment of the ideology of the "myth of Venice."

Even when, much later, in 1557, Sansovino came to design for the Piazza a facade for the little parish church of S. Geminiano, he turned once more to Serlio's *Libro quarto*, published twenty years before, for inspiration, as if to reinforce the connection

between this pioneering printed source and his own designs. S. Geminiano had been rebuilt from 1505 onward on a Byzantine-style Greek-cross plan. Sansovino had to adapt Serlio's model, designed to fit an aisled nave plan, to a squarer format; but the link is still recognizable. He even followed Serlio's advice that the profile of the pediment should follow the line of a circle projected from the diameter of the first cornice. The Corinthian order was the one missing from his earlier sequence in the Piazzetta; it also echoed the capitals of S. Marco at the opposite end of the Piazza, reflecting the common religious function.

It is futile to try to define the direction of influence between Serlio and Sansovino: both architects came from similar artistic backgrounds and shared a similar conceptual framework. Both had spent their formative years in the Bramante circle in Rome where they had studied the ruins of antiquity. Both must have known not only Bramante but also Raphael and Giulio Romano, as well as Serlio's mentor Peruzzi. Each surely recognized the special gifts of the other: Sansovino, the gifted sculptor-architect, and Serlio, the brilliant communicator of the new theory through his innovative combination of text and woodcut. Each must have recognized how the success of his own personal venture not only reinforced, but also depended on, the creativity of the other. Under Gritti's auspices, they must have exchanged ideas freely and openly.

If Serlio's treatise provided the key to the understanding of the modes of architectural representation, so too printed texts were to play a vital role in the dissemination of the scheme to an international audience. Effective written support for Gritti's *renovatio* was provided by the copious letters of Aretino, written expressly for publication, though disguised as spontaneous, intimate communications by the inclusion of references to everyday subjects such as food and women. In 1537, the year of the start of the Library, Aretino wrote a panegyric letter to Sansovino, listing his Venetian works with precise details of the orders of each building. Only the Loggetta, not yet begun, was described without specifying the order (and as having *gran colonne*, for this was before the smaller precious marble columns were supplied). Thus the European public learned the primacy of the orders in the design and meaning of the new Roman style of Gritti's Venice.

When Aretino died in 1556, Francesco Sansovino, the architect's son, and lawyer and polymath, inherited the role of propagandist for the new urban face of Venice. In that year he published a dialogue, under the pseudonym of Guisconi, in which a Venetian explains to a foreigner the architecture and its iconography. This was followed by an edition of the

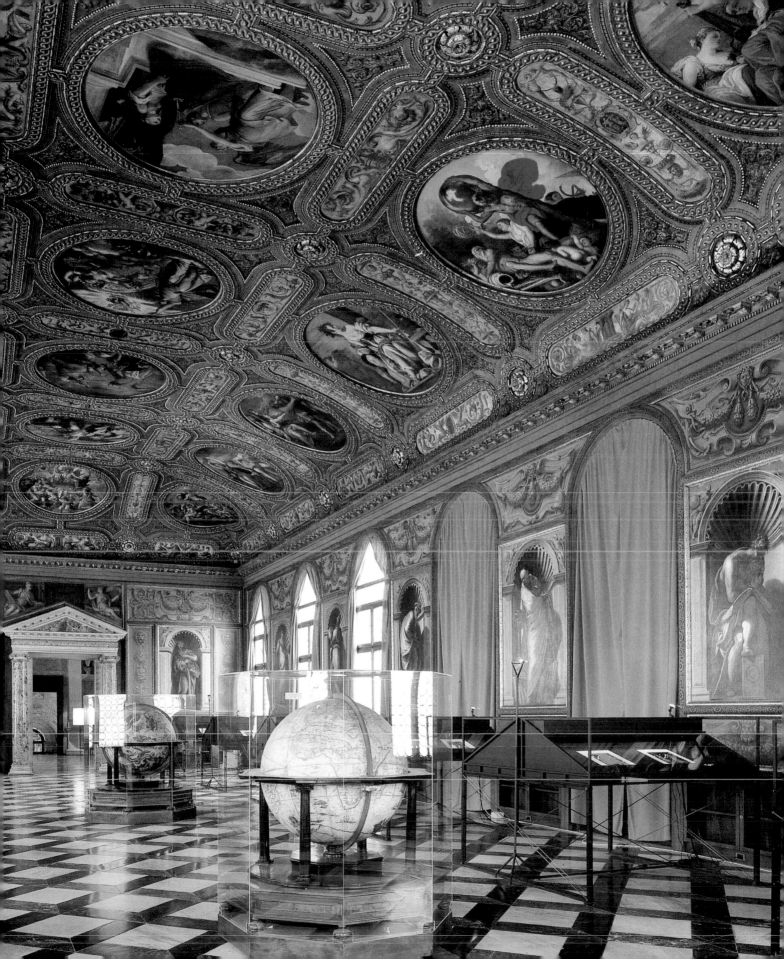

Two miniatures by Jan Grevembroch, representing a merchant and a tobacco seller. Venice, Museo Correr.

Rialto Bridge, seen from the north. Originally built of wood, it was rebuilt in stone between 1588 and 1591 by Antonio da Ponte.

dialogue under his own name in 1560, and most importantly, in 1581, his pioneering guidebook to Venice, *Venetia citta nobilissima et singolare* [Venice, a most noble and unusual city]. These writings precisely explained the iconographic program of the Loggetta, glorifying Venetian power on land and sea and extolling the virtues of the Republic. Any viewer, whether Venetian or visitor, could have admired the richness of the polychrome marble, the grace of the four bronze statues, and the fine quality of the relief carving; but it needed a literate viewer to understand the full significance of the patriotic iconography.

At the start of this chapter we remarked on Palladio's words of admiration for Sansovino's Library, and it is in his own facade design for S. Giorgio Maggiore that we find implicit acknowledgment of Sansovino's triumphal design in the Piazza. Just as the Torre dell'Orologio forms the focal point for the entry into the Piazzetta, so too, S. Giorgio forms the backdrop to the act of departure. Palladio adopted the Loggetta's triumphal motif of the Composite order with swags festooned between the capitals, but here the essence of the language of triumph is distilled into a purified whiteness, eliminating color and restoring the integrity of the wall plane which had been negated by Sansovino's exuberant chiaroscuro. As the destination of an annual ducal *andata*, S. Giorgio played its part in the triumphal ducal scenery, but as a Benedictine monastery it was also an abstraction, the destiny of a sacred pilgrimage, remote from the rich intricacies of life in the Piazza.

Rialto: the Architecture of Commerce

In their daily life the Venetian nobility passed to and fro between Piazza S. Marco and the Rialto, furthering their dual political and commercial interests in a finely tuned equilibrium. Whereas S. Marco was the setting for displays of triumph and magnificence, the Rialto was a place of the utmost seriousness. The Venetian historian Sabellico records that trading negotiations were carried out in hushed voices, as if in recognition of the scale of the risks involved and of the primary role of trade in the Republic's viability. The sobriety of the market was reinforced by the fact that the two churches of the Rialto—S. Giacomo, reputedly the oldest church in the city, and S. Giovanni Elemosinario—were visited annually by the doge on the two most solemn feasts in the ecclesiastical calendar, Good Friday and Ash Wednesday.

The element of risk was dramatically highlighted in Venetian consciousness by two great fires in the opening years of the Cinquecento: the blaze that

destroyed the Fondaco dei Tedeschi in 1505 and the great conflagration that devoured most of the market area in 1514 (poignantly, this was in the midst of the Cambrai wars). Already in the rebuilding of the market in 1514, the dialogue between ideal and reality, the theme that was to characterize the development of the area throughout the century, is evident. Fra Giocondo's utopian scheme for a new market based on the square plan of the "Greek forum" was a costly dream that could never be realized, though it was reverently described by Vasari. Yet this design focused the imagination on the role of the market as a meeting place between East and West, and underlined the potential of classical authority to give dignity to the essence of the place. The task of rebuilding the market was assigned, instead, to the local *proto* Antonio Abbondi, known as Lo Scarpagnino, whose restrained, functional design closely echoed the previous layout.

In 1525, two years before Sansovino's arrival in Venice, the spirit of *renovatio* induced by Gritti's dogate focused attention on the dilapidated state of the Rialto bridge, a rickety wooden drawbridge lined with shops, and led to the foundation of a magistracy to investigate its rebuilding. The Provveditori sopra la Fabbrica del Ponte were not finally elected until 1551, but significantly they included two of the Procuratori de Supra singled out by Vasari as Sansovino's most fervent supporters: Vettor Grimani and Antonio Capello. In 1546 Sansovino, together with his Veronese colleague Micheli Sanmicheli, had been asked to give his opinion on an innovative design for a trussed wooden bridge by the local *proto* Pietro dei Guberni. His equivocal reply veiled his limited understanding of the technology involved in

spanning the full width of the Grand Canal, and it may not be fanciful to suggest that his two promoters in the new magistracy helped to divert attention from the bridge itself to the scruffy state of the canal bank nearby. Instead of erecting a bridge, Sansovino designed and built a row of shops and warehouses along the shore of the Grand Canal, begun in 1554 and known as the Fabbriche Nuove di Rialto. This building provided a dignified facade to the processional route along the Grand Canal, encouraged by the fact that important visitors at this period were often housed further upstream, in the palace now known as the Fondaco dei Turchi. The simple three-storey facade of the Fabbriche Nuove—rustic, Doric, and Ionic—is enlivened by an oblique angle along its repetitive frontage. At the rear, the simplified brick elevation harmonizes with Scarpagnino's earlier structure, while the central aperture perfectly frames the facade of the venerable Veneto-Byzantine Ca' da Mosto on the opposite bank of the Grand Canal. All Sansovino's sensitivity to the nuances of urban context are revealed here. Yet, even when safely building on the canal bank rather than spanning the waterway, Sansovino's technical uncertainty is betrayed in the structure of the building, whose heavy internal partition walls on the upper storeys do not lie over those of the ground floor. Although Francesco Sansovino loyally asserted in his guidebook of 1581 that his father's design for the bridge

was the one preferred, it is doubtful that Sansovino possessed the structural expertise to confront the technological challenge, so brilliantly solved by Antonio da Ponte with the design eventually implemented in 1588–90.

Sansovino as a Domestic Architect

As we have seen in the chapter on the city's Gothic architecture, the Venetian nobility, as the ruling oligarchy of the city, viewed their own palaces as extensions of the imagery of the buildings in the Piazza—as the visual manifestation of their corporate identity and power. The transference of Gothic elements from the Palazzo Ducale to patrician palaces of the late Trecento and the Quattrocento finds its parallel in the diffusion of the new Roman style from the city center to the homes of wealthy nobles in the middle decades of the Cinquecento. Nonetheless, as we shall see, the nobility was far from homogeneous in cultural, political, and religious orientation; and fine gradations of family or personal affiliation could be reflected in palace design. Furthermore, a sensitivity to site and context also fostered subtle distinctions of architectural imagery.

Soon after his arrival in Venice, in about 1527–28, Sansovino seems to have planned a huge palace at S.

Fabbriche Nuove, long facade. Built by Sansovino from 1554, the building housed the magistracy that regulated trade. The facade and portico are slightly curved, following the line of the Grand Canal.

Portrait of Jacopo Sansovino, engraving.

Jacopo Sansovino

Born and educated in Tuscany,
Sansovino, both an architect and a
sculptor, succeeded in competing
with the great Michelangelo. He
won important commissions in
Florence and Rome where, in the
church of S. Marcello, he carved the
tomb of Cardinal Sant'Angelo, one
of his masterpieces. After working in
Rome, mainly as an architect, he left
the city in 1527 after the Sack and
took refuge in Venice, where his
talents were soon appreciated. He
rapidly received many important
civic and ecclesiastical commissions:
the facade of S. Francesco della
Vigna, the Scuola della Misericordia
and Palazzo Corner at S. Maurizio
are all from this period. When the
new plans for the area surrounding
Piazza S. Marco were proposed,
Sansovino was commissioned to
design the complex of buildings that
were to enclose the great area. Here
his genius is truly revealed. The
complex, inspired by the classical
world of ancient Rome, provided
impetus for other architects,
especially Palladio, who admired
Sansovino's Library and
acknowledged it in his own facade
design for S. Giorgio Maggiore.

Samuele for the procurator Vettor Grimani, for
which a large drawing of the ground plan survives in
the Museo Correr. Vettor Grimani was the nephew of
Cardinal Domenico Grimani, the great collector of
antiquities who, according to Vasari, had recom-
mended Sansovino to Doge Gritti. Vettor himself
was to become Sansovino's most consistently loyal
supporter in the Procuratia de Supra. The Correr
drawing has been variously attributed to Serlio and
Sanmicheli, but Tafuri's attribution to Sansovino is
the most convincing. Vettor Grimani acquired the
site in March 1528, a site sanctioned for classical
experiment by the existence there of fragments of the
famous mid-Quattrocento Ca' del Duca, begun by
the Corner family but left incomplete when it was
sold to the duke of Milan. Sansovino's plan suggests
a simple exterior, but he may perhaps have consid-
ered incorporating the Ca' del Duca's Istrian stone
diamond rustication and hefty columns into the
water storey of his design. Adopting the scheme of
two courtyards connected by an open loggia from his
own Palazzo Gaddi in Rome, Sansovino cleverly
exploited the change of axis necessitated by the irreg-
ular site, inspired, as Tafuri has shown, by Roman
precedents, both ancient and modern. Although he
probably intended to reuse the foundations of the
existing spine walls already on the site, he replaced
the central circulation space, the great *portego* or
salone, by an open courtyard. This radical transfor-
mation of local tradition would have required a
considerable change in lifestyle and may be one
reason why Vettor Grimani's palace at S. Samuele
was never executed.

Sansovino's second major project for a Venetian
patrician family, to rebuild the great palace of the
Corner family at S. Maurizio, destroyed by fire in
1532, was delayed by legal difficulties until the mid-
1540s, and the design was surely revised at that time.
We must therefore pass first of all to the palace of
Giovanni Dolfin, the Venetian merchant and ship-
owner; begun in 1538, it was the first of Sansovino's
Venetian palaces to be executed (see p. 293). Dolfin
had already manifested his personal interest in archi-
tecture when, as the Podestà [chief magistrate] in
Verona, he commissioned a new entrance to the
Palazzo del Podestà from Michele Sanmicheli. Dolfin
was a reluctant diplomat, who was eventually
allowed to return to his native city and his mercantile
career in 1533, the date on the frieze of the Verona
portal. Vasari's comment that Giovanni had insisted
on modifying Sanmicheli's design suggests that he
was not a passive patron. He had already decided to
rebuild the family palace at S. Salvador in 1536, but
it was not until 1538 that planning consent was
finally given, allowing him to build a waterfront

arcade which passed in front of the site. These events
confirm that the preparation of the design fell in the
very same years as the start of Sansovino's three new
buildings in the Piazzetta: the Zecca, the Library, and
the Loggetta.

In the first book of his *Quattro Libri*, speaking of
ornament, Palladio commented that "nothing
enhances the building more than columns, provided
that they are conveniently placed and well propor-
tioned in relation to the whole." This was the chal-
lenge which Sansovino was to solve triumphantly in
Venice: how to apply the classical orders to a palace
facade in a way that reconciled the dictates of
convenience and proportion. The traditional Venetian
palace facade, with its fenestration concentrated in
the center, is not easily adapted to the rigors of the
classical system, which requires bays of equal
width. In the Palazzo Dolfin, Sansovino provided the
clearest possible exposition of the correct superimpo-
sition of the Doric, Ionic, and Corinthian orders, to
impress an audience that would be already familiar
with the rudiments of classicism from Serlio's newly
published *Libro quarto*. The sculptural richness of
the buildings newly begun in the Piazzetta would not
have been appropriate for a *casa fondaco* which
served not only as a residence but also as the head-
quarters of Dolfin's trading activities. Instead we see
a purification of the forms, presenting the theoretical
principles with the clarity of a woodcut illustration in
a treatise. Sansovino resolved the need for uneven
illumination by placing two arched windows in each
bay of the central portion of the upper storeys, over a
single arch in the arcade below, a solution already
found in the Palazzo Ducale and the Procuratie
Vecchie. This apparent breach of classical rule could
be justified, as Serlio pointed out in his *Libro quarto*,
by its appearance in a celebrated Roman ruin known
as the Crypta Balbi, or the Portico of Pompey.

Unfortunately the interior of the Palazzo Dolfin
was completely rebuilt by Selva at the end of the
eighteenth century, preserving only the facade, but
surviving drawings and descriptions allow us to
consider the whole scheme. Because of the public
street in front, the main water entrance was placed on
the *rio* at the side of the palace, while the landward
access was from the *campo*. Both entrances led into a
"courtyard in the middle surrounded by loggias *alla
romana*," as Francesco Sansovino described it. Unlike
the scheme for Vettor Grimani, however, the *salone*
on the *piano nobile* was retained, allowing a more
conventional room distribution. Lacking a central
entrance on the Grand Canal, the facade is unusual in
having an even number of bays, with a solid rather
than a void at the center, as in the adjacent Palazzo
Bembo. The ground-floor *sottoportego* [waterfront

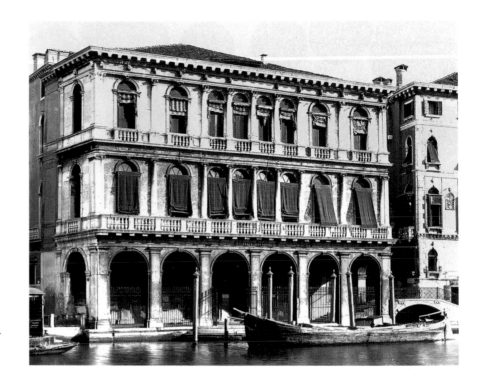

Palazzo Dolfin-Manin, built for Giovanni Dolfin, procurator of S. Marco, by Jacopo Sansovino, in 1538. Sansovino's project provided at ground level a great portico open onto the Grand Canal.

arcade] led into six long *magazeni* [storerooms], to provide warehousing for Giovanni's merchandise. Sansovino showed his sensitivity to the local context by using the traditional Venetian hipped roofline, *a quattro acque* [literally, with four pitches], to use Francesco Sansovino's expression, which facilitated the collection of water for the cistern.

From the facade alone it appears that Sansovino had already solved another of the problems in adapting classical language to the Venetian context, namely, how to place the cornices on the level of the internal divisions between storeys. At the start of the century, in his Ca' Loredan (Vendramin-Calergi), Mauro Codussi had already shown that a grid of columns and entablatures could be used to articulate a facade without compromising the standard tripartite internal layout. In Codussi's facade, however, the cornices were at sill level, with the internal divisions dropped down behind them. Sansovino introduced to Venice the innovation first seen in Bramante's House of Raphael, running balustrades between or in front of the column bases, so that the orders explained and represented the three-dimensional structure of the whole building rather than merely adorning the facade. The projecting balcony of the *piano nobile* followed a Venetian convention criticized by both Serlio and Palladio. Both treatises recommended making the upper storeys recede so that the balconies could rest on the wall of the storey below, but such an arrangement sacrificed internal space in the upper rooms and did not take account of traditional Venetian construction principles. Sansovino, by contrast, adhered to local practice, but reinterpreting the theme in Roman language, he elongated the dentils to act as cantilevers to support the projecting balconies.

Tafuri has suggested that Sansovino was too busy in the Piazza to supervise the execution of this building himself; he prefers to attribute the awkward details in the design to a lack of personal supervision on site, although the links with the plan of the Zecca suggest that Sansovino's input was not merely superficial. Doubtless the patron himself was not afraid to take his own decisions, as Vasari made clear in Sanmicheli's case, but the design is consistent with Sansovino's ability to infuse local tradition with Roman forms and syntax. As the architect's son remarked in his *Venetia città nobilissima*, the Palazzo Dolfin was the "the first after the Loredan to be built in Venice according to the rules of architecture."

The Palazzo Corner at S. Maurizio was finally begun after the legal difficulties in dividing Zorzi Corner's estate among his heirs were resolved in 1545 (see p. 294). Romanelli has recently suggested that Zorzi Corner could have known Sansovino before the artist arrived in Venice, through the family's Roman contacts. Zorzi's personal ambitions for the S. Maurizio site were evident in his expendi-

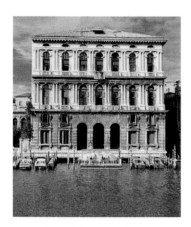

Palazzo Corner della Ca' Grande at S. Maurizio. Destroyed by fire in 1532, the palazzo was reconstructed by Sansovino after 1537. The project, which continued for more than twenty years, was commissioned by Jacopo Cornaro, nephew of Caterina Cornaro, former queen of Cyprus.

ture of the existing house on the site and the acquisition of adjoining properties. His will of 1524 had declared that: "If, in the future, it is proposed to build on the Grand Canal site, it must be in a form considered to be appropriate and honorable; nor should any expense be spared to make the work worthy of renown." Zorzi died on 31 July 1527, a few days before the first report of Sansovino's arrival in Venice, but the Sack of Rome (which began in May) was already a past event, so the artist's flight may have occurred earlier. The Roman leanings of the Corner family were well established (two of Zorzi's sons became cardinals and a third was an archbishop). If the *paterfamilias* had fostered ambitions to have his palace rebuilt by the refugee artist, it is tempting to speculate that this might have been the "model for a certain palace for a very wealthy man" mentioned by Lotto in a letter of 7 October 1527. After all, the Corner were renowned as the city's wealthiest family, and Zorzi's personal fortune was prodigious.

Sansovino had certainly been commissioned to undertake the rebuilding of the incinerated palace by 1537 when Aretino mentioned the "foundations on which must remain the superb Cornari roofs," but Aretino's vagueness suggests that little progress had been made (this was the letter in which he listed the architectural orders of Sansovino's new buildings, but the orders of the Corner palace are unspecified). When Sansovino himself surveyed the site with Scarpagnino in 1543, he still referred only to the "house destroyed by fire at San Maurizio, with its ruins, bricks, and freestone." By a cruel twist of fate another Corner palace, that at S. Polo, had also burned down, in 1535, but the family owned a third palace at S. Cassan, and one of Zorzi's sons, Giovanni, had bought the Palazzo Landi (Corner-Spinelli) after the S. Polo fire. These were the properties that were finally distributed among Zorzi's heirs in 1545.

The exuberant sculptural richness of the S. Maurizio palace is far removed from the distilled classical essence of the Palazzo Dolfin; indeed, it is more reminiscent of the lavish three-dimensionality of Sansovino's work in the Piazzetta. This affinity was certainly intentional. The Corner family, one of the nobility's *case vecchie*, had achieved almost regal status by the marriage of Caterina Corner to the king of Cyprus. When she was widowed in 1473 and persuaded by her brother Zorzi to abdicate, the family received huge estates in Cyprus in compensation, and their enormous wealth was legendary. After the fire destroyed the family palace in 1532, two of Zorzi's sons, Giacomo and Francesco, each petitioned Doge Gritti to be compensated for the

destruction of their palace, claiming to be lawful heirs to the dowry of Queen Caterina. Despite the tragedy the family could hardly claim destitution. The more compelling argument supporting their case was that their palace, on such a conspicuous site near the mouth of the Grand Canal, would enhance the beauty of the city. In other words, they considered their palace as an extension of the processional scenery of the city center, embellishing the great ceremonial route along the Grand Canal. It is easy to imagine Doge Gritti warming to this sentiment, and a grant of 30,000 ducats was duly awarded from Queen Caterina's dowry toward the cost of rebuilding the palace, equivalent to the total sum spent on the Library in Sansovino's lifetime.

It was Zorzi's grandson Zorzetto who eventually inherited the S. Maurizio palace, while the adjacent plot passed to the heirs of Cardinal Francesco, who had already died. As rebuilt by Sansovino the palace was left incomplete on the upstream side, as if expecting the addition of another great family palace on the west flank. (Scamozzi published in his treatise a design for a Corner palace, which seems to have been intended for this plot.)

Like his buildings in the Piazzetta, Sansovino's Palazzo Corner is rich in references to the works of the Bramante circle, adopting, for example, the paired columns from Bramante's House of Raphael and the triple-arched entrance of Giulio Romano's Palazzo del Tè in Mantua. (The destroyed Gothic palace on the site also had a waterfront loggia, an element found at that time only in showpieces such as the Ca' d'Oro.) The need for a greater window area in the center, to light the *portego* within, is discreetly achieved by enlarging the three central windows and slightly widening the outermost bays. Here the regular bay system almost conceals the internal room distribution, whereas in Venetian palace tradition the legibility of the plan from the outside was one of the distinguishing features, as Francesco Sansovino noted. Yet even in this extravagant display of dynastic might, there are concessions to local tradition in the slender arched windows, the hipped roof, and the tripartite plan: Francesco Sansovino remarked on the "invention accommodated to community usage."

In the Ca' Corner the three-dimensional consistency is carried through the whole palace, continuing the cornice levels right across the site and repeating the same triple-order system in the inner courtyard as on the facade. The insertion of a grand courtyard *alla romana* in the heart of the building suggests that the family were eager to show off their Roman leanings. Mezzanine levels in the side wings create a total of six living storeys, not to mention the attic: Francesco

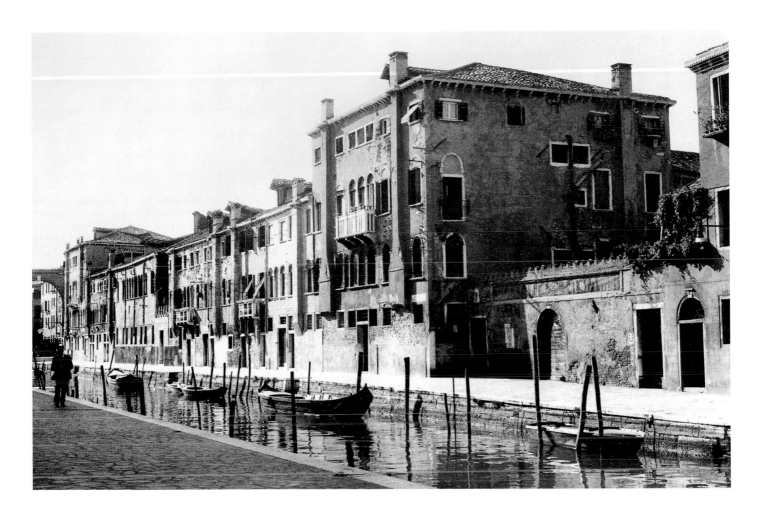

The architectural complex built by Sansovino, beginning in 1545, for his friend the senator Leonardo Moro constitutes a curious example of popular housing: a series of small structures to serve as workshops and houses for artisans is arranged in a long row and closed at each end by a palazzo decidedly more noble in appearance.

Portal of Palazzo Gritti, begun by Sansovino in 1525, beside the church of S. Francesco della Vigna.

Sansovino records that the apartments on one side were suitable for "any cardinal's household" (a reflection of the family's papal ties), and those on the other side for family living.

By 1545 Sansovino had already paid a return visit to his native Florence and seen the recent work of Michelangelo. The freedom with which he treats the windows on the rusticated Doric water storey reflects a certain Michelangelesque capriciousness, seen in the long consoles flanking the mezzanine windows which press down on the margins of the segmental pediments beneath. Yet the tectonic rigor of this level is never threatened, and in a display of brilliant virtuosity Sansovino teases the eye with his layering of the stonework, some smooth, some rough, all firmly integrated into the system of rusticated pilasters which articulates the wall surface.

Vasari was generous in his praise of the Ca' Corner "which, without doubt surpasses others in comfort and majesty and grandness, and is reportedly perhaps the most beautiful ever in Italy." By deliberately adopting the Roman language of the Grittian renewal of the Piazza the palace expressed the *magnificenza* of the Republic as much as a show of family wealth and honor. This was one of four palaces singled out for special praise by Francesco Sansovino "for their architecture, for the skill in stonecarving, for majesty, for great size and expense, because these alone cost more than two hundred thousand ducats." The other three were Codussi's Ca' Loredan (Vendramin-Calergi), Jacopo's own Ca' Dolfin, and the huge Grimani palace at S. Luca, rebuilt to the design of Michele Sanmicheli from 1556 onward. All four occupied Grand Canal sites and projected the glory of the Republic by embellishing this great processional route. At the start of the century Loredan had felt the need to apologize for his lavish classicism with the pious facade inscription: "NON NOBIS DNE. / NON NOBIS [not for us Lord, not for us]," but the spirit of the Grittian *renovatio* vindicated the aspirations of the later palace builders.

There was, however, another strand to the myth of Venice which seemed more appropriate in more peripheral sites: the legendary simplicity of the life of the first Venetians. This was the *mediocritas* [moderation] adopted by Doge Gritti in his own palace at S. Francesco della Vigna, begun in 1525, two years before Sansovino's arrival. A similarly understated, sober style characterized the remarkable complex of houses which Sansovino designed for his friend, Senator Leonardo Moro, on the northwest fringes of the city (see p. 295). Designed as a property investment, the scheme consisted of a row of twenty houses for letting, with a palace at either end and artisans' cottages between. The houses were probably begun in 1544, the date noticed by Tassini on one of the corner pilasters (but no longer visible). Half the row was inhabited by 1549, and the ten remaining houses were completed two years later. At this point Leonardo Moro himself decided to move from his own palace at S. Felice to one of the corner palaces, thereby implying that the scheme had caught his imagination. He transformed a walled enclosure at the rear of the site into a celebrated garden, mentioned by Francesco Sansovino in 1581 as one of the finest in Venice.

The Moro houses appear on early maps and views of Venice as a huge square enclosure surrounded by a quadrangular structure with four corner towers. Indeed, both Vasari and Francesco Sansovino compared the building to a *castello* [castle], suggesting that this rural site had acquired a quasi-feudal imagery. Yet the fascination of this design lay in the paradoxical nature of its complete renunciation of *signorile* identity at close range. The paternalistic relationship between the artisans' terraces and the flanking corner palaces bestowed on the scheme an idealistically democratic air. This peripheral location was not the place for a display of the ostentations of the Piazza, but instead a poignant site for the evocation of the simple lifestyle of the first lagoon settlers. As Gritti's choice of this austere mode for his own family palace had shown, it also conveyed a simple Republican sobriety. This was the other side of the myth of Venice, which existed in a finely balanced equilibrium with the romanizing ideology of the seat of power in the city center. Moro was a wealthy and distinguished noble, whose adoption of what Tafuri called "a timeless idiom" conveys as much patriotic idealism as the extravagant display of the Corner palace at S. Maurizio, erected in the very same years. The deep attachment felt by Leonardo and his heirs toward their palace and garden surely shows none of the "tragic aspects" that Tafuri saw in their renunciation of the orders of architecture, but instead a positive and imaginative reinterpretation of rustic living, adapted to the margins of the lagoon.

This was not the only time that Sansovino chose this undemonstrative local vernacular idiom in his designs. The same *mediocritas* can be seen in the almshouse block known as the Ca' di Dio, rebuilt to house twenty-four poor women for the Procuratia de Supra from 1545 (see p. 298), a project almost contemporary with the Moro houses. This commission, which required the strictest possible economy, shares the simple round-arched, Istrian-stone framed windows of Moro's complex. Like the latter, it achieves its dramatic impact not from learned classi-

Sansovino's house at S. Trovaso. For his own residence, the architect chose a building with a modest appearance which nevertheless expresses the simple elegance typical of his designs.

cism but from pure form—from the audacious line of outsized chimneys along the *rio* wing, and from the subtlety of the oblique angle that brings the end of the range into view. The simple serliana on the *piano nobile* of the Bacino facade (the second serliana above is a gratuitous addition during the 1970s restoration) frames a dramatic panorama of S. Giorgio Maggiore at the end of the communal corridor.

Even more anonymous are the houses that Sansovino rebuilt for the Procuratia de Supra on the Fondamenta S. Maurizio, just upstream from the Ca' Corner. These were begun in 1552, right after the completion of the Moro houses. In the same year the architect himself bought a property opposite the church of S. Trovaso, which he rebuilt in three stages in the same reticent style as the other designs just considered (see p. 297). Like Moro's scheme, this was a real-estate investment, although the houses were destined eventually to form part of the inheritance of his son Francesco. Of course, in these designs, both of which were intended primarily for rental housing, a distinctive dynastic identity was not appropriate; but at S. Trovaso, acting as his own patron, the architect was unconstrained by the tastes of a client. We can thus be assured that he himself valued the restrained Republican dignity of the lagoon vernacular style and recognized its appropriateness to the peripheries of the city.

Ca' di Dio, facade on the Rio di Dio. This large complex, founded as early as the 13th century, originally housed pilgrims and later served as a home for poor women. The characteristic oversized chimneys were part of the reconstruction by Sansovino, starting in 1545.

Charity and Devotion

We have already mentioned the dialectical relationship between the Roman magnificence of the Piazza and the discreet restraint of the Moro houses, the Ca' di Dio, or Sansovino's own houses at S. Trovaso. This conversation between the imperial and Republican identities of the Venetian state infused the city's visual culture with an eloquent range of inflections. Each extreme needed the other to highlight its own expressive significance. In the context of devotional and charitable buildings, the dialogue gained added complexity and depth from the interplay between traditional Catholicism and religious reform. Through the involvement of the *scuole* in processions and the regular ducal *andate* to far-flung churches, the ceremonial rituals of the State transported the splendor of the Piazza the length and breadth of the city. But, as Tafuri has emphasized, Venice and the Veneto were in direct contact with Protestant ideas from the north, not to mention the impact of local reform movements such as the Observant branches of the mendicant orders. Both Sansovino and Serlio, like Palladio, are known to have had contacts with "heretical" circles, though there is no direct evidence to suggest that their own religious views were unorthodox. Certainly these contacts made them fully aware of the range of religious beliefs in the city and the subtle ways of expressing these in architectural terms.

The project in which the rival concerns for charity and display clashed most dramatically was the rebuilding of the Scuola Grande della Misericordia (see p. 299). The network of *scuole grandi* across the city (one in each *sestiere* by the mid-Cinquecento) provided a focus for the ceremonial life of the great citizen confraternities as well as the headquarters for their charitable duties. The Misericordia had already decided to replace its huge Gothic *scuola* in 1498, but the Cambrai wars subsequently prevented the start of work. In 1531 Jacopo Sansovino, the newly appointed *proto* of the Procuratia de Supra, was called in to advise on the prewar model by Alessandro Leopardi "dal Cavallo [of the Horse]," the bronze-caster who had executed the Colleoni monument. Jacopo must have been critical of the old design, for in the same year an additional four models were commissioned, including one by Sansovino himself. In a ballot held later in the same year it was Jacopo's model that was chosen, and work began on site in 1532. The bold ambitions of the *scuola* were already evident in the choice of the refugee Florentine, whose only works so far in the city had been the restoration of the domes of S. Marco, the erection of a few vegetable stalls, and the continuation of Bon's still unfinished Procuratie Vecchie.

It is impossible to understand the history of the Misericordia without reference to the parallel activity at the rival *cantiere* of the Scuola Grande di S. Rocco. Scarpagnino had taken over at S. Rocco in 1527 after the previous *proto*, Bartolomeo Bon, had left in 1524 because of a dispute over the form of the staircase. The Misericordia was forced to revise Sansovino's initial design of 1531 in response to an objection from the site's landlords, the Moro family, to its projecting columns. Sansovino's revised model, with engaged rather than free-standing columns, was approved in 1535, whereupon S. Rocco immediately seized the opportunity to emphasize the Misericordia's discomfort by adding two orders of projecting Corinthian columns to its own facade. S. Rocco seized similar advantage when the Misericordia failed in 1544 to agree on the form of its staircase, a crucial element in the ceremonial scenery of any *scuola grande*. In 1545, in direct challenge to the vacillations at the Misericordia, S. Rocco ostentatiously demolished its newly built double-ramped staircase designed by the elusive Tuscan known as "Il Celestro" and expeditiously erected the present imperial-style staircase block to Scarpagnino's design. Whereas the Misericordia never managed to resolve

its state of perpetual financial crisis, the wealth of the Scuola Grande di S. Rocco increased dramatically during the century, thanks to donations from Venetians anxious to protect themselves from the plague. By 1581 not only was S. Rocco's building completed, but it was also decorated throughout by Tintoretto, whereas the Misericordia, lacking its roof and staircase, was still unusable. In that year Francesco Sansovino loyally described the building as "the most notable and best executed to be found in the city, according to the judgment of experts in the profession," but he doubted that funds would ever be found for its completion. The Misericordia was finally inaugurated in 1589, but its stone facing was never applied, and its massive brick carcass came to excite admiration for qualities of *terribilità* [awesomeness] that had never been intended.

Tafuri has suggested that Sansovino's Misericordia design, with its unambiguously Roman intentions reflecting the new style of Gritti's *renovatio* in the Piazza, represented a betrayal of the ideology of the citizen class. The incongruity was exaggerated by the *scuola*'s position on the margins of Cannaregio, at the opposite end of the same canal as Leonardo Moro's simple suburban retreat, and facing the

Scuola Nuova della Misericordia, as it is today and in an engraving attributed to Palladio (Vicenza, Museo Civico). Work started in 1532 under the supervision of Sansovino and dragged on for many years, but the brick structure never received its stone facing owing to lack of funds. To the right is the facade of the old building of the *scuola*, one of the *scuole grandi* of Venice.

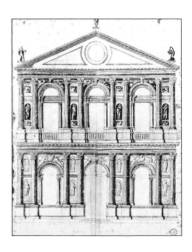

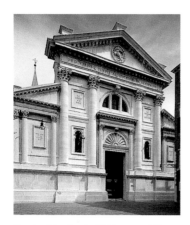

Facade of the church of S. Francesco della Vigna. The great church of the Franciscans, dating back to the 14th century, was rebuilt by Sansovino and Palladio, who is credited with the great facade commissioned by Cardinal Andrea Grimani.

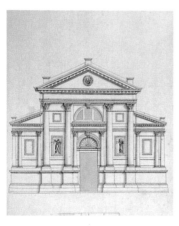

Antonio Visentini, Palladian facade of S. Francesco della Vigna. London, British Museum.

Palazzo Tiepolo where Sansovino had achieved fame for rescuing a venerable Gothic palace from collapse. The *scuola*'s grandiose scheme was presumably intended to attract munificent donations from members of the confraternity and other donors, but Alessandro Caravia's satirical poem *Il Sogno di Caravia* [The dream of Caravia], published in 1541, with its verses of withering mockery, must have dealt a deathblow to all hopes of completion. The vacillating policies of the ever-rotating boards of officers were symptomatic of their perplexity over this hopelessly over-ambitious scheme. As Giovanni Fabbri's restoration studies have made clear, the highly finished quality of the brickwork seems to suggest that Sansovino soon realized that his building might remain naked forever.

The large facade design in the Museo Civico in Vicenza, evidently connected with the Misericordia, though revised by Palladio in various details, gives some indication of Sansovino's intentions for the external stone cladding. The richly sculptural project embodies two superimposed triple triumphal arches, their orders of paired columns enclosing niches, with garlands hung between the capitals. This is the triumphal language of the Loggetta, as well as that of Sansovino's early temporary facade for the Duomo in Florence, prepared for the entry of Pope Leo X in 1515 and described in detail by Vasari. As Lotz aptly observed, the design is also reminiscent of Bramante's Santa Casa in Loreto, as if to highlight the Marian dedication of the *scuola*. The link with the Santa Casa is emphasized by the Scuola's almost free-standing site, which encouraged Sansovino to pursue his aim—evident also in his two Grand Canal palaces, as well as in the Library and the Zecca—to achieve a consistent relationship between the external system of the orders and the layout and construction of the interior. As the first major design of the architect's Venetian career, the Misericordia was an uncompromising statement of the artistic principles of High Renaissance Rome. Sansovino was soon to learn that the constitutional ideology and the weight of local tradition demanded radical modification of these aspirations. Conceived like an outpost to the buildings in the Piazza, the Misericordia project expressed the language of the State and hence, by implication, the ultimate control of the Council of Ten over *scuola* affairs, rather than the illusion of citizen democracy so deeply cherished by the *scuole grandi*. We can hardly wonder at its failure to attract sponsorship.

Sansovino was responsible for five complete churches in Venice, in addition to the facade of S. Geminiano in Piazza San Marco which we have already considered. Of these six churches, three—

S. Spirito in Isola, the church of the Incurabili, and S. Geminiano—were demolished during the Napoleonic period. No record survives of the drawings of "sixty plans of temples and churches of his invention, so wonderful that from antiquity until now one cannot see any that are better conceived or more beautiful than these," which according to Vasari were left to Francesco Sansovino at his father's death, and the son intended to have them engraved for publication.

Despite Vasari's praise, Sansovino's religious works are his least celebrated, in contrast to those of other Renaissance masters such as Brunelleschi, Alberti, and Bramante. Yet throughout his career he cared for the upkeep of S. Marco, and his sculptural works, tapestries, and intarsia designs transformed the appearance of the presbytery. His first ecclesiastical commission in the city, for the rebuilding of the church of S. Francesco della Vigna, was a contradictory one. On the one hand, this was a project with direct ducal involvement, for Doge Andrea Gritti, whose family palace lay just in front of the church, promoted the scheme and bought the right to use the chancel as his family burial chapel, while the side chapels were purchased by the richest and most powerful noble families in the city. On the other hand, this monastery belonged to the austere Observant Franciscans, who wanted a design appropriate to their ascetic ideals. The order's international network of monasteries, extending as far afield as Spain, widened the horizons of the architect beyond the boundaries of the city and its traditions. Here the Roman splendor of the Piazza would not have seemed fitting. Instead, Sansovino turned to his native Florence, where the Medicean interest in Observant orders dated back to the time of Cosimo il Vecchio. Sansovino's design is closely modeled on that of the sister church in Florence, S. Salvatore al Monte, begun for the Observant Franciscans by Cronaca in 1499. From Cronaca's church he borrowed the fluted Doric capitals and plain frieze, the arched side chapels and aisleless plan, and the two-storey pilastered nave with clerestory windows (see p. 301).

The foundation of the church in 1534 was commemorated by a medal showing Gritti's portrait on the obverse and Sansovino's model on the reverse. In the following year, the scholarly humanist friar Francesco Zorzi revised the design by adapting the proportions to fit a harmonic system based on multiples of the number three. Zorzi's *relazione* is also remarkable for the sophistication of its ideas on acoustics. The chapels, including the *cappella maggiore*, where masses would be sung, should be vaulted, he recommended, while the nave should be roofed with

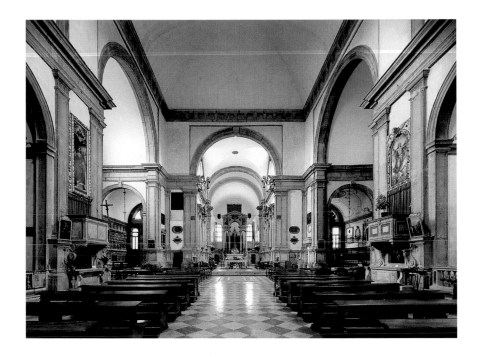

S. Francesco della Vigna. The interior by Sansovino retains hints of his Tuscan origins. The plan, in the form of a Latin cross, has undergone various changes, among which are the elimination of the cupola, the extension of the nave, and the addition of the deep choir.

gray coffers to make the voice of the preacher intelligible. In the event, the flat wooden ceiling was never constructed—the existing false vault was added in 1630—but Sansovino was to retain this preference for flat wooden ceilings in all his Venetian churches.

Palladio was to learn much from S. Francesco della Vigna, especially with regard to the arrangement and lighting of the presbytery and its retro-choir, the latter secluded behind the high altar to allow the congregation an unimpeded view of the nave. But S. Francesco's *ascetico fiorentinismo*, to use Tafuri's apt expression, was at odds with the three-dimensional, majestic, *all'antica* voice later adopted in Palladio's Venetian churches. The contrast was brought sharply into focus in the early 1560s, within Sansovino's own lifetime, when Palladio was commissioned by the Grimani family to build a facade for S. Francesco della Vigna. This display of grandiose classicism, with its gigantic columns raised far above head height, seems ill-fitting in this peripheral zone of the city, set between the lucid simplicity of Sansovino's church and the austerity of Gritti's palace in front.

By contrast, Sansovino's executed church facades (like the medal project for S. Francesco della Vigna) were two-storey designs on a more intimate scale, as we have already seen in the case of S. Geminiano. The commemorative facade of S. Giuliano in the Mercerie is graced by the bronze effigy of Tomaso

Rangone over the door, with an inscription dated 1554. The modest, flat-roofed, square-plan church behind it was rebuilt by default from 1566 after the old Gothic church collapsed as Sansovino was erecting the new facade. This was not the only project in these years in which Sansovino chose a centralized plan for the needs of parish worship, following in the wake of the revival of the Veneto-Byzantine typology by Codussi and his successors. Though conceived in the 1540s, S. Martino at the Arsenal was begun in 1553, the year in which Rangone was authorized to place his own effigy on S. Giuliano. We know from Barbari's map that the previous church of S. Martino, like S. Giuliano, had been longitudinally planned. Sansovino changed the axis, placing the entrance on the north side (where a broad street forms a modest *campo*), but retaining as many foundation walls as possible from the older structure. The simple Greek-cross interior recalls Codussi's use of elongated pilasters; its ornate eighteenth-century decoration replaced the simple white-wash prescribed for both interior and exterior in the original building contract. This was a much poorer parish than S. Giuliano or S. Geminiano, and no wealthy donor was at hand to pay for an Istrian stone facade. Indeed funds were so short that building proceeded very slowly, and a mere half of the church was complete by Sansovino's death. The remainder was only finished by 1633, and, as Tafuri has shown, the Istrian stone details on the facade are

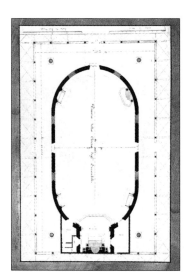

Elliptical plan of the church of the Incurabili, designed by Sansovino, destroyed during the Napoleonic era, in a drawing by Antonio Lazzari. Second half of the 17th century. Venice, Museo Correr.

a Sansovinesque reinvention by Berchet and Rupolo in the nineteenth century.

It is in the hospital church of the Incurabili that we find Sansovino at his most inventive—in the very last years of his life. The hospital had been founded in 1522 to care for the unfortunate victims of the *mal francese* [syphilis], and two years later had begun to care for orphans as well. Whereas the male orphans were educated in useful trades or crafts, the female orphans were brought up in a conventlike environment where music was regarded as the most suitable subject for instruction. As in the other four state hospitals, the girls' choir was celebrated for its skill in polyphonic music, their sung masses becoming one of the city's most famous tourist attractions. By 1565 the original wooden church was in danger of collapse, if we are to believe the petition to the doge in that year appealing for State funds to subsidize the building of a simple brick replacement. It is to Francesco Sansovino that we owe the attribution of the design to Jacopo. Since the architect was now almost eighty years old, supervision of the *cantiere* was assigned to the local *proto*, Antonio da Ponte.

The Incurabili church stood in the cloister of the hospital on the Zattere until it was demolished in 1831 (see p. 303). The idea of placing the church in the courtyard of the hospital may have been suggested by Filarete's design for the Ospedale Maggiore in Milan. (The beautiful Latin manuscript copy of Filarete's treatise made for Matthias Corvinas was then in the library of SS. Giovanni e Paolo in Venice.) Its elliptical plan—in reality a rectangle with rounded ends—was unprecedented in the Veneto (see p. 302). There seems no reason to doubt Sansovino's authorship, especially when one considers the roots of the idea in earlier projects of Peruzzi, taken up by Serlio, who published an oval plan in Book V of his treatise. Vignola's oval church of S. Anna dei Palafrenieri, the chapel of the Swiss guards at the Vatican, is exactly contemporary with Sansovino's Incurabili church, and, significantly, the church of S. Giacomo degli Incurabili in the Corso in Rome, begun by Francesco da Volterra in 1592 is also oval in plan.

As late as the eighteenth century the oval was believed to have exceptional acoustic properties, and Sansovino's flat wooden ceiling was also thought to enhance the clarity of the rich polyphonies of the *coro spezzato* singing by absorbing echoes. The choirs sang from raised singing galleries reached by overhead passages and concealed behind iron grilles.

The Incurabili church was a low-budget scheme, with four simple, pedimented nave altars based on the Pantheon aediculae, two of which may now be seen in the church of S. Giovanni di Malta in Venice.

(The Baroque high altar is in the cathedral of Vittorio Veneto.) The church's modesty must have seemed all the more striking in comparison with Palladio's S. Giorgio Maggiore, begun in the very same year. Yet the design reflects not the declining powers of the older master but rather the ingenious invention of a new type which was to influence the design of hospital churches in Venice down to that of the Pietà, begun as late as 1745. Whereas S. Giorgio was the church of a prominent and wealthy Benedictine monastery (its role being comparable with that of Saint-Denis in Paris or Westminster Abbey in London), the Incurabili—founded by Gaetano Thiene and visited by Ignatius Loyola—was one of the focal points of Counter-Reformation zeal in Venice. The contrast of cost, scale, and architectural expression between these two churches on either side of the Giudecca Canal was rich in ideological resonances.

Visitors to Venice at the end of the Quattrocento such as Philippe de Commynes and Canon Pietro Casola had remarked on the beauty and richness of Venetian churches and the intensity of popular devotion. In the complex religious currents of mid-Cinquecento Venice, richness for its own sake became an ideal racked by doubt, and Sansovino's six churches reflect an uneasy search for new devotional settings. His most lavish ecclesiastical design must have been for the completion of the island monastery of S. Spirito in Isola, now destroyed, but once adorned by a masterful series of works by Titian now to be seen in S. Maria della Salute. His other ecclesiastical work (excepting the prominent city center facades of S. Geminiano and S. Giuliano) is characterized by lucid, aisleless plans, simple decoration, and flat ceilings—a modesty which enacted its own reforming agenda, due as much to Sansovino's contacts with Protestant circles in Venice (if we are to believe Tafuri's hypothesis) as to the more general impact of the Council of Trent.

Conclusion

How was it that Jacopo Sansovino, the Tuscan sculptor who proudly signed himself "fiorentino" until the end of his life, succeeded in dominating the architectural scene in Venice from the time of his flight from Rome in 1527 until his death in 1570? It was only in the very last decade of his life that he received serious competition from Palladio. Why was it that, according to contemporary sources such as Lotto and Vasari, he consistently refused invitations from the great rulers elsewhere in Europe—from Francois I of France, Henry VIII of England, Duke

Cosimo I of Florence, Duke Ercole II of Ferrara, Pope Paul III, and Philip II of Spain? His close friend Pietro Aretino, a fellow Tuscan who had himself happily found refuge in Gritti's Venice, sympathized with Jacopo's reluctance to return to Rome: "A greeting from these noble sleeves is worth more than a gift from those ignoble mitres."

The answers to these questions are not simple. In the first place we must remember that the romanizing bent of Gritti's patronage was well established before Sansovino's arrival. After all, the imagery of the new Roman style perfectly fitted the new historiographical ideology of the myth of Venice, with its stress on the city's Roman origins and *all'antica* republican values. Moreover, Sansovino was not the only protagonist in the *renovatio*. Serlio, Sanmicheli, and Scarpagnino all played their part. Serlio's role was primarily didactic, but as we have seen, it was crucial to the success of Sansovino's program in the Piazza, articulating the theoretical principles of the orders which made this triumphal scenery so eloquent. Sanmicheli was a specialist in military architecture, and only his splendid palaces for the Corner family at S. Polo and the Grimani at S. Luca offered any serious competition to Sansovino in Venice, Verona remaining the principal arena for his activity. And Scarpagnino lacked the direct experience of Rome, both ancient and modern, which was so important in enriching and revitalizing Venetian tradition at this time.

Jacopo's friendships were eloquently recorded by both Vasari and Aretino, who recognized the artist's dependence on this extensive network of contacts within Venice. Vasari stressed not only the support of Doge Gritti, but also the artist's close ties with individual procurators, especially Marcantonio Giustinian (whom he had known in Rome), Vettor Grimani, and Antonio Capello. Through his voluminous letters, Aretino made legendary Sansovino's friendship with Titian and with the writer himself. And the documents of the time testify to the strength of the support that Sansovino derived from his friends, especially at times of crisis, such as the collapse of the first bay of the Library in 1545.

Perhaps the architect's most significant asset, one shared by Codussi before him, and by Longhena afterward, was that he steered a skilful course in the midstream of Venice's creative environment, between the two extreme architectural positions of the utopian idealist and the technically competent *proto*. Although Sansovino's technological credentials were never secure, he had more successes than failures; and his supporters, through words and actions, succeeded in promoting his reputation for technical virtuosity. The repairs to S. Marco, the innovative

restoration of the Tiepolo Palace at the Misericordia, and the conscientious efforts to serve the Procuratori de Supra in the maintenance of their properties were lauded by both Vasari and Francesco Sansovino. To reinforce this image, myths were created, such as the supremacy of Sansovino's own Rialto bridge scheme, implausibly claimed by Francesco. And in 1550 Aretino praised his pillaging of marble columns from the Justinian church of S. Maria in Canneto at Pola, which led soon afterward to the total collapse of this venerable monument. But Sansovino's technological skill seems to have been more than a myth: recent investigations by Giovanni Fabbri at the Scuola della Misericordia have revealed an ingenious system of arched foundations, unprecedented in Venice and apparently highly effective.

While sustaining his position as a true *proto*, with the help of propaganda both written and spoken, but also with the aid of intuitive gifts that often served him well, Sansovino also adopted the guise of an artist of genius endowed with both utopian vision and classical erudition, like Fra Giocondo before him and Palladio and Scamozzi afterward. He could build economically or extravagantly as the situation demanded; he adopted the reticent lagoon vernacular as readily as the Latin language of the classical orders. He learned as much from the architectural traditions of the city as he himself contributed to them. As Vasari remarked: "In truth, the excellence of Jacopo deserves to be placed in the top rank among masters of design in that city; and in order that his merits might be appreciated by the nobility as well as by ordinary people, he was very agreeable to the great, to the humble, and to his own friends."

Deborah Howard

The church of the Incurabili was built within the cloister of the hospital. Constructed between 1527 and 1591, the church was almost certainly designed by Sansovino, although the supervision of construction was left to the local *proto*, Antonio da Ponte. It was demolished in 1831.

The Sculpture of Jacopo Sansovino
and the Later Cinquecento

Entrance to the Arsenal. Engraving by Giacomo Franco, 16th century.

In August 1527 the painter Lorenzo Lotto recorded the arrival of Jacopo Sansovino, together with a younger, unidentified artist, in Venice, the city which would be his home for the next four decades. Like many of his contemporaries, Sansovino had been driven from central Italy by the terrible Sack of Rome and was in transit to France and a new career at the court of François I. Sansovino's reputation preceded him to Venice—Lotto describes him as the greatest man after Michelangelo in Florence and Rome—and he arrived there as an artist at the height of his powers. Born in Florence in 1486, Jacopo Tatti was apprenticed to Andrea Sansovino, an accomplished sculptor whose name the younger man subsequently adopted. After a period of study in Rome, where the young Sansovino attracted the attention of Bramante and Raphael, he returned to Florence and scored a notable success with his virtuoso statues of *Bacchus* and *St. James the Greater*, works that signaled his standing as a considerable rival of Michelangelo. During the years before the Sack, Sansovino alternated between Florence and Rome, where he produced two additional distinguished statues and became involved in two major architectural projects, the church of S. Giovanni dei Fiorentini and the Servite church of S. Marcello al Corso. Had Sansovino died in 1527, he would still be remembered today as one of the most distinguished figures of the High Renaissance.

Giorgio Vasari, whose biography of Sansovino is exceptionally well informed, observed that the sculptor had contacts with Venice long before he settled there. His copy of the famous Hellenistic sculpture, the *Laocoon*, was cast in bronze for the great Venetian patron Cardinal Domenico Grimani, and it may have been Grimani who alerted his Venetian contemporaries to Sansovino's talents. After his arrival in Venice, Vasari records that Sansovino was persuaded to settle there by a group of admirers, among them the reigning Doge Andrea Gritti. In 1529 Sansovino was rewarded with the important position of *proto*, or chief architect, of the Procuratia de Supra of S. Marco, an office he held until his death in 1570. As *proto*, he supervised the fabric of the doge's chapel of S. Marco and the other properties owned by the church, including the buildings on the Piazza S. Marco. His employers, the procurators of S. Marco, were drawn from the wealthiest

and most notable patricians and were in a position to bring major commissions in his direction. In addition, Sansovino's talent and conspicuous position earned him more commissions from private patrons. These factors enabled him to create a remarkable network of disciples, assistants, and followers, something Vasari aptly termed "almost a seminary in Italy in that art."

Sansovino's career as sculptor and architect was extraordinarily prolific in Venice. Fortunately most of his sculptures still remain in situ so that the best way to appreciate his work and that of his school is by walking around the city. Probably his earliest work seen by the Venetian public was the Arsenal *Madonna*, which occupies the same niche in which it was first placed in 1534 (see p. 305). The statue stands just inside the land entrance to the Arsenal complex and above the door leading to the quarters of the *patroni*, or lords, of the Arsenal who were required to live on site during their term of office. The function of the sculpture, clearly talismanic, invites comparison with the use of images of the Virgin and Child in public buildings and private houses, but the impression made by Sansovino's statue is nonetheless remarkable. Its archaic appearance has reminded many scholars of Donatello's bronze *Virgin and Child* on the high altar of the Santo in Padua, and the similarity is evident in the manner in which the Virgin displays the Christ Child as well as in his solemn, unblinking expression. Like Donatello, Sansovino may have been required by his patrons to accommodate his own style to the Veneto-Byzantine image of the Theotokos, the mother of God, but the almost primitive character of the Arsenal *Madonna* is so unlike any comparable work by Sansovino that it may have been a deliberate departure from his normal practice. What he appears to have created is a sixteenth-century version of a Venetian icon, much as Giovanni Bellini did with his devotional paintings of the same subject.

The predominant impression left by the Arsenal *Madonna* is of a work resolutely grounded in a Tuscan style, though not reminiscent of Sansovino's most recent sculpture. The youthful, tentative expression of the Virgin, her peaked cap, and the wealth of drapery draw upon the example of Donatello, but also find echoes in one of Michelangelo's most Quattrocentesque works, the Bruges *Madonna*;

Sansovino exploits his virtuosity in carving drapery to create the remarkable folds that encompass both Virgin and Child. The patterns establish a sequence of ovals from the head of the Virgin through her torso and legs, while the deep cutting of the marble allows the surface to reflect a variety of tonal nuances, which is one of the statue's most distinctive features.

Sansovino may have gauged his design to suit the tastes of a Venetian audience, which were rather different from those of his central Italian patrons. This proved to be a critical change from his pre-Venetian sculpture, anticipating the evolution of his later works. Essentially, Sansovino returned to a Quattrocentesque style that drew upon his own roots in Florentine art of the late fifteenth century and blended in with what he judged to be the prevailing artistic climate in Venice. The resurgence of earlier artistic traits in Sansovino's Venetian statues also coincided with his discovery of Venetian sculpture, not only the works of Tullio and Antonio Lombardo, but of their predecessors as well. This Quattrocento revival would become a predominant feature in Sansovino's Venetian sculpture, clearly evident in other early works like the marble *St. John the Baptist* in the Frari or the tomb of Galesio Nichesola in Verona cathedral, as well as in his numerous works in bronze.

The Nichesola monument, the *Baptist*, and the Arsenal *Madonna* were commissions for individual patrons. As Sansovino grew more involved in his work as *proto* of the Procuratia de Supra, the rhythm of his activity changed, and the nature of his commissions did as well. From the middle of the 1530s, Sansovino embarked upon a variety of sculptural and architectural projects for his employers, including the Library of S. Marco, the Loggetta, and a wholesale renovation of the choir of S. Marco. During the same period he began to acquire important private commissions from the Venetian State and nobility. All of these factors forced Sansovino to rationalize his working procedure: the slow production of autograph works was generally abandoned in favor of a system in which he designed models that would be subsequently turned over to others for execution. Bronze proved crucial for many of these Venetian projects and became increasingly the sculptor's chosen mode for sculptural expression. It was also a medium with a long tradition in Venetian sculpture but one in which Sansovino had had little experience. The great advantage of bronze lay in the ease with which an artist's model could be transformed into a durable work of art, a facility just right for the demands imposed on Sansovino by his growing architectural commitments.

Sansovino's bronze reliefs are among the most beautiful and original of the sixteenth century, a tribute to his narrative skill and to the superior capabilities of Venetian bronze-casters. Bronze was, of course, the most prized and the most expensive medium for sculpture, and its use in S. Marco had recently been established by the chapel of Cardinal Zen, which set a new standard for bronze sculpture in Venice. When Sansovino was asked to redesign the

Madonna and Child, also known as the Arsenal *Madonna*, Jacopo Sansovino. Marble, signed and dated 1534; located in the atrium of the Arsenal. Of clear Roman inspiration, especially in the structure of the aedicula that encloses the Virgin, the sculpture was executed during the early years of the artist's residence in Venice and marks the beginning of Roman classicism in an environment where local tradition was still marked by Gothic forms.

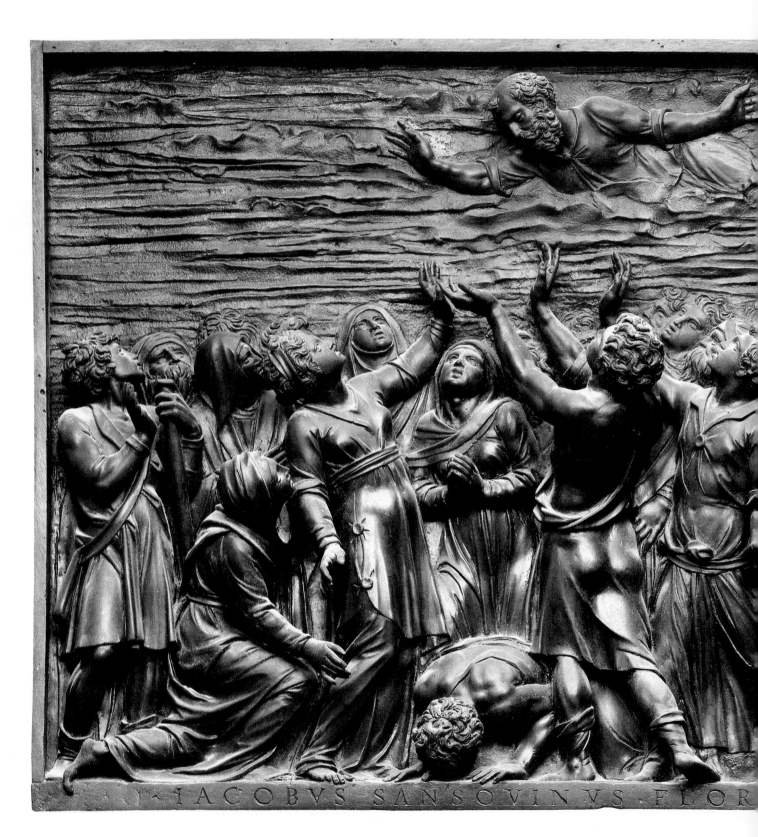

furnishings of the choir of S. Marco, the inclusion of relief panels in the two *pergoli*, or tribunes, must have seemed a natural component in upgrading the appearance of the *sanctum sanctorum* of the church. The eight panels, six narrative reliefs and two separate figures of St. Mark and his lion celebrated the miracles of the patron saint of Venice. Here Sansovino was doubtless following the precedent of Donatello's analogous bronze reliefs for the basilica of St. Anthony in Padua. Produced in two campaigns between 1537 and 1542, the reliefs were praised by Sansovino's friend Pietro Aretino for the "marvelous context of their figures," but whereas Donatello employed up to seventy figures in a spatially ambitious setting, Sansovino reduced the protagonists to no more than twenty, set in high relief against an architectural backdrop. He chose moments of great drama from the legends of St. Mark, when the Evangelist cast out demons or converted the infidels. Each scene is not only highly charged but also rich in the variety of its figures: larger groups are broken down into component elements of two or three figures who react in varying degrees to the central incident. The sculptor here followed the precepts of dramatic narrative by then common in Italian art, and his talent for creating evocative types—swooning women and figures of pathos—is evident throughout. If there is a difference between the two sets of reliefs, it lies in a greater preoccupation with the formal qualities of the protagonists in the second series, which may reflect an attempt by Sansovino to emphasize movement and gesture rather than anecdotal embellishments. The most dramatic, and in some ways the most beautiful, of the second suite of panels deals with the miraculous salvation of a servant, or *villein*, from Provence who was threatened with death for converting to Christianity. The figures of the would-be executioners pulsate with a brutal vitality while the spectators recoil more in distaste than horror. Above, a bust-length figure of St. Mark intervenes to stop the torture and thereby unites the disparate elements into a more coherent ensemble. Above all, one is aware of the undulation of the figures, of their sinuosity, and of a stylized treatment of the scene, features that link Sansovino's art here with the fashionable *maniera* [manner] brought to Venice by visiting younger Tuscan artists like Francesco Salviati and Vasari.

This rapprochement with central Italian *maniera* is characteristic of Sansovino's sculpture during the 1550s and can be found in his other major works of the period, the sacristy door and the Loggetta figures. As with the Arsenal *Madonna*, Sansovino's bronze sculpture derived from a complex interaction of his response to the climate of taste he found in Venice

St. Mark Rescues the Servant from Provence, Jacopo Sansovino, from the parapet of one of the two tribunes in the choir of S. Marco.

Jacopo Sansovino, door of the sacristy of the basilica of S. Marco. The bronze masterpiece was created between 1546 and 1569 and depicts the Resurrection of Christ on the upper portion and the Entombment on the lower. The rich cornice is ornamented with heads of Prophets, Evangelists, and portraits of artists close to Sansovino.

as well as a recollection of his own roots in the workshop of Andrea Sansovino, a master who never entirely shook himself free from the world of Ghiberti and Desiderio da Settignano. Beyond that, when faced with the task of creating panels in bronze, Sansovino would have had little guidance from contemporary sculpture. Consequently, it is not surprising that he recalled the works of Ghiberti and Donatello to fashion a personal style. Like a gifted mimic, he blended elements from Venice and Florence in what would become the influential medium for followers like Minio and Vittoria.

The painterly style of Sansovino's reliefs for S. Marco reached its apogee with the sacristy door. Conceived around 1545, this is one of only a few bronze doors executed in the sixteenth century, although Leopardi had proposed a set of bronze doors for the Palazzo Ducale in the 1490s and the Scuola Grande di S. Marco commissioned a model for a bronze door for its *albergo* in 1542. A trip to Florence in 1540 would have refreshed Sansovino's acquaintance with Ghiberti's *Gates of Paradise*; the fifteenth-century master's work was clearly the main point of reference for Sansovino's. At S. Marco, the portal is pared down to essential elements, consisting of two large relief panels separated by recumbent Prophets; on either side of the curved frame are standing figures of the four Evangelists in niches and six busts, three of which we know to be portraits of the sculptor and his friends Titian and Aretino.

As a whole, the door is difficult to interpret in the ill-lit conditions of S. Marco, but it repays careful looking. It is the great masterpiece of Venetian bronze-relief casting, and the dramatic scenes of the *Entombment* and *Resurrection* (see p. 309) show how gifted a narrative artist Sansovino could be. Francesco Sansovino described his father's reliefs as "made to resemble painting," conveying the painterly quality that remains one of their most outstanding features. The sculptor disregards conventional rules of perspective and allows plasticity of form and evocative modeling to predominate. This can be seen most clearly in the background to the *Entombment*, with its view over hills, the scene of the Crucifixion, and a procession of soldiers; in both relief panels, the sky is given a rich impasto of clouds that reflects in metal the malleability of the wax model. Individual figures, whether the swooning Virgin or the attendant holding Christ's shroud, assume an importance dictated by narrative rather than strictly logical considerations. Sansovino also created a strong chiaroscuro effect through his exaggerated modeling; the contrast between the serenely elegant figure of Christ and the recoiling figures of the soldiers is especially striking.

Of all Sansovino's contributions to the Venetian cityscape, the Loggetta is the most celebrated (see pp. 310–311). Conceived as part of a larger renovation of the entire Piazza, it replaced a humbler wooden and stone structure which served as a meeting place for the nobility beneath the Campanile of S. Marco. The decision of the procurators of S. Marco to build new houses for themselves adjacent to the Campanile, directly opposite the Palazzo Ducale, must have led to plans for upgrading the loggia as well. This would have become more pressing in August 1537 when the Campanile was damaged by lightning; Sansovino's project for a new loggia was ready by November of that same year, and the building was finished by February 1546, thus making it the first complete statement of Sansovino's sculptural and architectural style in his adopted city.

Essentially, the new structure is a brick box, raised five steps above the level of the Piazza and divided into three bays by free-standing columns. Prior to the addition of a terrace in the seventeenth century, there had been benches on the basement level of the facade; each bay contained a round-headed arch, the central one serving as entrance and the lateral ones as windows. Framing the arches were pairs of niches, each containing a bronze statue. Relief sculpture formed a conspicuous part of the decoration, above and below the four bronze figures and across the attic (see p. 314). Like the sculpture adorning the facade of the Palazzo Ducale opposite, the Loggetta's decoration invoked the virtues of the Venetian Republic, especially the bronzes: Minerva or Pallas representing martial vigilance, Apollo, political harmony, Mercury, persuasive eloquence, and Peace, that divine gift conferred on the Venetians by their Evangelist, St. Mark. What was unusual here was the couching of this political message in terms of classical, rather than the more conventional Christian, allegorical figures. In this context, Sansovino was following a precedent already established with Leopardi's bronze standard bases of 1501–5, each of which bears the profile of the reigning doge, Leonardo Loredan, and the names of the procurators responsible for commissioning them, as well as relief scenes which illustrate the bounty of the earth being brought to Venice from her colonies over the sea and from the *terraferma*, and images of Justice, Minerva, and Abundance as tutelary guardians of the Venetian empire. The imagery was drawn from classical literature and would have been appreciated by any contemporary versed in the writings of Virgil and Ovid. Leopardi's standard bases constituted the first phase in the transformation of the Piazza and anticipated the change from religious to classicizing allegories in celebration of the Republic. Sansovino gave

Resurrection of Christ, detail of the bronze door of the sacristy of S. Marco, Jacopo Sansovino, 1545–1569.

The Loggetta of Sansovino, built between 1537 and 1546, with its facade of three great arches and niches in which are bronze statues of Minerva, Apollo, Mercury, and Peace. In 1663 the balustraded terrace was constructed which, in 1735, was closed off with the elegant iron railing by Antonio Gai. Damaged by the collapse of the Campanile in 1902, the Loggetta was reconstructed using the recovered original fragments.

this trend greater visibility with the Loggetta, and Veronese and Tintoretto would further develop it with their ceilings for the Palazzo Ducale.

The Loggetta marks a brilliant fusion of its disparate elements, from the Venetian love for polychrome facades to a central Italian sense of architectural structure. The point of departure for the facade was, in fact, the tomb by Sansovino's contemporary Baldassare Peruzzi for Pope Hadrian VI in the Roman church of S. Maria dell'Anima. Peruzzi's design was particularly important for Sansovino through its orchestration of colored marbles and adaptation of a Composite order with a convex frieze flanking niches with allegorical figures. In Sansovino's hands, the triumphal arch motif of the papal tomb becomes a series of rhythmic arcades crowned by an attic with relief panels. Though broadly accommodated to Venetian tastes and traditions, the Loggetta registers a distinctively Tuscan flavor in its sculptural decoration. This is what one would expect from an artist like Sansovino; after all, one has only to imagine how Tullio Lombardo would have conceived such a facade to appreciate how unlike the present one it would have been. Sansovino's sense of artistic decorum was more flexible, if less learned, than Tullio Lombardo's, and he fashioned the four figures on the Loggetta's facade in the manner of small-scale Florentine bronzes.

The four figures of the classical gods are under life-size and are conceived with the same *Kunstkammer* virtuosity as the small bronzes later made by Giambologna and his circle for the studiolo of Duke Francesco I de' Medici in Florence. Though they are intended to be *all'antica*, the chief source of the sculptor's inspiration was the Florentine tradition of Donatello and Michelangelo. This is not surprising: his Tuscan predecessors formed a more immediate part of Sansovino's artistic makeup than did the works of classical antiquity, far more than contemporary Venetian sculpture, which Sansovino apparently found dry and stilted. The choice of bronze as the medium for the four gods also led Sansovino to think in terms of prototypes like Donatello's famous nude figure of the youthful *David*, here skilfully blended with the dynamic torsion of Michelangelo's unfinished *St. Matthew* to create the pose of the god *Mercury*. Reminiscences of Donatello's *St. George* also inform the stalwart, martial pose of *Minerva*, while *Apollo* is an irreverent offspring of the famous Belvedere *Apollo* (see p. 312). But it would be wrong to insist too much on the pedigree of these marvelous figures, for they, like the reliefs in S. Marco, are genial confections that were clearly prized for a preciosity of style. The *Apollo* and *Mercury*, particularly, served as prototypes for the elegantly sinuous

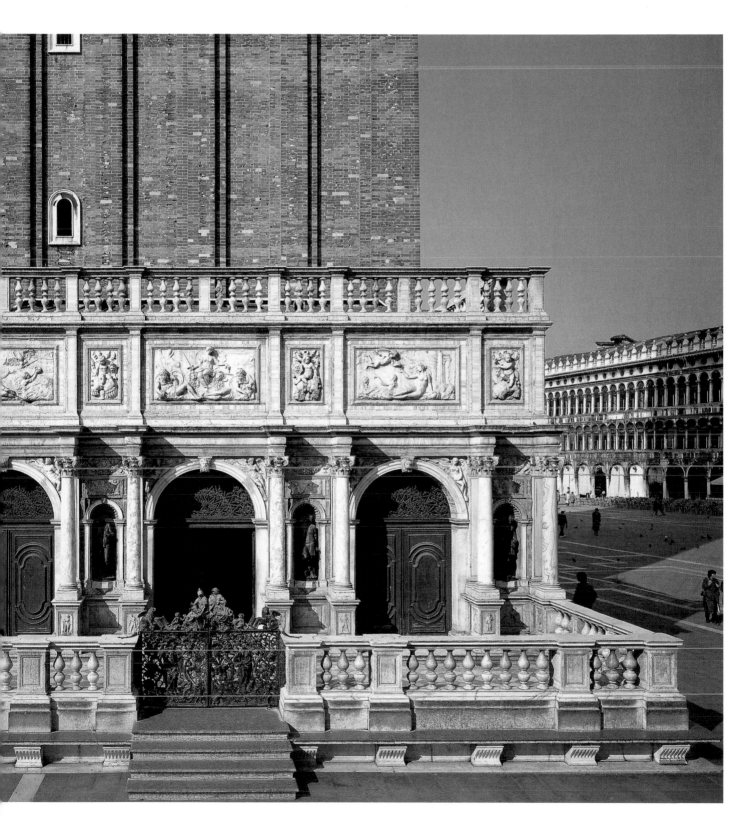

small bronzes associated with Vittoria, Aspetti, and Roccatagliata in the latter part of the century.

One could not find a greater contrast between the Loggetta bronzes and the other great works of Sansovino's last years as a practicing sculptor than the "giants" for the staircase of the Palazzo Ducale (see pp. 316–317) and the pompous tomb for Doge Francesco Venier in the church of S. Salvatore (see p. 315). As he entered the 1550s, Sansovino was well into his sixties, long past the normal age for retirement as a practicing sculptor, and he confessed in a remarkably candid letter to the duke of Ferrara that he hardly touched a chisel any more. Marble carving was much more difficult than modeling for a bronze-caster, and Sansovino's last public works were largely the product of a small army of assistants, following the master's general guidance. This was clearly the case with the "giants," the colossal figures of *Mars* and *Neptune* adorning the top of the ceremonial staircase in the Palazzo Ducale. The two statues were executed by a group of nine men, usually working in groups of three or four, over a period of twelve years, beginning in 1554. The large and rather narrow blocks of marble had been in the stores of the palace for some time when Sansovino accepted the challenge of fashioning them into the ancient gods who symbolized the dominion of Venice on land and sea. The challenge of carving figures from oversize blocks of marble was one that no ambitious sculptor could turn down. For one thing, such blocks had a rarity value which meant that they often turned up only once in a sculptor's career; for another it pitted modern artists against the great sculptors of antiquity, who had created the Colossus of Rhodes and the Dioscuri on the Quirinal in Rome. Then, too, the technical challenges posed by such tasks were by no means inconsiderable: compositions had to be calculated very finely in order to become feasible on a colossal scale; small-scale models had to be enlarged far beyond normal practice; and the complexities of execution in marble or bronze grew exponentially according to the size of the finished product.

Sansovino had already experienced the task of carving over-life-size sculptures, most recently a *Hercules* for Ercole II, duke of Ferrara. Although that statue was hardly an unqualified success, Sansovino's reputation as the leading sculptor in Venice was still uncontested. At the same time, the challenge of carving two prominent works for the most conspicuous site within the Palazzo Ducale was clearly irresistible. Though the contract of 1554 did not specify an exact location and instead employed a vague phrase, the top of Rizzo's ceremonial staircase was probably always intended. The site had the advantage of bringing the figures into view as one

entered the palace through the Arco Foscari, and they flank the entrance to the state rooms much as the *giganti* by Michelangelo and Bandinelli do the entrance to the Palazzo Vecchio in Florence.

Large and unsubtle, the *Mars* and *Neptune* convey effectively the power of the Venetian state. Paintings by Canaletto show how they struck the right note at ceremonies such as the coronation of a new doge. As with the Loggetta deities, here too Sansovino demonstrates his Tuscan origins, turning to Donatello's *St. George* for the pose of his *Mars* and to Bandinelli's *Hercules and Cacus* in Florence for the basic stance of his *Neptune*. The two "giants" were clearly conceived as a pair, their feet placed widely apart and their bodies turned at complementary angles. In fact the similarities between the two figures extend as far as their torsos, which seem to be based upon the same antique prototype with a blandly generalized articulation. There is, too, a sense of constraint about the figures which suggests that the blocks from which they were carved were relatively narrow. This would explain the sharp turn of *Neptune*'s head and the bend of the torso and legs of *Mars*. Jacob Burckhardt, who wrote perceptively about Sansovino's sculpture, touched upon the essential

purpose of these statues when he called them "works without pretension, created with faith, without violent movements or exaggerated musculature. . . . the types, if not perfect, are at least original, and by an artist capable even of sustaining defective motifs with the grandeur of his design."

Shortly after signing the contract for the *Mars* and *Neptune*, Sansovino embarked upon his most important tomb commission in Venice. This was the imposing memorial to Doge Francesco Venier, who reigned from 1554 to 1556. Venier had held important diplomatic and government offices before his election as doge at the age of sixty-five. As he was not robust physically, Doge Venier began to concern himself with his final resting place only a year after he entered office. Previously he had intended to be buried at S. Francesco della Vigna in a humble grave, but his election as doge prompted him to redefine his plans radically, leaving up to 1,500 ducats for a monument occupying an entire bay of the new and prominent church of S. Salvatore. Venier's will suggests that public expectations played a role in his decision to create an imposing monument, which would also be a monument for his brother and nephews. This was typical of the tradition of ducal

Venice Represented as Justice, Jacopo Sansovino, detail of the central scene in a marble relief over the central arch of the Loggetta.

OPPOSITE:
Funerary monument of Doge Francesco
Venier in S. Salvador. Executed between 1555
and 1561, the figure of the deceased lies
between Charity and Hope; the work is
signed: JACOBUS SANSOVINUS
SCULPTOR ET ARCHITECTUS
FLORENTINUS. The lunette with the Pietà
between St. Francis and the doge is by
Alessandro Vittoria. Its classical simplicity
distinguishes the monument from the
grandiloquence of other funerary monuments
in Venetian churches.

tombs at least from the fourteenth century, and
competition between families led to the expansion in
scale and numbers of such monuments from the
latter half of the fifteenth century. Throughout this
period, the most elaborate tombs in Venice were built
by or for doges; possibly decorum prevented private
persons from emulating them too closely. Doge's
monuments typically included a recumbent effigy
and figures of Virtues or patron saints, often placed
within an architectural framework. As with many
other tombs, the doge's memorial celebrated his
family and *casata* as well as himself. Sometimes the
presence of more than one doge within a family led
to dynastic monuments, like the Mocenigo tombs in
SS. Giovanni e Paolo.

Venier's monument was finished by 1561, a few
years after his death. It conforms almost rigidly to
the pattern of previous ducal monuments, especially
Tullio Lombardo's classicizing tomb for Doge
Giovanni Mocenigo, executed in the 1520s, only a
few years prior to Sansovino's arrival in Venice (see
p. 315). It anticipated Sansovino's model for Doge
Venier in its subdued polychromy, austere lines, and
reduction of the ancillary figures to two. The
retrospective quality of the Venier tomb may derive
from a wish by the doge or his family for a monu-
ment following the general pattern of its predeces-
sors. Here again Sansovino accommodated his style
to Venetian traditions. The design is reminiscent of
the Loggetta in its orchestration of polychrome
marbles and free-standing Composite columns divi-
ding the work into three bays. Though largely
executed by assistants, the tomb succeeds through its
controlled opulence and the high quality of its sculp-
tural details. This is especially apparent in the single
figure of *Hope*, shown in the act of turning inward
and upward toward the effigy of the doge. Far more
arresting than its companion *Charity*, *Hope* is gener-
ally considered the finest of Sansovino's late auto-
graph works. It displays a family resemblance to
other works by Sansovino and has the grace and
elegance that were hallmarks of his female figures. At
the same time it has an affinity with the type of
demure figures of Virtues found on earlier tombs like
Antonio Rizzo's monument to Doge Niccolò Tron in
the Frari. Largely executed by Sansovino's shop,
Hope nonetheless comes alive through its extraordi-
nary intensity of expression. Whatever energy
Sansovino applied to the sculpture must have been
lavished on this aspect; although most statues never
transcend an external tableau, *Hope* does become an
embodiment of its virtue. The statue is a remarkable
tribute to the sculptor's creativity in a particular field
of sculpture in which, as Vasari put it, "Jacopo had
no equal."

Tombs and monuments in churches are one of the
most notable legacies of the Venetian Republic, as
any visitor to Venice can appreciate. The most
conspicuous among them were included among the
sites to see from the late fifteenth century, and their
number and variety expanded remarkably during the
sixteenth century. While those of doges like Francesco
Venier or Leonardo Loredan remained among the
largest and most visible, other monuments were
erected to military heroes and procurators, whose
office, like that of the doge, was held for life. The
great churches of the Dominicans and Franciscans,
SS. Giovanni e Paolo, and S. Maria dei Frari, had
gradually filled up with tombs by the sixteenth
century so that alternatives were found in newer
churches like S. Marina or S. Salvatore, or in a
church with which the deceased's family had connec-
tions. Monuments to doges and other political
figures were seen as reflecting glory not only on the
individual but upon his family, and several genera-
tions were often buried beneath one monument.

The facade tomb was undoubtedly the notable
development in this area during the sixteenth century.
This had been an ancient form of burial in the city, as
the Tiepolo, Bon, and Michiel monuments on the
exterior of SS. Giovanni e Paolo bear witness. The
custom enjoyed a revival with Antonio Rizzo's
monument to Vettor Capello at S. Elena during
the late fifteenth century. The tableau of Capello
kneeling before St. Helena inspired a number of vari-
ants during the sixteenth century, none more bizarre
than that to Tommaso Rangone on the facade of S.
Giuliano (see p. 318). The facade and Rangone's
bronze statue were a collaborative effort between
Sansovino and his most talented follower, Alessandro
Vittoria, but the driving force behind it was the
vanity of the patron. A poor boy who made good,
Rangone amassed a considerable fortune as a doctor
and began to translate a portion of his wealth into
benefactions in the 1550s. At the same time he began
to think about erecting an enduring monument for
himself on his parish church, which then lacked a
facade. In 1552 Rangone proposed to pay for the
completion of the facade in exchange for the right to
incorporate a monument to himself on it. This was
not an unusual offer in general terms, but the audacity
of Rangone's gesture lay in the location of his parish
church, S. Geminiano, facing S. Marco on the oppo-
site side of the Piazza. The petition was not accepted by
virtue of the long-standing custom that forbade monu-
ments to individuals in Piazza S. Marco, although
Rangone's offer did prod the Venetian government
into finishing the construction of the church.

The refusal did not deter Rangone for long. In
September 1553 he struck a similar agreement with

ON PP. 316–317:
The monumental Scala dei Giganti in the
courtyard of the Palazzo Ducale, based on a
project by Antonio Rizzo. The staircase
received its name following Sansovino's
arrangement of the statues of *Neptune* and
Mars in 1556. The coronation ceremony of
the doge was held here against a splendid
theatrical backdrop.

FRANCISCVS VENERIVS PRINCEPS PRISCAE MAIORVM
VIRTVTIS AC DISCIPLINAE SEVE IMITATOR EMVLVS NEC
ADMIRARI LAVDIS STIMVLARE PRIVATAE VTILITATIS
CONTINENTIAE IN DICVNDA SENTENTIA SENATORIAE
GRAVITATIS MODVS ET CONCORDIAE AMANTISS IN OMNI
SERMONE SAPIENTISS SEMPER IN PRINCIPATVM EIVS PRAETER
ORNAMENTA PRINCIPIS GRATO ESSE ALVTEM IMPERIVM
CVM IN CIVIVM LIBERIS GVBVS ITA EMPE MO
VIX ANNVM PRIDIE EI IN PRINCIPAL V ANIMVM AEDES XXII
OBIIT HIS O IVNII M D XV

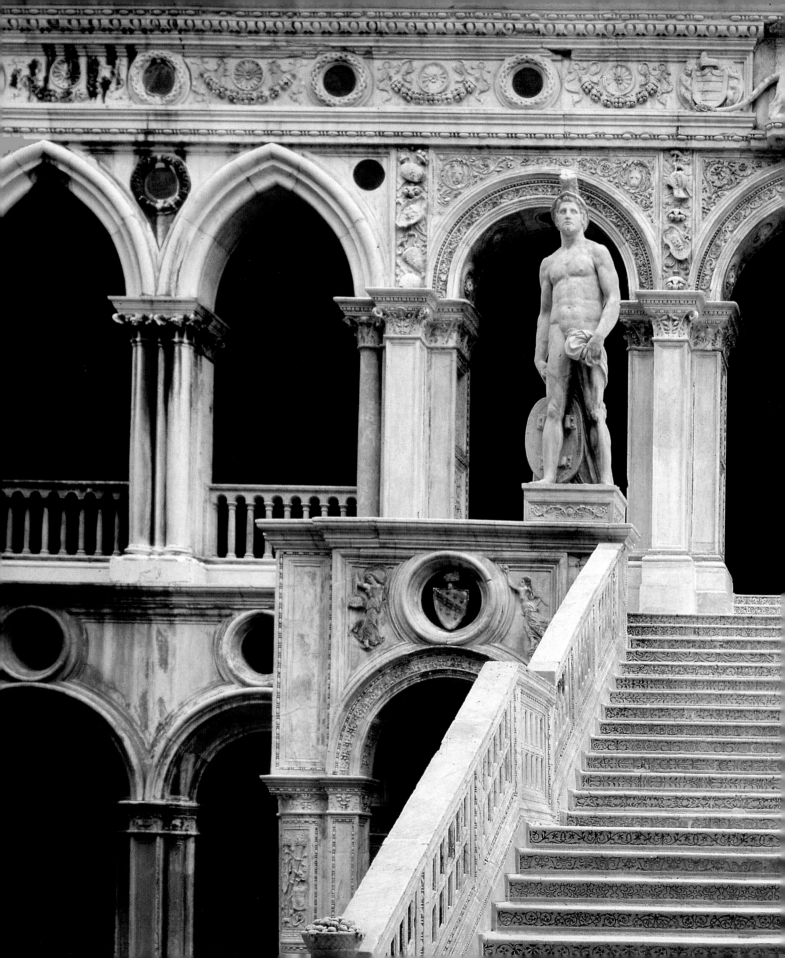

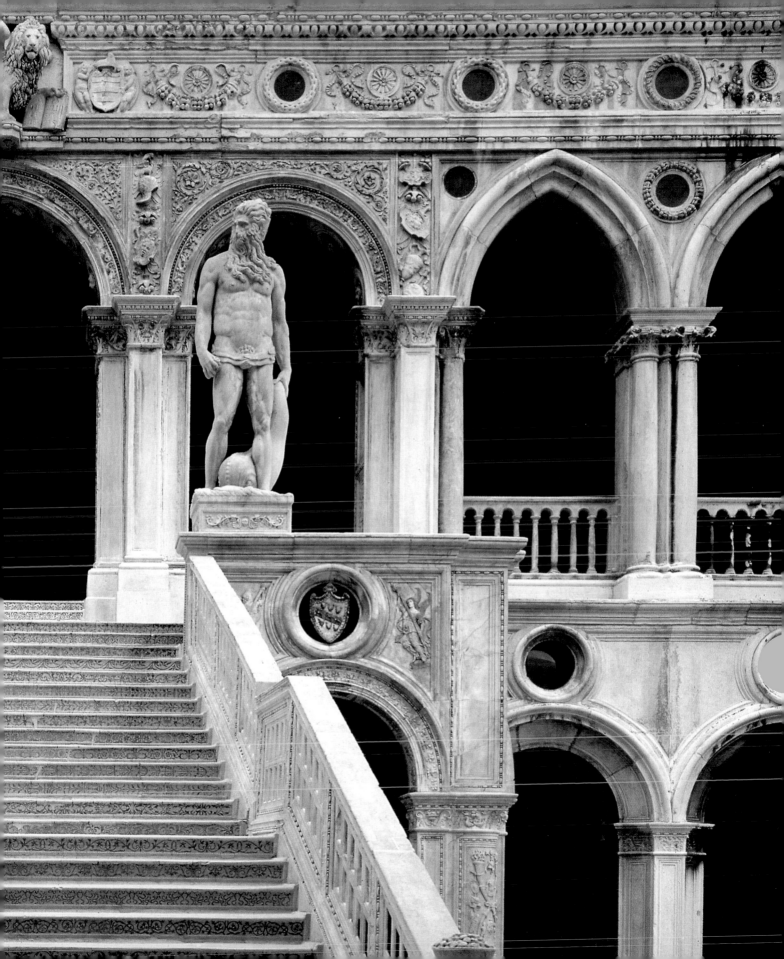

the chapter of S. Giuliano to pay for a new facade on which he could place his own image in bronze, together with inscriptions and other devices in celebration of his achievements. While not in so prominent a position, the church of S. Giuliano stood at a widening of the main thoroughfare between the Piazza and the Rialto bridge and was a conspicuous site for such a monument. Rangone spent almost as much money on his monument as he did on the church's facade, which became essentially a backdrop to the central image of the physician, seated at a desk and surrounded by books and terrestrial and celestial

Tommaso Rangone, Sansovino and Alessandro Vittoria. The bronze statue of the physician and philosopher was placed above the portal of the church of S. Giuliano.

globes. The accompanying inscriptions testify to Rangone's intellectual attainments and his other benefactions without so much as a passing reference to the Christian faith. The basic theme is the celebration of the scholar in his study, here turned into high relief. While the basic concept was designed by Sansovino, his model for Rangone's figure was damaged in the initial casting. It was replaced by another model, this time furnished by Vittoria; the casting was successful, and the work was finished early in 1557 (see p. 319).

Rangone's monument is, in many ways, exceptional, but it is an exception that proves a general rule about Venetian tombs of this period. Of those that survive or are recorded, the great majority were built for members of the patriciate, and the chief spur to their existence was the achievement of high office within the State, the military, or the Church.

The Contarini Chapel in Madonna dell'Orto, the Corner monuments in the transept of S. Salvatore, and the Da Lezze monument in the Gesuiti all fall into this category. The Da Lezze monument (see p. 320) is typical of several trends in funerary monuments during the later sixteenth century. It occupies the entire entrance wall of the church and consists of three busts of three generations of the same family who successively became procurators of S. Marco. The idea probably originated with the middle generation, Giovanni da Lezze, who commissioned it in 1576, and had his own and his father's portrait busts installed. The bust of Giovanni's son Andrea was added in the early seventeenth century. The motif of a Michelangelesque tomb surmounted by a bust appears to have originated with Vittoria, and it became a popular feature in many late-sixteenth-century memorials. The emphasis upon the celebration of the family was characteristic of aristocratic culture in Renaissance Venice, as the proliferation of such monuments testifies.

Sansovino dominated Venetian sculpture around the middle of the sixteenth century much as his close friend Titian did painting. He was able to do so through an extensive network of followers and collaborators who perpetuated his style long after his death in 1570. Any consideration of his achievement must take into account the role of his followers and how Sansovino employed them in his major projects. If one looks at the pattern of Sansovino's sculpture during his Venetian years, one can see that his practice was run along industrial lines. This was already true of the great dynastic workshops of the fifteenth century where specialization would have been encouraged by the volume of work. In Sansovino's case the constant pressure of his architectural commitments for the Procuratia de Supra of S. Marco forced him to rationalize his other commissions. This led to a highly disciplined and sophisticated division of labor, whereby Sansovino's attention was focused upon the first stages in the creation of a sculpture. This normally involved the fashioning of a model in clay or wax. Once a definitive design was adopted on this scale he could turn over the enlargement or casting of the model to assistants. This would have been the process for his bronzes and for statuary such as the "giants" or the Virtues on the Venier monument. Carving, too, was a fairly mechanical process in the early stages, which would have been entrusted to specialist *squadratori* who blocked out figures and to members of the workshop who brought the marble toward a state of completion when Sansovino could intervene if necessary. The process worked best with bronze because it allowed for mechanical reproduction of a design with a

Bust of *Tommaso Rangone*, Sansovino and Alessandro Vittoria, an elegant and expressive portrait. Venice, Ateneo Veneto.

higher degree of quality control than was the case with marble.

Of Sansovino's closest collaborators, Tiziano Minio, Danese Cattaneo, and Alessandro Vittoria represent the diverse career patterns of his Venetian followers. Minio was the nickname of Tiziano Aspetti, who was born in Padua around 1511/12, the son of the bronze founder Guido Lizzaro. His early years were spent in Padua where he learned his father's trade and was drawn into local artistic circles, especially that of the amateur architect and patron Alvise Cornaro. After learning bronze casting, Minio acquired training as a stuccoist under Giovanni Maria Mosca, participating in the decoration of the vault of the chapel of the Arca del Santo in Padua in 1533. There he worked under Falconetto and alongside another Sansovino protégé, Danese Cattaneo. Around 1536 Minio executed his first independent work, a large stucco altar for the confraternity of S. Rocco in Padua. Though provincial and derivative, the altar displays an awareness of Sansovino's style, in particular the general format of the Loggetta. By this date Minio was already working for Sansovino as a stuccoist in the atrium of S. Marco. His coming and going between Padua and Venice during the 1530s and 1540s reminds us how close artistic ties were between the two cities.

Sansovino evidently valued Minio as a decorative artist and for his knowledge of bronze casting. He assigned him some of the smaller relief panels of the Loggetta and possibly recommended him to Vasari as a collaborator on the setting for a production of Aretino's *La Talenta* in 1542. Few works survive that testify to Minio's skills, but one can be seen in the Baptistery of S. Marco, the cover for the baptismal font. This was a project very much in Sansovino's gift

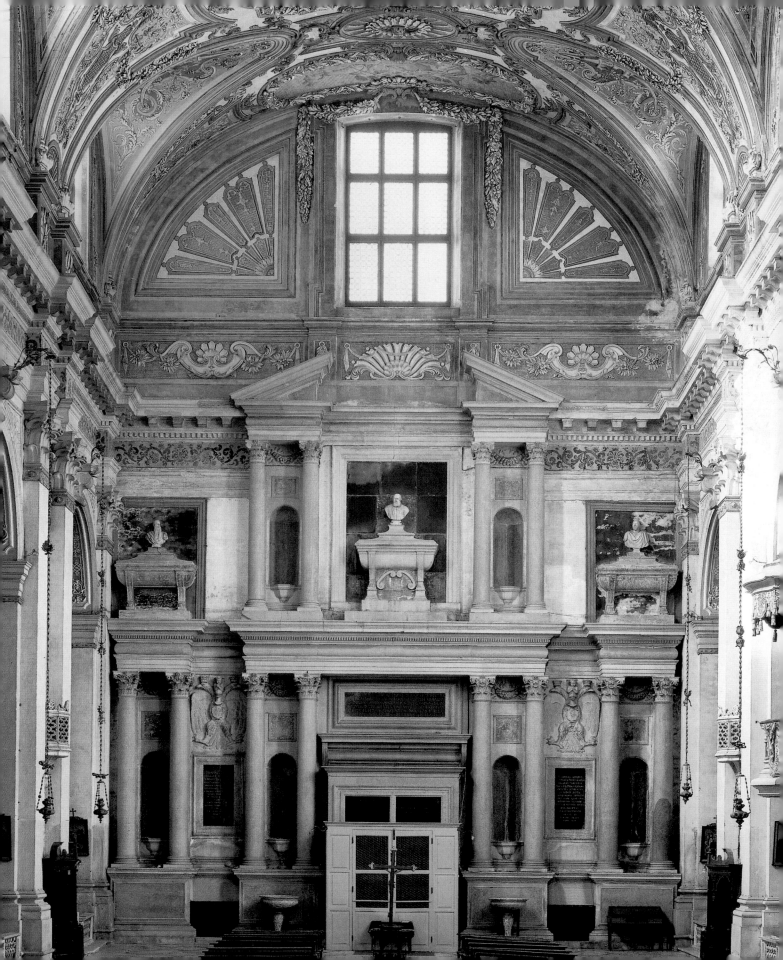

as he had persuaded the procurators to use a large block of marble in their stores for its base and drew up the contract for the execution of its bronze cover. Although the contract was also signed by Desiderio da Firenze, the bulk of the design reflects Minio Tiziano's style as known in other works, and must represent his own invention. The cover has lost the setting for its eight panels—probably the contribution of Desiderio—yet what survives is a series of bronze reliefs of great elegance. The reliefs treat four scenes from the life of the Baptist and the Evangelists. The latter are shown seated against an impasto of clouds, reminiscent of Sansovino's relief of the *Resurrection* on the sacristy door. The scenes from the life of the Baptist are more inventive, although many of the figures mimic Sansovino's style, and even that of Ghiberti and Donatello. This is especially clear in a relief like the *Baptism of Christ*, where the whole conception of narrative is completely alien to the Venetian tradition and oriented toward that of central Italy. Its basic premise derives from Sansovino's *Baptism of Ananius* in the choir of S. Marco, in which each figure is given a distinctive response to the main event. Individual figures and the impressionistic treatment of landscape recall the general style of Sansovino's bronze reliefs, but there are other elements, such as the bald spectator on the viewer's right, that point to an awareness of the work of Leonardo and Rustici, Florentine artists whose work Minio could only have known through Sansovino.

The reliefs of the baptismal font underscore the nature of the change effected in Venetian sculpture by Sansovino's presence after 1527. Minio's early death meant that he never realized his full potential, yet his position in the circles of Alvise Cornaro and of the Arca del Santo made him crucial in the diffusion of Sansovino's style in Padua and in the Veneto as a whole. His association with Agostino Zoppo and his own nephew, Tiziano Minio, fostered the continuation of the Sansovinesque style into the next century.

Minio occasionally collaborated with another Sansovino protégé, Danese Cattaneo. The two were almost exact contemporaries, Cattaneo having been born in the marble quarries near Carrara around 1509. His birthplace probably explains his inclination towards sculpture, and he was apparently apprenticed to Sansovino in the 1520s. He developed an especially close relationship with Sansovino, whose son Francesco affectionately described him as "full of genuine goodness." Cattaneo followed his master to Venice and quickly established himself as an independent sculptor. His earliest surviving work is a statuette of St. Jerome, which he executed in

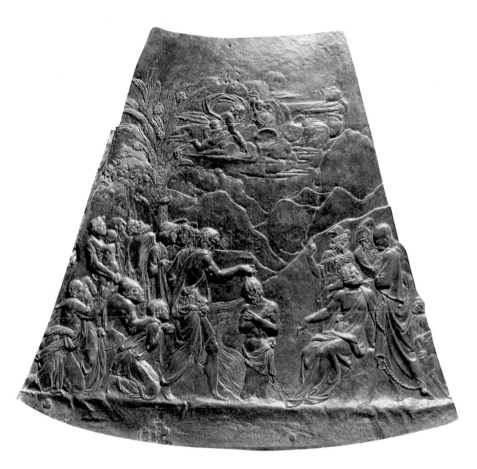

Baptism of Christ, Tiziano Minio. Bronze relief, in the Baptistery of S. Marco. Originally part of a cover for the baptismal font, designed by Sansovino in 1545 and executed by Minio.

OPPOSITE:
Funerary monument of the Da Lezze family, on the entrance wall of S. Maria Assunta dei Gesuiti, begun 1576. The imposing two-level architectonic structure frames busts, placed on sarcophagi, of three generations: Giovanni, by Sansovino, and Priamo and Andrea, by Giulio del Moro.

competition with a work by another Sansovino follower, Jacopo Colonna, in 1530. The *St. Jerome* was conceived as an ornament for the Merceria portal of S. Salvador, and with its figure Cattaneo already demonstrates a thorough familiarity with Sansovino's style. If imitation is a sign of discipleship, then Cattaneo proclaims himself here as Sansovino's follower; he was to remain so until his death in 1572.

Cattaneo spent his early years on a variety of projects, an experience he shared with most of Sansovino's Venetian followers. He worked with Tiziano Minio on the stucco decorations of the vault of the chapel of the Arca del Santo in the early 1530s, and subsequently teamed up with Jacopo Colonna and Silvio Cosini on the figural component of an altar by Sebastiano Serlio for a church in Bologna. During the 1540s Cattaneo received three important commissions which established his career: the statue of the sun god for the Zecca in Venice, the bust of Pietro Bembo for his monument in the Santo in Padua, and the task of creating bronze gates for the chapel of the Arca del Santo, this last remaining unfinished with the death of his collaborator, Minio. Both the *Sun* and the bust of Bembo illustrate aspects of Cattaneo's peculiar gifts as a sculptor. The *Sun* represented an important and unusual secular commission from the Venetian State, and Cattaneo may have obtained it through Sansovino, the building's architect. Vasari tells us that Cattaneo proposed a cycle of three statues for the Mint: a sun to signify gold, a moon for silver, and an unspecified work for copper. As Vasari received his information from Cattaneo, there seems little reason to doubt it, but in the event only one statue was executed. Formerly on the wellhead in the courtyard of the Zecca and now at Palazzo Pesaro, the *Sun* shows its creator's gift for poetic invention. By any standard, it is an unconventional piece of sculpture, with the sun god a nude figure seated upon a golden globe which in turn is supported by mounds of gold generated by the rays of the sun. In his left hand the figure holds a gold wand while in his right is a scepter surmounted by an eye. The basic pose recalls Michelangelo's statue of Giuliano de' Medici, but Cattaneo's grasp on anatomy is less sure, and the overall effect is more decorative. The features of the figure reflect the softer style of Sansovino and, possibly, of Bartolomeo Ammannati, whose presence in Venice and Padua during the 1540s had an evident impact upon Cattaneo.

The elaborate program of the *Sun* shows Cattaneo's highly literary approach to his craft, something conditioned by his other vocation, poetry. The pull between poetry and sculpture proved to be a recurrent theme of much of the sculptor's later work, but

it also made him a sympathetic student of human nature in the realm of portraiture. This can be seen in his bust of Pietro Bembo in the Santo and in later works like the professor Lazzaro Bonamico in the Museo Civico of Bassano, or Gianandrea Badoer in the little church of S. Giovanni Evangelista, opposite the *scuola* of that name in Venice. All three busts share an incisive characterization of the sitter and

Tomb of Doge Leonardo Loredan, in SS. Giovanni e Paolo, by Giovanni Grapiglia and Danese Cattaneo. The image of the seated doge was a break with prevailing iconographic convention; the doge is flanked by allegorical statues, including personifications of the League of Cambrai and a powerful Venice. Opposite: detail.

bell-like treatment of the upper torso. The bust of Bembo effectively launched the new type of *all'antica* portraiture in the Veneto. Executed between 1548 and 1549, the bust was admired by Aretino and Sansovino, among other contemporaries. It followed closely upon a pseudoclassical bronze bust of the

Roman author Livy which had been modeled by the Paduan sculptor Agostino Zoppo for a monument in 1547. As in the fifteenth century, Padua exercised the role of intellectual stimulus for Venetian art, both in terms of classicizing relief sculpture at the church of the Santo and in launching the vogue for the portrait bust *all'antica*. In this field Cattaneo's ability to convey personality within a classicizing framework

years, his career unfolded very much in the shadow of his master's, and he often had to content himself with the role of collaborator. Hence, he spent much of his career at work on the decorative sculpture for the Library and Loggetta and in carving fireplaces in the Palazzo Ducale under Sansovino's direction. But he also lavished much time on his literary career, culminating with the publication of a long poem,

laid the foundations for the kind of portrait bust more commonly associated with Alessandro Vittoria.

Despite his gifts, Cattaneo's output was meager and his material success less conspicuous than Vittoria's. As he only survived Sansovino by two

L'Amor di Marfisa [Marfisa's love], in 1562, as well as numerous unpublished poems and plays. Obviously these pursuits took time away from sculpture, and as early as 1545 Pietro Aretino observed that if Cattaneo gave his undivided attention to sculpture, he would surpass even his master Sansovino.

Toward the end of his career, Cattaneo created two of his greatest achievements, the Fregoso altar in Verona and the tomb of Doge Leonardo Loredan in Venice. Both, essentially family memorials, show a merging of the artist's interests in sculpture and literature. In both cases Cattaneo altered the conventional formulas for such memorials by his distinctive approach to art. He achieved this with the Fregoso altar by combining what was effectively a tomb to a condottiere with an altar dedicated to the Redeemer. Though the format of an altar-tomb was not without precedent in Verona, it was highly unconventional and in marked contrast to the more traditional types of monument created by Sansovino. Fregoso is seen standing between the Risen Christ and a figure representing military virtue; there are also reliefs of Minerva and Victory while statues of Fame and Eternity crown the work above. In the main, Cattaneo was following the example of Bartolomeo Ammannati's tomb of Marco Mantova Benavides at the Eremitani, Padua, in which abstract symbolism vanquishes religious imagery.

The Loredan monument builds upon this ambitious format with an almost pictorial treatment of the greatest episode from the doge's career, the war of the League of Cambrai (1509–16). Though he died in 1521, Leonardo Loredan's monument was postponed for several decades. His family acquired the rights to the presbytery of SS. Giovanni e Paolo for a free-standing monument of conspicuous proportions. The project fell victim to inertia and to the change in religious sensitivities that made such projects seem too worldly with the Council of Trent. Eventually, a more modest wall monument was commissioned from Cattaneo and Giovanni Grapiglia in the 1560s. As with the Fregoso altar, there is a tendency toward allegory, but here the message is exclusively secular. Within a triumphal arch, Cattaneo recreates something of the message of Sansovino's Loggetta with his allegorical statues framed by columns; indeed, Cattaneo's figure of *Peace* exactly copies that by Sansovino on the Loggetta. The center of the monument, however, contains a tableau in which the doge sits enthroned between female personifications of the League of Cambrai and the armed might of Venice, reminiscent of the commemorative painting of Doge Loredan by Palma the Younger in the Sala del Senato of the Palazzo Ducale. Only an artist with the imagination of Cattaneo could have drawn upon the allegorical mode of the Loggetta while marrying it to the format of a funerary monument. The inclusion of statues in action recalls the great tombs of the late-fifteenth-century doges like Pietro Mocenigo, and was doubtless intended to prompt such comparisons. The

The superb Scala d'Oro in the Palazzo Ducale, reserved for magistrates and other illustrious persons, gave access to the private ducal appartments and to the magistracy's meeting rooms on the *piano nobile*. The stairway was executed in the second half of the 16th century following a Sansovinesque design and was brought to completion by Scarpagnino. The barrel-vaulted ceiling was richly decorated with white and gilded stucco reliefs by Alessandro Vittoria.

St. Roch, St. Anthony Abbot, and St. Sebastian, Alessandro Vittoria, on the Montefeltro altar in S. Francesco della Vigna, 1561–1565.

OPPOSITE:
St. Jerome, Alessandro Vittoria, 1570, in S. Maria Gloriosa dei Frari. The tormented and powerful figure of the saint originally belonged to a now dispersed architectural-sculptural complex.

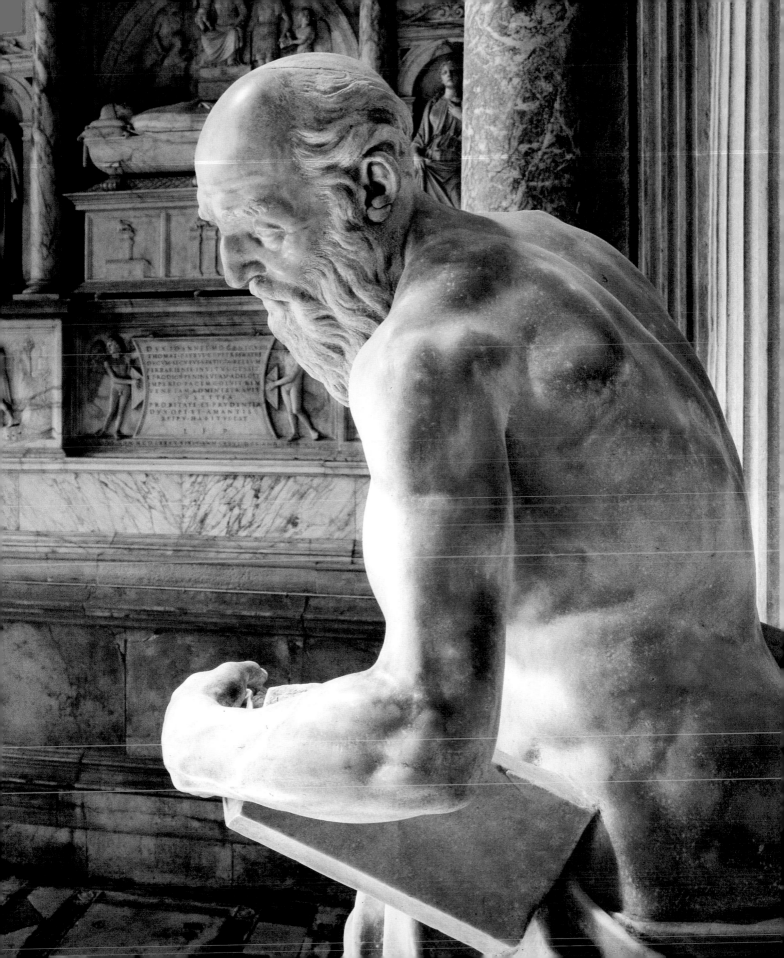

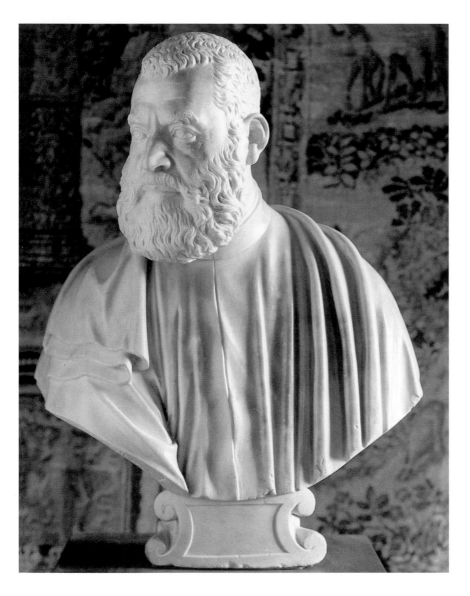

Benedetto Manzini, Alessandro Vittoria. Venice, Ca' d'Oro.

OPPOSITE:
The monumental fireplace in the Sala dell'Anticollegio in the Palazzo Ducale, a complex and splendid composition which combines two marble *atlantes* [Atlas figures], a frieze depicting *Venus Asking Vulcan for Armor for Aeneas*, ephebes, and putti.

consider service at the imperial court in Vienna. The reply of his agent is noteworthy because it gives a well-informed account of the Venetian artistic scene at that date. Among sculptors, the agent reports that Alessandro Vittoria is regarded as best after Sansovino, with Danese Cattaneo trailing a poor third. While this was a bit hard on Cattaneo, it underscores the preeminence that Vittoria enjoyed over his rivals even before Sansovino's death. Already in 1568, Vasari published a warmly appreciative account of his career in the *Vite*, and Vittoria's bravura in portraiture, statuary, and stucco work made him indispensable in Venice throughout a long and profitable career.

Vittoria was a generation younger than Cattaneo, born in 1525. As a boy he may have gained some knowledge of sculpture from his native Trent. He left Trent for Venice in 1543 and entered Sansovino's workshop. It was a fortunate moment for the young man's arrival: Sansovino was at the height of his powers and had in hand several important commissions, including the second series of choir reliefs, the sacristy door, the Loggetta bronzes, and the external decoration of the Library. These works, especially the bronzes, formed the basis of Vittoria's artistic style as well as the touchstone of his later career. By 1550 Vittoria was carving river gods for the spandrels of the Library arches and executing his first independent works in his master's style. The little *St. John the Baptist* on the holy water font in S. Zaccaria betrays an unmistakable debt to Sansovino's earlier marble of the same subject in the Frari for its physical type and pathos as well as for its treatment of drapery and extended right arm. At the same time, the elongated form and attenuated proportions of the *Baptist* point to the stimulus of more recent works, like the sacristy door reliefs and Sansovino's more mannered style when working in bronze.

Shortly after the execution of the *Baptist*, Vittoria quarreled with Sansovino and departed for Vicenza where he established himself as a stuccoist under Andrea Palladio at Palazzo Thiene. He remained there from 1551 until 1553, and his ceilings in Palazzo Thiene mark the first of numerous decorative cycles associated with his name. In Vicenza, Vittoria made contact with artists like Paolo Veronese and Bernardo India, whose interest in the work of Giulio Romano and Parmigianino widened Vittoria's artistic frame of reference considerably. In particular, the example of Parmigianino, whose drawings Vittoria would later collect, drew the young sculptor toward the inflected, ethereal manner that became a hallmark of his later work.

Vittoria's feud with Sansovino ended in 1553, and he was rewarded with his first major commission in

central image of the doge is unusual because it shows him seated, a break with prevailing iconographic conventions. The seated image invites comparisons with papal statues and those of other rulers, enhancing the pretensions of the doge. Cattaneo's efforts here resulted in a monument that is pivotal in the history of the ducal tombs, looking back to the earlier Renaissance and forward to the great Baroque *macchine* of the next century. The Loredan monument remains Cattaneo's most enduring achievement as a Venetian sculptor.

As Cattaneo was working on the Loredan tomb in 1569, the Emperor Maximilian II made inquiries in Venice about sculptors and architects who might

Venice, the two oversize female figures that flank the entrance to Sansovino's Library in the Piazzetta. Known as the *feminoni* [big women], these sculptures paraphrase similar caryatids designed by Sansovino, but they are even more reminiscent of the kind of corpulent women in contemporary paintings by Veronese and Tintoretto. The appeal of such figures is not immediate to a modern audience, yet they were praised by no less a connoisseur than Giorgio Vasari drew attention to Vittoria as the coming sculptor of the younger generation. By the late 1550s, Vittoria had landed two prestigious contracts for the stucco decoration of the Library's staircase and the new ceremonial entrance created in the Palazzo Ducale, the Scala d'Oro (see pp. 324–325). In both works, the basic decorative schemes stem from Sansovinesque designs which would have been approved by the elder artist even though they are more luxuriously embellished than in Sansovino's own work. Vittoria's figural style also breaks more decisively with Sansovino in these stuccoed reliefs, betraying unmistakable influence from Veronese's ceilings in the church of S. Sebastiano and the Sala del Consiglio dei Dieci. His more convoluted and attenuated forms distinguish Vittoria from Sansovino, and clearly align him with the younger generation of painters who made their debut with the ceiling paintings of the Sala d'Oro of the Library and in the Palazzo Ducale.

A similar aesthetic creed informs Vittoria's early statuary. During the early 1560s Vittoria carved three figures for the Montefeltro altar in S. Francesco della Vigna: *St. Roch, St. Anthony Abbot, and St. Sebastian* (see p. 326). The three are still much indebted to Sansovino in terms of morphology, but new influences also emerge. In particular, the *St. Sebastian* looks beyond obvious models such as the Loggetta bronzes to the elder son of the famous Hellenistic group of the *Laocoon*, albeit as seen through the spectacles of a Mannerist artist like Parmigianino. There is about Vittoria's figure on the Montefeltro altar a self-conscious preoccupation with beautiful forms, a feature characteristic of his best work. The *St. Sebastian* has the appearance of an enlarged bronze statuette; it is not surprising that the sculptor had its model preserved as a handsome small bronze whose sinuosity can be even better appreciated. Vittoria was probably at his best on a small scale, and he successfully continued making such works throughout his career, never perhaps, with greater panache than in the *Prophet Daniel* and *St. Catherine* for the Mercers' altar in S. Giuliano, executed in the 1580s to flank an altarpiece of the *Assumption of the Virgin* by Vittoria's close friend Palma Giovane. Here, too, the impression is of a

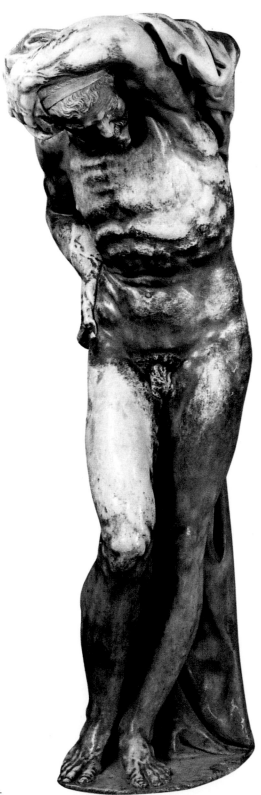

The *atlantes* supporting the fireplace in the
Sala dell'Anticollegio in the Palazzo Ducale.

composition that could as easily have been executed
in bronze as in marble. The gracefulness and formal
dexterity of the two figures would not have shamed
an artist like Parmigianino.

By contrast, Vittoria's *St. Jerome* in the Frari regis-
ters a movement towards larger forms and a careful
mastery of human anatomy that indicates an aware-
ness of Michelangelo, probably gained through
the mediating influence of Tintoretto (see p. 327).
The Frari *St. Jerome* was probably executed around
1570 and demonstrates how far the sculptor had
traveled since the Montefeltro altar. His second *St.
Jerome*, finished in the late 1570s for the Scuola di S.
Maria della Giustizia e S. Girolamo and now in SS.
Giovanni e Paolo, represents a less heroic, more
internalized conception of the saint, an image in
keeping with the *scuola*'s principal function of
accompanying prisoners to execution. The same
command of anatomy is there, but this time it is
coupled with a more complex, serpentine pose and
an expression of great pathos. These elements save
the composition from being an exercise in arid
academicism, and Vittoria shows himself here
conversant with the artistic preoccupations of
Tintoretto. With this second *St. Jerome*, Vittoria
created one of the great marble sculptures of late-
sixteenth-century Venetian art.

Vittoria ought to have been the sculptural equiva-
lent of Tintoretto, being essentially of the same
generation as the painter, yet painting and sculpture
did not develop *pari passu* in mid-century Venice.
Beyond that, Vittoria seems to have delegated an
increasing amount of work to his shop, with the
result that a certain flaccidity often pervades his later
statuary, such as the over-life-size *Evangelists* for
S. Giorgio Maggiore. The only sphere in which
Vittoria could be said to have outdone contemporary
painters like Tintoretto lay in portraiture, which the
sculptor monopolized for the latter part of the
century. It was also an aspect of sculpture for which
Sansovino evinced little interest; characteristic of this
was his handing over to Vittoria the statue of
Tommaso Rangone for the facade of S. Giuliano.

Vittoria's first ventures into portraiture, like the
bust of Marcantonio Grimani in S. Sebastiano or
Benedetto Manzini in the Ca' d'Oro (see p. 328), are
based on the *all'antica* style of Simone Bianco, who
was active in Venice in the 1540s, and of Danese
Cattaneo, especially his celebrated bust of Pietro
Bembo in the Santo which the young Vittoria prob-
ably saw being carved in Cattaneo's Venetian studio.
Vittoria built upon the psychological perceptiveness
and directness of Cattaneo's portraits, but his charac-
terizations are more dramatic, the treatment of
drapery in his aristocratic images more imposing

than Cattaneo's. The bust of Mancini initially adorned the church of S. Geminiano, of which the sitter was parish priest and largely responsible for the completion of its fabric. The bust of Marcantonio Grimani still stands in his chapel at S. Sebastiano and gives us an idea of how subsequent busts by Vittoria would have been displayed. The bust is placed in a niche on the left-hand side of the chapel, with an epitaph beneath. Two statuettes of Grimani's name saints, Mark and Anthony Abbot, stand to either side of the altar. Like the bust of Mancini, that of Grimani displays a vigor far removed from his classical models. Both focus the spectator's attention almost as if in conversation; their features, too, are closely observed, thus heightening their sense of presence. Evidently Grimani was pleased with the result and wanted a copy of the bust made for his palace; he also wrote in his will that if ever the church of S. Sebastiano fell into ruin, his bust should be removed to the offices of the procurators of S. Marco.

At their best, Vittoria's busts have an immediacy unmatched by any other contemporary artist. With his succession of doges and military heroes, Vittoria created a three-dimensional counterpart to that *gravitas* so noticeable in Tintoretto's presentation of the Venetian aristocracy. This is especially true of his masterpiece in official portraiture, the great half-length bust of Doge Nicolò da Ponte, now in the Seminario Patriarcale. This was Vittoria's only half-length bust and was modeled in terracotta before the doge's death in 1585. Measuring one meter high, the bust was Vittoria's largest, and was probably always intended for the doge's tomb. Certainly it is a rivetting characterization of power in the majesty of the head and the amplitude of drapery. The Da Ponte bust rivals that other great embodiment of power in sixteenth-century Italian sculpture, Cellini's bronze portrait of Duke Cosimo I de' Medici, and shows Vittoria at the height of his abilities.

Vittoria played a major part in the sculpture of Venice almost down to his death in 1608, but if any one sculptor dominated the last two decades of the sixteenth century, it was not Vittoria but his younger rival Girolamo Campagna. It is significant that Campagna was born in 1549, thus making him a generation younger than Vittoria and the youngest of the major sculptors operating in the final quarter of the century. He trained with Danese Cattaneo in his native Verona and could be described as an artistic grandson of Sansovino. He benefited from his master's unexpected death in 1572 and stepped into his first major commission, the *Miracle of the Raising of the Young Man at Lisbon*, the last relief in the cycle for the chapel of the Arca del Santo in Padua. Its successful completion gave Campagna the

The main altar designed by Girolamo Campagna for the church of the Redentore, with the great *Crucifixion* and statues of St. Mark and St. Francis.

OPPOSITE:
The main altar designed by Aliense for S. Giorgio Maggiore, with the monumental group of *Three Divine Persons,* the *World,* and the *Evangelists* by Girolamo Campagna. Monumental columns divide the presbytery from the choir.

momentum to compete seriously against Vittoria. It also gives some idea of Campagna's strengths as a sculptor, principally an ease with creating figures in movement and a talent for narrative. Unlike Vittoria or Cattaneo, Campagna apparently studied anatomy, to the extent that even his early *Pietà* in S. Giuliano conveys a powerful sense of the physical presence of Christ.

As early as 1579 Campagna won the competition to redesign the high altar of the Santo in Padua, a major commission which he secured against older

men like Vittoria, Francesco Segala, and Francesco Franco. Even allowing for the fact that Campagna was known to the *massari* [works committee] of the Arca del Santo, it was a sign of confidence in the young sculptor that he was awarded the task of replacing Donatello's high altar. This exposure helped Campagna consolidate his reputation, and he began making his presence felt in Venice as early as 1578, when he furnished the statue of St. Justine for the main entrance of the Arsenal. Initially Campagna's public work in Venice comprised small-scale allegorical figures for the Palazzo Ducale. At their best, as in the atlantes for the fireplace of the Sala dell'Anticollegio, they reveal an ability to transpose the concept of large-scale statuary into a more decorative format.

The most significant of Campagna's commissions in the early 1580s was undoubtedly his portion of the tomb of Doge Niccolò da Ponte. Executed between 1582 and 1584, the monument stood in the Carità until its destruction in 1807. The only part surviving is Vittoria's bust of the doge, discussed previously, yet it is noteworthy that despite Vittoria's fame he was awarded only the portrait; the six allegorical figures were given to Campagna instead, probably in recognition of Campagna's growing dominance over contemporary Venetian sculpture, especially in the field of statuary. But the most tangible evidence of Campagna's supremacy over Vittoria as a statuary sculptor came with the high altars of the Redentore and S. Giorgio Maggiore. In each case Campagna was called upon to design a new kind of altar, unprecedented in Venice, to meet the requirements of Counter-Reformation architecture. Beyond that, both churches were projects by Palladio, with whose ideas Campagna had an evident sympathy. Palladio intended each church to have a free-standing altar, to be seen in the round. The altar of the Redentore was the earlier of the two, probably conceived in 1589 and finished the following year. It may be that the procurator and art connoisseur Marcantonio Barbaro, who was actively involved in the early stages of the Redentore's design, promoted Campagna as the executant of the high altar, although there is no evidence for this.

At the Redentore, Campagna created a variation on the medieval meditation on the Crucifixion, with St. Mark and St. Francis flanking the cross. This was not only appropriate for a Capuchin church, but also allowed scope for a dynamic composition since the three figures relate vividly to one another and their surrounding space. In particular, the contrapposto of the two saints establishes a sense of three-dimensional movement while complementing the articulation of Christ's body. *St. Mark* and *St.*

Francis display Campagna's artistic pedigree from Sansovino and also invite comparison with the type of bronze sculpture at which Vittoria excelled. But it is the *Crucified Christ* that represents one of the high points of Campagna's career. Like the *St. Mark*, the *Christ* is a well-articulated figure. It has been likened to crucifixes by Cellini and Giambologna but such comparisons merely reinforce its peculiarly Venetian style. It is, perhaps, more instructive to compare Campagna's *Christ* with Donatello's for the Santo, a great touchstone of Quattrocento art and a work which Campagna had under his eyes in the late 1570s, when he was charged with rebuilding the Santo's high altar. Campagna obviously took away memories of Donatello's work, notably its anatomical exactitude, but the differences are also significant. Campagna's *Christ* is more superhuman, cast in a heroic mold unthinkable without the examples of Michelangelo and Tintoretto. The substantial proportions and fluently modeled, bell-shaped torso suggest a study of paintings like the *Risen Christ* of 1565 in S. Cassiano as well as the great set-piece in the *albergo* of S. Rocco. Though it would be difficult to insist upon a specific indebtedness to Tintoretto here, Campagna evidently responded to the same stimuli as his older contemporary. With this work Campagna obtained a balance between beauty of form and pathos unequalled in his later sculpture.

Shortly after completion of the high altar of the Redentore, Campagna received the equally prestigious commission for the new high altar of S. Giorgio Maggiore (see p. 333). The body of the church was nearing completion in the late 1580s, and impetus toward its internal decoration came in 1592 under the new abbot Michele Alabardi elected the year before. Contracts for the altars of the nave and for the high altar were issued, with Campagna securing the latter project for himself and his brother Giuseppe. Again, this was a work which by rights ought to have gone to Vittoria, but Ridolfi relates that Aliense, a painter and sometime collaborator of Tintoretto, was consulted by the abbot when the designs submitted did not prove satisfactory. This may not be strictly true. It is more likely that Aliense may simply have been asked to translate a conception of the Benedictines into an alternative project for the high altar. Carlo Ridolfi, who wrote extensively on Venetian art of this period in the seventeenth century, described the high altar of S. Giorgio as "the three Divine Persons, the World and the Evangelists, promulgators of the Catholic Faith." As such, the idea was not unusual and could be traced back as far as the mosaic representations of the Evangelists on the cupolas of S. Marco. What is unusual, however, is the form in which this is displayed. God the Father

stands on a globe, which bears the dove and before which stands a crucifix; the globe itself is supported by the Evangelists, John and Mark in front and Luke and Matthew behind. The primary sense of the work would seem to be, as Ridolfi implies, the promulgation of the Catholic Faith through the divinely inspired texts of the four Apostles. The concept of the Evangelists bearing the deity on a globe is visually arresting and gave scope to Campagna's flair for creating muscular figures in difficult poses.

Although Campagna's bronze group invites comparison with Tintoretto's late canvases on the lateral walls of the presbytery, it is unlikely that Campagna could have drawn inspiration from them since both commissions ran concurrently. Here the role of Aliense may have been more crucial than hitherto thought: as a disciple of Tintoretto, he could be guaranteed to produce a composition in tune with the flanking paintings. Thus, the decoration of the presbytery spans the Old and New Testament as well as encompassing the propagation of the faith through the Evangelists. It can even be seen as a triptych with Tintoretto's paintings as the wings and Campagna's group as its central component. In purely artistic terms, the *Evangelists* show some awareness of Michelangelo's mature sculpture, but it would be wrong to insist too much upon that influence. Above all, the four figures demonstrate a mastery of plastic form unrivaled by any other Venetian sculptor of the period and comparable only to the best work produced by the shop of Giambologna. The high altar of S. Giorgio remains one of the most underappreciated masterpieces of Late Renaissance sculpture.

Unfortunately, few of Campagna's later works equal the power and authority of his altarpieces for the Redentore and S. Giorgio. An exception can be made for the bronze statue of St. Anthony Abbot on the altar of the goldsmiths' guild in the ancient church of S. Giacomo del Rialto (see p. 334). Delivered in 1604, the figure demonstrates some of the dynamism that informed the bronzes for the high altar of S. Giorgio Maggiore while anticipating somewhat the fervor of Counter-Reformation iconography. In more traditional fields, such as the Virgin and Child or small bronzes, Campagna created a personal re-elaboration of the style of Sansovino and Cattaneo, a trend multiplied by Niccolò Roccatagliata and other imitators. By the middle of the 1590s Campagna faced little serious competition as the first sculptor in Venice, and lack of competition dulled his productions. The agent of the duke of Urbino, who dealt with Campagna over the commission for a statue of Federico da Montefeltro, shrewdly assessed the situation of Venetian sculpture in 1604, observing that Campagna was considered the best sculptor in Venice, if not in Italy, and could pick and choose among commissions on offer. Campagna, he continued, had no real competition so it was necessary "to go to him to solicit work in a sweet and gentle way, knowing that sculptors too have the same sharp temper as poets and painters, and Campagna in this respect is not inferior to any other."

Venetian sculpture of the sixteenth century can be divided into two phases. The first, dominated by the Lombardo family, had its roots in the evolution of Venetian sculpture toward a style more comparable to central Italian art during the late fifteenth century. Heavily influenced by the Antique and, equally importantly, by the antiquarianism of Mantegna, Tullio and Antonio Lombardo developed a precociously classical style by the turn of the sixteenth century. Their style, however, literally disappeared with the death of Tullio Lombardo in 1532. It was replaced by the more versatile and cosmopolitan manner of Jacopo Sansovino, with its more superficial commitment to classicism and distinctive inclination toward Florentine sculpture of the previous century. In many ways Sansovino's art fitted more easily into the Venetian penchant for decorative sculpture as espoused by earlier masters like Filippo Calendario and Antonio Rizzo. The diffusion of Sansovino's style was assured by his position as *proto* of S. Marco and by the substantial number of associates and followers who passed through his workshop during his Venetian years. Sansovino's school proved resilient and capable of adapting itself to include influences from the later work of Michelangelo and the painting of Tintoretto. If no Venetian sculptor of the later sixteenth century can stand serious comparison with Tintoretto, Girolamo Campagna nevertheless took part in that return to solid figural types and heightened naturalism so characteristic of Venetian art of the period. In particular, his high altar for S. Giorgio Maggiore, like Sansovino's reliefs for S. Marco a generation earlier, demonstrated the validity of Alberti's observation that painting and sculpture were kindred forms.

Bruce Boucher

Funerary monument of Doge Pasquale Cicogna in the church of the Gesuiti, with the recumbent statue of Cicogna, by Girolamo Campagna.

OPPOSITE:
The altar of S. Giacometto or S. Giacomo di Rialto, with the bronze statue of St. Anthony Abbot by Girolamo Campagna in the framework designed by Scamozzi.

Venetian Painting of the Cinquecento

OPPOSITE:

The *Tempest*, Giorgione. Venice, Gallerie dell'Accademia. In both form and content, this picture epitomizes the new painting, with landscape as a central constituent of the work's meaning.

Giorgione and the New Era

In the first decade of the Cinquecento the art of painting in Venice underwent profound changes in both pictorial technique and pictorial vision, changes that were to have a decisive impact on the future course of the art throughout Europe. The Tuscan artist and art historian Giorgio Vasari, however critical he may have been of these developments, nonetheless recognized their historic significance, situating them precisely within his own grand historiographic schema. If Leonardo da Vinci initiated "that third manner that we would call modern," that Florentine pioneer was immediately followed, "if at a certain distance," by Giorgione da Castelfranco, "who toned his pictures and gave a powerful sense of movement to the things he rendered by a certain, well-understood dark shadow." To account for the Venetian's ability to compete with the Tuscan innovators of the *maniera moderna*, Vasari explains that "Giorgione had seen some things by the hand of Leonardo that were deeply shadowed and cast, as they say, in terrible darkness; and this manner appealed to him, so that, while he lived, he always followed it, and imitated it especially in oil painting." In the course of his account, then, Vasari emphasizes two essential elements of Giorgione's art, its tonal structure and the oil medium. These, in turn, are intimately related to precisely that aspect of the painter's practice that the Tuscan critic condemns most emphatically, Giorgione's working directly on the canvas "without making drawings."

Technique and Poetry

Giorgione's technical achievement, as Vasari perceived with misgiving, represented a significant revolution in painting practice. Canvas as a support had been developed on a monumental scale in the Palazzo Ducale and the *scuole* of Venice as a substitute for murals in fresco, which never set properly in the perpetual dampness of the lagoon city. By the opening years of the Cinquecento, canvas had begun to serve as the major support for easel painting as well, for a new kind of cabinet picture, one intended for the intellectual delectation of a new kind of audience. Such a picture is the *Tempest* (Venice, Accademia),

the small canvas seen by Marcantonio Michiel in the collection of Gabriele Vendramin in 1530: "the little landscape on canvas with the storm and a gypsy and a soldier was by the hand of Giorgio da Castelfranco" (see p. 337).

In both form and content, the *Tempest* epitomizes the new painting. If its precise subject continues to frustrate interpretation, the composition itself declares the landscape as a central and determining constituent of the painting's meaning. With the figures displaced to either side, the core of the pictorial field opens to nature, to the aqueous atmosphere dominated by dark storm clouds and the sudden streak of lightning—like ancient Apelles, Giorgione painted the unpaintable. The nature invented by Giorgione is dynamic, in perpetual movement; the principle informing this universe, as it does Leonardo's, is *natura naturans*, nature in the constant process of creating itself.

In a fundamental way, that principle also informed the painter's own innovative practice. Again like Leonardo, Giorgione evolved a sense of artistic creation as an open process. What Leonardo had recognized and developed in his own drawing procedures, namely, the exploratory momentum of the free sketch, Giorgione worked out in oil paint on canvas. Vasari described Giorgione's procedure of developing his painting directly on the canvas without carefully preparing the composition in a series of preliminary drawings—culminating in a finished cartoon—and that description seems fully confirmed by a technical examination of the *Tempest*. Giorgione kept his painting in an open and fluid state, painting over and painting out, shifting and substituting figures, modifying architectural units and the landscape setting. Working on canvas rather than on panel, Giorgione naturally abandoned the delicate construction of color through translucent glazes—the kind of practice that achieved the deep illumination of setting in paintings by Giovanni Bellini. Reserving such glazes for the final layers, he exploited the possibilities of a more opaque application of paint; instead of depending upon the reflecting participation of a white gesso ground, he built up his brightest forms—flesh or white garment—in a thicker impasto. And just that thickness of application, that opacity of color, permitted

the kind of radical *pentimenti* [changes] that have contributed to the enigma of the *Tempest*.

Giorgione's achievement depended upon the Venetian adoption of canvas as a support and corollary changes in ground and paint structure. Reversing the light to dark sequence of traditional practice in panel painting, the new technique built toward light from the base of a darker layer; instead of the smooth gesso surface, the woven texture of cloth interacting with the substance of a more impasto medium yielded new possibilities. In Giorgione's art, light emerges from dark and the brushwork begins to be broken up, the individual stroke assuming a greater visual and expressive weight. The surface of a painting by Giorgione, particularly in his later work on canvas—and the *Tempest* probably should be dated in the

Concert Champêtre, Giorgione or Titian. Paris, Louvre. This painting offers the most evocative pictorial representation of the pastoral ideal.

years just before his death in 1510—is vibrant and open, the touches of the brush creating a loose atmospheric network that invites the eye of the viewer to participate in bringing forms into focus. Beginning on this formal level, then, Giorgione's art insists on active engagement.

Along with Giorgione's technical revolution, his radical transformation of the practice of oil painting, went a comparable revolution in the very meaning of painting. Along with the open technique went a certain openness of subject. The shifting of forms and their interrelations in the course of execution may well have involved more than a simple shift of

emphasis within a predetermined theme. Rather, it may indeed have offered a more open hermeneutic invitation to the beholder, to their imaginative projection into the picture, an invitation to wander at will through the space of representation—"vagare a sua voglia nelle pitture," as Pietro Bembo wrote of Bellini's imagining process. Landscape was integral to the new painting and to the new sensibility that inspired and sustained it. The undulating planes of the natural setting, the uncertain boundaries of form in shifting light and shadow, the organic instability of nature in constant motion—such phenomena become the special object of Giorgione's pictorial tonalism. That scholars have failed to agree on a single reading of the *Tempest* hardly means that the picture originated without a more precisely identifiable subject. Nonetheless, its enigmatic appeal does suggest a deliberate interpretive challenge, that a subject or theme may be accessible only through an active engagement of its pictorial structure. That inviting tonalism assumes an essential function in the poetics of Giorgione's art.

If Bellini had already set the human figure more fully within the luminous landscape, Giorgione achieved a still deeper unity of the two. Bellini had joined figure and landscape through light; the unifying medium in Giorgione's representation was shadow—that "certain dark, very intense shadow" appreciated by Vasari. Through the tonalism of his new manner, figures merge with, and emerge from, a surrounding darkness; it is that tonal continuity that binds them in a space that itself becomes pictorially tangible.

The fullest realization of this poetic pictorial aesthetic is to be found in the canvas in the Louvre known, at least since the early nineteenth century, as the *Concert champêtre*. Although now often attributed to Titian, the painting itself epitomizes everything we have come to appreciate as *giorgionismo*. In the late seventeenth century, when the picture entered the collection of Louis XIV, it was called a *pastorale*, and this generic label is probably more useful in that it suggests the rich tradition to which the image belongs. Indeed, the *Concert champêtre* offers the most evocative and resonant pictorial representation of the pastoral idea. Bringing together urban poet, rustic shepherd, and nude nymphs of the *locus amoenus* [pleasant place], the picture participates in the pastoral culture so deliberately revived in the opening years of the century in Jacopo Sannazaro's *Arcadia*.

By the end of the fifteenth century Giovanni Bellini had established an essentially sacred poetry of landscape. In the opening years of the sixteenth century, a younger generation, led by Giorgione, secularized that poetic sensibility. Venturing into landscape to discover and gratify other, more personal and poetic

needs, Giorgione created a realm of pictorial experience that responded to a new kind of aestheticism and a new kind of patronage, which sought delectation as much as edification in imagery. In paintings like the *Concert champêtre* the new patron—young, noble, and culturally refined—found a new kind of picture, in which a certain condition of private, secular meditation offered the basis for a new kind of

writes—Giorgione left "due eccellenti suoi creati [two excellent creations of his]: Sebastiano Viniziano, who was then keeper of the seal in Rome, and Tiziano da Cadore, who not only equalled him, but who greatly surpassed him." Marcantonio Michiel records that certain paintings left unfinished by Giorgione were indeed brought to completion by his younger colleagues: the *Three Philosophers*

Three Philosophers, Giorgione. Vienna, Kunsthistorisches Museum. The canvas was commissioned by Taddeo Contarini and was probably completed by Sebastiano del Piombo. The title derives from the three figures who, in their contemplation of nature, appear to be seeking the single source of knowledge.

aesthetic response, the evocation of a poetry in which his own sensibility could delight. Giorgione himself, we are told, participated fully in this world: "he continuously enjoyed amorous dalliance; he played the lute marvelously well, playing and singing beautifully, so that he was often invited to participate in musical gatherings by the nobility."

"Due eccellenti suoi creati"

Whatever its authorship, the *Concert champêtre* epitomizes the state of Venetian painting circa 1510, the year of Giorgione's premature death. In compensation for that deprivation, however—as Vasari

(Vienna, Kunsthistorisches Museum) in the house of Taddeo Contarini was finished by Sebastiano, and "the canvas of the nude Venus who sleeps in a landscape with Cupid" (Dresden, Gemäldegalerie) was completed by Titian.

Vasari himself sometimes confused the work of the master with that of his followers, occasionally correcting his attributions in the second edition of the *Vite*. One such work is the altarpiece in the church of S. Giovanni Crisostomo, painted shortly before Sebastiano left Venice for Rome in 1511. Although some critics still find a Giorgionesque design behind Sebastiano's execution, the classical

structure of the composition and of the figural grouping declare the independence of the disciple. Still, more than the young Titian, Sebastiano does seem to have built deliberately upon the technical lessons of the master. The organ shutters for the church of S. Bartolommeo (c. 1509) confirm Sebastiano's close attention to the art of Giorgione. Painted on a dark ground, the figures emerge from surrounding shadow with studied visual power. Equally revealingly, Sebastiano has taken the implications of Giorgione's brushwork to a monumental level—particularly in the robes of St. Louis of Toulouse, where a network of individual touches of color animates the surface like the tesserae of mosaic.

The full range of Giorgione's achievement is known to us imperfectly owing to the poor preservation of monumental projects like the frescoes on the

young Titian, whose contribution evidently surpassed the frescoes of the master. Indeed, it is as a fresco painter that Titian first emerges as a fully independent artist on a monumental scale, in the murals of the Scuola di S. Antonio in Padua (1511). Although he there exploited motifs adapted from Giorgione, especially the expressive shadowing of eyes, Titian nonetheless declared the essential classicism of his own compositional instinct, and nowhere more clearly than in the mural of the *Miracle of the Newborn Infant* where the rectilinearity and insistent parallelism of spatial structure, the gravity of the figures, and their measured pace and isocephaly distinguish the controlled balance of this design from the tilted spaces and shadowed volumes of Giorgione.

Already in the first of his altarpieces, that of *St. Mark Enthroned With Sts. Cosmas and Damian,*

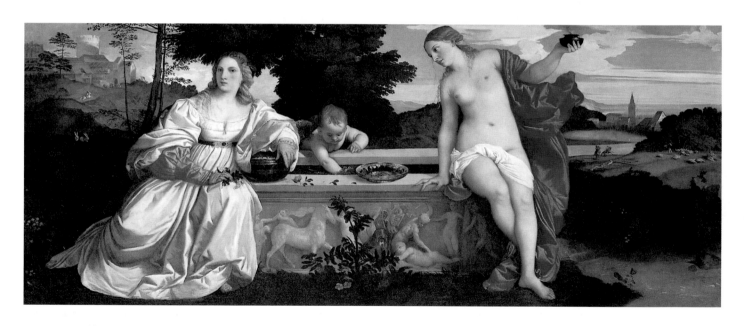

Sacred and Profane Love, Titian. Rome, Galleria Borghese. Of the artist's vast oeuvre of secular subjects, nothing remains in Venice. As early as 1608, this painting was already in Rome in the collection of Cardinal Scipio Borghese. The painting's theme was probably suggested to the artist by Pietro Bembo.

facade of the Fondaco dei Tedeschi (1508). Several decades later, Vasari, frustrated by the apparent illegibility of the subject matter, concluded that the artist had set out "to make there figures of pure fantasy just to demonstrate his skill." Nonetheless, he was able to appreciate the ambitious design of these mural decorations, with "heads and fragments of figures very well done with the most lively coloring." Evidently Giorgione had combined dramatic foreshortenings and deeply colored shadow to transform the external walls of the recently rebuilt German warehouse at the Rialto into a spatially dynamic and pulsating surface.

On that project Giorgione was assisted by the

Roch and Sebastian for the church of S. Spirito in Isola (now in S. Maria della Salute), probably executed before his departure for Padua in 1510, Titian had refined Giorgione's shaded art, bringing it to more precise dramatic focus. Thus the shadow cast across the face of the patron saint of Venice assumes heightened significance as a tragic or pathetic sign, testifying perhaps to the plight of a plague-stricken Venice. As Sebastiano had in his altarpiece in S. Giovanni Crisostomo, so Titian shifts the architecture off axis, creating the kind of asymmetry that he will pursue to greater expressive purpose in his later *Madonna di Ca' Pesaro* in the Frari (1519–26) (see p. 343).

Nowhere does the structured classicism of Titian's art more clearly distinguish itself from Giorgione's suggestive tonalism than in the *Sacred and Profane Love* (Rome, Galleria Borghese), painted on the occasion of a marriage in 1514 (see p. 340). The chromatic clarity of this painting accords with its precision of design, and its frontality of address presents its dialogic alternatives with comparable precision. Whatever he may have learned from Giorgione, the young Titian refused to allow shadow to compromise formal clarity; he remains a more precise painter, and in this he owes more to his experience of the art of Giovanni Bellini—as well as, perhaps, to his earlier training in the studio of Gentile Bellini.

On 31 May 1513 Titian offered his services directly to the Republic. Armed with an invitation to join the papal court in Rome, evidently arranged by Pietro Bembo, he volunteered to undertake the most difficult project in the Sala del Maggior Consiglio: to replace on canvas the deteriorating fresco of the battle of Spoleto first painted by Guariento in the fourteenth century—"that battle picture on the side toward the Piazza that is the most difficult, so that no one until today has had the courage to undertake the task." Although he gained the commission—along with the promise of the next *sensaria* [a broker's patent issued by the State that guaranteed its holder a certain income] to fall vacant at the Fondaco dei Tedeschi, then held by the aged Giovanni Bellini— Titian procrastinated for several decades, not delivering the painting until 1538. However, a byproduct of his early engagement with the battle picture was his design for the monumental woodcut published in 1515 of the *Drowning of Pharaoh's Army in the Red Sea*. Issued with copyright privilege by the enterprising publisher Bernardino Benalio, this grand seascape representing God's protection of his chosen people may well have been a graphic allusion to the recent apparently miraculous salvation of Venice from the threat of the forces of the League of Cambrai.

The Triumph of Titian

Titian's career began during the darkest years in the history of the Republic, when it saw its entire *terraferma* empire lost to the armies of an alliance of European powers that included the pope, the emperor, and the French monarch. His emergence as the dominant painter in Venice coincided with the rapid revival of the Republic and the successful recovery of her domain through astute diplomacy rather than military prowess. Despite that recovery,

however, Venice after the war of the League of Cambrai could never reclaim the same position on the European political stage; in place of real power, she developed a stance of rhetorical self-assertion, adapting her own political myths and iconographic traditions to new purposes. A significant aspect of that revival involved the physical development of the city itself and spectacular visual display.

The Altarpiece

In that light, the unveiling on 19 May 1518 of Titian's *Assumption* on the high altar of S. Maria Gloriosa dei Frari assumes added public significance (see p. 342). The event was, unusually, recorded in the semiofficial diaries of Marin Sanudo, suggesting that the painter's triumphal demonstration may indeed have been read as a sign of Venice's own triumphal survival. With this great altarpiece, a single panel of unprecedented dimensions (measuring 6.9 meters in height), Titian declared a new style in Venice, a monumental High Renaissance style to rival the achievements of Michelangelo and Raphael in Rome. Its composition, constructed of a circular zone above a lower rectangular unit, distinguishes the golden glow of heaven from earth below; its symbolic geometry and palette recall the theological structure of Raphael's *Disputà*. Titian's painted heaven naturalizes the golden half-domes of Giovanni Bellini's altarpieces—as well as their own ultimate inspiration, the mosaic domes of S. Marco itself. Titian, like Raphael and Correggio, renaturalized, as it were, the venerable architectural metaphor of the dome of heaven. Heavy cumulus clouds, completing the circle initiated above by the crowning arch of the frame, become structural elements in the pictorial realization of the celestial realm, their mediating role between heaven and earth punctuated by the extended limbs of celebrating angels and astonished disciples. The dynamism of Titian's figures animates the event with dramatic purpose as the earthly witnesses respond with vigorously differentiated gestures to the miracle of the Virgin's assumption and triumphal reception into heaven.

That basic theme is established by the very design of the monumental frame above the high altar of the Frari (which is dated 1516): a triumphal arch *all'antica* crowned by the resurrected Christ. Set within the Gothic apse of the Franciscan basilica, its classical proportions carefully adjusted to the contrasting medieval structure, the altarpiece is also conceived to be viewed scenographically through the aperture of the Quattrocentro choir screen. The imagination and sensitivity with which the new monument was fitted to its site and the ambitious size of its pictorial field suggest that Titian himself

Titian

Titian studied with Gentile and Giovanni Bellini. After Giorgione's death, he became the most important painter of the new generation. He executed the *Amori* (1518–19) and the *Andrians* (1523–25), both in the Prado in Madrid, and *Bacchus and Ariadne* (1520–23), in the National Gallery, London, for Alfonso d'Este, proving himself a consummate interpreter of ancient myth. Titian was an outstanding portraitist; masterpieces include *Pope Paul II and His Nephews* (Naples, Museo di Capodimonte). Titian was constantly altering and adjusting his compositions while in the process of executing them, painting directly on the canvas (*pittura di macchia*) without a preparatory drawing. His adjustments might affect details or the entire design. In the *Madonna di Ca' Pesaro* he altered the architectural setting more than once. Even Vasari, generally critical of Venetian painting, recognized his greatness: "Works are carried out in bold strokes, broadly applied in great patches in such a manner that they cannot be looked at closely but from a distance appear perfect."

PAGE 343:
Madonna di Ca' Pesaro, Titian, in S. Maria Gloriosa dei Frari. By moving the Madonna and Child off the central axis, Titian changed the conventional structure of the *sacra conversazione*, further naturalizing the sequence gestures and glances relating the figures to one another. To the left, the flag with the Pesaro insignia recalls the victory of Jacopo Pesaro against the Turks at the battle of Santa Maura; here he is presented by St. Peter to the Virgin, and, as the leading figure of the Pesaro clan, serves in turn as

OVERLEAF:
Assumption, Titian, on the high altar of S. Maria Gloriosa dei Frari. This, the artist's most important religious commission in Venice, was unveiled in 1518. The dynamism of Titian's figures animates the event with dramatic purpose as the astonished earthly witnesses respond with vigorously differentiated gestures to the miracle of the Virgin's assumption and triumphant reception into heaven.

was deeply involved in the overall design.

With the *Assumption* Titian transformed the genre of the altarpiece in Venice, expanding its imaginative range and redefining expectations. Already in his early altarpiece for S. Spirito in Isola he had begun to modify the conventions of the *sacra conversazione* through asymmetry of setting and dramatic chiaroscuro and he maintained that inventive momentum in his next project in the Frari, the painting commissioned by Jacopo Pesaro for the altar of the Immaculate Conception, which he had just acquired as his family funerary chapel. Titian's charge was to include, along with the Madonna and Child and appropriate saints, portraits of the donor and other members of the Pesaro family. His solution effectively combined two distinct pictorial genres, the *sacra conversazione* and the votive picture. The first involved the traditionally iconic presentation of holy figures, the second a narrative tableau in which an individual or group is presented to such holy figures. His synthesis of the two in the *Madonna di Ca' Pesaro* was achieved by means of an even more radical asymmetry of composition (see p. 343). Moving the Madonna and Child off the central axis, Titian deformalized the conventional structure of the *sacra conversazione*, and that obliquity further naturalized the sequence of gestures and glances relating the figures to one another. Jacopo Pesaro, bishop of Paphos and commander of the papal fleet that defeated the Turks at the battle of Santa Maura in 1502, is here presented by St. Peter to the Virgin, and Jacopo himself, as leading figure of the Pesaro clan, serves in turn as privileged intercessor for his relatives.

In creating a new kind of dynamic image in the *Madonna di Ca' Pesaro*, Titian was again responding to the exigencies of site. Located on a side aisle of the Frari, the altar first comes into view obliquely, seen from the nave like a wall painting, before it can be approached by a worshiper on axis. Titian's composition thus accommodated the shifting conditions of vision, acknowledging the dynamics of the beholder's changing relationship to the image.

If the presentation of donors to holy figures in the *Madonna di Ca' Pesaro* still required a certain decorum, maintaining the hierarchical distinction among levels of being, a definite relaxation of formalities characterizes the subsequent development of the *sacra conversazione* in Venetian altarpieces. In Pordenone's *S. Lorenzo Giustiniani* altarpiece, for example, commissioned in 1532 for the church of the Madonna dell'Orto, asymmetry combines with dramatic gesture and dialogue to create a complex of significant and signifying relationships, culminating in the titular saint's direct address of the beholder

(see p. 344). And three decades later Paolo Veronese, more clearly inspired by Titian's example, choreographs such figural counterpoint with more deliberate grace in the *Sacra Conversazione* painted for the sacristy of S. Zaccaria (now in the Accademia).

The climactic achievement of Titian's transformation of the altarpiece was the *Death of St. Peter Martyr*, which he painted between 1526 and 1530 for an altar on the left aisle of SS. Giovanni e Paolo, the major Dominican church in Venice. Destroyed by fire in 1867, this panel was, as Vasari writes, "the most highly finished, the most celebrated, and the grandest, the best conceived and most fully realized of any that Titian ever made;" it was certainly frequently studied and copied by generations of painters. Here, a dramatic narrative from the life of a saint, the kind of *istoria* that had traditionally been reserved for predella panels, found monumental expression above the altar. No longer presented as a static icon, the saint inspires the faithful by action, by his noble acceptance of death, and by the final affirmation he inscribes with his own blood: *credo* [I believe]. Beyond human action, however, Titian harnesses the forces of nature itself both as witness and participant. Matching the figures in heroic proportion, the trees demonstrate a new monumentality of conception; and the overwhelming naturalism of this landscape art lends further conviction to the opening of the heavens—"a bolt of lightning from heaven," as Vasari describes it, "which illuminates the landscape"—and to the angels bearing the victorious palm of martyrdom to the expiring saint. Through the power of his painting, his ability to lend material substance to depicted form, Titian found new and dramatic ways of linking heaven and earth. The visions he placed above the altar table opened onto realities of great conviction.

Although Titian clearly played the leading role in expanding the expressive range of the altarpiece, other Venetian painters participated inventively in this development. Lorenzo Lotto too, in a quieter way, endowed heaven with natural substance, as in the altarpiece of *St. Nicholas in Glory*, in S. Maria dei Carmini (1527–29) (see p. 345). Accompanied by St. John the Baptist and St. Lucy, as well as attending angels, St. Nicholas, enthroned upon white clouds, is elevated to an intensely blue heaven. The celestial reality is fully confirmed by the beautifully painted stretch of landscape below. The pictorial control of the natural world, developed with such purpose by Venetian painters since Bellini, enabled a surer, more proximate representation of heaven.

Bellini had indeed demonstrated the proximity of the sacred in the natural, bathing both figures and landscape in a warm luminosity of glazing technique.

Holy Family with St. Catherine of Alexandria and St. John the Baptist, Palma the Elder. Venice, Gallerie dell'Accademia. Intended not as an altarpiece but as a more private picture.

S. Lorenzo Giustiniani altarpiece, Pordenone (Giovanni Antonio de Sacchis), Venice, Gallerie dell'Accademia. Commissioned in 1532 for the church of the Madonna dell'Orto, this painting combines asymmetry with dramatic gesture and dialogue to create a complex of significant and signifying relationships, culminating in the titular saint's direct address to the beholder.

That immersion of man in nature, which Giorgione was to secularize and poeticize, continued to afford new possibilities to religious painting, offering new prospects of spiritual meaning. The *sacra conversazione*, a figural grouping that implied a social structure beyond the strictly iconic, was adapted by Venetian painters to the horizontal format of landscape: for example, in Palma Vecchio's [the Elder] *Holy Family With St. Catherine of Alexandria and St. John the Baptist* (Accademia), the asymmetrical arrangement extends the votive structure of Titian's *Madonna di Ca' Pesaro*. Intended not as altarpieces but rather as more private pictures, these religious images, ostensibly devotional in intention, became increasingly aesthetic in function; appreciated as cabinet pictures, they became the valued objects of new generations of patrons and collectors.

Courts and Myths

When, in 1513, Titian declined an invitation to join the papal court he declared his preference to remain *fidelissimo subdito* [most faithful subject] of the Republic. Nonetheless, from his base in Venice, he was in a position to serve other courts in northern Italy, especially the Este in Ferrara and the Gonzaga in Mantua. It was Alfonso d'Este's project to decorate his *camerino* [study] in the castle at Ferrara with a series of mythological images that offered Titian his first real challenge in painting subjects *all'antica*. Alfonso had begun by commissioning a *Feast of the Gods* from Giovanni Bellini, which the aged Venetian master completed in 1514—and which was eventually to be modernized by Titian, who monumentalized the landscape (Washington, D.C., National Gallery of Art). The duke's original ambition was to have pictures by a number of outstanding modern artists, including Fra Bartolommeo and Raphael. Both painters died before they could satisfy the commissions, and Alfonso turned to Titian, who completed the cycle with canvases based on descriptions of antique paintings. Two of these were taken from the *Imagines* of Philostratus the Elder: the *Amori* (1518–19) and the *Andrians* (1523–25) (both in Madrid, Museo del Prado). The third, *Bacchus and Ariadne* (1520–23) (London, National Gallery), derives from descriptions in Catullus and Ovid. Titian proved himself a consummate dramatic interpreter of ancient myth. With sensitive psychological insight he gave subtle figural expression to the emotional ambivalence of the abandoned Ariadne who turns with alarm to meet the amorous leap of her new, immortal lover.

In Venice itself ancient mythological imagery had been invoked initially for less dramatic ends. It tended to be adapted to more domestic purpose, as in the *Sleeping Venus* that Giorgione began for the

St. Nicholas in Glory with St. John the Baptist and St. Lucy,
Lorenzo Lotto, in S. Maria dei Carmini. This is one of the few
works done by Lotto in Venice as a public commission.
Below, a detail of the landscape which reflects the influence
of Giorgione.

wedding of Girolamo Marcello in 1507, the canvas left to be completed by Titian. Giorgione's invention, of a reclining nude in a landscape, established a compositional model that was to have a profound impact upon the subsequent history of painting—especially through its variations by Titian (see p. 347). In the *Venus of Urbino* (Florence, Galleria degli Uffizi), which he painted for Guidobaldo II della Rovere, Titian domesticated Giorgione's nude, bringing her indoors and articulating her epithalamic significance through appropriate symbolic attributes—myrtle, faithful dog, attendant maids at the open *cassone*. Ready for delivery in 1538, this painting in particular provided the basic pattern that Titian was to develop and modify throughout his career—above all, by the addition of a musician-courtier, as well as identifying cupid—making him the favorite painter of the goddess of love.

Among these variations was one that actually inflected the iconic mode of the original subject into a narrative: the *Danae* that Titian painted for Cardinal Alessandro Farnese (Naples, Museo di Capodimonte) was developed on the basis of a studio record of the Urbino composition. The canvas was in progress in 1544, when it was enthusiastically described by Giovanni della Casa, who fully appreciated its sensual appeal; he compared it to the *Venus of Urbino* which he pronounced "a nun compared to this one." Titian completed the *Danae* during his visit to Rome in 1545–46. During his sojourn as Farnese guest, he evidently painted a pendant to the picture, a *Venus and Adonis* (no longer extant). Both subjects were to be replicated in the first two canvases in the series of Ovidian subjects that Titian painted for Philip II of Spain. It was courtly patronage—Este, Farnese, Hapsburg—that offered the Venetian painter the opportunity to explore the realms of ancient myth, especially the loves of the gods. Indeed, with only Ariosto himself as a possible rival, Titian stands clearly as the greatest Ovidian poet of the Cinquecento.

In recreating painted images from classical antiquity, images known only through literary description, the modern painter participated fully in the very essence of the Renaissance as a revival of ancient culture. This was precisely what Alberti had envisioned in the early Quattrocento when he recommended that painters look for new subject matter to the ekphrasis of antiquity, citing the famed *Calumny* of Apelles. For no Renaissance painter more than for Titian, however, did the rhetorical title of *Apelles redivivus* [the new Apelles] assume such reality. When, in 1533, he was made Knight of the Golden Spur and Count Palatine by the Holy Roman Emperor Charles V, the patent of nobility declared

Titian "the Apelles of this age." In so doing, of course, Charles assumed for himself the role of the new Alexander the Great, who would allow his portrait to be painted only by Apelles. The very fame of the painter had become an enhancement to the glory of his patrons, and the courtly services of Titian thereby assumed a role in the diplomatic efforts of the Venetian Republic—as had those of Gentile Bellini a generation earlier.

The imperial patent of nobility celebrated Titian's "genius for painting persons from life," and it is clear that the artist's most impressive efforts in the genre were inspired by courtly patronage. His close friend Pietro Aretino, who found haven in Venice following the Sack of Rome in 1527, quickly took up the rhetorical celebration of the painter's ability to outdo nature: "And Titian, in rendering you, will with your image nullify any reason to believe in your mortality." Titian's name became synonymous with the power of painting, especially with the power of images to overcome mortality. "The face of one who is already dead lives a long life through the painting," as Alberti had declared in *Della pittura* [On painting]. The suggestive naturalism of Venetian painting—from the luminosity of Giovanni Bellini through the *sfumato* of Giorgione to the more vigorous brushwork of Titian—made it the ideal vehicle for creating that lasting impression of life which was the ultimate goal of the portrait.

Aretino himself, or perhaps the prolific writer Lodovico Dolce, may have been responsible for the selection of an appropriate motto for the noble painter. The device chosen for Titian, very likely inspired by a commonplace in the ancient biographies of Virgil, was that of a bear licking her still unformed cub into shape—the legend of the maternal molding becoming a metaphor of artistic creation—and the motto accompanying this image read "NATVRA POTENTIOR ARS": Art is more powerful than Nature.

Nobles, Citizens, and Brothers

Only occasionally did Titian sign himself "Eques Caesaris [imperial knight]," affirming the nobility bestowed upon him by Charles V. Despite his international renown, his frequent journeys to distant courts, and his notorious dilatoriness in fulfilling local commissions, Titian remained *fidelissimo subdito* of the Republic, as he had pledged in 1513. His career was solidly founded in and on the institutions of Venice, and throughout that career he participated fully in those institutions. The award by the *Fondaco dei Tedeschi* of a *sensaria* was in return for

his services in the Palazzo Ducale. In addition to overseeing the pictorial decorations of the palace, which were in constant need of renovation, those services included painting the official portrait as well as the votive picture of each newly elected doge (see p. 346). Titian was, in effect, court painter to the Republic, in which position he followed Giovanni Bellini, who in turn had succeeded his brother Gentile. Toward the end of his own career Titian, prince among painters, was seeking to secure the succession of his own son and chief assistant, Orazio Vecellio, who died, however, shortly after his father, during the plague of 1576.

Workshops and the Guild

The family workshop is one of those institutions central to the production of art in Venice. Its persistence throughout the history of Venetian art cannot be dismissed as a vestigial medievalism. If the history of Florentine art, especially as it has been codified for us by Vasari, is the story of creative individuals in brilliant competition—Leonardo and Michelangelo in the Palazzo della Signoria—the history of art in Venice tends to appear somewhat less heroic. It is rather an institutional history, with artistic production a more communal enterprise. With some conspicuous exceptions, like Giorgione, painters in Venice generally appear as members of families, working together in large workshops that often continued over generations. Indeed, this phenomenon is one of the most distinctive characteristics of the history of Venetian painting over the course of more than four centuries: the list of relevant names runs from Paolo da Venezia in the fourteenth century, through Vivarini, Bellini, Vecellio, Robusti, Caliari, and Da Ponte in the fifteenth and sixteenth, to Tiepolo and Guardi in the final years of the Republic and into the nineteenth century.

The resulting problems of connoisseurship are obvious and continue to frustrate the art historian trying to distinguish the hand of Titian from that of studio assistants such as Girolamo Dente or Orazio Vecellio, or the hand of Paolo Veronese from that of his brother Benedetto or his son Carletto Caliari. In a workshop all concerned cooperated in the production of paintings that were clearly marked by a characteristic style established by the master. A young apprentice learned by copying and then participating in the work of the master; his own artistic personality had first to submit to that of the master and only then, if it was itself strong enough, might it slowly begin to assert its own independent character. This pattern, of course, applied to workshop training and production in general throughout the later Middle Ages and Renaissance; it is hardly exclusive to

Venice. What is typically Venetian, however, is the longevity of the family dimension, which is itself both a product and a function of the traditions of institutional conservatism in Venice.

However much natural talent may have been appreciated, the institution of the family workshop was founded upon a fundamentally different notion: that an art like painting is essentially a craft, the practical knowledge of which can be taught to anyone with a minimum of aptitude. It was natural, socially and economically, for a father to pass on to his son not only the basic knowledge of his own occupation but, if possible, the practical means of production as well, that is, the bottega [workshop] with all its working material. A fully equipped workshop represented a major capital investment, not only of tools and materials but of accumulated experience and wisdom of the trade, often collected in pattern books, drawings, and models. The very practical function of drawings, for example—as records of inventions and useful motifs, solutions to standard compositional problems that could continue to serve as the basis for the production of new work—explains their prominence in the wills of artists, as the precious and most useful parts of their legacy to their professional heirs. In this way we well understand the special value of Jacopo Bellini's albums of drawings handed down by his widow in 1471 to Gentile, and at his death in 1507 passing to Giovanni. It is especially in the wills of artists that we can often follow the mechanics, so to speak, of the continuity of the workshop tradition.

Another, later example offers perhaps the most impressive documentation of the strength and momentum of that tradition. The Tintoretto workshop lasted over three generations: founded by Jacopo, son of a *tintore* [dyer], it was inherited by his sons Domenico and Marco, who, in turn, were succeeded by their apprentice and brother-in-law, the German-born Sebastian Casser. The situation is explicitly, and rather poignantly, described by the great master's daughter, Ottavia Robusti, in her final will of 1645:

> I find myself tied in matrimony with Master Sebastian Casser . . . painter of the family studio, and this by order and command of my brothers Domenico and Marco, who, before they died, made me promise that if the said Sebastian proved himself worthy in the art of painting, I would take him for my husband, so that, through his talent, he would carry on the name of Tintoretto.

Sebastian did eventually prove himself as a painter, especially in portraiture, and, after some hesitation,

Several scenes of trades depicted on the intrados of the third arch of the main portal of S. Marco, 13th century.

Three panels depicting Venetian gilds from the Palazzo Ducale series, now in the Museo Correr. From top to bottom: copper workers, woodworkers of the Arsenal, laceworkers.

Ottavia married him. Whatever may have been her personal sacrifice, she was clearly constrained not only by her brothers but by Venetian tradition as well to think first of the professional continuity of the dynasty, of the name of Tintoretto.

Underlying the phenomenon of the family workshop in Venice, helping to explain as well as to sustain it, is another, more formal institution, the Arte dei Depentori (the Venetian painters' gild). By his membership of the gild the Venetian painter found his officially sanctioned place in the great socio-economic hierarchy of the Republic. The *capitolari* [statutes] (*mariegola* is the Venetian term) of the Arte dei Depentori date from 1271, making it probably the oldest painter's gild in Italy. It differed from the others, however, especially in its relationship to the State. Unlike gilds in many other communes—the case of Florence being perhaps the best known—those in Venice never exercised actual power of government; nor could they participate in a government that was, we must remember, exclusively patrician. Rather, as in the Byzantine world, they were under the direct control of the State, to which they owed the privileges and powers they enjoyed in their respective fields. A special office of the Venetian government, the Giustizia Vecchia, was established in 1173, its three magistrates charged with supervising the activities of the gilds. The *capitolari* of the gilds, while covering the regulation of the particular trades, represented in fact an extension of the laws of the Republic in that the statutes opened with certain standard articles declaring the duties of members to the State. In affirming the *capitolari* of his gild, then, each master swore allegiance (*zurado*, in Venetian) to the State. In this light we can more fully appreciate the wording of Gentile Bellini's appointment as official painter in the Palazzo Ducale in 1474, with the senate's nomination of "master Gentile our most faithful Venetian."

Through the system of gilds and confraternities the patrician Venetian state could directly organize and control various segments of its disenfranchised population. Through his gild the artisan or tradesman found his place in the structure of Venetian society, an arena in which he could exercise public responsibility and earn honor according to his estate; and through his gild he paid his own obligations to the Republic, since each gild owed the government certain taxes and services, in return, as it were, for the guarantee of its privileges. In moments of crisis the State could make special financial claims upon the gilds as well as conscript members for military service. Thus, on 15 June 1310, the masters of the Arte dei Depentori joined the brothers of the Scuola Grande di S. Maria della Carità to fight for the doge,

Pietro Gradenigo, against the rebellious forces of Bajamonte Tiepolo. Such loyalty in effect confirmed the State's guarantee of the privileges and prerogatives enjoyed by the gild.

The statutes of the Venetian Arte dei Depentori, like the regulations of gilds elsewhere, also established the pattern and practice of an artist's career, from apprenticeship as *garzone* to registration as *maestro dell'arte*, with the right to open a shop, employ assistants, and make and sell art objects. The gild maintained professional standards and controlled, as an extension of the State, the working conditions and schedules of the shops; it saw to the religious and moral life of its members as well as to their economic and social needs. It assured broad distribution of available work by limiting the number of apprentices and assistants permitted the head of each shop. The number of novices entering the trade was also limited, varying with circumstances—such restrictions being suspended, for example, for a period of three years following a major plague to allow the replenishing of the profession in Venice.

Central to the protective function of the gilds was the principle of *arte chiusa*; this early model of the modern union shop, which forbade anyone not inscribed in the gild to practice his art, to make or sell articles in Venice, was the primary means of protecting Venetian artisans against foreign competition. The 1436 revision of the *mariegola* of the Arte dei Depentori forcefully reinvoked this law—but, as so often in the history of Venetian legislation, the periodic reaffirmation of a regulation seems evidence of the frequency of transgression. In this regard, the case of one famous foreigner is particularly revealing. During his second trip to Venice Albrecht Dürer described his problems with the local artistic community, whose members, he complained, did not hesitate to steal his inventions even as they criticized his work and forced him to pay the price of a foreigner trying to practice his art in the city of St. Mark. "The painters here, let me tell you, are very unfriendly to me," he writes in a letter of 2 April 1506. "They have summoned me three times before the magistrates [the Giustizieri Vecchi] and I have had to pay four florins to their school."

Within the larger contexts of Venetian society and history, the position and function of the Arte dei Depentori assume their special relevance, defining mechanisms of artistic production, commerce, and tradition. Perhaps still more revealing, however, are the internal organization and operations of the gild. They cast a fascinating light upon the somewhat ambivalent status and self-image of the Venetian artist, especially within the developing cultural assumptions of the Renaissance.

The painters of Venice, like those elsewhere, were organized with other craftsmen. In the sixteenth century the masters of the Arte dei Depentori were listed under separate *colonelli* [headings], including *figureri* [figure-painters], *doradori* [gilders], *cortineri* [screenmakers], *cofaneri* [cabinetmakers], *cartoleri* [stationers], *cuori d'oro* [leather workers], *recamadori* [embroiderers], *maschereri* [maskmakers], *specchieri* [mirrormakers], *targeri* [shieldmakers], and *miniadori* [miniaturists]. The gild thus comprised painters of the most varied kinds; those under the first heading were distinguished as *depentori de figure*. Thus, when in 1573 Paolo Veronese was called before the Inquisition, he identified himself and his work in strict accord with the legal distinctions of the Arte: "Io depingo et fazzo delle figure" [I paint and make figures].

Purely a descriptive label, the denomination *figureri* conferred no special status or privilege on these painters; within the organization of the gild they were merely one among several specialties, and the *mariegola* guaranteed an equitable distribution of authority and responsibility among the various *colonelli*. And yet, given the rising social and intellectual aspirations of Renaissance artists in general, it seems almost inevitable that the artisan democracy of the Arte should have been subject to internal tension, that Venetian figure-painters should have sought to assert their supremacy in some way over the other painters. That the challenge should have been sounded by Cima da Conegliano may surprise us, but in 1511 this brilliant conservative painter evidently attempted to weight the membership of the *banca*, the governing board of the gild, upsetting its representational balance by having two *depentori de figure*. Objections were obviously raised by *compagni* [members] of the other *colonelli*, and Cima was reprimanded by the Giustizieri Vecchi. In a predictably Venetian response, the magistrates sternly upheld "el modo et ordene antiquo" [the ancient way and order]—always the key to the unruffled stability of Venice.

Although unsuccessful, Cima's move attests to a certain disaffection within the ranks of the Arte dei Depentori. The new Renaissance ideals of art and of the artist, born in Florence a century earlier, had indeed taken hold even in Venice. Since Alberti's *Della pittura* of 1435, painting had been defended as a liberal and not a mechanical art, and the painter recognized as no mere artisan working with his hands but rather as a man of intellectual and social standing, "a good and learned man." Such ideals may well have inspired the Venetian *figureri*, but they could be of little relevance to *cofaneri*, *cortineri*, *doradori*, or other *depentori* of the Arte. Legally joined with such mechanicals, the painters of Venice

were inevitably frustrated in their aspiration to be recognized as modern artists.

Indeed, until the end of the seventeenth century the figure painters of Venice remained *compagni* of the other *depentori*. Even the most famous masters of the Cinquecento fulfiled their obligations to the gild and served as officers in various capacities. Apparently the only exception was Giovanni Bellini, who, as official painter in charge of the Palazzo Ducale decorations, had been exempted in 1483 from all responsibilities to the gild. His successors in that position, however, seem not to have enjoyed such an extraordinary privilege—not even Titian. In 1531 Titian was elected along with Lorenzo Lotto and Bonifazio de' Pitati to the Comessaria di Vincenzo Catena, a board of twelve executors charged with the distribution of a charitable fund left by Catena to the Arte dei Depentori.

Catena's will specifically documents the gild's function as a confraternity concerned with the social well-being of its brothers and their families. A sum of 200 ducats was left by this master, half of which was to be distributed to needy members of the gild, the other 100 ducats to be used to marry the daughters of five poor brothers by supplying them with dowries of twenty ducats each. Such acts of charity—especially the establishment of dowries—were frequent and normal within the larger social structure, and the various *scuole* served to organize and channel distribution. That Catena himself was fully aware of the example of the other confraternities is clear from another item in his will. After having taken care of his own family, he stipulates that the remainder of his legacy should go to the gild, to be used to acquire real estate so that the painters might have a proper meeting house. And it was indeed thanks to Catena's generosity and professional concern that the Arte dei Depentori was able to establish its own center near S. Sofia in 1532.

A still more interesting commentary on the social world of the Venetian painters is offered by the rather unusual testament of Lorenzo Lotto, one of the trustees of the Catena bequest. The seventh article of the will Lotto had drawn up in 1546 asked the gild to select his heirs and, in effect, to see to the continuity of his workshop. He asked his colleagues to find two worthy young painters who would know how to benefit from the professional materials he was leaving behind. He then asked that two girls be chosen from the hospital of SS. Giovanni e Paolo "who are of quiet disposition, healthy of mind and body, and capable of running a household, to be given as wives to the above-cited young painters, the professional material of his studio to be divided equally between the two." By this idiosyncratic and

Jan Grevembroch, miniature paintings. Venice, Museo Correr. This artist worked in Venice in the service of the Gradenigo family, for whom he painted a series of watercolors showing the crafts, costumes, and monuments of the city.

complicated extension of normal charitable practice, the very idiosyncratic Lotto intended to set up two young artists in their careers; by extending his benefaction to two poor girls, he would have seen also to their domestic comfort and well-being. However unusual the particulars of the case, they reflect the values of the communal world of the *depentori* with its network of economic concerns and social responsibilities.

The larger dimensions of that world and the tensions inherent in it may be gauged by the comparable situation of Titian, another of the *comessari* [executors] of the Catena fund. Specifically, a comparison of the dowry provided each of the five *donzelle* by Catena's will (twenty ducats) with that accompanying Titian's daughter in marriage in 1555 (1,400 ducats) affords some measure of the socioeconomic distance separating the poles of the Venetian painters' world. Within two years of Titian's service on the Comessaria di Vincenzo Catena the painter was knighted by Charles V. Whether or not the "new Apelles" continued to associate in any official capacity with his *compagni* in the Arte dei Depentori, however extraordinary his growing international success, Titian himself, like the other *depentori de figure*, continued to operate within the legally determined hierarchies of the Venetian sociopolitical structure.

The Scuole

Perhaps no other painting by Titian is as deeply invested in and expressive of that sociopolitical structure as the *Presentation of the Virgin in the Temple* that he painted for the Sala dell'Albergo of the Scuola Grande di S. Maria della Carità (now the Accademia) (see pp. 353–355). The commission was awarded in 1534, the year after he received his imperial knighthood, and the painting was completed some four years later.

No other institution so well represents the sociopolitical structure of nonpatrician Venice as the *scuole grandi*. The government of Venice was an oligarchy from which were excluded all the nonpatrician elements of the population. Yet the Most Serene Republic had earned her title by maintaining internal equilibrium and concord as well as independence from foreign domination, and this required offering compensation to the disenfranchised segments of society. Institutions such as the gilds and confraternities afforded the means by which the average Venetian citizen found their place within the structure of the State, for they were, in effect, extensions of that structure. With regard to the *scuole*, Francesco Sansovino is quite explicit in his apology for Venice: "They represent therefore a certain kind of civic government, in which the citizens, as though in their own republic, enjoy rank and honors according to their individual merit and quality." The *scuole* reflected in plebeian microcosm the larger order of the patrician State, and their wealth and splendor were in turn an adornment of that State as well as of religion. Through the *scuole* the brothers participated in the functioning of the larger order, especially through the distribution of charity. In his *Presentation of the Virgin in the Temple*, Titian gave full pictorial representation to these Venetian realities.

Filling the entrance wall of the *albergo* of the Scuola della Carità, Titian's long canvas recalls a rather archaic type of Venetian mural decoration, the narrative tableau. This type, the essential compositional unit of the decorative cycles of the Venetian *scuole* from the later Quattrocento, is preserved for us especially in the *teleri* [canvases] from the Scuola Grande di S. Giovanni Evangelista and those by Carpaccio from the Scuola di S. Orsola (both cycles now in the Accademia). Indeed, it is possible that Titian was given as a model the design submitted by Pasqualino Veneto in the original competition of 1504. The format of the pictorial field, often a long horizontal, no doubt contributed significantly to the development of an aesthetic common to most *teleri* painted for the Venetian *scuole*. The insistent narrative quality of these compositions is perhaps their most distinctive feature, especially important since the cycles often did unfold stories in some chronological sequence. Maintaining the continuity of narrative flow, the figures tend to be kept immediately behind and parallel to the picture plane; although deep spatial recesses may serve as backdrops, such spaces are, as it were, functionally ignored. The eye is held to the surface, and as it moves along these individual processional friezes, and then from canvas to canvas, the resulting sequence establishes a decorative unity as well as a directional impulse.

These same principles inform the composition of Paris Bordone's canvas of the *Consignment of the Ring to the Doge* (Venice, Accademia), which completed the decoration of the albergo of the Scuola Grande di S. Marco (see p. 356). The decision to commission this final canvas was taken early in 1534, several months before the project for their own *albergo* was revived by the brothers of the Carità, who were undoubtedly inspired and challenged by the competition: "In consideration of which the honorable master Nicolò dalla Torre, principal guardian, agrees to make provision to carry out that pictorial decoration, as is only appropriate for our *albergo*, especially as it is to be seen in the *alberghi* of the other *scuole grandi* of this most illustrious city." Rivalry among the *scuole grandi*—especially in

splendor of architecture and pictorial decoration—was indeed encouraged by the Venetian State, for these nonpatrician institutions contributed significantly to the magnificent spectacle of the Republic, attesting to her wealth as well as to her political stability.

Titian's *Presentation of the Virgin in the Temple* adapts itself to the conditions of its site with studied precision. Most immediately, the composition responds to the lighting conditions of the *albergo*: against the natural light entering the room (and the picture) from the left it sets the supernatural radiance of the Virgin Mary, glowing in expectation of her divine motherhood. Behind the steps she ascends to the temple, the walls of the palace of Solomon are characterized by a polychrome masonry pattern that clearly recalls the Palazzo Ducale itself; in that analogy resounds a basic theme of the "myth of Venice." The palace of the doges was a palace of justice (*ad jus reddendum*) and deliberately associated with the palace of Solomon—most explicitly in the corner sculpture before the Porta della Carta representing the *Judgment of Solomon*. Wisdom and justice, the two great virtues of the Hebrew king, were claimed by the Venetian Republic as her own special attributes—along with charity. Charity, of course, is the virtue to which the *scuola* itself is dedicated, and it is practiced within the painting by its officers whose individual portraits, like the architecture, extends the subject directly into the contemporary world of Venice.

The resonance of Titian's *Presentation of the Virgin* expands to encompass a complexity of dimensions—religious, historical, political—as the canvas becomes a very *summa* of basic Venetian values. A major monument in what may be considered the extended life of an older Venetian pictorial tradition, its stylistic reference functions as a part of the meaning of the picture; evoking as it does an unmistakable sense of history and tradition, it celebrates the continuity and stability of the Serenissima and, of course, its institutions such as the *scuole grandi*.

A New Generation

A decade after the installation of Titian's painting in the Scuola della Carità, another of the *scuole grandi* became the site of intense aesthetic activity and debate. In 1548, Jacopo Tintoretto, not yet thirty, delivered his *Miracle of the Slave* to the Scuola Grande di S. Marco (Venice, Accademia) (see p. 358). Initiating a cycle in the Sala del Capitolo dedicated to events in the life and legend of St. Mark, the canvas became the center of public controversy. Although it was enthusiastically acclaimed by Pietro Aretino in a letter of April 1548, in which the grand publicist speaks for the painter's admirers, the brothers of the *scuola* were evidently of divided opinion. Carlo Ridolfi reports that Tintoretto, offended by such hesitation, removed the picture and took it home. Eventually the factions were reconciled and the painting returned to the Sala Grande. While internal politics are likely to have been one source of discord, the painting itself was clearly intended as a bold public gesture, a challenge to the conventions of Venetian *teleri*, provocative especially in its radical foreshortenings and violation of the flatness of the picture plane.

The *Miracle of the Slave* represents a moment of arrival in the art of Tintoretto. Summarizing all the forces present in his youthful work, of which it is the culmination, its still greater energies announce the course of his future development. The painter's early, if distant, study of the art of Michelangelo here achieves a fully fluent language of corporeal eloquence, as quotations from the Florentine's Medici *Crepuscolo* [Dusk] and from the Sistine ignudi are conspicuously woven into the rich network of figural continuities. The *Miracle of the Slave* represents a synthesis of pictorial values, a demonstration of the principle Tintoretto was said to have inscribed on the wall of his studio, which read: "The drawing (*disegno*) of Michelangelo and the coloring (*colorito*) of Titian."

Crisis of Style

This eclectic aesthetic ideal, which found critical articulation in these very years, marked a turning-point in the development of Venetian painting. As Paolo Pino wrote in his *Dialogue on Painting* published in 1548, the very year of Tintoretto's *succès de scandale*, "if Titian and Michelangelo were a single body, in which the color of Titian were added to the drawing of Michelangelo, one would declare it the god of painting." The notion of reconciling the aesthetic virtues of the two most celebrated artists of the Cinquecento was at once a response to, and an effort to transcend, the local chauvinism of Italian art criticism. It also came at a time of stylistic challenge and turmoil within the Venetian art world.

By the fourth decade of the sixteenth century the Giorgione tradition appeared in general a tired one; of the painters active in Venice only Titian had been able to build upon Giorgione's example, creating a distinctly personal style, constantly growing and developing. Basically, the developments of these years center on an ever greater rapprochement with the more three-dimensional and solid formal values of central Italian art. Catalytic in these developments was Giovanni Antonio Pordenone, who brought to

Mars Disarming Love Between Venus and Flora, Paris Bordone, detail. Vienna, Kunsthistorisches Museum. The features of this Flora appear often in other mythological scenes by Bordone, who had great success owing to the freshness and charm of his subjects.

OPPOSITE:
Consignment of the Ring to the Doge, Paris Bordone, 1534. Venice, Gallerie dell'Accademia. Commissioned for the Sala dell'Albergo of the Scuola Grande di S. Marco, the painting recalls the legend of the fisherman who, having assisted in the defense of Venice against the demons on the side of St. Mark, presents the doge with the ring that the saint had given to him as a token.

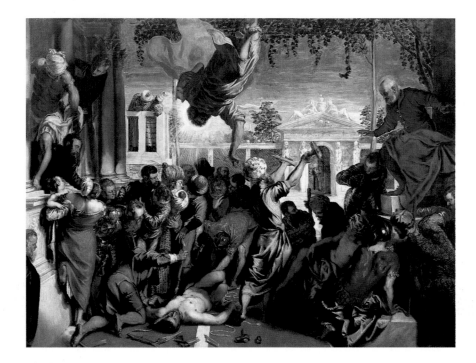

Miracle of the Slave, Jacopo Tintoretto. Venice, Gallerie dell'Accademia. This was the first of the canvases executed for the Scuola Grande di S. Marco. Before its final installation, the painting aroused controversy among the members, although it excited the admiration of Aretino. Opposite: detail with a self-portrait of Tintoretto as a young man, bearded, with dark hair.

Venice in the late 1520s a decidedly plastic monumental figure style, intense and aggressive, displaying a breadth of form inspired by central Italian models and heightened by an immediacy of expression that may well have been influenced by Dürer and northern art (see p. 344). In the decade following his arrival, Pordenone decorated many palace facades and in 1537 received a commission for the Sala del Maggior Consiglio of the Palazzo Ducale. Thus Titian found himself in active competition with an artist and a style that blatantly challenged the local traditions.

The new manner involved a greater emphasis on the human figure and its anatomical mass and movement, and on architecture. Venetian painters in the 1530s began to develop architectural settings for their *istorie*, adding a further plasticity to their handling of space but, even more importantly, articulating that space with a stylistic precision inspired by Roman models, modern as well as ancient. The shift is evident in the work of Paris Bordone and even in that of the more conservative Bonifazio de' Pitati and his active shop, as well as in the paintings of Titian himself.

Although the art of Michelangelo and Raphael was known to Venice through drawings and engravings—as well as in original works collected by Venetians, such as Raphael's tapestry cartoon for the *Conversion of St. Paul*, in the Grimani collection—

Roman values were brought to the lagoon personally following the Sack of Rome in 1527. The flight of artists from that center was to be of great significance for local schools throughout Italy but perhaps nowhere more so than in Venice, where both Pietro Aretino and Jacopo Sansovino found haven. These two strong individuals became close friends of Titian and leading members of the artistic and cultural community of Venice and played crucial roles in the metamorphosis of Venetian visual culture. Aretino brought to the lagoon all his Roman enthusiasm for Michelangelo and Raphael; Sansovino introduced a related figural style in his sculpture and established a monumental Roman mode of design in his architecture, transforming the very face of Venice. While both, in turn, were to be influenced by stubborn Venetian traditions, adapting their conceptions and styles to a new environment, their importance as conveyors of Romanism to Venice was essential.

Before any other aspect of central Italian art had gained a hold in Venice, the cult of Michelangelo began to be felt there. Indeed, the first Venetian to show an appreciative awareness of Michelangelo was Titian himself—who seems to have been familiar with the Florentine's cartoon of the *Battle of Cascina* (in the *Three Ages of Man* of c. 1513 [Edinburgh, National Gallery] and the *Andrians*) as well as one of the early slaves for the tomb of Pope Julius II (in the *St. Sebastian*, dated 1522, for the Averoldi polyptych

David and Goliath, Titian. Painted for the church of S. Spirito, the work is now in the sacristy of S. Maria della Salute. David is shown audaciously foreshortened at the moment when he raises his arms to thank God for his victory over Goliath.

in SS. Nazaro e Celso, Brescia). Venetian painters soon had the opportunity to become directly familiar with the very latest in Roman painting. Francesco Salviati arrived in Venice in 1539 and remained there for about a year; his principal patrons were Giovanni and Vettor Grimani, in whose palace he worked on two different decorative projects. The Grimani family, with some of its members in Rome, was the center of the Venetian Romanophile circle, and they selected Salviati and Giovanni da Udine to create a scheme of fresco and stucco decorations *alla romana*. Salviati's pupil, Giuseppe Porta, remained in Venice, a permanent representative of Roman training who became an

active participant in the artistic life of Venice—initially designing illustrations for book publishers.

On 1 December 1541 Vasari himself arrived in Venice. Invited there to design the stage sets for Aretino's comedy *La Talenta*, he also executed ceiling decorations in the Palazzo Corner-Spinelli and was commissioned to paint three ceiling panels for the church of S. Spirito in Isola. When he left Venice the following August, the latter commission passed to Titian, whose own solutions to the particular problems of ceiling painting may well depend on models by Vasari. The three canvases Titian painted for the nave of Sansovino's church—*Cain Killing Abel* (see p. 361), the *Sacrifice of Abraham*,

and *David and Goliath* (see p. 360) (now in the sacristy of S. Maria della Salute)—display a greater emphasis on controlled draftsmanship, on the anatomical solidity of human form, and, especially, on boldness of foreshortening. Although the strong use of *di sotto in sù* [use of a low viewpoint, literally upward from below] was not entirely new to Venice, it had never become a favorite decorative mode; of the painters working in Venice during the first half of the sixteenth century only Pordenone had utilized this perspective device.

In the early 1540s, then, Titian's art in particular seems to have turned in a new direction. Other works of this period confirm his increased interest in powerful figures and straining action—although we must not forget the dynamism of his *St. Peter Martyr* altarpiece, completed in 1530. In 1545 the Venetian master finally visited Rome. He took with him the *Danae*, a work in progress, which he completed in the Belvedere studio provided him by the Farnese. In that studio occurred the great encounter: Michelangelo himself, accompanied by Vasari, visited Titian at work. "After leaving him," Vasari reports, "Michelangelo praised him, saying that he very much liked his coloring and his technique; but it was a shame that in Venice they didn't learn from the beginning to draw well, and that those painters don't have a better way of studying. With that (he said) if this man were aided by true art and by drawing, as he is by Nature, and especially in copying from life, no one could not do more or better, having as he does a most beautiful, pleasing, and vivacious manner."

Aesthetic Polemic

In this anecdote Vasari invokes the authority of Michelangelo to reiterate a theme that runs through his criticism of the Venetian painters, beginning with his response to Giorgione's rejection of thorough preparatory drawing. Without *disegno*, and deprived of the benefits of Roman culture in general, the Venetians could never hope to attain perfection in their art, since, according to Vasari, they lacked the means of freeing themselves from slavish dependence on nature and were forced to conceal under the superficial charm of coloring their ineptitude at drawing. Not even Titian, "the greatest and most beautiful imitator of nature through coloring," could fully overcome the handicaps of Venetian training. Without *disegno* he could never raise his art above the mere reproduction of natural appearances to imitation in a higher, Aristotelian sense, ennobling nature by representing its ideal aspects, by imposing style upon its raw material.

The distance between the pictorial aesthetic of Venice and that of Florence and Rome reflects essential differences in painting technique. Vasari's definition of painting establishes a fundamental distinction: "a plane, a surface either of wood or of a wall or of canvas, covered with fields of color bounded by lines . . . which by virtue of good drawing circumscribe the figure." In this aesthetic, *disegno* functions on both a theoretical and a practical level: in theory as a governing principle in all the arts ("father of our three arts, Architecture, Sculpture, and Painting, born of the mind"); in practice as the actual making of a line by the application of chalk, pen, or brush ("profiles, contours, or lineaments"). *Disegno*, then, provided the very basis for both invention, that is, the conception of a compositional idea, and for its realization; it was the link between mind and hand. In practice, an artist developed his ideas through drawing, from first sketch to finished cartoon. And it was the cartoon, the final graphic representation of the composition, the end of the true creative process, that invested the outline with such special practical significance; for it was the contour, transferred by tracing to wall or panel, that carried the composition.

As the Venetians developed painting on canvas, however, they evolved alternative creative techniques. A Venetian painting, as Vasari recognized with disapproval, could be constructed directly on the canvas, the ideas tested and modified during the actual painting process. The Venetian masters, beginning with Giorgione and particularly Titian, were constantly altering and adjusting their compositions in the course of executing them. Their changes might affect details only or an entire design—as in the *Madonna di Ca' Pesaro* where Titian radically altered the architectural setting several times. Both style and technique rendered the cartoon, the grand monument of central Italian *disegno*, irrelevant to painting in Venice and called into question the very necessity of the systematic graphic preparation of a painted composition.

In response to central Italian criticism, Venetian apologists tended to reverse the values, assigning precedence to color over line. But the Venetians never developed a rational or systematic theory of art comparable to the grand aesthetic statement of Vasari. *Colorito*, unlike *disegno*, did not provide a conceptual base for theoretical elaboration. "Infinite are the things pertaining to color," declared Paolo Pino, "and it is impossible to explain them with words." The most effective critical language in Venice was not objectively analytical but rather more loosely suggestive, poetic and evocative, a literary correlative to the style of Venetian painting. One thinks above all of Pietro Aretino's prose, and especially of the famous ekphrasis in which he describes a natural scene, a view of the Grand Canal, in purely

Cain Killing Abel, Titian, detail. Painted for the church of S. Spirito, now in the sacristy of S. Maria della Salute.

Presentation of the Virgin in the Temple, Jacopo Tintoretto. Exterior of the large organ doors in the church of the Madonna dell'Orto. The composition recalls, with innovative foreshortening, the large canvas by Titian for the Scuola della Carità.

painterly terms, deriving his vocabulary as well as his vision from Titian's palette.

Other Venetian critics did, however, attempt an intellectually more orthodox presentation, beginning with the standard tripartite division of painting into *disegno*, *colorito*, and *composizione*. But they denied the superiority of *disegno*, regarding it rather as one, limited aspect of a larger pictorial experience. They dwelt upon the incompleteness of drawing as a mimetic medium and defined *disegno* in such a way that it became merely a subheading of color. Pino, for example, argues that since color and shading are indispensable to pictorial imitation of nature, and since any preliminary design must necessarily be covered over with color, a carefully delineated drawing "is wasted effort." Lodovico Dolce also emphasizes the mimetic obligations of the art of painting in his *Dialogo della pittura, intitolato l'Aretino* [Dialogue on painting, entitled the Aretino] of 1557, a response to the first edition of Vasari's *Vite* and an apologia for Titian. Since contours are abstractions and do not exist in nature, which is perceived as color and tone, successful imitation in painting must therefore be based on color, not line.

Colorito, or *colorire*, is the term used by the Venetians, not *colore*, that is, not the noun but a form of the verb. They are not concerned with color per se. Pino and Dolce agree that the quality of *colorito* does not reside in the physical properties of the colors themselves, which are beautiful even in their boxes, but in the manner in which these colors are applied: *colorito* is an active, constructive concept. Although their primary consideration is the imitation of nature, the duplication of its tones and hues on the canvas, both authors demand a certain manual dexterity in the application of the pigments, a "swiftness and sureness of hand." In theory as in practice, Venetian coloring is inseparable from Venetian brushwork; the effect of the color depends on the touch of the painter's brush.

Despite his polemical stance, Vasari himself was a fine enough critic to recognize the positive achievement of Venetian painting, at least in the art of Titian. He saw that the full potential of this manner of painting directly on the canvas was most eloquently realized in the late style of the Venetian master—which he observed directly during his second visit to Venice, in 1566—to which he responded with genuine sympathy in what is perhaps the most eloquent appreciation of that *pittura di macchia* [freely brushed painting]:

> But it is quite true that his method in these latter works is rather different from that of his youth: his early paintings are executed with a certain

Tintoretto

Tintoretto's life was lived within the circle of Venice, without outside interruptions. He was apprenticed to Titian's studio but was also influenced by Bonifazio de' Pitati. By 1540 he was not only demonstrating a strong interest in the styles of Pordenone, Salviati, and Giulio Romano, but was also championing the *maniera moderna*. His awareness of *pittura di macchia* led him to abandon the closed forms and muscular torsions of Michelangelo in favor of a more open, almost visionary style of painting. His fifty canvases for the Scuola di S. Rocco were by the time he had finished in 1587 a monument to himself and his art. His *Presentation of the Virgin in the Temple* in S. Maria dell'Orto is a masterpiece of composition and color, as are his many versions of the Last Supper. Like Titian, Tintoretto was a great portrait painter. He also received frequent public commissions, such as the paintings in the Palazzo Ducale that were made for the Atrio Quadrato and moved to the Sala dell' Anticollegio the four mythological canvases that require interpretation in terms of contempoary political and religious affairs.

fineness and incredible diligence and can be viewed both from close up and from afar; these recent works, on the other hand, are carried out in bold strokes, broadly applied in great patches in such a manner that they cannot be looked at closely but from a distance appear perfect. And this method has been the reason that many, wishing to imitate Titian and so demonstrate their own ability, have produced only clumsy pictures [goffe pitture]. This happens because they think that such paintings are done without effort, but such is not the case, and they delude themselves, for Titian's pictures are often repainted, gone over and retouched repeatedly, so that the work involved is evident. Carried out in this way, the method is judicious, beautiful, and magnificent, because the pictures seem to come alive and are executed with great skill, hiding the effort that went into them.

The Challenge of Tintoretto

Among those painters responsible for producing *goffe pitture* the worst offender in Vasari's mind was Jacopo Tintoretto. Refusing to extend to the younger Venetian the same critical sympathy he showed for Titian, Vasari declared Tintoretto "extravagant, capricious, quick and resolute, and the most terrible brain ever seen in painting . . . he has worked by pure chance and without *disegno*," leaving "sketches for finished works," working "by chance and by boldness, rather than with *disegno* and judgment." If in the rough brushwork of Titian one could see a new nature, the art of Tintoretto seemed without any such redeeming mimetic quality; his speed of execution seemed to go beyond any legitimate "swiftness and sureness of hand." Even Aretino, who hailed the "swift and eager youth" in his letter celebrating the *Miracle of the Slave* in 1548, added a caveat: "And your name would be hailed if only you would reduce your speed of execution in favor of greater patience."

Tintoretto, however, developed the uniqueness of his bold style consciously and with purpose; even if that manner of painting offended some, it guaranteed notice. According to Ridolfi, "to acquire technique in the handling of colors," Tintoretto deliberately studied the hasty techniques of lesser painters: "Moreover, he practiced with lesser painters, those who painted the stalls in Piazza S. Marco, just to learn their techniques." This was precisely the kind of low painting, or "clumsiness," condemned by Pino as "disgraceful and incorrect." Ridolfi then recalls Tintoretto's great admiration for the "beautiful way of coloring" of Andrea Schiavone, which had quite pointedly been condemned by Pino as "this smearing, working by habit." Schiavone, another

master of the rapid brush, suffered such criticism without the commercial success of Tintoretto. Vasari, for example, admitted, grudgingly, that Schiavone was a good painter, adding, however: "I say good, because by accident he even occasionally made a good work." Clearly, then, a new generation of Venetian painters, in pushing the limits of technique and style, questioning the values of diligence and finish, was sounding a serious challenge to critical response.

And yet Vasari himself was capable of distinguishing among the pictures of Tintoretto. If the great canvases in the presbytery of the Madonna dell'Orto seemed to him painted "as a joke," the *Presentation of the Virgin in the Temple* decorating the organ shutters of the same church was appreciated as "a finished work, the best executed and most joyous painting in that place" (see pp. 362–363). Moreover, the Tuscan critic was evidently undisturbed by the execution of the *Miracle of the Slave*, which he admired for its "great copiousness of figures, of foreshortenings, of armor, buildings, portraits, and other such things, which greatly embellish that work." Evidently Vasari understood that this particular canvas was executed to be seen from a distance, the entire length of the Sala del Capitolo of the Scuola Grande di S. Marco, justifying the looser execution of this example of "il colorito alla veneziana."

For the paintings on the long walls, however, Vasari had no patience. The three canvases commissioned in 1562 at the expense of Tommaso Rangone appeared to him "the most eccentric strokes in the world:" "these works . . . are barely conceived before they are begun and finished." Indeed, the *Translation of the Body of St. Mark* (Venice, Accademia) seems deliberately to invite such criticism (see p. 364). The canvas itself remains clearly in evidence; it seems barely prepared with a brown tint to serve as the base for a simple chiaroscuro pictorial structure with umber and white. Only the bodies of the saint and his faithful porters carry any weight, an opacity of paint that translates as material substance. The rest, however, is rendered nearly exclusively in white, the brush either loaded with paint, tracing impasto lines, or dry, leaving a veiled effect—the lightning and the specters of the infidel who abandon the piazza and the pyre, and the rapidly receding architecture itself. The setting is defined as an only slightly fantastic Piazza S. Marco; the arcaded Procuratie to the side and the background closed by an elongated version of Sansovino's facade of S. Geminiano make the local reference clear. It is quite appropriate, at least from a Venetian point of view, that "the miracles of our most sainted protector St. Mark" be translated from Alexandria, that the body of the saint be transported to its

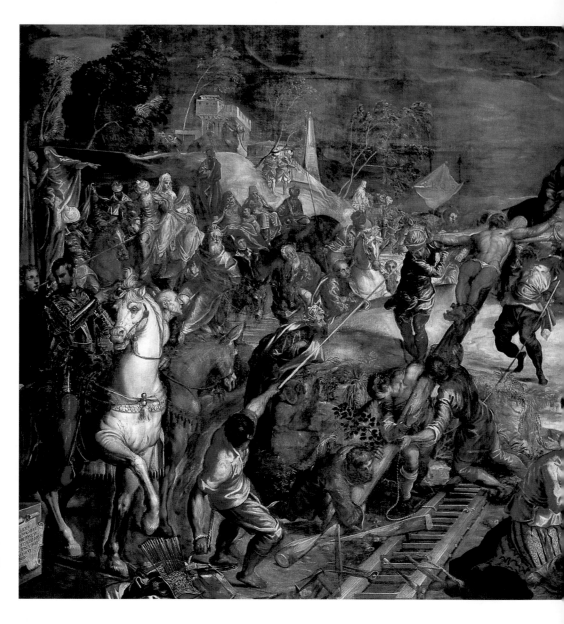

Crucifixion, Jacopo Tintoretto, 1565. Scuola di S. Rocco, Sala dell'Albergo. This most impressive of Tintoretto's paintings presents a panoramic spectacle containing a wealth of incidents— for example, the pathetic figure of St. John at the foot of the cross—all of it emanating from the central and controlling event, the Crucifixion of Jesus.

promised resting place, the reliquary basilica of S. Marco in Venice. Like Titian, then, Tintoretto knew well how to adapt a Christian *istoria* to a specifically Venetian site, inflecting it with special Venetian meaning.

Tintoretto was the only one of the dominant Venetian painters of the Cinquecento actually born in Venice, and he remained the most determinedly parochial, hardly ever leaving the city. He married into a family of native citizens, and "at a mature age, prodded by his wife," Ridolfi records, "he dressed in the Venetian robe." Indeed Tintoretto seems to have

claimed all Venice as the rightful arena for his art. Already by 1561 Francesco Sansovino, listing among the "notable things of the city of Venice" this painter, "all spirit, all quickness," observed "that he alone has painted more in this city, and elsewhere, than all the other painters together; for his hand is accompanied by his quick mind. . . . He has abundant invention, but not much patience, which is needed to bring anything to completion, and it is certain that he takes on too much." And Vasari, after criticizing the painter for working "by chance and by boldness, rather than by *disegno* and judgment," declares:

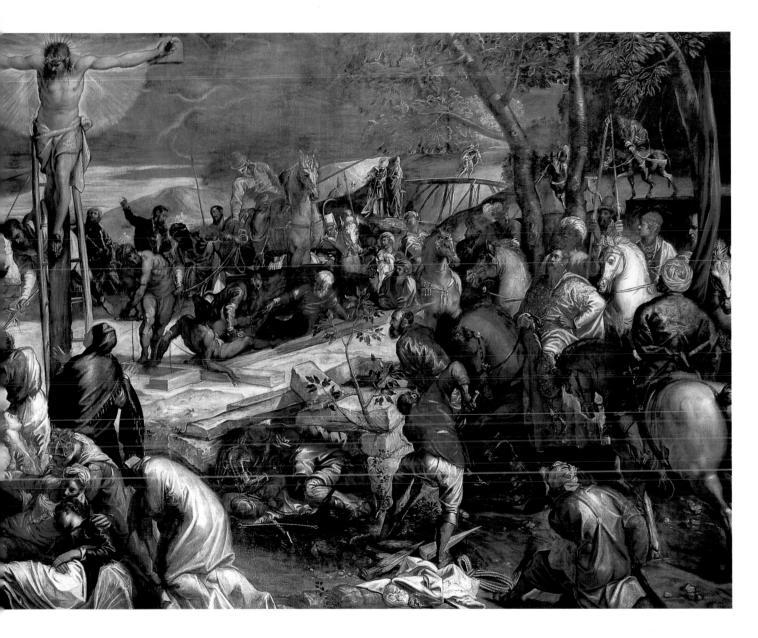

"with these ways of his he has made and is making the majority of paintings that are done in Venice."

Tintoretto seems to have been driven by a desire to cover the walls of Venice with his art. He was unscrupulous in securing commissions—undercutting the competition on price, offering to paint in the style of others and for less, at times even giving away his work. No other painter seems to have enjoyed such a reputation. The scandals that accompanied his canvases for the Scuola Grande di S. Marco—those commissioned by Rangone were also withdrawn for a while—were repeated in 1564 at the competition

for the central ceiling painting of the Sala dell'Albergo of the Scuola Grande di S. Rocco, *St. Roch in Glory*. Instead of submitting a *modello* for competitive evaluation, Tintoretto managed to have installed a completed canvas before the competition; then, to the chagrin of the brothers, he donated the work in the name of their patron saint, a donation they could not refuse. This most Venetian of Venetian painters had a habit of challenging "el modo et ordene antiquo."

Despite the opposition of many, Tintoretto nonetheless managed to secure for himself the decoration

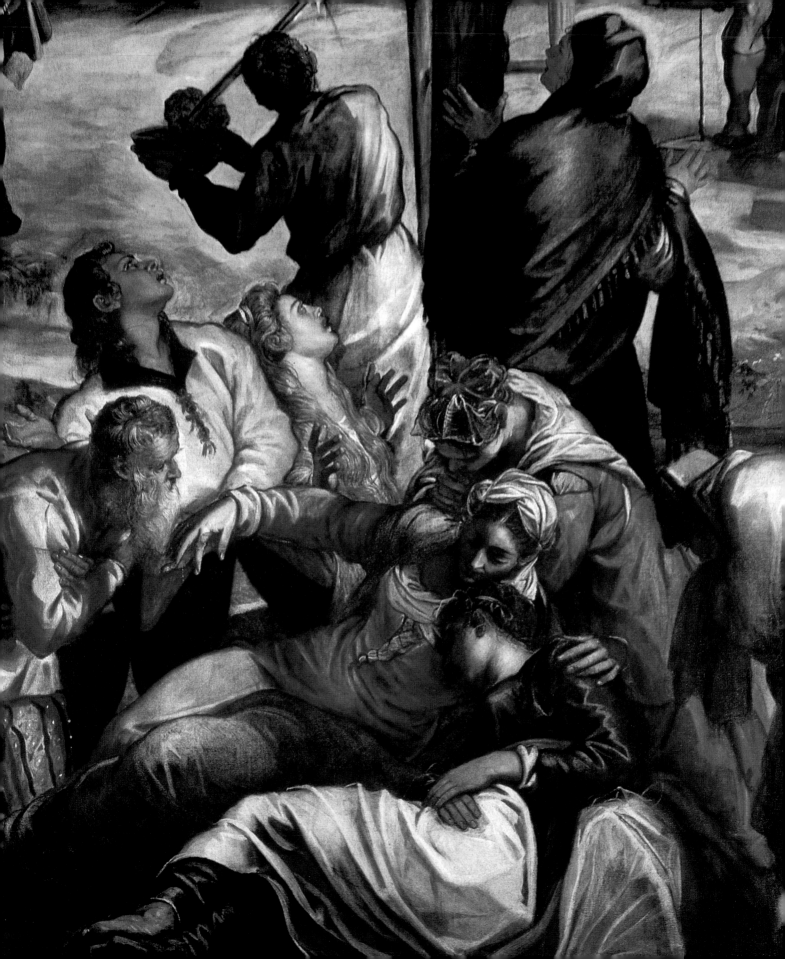

of the rest of the *albergo* and, moreover, to be elected a *confratello* of the Scuola di S. Rocco. Following the decoration of the ceiling, he painted the great *Crucifixion* in the *albergo* in 1565. Extending over twelve meters across the long wall over the tribunal, this most impressive of Tintoretto's paintings presents a panoramic spectacle containing a wealth of incident, all of it emanating from the central and controlling event, the Crucifixion of Jesus. Central to the expansive composition is Christ himself; set above the earth against the turbulent sky, he is the source of a circular aureole of divine light. His radiance is reflected below in the illuminated zone of the middle ground, which is defined by divergent orthogonals receding from the foot of the cross with a centrifugal energy that charges the entire picture. Figures and objects, the mechanical details and tools of the Passion, enact the counterpoint of Tintoretto's dynamic compositional mode. Here, in particular, the physical forces of perspective and radical foreshortening that had threatened the traditional planarity of Venetian *teleri* are reaccommodated to the picture plane by the larger controlling patterns of light and dark. In this *Crucifixion* are eloquently manifest the principles of Tintoretto's art, his rethinking of traditional values, but also his continuing recognition of the importance of the plane as final determinant of pictorial coherence.

Tintoretto completed the decoration of the *albergo* in 1566–67 with scenes of the Passion of Christ leading up to the Crucifixion. In 1575 he volunteered to paint the central canvas in the newly redesigned ceiling of the Sala del Capitolo for nothing, and beginning with that work, the *Erection of the Bronze Serpent*, he laid claim to the rest of the ceiling, which he completed by the end of 1577, at the cost only of materials. At that point, he offered to paint the rest of the room, promising to deliver three *teleri* annually in exchange for a lifetime stipend from the *scuola* of one hundred ducats per annum (the normal price for a single such canvas). By the summer of 1581 the decoration of the Sala Grande was complete, with scenes from the life of Christ, and the following year he began work in the Sala Terrena (ground-floor hall), essentially a Marian cycle (see p. 397). By the time he finished in 1587 Tintoretto had succeeded in turning the Scuola Grande di S. Rocco into a monument to himself and his art (see p. 373).

The Venetian Ceiling

Ceilings in Cinquecento Venice tend to be flat wooden affairs rather than masonry vaults; wooden ceilings are lighter and require simpler supporting structures, an important factor in a city founded on mud and piles. To the basic construction of supported beams a decorative framework, gilded and painted, is attached; that framing pattern left open fields that awaited pictorial elaboration. This basic system is to be found throughout Venice, in churches and in secular rooms, private as well as public. "There are an infinite number of buildings where the ceilings of bedrooms and other chambers are worked in gold and other colors, and decorated with paintings and excellent skills," wrote Francesco Sansovino in his monumental guidebook, *Venetia città nobilissima et singolare* of 1581. In the course of the sixteenth century the framework itself became increasingly complex, as organic strapwork wove its way beyond the tectonic grid pattern of the older ceilings.

This development can be followed from the *albergo* to the Sala Grande of the Scuola Grande di S. Rocco: one is a relatively simple design with a single central oval set within a generally rectangular ceiling, the other a much more complex affair, larger in size and with a longitudinal axis, with fields of more varied shape and scale. In both cases, however, the painter confronted an already completed ceiling structure, its architectural design determining the number and shape of the paintings required.

Earlier in the century, painters tended to treat the horizontal surface of the ceiling in the same way as that of a wall: little attempt was made to acknowledge the very different viewing situation. Only in the second quarter of the century—following examples by Pordenone and then by Vasari, succeeded by Titian—were efforts made to accommodate the view *di sotto in sù* [from below], through perspective foreshortening or an opening of the image to sky beyond. The great challenge to the painter was to maintain the conviction of dramatic action when viewed under such unnatural circumstances, as well as the integrity of the picture plane in the face of such a drive to celestial infinity.

In the *albergo* canvas of *St. Roch in Glory* Tintoretto grounded the foreshortened saint along one side of the frame and countered that recession with the opposing forward thrust of God. His solutions in the Sala del Capitolo involved an expansion of that basic principle of counterpoint as well as an extension of the kind of large chiaroscuro structures that inform the great *Crucifixion*. Raising the horizon high in the field or bisecting the field by other devices, he established a certain dynamics of opposition, a large-scale compositional contrapposto that set areas of light against dark. Then, within those areas and on the smaller scale of individual figures, he reversed the values, setting dark against light or vice versa. And these chiaroscuro patterns, countering the spatial thrust of radically foreshortened forms, imposed a new order on the surface. Tintoretto's

OPPOSITE:
Crucifixion, Tintoretto, detail.

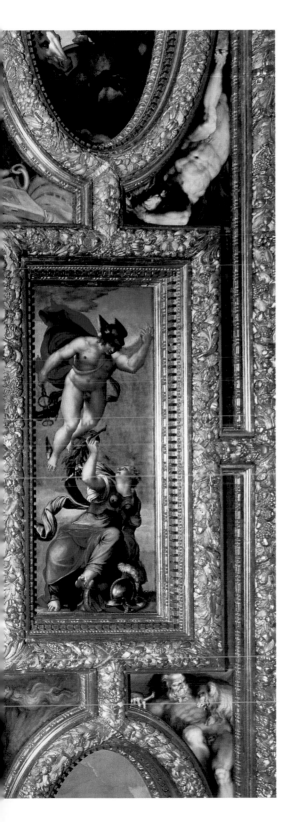

response to the challenge of ceiling painting was predicated on the same principles of pictorial construction that had allowed him to break with the Venetian tableau tradition, the planar conventions of the *teleri*.

A decade before Tintoretto's efforts in the *albergo* of the Scuola di S. Rocco, in 1554–55, Paolo Veronese and his compatriot Giovanni Battista Zelotti decorated the ceiling of the hall of the Council of Ten in the Palazzo Ducale (see pp. 370–372). In these canvases, too, the field is weighted since the attachment of forms to the frame establishes an orientation as well as a base for the figures; surface and space are held in equilibrium by figural counterpoint.

Veronese quickly established himself as a major artistic presence in Venice. In 1555 he began his pictorial appropriation of the church of S. Sebastiano, which over the course of the following decade he transformed into a personal monument—in which he was indeed to be buried (see p. 373). The ceiling of the nave of S. Sebastiano is more tectonically regular than the later ceiling of the Sala Grande of the Scuola di S. Rocco. Typical of the themes of ceiling painting, which tend to serve as precursors to the wall images, the subject of the S. Sebastiano ceiling is drawn from the Old Testament: three scenes from the story of Esther, savior of her people and thus antetype of Christ. Veronese had originally been trained as a stonecutter (*spezapreda*) and had practical familiarity with the language of architecture (he designed the high altar of S. Sebastiano). In his ceiling paintings he manipulates architecture inventively to structure his compositions. Exploiting the *di sotto in sù* perspective with precise purpose, he forces it to the point of absolute accommodation to the picture plane: the radically foreshortened units of buildings—cornices, canopies, balconies—align to create an axial continuity running through all three canvases, the length of the nave. Veronese's stringent control of the compositional structure responds to, even as it reinforces, the architectonic system of the framing pattern of the ceiling of the nave—just as Tintoretto was to find in the swirling movement of the ceiling framework in the Scuola di S. Rocco a congenial match for the exuberance of his own figural compositions.

Venetia Triumphant

Although Titian continued to be the dominant figure in Venetian painting until his death in 1576, the third quarter of the century witnessed the establishment of a younger generation of challengers. Tintoretto's

Wooden ceiling decorated with canvases by Paolo Veronese in the hall of the Council of Ten in the Palazzo Ducale. The sumptuous pictorial decoration celebrates the glories and triumphs of Venice. Subjects include *Juno Showering Gifts on Venice*, as well as the great oval with *Jupiter Hurling Thunderbolts* (the latter is now in the Louvre and has been replaced by a 19th-century copy).

OVERLEAF:
Old Man Wearing a Turban, Paolo Veronese, ceiling of the hall of the Council of Ten, Palazzo Ducale.

clamorous entry onto the public scene in 1548 occurred, not coincidentally, when the older master was away from Venice, attending Emperor Charles V at the imperial diet in Augsburg. By 1555 Veronese had become a resident of Venice, having already executed an altarpiece for the Giustiniani at S. Francesco della Vigna and ceiling paintings for the Council of Ten (see p. 372). These two painters, then, masters of growing workshops, became the major challengers to Titian's aesthetic hegemony, as well as each other's fiercest competitor. And they did indeed offer alternative pictorial styles and visions.

Tintoretto's art seemed ideally suited to the citizen class, to its *scuole grandi* and smaller religious confraternities. The relative simplicity of his represented surface, the sartorial modesty of the players in his theater and their physiognomic anonymity, the modesty of setting of his *Last Suppers*—such qualities conformed to a Venetian mean. Despite the energies of his staging and the bravura of his technique, there is something essentially humble about Tintoretto's world. Veronese's, on the other hand, offers a more controlled, aristocratic vision. His figures move at a more deliberate pace, with studied decorum, and their actions take place before architectural settings of Vitruvian magnificence. That splendor extends as well to technique: not until late in his career did Veronese exploit the tonal base that was central to the legacy of Giorgione. Rather than coax color out of a darker ground, he built a palette of chromatic clarity on a lighter base. The opulence of that palette was carried by a pattern of brushwork more elegantly refined than Tintoretto's bolder attack, and that aesthetic sensibility perfectly matched the grander spectacle of his costumes and staging. Veronese's art was more obviously suited to an aristocratic taste that was not adverse to pushing the limits of Venice's famed—and generally flouted—sumptuary laws.

Luxury Painting

On 6 October 1563 Veronese acknowledged final payment of the 324 ducats he received for the grand canvas for the refectory of the Benedictine monastery of S. Giorgio Maggiore, the *Marriage at Cana* (now in the Louvre). This was the first of the great paintings of feasts that are a hallmark of Veronese's achievement and that were to enhance his reputation as that of a painter of luxury and ostentatious display. And yet precisely that pomp eventually came to mask the keen pictorial intelligence that informs these spectacular representations. Despite its size (6.66 x 9.90 m) and the undoubted participation of workshop assistants, the *Marriage at Cana* reveals a level of execution that confirms its intention as a public "demonstration of his art," of Veronese's

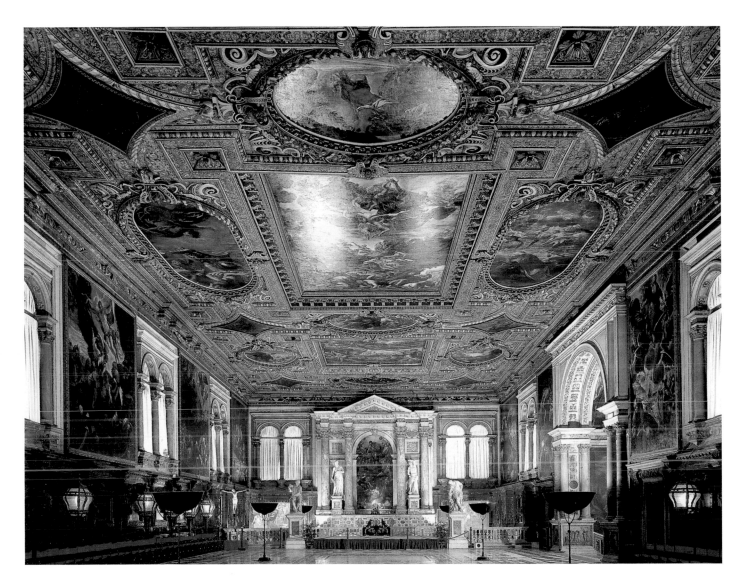

powers of invention as well as subtlety of brush handling. Its chromatic brilliance, always appreciated, has become all the clearer since the recent restoration. Veronese more than satisfied the stipulation in the contract to use "the very best colors and not to neglect any opportunity to introduce the finest ultramarine and other most perfect colors."

However, for all the opulence of its spectacle, the grandeur of its monumental setting and the chromatic exuberance of its participants, Veronese's *Marriage at Cana* is no mere hedonistic indulgence. Rather, it is a carefully calculated representation of "the story of the miracle performed by Christ at the Supper in Cana, Galilee," the subject called for in the contract. Christ, ironically frontal and directly on the central axis, is

the still center of a world in motion, the efficient cause of the miracle and hence of the responses of those figures, to the lower left and right, who are at this moment aware of the liquid transformation: "This deed at Cana in Galilee is the first of the signs by which Jesus revealed his glory and led his disciples to believe in him" (John, chapter 2, verse 11).

Critics have occasionally been disturbed by the displacement of the bride and groom to the extreme left of the composition. But this is the feast at which Jesus sanctified the sacrament of marriage. Here Christ himself, manifesting forth his glory, usurps the central place of honor thematically as well as visually: we are directly confronted by the heavenly groom whose beloved bride is Mary, *sponsa Christi*.

Scuola Grande di S. Rocco. This chapter room still has the original grand pictorial decoration, with the entire cycle of canvases executed by Tintoretto between 1564 and 1567. On the ceiling are twenty-one canvases with scenes from the Old Testament. At the back is the altar with statues of St. Sebastian and St. John the Evangelist by Girolamo Campagna.

ON THE FOLLOWING PAGES:
St. Mark and St. Marcellinus Exhorted at Their Martyrdom by St. Sebastian, Paolo Veronese, in the church of S. Sebastiano. Along with the *Martyrdom of St. Sebastian*, this scene decorates the walls of the presbytery. As in so many works by this artist, the subject serves as a pretext for a grandiose composition of figures in motion amid fabulous architecture.

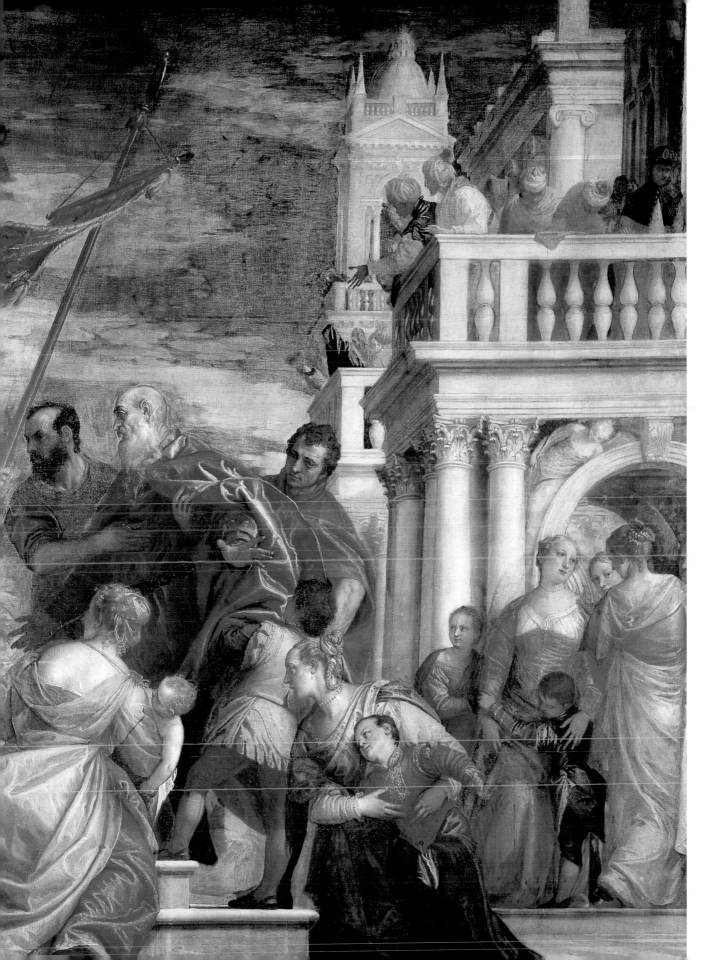

Marriage at Cana, Jacopo Tintoretto, S. Maria della Salute. Tintoretto painted the picture for the refectory of the monastery of the Crociferi, from where it was transferred some time after 1657 to the church of S. Maria della Salute. The painting with its bold perspective transpose the scene to 16th-century Venice and shows interesting details of everyday life, customs, and fashion. Paolo Veronese painted the subject in quite a different way in 1563 for the monastery of S. Giorgio Maggiore, the first of his famous, luxuriant banquet scenes. Veronese placed the icon-like frontal figure of Christ as an anchor, so to speak, right on the central axis of the picture, while bride and groom are moved over to the left.

Veronese's placement of the miraculous transformation to the sides of the field and his depiction of Christ rigidly on axis, *in maestà* [in majesty], thus responds with pictorial sensitivity to the essential subject itself. Indeed, it is precisely along that axis, figured by the iconic frontality of Christ, that the meaning of the image most fully manifests itself. At its base is the famous quartet of Venetian painters, a direct link with the contemporary world of the viewer. At its apex, immediately above Christ, is the upraised cleaver of the butcher preparing the lamb, so prominently silhouetted against the sky. A key to the meaning of that sequence—musicians-Christ-butcher—is offered by the hourglass on the table amidst the musicians. Totally without function in musical practice, it is purely symbolic, making explicit the interpretation of music as measured time. The hourglass thus alludes directly to the words of Christ to his mother: "My hour has not yet come" (John, chapter 2, verse 4).

Veronese himself offered further commentary on the kind of pictorial intelligence manifest in the *Marriage at Cana* in his famous response before the Inquisition in 1573. The cause was the *Last Supper* painted for the Dominican refectory of SS. Giovanni e Paolo, the canvas now known as the *Feast in the House of Levi* (Venice, Accademia) (see pp. 378–380). Veronese's painting replaced one by Titian that had been destroyed by fire in 1571. On 20 April 1573 Veronese dated his completed canvas, and on 18 July of the same year he was summoned before the Holy Tribunal to answer charges of indecorum—specifically, of having depicted in a Last Supper "buffoons, drunkards, German soldiers, dwarfs, and other similar vulgarities." The outcome of the hearing was that the painter was ordered to make, at his own expense, appropriate corrections in the composition to remove the offenses. As is well known, the only change Veronese made was to add an inscription that retitled the painting: "FECIT. D. COVI. MAGNU LEVI — LUCAE CAP. V." The new subject indeed required the presence of "publicans" and "sinners" (Luke, chapter 5:, verse 30) and presumably could also accommodate "similar vulgarities."

The part of Veronese's testimony that is most frequently quoted is his defense of poetic license for painters. His explanation begins: "We painters take the same license as poets and madmen. . . ." Much of Veronese's declaration may indeed be read as a defense of relative pictorial liberty—if not of "pure aesthetic values." If the jester with a parrot was there for ornament, *come si fa*, and the extras were present because the painter was told the host at Cana was a wealthy man and must have had lots of servants, the painter's final defense reflects certain basic aspects of

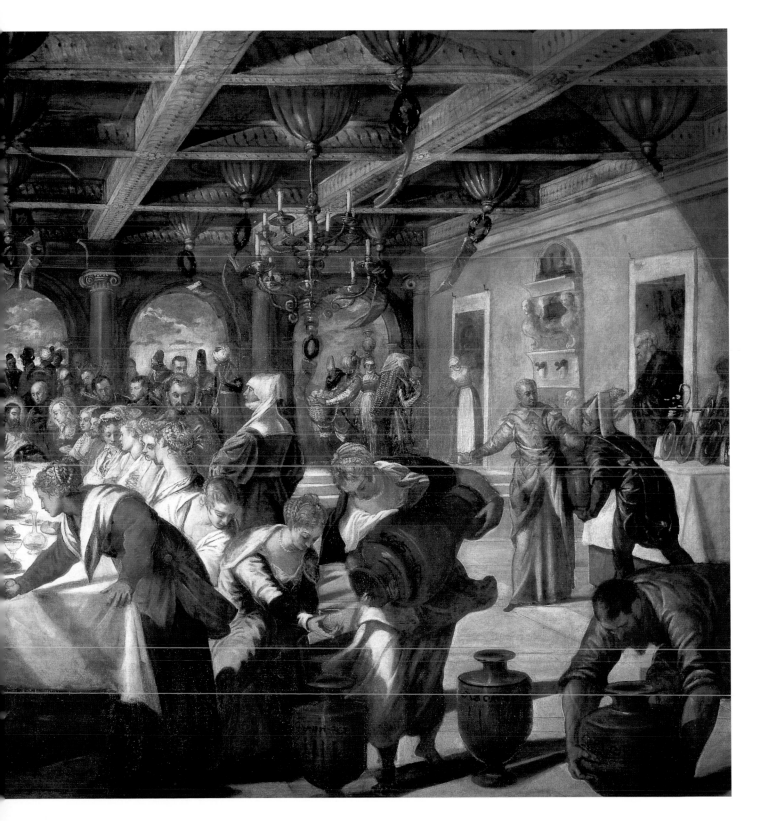

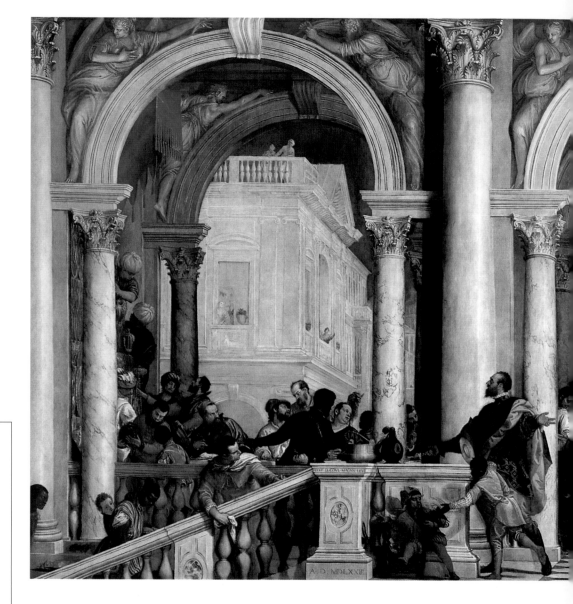

studio thinking: "But the commission was to decorate the picture as it seemed appropriate to me; it seemed to me large and capable of holding many figures." More revealingly still, it reflects his basic artistic intelligence, the kind of intelligence that structures his pictures: "I make paintings with that consideration of what is appropriate, as my intellect may understand it." Why then did he paint such things in a Last Supper? "I did it because I assumed that these types were outside the place where the supper was set." His final appeal: "Most Illustrious Lord, it is not that I wish to defend myself, but I thought I was doing the right thing. And while I may

not have considered many things, I thought I was creating no confusion since those figures of buffoons are outside the space where our Lord is."

In these lines the painter offers us a rare commentary on his own art, an analysis of his own composition and an interpretation of its meaning. The grand triple arcade of this *Last Supper*, like the *scenae frons* of the Palladian theater, divides the field like a triptych. The central arch is reserved exclusively for Christ and his immediate disciples, Peter and John, as well as shadowed Judas; Christ himself, on axis, is silhouetted against the celestial background. Here too, then, Veronese has brought his own kind of

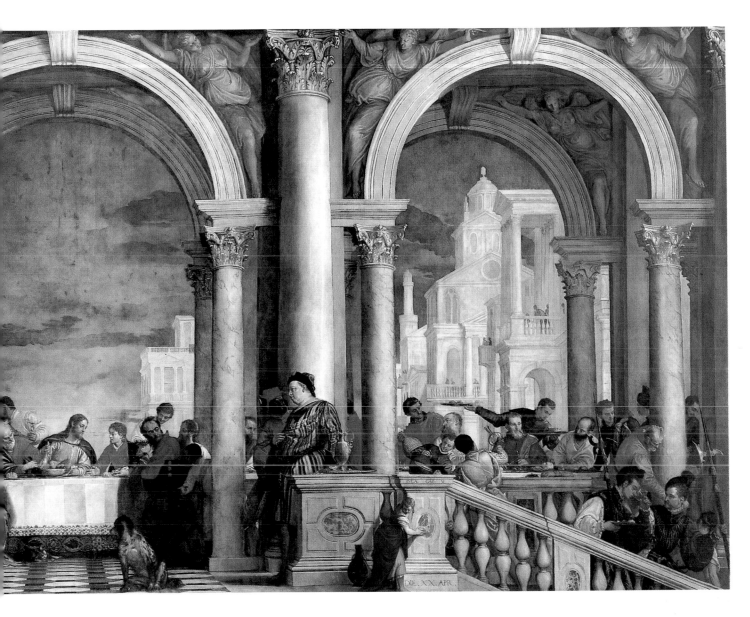

pictorial analysis to bear on the requirements of the subject. No mere display of worldly pomp, this feast too sets the events of Christ's life within the world he entered, even as those events are distinguished and isolated by means of the painter's art. And by that art, Veronese—like Tintoretto but in a different mode—demonstrated the place of religion in the world of Venice.

Images of the State

More consciously and deliberately than any other Renaissance state, Venice developed an iconography of herself. That self-image was predicated on a series of assumptions and associations that appropriated both ancient Roman and Christian history, both Olympian gods and Christian holy figures. In addition to its patron St. Mark, Venice also put herself under the protection of the Virgin Mary, like so many Italian communes, but she went beyond them in identifying her civic self with Mary: like Christ, Venice too claimed to have been conceived on 25 March. According to standard legend, the city was founded on the day of the Annunciation in the year 421. Boasting of her lack of Roman foundation, this was a republic born in Christian liberty. The Roman empire had been destroyed by the barbarian tribes;

Last Supper/Feast in the House of Levi, Paolo Veronese. Venice, Gallerie dell'Accademia. Painted for the Dominican refectory of SS. Giovanni e Paolo. Although the commission called for a Last Supper, Veronese changed the title after he was charged with "indecorum" by the Inquisition and ordered to make, at his own expense, appropriate corrections in the composition to remove the offenses; his response was to add an inscription that retitled the painting *Feast in the House of Levi*, a subject that did require the presence of "publicans," "sinners," and other "similar vulgarities."

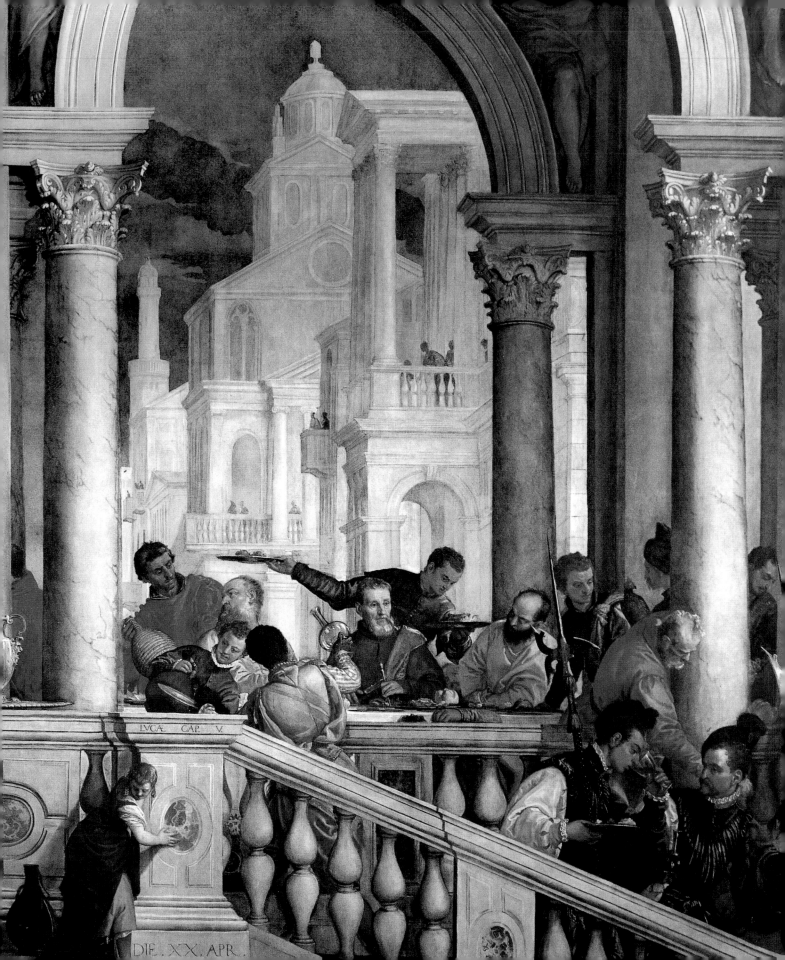

LVCAE CAP V

DIE XX APR

pagan might was fallen, and God in his infinite wisdom saw to a proper, Christian succession. On 25 March, the day chosen for the beginning of redemption, began as well a new era of political grace. Perhaps no image makes the point so succinctly as the *Annunciation* triptych from the studio of Bonifazio de' Pitati painted for the Camera degli Imprestidi of the Palazzo Ducale before 1540 (Venice, Accademia). Between fields containing the Archangel Gabriel and the Virgin, its central field is dominated by God the Father and the Holy Spirit soaring above Piazza S. Marco: Venice herself thus participates directly in the theological mechanics of salvation, simultaneously hosting and sharing in the moment of the Incarnation, and thereby receiving her own peculiar divine sanction. Indeed, Venice, never conquered by others, vaunted her virginity. Among the images devised by Francesco Sansovino for the Sala delle Quattro Porte in the Palazzo Ducale and painted by Tintoretto was one (destroyed) representing *Venetia Vergine*, Virgin Venice, "who with her incorruptible purity, defends herself against the impudence of others, and is supported by the world because she alone among nations has remained uncorrupted and intact, free of foreign barbarians and tyrannical empires."

Successor to Rome, Venice identified herself with the figure of Justice, but that association acquired new dimensions in the course of the sixteenth century—especially following the war of the League of Cambrai, when the Republic was forced into an ever more rhetorical position. Venetia herself is most gloriously represented in Veronese's triumphant ceiling painting above the ducal throne in the Hall of the Great Council (see p. 382). Set triumphant upon a throne of clouds, surrounded by an Olympian court, she rules over a peaceful empire of grateful subjects. Her meaning is set forth in the program for the redecoration of the room following its destruction by fire in 1577: "A figure of Venice, enthroned above cities and towers, in imitation of the ancient goddess Roma seated above the world, with a small winged victory in flight over her head who crowns her with laurel; around this Venice are personifications of Peace, Abundance, Fame, Felicity, Honor, Security, and Liberty, all represented with the attributes that were devised by the ancients, and accompanied by a celebrating populace of varied costume and type, men and women, young and old."

The figure of Venice personified commanded a rich and complex genealogy, combining the qualities of the Virgin Mary and Dea Roma, Justice and Venus (who, like the city, was born from the sea) into a single majestic figure, the Queen of the Sea ruling the heavens. And this allusive complexity epitomizes the self-presentation of the Serene Republic herself,

where religion, history, mythology, and politics were interwoven into a unified social fabric. The iconographic repertory was vast, since all images were susceptible to a patriotic hermeneutic. Thus the four mythological paintings executed by Tintoretto for the Atrio Quadrato of the Palazzo Ducale (later transferred to the Anticollegio) (see p. 383) were to be interpreted in a definitely Venetian key—as Ridolfi read the representation of the *Marriage of Bacchus and Ariadne in the Presence of Venus*: "See Ariadne, discovered by Bacchus on the strand, crowned by Venus with a golden crown, declaring her free and welcoming her among the number of heavenly images, which means, Venice born on the sands of the sea, rendered abundant not only by every earthly good through heavenly grace, but crowned with the crown of liberty by the divine hand, and whose dominion is recorded in eternal characters in Heaven."

The decorations of the Palazzo Ducale exploit this Venetian syncretism programmatically and with pictorial splendor. And yet the iconographic fantasy that harnessed the Olympians was a rhetorical facade, a veneer of pagan propaganda over a more basic political and religious truth. Venice saw herself primarily as the only Christian republic; her essential mythology involved her patron saint, Mark, the Virgin Mary, and, ultimately, the Savior himself. The truth of Venice on the walls of the Palazzo Ducale was represented in the votive pictures of her doges. It was, in reality, the doge who personified Venice, and in his representation to the Virgin and Child, through the intercession of St. Mark and other saints, he stood for the entire Republic and its subjects. To St. Peter of the Roman Church Venice held up her own Evangelist as she claimed her own, more direct access to heaven. In these images, then, were figured the deepest values of Venice, and in the sequence of ducal portraits a chronicle of her history personified.

The Triumph of Coloring

The history of Venetian painting in the Cinquecento is founded in the realities of the city itself: the physical realities of its humid climate, which encouraged the development of canvas support; the socioeconomic realities of its confraternities and guilds, which offered ambitious patronage and controls on production; its political and historical realities, which required an expanding and flexible iconographic vision; and, of course, the religious realities of its churches and religious houses. Each of these dimensions was informed with a particular *venezianità* that found unique pictorial expression.

The most lasting legacy of this painting, however, transcends the parochialism of such historical realities. It lies rather in the art itself. In Venice was established an essential foundation for modern painting: in the *pittura di macchia*, developed out of the tentative suggestion of Giorgione's technical revolution, was born the basic valorization of the individual touch of the painter, the brush stroke.

The Signature of the Brush Stroke

Il colorito alla veneziana involved more than color per se; rather it referred to the application of paint. It was that technical aspect of painting that determined individual style. Ironically, it is Vasari, the great spokesman for *disegno*, who offers some of the clearest testimony to the brush stroke in Venetian painting. When he complained that Tintoretto "worked by chance and without *disegno*, as if showing that this art is a joke," the Tuscan critic continued by condemning the painter for having "left sketches as finished works." To finish a work properly, according to Vasari's aesthetic, meant blending the strokes into unbroken surfaces; the visibility of the stroke was the sign of a work still in progress.

Titian, whose reputation was secure, could be forgiven such openness of surface, and Vasari himself could indeed appreciate its natural effect. But Vasari was a professional; he understood the mechanics of painting. To the layman, however, Titian's rough manner could prove a real obstacle. When Aretino sent his portrait (Florence, Palazzo Pitti) to Cosimo I de' Medici in 1545, he felt obliged to apologize for its lack of finish. He had already hailed the image as "such a terrible marvel," and to Cosimo he confessed, "Surely it breathes, the pulse throbs, and its spirit moves in the world just as I do in life." Nonetheless, with a certain hypocrisy, perhaps—for he fully appreciated Titian's brush—but with a keen awareness of Florentine taste, he added: "And if I had paid him a few more scudi, truly the draperies would have been polished, both soft and stiff, as in satin, velvet, and brocade." Less aesthetically sophisticated than Aretino, Philip II of Spain, sending his portrait (Madrid, Museo del Prado) to his aunt, Mary of Hungary, in 1551, also apologized for its lack of finish: "It is easy to see the haste with which it has been made, and if there were time it would have been done over again."

The most revealing testimony comes from the imperial envoy Francisco de Vàrgas, who visited Titian's studio in the 1550s. Seeing the master painting in broad careless strokes with a brush as big as a broom, Vàrgas asked Titian why he did not paint in the delicate style used by the best painters of the time. In response Titian explained that he wished

OPPOSITE:
Apotheosis of Venice, Paolo Veronese. Painted for the ceiling of the hall of the Great Council in the Palazzo Ducale. The old ceiling of the room, destroyed in a fire in 1577, was replaced by a new one, richly decorated with 35 canvas panels by Tintoretto, Palma the Younger, Bassano, and Veronese.

The Three Graces, Jacopo Tintoretto. One of four mythological paintings by the artist for the Atrio Quadrato of the Palazzo Ducale, it was later moved to the Sala dell'Anticollegio. Symbols of the four elements—air, water, fire, and earth—are incorporated into the composition.

ON PAGES 384 AND 385:
Rape of Europa, Paolo Veronese. Painted for the Sala dell'Anticollegio, the room in which visitors waited to be received by the doge and the signoria. This work, with its beautiful passages of landscape, is among the most fresh and vivacious from the hand of this prolific artist.

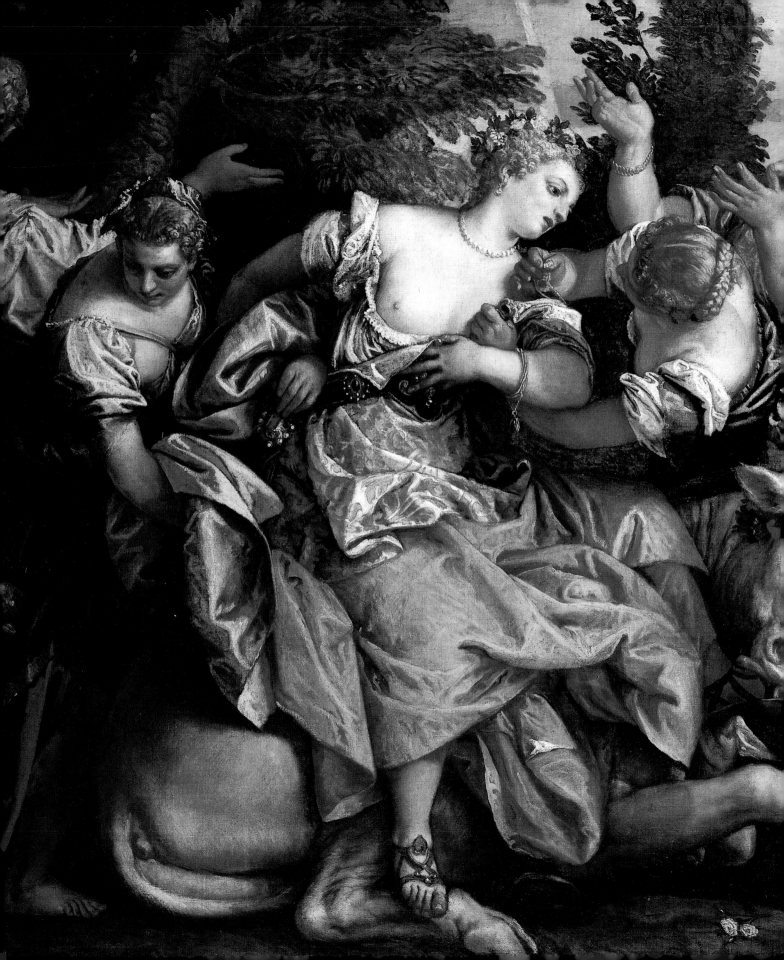

Ceiling of the Sala del Collegio in the Palazzo Ducale, decorated with canvases by Paolo Veronese.

OPPOSITE:
Lion of St. Mark Between Mars and Neptune, Paolo Veronese. Painted between 1575 and 1577 for the ceiling of the Sala del Collegio in the Palazzo Ducale, it is one of three main canvases surrounded by eight allegories of the Virtues. On the left, Mars, seated on a trophy of armor, brandishes a club; on the right, a putto pouring water from a shell flies over Neptune in his guise as god of the sea; above the superb horse's head, another putto—opposite the first—holds up a shield. At the center of the composition are the two symbols of Venice, the lion of St. Mark and the bell tower.

ON THE FOLLOWING PAGES:
Paradise, Tintoretto, from 1446. This enormous canvas dominates the immense Hall of the Great Council in the Palazzo Ducale. To assist him with this project, Tintoretto used numerous pupils, including his son Domenico and Palma the Younger. Details on pp. 390, 391.

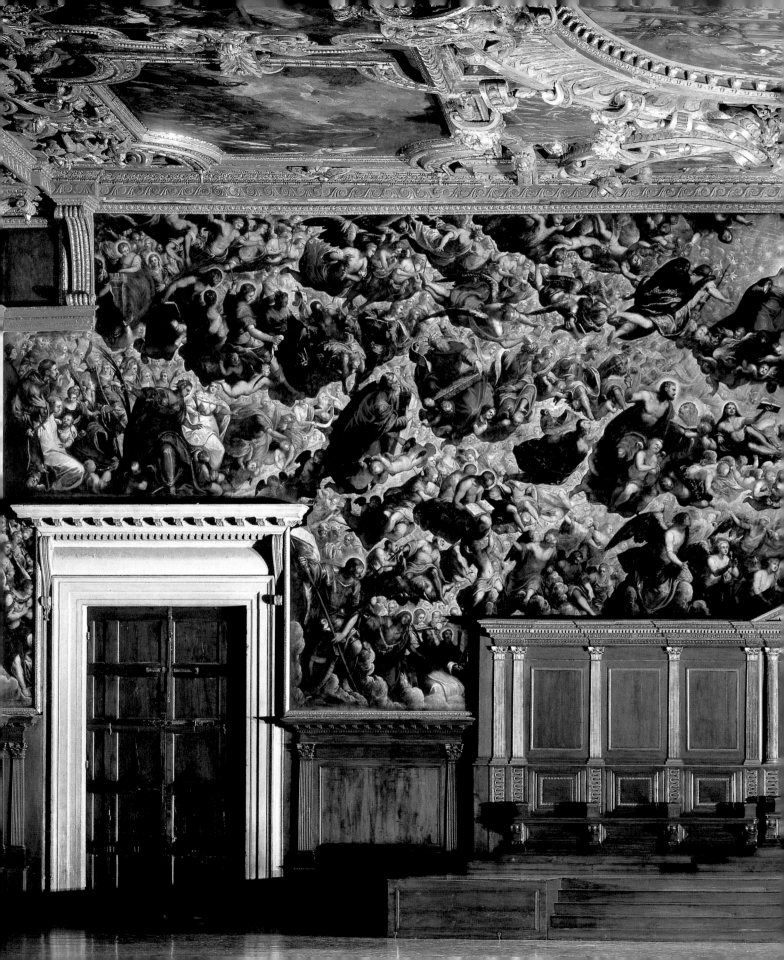

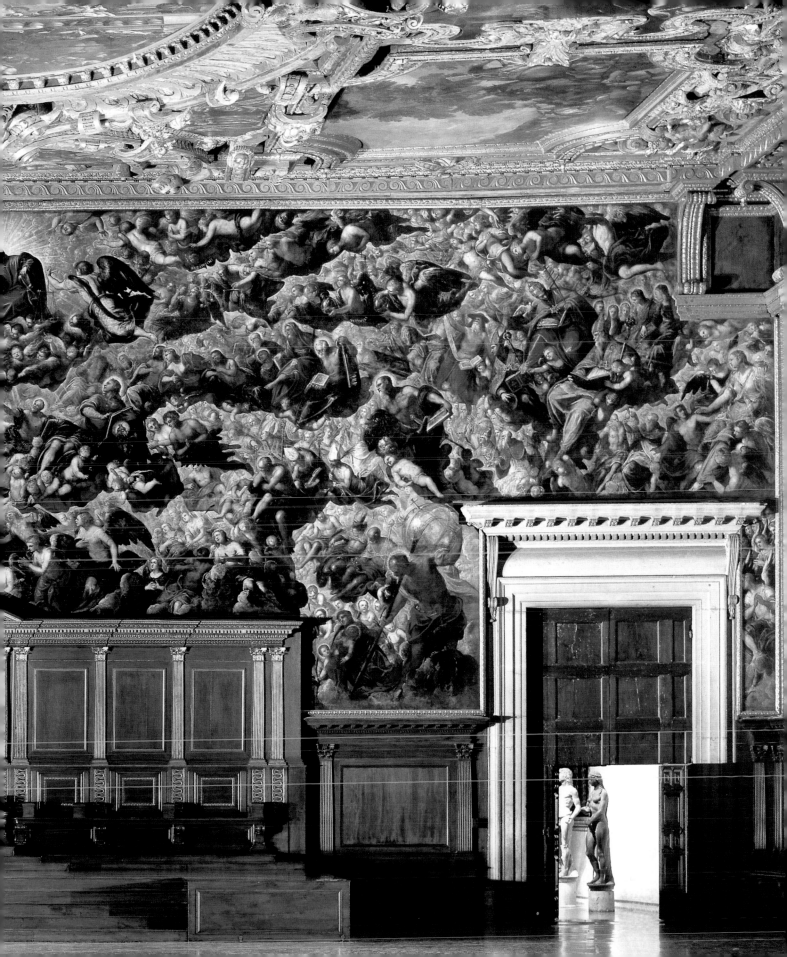

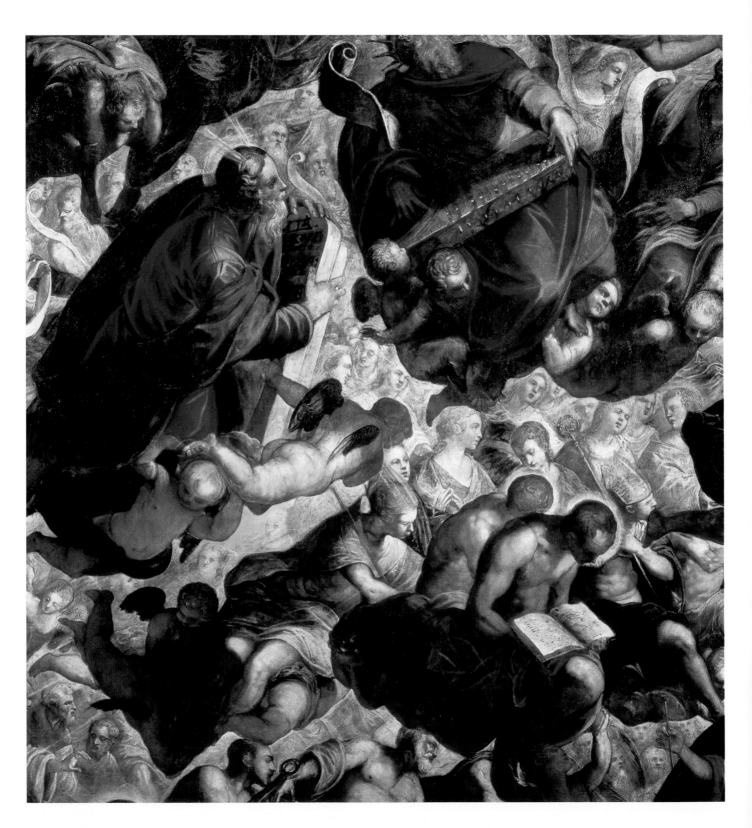

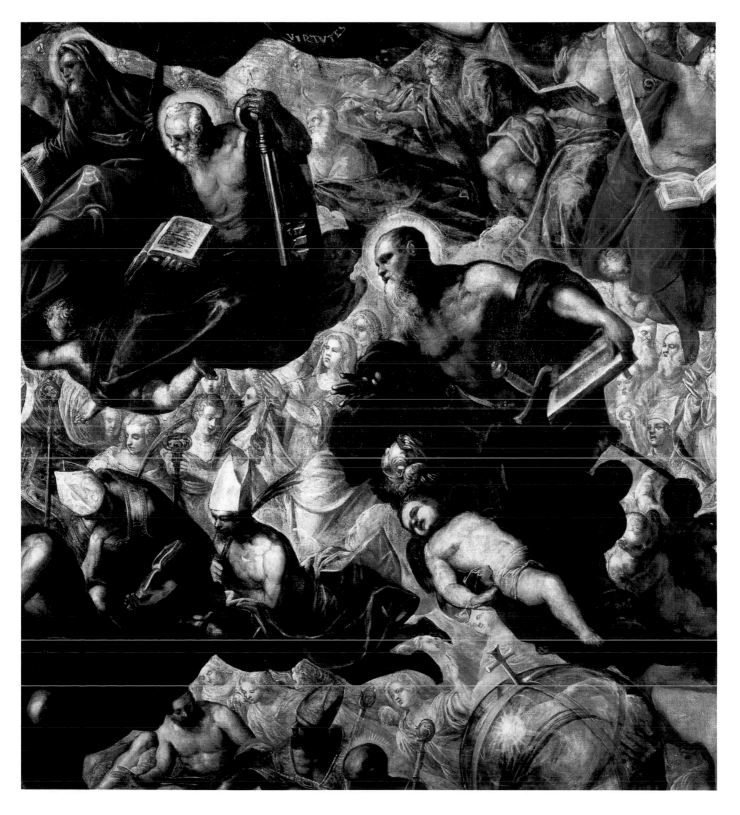

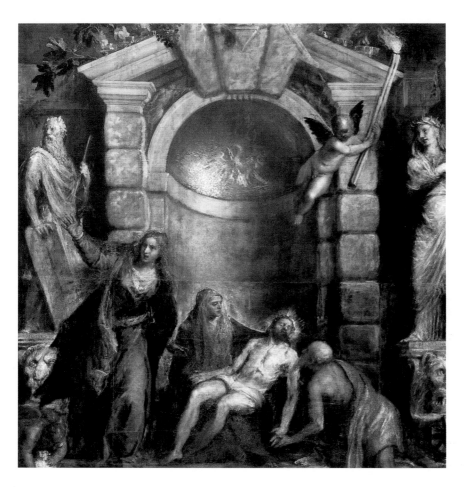

Pietà, Titian. Venice, Gallerie dell'Accademia. This is the work that Titian prepared for his own tomb in S. Maria Gloriosa dei Frari. Incomplete at his death in 1576, it was finished by the faithful Palma the Younger, whose intervention has been shown to be very minor.

OPPOSITE:
Martyrdom of St. Lawrence, Titian, completed c. 1557. Church of the Gesuiti. Painted after a stay in Rome, the memory of which is evident in the classical elements, this work is impressive for its dramatic contrast of light and dark, which makes it one of the most mysterious night scenes in Venetian painting.

to paint in a manner different from the others—Michelangelo, Raphael, Correggio, Parmigianino—in order not to be considered a mere imitator of them. Ambition, he continued, which is natural in his art no less than in others, drives him to seek his own way to acquiring fame, as other artists have acquired fame through their individual styles. That big brush was for Titian the means of declaring his own individuality, for presenting his own artistic self.

The anecdote is no less valid for the other ambitious painters of Venice. Each of the leading masters developed his own unique manner of applying paint; each was known by his particular application of the brush, his personal inflection of *il colorito alla veneziana*. In Venice, the brush stroke is signature, the sign of the hand.

Ever since Aretino began broadcasting his praise of Titian, the painter's stroke had been publicly recognized as a source of vitality; the very dynamic of the mark was life-giving, art more powerful than nature. And, inspired by Titian's painting, the inventive critic in turn found art in nature—as well as a new and more vital critical language: "Oh, with what beautiful strokes did Nature's brush sweep back the atmosphere, clearing it away from the palaces in the way that Titian distances it in his landscapes!" Aretino writes in his letter of 1544 describing the sky over the Grand Canal.

Always in competition with nature, Titian's brush, no matter how gross or independent its mark, insisted upon meeting the mimetic challenge of painting; indeed, as all came to recognize, it surpassed nature, creating realities beyond. Titian's brush gave new substance to heavenly and symbolic light. Thus, in the nocturnal setting of the *Martyrdom of St. Lawrence* (church of the Gesuiti), completed about 1557 but begun nearly a decade earlier, light itself becomes the true protagonist (see p. 393). The entire composition assumes a complicated Manichaean structure as light competes not only with darkness but its own various manifestations as well. Vasari's enthusiastic description recognizes the peculiar moral dynamics of the picture, especially the triumph of heavenly light: "and beyond that he created a lightning that, coming from heaven and cleaving the clouds, surpasses the light of the fire and that of the lantern." Vasari's response aptly corresponds to the letter and spirit of Titian's literary source, the account in the *Golden Legend*, in which St. Lawrence triumphantly declares, "My night hath no darkness: all things shine with light!"

The *Annunciation* painted for S. Salvador about 1560–65 offers another particularly revealing example of Titian's pictorial translation of textual sources. The powerful explosion of celestial glory,

realized through the luminous activity of the brush, assumes more particular significance in the context of the words actually inscribed on the step below the Virgin: "IGNIS ARDENS ET NON COMB-URENS [burning with fire yet not being consumed]." Mary, who conceived and bore the child while remaining virgin, is the burning bush that was not consumed (Exodus, chapter 3, verse 2), and Titian's painting, in the violent incandescence of the holy presence, seems to exploit the energy implicit in the text. In delicately fragile contrast to that heavenly eruption is the crystal vase with flowers poignantly set above the inscription. Instead of the traditional lilies, however, this vase contains a heavier plant whose petals do indeed burst into flame. Through the suggestively ambiguous *macchie* of the brush, the bush blooms literally into fiery flower. Titian found in his medium and his knowing application of it a vehicle for giving visible life to the poetic metaphor of theological imagery.

We have seen how it was through his brush that Tintoretto announced his presence in 1548 with the *Miracle of the Slave*. Although Vasari himself recognized that Tintoretto could bring his brash manner under more rigorous control, there remains nonetheless a certain consistency to his brushwork. Tintoretto's strokes tend to be long and relatively uninflected, tracing their course with vigorous determination, asserting the independence of their own momentum. That determination, that aggressive confidence, presents itself as the personality of the artist, and we have seen that viewers could be offended by such self-affirmation. Asserting their independence, Tintoretto's strokes seem to insist upon their superficial value, marks on the surface made by a brush in motion; they seem to avoid the mimetic identification with represented objects and surfaces. In the later *teleri* for the Scuola Grande di S. Marco, Tintoretto's brush exploited its interaction with the rough texture of the woven canvas to create a world of spirits. Near the very end of his life those attenuated strokes of the brush created the spectral forms whose presence confirms the angelic bread of the body of Christ in the *Last Supper* of S. Giorgio Maggiore (1592–94).

Veronese's strokes also retained an allegiance to the surface. More flexible and inflected than Tintoretto's, they display a calligraphic quality. Instead of running, they seem to dance, and we appreciate the choreography of their fluid motion which seems so well attuned to the brocaded arabesques of Veronese's costumes. That delicacy of touch is matched by a more deliberate exploitation of glazing technique—as in the rich folds of the saint's dress in the *Mystic Marriage of St. Catherine* (Venice, Accademia)—which creates

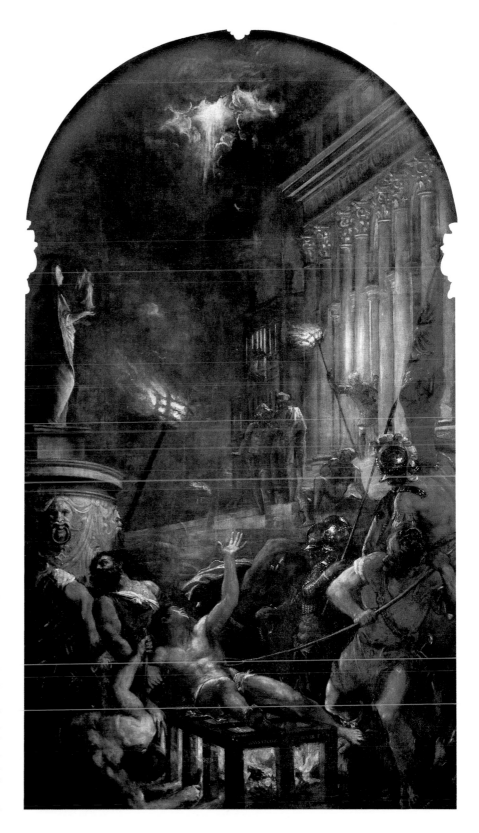

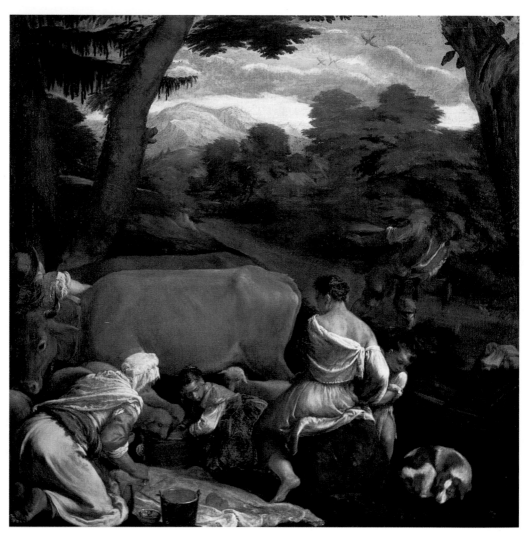

Pastorale, Jacopo Bassano. Madrid, Thyssen-Bornemisza Foundation. With this picture, the painter realized one of his most intimate and poetic works, a theme that was to be repeated many times two centuries later by the great Venetian landscape painters.

a chromatic notional space for the brushwork, allowing the stroke to break away from its initial surface constraint and enter the illusion of the image.

One great master of the brush has not been mentioned yet. Although he came to the capital rarely, preferring to remain in his native town, Jacopo da Ponte from Bassano, known as Jacopo Bassano, enjoyed the patronage of an aristocratic Venetian clientele. High professional tribute to his mastery was paid by Veronese himself, who (according to Ridolfi) sent his son Carletto to study with Bassano, "whose brushwork Paolo liked." Ridolfi's observation, in fact, is more than confirmed by Veronese's own later development, which, in its more vigorous brushwork and chromatic structures

emerging from darker depths, fully attests to his admiration. Jacopo Bassano is perhaps the greatest realist of the Venetian painters (see p. 394). His stroke tends to take its mimetic function most seriously, identifying completely with, say, the weakened flesh of the body of the meditating *St. Jerome* (Venice, Accademia), without, however, sacrificing its own self-awareness.

Late Styles

The ultimate value of *il colorito alla veneziana* was the identification of paint with the very substances of imitated nature, especially with flesh. This is the central theme of Marco Boschini's famous account of the old Titian at work, an account the seventeenth-

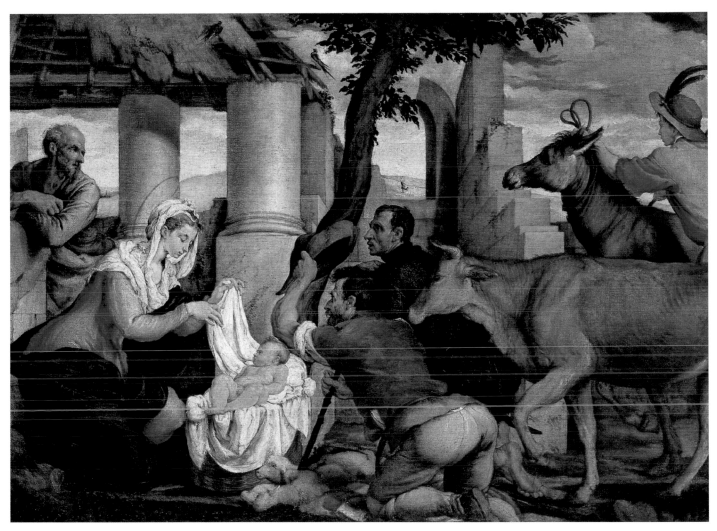

century artist and critic claims is the record of an eye-witness, Jacopo Palma the Younger, who claimed to have studied with the great master. It is an account (published in 1674) worth repeating.

[Titian] blocked in his pictures with a mass of colors, which served as a bed or foundation for what he wished to express, and upon which he would then build. I myself have seen such under-painting, vigorously applied with a loaded brush, of pure red ochre, which would serve as the middle ground; then with a stroke of white lead, with the same brush then dipped in red, black, or yellow, he created the light and dark areas of the relief effect. And in this way, with four strokes of the brush he was able to suggest a magnificent figure. . . . After having thus established this crucial foundation, he turned the pictures to the wall and left them there, without looking at them, sometimes for several months. When he later returned to them, he scrutinized them as though they were his mortal enemies, in order to discover any faults; and if he did find anything that did not accord with his intentions, like a surgeon treating a patient, he would remove some swelling or excess flesh, set an arm if the bone were out of joint, or adjust a foot if it were misshapen, without the slightest pity for the victim. By thus operating on and reforming these figures, he brought them to the highest degree of perfection . . .

Adoration of the Shepherds, Jacopo Bassano. Venice, Gallerie dell'Accademia. The work is noteworthy for the keen observation of animal, as well as human, characteristics.

and then, while that picture was drying, he turned to another. And he gradually covered with living flesh those bare bones, going over them repeatedly until all they lacked was breath itself. . . . For the final touches he would blend the transitions from highlights to halftones with his fingers, blending one tint with another, or with a smear of his finger he would apply a dark accent in some corner to strengthen it, or with a dab of red, like a drop of blood, he would enliven some surface—in this way bringing his animated figures to completion. . . . In the final stages he painted more with his fingers than with the brush.

And, Boschini concludes, Titian was right to work in this way, "for, wishing to imitate the operation of the Supreme Creator, he used to observe that he too, in forming the human body, created it out of earth with his hands." *Natura naturans*, the creative principle articulated first in the practice of Giorgione at the beginning of the century, finds its greatest realization in the aged Titian's imitation of the dynamic processes of natural creation.

Despite its enthusiastic hyperbole, the validity of Boschini's account may be gauged by Titian's late paintings themselves, especially the *Pietà* he intended for his own tomb in the Frari (Venice, Accademia) (see p. 392). The canvas remained in the master's studio at his death in 1576; it was acquired by Palma the Younger, who added the inscription: "QVOD TITIANVS INCHOATVM RELIQVIT/ PALMA REVERENTER ABSOLVIT/ DEOQ. DICAVIT OPVS [Palma reverently completed what Titian had left unfinished and dedicated the work to God]." Palma probably did little more than retouch the angel with the taper, and the *Pietà* remains grand and eloquent testimony to Titian's art at the very end of his long life, his own very personal artistic testament. An image climaxing and summarizing a venerable career, its art-historical recollections are indeed formidable: the distraught Magdalene transforms a lamenting Venus from an ancient Adonis sarcophagus; the statues of Moses and the Hellespontic Sibyl and the central group of Mary and Christ continue Titian's response to the challenge of the sculptural art of Michelangelo; the setting itself, with its glowing apse, pays tribute to the painted mosaics of Giovanni Bellini and, ultimately, to the golden domes of S. Marco itself. Such artistic self-consciousness, which seems appropriate in the context of a painter's final testament, is punctuated by the kneeling figure of St. Jerome reaching out to touch Christ: the penitent saint is a portrait of Titian himself. Like Michelangelo in the Florentine *Deposition* he meant for his own sepulchral monument, Titian would

Annunciation, Jacopo Tintoretto. Sala Terrena [ground-floor hall],
Scuola di S. Rocco. Far from the traditional iconography, the scene
is set in an ambience that could be a rustic dwelling in the Veneto
countryside. The dove of the Holy Ghost and the angel arrive in a
free and easy disorder that contrasts with the solemnity of the
event.

OPPOSITE:
St. Mary of Egypt, Jacopo Tintoretto. Sala Terrena, Scuola di
S. Rocco. A cascade of reflected light in an unreal and timeless
landscape contributes to the profound sense of solitude portrayed.

approach the body of his savior directly. And that body, the sacrificed human flesh, broadly and thickly brushed and yet delicately glazed, is a pure demonstration of the painter's art; here, paint becomes flesh in a eucharistic transformation that is a triumph of Titian's *colorito*.

Boschini, although distant heir to the artistic achievements of the Cinquecento, proved to be an extraordinarily sympathetic and articulate critical spokesman. His appreciation of Jacopo Bassano helps to focus the achievement of that master, raising it above the overproduction of the prolific family workshop. Confirming the judgment of Veronese, Boschini writes of Bassano:

He had such a bold brush stroke . . . scorning diligence and high finish, with a chaos (so to say) of indistinct colors and confusing mixtures, so that from close up it seemed to the eye a disconcertment rather than a perfected work; and yet such is its virtuoso deception that, not sticking close to the surface but pulling back to a proper distance, the eye and the ear of the Mind are content and delight in the sweetest harmony that might be produced by a well-tuned instrument played by a master, the most sympathetic union between Art and Nature achieved by human concert.

However much this passage may evoke Vasari on Titian, Boschini validates his account by his own experience before the late *Adoration of the Shepherds* (1592) (see p. 395):

Whoever views that Child Redeemer from up close becomes quite confused, as the eye loses sight of the Child, bedazzled and uncomprehending, discerning neither form nor substance, so that almost as though fearing to have inadvertently approached too intimately that representation of the Divinity, pulling back, it returns then to an appropriate distance to see the perfection that it should have seen before, through all the stupefaction and wonder.

Like the shepherds themselves within the picture, the observer is attracted to "those brightest splendors that sparkle from the Infant Jesus," only to find the divinity incomprehensible within the confusion of brush strokes. In his dialectic poem *La carta del navegar pitoresco* [A map for picturesque journeys] (1660) Boschini had elaborated the critical topos of the proper distance of the beholder from the image:

*Star ne bisogna in proporcion distante
Davanti a Dio, col cuor tuto adorante,
E con modestia starghe ala presencia.*

*[One must stand at a proper distance
Before God, with an adoring heart,
And approach with all modesty.]*

Aesthetic vision acquires a spiritual dimension—as indeed it must before an image on an altar—as meaning and technique find new correspondence.

Two canvases in the Sala Terrena of the Scuola Grande di S. Rocco represent the culmination of Tintoretto's art: *St. Mary Magdalene* and *St. Mary of Egypt* (see p. 398). Both saints are represented in a landscape wilderness rendered with long strokes of the brush, charged essentially with white paint, articulating form through highlight on a dark ground. In this fantastic development of tonal painting the matter of nature is transformed into an immaterial reality, and yet the pictorial vision retains its own materiality, that of the paint itself. Here too the beholder is invited to shift between the realm of the brush stroke and the realm of illusion. The technique seems less painting than a form of spectral drawing, drawing with light on a dark ground that is in effect a drawing out of light from deep within the darkness. Before these canvases, the viewer can only join in Boschini's ironic salute: "To you, oh Great Tintoretto, falls the title of Monarch of Drawing."

Ultra quid faciam? "Who could pretend to go beyond such achievement?" Ridolfi asked, invoking the Herculean motto as he opened the biographies of the generation of Venetian painters following the great masters of the Cinquecento; "vain it would be to expect better, rarer examples and stranger beauties." This indeed was the dilemma that faced the heirs of Veronese, Tintoretto, and Bassano. Titian's workshop had ceased to exist following his death with that of his son Orazio during the plague of 1576. The others, however, continued well into the seventeenth century. Trained to paint in the manner of their masters, the established style of the studio, the heirs faced a challenge that was inherent in workshop production: to produce work on a commercial scale in a painterly style that was deeply personal. How, in other words, to keep on imitating the brushwork of the master? The results, no matter how proficient, tended to render academic and rigid what had been spontaneous and natural. The true heirs of the great Venetians of the Cinquecento were, instead, those painters strong and independent enough to claim Venetian *colorito* for themselves and to make the language of the brush their own—Rubens and Poussin, Rembrandt and Velazquez.

David Rosand

OPPOSITE:
Adoration of the Shepherds, Jacopo Tintoretto. The traditional iconography is replaced with the invention of a representation on two levels, but the two areas are united by the light that filters down from above. Above: detail.

From Mannerism to Baroque

Toward the Baroque: Longhena and Seventeenth-Century Architecture

Vincenzo Scamozzi and Antonio da Ponte

At the time of Palladio's death in 1580, the panorama of Venetian architecture revealed certain distinctive characteristics. On the one hand, Palladio's teachings seemed to have been absorbed and perpetuated by Vincenzo Scamozzi who appeared, to some, as the master's cultural and moral heir. On the other hand, the celebrated *proti*—technicians and civil engineers—were assuming an ever greater prominence, and their preoccupation with architectural vocabulary was of only relative importance compared to that given to the structural and economic forces behind the drafting of projects and the managing of building sites. In a certain sense, then, two different forces confronted and contrasted with each other in the ongoing massive task of radically remolding the face of Venice, a task that was begun by Jacopo Sansovino and continued after his death.

Scamozzi's fame and reputation were anything but negligible: he numbered among his clients nearly all the great families of the Venetian nobility. However, the theory that he was Palladio's natural heir is both approximate and superficial. Both as an architect and as a theoretician (*Idea dell'architettura universale* [Idea of universal architecture]), Scamozzi distanced himself significantly from Palladian thought, although he absorbed fully each word and phrase of Palladio's language. The experimental and anticanonical research inherent in Palladio's architecture—and expounded in detail and with the same freedom of conception and language in the *Quattro Libri*—was translated by Scamozzi into a tidy system of rules and principles.

The importance, both qualitative and quantitative, of the role of Antonio da Ponte during that vital period which includes the last three decades of the sixteenth century and the first two of the seventeenth has only recently been fully understood. Not only did he find himself having to supervise the completion of a whole series of edifices which were crucially important to the face and structure of the city, but he was also obliged to prove himself superior to all his

Ponte dei Sospiri [Bridge of Sighs], designed by Antonio da Ponte in the 1580s. This bridge over the Rio di Palazzo links the Palazzo Ducale and the Prigioni Nuove [New Prisons].

competitors by producing his own original and autonomous projects. Emblematic of these are the works inside the Arsenal, the massive project for the Rialto bridge, and the Prigioni Nuove at the Ponte della Paglia (quite correctly considered the final seal on the overall development of the area around S. Marco, although in the Piazza itself, as we know, work continued on Scamozzi's Procuratie Nuove). Da Ponte's architecture—like that of his colleagues

Church of S. Maria di Nazareth, also known as the Scalzi, designed by Baldassare Longhena between 1656 and 1672 and completed in 1680 by Giuseppe Sardi, who also designed the facade. View from the Grand Canal.

power, and were simply the physical manifestation of a design for political and moral renewal (examples include the language of the Prigioni Nuove and the portals inside the Arsenal). At the same time we can also see an explicit affirmation of a true return to order. There was no desire whatsoever to deny or disclaim the almost heroic period of the early and middle sixteenth century, up to and including Palladio, but there was a desire to eradicate the bitterness of a debate that had frequently spread from architecture to ideology, infecting the various alliances in the halls of Venetian power. Nor must we forget that other battles were looming on the horizon in the uneasy world of Venetian politics, and that a newer, more solid internal majority appeared indispensable for dealing with the Republic's external enemies. Venice would shortly become involved in the political and institutional crisis which culminated in the break with the Holy See and the interdict, when the pope excommunicated the entire Republic. Even in these circumstances, however, the language of architecture continued to carry weight and to have an undoubted value. If nothing else, it was able, with tremendous strength and eloquence, to proclaim the Republic's illustrious qualities and repropose images and figures from an ethical and emblematic system of great symbolic value.

As far as civic architectural models are concerned, a simplification took place. A marked difference appeared in the level of complexity and monumentality of the majority of patrician homes. Although they continued to expand in terms of dimension, these palaces presented a recurrent, almost modular typology: great Serlian (after Sebastiano Serlio, the first to design them) windows, stringcourses in Istrian stone, vast *campiture* (some probably once frescoed), and huge ground-floor entrance halls. Of the many palazzi which survive, the following are particularly significant: Palazzo Foscarini, Palazzo Mocenigo, Palazzo Albrizzi, Palazzo da Ponte and Palazzo Donà (all dating from the end of the sixteenth and the beginning of the seventeenth centuries). This more sober and modular architecture, the most common language and the easiest to reproduce, dominated for almost two centuries and was widely translated into nonpatrician, even popular, dimensions and contexts throughout the city, to the extent of becoming one of the most successful architectural languages within the urban fabric.

To be noted also are the experiments which can be traced back to, on the one hand, those architects who were aware of the necessity for research in architectural vocabulary in spheres which can be roughly defined as Mannerist (as in Alessandro Vittoria's work on Palazzo Balbi and, perhaps, that of

Contini, Sorella, Smeraldi, and others—placed greatest emphasis on the structural quality of the edifice but without abandoning itself to pure experimentation with architectural vocabulary it declared with unequivocal finality the necessary harmony between certain fundamental architectural precepts and, more generally, the ideological and cultural message which architecture is required to promulgate. It was necessary to repropose functions and roles which were still anchored to clear declarations of substance and

Guglielmo Bergamasco on Palazzo Tiepolo-Papadopoli), and, on the other hand, to the revival and the more complex and extreme interpretations of the work of Sansovino and Palladio. Vincenzo Scamozzi's activity at the turn of the century cannot be ignored (Palazzo Contarini degli Scrigni, for example), just as we cannot avoid taking into account the teachings of Michele Sanmicheli and his striking antiquarian architecture.

It should be pointed out, however, that the prevailing culture in Venice was that of the *proti* and the engineers who dominated when it came to the more important public commissions. The Palazzo Ducale, drainage works, bridges, prisons—these were all in practice the prerogative of a restricted circle of State employees with vast building experience and with equally valuable experience of moving through the dangerous corridors of power. From the so-called Ponte dei Sospiri [Bridge of Sighs] (see p. 401), to the completion of the Procuratie Nuove, from the Sala dei Banchetti to the new staircases in the Palazzo Ducale, an intense operation of adaptation and response to new practical and functional demands was under way, employing these authoritative and powerful operators. Through their hands passed most of the appointments and most of the money destined for Venice's large-scale building projects.

At the beginning of the seventeenth century and throughout it—contrary to a view widespread even today—building activity was intense and continuous. While it is true that this activity often consisted of renovations, restorations, and restructuring of architectural vocabulary, as well as functional additions, it is also true that there were many new and significant projects. By the 1620s, we can consider that the major revolution in Venetian seventeenth-century architecture had already taken place. It was during the earliest years of the century, though, that various new figures stepped into the limelight, not necessarily from the offices of the *proti*.

Bartolo Manopola

The figure of Bartolo Manopola can be interpreted as transitional. He worked a great deal in the Palazzo Ducale (Arco Foscari, Sala dei Banchetti) and his work on Palazzo Ruzzini near S. Maria Formosa is both original and unusual, as are the unfinished facades at Palazzo Emo (later Treves) at S. Moisè. The great Palazzo Pisani at S. Stefano (continually remodeled during the seventeenth and eighteenth centuries) is more articulated and more difficult to understand: Manopola gives the impression of overlapping new vocabulary elements with the traditional structure employed by his colleagues and adopted without any major modifications by the age-old Venetian building industry. However, the new elements—corbels, great volutes, perforated latticework, interplays of chiaroscuro and color resulting from the use of ashlar and *specchiature* [inlays] of Istrian stone, etc.—created a vivacity and dynamism which undoubtedly brought life to the rather obvious seriousness of late sixteenth-century

Church of S. Moisè, designed by Alessandro Tremignon in 1668 with the funeral monuments of the brothers Girolamo and Vincenzo Fini by the sculptor Heinrich Meyring.

ON THE FOLLOWING PAGES:
Basilica of S. Maria della Salute, a work of Baldassare Longhena. Begun in 1631, it was completed in 1687, five years after the death of its architect.

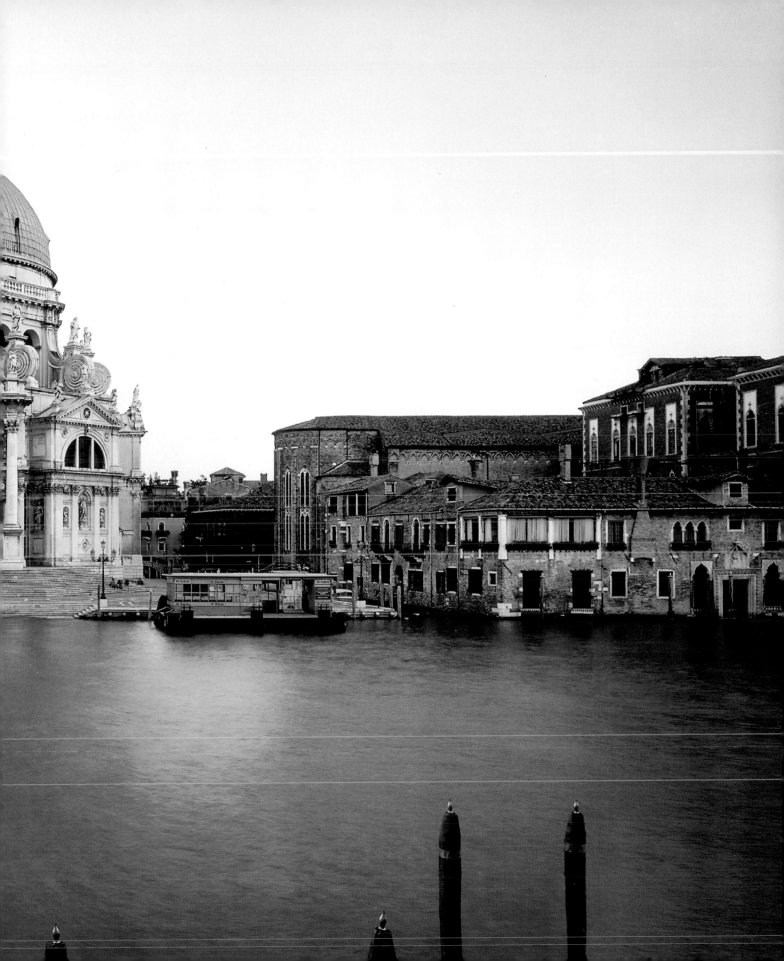

architecture, flinging wide the doors to admit the onrush of the sensitivity and symbolism of Baroque culture.

Baldassare Longhena

It was left to Baldassare Longhena to offer the city the most complete and flexible architectural vocabulary that would be capable of giving form to the requirements of public image and those of patrician greatness and wealth. It was he, also, who worked out the most efficacious formal schemes for responding to the terrible blow of the devastating plague of 1630, designing the votive temple to S. Maria della Salute [the Madonna of health], and it was he, finally, who created the complex architectonic code of undoubted structural value which brought together the two different moving spirits of late sixteenth-century architecture, bringing Venetian architecture more into line with the advanced and innovative forms of Rome. As a result, in Wittkower's famous words, "the only alternative to the high class of Roman Baroque" was born.

Early Career

Baldassare Longhena was born in Venice in 1597, although his family came from Brescia. According to the noted chronicler Tommaso Temanza, he was a pupil of Scamozzi, an important piece of information, obviously, but so weighty as to have constituted an embarrassing preconception for those who in later years studied his background. Longhena's training, undoubtedly along the lines of Scamozzi, was also influenced by Sanmicheli, Antonio da Ponte, and the Contini. What seems to have been the principal influence, however, was his skill at his father's trade, that of stoneworker, sculptor and, in part, designer of architectural compositions. Melchisedek Longhena passed his trade on not only to Baldassare, but, according to documents which have recently come to light, to another son, Giovanni, who continued quietly in his father's footsteps in the humble profession of stonecutter while his brother was called at an early age to work on architectural projects of far greater significance and scale.

Baldassare immediately, in his first works, demonstrated himself capable of shaking off the general nature of an artisan background and of growing into the sharply defined and intellectually significant figure of the drawing-board architect. He also maintained, until late in life, certain rhythms and insights from his origins as a craftsman. It is Tommaso Temanza once again who tells us of this curious and modest gift:

He had in his confidence certain highly experienced workmen with whom he discussed his dealings. He also had the custom of listening to all; in fact, when he visited his workshops, he would summon the foremen to his presence, and on many occasions even the most inexperienced daily laborers, and with them he would discourse on the progress of the work. Then he would obtain the opinion of each of them and, thus enlightened, would resolve upon what appeared best to him.

The cathedral in Chioggia, a small town of strategic and economic importance at the extreme southern end of the lagoon, was destroyed in a disastrous fire on Christmas night 1623. A rapid decision was taken to rebuild, and the task was entrusted to the promising young Baldassare Longhena. Baldassare proposed making radical alterations to the building's orientation and was supported by the Venetian Senate, contrary to the more cautious and frugal position of the local government. The general ambience of Chioggia cathedral is still part of the late Palladian movement and was particularly influenced by S. Pietro di Castello.

Longhena worked on numerous churches in Venice, and his work often coincided with that of other architects. This is the case with Giuseppe Sardi, who completed various of Longhena's buildings and various of whose works were, in turn, completed by Longhena. The typology of the facades was once again influenced by Scamozzi. Longhena, as always, embraced these models, gathering together creatively the elements of which they were constituted. He added or took away whatever was useful or superfluous to his aims, dismantling and destructuring the complexes and endowing the results with new values.

The church of the Scalzi (the facade the work of Sardi) appears in a way which has often been described as approaching the Roman style; it is, therefore, a moment of change in Longhena's language. That it was commissioned by the Carmelites (in particular Padre Giuseppe Pozzo, brother of the more famous Andrea) was crucial and helped Longhena develop a particular style. The interior reveals a slight similarity to the church of the Tolentini (one of Scamozzi's works), but it is the flavor of Rome in the mid-seventeenth century which dominates: Rainaldi, Fontana, the Longhi, and the first popularizers of the Baroque—so dear to those religious orders that were in rapid expansion—appear to have been the obligatory terms of reference for Longhena.

But it was for those private clients endowed with sensitivity, great wealth, and an equal desire to

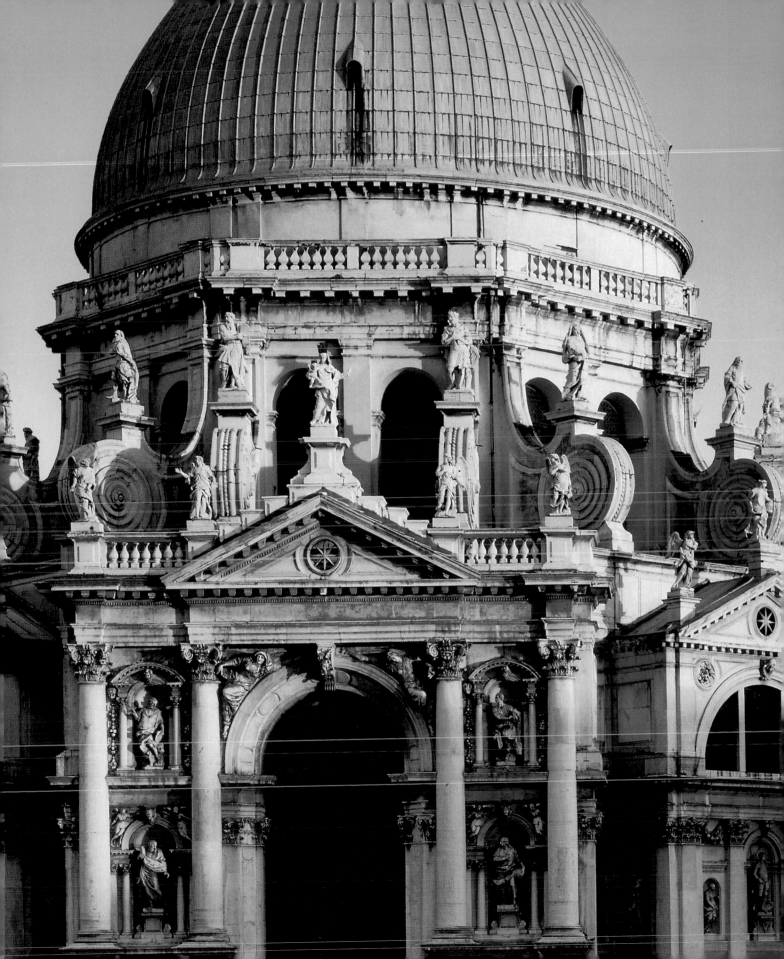

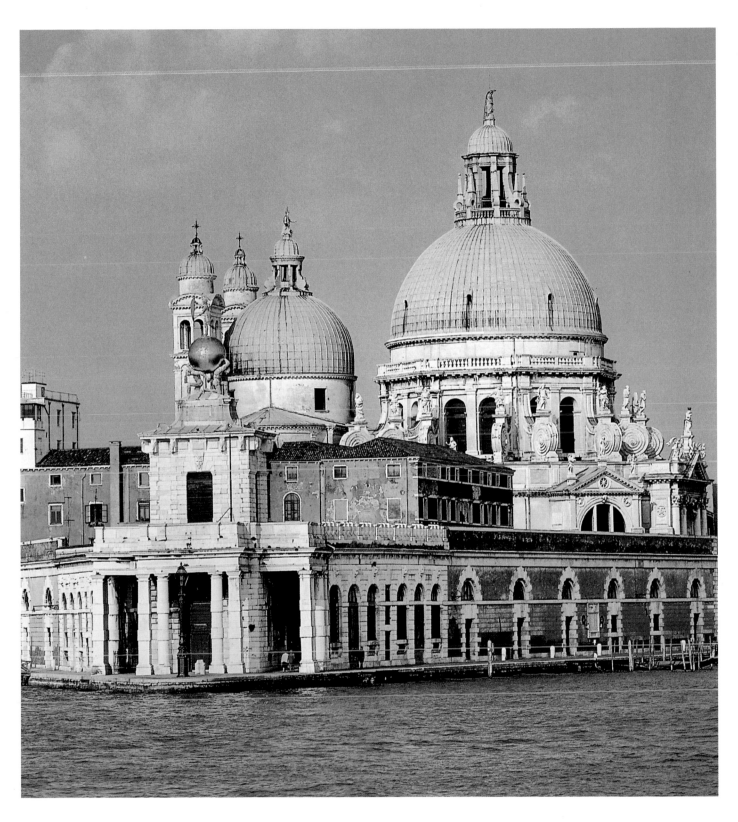

Details of the carved decorations on the facade of the church of the Ospedaletto in Cannaregio. Top: one of the grotesques on the supporting pilasters at the entrance portal. Bottom: one of the telamons from the upper order.

glorify themselves that Longhena developed a new architectural vocabulary in his designs. The church of S. Giustina (c. 1640) has the classic cenotaph facade: Sansovino had created his own composed and cultured version for the church of S. Zulian. Longhena constructed the entire front with the aim of emphasizing the busts and urns, placed high up in the second order (today removed), of the Soranzo family, patrons of the church. In its original version, prior to nineteenth-century alterations, the building displayed the characteristics of an emphasized secularity. The vigorous architectural framework is dominated by the four pilasters of the colossal order which rest on high plinths, and by the clear smooth trabeation. The broken curvilinear tympanum, oval apertures, volutes surrounding the central plaque, and reliefs covering the whole of the lower fascia remain subordinate to the commanding fundamental architecture and the triumph of the marble busts decorating the urns. This avowed concentration on the intersection of orders appears to be more an expedient for emphasizing the upper order than a serious architectural alternative. This is Longhena at his most heroic, proclaiming his intention of subjecting all decorative elements to the monumental vocation of his art (the instruments and symbols of decoration appear humiliated by the greater essential elements of the construction, columns and trabeations).

Longhena's aims, despite his declarations, do not appear to have changed greatly in two later major projects, the Pesaro monument in the church of the Frari and the facade of the Ospedaletto, or S. Maria dei Derelitti, both constructed around thirty years after S. Giustina. The only difference seems to be the level of maturity of his means of expression and the more liberal intermingling of his search for conviction and his declared aim of linguistic experimentation, resulting in a greater objectivity and a stronger critical detachment, not from his project, but from the desires of the patrons. The result is a more audacious and creative use of the rhetorical resources of his art.

Santa Maria della Salute

But in order to understand Longhena's religious architecture it is necessary to go back to S. Maria della Salute, the building which possesses the richest and most complete historical and critical apparatus (see pp. 404–409). This also means going right back to the fundamental critical key constantly present in Longhena's work, that of the combined presence of architectonic structure and rhetorical framework, and the links which render obligatory and rigid their reciprocal dependence. The Salute appears, in fact, as a great secular and civic prayer and, at the same time, a triumph of the rationality and structuralism of the architectonic system behind it. From this point of view, all the interpretations that have been made of both the object in itself and its place within the urban context— the use of quotations and the assembling of them in utterly original forms, the mastery of symbolism and the control of its potential proliferation into multiple symbols of religion, worship, statuary, culture, and aesthetics—can at heart only confirm the incredible architectural quality of the system, the *macchina* [machine], as Longhena himself called it, of the Salute, a new and sensational victory of the rightful survival of the great Venetian State in the face of chaos, disease and squalor, the social and moral wounding of both the individual and the group, and the triumphant resounding victory of a secular, almost pagan, religion,

OPPOSITE:
Church of S. Maria dei Derelitti, also known as the Ospedaletto. Giuseppe Sardi was commissioned in 1664 by the merchant Bartolomeo Cargnoni to rebuild the church, which was completed by Baldassare Longhena; the facade was designed by Longhena and its sculpture carved by Juste Le Court.

of Venetian faith in the Virgin over the obscure and humiliating rituals of Lombard devotion and over the theatricality of exuberant Roman theocratic splendor.

The history of Longhena's masterpiece is well known. When the epidemic of plague broke out, the Senate, inspired by the events of 1576 when Palladio erected the church of the Redentore on the Giudecca, decreed that a votive building would be constructed to the Virgin in the hope of freeing Venice from the nightmare. In November the three delegates appointed to investigate the matter reported that a suitable site had been found and that it would be opportune to employ an architect from outside Venice, and that "in Rome, or even elsewhere" they should find "an architect of talent, in order to form the design and the construction of the Church, since we are afraid that we are ill-provided with such here." However, on 13 April of the following year, as if challenging such skepticism, Longhena presented his project for an outstandingly innovative octagonal building:

> *I have designed a church in a round form, the result of a new invention, never before built in Venice . . . as it is dedicated to the Blessed Virgin, it came to me . . . to build it in a round form being in the form of a crown to be dedicated to the Virgin.*

After having fought off the competition of two other projects, and after several months of uncertainty concerning the site, on 13 June the decision was taken to proceed with construction. The church was completed in 1687, five years after Longhena's death. The siting of the church, between Longhena's seminary of the Somaschi order (now the Seminario Patriarchale), the Dogana (rebuilt shortly afterward, not by Longhena but by Benoni [see pp. 408–409], on whom Longhena poured scorn, having lost out during the call for tenders), and the Gothic church of S. Gregorio, was of a clamorous conspicuousness, and radically altered the face of the city given the centrality and monumentality of the position (a fact rapidly appreciated by view painters). Longhena demonstrated himself capable of exploiting brilliantly the site's advantages. The church immediately became the visual focus of the entire system of the S. Marco basin and one of the strongest architectural symbols in the whole city.

The language of S. Maria della Salute covers a lexical and syntactical arc that begins with Palladio and Venetian Mannerism and touches on the instruments and locations of the Roman manner, yet masters them all with brilliant, almost arrogant, innovation. The clarity and precision of this enterprise lie in the intelligibility and confidence of

Palazzo Giustinian-Lolin at S. Vidal, designed by Baldassare Longhena for Giovanni Giustinian Lolin after 1623. The project is the only one among Longhena's facades that makes use of the Serlian window.

architecture put at the service of a building whose central location permitted a free observation of each relationship, regulation, and solution, each confrontation with pre-existing elements that had stamped on the form of the basin the urban outline of the area surrounding S. Marco and its extension into the water.

This unequivocal legibility continues inside the church, where there are various possible ways of interpreting the articulation of the system but where the architectural whole is subordinate to a longitudinal perspective and optical axis, and where one finds a point within the church—and one point only—of such significance that everything becomes clear and comprehensible; the structure is revealed, the volumetric connections acquire meaning, and the limpid rationality of the discourse is heightened.

Here, the structural junctions declare their pre-eminence over the explosiveness and dynamism of the forms. The architect's youthful confidence and the euphoric certainty of the project's commissioners meld together, each singing the other's praises in the great Marian bulk.

The Ospedaletto

Later works include S. Giustina and S. Antonin, the Scalzi, and perhaps the church of Loreo. But it is at the Ospedaletto, or S. Maria dei Derelitti, that Longhena's religious architectural journey finishes (see pp. 410, 411). What appears most astonishing is the direct and multiform connection which seems structurally to link the two extremes of a spiritual and moral architectural journey, the Salute and the

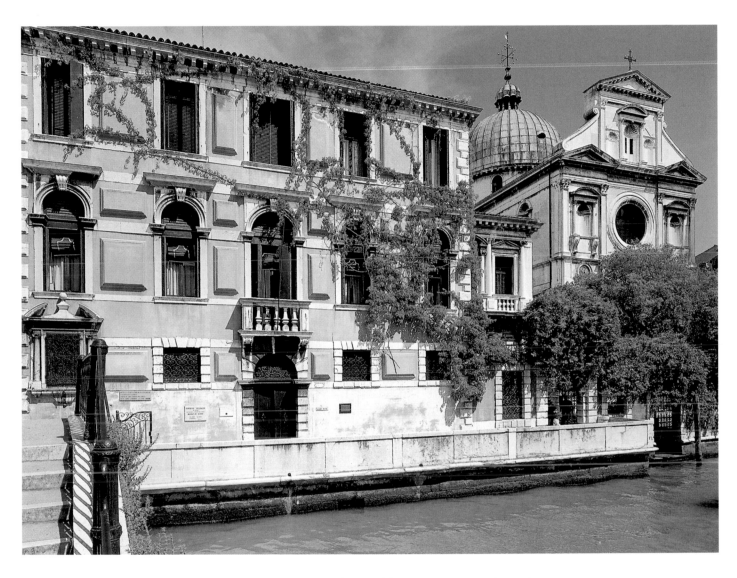

Ospedaletto, in formal adherence or in no less explicit and eloquent contrasts and negations, the round, three-dimensional basilica, so clear and legible, and the ponderous, dark, and monstrous facade of the Ospedaletto, indecipherable in its appearance of grotesque deformity and distorted games, tightly closed in, yet evading the observer, as obsessive as a nightmare.

The derision of the monstrous masks on the dadoes of the pilasters of the first order, the absurd strength of the four gigantic telamons, the ironically exaggerated cornices, the invisible cartouche on the attic, and the four poised statues, more hinted at than truly seen: all of these elements sing of the victory of the didactic over the structural, and declare a failure which is linked by the law of retaliation to the

triumph of a solidified and concrete ephemeral culture, sanctioning an exchange of roles, a total inversion of values. Far from dissimulating this process and its final result, Longhena follows it and emphasizes its values, once more reinvesting all his cultural inheritance, trusting in the rhetorical efficacy of his skill and of his art.

In contrast to the clarity and total legibility of S. Maria della Salute, we have here an *impossibility of seeing*, an absence of points of perspective. Instead of the three-dimensional construction—around structural junctions of consummate technical skill—of an architectonic machine, articulated in all its solidity, we have its counterpoint at the Ospedaletto, the senseless overhanging of a tormented and illogical marble scene. Equally illogical is the inverse tapering of the

Collegio Flangini, designed by Baldassare Longhena, who began construction in 1678 thanks to the legacy of Tommaso Flangini. Until the fall of the Republic, the Collegio was the seat of learning for the Greek community. View from the Ponte dei Greci of the facade on the Rio dei Greci.

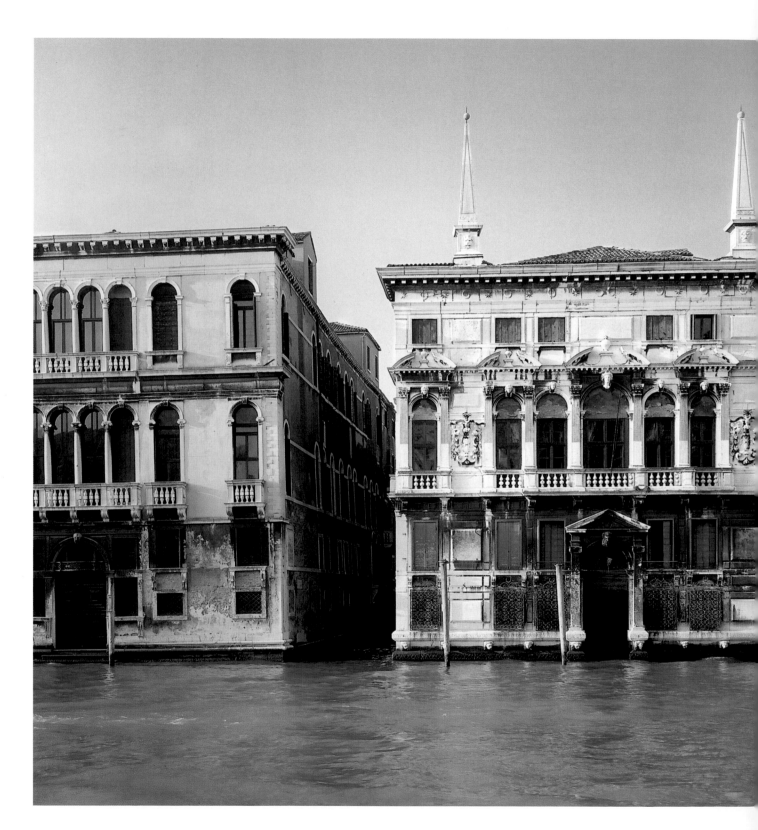

pilasters and the small caryatids supporting plaques, crowded against the giant ones. But it is the suffocating zoomorphic and vegetal family dominating the whole of the facade which demonstrates the monstrous metamorphosis taking the place of architecture and the spirit of clarity and reason represented at the Salute, becoming instead an existential metaphor, a theatrical scene, a mass of literary figures which, as a crowning irony, reveal themselves as no less wise, solid, and sure than the Palladian framework of classical architecture.

The Pesaro Mausoleum

That which in the Ospedaletto appears as the manifestation of a finished metamorphosis is revealed in an even more advanced phase in the Pesaro mausoleum (which, similarly, can be linked with the Severo, Lezze, and Michiel monuments, all expressions of the "heroic" and "architectonic" Longhena of earlier years), where the theatrical composition appears to be even more ordered on a more usual architectonic scheme of relative clarity, but where likewise one can already see the invalidation of linguistic choices, and the use of a repertoire of ornamentation of extreme literary rhetoric.

Family Palaces

A similar process to that occurring in religious architecture was taking place in secular architecture. The instruments employed by Longhena, given the obvious differences of the individual contexts, are also similar.

Palazzo Giustinian-Lolin

Palazzo Giustinian-Lolin at S. Vidal (built immediately after 1623) made use of the divisions and the distributive choices in the facades of Palazzo Balbi and Palazzo Coccina-Tiepolo, in other words, less emphasis and stress on the arrangement of the orders than in palaces of more direct Scamozzian derivation or inspiration, but a greater tectonic awareness of those designed or influenced by Vittoria (see p. 412). Palazzo Giustinian, alone among the facades designed by Longhena, uses the Serlian window, but the two external windows are so close together as to appear to be in the form of a quintuple lancet window. The *campiture* on the wall contain the square frames which became a hallmark of Longhena's work, and which in the Collegio Flangini are the facade's dominating motif (see p. 413). There are many other aspects of Palazzo Giustinian which reveal Longhena's new maturity of design: the ascending movement of the facade is extremely

Palazzo Belloni-Battagia at S. Stae, designed by Baldassare Longhena for the merchant Bartolomeo Belloni around 1650. The wealthy merchant ordered the carving of his family's crest, stars and half-moon, along the frieze on the cornice.

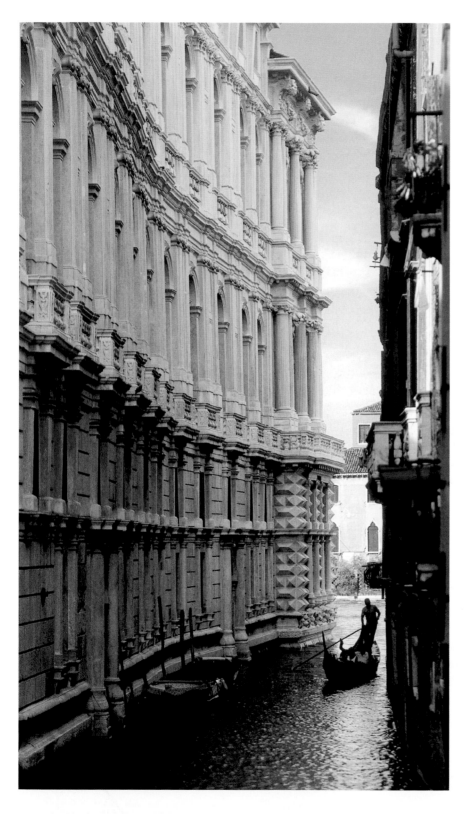

regular and "ordered"—Doric in ashlar on the ground floor, Ionic on the *piano nobile*, and Corinthian on the second floor—while the attic is characterized by small square windows with a lightly carved marble strip under the roof. Although there are no brackets or molded modillions, there are false draperies on the second floor between the capitals of the Serlian windows and, above all, a refined abundance of heads on the keystones of the arches, which becomes a constant feature of Longhena's architecture.

Palazzo Widmann

Palazzo Widmann at S. Canciano (designed in the 1720s) demonstrates certain similarities to Palazzo Giustinian, but the Serlian window has disappeared, as has the attic floor. The lower zone thus acquires much greater importance. A mezzanine has been introduced between the ground floor and the *piano nobile*, creating an intermediate band of great plastic importance and structural consistency, initiating the architectural confrontation between the building's various elements which will become the determining motif in the dynamism and drama, albeit restrained, of Longhena's edifices. In Palazzo Widmann we can see the conflict between the corbels, with their Sansovinian volutes, and the broken curvilinear tympanum which overlaps the pedestals of two of the corbels. Similar is the conflicting relationship between the corbels themselves and the overlapping trabeation on the one hand and the strongly overhanging balcony of the central three-mullioned window on the other. Palazzo Widmann's location, with its extremely foreshortened perspective, encouraged Longhena to accentuate the weight of the ground floor and mezzanine in comparison to the upper floors, in other words, to present in this zone an increasing monumentality to which it was easier to allude than to repeat in precise real "views."

Palazzo Lezze

When it came to Palazzo Lezze, however, Longhena abandoned this process entirely. For this palace, which extends in a perspective of unusual width, Longhena adopted other devices in order to emphasize his architectural consistency and compositional originality. At Palazzo Lezze the minor facade near the Scuola della Misericordia is of extreme importance. Here Longhena eliminated the *campiture*, leaving bare the architectural framework, partly recalling the facades of certain civic edifices by Palladio and Sansovino. The Doric order is almost squashed by the growth of the vast upper floors, clearly echoing the tremendous monumentality of the *scuola*. The attic floor not only suffers from the compression which is nearly always a feature of

palaces without friezes and trabeation, but also reveals a new and unusual development: small brackets interspersed with little carved heads, echoing the heads on the keystones of the arches. In contrast to Palazzo Widmann, here Longhena places less importance on the lower face in order to highlight the unusual and monumental size of a highly legible and, above all, approachable complex.

Unlike his other works, here Longhena makes use of the device of seriality, creating a succession of no fewer

Battagia, Bon-Rezzonico, and Pesaro—are all fine examples of originality and innovation, displaying unusual themes and extraordinary architectural quality, both linguistic and structural.

Palazzo Belloni-Battagia

The palace on the Grand Canal at S. Stae for the Belloni family dates from around 1650 and is a building of unusual innovation and surprising elegance, even in the triumphal emphasis of its facade (see pp.

OPPOSITE:
Palazzo Pesaro at S. Stae, by Baldassare Longhena. View of one side.

Palazzo Pesaro at S. Stae, by Baldassare Longhena, commissioned by Doge Giovanni Pesaro. The monumental edifice was begun by Longhena and brought to completion in 1710 by Antonio Gaspari. View of the facade overlooking the Grand Canal. Today it is the seat of the Galleria Internazionale dell'Arte Moderna.

than six almost equidistant double lancet windows within the first simple bipartite framework defined by the corner single lancet windows and by the great central window. The stone *specchiature* contribute to the emphasis, found throughout the building, on the extreme nobility of form and material, which appears to be its declared aim. Despite this, with the exception of the facade overlooking the *scuola*, animated by a much greater desire for affirmation and confrontation, there is a general sense of repetitiveness and monotony.

In contrast, Longhena's three great palaces—Belloni-

414–415). The most unusual element is perhaps the fact that it consists of a single *piano nobile* with the mezzanine and ground floor below and a compact attic above. Above the attic two obelisks stand out, once again decorated with large masks on the outer face of each pedestal. Despite the fact that the building appears formed of three great superimposed bands, it is the central one of the *piano nobile* that constitutes the hierarchical apex of the building in that it appears—dimensionally, stylistically, and functionally—to concentrate in itself and fully

develop the theme and the architect's aims. Here, more than in any other Venetian palace—more, even, than in the very first example of this genre, Palazzo Balbi by Alessandro Vittoria—it is possible to see a type of ornate facade cleverly overlapping a more general architectural backdrop. Here we have the massive ornamentation carved on the Corinthian face of the *piano nobile* and developed in the great broken curvilinear tympanums through the insertion of vases. The tympanums are supported by a cornice with modillions similar to those of Palazzo Lezze but, unlike other examples, they overflow into the section above the stringcourse, invading the space of the attic floor but at the same time forming the basis of the last area of marble, which concludes with a frieze with the moon and stars under the cornice (Diana-Bellona was the source of both the name and the heraldic badge of the family). The head of Diana on the keystone of the arch over the central aperture and on the broken curved tympanums, the fascia with marble *specchiature*, the frieze of astronomical heraldic figures and, finally, the obelisks on the roof, are all elements which develop an unusual allegorical and celestial theme into which the large ornate coats of arms on the *piano nobile* fit perfectly. Underneath, where in other works by Longhena the ashlar is replaced by a more refined decorative marble border of geometric designs and by windows with small brackets, is concentrated the "earthly" part of the building, which concludes with a vigorous and important cornice resting on a series of lion's heads which face outward from the stone, almost on the surface of the water, and which, according to the by now famous words of Martinioni, "seem to be holding up the entire building on their backs." Longhena was undoubtedly aiming at such an effect and makes use of it again, with greater articulation and richness of detail, on Palazzo Pesaro and, in a slightly different form, on Palazzo Bon-Rezzonico.

Palazzo Pesaro

Palazzo Pesaro, like nearly all the major building enterprises of the seventeenth century, was being reconstructed in order to satisfy new decorative and entertainment requirements, creating a composite and fragmentary property, the result of various interventions over different periods (see pp. 416, 417). The driving force at the beginning was Giovanni Pesaro, who became doge in 1658 but who had already by 1628 commissioned the task of homogenizing and renovating his home. The project was carried on by his nephew Leonardo, and the most decisive years for the building were the 1660s and 1670s. As mentioned earlier, however, for many years the edifice stopped at the *piano nobile* and

although the ground floor area was already inhabited, it was not completed until 1710, a fact confirmed by Coronelli's drawings.

The palace that the Pesaro family had wished to be in proportion to their power and prestige is today one of the most imposing and massive edifices in the city. If it is true that its monumental conception, architectonic divisions, and choice of materials all recall both Sansovino and Sanmicheli, then the innovations deriving from its genre, the finished, exclusive result of Longhena's creativity, should be given equal emphasis, especially—as can be seen quite clearly in Palazzo Bon-Rezzonico as well—the existence of a double organism which, as such, constitutes the building and endows it with dynamic life (an element which had already been well defined on the central band of Palazzo Belloni-Battagia where, however, the elegant and refined decorative play prevailed over structural concerns).

We are dealing here with the material or the volume (or the mass of the building), formless, although not inert, which gives weight and substance to the body of the architectural object. At the same time, more externally, we have the logical web (and linguistic game) which encloses and gives legibility and rationality to the volume: columns, pillars, balustrades, trabeations, arches, and so on. The diamond-shaped ashlar and the mass of plastic elements which appear here and there are the manifestation of Longhena's attempt to smash the architectural cage, going beyond—with naturalism or fantasy, as a bizarre decoration—the mediation which that cage/parameter constitutes both for the observer and for the more general context (we mentioned above how only on the facade of the Ospedaletto does the exchange of roles and the inversion of values between these two elements which inform the edifice take place). The most obvious sign of this passionate and fantastic conflict (a constant feature of the Baroque) is the jarring bewilderment on the faces of the "chimerical heads of diverse animals," in the keystones of the arches, in the figures of the rivers, in the crests and the other reliefs distributed here and there, and in the robustly encircled rusticated columns.

Without going into too much detail (the small pilasters of the long balustrade that runs along the whole of the facade are an outstanding example), it should be stressed that the entire edifice is as original as the facade. Above all, the huge heroic entrance hall, with its series of busts that accompany and emphasize the visitor's progress, reveals an incredible imagination and creative freedom. Longhena could not have ignored—like his successor at Ca' Pesaro, Antonio Gaspari—what Sanmicheli had done in this field. But at Ca' Pesaro everything is transfigured into a different and shrewd choice of decoration,

resulting in the theatrical effect which Longhena desired and achieved.

In contrast, the courtyard is characterized by an innovative and unusual theme for Venice. The overlapping loggias on one side and the suspended passages on the other (the "noble courtyard girt by loggias and graceful corridors" recalled by Martinioni) might, from a certain point of view, recall Palazzo Pisano at S. Stefano, but are perhaps more common in mid-sixteenth century Roman architecture. What is absolutely new, however, is the top floor of the loggia itself, with its inversely tapered pillars referring back to other of Longhena's specific linguistic solutions.

Palazzo Rezzonico

Less peremptory is the mass of the other great palace, Palazzo Bon, later Rezzonico (see p. 419). Its

Facade of the Spanish or Western Synagogue or Scuola overlooking the piazza in the Ghetto. Built c. 1657, this was the first major edifice to be constructed in the Ghetto in Venice in the 17th century and was based on the late 16th-century Sephardic synagogue.

construction was even more slow and tortuous than usual, and the various interventions which took place during the decades following the suspension of work due to the family's economic difficulties were even more invasive. However, the addition of the ballroom designed by Massari in the eighteenth century was extremely prestigious. The dialectic between architectural logic and the flowering of nature and strange beasts which animates Ca' Pesaro is, in part, peacefully resolved here via a more composed and tranquil geometry. However, the whole lowest band is robustly entrusted to the strength of the

Sansovinian corbels on the windows, the lions whose heads appear below, the massive rusticated pillars, and the bearded heads which with difficulty—a symbol of controlled power—look out from under the Doric trabeation.

Less vast and radically innovative than Ca' Pesaro, the facade of Palazzo Rezzonico also appears less unified and more monotonous. The innovation of the development above the entrance hall and toward the courtyard is less imperative than that in Palazzo Pesaro. In addition, there are frequent grammatical mistakes and syntactical omissions which, we can assume, are the result of the vicissitudes of the long and tortuous life of this project. On the whole, Longhena in these two great palaces appears less interested in renovating the planimetric distribution of the rooms than in highlighting, in unusual, shrewd, and extraordinary linguistic notes, his desire to make perfectly clear the coherence and logical rigor of his architectonic organisms.

Galleried Staircases

Unusually for Venetian architects, Longhena frequently tackled great staircases as a separate theme within large-scale building projects. These staircases, far from being moments of mere functional importance within the building's economy, become architectural, thematic, and figurative junctions of crucial importance within the edifice's organic construction, assuming a different relevance and semantic role according to the nature and quality of the context, to the extent that typologically akin staircases appear to manifest respectively the strongest and most linguistically consolidated moment, in other words, the critical junction of greatest difficulty and dynamic tension in the whole structure.

The three great galleried staircases—the monasteries of S. Giorgio Maggiore and of the Somaschi at the Salute, and the Dominicans at SS. Giovanni and Paolo—seem to have been different attempts to resolve one of Longhena's recurring problems. The staircase of S. Giorgio is both emphatic and complex, with its arrangement of flights and counter-flights from which the system grows, assuming the tranquil, solemn progress of a Veronese loggia (see p. 422). Two decades later, designing the other two great staircases, Longhena referred back to S. Giorgio, fully aware of the new contexts in which he had to operate and of the evolution that had taken place in his own architecture in the meantime. The staircases of the Somaschi and Dominican monasteries include—compressed into the space of a simple double flight and deliberately emphasized by an extremely vigorous series of cornices, pillars, tympanums, and brackets—all the

Facade of the Eastern Synagogue or Scuola overlooking the campo in the Ghetto in Venice, built c. 1683 opposite the Western Synagogue.

elements of a far more complex and powerful system which, forced into a restricted space, manages to thrust its way out and reveal the irrepressible tension of possibilities and potential, which are perhaps greater than those in S. Giorgio.

Urban Planning

The urban relevance of Longhena's projects should also be stressed and, once again, ambiguously or shrewdly extended over a typological arc which stretches from the composite and articulated complex to the object, and entrusts to the internal and allusive profundity and even harshness of the construction materials and of the hewn stone a message of penetrating formal efficacy and symbolic richness. The two levels of Longhena's architecture constitute the very element which could be neither understood nor embraced by successive classicizing critics, armed by Palladian prejudices. Nor has it been understood more recently by those who wish to interpret Longhena from a picturesque and architectural-color, antiplastic, and antistructural

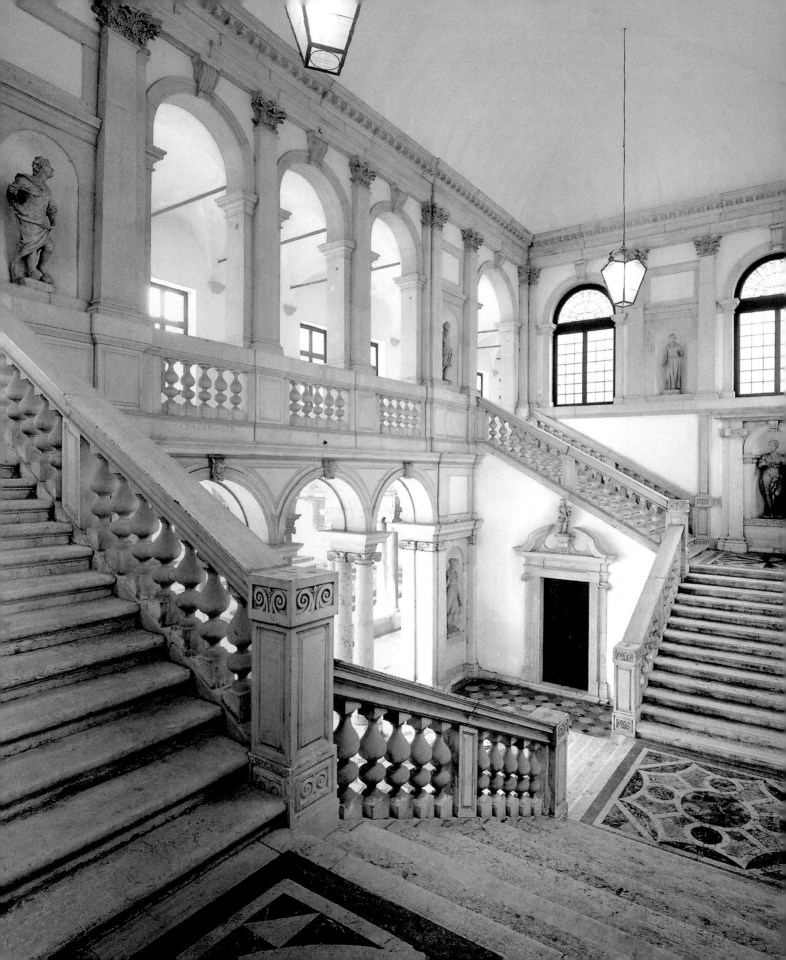

point of view. In reality we are dealing with a vast system of architectural frameworks and original linguistic emphases brought together in substantially dynamic connections. Even here, Longhena maintains the aims of his discourse on the accepted and embraced architectonic theme with an unusual astuteness of method, respecting fully the superior rules of the game and thus with a profound and inalienable adherence to the professionalism of building solidly, economically, and with clarity.

That Longhena frequently conceived his schemes in the light of a diachronic projection which he did not intend to resolve within the spatial and temporal limits of the object and its execution is demonstrated by the frequently protracted commissions which, in the form of appendices or the extension and continuance of the supervision of larger portions of the city, he succeeded in obtaining for his workshop. The most famous example is that of the church of the Salute, which he completed with the monastery of the Somaschi and later with the customs warehouses up to the humiliation of his lack of success at the Dogana da Mar, entrusted to Benoni. However, even with the complex of S. Giorgio dei Greci he managed to bring order and formal rationality to the entire area: houses, *scuola*, Collegio Flangini, monumental approach, various inns, and the space between the different areas and the church.

Longhena's work, in his role as *proto*, on the area surrounding S. Marco is no less articulate, as can be seen from the Procuratie Nuove, as already mentioned, the *baccherie* of the Ascensione and the Casaria and beyond, and many other examples. Longhena demonstrated in these cases his desire to extend the reach and dimension of his designs beyond the limits of the architectural object: we are dealing here with choices and tensions which cannot be explained away as mere greed for work (and money). They should rather be interpreted, as is confirmed by the very nature of Longhena's design style, as a deep and intelligent interest in urban problems, an interest which can easily be seen in the language of his work. The methods, for example, according to which he mediates between private and public space are extremely significant: the water entrances to Palazzo Pesaro and Palazzo Rezzonico and their vast entrance halls leading to internal courtyards, the relationship between the palazzo and its foundations at Palazzo Lezze and Palazzo Widmann, the horizontal extension of Palazzo Zane and Palazzo Lezze, which marks, both formally and spatially, the deliberate urban perspectives, and the masterly construction of the area known as *dei Greci* [of the Greeks], between the bridge and the church.

All these elements also reveal another aspect of Longhena's work in Venice, his extreme willingness to adopt solutions and experiment with interventions that were not preordained, that were innovative, absolutely anti-ideological (in other words, and despite being only an approximation, the fact that he was not bowed down by the weight of much of the philosophy of Baroque culture).

This coincides, at least in part, with the demise of the absoluteness and imperativeness of the isolated and perfect object in favor of an ensemble of articulations and connections conducted in parallel and in subordination, sometimes even mitigating the predetermination of a large-scale project. This was, once again, the case with the Salute and its function as mediation, not exaltation, a function entrusted to the architectural design of the campo, the bank of the Grand Canal, and the accompanying urban fabric. Beyond all decodification—justifiable and legitimate—of Longhena's architectural choices within cultural systems and codes (formal, philosophical, theological, iconographical) subsists, as the primary and irreplaceable aim of his work, a dialogue with the site. Always at determined locations—and not at others—all Longhena's projects and architectural objects adapt and shape themselves until they have constructed fragments of a renewed city, modular and coordinated even when not strictly connected in a deliberate project of growth for the whole *forma urbis*.

The dual values which are characteristic of Longhena's methods are, in fact, the key to his work. We can see there all the unease of the research into language, no less than the mastery of the instruments of technique. The method according to which a continuous exchange of roles took place is astonishing—and probably the main reason behind the open, anticanonical, and yet not iconoclastic qualities of Longhena's work—and allowed the architect to make use of an articulated range of semantic registers and linguistic choices while remaining constantly within the terms necessary for the architectural propriety of his work. It also allowed him to stay on the near side of rhetoric and to go beyond the limits of scenography, leaving his mark in the most pertinent manner on the wise and creative essence of an architecture that is one of the highest cultural accomplishments of the epoch.

Giandomenico Romanelli

Sculpture in Venice in the Seventeenth Century

The Early Decades

In contrast to what had already happened in Rome, the face of Venetian sculpture did not change into Baroque until the mid-seventeenth century. In fact, the late Mannerist style persisted even longer in Venetian sculpture than it did in Venetian painting. Not just devotional and Counter-Reformation exigencies weighed heavily upon sculpture but so did obligations linked to a certain type of production—State commemorative portraiture and sculpture intended to decorate funerary monuments—that was itself tied to traditional formulas whose great success in stuccoes and small bronzes assured its persistence.

The art of Alessandro Vittoria, the most original interpreter of Venetian Mannerism in the field of sculpture, was to influence sculptors of the younger generation greatly. His own teaching was limited to passing on professional skills to those who collaborated closely with him at the end of his career in 1602–03 (Andrea dall'Acquila and Vigilio Rubini). However, not one single pupil with original talent emerged from his studio in Venice. The most important part of Vittoria's visual language was adopted by his contemporaries, those same sculptors who, in the Venice of the late Cinquecento, had already demonstrated their independence, in particular Girolamo Campagna and Giulio Dal Moro, both sculptors and architects, the latter a painter too.

Girolamo Campagna

Girolamo Campagna, a pupil of Danese Cattaneo and active in Venice from 1571–72, was at the peak of his maturity and his success at the start of the new century. From commissions for the doges and for the most prominent noble families of Venice to his work for churches and *scuole*, his Seicento artistic production is evidence of a creative activity receptive to the different themes and diverse requests which he took on with the confident skill gained from a long apprenticeship. Funerary sculpture acquired greater importance as the century progressed, becoming an integral part of the historical and cultural fabric of the city. Campagna's work on the funerary monument of Doge Pasquale Cicogna (for which he was also the architect) in the church of the Gesuiti and on that of Doge Marino Grimani and his wife in S. Giuseppe di Castello (the architectural part for which is by Francesco Bernardino Smeraldi) are good examples of the use of a type that suited the commemorative theme well: the statues of Cicogna (1600–03) and of Grimani (1604) introduce a change, only slight in the case of Cicogna, in which the doge is shown sleeping half lying down, more noticeable in the other two figures, also half-recumbent but wide-awake. This inventive choice conveys an impression of naturalness along with, in the statue of Cicogna, an elaborate and precise execution of high quality, in which the gold decorative features of the clothing strike an appropriate note, while the ducal couple are depicted more modestly. In 1603 Cesare Groppo, a bronze specialist of Genoese origin, sculpted two reliefs for the Grimani monument depicting the coronation of the doge and his wife in which the narrative elements recall those of the contemporary votive canvases of Jacopo Palma the Younger.

Girolamo Campagna's busts of the procurator Andrea Dolfin and his wife Benedetta Pisani (1603–04) are placed in the traditional manner above their sacrophagi on their monument in the church of S. Salvador, the architect for which was Giulio Dal

MARCO ANTONIO MEMO
DVCE
ANNO. M.D.C.XIII

Moro, creator too of the other sculptures of the ensemble. These busts, and Campagna's bronze statue of St. Anthony, sculpted in 1605 for the altar of the Orefici [goldsmiths] in S. Giacomo di Rialto, stand up excellently to comparison with the best of Vittoria's work. In the two portraits the sculptor has created works whose formal elegance effectively conveys a sense of noble and dignified composure. The bust of Dolfin in particular betrays in the soft chiaroscuro passages a Veronese-like sensibility, one of the components of Campagna's idiom. The *St. Anthony* is solemn, modelled to stress the pictorial play on clothing, and with an ability that reveals Girolamo's skill as a maker of bronzes, apparent in the production of small bronzes. The angels and putti

dignified yet arid academicism prevails, seen also in the use of the Vittoria formula in portraits like the signed bust of Vincenzo Cappello on the portal of the facade of S. Maria Formosa (1605–10) and that of Lorenzo Bragadin (c. 1615), now in the Seminario Patriarcale, made for his monument in the church of S. Sepolcro.

Giulio Dal Moro

In the field of portraiture during the early Seicento, Giulio Dal Moro, working in Venice until the beginning of the 1680s, stands out for his expressive force. He did not bow to academicizing compromise, noticeable in other works of his that correspond to the late period of Campagna, from whose art he still

Allegory of the Redemption, Nicolò and Sebastiano Roccatagliata, bronze relief. Church of S. Moisè. The canopy relief was donated by Antonio Damiani in 1779 and placed on the sacristy altar.

made in 1615–17, toward the end of his artistic activity, for the tabernacle of S. Lorenzo (now in the Museo Correr), are especially worthy of note. Possessing a casual elegance of movement and a soft painterly effect, they reflect a less stylized gracefulness compared with Vittoria's bronzes.

The statues for the same altar depicting St. Lawrence and St. Sebastian and those, signed and dated 1616, of St. Peter and St. Paul for the church of S. Tomà do not achieve the same standard. A

assimilated influence in the early years of the century. The signed busts of Giovanni da Lezze (c. 1610), on the family monument in the church of the Gesuiti, of Marcantonio Memmo (c. 1615), on the funerary monument he designed in S. Giorgio Maggiore, and of Paresano Paresani (c. 1611), in the church of S. Fantin (at the top of a simple aedicula that frames the epitaph inside a shell that functions as a niche), revive the tradition of Vittoria, revealing Dal Moro's genuine talent for portraiture. It is a type of

statesman's portrait of a totally sixteenth-century spirit, which in the bust of Paresani even harks back to the humanistic formula of the portrait *all'antica* in the work of Danese Cattaneo.

Giulio Dal Moro also worked in stucco decoration, carrying on another sixteenth-century tradition which, thanks to his gifts as a sculptor, gives elegant results in the two allegories that flank the coat of arms of Doge Marcantonio Memmo above the door of the Sala degli Scuderi in the Palazzo Ducale (see p. 425).

Francesco Terilli and Giambattista Albanese

The artistic situation apparent in the work of Dal Moro and Campagna, in other words the ending of an old tradition and the lack of a new one, weighed more heavily on sculptors of more limited scope who nevertheless took part in the decoration of prestigious buildings in Venice. We need recall only Francesco Terilli and Giambattista Albanese among the sculptors whose style we are familiar with. On the other hand, the art of other minor masters, particularly bronze-makers, sculptors in stucco, and engravers, is still unclear, placed under the generic labels of "school of Vittoria" or "late Mannerist Venetian."

Francesco Terilli, from Feltre, worked on commissions for the State. These include small bronzes like the statues of the Redeemer and of St. John the Baptist for the two holy water basins at the entrance to the church of the Redentore, signed and dated 1610 and paid for in 1611, as well as the wooden sculpture (his principal field of activity) of Pompeo Giustiniani, the erection of whose equestrian statue in gilded wood, preserved in SS. Giovanni e Paolo, was decreed by the Senate in 1616. The two bronze statues reflect the common experiences of late Mannerist sculpture. Apart from the obvious influence of Vittoria, that of Giulio Dal Moro and Girolamo Campagna can be seen. The equestrian group is a variation of the celebrated nearby prototype by Verrocchio in the campo in front of the church. In the interpretation by Terilli, horse and rider lose their dynamic tension and become frozen into an elegant heraldic formula.

The Procuratori de Supra of S. Marco called on Giambattista Albanese, born in Vicenza but working at this time in Padua, to sculpt the four statues called the *Knights of the Holy Church* (1618), which are still on top of the two lateral arches of the façade of S. Marco. The four warrior saints were commissioned to replace the ones destroyed a century earlier by an earthquake (1511). The importance of this commission must have inspired Albanese to a major effort, and he succeeds in combining elegance of movement with more obvious ornamental detail than usual, reflecting his intention to harmonize the sculptures with their context.

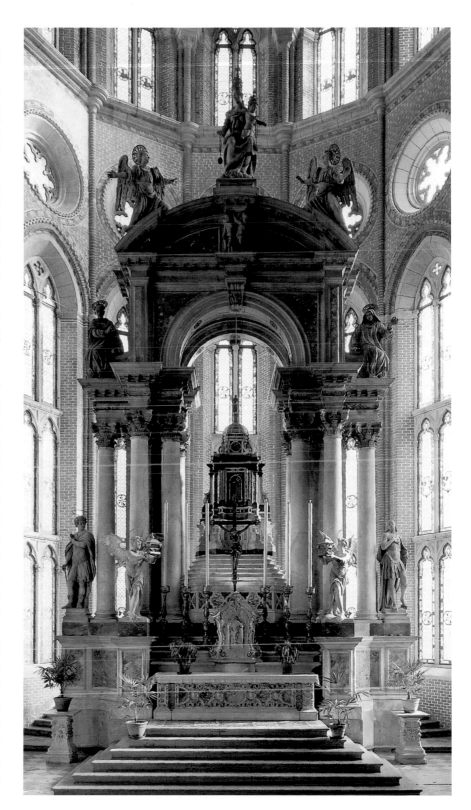

Guardian Saint, Clemente Molli, signed by the artist as "BONONIENSIS [the Bolognese]." Church of SS. Giovanni e Paolo, high altar.

The 1630s and 1640s

During the 1630s and 1640s, when, thanks to the work of three "foreigners"—Fetti, Liss, and Strozzi—Venetian painting finally enters the Baroque era, sculpture was still in a period of transition despite some outside influences worthy of note. Late Mannerist characteristics were becoming less common, and while there are occasional and more or less valid interventions, none was capable of introducing innovative change. One significant example is the bronze canopy dated 1633 on the altar of the sacristy of S. Moisè, signed by Nicolò Roccatagliata and his son Sebastiano (see p. 426); the work of this Genoese artist, a pupil of Cesare Groppo, is seen in Venice after 1594 in the production of small bronzes. As can be read on the canopy itself, it was placed there following a donation by Antonio Damiani. The canopy, informed by the work of Alessandro Vittoria and Girolamo Campagna, is an isolated case within Roccatagliata's own production, both for its Counter-Reformation theme, doubtless determined by the particulars of the commission, and for the way the scene is articulated. The various narrative focuses of the scene are arranged, according to Nava Cellini, in "an extremely turbulent composition, split up into different areas and embraced by one single space, the distinctive note of which is given . . . by an almost simultaneous effect of narration." There are allusions not only to Campagna and Groppo, but also, as Venturi noted, to the Genoese works of Giambologna. In the absence of precise knowledge of the work of the son, Sebastiano Roccatagliata, it is impossible to evaluate his influence on the canopy, in which Baroque elements are noticeable.

Clemente Molli

Around 1639 the altar in the Widmann Chapel in the church of S. Canciano made its mark on Venetian sculpture in a rather unusual way. Clemente Molli, the Bolognese artist responsible for the whole piece, was a sculptor with diverse interests, including architecture, poetry, and, according to Marco Boschini (*La Carta del Navegar Pitoresco* [Map of picturesque navigation]), painting, in which he was expert and dealer. In the period before his Venetian work he had been active in Emilia and Romagna, sculpting in marble and in stucco, and had probably brought his own artistic culture up to date with a journey to Rome. The novel features Molli introduced into the Widmann Chapel can be traced back to his Bolognese background which included familiarity with the plastic and pictorial models of Guido Reni: the pompous St. Maximus, the Virgin rapt in the ecstasy of prayer in the center of the high point of the altar, the similarly ecstatic St. John the Evangelist,

and the two angels flanking the saint are cast in the Reni mold. The angels supporting the urn are encountered in the figurative repertory of Ludovico Carracci, and the *St. Paul* likewise recalls Michelangelo's *Moses*.

The felicitous style of the Widmann Chapel and its modernity derived from the link with Bolognese culture recurs in the 1650s in Molli's four marble angels on the altar of Blessed Lorenzo Giustiniani in S. Pietro di Castello and in one of the guardian saints, signed by the sculptor who calls himself "BONONIENSIS [the Bolognese]," on the high altar of SS. Giovanni e Paolo, reminiscent of Algardi during his Bolognese period (see p. 428).

By contrast, the other sculptures Molli made in Venice, where his work is documented up to 1662, reflect the beginnings of a stylistic withdrawal and an aridity which in the end was to gain the upper hand. One might say that his residence in Venice and his limited artistic talent interacted in a negative sense, dulling his initial verve which had seemed so promising and leading him to express himself in conventional, decidedly mediocre and, by this time, anachronistic ways, as in the statues of constancy and mercy on the facade of the church of the Misericordia.

As far as the architectural activity of Molli is concerned, to which Martinioni (1663) referred, no documentary evidence has yet emerged, but it must have constituted only a marginal part of his oeuvre. Some of his other sculptural work, like the lost statues for the facade of S. Giustina of 1640 (the portrait of the procurator Girolamo Soranzo flanked by allegories of war and peace) and the above-mentioned sculpture for the high altars of SS. Giovanni e Paolo and S. Pietro di Castello, are in architectural settings by Baldassare Longhena. Indeed, in the absence of artists able to work with equal competence in both disciplines, as Jacopo Sansovino, Alessandro Vittoria, and in part, Giulio Dal Moro and Girolamo Campagna had done, sculptors began to depend increasingly on architects from the 1640s onward. Architects working as *protos*, particularly in the case of Longhena, worked out projects in their entirety, entrusting single parts of the work to the different masters, from stonecarver and sculptor to the more modest artisans. The architect himself supervised and once finished, he approved, signing the relevant invoices and submitting them to the client for payment.

If this was the accepted practice of the workyards, about which the extant documents inform us in the case of Longhena and the other *protos* active in prestigious enterprises in Venice during the Seicento, what the archives do not tell us are the reasons

Guardian Saint, Francesco Cavrioli. Church of SS. Giovanni e Paolo, high altar. This sculpture is a pendant to Molli's *Guardian Saint*.

Funerary in monument to Renato de Voyer de Palmy, count of Argenson, signed by the artist Claudio Perreau as "PARISINUS [Parisian]." 1653–55. Church of S. Giobbe.

behind the choice of particular artists, those circumstances we attempt to understand in order to bring the work into focus within the context of the milieu for which it was created.

Baldassare Longhena, the Paliari, and Francesco Cavrioli

At the beginning of Longhena's career, which, thanks above all to the commission for S. Maria della Salute (1631), was to bring him great renown and turn his workshop into a magnet for the most gifted sculptors, his collaborators were modest artists like Giambattista and Giovanni Paliari who were at work on statues on the staircase of the monastery of S. Giorgio Maggiore. Paliari's place was subsequently taken by Francesco Cavrioli from Serravalle near Treviso, who made the allegorical statue of Venice for the central niche of the staircase in the second half of 1645. Cavrioli was of a higher standing than Paliari, and his collaboration in the decoration of Longhena's architecture was particularly regular.

The penchant for decorative detail in the *Venice* is also to be found in the pendant to Molli's titular saint for Longhena's altar in SS. Giovanni e Paolo (see p. 427): its elegant outline is accompanied by a suppleness that is still Mannerist (see p. 429). The decorative vein and a craftsmanlike meticulousness are constant in Cavrioli's work. From the very beginning it included small works in stucco, now lost, as well as small bronzes such as the putto for the keystone of the altar (possibly by Longhena) of Francesco Morosini in the church of S. Pietro di Castello, dated between the end of 1646 and early 1647, and the three gilded bronze compartments in which Faith, Hope, and Charity are depicted on the altar of the Blessed Lorenzo Giustiniani in the same church, ascribable to the first phase of the work, in the 1650s, on the great altar whose erection had been decreed by the Venetian Senate as early as 1646 and entrusted to the Procuratie de Supra, of which Longhena had become *proto* in 1640.

The 1650s and 1660s

After a period of collaboration with Giuseppe Sardi on the Villa Selvatico in Battaglia Terme (1652) and on the altar of the *Deposition* in the basilica of S. Antonio in Padua (1654), Cavrioli was in Venice once again in 1657 when he sculpted two angels for the pediment of the high altar of SS. Giovanni e Paolo, and *Prudence* and *Magnanimity* and the Cavazza coat of arms for the monument to Girolamo Cavazza in the church of the Madonna dell'Orto, which he designed himself. In these pieces, he

expresses himself again in his characteristically elegant decorative style, which only later would reflect an attempt at modernization when faced with examples by artists from other cultural areas, the most prominent of whom, Juste Le Court, worked with him on the Cavazza monument.

In the 1650s Claudio Perreau, Juste Le Court, Bernardo Falconi, and Melchior Barthel were all active in Venice, artists of differing stature who as a result exerted different influence. Once again, it was left to the "foreigners" to establish the basis of a new style. While the four sculptors had neither common origins nor the same training, for all four a knowledge of the Roman artistic scene is very probably an explanation for their modern style.

Claudio Perreau

Claudio Perreau, of whose life we still know little, signed himself as *Parisinus* [Parisian] on the sculpture on the monument to Renato de Voyer de Palmy (1653–55), count of Argenson, in the church of S. Giobbe, and under the two angels (c. 1657) in the pendentives of the altar of St. Anthony designed by Longhena in the church of S. Maria della Salute. De Palmy's monument, the design for which had been sent to Rome according to Martinioni (1663), is the first example of funerary architecture which develops the Raphaelesque theme of the pyramid tomb (Chigi Chapel in S. Maria del Popolo, Rome) in terms of a Baroque style derived from Bernini. The stylistic features of the plump little angel sleeping on the urn echo Bernini and support the hypothesis that Perreau had been in Rome. We do not know whether he was already in Venice when he took on the work for the monument or whether he was called to the city specifically for the task. Commissions for French clients, however, could have been a possible motivation for his S. Giobbe project: work for the son of the count of Argenson, who bore the same name as his father, and for Bernard de Besançon, the French ambassador to Venice, and his wife who in 1656 had a tomb slab sculpted for their son when he died prematurely. Perreau reveals himself to be oriented at times toward classicist idioms and styles of late sixteenth-century origin, which imbue his language with a Baroque flavor. This can be seen in the small funerary angels on the tomb slab, in the angels on the altar of St. Anthony in S. Maria della Salute, in the ovals with four female allegories on the bases of the pillars of the same altar, and, later, in the statue of St. John the Baptist for the high altar of S. Pietro di Castello, for which he was paid in 1663. After this year all traces of Perreau are lost. It was this classicist element which had a lasting impact on Venetian sculpture for the whole century and which comes to

Martyrdom of St. Sebastian, Bernardo Falconi, bronze relief, signed. Church of the Scalzi, Venier Chapel.

St. John the Baptist, Melchior Barthel, signed, c. 1660. Church of the Scalzi, Mora Chapel.

OPPOSITE:
High altar, designed by Baldassare Longhena, with sculpture by Juste Le Court, Clemente Molli, Melchior Barthel, Francesco Cavrioli, Bernardo Falconi, and Claudio Perreau. Church of S. Pietro di Castello. This powerful composition, commissioned by the Senate, was erected in honor of the Blessed Lorenzo Giustiniani. Work began in 1646.

the surface in the language of several sculptors who had modernized their craft.

Juste Le Court

The style of Le Court's first Venetian works—from the two candle-bearing angels (1655) placed on the external pillars of the Labia Chapel in S. Nicolò da Tolentino to the *Honor* (1657) on the Cavazza monument—leans toward the classicizing orientation of Perreau. The little information we have regarding the pre-Venetian years of Le Court, born in Ypres in 1627, is imprecise. There may have been a period of apprenticeship under his father, who was

also a sculptor, and a trip to Rome after some time spent in Antwerp, around 1648, in the studio of the sculptor Cornelis van Mildert. The stylistic traits of the above-mentioned statues, which are reminiscent of the classicist tastes of Duquesnoy (his *St. Susanna* in the church of S. Maria di Loreto in Rome comes to mind), can be traced back to Le Court's Roman experience, and a reference to Bernini (the statue of the Countess Matilda on her tomb in St. Peter's, Rome) is apparent in *Virtue*, the pendant to *Honor* on the Cavazza monument. Over the next few years, Le Court's language took on more grandiose formulations, with the chiaroscuro dialectic made softer, and classicizing cadences inserted more emphatically. In the two statues of *Strength* and *Prudence* (1658–64) for the monument of Tommaso Luigi Mocenigo in the church of S. Lazzaro dei Mendicanti, also designed by Giuseppe Sardi, Le Court's style is revealed as having already acquired those traits which, until his death (1679), informed his work with a power that endowed Venetian Baroque sculpture with unequivocal Lecourtian characteristics which would continue to exert influence into the following century.

Bernardo Falconi

Perreau and Le Court were joined by Bernardo Falconi and Melchior Barthel in the second half of the 1650s. Falconi, originally from Rovio in the Ticino, began his career in Venice in 1657–58 with the sculpture of St. Theodore and four angels for the top of the facade of the Scuola Grande di S. Teodoro. This commission may be linked to his relationship with architects who were his contemporaries, Antonio and Giuseppe Sardi, the former responsible for the design of the facade. In the absence of information concerning Falconi's training, the classicizing style of the five sculptures, which resembles that of Le Court's first Venetian works, could similarly point to time spent in Rome. Falconi's style becomes more refined in later sculptures, starting with the *St. Sebastian* at the beginning of the 1660s, signed and placed above the altar in the church of the Scalzi which the abbot Sebastiano Venier had obtained in concession in 1655. Falconi developed a supple and elegant manner and increased emotional expressiveness in pieces like *Hope* (signed B.F.F[ecit] [executed]) and *Charity* (c. 1663), located in the lower right and upper left niches of the altar of St. Anthony in the Frari, in which stylistic similarities to the Roman work of Alessandro Algardi are apparent. In these first few years of activity in Venice, the quality of Falconi's production already appears uneven, revealing at times a certain gaucheness, as in the three statues, a male and female saint (1659–61) and

Truth and Justice, Melchior Barthel, detail of the monument to Doge Giovanni Pesaro. Church of S. Maria dei Frari.

OPPOSITE:
Monument to Doge Giovanni Pesaro, designed by Baldassare Longhena, with sculptures by Juste Le Court, Michele Fabris, Melchior Barthel, and Francesco Cavrioli, 1665–69. Church of S. Maria dei Frari.

a Madonna and Child (1663), sculpted for the high altar of SS. Giovanni e Paolo. This commission also signals the beginning of his collaboration with Longhena, with whom he continued to work, especially alongside Le Court.

Melchior Barthel

Melchior Barthel's style in the 1660s at times appears so Lecourtian as to create a problem of attribution, given the close consonance of artistic language of

certain works. Originally from Dresden, presumably between the end of the 1650s and the start of the next decade he sculpted and signed the statue of St. John the Baptist for the altar of the Mora Chapel in the church of the Scalzi (see p. 432). The *St. John* manifests a Northern style true to the artist's origins and artistic background about which details are scarce, except for the testimony given to us by Sandrart (1675), who mentions a journey to Rome by the artist. The sculpture, in an unusual compositional solution, is in a niche that consists of a flat surface and a rocky background. The figure is rendered on an even footing with these landscape elements and the face and every detail is carved with a realistic meticulousness of Northern stamp and undoubted expressive effect, making it a landmark in Venetian sculpture of the time.

The High Altar of San Pietro di Castello

Between 1663 and 1664 Barthel also became part, along with Perreau, Cavrioli, Le Court, and Falconi, of the group working on the last stage of the decoration of the main altar of S. Pietro di Castello (see p. 433). The altar statues offer us an overview of the sculpture of the period and illustrate the coexistence of different styles (style was evidently not a determining factor in Longhena's choice of collaborators). Certainly the participation of Le Court, by now at the height of his maturity and prestige, is the most significant, not least for the number of sculptures he carved: *Blessed Lorenzo Giustiniani* and the two angels flanking him on top, the *St. Paul*, and the three angels supporting the urn. The *St. Paul* (1664), draped in a large mantle, appears commanding in his solemn, almost ostentatious monumentality; the tenseness of his face recalls that of Michelangelo's *Moses*, a work Le Court had certainly seen during his stay in Rome. The three angels (1664) that support the urn, realized with soft plastic curves and placed with ease into their forced postures, recall the theme of the putto and plump little angel, variously posed, picked up by Duquesnoy and common in the oeuvre of Le Court. This theme is formulated in different and successive variations: from the weeping putti with skulls on their knees, a funerary motif dear to Northern tradition and representative of a sort of tender affection, to the two ends of the trabeation of the Cavazza monument (1657), and the angels of the Giustiniani altar flanking the *Blessed Lorenzo* (1665) and those of the next decade on the high altar of S. Maria della Salute, which show a more refined gracefulness. Contemporary with the sculpture for the altar at S. Pietro di Castello are the putti depicting autumn and winter on the staircase of Ca' Rezzonico, the secular version of the theme.

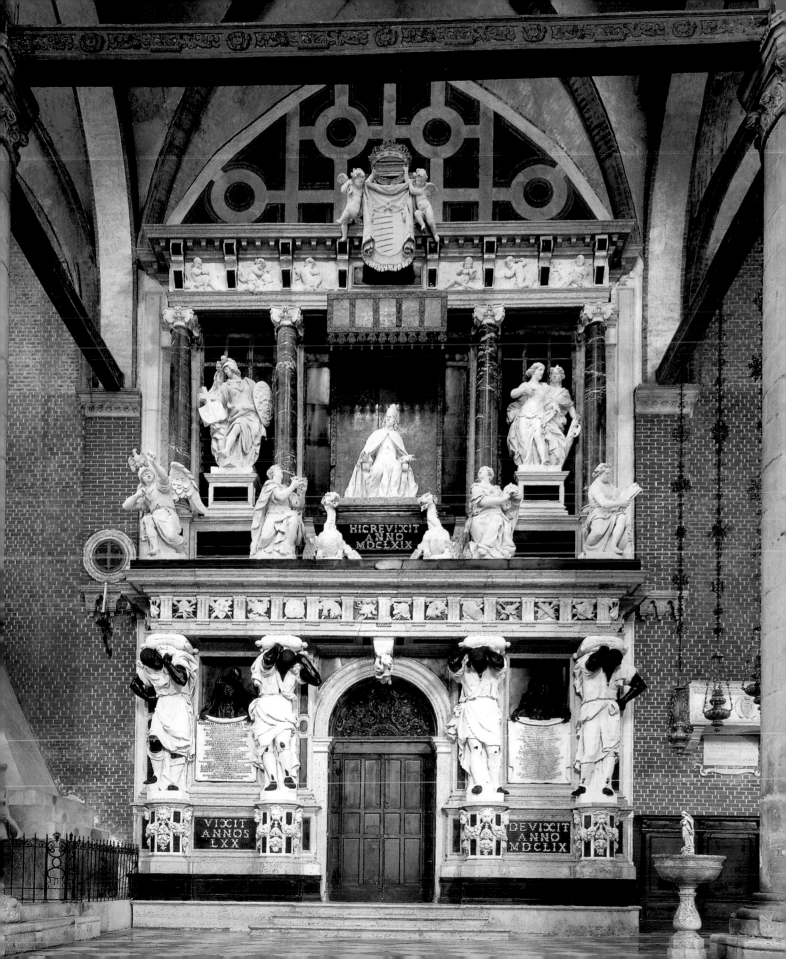

HIC REVIXIT
ANNO
MDCLXIX

VIXIT
ANNOS
LXX

DEVIXIT
ANNO
MDCLIX

Pope Paul V Giving the Cardinal's Hat to Francesco Vendramin, Michele Fabris, known as Ongaro, signed "Michal Ungaro F [*fecit*: executed]." Church of S. Pietro di Castello, Vendramin Chapel.

OPPOSITE:
Poetry, Michele Fabris, known as Ongaro. Church of S. Pietro di Castello, Vendramin Chapel.

The gestures of Blessed Lorenzo Giustiniani and the two angels are represented with sober effectiveness. In the modeling of the face of Giustiniani we can see the realistic accents which were to resurface in works of the next decade, revealing Le Court's inclination toward portraiture. Less important, given the placing of the sculptures at the rear of the altar, are Falconi's three angels holding up the urn. These form the pendant to Le Court's angels in the front section, and they reflect an attempt by the sculptor— not a particularly felicitous one—to paraphrase Le Court's idiom in order to provide uniformity in the work. Perreau, as has already been mentioned, in his St. John the Baptist (1663), remains true to his classicizing leanings, while Cavrioli, in his two angels holding up the urn (1663–65), reflects, without reneging on his decorative tendencies, an attempt to turn the page and move toward the Baroque style. This attempt at change is already apparent in the two angels supporting the relics (1662) on the high altar of SS. Giovanni e Paolo, but it is limited compared with the style of the innovators. Barthel, by contrast, lost no time in espousing the new Baroque developments: his statues of St. Mark and St. Peter (1663–64) reveal a language close to that of Le Court. Barthel, at times with some effort, tends to accentuate the monumental plasticity of the forms and the generous play of drapery which underlines sudden movement (usually better expressed by Le Court), and emphasizes certain poses, as can be seen in the pairs of figures on the funerary monument of Doge Giovanni Pesaro in the Frari (*Religion* with *Constancy*, and *Truth* with *Justice*).

The Pesaro Monument

The sculptural decoration of the Pesaro mausoleum, which the nephew Leonardo Pesaro commissioned Longhena to build (1665–69), was carried out by Barthel, Le Court with Francesco Cavrioli, and Michele Fabris, known as Ongaro [the Hungarian] (see p. 435). Le Court, and Barthel, through their stylistic similarities, represent the new Baroque style. Cavrioli, called on to work on the two bronze skeletons supporting the two scrolls, was presumably chosen in view of his specialization in this field. Michele Fabris, born in Bratislava, who had come to Venice around 1662, was given the task of carving the two dragons, symbols of eternity, which were evidently held to be appropriate to the sculptor's taste and Northern background. The Pesaro monument and its decoration takes on particular importance in the field of funerary sculpture in Venice at this time as a work that reflects the common ideas of the Baroque aesthetic which made the "stones speak," and which culminates, in this instance, in

High altar, designed by Baldassare Longhena, with The *Virgin Driving the Plague from Venice, with St. Mark and the Blessed Lorenzo Giustiniani, Juste Le Court*. Church of S. Maria della Salute.

Emanuele Tesauro, in particular his *Cannocchiale Aristotelico* [Aristotelian telescope]. This notion is outlined in the words "STABUNT SPIRANTIA SIGNA" carved on the scroll held by one of Le Court's putti on the keystone of the church's entrance portal in the center of the lower part of the monument. Leonardo Pesaro's secretary, Cristoforo Ivanovich related how Emanuele Tesauro had furnished an initial model for the mausoleum, suggesting that the doge's statue be surrounded by his exploits expressed through symbolic emblems and trophies, and that the text of the elegy be transcribed in abridged form on the scrolls. Apart from the above-mentioned putto, Le Court was also responsible for the little angels holding up the Pesaro coat of arms, the statue of Giovanni Pesaro, and the four allegories of Intelligence, Nobility, Wealth, and Study which allude to the exploits and merits of the doge. In his angels holding drapery, on the inside of which is sculpted the coat of arms, the artist repeats, with the brio typical of his depiction of angels, a motif traceable to one of Duquesnoy's Roman works (the small angels holding inscribed drapery on the funerary monument of Hadrian Uryburch in S. Maria dell'Anima). The figures of the doge and the four allegories are on a grand scale, similar to that of the four *Moors* as well as earlier works. While *Intelligence* and *Study* are animated with a heroic appearance conveyed through the solidity of their exaggeratedly muscular bodies, the faces of the other two allegorical figures seem to be veiled in the controlled tension typical of Le Court's female figures.

The Moors are a variation on the theme of the artist's telamons, present in those works that are linked particularly to Longhena's designs. The angels on the tabernacle of the high altar of S. Nicolò da Tolentino are also part of this typology. The agreement between the monks and Longhena had included Le Court's work on the above-mentioned angels. Le Court expressed the typology through a line of stylistic continuity from the angels of the Labia Chapel in S. Nicolò da Tolentino to the two allegories on the Mocenigo monument in S. Lazzaro dei Mendicanti. The motif recurs, at the beginning of the 1670s in a softer modeling and milder chiaroscuro in the angels on the altar of S. Maria della Salute and, with a plastic force and a tension closely resembling that of the Moors, in the monument to Caterina Cornaro in the basilica of S. Antonio in Padua also by Longhena.

Telamons also appear in a funeral ensemble known only through engravings. This was erected by Longhena in 1669 in S. Marco for the duke of Beaufort who died fighting for Venice against the Turks in Crete. It is very similar, in its architectural scheme and in the deployment of certain sculptural elements, to the altar in S. Nicolò da Tolentino, and it reveals a close relationship between temporary erections and monumental creations, both of which respond to the same Baroque tendency apparent in the Pesaro monument.

The mausoleum displays, moreover, that tightly knit integration between architecture and sculptural decoration which is particularly characteristic of the Baroque facade of some Venetian churches. In particular, the facade of the Ospedaletto (S. Maria dei Derelitti, 1670–74) designed by Longhena is reminiscent of the Pesaro monument, transfering its plastic and structural elements out into the open. The facade revives the traditional typology of the facade which commemorates the client or benefactor—in this case Bartolomeo Cargoni, whose bust is placed in a shell-niche in the center of the facade—with allusions in the other sculptures to the charitable function carried out by him and by the pious institution to which the church was connected. Archival research has not shed any light so far on the question of the authorship of the sculpture, furnishing us only with the name of Marco Beltrame who sculpted some decorative parts in 1673. The theory of Le Court's involvement advanced by critics is convincing, especially in light of the stylistic details of the sculpture, which parallel the monumental and expressive language of his mature phase and are apparent in some of the sculpture of the Pesaro monument.

The 1670s

While Barthel left Venice in 1672 for Dresden, where he was to die in the following year, Ongaro continued to live and work in Venice, almost always following in the footsteps of Longhena and working on S. Maria della Salute where most of the sculptors of the time were active on the internal and external decoration. It is not always easy to determine whose handiwork lies behind the different figures as there is often a uniformity of language common to them, in relation to themes running through the whole sculptural work and on account of the influence of Le Court, whose style had an increasing influence on the sculptors working with Longhena. In particular, attribution of the small allegorical figures which decorate the bases of the altar pillars is difficult, although some were made by Ongaro. Ongaro's work is recognizable through its Northern roughness and incisiveness, features shared with the sculpture of the Vendramin Chapel in S. Pietro di Castello (see p. 437). It was for this Longhenian chapel that

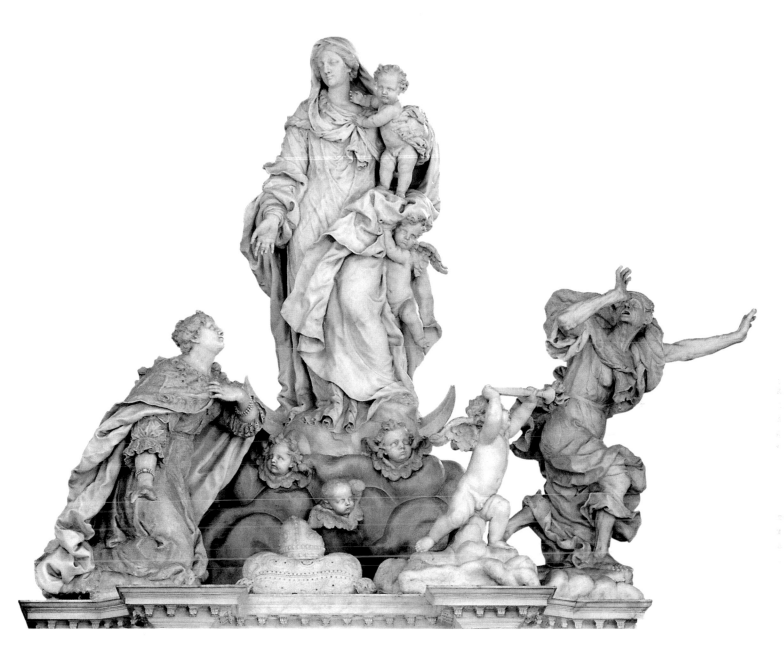

Ongaro, signing himself as "Michal Ungaro F. [*fecit*: executed]," carved his most original work, the high relief of Pope Paul V giving the cardinal's hat to Francesco Vendramin, notable for its vivacious narrative tone and Northern sense of realism (see p. 436). This sculpture remains an isolated case in Ongaro's work, which otherwise reveals at the height of his career the Lecourtian stamp already apparent in the same chapel in the statues of eloquence and Christian religion. Both of these reveal Ongaro's tendency to select and accentuate the more emotional and elegant intonations of Le Court's female prototypes.

The High Altar of Santa Maria della Salute

It was Le Court who was to express his full maturity at the beginning of the 1670s in the extraordinary complex of the high altar of S. Maria della Salute, and who was to dominate and guide Venetian sculpture through the decade (see p. 438). These are the statues on Longhena's altar which were the most evocative and influential, even into the following century. This fascination is fully comprehensible if one takes account of the significance of the work within the frame of Baroque taste and sensibility which by this time appeared to be not only the norm in Venice, but completely integrated with Venetian artistic culture. Le Court had submerged himself in this culture, absorbing its intrinsic values while not negating, but actually enhancing, the value of his own past. The altar sculptures are the result of a coherent stylistic journey. The basic elements of Le Court's artistic background with its Roman influ-

Venice Calls for the Intercession of the Virgin to End the Plague, Juste Le Court, detail of the high altar. Church of S. Maria della Salute. The figure of *Plague*, on the right, is put to flight by a small angel.

OVERLEAF:
St. Mark, Juste Le Court, detail of the high altar. Church of S. Maria della Salute.

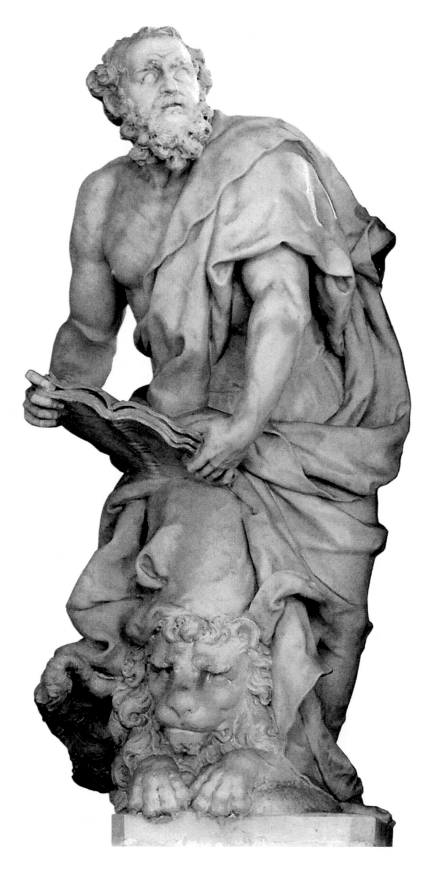

ences continue to emerge. An attention to detail, in keeping with his Flemish roots and expressed with a decorative meticulousness pushed almost to virtuosity, is to be found in the clothing decorated with arabesques and in the open lace on the figure of Venice, in the pillow with the doge's cap, and in the musculature of St. Mark. A memory of Attila's melodramatic gesture in one of Algardi's Roman works, the *Meeting between Pope Leo the Great and Attila* (St. Peter's), could have played a part in Le Court's personification of plague, but the possible influence is reworked in a style that has nothing to do with Roman inspiration. The affected naturalism of the figure borders on the grotesque: plague is shown as an old woman with a hollow face and skeletal arms fixed in a gesture that underlines the drama of the scene. She is paralleled in the painting of the time, in the most extreme methods of the Tenebrists or in certain aspects of the grotesque of Pietro Vecchia. As the focal point of the church interior, the group of altar sculptures is arranged on different levels and appears like a stage set, culminating in the divine yet most human apparition of the Virgin, to whom all the attention of those at prayer and in contemplation of Venice, of St. Mark, and of the Blessed Lorenzo Giustiniani, and of those laid low by plague, put to flight by the small angel, is turned.

Francesco Pianta

If the network of allusive and symbolic references and the obscure nature of some compositional features make the Pesaro monument in the Frari a classic example of Baroque subtlety, the theatrical element, congenial to the art of the century, finds its own form of expression in the altar of S. Maria della Salute. The looseness of form and dynamism that characterize the figures in their different poses appear strengthened through the cleverly varied play of the drapery with different chiaroscuro effects. The violence of Le Court's personification of plague, the notes of extreme realism in the works of Ongaro, and, in an often fantastic key, the large masks, dragons, and skeletons (mostly sculpted by unknown hands) that decorate the facades of Venetian churches, palaces, and other buildings are paralleled, as expressions of the diverse elements of Baroque, in the group of carved wooden altar frontals which decorate three walls of the *sala grande superiore* [upper hall] of the Scuola di S. Rocco, reflecting aspects of the most capricious imagination and the most exaggerated realism of the culture of the time.

This extraordinary assembly is linked to the name of Francesco Pianta, who signed himself "Franciscus Planta iunior venetus [Francesco Pianta the Younger of Venice] on the base of his portrait of Tintoretto.

He belonged to a Venetian family of stonecarvers, but the list of books left to his heirs documents a level of culture unusual for a stoneworker. They focus on the classics and include Cesare Ripa's *Iconologia*, a knowledge that seems implicit in the group of carved altar frontals, the conception of which and the execution, at least in part, is ascribable to him. The symbology of Ripa's text offered Pianta a precise point of reference and an inspirational point of departure, freely developed alongside other elements of his cultural baggage, for those figures in which conceits alternate with acute wit, and extreme realism (*Cicero*), or which border on caricature (portrait of Tintoretto, *Scandal and Scruple*), or blend with the grotesque (*Abundance*).

As with the Pesaro mausoleum, where the inscriptions carry the task of making the monument's message absolutely clear, so in this case Baroque density of meaning offers assistance in its decipherment through the writing on the long scroll that *Mercury* (on the right of the entrance to the room) holds out before him and through the words that accompany the individual sculptures. At the sides of an extraordinary *Library*—alone sufficient to demonstrate the artistic stature of Pianta, such is the effect of the skilful realistic illusion of those antique bound volumes—the blindfold and chained *Fury* with gnashing teeth, in the words of Mario Praz, "inspires in his torment a grim dark beauty," while the *Spy* is almost a caricature, enveloped in his ample cloak and with his hat pulled down and partly covering his eyes (see pp. 442, 443).

Pianta's work, unique on account of its themes and high quality, takes its place in the history of Venetian wood sculpture in which foreign artists are often prominent. It was a field in which, alongside artisans, even in the Settecento, artists dedicated equally to sculpture and stonecarving—specialists in the genre—increasingly made their mark.

Le Court in his Later Years

In 1674 Le Court moved to Padua to work on the basilica of S. Antonio and on S. Giustina; beginning in the same year, Ongaro was also active there. The last works of Le Court (1677–78) in Venice, where he died in 1679, continue to demonstrate his creative energy. It was in these final years that he sculpted the busts (paid for in 1677) of the Mora brothers (Bartolomeo, Francesco, and Alessandro) for their mausoleum, designed by Longhena, in the church of S. Lazzaro dei Mendicanti, the portrait of Giorgio Morosini (1677) showing him kneeling and deep in thought in the splendid monument to him in S. Clemente in Isola, and the bust of Giovanni Maria Gratarol, dated 1678, in S. Canciano. These sculptures

not only confirm Le Court's ability in portraiture which some realistic features in previous works had hinted at, but confirm that this genre, too, was finally "renewed."

Placed against the dark background of the wall, the busts of the three Mora brothers command attention. The portraits of Francesco and Alessandro possess a sense of emphatic vitality, delineated by the decisive motion of the turned heads. All three portraits are executed with ample plastic modeling and soft painterly effects in the arrangement of the drapery and in the contrasts between the different surfaces of the clothes, meticulously defined in their detail and material.

In the altar complex of S. Andrea della Zirada, which Le Court signed and dated 1678 as both sculptor and architect, he once again expresses, in line with the sensibility already shown in the altar of the Salute, the theatrical component of his language by staging a sort of religious play. Christ is depicted in ecstasy at the top of Mount Tabor while at the bottom Moses, Elijah, and the Apostles watch the Transfiguration, commenting on the event with well-orchestrated gestures and demonstrative expressions. In the open vault under the altar, the recumbent figure of the dead Christ echoes a Roman iconographic motif which, starting with the *St. Cecilia* by Stefano Maderno, enjoyed much success.

Falconi in his Later Years

Falconi left Venice in 1665 to go to Turin to work in the service of Carlo Emanuele II of Piedmont. He had already been there in 1664, but had never cut off his links with Venice and in the second half of the 1670s began working again in Venice. During one of his absences from Turin, presumably a little before 1674, he worked again on the Vernier Chapel in the church of the Scalzi, sculpting three octagonal bronze reliefs for the altar. Between the end of the 1670s and the start of the 1680s, he made two stone statues depicting St. Sebastian and St. Francis, placed in niches at the sides of the high altar in the church of the Ospedaletto, having possibly been solicited by Longhena who had directed work on the choir in 1676–77. In 1678, when Falconi was living in Padua, he agreed with the Procuratori de Supra to make in embossed copper the group of two atlases holding up the globe, with Fortune over them, on the point of the Dogana da Mar [customs house].

During his time in Piedmont, Falconi matured and refined his Algardian classicizing tendencies, already detectable in his earlier Venetian work. The excellent results are apparent in the three octagonal bronzes depicting episodes from the life of St. Sebastian (see p. 431), and in the statue of St. Sebastian in the

Mercury, Francesco Pianta, wooden altar frontal. Scuola Grande di S. Rocco, Sala Capitolare.

On the following pages:
Spy and *Fury*, Francesco Pianta, wooden altar frontal. Scuola Grande di S. Rocco, Sala Capitolare.

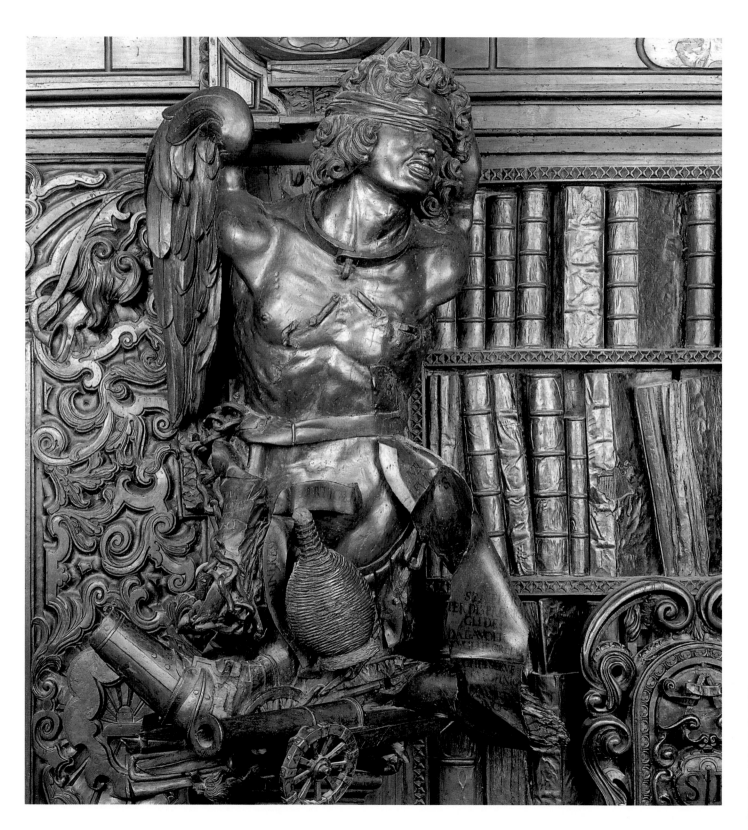

Ospedaletto. The bronzes reflect Falconi's qualities as a refined bronzemaker, the statue is a reworking, more relaxed and elegant in its modeling and more delicate in its pictorialism, of the *St. Sebastian* above the altar in the Vernier Chapel. Works like these and the above-mentioned *Hope* and *Charity* on the altar of St. Anthony in the Frari, which belong to the first phase of his activity in Venice, are Falconi's most important contribution to Venetian sculpture of the time. He helped keep alive classicist taste, which in the last decade of the century became an intrinsic element in Venetian sculpture, albeit secondary compared with the Baroque developments of Le Court.

In his work for the Dogana, Falconi's standards slip. Such a lapse is perhaps attributable to the limitations inherent in a certain type of commission, but it is also probably due to a lack of concentration, which brought him into conflict with his clients on at least two occasions. The monks of the monastery of SS. Giovanni e Paolo initiated a lawsuit against him over the statue on the high altar of the church, and the Procuratori de Supra ordered the removal of four other copper statues made for the Dogana and already *in situ*.

The 1680s

In 1680 Ongaro sculpted a St. John and a Virgin for S. Clemente in Isola and a St. John the Evangelist for S. Nicolò di Lido, works which reflect his enduring Lecourtian tendencies. In the work for S. Nicolò, under the direction of Alessandro Tremignon, two sculptors of the new generation found themselves working side by side: Heinrich Meyring, of German origin, officially resident in Venice in 1679, where presumably he had lived for some time and where he died in 1723, and Giovanni Comin of Treviso, documented as living and working in Venice from 1677 onward. They created three other statues of Evangelists (Meyring, *St. Mark* and *St. Luke*, and Comin, *St. Mark*), the style of which reveals that the influence of Le Court was the principal component in the artists' development. This is also evident in the sculptures made almost contemporaneously (1679–81) by Tremignon for the decoration of altars in S. Giustina in Padua, where in 1680–82 Falconi's activity in the Veneto also came to an end. The string of work by artists from cultural areas outside the Veneto—a constant feature of Venetian sculpture of the Seicento, and one that helped to shape it—was interrupted between the second half of the 1670s and the next decade not only by the appearance of Giovanni Comin, but also by that of the brothers Orazio and

Funeral monument of Cardinal Francesco
Morosini, Filippo Parodi, c. 1680. Church of
S. Nicolò da Tolentino.

limitations of their provincial training. For all, their Lecourtian apprenticeship was the means of their acquisition of a modern stylistic language. Although this is not well documented, it must have been a very close collaboration which provided their first Venetian commissions. Orazio's link with Le Court is evident in his signed *Virgin and Child* for the church of S. Alvise (the altar on the left-hand wall of the nave), which skilfully paraphrases the prototype of the master's altar in S. Maria della Salute. Meanwhile his brother Angelo demonstrates his full assimilation of Le Court's more solemn methods and the ample monumental plasticity, backed up by lively chiaroscuro play of drapery, in the signed statues representing two doctors of the Church, in S. Nicolò di Lido; these probably belong to a phase more or less contemporary with that of Meyring and Comin on the *Evangelists* for the same church.

Only a few other Venetian sculptures by Orazio Marinali are linked to commissions, and they fall chronologically in the new century. From 1681 his activities and those of his brother Angelo were centered on Vicenza. Their style took on more original characteristics, opening the chapter of Baroque sculpture, albeit late in the day. This happened most notably in Vicenza but also in other parts of the Veneto and in Friuli, as they extended the large area from which they drew commissions, in which they were joined by collaborators in their studios. The Marinali brothers, therefore, particularly Orazio, took on the important role of intermediaries in the spread of the Venetian Baroque.

Filippo Parodi and the Morosini Monument

In Venice, other artists continued to be a source of updating and inspiration, thanks to their innovative ideas and the high quality of their work. An exception to this with respect to the dominant Lecourtian manner can be seen, at the beginning of the 1680s, in the funerary monument of Cardinal Francesco Morosini in S. Nicolò da Tolentino. This prominent work is among those made by the Genoese sculptor Filippo Parodi, who arrived in Venice with vast experience from previous commissions in Rome and Genoa. The Morosini monument introduced to Venice an example of a clearly Berninian style, expressed with an exuberance and compositional emphasis without precedent in the city—even taking into account some Berninian features in the work of Le Court. From Bernini's equestrian monument of the Emperor Constantine (Rome, Vatican) derives the grandiose white drapery with gilded decorative motifs which, in their architectural context and in the restricted space available, work as a felicitous expedient to increase the vertical thrust illusionistically.

Angelo Marinali. These artists share a common background in the Veneto, hailing from Treviso and Vicenza respectively, and their training can be traced back to a family workshop. Comin possibly spent time in Rome, and the results of his inspiration by Bernini and Duquesnoy can be seen in his Paduan sculpture (1679–80). As has already been indicated, Comin immersed himself fully in the Lecourtian current and continued to work in Venice. For the Marinali brothers, by contrast, Venice was a source of stylistic maturity which allowed them to engage with their own period and helped them overcome the

The composition unravels with a free and lively rhythm against the luminous background of the drapery, from the figure of Fame on the left, whose drapery, like that of the other figures, is sculpted with a skill that is also the result of Parodi's experience in the field of stonecarving (to which he dedicated himself from the beginning), and extends up to the angels, captured in graceful movements. The deceased, half rising above the urn, is shown at prayer. Below him writhes Time, in chains. Fame and Charity rise up at the sides of the pyramidal composition. In the words of Fagiolo dell'Arco, "the allegory gives itself over to the flow of drapery and the undulating clothing which signals the passage between life and death," and expresses, judging from the sweetness emanating from the smiles of *Fame* and *Charity*, their victory over Time. This work, particularly intense in the characterization of *Time* and in the high standard of composition (despite some weak points which have raised the question of another hand at work on *Fame* and *Charity*), thus constitutes in Venice another important testimony to the fact that the city's culture had become completely attuned to Baroque taste, and was receptive even to its most theatrical features.

The Facade of San Moisè

That Venetian sculpture had been brought fully up to date is also apparent in the significant detail, compared with the past, in some building and church facade ornamentation. In order to define the state of Venetian sculpture in the early 1680s, to the above-mentioned Pesaro and Ospedaletto sculptural ensembles must be added decorative enterprises that are significant for their role in shaping the face of the city. They are less important as far as the artists are concerned, whose identification is still not easy. The sculpture in question is the imposing assembly of sculptures on the facades of S. Moisè and S. Maria del Giglio, both usually generically linked by critics to the first Venetian period of Meyring although his characteristic style is clearly recognizable in only a few statues. As for the others, considering their precarious state of conservation and the absence of archival material, further research must be carried out.

The facade of S. Moisè was erected according to a design by Alessandro Tremignon and decorated at the expense of Girolamo Fini, who had already given a contribution for the construction of the church and, in 1668, had obtained permission from the chapter to embellish the facade, reserved for him and his heirs, in honor of God and in memory of his brother Vincenzo, procurator of S. Marco. At the time of Domenico Marinelli's *Ritratto di Venezia* [Portrait of Venice], published in Venice in 1684,

which mentions it, the facade appears to have been almost finished. The bust of Vincenzo in the center is flanked by those of two other family members, whose virtue is alluded to in several other allegories, and a group of saints decorates the upper part of the facade. Its typology falls within the tradition of benefactor portraits, but it also responds to the specific aim of family glorification, which accordingly brings the facade closer to those grandiose sepulchral monuments that sometimes cover an entire wall. The Pesaro monument comes to mind, as does the monument to Tommaso Luigi Mocenigo, erected in

Battle of Paros, detail of a relief on the funerary monument of Admiral Tommaso Luigi Mocenigo. Church of S. Lazzaro dei Mendicanti. The monument, which was designed by the architect Giuseppe Sardi and decorated with sculpture by Juste Le Court and others (1658–64), exalts the virtues of Mocenigo, a hero of the war of Crete fought against the Turks between 1648 and 1651.

The Eternal Father Handing Over the Tablets of the Law to Moses on Mount Sinai, Heinrich Meyring, c. 1684. Church of S. Moisè, high altar.

1658–64 by Giuseppe Sardi in S. Lazzaro dei Mendicanti and made up of two sides, one looking onto the vestibule and the other down the nave (see p. 445).

Even more than the purely exuberant decoration of the facade of the Ospedaletto, the facade of S. Moisè is a turning-point on account of its inversion of the value of architecture and sculpture. Sculpture is no longer subordinate to architecture, but integrated into it in a free relationship in which the surfaces take on new chiaroscuro vibrations, thanks to the lively play of the reliefs. In the execution of the decorative ensemble, Meyring's involvement seems plausible, given the relationship which linked him to Tremignon from the very beginning of his artistic activity.

The Barbaro Monument, the Mocenigo Monument, and the High Altar of San Moisè

At the beginning of the 1680s, the facade of S. Maria del Giglio, brought to completion by Giuseppe Sardi, represents the Baroque version of the sixteenth-century tradition of facades erected in honor of *condottieri*, to the extent of becoming an apotheosis not only of the subject but also of his family. The client, Antonio Barbaro, in his will dated 1678, left money and precise instructions to be followed by the artists who sculpted his and other statues on his funerary monument: he was to be shown as an admiral, standing on an urn, in the center of the facade itself, while the representations of his brothers were to be part of an allegorical group with reliefs showing city maps and naval battles.

The statue of Antonio Barbaro is closely linked to Le Court's statue of Caterina Cornaro on her tomb in the basilica of S. Antonio in Padua. If the statue of Barbaro was made before his death, it could even be one of the last works of Le Court, albeit helped by a collaborator in the architectural backdrop to the

sculptor of the reliefs of naval scenes and maps of the city, it should be emphasized that these two motifs, which call attention to the heroic past adventures of the deceased, though common to the funerary sculptural tradition of Venice in the Cinquecento, in this case, assume a more important role. There are twelve panels on plinths in the first and second registers of the facade in comparison with, for example, just two reliefs under the busts of Tommaso and Francesco Morosini (c. 1654) on the facade of S. Clemente in Isola, and only four reliefs on the upper part of the front of the above-mentioned Mocenigo monument in S. Lorenzo dei Mendicanti (all anonymous).

On the inner side of the Mocenigo monument, the *Battle of Paros* (won by Mocenigo in 1651) (see p. 445) stretches over the entire right-hand wall, matching the *Turkish Attack on the Ramparts of Crete* (defended in 1648 by Mocenigo) of the left. Even today we are still unable to confirm, either from other works or other sources, the name of Giuseppe Belloni to whom Martinelli attributes the execution of the reliefs. The reliefs have a unique place in the history of Venetian sculpture of the Seicento, reflec-

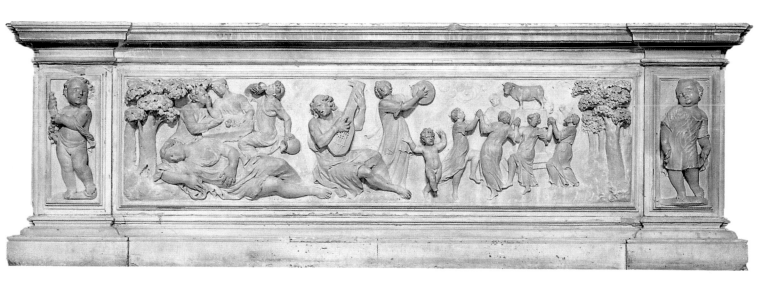

statue itself, reproducing—somewhat halfheartedly—the Berninian motif of drapery held up by angels on the monument of Giorgio Morosini in S. Clemente in Isola.

In the absence of documentary evidence, and given the present state of research into Venetian sculpture of the Seicento, it is difficult to advance precise theories for the rest of the decoration, all of which varies greatly in quality and some of which recalls the style of Meyring. Even though we do not know the

ting a taste for lively narration that is related in meticulous detail in the foreground and fades into the crowded background to suggest illusionistically spatial depth. The mere allusive suggestion which in the mausoleum evokes the glorious deeds of the captains has taken on, in the episodes that recall the exploits of Mocenigo has the flavor of historical documentation. The question remains open whether Alvise and Piero, the nephews of the deceased, who were in charge of the erection of the monument, gave

Adoration of the Golden Calf, Heinrich Meyring. Church of S. Moisè, high altar front.

any weight in their choice of battle scenes to the general interest in the war genre apparent in Venetian art, especially by Northern painters whose works were in Venetian collections.

The documented friendship between Meyring and the painter Johann Carl Loth may account for certain affinities between some of Meyring's sculpture and the work of the Tenebrists; knowledge of the figurative world of the painter seems to have fired Meyring's imagination. This can be seen, for

Jews who after raising the golden calf onto the altar give themselves over to joyous abandon (see p. 447). The *Eternal Father* seems to refer back to Loth's altarpiece in S. Silvestro (*Holy Family and the Eternal Father*, 1681); also similar in type are the faces of Aaron and of the figure behind him. A certain kinship with Loth's figures is revealed in the half-naked Jew in the foreground whose face is characterized by crude realism and whose body is overly muscular, and in the woman in front of him, similarly

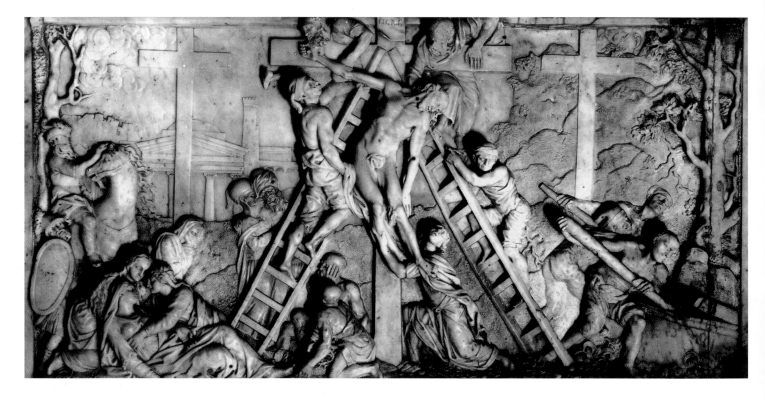

Deposition, Tommaso Rues. Church of the Redentore, high altar.

example, in the sculptural ensemble of the high altar in the church of S. Moisè (c. 1684) which, even following in the wake of the Lecourtian altar of S. Andrea della Zirada, reveals the more typical idioms of Meyring's language. The idea of dividing the composition, centred on the mountain, into stage scenes derives from Le Court's altar. Here statues are grouped from the summit down its slopes to the bottom in order to suggest a narrative flow that articulates the sequence of the biblical story. The Eternal Father, surrounded by angels, hands over to Moses the tablets of the Law on Mount Sinai (see p. 446) while in Moses' absence, following the instructions of Aaron, three figures prepare the jewelry that will be used for the golden calf. The story is concluded in the relief on the altar frontal with the episode of the

vigorous but with her delicately featured face turned pleadingly to the sky. While the female figure in the foreground on the right, making up the pair with Aaron, reveals a close link with statues by Le Court—in particular, the allegory of *Generosity* made, together with *Prudence*, in a second phase of work for the Cavazza monument in the church of the Madonna dell'Orto—the impressed accent on the relief appears unique, one of the most evocative of the artist's creations. In it his style appears with freshness and brio in the lively narrative nuclei into which the scene is divided. Meyring's Northern training leads him to emphasize landscape and realistic details in a pleasing and descriptive manner. Details of a calm sweetness (the woman asleep in the foreground, the figures intent on playing their instru-

Portrait of Francesco Morosini as an Admiral, Filippo Parodi. Palazzo Ducale, Armory. The work was commissioned by the Senate on 23 December 1687.

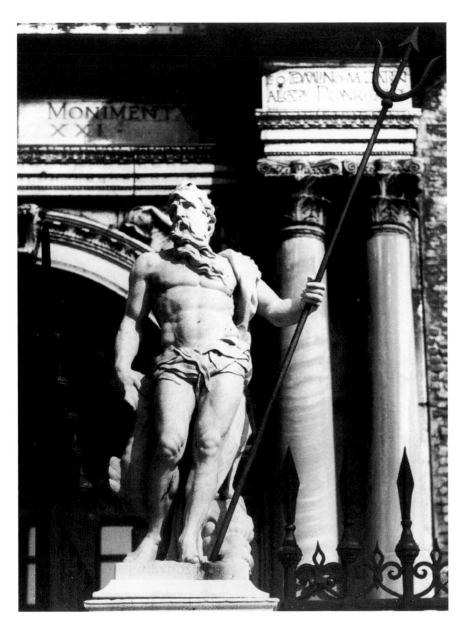

Neptune, Giovanni Comin, 1692, signed.
Arsenal, entrance campo.

OPPOSITE:
Holy Family, Heinrich Meyring. Church of
the Scalzi, Manin Chapel.

garzone [apprentice] for eight years in the studio of
Giovanni Hach, a sculptor and stonecarver from
Bamberg who was in Venice after around 1627. Rues
owes the Northern strand of his training, apparent in
works from the 1670s, which also show strong
Lecourtian influence, to the long period spent work-
ing with this German master, whose oeuvre is still
unknown. It is the Northern element of his idiom
that surfaces in the above-mentioned reliefs and
represents the most original part of his production.
The Redentore reliefs demonstrate the high quality
and expressive intensity of his work: the frontal of
the high altar with the *Road to Calvary*, begun by
another artist, and, on the other side of the same
altar, the *Deposition* (see p. 448). Particularly in the
latter, the dramatic subject is rendered with realistic
elements, at times with a tense expressionism. The
narrative intensity relies on a compositional scheme
that is well articulated in its sequence of movements
and chiaro-scuro effects. The three reliefs depicting
supper in Emmaus, the Last Supper, and Christ at the
home of Simon the Pharisee on the parapet of the
high altar of S. Cassiano, although qualitatively more
modest, reflect the same ability to render episodes
with narrative vitality. Here the artist makes use of
observed daily realities, transforming them into the
details of his art.

Giovanni Comin falls between Meyring and Rues
as a sculptor of altar frontals. In the signed altar
frontal with *Purgatory* (1684–85), originally in the
chapel of S. Maria della Pace annexed to the church
of SS. Giovanni e Paolo and now in the parish church
of Barcola near Trieste, Comin expresses himself in a
relaxed narrative manner resembling that of Meyring
in its elegant cadences and subtleties. Later, in 1694,
on the altar frontal in the chapel of the Monte di
Pietà in Udine depicting the meeting of Christ with
St. Veronica, he also seems to have taken on board
the dramatic intensity of Rues.

The Last Decade

During the seventeenth century, funerary or commem-
orative marble busts of distinguished persons were
produced continuously. Such portraits were included,
as has been seen, in grandiose monuments or formed
part of more modest privately commissioned memo-
rials. Le Court, as has been noted above, having
proved his versatility in different idioms, was also
involved in this field. In 1687–88 the genre was enri-
ched with an example in bronze by Filippo Parodi of
Francesco Morosini as admiral, still kept in a room in
the Armory in the Palazzo Ducale (see p. 449). It
stands on a marble pedestal, also by Parodi, with

ments and on singing) are linked to his tendency to
lend an emotional intonation to faces and postures.
An atmosphere of jollity completes the scene on the
right.

Tommaso Rues and Giovanni Comin
Meyring's narratives can be compared with scenes in
the contemporary reliefs sculpted by Tommaso Rues
for the churches of the Redentore (1682) and of S.
Cassiano (1684). Rues, who was born in Bressanone,
moved to Venice around 1650, where he worked as a

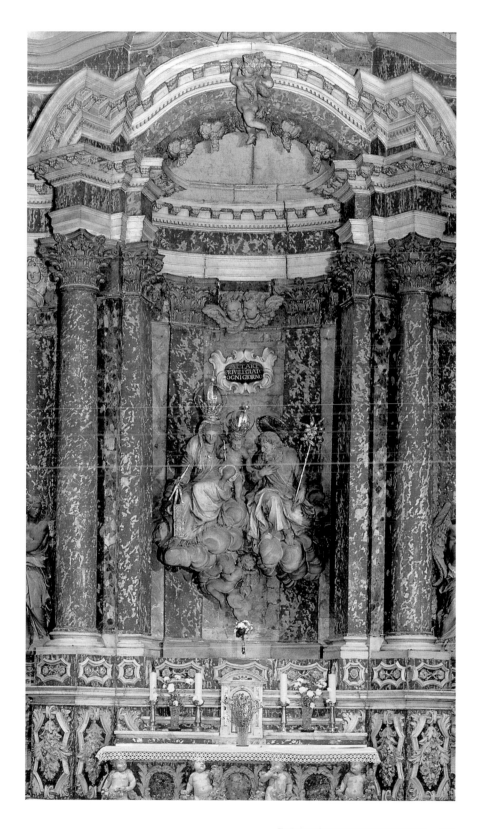

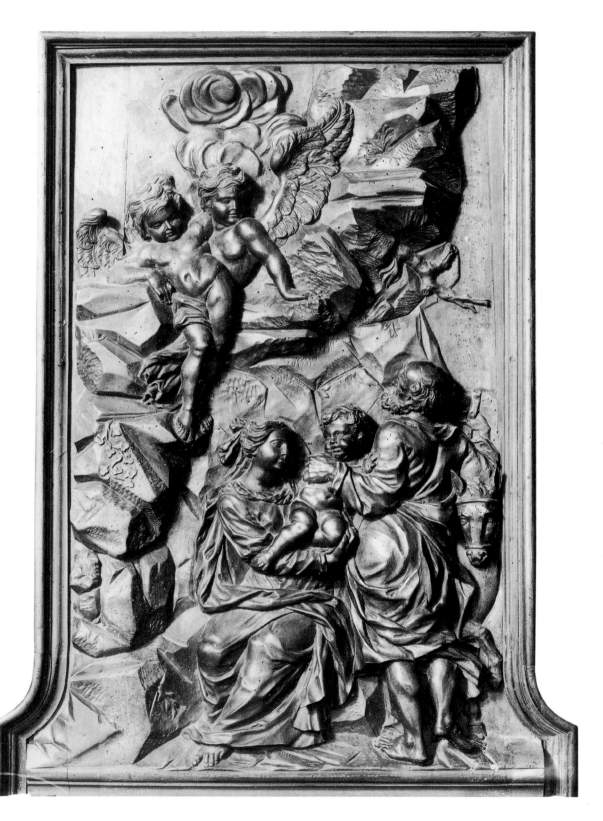

Flight into Egypt, Giacomo Piazzetta. Church of SS. Giovanni e Paolo. One of eight wooden altar frontals carved for the Rosary Chapel.

PREVIOUS PAGES: Wooden decoration with biblical reliefs and telamons, Giacomo Piazzetta. Church of SS. Giovanni e Paolo, Rosary Chapel, right wall.

trophies and artifacts of war and an inscription which records that the portrait had been commissioned by the Senate while Morosini was still alive to express the public gratitude for his victories over the Turks. Parodi was in Padua at the time, where he worked from 1685 to 1691 and where in the works made for the basilica of S. Antonio he left an example destined to be fruitful for the Veneto. The bust of Morosini, however, reveals his abilities in bronze sculpture. In adopting the State commemorative type common to contemporary portraiture—whether sculpted or painted—Parodi succeeded in finding a particularly felicitous compositional solution in the connection between the bronze of the bust and the marble of the pedestal and the lively interplay of light and shade.

In its tendency to accentuate realistic characteristics and pay attention to detail, Meyring's sculpture is closely linked to Le Court's portraiture. This relationship can be seen in the bust of Ottone Guglielmo, count of Königsmark, known for his campaign in Morea. The piece was sculpted in 1689–90 for the funerary monument placed at the Arsenal. It is also evident in Meyring's signed bust of Johann Carl Loth (1699) which, after the death of the Bavarian painter in 1698, demonstrated the closeness of their friendship. At the Arsenal, a site dedicated to public celebration and where, particularly in the years of Doge Francesco Morosini (1688–94), it was decided to launch a series of architectural and decorative projects, Meyring and Comin sculpted three allegorical statues. The first was *Justice*, signed, and comparable to their most elegant female figures, and next *Neptune* and *Mars*, also signed, and placed on the campo at the entrance (1692) (see p. 450). These last two statues were by Comin and clearly recall the prototypes by Sansovino that flank the Scala dei Giganti in the Palazzo Ducale. Here they acquire a special meaning within the allegorical and celebratory context linked to the myth of Venice. The Baroque interpretation is present especially in *Neptune*, where the sixteenth-century model appears to be revisited with Lecourtian expressiveness.

Meyring was without doubt the most prestigious artistic figure by the end of the decade, on account of both the many commissions that continued to come to him and the importance of his example to the younger generation of sculptors. Among his later work, the melancholy Virgins are noteworthy, in particular the *Virgin Annunciate* placed together with the *Angel of the Annunciation* on the high altar of the church of S. Maria del Giglio, whose face, like that of the Virgin in the *Pietà* in the chapel of the Monte di Pietà in Udine, recalls the work of Antonio Zanchi, confirming Meyring's interest in the language of some of the painters of his day.

The *Holy Family* in the church of the Scalzi also calls to mind inventive Zanchi-inspired formulations while it also refers back to Meyring's milder and, as has already been mentioned, touching, expression in the Virgin and Child sculptures and the plump little angels inspired by Le Court. The group is sculpted in a more measured and elegant manner, less common in other works of his late period, with soft effects in the chiaroscuro passages, skilful rendering of detail, and, in some cases, light use of the drill. This turn-of-the-century work (based on the similarity between *St. Joseph* in this group and the *St. Peter* in SS. Apostoli, paid for in 1701) could constitute the premise for a language lighter in form and expression, foreshadowing a change in the Settecento, which Meyring, by this time old and aided by the studio, did not succeed in making. Meyring's influence can be seen in artists of the new generation such as Alvise Tagliapietra and Giuseppe Torretti.

The works too of Giacomo Piazzetta, an excellent sculptor in wood and stone, reflect at the end of the century a manner that has features in common with those of Meyring, by whom he was influenced, as can be seen in the marble group *St. Romuald and Two Angels*, in S. Michele in Isola (c. 1698). There is also the inspiration he derived from contemporary painting: allusions to the world of the Tenebrists, with idioms falling somewhere between Loth and Langetti, can be seen in the ponderous *Telamons*, whose obvious musculature produces an image of slightly threatening solemnity, in the Rosary Chapel of SS. Giovanni e Paolo.

The *Flight into Egypt*, one of eight wooden altar frontals sculpted for the same chapel, shows a compositional development in which accents of naturalism sit alongside more elegant notes and rhythms with formal and narrative cadences that suggest the style of Antonio Molinari (see p. 454). Piazzetta and Molinari must have known each other, given that Piazzetta's son, Giambattista, had already started his apprenticeship with Molinari around 1695, a significant occurrence for an artist on the threshold of the new century.

The sculptural decoration of both the exterior and the interior of S. Maria della Salute, finished in 1687, left little room for eighteenth-century additions. For seventeenth-century artistic culture, the vastly ambitious project represents the Venetian alternative to the great Roman works in which, in the words of Fagiolo dell'Arco, "the statue ... becomes choral group and representation" and "the external sculptures of the churches ... speak among themselves." It is this very "choral" nature that imbues the statues of the Salute with their appealing strength, so much so that one hardly notices the uneven quality of the pieces made by different hands.

Paola Rossi

Telamon, Giacomo Piazzetta, detail of the wooden decoration. Church of SS. Giovanni e Paolo, Rosary Chapel.

Venetian Painting in the Late Sixteenth and Early Seventeenth Centuries

Caught between the century of "genius" and the century of "glory," to quote from the titles of two famous London exhibitions of Venetian art, this period began inauspiciously: the death knells of the great interpreters of the sixteenth century, first for the tutelary deity, Titian, followed by those for Veronese, Bassano, and Tintoretto, were echoed at regular intervals between 1576 and 1594 by a series of grim events which directly or indirectly influenced art and darkened Venetian horizons. There were two fires in the Palazzo Ducale, in 1574 and 1577, which

Rape of Lucretia, Jacopo Palma the Younger. Kassel, Gemäldegalerie. The artist pays homage to Titian through the theme of violence unleashed by the senses.

destroyed the paintings of a century in only a few hours; there was a ferocious outbreak of plague in 1575–77 which drove the decimated populace to beg for divine mercy with prayers which were publicly visualized in votive paintings and edifices and in the widespread dedication of redemptive altar paintings and sculptures to miracle-working saints. Although the victory of Lepanto in the war against the Turks in the eastern Mediterranean depleted the Republic's economic resources, it nevertheless was turned into a reason for the celebration of Venice's history and heroes, a determined reaffirmation in the face of growing political isolation.

The desire of the great sixteenth-century masters to keep artistic dominance within their own families and their failure to appreciate that what they had created was unique—the fruit of their own experience and intimate meditation—discouraged innovation. After the death of Orazio Vecellio, Titian's favorite child but a painter of inescapable mediocrity, his brother Pomponio sold the paternal residence and all it contained to Cristoforo Barbarigo in 1581. The studios of Veronese, Tintoretto, and Bassano continued well into the seventeenth century to produce works which reveal, on the whole, incapacity for independent thinking on the part of heirs who were merely inexorably wearing out paternal teachings. In this context the *Pietà*, unfinished on Titian's death, is typical: in the absence of true followers (the style of Titian's later works is not seen until many years later in the audacity of the late works of Velasquez and Rembrandt), and given the dominant influence of Titian's style on up-and-coming painters, it was easy for Jacopo Palma the Younger, who at fifteen years of age had worked on the *Martyrdom of St. Lawrence* in the church of the Crociferi, on his return from Rome to take over the role of "heir," cleverly inventing an entirely false apprenticeship with Titian. His future fame was guaranteed by the unsuspecting Marco Boschini who, in 1674, in his *Breve istruzione* [Brief instruction], the preface to *Ricche Minere* [Rich mines], furnished an incisive and accurate description of Titian's late technique, and passed on to history "the fortune [of Jacopo] having enjoyed the erudite teachings" of Titian. The truth is that Palma's intervention in the *Pietà* is limited to the torchbearing angel, and in any case was executed in deference to Titian's artistic "last will and testament," as is demonstrated by the younger artist's addition of *reverenter* [with reverence] next to his name at the bottom of the canvas. Titian's youthful works, the *Bacchanals*, became the inspiration thirty years later for the anti-Mannerist, and therefore anti-Palma, movement led by the artist whom Boschini named as Titian's last pupil, Padovanino.

Palma the Younger and the Pictorial Cycles of the Palazzo Ducale

On completion of the *Pietà*, around 1581, Palma was the rising star of painting, under the protection of the sculptor Alessandro Vittoria since his return to his native city after eight years in central Italy, first in Pesaro or Urbino, and then in Rome, from 1568. During this period Palma had absorbed both the trend toward naturalism which had grown out of

Venice Crowned by Victory Gathers the Subject Provinces, Jacopo Palma the Younger, 1578. Palazzo Ducale, ceiling of the Sala del Maggior Consiglio. The work is characterized by a complex scenography constructed through the use of spectacular perspective and foreshortening.

Reconquest of Padua by Andrea Gritti,
Jacopo Palma the Younger, 1578. Palazzo
Ducale, ceiling of the Sala del Maggior
Consiglio. The painting forms part of a cycle
aimed at illustrating "the most outstanding
Victories of the Most Serene Republic,"
according to the program begun after the fire
of 1577.

Mannerist culture and a more modern necessity for
communication, in a compromise between the stylistic
demands of Mannerism and the conditions imposed
by the Counter-Reformation.

It is precisely in that secular treasure house of
Venetian art, which the Palazzo Ducale was destined
to house almost permanently (given the damage
caused by climate and by repeated fires), that Palma
had the opportunity to establish himself publicly as
the most promising young artist in Venice when on
the ceiling of the Sala del Maggior Consiglio he
executed the central oval *Venice Crowned by Victory
Gathers the Subject Provinces* (see p. 457), a spectac-
ular example of perspective and compositional illu-
sionism with its dynamic and foreshortened forms, as
well as the two side panels, the *Victory of Francesco*

Bembo over the Fleet of Filippo Maria Visconti (see
p. 459) and the *Reconquest of Padua by Andrea Gritti.*

After the fire of 1577, with its destruction of
works by Carpaccio, Bellini, Titian, Tintoretto,
Pordenone, and Veronese, the Republic, with great
diligence, proceeded simultaneously with the restora-
tion of the building and the planning of the new
decoration which, according to the prevailing theo-
rists, Jacopo Marcello, Jacopo Contarini, and
Gerolamo Bardi, would "demonstrate to the world
that from the city's birth until present times this
Republic has been made glorious both by victories
and by the illustrious acts of her citizens." In Venice
painting's most noble function had always been
considered to be the representation of history and,
like the fifteenth-century narrative cycles in the

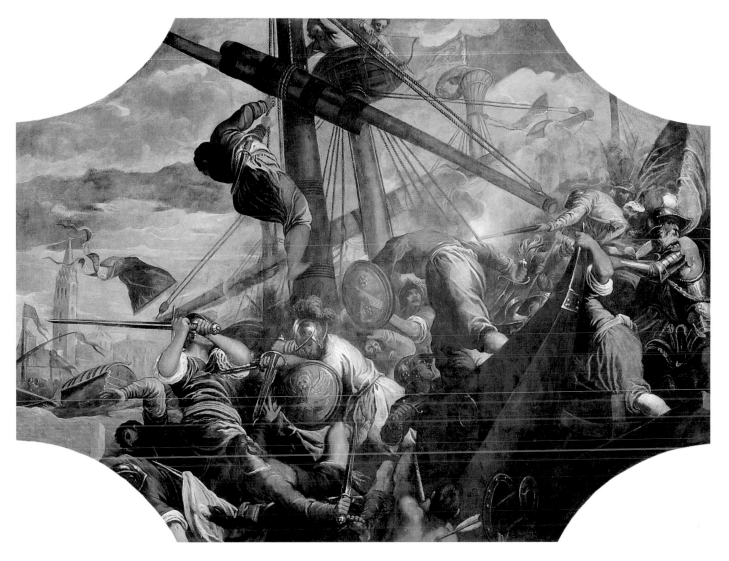

scuole, the paintings in the Palazzo Ducale were perceived above all as attesting to Venetian glory, and were thus carefully chosen by the public commissioners:. In the new decoration of the late sixteenth century, both in historical cycles and in allegories, the political situation is clearly evident. The renewal of these decorations provided an opportunity for contemporary artistic culture to celebrate the Republic's venerable political and military deeds, giving painters the task of glorifying the government's political ambitions for Venice. If the painters were given only general recommendations as to how the chosen episodes were to be narrated, their instructions regarding the message that all these images had to convincingly convey were precise and coherent. Venice's aim in fighting is not war, but the

achievement of peace, in defense of herself, her dominions, and her faith. The reaffirmation in 1578 of this general principle, that peace is the supreme goal of all governments, was an explicit response to the accusations of treason which most of Europe had made after Venice signed a separate peace with the Turks.

All this is summed up on the walls, on the ceiling, and in the *Paradise* on the east wall of the Sala del Maggior Consiglio and in the *Last Judgment* in the Sala dello Scrutinio [voting chamber]. The Republic's constitution thus acquires theological significance under the special protection of heaven, in full accord with divine will.

The battle scenes and allegories on the ceiling, commissioned by the spring of 1578, and the

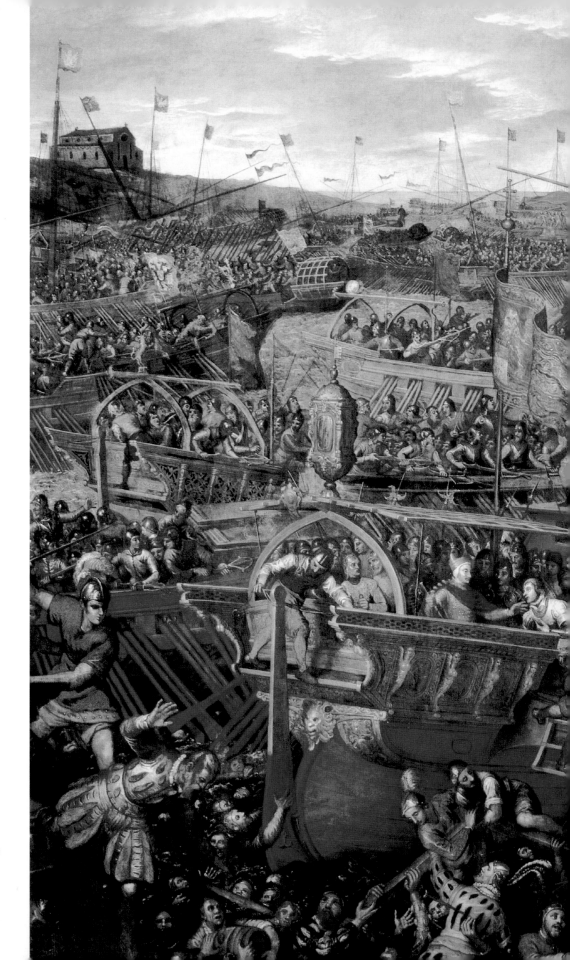

Battle of Salvore, Domenico Tintoretto,
1580s. Palazzo Ducale, Sala del Maggior
Consiglio. The canvas belongs to a cycle on
the walls illustrating the conflict between
Emperor Frederick Barbarossa and Pope
Alexander III.

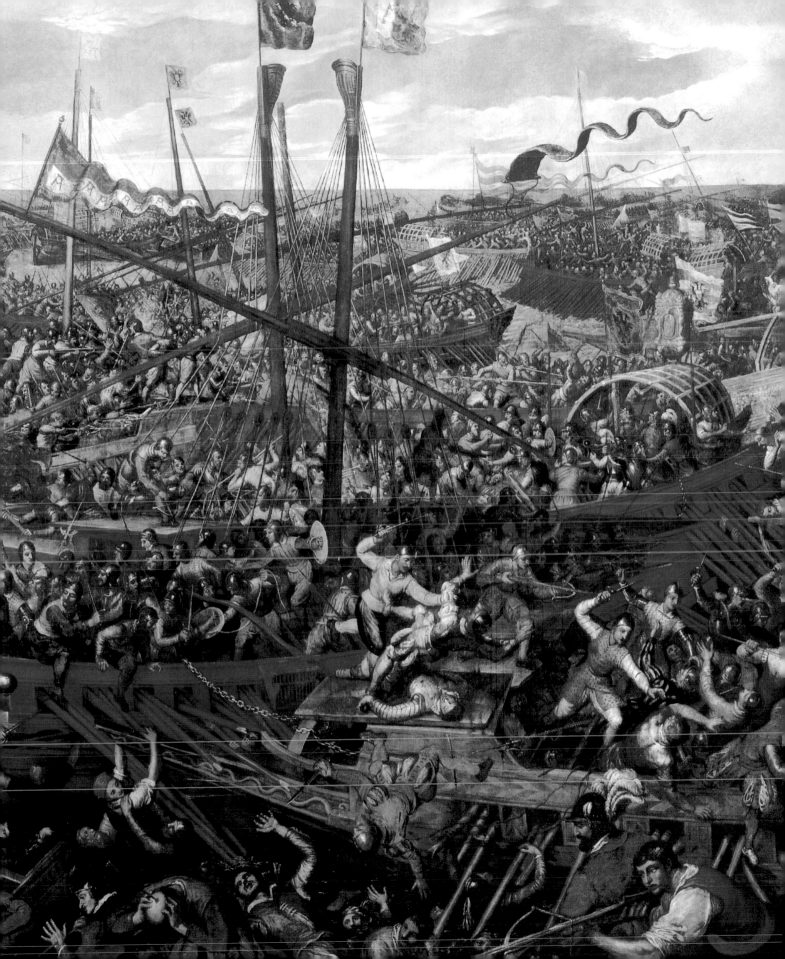

ceremonies and military scenes on land and at sea on the walls of the Sala del Maggior Consiglio and the Sala dello Scrutinio, not completed until the early seventeenth century, provided the opportunity for many of the new generation to make a name for themselves. This generation, born in the mid-sixteenth century, includes Francesco and Leandro Bassano, Carlo and Gabriele Caliari, Paolo Fiammingo, Domenico Tintoretto, Andrea Vicentino, and Aliense. They produced paintings recounting the popular subject of the "Peace of Venice" between Frederick Barbarossa and Pope Alexander III achieved by Doge Sebastiano Ziani, and the deeds of the Fourth Crusade (see p. 460).

Working on the scaffolding in the Palazzo Ducale toward the end of the century therefore were the sons

toward the foreground with the highly individualistic portrait of a dog, so different from the mysterious and lyrical scenes in contemporary works in the nearby *scuola*, contain nonetheless original construction and conception which later achieves mature evolution in works in which Fiammingo tackles pure landscape, freeing himself in the final phase of his career from the pretext of sacred or secular themes. By contrast, in *Doge Ziani Receiving the Benediction of Pope Alexander III* (see p. 463), in the public context of the Sala del Maggior Consiglio, Fiammingo appears to be adapting himself willingly to the uniformity of Tintoretto's influence, from whose formulas he was able, like many others, to extract those elements which almost automatically amplified the rhetorical discourse to be depicted. It

St. Roch in Solitude Comforted by an Angel, detail, Jacopo Tintoretto and Paolo Fiammingo, 1580. Church of S. Rocco. An example of collaboration with an artist from northern Europe who was working in Tintoretto's studio and responsible for the landscape with the highly individualistic portrait of a dog.

or the most trusted pupils of the older masters, with rare exceptions such as Paolo Fiammingo from Antwerp, one of the many foreigners who arrived in Venice during the second half of the century, with a serious reputation as a landscape specialist, a field still perceived as the dominion of the northerners. Around 1580, he had been entrusted with a large area of a canvas by Jacopo Tintoretto in the church of S. Rocco. In the *St. Roch in Solitude Comforted by the Angel,* the clearly and tenderly painted background of the hut with its typical sloping roof and the little bridge over the river flowing tranquilly

was not that in Venice individual forms were inviolable—in fact, they were constantly renewed—but when it came to the standard events in the city's history, what the Venetians said went. Thus, presented with a large-scale task to be completed rapidly, and responding to Venetian commemorative and triumphal requirements, artists of the new generation chose the easier approach of tried and tested formulas and structures rather than experimenting with something new. The crucial responsibility for maintaining a homogeneous idiom on the walls of the Sala del Maggior Consiglio and the Sala dello

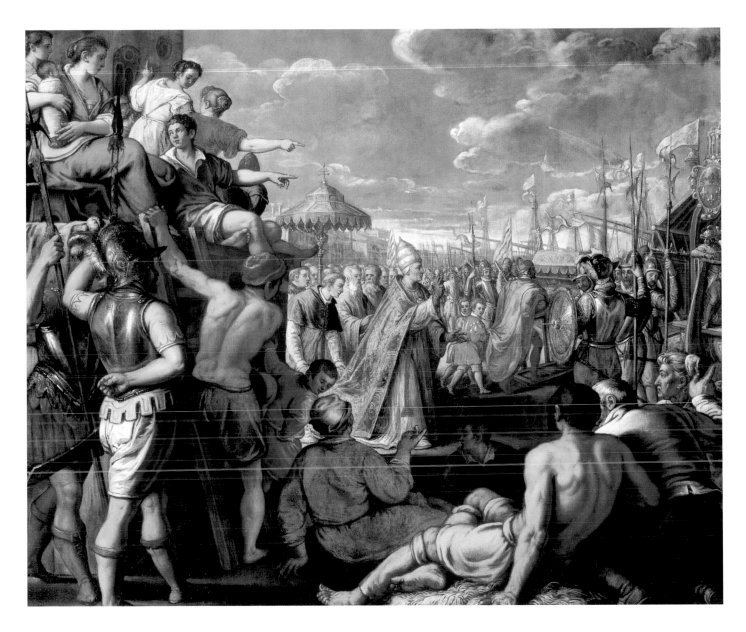

Scrutinio went to Jacopo Tintoretto, not only on account of the numerous paintings with which his workshop was entrusted, but also, indirectly, because he established himself as an example to be followed. The Palazzo Ducale became a great academy of painting, without statutes, but no less binding, an academy of representational and didactic painting in which places and characters, both ancient and contemporary, had to be emphasized in order to be easily recognizable as witnesses to the truth of the events narrated. Federico Zuccaro, from central Italy, during this same period appears to be incorpo-

rating elements from Tintoretto into his painting *Frederick Barbarossa Submitting to the Pope* (1582), represented in front of the basilica of S. Marco. Zuccaro modified these elements, referring back to the venerated model of Raphael, as if offering the Venetians a lesson in compositional ingenuity, with a strong hint of anti-Tintoretto controversy. Zuccaro's painting contrasts with the work of the artist which in all Venice most closely resembled his own. In 1583, Palma the Younger's painting *Pope Alexander III and Doge Sebastiano Ziani Concede to Otto Permission to Negotiate Peace with Frederick*

Doge Ziani Receiving the Benediction of Pope Alexander III, Paolo Fiammingo, 1580s. Palazzo Ducale, Sala del Maggior Consiglio.

Pasquale Cicogna Attending Mass, detail,
Jacopo Palma the Younger, 1586-87.
Ospedaletto dei Crociferi, oratory. The future
doge received notice of his election while
attending mass here. The poetry of daily life,
portrayed by the elderly women receiving
mass and the bunches of flowers on the altar
front, renders this decorative cycle unique.

Barbarossa was inserted next to Zuccaro's painting of the subject. In it, Palma creates perfect continuity in the architectural structure, setting the backdrop to his work directly opposite Zuccaro's, under an imaginary Loggetta but within a faithful representation of Piazza S. Marco. He employed similar large-scale figures in the foreground to communicate the atmosphere of the historic encounter.

The same date marks the beginning of the extraordinary period of Palma's decoration of the Ospedaletto dei Crociferi which was to occupy him for a decade (1583–92). The project was commissioned by Priamo Balbi, warden of the hospice for poor women, under the jurisdiction of the procurators of S. Marco de Citra who administered the legacy of Doge Renier Zen. In a period convulsed by famine and by the spread of old and new diseases, charity apart from that prescribed by officialdom multiplied in Venice. The *scuole grandi* took care of respectable and pious poor, while these new organizations attended to the outcasts, incurables, prostitutes, and the "unrespectable" poor.

On the edge of the city, opposite the church of the Crociferi in which Titian's *Martyrdom of St. Lawrence* dominated one altar and Tintoretto's explosive *Assumption of the Virgin* another, like spirits guarding the young artist who owed them so much, Palma launched his challenge, demonstrating clearly and immediately in the first canvases his stand against the late Mannerist climate, which was particularly diffuse in the language of the new decoration of the Palazzo Ducale, on which—one of the paradoxes of the time—Palma himself was collaborating.

The Crociferi decoration, the celebration of a Venetian benefactor and protector of the poor, the doge Renier Zen, and of a procurator of S. Marco, Pasquale Cicogna, who received the news of his election as doge while attending mass in the church of the Crociferi, unites religious themes connected to the oratory's role as hospice chapel with recent events. It is the recounting of an individual story, that of Cicogna, and, at the same time, that of a group that today would be defined as outcast. In the three works recounting episodes from the life of Doge Pasquale Cicogna, the then patron, the presence of the "poor women ... who seem alive" in the painting dedicated to the hospice's first patron, Cardinal Zen, become "various women ... represented naturally," as noted by a perceptive Carlo Ridolfi in 1648 (see pp. 464, 465). The work's domesticity, its frugality and humility, and the poetry of daily life—the old women receiving the host, their faces framed by black and white shawls, the bunches of flowers overflowing from Murano glass vases on the altar make this cycle unique in late sixteenth-

century Venice. The struggle to portray things more objectively and to simplify compositional structure in order to create a new and more intimate relationship with the spectator, including the presence in the paintings of one or more witnessing figures who focus attention, becomes in Palma's public work a recurring theme. It is paralleled, partly because of the pressure of the decrees of the Council of Trent, in Bologna by the Carracci, and, even more so, in Florence by the so-called reformist painters, from Santi di Tito to Passignano, in whom the tangible

immediacy which they infuse into certain paintings reveals a conversion from a Mannerist philosophy to naturalistic ideals. But never, for the reformers or for Palma, was it a question of choosing between late Mannerism and naturalism.

Palma the Younger is an artist who was extremely sensitive to the problem of communication in general and of a painting's location in particular. From time to time he uses the formulas which he believes most suitable for both the painting's subject and its intended position in order to render his vision plausible and to arouse the attention of the faithful with

Doge Renier Zen and his Wife Blessed by the Redeemer, detail, Jacopo Palma the Younger, 1585. Ospedaletto dei Crociferi, oratory. The glorification of a munificent patron is here combined with a portrayal of real life in the expressive faces of the minor figures who inhabit the canvas.

the aim of instructing and encouraging devotion. It is on the basis of the constant application of this principle that we can explain what appear as inconsistencies in his output, inconsistencies which are nothing more than divergences, and which range from interest in certain aspects of naturalism and daily life to a strict adherence to Mannerist formulas, from paying homage to the glorious and overwhelming legacy of his great predecessors to the opportunism displayed in certain altarpieces and

The Eucharist Adored by the Four Evangelists, Jacopo Palma the Younger, 1580–81. Church of S. Giacomo dell'Orio, ceiling of the old sacristy. The cycle, commissioned by the priest Giovanni Maria da Ponte, illustrates the eucharistic mystery, celebrated on the ceiling in its revealed presence.

canvases in connection with the political will of Venice.

With the deaths of the last of the great sixteenth-century masters, Palma became the principal figure in Venetian painting and his art the expression of an age. He did not reject tradition but established himself as the authoritative repository of a rich inheritance. He was, moreover, in harmony with the new mood: he eliminated extravagance and excess, searching for a more balanced language suitable for a society which, having passed through a difficult period wanted order, not trauma.

Painting and Piety after the Council of Trent

The patriarch of Venice, Giovanni Trevisan, considered the apostolic visitation of 1581 an annoying and unwelcome interference from both the religious perspective and that of public expense. The aim of

the visitation was the reform of popular worship of saints and relics—frequently a mass of superstition with a strong dose of patriotism—and its subordination to the worship of the eucharist. Venice had reacted to the announcement of the visit by loudly proclaiming her sincerity and the strength of her faith, from the simple worship of the common people to the spirituality of the ruling classes and the fervor of the new religious orders.

Venice expressed her post-Tridentine orthodoxy primarily in the chapel of the sacrament. Although this was a widespread phenomenon in Italy, the traditional faith in, and devotion to, the sacrament on the part of Venetians, who were wary of Counter-Reformation debate and tended to prefer expressing elaborate and complicated messages through pictorial means, meant that in Venice, in contrast to Rome, there was considerable emphasis on sacramental chapels. It is difficult to put into strict chronological order the decorative cycles of the sacramental chapels and shrines between approximately 1580 and 1600, a period characterized by competition to see who could express their faith in the richest and most profound manner possible. If a prize had ever been awarded, it would undoubtedly have gone to Giovanni Maria da Ponte, priest of S. Giacomo dell'Orio from 1576 to 1606, a church which dedicated no fewer than three separate areas to eucharistic devotion. The paintings in the old sacristy, completed by Palma the Younger in May 1581, concentrate on the double aspect of the eucharistic mystery as defined by the Council of Trent: the sacrifice of the mass and of the sacrament. As a counter to ignorance and doubt, the paintings trace an illustrious history from the Old Testament, with episodes symbolically foretelling the eucharistic mystery in the *Jewish Passover* (reminiscent of Jacopo Bassano in its candlelit nocturnal atmosphere) (see p. 467) and the *Crossing of the Red Sea* with its intellectually constructed movement, to the Gospels, with the consummation of the sacrifice in the pure severity of the *Burial of Christ*. The cycle revolves around the center of the ceiling where the eucharist is presented in its full glory and reality: a ciborium supported by four columns stands over an altar with the host in a monstrance in the form of the sun, surrounded by the four Evangelists who testify that the truth of the eucharistic presence is revealed mystery. The overall image is clearly anti-Protestant: Christ is present in the very substance of the bread received by the faithful as holy communion, and as prescribed by the Council of Trent, while the insistence on the eucharist is a reminder that its real presence goes beyond the act of the mass.

The second eucharistic area in S. Giacomo dell'Orio is the chapel built next to the main altar,

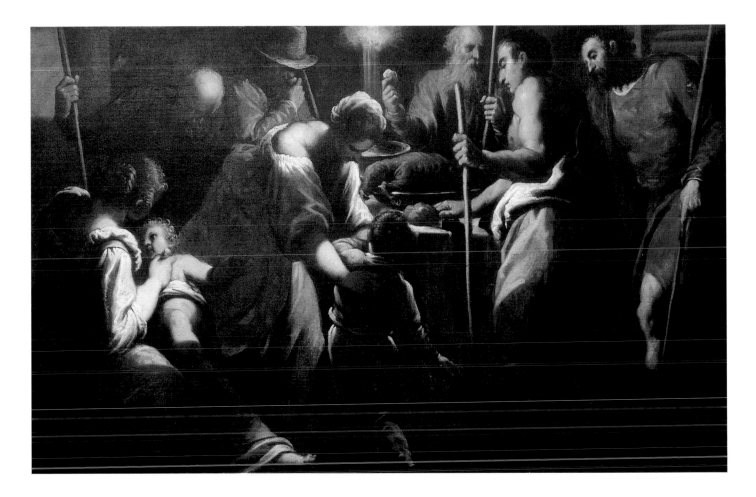

commissioned by the Scuola del Sacramento at the beginning of the seventeenth century, with a new altar and cycle of paintings commissioned from Palma, Giulio del Moro, and Tizianello. Through the *Passion* sequence (*Flagellation*, *Ecce Homo*, *Procession to Calvary*, and *Burial of Christ*), the meaning of the eucharist is exalted in the way each artist emphasizes the body of Christ as central protagonist through its central position and through reflected light (see pp. 468, 469). The decoration of sacramental chapels as an emerging phenomenon in Venetian religious practice at the end of the sixteenth century, part of the intimate relationship between iconography and theological thought, appears to symbolize a more general attitude toward religion which is also reflected in the Palazzo Ducale, where the image of Christ came to dominate all the meeting rooms presided over by the doge. As Staale Sinding Larsen has pointed out, it is only in Venice that one can find in a public context a religious iconography as articulated and systematic as that of the new pictorial order of the Palazzo Ducale

from the 1580s onward. In the Sala del Pregadi the *Votive Portrait of Doges Marcantonio Trevisan and Pietro Lando* by Jacopo Tintoretto, above the dais, is dominated in the center by the dead Christ supported by angels, an image designed to express sacrificial and eucharistic concepts. Opposite, and closely related, in the *Votive Portrait of Lorenzo and Gerolamo Priuli* by Palma the Younger, Christ appears in glory blessing the onlookers. In the same hall the doge Pasquale Cicogna (1585–95), who died "non sine opinione sanctitatis [not without being considered saintly]", according to the inscription on his tomb, a man of incisive action, is portrayed by Palma kneeling in prayer with Faith beside him and behind him the resurrected Christ to whom an angel is offering the paten with the host.

The new century was still dominated by the eucharistic sacrifice but in the context of mourning for the dead faithful. In one of the sections of the ceiling, dated 1600, of the ground-floor hall of the Scuola di S. Maria della Giustizia e di S. Gerolamo

Jewish Passover, Jacopo Palma the Younger, 1580–81. Church of S. Giacomo dell'Orio, old sacristy. The eucharistic mystery was believed to be foretold in Jewish ritual observance.

ON THE FOLLOWING PAGES:
Procession to Calvary and *Burial of Christ*, Jacopo Palma the Younger, 1604. Church of S. Giacomo dell'Orio, chapel of the Sacrament. The meaning of the eucharist is exalted through the centrality of the position of the body of Christ and the dramatic lighting.

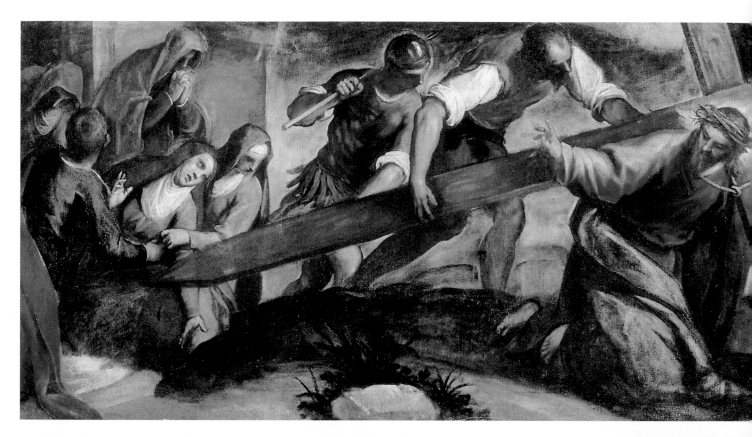

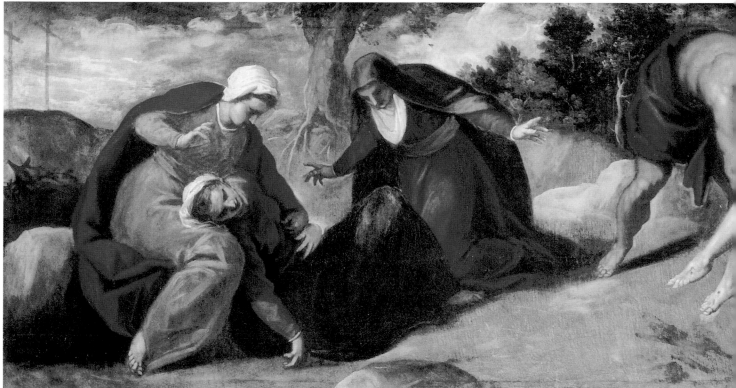

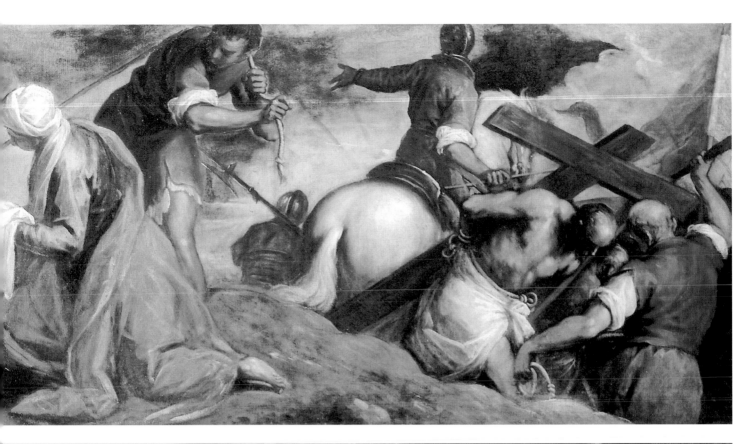

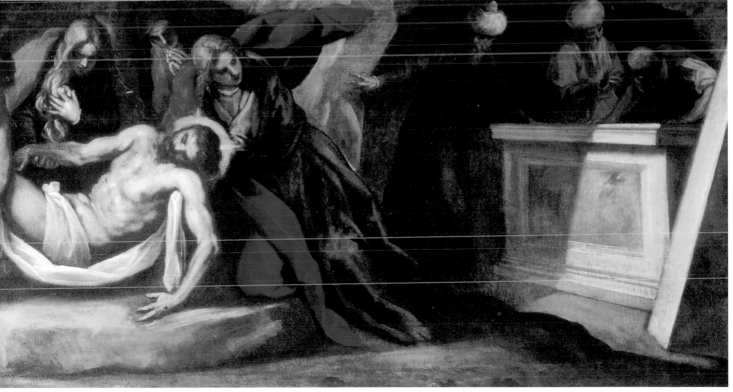

Madonna della Cintola and Saints, Leonardo Corona. Church of S. Stefano.

(now the Ateneo Veneto), a priest lifts up the chalice at the climax of the mass while angels lift tormented souls out of the fire. The *Offering of Alms* and the *Distribution of Charity* illustrate the other two methods of atonement, while the remaining ten panels portray the doctors of the Church who expounded on the subject and those souls among the flames who are atoning through the two punishments of *poena damni* [spiritual suffering] and *poena sensus* [physical suffering]. By closely linking the illustrative cycle to the *scuola*'s function, which was to accompany to the scaffold those condemned to death, and to work for the atonement of their sins, Palma, in anticipation of the Baroque, not only substitutes the symbolic figures dating back to the Middle Ages with solid naked bodies, which the angels have trouble lifting up, but also succeeds in rendering in a more easily understandable form the difficult theological concepts connected with the theme of purgatory. In his dense and substantial canvases, rich with a chromatic orchestration whose climaxes are brought to life by the light, one is aware of a drama of accents which confers an unusually visionary character on Palma's final attempt to reconcile manner and nature, and to go beyond painting as re-elaboration for the attainment of an autonomous existence.

While in Palazzo Farnese and the church of S. Luigi dei Francesi in Rome artists were finally burning the dross of Mannerism, in Venice with Palma a whole generation of painters was continuing to work within the protective walls of tradition, in homage to the great masters of the previous century, on the walls of churches and monasteries, public buildings and private palaces, and in the workshop of S. Marco, where the mosaics had to be continually renewed due to problems of structure and conservation.

The input of foreign artists did not succeed at this stage in stirring the stagnant waters of the local culture, partly because they were usually painters who came to Venice as pilgrims, worshiping those same elements from which the Venetians themselves drew inspiration. This is the case with Hans Rottenhammer, who arrived from his native Munich for the first time in 1589, returning in 1596 and remaining for ten years. A specialist in small-scale work, mostly on copper, he catered to the market by miniaturizing the compositional proportions of Tintoretto and rendering them translucent through Veronese's coloring. He also made his name with large works such as the *Annunciation* in the church of S. Bartolomeo (currently in storage at the Gallerie dell'Accademia), in which the silent dramatic dialogue between the angel and the Virgin in Titian's painting in the nearby church of S. Salvador, a major inspiration, is transformed into a stately encounter, and the brilliance of the light and color solidifies into polished surfaces.

Many others halted briefly, but always fruitfully, on the lagoon, including Adam Elsheimer, another attracted by the art of the sixteenth-century Venetian masters. He was able to study them during his stay in Venice both directly and through his fellow-German Hans Rottenhammer. During this period, the exchanges between artists of different nationalities and backgrounds were frequent and lively, Venice's isolation being only political. According to tradition, another visitor, in the summer of 1600, was a twenty-three-year-old from Antwerp, Peter Paul Rubens.

At the end of the sixteenth century the journey to Venice was the goal of all northern artists. Rubens came to study in full color an artistic reality which he had previously known only in prints: Titian, especially the Titian of the fifth decade of his life, Tintoretto, who made a huge impact on him, Veronese, whose scenes fascinated him, and Pordenone and Porta Salviati. But although Rubens's Venetian apprenticeship led almost immediately to an extraordinary maturity, he left no work in the city and only a long time afterward, and by means of others, did he repay the debt.

The Seven Manners

Heedless of all that was not strictly Venetian, Palma's seventeenth-century output, largely destined for churches, was cut off only by his death in 1628. There are few surprises, and the work is frequently characterized by an irascible Counter-Reformation spirit: crucifixions with saints, evangelical and biblical episodes alluding to the sacraments, penitent Magdalenes and St. Jeromes which implacably, year after year, became more arid, trapped within fossilized Mannerist forms. However, the critic Marco Boschini in 1674 conceded Palma to be the leading figure during his fifty years of activity, awarding him "first prize" for his "strong and vigorous" manner, and making a qualitative choice in his *Distinzione di Sette Maniere in certa guisa consimili* [Distinction of seven manners, in a certain way similar], derived from Titian, Tintoretto, and Veronese.

As for others, Leonardo Corona's manner "had a more serious element and produced a more robust impression," as can be seen in the cycle of eight episodes from the *Passion of Christ* completed between 1600 and 1605, in other words immediately following, and iconographically completing, Palma's paintings of purgatory on the walls of the Scuola della Giustizia, with their anguished pulsating

chiaroscuro. To look at them, according to Ridolfi, writing in 1648, "no onlooker could be so unfeeling as to remain hard of heart and dry-eyed."

Andrea Vicentino, "master in the use of color," whose specialty was large-scale portrayals of the celebrations for illustrious personages, such as the *Entry of Henry III into Venice* for the Sala delle Quattro Porte, and epic encounters such as the *Battle of Lepanto* in the Sala dello Scrutinio, grafts Veronese's ability in architectural structure and serenity of color onto the underlying inheritance of Tintoretto (see p. 472).

Sante Peranda, whose was "so graceful, elegant, and lovely," and who alternated occasional sojourns in Venice with periods at the courts of the Este family in Modena and the Pico family in Mirandola, demonstrates in his *Battle of Jaffa* in the Sala dello Scrutinio and in the *Adoration of the Magi* in S. Nicolò da Tolentino how he has tempered the influence of Tintoretto and Palma into the acid tones which distinguish his work.

Antonio Vassilacchi, known as Aliense, whose forms revealed "robustness, dignity, and mastery of paint," and who, of the whole group, is the most strongly influenced by Tintoretto, in his *Death of Ordefalo Falier at the Walls of Zara* for the Sala dello Scrutinio concentrates the light on the angles and edges of the forms with nervous strokes, accentuating their somberness. While there are merely generic comments on Pietro Malombra, whose precisely organized historical compositions such as the *Audience with the Doge* in the Sala del Collegio are of more than ordinary interest, even by sixteenth-century standards, the inclusion in the seven of a nonentity like Gerolamo Pilotti is curious. Boschini's catalogue of the Seven Manners does not, obviously, cover the whole panorama of Venetian painting in the sixteenth and seventeenth centuries. Tintoretto's studio was crowded with collaborators who, mistakenly, believed themselves capable of "following his madness." This negative comment appears in Federico Zuccaro's treatise *Lamento della pittura* [Lament for painting], written in 1605. Jacopo Tintoretto's son, Domenico, despite moments of ability in which naturalistic aspects are discernible, in the myriad portraits commissioned from him by doges, officials, nobles, and men of letters, and despite revealing a certain Mannerist elegance in the handling of secular themes such as the *Venus, Adonis, and the Graces* (Chicago, Art Institute), in his religious and historical compositions translates into descriptive and circumspect prose his father's creativity, overlaying it with vigorous chiaroscuro.

If, therefore, Venetian painting between the end of the sixteenth and the beginning of the seventeenth century is somewhat uneasy and lacking in origi-

Crusaders Conquer the City of Zara,
Andrea Vicentino, 1580s, Palazzo
Ducale, Sala del Maggior Consiglio.

nality, this does not mean that innovation is completely absent. Palma's collaboration on the treatises *Il vero modo et ordine per disegnar tutte le parti et membra del corpo umano* [The true method and order for drawing all the parts and members of the human body], published in 1608 by Odoardo Fialetti of Bologna, and *De excellentia et nobilitate delineationis libri duo* [On the excellence and nobility of drawing in two volumes], written with Giacomo Franco in 1611, is symptomatic of the striving for a transformation of the tradition of the Venetian workshop, re-examining aesthetic practice and, at the same time, redefining the social and intellectual position of the artist according to more modern models, in line with what had taken place in Bologna in the Accademia degli Incamminati and in Rome in the Accademia di S. Luca. The attempt was destined to fail probably because in Venice, more than at any other time, innovation was discouraged by the system. Nevertheless, that the Venetian school was still highly esteemed everywhere is confirmed by a letter dated 6 May 1616 which Marcantonio Bassetti wrote to Palma in Rome: "having opened our academy, laying down the methods with brushes and colors, so that the people call this a Venetian academy, and thus show a great deal of satisfaction on seeing such worthy efforts, they are full of admiration on seeing that we still draw and paint. . . ." No less negligible are the appreciations of Palma after his death from contemporaries such as Antonio Tempesta, Domenichino, and Carlo Saraceni, "leading citizens of the city of Rome sincerely attached to your person, not without reason."

The Beginning of Revival: Carlo Saraceni and Padovanino

In 1616, when Bassetti wrote to Palma, Carlo Saraceni had been in Rome for eight years. He had probably been a teacher of Palma, and had arrived at a profound understanding of Caravaggio, partly with the encouragement of Adam Elsheimer. In the mythological and biblical scenes he produced during the early years of the new century, landscapes dominate: sweeping, well structured, and classically inspired, with a concentration on natural elements that reveals the influence of the young Caravaggio, an influence that was to increase in the work produced in the second decade. In the *St. Roch* in the Doria Pamphili Gallery in Rome, the exhausted pilgrim is cared for by a winged boy in the moonlight. In *Judith* (Vienna, Kunsthistorisches Museum), an artificial light brings forth from the gloom glimpses of faces from the astonishment on that of the servant to the horror on

Ecstasy of St. Francis, Carlo Saraceni, 1620. Church of the Redentore. The work reveals the influence of Caravaggio in the poverty of the setting and the illumination by artificial light.

that of Holofernes and the determination of the heroine. Here the lessons of Caravaggio are revealed as much in the choice of theme as in the forms and in the trajectories of the light.

Even in the larger format of the later altarpieces for S. Maria dell'Anima (1617–18), Saraceni continues, as part of the originality of his chromatic orchestration, to draw inspiration from Caravaggio both in the emotional content of his "natural" religion which springs forth from the canvas and in the black wall, an authentic literary quotation, which forms the background to the group of peasants surrounding St. Benone.

Saraceni's presence in Venice, his native city, is recorded from November 1619. He was probably enticed by a major public commission: the work on the canvases for the Sala del Maggior Consiglio was finally coming to an end with the substitution of an existing painting by Domenico Tintoretto, *Doge Enrico Dandolo and the Captains of the Crusade Taking their Oaths before their Task Begins*. Even for a foreigner as cultured as Thomas Coryat whose book, *Crudities*, appeared in 1611, on a visit to Venice in 1608, the only paintings worth lingering over were the most recent works in the Sala del Maggior Consiglio in the Palazzo Ducale: "the

St. Liberale Persuades the Emperor to
Absolve Two Innocents Condemned to
Death, Alessandro Varotari, known as
Padovanino, 1638. Church of the Carmini.
Numerous two-dimensional figures are
articulated with undoubted elegance within a
luminous neo-Veronese scenario against a
classicizing background. Opposite: detail
with S. Liberale.

ceiling is of truly incomparable beauty, at least as
beautiful as the most beautiful ceiling in the Louvre
or the Tuileries, the Paris palaces of the king of
France. It is gilded most marvelously, with many
paintings of astonishing grandeur, of which three in
particular are most beautiful." Saraceni, who
returned to Venice accompanied by Antonio Giarola
from Verona and the Frenchman Jean Le Clerc, must
have been flattered to be involved in such a task after
so long an absence, but the fact that Venice invited
one of her own sons, even one who had developed as
a painter under different skies, to complete her most
important cycle of paintings is interesting. Three
years later, the State commissioned another canvas
for the Sala del Senato from the "foreigner"
Domenico Fetti.

Saraceni's return home, however, was not favored
by fortune: by the middle of the following June he
was dead of typhus. In his will, drawn up three days
before he died while staying with the procurator
Giorgio Contarini in his palace of S. Trovaso, certain
paintings are mentioned, definitively produced in
Venice, which are crucial to an understanding of
his last and brief phase: the *Ecstasy of St. Francis* and
the *Assumption of the Virgin* (Munich, Alte
Pinakothek), the *Altarpiece with Four Saints*
(Würzburg, Staatliche Galerie), and the only one
accessible in Venice, a second *Ecstasy of St. Francis*.
It is more than likely that the Munich *St. Francis* is
the one commissioned by the German Sebastiano Full
von Windach. In contrast to the traditional Venetian
iconography in which the saint had been depicted, in
the fifteenth century, against a landscape by day, and
in the sixteenth, by night, the miraculous event,

inspired by an engraving based on Raphael Sadeler
the Younger by the Capuchin monk Callisto Piazza,
takes place in a poor and artificially lit interior. The
bedstead is set on a slant, with a stool and chair,
while a propped-up stick contributes to the atmos-
phere. The angel descends playing the violin, and
emerges from the shadows. A faithful copy in the
sacristy of the church of the Redeemer, often quoted
by Venetian sources starting with Boschini, who
remarked that the angel who is giving St. Francis a
foretaste of the sweetness of Paradise through the
sound of his violin was a request by the painter to the
Capuchin monks "sometimes to pray for him" (see
p. 473).

It was probably this version that inspired Fetti
during his stay in Venice between 1622 and 1623 for
a canvas, now lost but recorded in a preparatory
drawing in the Staatliche Graphische Sammlung in
Munich. It was also probably the inspiration for
Gerolamo Forabosco's painting of the same theme in
S. Nicolò da Tolentino. The *Altarpiece with Sts. Francis,
Anthony Abbot, Jerome, and Mary Magdalene*,
another commission from Count Full von Windach
for the Augustinian church in Munich, consists of a
sacra conversazione in a landscape with a very low
horizon, with only a Palladian architectural wing on
the right which propels into the foreground three of
the saints who seem almost to be sliding downward
toward the onlooker's space, while St. Francis,
behind and alone, stands out against a menacing
stormy sky, toward which his gaze is raised. The
storm, and at the same time the changing light, is the
artist's way of affirming his Venetian roots. It has
been noted that as far as the dramatic conclusion of
Saraceni's life is concerned, this objective must have
been only an episode, reminding us that the months
of work in Venice are still surrounded by numerous
questions relating to changes in the artist's intentions
and to the fact that he seems unexpectedly and
brusquely to move away from the achievements of
recent Roman painting and from orthodox natu-
ralism, preferring instead more conciliatory and
composite solutions conditioned by the local artistic
culture which made no allowance for his inherent
caravaggismo.

It is not necessary, however, to dwell on the dull-
ness of Venetian painting during these years, nor
does the scarcity of works, nearly all commissioned
privately and by foreigners, leave scope for much
hypothesizing. The only work for the State, that of
the Sala del Maggior Consiglio, brought Saraceni
back to Venice, and it must have been completed by
his French pupil Le Clerc who had the honor of
signing it. Scholars are more or less agreed that
Saraceni was responsible for the inspiration and

design and Le Clerc for the execution of the work, in which it would be extremely difficult to identify accurately the hand of Saraceni. If the masterly construction of the multilevel perspective scheme of the crowd, within which characters and emotions are emphasized by a new luminism around extraordinary glimpses of the basilica of S. Marco, is the responsibility of the master, then it is to the sensitivity of Le Clerc that we owe the variety of expressions and emotions into which the minutely described narration shatters.

Saraceni's contribution to the Venetian revival was obviously limited, but it was nonetheless the first drop that began to wear away the rock of late Mannerism. Alessandro Varotari, known as Padovanino, made a more mature stand, on an absolutely contrary basis. He is the only seventeenth-century artist of whom Boschini wrote at length in his *Breve istruzione* and, symptomatically, is the only one of Titian's pupils to be included. After having copied in his native Padua the frescoes in the Scuola of the basilica of S. Antonio, "he went to Rome, in order to copy those *Bacchanals* which had been executed by Titian for the duke of Ferrara, then transported to Rome, to the Palazzo Lodovisio e Aldobrandino." Although no documentary evidence exists for this journey to Rome, a letter to the Senate of 1631, in which Padovanino claims to have been in Rome and other Italian cities, and, above all, his copies of the *Bacchanals* then in the Aldobrandini collection, lead to the conclusion that the journey took place before 1622–23, as Walker has pointed out, because before then van Dyck copied the reclining nymph in the *Andrians* with her belly covered by leaves (as can be seen in the drawing in the Italian book of sketches now at Chatsworth in England), while Padovanino depicted her as nature originally intended. Although the paintings the *Feast of Venus* and the *Andrians* did not remain in Rome for long, being sent as gifts to Philip IV of Spain in 1638, the *Bacchus and Ariadne* and the Bellini-influenced *Feast of the Gods* stayed there for the whole of the seventeenth century. All these works, a sublime paradigm of Titian's chromatic classicism, were the source of extraordinary inspiration not only for Padovanino but also for a host of artists from Rubens to Poussin and Albani, nurturing the Roman classicist movement which experimented with a path parallel to the naturalism of Caravaggio. This was the beginning of the new Venetian movement, and it is legitimate to suppose that Pietro da Cortona was one of the first to profit from the lesson.

Aided by his study of the young Titian, Padovanino put it to good use in his work in Venice, grafting his experiences onto his innate capacity as a story-teller and proposing himself, in a way, as the founding father of the classicist movement, one of the cornerstones of the revival, based on the use of a coloring which would be fully and coherently developed by the following generation, Pietro Vecchia, Pietro Liberi, and Giulio Carpioni.

In the *Marriage at Cana* (1622) for the refectory of S. Giovanni di Verdara in Padua (now in the Scuola Grande di S. Marco in Venice), we can already clearly see Padovanino's rebellion against the late Mannerism of Palma the Younger and his colleagues. Against a theatrical background of classical edifices emphasized by a double line of cypresses, prominence is given to the crowd of guests and, on the right, to a group of musicians with a harpsichord and stringed instruments which recalls, in a seventeenth-century vein, the famous quartet in Veronese's *Marriage at Cana* in the Louvre.

The most interesting aspect of the later works, besides the signs of an anti-Mannerist, programmatic neo-Titianism, is the felicity of the narration, executed with ease and superb rhythm, with the succession of fragments which interconnect through key figures, as in the *Miracle of a Woman Giving Birth on the Seashore* for the church of S. Maria Maggiore, now in the parish church of S. Giorgio in Nogaro, signed and dated 1628.

When working on a small scale, which does not allow narrative indulgence, and on a theme such as the *Deposition*, commissioned in 1630 by the parish priest of S. Pantalon, Giovanni Martini, Padovanino achieves intense pathos in the clarity conferred on the fragile figure of Christ, emphasized by the light in the crowd of mourners in the foreground compared to the background of a stormy sky against which the arm reaching toward the cross stands out dramatically. He paid further homage to his chosen master in the little angels so reminiscent of the pagan *putti* of the *Bacchanals*.

Padovanino's need to compose formal structures based on Titian-inspired coloring grew, supporting the scenic narration both when tackling mythological subjects such as the *Three Graces and the Amours* (St. Petersburg, the Hermitage) and the *Abduction of Deianeira* (Sarasota, Ringling Museum), from the early 1630s, which he interprets as arabesques, and also when handling religious themes such as *St. Liberale Persuades the Emperor to Absolve Two Innocents Condemned to Death* (church of the Carmini) from 1638, in which numerous two-dimensional figures are articulated with undoubted elegance within a luminous neo-Veronese scenario (see pp. 474, 475). The creeping cold of death continually caresses the bodies, dispelled only by the inten-

sity of the color. Whether Padovanino's aim was one of conservatism or whether it was a courageous refusal to compromise with late Mannerist academicism, culturally it should be considered analogous to the work of the Bologna group, followers of the Carracci, who were rediscovering the classical ideal of Raphael.

Foreign Contributors

Venice, especially during the 1620s, was an artistic crossroads, but even those who stayed only a short time, such as Anthony van Dyck in September 1622, seemed irresistibly drawn to Titian's ceiling paintings for S. Spirito in Isola. According to Boschini, van Dyck studied them at length and the young Rubens had already copied them, as is demonstrated by the drawing in the Albertina in Vienna of the *Sacrifice of Isaac*, the same work that would later inspire Liss's treatment of the subject, now in the Uffizi in Florence.

During the winter of 1623–24 a decisive encounter took place at the French court between the poet Giovanni Battista Marino—a fascinating figure by reason of his close links with the figurative arts, and his gallery, both in ideas and aesthetic practice—and Nicolas Poussin. Marino encouraged Poussin to undertake the journey to Rome, with a stop in Venice that formed the basis for Poussin's "Venetian-ness" that would later be electrified by study of the *Bacchanals*. In 1629 Diego Velasquez visited Italy for the first time, probably as a result of his conversations with Rubens and his meditations on the elements he most admired in the Spanish royal collection. Venice must have signified for him, as for Rubens, the ideal aesthetic ambience, constantly stimulating. We know from the writings of Francisco Pacheco, among others, that Velasquez produced many drawings of what he saw in the churches, palaces, and private collections, thus completing his study of the great Venetian masters, to whom he remained faithful for the rest of his career. During his second visit, in 1649, sent by Philip IV to acquire works of art, there was nothing more he could learn, but Boschini recalls his opinion: "In Venice one finds the good and the beautiful. I give the first place to that painter Titian who carries the flag." Rubens's own understanding of Venetian art was renewed and deepened through his encounter with the paintings in the Hapsburg collection in Madrid in 1628–29.

But if a visit to Venice was, for Rubens and others, really a pilgrimage to see Titian, and not principally the practice of their art in the city itself, Rubens's teachings acted as a catalyst for other "foreigners" who during the 1620s came to work in Venice and contributed to the revival. Three painters, the Roman Domenico Fetti, the German Johann Liss, and the Genoese Benardo Strozzi, interpreted Rubens's message individually, according to the different phases of their career: Fetti saw the Roman and Mantuan Rubens, Liss, the Flemish Rubens via the mediation of Jordaens, Strozzi, the Rubens of Genoa. Thus the revival also took place under the aegis of Rubens, who taught the Venetians above all to appreciate the true legacy of the Cinquecento.

Domenico Fetti's greatest opportunity arose from his encounter with Cardinal Ferdinando Gonzaga whom he followed to Mantua as court painter when Ferdinando became duke in 1614. In the summer of 1621 Ferdinando sent him to Venice to buy paintings. Fetti thus came into contact with the senator Giorgio Contarini dagli Scrigni, his future patron, and he took refuge in his home during the summer of 1622 following a quarrel with a friar during a game of *pallone*. For the young artist, who had grown up in early seventeenth-century Rome, the years in Mantua were intense. He had the extraordinary opportunity of studying the immense Gonzaga collection with its numerous Venetian works, with the result that he gradually freed himself of his Roman origins, eventually attaining a Rubenesque sensuality. But he never lost his inborn tendency to melancholy, this bitter-sweet emotion which seems always to reveal itself in the key figure of the angel, obsessively present either as main or second character in many of his works.

Fetti pushed the influence of Rubens toward a fluid brush stroke, full of light and color, which he used to produce naturalistic portrayals of Gospel stories or to recount episodes from mythology, demythologizing them and giving birth to a detailed, almost slow-motion concept of reality. A profoundly human interpretation of sacred events, an inspiration born in a natural setting, marks Fetti's *Parables*, moving scenes of daily life which, although influenced by Jacopo Bassano, are set in a temporal dimension which endows them with a new, and totally seventeenth-century, meaning.

Dating from before Fetti's stay in Venice, but in Venetian collections from early days, are the *David with the Head of Goliath* and *Melancholy* (Venice, Gallerie dell'Accademia), both originally belonging to the Contarini family. *David* (see p. 479), painted between 1617 and 1619, shows the influence of Caravaggio in the choice of the model, a young man with a feathered hat, in the single powerful source of light, and in the typology, but the expression is sweeter and the pictorial surfaces fragmented. In *Melancholy*, dated around 1618, the iconography is more complex, given the many texts on which it is

Melancholy, Domenico Fetti, 1617–19.
Venice, Gallerie dell'Accademia. The painting
is remarkable for its iconographic complexity
and the realism of the lighting.

based, from a second-century Roman relief to the celebrated engraving by Dürer; it is enriched by the addition of brushes, palette, astrolabe, and ancient torso, all of which move the emphasis toward the concept of *vanitas* (see p. 478). (The introduction of the skull could lead the subject to be interpreted as a penitent Magdalene.) What emerges most strongly is the woman kneeling in prayer, a figure that acquires concreteness beyond any intellectual transcendence, through the solidity of the color and the realism of the vivid and strongly contrasted light.

The three panels in Vienna (Kunsthistorisches Museum), possibly originally intended to decorate furniture, date from the late Mantuan period, between 1621 and 1622, and depict three myths from Ovid: *Perseus Liberating Andromeda*, the most beautiful of the three, *Hero and Leander*, the most tragic (it has been noted that Claudio Monteverdi, sometime around 1610, had set to music the lament of Leander by Giambattista Marino), and the *Triumph of Galatea*, the most festive. All three are in a strongly elegiac vein and are executed with colors so rarified as to attain effects of immateriality.

Although there is no solid documentary evidence about the works executed in Venice, it seems clear that Fetti had become "Venetian" even before he moved there, since his brief stay of six months cannot have been long enough for him to acquire the profound understanding of Venetian art which appears in the *Flight into Egypt* (Vienna, Kunsthistorisches Museum), in which the similarity to the painting of the same subject by Tintoretto in the Scuola Grande di S. Rocco could almost be disconcerting were it not for the variations of the two dead children in the foreground, the woman and child chased by soldiers at the edge of the forest, and the greater luminosity of the sky, just before sunset, which causes the leaves on the trees to tremble.

While in Venice, Fetti, like Carlo Saraceni, was officially requested to produce "a work to be executed in the Senate," attested by a letter dated 9 February 1623 from his Mantuan agent Valerio Crova (Luzio, 1913), though no other references survive concerning this prestigious commission. Fetti's stay in Venice lasted less than a year, and on 16 April 1622, during a violent fever, he died in the solitude of a foreign city. The modernity of the idiom of his paintings, the experimentation with new genres, and his deep underlying religious sense were destined to have a much greater impact than might be supposed from the scarcity of his works in the city, most of which were in private collections.

The first truly to understand the innovations taking place was another wanderer, the German Johann Liss, who developed a style spontaneously

dedicated to painting "live" from reality, transfigured by color. This can be seen in his version of a theme typical of Fetti, the *Return of the Prodigal Son* (Vienna, Gemäldegalerie der Akademie der Bildenden Künste). Liss ended his travels between Venice and Verona, dying of the plague on 5 December 1631, after a journey which had taken him from his native Oldenburg via Amsterdam, where he met Hendrick Goltzius, to Antwerp, to see Rubens and Jordaens, possibly to Paris, and to

David with the Head of Goliath, Domenico Fetti, 1617–19. Venice, Gallerie dell' Accademia, previously in the collection of the original patrons, the Contarini family of S. Trovaso. The youthful David with his feathered hat is reminiscent of Caravaggio.

Venice, for the first time in 1621, as is apparent from the drawing in the spirit of Callot of the *Brawling Hunchback Musicians* (Hamburg, Kunsthalle), to Rome, and again to Venice in 1623 or 1624.

Liss was receptive to the most diverse artistic experiences, from late Mannerist refinements of style to the immediate sense of reality of genre painting, an appreciation of the Baroque sensuality of Rubens, and the moods of Caravaggio à la Valentin and Manfredi. He arrived at a profound understanding of the sixteenth-century Venetian masters not because of the mere overlapping of cultural influences or eclectic experimentation, but because of considerable consistency and integrity of purpose.

For Liss, Venice signified, in addition to the sixteenth-century tradition, above all Fetti, as Sandrart observed perspicaciously during his stay in Venice between 1626 and 1629:

> In our Venetian Academy he frequently drew nudes from life, to which, in painting, he added the most realistic grace and vitality. He concentrated less on the study of the ancients, not because he had little respect for them, but because he declared that in order to take up a style contrary to his own he would have had to adopt a new method of study, so he would rather follow the style of Titian, Tintoretto, Veronese, Fetti, and other Venetians, but especially Fetti.

Fermenting color and pure light characterize the *Discovery of Moses* (Lille, Musée des Beaux-Arts), from the second half of the 1620s, which, given the theme, forms part of the series of tributes paid by foreigners to Paolo Veronese, although the reduction in the space represented emphasizes to a much greater extent than the original model the emotional thrust of Pharaoh's daughter toward the child.

Although Roman influence persists in works from Liss's Venetian period, such as the Caravaggio effect in *Judith* (London, National Gallery) and that of the Carracci in *Hercules between Vice and Virtue* (Dresden, Gemäldegalerie), albeit always with Liss's unique picturesqueness, it is the pair of the *Sacrifice of Abraham* and *Adam and Eve Mourning Abel* (Venice, Gallerie dell'Accademia, previously in the Giovanelli collection at S. Agostino) that forms the foundation of Baroque painting in Venice. The *Sacrifice* still shows traces of the influence of Titian's ceiling paintings in S. Spirito in Isola, which so dominate seventeenth-century painting, with the angel dramatically restraining the hand of Abraham, who is placed on high ground from which it is possible to glimpse a vast landscape and a distant low horizon. In *Adam and Eve*, the tragedy is depicted with great

spontaneity and yearning melancholy, in the same spirit as the simple story-telling which would characterize Rembrandt: the parents mourn the murder of their son, found dead at the hour when sunset tinges the landscape with warm light.

Two other paintings of great religious inspiration date from the end of Liss's Venetian period. One is a small *Ecstasy of St. Paul* (Berlin, Staatliche Museen, Gemäldegalerie), commissioned by the Reynst brothers of Amsterdam, to whom Carlo Ridolfi dedicated the first volume of his *Maraviglie dell'Arte* (Wonders of art), one of whom, a merchant, was in Venice in 1631. Taking as his inspiration the Second Letter to the Corinthians (12, 1-4), Liss shows the elderly saint in his study, his reading interrupted brusquely, nearly falling over backwards before the vision of the Trinity which appears to him in dazzling luminosity from behind a dark gray cloth drawn back by an angel, the device which renders the painting so theatrical. The second work, the *Inspiration of St. Jerome*, is a commission, painted around 1627, for the church of S. Nicolò da Tolentino (see p. 481). Liss probably owed the commission to Nicolas Renieri, a Franco-Flemish painter who had taken refuge in Venice at the end of 1625 after a long period spent in Rome where he came into contact with the Caravaggio-influenced Bartolomeo Manfredi and Simon Vouet, an influence which appears in diluted form in his Venetian works, in the mythological and historical themes and in the highly decorative female figures which he preferred (*St. Mary Magdalene*, City Museum and Art Gallery, Birmingham; *Erythraean Sibyl*, Gallerie dell'Accademia, Venice). Liss's altarpiece, with its zigzag composition, dynamism of the figures' glances and gestures, and blazing light, soon became one of the most characteristic works of the revived artistic culture of Venetian seventeenth-century Baroque.

The church of the Theatines, on which the late Mannerist generation continued to work in the 1620s, was further enriched about ten years later by two canvases by Padovanino, *St. Andrew Avellino Crossing the River* and the *Fall from Horseback*, both of which show clear traces of the presence in the city of another "foreigner", the Genoese Capuchin friar Bernardo Strozzi. Strozzi matured as an artist within a complex ambience in which, in addition to having contacts with Lombardy Mannerism, he absorbed the teachings of Rubens and the naturalism of Caravaggio and his followers. Present in Genoa in 1632, on 20 July 1633, Strozzi appealed to the Venetians for a safe conduct to Venice, "refuge of the oppressed and the sanctuary of freedom;" his petition, endorsed by Fulgenzio Micanzio, the biographer and friend of Paolo Sarpi, was approved.

Around 1640 Strozzi created, again for the church of S. Nicolò da Tolentino, one of the masterpieces of his years in Venice, *St. Lawrence Distributing Holy Vessels and Vestments to the Poor* (see p. 482), a work that is light years away from the painting on the same subject by Palma the Younger in the nearby church of S. Giacomo dell'Orio and from earlier versions of the same theme by Strozzi himself. The horizon is amplified by the audacious use of a low perspective, which emphasizes the theatricality of the scene, especially the full-length figure of St. Lawrence, dressed in a red dalmatic and in profile against the sky, while the figures of the poor are highlighted against the vague outlines of a dark architectural background. These works, together with the late work of the Paduan Girolamo Forabosco, renowned at the time for his portraits, identifiable in two canvases focusing on the theme of communion with angels—*St. Magnus* and *St. Francis*, the latter based on Saraceni's painting in the sacristy of the church of the Redentore—made the church of the Theatines one of the most famous sites of seventeenth-century Venetian painting.

When he received the commission for S. Nicolò, Strozzi had been living in Venice for seven years and had built a superb reputation for himself as a portrait painter with a profound capacity for physical and psychological characterization and as a painter of religious subjects. His characterization ability is evident in the portraits executed shortly after his arrival of Doge Francesco Erizzo (Vienna, Kunsthistorisches Museum; Venice, Gallerie dell' Accademia) and Cardinal Federico Corner (Venice, Museo Correr), in which compositional sobriety combines with a genuinely Baroque affectation of manner. An excellent example of his interpretation of a religious theme is *St. Sebastian Cared for by the Pious Women*, painted for the church of S. Benedetto; its exaggeratedly refined monumental construction is relaxed by the dynamic Baroque rhythm and atmospheric luminosity of the melodramatic evocation of the face of the saint and the still-life vignettes.

Via his contact with Venetian culture, Bernardo Strozzi was able to develop coherently the Genoese basis for a Baroque that bubbles with color and crackles with light. His enthusiastic tribute to Paolo Veronese, the *Rape of Europa* (Poznan, National Museum), inspired by the canvas of the same subject in the Palazzo Ducale, concentrates instead on the second part of the episode, when Europa is carried to sea by the bull, and overflows with an exuberance of color and glittering light.

Francesco Ruschi arrived in Venice at the same time as Strozzi, having studied in the Rome of neo-Caravaggism influenced by Pietro da

Cortona. He immediately became friends with one of the most interesting personalities of seventeenth-century Venetian culture, the "libertine" man of letters Gian Francesco Loredan, who produced a great number of works (*Scherzi geniali* [Ingenious effects], 1632; *Dianea*, 1635; *Novelle amorose* [Romantic short stories], 1641–43) following the style of Marino, was the founder in 1630 of the Accademia degli Incogniti, and chose as illustrators of his works the artists Pietro Vecchia, Francesco Ruschi, and Daniele van den Dyck.

The painter and poet Sebastiano Mazzoni, in his *Tempo perduto* [Lost time] (1661), dedicated two sonnets to Ruschi, "the most famous painter." In one of these, written at Ruschi's death shortly after completing the altarpiece depicting St. Ursula, St. Mary Magdalene, and angels for the church of the Carmelites (rebuilt in 1660), decorum is combined

Madonna Interceding with Christ for the Cessation of the Plague, Domenico Tintoretto, 1631. Church of S. Francesco della Vigna. A votive altarpiece for the epidemic of plague in 1630.

with nobility and both are mutated into conventional rhetoric. Ruschi's contribution is to be found on the one hand in the stimulus of the Veronese revival, to which he was drawn by his Tuscan origins, and, on the other hand, in the Tenebrist movement which influenced the later stages of his mature career.

The Venetian Revival

A major outbreak of plague signaled the beginning of our story, and a second and even more violent outbreak occurred in Venice in 1630. Some artists, such as Liss, died, while others were commissioned both publicly and privately to produce works appealing to the Almighty or thanking him for saving them from danger.

In 1631 the elderly Domenico Tintoretto, an exponent of late Mannerism (the style persisted longer in Venice than anywhere else), produced a votive altarpiece for the church of S. Francesco della Vigna, the *Madonna Interceding with Christ for the Cessation of the Plague*, a work demonstrating the limits of his potential, not lacking an earthy freshness in the portrait of the two women, and almost naivete in the scenes of the city with the macabre work of the *pizzegamorti* who carry away those dying of plague on handcarts while the dead lie on the ground, a striking vision of evil in all its complexity. Baroque influence in the figurative arts, almost a desperate response of vital energy, marks the depiction of the calamity, giving greater predominance to allegorical drama.

The drama was dominant but not total. In 1633 the Scuola della Santissima of S. Lio commissioned Pietro Vecchia to produce a work for the church. This first work, a populistic ex voto, is a *Crucifixion* in which the religious event becomes the pretext for the portrayal of various naturalistic episodes. Joseph Heintz the Younger, a native of Augsburg, who moved to Venice in 1625, where he became famous for his eccentricity and affectation, especially in his "views" of the city, had executed, a year before Vecchia's work, another votive painting at the request of the priest of S. Fantin, Giovanni Pomelli, who is accurately portrayed against the background of Piazzetta.

These are not the only examples of the important role of Venetian priests who wished to be immortalized in the churches under their care. The fashion had begun as early as 1581 with Giovanni Maria da Ponte, mentioned earlier in the context of Palma's cycle in the sacristy of S. Giacomo dell'Orio. Da Ponte was followed in 1586 by Bartolomeo Borghi, priest of S. Pantalon, who arranged to be portrayed

Transporting the Body of St. Mark from Alexandria to Venice, detail, Pietro Vecchia. Church of S. Alvise.

in a prominent position in *St. Pantalon Succors a Young Boy*. Perhaps the most remarkable portrait of a priest, however, is the one painted in 1648 by Sebastiano Mazzoni, in which the priest kneels on a flight of steps in the act of staring in a rather disturbing fashion at the faithful while St. Benedict commends him to the Virgin who appears in a glare of yellow light, contrasting violently with the gloom of the shadows (church of S. Benedetto). As in the case of Pietro Vecchia, this painting too is the first in Venice by an artist of the revival generation, the generation born in the first decade of the seventeenth century and the first to exploit fully the lessons of the "foreigners." They showed the greatest respect, however, for sixteenth-century tradition, given that the examples of its three great masters, Titian, Tintoretto and Veronese, although seemingly restrictive, were fertile soil for any attempts at revival. It should be stressed that this generation includes artists from Padua, Vicenza, and as far away as Florence,

and hardly any from Venice. Within the narrow confines of seventeenth-century Venice few painters were born. The hegemony of non-Venetian forces over local ones lasted throughout most of the century.

Pietro Vecchia is one of the exceptions, a man of multiple talents, philosopher, mathematician, and scholar who, although born in Vicenza, had Venetian parents. His *Crucifixion*, dated 1638, for the church of the Ognissanti (currently in storage at the Fondazione Cini) demonstrates, when compared to an earlier version of the same subject, not only a much greater compositional balance but also an increase in the foreground of a repertory of inspired genre episodes, such as the soldiers who are gambling for Christ's robes, the pages with plumes, the lowly people watching—all themes that could be developed into individual compositions. Vecchia draws on this type of image for the themes of the works which distinguish his Venetian period, such as *Ius in armis* (Heidelberg, Kurpfalzisches Museum), *Soldiers*

Visiting the Fortuneteller (Vicenza, Museo Civico), and the so-called *Bravo* (Vienna, Kunsthistorisches Museum), all of which contributed to his fame among his contemporaries as an imitator, the *simia de Zorzon* [monkey of Zorzon (Giorgione)], according to Boschini. It should not be forgotten, moreover, that the cult of the copy contributed to Venice's unique atmosphere, and that imitations of sixteenth-century masterpieces, or even the authentic falsifications by Renieri, Pietro Liberi, and Vecchia, were not regarded with disapproval but were seen as a test of artistic ability.

Martinioni, in 1663, described the artist in the *Self-Portrait of Titian* (Washington, D.C., National Gallery) "in the act of drawing, with the statue behind him of the complete Medici Venus," a statue which formed part of the collection of Nicolò Renieri, Vecchia's father-in-law and an influential figure in his career. The falsification is thus clearly revealed by the addition of the statue. In addition, the intensity of the chiaroscuro is markedly different, endowing the image with a hint of something bitter and bewitching. In this sense Vecchia's painting is fully Baroque: the sensuality that accompanies the melancholy, the extravagant manipulation of reality as if seen through a warped lens, the convulsive gestural expressiveness, and the inclination toward an anguished and disturbed humanity made up of gamblers, astronomers, and soothsayers and surrounded by compasses, skulls, books, and scrolls with Jewish and Latin writing mixed with geometric figures and cabalistic signs.

Many of the themes are horrifying, both visually and in the way they evoke other senses: smell, for example, as in the *Conversion of Francesco Borgia* (Brest, Musée, formerly in the church of the Gesuiti). If Pietro Vecchia was an imitator, Gerolamo Forabosco was judged by Boschini as "the rival of nature" due to the absence in his art of all artificiality, a fact which explains his success as a portrait painter. He is one of the greatest portrait painters of the century, almost on the same level as the older Tiberio Tinelli, of an almost Cinquecento dignity but translated into the sensuous richness of the Baroque. The foundations are already present in Forabosca's huge group portrait, commissioned by the family of Giovanni Urbani, who wished to offer thanks to the Virgin for a happy ending to their near-shipwreck. The *Miraculous Rescue* in the church of S. Maria Assunta in Malamocco has recently been redated to 1646 (see pp. 488–489). The group, which has escaped shipwreck, reaches the shore, finally escaping from the rage of the storm on the lagoon, a muddy green orchestrated with the gray of the sky, the clouds scudding in the wind with a fisherman's hat being blown away, all rendered by a hand which is contemplative and modest rather than dramatic, gifted with a penetrating awareness and an outpouring of color somewhere between Strozzi and Mazzoni.

The portrait of Doge Carlo Contarini and of his wife Paolina Loredan are remarkable works (Venice, Brogliato-Bentivoglio collection), dating from 1655–56. The intricacy of the lacework, the jewels, and the rich purple and gold materials in no way damage the spirituality of the figures nor the study of their psychological characteristics.

Francesco Maffei, from Vicenza, even more nostalgic for the great painting of the Cinquecento, for Bassano, Tintoretto, and Veronese, turned to them continuously for inspiration in his new conquests which take account of the experience of the "foreigners" whose work he encountered in Venice during the second half of the 1630s. Varied cultural stimuli, the most unexpected forms and the most violent contrasts are captured by Maffei and set within a witch's still. The result, particularly during his later years, when his brush strokes are more excited, is that the substance, seemingly dense, looks as if it will disintegrate at the slightest breeze.

Maffei's few Venetian works, especially those from the later years, reveal an uneasy, visionary world, as in the *Portrait of Laser Mocenigo*, dating from 1656–57 and now in Schleissheim Castle, where the dignity of the pose is amplified in terms of Baroque

Annunciation, detail, Sebastiano Mazzoni. Venice, Gallerie dell'Accademia.

rhetoric, rendering almost spectral the figure of the squinting soldier in the uniform of a captain with the Dardanelles in the background. The image, unbalanced and passionate, possesses incredible chromatic range and an artful atmospheric clarity.

The ceiling decoration of Palazzo Nani in Cannaregio, now in Ca' Rezzonico, dates from around 1658. It consists of sixteen canvases, reworked during the eighteenth century, which form a complex design of the *Senses*, of which there are now four though originally at least five. The outstanding feature is the masterful play between the two mirrors in *Sight*. The four elements are depicted in *Perseus and Andromeda*, *Peleus and Atalanta*, *Daedelus and Icarus*, and *Prometheus Freed by Hercules*. The seven planets are represented by their governing deities (Jupiter, Mars, Apollo, Diana, Saturn, Venus and Mercury) while Minerva, the allegory of divine wisdom, acts as a link between earth and the heavenly sphere. The more complicated scenes of exemplary punishment or liberation would acquire more precise meaning if we knew who had commissioned the work. If the elaborate iconography is a legacy of the sixteenth century, the use of audacious foreshortening, the typology pushed almost to grotesque limits, the lightning movements, as in the *Perseus*, and the figures decorated with arabesques on the tondi, are all signs of a purely Baroque sensitivity. The *Guardian Angel*, the small altarpiece still on the altar of the chapel of SS. Apostoli, belonging to the brotherhood of the same name, dates from around 1658. Its space is somehow suppressed so that the two figures come into view through the intensity of their color, in contrast to the diaphanous apparitions in the background. The figures' movements are exaggerated and their faces become masks, with sunken eyes and nasal cavities sharply outlined by the light. The screaming child who seems to be trying to escape the angel's protection is a typical creation of this extraordinary painter.

The work of Pietro Liberi is spiritually and stylistically different. Liberi was a highly cultured man of wide experience, much favored by Venetian and foreign collectors, for whom he produced delightful works on sensual and erotic themes dominated by nude female figures. His principal models are Paolo Veronese and Pietro da Cortona, the latter encountered during a sojourn in Rome between 1638 and 1641, whose influence results, in the works based on mythology, literature, and ancient history, in exuberant painting. Rhythms and faded colors contribute to the creation of a story-book atmosphere, an ancient, pleasurable sensuality, even though he sometimes employed allegorical abstractions, as in the *Man Dragged Down by Vices* (Venice, Galleria

Miraculous Rescue, Girolamo Forabosco, 1646. Church of S. Maria Assunta in Malamocco. A vast portrait of the Urbani family giving thanks for having been saved from a storm on the lagoon.

Perseus and Medusa, Francesco Maffei.
Venice, Gallerie dell'Accademia. The moment
when Perseus is about to decapitate Medusa
is depicted with an exaggerated gesture.

Querini Stampalia), dated around 1650, a bizarre creation of divergent lines and motions. His moral aims seem contradicted by the display of pink flesh on the lavish nudes (see pp. 492–493).

In *Venus and the Three Graces* in the Palazzo Albrizzi, dating from the 1650s, the human figure once again provides the opportunity to articulate bodies in an open space where they seem to float against the sky, like clouds refracting the light, so that the almost too obvious influence of Veronese is clearly and coherently translated into the decorative effect of the Baroque, revealed by the intertwining hands around the head of Venus.

The Florentine Sebastiano Mazzoni completes the list of masters of the revival active in Venice during the second half of the seventeenth century (see p. 487). Trained within Furini's circle, he was a painter, poet, and architect. He had been in the city for some time by 1648, the year inscribed on the altarpiece mentioned above, *St. Benedict Recommending the Church's Priest to the Virgin* (Venice, S. Benedetto), which reveals the underlying influence of Strozzi in both the approach to the portrait and certain combinations of color (see p. 486). This is also the case for the other work in the same church, *St. Benedict and the Theological Virtues*, with its incredible inspira-

tion, compositional dynamic, and pathos, all set within a chiaroscuro that seems to be anticipating the new solutions of the Tenebrists.

Alongside these devotional works, executed with anticonformist boldness, both in the interpretation of traditional themes via foreshortened staging and in the vivid chromatic values, obtained through subtle and light brush strokes, there are other paintings of mythological and historical subjects, destined for private collections. By the 1660s, these reveal even more complex scenographic effects, based around what has been called "centripetal" movement, as in *Cleopatra's Banquet* (Washington, D.C., National

Gallery) and the *Death of Cleopatra* (Rovigo, Accademia dei Concordi). Such centripetal movement is followed, principally toward the end of Mazzoni's career, by the dominance of "centrifugal" movement, in which the space is extended in order to emphasize the greatly accentuated rotational effect, which seems to drag the figures beyond the limits of the painting. Typical of this phase is the *Temple of Janus* (Llanrwst, Aberconway collection), the theme probably drawn from contemporary literature, in which three female figures (probably the Furies) are running, chased by a warrior against a backdrop which is an integral part of the composition, and whose perspective is

Circe and Ulysses, Francesco Maffei. Venice, Gallerie dell'Accademia. The pendant of the preceding painting, it represents a mature expression of the Baroque with its decorative audacity and vibrant brushwork.

enhanced by the action of the bodies, with a new, contorting sense of the image. Also part of this same direction is the *Wheel of Fortune* (Venice, Palazzo Albrizzi), in which the movement of the wheel itself is used to accentuate the rotary movement of the victims, their crowded swollen forms in the foreground, against a background of open space with a counterpoint of arches, columns, and foliage. The same devices turn the portrait, from 1669, of Pope Honorius III on the walls of the church of the Carmini into a nightmare, not a dream. This work must have been spiritually akin to one of Mazzoni's last paintings, the *Last Judgment* in the church of S. Trovaso, which Charles de Brosses managed to see and describe; he was so impressed by the "incomparable aerial perspective" that he declared that "this painter's style is distinctive and deserves attention. I am amazed he is not better known." Among the few who did understand the extraordinary modernity of the retiring Mazzoni was Luca Giordano, whose works in Venice, rather than his sole documented visit, contribute to the Tenebrism of Venetian painting during the second half of the seventeenth century.

Light and Shadow: The Artistic Trends of the Second Half of the Sixteenth Century

In Venice during the 1650s there appears to be the recurrence of a phenomenon which had occurred in the 1580s, when *tenebre* [shadows] invaded the canvases of the great masters, darkening the skies of Jacopo Bassano and Tintoretto and bringing twilight into those of Veronese. If the earlier phenomenon was influenced by Titian's late work, the seventeenth-century trend had other causes: partly a dramatic re-examination of the poetic language of Tintoretto, partly renewed foreign contributions, not necessarily by artists physically present in Venice. Pushing the argument further, one might say that the influence of Caravaggio, which had been marginal in Venice despite the brief interventions of Saraceni and Le Clerc and the reform of the revival artists from Verona during the early part of the century, was finally making itself felt, fifty years on, with the trend toward naturalism which, despite the influence of Ribera, can be seen in Venetian painting. In addition, when confronted by a series of artists who were isolated for the entire first half of the century, one is witnessing the creation, if not of a school, at least of a trend which attracted artistic forces which, as contemporary critics appreciated, were diverse.

Once again the change was promoted and developed by outsiders. The crucial *Catalogo de gli pittori*

Man Dragged down by Vices, Pietro Liberi, c. 1650. Venice, Galleria Querini Stampalia. The flagrant nudity contrasts with the moralizing theme.

ON THE FOLLOWING PAGES:
Victory of the Venetians over the Turks in the Dardanelles, Pietro Liberi, c. 1664. Palazzo Ducale, Sala dello Scrutinio. The painting, commissioned in 1656, represents the defeat of the Turkish fleet by the Venetians under the leadership of Lorenzo Marcello on June 27, 1656.

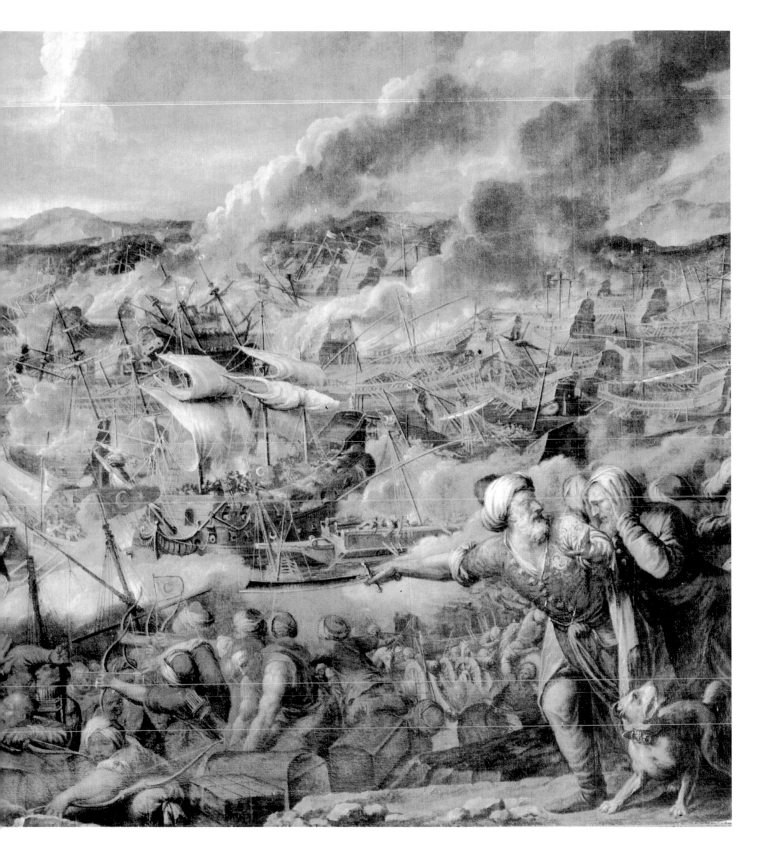

di nome che al presente vivono in Venetia [Catalogue of painters of reputation who at present live in Venice], compiled by Martinioni in 1663, provides confirmation. An important role, however, was played in this change of direction during the second half of the seventeenth century by non-Venetian easel paintings and altarpieces found in private collections and the city's churches.

At this point a brief parenthesis on the principal sources for all studies of this period is necessary. First is Carlo Ridolfi's *Le maraviglie dell'arte* [The wonders of art]. Published in 1648 and inherently Baroque in its title, this book provides a mass of biographical information on Venetian painters, and, stripped of anecdotes, it is one of the most accurate contemporary accounts. Study of the three editions of *Venetia città nobilissima et singolare* [Venice, most noble and unique city] by Francesco Sansovino (1581) (Giuseppe Stringa [1604] and Giovanni Martinioni [1663]) reveals almost year by year the additions to the paintings in Venetian public buildings. Marco Boschini, with his *Minere* [Mines] and *Ricche minere* [Rich mines] (1664 and 1674), completes the contributions made in his time, with the exception of those in monasteries and private collections.

Boschini's extraordinary critical contribution lies, above all, in the epic poem in quatrains, *Carta del navegar pitoresco* [Map of pictorial navigation] (1660): despite its lack of historical sense and Venetian bias, it provides a stream of contemporary judgments on the pictorial phenomena of the day. It is full of the author's remarkable intuition for the history of the great Venetian Cinquecento and the links between the painting of his time and the city of Venice, in other words, the neo-Venetian movement of the 1630s, and the involvement of Rubens and Velasquez in Venetian culture. For Boschini, as an exponent of the concept of art as creation, the problem of painting was that of depicting things not as they are, but as they are seen, with freedom of transformation; therefore painting must be considered the greatest of the arts, given its greater artifice. His philosophy is represented by the image of the world as a theater, the curtain being brought down at night and raised again in the morning by Apollo.

The fashions in painting during Boschini's lifetime are clearly revealed in the descriptions of contemporary galleries and in Boschini's personal taste and his ideal gallery. In reality, however, glancing through the lists of paintings which hung in the palaces of the nobility, the impression is one of a certain conservatism in the ducal families. It tended to be the *homines novi* [new men] who were more open to contemporary art, while true audacity was left to the *colleghi*

Diogenes and Alexander, Giambattista Langetti. Venice, Pinacoteca Querini Stampalia. The theme is typical of the Tenebrist repertory, which tended to have moral aims and depicted a humanity either detached from the material world, like the ancient philosophers, or wounded.

[colleagues], as is demonstrated by Nicolò Renieri's collection. With the exception of Guercino, modernization was achieved through local artists or immigrant foreigners, but apart from the odd flutter of curiosity for Tenebrism, the preference was for the light vivacious painting exemplified by Pietro Liberi, or for Strozzi, Liss, and Fetti. The preferred portrait painters were the naturalist Pietro Bellotti, Tiberio Tinelli, and Gerolamo Forabosco, and above all, Pietro Vecchia. Venetian seventeenth-century collectors represent an aspect of the political and economic situation, that of the passage from a mercantile to a land-based structure, with the wealthy and the politically powerful investing their capital in secure personal property. One can, therefore, understand the prevailing conservatism, the search for recog-

nized and established values which would satisfy the desire for prestige. There were pioneering exceptions: the Widmann family, who decorated the *salone* of their palace with works by Zanchi, Langetti, and Pietro Vecchia, Antonio Giustinian of S. Stae, the Cavalli family of S. Vidal, and especially the so-called nobles of Iraklion (those to whom nobility was sold to finance the war of Crete) such as Aurelio Rezzonico, who owned many works by Langhetti and Loth as well as ten paintings by, or influenced by, Luca Giordano. Tenebrist paintings were more likely to be found in the houses of citizens and the clergy.

At a certain point, the patron was gradually transformed into a buyer, and the brokers and forgers were ready for him, to procure, or to manufacture, his requirements. The inspiring role of the Venetian

OPPOSITE:
Holy Family, Carl Loth, 1681. Church of S. Silvestro.

collector resulted in the dissemination of culture, with major consequences both in Venice herself and, via the export of individual works and entire collections, throughout Europe.

Sources are of crucial importance if we are to understand the complexities of the late seventeenth century in Venice, especially concerning the arrival of Tenebrism. Who or what was responsible for this change of direction? The legacy of Tintoretto, despite its adoption for certain compositions, is not suffi-

cient to explain the naturalistic somberness, resurgent chiaroscuro, choice of humble working-class models, and the different themes and typologies which appears in some areas of Venetian painting. One of the catalysts behind Tenebrism has always been thought to have been the presence in Venice on several occasions of Luca Giordano of Naples, but recently, on the basis of studies of the absence of confirmation from Venetian sources, doubts have been raised as to whether the altarpiece for the

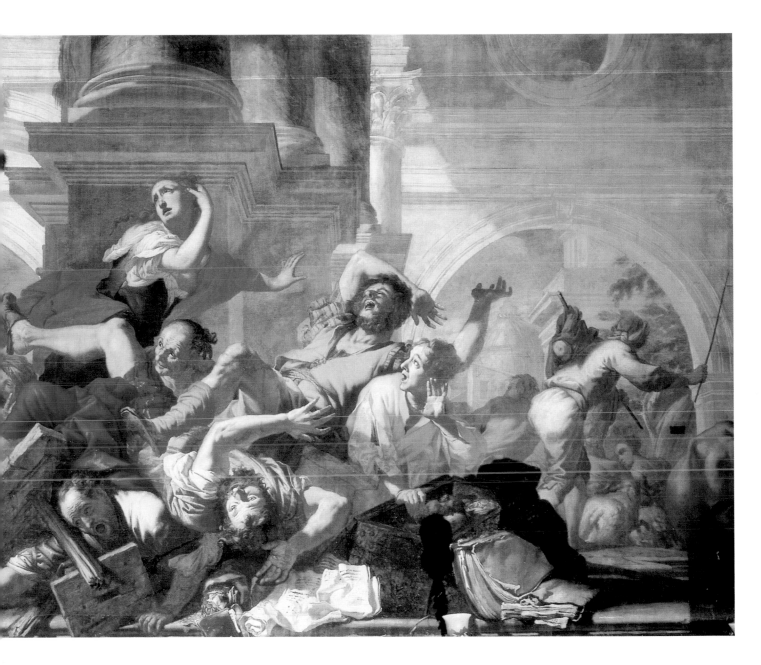

Vendramin Chapel in S. Pietro di Castello (the *Madonna of the Graces with the Souls in Purgatory*), the *Deposition* for S. Maria del Pianto, and the *Madonna and Child with St. Joseph and St. Anthony* in the church of S. Spirito (now in Milan, Brera) were executed during a first visit, traditionally dated around 1650 and definitely before 1653. But there are no documented visits by Giordano to Venice during the first half of the 1650s, and none can be hypothesized, despite his increased cultural maturity.

Greater credence is given to the *Relatione della vita di Luca Giordano* [Account of the life of Luca Giordano], written in 1681 by Francesco Saverio Baldinucci, which states that in 1665 Giordano went first to Florence and then to Venice where he remained for six months, producing several paintings for collectors including "a large Panel in the manner of Spagnoletto," which he painted while staying in the house of the marquis Agostino Fonseca, ennobled in 1664. One wonders why Giordano made his debut

Expulsion of the Money-Lenders from the Temple, Antonio Zanchi, 1667. Scuola di S. Fantin. The influence of Veronese, which can be seen in the architectural framework, is combined with a violent chiaroscuro which highlights the dramatic action.

The Virgin Appears to Sufferers of the Plague, Antonio Zanchi, 1666. Scuola di S. Rocco, grand staircase. Commissioned by the senior warden, Bernardo Broli, this moving portrayal of the plague contains powerful representations of dying figures.

on the Venetian artistic stage with works which despite their varied stylistic inflections were all obviously reminiscent of "the manner of Spagnoletto." Perhaps he wanted to comply with the preferences of the purchasers, like Alvise Molin and the Pesaro family, who appreciated a more traditional style of painting and who during this period favored artists such as Langetti, Loth, and the young Zanchi, and collected Ribera.

A major contribution to the development of Tenebrist aesthetics was made by Rembrandt's engravings, imported to Venice during the 1650s by his pupils Willem Drost and Eberhat Keihlau (Monsù Bernardo), one of the so-called reality painters.

Keihlau's work with Rembrandt in Amsterdam aroused his interest in psychological portrait painting. Already a mature artist and familiar with the works of Ribera and Velasquez, he was fascinated by the growing popularity of the *tonmalerei* [Dutch followers of Caravaggio] in the Netherlands, a phenomenon of the 1630s, in which brown predominates, producing almost monochrome results. In 1651 Keihlau left for Italy, remaining in Venice for three years, where he lived under the protection of Giovanni Carlo Savorgnan for whom he painted several works. He was influenced by both Strozzi and Fetti, as well as, obviously, the great painters of the past from Titian to Tintoretto and

Veronese, although he remained attached to his Tenebrist *chiaroscuro*. Although Keihlau usually neither signed nor dated his canvases, we can legitimately draw the conclusion, given the uniformity of his themes, that we are dealing with half-length portraits in which the four elements, the ages of man, the five senses, and the seasons were all depicted in the form of portraits of humble working people.

the birth of this trend, which includes names such as Loth, Zanchi, Negri, and Langetti, from the reality painters to the poetry of Ribera, directly or through the works of Luca Giordano, and especially the compelling model of Giovanni Battista Langetti, who moved from Genoa to Venice halfway through the 1650s. The name Tenebrist derives from a phrase Boschini used to describe Langetti: "ingegno tenebroso e scuro" [a shadowy and dark genius]. The same

Pietro Bellotti, a native of Brescia, must already have been established in Venice for some time by the 1650s, given that Gian Giorgio Nicolini pronounced a eulogy on him in *Ombre del pennello glorioso di P. Bellotti* [Shadows of the glorious brush of P. Bellotti], published in 1659; Boschini also spoke well of him a year later. His output consists principally of half-length portraits and busts of old men and women, characterized physiognomically by a ruthless stereotyping, as in *The Fate Lachesis* (Stuttgart, Staatsgalerie), dated 1654, in which the classical repertory becomes the pretext for a hyper-realistic portrait of an ancient peasant woman, on whose face nature and time have left their mark. Various factors influenced

term was used again a century later by Lanzi—*principe dei tenebrosi* [prince of the shadowy ones, or tenebrists].

The Tenebrists cannot be understood without taking into account certain elements that are identifiable within a specific culture, the most important being a profound religious sensibility with a return to the central position of the divine in relation to humanity, with the consequent dramatically submissive approach, the whole effect sharpened by the climate of war, pestilence, and famine. This is the background to the wave of meditative spirituality and penitential rigor, partly inspired by the Counter-Reformation, and the obsessive fear of sin (pride,

Abraham Teaching Astrology to the Egyptians, Antonio Zanchi. Church of S. Maria del Giglio. The subject is unusual for a Tenebrist. The composition revolves around a huge globe of the world lit by a merciless light.

Beheading of St. Julian, Antonio Zanchi, 1674. Church of S. Giuliano. Extremely foreshortened and set against a darkening sky, the only light appearing to be supernatural, the work signals a slight change of direction and the emergence of Veronesian elements.

envy, greed, lust). It was generally felt that the only possible escape was through prayer and meditation on the hollowness of earthly goods, according to the warnings of the ancient philosophers.

Chiaroscuro thus became a means of expressing the intimate essence of individuals, a way of probing their soul and of accentuating the moral significance of the events represented, whether taken from the Gospels or from Greek mythology and Roman history. In the canvases of these artists one sees a wounded humanity, a humanity detached from earthly things, like the philosophers whose works were so widely desseminated in seventeenth-century Europe with neo-Stoicism.

Given these premises, a tour of the works of the Tenebrists would no longer begin in the church of S. Maria del Pianto, constructed at the Senate's command during the weary vicissitudes of the Cretan war, on whose high altar, around 1665, Luca Giordano's *Deposition* was placed (Venice, Gallerie dell' Accademia). The articulation of light and shadow and the unusual chiaroscuro which accentuates the movements of the extravagant off-balance figures, emphasizes in a naturalistic sense the pathos of the tragic event. Rather, this tour begins in the equally small church of the Carmelites, apparently insignificant yet visited annually by the doge.

The *Crucifixion* commissioned by Maffio Milles, whose sister was a nun in the Carmelite convent, executed around 1663, is a masterpiece from Langetti's early maturity. It signals his definitive establishment in Venetian circles and is marked by a personal style in which are mingled and harmonized echoes of Genonese culture, imbued in turn with Flemish influence, especially that of van Dyck and Rubens, the decorative lessons of Cortona, and the naturalism of Ribera, whom Langetti had studied in Rome.

A tour of Tenebrist paintings in private collections, even more interesting, begins with *Apollo and Marsyas*, also by Langetti. Mentioned in 1660 by Boschini as in the house of Count Thiene, and described as all "howls and grimaces," it can be identified with the *Apollo and Marsyas* formerly in Dresden (Gemäldegalerie). It shows the influence of Ribera, especially when compared with Ribera's *Apollo and Marsyas*, dated 1637, in the Museo del S. Martino in Naples. The theme, the pagan equivalent of, and the model for, the flaying of St. Bartholomew, embodied, in the world of the Counter-Reformation, the punishment of pride and deceit.

Another work rich in symbolic significance is *Vulcan and Jealousy* (Munich, Alte Pinakothek), commissioned by the imperial ambassador H.J. Cernin in 1663, in which Langetti's worship of

Martyrdom and Apotheosis of St. Pantalon, Antonio Fumiani, 1684. Church of S. Pantalon. Overall view of the ceiling and detail. A virtuoso *tour de force* in which the architectural illusionism aims to create for the faithful the image of the celestial firmament.

Tintoretto is revealed by the mirror reflecting the two lovers. According to Boschini, the Tenebrists' work spread to the palaces of many *Procuratori venerandi* [venerable procurators], whose walls were hung with half-length portraits by Langetti of Cato, Samson, saints, prophets, and philosophers (see p. 497), and more complex works such as the *Murder of Archimedes* and the *Good Samaritan*, in which the protagonist is generally lying supine on the ground in such a way as to emphasize through anatomical contortion the physical torment which is being suffered or which has already been superseded by death. Langetti's themes stress the terrible and the dramatic. His characters behave as if in a trance, impelled by an interior agitation which is manifested by a naturalistic brutality which sometimes reaches fierce rhetoric. *Ixion* (Museo de Ponce, Puerto Rico), bound with serpents to an endlessly spinning fiery wheel is one of the most violent themes, both conceptually and compositionally. It belongs to a series of condemned characters depicted by Titian for Mary of Hungary, and by Ribera for Lucas van Uffel in Amsterdam. Punished for irreverence, disobedience, and ingratitude, Tityus, Ixion, Tantalus, and Sisyphus are portrayed as warnings to the subjects of a monarchy which by virtue of its divine right was almost deified.

Whether dealing with the mythological damned or the heroes of freedom, the compositional scheme is similar, highlighting the nude body of the protagonist caught in the agony of torture or violent death while the onlookers or torturers move around in semi-obscurity. In the *Death of Epaminondas* (Basle, Kunstmuseum), from the last decade of Langetti's life when his chiaroscuro becomes less violent, leaving an evocative penumbra with glimpses of faces and intensified color, the subject, a rare one in seventeenth-century painting, shows the military leader Epaminondas dying as a result of a wound received during the battle of Mantinea where the Thebans were defeated by the Athenians and the Spartans.

Violent deaths and suicides appear in the world of another Tenebrist popular with Venetian collectors, Johann Carl Loth, who arrived in Venice from Bavaria sometime around 1655 (see p. 496). In the *Death of Seneca* and *Death of Agrippina* (Munich, Bayerische Staatsgemäldesammlungen), both of which owe a profound debt to Langetti, the contrast of chiaroscuro are violent. The light strikes the figures in the foreground, forcefully shaping them. This also occurs in the more peaceful rhythm of mythological subjects such as *Jupiter and Mercury Entertained by Philemon and Baucis* (Venice, Palazzo Albrizzi) or the youthful *Mercury and Argos* (London, National Gallery).

Antonio Zanchi, a native of Este, is the first Venetian to be associated with the Tenebrists. His

two great Tenebrist works date from around 1660, *Samson and Delilah* and the *Death of Darius*. These now constitute the decoration on the walls of the *portego* of Palazzo Albrizzi, together with works by Pietro Liberi, Sebastiano Mazzoni, Ludovico David, and Pacecco de Rosa. Their original provenance is not known, but the source of the iconography for the *Death of Darius* was Plutarch's life of Alexander the Great. The painting portrays the vanquisher's pity for the vanquished, and the influence of Langetti can be seen in the nude body of Darius seen from the side, with his head hanging down, similar to the vigorous naked body of Samson, fully, almost violently, lit, in the pendant.

For the Venetian Tenebrists, the time for official recognition had come, through public commissions for churches and *scuole*. Zanchi's canvases demonstrate this. For the Scuola dei Carmini he painted the *Miracle of the Boy Fallen in the Well* (post-1664), set in a twilight atmosphere, and for the church of S. Maria del Giglio, *Abraham Teaching Astrology to the Egyptians*, a composition that revolves around a huge map of the world which the elderly prophet is measuring with a compass (see p. 501). It is lit by a merciless light that shrivels and contorts the figures like burning paper.

The real triumph of the Tenebrists took place in a setting—the Scuola di S. Rocco—that was more congenial to them for a variety of reasons, not the least of which was that it already held a great number of works by their preferred artist. Here during the Cinquecento Tintoretto had painted cycles which included not one representation of the plague. Now the Tenebrists produced here some of the most awe-inspiring depictions of the scourge, the two works by Antonio Zanchi and Pietro Negri which decorate the great staircase. Commissioned by the senior warden Bernardo Broli and executed in 1666, Zanchi's work, a tragedy reminiscent of Seneca or of a Baroque version of a morality play, is impressive for the dramatic presentation of its life-size figures, the dying, the boats overflowing with corpses, the grim pall-bearers, and the horror and desolation of the living (see p. 500). There is no pity here; the man holding his nose is worrying only about avoiding the stench. Pietro Negri's canvas, dated 1673, has a complex architectural plot which emphasizes the space and exploits the interruption caused by the pilaster. On the right is the supernatural event, echoed on the left by the ray of light which strikes Plague being embraced by Death. Negri left room for the reality of Venice, a massive Baroque city bowed down by the epidemic, with the dead lying on the ground and the living locked in their houses, but the most precise iconographic reading of the two paint-ings is by Boschini who stresses the importance of the presence of the plague in the first and the pattern of intercession in the second.

Zanchi's later works for the church of S. Giuliano, which Boschini dates to 1674, are *St. Julian Led to Martyrdom* and the *Beheading of St. Julian* (see p. 502). Both are extremely foreshortened and set against a darkening sky, the only light seeming supernatural. They signal a slight change of direction and the emergence of elements from Veronese.

With Langetti's death in 1676 the movement he had inspired seems to break up. By the 1670s the work of even his most faithful follower, Loth, reveals signs of a tendency toward a less intense naturalism, and even Zanchi distanced himself from the tene-brists' style. Other—and very different—trends were beginning to prevail in Venice, once again stimulated by the contribution of outsiders.

Almost thirty years after Pietro da Cortona's desire to journey to Venice in 1637, while he was working on the frescoes for Palazzo Barberini in Rome (1663–64), his altarpiece *Daniel in the Lions' Den* (Venice, Gallerie dell'Accademia) was placed in position in the church of S. Daniele, an event of crucial importance to the Baroque, against the pano-rama of the artistic culture of the time. As in other work from this last phase of his life, Cortona, who in his youth had been fascinated by Titian's *Bacchanals*, rejected more traditional formats and rediscovered new, simple, and effective compositions, a world populated by uneasy figures in the most dramatic instant of movement, in a half-light broken by unex-pected illumination and by oblique apparitions among the sulphurous rays plunging down from a darkening sky from the stormy clouds which suck into their vortex angels and cherubim.

Cortona's view is re-emphasized in Luca Giordano's Baroque-influenced *Assumption of the Virgin*, dated 1667 and sent from Naples for the altar of the Salute, and in his *Presentation of the Virgin at the Temple* and *Birth of the Virgin*, both dating from the early 1670s and painted for the same church. Boschini is highly complimentary in his 1674 edition of *Minere*, stressing, however, the Venetian element of Giordano's art and his debt to the great sixteenth-century masters. Loth also converted to a Roman- and Cortona-influenced Baroque in his altarpiece, the *Holy Family*, for the church of S. Silvestro, dated 1681, in which a great light illuminates the scene from the left, flowing over the forms and creating a marvelous sense of movement.

If, with the Tenebrists, the walls of churches and palaces had become gloomier because of the severity and grimness of the themes and the emphasis on violent shadows, then lifting one's eyes to the ceiling,

from which the influence of Veronese had never been fully excised, the impression received must have been very different indeed, one of the dominion of light.

In the first half of the century Strozzi and Padovanino's artistic dignity had already been fully recognized in Venice by virtue of their "Veronesism" with their tondi for the ceiling of the Libreria Marciana, respectively the *Allegory of Sculpture* (1635) and *Astronomy, Atlas, and the Nile*. During this period, the two painters worked side by side on the ceiling of the church of the Incurabili whose center was dominated by the *Paradise* begun by Peranda and finished by Maffei, and which had at the sides the ovals with the parables of the *Unworthy Wedding Guest* by Bernardo Strozzi and the *Wise and Foolish Virgins* by Padovanino. From what has survived—Padovanino's oval, now in the Gallerie dell'Accademia, and fragments and two drawings of Strozzi's work—it is possible to see the audacity of the illusionistic foreshortening of the figural groups situated directly against the open sky, combined with a full burst of color. The lost painting by Maffei must have been similar if we recall the decoration of Palazzo Nani in Cannaregio (now at Ca' Rezzonico), dating from around 1658. Less than ten years later Boschini discussed the work taking place on the island of S. Giorgio: "For the new library, five paintings are currently being prepared, to be mounted on the ceiling, by two young students, one named Giovanni Coli, the other Filippo Gherardi, both of the school of Pietro da Cortona." It was with these two artists from Lucca, who had arrived in Venice via Rome on the advice of Pietro da Cortona himself, that the Veronese revival became truly established, with the declared aim of fully exploiting the compositional structures and the tonal coloring of the sixteenth-century master. In the conceptual refinement of the themes, inspired by divine wisdom and expressed in the wooden statues on the bookshelves depicting pagan and Christian sages from antiquity, Veronese became Baroque through the body of the architecture, the complex edifices reaching for the sky, the audacity of the lowered perspectives, and the evocativeness of the decoration.

The next step, developing the potential of this neo-Veronese style by marrying it with large-scale *quadraturismo* [scenographic perspective painting] was taken by Giovanni Antonio Fumiani on the occasion of his commission, in 1684, to decorate the ceiling of S. Pantalon with a scene of the martyrdom and glory of the saint. Despite his relative youth, Fumiani produced a *tour de force*, spending nearly twenty years painting the vast surface. His apprenticeship in Bologna with the *quadratura* painter Domenico degli Ambrogi had given him the necessary tools for the scenographic construction of the various moments of the saint's martyrdom, linking the human figure to the architectural support, while his studies of Veronese-influenced ceilings enriched his language with the most varied complexities of perspective and luminism. Fumiani had already worked on sacred themes (*Disputation of Jesus in the Temple*, in S. Aponal; *Charity of St. Roch*, in the church of S. Rocco), presenting his subjects from a lowered perspective against ample theatrical backgrounds which articulate the space, endowing it with a full and monumental cadence.

In S. Pantalon, Fumiani faced his greatest test, aiming to give the worshiper the impression of celestial space, animated in the center by a vortex of angels to which one's gaze is drawn via the illusion of foreshortened architecture and great perspective strength. His painting is integrated into the actual architecture, adapted to the two great arches of the chancel, to the large window of the facade on one of the short sides, and to the smaller semicircles of windows on the long sides. All around the walls, sweeping flights of steps tower above, peopled with armed men and knights in poses so reckless that the figure of the saint immediately stands out, immobile, outlined against the arch of a colossal colonnade. The various episodes into which the ceiling is divided are incorporated into the calculated contrast between the foreshortened human figure and the architectural structure, creating the effect of imbalance. The resulting illusion of Baroque metaphor renders this ceiling a Venetian parallel of that created in Rome, around 1685, by Andrea Pozzo in the church of S. Ignazio.

Documentary evidence demonstrates that the ceiling of S. Pantalon was still unfinished on 23 October 1706, when the enormous canvas was uncovered for eight days at the request of the Elector of Bavaria, Theresa Cunegond Sobienski, during one of her many visits to Venice, to her great delight and "the satisfaction of all the nobility." By this date the Settecento, under the dominant influence of Veronese, was fully under way, mainly in the hands of Venetian painters.

Stefania Mason

The Interior Decoration of Palaces in Venice: From Baroque Magnificence to Rococo Elegance

Pesaro family coat of arms emblazoned in gold and silver.

OPPOSITE:
The Triumph of Venice, Nicolò Bambini, 1682. Palazzo Pesaro in S. Stae, central ceiling decoration. Bambini, a favorite with the Venetian aristocracy, executed this commission for the Pesaro family, glorifying both the Republic and the family through clear visual allusions to the 16th-century ceiling paintings in the Palazzo Ducale; the theme is spelled out in the Latin inscription "ferro aeque sceptroque potens [powerful equally through sword and scepter]" on the scroll near the bottom of the composition.

Magnificence, Gold, and Splendor

The edifices of this city offer themselves marvelously to the eyes of the onlooker, but seen from inside they provoke greater astonishment and wonder, being embellished in such a delightful and elegant fashion. If one tried to describe them, one could appear a liar.

Thus wrote the Venetian engraver and publisher Giacomo Franco in 1610 (*Habiti delle donne veneziane* [The dress of Venetian women], echoing Francesco Sansovino who in his celebrated guidebook, *Venetia città nobilissima et singolare,* had emphasized the magnificence of Venetian palaces and their interiors. This is something that has always struck the visitor to the city: going back in time a little, a pilgrim from Lombardy who arrived in Venice in 1494 on his way to the Holy Land reported, in tones of astonishment, that he had seen in Palazzo Dolfin "a fireplace of solid Carrara marble which shone like gold, so finely carved with figures and foliage that neither Praxiteles nor Phidias could have added anything. The ceiling of the salon was so marvelously worked with gold and ultramarine blue, and the walls so finely carved that I cannot describe it . . . So many figures, beautiful and lifelike, and so much gold everywhere." The regal, radiant gleam of gold surrounded everything, and this priceless glitter became the image most commonly associated with Venetian taste, manifested particularly in interior decoration: it was as if each patrician residence was required to reflect the gold lavished on the basilica of S. Marco and the reception rooms of the Palazzo Ducale.

Sansovino himself indicated the cause of so much splendor: it was partly because Venice, from her foundation onward, had never been "touched by the hand of a predator or enemy," and partly on account of the wealth acquired from mercantile activities. "To this can be added the fact that the noble houses for hundreds of years have remained beautiful because the authorities desire it, and because of sea trade, they have most happily augmented their beauty. And although in the past they were most parsimonious, they nevertheless adorned their houses splendidly." In the words of Sansovino, whose guidebook was intended to shore up the myth of Venice, this sumptuousness, far from being a mere display of opulence, reflected greater glory on Venice. The splendor with which private houses were decked was the tangible, highly visible sign of the privilege of inviolability of which only Venice could boast: a providential privilege which had made possible the accumulation of wealth and its "artful" use. The combined efforts of Mercury and the Graces had endowed Venice, the virgin city, with the seductive charms of Venus.

Sansovino placed emphasis particularly on the external architecture of the palazzi, leaving to the imagination what was concealed behind the facades or could be glimpsed through the huge leaded windows which seemed to magnify vertically the refraction of the light on the water. Giustiniano Martinioni, by contrast, in his revision of Sansovino's guidebook published in 1663, focused on the interior decoration and, in one instance, indulges himself with a highly detailed description. This was a clear sign of the change that was occurring. The role of status symbol was gradually being attached to the interior decoration of the private residence. Among the "memorable edifices" being restored or newly constructed, Martinioni mentions the Palazzo dei Corner Piscopia at S. Luca: "partly remodeled, embellished, and enlarged with noble salons . . . regally ornamented" with "surrounding moldings . . . most skilful, of graceful form and marvelously carved." He also describes the residence of the Widmann family at S. Canciano, remarkable "for its magnificent rooms . . . and for being furnished inside with statues, paintings, and other riches," that of the Tiepolo family at S. Felice, "remodeled, and decorated in many places, richly adorned with precious furnishings, and ornamented with many excellent paintings," and that of the Basadonna family at S. Trovaso, "built a few years ago, of delightful contours, with many comfortable rooms, and gracefully ornamented." It is worth pointing out that alongside the old patrician families

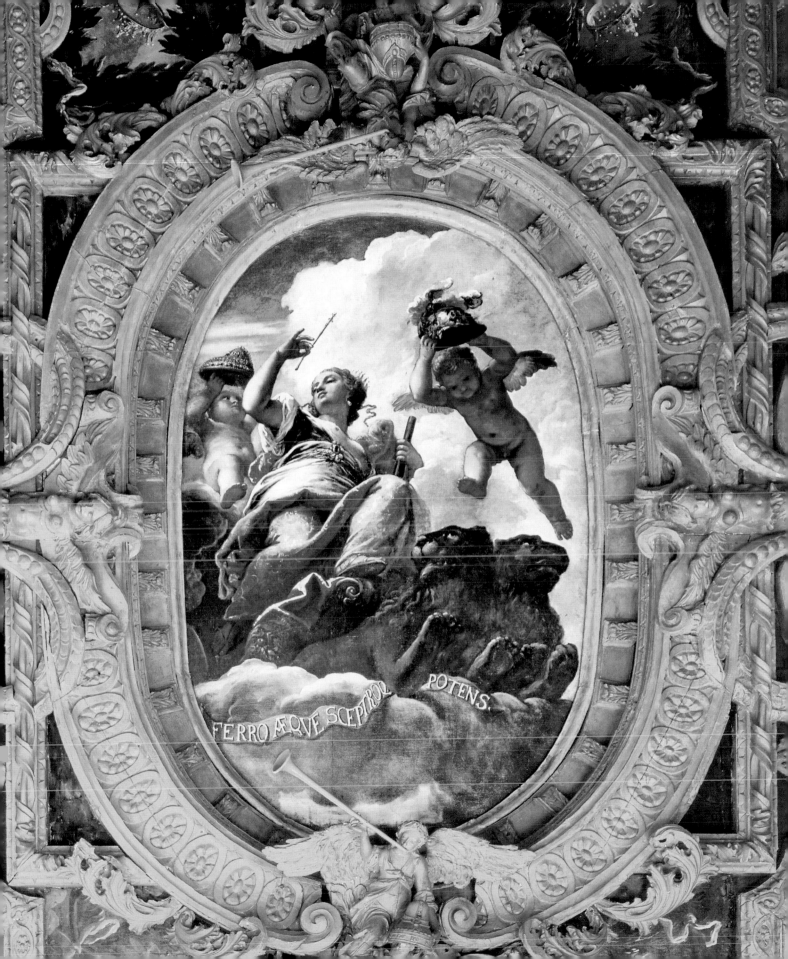

FERRO AEQVE SCEPTROQ POTENS.

appear others of more recent date such as the Widmann, elevated to the nobility as recently as 1646. Such new patricians were the so-called Iraklion nobles, those whom Venice, searching for new blood in order to confront the Turks in the war in Crete, had decided to welcome into the ranks of the patriciate, after, of course, the payment of a considerable sum. In fact it seems to have been the creation of this new nobility, whose prestige was founded on wealth rather than on lineage or past glory, which sparked off the spirit of emulation among the Venetian aristocracy, inciting them to compete in the exhibition of their private splendor. With the aim of distinguishing themselves

"the eyes and the soul are entranced by the whiteness of the ceiling, its extraordinary height, and the surroundings decorated with stuccoes, festoons, figures, and other graceful forms . . . the noble adornments which shine there, and the variety of delightful objects which are placed all around." Statues were distributed in niches with discerning symmetry, busts and heads on shelves, low reliefs, and oval paintings in gilt frames by Liberi, Pietro della Vecchia, and Ruschi, as well as other older masters. The staircase divided into two, forming "a space converted into a Grotto" in which were conspicuous, in "a niche completely lined with mother-of-pearl . . . a group of two statues, Adonis and Venus,

Project drawing for a stucco and painted ceiling for a *salone* in Palazzo Erizzo at the Maddalena, by Andrea Celesti, 1680–90. Paris, École des Beaux-Arts. The cartoon illustrates the deeds of Paolo Erizzo, 15th-century ancestor of the commissioning family, who was executed by Mehmed II after his heroic defense of Negroponte in 1469. The central panel depicts his execution, while the surrounding panels are taken up with allegorical figures—Faith, History, Fame, Strength, Constancy, Martyrdom—and the whole conception is structured in an ornate decorative continuum.

they even imported foreign models, mingling them with traditional forms, and in order to render their rooms more sumptuous, they modified their original use. To magnificence they added the spice of novelty, which in itself provoked wonder. Thus Giacomo Cavazza, raised to the ranks of the nobility in 1653, transformed the rooms on the ground floor of his palazzo at S. Lucia, normally destined "for lesser domestic use," into "places of delight." Martinioni's enthusiastic description is worth quoting in full. The description itself is Baroque in the way in which it lists one detail after another, with a cumulative effect which is both varied and brilliant. The *androne*, or *entrada* [atrium, or entrance] had been turned into a gallery. Upon entering

embracing each other, admirably sculpted." The gallery led into an equally splendidly adorned *salone*. One then passed into a loggia "with a stuccoed ceiling and gouache paintings all around" which gave onto a courtyard decorated in *prospettive* [perspectives], in other words, illusionistic architecture, the work of specialist painters from Brescia. The visit concluded in a room which resembled a picture-gallery, on account of the statues in niches and the figured stucco panels painted by contemporary artists, including a *Diana at the Bath* and an *Andromeda on the Cliff* by Francesco Cairo.

Nothing like it had ever been seen before in Venice, as we can tell by the prominence given to it

Infant Cupid with Jupiter and Juno, detail, Sebastiano Ricci, 1705. Berlin, Staatliche Museen. This work, probably commissioned in celebration of the marriage of Alvise IV Mocenigo to Pisana Corner, decorates the ceiling of one of the rooms in Palazzo Mocenigo at S. Samuele, possibly intended to be the couple's bedroom.

Apollo Rising, Louis Dorigny. Palazzo Zenobio, *salone* ceiling. The French painter celebrates the myth of Apollo who rides his chariot over the horizon in the central oval, itself framed by an elaborate illusionistic (*trompe l'oeil*) portico decorated with plaster medallions.

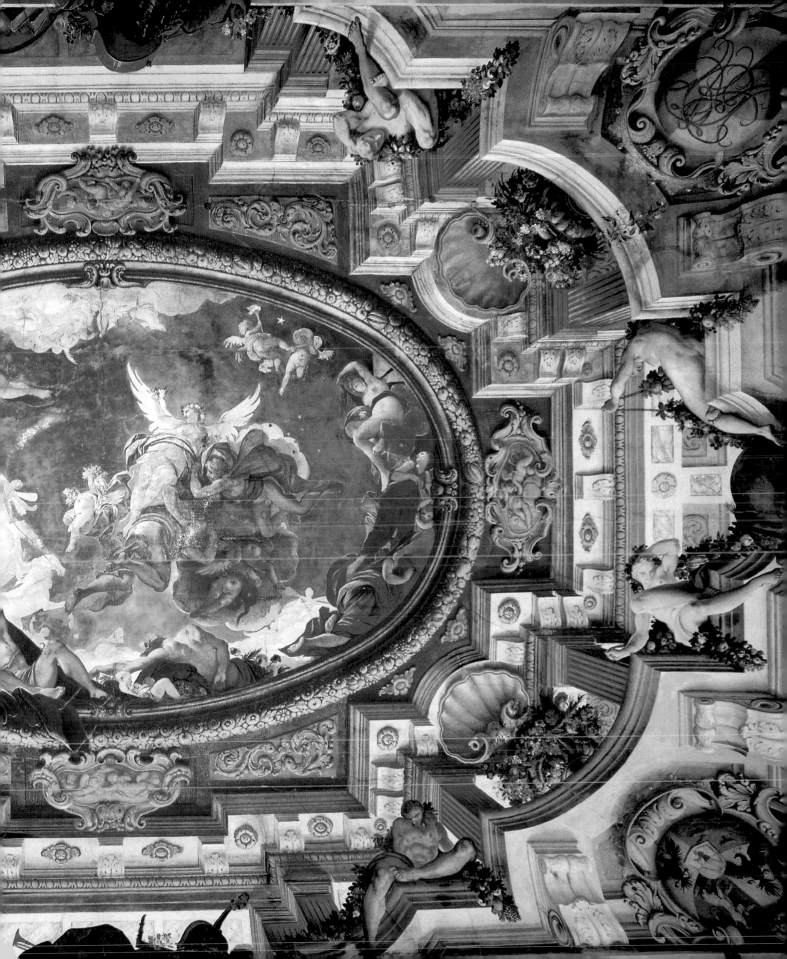

by Martinioni. To the best of our knowledge, it is the first example of interior decoration governed by a style which, in the variety and density of the decorative elements, the mingling of different materials and techniques, and the striving for the element of repeated surprise, can, in the broadest sense, be defined as Baroque.

Ca' Pesaro

During the same period, the massive edifice which would become the most imposing Venetian palace of the seventeenth century was rising up from the banks

1688]. A ceiling remains from the original seventeenth-century decoration containing an inscription with the patron's name and the date of the work, 1682. It is in sections, the wood of the cornices having been left in its natural state, enlivened by the presence of figures fully in the round (the Spirit of Fame overlooking the Pesaro family crest (see p. 508) and pairs of chained slaves), rendering them even more impressive than the paintings. The mounted canvases by Nicolò Bambini, a pupil of Pietro Liberi, during his long career one of the Venetian aristocracy's preferred painters, depict in the central oval the *Triumph of Venice* (see p. 509), "ferro

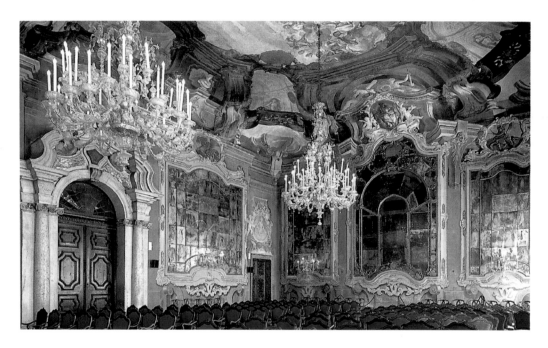

Palazzo Dolfin at S. Pantalon, *salone*, 1709. The original decoration was probably intended for a reception given by Daniele IV Dolfin for Frederick IV of Denmark. On the walls were ten canvases by Giambattista Tiepolo, but these were sold and dispersed in the 19th century.

of the Grand Canal. The doge Giovanni Pesaro, a passionate collector of contemporary painting, who had begun its construction, entrusting the project to Baldassare Longhena, had bequeathed the edifice to his nephew Leonardo (Lunardo in Venetian dialect) with the clear exhortation to increase its "beauty and size." He could not have made a more shrewd choice, considering Leonardo's love of pomp and splendor. It was Leonardo, in fact, who erected the spectacular funeral monument to his uncle the doge in the church of S. Maria Gloriosa dei Frari, and who astonished his contemporaries on the occasion of the wedding of Elena Pesaro to Pietro Contarini degli Scrigni in 1676 when he lined the palace walls "with superb embroideries, and placed quilted curtains at the windows, made of fine wool interwoven with gold and silver, and other rich adornments" [Ivanovich,

aeque sceptroque potens" [powerful equally through sword and scepter] on the ceiling, and along the frieze below an array of Virtues: *Strength, Prudence, Faith, Christian Religion, Experience, Liberality*). These were the virtues of the nobility and, in particular, of the Pesaro family: in exercising them, the Pesaro had contributed to the glory of the Republic. Both in the themes, which only a family as ancient and noble as this could choose, and in the decorative typology, there is an obvious resemblance to the sixteenth-century ceilings in the Palazzo Ducale; the aim was to provoke in the observer an immediate association of ideas between the Palazzo, in its meaning as the seat of power, and the dwelling of the ducal family. In the suggestion of this intellectual link between the two buildings the indissoluble link between the State and the aristocracy is affirmed.

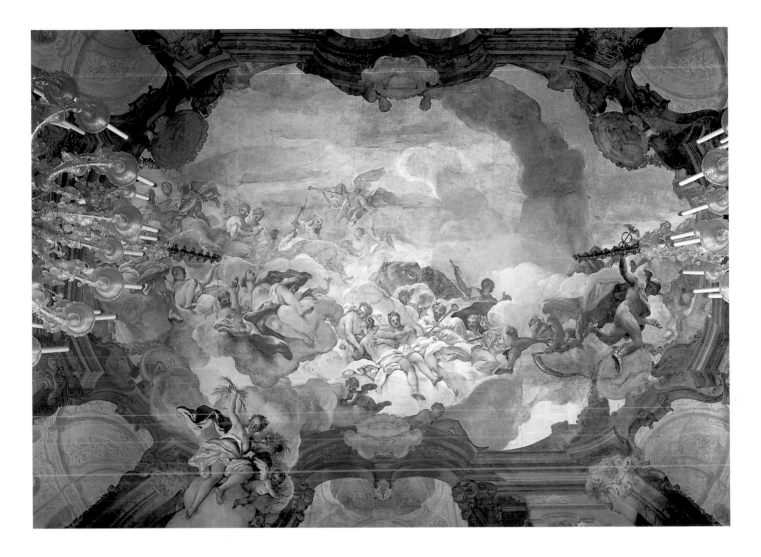

Palazzo Mocenigo

From the end of the sixteenth century onward, in the wake of the pictorial decoration of the Palazzo Ducale with primarily historical themes, the practice became widespread among the nobility of portraying the deeds of their ancestors in series of canvases arranged like a frieze immediately below the ceiling. The frieze of Palazzo Mocenigo at S. Samuele is an example. It was executed during the 1620s by a number of painters (Ingoli, Ponzone, Padovanino, Zaniberti) and illustrates the glorious adventures of Tommaso Mocenigo. A comparison between this simple regular sequence of canvases and Andrea Celesti's project for a *salone* in Palazzo Erizzo at the Maddalena, dating from the late seventeenth century (Paris, École des Beaux-Arts) (see p. 510), reveals to what extent tastes had changed during the Baroque. Although the protagonist here is

also a family hero, Paolo Erizzo, who, as a punishment for his strenuous defense of Negroponte in 1469, was sawn in half at the orders of Mehmed II (a hero-martyr of particular relevance at this point since between 1683 and 1699 war was raging against the Turks), the principal paintings and those which surround them, almost like petals, depicting allegorical personifications (*Faith, History, Fame, Strength, Constancy, Martyrdom,* etc.), are structured in an ostentatious ornamentation, markedly plastic, packed with trophies, foliage, shell-like elements, and grotesque masks. The effect is one of *horror vacui* [literally, fear of the void, of empty space], a decorative continuum in which curves predominate. The ornamentation was almost certainly intended to be carried out in stucco as its malleability rendered it the most suitable material for the realization of artistic fantasy. As the touch of the spatula or the hand

Allegory of Venice between Personifications of Virtues and the Gods of Olympus, Nicolò Bambini, in collaboration with the *quadraturista* Antonio Felice Ferrari. Ca' Dolfin, *salone* ceiling. A false loggia in rose marble, articulated with sinuous corner shelves and balconies, increases the room's height, opening onto an expanse of sky. Abundance, bearing gifts to Venice, is painted in full flight, and Amphitrite, riding a gigantic dolphin, alludes to the Dolfin family. The fresco is an early 18th-century example of monumental Baroque decoration.

breathed life into it, stucco rapidly became the preferred medium for Venetian interiors.

Ca' Zenobio

If the ancient nobility had the privilege of staging its own past, the new aristocracy entered the lists raising the tone, so to speak, by concentrating, as we have seen, on innovations both in architectural typology

At Ca' Zenobio, Antonio Gaspari, the most sought-after architect for the remodeling of palazzi between the Seicento and the Settecento, kept only a portion of the original *portego*, a modest space, which contrasts strongly with the immense *salone* into which it leads via a Serlian arch. The surprise effect here is enhanced by the frescoes which extend along the upper walls and ceiling, an operation

Gilded stucco decoration by Ticino masters. Palazzo Barbaro-Curtis, salone, overdoors.

and interior decoration. The case of the Zenobio family is typical. Elevated to the nobility in 1646, the family remodeled, during the late seventeenth century, the palace they had acquired from the Morosini. On the first floor they created a splendid *salone*, two floors high, for entertainment and music. This was an audacious innovation when one considers that the interior spatial arrangement of Venetian palazzi had remained more or less unchanged for centuries: the *portego*, or entrance hall, had acted as the building's spine, a great corridor that ran all the way through the building, with rooms on either side.

which further amplifies the height, simulating an open gallery, following the *quadratura* [scenographic perspective] models promoted by decorators from Emilia Romagna. The room is flooded with clear brilliant colors, enhanced by the light pouring in through the double row of windows in the wall that overlooks the canal. The decoration in stucco over the doors and on the moulding of the mirrors consists of putti with garlands and palm branches, gilded medallions and trophies, further enlivening the ambience and, through the use of white and gold, increasing the effect of diffuse splendor. Apollo, god of the sun and of the arts, is the theme, a choice which

may have been inspired by ideas imported from France, where during the same period the myth of Louis XIV, the Sun King, was establishing itself. The theme may have been suggested by the painter himself, Louis Dorigny, a Frenchman, who was obviously familiar with his father Michel's engraving, based on a ceiling by Vouet, the *Rising Sun*. Similarly here, in the large central oval, the god rises above the horizon in his

over the cornice, azure vases overflow with flowers, and, with a touch of comedy, a dwarf smoking a pipe sits on the sill of a false window.

Fresco Painting

Such an extensive decoration in fresco, the technique most suited to the creation of spatial illusionism and chromatic brilliance, was common for inland palazzi

chariot, preceded by Aurora, the dawn, who with her companions the Hours and the zephyrs chases away the ghosts of the night announcing and auguring a brilliant future for this family which had so recently joined the ranks of the nobility (see pp. 512–513). The adventures of Apollo are depicted in the frescoed medallions in false relief and in the gilded stuccoes over the doors, while the Muses are displayed along the upper part of the walls, above the rose marble cornice. The insertions of illusionistic vignettes, authentic *trompe l'oeil*, emphasize the "artful" character of the whole, as if it were a temporary staging for some feast: carpets and musical instruments spill

and villas, but relatively unusual in Venetian secular architecture. Nor is it surprising that the author of such an undertaking was a "foreigner." Venetian painters, wrote Ravelli in 1692, preferred to paint in oils, with which they could pass "for serious virtuosi, whereas with frescoes they were ridiculous. In fact here one rarely uses this form of painting because, due to the salt, the lime pastes do not hold and within a short space of time the paints break down; therefore no one studies the technique."

A significant episode is related concerning this point. Antonio Lin, in the palace which he acquired in 1691, had planned:

Barbaro family coat of arms with two-headed eagle on top of a silver oval with red.

ON PAGES 518–521:
Allegories, painted by Antonio Pellegrini, surrounded by richly molded plaster decoration by Abbondio Stazio. Palazzo Albrizzi, *portego* ceiling. The ceiling canvases within their curvilinear frames give the impression of being supported by the plaster angels which are almost in the round.

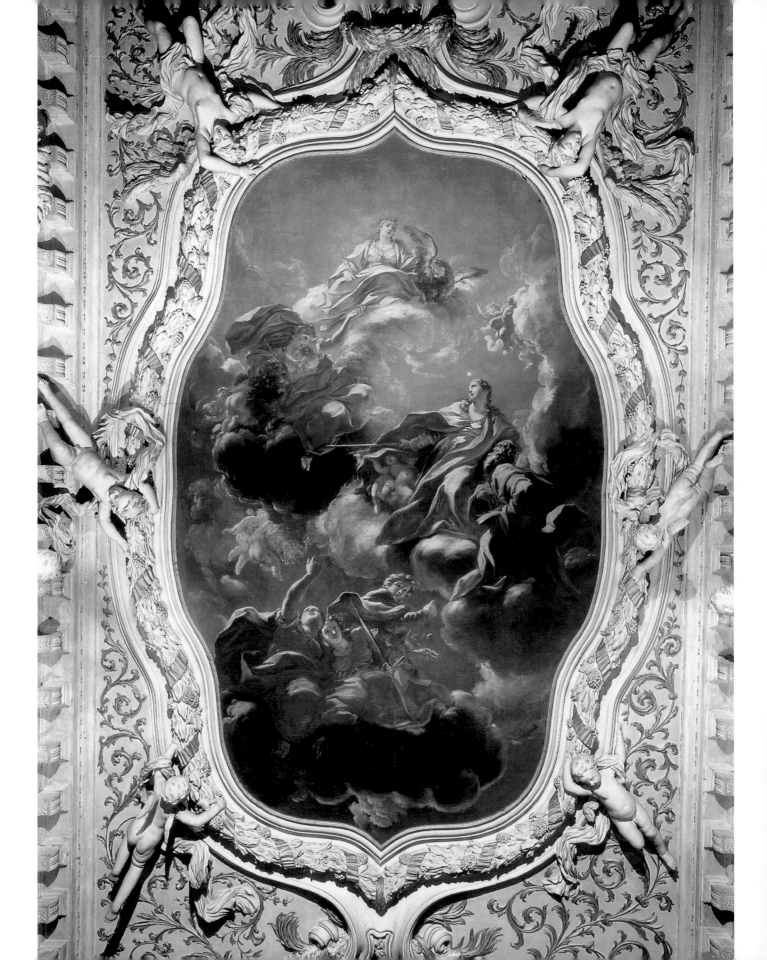

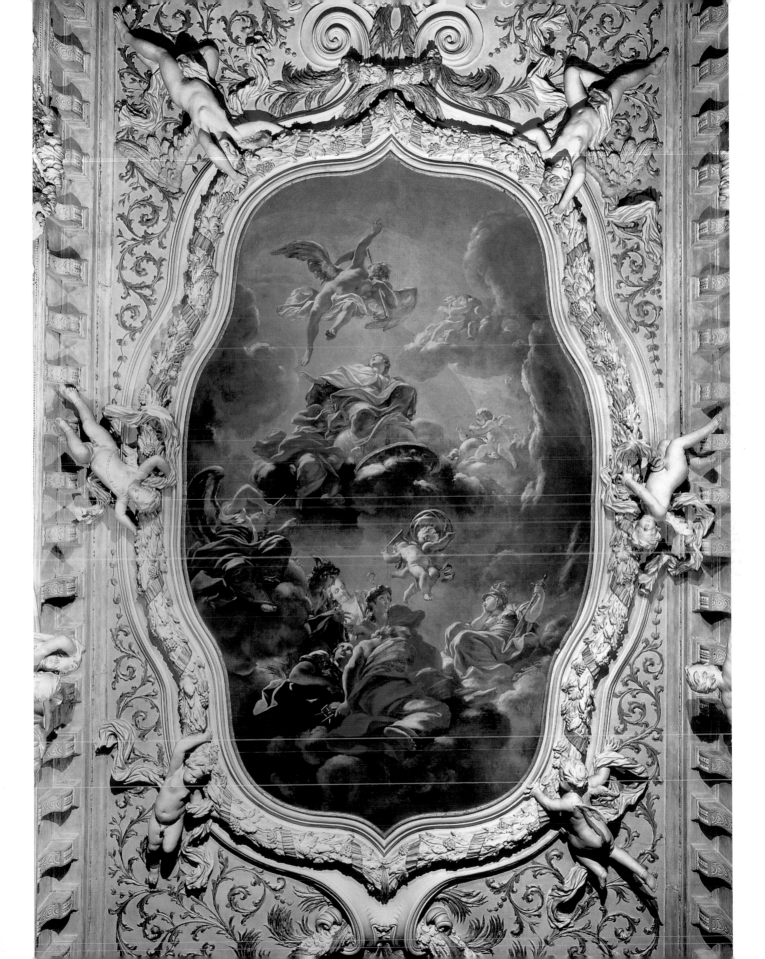

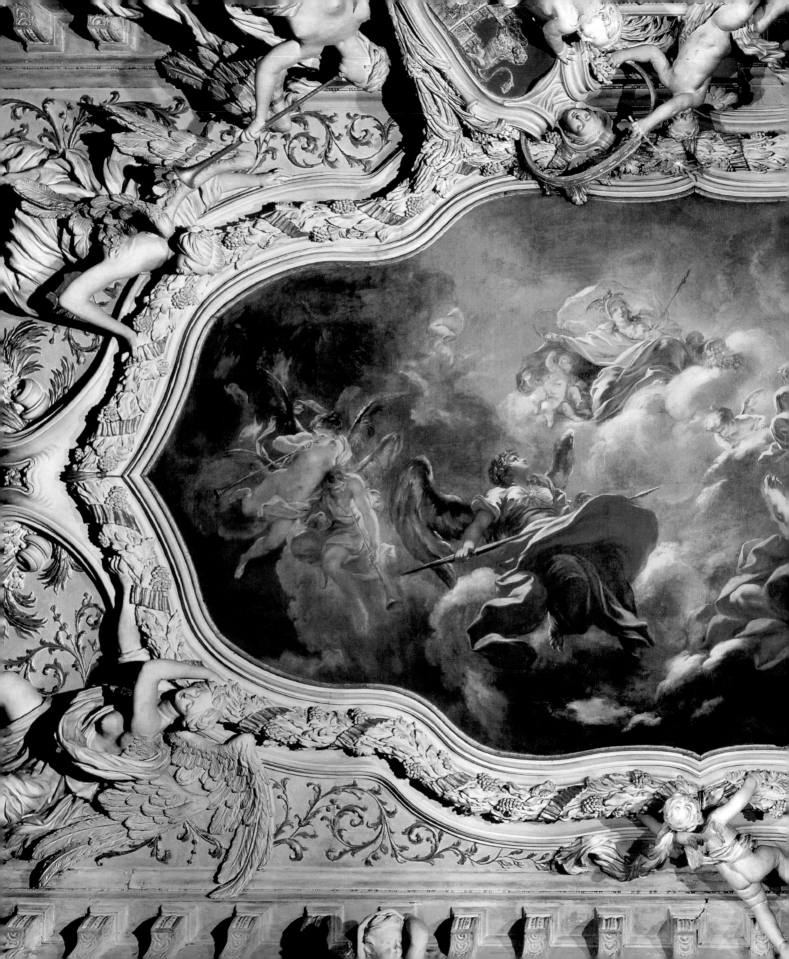

Allegory, Pellegrini and Stazio. Palazzo Albrizzi, *portego* ceiling, center. As in the other two *Allegories* in this room, the precise meaning remains unknown.

Fame with the Merati Family Coat of Arms, detail of plaster decoration, Abbondio Stazio and Carpoforo Mazzetti, 1689–1712. Palazzo Merati on the Fondamenta Nuova. This splendid group surmounts the double doorway into the *portego*.

a salon decorated in stucco with niches, which were meant to be painted with frescoes. Desirous of seeing the work completed, he had the wall prepared. He then invited to his table the painters Bellucci, Molinari, and ... Lazzarini, all three already familiar with his house. After the meal, all of them being ignorant of the matter, he most courteously advised them of what he desired. They were all disturbed, never having worked with frescoes in that manner. However, having seen that all was disposed, they applied themselves

with great enthusiasm, completing the work in three days so marvelously that it was impossible to decide to whom to award the palm [Da Canal, 1732].

For these three renowned Venetian painters, working with frescoes was the exception. Shortly afterward, around 1698, all three were employed on a room in Ca' Correr near the Fondaco dei Turchi, but each one was at work on a large canvas with oils (now in Ca' Rezzonico).

The episode reveals to what extent the taste for fresco decoration had become fashionable in Venice. It is symptomatic that Nicolò Bambini applied himself to it, being appreciated for his ceilings "interwoven with poetic and bizarre inventions." In the Palazzetto Zane, for a project designed toward the end of the seventeenth century by Antonio Gaspari as a library and entertainment space, Bambini's contribution was precisely in the form of frescoes, married in this case to stucco work, the other fashionable decorative technique, which multiplied the presence

the collaboration of *quadratura* painter Antonio Felice Ferrari on the vault of the *salone* of Ca' Dolfin (another modern architectural structure, without the traditional *portego*). It was completed in a great hurry, as the painter himself boasted, possibly for the reception held in 1708 by Daniele IV Dolfin, the hero of Metelino, in honor of Frederick IV of Denmark. A false loggia in rose marble, articulated with sinuous corner shelves and balconies, augments the height of the *salone*, opening it onto an expanse of sky (see p. 514). Arrayed among the clouds is an allegory of

of putti in a tangle of oak branches and shells, creating a graceful, now eighteenth-century, effect. Subjects included moralizing myths and allegories, *Time Embracing Truth* on the ceiling above the stairs and *Hercules on Mount Olympus* on the ceiling of the *salone*. Also in fresco is a sacred theme, combined with vigorous stucco ornamentation, which Bambini executed in the *alcova* of Palazzo Savorgnan sometime around 1710.

The most extensive fresco work after Dorigny's at Ca' Zenobio was also carried out by Bambini with

Venice between personifications of Virtues and the gods of Olympus, including Amphitrite riding a gigantic dolphin, an allusion to the Dolfin family, while Abundance in flight spills over the cornice bearing gifts (see p. 515). This is undoubtedly the most Baroque creation in the field of monumental decoration in early eighteenth-century Venice. Echoing Luca Giordano but lacking his pictorial verve, it is an exaltation in human form of Venice and her aristocracy, the guarantors of "the best of all possible governments," perfectly justifiable in the

Charity, Nicolò Bambini. Palazzo Savorgnan at S. Geremia. The old photograph reproduced here shows the work in a good state of conservation; restoration work is now needed.

climate of optimism and rediscovery of her own image which characterized Venice between 1699, the year of the Treaty of Carlowitz which confirmed the Republic's conquest of the Peloponnese, and 1714, when war once again broke out with the Turks.

Ca' Barbaro

A *salone* devoted to entertainment, as magnificent as possible, became the new element which characterized the remodeling and expansion of Venetian palazzi. Another impressive example from the end of the seventeenth century is the *camerone* [large room], as it is called in the documentation, with typical Venetian understatement, built for Alvise Barbaro by Antonio Gaspari in the palazzetto adjacent to the ancient family home. The vault, decorated with great conservatism, contains oval canvases by Antonio Zanchi depicting famous women of antiquity; a dense network of white stucco in the form of plants and vegetation acts as a link between the canvases, creating an overall impression of joyousness. Contemporary painters were also responsible for the canvases on the walls, originally lined with gilded leather and later covered by a proliferation of stucco, creating an overall decorative unity (see pp. 516, 517). Prominent on the larger wall is the *Rape of the Sabine Women* by Sebastiano Ricci, painted shortly after his return to Venice in 1696. The main characters in the *Coriolanus* by Antonio Balestra, executed around 1709, are also women, the mother and wife of Coriolanus, who are dissuading their kinsman from attacking Rome; and there are more women on the overdoors which Tiepolo painted toward the end of the 1740s. A theme of women pervades the room, therefore, with the exception of *Mucius Scaevola before King Porsenna* by Giambattista Piazzetta (also probably painted toward the end of the 1740s, possibly to replace another work).

It is the choice of subject which leads us to conclude that the apartments at Ca' Barbaro, culminating in the *salone*, were designed and decorated with a wedding in mind. Such splendid decorations were generally undertaken on the occasion of a marriage, partly because this was one of the rare occasions on which Venetian palaces opened their doors to guests. It provided, therefore, the ideal opportunity for a display of private splendor, an abundance of ornamentation being considered auspicious for the new couple. For example, it was probably on the occasion of the marriage of Alvise IV Mocenigo to Pisana Corner in 1705 that Sebastiano Ricci painted the works (now in Berlin, Staatliche Museen) for the ceiling of one of the rooms in Palazzo Mocenigo at S. Samuele, possibly intended to be the couple's bedroom. The subject of the paint-

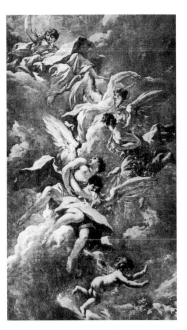

Aurora and the Nymphs of the Air, Antonio Pellegrini, painted on canvas for Alvise Pisani's palazzo on the Grand Canal. Biltmore House, Asheville, North Carolina. The subject-matter, painted with swift and light brush strokes, makes this one of the first works in Venice to embody the rococo spirit.

OPPOSITE:
View of a reception room in Palazzo Widmann in the S. Canciano district. Martinioni wrote extensively about this residence, remarkable "for its magnificent rooms."

ings supports this hypothesis: an infant Cupid is welcomed by Jupiter and Juno while the principal Olympian gods form a circle around them (see p. 511). The ceiling is a segmented one, following a sixteenth-century type; on it Ricci brilliantly illuminated his subject, evoking the Carracci and Veronese. A comparison with a similar type of ceiling at Ca' Pesaro, about twenty years earlier, reveals Ricci's innovative contribution to "modern good taste" not only in the choice of theme and the liveliness of his palette, but also in the simplification of the framing

popular and as finely executed in Venice as elsewhere. If painting, in particular fresco, dissolves the wall and illusionistically expands the space, stucco masks the wall itself under a metamorphic proliferation of motifs and images which tend to invade the real space. In each case, painting and stucco combine to eliminate borders and architectural measure, transforming living space into a theater of the imagination. The phenomenon became extravagant in its diffusion and quantity, partly owing to the presence in Venice of a genius in stucco work, Abbondio

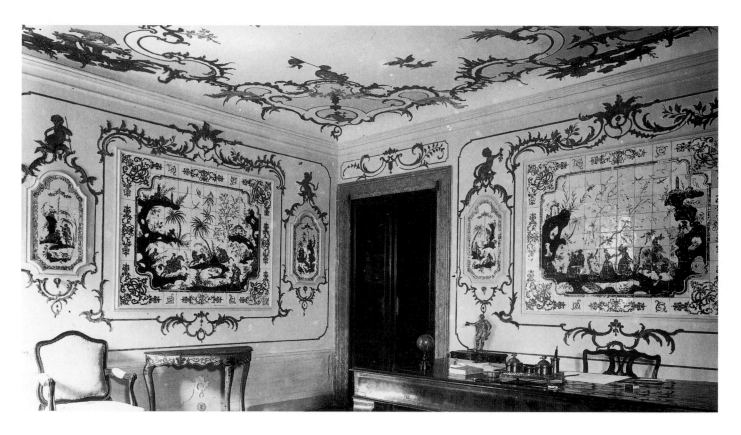

Chinoiserie decoration in a mezzanine room of the Palazzo Foscarini in the Carmini district. The photograph was taken in the 1950s.

structure (recorded in an old photograph), which exchanged opulence for elegance, to the advantage of the paintings.

Stucco Work

On several occasions we have mentioned how around the turn of the century the use of stucco in interior decoration was gradually gaining in importance. It was not until the second half of the seventeenth century, through the example and influence of chiefly Roman models, that stucco became as

Stazio, originally from the Ticino region, and his associate Carpoforo Mazzetti, known as Tencalla. For almost half a century they were, deservedly, leaders in their field.

Palazzo Albrizzi

The triumph of stucco is in the palace which the Albrizzi family, nobles since 1667, acquired in the late seventeenth century. They had made their money in trade and now aspired to be known as patrons of the arts, as is illustrated by the painted ceiling executed by Bambini in one of the rooms of the palace. The canvas shows Mercury, god of

View of a reception room in Palazzo Widmann in the S. Canciano district. Martinioni wrote extensively about this residence, remarkable "for its magnificent rooms."

ON PAGE 528:
Fall of the Giants, detail of the wall of the monumental staircase decoration in Palazzo Sagredo, painted by Pietro Longhi, signed and dated 1734. The monumental fresco depicts Jupiter crashing down on the Titans.

ON PAGE 529:
Detail of the interior decoration of the mezzanine on the third floor of Palazzo Sagredo with stucco decoration by Abbondio Stazio and Carpoforo Mazzetti Tencalla, 1718. The interlacing stucco with trophies and garlands, livened by naturalistic brightly colored birds, as a whole creates a highly decorative impression full of grace and charm.

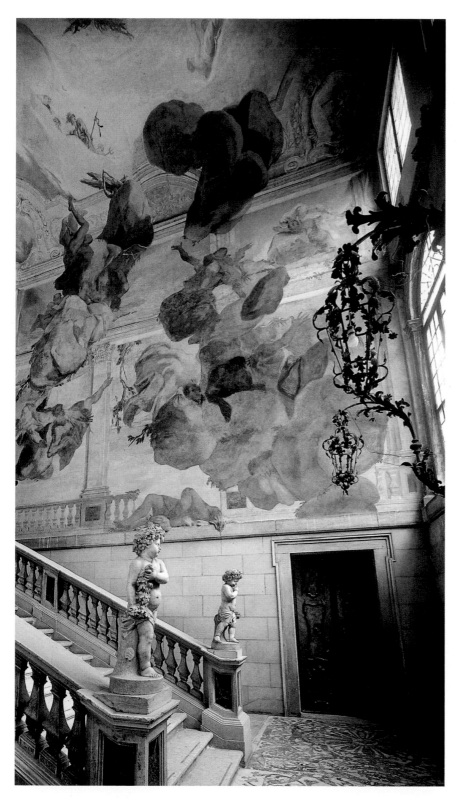

commerce, gliding down while Apollo presides over a gathering of the Muses. The decoration was executed at the beginning of the eighteenth century. The structure of the building, which dates from the late sixteenth century, was maintained. In recompense, the luxuriance of the stucco work, traditionally attributed to Stazio and payments for which appear to have been made between August 1700 and May 1701, transforms the interior into a phantasmagoric scene. The walls of the *portego* had paintings by some of the most important Venetian artists of the late seventeenth century, while the ceiling was painted by Antonio Pellegrini, who had recently returned from studying in Rome and whose work shows the combined influence of Baciccio and Maratta (see pp. 518–521). But it is the stucco adornments in gold and white which mold and give character to the ambience, animating every surface, the plastic arts finally taking their revenge on painting, even if their methods were undulating and touched by chiaroscuro, almost painterly, the hallmarks of Baroque stucco. The long and somewhat narrow room is transformed into an aviary of winged figures, of leaping putti. The very canvases of the ceiling, with its molded form, are held up by angels fully in the round, according to the illusionistic principle of the *quadro portato*, much favored in Rome. In another room, perhaps intended as a bedroom, it is the milky, malleable stucco, faintly luminescent due to the presence in the mixture of marble powder, which gives shape to the spectacle of flying putti (twenty-eight in total) who are busily unfurling a filmy curtain over the ceiling, an ornament for the staging of a feast, an ephemeral and joyous vision fixed for eternity. The inspiration comes from Rome (Stazio had been apprenticed as a youth in the city) and from Bernini (for example, the putti in white stucco holding up a heavy curtain in the Sala Ducale in the Vatican), who had already inspired the sculptor Filippo Parodi for the fluttering curtain in the background on the funeral monument of Patriarch Francesco Morosini (d. 1678) in the church of S. Nicolò da Tolentino.

Palazzo Merati

Although Palazzo Albrizzi is the only Venetian palace containing such an exuberance of stucco (which might almost appear excessive, typical of *nouveaux riches*), the fashion for "Roman" stucco proved contagious, with its figures in the round or in high relief, materializing or slipping out from between gilded garlands, ribbons, foliage, and drapery moving in the breeze. In Palazzo Merati on the Fondamenta Nuova, whose decoration dates from between 1698 and 1712, a Fame in stucco, as in

ON THE PRECEDING PAGES:
Ceiling fresco, Giambattista Tiepolo,
1724–25. Palazzo Sandi. Reserving the
central zone for the divinities, Tiepolo
arranged the mythological episodes around
the cornice, like an imaginary ground floor.
An astonishing awareness of life animates the
individual figures who, seen from below,
stand out against the background of the sky.

Triumph of Marius, Giambattista Tiepolo,
1729, painted for Palazzo Dolfin at S.
Pantalon. New York, Metropolitan Museum
of Art. The painting is part of the cycle
commissioned by Daniele III and Daniele IV
Dolfin for the main reception room of the
palazzo. The cycle depicts episodes from
Roman history and wartime triumphs which
allude to the military valor
of the patrons themselves.

OPPOSITE:
View of the main reception room in Palazzo
Labia showing the fresco decoration by
Giambattista Tiepolo, 1746–48. The story of
Antony and Cleopatra is illustrated in a series
of paintings framed by fabulous illusionistic
architecture created by Girolamo Mengozzi
Colonna. The decoration, which covers the
entire room, is unique in 18th-century Venice.

ON THE FOLLOWING PAGES:
Meeting of Antony and Cleopatra and
Banquet of Antony and Cleopatra,
Giambattista Tiepolo. Palazzo Labia. Each
scene, disposed between false columns,
creates an illusionistic space that perforates
the wall. In the *Meeting of Antony and
Cleopatra*, the queen of Egypt steps out of her
magnificent barge at anchor in the river port
to meet the Roman warrior. In the second
fresco, the banquet, given by the queen in
Antony's honor is set on a splendid terrace to
which the viewer appears to have access by
means of a painted flight of stairs that seems
to rise from floor level.

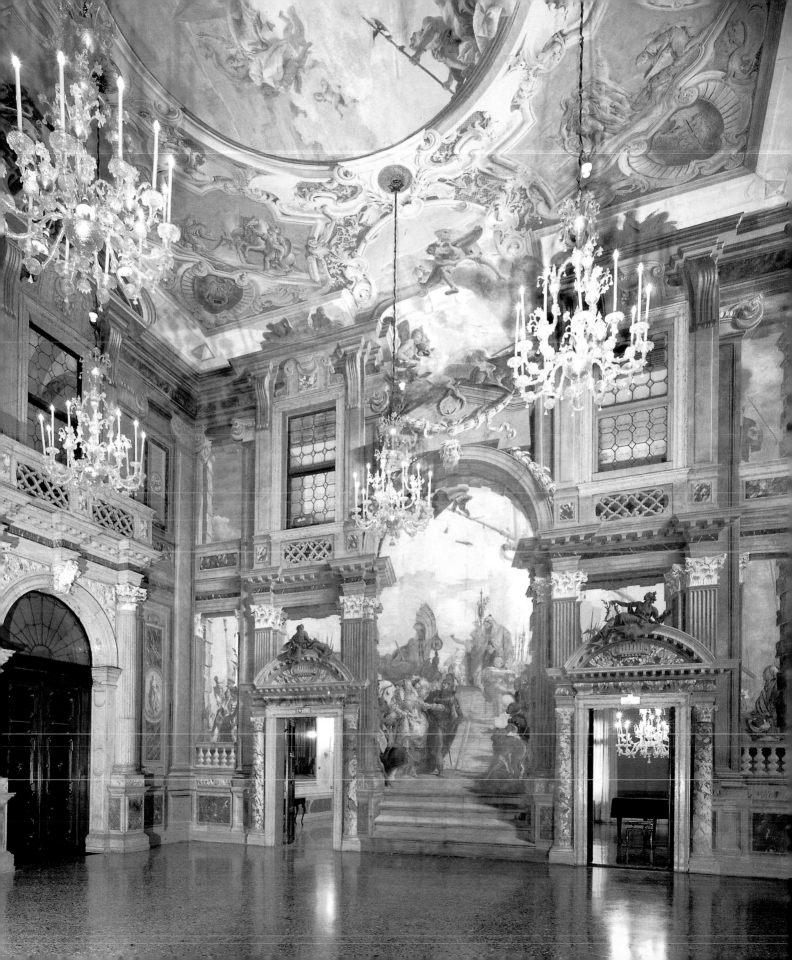

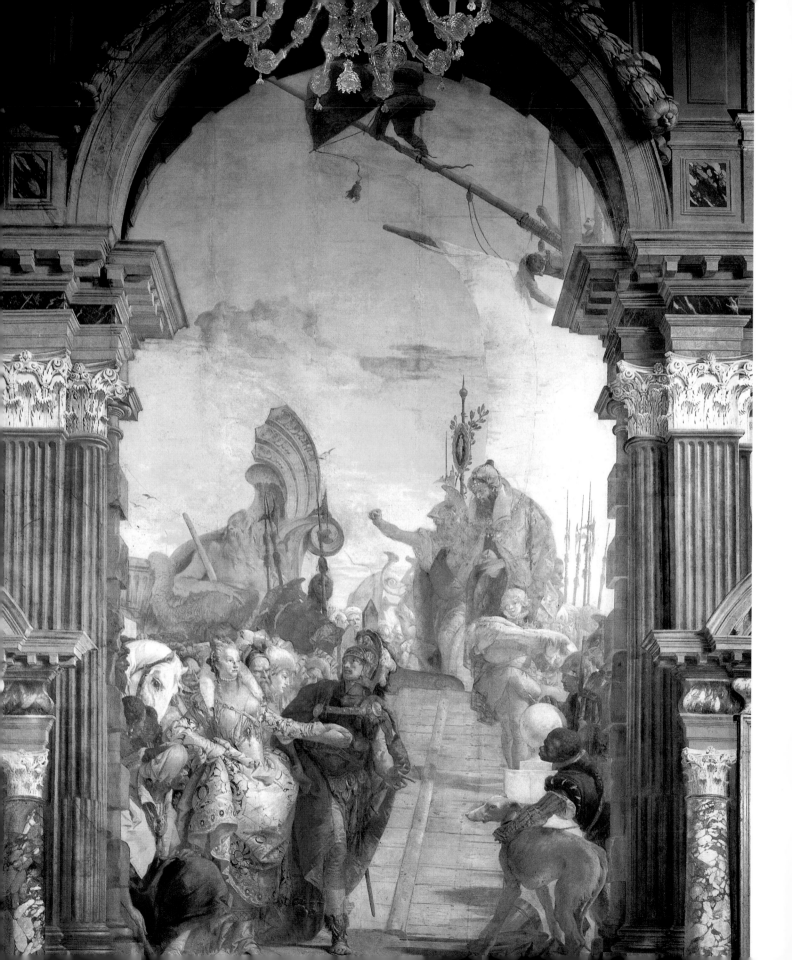

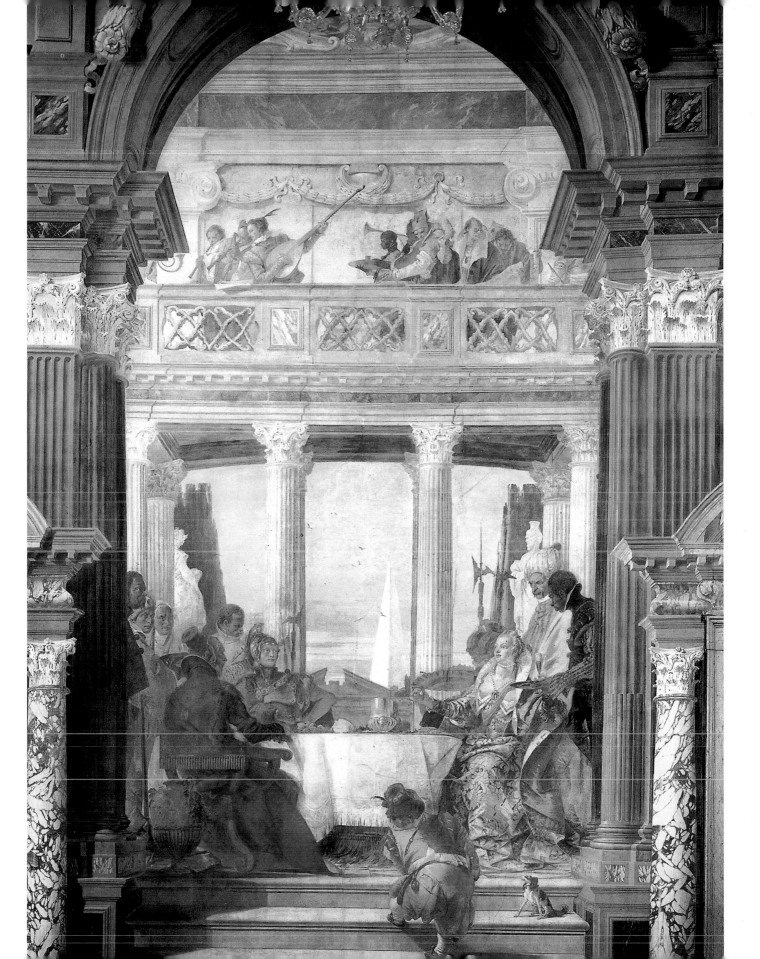

Cleopatra, detail of *The Meeting of Antony and Cleopatra*.

century examples can be found in Palazzo Merati, Ca' Zenobio, Ca' Sagredo, and in the bedroom (which could, in fact, be a boudoir) of Palazzo Widmann, an enchanted recess swarming with putti between flowery arabesques, ribbons, garlands, and luxuriant foliage in white and gold. This is probably the work of Giuseppe Maria Mazza, from Bologna, to whom are also attributed the overdoors in one of the other rooms, clearly modeled and at the same time vivaciously naturalistic, inspired by the overdoors frescoed by Carlo Cignani in S. Michele in Bosco in Bologna (1665). More putti, this time in pairs, extricate themselves from the soft folds of drapery, supporting medallions containing personifications of the liberal arts.

Ca' Pisani

A panegyric essay, one of the many published in Venice, reveals the ideological motivation behind this competition in decorative splendor which manifested itself with such exuberance between the seventeenth and the eighteenth century. In the *Oration in Praise of His Excellency Signor Cavalier Luigi Pisano, Procurator of S. Marco*, published in 1711, the panegyrist, listing the virtues of the newly elected procurator, writes: "To Liberality ... one must add another Virtue, which makes heroic use of wealth: Magnificence." The example came from the Republic itself, which had desired the creation of Piazza San Marco, the heart of its power, a defined "theater of marvels," with its scenographic surroundings consisting of the basilica and other buildings. The palaces therefore had to express "the greatest efforts of an art intended to demonstrate, through the nobility of the edifices, the greatness of whoever lives there, or whoever commanded the construction, or whoever enjoys dominion over it."

Alvise Pisani himself, who was elected doge in 1735, confirming his possession of the virtue of magnificence, ordered the expansion of the already impressive family palace. The job of painting certain ceilings, by this stage the interior decorator's favorite area, was entrusted to the most avantgarde painters, exponents of "modern good taste" such as Sebastiano Ricci and, later on, around 1721, Antonio Pellegrini, responsible with others for the vast ceiling of the ballroom depicting *Aurora and the Nymphs of the Air* (now in Biltmore House, Asheville, North Carolina) (see p. 525), a graceful, carefree subject in the spirit of Rococo (the artist had recently returned from Paris), and totally different, even in the handling of the brush, from the ceilings he had produced at the beginning of the century in Palazzo Albrizzi, populated by abstract allegorical personifications. Alvise Pisani had acted as ambassador to the court of Louis XIV, and the

Palazzo Albrizzi, nestles between the structures of the roof and the family crest, which blossoms into a mass of eagles, putti, and olive branches (see p. 522). Despite the varied repertory of the modeled images, putti are everywhere, caught in the most unusual poses (these are, after all, the years in which Louis XIV was requesting his decorators, after a period dominated by the figure of Apollo-Sun, to "répandre de l'enfance partout" [to spread childhood everywhere]). The bedrooms were especially populated with them, as if these lively and graceful presences were endowed with the function of stimulating the fruitfulness of the newly-weds. Some early eighteenth-

Detail of *Banquet of Antony and Cleopatra*.

style of Versailles had undoubtedly influenced his artistic choices.

The Influence of France

Whatever the case, Pisani was not the only one aware of the French innovations. Venice herself, in fact, from the early years of the eighteenth century, was influenced by French taste, as can be seen in interior decoration. Paris was the leader now, not Rome, and the styles being developed at Versailles became everyone's model. It is significant that the fictitious letter published in the newspaper *La Galleria di Minerva* [The gallery of Minerva] in 1708, in which

are described the furnishings of Palazzo Manin on the occasion of a particularly sumptuous family wedding, was addressed to the "Marchioness N.N. in Paris." The imaginary Venetian correspondent describes the rooms as hung with "damasks embellished with gold . . . golden drapes woven like velvet . . . pure velvet decorated in high relief with cloth of gold," concentrating in particular on a room lined with "an exquisite damask embroidered with lifelike flowers against a white background" which resembled a garden of silk. "I would have heard you burst forth with the exclamation one usually hears when encountering such greatness in Italy: *Cela se pourrait*

Hall of mirrors, Palazzo Labia, detail, 18th century. Elegant monochrome frescoes are inserted between antique mirrors.

faire à Paris [That might be done in Paris]." And he adds: "If our Nation had as much spirit as yours in creating an income and in trading on the curiosity of others, we would quickly see maps of all these apartments, just as we see those of Versailles hung at our fairs. . . ."

The French influence signified grandeur and wealth, certainly, but accompanied "by grace and loveliness." These terms, which refer to the court of Versailles, are taken from the *Diario di Francia dell'anno 1668* [Diary of France for the year 1668] by Lorenzo Magalotti. "Each object is laughing inside," he noted, marveling at the ample proportions of certain rooms, in which everything tended "to entertain and delight the eye and nothing to fatigue the mind." Thus there were no pictures except for portraits of princesses and ladies.

Ridotti

Besides rooms for entertainment, the French model resulted in the proliferation of private areas of greater comfort and intimacy, such as the *ridotto* or *casino*, often to be found on the mezzanine floors of palazzi, whose decoration tended precisely toward "grace and loveliness." A fine example is the *ridotto* in Palazzo Sagredo. On the surfaces of such relatively small spaces the stucco decorators Abbondio Stazio and Carpoforo Mazzetti Tencalla alternated late seventeenth-century motifs such as trophies and draperies with networks of lighter stucco, like lace or embroidery (see p. 529). They enlivened them with birds in natural colors and embroidered their work with grotesques and miniaturized motifs among little pavilions, tassels, and ribbons. Even the figures were in stuccoed low relief. Color vivified the background and colored too were the fascias, delicate borders, and intertwining cornices and ribbons in subtle tints, mostly pink or pale yellow. Fully aware of having created something unique and original, the stucco decorators affixed their signatures and the date, 1718. Obviously, the inspiration for this type of decoration came from French models, such as Bérain's *Arabesques*, carved at the end of the seventeenth century, but the refined tone and the freshness of the naturalistic insertions rendered it unmistakably Venetian. Or, rather, this is how it seems to us, given that the repertory of forms and motifs invented by Stazio and Tencalla spread throughout Venice over the following decades, on walls and ceilings, in inexhaustible variations, gradually cross-breeding with more flexible and unfettered *rocaille* devices.

Complex low-relief stucco, which embraces the most diverse motifs, was complemented by the use of precious fabrics for lining the walls. This was a "foreign" fashion, of increasing popularity, although

View of the splendid airy *portego* in Palazzo
Pisani-Moretta on the Grand Canal. The
fresco by Jacopo Guarana was completed at
the end of 1772; the chandeliers are from
Murano.

OPPOSITE:
Partial view of a small chamber in Palazzo
Pisani-Moretta showing plaster decoration
and *grotteschi*.

not everyone approved. Anton Maria Zanetti the
Younger, a great connoisseur of Venetian painting,
deplored the preference given to "adornments in the
foreign fashion, in other words textured fabrics, inta-
glio, earthenware vases, and various graces . . . over
beautiful and cultured paintings" (1733). As a result,
local painters, greatly appreciated abroad, were obliged
to emigrate in order to find work suited to their
talents. The use of the expression "earthenware vases"
probably refers to the work of Stazio and Tencalla,
who frequently employed the vase motif in their
stucco work, in a wide variety of forms (an example

in a public building is the stuccoes on the vault of the
church of the Gesuiti).

Mythological Themes

As for the "beautiful and cultured paintings,"
Zanetti was undoubtedly thinking of the cycles on
canvas of historical or mythological themes painted
for a precise location—usually the portego or enter-
tainment salon—frequently by more than one hand,
and governed by a fashion which had established

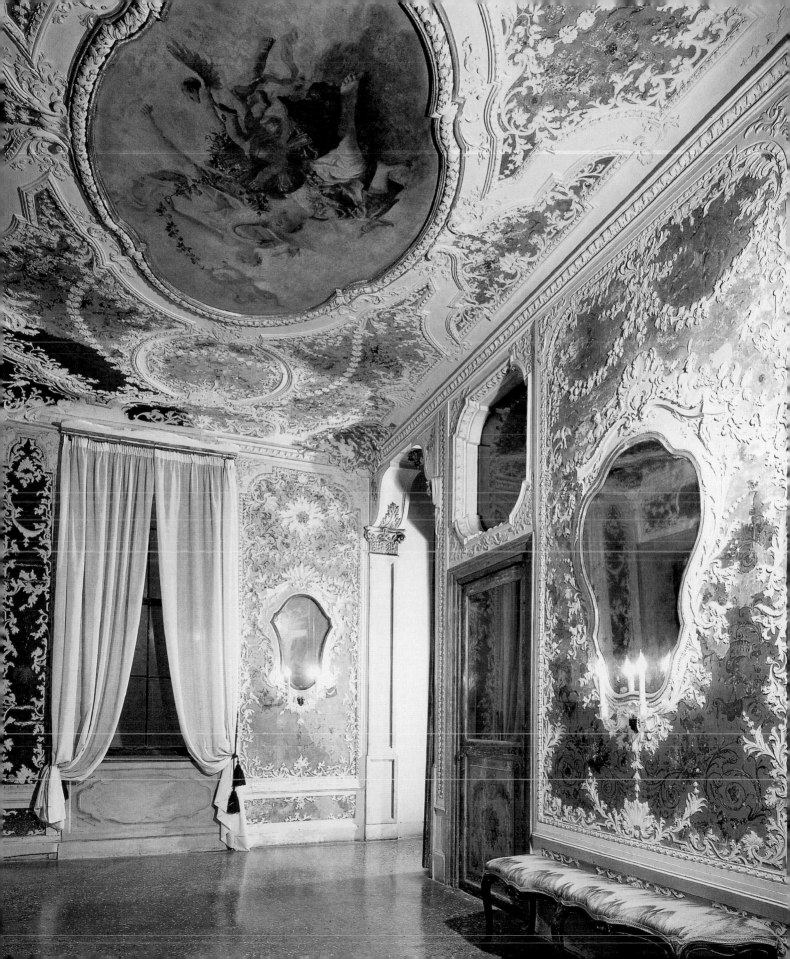

Pisani-Moretta family coat of arms surmounted by the lion of St. Mark.

itself in Venice during the late seventeenth century. Fine examples of cycles still in place or which have not been dismantled include those in the portego of Ca' Barbaro, painted by Bambini and Segala, and the vast mythological canvases for Ca' Correr, now in Ca' Rezzonico, by Lazzarini, Molinari, and Bellucci (mentioned above).

Even more magnificent works were produced during the early decades of the eighteenth century, distinguished by a greater unity and coherence with respect to content. At the beginning of the century Louis Dorigny painted for Palazzo Tron, in addition to a ceiling depicting *Hercules on Mount Olympus* (Dézallier D'Argenville, 1762), a cycle, still in place in the *portego*, of no fewer than fourteen canvases of biblical subjects, a sign that sacred themes were finally appreciated in, and appropriate for, a private, secular context.

One of the most spectacular examples of entirely pictorial decoration (now in the United States; only a rare photograph records its original location) was to be found in the salon of Palazzo Corner at S. Tomà, produced over a period of time by several painters. The first work, at the beginning of the century, was done on the overdoors with episodes illustrating the family's history (executed by Lazzarini, Molinari, and Ricci). Later, possibly carried out in stages, came vast wall canvases portraying the story of Scipio, supposedly an ancestor of the Corner family (by, among others, Pellegrini and Bortoloni).

The iconography accurately represents the taste of the old nobility and its conception of art as a means of self-promotion, a provocative choice, it could be said, in open conflict with the new nobility, who could not boast of such illustrious forebears, some of whom allegedly even dated back to the Roman republic. What is more, the idea of completely covering the walls with historical paintings recalls the Palazzo Ducale, also completely lined with paintings, another way of underlining the link between the family and the State.

However, themes are not always so solemn and profound. Between 1707 and 1709, one Giustinian Lolin hung the walls of his palazzo on the Grand Canal with paintings by the Frenchman Jean Raoux, summoned for the purpose from Rome. This is the triumph of mythology, with a preference for tales with an erotic or courtly content. *Trompe l'oeil* simulates the gilt frames of the pictures and the ornamental decoration of draperies as well as cascades and festoons of fruit and flowers, in a cheerful illusionistic game and with an exuberance of ornamentation resembling the style of the French court.

OPPOSITE:
Venus Welcoming Mars, Giambattista Tiepolo and Francesco Zanchi, 1743. Palazzo Pisani-Moretta. The central part of the ceiling, commissioned by Chiara Pisani, has been recently restored.

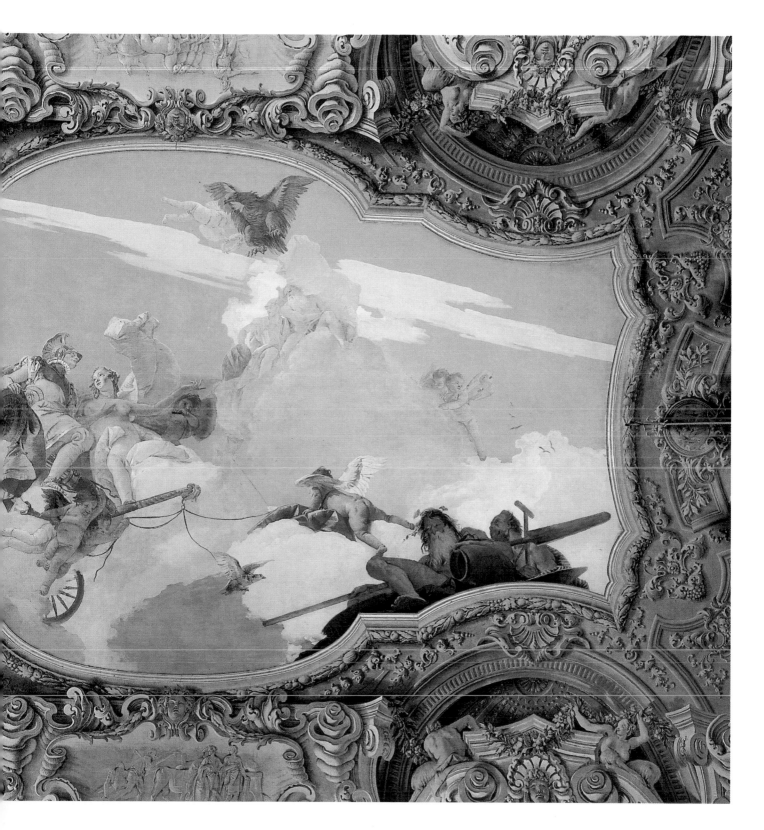

Giambattista Tiepolo

A new and increased interest in large-scale historical scenes arose from the success, around the end of the second decade, of a young and brilliant painter, Giambattista Tiepolo. The cycle of paintings which he produced around 1720 for a room in Ca' Zenobio, portraying the deeds of Queen Zenobia, who had, due to her name, been adopted by the family as an ancestor, and the vast canvas (almost six meters across) of the *Rape of the Sabine Women* for the Patriarch Jacopo Zorzi (now in the Hermitage, St. Petersburg), from more or less the same period, ...ked tremendous enthusiasm due to their ...gy, pathos, originality, and creativity. It is not ...prising that both the old and the new nobility immediately took under their wing this youngster who was "all spirit and fire," and whose fantasy was as admirable as the rapidity of his execution.

Palazzo Sandi

Tiepolo quickly mastered the fresco technique, suited to his genius which designed on a grand scale and required vast surfaces. He was, as a result, the perfect artist for monumental decoration. He produced a marvelous demonstration of his skills in Palazzo Sandi, which had recently been remodeled (1724–25). Not only did he produce three wall canvases for the salon, but he also frescoed the vault with esoteric myths, alluding to eloquence, the gift which had procured for the Sandi family, famous lawyers for generations and recent members of the aristocracy, their wealth and prestige (see pp. 530–531).

Taking as his reference the typology favored by Luca Giordano in the gallery of Palazzo Medici-Riccardi in Florence, Tiepolo flung wide the celestial space and, reserving the central zone for the divinities, arranged the mythological episodes around the cornice, like an imaginary ground floor. An astonishing awareness of life animates the individual figures which, seen from below, stand out against the background of the sky. The space appears to be swept by a powerful wind which, generated by the central vortex of yellowish clouds, reveals shafts of azure, and raises and swells cloaks, unveiling vigorous or delicate nudity. Tiepolo's different treatment of the distribution of the mythological episodes as compared to his original design (London, Courtauld Institute Galleries)—he moved the scenes with greater narrative development to the long sides—demonstrates his awareness, when tackling fresco, of the shape and dimensions of the room space, and of the visual conditions and sources of light, rendering him a truly great director of the pictorial spectacle. The decorative typology of these ceilings, which Tiepolo went on to develop on the vaults of the gallery of Palazzo

Details of plaster decoration with *grotteschi* and animals. Palazzo Barbarigo.

Clerici in Milan, the grand staircase of the bishop's palace in Würzburg, and the throne room of the royal palace in Madrid, curiously enough did not become popular in Venice itself. Here the preference was for compositions with free figures in a celestial setting or structures resembling false pictures seen from below, following the example of Paolo Veronese, and always within elaborate frames.

Ca' Dolfin and Ca' Pesaro

The young Tiepolo faced his greatest challenge in the field of secular pictorial decoration shortly after working on Palazzo Sandi in a cycle of ten canvases depicting episodes from Roman history, for the salon of Ca' Dolfin at S. Pantalon (now divided between the Hermitage in St. Petersburg, the Metropolitan Museum of Art in New York, and the Kunsthistorisches Museum in Vienna). These were the final elements of the pictorial furnishings of this vast room, whose vault, as mentioned earlier, had been frescoed by Nicolò Bambini in collaboration with the *quadratura* painter Antonio Felice Ferrari. Tiepolo and his patrons, Daniele Dolfin III, a skilful orator and ambassador for the Republic, and Daniele Dolfin IV, a courageous soldier who had lost his left hand fighting against the Turks, understood each other well. He created for them the most prodigious historical painting seen in Venice since the sixteenth century. The theme is the usual one favored by the old aristocracy: heroic episodes, military triumphs, excerpts from the history of Republican Rome. It sets forth and exalts values which were by then obsolete, since the Venetian Republic, after the Peace of Passarowitz which finally brought to an end the war against the Turks (1718), had chosen a policy of neutrality and withdrawal. Defying the times, Tiepolo projected the past into the present, rendering it with a passion equalled only by Rubens. The two triumphal processions, portrayed head-on, seem to be advancing toward us with a plunging movement; the chromatic clangor, strengthened by the light coming from the windows overlooking the canal, becomes a unified whole with creative audacity and imitative and expressive emphasis. This was truly the last great example of epic painting in Venice and seems almost to have been a sign of destiny. The year in which the painting was finished, 1729, signed on the *Triumph of Marius* (which includes Tiepolo's self-portrait) (see p. 532), was also the year in which both patrons died.

Despite the example of Palazzo Sandi, it was not, for the time being, Venice which brought Tiepolo success as a fresco artist, but Milan where, in a series of rooms in Palazzo Archinto and in the great hall of Palazzo Casati (1730–31), he had the chance to demonstrate his skill in this field. During the same period he was called to work on Ca' Pesaro, where the ceilings of a suite of rooms were being painted for the marriage of Antonio Pesaro and Caterina Sagredo. (Tiepolo was one of a whole group of artists of different generations including Angelo Trevisani, Gerolamo Brusaferro, and Giambattista Pittoni working on the project.) Most of the paintings were oil on canvas, including the portrait of Tiepolo himself (now in Ca' Rezzonico). In his sky, surrounded by putti, Flora and Zephyr sail in a flying embrace, he with the transparent wings of a dragonfly—a vision of Rococo grace (see p. 559).

In some of the rooms in Ca' Pesaro the canvases are surrounded by a frescoed cornice, embellished in

one instance by false reliefs, and inhabited in another by allegorical figures in niches among vases of fresh flowers, a less important accomplishment, but one which is crucial to the definition of the decoration. It was the work of a colleague of Tiepolo, Giambattista Crosato, possibly completed just before his departure for Turin where his gifts as an ebullient fresco artist were put to marvelous use in the hunting lodge of the Stupinigi family (he had to wait another twenty years before achieving recognition in Venice).

Palazzo Sagredo

The most spectacular pictorial undertaking of the 1730s in a patrician dwelling, even though the quality of the results does not equal the project's

View of part of the ceiling in the Sala dell'Alcova, Palazzo Tiepolo (later Palazzo Papadopoli). Frescoes by Giambattista Tiepolo depict putti announcing the chariot of Venus. The corner medallions contain gilded allegories of the seasons.

OPPOSITE:
Time and Truth, detail, Giambattista Tiepolo, 1744–45. Palazzo Barbarigo, ceiling. The painting, depicting one of the Venetian aristocracy's favorite subjects, is surrounded by Gerolamo Mengozzi Colonna's exquisite ornamentation.

aims, is the fresco decoration of the great staircase in Palazzo Sagredo at S. Sofia (see p. 528). The creation of monumental staircases is one of the most important innovations in the remodeling of Venetian palazzi from the late seventeenth century onward. The area was generally decorated with a pictorial work on the ceiling, usually in fresco, according to mainland typological models. Examples are the staircases of Ca' Farsetti at S. Luca and of Ca' Sceriman, the latter dating from 1728, and the work, among

too vast and splendid for the needs of contemporary living.

The Palazzo Sagredo staircase is a work still characterized by Baroque hyperbole, still the dominating feature of patrician dwellings. A French traveler and connoisseur of art, De Brosses, during a visit to Venice in 1739 found that in the Venetian palaces "great magnificence was lavished with very little taste." Obviously, for someone used to the comfort and elegance of French interiors this judg-

View of the ceiling above the monumental stairway in Palazzo Bernardi. The fresco by Francesco Fontebasso shows groups of musicians, pages, and servants at an illusionistic balustrade turning to greet the guests.

others, of Mattia Bortoloni, a fresco specialist of the same generation as Tiepolo. In the case of the great staircase in Palazzo Sagredo, the frescoes cover all the walls. The subject is a powerful fall of the giants, with Jupiter launching thunderbolts from on high, the painter Pietro Longhi, who both signed and dated his work (1734). Longhi shortly afterward abandoned forever the painting of large-scale historical subjects and became famous as a painter of "small figures," of the subdued, intimately detailed life which took place in those splendid interiors, perhaps

ment was inevitable. "There are no fewer than two hundred rooms, overloaded with treasure, in Palazzo Foscarini alone [see p. 526]; but everything is exaggerated," noted De Brosses, himself exaggerating. "There is not a single study or armchair in which one can sit down because of the fragility of the carvings." (One immediately thinks of the carved chairs by Brustolon.) Of "modern architecture" only Palazzo Labia appeared to him to be well designed internally. Who knows what he would have thought had he returned ten years later and seen it transformed, by

the hands of Tiepolo and Mengozzi Colonna, into the kingdom of Cleopatra!

The Apotheosis of the Painted Ceiling

In the history of the remodeling and interior decoration of Venetian palazzi, the phase that could be defined as "heroic," distinguished by its late Baroque style, falls as we have seen at the end of the seven-

the Scalzi, and the Scuola Grande dei Carmini), that he was inundated with requests—obviously by those who could afford him—to leave a mark of his genius in the dwellings of the noble Venetian families. If Tiepolo was unavailable, they turned to other highly esteemed painters such as Gaspare Diziani, Francesco Fontebasso, or Giambattista Crosato, all valorous performers in the field of monumental decoration. It was the triumph of the painted ceiling, to be admired looking upward, so that one became dizzy. The

Winter, fresco by Francesco Fontebasso. Palazzo Contarini in the S. Benedetto district, portion of the ceiling in the Salone delle Nozze e Alcova. The cold season is captured by the portrayal of a young woman warming herself at a brazier.

teenth and the beginning of the eighteenth century, when Venice, after the war of Crete, was relaunching her own image of power. But an even more luxuriant and splendid season, whose causes, if they cannot be attributed to a mere change in fashion, have yet to be revealed, opens in the early 1740s. In this decade Venetian painting achieved its greatest international stature, dominated by Tiepolo, who was heralded as the reborn Veronese. It was in the wake of the success of his public works, and parallel to them (especially the ceilings of the church of the Gesuati, the church of

protagonist was the human figure, whether a divinity of Olympus, the personification of a virtue or a season, or the tragic or gentle heroine of a legend; the sky was the stage. And around these celestial openings, which dispensed both the pleasures of the imagination and those of great art, the role of ornamentation, whether painted or stucco, was that of simulating a variety of frames in the finest of materials, like the musical accompaniment, one might say, to the song.

The first request came, it would seem, from Chiara Pisani who, having inherited a fortune from her

father, began, in 1739, the modernization of the interior of the Gothic family palace on the Grand Canal (see pp. 541, 542). Not only did she commission a monumental staircase and elevate the whole palace by one floor, but she also ordered the decoration of the rooms, summoning stucco artists and artisans, and the most renowned painters of the day, beginning with Tiepolo who, in 1743, frescoed a ceiling with the *Apotheosis of Admiral Vettor Pisani* in which the family hero, idealized and armed *all'antica*, so that one might confuse him with Mars, is carried up to heaven by a nude Venus in her chariot (see pp. 542–543). The celestial vision is surrounded by a bevelled frame, frescoed to resemble stucco, gilded wood, and marble, into which Tiepolo himself inserted false reliefs and small figures of satyrs. The decorator was Francesco Zanchi, who was also overall director of works. Zanchi was highly active during this period, his products unmistakable on account of their characteristic *cartouches,* enriched with elaborate sculptural forms. Other rooms were tackled by Gaspare Diziani and Giuseppe Angeli, a pupil of Piazzetta, who painted three ceiling canvases depicting the allegory of the four corners of the earth and, in the center, an apotheosis of Minerva between Mars and Hercules, as if providing a counterweight to Tiepolo's Venus. Both figures allude to Venice, and also, possibly, to Chiara Pisani herself, in the style of a hyperbolic eulogy. Whatever the case, the choice of theme is indicative of the importance that women were gradually assuming in Venetian society and their influence on style.

Tiepolo painted ceilings for the Manin family (1748), the Barbarigo (1744–45), the Cornaro (1748–50), and the Barbaro (c. 1750), both frescoes and oil on canvas. These ceilings are shafts of heaven in which, for example, Nobility and Virtue, personified by beautiful young men and women, by their mere presence cause the defeat of Ignorance, or, as on the ceiling for the procurator Barbaro (New York, Metropolitan Museum of Art), a dominating Valor (one of the most common of allegorical figures) is encircled by graceful Virtues while Fame sounds the trumpet. The art is always magnificent: Tiepolo succeeds in breathing life into and rendering attractive these encomiastic and moralizing themes, the same employed by the authors of the innumerable eulogies then being published in Venice for all sorts of occasions, from weddings to the accession to a prestigious public office. On a ceiling in Palazzo Barbarigo, surrounded by Gerolamo Mengozzi Colonna's exquisite ornamentation, Tiepolo depicted one of the Venetian aristocracy's favorite subjects, *Time and Truth* (see p. 546). The two embracing figures, the predatory old man and the splendid young woman, could almost be

Decorated walls and ceiling in the Salone delle Nozze e Alcova, Palazzo Contarini. Frescoes by Francesco Fontebasso in shaped oval frames surrounded by elegant stucco decoration by Carpoforo Mazzetti.

Detail of stucco ceiling, Casino Venier of the
wife of the procurator Venier.

OPPOSITE:
Detail of Delft ceramic decoration, ridotto of
Palazzo Contarini a fine example of 18th-
century capriccio taking a clever if bizarre
form.

interpreted as an allegory of the underlying motivation for these decorative undertakings: the aim of creating harmony between the legacy of an ancient civilization nearing its end and the revelation of a new, radiant beauty.

Palazzo Labia

The frescoes in the salon of Palazzo Labia are an anomaly, a unique case, Tiepolo's greatest and most memorable undertaking in a Venetian palazzo since the cycle of canvases for Palazzo Dolfin (see pp. 533–537). Less than twenty years had passed (the frescoes date from 1746–48), and yet the choice of subject, and thus the values which inspired it, could not have been more different. The most prestigious member of the Labia household in this period was Maria Civran Labia, a woman of character, with an amorous past. In Cleopatra, the protagonist of the frescoes, many critics have seen both a representation of the lady of the house and a personification of Venice. If this is the case, it means that Venice by this stage drew her strength from her unique beauty, promoting herself as a capital of art and a place for celebration, where one's gaze is captured by the spectacle, in which painting has a starring role, the mirroring of reality and fiction.

This is the first time, after the great staircase of Ca' Sagredo, that the frescoes in a Venetian palazzo covered a whole room, as was usual in the villas and palaces of the mainland. This allowed Tiepolo and Gerolamo Mengozzi Colonna, who devised and painted the false architecture, to transform the *salone* of Palazzo Labia into the palace of the queen of Egypt, a salon of rose marble whose main walls, pierced like great transepts, open on one side onto the river port, where Cleopatra, descending from her magnificent barge, encounters Antony, and open on the other side onto the garden and terrace which hosted the banquet in honor of Antony. Attracted at one and the same time by the two scenes with which they are confronted, guests are fooled for an instant into thinking that they themselves are in Antony and Cleopatra's retinue, that they have crossed the threshold into the world of the story.

Although he often worked on large-scale projects, Tiepolo, with the soul of the traditional Venetian artisan, also accepted lesser commissions. For example, in the bedroom of Palazzo Tiepolo (later Papadopoli), decorated for the wedding of Alvise Tiepolo and Elena Badoer in 1747, he created glimpses, through the fretwork of a fantastic pavilion modeled in stucco, of groups of putti who act as outriders for the coach of Venus (of which can be seen only the shaft and one wheel) (see p. 547). In the medallions in the corners, overlooked by eagles bearing festoons, he

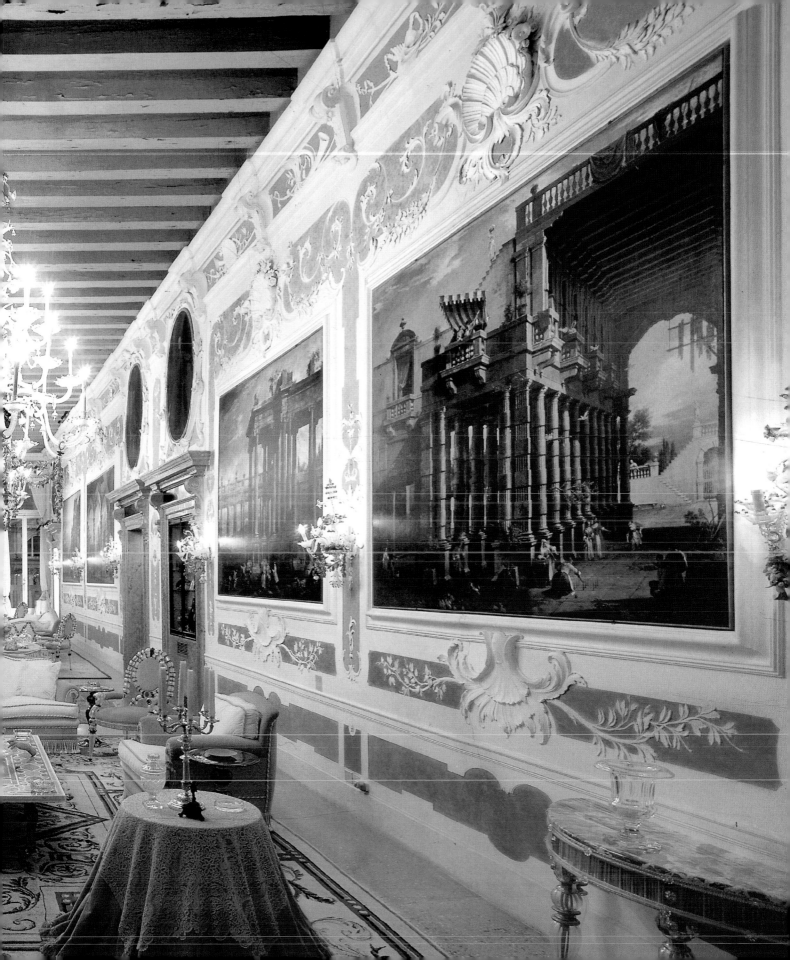

Nobility, Virtue, and Merit before the Temple of Glory, Giambattista Tiepolo, 1757–58. Palazzo Rezzonico, ceiling. This painting was commissioned on the occasion of the marriage between Ludovico Rezzonico and Faustina Savorgnan.

OPPOSITE:
Flora and Zephyr, Giambattista Tiepolo, 1730–31, painted for a ceiling in Palazzo Pesaro. Ca' Rezzonico.

sketched allegories of the seasons in monochrome on gold to signify that love reigns throughout the year.

Gaspare Diziani and Francesco Fontebasso

One of the busiest painters in the field of monumental decoration was Gaspare Diziani, who, "like a fast-flowing torrent, diffused his spirit of fantasy, inventing and coloring, covering vast canvases for Churches and Palaces." Another was Francesco Fontebasso, who painted "in oils and fresco, with such ease as to arouse admiration." He worked with Tiepolo and with Giambettino Cignaroli from Verona (Palazzo Barbarigo) and with Diziani (Palazzo Bernardi, 1743–50; Palazzo Contarini at S. Benedetto, c. 1748), and on his own (Palazzo Boldù, 1744–45; Palazzo Duodo, c. 1743), lavishing on vaults and ceilings his vividly colored, theatrical, and slightly awkward creations "without begging anything from reality." He generally structured his works within elaborate frames, in which the architectural and perspective elements predominate, in the style of Bibiena. His repertory included allegorical themes, usually with the addition of painted epithalamia, and episodes from ancient history and mythology, but he also employed less serious motifs (an innovation in Venetian palaces), characterized by an informal vivacity as, for example, on the ceiling above the great staircase in Palazzo Bernardi (see p. 548). Taking as his reference the recent and much admired works by Tiepolo in Villa Contarini Pisani at La Mira, Fontebasso distributed along a false balustrade groups of musicians, serving-men, and pages, all gaily welcoming the guests. And in Palazzo Contarini, completely redecorated on the occasion of a wedding by Fontebasso, Gaspare Diziani, and the stucco artist Carpoforo Mazzetti Tencalla, Fontebasso manages to surprise us, in the midst of so much vacuity and pomposity, with delightful creations, such as the *Seasons* in the bedroom. Instead of the usual "gray-haired and wrinkled old man or woman," according to the canons laid down in Cesare Ripa's *Iconologia*, Winter is represented by a young woman who, due to the inclement conditions, is warming herself at the flames of a brazier, accompanied by a couple of fur-wrapped children (see p. 549).

Certainly, in order to fully appreciate this type of painting it is necessary to consider the furnishings of which it was an integral part: the stuccoes, wall hangings, gilded or lacquered furniture, lamps in Murano glass overflowing with multicolored flowers, and highly polished floors. The frescoes or canvases on the ceiling were a variation of color within color; the personages presented there, of whose identity the proprietors themselves were frequently ignorant, had more than anything else the role of animating the

space, multiplying the visual emotions. Anton Maria Zanetti, writing in 1771, must have been thinking of this type of work when, not without some reservations, he compared the paintings of the Venetian masters of his time to "a beautiful vase of fresh flowers, or a basket of mature fruit, in which triumph red, green, blue, perse, and yellow; and it is a lovely thing to see, since no other reason for it can be found."

Rococo

In the seething years of the 1740s, there was a return to the custom of covering the walls with vast paintings, and the desire for innovation and variety, typical of Rococo, was reflected in the choice of themes. No longer restricted to family or ancient history—*exempla virtutis* [deeds of renown and valor which served as a moral example] drawn from the classical repertory—artists now turned to contemporary poetry for their subjects, as in the case of the eight canvases depicting episodes from *Gerusalemme liberata* [Jerusalem liberated] by Torquato Tasso, painted by Giambattista Tiepolo around 1743–45, possibly for one of the rooms in Palazzo Corner at S. Polo (see pp. 554–555). Virtue triumphs over Vice, light over the shadows of error. This, once again, is a morality tale, but it is significant that, in order to illustrate it, the episode selected from the poem was the passionate adventure of the lovers Rinaldo and Armida. Even the so-called lesser genres, landscapes and view paintings, were used for large-scale decoration, such as the enchanting *vedute ideate* [idealized views] of villas painted by Antonio Visentini, the popularizer of Canaletto, for the entrance hall of Palazzo Contarini-Fasan (see pp. 556–557).

As has been mentioned before, interior redecoration was generally undertaken on the occasion of a wedding, but it was also necessary when a property changed hands. In 1750 the Baglioni family, extremely wealthy booksellers who had been elevated to the nobility in 1716, purchased an old palazzo and began imprinting it with their own style, a style both splendid and festive at the same time, according to the canons of contemporary taste. The walls of the *portego* were modeled with a flowering of stucco, forming a frame for some of the most important paintings in the family collection. The Baglioni commissioned Giambattista Crosato to fresco a ceiling with the *Triumph of Juno between Hebe and Diana* as a tribute to the lady of the house (see pp. 564–565). In a network of polychrome stuccoes, in white, gold, pink, and lilac, resembling sea foam, shells, and floral festoons, we see what is probably the most exquisite Venetian ceiling of the mid-

eighteenth century. In the central pictorial section the colors are soaked in air and light and the form is lightened, transformed into a live and silky substance, like fresh corollas.

Ca' Rezzonico

During the same period, in 1751 to be precise, another recent addition to the ranks of the nobility, the Rezzonico family, purchased the unfinished Palazzo dei Bon on the Grand Canal, designed by Baldassare Longhena. The palazzo was completed and enlarged with the addition of a grand staircase and an entertainment salon designed by Giorgio Massari, the elements which since the late seventeenth century had constituted the most important innovations in the restructuring of Venetian interiors. On this occasion they were of a majesty and elegance unequaled in Venice, rendering Ca' Rezzonico the greatest achievement of the movement which we have been following in this chapter. The achievement is even greater if one considers the quality of the pictorial decoration. Tiepolo was in Würzburg, and thus the frescoes in the salon, which extended throughout the room, as in Palazzo Labia, were entrusted to Crosato, who demonstrated that in this field he was, after Tiepolo, the most original painter in Venice. His collaborator for the false architectural details was probably Pietro Visconti, who restructured the space by distributing along the walls a pattern of columns in gray marble with gilded capitals alternating with fake statues, and expanded it upward, creating the suggestion of a suite of rooms glimpsed beyond loggias and projecting balconies. As if in homage to Ca' Zenobio, the first palazzo to be decorated in the modern style, the leading figure here is Apollo, god of the sun. But whereas at Ca' Zenobio he is represented rising, preceded by Aurora, here, although his mien is one of tender adolescence, he is at his triumphant zenith, driving his chariot. He irradiates the four corners of the earth, instead of by the customary disturbingly beautiful queens like those Tiepolo was painting at that very moment over the grand staircase of the bishop's palace in Würzburg, by gentle young girls of different races, surrounded by swirls of putti and exotic touches. The fake statues on the cornice represent the signs of the zodiac and the winds. The whole universe appears to be reflected in this salon, obviously to the greater glory of the Rezzonico family, whose crest dominates the windows. A vast encomiastic project, but the creative liveliness, the freshness with which the paint is handled, and the elegance of the false architecture all render it no more than a pretext for the creation of a fairy-tale abode. What is being celebrated here is not so much the greatness of the Rezzonico family but rather, as in the salon of

Palazzo Labia, painting itself, which demonstrates its immense illusory power to carry us into a different and fantastic reality within the four walls of home.

A few years later, between 1757 and 1758, the marriage of Ludovico Rezzonico to Faustina Savorgnan provided the excuse for frescoing the ceilings in a series of rooms which were destined for the newlyweds. This time Tiepolo was available, he alone, in fact, capable of rendering visibly plausible and attractive the idea of bringing in the bride on the chariot of the sun. On a second ceiling, also by Tiepolo, allegories (*Nobility, Virtue, and Merit*

Top: Project for a ceiling, Francesco Guardi. Paris, École Nationale des Beaux-Arts.

Bottom: Project for a wall decoration, Francesco Guardi. New York, Cooper Hewitt Museum. The painting, with its small-size human figures, was probably intended for a mezzanine decoration.

OPPOSITE:
Apotheosis of Venice, Jacopo Guarana, 1767. Private collection. Painting for the fresco commissioned by the Venetian Senate in 1767 as part of the redecorating of the Sala dei Banchetti, the most important public room in the doge's apartments.

before the Temple of Glory) are gradually drifting apart against a pale background, while other Virtues look on (see p. 558). In the adjacent rooms Gaspare Diziani projected onto the vault the personifications of the arts, and his younger colleague Jacopo Guarana frescoed, using a somewhat opaque palette, the *Triumph of the Virtues*. Fresco had by definitively established itself in Venice as the most suitable technique for monumental decoration: not only did it render possible the most incredible flights of imagination, but it was also quicker and cheaper.

State Painting

When finally the State (which had been notably absent in the field of eighteenth-century patronage) succumbed to the prevailing fashion and decided to redecorate the most important room of the ducal apartments, the banquet hall, the Venetian Senate, on 30 April 1767, adopted "the idea of painting, instead of on canvas, in fresco, as it was more modern and of greater beauty." The project, which would have gone to Tiepolo if he had not been in Spain, was entrusted to Jacopo Guarana "for the painted illustrations, and to Francesco Zanchi for the ornamentation." The subject was taken for granted: the umpteenth, and perhaps the last, *Apotheosis of Venice* surrounded by swarms of virtues (see p. 560). It is worth noting that although the technique was "modern," the segmented typology is the same as that of the sixteenth-century ceilings in the Palazzo Ducale. Comparing this new project with the older models, in which the ornate frames of carved and gilded wood played such a crucial part, one is tempted to draw the conclusion that, besides motives of taste, the more basic requirements of economy lay behind the choice of fresco. Undoubtedly the only artist who could have breathed life into such a subject was Tiepolo.

Guarana, however, demonstrated on other occasions a vein of carefree and playful originality, as in the music room of the Ospedaletto, frescoed in 1776, an ambience in which the perfect understanding between the figurative painter and the *quadratura* painter resulted in one of the most delightful Venetian interiors from the second half of the eighteenth century. On the curved back wall, between the classical *trompe l'oeil* colonnade painted by Agostino Mengozzi Colonna, the son of Tiepolo's brilliant collaborator, Guarana frescoed a somewhat unusual Parnassus. A naked Apollo, looking rather more like a boy with no clothes on than the god of the sun, is somewhat awkwardly conducting a completely listless orchestra of Muses. One of them, instead of concentrating on the music, is even distracting herself

by attracting the attention of a small dog by offering it a cake. Nor does the presence of the celebrated maestro Pasquale Anfossi, composer of the work they are performing, induce a little discipline. It was, in fact, the young girls of the conservatory who portrayed the Muses for that impromptu recital, watched by some of their classmates on side-balconies screened by gratings. The need to come closer to reality led to an interpretation of mythology in a slightly ironic, comic key.

The "natural style," as Goethe defined it when referring to Tiepolo's frescoes of scenes of contemporary life in the guest rooms of Villa Valmarana ai Nani at Vicenza, led the field with the "sublime style." For some time, the more enlightened and up-to-date members of society had begun to turn away from a type of painting in which everything, as Gaspare Gozzi commented in the *Osservatore Veneto* of 14 February 1761, "seems rather to come from those great clouds which appear in the sky in summer in which one sees and does not see that which they show: much light, much obscurity, men and women who are and are not." The new key phrase was "beautify nature herself, and nothing else."

The decoration of the walls above the grand staircase in Palazzo Grassi, executed around 1770, adhered to this principle, and to those of "rationality" and "convenience" so beloved by the theorists of the avantgarde (see p. 562). This was the last great private building to be constructed *ex novo* in Venice. Once again the entertainment salon reaches a height of two floors, frescoed by the Tiepolo-influenced Giambattista Canal with the usual flock of allegories dispersed in the sky. But the true meeting-point of the building is the great staircase, whose decoration was possibly inspired by prints of the ambassadors' staircase at Versailles. The first image is a relief of *Hercules with a Sheaf of Arrows* (the work of Gian Maria Morlaiter), signifying, as the engraved motto makes clear, the force generated by harmony. On the upper part of the walls, beyond a fake loggia, guests gather at a reception: ladies, gentlemen, people in the uniforms of procurators or masked, orientals and servants, all appear on the level of the *piano nobile* like the "doubles" of the guests who thronged the palazzo on the occasion of some feast, a "live" *tranche de vie* [slice of life], with a certain allegorical significance, to which the relief of Hercules, the true symbolic center of the decorative scheme, provides the key. Those contemporary personages who are united within the dimension of the domestic celebration represent social harmony, which is restricted to the aristocracy. The era of gods and heroes seems to be over. Michelangelo Morlaiter, working in the wake of Pietro Longhi's painting and simultaneously exploiting the portrait style of Longhi's

Palazzo Grassi and the Great Exhibitions
Palazzo Grassi, which overlooks the Grand Canal, was designed by Giorgio Massari for the Grassi family, wealthy merchants and maritime suppliers. The building, completed in 1762, was the most luxurious example of a noble residence before the end of the Republic. Through the years the palazzo was put to a variety of uses until in 1950 it became a location for art exhibitions and theatrical productions. In 1984 it was bought by FIAT with the aim of turning it into an international exhibition center. Between May 1986 and December 1997 sixteen major exhibitions were held, the first to "Futurism and the Futurists", the last "German Expressionism." The most popular exhibitions were those linked to ancient civilizations: "The Phoenicians" (1988), "The Celts" (1991), and "The Western Greeks" (1996)." The exhibition space continues the tradition of rebuilding, redecorating, and remodeling so characteristic of Venice.

OPPOSITE:
Monumental staircase, Palazzo Grassi in the S. Samuele district, with frescoes by Michelangelo Morlaiter. The design of the decoration may have been borrowed from the ambassadors' staircase at Versailles.

son, Alessandro, has left us with a seductive image of Venetian society, a mirror in which it could contemplate and admire itself as a successful work of art.

This is certainly not the only case of contemporary figures employed in large-scale decoration: Pier Antonio Novelli, in a project for a ceiling (Paris, École des Beaux-Arts), designed a fake loggia immediately below the allegorical section, occupied by masked couples. There is also evidence that the "great ballroom" in Palazzo Lezze at the Misericordia was "painted with architecture, in which the stock comic characters seem to wander about, the work of Domenico Tiepolo, with ornamentation by Mengozzi Colonna."

Ridotti and Capricci

Until now, we have considered almost exclusively aristocratic areas of entertainment. But for a truly representative history of Venetian interiors it would be necessary to cross the threshold of the more secret rooms in which daily life took place, the areas controlled by women, the private meeting-places, where, without the rigid formality imposed by rank and law, one could converse freely, play, enjoy oneself: mezzanines, *ridotti, casini*. From the beginning of the 1740s, given the increased need for comfort and freedom, this type of room became more frequent. It is here that we see the triumph of the *capriccio*, or caprice, in its eighteenth-century meaning of an ingenious and bizarre art form, which appealed, according to a contemporary source, "because of a decided vivacious individuality, and because of the freedom and audacity with which it was executed." Unfortunately, we can only offer some examples: the unusual *ridotto* in Ca' Contarini, shining with bright blue Delft tiles (see p. 552), a room on the mezzanine of Palazzo Foscarini near the Carmini, animated with brightly colored patterns of shadow play, the *ridotto*, like a jewel-casket, completely lined with stucco, of the wife of procurator Venier. Here, the human figure has a purely secondary role, if it is there at all. In Francesco Guardi's decorative project (New York, Cooper Hewitt Museum), the human presence is reduced to the odd hesitant sketch (see p. 561). Within a cartouche modeled like the edge of a tray, in two different versions, a lagoon landscape fades into infinity. If the project ever was realized, Guardi would have endowed those enclosed areas with the feeling of a space in which all things, in the moment before they finally dissolve, flash with light.

Adriano Mariuz, Giuseppe Pavanello

Triumph of Juno between Hebe and Diana, Giambattista Crosato. Palazzo Baglioni. This is probably the most exquisite Venetian ceiling of the mid-eighteenth century, thanks to the colors imbued with light, the apparently weightless forms, and the network of polychrome plaster decoration.

Tiepolo, Rococo, and the Eighteenth Century

Patronage and Artistic Collaboration

Most histories of Venetian art of the Settecento begin with Sebastiano Ricci. According to the usual interpretation, Ricci abruptly turned away from the Tenebrism that had dominated local painting during the seventeenth century. Purposefully breaking with the past, he introduced bright tonalities and attenuated figures, and generally reduced the heaviness of his earlier imagery with elegant decorative detail. His style changed the course of Venetian art and eventually influenced painting in other European centers. The problem with this approach is that it only partially elucidates the truth. For while Ricci's style was a new blending of elements that eventually did gain ascendancy over Tenebrism, particularly in the hands of the young Giambattista Tiepolo, Tenebrism itself did not disappear after 1700. Most painters working in the city until about 1720 employed strong luministic contrasts in their work. Moreover, Giambattista Piazzetta, one of the century's greatest artists, preferred a Tenebrist style throughout his career. Finally, Ricci's "new manner" was not totally innovative, but had been prefigured in the work of several painters of the Seicento who also used light palettes and conceived elegant figures.

What really divides eighteenth-century Venetian art from the past is the unexpected birth of new genres and the revitalization of old ones. View painting, scenes of daily life, portraiture, ruin painting, and pastoral landscapes were all produced for a thriving market. But it was in the field of large-scale figurative painting that Venice produced its most ambitious painters, all of whom participated in a new category rarely seen before in the city: large-scale cycles of history painting decorating the homes of the city's patricians. Many of the first-rate narrative artists in eighteenth-century Venice participated in such commissions, but Giambattista Tiepolo was the "presiding genius," outclassing all his compatriots. Despite his unmatched talent, Tiepolo's art was inextricably linked to that of his contemporaries. He was not a lone genius: he contributed along with other painters working in Venice to many of the same commissions offered by the same patrons. Narrating heroic subjects that celebrated time-honored concepts of Olympian virtue or portrayed the search for Christian salvation, Tiepolo and his contemporaries decorated and ennobled public as well as private space.

To appreciate what Tiepolo, Piazzetta, Ricci, and others left in their city, one must look at the world in which they operated. Venice in 1700 both benefited and suffered from the policies and practices of the preceding centuries. Her governmental apparatus ran smoothly and efficiently, for the patriciate that controlled it had done so for nearly a thousand years. Collaboration and teamwork characterized public discourse, as they did the *scuole grandi* and the smaller *scuole di devozione*, organizations in which lay males excluded from public office because of their middle- or working-class status devoted much of their time and money to social issues. Partnership controlled the family unit, too. Wealth was managed by the *fraterna*, the financial unit that combined brothers' business interests. Moreover, only one son in each patrician family was usually permitted to marry, thereby assuring the clan's assets and preserving its cohesiveness and special bond. The entire blood group or kinship cohabited in one palace, meeting in common rooms while passing to and from their private spaces. This attitude of "corporate unanimity" not only permeated government, charitable institutions, and family, it also characterized artistic practice. For example, two of Tiepolo's sons, Giandomenico and Lorenzo, joined their father's studio and assisted him until his death. Francesco Guardi, whose sister married Tiepolo, also worked in that same studio, later entering that of his own elder brother, Giannantonio, under whom he willingly played a subordinate role until the age of fifty. Ricci often collaborated with his nephew Marco, even following him to England.

If tradition required that people collaborate, cooperate, and assist one another in the running of government, their professions, and family life, it also devoutly accepted the premise that Christ reigned over earthly existence and his mother Mary protected

the city. Such certainties had controlled Venetian thought since time immemorial. Venice was a Christian republic governed by a noble patriciate respectful of tradition. Eighteenth-century Venice saw little need to alter these beliefs, or to change or modify her institutions or structures. Few were willing to abandon a life linked to the millennial past or to restructure a state whose invulnerability was assured by divine guidance. Life was orderly and harmonious, "fraternal" for Venetians themselves and alluring to foreigners.

And yet there was reason to fear the future. Venice's very existence was threatened by recent events. The state was small and totally unable to compete either economically or militarily with the great nations surrounding it, one of which was the Ottoman empire. Venice had been at war intermittently with the "infidel Turk" since the fifteenth century, and the two states renewed their enmity twice in the seventeenth century in campaigns that were both long and fatiguing, the War of Crete and the First Peloponnesian War. Istanbul perceived Venice's increasing weakness and plotted to deprive her of her possessions in the Aegean and along the Dalmatian coast. It sought the total destruction of the Republic, whose government was forced to look for new ways to finance its survival. From 1646 on, wealthy merchants were encouraged to buy their way into the patriciate. This ostensibly strengthened the government, but tradition was profoundly altered.

Whether it was the Republic's happy survival after two long wars or, more likely, the recent loss of their unique historical position after 1646, several old patrician families began to commission large-scale decorative cycles for their palaces around 1690–1700. These works depict heroic subject-matter, exalting noble deeds, honorable virtues, and high-minded self-denial, all for the purpose of referring to the patrons' status or of glorifying the state. Not to be outdone, some of the "new" families also started to beautify their interiors with grand decorative schemes. The needs of these fledgling patricians may have been even greater than those of the *patrizi vecchi* [old patricians], because their homes, whether old or recently built, lacked the *scenografia* [interior decoration] pretended to by many members of the government. Finally, old and new patricians alike also promoted the building of churches, the financing of pictorial cycles to embellish them, and the adornment of altars with devotional paintings.

To understand what Venice's history painters produced, an investigation of both "corporate art" and individual style must be undertaken. A discussion of three important and representative pictorial cycles demonstrates, in the first part of this essay,

how patrons encouraged artists to cooperate, even to collaborate, in order to decorate private rooms and public halls. What emerges from the second part of this essay, a consideration of style, is that whereas themes were insular in focus, pictorial style was not.

The Barbaro Commission

One of Venice's oldest patrician families, the Barbaro, commissioned a series of paintings depicting great figures from classical history and the Old Testament. Work in the Palazzo Barbaro on the Grand Canal stretched over half a century, involved more than half a dozen artists, and ultimately yielded nineteen canvases for three different rooms. The commission was begun by Alvise Barbaro, for whose *portego* on the *piano nobile* Nicolò Bambini and Giovanni Segala had completed six paintings by 1699. Bambini's four Old Testament subjects—*Lot Lying with His Daughters, Hagar's Succor of Ishmael in the Wilderness, Tamar's Conception of a Child by Judah*, and the *Egyptian Princess Saving Moses from the Waters*—all emphasize the longevity of a family line. Segala's two works, the *Judgment of Paris* and *Faith, Hope, and Charity*, were placed in the middle of the *portego*'s two long walls at the center of the entire pictorial grouping. Each glorifies a trio of females, the first paying tribute to the worldly attributes of women, the second praising spiritual virtues. In the nearby *camerone*, Antonio Zanchi painted five ceiling *tondi* of famous Greek and Roman heroines whose moral superiority must have appealed to Alvise Barbaro: Artemisia, conjugal love; Cloelia, fortitude; Hypsicrateia, valor; Hersilia, reconciliation; and Zenobia, honor in submission.

Just before the end of the century, Sebastiano Ricci painted the *Rape of the Sabine Women* on one of the *camerone*'s walls (see p. 567). This subject, though a violent and terrible tale of women's passive role in a great event, agrees with the thematic emphasis of the scenes by Bambini, Segala, and Zanchi that decorate both the ceiling above and the *portego* beyond. Like the narratives in the *portego*, it too points to the survival of a race. But Ricci's scene is also stylistically different from the work of Bambini, Segala, and Zanchi. Zanchi's dramatic Tenebrism contrasts with Bambini's academic classicism, while Segala's bright tonalities and elongated figures announce a decided turn away from both. Ricci, in turn, opted for a heroic composition full of dramatic sweep, enlivened with convincing archaeological detail and made vivid through broad gesture and facial expression. For his organizational and figural ideas, he turned specifically to two works of the same ancient subject by Pietro da Cortona and Nicolas Poussin, but the tonalities and figural proportions of Ricci's painting

OPPOSITE:
Mucius Scaevola before King Porsenna, Giambattista Piazzetta, c. 1745. Palazzo Barbaro-Curtis. The detail shows the strength of character exhibited by Mucius Scaevola by putting his hand into the fire.

were decidedly modern in origin. They capture the late style of Luca Giordano, whose altarpieces were in Venice by 1675 and who was himself present in Padua in 1685. Ricci must have studied Giordano's impressive frescoes and canvases while traveling in Florence and Rome during the early 1690s, before he returned to Venice in 1696.

In 1709 Almorò Barbaro continued his father's patronage and employed Antonio Balestra, from Verona, who had studied with Carlo Maratta, to depict Coriolanus at the gates of Rome on another of the *camerone*'s walls. Venturia pleads with and Volumnia exhorts Coriolanus, their husband and son respectively, to halt his assault on Rome. Like Ricci, Balestra referred to a military narrative from Roman history, but whereas the *Rape of the Sabine Women* implies only that women's intervention brings peace to two warring tribes, this new painting illustrates a mother and wife interrupting the course of action. Balestra's quiet composition and deep tones contrast with Ricci's whirlwind of action and bright colors, thereby broadening still further the range of artistic styles visible in Palazzo Barbaro by 1710.

Piazzetta's *Mucius Scaevola before King Porsenna* is the third wall painting in the *camerone* (see p. 569). Now that Balestra's painting is a proven work of 1709, the suggestion of an early date also for *Mucius Scaevola* would coincide with Almorò Barbaro's commissioning of *Coriolanus* to complete his father's project. But questions of style complicate the issue. Piazzetta's painting, with the deeply moving figure of the enthroned Porsenna, the stunning antique statue in the upper right corner, and the appearance on the left-hand side of the canvas of a man absolutely identical to one in the same artist's *Alexander and the Dead Darius*—a work known to have been painted c. 1745—must have originated in the artist's maturity, not in his youth (see pp. 572–573). Not even Tiepolo, the most accomplished history painter of the century, was able to produce so sophisticated or affecting an image before he reached his early forties, and Piazzetta was only twenty-eight when he is said to have painted *Mucius Scaevola*. Thus the question of the painting's date, and of the commission's thematic coherence, must be approached from another point of view.

For fifteen years, Alvise and Almorò Barbaro commissioned paintings that depict either the important deeds of women or their involvement in dramatic moments in history. If one accepts that Piazzetta was painting *Mucius Scaevola* c. 1710, while Balestra was finishing *Coriolanus*, however, one must conclude that the room's thematic focus was abruptly and unexpectedly changed. For although the two facing history paintings are equally concerned with a male's momentary faintheartedness and his subsequent achievement of manly valor through the willing acceptance of physical punishment, and despite the compositional elements the two paintings share, *Mucius Scaevola* contains no women and is not linked thematically to the room's pictorial decoration. If the aim of Venetian historical and allegorical cycles of the period was not simply to tell stories but rather to glorify principles and traditions in a consistent fashion, then Piazzetta's work sits disconnected from its pictorial environment. Situating *Mucius Scaevola* in c. 1745 instead makes good sense.

Around that same date, or shortly thereafter, Tiepolo executed a ceiling canvas now usually called the *Apotheosis of the Barbaro Family* (New York, Metropolitan Museum of Art) that glorifies military valor. Although Almorò commissioned the painting for another of the palace's rooms, its central male figure proclaims the same virtue bravely demonstrated by Mucius Scaevola as he reaches his hand into the flames: Tiepolo's figure of valor symbolically exemplifies what Piazzetta's history painting narrates, and the figure sits, in addition, within a grouping of at least half a dozen female personifications (not five, as is always stated). At approximately the same time, Almorò commissioned six *soprapporte* [overdoors], also from Tiepolo, for the nearby *camerone*, each depicting a famous classical heroine. The reasonable conclusion, therefore, is that decades after work had been left unfinished there, Almorò commissioned a new wall canvas, *Mucius Scaevola*, along with six overdoors to complete the *camerone*'s decoration. Although the new commissions in the *camerone* could not be seen alongside Tiepolo's ceiling in the nearby *gran salone*, the identical thematic emphasis throughout suggests that one mind stood behind both. To the Barbaro patrons, then, thematic unity mattered more than stylistic cohesion. Alvise employed Bambini, Segala, Zanchi, Ricci, and Balestra in combinations that underscored artistic individuality. Likewise, Almorò pitted Piazzetta against Tiepolo, painters whose use of color and conception of narrative drama could not have been more different.

The Sandi Commission

In contrast to the Palazzo Barbaro cycle, the Sandi commission of the 1720s highlights a tightly rather than a loosely conceived pictorial complex. Vettor Sandi and his son Tommaso were famous lawyers, and each earned a fortune. Vettor bought his way into the patriciate in 1685, and Tommaso later had the family palace near S. Angelo restructured by Domenico Rossi. In the early 1720s, Tommaso invited

the elderly Bambini, then over seventy, and the younger Tiepolo, close to thirty, to paint a ceiling fresco, frieze, and five large wall paintings for the *salone* of his palace. Bambini was responsible for two wall paintings and the frieze below the ceiling while Tiepolo painted the three remaining canvases and frescoed the ceiling. It was his first secular fresco in Venice and, arguably, his very first fresco at all in the city. Given the rarity with which fresco painting had been practiced in Venice during the previous several hundred years, the Sandi ceiling was a milestone, although a private one. Ceiling decorations in churches and public buildings were, with rare exceptions, all painted in oil on canvas, and they formed a discrete tradition, too, that determined how a painter conceived pictorial space and composed his composition. The Sandi ceiling spurns both local canons. Tiepolo renewed Venetian painting by turning, like Ricci in the Barbaro *Rape of the Sabine Women*, to Luca Giordano, Italy's most prominent painter of the late Seicento. The debt to Giordano's frescoed vault of 1682 in the *salone* of Palazzo Medici-Riccardi in Florence is unmistakable, even down to individual figures and their gestures.

Using the cornice like a stage platform and arranging the figures of each unit into a triangular grouping like the pediment of an ancient temple, Tiepolo linked four unrelated narratives from classical mythology through themes and iconography. Visitors entering the *salone* look up toward the opposite cornice and see Amphion building the walls of Thebes by playing his lyre. Along the ceiling's right side, Hercules dressed in the skin of the Nemean lion pulls the thieving Cercopes with chains. Above the left cornice, Bellerophon sits astride the winged Pegasus and destroys the chimera. Over the entrance, Orpheus looks at the three-headed Cerberus while embracing Eurydice. The Olympian wisdom and valor symbolized by Minerva, and the divine oratory and eloquence of Mercury refer to the renowned accomplishments of the Sandi father and son as lawyers.

Complementing and contrasting with the fresco, Bambini's frieze directly below encircles the walls of the room. Its wild animals and fantastic creatures engaged in ferocious combat point to forces antithetical to the ceiling's mythological figures, who allude to eternally inviolable virtues. The frieze is a footnote, as it were, elucidating the larger painting above. On the one hand, although Bambini and Tiepolo depicted contrasting moral behavior, both painted energized figures with febrile gestures in order to complement each other's style. On the other hand, the younger artist's open cornice and air-filled sky contrast with the older man's densely packed, ledgelike space, while Tiepolo's bright and richly colorful tonalities are set off by Bambini's darkened and grisaille-like oils.

Each of the artists executed a large oil painting on canvas to decorate one of the two short walls: Bambini depicted Coriolanus before the gates of Rome, and Tiepolo portrayed Ulysses discovering Achilles among the daughters of Lycomedes. Narrating the same Roman story that Balestra had portrayed in the *camerone* of Palazzo Barbaro, Bambini points to two virtues relevant to the Sandi: the power of oratory and the willingness to sacrifice oneself for the State. Tiepolo's canvas depicts Ulysses' detection of Achilles, who, unable to restrain his military valor, reaches for a sword amidst the jewels brought to the daughters of King Lycomedes, on whose island he was hiding. This subject clearly refers to the Sandi's own valor when, as new members joining the patriciate in 1685, they assumed a governmental role in the nation's defense against the Turks; like Achilles, the Sandi readily took on a public role.

The cooperation of Bambini and Tiepolo in painting the wall canvases seems even more studied than it did in the frieze and ceiling, perhaps because the two works were to decorate identical surfaces and the artists' individual styles were open to closer inspection at eye-level than they were higher up in the room. The compositions are almost mirror images, not only in the deployment of the protagonists, but also in the scale of the figures and how they are set in the landscape. Each setting, furthermore, is closed on the side of the painting that once hung closer to the room's entrance—Bambini using mountains and Tiepolo a clump of trees—while the scene opens into the distance on the section of canvas formerly nearer the windows. Finally, the horizon lines correspond, gestures reflect one another, and the groups of standing, crouching, and kneeling women clearly and deliberately harmonize.

For the entrance wall, the two painters furnished smaller paintings: Bambini's centralized trio of females in the *Three Graces* is posed to coordinate with Tiepolo's pairs of males in *Hercules and Antaeus* and *Apollo Flaying Marsyas*. Tiepolo's scenes suggest that virtue overcomes evil which is both arrogant and presumptuous; Bambini's *Three Graces*, which probably hung alone on its own segment of wall, honors marriage and its legitimate issue. The Graces presided at all human and divine celebrations, bestowing beauty, joy, and moral happiness on those in attendance. They symbolized, moreover, abundant nature, a meaning Bambini emphasized by including Mercury, associated with fertility. Mercury was also the god of rhetoric, a further reference to the Sandi as lawyers. Venus's appearance above the Graces furthers the connections with both love and fertility.

In sum, the Sandi cycle, like the Barbaro series, found new ways to praise the nobility of the family.

The Commission for the Church of Santi Cosma e Damiano

The need to glorify Venetian tradition also characterizes ecclesiastical decoration. The largest such commission of the period was for the interior of SS.

canvas on the left wall. The canvas, showing Solomon gathering his people into the temple, underscores God's protection of Israel from both sickness and enemies, and introduces a thaumaturgic theme suitable to a church dedicated to two early Christian doctors. By 1720, the chancel of SS. Cosma e Damiano was pictorially complete. Below Pellegrini's overhead fresco that glorified female saints in deference to the church's resident nuns, the walls pictured

Brazen Serpent, Giambattista Tiepolo, 1732,
detail. Formerly in the church of SS. Cosma e
Damiano on the Giudecca, now in the
Gallerie dell'Accademia. Detail from the
13-meter frieze that decorated the front of
the choir gallery. The combination of drama
and decorative elegance is characteristic of
Tiepolo.

Cosma e Damiano on the island of Giudecca. A monastic church that served a group of Benedictine nuns, SS. Cosma e Damiano contained by c. 1670 several painted altarpieces and a fresco by Girolamo Pellegrini on the dome over the chancel. Shortly thereafter, Antonio Zanchi painted four canvases for the chancel. One pair represented Old Testament prophets, while the other two paintings were *David Showing the Head of Goliath to King Saul* and *David and Abigail*, both implying that God's grace had fallen on David as hero and leader. A few years later, Antonio Molinari delivered the *Sacrifice of Saul* to decorate one of the chancel walls. Narrating Saul's coronation as the Jews give thanks for having conquered the Ammonites, Molinari's work, along with Zanchi's, presented the themes of divine grace, leadership, and national victory.

The commission lay dormant until c. 1716–17 when Sebastiano Ricci—newly returned from a successful stay in England—delivered his grandiose *Solomon Speaking to the People at the Dedication of the Temple* for the right wall of the chancel of SS. Cosma e Damiano, where it faced Molinari's older

subjects apotheosizing Jewish leaders and emphasizing their nation's liberation and unification. Because the Republic had been engaged in two bitter struggles with the Turks in the second half of the seventeenth century and faced yet another war with the Ottoman empire during the years 1716–18, the chancel paintings discharged a powerful message to their gathered audience. Ricci subsequently furnished SS. Cosma e Damiano with two more paintings, each approximately five meters in height and eight in width. *Moses Striking the Rock at Horeb*, painted in collaboration with his nephew Marco Ricci, and the *Transportation of the Holy Ark* show, respectively, the Jewish leader guiding his people from bondage and caring for their wants, and the unity of the Jewish nation and its covenant with God.

Around 1725, the focus and original meaning of the series of biblical paintings in SS. Cosma e Damiano changed. Giambattista Pittoni and Angelo Trevisani completed, respectively, the *Miracle of the Loaves and Fishes* and the *Cleansing of the Temple*. Taken from the New Testament, these narratives were placed on the nave's right wall as pendants to Ricci's

images from the Old Testament. By 1730, then, SS. Cosma e Damiano boasted a grandiose set of paintings that covered large parts of the nave and chancel walls, and celebrated the leadership, liberation, and unification of the Jewish people. But the entrance wall still remained undecorated. In July 1732 the church received a generous sum of money to buy an organ, and the decision to embellish the front of the choir loft, or *barco*, over the inside of the entryway with Tiepolo's *Brazen Serpent* must have been taken with that donation in hand. Postdating his Sandi ceiling by only six or seven years and preceding the Barbaro canvas by almost twenty, Tiepolo's *Brazen Serpent* is more akin to his mature works of the 1740s and 1750s than to those of his youth (see p. 574). Boldly gesturing Jews in complicated poses, massed partly within and partly without their compartmentalized spaces, direct viewers' glances from one segmented opening to another. Tiepolo's mix of profound drama and decorative elegance is his own.

The final scenes for SS. Cosma e Damiano are the *Finding of Moses* by Giambattista Crosato and *Christ and the Centurion* by Girolamo Brusaferro. The first was appropriate to the commission's partial emphasis on Moses, and the second repeated the curative theme found in several of the other paintings. Like the Barbaro and Sandi cycles, the entire series in SS. Cosma e Damiano spoke metaphorically for Venetian patriotism, but whereas the two secular groups spoke parochially for each clan, this cycle extolled the larger themes of political survival and nationhood.

The insistent emphasis found in these three commissions—as well as in many others—upon Venetian traditions, local history, and family accomplishments is nothing if not insular in outlook. The artistic language voicing this attitude, however, was not provincial. Pictorial style in Venice encompassed a gamut of sophisticated possibilities. The near-contemporaneity of Ricci's *Rape of the Sabine Women* (1696) and Balestra's *Coriolanus at the Gates* (1709) in Palazzo Barbaro, of Bambini's painting of that subject and Tiepolo's *Ulysses Discovering Achilles among the Daughters of Lycomedes* (both c. 1724–25) for Tommaso Sandi, of Pittoni's *Multiplication of the Loaves and Fishes* (c. 1725) and Tiepolo's *Brazen Serpent* (c. 1730), both in SS. Cosma e Damiano, and of Tiepolo's *Apotheosis of the Barbaro Family* with Piazzetta's *Mucius Scaevola before King Porsenna* (both c. 1745–50) for Almorò Barbaro, makes it clear that varying artistic trends interwove with one another to produce a rich cultural fabric.

Birth of the Virgin, Nicolò Bambini, 1710–15. Church of S. Stefano. The monumental altarpiece is one of the artist's most important works. Here the divine miracle is blended with the joy of the actual birth.

The Generation of 1650–1655: Nicolò Bambini, Louis Dorigny, Giovanni Segala, Antonio Bellucci, and Antonio Balestra

The art of the first generation of artists active in eighteenth-century Venice, those born between c. 1650 and c. 1665, reflects in general the ideas of older Venetian artists like Pietro Liberi and Andrea Celesti, a form of late Baroque classicism often similar to the contemporary, more famous, work of Carlo Maratta in Rome. Nicolò Bambini, who collaborated with Tiepolo in Palazzo Sandi, was the generation's oldest and perhaps best-known painter. He was responsible for a series of decorative projects in patrician homes, and also worked for the State and painted altarpieces for several of the city's churches, among them S. Pantalon, S. Stae, and S. Zaccaria. The most famous of these altarpieces is the *Birth of the Virgin*, produced c. 1710–15 for S. Stefano. More impressive than photographs suggest, the painting captures simultaneously the miracle of God's intervention in Mary's birth, St. Anne's immediate understanding of

Virgin and Christ Child with Sts. Stanislaus Kostka, Luigi Gonzaga, and Francesco Borgia, Antonio Balestra, 1704. Church of the Gesuiti. Balestra's classicizing art is apparent in the clearly defined physiognomies, and the composition is a lesson in the representation of unequivocal forms.

OPPOSITE:
Brazen Serpent, Antonio Pellegrini, 1707. S. Moisè. An impressive example of the artist's heroic and still youthful mode.

her daughter's role in Christianity, and the joy surrounding the baby's arrival in the "delivery room." Bambini stabilizes his dynamic composition with color, using corresponding areas of warm red on either side of a series of blues—the robes of God the Father, St. Anne's blanket, and the skirt of the woman holding the newborn child—which articulate the central vertical axis. Bambini's sweetened classicism is seen in his figures' broad brows and sharply defined noses, their rouged cheeks, the crisply articulated folds of draperies, and his cool lighting. He carried this style well into the next century, not only in the paintings for Tommaso Sandi, but, more impressively, in the two large narratives of the life of St. Teresa of Avila in S. Maria di Nazareth, the church of the Scalzi.

Contemporary artists whose pleasing elegance is akin to Bambini's are Louis Dorigny, a Parisian active in Venice and the surrounding area between 1672 and 1704, Giovanni Segala, whom we have already encountered in the Barbaro commission of the 1690s, and Antonio Bellucci. Bellucci's art displays great pictorial refinement: long and languid figures are clothed in draperies of richly burnished colors or their nude bodies are emphasized by shadows with undulating outlines. Like Bambini, he opted for classical profiles articulated by gentle curves. Bellucci's

masterpiece in Venice is *S. Lorenzo Giustinian Interceding for the Liberation of Venice from the Plague of 1630*, an enormous canvas dating from about 1691, which hangs on the right wall of the chancel of S. Pietro di Castello, then the seat of Venice's patriarch. Its pendant is the contemporary *Almsgiving of S. Lorenzo Giustinian* by Gregorio Lazzarini. The pair shows what late seventeenth-century Venice wanted: both are enormous "machines" in which miraculous apparitions intrude into believable architectural settings, an interior in the Bellucci work and an exterior in the Lazzarini. Dramatically twisting figures gesture broadly within a space defined by heavy columns, arcades, distant buildings, and flights of stairs. Differences distinguish the two paintings: Bellucci's elegantly gowned patricians contrast with Lazzarini's humble folk, his deep colors are chromatically at variance with the matte surfaces in the *Almsgiving*, and his highlights and shadows interrupt each other in a way totally foreign to Lazzarini's approach. But the two works betray a common pictorial conception: breadth of form, clarity of outline, elegant patterns, and histrionic explicitness.

Consonant with this style are Antonio Balestra's *Coriolanus at the Gates*, completed for Palazzo Barbaro in 1709, and his altarpiece of the *Virgin and Christ Child with Sts. Stanislaus Kostka, Luigi Gonzaga, and Francesco Borgia*, painted for the church of the Gesuiti in 1704. Here Balestra's classicizing art is apparent in the clearly defined physiognomies, and the composition is a lesson in the representation of unequivocal forms: Borgia's black robe ripples down in front of Gonzaga's white one, his right hand turns in space above Gonzaga's left hand, and the two together guide the worshiper's glance upward across the angel's arms to the Virgin, who reaches for her baby. Every drapery fold contrasts with the next one, angelic limbs sit legibly over clouds, the Virgin's arms mirror those of Borgia, and the dove of the Holy Spirit defines the top of the painting's central vertical axis, which extends downward through Kostka's hand to the lily offered to St. Luigi. Even color is handled with remarkable clarity: the Virgin's red dress is pitted against blacks, whites, and neutrals, and that red is repeated on the angel's robe in the top left-hand corner, on Borgia's cardinal's hat, and on the drapery of the little angel on the ground who handles the princely crown.

Two artists of the first generation stand stylistically apart from their contemporaries. Antonio Molinari and Paolo Pagani filled their grand compositions with dense and opaque shadows irregularly broken by sharp lighting. Faces are partially obscured at times, and the general mood is somber. Molinari

and Pagani descended artistically from Zanchi, Venice's most famous Tenebrist of the third quarter of the seventeenth century who was responsible for the ceiling of the *camerone* in Palazzo Barbaro. Bambini, Bellucci, Balestra, Ricci, and Lazzarini, in contrast, can be linked to styles popular in Bologna and Rome.

The Generation of 1675–1690: Giannantonio Pellegrini and Sebastiano Ricci

The second generation of painters, those born between 1675 and 1690, significantly enlarged the pictorial possibilities of Venetian art, for each artist created a sharply defined, individual style. This more pictorially diverse second group, comprising Piazzetta, Pittoni, Jacopo Amigoni, Giannantonio Pellegrini, Gaspare Diziani, and the mature Sebastiano Ricci, was trained by the stylistically more homogeneous group of older artists. Molinari taught Piazzetta, Pagani instructed Pellegrini, Lazzarini directed Diziani (and then Tiepolo), Pittoni studied with an older painter-uncle of mediocre talent, and Amigoni was probably associated with Balestra. What sparked these younger artists to break from their local preparation was travel, which offered them a font of sources wider than their masters had enjoyed.

Giannantonio Pellegrini is the oldest of the second generation of painters. He studied with Pagani in Venice and then accompanied his master to Moravia and Vienna, where his pictorial vision was profoundly altered by artists such as Johann Heinrich Schönfeld and Johann Michael Rottmayr, who had himself worked in Venice from 1675 to c. 1688. Pellegrini later traveled to Bologna and Rome; in Rome, he encountered the contemporary art of Giovanni Battista Gaulli (Baciccio), a Genoese whose loose application of brightly colored oils fragments forms on the canvas. On the basis of these varied experiences, Pellegrini developed a highly individual and personal manner. The *Brazen Serpent* in S. Moisè, dating from 1707, is an impressive example of his heroic and still youthful mode. The elderly and bearded Jews, their younger, muscular companions, and the bright highlights sharply cutting dark shadows (note the extended arm of the boldly gesturing figure in the foreground) indicate Pellegrini's training with Pagani. But his open dynamic composition and his figures' elongated proportions bring about a compositional lightness in comparison to which Pagani's fuller figures, stifled by thick clouds and engulfed by heavy atmosphere,

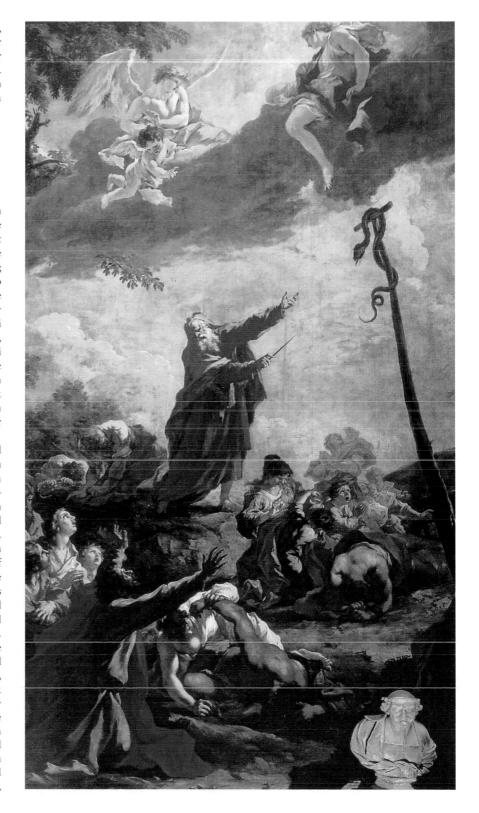

OPPOSITE:
Virgin and Child with Sts. Peter, Gherardo Sagredo, Scholastica, Catherine of Alexandria, Jerome, and Paul, Sebastiano Ricci, 1708. Church of S. Giorgio Maggiore. The painting represents the moment in which Ricci's style was closest to that of Veronese. Zanetti proclaimed its fame in 1733.

seem cramped and overwhelmed. A further, and fundamental, difference between Pellegrini's and Pagani's art lies in their treatment of the pictorial surface. Like most artists of his generation, Pagani used paint to enclose and finish forms. Pellegrini heralded later developments in eighteenth-century Venetian art by superimposing a new figurative canon and a fresh approach to color and brushwork onto an older concept of dramatic action.

While the young Pellegrini matured his style, the older Sebastiano Ricci began to alter his. Around 1705, Ricci painted the *Glorification of the Arts and Sciences* for the ceiling of the library of the Patriarcal Seminary in Venice, which also contained Zanchi's *Burning of the Books* and Bambini's *Minerva Crowning Titus Livy*. Triumphantly seated on a cloud above the trumpet-blowing Fame, Minerva rules over a temple of knowledge filled with personifications of the virtues and the liberal arts. Ricci's *Glorification* only partially follows his earlier manner, for, sensitive to the possibilities of ceiling painting, he lightened his tonalities, increased the illusion of open space, and constructed a dynamic, zigzagging composition. And like Pellegrini in the *Brazen Serpent*, he designed figures whose ample bodies are topped by small heads.

Ricci's most obvious debt in the Seminary's canvas is to Paolo Veronese, whose own ceiling paintings of more than a century earlier supplied the *Glorification* with its successful *di sotto in su* [looking upward from below] perspective. Ricci returned to Veronese's art many times in subsequent years, most notably in the *Virgin and Child with Sts. Peter, Gherardo Sagredo, Scholastica, Catherine of Alexandria, Jerome, and Paul*, completed in 1708 for S. Giorgio Maggiore, one of the few paintings specifically picked out for praise by the connoisseur Vincenzo Da Canal in his *Della Maniera del dipingere moderno* [On the modern style of painting] of c. 1730 (see p. 579). Predicated on Tiepolo's *Mystic Marriage of St. Catherine* (Venice, Gallerie dell'Accademia), the S. Giorgio altarpiece transforms that solemn gathering accompanied by angelic harmonies into a lively conversation piece, in which only the female saints and St. Benedict pay attention to the Christ Child. St. Gherardo Sagredo, who has unceremoniously placed his mitre on the ground, explains a point to the ungainly St. Peter; St. Paul checks his biblical sources; St. Jerome inexplicably looks away; and a cherub tunes his lute to avoid cacophony. In comparison with Veronese's ravishingly euphonious concert, Ricci's disparately focused saints and separate fields of color appear to offer little pictorial or spiritual unison, but the artist more than compensates for this with his wonderful application of paint. Draperies are rendered with an apparent quick-

ness of touch, and Ricci uses a rich application of thick oils to build Sagredo's hands, the pages of St. Peter's Bible, and other details.

It is instructive to compare Ricci's altarpiece of 1708 for the Benedictines with Balestra's of 1704 for the Jesuits, for these almost exactly contemporaneous paintings by two artists born only a few years apart reveal a significant divergence in style. Although both compositions emphasize diagonals, Balestra's insists upon a central vertical axis and a separation between the heavenly zone and earth. Its tone, moreover, is passionately serious and reverential. But the real contrast between the two lies in Balestra's polished surface versus Ricci's fragmented forms. It is commonplace by now to cite Ricci's and Pellegrini's loose handling of the brush, c. 1705, as a sign of the new century's changing pictorial taste. Precedents for such a technique abound in the history of Venetian art, but it is surely not coincidental that both these artists had fallen under the influence of Genoese art. Pellegrini's interest in Gaulli has already been noted: Ricci's comparable experience was the painting of Alessandro Magnasco, an artist he certainly knew in Florence in 1706–7 and whom he had previously met in Milan in the mid-1690s. Magnasco's bravura handling of paint, and his long, thin, and wiry forms loosely negotiated with a brush laden with oils had a profound impact on Ricci's art by the time he finished the S. Giorgio altarpiece.

For all their innovations, however, Pellegrini and Ricci had little influence on local painting during the century's first decade. Pellegrini left Venice in 1708 and spent the next dozen years working in England and Germany. Ricci went to England during the winter of 1711–12 and did not return permanently to Venice until 1718. Thus, while younger painters and contemporary connoisseurs must have noticed that a trend toward pictorial revitalization began around 1705–8, they also must have seen that it disappeared shortly afterward. Meanwhile, older painters maintained the status quo. For the next quarter century, Bellucci persisted with his elegant nudes, Lazzarini preserved his officially approved art, Bambini carried on as he had for decades, and Balestra continued his earlier Marattesque manner. The classicism they had evolved during the 1680s and 1690s did not disintegrate under the weight of Pellegrini's and Ricci's more modern ideas.

Filippo Bencovich and Giambattista Piazzetta

While those two painters worked abroad, the Venetian public witnessed the burgeoning careers of

Filippo Bencovich and Giambattista Piazzetta, both
of whom began by practicing the dramatic Tene-
brism that Zanchi had popularized and which
Molinari and Pagani subsequently developed.

Although the site of Bencovich's birthplace is
unsure, it is certain that he trained in Bologna, after
which he settled, c. 1710, for a period in Venice. His
Ecstasy of Blessed Piero Gambacorta of Pisa,
painted in the 1720s, is his only Venetian work still
in situ, and it demonstrates the kind of deeply shad-
owed image of quiet and humble piety that
Bencovich offered the public. The painting accords
with what can be assessed of Piazzetta's early relig-
ious art, a not unexpected coincidence given that
both men may have been influenced by Giuseppe
Maria Crespi in Bologna, where they studied during
the first years of the century. Piazzetta had first been
apprenticed under Molinari in Venice, but no secu-
rely dated painting by him exists from before c.
1718. Given this lack, one is forced to generalize
about probable youthful works: *David with the
Head of Goliath* (Dresden, Gemäldegalerie) may be
representative of the type in which deep chiaroscuro
fills a scene of traditional subject-matter innovatively
interpreted. Just before 1720, Piazzetta painted the
*Guardian Angel Interceding with the Virgin and
Child* for the Scuola dell'Angelo Custode, known
today from a fragment of the original altarpiece
(Detroit Institute of Arts), two oil sketches (Los
Angeles County Museum of Art and Kassel, Gemälde-
galerie), and a print.

Beginning around 1720 and continuing to approx-
imately 1760, Venice witnessed almost a half century
of wonderful painterly variety. One factor that helps
explain the artistic richness of the period must be
that after three debilitating and costly wars, the State
finally enjoyed political calm for nearly two genera-
tions. As a result, any Venetian or foreign resident
interested in artistic patronage was in the fortunate
position of maneuvering within a comparatively
favorable financial market. A second, and unex-
pected, circumstance was that this same patron could
choose from outstanding talent: three generations of
artists happily overlapped. Examining the dates of
death of the oldest group (excepting those of
Molinari and Pagani who died early, in 1704 and
1716 respectively), one discovers that the mean for
that generation falls in 1732, surprising for men
whose average birth date was in the mid-1650s. The
second generation of painters was, by and large, in
their thirties or early forties by 1720, and most of
them lived on until c. 1750 or even later. Even
members of the third generation, notably
Giannantonio Guardi and Tiepolo, were active by
1720. In fact, the greatest years of the grand style in

Martyrdom of St. Bartholomew,
Giambattista Tiepolo, 1722–23. Church of S.
Stae, chancel. The painting makes reference
to Piazzetta's *Martyrdom of St. James the
Great,* which hangs in the same place.

ON THE PRECEDING PAGES:
Orpheus Attacked by the Bacchantes, detail,
Gregorio Lazzarini, 1698. Ca' Rezzonico.
This monumental canvas, painted for
Procurator Correr, represents a Venetian
interpretation of the classical world.

eighteenth-century Venetian painting ran simultane-
ously with Tiepolo's own career, which began just
before 1720 and ended when he left for Spain in 1762.

Painting in the 1720s and 1730s

The San Stae Cycle
If the year 1720, approximately, was the beginning
of an unexpected array of differing styles in Venetian
painting, then the full gamut became evident in a
single location only three years later, when a dozen
artists painted twelve canvases of the Apostles for the
church of S. Stae. A late seventeenth-century construc-
tion, S. Stae boasted a new facade in 1709, and paint-

ings for several of its side-altars were commissioned
from Bambini and Balestra shortly thereafter. In
1722, funds became available for the commissioning
of twelve paintings of the Apostles, to be executed by
as many different artists. The selection mirrors
Venice's traditional conservative taste. Seven
Apostles were depicted by men born between 1650
and 1670: Bambini, Balestra, Lazzarini, and Ricci, as
well as the lesser known Silvestro Manaigo, Angelo
Trevisan, and Pietro Uberti. Only three Apostles fell
to artists of the second generation: Pellegrini,
Piazzetta, and Pittoni. Just two younger, and largely
unproven, painters were invited into the group:
Giambattista Mariotti and Tiepolo. When the
project was completed by c. 1724, S. Stae had in
effect become a gallery of modern art.

Lazzarini's *Glory of St. Paul* demonstrates his
generation's overriding allegiance to the classical
tradition; Domenichino's *Ascension of St. Paul* (Paris,
Louvre) draws on the formulaic image of the ascen-
ding saint. Ricci's *St. Peter Liberated by the Angel* is a
decidedly less conventional design, due particularly to
the angel's elegantly composed forms, fiery-colored
cloak, and the highly sophisticated use of color in
general. Pellegrini and Pittoni contributed, respec-
tively, the martyrdoms of St. Andrew and St. Thomas:
the elderly but still vital St. Andrew is being forcibly
tied to his cross whereas a massive St. Thomas will-
ingly yields to his fate. Pellegrini heightened his
scene's brilliance by brushing broad strokes of pure
white paint to depict draperies lying across St.
Andrew's loins, while Pittoni, in contrast, covered St.
Thomas with a drab olive-colored robe that enfolds
him into a shadowy world of approaching death.

Today it appears that the most obvious successes
of the S. Stae commission are Piazzetta's earthy
Martyrdom of St. James the Great and Tiepolo's
incandescent *Martyrdom of St. Bartholomew.* If the
younger man's composition is the bolder of the two,
one must remember that it is also likely that he
followed his elder's example. The harsh brutality of
Tiepolo's *St. Bartholomew* was probably predicated
upon that in *St. James.* Moreover, the overall chiaros-
curo, the forceful pull of opposing tensions, and the
sharp view upward, emphasized by a figure in the
rear who is brightly lit but only partially visible on a
lower ground level, must also have originated with
Piazzetta. Both painters took ideas from foreign
artists who had been active in Venice in the preceding
century. Piazzetta must have considered the chro-
matics of the German Johann Liss, and both he and
Tiepolo lifted figural motifs from the Neapolitans
Luca Giordano and Francesco Solimena.

Giulia Lama, eighteenth-century Venice's only
important woman artist of history paintings, was

excluded from the commission at S. Stae. Her impressive *Virgin and Child with Saints and a Personification of Venice*, painted for the high altar of S. Maria Formosa around 1722, displays the same tonalities as Piazzetta's earlier paintings for the Scuola dell'Angelo Custode, implying an artistic relationship which historians have not fully defined. In the bottom left-hand corner, the kneeling Venice, dressed in ducal robes and accompanied by the lion of St. Mark, crosses her hands piously on her chest

Elector Palatine Johann Wilhelm in Düsseldorf and then moved on to the Netherlands and Paris, returning to Venice in 1721. An oil sketch for a never-executed ceiling painting of the Assumption shows that his art was transformed in the north and that by c. 1720 he had developed all the characteristics associated with Rococo art: an open and light-filled composition, bright and highly pitched colors, and fluid brushwork of thick oils. Ricci, too, had worked in England for noble patrons. His most significant commissions

Judith and Holofernes, Giulia Lama. Gallerie dell'Accademia. The painting is inspired by Piazzetta's expressionistic luminism.

while St. Magnus emphatically indicates his rank with his crozier, and St. Peter rhetorically points to the Virgin and Christ above. Although its figures are conventional in pose and gesture, Lama's canvas is no less successful than many of the S. Stae paintings.

Sebastiano Ricci and Giannantonio Pellegrini

The participation by Ricci and Pellegrini in that commission reminds us that they were home by 1722. Pellegrini returned from the north: in England between 1708 and 1712, he painted for the stage and was employed by prominent patrons like the third Earl of Carlisle, Lord Kimbolton, and Lord Burlington. On the continent, he worked first for the

there between 1712 and 1716 included mythological paintings for Lord Burlington in his London house, a group of christological subjects for the chapel in Bulstrode House in Buckinghamshire (all destroyed but known from oil sketches), and the *Resurrection* in the chapel of the Royal Hospital in Chelsea. While in London, he also painted individual canvases, such as the *Bacchanal*, a light-hearted, minuetlike interpretation of a subject treated more seriously in the seventeenth century, and *Diana and Callisto*, which prettifies Titian's dramatic encounter (Edinburgh, National Gallery of Scotland) between the goddess and the nymph (see p. 584). Ricci's long-limbed "English" females with their delicate bone structure and minute physiognomies reflect the influence of earlier painters at the English court such as Peter

Diana and Callisto, Sebastiano Ricci, 1712–16. Gallerie dell'Accademia. The painting is a graceful interpretation of the painting of the same subject by Titian, now in the National Gallery of Scotland, Edinburgh.

Lely, a Dutchman who first worked in London during the Commonwealth and was then patronized by the Frenchified milieu of Charles II.

The Early Careers of Giambattista Piazzetta and Gian Domenico Tiepolo

The return of Ricci and Pellegrini to Venice coincides with Piazzetta's emergence as an important master and Tiepolo's appearance as a rising star. During the mid-1720s, the older of the two painters was at work on a pair of important canvases: the *Virgin and Child* with *St. Philip Neri* for S. Maria della Consolazione, the church of the Fava, and the much larger *Glory of St. Dominic* for the ceiling of the chapel of St. Dominic in SS. Giovanni e Paolo (see p. 585). Like many religious paintings of the period, their compositions were conceived as zigzagging diagonals moving up and across the canvas to bright visions of the Virgin, who stands alone at the Fava but is united with the Holy Trinity on the chapel ceiling. In both works, the sacred figures emerge from light-filled cloud formations, more luminous than anything

Glory of St. Dominic, Giambattista Piazzetta, c. 1730. Church of SS. Giovanni e Paolo, St. Dominic Chapel. Like many religious paintings of the period, the composition was conceived as several zigzagging diagonals moving up and across the canvas to bright visions of the Virgin, who is here united with the Holy Trinity on the chapel ceiling.

King Midas with Apollo and Marsyas, Giambattista Tiepolo, 1720–22. Gallerie dell'Accademia. Part of a series of four mythological stories in which the artist experimented with the Arcadian genre.

Piazzetta had previously painted. The earthy authenticity that characterizes Piazzetta's saint and executioner at S. Stae reappears in the humble St. Philip in the Fava and in the Dominicans gathered on a feigned ledge at SS. Giovanni e Paolo. But the intense visionary experience of St. Philip and St. Dominic stems instead from Tiepolo's martyr at S. Stae, marking the beginning of a beneficial exchange of ideas between the two artists that lasted for as long as they lived.

Tiepolo first appears as an important artist in 1716, when aged twenty he exhibited the *Crossing of the Red Sea*. Around the same time, while benefiting from the patronage of Doge Giovanni II Cornaro, he produced ducal portraits for that patrician family. A few years later, before participating in the S. Stae commission, Tiepolo painted four Ovidian landscape-mythologies including the *Rape of Europa* and *King Midas with Apollo and Marsyas*. The ensemble shows Tiepolo's early taste for chiaroscuro, his playful interpretation of classical myth (particularly evident in *Europa*), his awareness of the Venetian pictorial tradition, visible in both the Veronesian black page next to Europa and the Titianesque Apollo, and his adaptation of Riccesque proportions for his females. The four paintings

demonstrate, moreover, his ability to compose complicated figures whose forms respond to one another from painting to painting. The native ease with which he drew such figures, apparent in these early mythologies as well as in the complicated *St. Bartholomew*, is evident, too, in the *Sacrifice of Isaac*, which is close in date to the S. Stae canvas. The figure of St. Bartholomew, in fact, reappears as both Abraham and Isaac, apparent especially in the similarities with the patriarch's bearded face and the youth's long and muscularly sinuous body. But the *Sacrifice* is most impressive for the way in which its figures enact their narrative while simultaneously conforming to the shaped canvas. Tiepolo achieved here on a small scale what he was to accomplish monumentally in the *Brazen Serpent* for SS. Cosma e Damiano a few years later.

The mid-1720s were a turning-point for the young Tiepolo. Important commissions were coming quickly, his career was burgeoning, and his self-confidence grew as he resolved fundamental artistic challenges like narrative, viewpoint, and tonality. His achievements appear in the ceiling paintings of the *salone* of Palazzo Sandi and the archbishop's palace in Udine (see p. 587). In Palazzo Sandi Tiepolo organized his scenes so that viewers read each of the four myths

separately while experiencing at the same time the large rectangular surface of the ceiling in its entirety. The challenge at Udine was simpler. Only one approach to the *Sacrifice of Isaac*, in the center of the ceiling, was possible because the long and narrow space of the gallery restricted movement. The scene is directed along the same axis as its two flanking works, *Jacob's Dream* and *Hagar and Ishmael in the Desert*. Painted in fresco, these two ceilings differ in tonality from the four Ovidian canvases, *St. Bartholomew* at S. Stae, and the *Sacrifice of Isaac* at the Ospedaletto, all of which are characterized by deep chiaroscuro. The Sandi and Udine ceilings display new chromatic harmonies: in the first, for example, a lavender-robed Minerva reigning on a similarly hued cloud is paired with Mercury clad in a light green cloak, the two of them seen against a brilliantly yellow sun. This bright light was perhaps Tiepolo's response to the art of Ricci and Pellegrini after their return from the north. Beyond the coloristic and tonal differences, Tiepolo also effected a basic change in narrative drama. Comparing his two Isaac paintings, one sees a charged moment of devout obedience and divine salvation at the Ospedaletto. Although terrified by his responsibility, Abraham is ready to fulfil his sacred obligation, and Isaac willingly submits his neck to his father's sharpened

Frescoes in the archbishop's palace in Udine, commissioned by the patriarch of Aquileia, Dionisio Dolfin, and painted by Giambattista Tiepolo, 1726–28. Left: *Sarah and the Angel*, almost a caricature of old age. Below: *Meeting between Rachel and Laban,* depicted as a huge theatrical scene in a pastoral setting.

Sebastiano Ricci

Venice's most valued artist around 1730, however, was Sebastiano Ricci, who at more than seventy years of age continued to astonish the discriminating public with his output; a comparison of *Moses Striking the Rock at Horeb* of c. 1725 with the *Rape of the Sabine Women* of 1696 demonstrates his success in a contemporary pictorial idiom. The Barbaro painting is the product of a seventeenth-century sensibility: the Roman soldiers and Sabine women are broad, heavy, and dramatically involved in their terrible struggle; the figures are crowded together, and the composition reads like that of a Roman sarcophagus where one twisting form connects immediately with the next. Moses presents another kind of artistic commotion altogether. Voids contribute to the composition as do the figures; the dramatic impact of the gestures relies more on the viewer's ability to complete forms and shapes imaginatively across the pictorial surface than it does on the gestures themselves. Although the Jews are broad and muscular, they are also more attenuated, and their heads seem somewhat reduced from proper proportions. The greatest difference between the two paintings, however, is in the dramatic impact that each makes. The desperation of the Jews to quench their thirst—that is, to survive—is less convincingly enacted than the terror of the Sabine women. Opting for an elegant, delicate, and suave style in *Moses Striking the Rock at Horeb*, Ricci abandoned the manner he formed during his seventeenth-century youth for one he evolved during his eighteenth-century maturity.

Da Canal wrote in his treatise on "modern painting" that Ricci outshone all his colleagues, which may explain why he was given the prestigious commission in 1728 to prepare the cartoon for the mosaic over the second doorway from the left in S. Marco. *The Body of St. Mark Venerated by the Doge and Magistrates*, a work much appreciated in its own century, is staged in a Palladian setting with figures grouped *alla Veronese*. Da Canal praised Ricci's taste as being even "finer than Paolo's," and he went so far as to conclude his tribute by stating that "by observing the best of his works, one could study enough to make oneself into a good painter." Ricci's swansongs for his native city were two fine altarpieces of 1732–34 for the first altars, right and left, in S. Rocco. The *Finding of the Cross* on the left shows the old painter's ability to combine his solid understanding of anatomy with physical grace and delicacy, all within the context of a historical costume drama imbued with spiritual fervor.

blade. At Udine, temporal beauty and pastoral sweetness replace religious mystery: a resplendent angel in billowing cherry-red drapery stays Abraham, who is robed in a tightly gathered, plum-colored garment; both Isaac and the ram look out vacuously at visitors below. While the difference in Tiepolo's solutions for the same subject impresses us, even more remarkable is his sensitivity to the quite different surroundings: one painting hangs near a consecrated altar, and the other decorates the reception hall of a palace. Younger than every first-class painter working in Venice at the time, Tiepolo was the only one whose art was capable of covering so wide a stylistic range even as he retold the same story. None of his contemporaries could compete with this breadth of vision.

Giannantonio Pellegrini and Giambattista Pittoni

Ricci died shortly after completing the two works for
S. Rocco. Who would replace him as the city's most
illustrious painter? By the mid-1730s, his generation
had mostly disappeared, but its heirs were enjoying
success. Da Canal and Zanetti both tell us that
Giannantonio Pellegrini and Giambattista Pittoni
ranked high. Da Canal lauded Pellegrini's "skill,
brushwork, and coloristic abilities," and Pittoni's
"grace . . . [and] use of color." Pellegrini's *Painting
and Sculpture*, the latter paradoxically more richly
colored than the former, and his dramatic *Mucius
Scaevola* convey what Da Canal valued, his
"Venetian manner" and "brilliant brushwork;" Da
Canal warned, however, that Pellegrini worked so

fast that his paintings, particularly in fresco, risked
disappearing altogether. Pellegrini never assumed
Ricci's mantle, for he worked abroad more than he
did at home and survived him by only six years.

Pittoni, however, lived until 1767, and according
to Da Canal, his works were appreciated by
everyone, "da' professori e da' dilettanti [by teachers
and by artlovers]." His colleagues elected him presi-
dent of the Venetian Academy in 1758 and again in
1763. Like Ricci, Pittoni too was involved in the
commission at SS. Cosma e Damiano, for which he
produced a monumental and impressive *Miracle of the
Loaves and Fishes*. Here vivid colors model groups of
figures in the foreground, whereas neutrals delineate
those in the middle ground. Although grand in scope,
the painting's force is cut by an accumulation of

anecdotal detail, and undermined by the lack of a heroic protagonist. Pittoni's ceiling of *Justice and Peace* for Palazzo Pesaro, around 1730, again reveals his mixture of painterly bravura and dramatic weakness. The ceiling's sure composition combines several expertly conceived figures: two elegant female personifications are sandwiched between Minerva, robed in a cold and deep blue, and Jupiter, swathed in hot red-orange. But the theme's noble intent does not resonate across space, perhaps because of the weak physiognomies, a vulnerable aspect of Pittoni's art.

Midway in his career, Pittoni painted a large *Sacrifice of Polyxena*, one of his many versions of this ancient story, to fit in with a decorative program Ricci had already produced in Palazzo Gabrielli-Taverna in Rome around 1717–20. Unlike Piazzetta's somber reenactments of classical history and Tiepolo's stately and monumentalizing tableaux, Pittoni's *Polyxena* is stagey and theatrical. Pyrrhus points to the tomb of his father Achilles and leads the doomed maiden to her sacrifice. He and Polyxena are a stately vertical caesura between the massive architecture in the distance and the tomb complex on the left. Amidst the brightly colored protagonists, the robes of Polyxena repeat the grays and whites of the surrounding environment. About a dozen years later, Pittoni was approached by Francesco Algarotti who asked him, as he did Piazzetta, Tiepolo, and Amigoni, to paint a work for the royal collection of Augustus III of Poland. Pittoni completed *Craxus Sacking the Temple of Jerusalem* in 1743–44, but it had disap-

Venus and Adonis, Jacopo Amigoni, Gallerie dell'Accademia. The work possesses considerable compositional elegance thanks to its classically inspired forms and patterned areas of shadow.

Stories from the New Testament with the *Flight into Egypt, Adoration of the Magi*, and *Massacre of the Innocents*, Gaspare Diziani, 1733. Church of S. Stefano, sacristy, inside entrance wall.

OPPOSITE: detail.

peared by 1765; happily, Algarotti preserved its *modelletto*. Recounting the destruction of Solomon's temple, Pittoni here recycled the classical paraphernalia of his *Polyxena* and *Scipio* paintings, and inserted the protagonists from his various versions of the *Sacrifice of the Daughter of Jephthah*. The rich

application of oils visible in Algarotti's sketch differs from the more polished surfaces of Pittoni's finished canvases.

Pittoni's moving *Deposition* and artful *Annunciation*, both of the 1750s, attest to his increasing resources even as he neared the age of seventy. The despondent

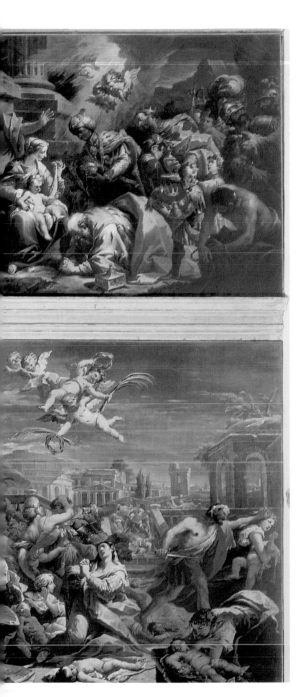

his family and friends, so that the composition seems to explode outward from the Savior's limp body. A cloud formation separates the imposing figural mass from the top of the cross that crowns the composition. Pittoni produced the almost contemporary *Annunciation* to decorate the first seat of the Venetian Academy. The subject, central in the city's iconographic tradition, recalls the legendary founding of Venice on March 25, the feast day of the Annunciation. The delicate gestures and graceful movements of Gabriel and Mary create an elegant decorum, fitting to both the golden space between them and the canvas's original site.

Jacopo Amigoni and Gaspare Diziani

Pittoni was not the only painter born in the 1680s who worked successfully into the third quarter of the eighteenth century. Jacopo Amigoni, Gaspare Diziani, and Giambattista Piazzetta were all engaged in important secular and religious commissions through the middle of the Settecento. Amigoni, who was probably born in Venice, worked in Germany as a young man and then traveled from one Italian city to another. He spent the years 1729 to 1739 in England where, like Ricci and Pellegrini before him, he was employed in the theater and by the nobility. After returning to Venice, and before departing in 1747 for Spain, where he died, he produced a lovely *Venus and Adonis* whose elegance matches that of Pittoni's Annunciation but insists more on classical form and patterned areas of shadow (see p. 591). Amigoni's attraction for an international audience is apparent in the ceiling canvas of the *Judgment of Paris*, in the Villa Pisani at Strà, in which the composition and the viewpoint of the figures conform to local tradition. The cooler greens, blues, and pinks link him, however, more with François Boucher's classical pastorales than anything produced in Venice at mid-century. Amigoni emerged from the world of Bellucci, Bambini, and Balestra, but he was the most of his generation. It is startling to realize that although their art is poles apart, he and Piazzetta were exact contemporaries: both were born in 1682, painted altarpieces for the same churches, and died within only two years of each other.

Gaspare Diziani studied with two local masters, the very different Lazzarini and Ricci. Like Amigoni, he worked in Germany during the new century's second decade, but he spent most of his career in Venice. His painterly brushwork is close to Ricci's, with whom he shared the same place of birth, Belluno. In 1733 Diziani executed the canvases now covering the entrance wall facing into the sacristy of

emotionalism of the altarpiece is given voice by open gestures alternating with clasped hands, and its immense pile-up of forms is cleverly composed of pairs of mirrored or contrasting figures. Pittoni surrounded the whites, beiges, and browns delineating Christ with the more vivid and sharp hues of

ON THE FOLLOWING PAGES:
Massacre of the Innocents, detail. The enormous quantity of narrative detail is combined with explosions of heavenly light through night skies.

OPPOSITE:
*Judith with the head of
Holofernes*, Giambattista
Piazzetta, 1750. Scuola dei
Carmini, Sala dell'Archivio. The
work is part of a painted cycle
illustrating episodes about
biblical heroines, all of whom
allude to the Virgin.

The Fortune-Teller, Giambattista
Piazzetta, c. 1740. Gallerie
dell'Accademia. This is one of the
artist's most famous paintings; it
marks his transition toward a
more intensely chromatic style
and the introduction of a subject
connected with sex and the
paying public.

S. Stefano: above and to the left, the *Flight into Egypt*, to the right, the *Adoration of the Magi*, and on the entire expanse of wall below, the *Massacre of the Innocents* (see pp. 592–595). In its massive accumulation of detail across one surface, the cycle repeats earlier pictorial schemes such as those in S. Zaccaria and S. Maria ai Carmini. The proportions of Diziani's figures, their physiognomies, and even some of the groupings recall Ricci, particularly if one compares Ricci's *Rape of the Sabine Women* in Palazzo Barbaro (see p. 567) with Diziani's *Massacre*. The bursts of heavenly light breaking through the nocturnal skies belie the tired cliché that Venetian art of the period is typically bright in color, and remind us of the century's strong current of Tenebrism.

Giambattista Piazzetta

Indeed, the most famous painter of Diziani's generation was Venice's greatest Tenebrist, Piazzetta. Although his art is ranked today second only to Tiepolo's, Da Canal's verdict at the time was harsh: Piazzetta was a great draftsman but "his use of color was prejudicial to his drawings [and] he very often used a raking light on flesh, which produced an ugly, unnatural effect." But Da Canal added that Piazzetta eventually became aware of his mistakes, "so that he sweetened [his style], which led to a positive development, and he turned out in these last years to be one of the best living painters. . . ." *Sts. Vincent Ferrer, Hyacinth, and Louis Bertrand*, over the third altar on the right in the church of the Gesuati, proves Da Canal's point. Executed in 1737–38, a decade after the *Madonna and Child Appearing to St. Philip Neri*, the Gesuati altarpiece not only displays a tighter compositional structure than its counterpart at the Fava but is also a brighter image. It shows Piazzetta working from a field of dark color at the composition's bottom across a weave of whites and grays to the white-winged angel above, whose fair head and vivid red lips crown the top center of the canvas. The tonalities of the earlier Madonna and Child at the Fava are instead tawnier and darker, and the zigzagging movement upward closes on the somber chord of the Virgin's deep blue mantle.

Piazzetta's early success stemmed in part from his deeply shadowed paintings of Old Testament narratives and such works continued throughout his career. One story he represented at least four times was *Judith with the Head of Holofernes*. Although all of the versions show the sleeping warrior still alive, each presents a different dramatic solution. His last depiction of the subject, produced c. 1750 for the Scuola dei Carmini, presents his only full-length

Judith, gazing upon the heroically beautiful body of her adversary (see p. 596). The painting captures the nocturnal calm in the Assyrian general's tent just a few moments before Judith decapitates him.

Giulia Lama also painted several versions of this same subject. That in the Accademia (see p. 583) is closely related to Piazzetta's depiction of the story now in a private collection in Milan, in which Judith looks heavenward for the Lord's assistance. But Lama's Holofernes must have been the source for the general in Piazzetta's Carmini canvas of c. 1750, for it postdates her death in 1747. It seems, then, that each looked to the other. Given that Piazzetta's well-known portrait of Lama is usually dated to c. 1715–20, a long and ongoing professional give-and-take between the two artists must have existed.

In contrast to all his colleagues, including Lama, Piazzetta had a unique taste for genre, resulting no doubt from his early study of Crespi's art in Bologna. He painted several large works of "bucolic" subject-matter, three of which—two are now in Chicago and Cologne—belonged to Marshall Johann Matthias von der Schulenburg, the German mercenary who had led Venice in overcoming the Turks during the War of Corfu (1716–18) and then retired with a state pension to a palace on the Grand Canal where he formed a major collection of paintings. Along with the *Fortune-Teller* (Venice, Gallerie dell'Accademia, Venice), the Schulenburg canvases were completed by c. 1740 and present desirable women posed alongside young male peasants. They have been subject to a wide variety of interpretations, but Knox is probably right when he calls the scenes "Flemish caprices" and relates them to Piazzetta's book illustrations for Giambattista Albrizzi. The *Fortune-Teller* is the most easily decipherable of the three and centers around sex and a paying public: the pointed finger of the man in the rear corresponds to the hands of the woman on the other side of the grouping, and both sets of gestures are on line with the central figure's groin (see p. 597). She herself looks directly at the viewer, passive but also ready for action. Her fair complexion and full face, cut only partially by her hat, are paired exactly by the depiction of the boy in the rear. The relationship of the two couples is as pointed as the fingers, and the pair of trussed chickens in the bottom right corner surely mocks and pokes fun at them.

Tiepolo in the 1730s and 1740s

Piazzetta's success during the second quarter of the century was outmatched by Tiepolo's contemporary accomplishments, phenomenal in their range.

Beginning in the early 1730s, he painted a series of important altarpieces for churches in Venice and elsewhere, among them the *Adoration of the Christ Child*, displayed in S. Zulian, and the *Education of the Virgin*, for the Fava (see p. 600). Both show a close-knit family anchored in a real world into which the miraculous and Church doctrine intrude. The Virgin's immaculacy is translated into a brilliant white garment in the Fava altarpiece, and Christ's power to redeem mankind through his sacrifice is communicated by the shroudlike cloth with which Joseph respectfully cradles him in the *Adoration*. Jewel-like colors emerge so that Tiepolo clearly differentiated his Tenebrism from Piazzetta's.

The most distinguishing mark between the two great painters, as well as between Tiepolo and every other artist working at the time, was the younger man's innate ability to conceive pictorial drama on a grand scale, and to translate it into monumental imagery in either oils or frescoes that both gives meaning to, and exquisitely decorates, ecclesiastical and secular interiors. While Piazzetta was working on the *Fortune-Teller*, for example, Tiepolo was frescoing the large expanse of the Gesuati ceiling and painting a grand triptych in oils for S. Alvise (see pp. 600–601). In the first, whose date of execution is documented to 1738–39, he painted forty scenes of varying dimensions focused on and centered around the institution of the rosary. Using ceilings by Veronese and others as his models, Tiepolo demonstrated the efficacy of the rosary's power to cast evil from the world while narrating at the same time St. Dominic's mission to carry it personally to humanity, among whom prominently figures the doge. The theme's centrality to the Dominican order housed at the Gesuati monastery and the scene's specific relationship to Venice are therefore self-evident. The *Institution*'s zigzagging composition makes the Gesuati's solid interior pictorially vibrant. Tiepolo's effective exposition of the Virgin's and St. Dominic's role in the cult of the rosary contrasts with Francesco Fontebasso's slightly earlier cycle of *Abraham and the Three Angels* and *Elijah Carried into the Heavens* on the vault of the Gesuiti. Born in 1707, Fontebasso was eleven years younger than Tiepolo, but he frescoed this, his first church ceiling in Venice, in 1734, four years before the older Tiepolo began his. Richly colored stuccoes lavishly ornament and cover the ceiling surface, competing for attention with the narrative episodes and weakening, too, the appearance of the vault's structure. Tiepolo, on the other hand, simplified surface decoration; moldings thicken and broaden toward the middle, creating, as it were, a hierarchy of importance. Using color, moreover, he contrasted the pictorial and narrative force of the scenes in the center of the ceiling against the surrounding neutral tonalities.

The *Road to Calvary* in S. Alvise, along with the *Flagellation* and the *Crowning with Thorns*, creates an altogether different mood from the Gesuati frescoes. Painted in rich oils, the scene is a forceful melodrama of Christ's agony under the weight of the cross, his plight pictorially intensified by the jagged rock formations, sounding trumpet, and whinnying horse, and the martial arms silhouetted against the sky. Rather than referring to Veronese, Tiepolo here recalls Tintoretto's several paintings of the Crucifixion, the most famous of which covers one wall of the Sala dell'Albergo in the Scuola Grande di S. Rocco. The art of Rubens may also have played a part in establishing Tiepolo's melodramatic tone for the Venetian painter probably knew a sketch that the Flemish master had prepared for his *Road to Calvary* in the Benedictine abbey of Afflighem, which was in a private collection in Venice during the early eighteenth century.

Tiepolo's fame had spread far and wide by 1740 when notice of the triptych at S. Alvise first appeared in print. He had frescoed in Udine during the 1720s and in the 1730s he painted for churches in Padua and Bergamo, in Villa Loschi outside Vicenza, then for churches in Vicenza, Rovetta (province of Bergamo), and Milan, and later for churches in Germany. During the 1740s, he continued to turn out devotional paintings for churches on the *terraferma*. The *Fall of Manna* and its pendant, the *Sacrifice of Melchizedek*, which decorate the two side walls of the chapel of the most holy sacrament in S. Lorenzo, the parish church of Verolanuova outside Brescia, were completed by c. 1742–43. Each offers an Old Testament narrative in relation to Francesco Maffei's *Last Supper*, over the chapel's altar. Tiepolo's *Manna* catches the sublime and unexpected miracle of God's celestial nourishment falling upon the starving Israelites during their flight from Egypt. Most often depicted in a horizontal format that emphasizes its narrative content, the story had necessarily to be reinterpreted at Verolanuova because of the chapel's requirements. Tiepolo was not stymied, however: he incorporated trees soaring upward to link the angelic vase above with the great salver below, creating a vertical axis to underscore the painting's essentially devotional content. Having perfected by the mid-1740s his long-standing repertoire of bearded patriarchs, muscular male nudes, turbaned "orientals," glamorous women, golden-haired children, and reverential Israelites, he expertly disposed them in the *Fall of Manna* through a deep spatial continuum, coordinating shadows and highlights to compose visually harmonious groupings.

Secular Cycles

After Verolanuova, Tiepolo began a series of more than half a dozen decorative cycles in urban palaces and country villas. During the summer and autumn of 1743 he frescoed the two-storied salone in the center of Carlo Cordellina's villa outside Vicenza. Cordellina was a lawyer like Tommaso Sandi, for whom the artist had decorated a reception hall twenty years earlier. As on that occasion, the patron's profession determined the choice of subject-matter. A specialist in international jurisprudence, Cordellina opted for two narratives of heads of state offering clemency to foreign prisoners, the *Generosity of Scipio* and the *Family of Darius before Alexander*. As in the past, Tiepolo turned to Veronese for ideas, choosing as a model for the *Family of Darius* the earlier master's famous depiction of the same subject, which then decorated a room in Palazzo Pisani in Venice. Tiepolo followed his predecessor in several ways, but since the Cordellina fresco is almost square in format rather than rectangular like Veronese's canvas, Tiepolo was compelled to rethink—as he had for Verolanuova—the subject's earlier artistic tradition. Placing a magnificent military tent behind Alexander that both conveys his majesty and embodies his open-hearted generosity toward the family of his vanquished enemy, Tiepolo employed it to fill the right half of his large pictorial surface, at the same time contrasting the swelling form of the monumental tent with the sinking and pleading figure of Darius's mother, whose deep cobalt-blue gown sings a woeful lament from the fresco's bottom center. Tiepolo subtly underscored the woman's age by positioning an old man directly behind her. He then juxtaposed the pair with figures of youthful beauty aligned on either side, whose colorful robes are scaled chromatically across golds and cinnamons toward a white stallion on the far left and a young page in white on the far right. In the distance, a Palladian loggia spanning more than half of the painting's width turns brilliantly white under a blazing sun. The *Family of Darius*, along with the equally successful *Generosity of Scipio* facing it, is one of Tiepolo's mature masterpieces. With their simple gestures, monumental spaciousness, and exquisite harmonies of color, the pair of paintings convincingly portray deeply felt emotions that shine forth into the Cordellina *salone*, giving voice to the uniquely human virtue of magnanimity.

In the same decade, but in an urban palace in Venice, Tiepolo filled another *salone* with quite a different spectacle. The love affair of Antony and Cleopatra is reenacted in a fresco cycle in Palazzo Labia, part of what appears to be the painter's own infatuation with that amorous couple in the mid-

Education of the Virgin, Giambattista Tiepolo, c. 1732. Church of S. Maria della Fava. The work shows a close-knit family anchored in a real world into which the miraculous and Church doctrine intrude.

OPPOSITE:
Road to Calvary, Giambattista Tiepolo, 1738–40. Church of S. Alvise. The subject is the central portion of a triptych, flanked by the *Flagellation* and the *Crowning with Thorns*. Painted in rich oils, the scene is a forceful melodrama of Christ's agony under the weight of the cross.

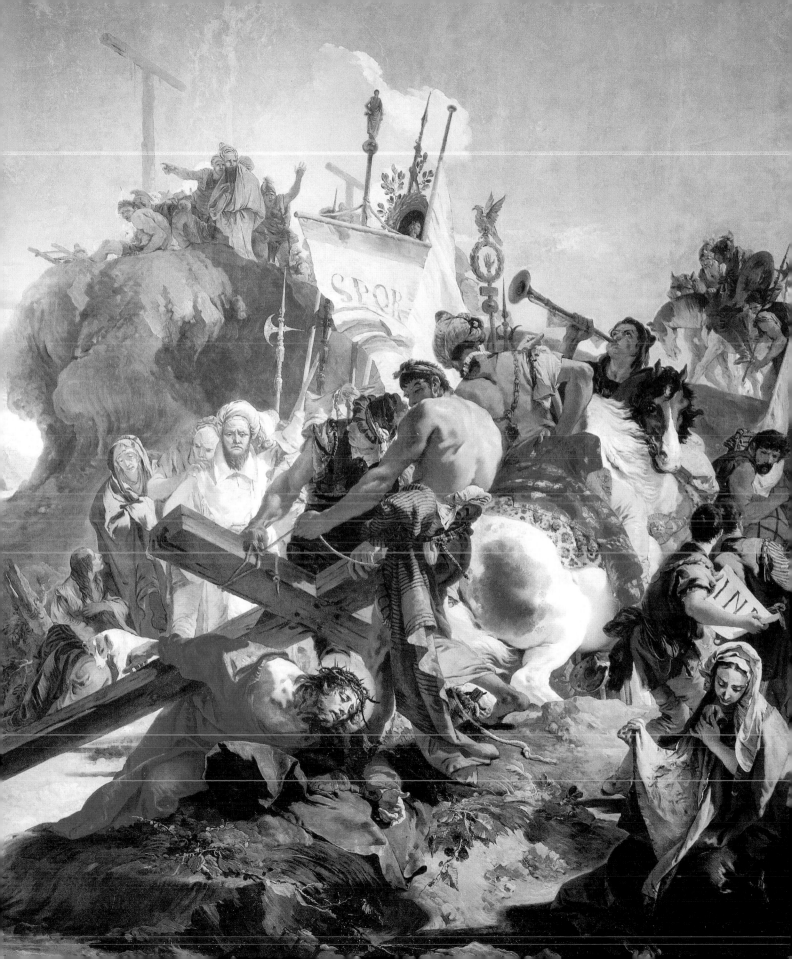

Diana the Huntress, Giannantonio Guardi, detached fresco. Ca' Rezzonico, formerly at Casa Barbarigo all'Angelo Raffaele.

ON THE PRECEDING PAGES:
Marriage of Tobias, Giannantonio Guardi, c. 1750. Church of S. Angelo Raffaele, organ parapet. The detail shows the preparations for Tobias's marriage with Sarah. Nothing in the apocryphal biblical text suggests the shimmering light, the radiant landscape, or the silvery tones that the artist has pictured in this commission from the Savorgnan family.

1740s. In 1743–44 he painted a *Banquet of Antony and Cleopatra* for Augustus III, king of Poland and elector of Saxony, and in 1747 completed another depiction of that same subject which, along with its pendant, the *Meeting of Antony and Cleopatra*, is now in Russia. Tiepolo's completion of the *Banquet of Antony and Cleopatra* and the *Meeting of Antony and Cleopatra* in Palazzo Labia, timed perhaps to celebrate the centenary of the family's admission into the patriciate in 1646, was either in the years between 1744 and 1747, or immediately thereafter. Each of the Antony and Cleopatra paintings, in oil or

fresco, can be associated with its own sketch or small copy in oil.

The Labia cycle differs from Tiepolo's other paintings on the theme because of its essentially decorative nature. Frescoed on two of the *salone's* walls and accompanied by a ceiling painting, the Antony and Cleopatra narratives are enlivened by a series of *trompe l'oeil* openings that are the work of Tiepolo's longtime collaborator in the genre, Girolamo Mengozzi-Colonna from Bologna. His feigned cornices and columns give way to solid moldings, painted balustrades attach to actual balconies, and imaginary spaces seem attainable through real doorways. Thus Tiepolo's banquet of Cleopatra and Antony appeared to contemporary Venetian patricians as if it were taking place before them—as indeed it was for the dwarf on the stairs. The delicious visual game extends to the painted musicians above, who look as if they are responsible for the music that formerly filled the *salone* during receptions. The hall is now silent, but the meaningful glances between the Egyptian queen and her Roman guest still resonate. Unlike the *Meeting* that bustles on the wall across from it, the *Banquet* is quietly restrained, awaiting resolution. Lucius Plancus, Antony's fellow consul, conveys the general nervousness of the moment as the poised Cleopatra stops before dissolving a pearl in wine. Even Tiepolo himself, dressed in a lordly blue ensemble and standing at the far left between two other men, is concerned for the denouement. Yet it is all artifice. The Labia frescoes rank among Tiepolo's greatest accomplishments on a secular theme during a sixty-year career. In the tension between frivolous fancy and real drama, and in the protagonists' perfumed earnestness, these works are also his most ironic comments on ancient history.

While painting the fabulous *Antony and Cleopatra* frescoes, Tiepolo produced a number of serious religious works, both ceiling paintings and altarpieces. In late 1743 or early 1744, he began planning the *Translation of the Holy House* for the feigned vault of S. Maria di Nazareth, the church of the Scalzi in Venice. The fresco itself, completed in late 1745, was destroyed during World War I by bombs, but two oil sketches for it survive. The one still in Venice shows Tiepolo's first thoughts, but both reveal the brilliant handling that he had developed after a quarter century of painting. Quick, short, choppy strokes of paint outline forms; irregular and bluntly formed daubs of color define small patches or areas of light and shadow. The staccato-like movement of the brushwork matches the eccentric positioning of forms in space, so that figures appear to move, angelic wings to flutter, clouds to fly by, and the atmosphere itself to

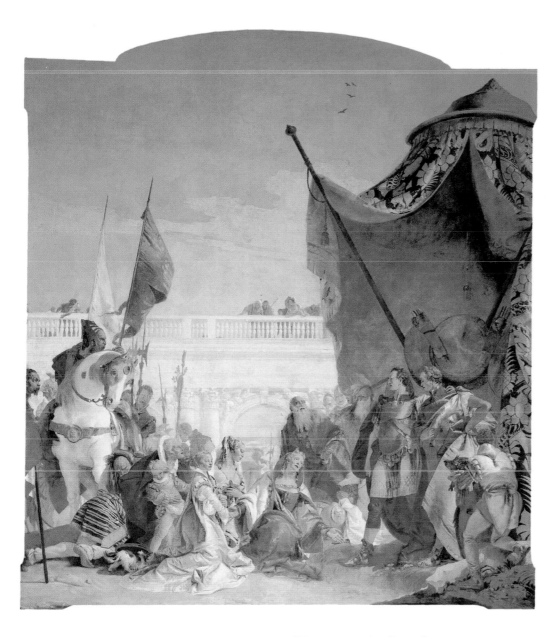

vibrate. Tiepolo, like many of his contemporaries, was breaking up the paint surface. Ricci and Pellegrini had led the way decades earlier, and most Venetian painters of the period chose to follow their example. In his *Adoration of the Magi*, for instance, the young Fontebasso used the same fragmented and sketchy application of paint, particularly in the rich garb of the three kings.

Giannantonio Guardi

The artist most noted for this technique, raising it to a new richness of expression, was Giannantonio Guardi, Tiepolo's brother-in-law. The two were linked through Cecilia Guardi, Giannantonio's sister, who had married Tiepolo in 1719, while Giannantonio's brother Francesco, born in 1712, probably worked under Tiepolo during the 1730s. Neither Guardi painter, however, ever achieved the contemporary fame enjoyed by their sister's illustrious husband, nor did they send their paintings

Family of Darius before Alexander, Giambattista Tiepolo, 1743. Montecchio Maggiore, Villa Cordellina, main reception room. The fresco was inspired by a work on the same subject painted by Veronese for Palazzo Pisani in Venice.

ON THE PRECEDING PAGES
AND ON P. 608:
Ceiling of the Sala Capitolare, Scuola Grande dei Carmini, 1740–44. On the preceding pages: details of the figures of the virtues and beatitudes framed in plaster decoration by Abbondio Stazio. On p. 608: *Virgin and Child Appear to the Blessed Simon Stock*, Giambattista Tiepolo. The figures' closeness and corporeal reality, the structural solidity of the plinth on which Stock kneels, and the dark presence of purgatory below contribute to the forceful and immediate impact made on the viewer.

OPPOSITE:
Exaltation of the Cross, Giambattista Tiepolo, 1744–45. Gallerie dell'Accademia. Fresco painted for the former church of the Capuchins in the Castello area.

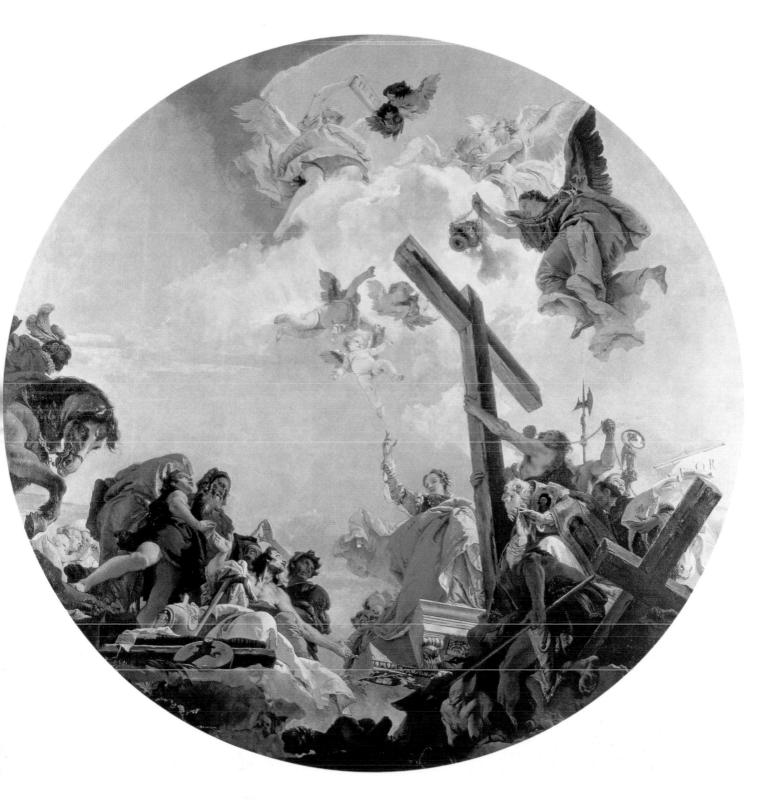

abroad or travel to foreign capitals. Their patronage was restricted mainly to locals and to Marshall Schulenburg, for whom Giannantonio painted over a hundred works. Despite Giannantonio's lack of international esteem at the time, his style is recognized today as one of the most remarkable of its era. Even more than Tiepolo, he applied his paint to create a scintillating mesh of staccato brush strokes.

The Belvedere altarpiece, painted c. 1748–49 for a country church near Aquileia, is a typical and brilliant example of Giannantonio's style. His most splendid paintings, dating from the same years and covering the organ parapet in S. Angelo Raffaele, Venice, narrate episodes from the Book of Tobias (see pp. 602–603). The central and largest scene shows the preparations for Tobias's marriage with Sarah, the Archangel Raphael's blessing over them, and their wedding chamber. Nothing in the biblical apocryphal text suggests the shimmering light, the radiant landscape, or the silvery tones that Giannantonio pictured. The glittering architecture and the splendid draperies, every one of their surfaces faceted like a gem, flank a landscape glowing with incandescence, at whose center a lone gondolier, depicted with fewer than a dozen strokes of the brush, glides into the distance. The series, a commission from the Savorgnan family like the Belvedere altarpiece, is unique.

Tiepolo and the Scuola dei Carmini

And so, it would seem, is the ceiling decoration that Tiepolo, Giannantonio's brother-in-law of three decades, finished in 1749 for the chapter room of the Scuola dei Carmini. Unlike his ceilings for the Gesuati and the Scalzi, and the one he would later tackle in the Pietà, this pictorial complex was not painted on a large vault high above parishioners but on a low flat surface of moderate size and was painted with rich and deeply colored oils on canvas and set into a fancifully designed stucco surround colored with ochers, light greens, pinks, whites, and golds. The beautiful totality is unexpected because the Venetian ceiling tradition paired canvas paintings with wood coffers. Tiepolo's cycle comprises nine works, eight of which show virtues, beatitudes, and cherubs with objects and events relevant to the scapular. The central scene reveals the thirteenth-century English Carmelite the Blessed Simon Stock humbly accepting a homespun scapular from an angel as the Virgin and the Infant Christ hover in the heavens above (see p. 608). Given the figures' closeness and corporeal reality, the structural solidity of the plinth on which Stock kneels, and the dark presence of

purgatory below, the scene strikes viewers with a more forceful and immediate impact than any of Tiepolo's other church ceilings.

During the 1740s, Tiepolo also completed several altarpieces for churches in the Veneto and in the city. In Padua he painted three for S. Massimo, two for its lateral altars and *St. Maximus and St. Oswald* for its high altar, and in Venice, the *Last Communion of St. Lucy*, for the Cornaro Chapel in SS. Apostoli. The S. Massimo altarpiece is related to a group of more than a half dozen similarly conceived *bozzetti* [preparatory drawings]. The Cornaro canvas, which refers to St. Lucy's imminent martyrdom, resulted from Tiepolo's consideration of paintings from three different centuries: Veronese's *Martyrdom and Communion of St. Lucy* of about 1580 (Washington, D.C., National Gallery of Art), Domenichino's *Last Communion of St. Jerome* of 1614 (Rome, Pinacoteca Vaticana), and Ricci's *Last Communion of St. Lucy* of c. 1730 (Parma, S. Lucia). Tiepolo's solution for both altarpieces was what he had evolved in general since the early 1730s: a tightly knit figural composition within solid-looking architecture linked to the worshiper by a platform and steps. The paintings reveal, further, the mature Tiepolo's capacity to picture the mystery of religion within a lusciously painted scene.

Domenico Tiepolo

By the end of the fifth decade, Tiepolo was no longer working alone in his studio. His eldest son Domenico, who was born in 1727 and had been helping him for several years, debuted in 1747 as an independent artist in the Oratory of S. Polo with fourteen canvases depicting the stations of the cross. They are very different from his father's heroic images. Stations IV and VIII, respectively, set Christ within landscape and against architecture. Although many of Domenico's figures and artistic devices recall those of his father, the sure sense of personal relationships and private exchange within the context of Christ's sufferings differs totally from the older painter's dramatic mode. Domenico's small canvases are historically significant, too, in the context of Catholic worship, for they were contemporary with events in Rome that elevated Christ's progress to his death as a major form of devotion. The series is the first painted cycle of the stations in Venice, where other sets subsequently appeared. Fontebasso collaborated in the mid-1750s in one of the most important, for S. Maria del Giglio, for which he executed stations IV and XI. In its build-up of monumental architecture, bustling activity, crowds of onlookers, and dramatic gesturing, his *Christ and the Virgin* differs radically from Domenico's and is closer to Giambattista's conception of Christian drama.

Venetians Abroad

The elder Tiepolo's fame was so widespread by 1750 that he was invited by the prince-bishop of Würzburg, Karl Philip von Greiffenklau, to fresco the Kaisersaal, or imperial hall, in the newly built archbishop's palace there. Accompanied by Domenico and another son, the fourteen-year-old

Portrait of a Lady, Rosalba Carriera, Ca' Rezzonico. Carriera was the only Venetian portrait painter apart from Sebastiano Ricci to use pastels. Her work was appreciated beyond the boundaries of Venice, and she received commissions from many European courts.

OPPOSITE:
Last Communion of St. Lucy, Giambattista Tiepolo, 1748–49. Church of SS. Apostoli, Cornaro Chapel. The tightly knit figural composition is placed within solid-looking architecture and linked to the worshiper by an illusionistic platform and steps.

Lorenzo, Giambattista left Venice in November 1750, arriving in Würzburg on December 12. By late 1753, when he returned home, he had frescoed not only the ceiling of the Kaisersaal and two surfaces of its springing vault, but also the immense ceiling over the palace's main stairwell. In addition, he produced various oil paintings during that period. The *Allegory of the Four Continents*, or *Olympus*, was a type of secular ceiling that he had painted before, although nothing in his earlier career was as large or as iconographically complicated as what Greiffenklau asked him to execute. Each of the four cornices in the stairwell "supports" a continent. Europe is the last seen by visitors ascending the stairs. Unlike America, inhabited by savages, Africa, where merchants exploit indigenous peoples, and Asia, whose ancient cultures have disappeared, Europe knows virtue and produces lasting achievements. Civilization flourishes, the arts thrive, and the Church reigns supreme. At its compositional center a crozier carries our glance upward to a portrait of the prince-bishop wrapped in an imperial mantle; the golden frame is a wreath of simulated laurel steadied by a griffin's claws (Greiffenklau). The ceiling is the century's most monumental statement of absolutism: Truth crowns the portrait, Fame proclaims the patron's accomplishments, and Mercury signals his arrival in the heavens, where Apollo, his magnificent body taut and springing with energy, holds aloft a statuette of the Farnese Hercules. Cloudbanks both envelop and expand outward from the sun god, whose distant form catches our attention through the brilliant nimbus around him, the entablature of the temple of truth behind, and the zodiacal band below. Nothing in the history of Western painting prepares viewers who have left behind the darkness of the palace's vestibule for the experience of climbing toward Tiepolo's brilliant heavens, for their unique ascent through actual vertical space to Apollo and his celestial court.

Tiepolo's achievements in Würzburg contributed to the general success that eighteenth-century Venetian art enjoyed in contemporary Europe. As noted earlier, Pellegrini and the two Riccis, uncle and nephew, popularized the Venetian style in Britain during the first years of the century. They were later followed there by Amigoni, and eventually by Antonio Canaletto, Venice's master view painter. Sebastiano Ricci and Rosalba Carriera, the city's only portraitist working in pastels, were successful in Paris; Pellegrini, Amigoni, and Bernardo Bellotto, Canaletto's nephew and "follower" in view painting, carried local traditions to Germany and Austria. Warsaw benefited from Bellotto's years there, while the Russian imperial court patronized Tiepolo

through intermediaries. Amigoni's success in Spain preceded Tiepolo's by a decade. Only Piazzetta never set foot outside Italy, but he made his name known to a large audience on the continent through paintings and prints sent abroad. In sum, Europe enjoyed Venetian art, and its presence in several capital cities effectively changed the course of local schools of painting.

The measure of the distance Tiepolo had traveled artistically between youth and maturity can be gauged by comparing the immense fresco over the Würzburg stairwell with his much smaller ceiling of the *Triumph of Zephyr and Flora*, a canvas he painted in the early 1730s. There, space is shallow,

Sacrifice of Iphigeneia, Giambattista Tiepolo, 1757. Vicenza, Villa Valmarana, Sala di Ifigenia, detail of the main wall. The fresco's *trompe l'oeil* columns ennoble the villa's simple architecture and set the stage for the dreadful sacrifice. But the goddess Diana sends a small hind, illusionistically represented on the fresco's far left-hand side, to replace the Greek princess at the altar.

OPPOSITE:
Apollo and Allegories of the Four Corners of the World, Giambattista Crosato, 1753. Ca' Rezzonico, *salone* ceiling. A complex creation of figures moving through open space, set within an overwhelming scenographic perspective.

figures seem inert, and lighting effects are more contrived, less apparently accidental.

Even more relevant comparisons can be made with contemporary secular visionary ceilings by other Venetian artists. Diziani glorified the new patrician family of the Widmann on a ceiling of their Venetian palace around 1750, and Crosato the Rezzonico, also recently admitted to the patriciate, in their home on the Grand Canal c. 1753 (see p. 612). In each painting space is static, and there is little sense of the infinity of the heavens. The frame, moreover, not only confines the central image but, its *quadratura* [scenographic perspective] overwhelms it. Diziani's and Crosato's ceilings successfully ornament richly appointed private spaces below, but Tiepolo's accomplishment at Würzburg is greater. As in Palazzo Labia, he appears to alter the actual architecture so that it seems grander and larger than it is, but he also conditions visitors themselves. Sensing that space is limitless, their steps quicken as they climb, and their attention darts from continent to continent; in traveling the world, their physical reality, like their imagination, moves without restraint, and they enjoy total freedom.

Tiepolo's Last Work in Venice

When Tiepolo reestablished himself at home in 1754, he was the grand old man of Venetian art. He surpassed all his contemporaries as well as every painter of the previous generation, which he outlived except for Pittoni and Diziani, both of whom survived until 1767. Piazzetta, the only painter who could measure up to Tiepolo, died in April 1754. From then until his definitive departure from Venice in 1762, Tiepolo painted several more ceilings and altarpieces, which have sometimes suffered under the accusation that they repeat old formulas. Motifs and character types are indeed familiar, but following upon Würzburg, he continued to open up space in relation to figures, and he intensified his protagonists' emotional level. In Venice itself, he painted one final altarpiece and one last ecclesiastical fresco. On 8 May 1754, he unveiled the *Virgin and Christ Child Appearing to St. John Nepomuk* in S. Polo, and a year later he completed the *Triumph of the Faith* in S. Maria della Visitazione, the church of the Pietà. Both commissions celebrate the mother of Christ. The S. Polo altarpiece also honors a fourteenth-century Czech saint canonized in 1729, setting his vision of the Virgin and Christ in an otherworldly realm with few tangible points of reference. Dressed in a ruby-red gown covered by a rich blue mantle, the Virgin stands on a cloud floating toward St. John, from whom emanates a radiant aura of spiritual enlightenment. At the Pietà, the mother of Christ also stands on a cloud. Here, however, worshipers contemplate Christian hierarchy and doctrine rather than a saintly vision. The brilliantly gowned Virgin is the Christian ideal of immaculacy, the cross-bearing Christ recalls sacrifice, and the haloed God the Father offers Christian victory in the name of the Trinity. The Holy Spirit enlightens the universe from a distance. Reminding us of the Pietà's resident music school for orphaned girls, music-making angels sing and play heavenly harmonies on a feigned balcony that separates the celestial gathering from mundane reality. Tiepolo's atypical monochromatic emphasis in the fresco may be his homage to the recently deceased Piazzetta, who before his death had begun the altarpiece for the principal tabernacle in the church below. A similar coloristic treatment is evident in the S. Polo painting, where a thick amber-colored glory hovers around the Virgin. Tiepolo's purposeful recall of the other Giambattista in both these instances is comprehensible, for he must have sorely grieved the loss of his colleague. Since the S. Stae Apostles of 1722–23, the two had engaged in a spirited and friendly artistic competition across a number of commissions. Their dual importance in the city was recognized by their contemporaries: in 1750 Piazzetta was elected the first director of the *scuola del nudo* [life-drawing class] on the establishment of the Academy in Venice and shortly after his death Tiepolo followed him in that office.

In 1757 Tiepolo painted his last large-scale fresco cycle in Italy, that in the Villa Valmarana "ai Nani" outside Vicenza. He decorated the villa while Domenico painted in the *foresteria*. Entering the villa, guests see on the right wall of its vestibule, behind a feigned portico recalling the actual structure that leads onto the Valmarana grounds from the Via di S. Bastiano outside, Tiepolo's *Sacrifice of Iphigenia* (see p. 613), the proemium to his series of Greek, Latin, and Italian epic poems that follows in adjacent rooms. The fresco's *trompe l'oeil* columns ennoble the villa's simple architecture and set the stage for the dreadful sacrifice about to take place. But as Agamemnon covers his eyes, unable to behold his daughter's slaughter, the goddess Diana in the heavens (that is, on the ceiling) sends a small hind, illusionistically represented on the fresco's far left-hand side, to replace the Greek princess at the altar. Tiepolo discloses instantaneously Iphigenia's terrible fear, her father's suffering, and celestial benevolence. The painting forces visitors to abandon reality and separates them from quotidian details. Moving into a world of passion and heroism, they then encounter the love stories of Achilles and Briseis (from Homer's *Iliad*), Angelica and Medoro

(from Ariosto's *Orlando furioso*), Dido and Aeneas (from Virgil's *Aeneid*), and Rinaldo and Armida (from Tasso's *Gerusalemme liberata*). Why Giustino Valmarana, a noble and learned Vicentine patron, desired these amorous tales in his home is unknown. But seizing the opportunity given him, the sixty-year-old painter pictured love's desire, its power to enrapture, and the sadness suffered at its loss.

The Valmarana frescoes is Tiepolo's only cycle of private secular paintings to encompass narrative from ancient history, myth, and modern poetry. Their place in the artist's oeuvre is special, moreover, because they seem to be one of only three secular commissions that were exclusively literary in subject-matter, without any intention to display the patrons' noble virtues, magnanimous deeds, or important actions. Tiepolo's almost two dozen other private secular commissions in Venice and the Veneto stand in contrast because they aimed instead to do just that. Using allegory or ancient history either to ennoble the family in question or to draw parallels between it and the past, or displaying events of modern history to recount significant moments of that family's history, these cycles sought to glorify patrons before both themselves and society.

Such a commission occupied Tiepolo just as he completed the Valmarana frescoes. To celebrate the marriage in January 1758 of Ludovico Rezzonico and Faustina Savorgnan, both of whose families had joined the patriciate in the late seventeenth century, he frescoed two ceilings in the newly completed Palazzo Rezzonico, *A Wedding Allegory* and *Nobility and Virtue Accompany Merit to the Temple of Glory*. In the first, Fame, the Three Graces, Wisdom, and Merit surround a chariot illuminated by Apollo's golden light which ferries a bride, and an almost invisible groom, across the skies. For the occasion Tiepolo reworked his Kaisersaal ceiling fresco in miniature, reversing the chariot's progress, reducing the number of figures, and simplifying the cloud formations.

Rezzonico wealth is mirrored in the family's artistic patronage and the magnificent palace it bought on the Grand Canal in the 1740s and completed in the 1750s. Such worldly fortunes in the hands of an Italian family often accompanied a prominent position in the Church, and Carlo Rezzonico, Ludovico's uncle, had been bishop of Padua since the 1730s. In 1758, the year the nephew married, his cardinal-uncle was elected pope and took the name Clement XIII. Is it coincidental that Tiepolo, the painter who decorated the Rezzonico palace in Venice, was also commissioned in that very year to furnish a painting for the high altar of the cathedral of Este which Bishop Carlo himself conse-crated? Unveiled on Christmas Eve 1759, *St. Thecla Liberating Este from the Plague*, the artist's last great devotional work in Italy, recalls the scourge that hit the Veneto in 1630–31. Here Tiepolo worked with motifs taken from the long tradition of plague imagery, which included paintings, prints, and drawings by Raphael, Marcantonio Raimondi, Pietro Testa, Nicolas Poussin, and Sebastiano Ricci. He pictured the death and desolation that had devastated Este, whose bell tower and medieval walls are seen in the distance. God the Father banishes pestilence, represented by a shadowy figure flying off on the left, as St. Thecla, a first-century saint from Asia Minor, pleads for the town and its people.

Almost seven meters in height, the Este canvas makes a profound impact *in situ*. God and St. Thecla engage in direct and private communion. She raises her head beseechingly, and he sweeps his arm in a sublime gesture of command. Equally striking are the layers of St. Thecla's gold, rose, vermilion, and white draperies that resound through the church. Tiepolo had always been a great colorist. Jewel-like primaries flash from his youthful Tenebrist works; hotter and more vivid colors scintillate in the bright sunlight of his mature paintings; his Valmarana frescoes are pale, almost pastel, with lavenders, roses, and lilacs blooming next to rich blues and greens; and an intense and saturated palette often characterizes his last works from Spain. The Este altarpiece is remarkable for its own subtle control of color, as is evident in a comparison between the finished image and its oil sketch. The *bozzetto* (New York, Metropolitan Museum of Art) dresses God in cerulean blue and St. Thecla in gold; beiges, ochers, and earth tones delineate the landscape. Such muted harmonies, however, would never have carried from the cathedral's dark chancel into its giant nave. Tiepolo altered his protagonists' clothing in the altarpiece so that St. Thecla's prayers soar to heaven on the fiery tonalities of her draperies while God's rich cobalt blue cloak reassuringly gives answers to her and everyone in church.

Tiepolo in Spain

On the last day of March 1762, Tiepolo left Venice once more, this time never to return. He, Domenico, and Lorenzo went to Madrid to paint in the palace of His Most Catholic Majesty, Charles III. Giambattista eventually frescoed three ceilings for Charles: in the throne room, the *saleta* adjoining it, and the guard-room. An enormous undertaking simply in terms of size, the ceilings are also dense in meaning and politically eloquent. Although they repeat many of his

Punchinello and Tumblers, detail,
Giandomenico Tiepolo, c. 1790, painted to
decorate the Villa Tiepolo in Zianigo. Venice,
Ca' Rezzonico. In his paintings for the
Tiepolo family villa, the artist could allow his
imagination to roam as it could not in the
splendid villas he and his father had
decorated for others. Here he depicted a wide
range of subject matter, from time-honored
histories and elegant city folk on country
outings to zany punchinellos at play.

earlier pictorial solutions and figural groupings, they also reveal new artistic directions. Individual elements are easier to read than they were in previous frescoes, and Tiepolo may well have been responding to Neoclassical tendencies then enjoying favor at the royal court. When he completed his work in the palace in 1766, he petitioned the king for permission to remain in Spain and serve him in oil paint as he had in fresco. Granted the king's favor, Tiepolo produced a cycle of seven canvases for the new church dedicated to S. Pascual Babylon at Aranjuez. The three altarpieces still extant today and the fragments of the others that survived their dismantling in 1775 are impressive works of art. Even more so are the five related *bozzetti* (London, Courtauld Institute Galleries), showing that the seventy-year-old painter was still capable of powerful imagery. These and his other last paintings capture a depth of feeling and economy of gesture that are communicated in part through tremulous brushwork that the old man must have quickly flicked onto his canvases.

Domenico Tiepolo

Tiepolo died on 27 March 1770. Lorenzo, his younger son, remained in Spain and continued to paint; he died there six years later. Domenico, however, returned home before the end of 1770. The last thirty or so years of his life were mostly occupied with commissions for secular and religious paintings. He prolonged his father's style, but rather than merely imitating it, he adapted it, as in *Abraham and the Three Angels*, which he painted c. 1773–74. Although predicated on Giambattista's art, the work is visibly different from it. The composition derives from his father's designs for the same subject in a drawing now in Berlin and two paintings still in Madrid. But Sarah's melodramatic gesture at the far left, the adjacent genre and landscape details, and the rustic Abraham genuflecting onto a seemingly resilient cloud are all elements inconsistent with Giambattista's religious imagery, and mirror instead Domenico's taste for quotidian reality. While his three angels generally restate the equivalent trio from his father's canvas of the same subject in the Prado, he altered the colors of their robes to a more flamboyant harmony and he insisted that each angel make a rhetorical gesture. Giambattista's subtly authoritative heavenly apparition is transformed into a group of brilliant pedagogues. Domenico's natural proclivities for depicting the here and now rather than for giving form to revelation and mysticism appear in his scenes of genre, in the extended series of biting drawings recording Punchinello's life, and in

Walk in the Countryside, Giandomenico Tiepolo, c. 1790, painted to decorate the Villa Tiepolo in Zianigo. Venice, Ca' Rezzonico.

the charming fresco decorations he executed for the family villa at Zianigo (see pp. 616–617).

When the French armies entered Venice in May 1797, they undid a society that had flourished for more than one thousand years. In extinguishing local government and its functioning bodies, they smothered the patrician class that had nourished a unique artistic tradition. In suppressing many of the city's churches and religious houses, troops closed public buildings that housed artistic treasures whose production had taken more than a millennium. And in carrying off many of those treasures, those same foreign forces deprived Venice of some of her most beloved offspring. The first half of the eighteenth century had witnessed a remarkable enrichment of that tradition, but such artistic flowering was less evident after 1750. In fact, the well eventually ran dry—before Napoleon crossed the lagoon. The history painters whom Venice had valued more than any other group of artists were apparently no longer in supply. It seems paradoxical that just as the political establishment formally recognized such artists by giving the Academy a charter right after mid-century, the local pictorial tradition slowly ground to a halt.

William Barcham

The Eighteenth Century of the Enlightenment and of the Bourgeoisie

Architecture in Eighteenth-Century Venice

It's a wonderful morning. At sunrise there it is, that other Venice. It's really there, wide awake, so delicate that a breath disturbs it; it does not emerge—at all—from its dreams. A Venice which by sheer willpower came out of nothing above submerged forests, forcibly created by the very wonder of wanting it, and grown into the miracle of its unmistakable body and soul.

These words, written by Rainer Maria Rilke in 1910, underline an image of the city that was invented by nineteenth-century Romantic culture but whose shadow has lingered through the twentieth century right up to the present day. They conjure up the idea of the former Republic as a place afflicted by unhappy political circumstances and a doggedly adverse economic situation, a city which the incomprehensible dark forces of Fate had condemned to lose sight of her own identity and history. Venice becomes, in Turner's hazy and glittering images, in Monet's fragmented atmosphere, in Whistler's immaterial views, nothing more than a memory—and only a memory—of an exhausted figure of beauty that has gone forever. What remains is nothing but a myth.

There is no doubt that 1797 was a fateful moment of transition which definitively extinguished all vain ambitions and any hope of recapturing the greatness, ideals, and prestige that had once given the city its peculiar and unrepeatable dimension and quality. Indeed, we know that in the Cinquecento the Most Serene Republic was exalted to the status of perfect political regime. This perfection was translated, made concrete, and structured into an exceptional *forma urbis*. "You, Venice," the poet Adria Luigi Groto proudly proclaimed in the sixteenth century, "were born free and full of charity toward God, your citizens, and all foreigners. You are the new Venus rising naked from the sea, more divine creature than the work of man... Your location is invincible and, being without walls, your walls are impregnable as they are provided by the Nereids and by Neptune himself." This is a topos in both the literary and figurative senses, and one which continued through two centuries. Paradoxically, it reached its climax at the very time when in the most dramatic of ways the politico-economic foundations underpinning the continuation of this unique place crumbled away. It is well-known that the Peace of Passarowitz in 1718 spelled out in unequivocal terms the unstoppable decline of the Republic. Nonetheless, the city remained the preferred destination of famous travelers, of sovereigns and intellectuals who enjoyed its final glowing splendors that are captured in the paintings of Canaletto, Guardi, Longhi, and Tiepolo.

Sources indeed document how diversions, entertainments, receptions, and parties punctuated the century as famous people arrived in the city. Frederick IV of Denmark came just before 1710, and the northern branch of the Conti family paid an extravagant visit as late as 1782. The descriptions of these occasions continue to portray the city as an amazing place that completely overwhelmed even these nominal "tourists." None of them caught any hint of the clouds that were gathering or of the imminent death of a capital which, at least as far as appearances went, still seemed rich and full of economic and cultural resources.

Hard Times and Investment in Building

That the ruling political class was already threatened with crisis is clear from archival research. Beltrami's

studies, based upon a representative sample from 1754 to 1760, show that only nineteen new buildings were constructed in the city in these years compared to 175 in the twenty-year period from 1539 to 1559. At first glance this figure seems extremely low. This is supported by other information in the second half of the century which confirms that the building industry was the hardest hit by the economic slump, by the sharp decline in the number belonging to the gild of *mureri* [bricklayers], which lost almost forty percent of its membership. The patrician families of Venice formed the heart of a social structure based on a constant and monolithic patrimony mostly land ownership. Wealth was inherited through the male line only and was guaranteed by the custom of *fidei commissum*, or administering property through a trust. The patrician class was waning, and year after year its decline became more vertiginous. As the richest families died out, so the number of impoverished nobility increased. This led to a fragmentation of the wealth available to individual family nuclei and made it difficult to contemplate expensive projects like new buildings.

When we look at the results of Beltrami's work, however, we should mention one curious fact. Alongside the decline in new construction, there was a constant and noticeable growth in the number of private residences and commercial properties being restored.

Another fashion was to split buildings into smaller residential units, more modest in size, easier to live in, and cheaper to maintain. Besides, in a depressed market their value was more readily convertible. The first thing to go, therefore, was the *portego*, the central room which ran from the front to the back of Venetian houses and which in the previous century had been at the heart of every residence. The *portego* was not only reduced in length, but false ceilings were installed to lower its height. Mezzanine floors, attics, and small rooms were in fashion as they were more easily adapted to the desire for greater comfort. That people felt a need to build in a manner better suited to the new demands of practicality and functionality is confirmed by Gasparo Gozzi. "This blessed art [architecture] has taught us," he wrote in a perplexed vein, "to rely so much on ornament that we are building more for the eyes of passers-by than for the people who have to live in the houses. If a man came to Venice who in his own country was used only to finding shelter from the cold and the rain, seeing our houses and not their inhabitants he would think we were all giants."

Those who suffered most from the long slump in the construction industry were architects. Tommaso Temanza complained:

Three centuries ago, Italy was full of patrons interested in Fine Art. With admirable generosity, private sponsors and princes alike supported and promoted the Arts. There were so many different commissions by noblemen enthused by the idea of constructing houses, palaces, temples, and buildings of every nature that in those days the Masters, albeit numerous and talented, struggled to force their fertile imaginations to invent ever new forms to suit everyone's taste. . . . But what of our times? Compared to then, they are truly miserable and stingy. So rarely does today's architect get the chance to show off his talent in works of any importance to his calling that he is forced to use it for the baser purpose of refurbishment and restoration. It won't be long before he's obliged to call his art a hobby and stay at his desk making buildings with the sole aid of a compass and a pencil.

In short, with contemporary accounts all in agreement, certain facts seem clear. First, and quite obviously, there was less money around in the building sector. It appeared to be a better bet financially to make use of existing structures and reused materials than to take on the huge expenditure that building from scratch involved. Second, by the eighteenth century Venice was so crowded with earlier buildings that it was not easy to find new land on which to build or to expand the urban fabric limitlessly. Then again, at the time in question, the most recent sale of building plots was to a large extent used for what were called minor constructions (even here we should distinguish between affluent apartment blocks and dwellings of modest specification). This type of building was driven by real-estate speculation, which also provided rental space for the lower classes.

As we have already mentioned, the large prestigious detached palazzo was split into more functional units. Similarly, the buildings traditionally used to house the less well-off classes and for rentals also underwent substantial changes. On the outside the buildings retained the same appearance as in the past: the *piano nobile*, or lofty main floor, set aside for the richest residents, was topped and tailed by attics above and mezzanine floors below. The biggest change, however, was the way the spaces inside the building related to each other through communal areas such as stairs, hallways, and courtyards. The privacy of individual dwellings had been assured in the sixteenth century, when buildings used a series of adjoining modules—giving a layout where nighttime areas were directly over daytime rooms—each with its own services (staircase, courtyard, well). This was now swept aside by less expensive shared structures.

The communal stairwell became standard. The single most important innovation of the times, it spread like wildfire.

Take, for example, the double block on the paved shopping area of S. Provolo in the SS. Filippo e Giacomo district rebuilt in 1737. It has two distinct *piani nobili* which are higher than the others. Inside, the interior follows the usual pattern arranged around a full-depth *portego* with two pairs of matching rooms to either side and two smaller rooms in the center. The stairwells are housed on the lesser facades of the long elevation of the building, lit by a single window each. Their long connecting galleries are the only horizontal communication between the different dwellings. "Venetian architecture," writes Egle Trincanato, "had always been so organic in the way the inside related to the outside. In this period of decline it became willing to sacrifice all this to a preconceived notion about the outward appearance based on the rhythms of the rational layout of the building. . . . Elevations lacked the picturesque sensitivity possessed by all the architecture that had gone before. The Neoclassical spirit already seemed to make spatial expression cold and rigid."

We do not have time to analyze the reasons underlying this phenomenon, a task recently undertaken by Gianighian-Pavanini. Suffice it to mention the cases of Campiello S. Tomà in S. Polo, Calle delle Mende in Dorsoduro, Corte di S. Girolamo on the Tana canal, and Campo S. Margherita and Calle delle Rasse in Castello.

Despite the objective difficulties that we have listed, the eighteenth century nevertheless did have moments in which designers and patrons worked together on major architectural undertakings big enough to introduce, albeit with a few hiccups, a distinct and forward-looking vocabulary. The new taste was first developed by players still firmly rooted in the world of the Baroque, such as Domenico Rossi and Bernardino Maccaruzzi. It evolved over the decades until it turned into the unrestrained language of Antonio Tirali and Tommaso Temanza.

Domenico Rossi

Domenico Rossi came to Venice from his native Morcote on Lake Lugano in 1665, "at the age of eight in the clothes he stood up in." He lodged with his mother's brother, a priest named Francesco Sardi, who promised to educate him and get him into the workshop owned by his brother, the famous architect Giuseppe Sardi. From here Rossi was gradually able to go his own way by accepting frequent and profitable jobs as a junior on the teams of the principal figures in the building scene of the day, including Baldassare Longhena and Alessandro Tremignon. This arrangement lasted well into the new century until Rossi was able to enjoy his own clientele, which consisted mainly of noblemen and landowners from Friuli (notably the Savorgnan and Manin families) living in the capital. This is the reason why the architect worked so often in Udine, San Daniele, Osoppo, Passariano, and the surrounding region.

S. Stae

The most significant project that Rossi worked on in Venice was the facade of the church of S. Eustachio, generally referred to as S. Stae (see p. 619). The church was on a wonderful site on the Grand Canal where the imposing Palazzo Pesaro had just been built. In 1709 a competition was organized for the design of the external elevation of the church, until then unfinished. From the plans submitted—there were at least twelve entries if we are to believe Vincenzo Coronelli—Rossi's was chosen; the work was already finished by the following year. In 1893 Merzario summed up the unfavorable criticism that had been directed against the building during the nineteenth century: "a mish-mash of contorted lines, agonized figures, caprices, and all sorts of nonsense." But Elena Bassi has recognized "a foretaste of the Neoclassical," which she thinks is derived from the Palladian tradition and worthy of comparison to S. Giorgio Maggiore. Certainly the elevation abounds with plastic decoration which to some extent interrupts the linearity of the design, especially in the broken tympanum over the main entrance portal. Among the decorative elements are three statues on the pediment (the *Redeemer*, *Faith*, and *Hope*), low reliefs within square frames on the attic storey, and still more figures in the niches, not to mention the female figures on the corner pilasters. All of these clutter a structure that would otherwise be quite simple. In many specific respects, though, the architect has learned from Palladio, and his edifice descends from the sixteenth-century tradition, obviously watered down by later experience and trends in taste.

The Gesuiti

A far more elaborate project was the church of the Gesuiti (see p. 622). It was the fruit of a much more complex meditation on styles that had come into fashion outside the narrow Venetian context and contained reminders of Baroque and Roman taste. The reconstruction of the church was funded by the Manin family who wanted to house their own monumental tomb on the site. Work started in 1713 and went on to the end of the 1730s. The clients called in

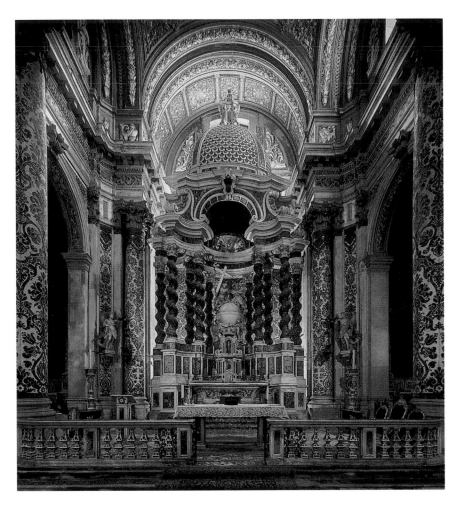

Church of the Gesuiti, general view of the chancel. The reconstruction, funded by the Manin family, was begun in 1713 by Domenico Rossi. The theatrical high altar in colored marbles, designed by Frate Giuseppe Pozzo, houses a marble sculptural group by Giuseppe Torretti.

each was individually responsible. The architecture goes hand in hand with the exuberant plastic adornment, the theatrical effect of the interior, and the close attention paid to every detail.

Palazzo Corner della Regina

From 1718 Rossi started work on the last of his major building works, rebuilding the old Gothic palazzo belonging to the most illustrious branch of the Corner family, known as the Regina since they were descended from the brother of Catherine, once queen of Cyprus. The building was on the Grand Canal close to where the new church of S. Stae was built. Though it had never been given an architectural face-lift, it had continued to play a major role in Venetian city life, hosting shows, fairs, and entertainments. Only now did the family seem to realize that the palazzo itself was not on a par with the role the Corner played in the city. The decision indicates that at the time the family still had considerable wealth. Documents relating to the work confirm that the pre-existing building was not completely demolished, rather that the construction work incorporated large chunks of it into the new fabric. Rossi's plan envisaged what would be the highest building along the Grand Canal. The entire section facing the water had to be rebuilt, and part of the canal bed was used for this purpose. As we see it today, the imposing building still shows traces of a noticeably persistent Baroque origin (see p. 623). In its structure "we note a certain lack of overall organic unity but many qualities in the details. The rhythm of the columns and the continuous balcony running around the sides are inspired by Longhena and the nearby Palazzo Pesaro. But here we see a new way of encapsulating the small windows of the eaves between the elements of the architrave. This lengthens the elevation and highlights the loftiness of the rooms, especially those of the entrance hall. The columns are arranged so as to create a play of perspectives that was without precedent in local tradition." Elena Bassi's comments are in line with earlier remarks by Pietro Selvatico, who noted that Rossi had come close to the highest achievements of Venetian Baroque. To this we must add that he also set out to please the contemporary taste for illusionistic effects.

Andrea Tirali

A very different reception was given to the career and works of Andrea Tirali. The details of his life were similar to Rossi's. The main difference was that Tirali was self-taught, his design ability emerging from work on building sites where he was employed as a

the same professionals they used on their private work. This meant they employed a *proto*, or chief architect, namely Rossi. They also used other architects such as Giovanni Pozzo, Giuseppe Torreti, and Stazio. Tradition has it that Giambattista Fattoretto was works supervisor for the project, and the final result has been attributed, with some merit, to him. However, sources from the time the work was finished agree with more recently discovered documents that Domenico Rossi was responsible for "the plans, the design, and the model of the church," working under the supervision of a member of the Society of Jesus, Father Donato Mora, who briefed him on the requirements of the order. This would explain the criteria used, uncommon in Venice. Despite all this, the building was produced by the indistinguishable contributions of a tried-and-tested team of professionals accustomed to working together. It is difficult to highlight items for which

bricklayer. He acquired his first break working as *proto* for the Magistrato delle Acque [water magistracy] and graduated to architect fairly late in life. He immediately set about doing things differently, choosing his own objectives and references through which he managed to recover the great lessons of the Renaissance in general and of Palladio in particular.

Churches

A tangible example of this is his design for the facade of the church of S. Nicolò da Tolentino, built, with interruptions and resumptions, between 1706 and 1714. His brief was to construct a facade on an unfinished sixteenth-century building that had been started by Sansovino. The solutions Tirali devised cover a range of possibilities, all classicizing in taste. What we do not know is whether what we see today is completely in line with Tirali's intentions or whether the design was modified in accordance with the client's wishes and funds. The imposing facade is structured around a protruding pronaos where six tall Corinthian columns support a triangular tympanum. Tirali drew his inspiration from the Antique, making a statement intended to distance himself from recent religious architecture and to establish a more modern direction. It is interesting to note that the client stated his wish to create a building with a portico "guaranteed to make a magnificent building, similar to one

Church of S. Nicolò da Tolentino, new facade designed by Andrea Tirali, rebuilt 1706–14. The building is distinguished by its imposing pronaos, or porch, supported by colossal Corinthian columns.

he had seen in Germany." We do not know which building he was referring to, but it is significant that his reference-point was not, for once, in the same country. This indicates that at least at this time foreign architecture was considered more modern and forward-looking than the local tradition, which now was viewed as no longer fertile.

Another step in the evolution of Tirali's designs can be seen in plans in the Museo Correr for the Scuola dell'Angelo Custode in the church of SS. Apostoli (dating from 1713). They document his preference for simplicity and for precise quotations of classical monumentality. Nevertheless, he was not averse to borrowing from styles not strictly Venetian, especially in the way he accents the fascias dividing the storeys to interrupt the vertical rhythm of the building.

State Commissions

In 1721 Tirali received his greatest public recognition of his technical skills when he was nominated *proto* to the Procuratia de Supra, an appointment which among other things put him in charge of conservation work on the basilica of S. Marco. This kept him busy on countless rebuilding and restoration projects alongside Giovanni Poleni and Bartolomeo Zendrini. Later on, it also led to the post of superintendent of hospitals, religious houses, and shores. It was as a senior civil servant that he was immediately given the

Palazzo Corner della Regina, elevation on the Grand Canal. In 1718 Domenico Rossi undertook the rebuilding of the old Gothic palazzo.

ON THE FOLLOWING PAGES:
Church of the Pietà on the Riva degli Schiavoni, facade. Designed by Giorgio Massari, 1736. Construction finally began in 1744 when the foundation stone was laid in the presence of Doge Pietro Grimani.

job of taking care of the drainage system of Piazza S. Marco and the small Piazzetta (which was rechristened *dei Leoncini* at the time). Just a few months later came the task of repaving Piazza S. Marco. Tirali was able to demonstrate that his talents were out of the ordinary. The storage drain in Piazzetta dei Leoncini had been strictly functional in nature (in other words, it was needed to maintain the ancient cistern). Tirali turned it into street furniture and decoration by creating an artificial rise in levels. Henceforward the Piazzetta became a place where people congregated and chatted. In Piazza S. Marco he disposed of the old red herring-bone brickwork that had been captured in so many images of Venice. The brickwork was easily broken and difficult to maintain. Instead, he used large slabs of volcanic rock interspersed with strips of Istrian stone. In the lively contrast of their colors, these materials create an elegant pattern (they were relaid in accordance with the original design in 1888). They provide both a refined pavement and optical—and perspective—

Church of the Pietà, interior looking toward the chancel. Although Massari's facade seems to make a clear reference to the nearby Palladian elevation of S. Giorgio, the interior and the way he fills the space are indicative of deep conservatism.

plays of incredible depth. In 1723 he was assigned another paving job, the long corridors of the Procuratie Nuove. Here he used alternating rhomboids of white and red stone. In 1735 Poleni was brought in on the project, and his proposals slowed the work down to such an extent that it was not finished until after Tirali's death.

S. Vidal

In 1735 Tirali submitted plans for the hospital and church of the Pietà, but they were not well received,

and Massari's were chosen in their place (see pp. 624–625). One of his last projects was for the facade of the church of S. Vidal in Campo S. Stefano. The church was by Gaspari, who had in fact already drawn up his own plans for the design of the front elevation, suggesting four Corinthian columns supporting a classically styled tympanum. The way Tirali approached the task is clearly indebted to the Palladian successes of S. Giorgio and S. Francesco della Vigna. He cut out any reference to the exaggerated ornamental elements that Gaspari so loved and concentrated on allowing the building to be appreciated from the point of view of its perspectives. Temanza reports that the theorist Antonio Visentini took the trouble to talk through and correct Tirali's first draft. This indicates the lively interest that the city—and, better still, other specialists—took in the project. The result of the consultation was a layout whose lines were deliberately lengthened, even allowing for the usual portal, giving the illusion of upward projection. This gives a recognizable shape to the elevation of a building which otherwise would be difficult to distinguish from the rest of those in the campo.

Family Palaces

Tirali produced one building that was most disturbingly modern. Although we have no exact documentation about the construction dates, it can be assigned to the final stages of his career. According to Temanza, the commission was to rebuild Palazzo Priuli-Manfrin in Cannaregio. The main elevation of the building is free of decorative overhangs, relying entirely on the schematic counterpositioning of solids and voids. Once more we can note Tirali's use of the now familiar elongated window modules. This time, however, their effect is softened by storey-divider fascias which rebalance the overall appearance by restating the horizontal. The design of the staircase was unorthodox. It is totally asymmetrical and off-center compared to the *androne*, and it is structured, most unusually, so that it occupies the space of a pair of windows on each storey of the facade.

Tirali also worked on Palazzo Diedo-Emo on the Grand Canal, but it was finished only after his death. His original design may well have been altered. The entire development of the facade revolves around the motif of windows with three lights framed by Ionic columns and topped by a triangular tympanum. This may be a reference to the neighboring church of S. Simeone Piccolo (see p. 634). The facade is raised on a rusticated base. The motif, which appears to graft a facade in relief onto the main facade, was recognized at the time and later for its creative modernity and was copied many times.

Church of S. Maria del Rosario, usually known as the Gesuati, in the Zattere district. The facade overlooking the Giudecca Canal, designed by Giorgio Massari and built 1726–37, was commissioned by the Dominican friars.

Giorgio Massari

If Andrea Tirali's career served as an early warning of the advent of Enlightenment architecture, others were still clinging to tradition even though they did some modernizing. This is the case with Giorgio Massari, who had commissions in Venice as well as numerous commitments on the mainland. Massari showed that he did in fact understand the doubts about the previous fashion in taste. Indeed, none of his work can be labeled as strictly Baroque. On the other hand, neither does it show true signs of

following an Enlightenment Neoclassical canon. Rather, it hovers in suspension between the new intellectual and social ferments and the constant (and newly re-adopted) lessons of the sixteenth century. This could not help but underline his discovery of classicism. Not only this, but from what we read, Massari personally defended himself when Lodoli attacked his lack of clarity in language and lack of initiative in seizing avant-garde ideas, even if clients were not keen on them. Massari stood up for himself with great candor, defending his extreme empiricism

which, however, came across as slavish adherence to whatever the public seemed to fancy. He stated that it was the designer's task "to imitate as best and as far as . . . he can those works which are most appreciated, trying diligently to avoid their defects," since "an architect who has no wish to die of hunger must necessarily adapt himself to thinking in the usual manner."

The Pietà

The plans for the church of the Pietà on the Riva degli Schiavoni date from 1736, but work was started only in 1744 (see pp. 624–626). It is symbolic of Massari's ambiguous behavior: the way he handles the facade seems to make overt reference to the nearby Palladian elevation of S. Giorgio, but the interior and the way he fills the space are still indicative of deep conservatism. Archival sources, however, inform us that as early as December 1744 the clients sought advice on the architect's model from Giovanni Poleni and Bartolomeo Zendrini. This resulted first and foremost in confirmation of Massari's technical ability to fit the building to the acoustic demands made on it by the frequent celebratory concerts held there. Their comments were positive, and they noted in particular that Massari had managed to combine past tradition with "the comfort of the Hospital [and] the decorum of the Temple."

The Gesuati

This is, in fact, almost a rehash of the plans, never executed, for the facade of the church of SS. Ermagora e Fortunato (commonly called S. Marcuola) (1728–36), a scholastic imitation of sixteenth-century style. So too is the church of the Gesuati (S. Maria del Rosario) (see p. 627) in the Zattere district, built between 1726 and 1737, with its classicizing structural clarity on the facade and faithful Palladian quotations (for instance, the pair of side bell towers are a clear visual reference to the Redentore complex opposite), as well as an attentive eye regarding the way Gaspari handled the interior of S. Maria della Consolazione. These elements are tempered by the theatricality of the overall effect: plastic decoration dominates a result crowded with statues and celebratory epigraphs, compounded by an indiscriminate and heterodox use of detail.

Yet again, we have the hugely imposing Palazzo Grassi on which Massari started work in 1748 (see p. 631). Here the architect seems to concentrate on the deep chiaroscuro accents of the elevation over the water and the syncopated rhythm of the openings and vertical divisions, rather than attempt an organic treatment of the whole.

Church of S. Barnaba facing the campo; rebuilt 1749–76, using plans by Lorenzo Boschetti, a follower of Giorgio Massari.

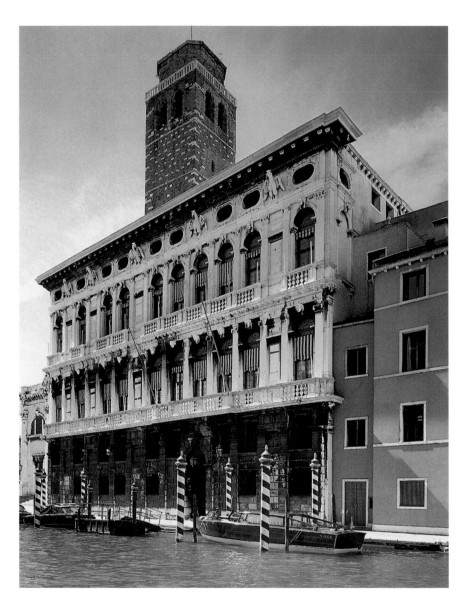

Palazzo Labia in the S. Geremia district, facade overlooking the Rio di Cannaregio, designed by Andrea Cominelli, 1696. The design is influenced by Longhena. The family later commissioned Giambattista Tiepolo to decorate the interior.

Bernardino Maccaruzzi and Giorgio Fossati: The Facade of the Church of S. Rocco

Bernardino Maccaruzzi appears to have been aware of preceding tradition. His work was limited by the fact that it frequently dealt with architecture of an ephemeral nature. Examples are the scenic bulkheads he designed for the bullfight during the duke of Wittenberg's stay (1767) and the creation of the magnificent decorations used for the annual Ascension Day festival, the Fiera della Sensa (1777). It is hardly surprising therefore that he ended up using his talents as a set designer when he was chosen to carry out the most important commission of his career, the renovation of the facade of the church of S. Rocco (1760), a job that did not fail to spark polemical debate.

The architectural competition (1756) had been promoted by the *scuola* of S. Rocco and was a critical moment in the lingering uncertainties about alternative vocabularies. Only three architects entered. Giorgio Fossati submitted no fewer than eleven designs. He collaborated with Ignazio Caccia, an ordinary *proto* for the *scuola* and Fossati's father-in-law. Giorgio Massari was also competing. He was older and more famous than the others, but he limited his submission to just one design. It was clear that under the circumstances the favorite had to be Giorgio Fossati, who since 1743 had been chief *proto* for the very institution that was now judging his work. Indeed, the decision went his way.

But let us tell the story from the beginning. Fossati was a leading light in Venetian cultural circles. He had been a pupil of Domenico Rossi, had worked alongside Francesco Muttoni, and was one of the group which frequented the salon of British consul Joseph Smith. There he met the outstanding artists of the day, such as Francesco Algarotti, Carlo Goldoni, Canaletto, and Tiepolo. Moreover, we know that he got on well with proponents of the need for an Enlightenment turnabout in architectural practice, such as the priest Carlo Lodoli, Temanza, and Lucchesi. It has been presumed that he was in contact with circles distinguished by their cultural radicalism. This would tie in with the familiarity between him and members of the Paduan school, such as Morgagni and Poleni.

In 1757, the *guardian grande*, or warden, of the Scuola di S. Rocco put up his own money to have a splendid model made that was faithful in every particular to the competition winner's plans (see p. 632). This model enables us to see that once again it was Andrea Palladio's classical designs that provided the inspiration for the plans, which nevertheless displayed Fossati's indulgence in excessive decoration, and clashed horribly with the severity of the structural layout. Doge Francesco Loredan expressed his approval of Fossati's project, and the way was clear for building work to start.

But shortly afterward everything was unexpectedly overturned. Indeed, even the part of the facade that had been started according to Fossati's specifications was demolished and completely rebuilt along totally different lines dictated by Bernardino Maccaruzzi, who worked on the building from 1765 until 1771 (see p. 633). What had happened was that a commission of experts was called in after a budget

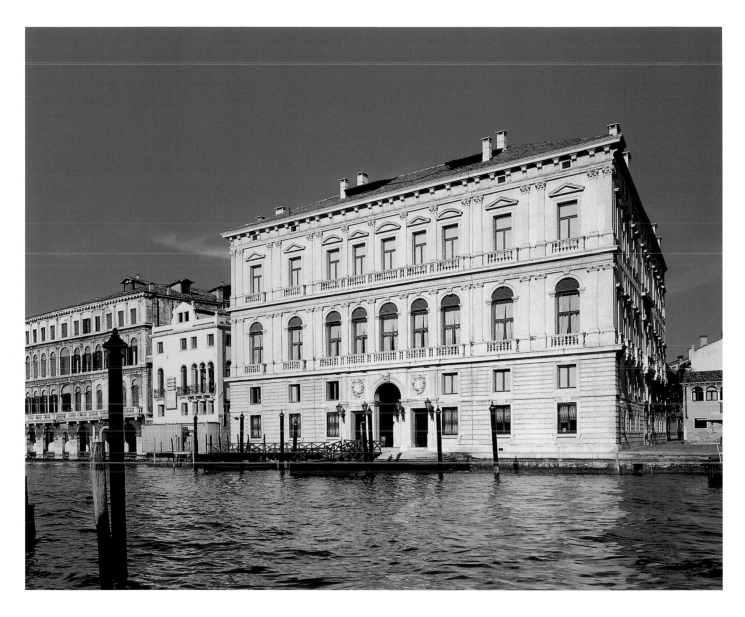

overrun. A number of Maccaruzzi's most influential friends were on the commission—Matteo Lucchesi, Tommaso Temanza, and Giovanni Poleni. They questioned not only the validity of Fossati's work but even the measurements of the building. The result was that the commission was reassigned to someone who had not even taken part in the competition but who, sources hint, had been maliciously busy persuading people of his case. Another surprising fact in this episode was that the resulting work, completed late in the century, is still so deeply rooted in Baroque language, so full of unashamedly theatrical taste in its decoration, so keen to kowtow

to popular preference that it almost seems to extemporize.

Giannantonio Scalfarotto

But the roller-coaster sequence of events and judgments does confirm yet again that conflicting tendencies existed side by side in the Venetian art world and that no individual was strong enough to sweep all before himself, not even Giannantonio Scalfarotto, despite the fact that his work had put forward a lively case for linguistic renewal and that he had been

Palazzo Grassi in the S. Samuele district, facade overlooking the Grand Canal, designed by Giorgio Massari. Construction began c. 1748.

able to impose his brand of naive classicism. An assistant of Domenico Rossi, Scalfarotto was one of a busy group of *proti* employed by the Republic to work for the Magistrato delle Acque and was therefore specifically qualified in the fields of engineering and hydraulics. His own interests, however, concentrated on the study of classical and Renaissance architectural culture. We know that he traveled to Rome with Rossi as early as 1710. We are also aware that some fifteen years later he explored Rimini with his nephew Tommaso Temanza, finding archaeological remains from the famous bridge and arch built during the rule of Augustus.

S. Simeone Piccolo

A direct result of this is the church of SS. Simeone e Giuda, later called S. Simeone Piccolo, at the

entrance to the Grand Canal in the S. Croce ward (see p. 634). The church was built between 1718 and 1738 and is without a doubt the first expression of Neoclassical architecture in Venice. The dome surmounting the building and towering over the shell below is, in fact, a clear reference to the Pantheon. As Joseph Rykwert comments, it descends in a direct line from everything that famous architects had already done throughout Europe starting with that powerful image. We can see this in the Karlskirche in Vienna by Fischer von Erlach and Charles Errard's Parisian church of the Assumption, whose date is close to that of S. Simeone.

The building features a wide pronaos topped by a triangular tympanum richly decorated with plastic motifs. The vestibule is reached from imposing stairs just a few yards from the edge of the Grand Canal. The portico leads into the centrally planned body of the church, above which the huge dome stretches upward, capped by a dominant lantern. Every element of the composition, starting with the stairs and the majestic columns on the portico, combines to emphasize the upward movement of the whole. So well does this work that we tend to overlook the rather modest dimensions of the floor plan. Having said that, it is worth saying once more that the outcome is one of great elegance, especially toward the rear of the building, which is characterized by an essential simplicity of forms and volumes.

Theories of Architecture and Neoclassicism

On 28 September 1759, Francesco Algarotti wrote a letter to Prospero Pesci in Bologna. The Venetian gentleman described a famous painting by Canaletto for which he claimed—albeit rather belatedly since the work definitely dates from the beginning of the 1750s—responsibility for the invention, even declaring that the work was a prototype of "a new genre . . . of painting, which consists of choosing a real site and then adorning it with beautiful buildings taken from here and there to make an ideal scene." What he was describing, of course, was *The Rialto and Its Bridge in Accordance with Palladio's Plan and with Other Palladian Buildings* (Parma, Galleria Nazionale) (see pp. 638–639). What we are trying to underline here is not the playful nature of the image, but rather the way that the painter uses a well-known scene to repropose formal structures. This in turn tells us that he intended to relaunch the great architecture of the Renaissance with intimate classical overtones. In other words, he was trying to bring about yet another turnaround in the appearance of

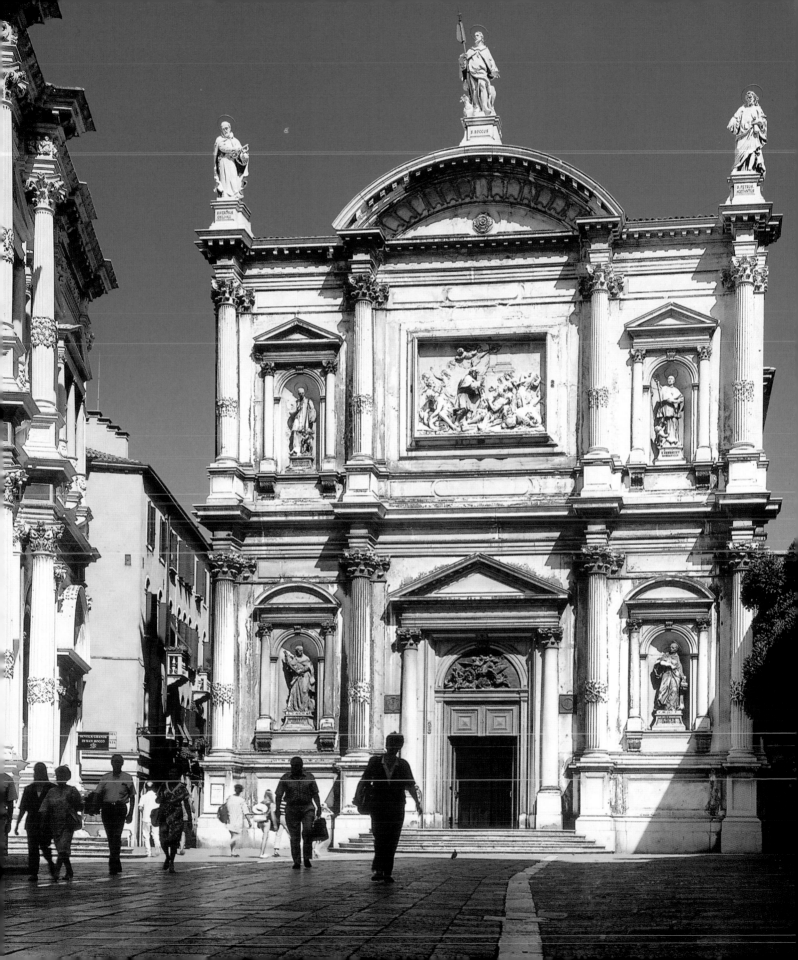

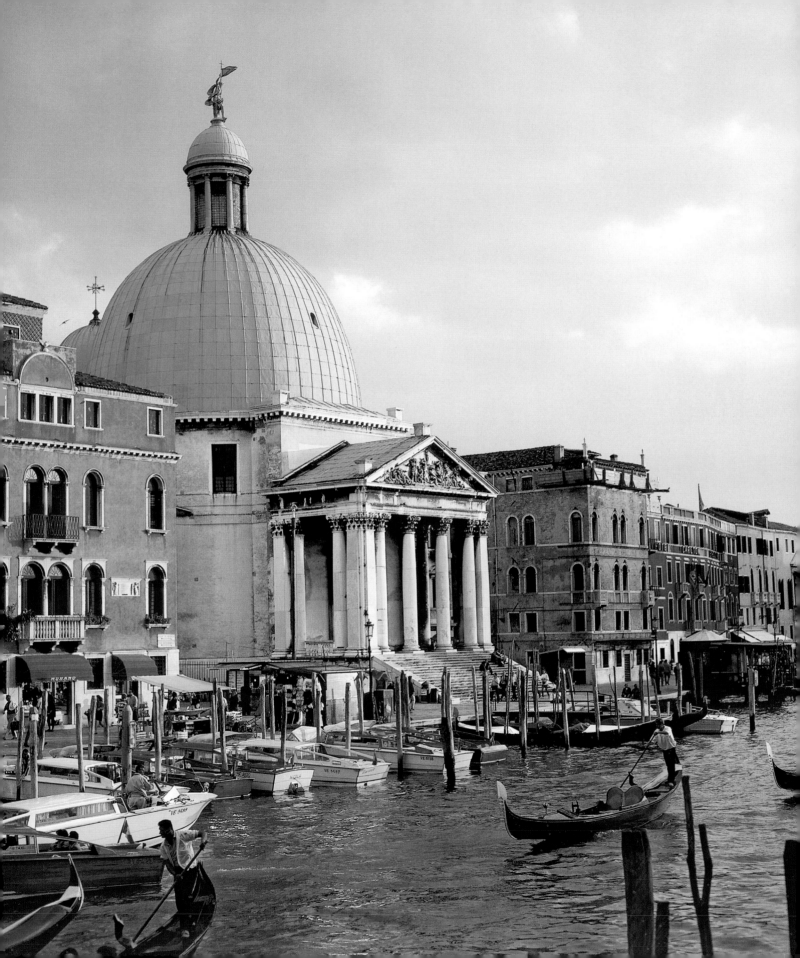

the city. The key feature was to be precisely that Palladian vocabulary which during the seventeenth century had only touched the edges of the city. The dream within Enlightenment circles, and especially within the Algarottian interpretation of Palladian scholarship, was to transform the cityscape into one where the great architecture of the classical past would take precedence, triumphing with rational intensity as never before, in short, a Neoclassical Venice.

We know that the circles in which Algarotti moved were the liveliest of their day and very open to influence from beyond the Alps. People who moved in this milieu included great collectors like consul Smith, intellectuals of the caliber of Carlo Lodoli and Giovanni Poleni, and younger members of the Venetian aristocracy such as Andrea Memmo and Angelo Querini—both later to play an active role on the political scene—as well as artists and architects who seem profoundly influenced by these ideas. It has been said many times that Lodoli's great lesson led to exceptionally fertile results in his entourage. In fact, the theories of the "Socrates of architecture" were largely handed down by word of mouth or else on scraps of paper sadly ruined by their careless keepers. Lodoli expounded the new principles of the *ars aedificatoria* [art of building]: it must, above all, meet needs of a functional nature and had to be based on the highest degree of achievable rationality. Starting with his well-known motto, "having to unite building and reason is the function of appearance," Lodoli explicitly summed up the expectations of a society which would no longer blindly follow past tradition but wished to pursue the most modern and up-to-date ideas.

"The best way of building," as Francesco Algarotti interpreted Lodoli's theory, "must shape, decorate, and demonstrate. . . ." He continues:

Nothing is worth seeing in a building that does not fulfil its purpose which in turn must be an integral part of the fabric. It is from what is necessary that all ornament springs, and everything that architects introduce will be affectation and falseness that falls outside this purpose, for it is the nature of the building that ordains how it must be.

As it is all too easy to note, this is a concept where the radicalism of the statements made denies any form of compliance with license, caprice, or manneristic exaggeration. But even the classical masters now had to be re-examined in the new light, and henceforth Vitruvius himself was no longer an unquestioned authority.

The scientific nature of this critical way of looking at architecture was to lead to research, in the form of writings, treatises, and specific pamphlets, into the ideal canon which would provide a precise reply to everything described above. It also led to experiments into the truth of the theories. These, however, were of a far more tenuous nature and were mainly carried out in the Venetian hinterland rather than in the central city area. The reason for this was that Venetian society closed in tightly around the defense of its own self-celebratory myths and therefore around tradition. While wishing constantly to modernize, it never attempted anything daring. It felt that the new trends were dangerously revolutionary, and it was always reluctant to turn them into concrete terms in its own backyard.

That the two main publishing houses which printed critical reevaluations of Palladio's work in the light of the new interests of Enlightenment culture were both Venetian in origin demonstrates that there was a specific market opening ready for this type of work, which indeed was highly specialized. So it was that in 1740 the first edition of *L'Architettura di Andrea Palladio vicentino . . . con le osservazioni dell'Architetto N.N. e con la traduzione francese* [The architecture of Andrea Palladio of Vicenza . . . with observations of the architect N.N. and a French translation] appeared in Venice herself from the press of Angelo Pasinelli. As we can see from the frontispiece, this edition was aimed at an international public. The French translation was to aid understanding of a work which otherwise relied heavily on the quality of extensive and accurate illustrations. A similar but broader view was contained in *Progetto per un'edizione delle Fabbriche del Palladio* [Project for an edition of the buildings of Palladio] that was put forward in about 1770 by Ottavio Bertotti Scamozzi in collaboration with Pietro Edwards, who taught at the academy. This anticipated translating the four volumes not only into French but into English as well since "the main aim of the author of this work is directed toward the English nation, and for this reason he wishes that the sumptuousness and nobility of the work itself should please English taste . . . and accord with the great esteem in which they hold not only Palladio but everything that is remotely connected with him."

We cannot go into details of the different points of view that inform the way the two authors approach their work. It is, however, closely linked to the prospect of a thorough re-examination and implementation of the lessons learned from the great Renaissance architect. We must also skip over the fact that both of them pursued their professional careers only on the mainland. Nevertheless we must

underline the importance of the very fact that the books were conceived. On the one hand, there was a perceived need for Palladio's work to be subjected to the scrutiny, one could almost say "scientific" scrutiny, of Venetian artistic and intellectual circles of the day. On the other hand, the publications signaled the way for Palladio's work to become a reference point once more.

Tommaso Temanza and Francesco Maria Preti

In this context, the most prominent person within these cultural circles was Tommaso Temanza. He made a lively contribution with his *Vita di Andrea Palladio* [Life of Andrea Palladio] which appeared in 1762. He claimed for Palladio the role of fundamental reference point of the new architecture, based upon a rational approach to construction practice. Temanza was thoroughly versed in Renaissance treatises, especially those of Leon Battista Alberti and Palladio. His own particular interest centered upon the theory of harmonic proportions and its practical application to construction. Temanza translated the theory into an apparently upside-down principle of counterharmonic proportions. As Rudolf Wittkower first noted, and Liliana Grassi later confirmed, he set out to calculate the ideal ratios between the various elements in a building, bearing in mind the mean value, in other words the "counterharmonic" value. Using this expedient an architect could "remove or add something from the harmonic mean value in order to obtain consonances." All of this was based upon specific and, as we will see in a moment, Enlightenment considerations regarding our optical perception of a building.

Temanza reached these convictions after heated debate with Francesco Maria Preti from Treviso. Contrary to Temanza, Preti upheld "a stable and firm law" of architectural proportions connected to musical progressions, which in turn were based on the criteria established by Gioseffo Zarlino in the second half of the sixteenth century. Temanza, by contrast, maintained that people were physically incapable of "simultaneously grasping ratios of length, width, and height" in a building. Furthermore, he questioned the supposed absolute quality of architectural proportions and their inevitable relativity on the basis of a necessary variability in individual degrees of optical perception, "almost as though he were trying to introduce a new theory of proportions into architecture." And indeed the result was that "to the three well-known proportional means of Arithmetic, Geometry, and Harmony, we must add a fourth, that is, Counterharmony, which in some cases could prove very useful to architects."

For her part, Venice was at the time one of the most important European centers in which the theoretical debate on the *ars aedificatoria* was taking place. Here, in 1767, we find the first edition of Teofilo Gallaccini's *Trattato sopra gli errori degli architetti* [Treatise on the errors of architects], to which in 1771 Antonio Visentini added his own *Osservazioni* [Observations]. James Ackerman has recently claimed for Gallaccini's remarks the honor of containing the first "classicizing" accent in Italian artistic literature. They were almost entirely centered around the need to impose onto the working practices of the day precise dogmatic restraints whose validity was proven by the prestige of ancient remains. Gallacini also spoke out against the "numerous and unconstrained" liberties taken even by unquestioned masters of the Renaissance. These remarks were articulated in the eighteenth century at almost the same time as they were being incorporated with new critical remarks which, on the whole, referred to examples in and around the Venetian lagoon. The fact that the book was published at all does, in fact, prove that there was a will to effect a controlled aesthetic turnaround which, it was hoped, would combine the authority of Roman remains with the new perspectives of the age of reason. In the wider Italian context, the debate brought in other important voices such as that of Francesco Milizia who, in the Venetian milieu as a whole and in Temanza's close circle in particular, was held in high esteem. Over and above a number of uncertainties of a theoretical nature which pushed him to speak out frequently against "a blind and unreasoned respect for antiquity," Milizia too seems to fall in line with rigorous and functional principles. On the whole he appreciated the work done by architecture in the sixteenth century, "the century of reform," while railing against the supposed license, abuse, excess, and exaggeration of Baroque taste.

Mapping the "Forma Urbis"

In this period we also see, after centuries of representational maps of Venice that were all the same, a determined attempt to rethink the shape of the *forma urbis*. We know that the archetype was established by Jacopo de' Barbari's bird's-eye view of 1500. For more than two hundred years this conditioned not only the viewpoint from which the city was portrayed—suffice it to think, for example, of the later images by Pagan (1559), Salvioni (1597), and Merian (c. 1635)—but also the criteria on which the task of mapping would be based. In its place, Ludovico Ughi's *Iconografica Rappresentatione della*

inclita Città di Venezia [Iconographic representation of the glorious city of Venice], published in 1729, substituted a "scientific" approach to the task, providing no less than a vertical survey of the urban area on the lagoon. This, of course, meant that the practice of "view" mapping had to be abandoned. The facades of some of the most important buildings were now relegated to the margins of the picture. Finally, the map incorporated the six wards into a single unit. The districts were no longer distinguishable by the quality of their buildings or monuments but were marked only by the way the small canals crisscrossed the city, cutting through a succession of urban blocks which were measured with mathematical precision.

This was pushed still further by Giorgio Fossati (1743). While his *Venezia* did indeed return to the use of view mapping, he sharply reduced the level of the visible horizon. This enabled him to show only the buildings of the foreground, throwing the remaining parts of the city into an undefined jumble. The viewpoint he used seems to be that taken by Barbari, so once more the Giudecca and S. Giorgio districts are most prominent. But the similarities end here, since his urban view is clear only around the section of elevation that runs from S. Elena, along the Riva degli Schiavoni, across the pavement in Piazza S. Marco, and down the houses overlooking the Giudecca Canal along to S. Marta. He completely loses the Grand Canal and the Rialto market, not to mention the traditional portrayal of Venice's "fish" shape. "But, more subtly perhaps, the very destiny of the Republic and her capital to decline," Giandomenico Romanelli poignantly underlines, "is insinuated in a view which conveys the feeling of lost identity. At the same time, the usual illustrative anchor-points used by traditional cartography and view-painting disappear. Their loss, however, is not compensated by any rediscovery . . . of an objective clarity of exposition that belongs to a modern, newly conceived method and technique. These could have provided both the opportunity and the motive to move forward inspired by faith in reason, and thus brilliantly overcome the recurrent temptation to fall into crisis."

Nevertheless, even in this period of uncertainty, there were those who were working to re-establish more solid foundations. Once again Tommaso Temanza illustrates the point. In 1781, toward the close of his long career, he published something that can be construed as his final exposition of ideals, a critical edition of the earliest cartographic notes on Venice taken from a fourteenth-century manuscript in the Biblioteca Marciana. This shows his desire to research the historical roots of the city using scien-

tific methodology. He therefore took authentic documents as his starting point. It also demonstrates that he had a strong intuition about the necessity for an ongoing debate on the fate of the city. It would appear, that by transcribing the ancient document, the architect was embarking on a program aimed at illustrating a possible redesign of the city of Venice. In this, a radical rethinking would be applied to its various constituent parts (see, for example, how he identifies the internal and external watercourses) which over the centuries had given the place its characteristic identity. Patrizia Valle writes:

> *This map is nothing less than a topographical plan in which the system of relationships becomes the central pivot. In the map, the real distances between the parts of the city are not so important, nor are its dimensions. What is important here is how the relationships between place, architecture, and civil society are shown. . . . The physical shape of Venice is proved to be the fruit seeded by the different activities that take place in organized spaces. Temanza's observation appears to be aimed above all at establishing the availability of a number of elements that can be changed, in accordance with reasons which gradually emerge from the requirements of organizing and developing civic activity.*

Temanza and Town Planning

It is no coincidence that Temanza is credited with the most concrete town-planning initiative to get underway in the eighteenth century. The undertaking in question set out to establish the effective boundaries of Venice, enhance her internal watercourses, organize work on sea defenses against the tides, and instal a complex network of hydraulic barriers and engineering works which had a capillary effect throughout the ecosystem. In this task, the architect drew upon a tradition that had never died out, working first with Matteo Lucchesi, Giovanni Filippini, Bernardino Zendrini, and Domenico Piccoli, and later calling in trusted colleagues such as Tommaso Scalfarotto and Giulio Zuliani. Needless to say, he was tackling a problem which the Venetian authorities should have faced as early as the thirteenth century. What is certain, however, is that it is precisely during the eighteenth century that we see a last organic attempt to sort out the disorder that threatened the integrity and correct functioning of the Venetian State. And in fact, if we examine the many writings that Temanza produced on the subject from 1727 onward, we are able to see that they all

ON THE FOLLOWING PAGES:
Capriccio of a Palladian Design for the Rialto Bridge, Antonio Canaletto. Parma, Galleria Nazionale. The great architect's abortive project for spanning the Grand Canal is the focus. The bridge is flanked by the Palazzo Chiericati on the left and the Basilica di Vicenza on the right.

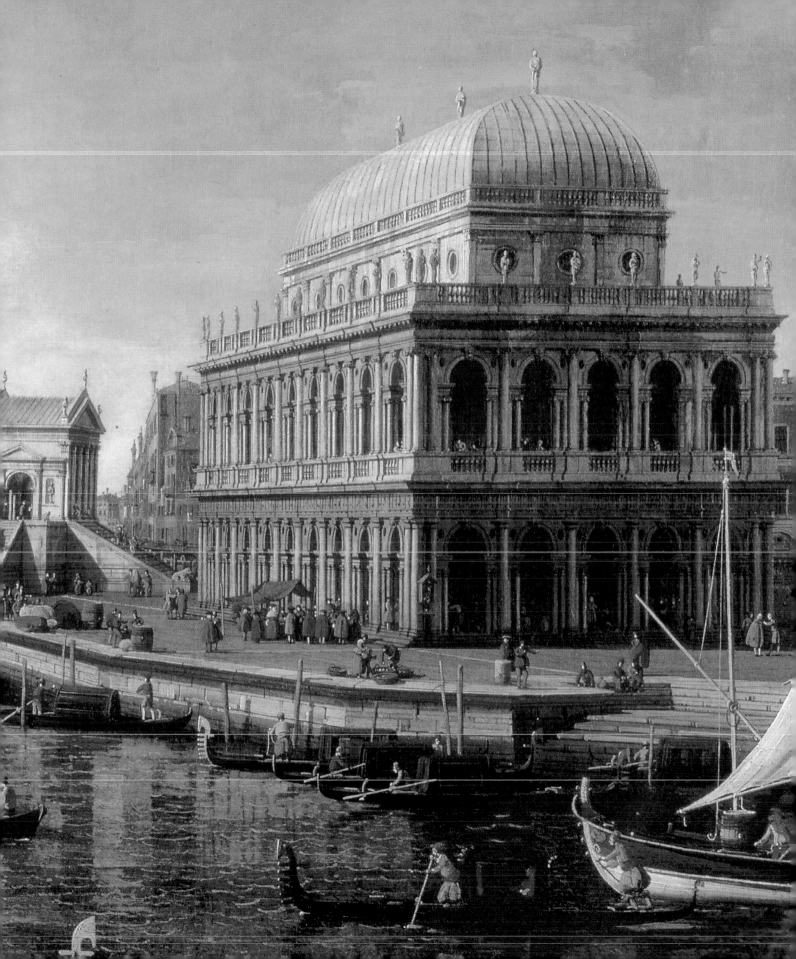

reveal a sense of certainty about the individuality, and indeed the uniqueness, of the Republic. The absolutely specific characteristics that historical documents had praised from the city's very beginning must be maintained through systematic conservation and maintenance.

The first thing that had to be done was to build a defense for the beaches at Pellestrina, Malamocco, and Chioggia. But within the urban fabric itself it was necessary to take action by implementing a scheme (unfinished) to extend the quayside at Riva degli Schiavoni toward S. Elena. Another unending job was dredging the small waterways in order to keep the canals navigable. Together these made up a series of works which, it should be noted, may seem unimportant only at first sight. In reality they proved crucial and were laden with strong political content since they aided the correct and rational working of the machine of the State.

So if this complex scheme can be interpreted in the light of a *defensio urbis* [defense of the city], other facets of Temanza's complicated personality mark him out as an "architect-philosopher" who became the reference point of a whole generation of professionals and surveyors. He was a careful scholar of what we could call the archaeological substrata of architectural language. Indeed, an analysis of the Antique remained one of the mainstays of his research, as well, as we will see shortly, of the creative path that he set out in his *Regole generali dell' architettura civile* [General rules of civic architecture]. Here Temanza showed that he was well enough versed in the treatises of the past from Vitruvius onward to be able to concentrate on those of the Renaissance. In that context, he then looked closely at its most illustrious figures, from Alberti to Palladio, Serlio, and Scamozzi, while also taking the time to examine less well-known proponents such as Filarete. Temanza had come across Filarete in a manuscript in the Biblioteca Marciana translated into Latin for Matthias Corvinus of Hungary; he also found—but here we are dealing with treatises written well into the seventeenth century—works by Alberto Capra and Giovanni Viola Zannini and even foreign writers, such as Blondel. The first thing to which Temanza applied his wide range of precedents was a restatement of the prestige derived from the experience of a thousand years:

> Some people think that architecture is nothing more than mere ornament, and of more importance to enjoyment than to the usefulness of what it provides. . . . If only these people knew how far back this art goes . . . they would soon discard such outrageous opinions. . . . For if they were to

study Antiquity . . . they would clearly understand that [architecture] is as old as the world itself.

Nevertheless his respect for architectural history did not mean that he uncritically accepted whatever canon was offered him. "While I religiously worship these Masters, I do not go as far as superstition, and where open truth sheds contrary light in my mind I welcome it without following elsewhere."

We know that there were frequent arguments and misunderstandings between Temanza and Lodoli. Temanza was no stranger to critical assertions regarding the architecture of the past filtered through the principal and determining test of reason: "it is well known," he wrote to Lucchesi, "that Architecture is not the blind imitation of all that is Antique but rather the informed imitation of all that is true and natural."

Temanza and Building

In the practical work of building too, Temanza played an important role in Venice in the latter half of the eighteenth century. His projects are generally situated close to the main line marked out by the Grand Canal which, as we have seen, had been the preferred thoroughfare since the end of Baroque times. Along this axis we find the "classical" church of S. Maria Maddalena, work on which started in 1763 but was finished in 1789 after its architect's death (see p. 640). In many ways this resembles his youthful work on the small oratory of S. Margherita in Padua. The Maddalena borrows from the oratory the essential lines of its elevation and a main entrance framed by two pairs of unfluted Ionic half-columns. It also makes further reference to the Antique with a clear quotation—by Temanza's own admission—from the Pantheon. The circular plan, which in the interior of the building contains an inscribed hexagon, concedes—and this is underlined in the architect's still extant handwritten plans—a single exception to the regularity of the order in that the apse is a separate and eccentric space, echoing the Palladian churches of S. Giorgio and the Redentore. The innovative nature and originality of Temanza's design did not secure unconditional praise. Far from it: Giorgio Massari in particular "spat out his opposition and spite" in relation to the pagan nature of a building which, he believed, did not meet the needs of its religious office, not to mention the fact that its eccentric shape did not fit in with the surrounding urban context. Temanza, on the other hand, thought of it as one of his best efforts, so much so that he planned to be buried there. He also wrote of it in self-

Alzata di fronte

OPPOSITE:
Church of S. Maria Maddalena in Cannaregio, designed by Tommaso Temanza and built 1763–89.

Drawing of the front elevation of S. Maria Maddalena, Tommaso Temanza, 1760. Venice, Museo Correr.

congratulatory terms in a letter to Francesco Maria Preti in which he sums up the features of the building. He describes them as "simple and regular," where "the external parts correspond exactly to the interior and the proportions are musical."

It has been justly remarked that "the Maddalena is the manifestation of the new architecture in Venice at a time when a design possessing organic cohesion encapsulates many of the innovative impulses scattered throughout the work of countless exponents of architecture contemporary to, or even preceding, Temanza himself. Here he takes concrete steps to show the way forward, and then follows them through logically."

Nevertheless, we should mention that Temanza's design ability has to a large extent been pieced together from the evidence of drawings drafted at various stages for works which generally never got further than the drawingboard (see p. 642). It is easy to guess that this was due to the economic situation which, especially in the second half of the century, did not favor the execution of buildings of any great size since only a few families were still able to meet such costs. In this climate, it took just one potential commission to fall by the wayside for many other undertakings to be looked at again. Only in this way can we explain the clamorous discrepancy between the enormous volume of ideas that were developed as far as the blueprint stage and the final tiny number actually constructed. In the former category we

Drawing of the front elevation of a theater on the Grand Canal, Tommaso Temanza, second half of the 18th century. Venice, Museo Correr.

died with him, so none of Temanza's plans was ever carried out.

Among the smaller number of plans that were actually implemented, we must mention at least Temanza's work in the garden of Palazzo Zenobio in the Carmini district. He had previously been commissioned to work on the side wings of the building, dating from the seventeenth century, which had been designed by Gaspari, uncle of the architect Giannantonio Scalfarotto. Temanza's work can be dated to the early 1770s and consists of a pavilion used as a study-cum-library and for civic receptions. It has separate access from the canal behind the main elevation. The small building, whose preliminary design had included large wings, was only partly completed. Once again following Palladio, it places Ionic and Corinthian orders on top of each other, although the building is also scanned by columns on the lower storey and pilaster strips on the attic storey. The attic is crowned by a tympanum grafted onto the elevation, reminiscent of numerous Palladian villas. Here it is broken by a balustrade that runs across the length of the building, forming a wide balcony. But the balustrade convinces more when we notice how it is meant to link onto a kind of overhanging gallery running along the perimeter wall. In order to sustain this strong linear sweep, the attic storey needed to be free of too much visible ornament. It is almost a transparent area compared to the lower loggia, which contributes a marked chiaroscuro effect to the composition.

Antonio Visentini

Someone who was equally interesting and stimulating, an eclectic and curious mind, though one that was less systematically addressed toward architecture, is Antonio Visentini. He perfectly incarnates the intellectual in the age of Enlightenment precisely through the diversity of his numerous professions. He was capable of expressing his talents in many ways, shifting effortlessly and cleverly from painting to decorating and engraving, and onto far more complex and variegated fields such as art theory, perspective theory, and treatises on architecture. He also had the opportunity to put his design ability to the practical test. He was a member of one of the most lively cultural circles of Enlightenment Venice, the one that centered around consul Joseph Smith. His career ran in parallel to Canaletto's, with whom he shares a number of important similarities. With regard to Venice and the monuments that enriched her, both artists show a specific sensitivity to Venice's language and the message of her architecture. Thanks

have studies to finish Palazzo Sagredo in the S. Sofia district, plans for Palazzo Pisani at S. Maria del Giglio, and even plans for the S. Benedetto theater.

Of particular interest is the study for the Palazzo Pisani where Temanza was invited to modernize the Gothic family palace on the Grand Canal. He came up with an "invention" with which he "was extremely well satisfied, saying that in it he had reconciled novelty of idea with solidity, comfort, and decorum." If we look at the elevation of the building shown in his drawings, we immediately notice that he has rearranged the facade, removing all traces of its original layout and introducing a symmetrical and absolutely regular scansion. Once again, the typological cue is taken, more clearly than ever, from Palladio (for instance, the Vicenza palazzo built for Iseppo da Porto). Temanza's design for the facade incorporates a high rusticated dado over a horizontal fascia with no ornament or decoration. A double-storeyed *piano nobile* clearly stands out and is emphasized by a modular order of twin Corinthian columns. The "novelty of thought" is concentrated on an unusual double stairway for access to the canal. Conceived in terms that are anomalous to the tradition handed down over the centuries, it makes no pretense to monumentality and instead features only two small angular flights of steps. These, however, have the advantage of displaying the entire elevation in accordance with Temanza's convictions about optical perception that we described above. We can assume that the plans were drawn up in about 1755 since this was when the client, Vincenzo Pisani, married Caterina da Mula. However, Pisani died shortly afterward and his branch of the family

to their thorough assimilation of Renaissance ideas, above all of Palladio's example, they were both implicitly drawn to a close criticism of that late Baroque culture which had largely, if not exclusively, informed the later portion of the seventeenth century and the start of the eighteenth.

We should also take time for a note about the decisive role played by the British in the spread of Palladian vocabulary. Palladio's visual language was hailed at the time as that most suited to give a firm foundation to a trend leading decisively toward classical taste. Suffice it to recall that in this period there is an enormous growth in treatises aimed specifically at critical analysis of the work of the sixteenth-century master. Then again we can quote proven ties between British aristocrats and Francesco Muttoni regarding a project centered on the philological revision of architectural texts written by Palladio, a project of Ottavio Berotti Scamozzi and Smith himself. Then again there is the biography of Palladio written by Tommaso Temanza in 1762, which was published by Giuseppe Pasquali, a publisher close to Smith.

Palazzo Smith-Mangilli

Right down to the smallest detail of practical execution, Visentini revealed the need to simplify the way in which the facade modules of a building are composed. His best-known work is the residence of consul Smith himself. This was commissioned and built on the Grand Canal at the point where it is joined by the Rio dei SS. Apostoli. The building was inaugurated on 22 October 1751. The elevation, later modified by a succession of owners, exhibits an intention to follow both proportions and canon that is fully in line with the mood of the Renaissance revival heralded by the Neoclassical aesthetic. In accordance with a practice already noted as current in this period, the architect had to refashion an old, fourteenth-century building. The overall volume had by necessity to remain unchanged, and only the perimeter walls could be altered. Visentini's "invention" concentrated on raising the level of the attic storey, which was subsequently divided in later works supervised by Mangilli. Visentini's attic comprised a wide upper terrace crowning the top storey. His qualities as a student of architecture and avid excavator of compositional fragments from established tradition are revealed in the capacity that he shows for weaving these elements together again and blending them into sober equilibrium. Well-defined rustication work on the foundation course, centered around a gabled portal, supports the spread of the Corinthian pilaster strips which scan the rhythm of the *piano nobile*. The only unusual motif (which indeed was to become Visentini's hallmark) is the inclusion of a curvilinear pediment framing the

Palazzo Smith-Mangilli in the SS. Apostoli district, facade on the Grand Canal. The front elevation, commissioned by British consul Joseph Smith, was designed by Antonio Visentini and Giannantonio Selva in 1751.

central arch and placed immediately above the huge cornice of the stringcourse.

Palazzo Coletti-Giusti

Even more at peace with itself is the elevation of Palazzo Coletti-Giusti, which is situated right alongside the far better known Ca' d'Oro. An extant signed drawing with the original design is inscribed with the date 1766, which doubtless refers to when construction work was completed. Here again Visentini concludes the building with a short gabled attic storey, flanked on either side by two spectacular terraces. It is important to note the simplification of the division: quotations from the Antique become so slight as almost to disappear, the use of orders is limited to the loggia on the ground floor, and even the *piano nobile* loses its need for a distinctive personality. What is preserved, however, almost as a single decorative feature, is the unusual and attractive device of small pediments placed so as to break up the uniformity of the upper fascias of the string-course and of the entablature that crowns the lower attic storey.

Della Valentina states that Temanza sent his best pupil, Giannantonio Selva, to Visentini to study architectural elevations. If so, we can interpret this as a symbolic handing over of the baton of ideals. But it also threw the doors open for a more mature and organic era of Neoclassicism. Within a few decades, architecture and planning in the city were to assume the dreamed and dreamy qualities described by Rilke at the beginning of this chapter.

Loredana Olivato

Venetian Sculpture in the Eighteenth Century

The Valier Monument in SS. Giovanni e Paolo

Venetian sculpture at the start of the eighteenth century was no different in style or taste from what had been produced in the late seventeenth century. Established artists like Heinrich Meyring and Orazio Marinali continued to work while a younger generation was coming up behind them. As is so often the case in the seventeenth century, the state of sculpture in the early Settecento can be judged from a funerary monument, namely the monument to the Valier family (1705–8) in the church of SS. Giovanni e Paolo (see p. 645). Architect Andrea Tirali was aided in the decoration by a number of artists, three of whom can be clearly identified since they signed their work: Giovanni Bonazza, Antonio Tarsia, and Pietro Baratta, three of the best-known sculptors of their day.

The Valier monument was ambitious. Its debt to Longhena's mausoleum for Doge Giovanni Pesaro in the church of the Frari is combined with references to the Morosini monument by Filippo Parodi in the church of S. Nicolò da Tolentino. The drama of the monument comes from the drapery which forms the backdrop against which the three figures of the doge's family stand: Bertuccio Valier is in the middle between his wife, Elisabetta Querini Valier, and their son Silvestro.

Giovanni Bonazza, Antonio Tarsia, and Pietro Baratta

Parodi's influence shows up most clearly in Bonazza's work on the monument, in particular in the relief of Time on one of the marble sections of the base and in the group above it, *Virtue Crowning Merit*, placed in the center of the two arches (see p. 647). Giovanni Bonazza was probably Venetian in origin, and his early training was in the tradition of Juste Le Corte. This is evident mainly in some of his late seventeenth-century works, after which he was attracted to the style of Parodi. He was spurred on especially by seeing the work that the Genoese sculptor had done in the basilica of S. Antonio in Padua, where Bonazza himself worked on the reliquary sanctuary in 1697. The free-flowing stances of the saints and virtues that Parodi sculpted for the sanctuary and his vividly pictorial style, seen especially in the women's clothes, provide us with the key to understanding the stylistic features of Bonazza's contribution to the Valier monument. In the group, he successfully manages to soften the plastic consistency of the images, still tinged with Le Corte's influence, by fragmenting the play of the drapery and painstakingly sculpting the detail. In this way, he obtained a lively and painterly effect and overtones of softer elegance.

The pendant statues that flank Bonazza's group are Antonio Tarsia's *Liberality* and Pietro Baratta's *Wisdom* (see p. 646). Both derive from Le Corte's earlier models, as can be seen from the consistency in style. Indeed, were they not signed separately, one might believe that they were by the same hand. Similarly, *Peace* and *Charity* are signed by Tarsia and Baratta, who also initialed *Gentleness*. The work of both artists, particularly Baratta's, stands out for its high quality. We can begin to see that trends in taste were breaking free from Le Corte's influence. The two sculptors seem to be aiming for a more contained effect in both form and expression; their figures are fashioned using a less exuberantly plastic technique. The drapery, the gestures, and particularly the characterization of the faces have also changed, with hints at a more tender nature than Le Corte's pathos.

We must remember, however, that at this time the seventeenth-century practice in which artists

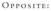

Charity, Antonio Tarsia, relief. Church of S. Stae, right-hand pillar at the foot of the high altar.

OPPOSITE:
Funeral monument of Doge Bertuccio Valier (1656–58), his wife Elisabetta Querini Valier (d. 1709), and their son Doge Silvestro Valier (1694–1700), with sculpture by Giovanni Bonazza, Antonio Tarsia, and Pietro Baratta. Church of SS. Giovanni e Paolo.

suppressed their individual style when contributing to an organic group work still continued. So if we want to examine the classicizing orientation of Antonio Tarsia's vocabulary we would do better to look at the marble reliefs, *Charity* and *Penance*, on the two pilaster bases of the high altar in the church of S. Stae. *Charity* is barely raised from the background but stands out with a fluent rhythm that gives the whole image a measured elegance (see p. 644). As far as we know, this work was done at the start of the sculptor's career. In it, we can see that the origin of Tarsia's classicizing interest was the influence of Bernardo Falconi's most original work (some of his female allegories on the altar of St. Anthony in the Frari), which reflects the debt to Algardi. Tarsia's taste was to move even further in this direction, and in later works it becomes a constant of his style. It recurs in his *Archangel Raphael* (1716–17) in the Manin Chapel in the church of the Scalzi, bringing to mind the elegant sweep of Falconi's angels at the top of the Scuola Grande di S. Teodoro; and it is there again in his *St. Jerome* (1720) in the church of S. Stae, in turn close to the slightly later *St. Paul* on the facade of the church of the Gesuiti. The *St. Paul* does, in fact, prove that Tarsia paid close attention to Falconi's art. From the lines of the face and the air of contained but solemn eloquence of the figure, it is clear that Tarsia knew at least one of Falconi's Paduan works, the *St. Matthew* on the St. Julian altar in the church of S. Giustina.

The classicizing influence on Pietro Baratta must have come primarily from his origins and early period working in Tuscany, about which we still know nothing. These formative years must have influenced the choices he made when he came to Venice, where we know he was still active in 1727. In the city he worked alongside artists belonging to the classicizing current which coexisted with work descended from the Baroque of Le Corte and Parodi. Artists such as Tarsia, Torretti, and Cabianca are all in this category. It is not easy to establish just how much Baratta and Tarsia owed to each other when they worked together on the Valier monument.

Francesco Penso Cabianca

Nor are we clear about Baratta's relationship with Francesco Penso Cabianca. According to Temanza (1738), Baratta worked for Cabianca when he first arrived in Venice around 1693. But even today we have not yet established a critical or chronological catalogue of the works of either artist. In the case of Cabianca in particular, we can discern breaks in style even in those works we know are his, especially those done at the end of the seventeenth century, which makes it hard to define him and to put the case for

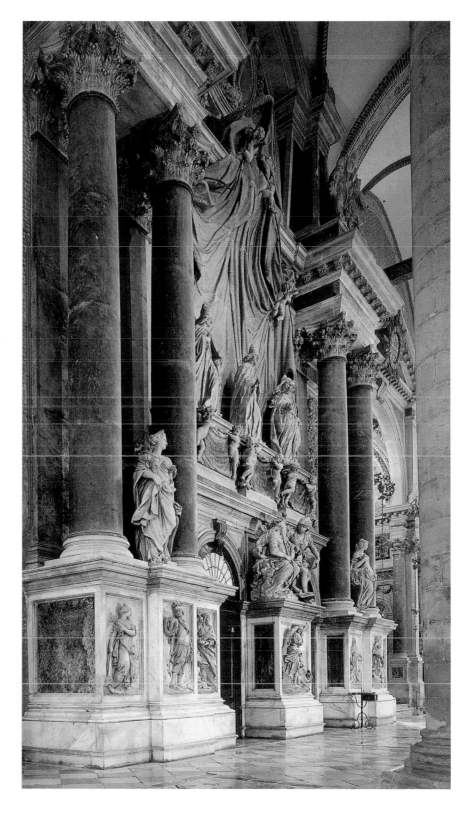

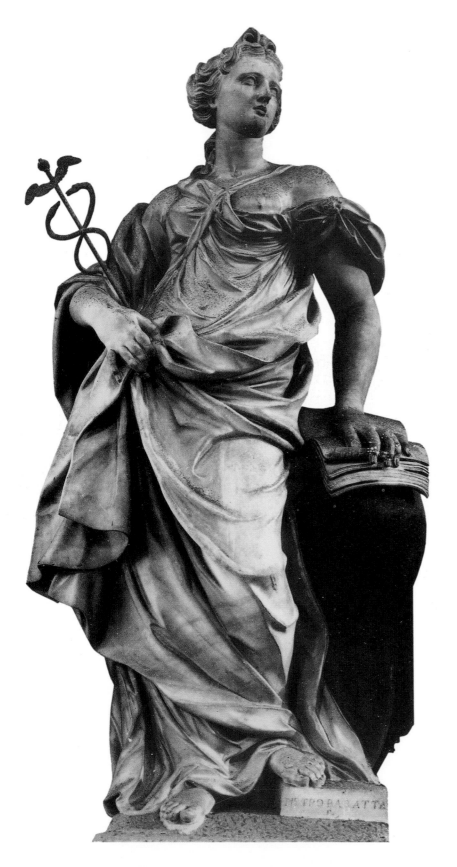

new attributions or to evaluate the importance of his work. Nevertheless, his vocabulary peaked with the reliefs he carved for the reliquary altar (1711) in the sacristy of the church of the Frari, showing the crucifixion, deposition, and burial of Christ (see pp. 648–651). The panels are the culmination of a process of maturation that the artist's reliefs had undergone at the beginning of the century when he worked in Dalmatia (1704–8; Kotor, cathedral of S. Trifone, reliquary chapel). A few notes seem to capture the intense expressive tone of Rues (compare the *Deposition* in the church of the Redentore), united with the elegant stylization of details and the exaggerated play of drapery.

Andrea Brustolon

Next to Cabianca's decorative work on the marble part of the altar there is also the gilded wood commissioned from Andrea Brustolon. The two parts combine to form a work of tremendously evocative power. Brustolon was from Belluno where his father Jacopo, also a woodcarver, taught him. He was eventually sent to Venice for further study and remained for about ten years. He became known for his excellent carved furniture, frames, chairs, and vase-holders which filled the city's palaces. He returned to Belluno in 1695 and continued to turn out this type of work as well as producing decorative schemes for altars, reliquaries, and other works of a religious or secular nature. The wooden frame and the angels in the church of the Frari are among the best of his output. We should also mention two lamp-holder angels which share a number of similarities with the angels in various stances that he carved for the altar of S. Croce di Mareson in Zoldo. The lamp-holder angels, however, are far superior in terms of the refinement of his expressive powers. When we look at the angels, we sense that they would not have been so successful had it not been for the lesson that Brustolon learned while he was Parodi's pupil in Venice. But if Parodi played an important role in Brustolon's acquiring the technical skills he needed to reveal his naturally dynamic virtuosity, it was also important to keep abreast of the times. The two angels in the Frari demonstrate that he did just this. The exuberance of the two sculptures, with their huge wings and billowing drapery, brings to mind the figures in the panel painted by Brustolon's contemporary, Sebastiano Ricci, just a few years earlier (1703–4). Here too is a sensibility beginning to veer toward the Rococo. An example is the angel in full flight to the left of the tondo of the *Miraculous Arrival of the Statue of the Virgin* on the ceiling of the church of S. Marziale.

The St. Dominic Chapel in SS. Giovanni e Paolo

The decoration in the St. Dominic Chapel in the church of SS. Giovanni e Paolo dates from the early 1730s. The architectural work, which had been started by Gaspari (1693–1700), was finished by

The works combine to give an extraordinary decorative effect, one in which sculpture and painting complement each other perfectly. Any differences in stylistic currents, such as that seen in the bronze reliefs, are secondary to the overall harmonious blend. The consonance between the sculpted and the painted figures remains close, not just in the virtues,

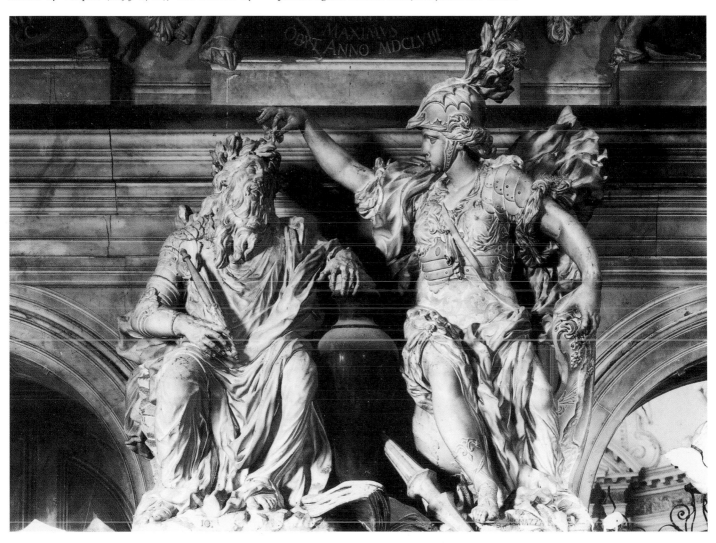

Tirali in 1705. The chapel decoration is a landmark in eighteenth-century Venetian sculpture. On the walls are bronze reliefs by Giuseppe Mazza and the lateral tympanums house wooden statues of virtues, documented in 1726–28 as the work of Francesco Bernardoni, to whom the angels holding up the frame of the huge ceiling canvas (1727) by Giambattista Piazzetta have also been attributed.

but also in the angels, which are audaciously foreshortened by the gilded wooden frame. In this connection, Moretti advanced the hypothesis that the design was by Piazzetta himself. Moretti backed this up with the fact that Piazzetta was related to Bernardoni and had worked for him in his youth, probably on the production of drawings and models in his workshop.

Virtue Crowning Merit, Giovanni Bonazza. Church of SS. Giovanni e Paolo, Valier monument, detail of the lower order between two arches.

OPPOSITE:
Wisdom, Pietro Baratta. Church of SS. Giovanni e Paolo, Valier monument.

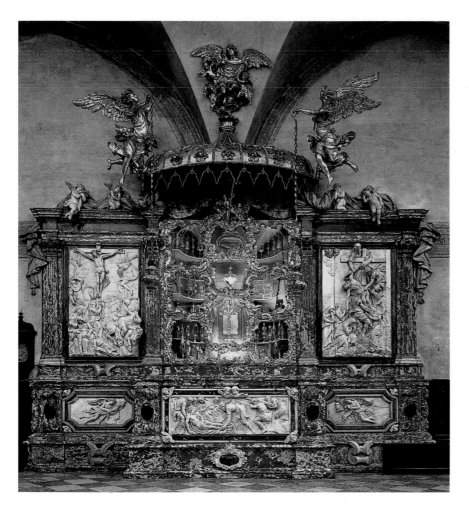

Reliquary altar with scenes from the Passion of Christ, Francesco Penso Cabianca, dated 1711. Church of S. Maria dei Frari, sacristy. The gilded wooden decoration is by Andrea Brustolon.

Giuseppe Mazza

This type of collaboration was standard practice. Mazza remained in close contact not only with his own teacher, Lorenzo Pasinelli, but also with Giovan Gioseffo Dal Sole and Marcantonio Franceschini, two other painters from Bologna. This explains why Mazza's style constantly borrows from contemporary painting which, even in his early plaster and clay output, he tried to translate with "the same refined loading [and] the same surface sweetness," while in his mature years he often worked alongside artists such as Dal Sol and Franceschini.

On 19 July 1716, Mazza signed a contract to produce large bronze reliefs showing episodes from the life of St. Dominic (see p. 652). The commission came about thanks to the generosity of Giovanni Francesco Gallo, a leading member of the Dominican order. By 1719 six clay models were ready to be handed over to Francesco Marcolioni for carving and

to Giovanni Battista Albergetti, who had his own workshop in the Arsenal, for casting. Work on three reliefs was finished by 1722, but the series was not yet completed in 1735; the sixth episode, executed as a wood panel painted to simulate bronze, was finally completed only in 1770, many years after Mazza's death.

At the time he accepted this commission, Mazza was at the height of his fame, earned in his native city with marble and plasterwork and later in Venice with statues cast in bronze. For the church of S. Clemente in Isola he made the *Adoration of the Shepherds* (1704), being paid for the model in 1703. He also made a group of fourteen small bronzes (saints, doctors of the church, and angels) for the tabernacle on the high altar of the church of the Redentore and was paid for these in 1706 and 1707. Apart from these documented works, in the same period other stucco works have been convincingly ascribed to Mazza along the lines put forward by G.P. Zanotti (*Accademia Clementina*, 1739), and these must have contributed to his fame in Venice itself. Because this type of decoration had traditionally been done by artists from outside Venice, Mazza may have initially been called in specifically for this purpose.

In the previous century, bronze reliefs had often been included in funerary monuments and altars, usually as an integral part of them. The importance of their role varied in the overall decorative scheme of things, but never before had they made up the whole thing, as in this case, or been produced in sizes to rival large canvases and altarpieces. Canvases were frequently part of a cycle illustrating events and miracles from the lives of saints connected to Venetian worship and pictorial tradition. It is easy to see, therefore, that they were the model for this series of low reliefs with their complex narration about St. Dominic. "Canvases sculpted not painted" is how one scholar has defined the reliefs. The same individual also points out that compared to Mazza's earlier work these betray a degree of staleness of ideas and rigidity in the artist's vocabulary. Despite discrepancies in quality, in these works we can still see and appreciate Mazza's considerable narrative talent as well as his capacity to orchestrate complex compositions within which some of the detail remains at the very highest level he ever attained. In the episode showing the saint's death, the quiet tone of the scene springs from the measured quality of gestures and actions, combined with the slow rhythm of the angel's flight, of almost stylized elegance. The calm tone is emphasized by the angel's gesture, pointing toward the upper part of the relief. Here, among putti and cherubim who circle serenely, Christ and the Virgin Mary wait in tender welcome.

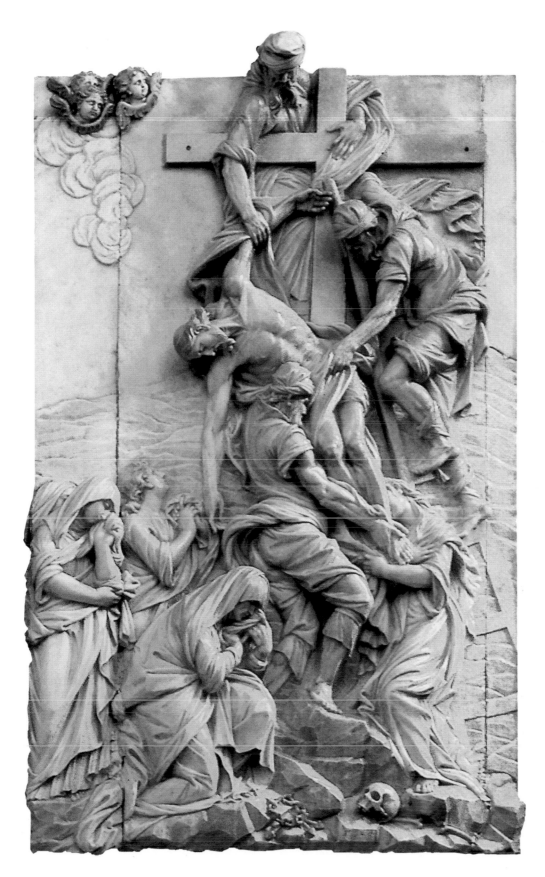

Deposition of Christ, Francesco Penso
Cabianca. Church of S. Maria dei Frari,
sacristy, relief on the reliquary altar.

ON THE FOLLOWING PAGES:
Burial of Christ, Francesco Penso Cabianca.
Church of S. Maria dei Frari, sacristy, relief
on the reliquary altar, detail.

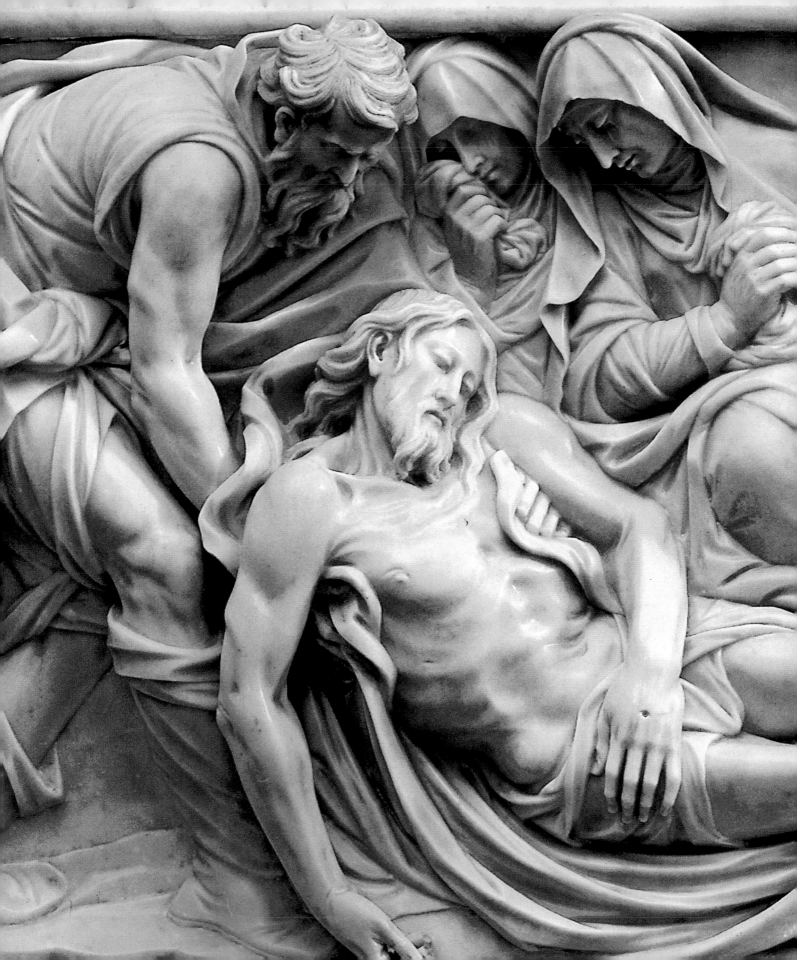

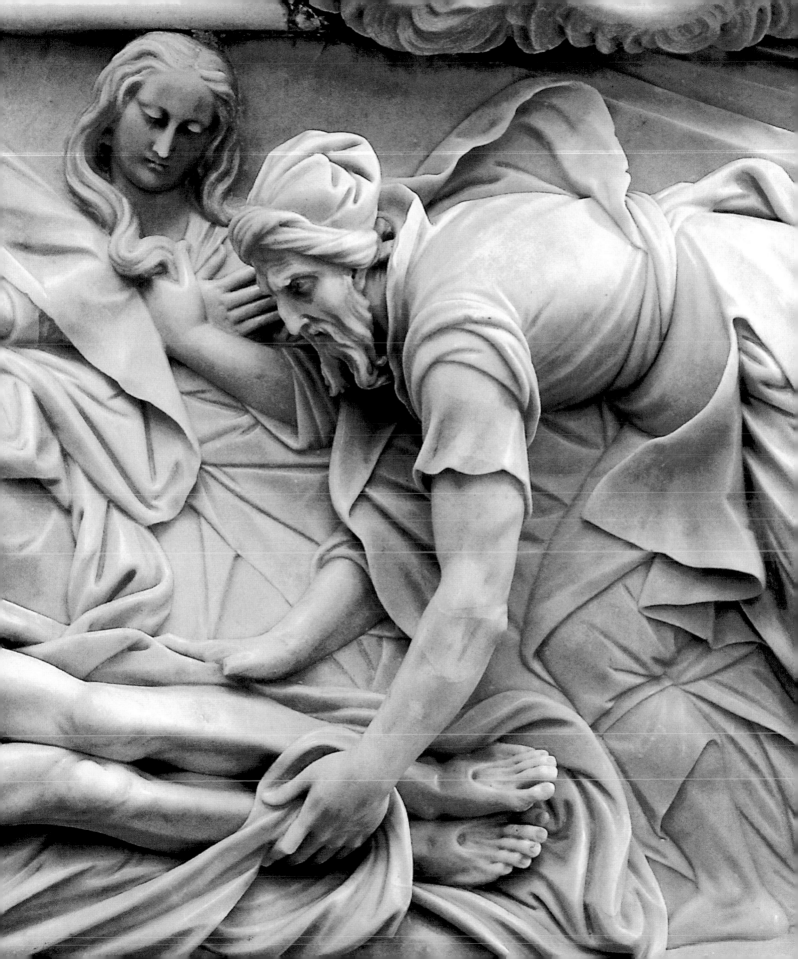

Thus, the dramatic nature of what is happening in the lower part of the relief—already restrained—is toned down. The stylistic characteristics of Mazza's vocabulary are in harmony with the ideals of classical "grace" and "naturalism" followed by the Bolognese school of painting. This, combined with the way in which he evenly spreads light and shade and the gentle grading of the relief planes, was bound to elicit interest, especially in a period when the trend toward classicizing taste was becoming an ever more vital strand in Venetian sculpture.

With regard to the whole field of relief, the tense drama seen in Cabianca's panels (1711) for the altar in the reliquary chapel, reminiscent of Baroque theatricality, was replaced a few years later by the calmer tone of Giuseppe Torretti's *Deposition of Christ* in the church of S. Stae (1715), enriched by inflections in a narrative key in the *Martyrdom of St. Barbara* in S. Maria Formosa (1719) and by indulging in the repetitive and stylized play of the drapery.

Giuseppe Torretti

Giuseppe Torretti, whose heyday was in the 1720s, was one of the main players in Venetian sculpture in the first half of the eighteenth century, but his school remained active throughout the whole century. He entered Venetian circles gradually after he came to

train in the city in about 1680, and his first successes were in woodcarving. By the beginning of the eighteenth century, he is frequently found at work alongside Baratta and Tarsia. According to Temanza, it was with Baratta, Domenico Rossi, and Giovanni Scalfarotto that he traveled to Rome in 1710. The journey was clearly a turning-point for him because it moved his language onto another level of maturity. In his later work, he is revealed as a sensitive and original artist who produced both statues fully in the round and the type of reliefs just discussed. Another commission from the Manin family was for the *Archangel Michael*, for which he was paid in 1716. This was one of a pair for the family chapel in the church of the Scalzi. The commission for the *Archangel Raphael* went to Tarsia. Both Tarsia's and Torretti's archangels appear to be indebted to models by Falconi (his *St. Theodore* at the top of the facade of the Scuola di S. Teodoro). They also quote from Bernini's angels, even more noticeable in the archangels in the cross vault of the church of the Gesuiti (1726–28); the *St. Gabriel* in particular is comparable to the *Angel with the Name of the Cross* in S. Andrea delle Fratte in Rome. But once again, when we look at the gestures of the *Archangel Althiel* and the *Archangel Raphael*, we have the impression that the reference-point is Falconi's two angels that were carved for the St. Urio altar in the church of S. Giustina in Padua.

In the work in question, the way Torretti handles the drapery departs completely from any of the models he may have used. While it is insistent, the sober elegance of the play of the folds, which enliven the surfaces by giving them delicately pictorial effects, can rather be traced back to Meyring's teaching. Torretti, however, reinterprets it in a modern manner in keeping with the Rococo style of painting. That Meyring was one of the late seventeenth-century sculptors who most interested Torretti is confirmed by other works he did during his years in Venice: his *St. Peter* and *St. Paul* (1711) for the high altar in the church of the SS. Apostoli bring to mind the saints of the same name that Meyring produced for the high altar in S. Silvestro, now in the parish church of Nimis; his *St. Gregory the Great* (1720) in S. Stae would appear to spring directly from the memory of the solemn *St. Magnus* on the high altar of the church of S. Giovanni in Bragora. Similarly, the work he undertook for Udine cathedral, in particular the *Annunciation* (c. 1718), can easily be linked to the typical Virgins produced by the German sculptor. The Manin family commissioned Torretti again, this time to decorate their tombs (1716–17) in Udine cathedral, where he again found himself working alongside Baratta and Tarsia. This relationship

MEDICINA DEI

Christ Sitting with the Eternal Father on the Globe of the World Supported by Angels, Giuseppe Torretti, 1720–21. Church of the Gesuiti, high altar.

encouraged Torretti's interest in the classicizing current into which the late seventeenth-century elements in his own training had merged. His own contribution is generally distinguished by its excellent quality and its wonderful evocative power. The lamp-holding *Archangels* (1722–23) that flank the high altar of the Gesuiti show how much in tune Torretti was with Baratta's taste (see p. 653). In the expression of the *Humility* (1722–23) are traces of the sweetness in the *Archangel Gabriel* in the Gesuiti.

Antonio Corradini

This complements Antonio Corradini's *Virginity*, placed as a pendant to the *Humility* in the church of the Carmini. Corradini was another sculptor who worked in Udine cathedral, and his figure of Christ in the marble group of the *Pietà* (1723–24) in the church of S. Moisè shows Torretti's influence (see p. 655). Whether, as in his *Christ Sitting with the Eternal Father on the Globe of the World Supported*

by *Angels* in the marble group of 1720–21 on the high altar of the Gesuiti, his figures are sweet, or whether they are sorrowfully full of pathos, as in his *Deposition of Christ* in S. Stae, they never fail to move the viewer.

The link between the artists can be explained by the common direction in which taste was moving and a shared reference to earlier works, once again those of Meyring whose *Pietà*, such as that now in Nimis, or that in the chapel of the Monte di Pietà in Udine, seem to have been the inspiration for the creative impulse in Corradini's group. But even the stance Corradini chooses for his *Virginity* (see p. 656), with the figure bending slightly backward, the gesture of the right arm and the face lifted upward, can be traced back to Meyring's work (for example, the *Virgin* in the church of S. Bartolomeo), where emotional tension cedes before a more superficial attitude revealing, right down to the tiniest detail, the completely worldly elegance of the figure. As in the *Pietà*, the work concentrates on the elaborate interpretation of the clothes, with folds even smaller and more closely pleated than in the Udine sculptures. Among the Venetian work of the 1720s, the signed *Madonna and Child* in the church of the Eremite is full of gentle pictorial vibrations that underline the contours of the body. So in addition to Corradini's debt to Meyring, he was also stimulated by not only Torretti, but also Baratta and Tarsia, who influenced his style until it reached true virtuosity.

Among all the sculptors of the first half of the eighteenth century, Corradini was the most successful and had the widest range of patrons. His value was recognized not only by the artists of his day, but also by the State and in commissions from other Italian and European centers. His veiled female figures were particularly admired and sought after. These figures, which he worked on from his early years, became a recurrent motif, used above all as an allegory for faith. A lost veiled *Faith* that Antonio Balestra praised in a letter in 1717 was at one time in the Manfrin collection in Venice. Corradini also worked on restoration in the Palazzo Ducale (1725–26) and sculpted the statue of Prudence that still crowns the Arco Foscari (it replaced the original which had been destroyed). In 1723 he promoted the establishment of the Collegio degli Scultori [college of sculptors], which for the first time distinguished sculptors from stonemasons. The Collegio, part of the Accademia [Academy], was an important turning-point since it gave the sculpting fraternity an organization similar to that enjoyed by painters since 1682, the impetus for sculpture to be recognized as a liberal art.

Corradini's work for non-Venetian patrons was done only partly in Venice. Most importantly,

OPPOSITE:
Pietà, Antonio Corradini, 1723–24. Church of S. Moisè.

Corradini was one of a group of sculptors who, from 1716 to the early 1720s, produced an astonishing number of statues for the Russian court. In addition, he spent long periods working abroad and paved the way for a phase that reflected the rising fortunes of sculpture, finally becoming on a par with what was already happening with "traveling" artists such as Marco and Sebastiano Ricci, Giovanni Antonio Pellegrini, and Jacopo Amigoni. Corradini himself moved to Vienna, where in 1733 he was made court sculptor and remained for about a decade. He later returned to Italy and lived in Rome until 1747. At the start of 1748 he moved to Naples where he died in 1752. Rather than his Venetian works, it is his work in the Sansevero Chapel in Naples, and his earlier work in Rome, in the Grosser Garten sculptures in Dresden, and in Udine, which is so original and refined, often on the cusp between Rococo sensibilities and the first Neoclassical glimmerings.

Antonio Gai

In Venice herself the success of Corradini's veiled figures was echoed in the *Faith* executed in 1730 by Antonio Gai as part of a pair with *Fortitude* for the high altar of the church of S. Vidal. In *Faith* the sculptor shows his knowledge of Corradini's work, not just in the iconographic inspiration, but also in its studied virtuosity in the use of veils, which allows us just to glimpse the facial features and to visualize the body contours through the clinging drapery. Whereas in Corradini's work the veils, with their thick, detailed pleats, cover the entire figure, which often acquires a subtle sensuality, the abundant drapery of Gai's *Faith* relies on the contrast between the parts treated in this way and the play of surfaces more plastically modeled in the folds and flourishes. It is precisely this latter type of work, with its tighter rendering, that underlines the elongated form that Gai used for his *Fortitude*, with her luminous oval face, coining one of the images that best represents his unmistakable contribution to the classicizing current of Venetian sculpture. In the years that followed, the artist would accentuate such expressive conciseness in works like the *St. Mark* (1753) on the high altar in the church of the Pietà, in which the play of the folds tends to assume a geometricizing pattern that underlines the movement of the figure, emphasizing its construction in accordance with an elegant and formal canon (see p. 657).

About halfway through the century Gai revealed his true artistic temperament, forging an original style which combines ideas not only from Corradini but also from Tarsia, Torretti, and Baratta. Although

we still know little about his youthful production, mainly woodcarving, it is clear that he was endowed with a versatile and professional temperament. This is evident in a commission by the State—which by definition reflects the level of prestige Gai enjoyed—a bronze gate to the Loggetta of the Campanile of S. Marco which, as the inscription dated 1734 over the right-hand door tells us, he did together with his sons (see p. 658). Both in its totality and in its exquisite and patient detail, the gate demonstrates the value of his woodcarving experience. In terms of decorative elegance, it can be compared to the panels, frames, and reliquaries that Brustolon, also a specialist in the field, had left in the Veneto.

Stuccowork: Abbondio Stazio and Carpoforo Mazzetti

Among other "specialists" who made a decisive contribution to defining the decorative appearance of eighteenth-century interiors, stuccoworkers (plasterers) acquired a new importance. Their role alongside sculptors and painters in decorating total environments, from churches to palaces, was well-defined and helped to boost the position of the craft of stucco. It should not be forgotten, however, that they were also highly professional artists. The stucco masters tended to come from areas with a different culture, usually Lombardy. Their presence in Venice, fairly constant throughout the century, allows us to glimpse the various trends in taste in this field over the period, from late Baroque excess to Neoclassical decoration. These insights are even more meaningful when stuccowork provides the indispensable complement to the decorative finish in all kinds of spaces. The interiors of Palazzo Sagredo, the church of the Gesuiti, the Scuola Grande dei Carmini, the church of the Gesuati, and Ca' Zenobio are the most famous examples. In all of them we can see precisely the unbreakable relationship that binds the plastic and pictorial elements together.

Only rarely do signatures or documents provide us with the identity of these craftsmen who to a large extent remain anonymous. Very little study has been done in the field. Two names come up most often: Abbondio Stazio and Carpoforo Mazzetti, who worked together. As early as 1718 they were in Palazzo Sagredo, and later on they worked more than once in the Gesuiti (1726–27 and 1732–34). They were commissioned to work on the Scuola Grande dei Carmini (1731) to carry out white and gilded stuccowork on the ceiling of the Sala Capitolare there, for which Stazio was paid in 1732.

The decoration framing the canvases (1739–43) of Giambattista Tiepolo stands out not only for its delicate and elegant modeling, but also as an example of the integration between sculptural and pictorial forms leading to harmonious results (see p. 659). We can see, for example, how the small angels Tiepolo painted in the next few years (in particular, those on the edges of the *Angel Holding Two Scrolls*) are in harmony with the chubby putti portrayed in stucco. The decorative exuberance, the "abundance of gold," the "overflowing richness of motifs arranged to fill every available space," just like the "completely Baroque accent on theatricality, the scenographic elements, fake tapestries and curtains, and marble inlays" found in the Gesuiti, represent in Venice the unmistakable sign of artistic currents typical of the Jesuit order. This implies a common purpose in works linked to Manin family commissions and, therefore, to the artists who, as recently discovered documents show, had already worked together for the Manin family in Udine and in Venice herself, on the churches of S. Stae and of the Scalzi. As creators of the statues and reliefs on the facade of S. Stae, designed by Domenico Rossi in 1709, the names of sculptors already linked to the Manin family—Baratta, Torretti, Tarsia, and Corradini—have been put forward by the critics. These do not tally, however, with the attributions of the individual parts, the study of which deserves to be pursued further. Rossi, *proto* of the project, was also in charge of construction work on the Gesuiti (1714–28).

Abbondio Stazio and Giuseppe Pozzo both worked on the Manin Chapel in the church of the Scalzi. Documentary evidence suggests that Pozzo was the author of the splendid creation for the high altar of the Gesuiti with its green marble spiral columns. It included a group mentioned earlier, Torretti's *Eternal Father*, which became the focal point of the whole interior (see p. 654). Another result, in this case clearly of Roman origin, is the cohesion between design and execution.

Giovanni Maria Morlaiter

In the following decade there was a totally different, but nonetheless close, relationship indicative of changing taste: the sober architectural lines adopted by Giorgio Massari for the church of the Gesuati and the simple decorative motifs of the ceiling stuccoes by Angelo Pelle (1737) which frame the frescoes by Giambattista Tiepolo (1738–39); the luminosity flooding the walls and the sculpture of Giovanni Maria Morlaiter, statues in niches and reliefs

St. Mark, Antonio Gai, 1753. Church of the Pietà, high altar.

becoming prominent and enlivening the surfaces with effects that are often painterly.

By the time he worked on the Gesuati (1738–39), Morlaiter was a mature artist. Already established in 1729, he was well known by 1733 as part of a group of sculptors engaged in a prestigious commission supervised and designed by Giorgio Massari. This commission was for ten relief panels for the Scuola del Rosario [rosary] to go in the chancel of their chapel in the church of SS. Giovanni e Paolo (badly

OPPOSITE:
Virginity, Antonio Corradini, 1722–23. Church of the Carmini.

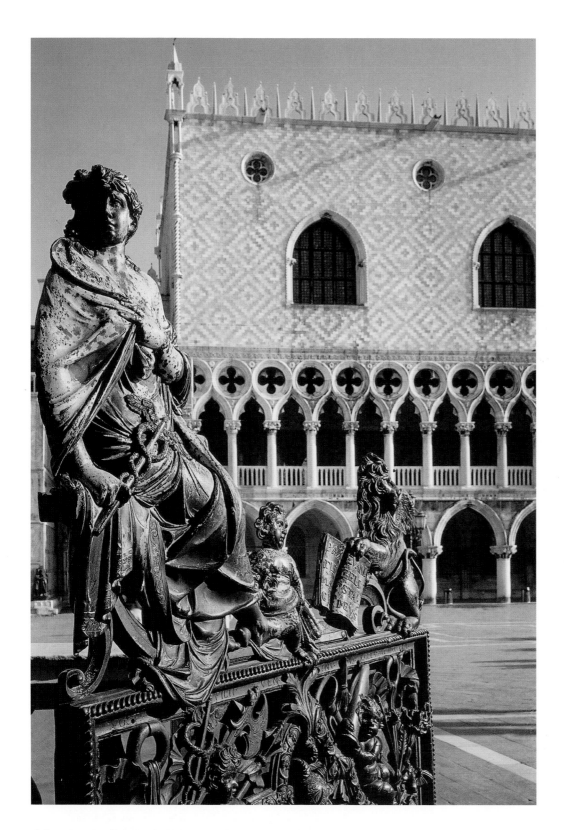

*Bronze gate of the Loggetta of the
Campanile of S. Marco* with
personifications of Vigilance, Public
Liberty, Public Happiness, and the
Government of the Republic, Antonio
Gai and sons, signed and dated 1734.
Detail of the gate with the Palazzo Ducale
in the background.

damaged by fire in 1867). Morlaiter sculpted *Jesus Disputing in the Temple* and *Rest on the Flight into Egypt* (1733–38), while the other eight reliefs (1730–36) were executed by Giovanni Bonazza with his sons Tommaso, Francesco, and Antonio, Francesco Cabianca, Alvise Tagliapietra with his son Carlo, and Giuseppe Torretti.

Morlaiter's talent for relief sculpture was already clear after his work in the church of the Gesuati, but it did not yet manifest the Rococo feeling evident in his later work. In this period his style, already fluent

Chapel in Passariano (1723–25) and, still more, in the four large narrative scenes in the Manin Chapel in Udine (1729–32). He exerted a strong influence in this field over younger artists and even over those of his own generation. Among these, Alvise Tagliapietra's two reliefs (the *Visitation* [1730] and the *Presentation of Jesus in the Temple* [1733–34]) seem to demonstrate this quite clearly, at least in the classicizing cadences of the two works, echoed in another relief, the *Allegory of the Ancient Law and the New Law* (1732) on the pulpit of the church of S.

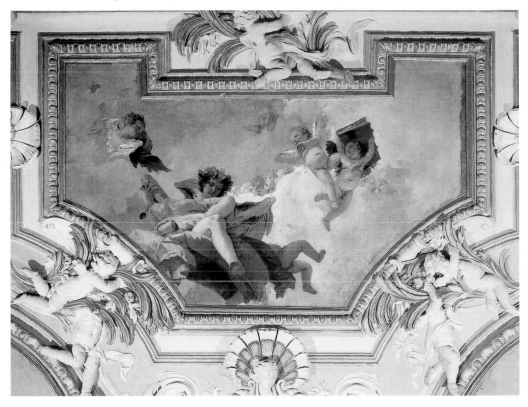

Putti, Abbondio Stazio and Carpoforo Mazzetti, 1732. Detail of the gilded stucco decoration that frames the painting by Giambattista Tiepolo (1739–43) depicting the *Angel Holding Two Scrolls*. Scuola Grande dei Carmini, ceiling of the Sala Capitolare.

in its handling of delicate pictorial effects and indulgence in elegant detail, was still under the influence of Baratta (compare, for example, Baratta's two reliefs for the chapel of St. Anne in the church of S. Pantalon, the *Nativity of the Virgin* and the *Presentation of the Virgin in the Temple*) and of Torretti, whose influence is noticeable in the youthful sculptures that are fully in the round. Torretti, in the low reliefs that he produced for the chapel of the Rosary in SS. Giovanni e Paolo (the *Presentation of the Virgin in the Temple* and the *Marriage of the Virgin* [1733–35]), proved that he was the greatest Venetian master working in relief sculpture. His early work was immediately well received. His talents emerge in particular in the reliefs in the Manin

Moisè, where the artist's vocabulary takes on a solemn and rather stiff idiom unusual for him. Some years later, with the *Temperance* (1737) on the facade of the church of the Gesuati, Tagliapietra rediscovered his elegant nonchalance, which in his best work—especially some of the statues (c. 1719–25) that he and other artists sent to Russia—reflects his most genuine inclination toward Rococo elegance.

Morlaiter was involved, as mentioned, in the sculptural decoration inside the church. His first task, completed between 1738 and 1739, was to sculpt a marble frame in the form of a drape held up by angels in the clouds which was to surround Giambattista Piazzetta's painting of St. Dominic (1743) on the altar dedicated to him. For the first

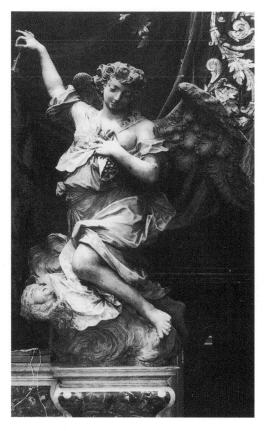

Angel, Giovanni Maria Morlaiter, 1750s. Church of S. Maria della Consolazione, known as S. Maria della Fava, detail of the high altar.

OPPOSITE:
St. Roch Healing Victims of the Plague, Giovanni Marchiori, 1741–43. Scuola Grande di S. Rocco, Sala Superiore, wooden door with carved relief decoration, from a series of 24 cupboards placed on either side of the altar.

contacts possible between the sculptor and the painter who, as we know from his relationship with Bernardoni, was particularly open in this direction.

The *Doubting Thomas* relief (1745–47) and others that decorate the upper part of the church walls confirm what could only be guessed from his youthful reliefs in the Rosary Chapel, that Morlaiter's true gift was for sculpture where modeling is soft, attention is paid to delicately pictorial values, and the recession of planes into the background is increasingly light. This is clearly also the fruit of constant practice making terracotta models. But the freshness of his vocabulary is seen not only in the lightening of his surfaces but also in the narrative rhythm of his episodes, in the play of elegant, slowed interaction between the two figures, reminiscent of the sophisticated narrative *tempi* of Giambattista Pittoni.

The statues in the wall niches of the church, for example, *St. Paul* (1743–44) and *Aaron* (1750–51), are more solemn in tone. Authoritative precedents from the seventeenth century or even more recent ones (Le Corte and Meyring spring to mind, as does the more grandiloquent work of Torretti), are revisited by a more fiery imagination that tends toward decorative effects and appears to have been stimulated by painting. Thus the *St. Paul* suggests Pittoni in its posture and gesture, the *Moses* is likewise close to the emphatic monumental quality of some of Pittoni's figures, and the *Aaron* could be a figure from Tiepolo. It is also interesting to see how close Morlaiter is in ideal terms to the *David* of the frescoed tondo (c. 1739) that the painter executed above the choir in the church, once more confirming the importance of contacts that developed when they were working together.

Morlaiter conceived the two angels on the high altar of S. Maria della Consolazione (also known as S. Maria della Fava) at the start of the 1750s, at about the same time that Giannantonio Guardi was producing his sweeter, more languid figures. Morlaiter's angels, however, seem particularly close to the work of Giambattista Pittoni; this is reflected in the billowing movement of the drapery and also in his borrowing of Pittoni's studied hallmark of the raised hand. In this case, too, the seventeenth-century origin of the images appears to be filtered through a changed sensitivity in taste which, just like the pictorial models, gives Morlaiter's angels a flavor that appears more worldly, and brings them closer to the slightly sensual dimension of some of the secular figures that can be seen in contemporary painting.

time, Morlaiter in this work produced a masterpiece that demonstrated the way his language had developed in terms of the Rococo grace and lightness that we associate with his best creations. At the heart of his pictorial capacity, increasingly enhanced by his ability to shape his material until surfaces broke and rippled, we can glimpse the fact that he had taken on board the softer and more detailed way in which Torretti handled drapery, and had perhaps even added a touch of Parodi's decorative flair.

His vocabulary acquired new inflections and rhythms in perfect harmony with contemporary painting. That the church contained works by Sebastiano Ricci (an altarpiece with three Dominican saints [1730–33]) and Giambattista Piazzetta (an altarpiece depicting St. Vincent Ferrer, St. Louis, and St. Hyacinth, dating from 1738, placed on an altar for which Morlaiter sculpted a cherub for which he was paid in 1743) provides us with a direct point of reference for this. It seems as though the same gust of wind blows the angel to the right of the frame, the flying angel in Ricci's altarpiece, and the one on the left of Piazzetta's work. The contemporaneity of the work of Piazzetta and Morlaiter in this church must have made real

The Academy of Painting and Sculpture

It was in this very decade and the next that leading artists finally had the opportunity to belong to a single professional organization, the Academy of Painting and Sculpture, established in 1750, which provided an important means by which to begin and consolidate relationships, to exchange ideas, and, in general, to stimulate the art world.

In 1756 Giambattista Tiepolo was elected president of the association, with Giambattista Pittoni and Morlaiter working alongside him as council members. All three artists were re-elected in 1758. Among the thirty-six Academy members who were chosen in 1756, we should mention Antonio Gai, Giovanni Marchiori, Giuseppe Bernardi, and Francesco Bonazza. In 1760, when Pittoni became president, the *sindici maestri* [council members] included not only Morlaiter but also Giuseppe Bernardi and Bonazza. In 1764 Pittoni was confirmed as president again, and Morlaiter remained as a council member.

Giovanni Marchiori

Giovanni Marchiori, who was almost exactly the same age as Morlaiter, rose to prominence in the 1740s, producing a number of important works in Venice where, according to archival material, he had probably been living for more than twenty years. It was in Venice that he expanded his working experience which probably followed on from his own training in the school of Brustolon, active in his mature and late years in and around Belluno. It is probable that Brustolon was Marchiori's teacher in woodcarving. We are still unclear about Marchiori's years in Venice with regard to both definite attributions and chronological information.

His two signed statues of St. Alexis and St. Juliana Falconieri (1738), formerly on the high altar of the Venetian church of the Servi and now in the parish church at Fratta Polesine, and the decoration (1741–43) of twenty-four doors of the cupboards on either side of the altar in the large upper hall in the Scuola di S. Rocco show an artist whose vocabulary, whether in his marble statues or his woodcarvings, reveals a mature and original personality. The two statues allow us to place his orientation somewhere between Torretti and Corradini. This is confirmed by the reliefs in wood, which also have hints of influence from Mazza's bronze reliefs in the chapel of St. Dominic.

Nevertheless, what comes across most strongly is his deeply Venetian style, which dominates the still

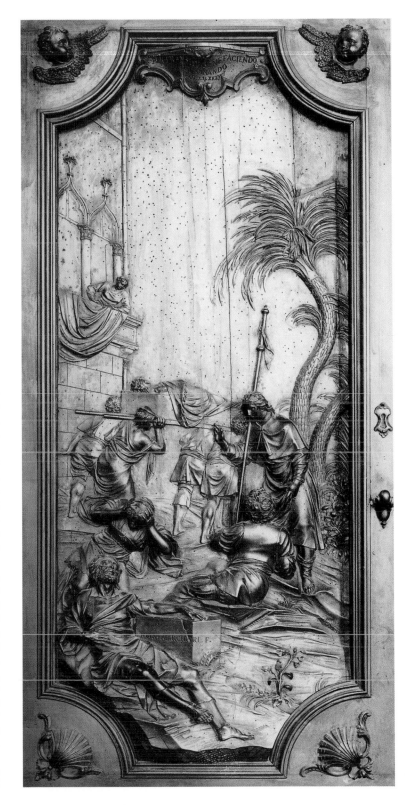

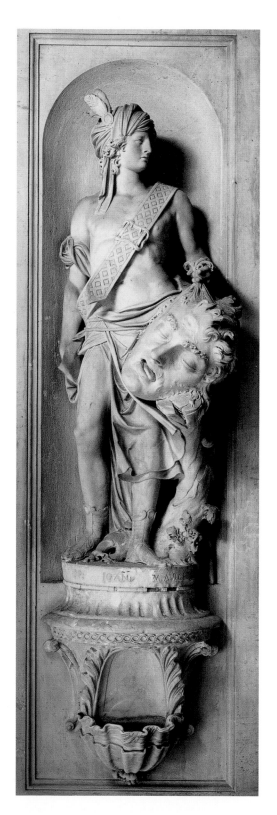

David, Giovanni Marchiori, signed and dated 1744. Church of S. Rocco, beneath the church organ, pendant to *St. Cecilia*.

unwritten chapter about carved wooden panels for narrative cycles dedicated to patron saints of churches and *scuole*. This tradition goes back—citing a few of the rare works that have a name attached to them—directly to the late sixteenth-century work in the choir of S. Giorgio Maggiore with scenes from the life of St. Benedict by the Flemish artist Albert van der Brulle; it continues through the seventeenth century with the scenes from the life of St. Nicholas in the choir of S. Nicolò del Lido by Giovanni da Crema, and the altar front showing scenes from the life of St. John the Baptist by Pietro Morando, formerly in the Scuola di S. Giovanni dei Battuti and moved in the nineteenth century to the sacristy of the church of S. Pietro Martire on Murano.

But if this was indeed the genre which Marchiori's work was continuing, his stylistic achievements are such as to put his wood reliefs on a par with those he sculpted in marble. They all reflect the lessons he learned from Torretti, a knowledge of whose reliefs must have played a crucial part in Marchiori's capacity to give his scenes spatial articulation over a large area. One of the ways he achieves this is in the gradation of the relief planes from foreground to background, which allows him to insert architectural or landscape elements and to stagger his figures cunningly over the various planes of the relief. He also emphasizes smooth surfaces, luminous fields against which groups of figures or other details stand out. In some episodes the brilliance of detail effortlessly captures moments from everyday life, clearly demonstrating the spirit of innovation that reflects the artist's ability to catch just the right narrative tone for this type of work.

Until at least 1745, based on his documented work, Marchiori continued to produce in wood alongside other sculptural media. Torretti too, as well as Corradini and Gai, also continued to work in wood, although we have yet to identify most of their products. This was continued with greater authority by Francesco Pianta and Giacomo Piazzetta, who managed to recoup an area that had traditionally been commissioned from non-Venetian specialists.

Should circumstances require it, a sculptor or woodcarver could take on craft commissions or even become an assistant in executing the marginal aspects of large-scale commissions provided by specialist decorators. Thus it was that Marchiori himself produced a carved and gilded wooden lamp (1745) for the Scuola Grande di S. Rocco while he left Giuseppe Gaggia the job of making an ornamental frame (cherubim heads, flowering shoots, shells) for the wardrobes. In 1743 he made seven wooden angels with musical instruments for the organ in the church of S. Rocco, and in 1744 he

added and signed the marble statues of David and St. Cecilia beneath the organ (see pp. 662, 663). When we consider that these two statues were being made almost in parallel with some of Morlaiter's sculptures for the Gesuati, we begin to realize how the stature and originality of the two sculptors reflected the principal strands of the artistic culture of the day, the Rococo and the classicizing.

In Morlaiter's work, Rococo experiences its most intense and still splendid season, although in the artist's late work it was destined to fade away in just a few years. In Marchiori's work, a cultural undercurrent that had never died acquired a new formal composure. Although his work still exercises its right to indulge in elegant and sophisticated detail or to emphasize some virtuoso angle (Goliath's head, or the way hair is dressed and styled), it nevertheless seems full of foretastes of things to come. The two statues under discussion, which were produced at the pinnacle of his art, more significantly than any others that Marchiori did in Venice begin to trace a road that would ideally have linked the art of Torretti and of Corradini with that of Canova. Marchiori inherited some aspects of his classicizing taste from Torretti and Corradini and passed them on to Canova.

We find traces of the late Baroque in Marchiori's work again a few years later in the statue of St. Peter in the church of the Pietà, which he completed in 1753 to match Gai's St. Mark. The Baroque comes through, despite the elegant motif of the drapery which, although more elaborate, brings to mind the typically classicizing style of the *St. Cecilia* drapery and the stylistic tone of *Vigilance* and *Clemency* (now in Gatçina Castle near St. Petersburg), which were sent to Russia in 1766 and which can be more directly linked to the drapery of the statue in the church of S. Rocco.

In the signed statues of St. Gerardo Sagredo and St. Pietro Orseolo (1766–67), which are in the first sequence of niches on the facade of the church of S. Rocco, a new, more eloquent vein in his vocabulary emerges: a versatility, expressed here through a treatment which composes the exuberant drapery into impeccable formal elements while simultaneously succeeding in conferring on the faces a great expressive intensity.

The Facade Decoration
of the Church of S. Rocco

The facade decoration for the church of S. Rocco was designed by Bernardino Maccaruzzi to include seven statues. Apart from Marchiori, therefore, Antonio

St. Cecilia, Giovanni Marchiori, signed and dated 1744. Church of S. Rocco, beneath the church organ, pendant to *David*.

St. John the Evangelist, Giuseppe Bernardi, c. 1766. Church of S. Maria della Consolazione, right-hand wall. The artist's main work in Venice was a cycle of Apostles and Evangelists, to which this piece belongs.

documentary evidence confirms. Gai, who was already very old, was no longer even in the competition. Morlaiter showed only routine talent, with no traces of the Rococo vivacity that had once distinguished him. The period of enormous creative success he enjoyed while working on the Gesuati was followed by years in which his sculptures gradually grew heavier in shape and lighter in quality. In some cases, especially from the 1770s onward, there is evidence that it was not all his own work—a clear indicator that his best season was over.

Giuseppe Bernardi

The fourth sculptor engaged to work on the facade of the church of S. Rocco was Giuseppe Bernardi, nephew of Giuseppe Torretti. Bernardi, who had studied and worked in Venice with his uncle. Later he took his uncle's surname and inherited his workshop on Torretti's death. He continued to work in the city even though most of his commissions were in other towns in the Veneto and Friuli regions. His major work in Venice is a cycle of Apostles and Evangelists for S. Maria della Fava (c. 1766). This gives us an idea of the artist's abilities and shows that although he worked along the lines taught him by his uncle, and was perhaps also influenced by Marchiori, and possibly even Gai, he developed his own distinctive gentle vein, tending toward rhythms of studied elegance and mellow chiaroscuro effects, with gestures sometimes apparently caught in slow motion and faces that are tenderly expressive (for example, the face of *St. John the Evangelist*).

His vocabulary frequently harmonized with the kind of Rococo overtones found in Amigoni. It is no coincidence that the calm and expressive gestures and poses of his *St. John the Evangelist* and *St. Luke* so pleasingly match those of the Virgin in the *Visitation* and the *St. Francis of Sales* in the altarpieces painted by Amigoni in the same church of S. Maria de la Fava in 1743; the harmony is born of a common direction, which can also be seen in the work of other artists toward forms that are forerunners, albeit in different ways and in different contexts, of a change toward Neoclassical taste. In this context, some of Marchiori's works are most interesting.

Gai, Giovanni Maria Morlaiter, and Giuseppe Bernardi also worked on the project. Gai was commissioned to produce statues of St. Lorenzo Giustiniani and the Blessed Gregorio Barbarigo for the second sequence of niches on the facade; these he sculpted between 1766 and 1768, probably with the assistance of his sons Francesco and Giovanni. Morlaiter received commissions for a relief, *St. Roch Healing Victims of the Plague*, and two statues for the roofline ornamentation portraying St. Girolamo Emiliani and the Blessed Pietro Acotanto. Giuseppe Bernardi made the statue of St. Roch (1767–69), which was to be the centerpiece of the roofline ornament, as well as the decorative fascias for the columns.

Once again, then, the commissioning of sculptural decoration from a number of artists, in accordance with tried-and-tested tradition, enables us to sum up the state of sculpture in Venice at the time. Only Marchiori stands out as a major personality, as the

Antonio Canova and Giovanni Ferrari

As far as Bernardi was concerned, his time was right. In about 1768 Antonio Canova joined his studio, first in Pagnano and then in Venice, where for some time he continued to work as an assistant even after

Bernardi's death, when his nephew Giovanni Ferrari took over the running of the workshop. Between 1773 and 1775 Canova sculpted his first works, which were still firmly rooted in the past. Within a few years, however, he was to open a completely fresh chapter in the history of Italian sculpture, one which would have enormous repercussions throughout the whole of European artistic culture.

In 1777 Giovanni Ferrari, known as Torretti,

of the half-reclining figure resting on his elbow and caught in movement. This had previously been used very successfully by Giuseppe Torretti in his *Blessed Bertrando* (1718) in Udine cathedral, but Ferrari gave it a completely new lease of life.

Of the independent stance taken by Ferrari while he remained within a genre which was, by its very nature, tied to official commemorative patterns into

closed the studio he had inherited in Venice, but he returned to the city in 1784 after a series of journeys to other Italian towns, spreading his work along the way. One commission that tied him down longer than the others was for a large group of statues for Prato della Valle in Padua, in which the two main elements of his vocabulary are evident: firstly, his tendency toward Neoclassicism and secondly, his tendency "to work with a greater naturalness that was already nineteenth-century and bourgeois in character." It was in this second aspect, carried to its highest level in terms of sculptural handling and the force of his realistic characterization, that he truly succeeded. The monument for Angelo Emo, the most interesting of his Venetian works, is now in the church of S. Biagio but was originally intended for the church of the Servi where, as the inscription reminds us, it had been commissioned by Emo's niece and nephew Labia and Zenobio. To portray the dead man, Ferrari had recourse to the formula

which Canova was already introducing new formulas, we have a clearer picture if we remember the State monument that Canova was making at almost the same time in honor of the same person, the monument to Angelo Emo (1792–95), now in the Museo Storico Navale.

Nonetheless, the promises that Ferrari's monument seems to contain found no follow-up since he did not possess the kind of talent needed to open up new avenues of expression. He had just enough to enable him to rework old models inherited from family tradition (Giuseppe Torretti and Giuseppe Bernardi), as in the statues, signed and dated in 1798, of St. Peter and Jeremiah on the high altar in the church of S. Geremia. The results are dignified and professional, but their execution is cold, impeccable to the point of virtuosity. With Giovanni Ferrari, the chapter of eighteenth-century Venetian sculpture closes.

Paola Rossi

Monument for Angelo Emo, Giovanni Ferrari, known as Torretti. Church of S. Biagio, formerly in the church of the Servi. The combination of the partially reclining pose, resting on one elbow, and the oratorical gesture gives the statue of the admiral, who died in 1792, a vivid natural quality.
An inscription on the base informs us that the monument was commissioned by his nephews.

Landscape, Portraiture, and Genre Painting in Eighteenth-Century Venice

Landscape, Luca Carlevarijs. Ca' Zenobio in the Carmini district. This painting belongs to the cycle commissioned by the Zenobio family, patrons of the artist, to be placed in the upper-storey *portego*, next to the frescoes by Luigi Devigny.

New Genres

In eighteenth-century Venice the time-honored themes of myth and allegory and ancient and sacred history comprised only a portion of the subject repertory available to wealthy patrons, who hired Tiepolo and Piazzetta, or Pittoni, Fontebasso, and Diziani, to paint large-scale narratives and altarpieces but turned to other artists to produce smaller paintings for the opulently damasked interiors of their palaces. Rosalba Carriera and Alessandro Longhi painted portraits, Marco Ricci landscapes, Pietro Longhi and Giandomenico Tiepolo, and, sometimes, Piazzetta,

genre scenes, while Luca Carlevarijs, Antonio Canaletto, Michele Marieschi, Bernardo Bellotto, and Francesco Guardi offered view paintings. Discarding old pictorial formulas for new ones, these artists introduced an unaccustomed informality into Venetian art. A village scene by Ricci, for instance, rather than a conventional landscape conceived around a classical theme, might appeal to clients; Longhi's portrayal of a patrician woman pursuing an apparently trivial pastime attracted her husband's fancy more than a formal portrait. Materials and techniques formerly considered unsuitable captivated viewers because of their untraditional look. Thus the distinctiveness of Carriera's pastels on paper and Ricci's temperas on kidskin attracted attention. Finally, because daily life assumed prominence as a fresh source of artistic inspiration, Carlevarijs, Canaletto, Marieschi, and Guardi portrayed the urban environment in ways that had never before seemed possible.

Why did the Venetian public warmly embrace pictorial innovation? The new diversity is partially explained by the growing interaction between native artists and the world beyond. Venetian painters traveling abroad encountered and assimilated a wide variety of artistic trends, and their dealings with foreign patrons and connoisseurs further contributed to their sophistication. Journeying through the Netherlands, for example, led Ricci to explore new types of landscape, Canaletto's tours through the English countryside increased his repertoire of architectural motifs, and contacts with French collectors probably encouraged Carriera to work in pastels. Very few artists endured as purely local phenomena, although there are exceptions: the two Longhi, who depicted members of the patriciate, and Guardi, whose poetic interpretations of Venice appealed to astute local professionals.

The bustling international trade of the day also brought Venetian art into contact with the world beyond the lagoon. Large numbers of canvases left the city, and many entered. Clients ordered from abroad, and foreign patrons also bought at source. Diplomats on mission and northern nobility enjoying

Luca Carlevarijs

the grand tour were charmed by Carlevarijs's views and later snapped up Canaletto's cityscapes. But foreign residents also collected Venetian art, the two most famous being the German field marshall Johann Matthias von der Schulenburg and the English merchant Joseph Smith. Both men extravagantly filled their palaces on the Grand Canal with art. Schulenburg was partial to views by Canaletto and pastorals by Piazzetta while Smith preferred Ricci's wooded landscapes and Longhi's peasants. Thus the "minor" genres were not an insignificant part of Venice's artistic ascendancy during the eighteenth century, nor an expendable aspect of its patronage. Rather, they greatly contributed to the thematic originality, stylistic innovation, and high artistic quality that distinguishes Venetian painting of the Settecento. Moreover, the wide range of clients who purchased paintings include highly placed patricians in government, foreign royalty, diplomats, members of the Venetian middle class, and refined intellectuals abroad.

The opening years of the eighteenth century witnessed the emergence of several new types of art in Venice. By 1705 Luca Carlevarijs was painting impressive city views, Marco Ricci was creating innovative landscapes, and Rosalba Carriera was producing portraits different from those of previous generations. Born in Udine, where his father was an architect, Carlevarijs probably trained in Venice. During the 1680s and 1690s he painted a number of dark landscapes, imaginary ports, and battle paintings (see pp. 666, 667). In 1703 he published a book of 104 etchings entitled *Le fabriche, et vedute di Venetia* [Buildings and views of Venice], which derive in type from printed views of the seventeenth century. The prints, which illustrate many of Venice's public buildings, private palaces, and open spaces, also catch the variety of street life and the peculiarities of the city's immense sky and brilliant light.

During the next several years visiting royalty and foreign ambassadors requested Carlevarijs to commemorate their official missions in paint. In 1706

View of a River Port, Luca Carlevarijs. Museo Correr, formerly Teodoro Correr collection, signed L.C. in the center on a chest. This singular capriccio illustrates the daily life of a port, characterized by an equestrian monument after Bernini.

Henri-Charles Arnauld de Pomponne commissioned the artist to record his arrival in Venice as France's emissary. Building upon the pictorial tradition of cityscapes that Gaspar van Wittel had brought to Italy from his native Netherlands, Carlevarijs faithfully captured Venice's topography as the setting for the ambassador's ceremonial disembarkation before the Palazzo Ducale. A broad spectrum of Venetian life animates the Riva degli Schiavoni. Figures of all types—from elegantly dressed patricians to somberly clothed citizens and humbly garbed laborers—parade and work along the quay, while ships and gondolas ply the waters of the Basin of San Marco on the left.

This view makes clear that Carlevarijs was well aware of the Venetian tradition of opulent festival paintings, a genre already in vogue in the Seicento, when its most popular exponent was Joseph Heintz, a Bohemian painter who had worked in Venice. Carlevarijs expanded the language of Heintz's festivals by conveying Venice's atmosphere and light. In his integration of the related genres of views and festival imagery, Carlevarijs happened upon a propitious moment, able to take advantage of the tourism that thrived following the Peace of Carlowitz (1699), which ended two terrible wars against the Ottoman Turks.

Marco Ricci

Marco Ricci, a decade younger than Carlevarijs, was born in Belluno and trained with his uncle, Sebastiano Ricci, one of Venice's most successful figure painters. The young Marco quickly discovered that his talent lay in landscape art and abandoned figurative painting to produce dark, windblown, and cloud-filled landscapes enlivened by small, dramatically gesticulating figures. Ricci's youthful development is difficult to trace, however, because he often copied the styles of earlier as well as contemporary landscapists such as Claude Lorrain, Gaspard Dughet, Salvator Rosa, Johann Anton Eismann, Pieter Mulier, Antonio Francesco Peruzzini, Bartolomeo Pedon, and Alessandro Magnasco. A further complication in unravelling his artistic progress is his periodic collaboration with colleagues on a single canvas.

Marco Ricci, like Carlevarijs, evolved his individual style by producing a synthesis of older trends and interpreting them through a keen observation of nature. For instance, in a small landscape, whose figures were painted by his uncle Sebastiano and which Grand-Duke Ferdinando of Tuscany bought in 1706, Ricci depicted a tall tree in

Landscape, Marco Ricci. Gallerie Querini Stampalia. Precise organization of the receding space is combined with a delicate vision of country life typical of the artist.

Portrait of a Young Lady, Rosalba Carriera. Venice, Gallerie dell'Accademia. This painting is remarkable for its sense of immediacy deriving from the careful study of the sitter.

OPPOSITE:
Portrait of M. Le Blond, French Consul in Venice, Rosalba Carriera, c. 1730. The courtly clothing and the facial expression effectively portray the bureaucrat connected to official ruling circles.

izing view of rural life, in the refinements he made on his pictorial surface, and in his sensitive evocation of a real site, such as can still be found today on the plains of the Veneto before the ascent into the Dolomites. The delicate light on the variously tinted leaves and the smoke rising across the tinged morning sky and in front of the distant blue-gray mountains evoke a poetic view of nature that had not graced Venetian art since the pastoral imagery of Giorgione and the young Titian. Like these famous predecessors, Marco Ricci hailed from the mainland, and his painted hills, craggy mountains, and broad valleys surely mirror his experiences in the country-side (see pp. 668–669).

Ricci's output during the next quarter of a century was extensive and varied. Sponsored by Charles Montagu, fourth Earl of Manchester, he traveled to England in 1708 and worked there until 1716, in collaboration first with Giannantonio Pellegrini and then with his uncle Sebastiano Ricci. He produced scenery for the London opera stage and painted landscapes for noble patrons for their country homes. He also produced caricatures of rehearsing operatic singers. When traveling through the Netherlands on his trips to London, he became acquainted with Dutch landscape painting, and his *Landscape with Horses Drinking at a Fountain* reveals his talent in adapting motifs from the Northern tradition to monumental imagery resonating with classical overtones. The weary horses and riders that stop to rest are dwarfed by the great tree trunks snaking upward; an ancient fragment lies nearby and a woman with an antique urn on her head poses *alla romana*.

Ricci's scenes of architectural ruins and violent storms reveal very different aspects of his art. But his most remarkable creations are his tempera works on kidskin, a combination of medium and support never before used for easel paintings. The artist may have become familiar with canvases of goatskin (parchment, vellum), of which there was a tradition in the Netherlands and England. These small paintings, all approximately the same size, must have found a ready market, for they comprise about half of Ricci's extant output. One charming example shows servants working in a villa garden. At the far left a standing figure, perhaps the steward of the estate, surveys a servant diligently cleaning the fountain basin. In the center another worker levels the earth while others trim and prune plants on the right. Differentiating the disparate worlds of subordinate laborer and cultivated master, Ricci contrasts the endless work needed to maintain the garden with the refined grace of the classical statuary ornamenting it. At the same time he cleverly pits the moving figures

the right foreground, its arching fronds reaching toward a group of smaller landscape motifs on the left. Together they define a dark area of woodland space and frame a panoramic view of a sunlit valley beyond. Warmly colored rustic buildings just left of center guide the viewer to an elegant and brilliantly lit villa in a commanding position below the foothills of a large mountain range. This careful plotting of sight-lines to establish a zigzagging penetration into distance was a well-established artistic device. Ricci's innovations lie in his sweeping but gently human-

Portrait of a Little Girl, detail, Rosalba Carriera. Venice, Gallerie dell'Accademia. The artist represents the innocent freshness of the child.

against those in stone: the servant stooping over the fountain corresponds in position to the Atlas-like statue just above, and the stance of the saucy young woman standing in the gateway on the far right amusingly mocks the white marble figure with raised arm slightly to the right of center. Ricci's most telling pictorial contrast lies in his juxtaposition of the garden's softly contoured trees in half shadow and the severely designed majestic Palladian portico in the sunlight.

Rosalba Carriera

The century's new taste for pictorial radiance is also manifest in the works of Rosalba Carriera, Venice's most innovative portraitist of the first half of the century (see pp. 611, 670–672). Carriera was born in the 1670s and studied with two all but forgotten men, Giovanni Antonio Lazari and the Cavaliere Diamantini. Her most important contacts, however, were with Antonio Balestra and Giannantonio Pellegrini. Pellegrini played an especially significant role in her artistic development: the fluidity of his brushwork is reflected in hers and his use of pure white color distinguishes her work as well. Their professional bond was cemented into a familial tie when in 1704 Pellegrini married Carriera's sister. Both painters also benefited from the same patrons, the most distinguished being the Elector-Palatine, Johann Wilhelm von der Pfalz.

By 1705 Carriera's reputation encouraged her to submit a reception piece to the Academy of St. Luke in Rome. Judging the miniature, *Girl with a Dove*, Carlo Maratta, the academy director, paid tribute to the artist by favorably comparing her to the seventeenth-century Bolognese master Guido Reni. Portrait miniatures like this earned Carriera international fame and patronage. She subsequently worked for Christian Cole, a resident of Venice and secretary to the British ambassador, for Frederick IV of Denmark during his visit to the city, and for the Elector in Düsseldorf and the duke of Mecklenburg. By the middle of the second decade of the century, Carriera had become so famous in Venice that foreign worthies called on her during their stays. Her work suggested to them—and to much of the cultivated audience welcoming the new century—all that was innovative and appealing. The radiant luminosity of her pastels rebuffed the lugubrious shadows of the Seicento, and the paper on which she drew emphasized simplicity rather than pomposity. Even more importantly, she conveyed a sense of immediacy through close-up views and a subtle manipulation of her sitter's gaze. Her manner was quite different from the usual Venetian portrait of the seventeenth century, a typical example of which is Sebastiano Bombelli's well-known portrait of Gerolamo Querini as procurator of S. Marco (see p. 673). Despite the easy movement of Querini's sweeping drapery and the apparent spontaneity of Bombelli's painterly brushwork, the young Venetian assumes an imposing full-length stance and is viewed against ennobling draperies while wearing fine robes of state. Most highly placed men sought such likenesses to affirm their positions in society. Viewers are kept at both a physical and a psychological distance through formality of pose, refinement of physiognomy, and the half-length format. Carriera, in contrast, concentrates on her sitters alone. Her close scrutiny repudiates the work of earlier generations of portraitists and insinuates familiarity.

Nowhere can this be better appreciated than in her portrait of Antoine Watteau. Carriera met her famous contemporary in Paris, where she arrived in April of 1720. Lodging in the luxurious home of Pierre Crozat, the French banker and connoisseur, she enjoyed a triumphant sojourn of about a year. She met all the painters then working in the city as well as numerous noblemen, including Jean de Julienne, one of Watteau's most noteworthy collectors. She portrayed the young Louis XV and was received into the Académie de Peinture. Her portrait of Watteau shows him against a glowing background of rich shades varying in intensity. The artist glances spontaneously toward the viewer, his

Full-length Portrait of Gerolamo Querini in the Robes of Procurator of S. Marco, Sebastiano Bombelli. This famous work is an eloquent example of the parade portraits typical of the Baroque period. The young Venetian creates an imposing impression in the rich costume of his office.

long, sharply angled nose accentuating his turn in space. A gentle wistfulness plays across his features. Although his debonair mien, tasteful neck scarf, and exquisitely coiffed hair denote discriminating taste and refined sensibility, his simple coat denies patrician wealth. The subtle skill of works like this conquered Carriera's Parisian audience and influenced French taste to such a degree that Maurice Quentin de la Tour took up pastels after her departure.

Despite her contemporaries' acclaim, Carriera suffers today from the double charge that her pictorial powers are insignificant and her psychological insight weak. An attentive perusal of her oeuvre reveals, however, that Carriera portrayed a broad range of humanity and her sensitivity to her sitters was impressive. To take two examples from around 1730, the portraits of the French consul in Venice, M. Le Blond (see p. 671), and of Sister Maria Caterina, a Dominican tertiary: neither sitter is handsomely portrayed while a homely corpulence defines the consul, and the nun is undeniably birdlike in countenance. More importantly, Carriera subtly characterizes each figure through dress and facial expression. Le Blond's courtly clothing places him in relation to the official circles in which he worked at home and abroad, while his prosaic face reassuringly confirms his abilities as an efficient bureaucrat. Sister Maria Caterina's gaunt features and enlarged eyes, in contrast, attest to her abstinence, reclusive existence, and deeply pious life.

Carriera left eight self-portraits, the most memorable of which depicts her crowned with laurels. The pastel's small size and intimate format force us to examine her intently. The septuagenarian artist avoided all reference to fine dress and setting and severely delineated her ordinary features. Such directness was not atypical for painters of her era. In

Grand Canal Viewed from Palazzo Balbi, Antonio Canaletto. Ca' Rezzonico. This famous view formed part of a series of four, recorded in 1767 in the description of the paintings belonging to the collection of Prince Joseph Wenzel. They later entered the collection of the princes of Liechtenstein. In the 1940s two of these passed to the Crespi collection in Milan and then, finally, to the city council of Venice and their present setting.

Capriccio of a Colonnade and the Courtyard of a Palace, Antonio Canaletto, 1765. This picture served as the competition piece for admission to the Academy of Painting and Sculpture. In presenting the work, Canaletto essentially concurred with his colleagues that perspectival studies were worthy of formal recognition. Signed in the lower left-hand corner "Anton . . . 1765," the painting depicts a typical mix of nobles and citizens of everyday Venice, thanks also to the fact that the architecture refers to a real place, the courtyard of the Ca' d'Oro.

1753 Tiepolo portrayed himself as a simple and unaffected painter in one corner of his immense fresco on the vault of the Kaisersaal in the Würzburg archbishop's palace. That same decade Piazzetta began a self-portrait whose frank realism echoes the uncompromising attitude of Carriera's pastel. And in Paris Chardin caught the prevailing tone of simple humility that the greatest painters of the *ancien régime* preferred. In this, her last self-portrait, Carriera intertwined the delicately half-shadowed leaves of the laurel wreath into her gray hair, telling viewers that her days of glory were numbered. Indeed, they did not even last until her death, for soon after completing this work she went totally blind. Her last years were difficult, and she died in 1757.

Antonio Canaletto

While Carriera enjoyed her visit to Paris in 1720–21, Venice's most renowned painter of views, Antonio Canaletto, launched his career back home. After a youthful collaboration with his father designing scenery for the theater, Antonio began painting architectural fantasies and city views on his own. An early caprice shows a conglomeration of assorted architectural styles—classical buildings and monuments, medieval ruins, and a Renaissance palace—built along a *scena per angolo*, or oblique perspectival setting, which the Bibiena, a Bolognese family of set-designers, had made popular on the stage. Canaletto's heavy shadows, mottled surfaces, and small groups of gesticulating figures suggest the unfolding of dramatic events in a dark and forlorn world. He used the same narrative tension and luministic contrasts in cityscapes. For example, in a scene of the Grand Canal looking from Palazzo Balbi toward the Ponte di Rialto (see p. 674), he repeated the compositional design of the caprice, but instead of boats he employed little outcroppings on the banks filled with pools of shadow and light, and he substituted palace facades for ruins. Although his tiny figures, or *macchiette*, are few, they suggest a workaday Venice rather than the ceremonial city Carlevarijs had depicted for foreigners. Moreover, by reducing color to only three principal fields—a blue sky, tawny-hued buildings, and a murky green canal—he depicted a somber rather than a festive image. Canaletto's deepened reality and heightened sensibility depart radically from Carlevarijs's concept of the view. His space is greater, his shadows deeper, and the sky more immense. Venice's glory is herself, not her entertainments.

Canaletto's art attracted a wide range of clients by the end of the 1720s, but few seem to have been

Rio dei Mendicanti, Antonio Canaletto, Ca'
Rezzonico. On the left can be seen part of the
church of S. Lazzaro dei Mendicanti while in
the background along the canal is the Ponte
del Cavallo. The painting was bought by
Venice city council from the Crespi collection
in Milan in 1983.

Venetian. His earliest documented patron was
Stefano Conti, a merchant from Lucca, who commis-
sioned Canaletto in 1725 to paint four views. Conti's
agent in Venice, the painter Alessandro Marchesini,
had recommended that Canaletto—and not Carlevarijs
—be engaged. Canaletto was developing new ideas
for his city views. By lowering the viewpoint in the
works for Conti, Canaletto enables his viewers to
focus on his increasingly varied secondary elements:
a Dominican brother and a red-cloaked procurator
hurry by in the early *View of SS. Giovanni e Paolo*
(private collection), and a priest and an elegantly
garbed patrician enhance the *View of the Grand
Canal from S. Maria della Carità to the Basin of S.
Marco* (private collection).

Canaletto quickly replaced Carlevarijs as the view
painter of choice in Venice, and non-Italians as well

as non-Venetians soon appreciated his expertise. In
1722 Owen McSwiney, an Irish impresario who had
worked successfully in the London theater at the
beginning of the century, conceived of a decorative
cycle of large canvases to honor heroes of recent
British history. The "Tombs of Illustrious Men,"
painted by Venetian and Bolognese artists, were sent
to England when completed, and many of them
entered Goodwood House, home of the duke of
Richmond, while others were sold to Sir William
Morice. Bypassing Carlevarijs completely, McSwiney
employed Canaletto to contribute the architectural
elements of two of the "tombs." The omission was
certainly not based on age, for Sebastiano Ricci, who
was even older than Carlevarijs, worked on two
other "tombs." Perhaps it was Carlevarijs's lack of
dramatic chiaroscuro that precluded his involvement,

which seems paradoxical today given his early wind-blown landscapes and turbulent ports. Canaletto's eclipse of his older colleague must have been apparent to the artistic establishment of north Italy. His vivid skies and variegated surfaces had great appeal in the 1720s, the decade in which Piazzetta and Tiepolo were producing darkly dramatic figurative paintings lit internally by bright light.

The late 1720s and 1730s witnessed Canaletto's increasing popularity among resident and touring British. Elizaeus Burges, who represented the Court of St. James in Venice 1719–22, and 1728–36, bought from the artist, as did the duke of Bedford, whose twenty-four views of Venice now constitute the famous "Canaletto Room" in Woburn Abbey. But Canaletto's art will always be associated with Joseph Smith, merchant, collector, and British consul in Venice from 1744 until 1760. Smith enjoyed a large circle of acquaintances and was the ideal agent to mediate between Canaletto and his many would-be clients. The Smith-Canaletto partnership began about 1730. Smith proposed sites for Canaletto to depict and initiated projects, like the series of twelve paintings of the Grand Canal, from the early 1730s, that were subsequently reproduced as engravings by Antonio Visentini in a book entitled the *Prospectus magni canalis venetiarum* [Views of the Grand Canal of Venice]. Sailing in imagination along the length of the city's main thoroughfare, Canaletto produced views of a bright and sunny Venice, taking a high viewpoint above the canal, lowering the view to just above the water's level, or stepping, as it were, onto an embankment. The apparently drab and unpretentious city he had pictured in the 1720s gave way to one lit by a brilliant Mediterranean sun and filled with anecdotal detail. It cannot be coincidental that this change in approach and style occurred at the same time the painter began to collaborate with Smith.

In this series Canaletto reinterpreted Carlevarijs's festival paintings, transforming, for instance, the latter's *Regatta in Honor of Frederick IV of Denmark*, which commemorated the king's entrance into Venice on 4 March 1709, into the *Regatta on the Grand Canal*, a work celebrating the feast day of the purification of the Virgin and dating to either 1733 or 1734. Canaletto's *Palazzo Balbi*, on the far left of the painting, is monumentally tall rather than broad. The sky is clear, the space impressively ample, and the building facades are splendidly lit by the sun or deeply darkened by shadows. Canaletto also portrayed the State ceremony enacted on Ascension Day, transforming Carlevarijs's *Bucintoro Departing from S. Marco* into the *Bucintoro Returning to the Molo on Ascension Day*.

A comparison of the two scenes pinpoints exactly why the younger painter is the greater master of

views. Instead of merely pictorializing the city as the older artist had done, he celebrated it metaphorically. Shifting the viewer's position further to the west than Carlevarijs had, placing it directly before Sansovino's Libreria, Canaletto converted the bell tower and its lion of St. Mark into urban icons proclaiming Venice's civic vigor and historical might. He painted the ceremonial craft and its banner of St. Mark a lustrous red so that in contrast to the cool blues of sky and water, the neutral shades of the buildings, and the grays and blacks of the boats, the ship of state warmly glows. The basin itself seems immense since Canaletto deployed fewer figures than Carlevarijs and set them in a sunnier foreground. Finally, his figures are ingeniously conceived: those close to the viewer are large and dominant, while the rowing boatmen, particularly the few who maneuver to halt their craft on the left, transmit a sense of immediacy. Canaletto's *macchiette* make Carlevarijs's seem stiff, just as those of Carlevarijs, when viewed against Heintz's, make the earlier tradition look wooden.

The richness of Canaletto's art is best appreciated by looking at two diverse works of the 1730s, the *Basin of S. Marco* and the *Interior of S. Marco*, which contrast not only in size and format, but also show totally dissimilar urban experiences. The *Basin* is the quintessential view of the city: the viewer looks down on the city as if positioned high up on a mast, and everything—the public buildings delimiting the distant horizon line and the commercial craft pulling to and fro—is united by the unique Venetian spectacle of the mutable elements of water, sky, and light. The *Interior*, in contrast, is a small assembly of worshipers gathered in a buoyant space defined by lines rather than air and spatial expanse. It captures, furthermore, a transitory moment. Light glimmers briefly into the church from its western entrances while people mill and jostle beneath the pulpit. Conversely, in the *Basin* the city's rhythms seem almost to have been brought to a standstill, as if the urban fabric were transfixed. Even the handling of paint on the two canvases is dissimilar. Often tight and meticulous in the outdoor scene, the brushwork is ragged in the *Interior* as it thickens, curls, and blotches to create light and form. Canaletto's mastery of paint is especially discernible in the most outstanding features of these two works—the immense and feathery white cloud billowing across the Lido in the exterior view, and the golden chain and globe hanging in the interior of the church. The control of material and technique argues for Canaletto's rightful ranking as the greatest view painter in Western art.

Canaletto

After visiting Rome Canaletto settled in Venice about 1720 and became a member of the painters' guild. In 1730 he met the English collector Joseph Smith (later British consul in Venice), who became his most important client and an agent for the sale of his work. At the start of the 1740s the artist's relationship with Smith grew close, and he dedicated a series of etchings to him in 1744. By then Canaletto was working for Smith on an almost exclusive basis. With Smith's help, he left for England in 1746, where he remained until about 1756. Canaletto produced spectacular panoramic views of London and the English countryside as well as unusual capriccios and *vedute ideate*. His arrangements of material reality during this mature period are perhaps even more sophisticated and satisfying than those produced during his youth. Though his tight application of paint may be less pictorially seductive than his earlier and more richly laden application of oils, the work of his years in England still demonstrates a sure technical control and reaffirms his commitment to record the details of daily life. In 1760 he returned permanently to Venice and in 1763 was admitted to the city's Academy of Painting and Sculpture.

ON THE FOLLOWING PAGES: *Il Fonteghetto della farina*, Antonio Canaletto. Venice, Giustiniani collection. In the foreground to the right, the grain warehouse, previously the office of the Magistrate for Grain, then seat of the Academy of Painting and Sculpture, and finally the harbor office. Behind the warehouse and to the left of the Dogana is Palazzo Valaresso (previously Erizzo), and in the background, the church of the Redentore.

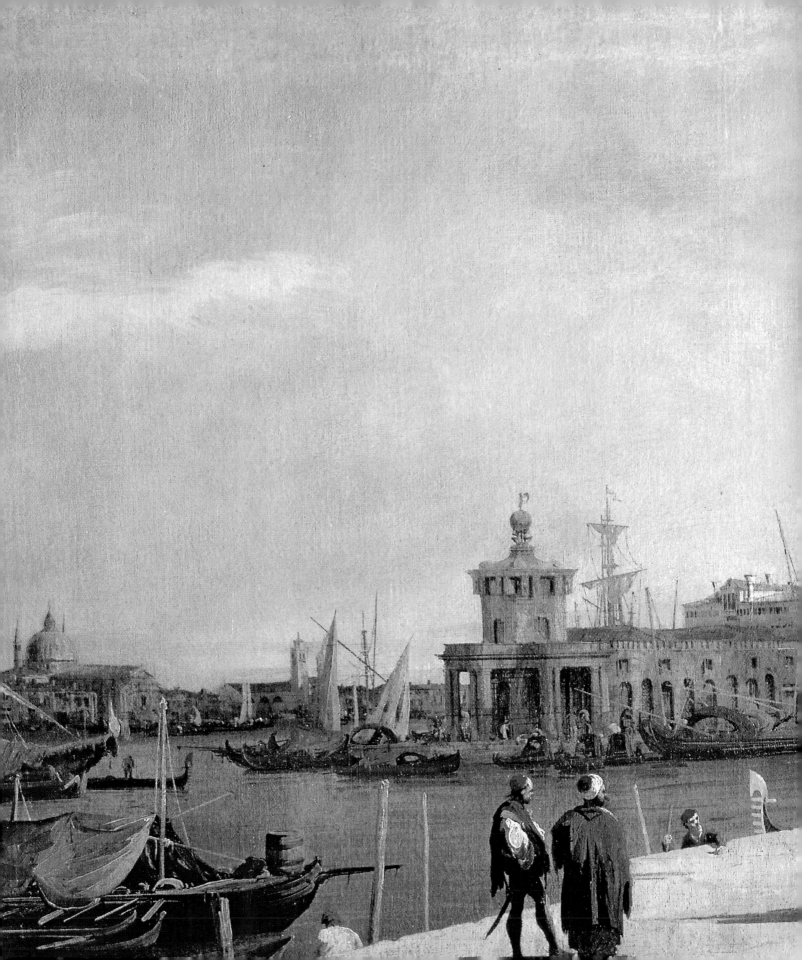

OPPOSITE:
The Moor's Letter, Pietro Longhi. Ca' Rezzonico. Previously in the Grimani dei Servi collection and subsequently property of the Morosini of Venice, the painting is dated c. 1751. On the wall within the setting of the picture is a reproduction of a painting by Zuccarelli.

Genre Painting: Giambattista Piazzetta and Pietro Longhi

While Canaletto demonstrated his primacy as an urban portraitist during the 1730s and 1740s, Pietro Longhi established himself as a painter of genre. He was not, however, the originator of this theme in eighteenth-century Venice, being preceded by Giambattista Piazzetta, who had been painting humble folk since at least 1710–15. Piazzetta's commitment to genre had resulted from a stay in Bologna where he perhaps worked with Giuseppe Maria Crespi. Crespi's *Sleeping Shepherdess Tickled by a Straw*, an early work now lost, suggested to Piazzetta the kind of homespun and piquant scene that might appeal to a public thirsting for novelty. Piazzetta produced his own version of the subject, the *Sleeping Peasant Girl*, which, with its pendant, the *Young Peasant Lad*, indisputably demonstrates his expertise in genre work. A lusty wench sleeps in a space accessible to the viewer. Her upturned and empty left hand offers itself to anyone within reach, her ripe breasts fall out of her blouse, bulbous turnips lie ready to be fingered, and her basket awaits filling. Her male companion looks toward her, and there is little question regarding his thoughts, for even if his hat partially hides his face, his knobbly, muscular hands forcefully seize his staff. Piazzetta's reasons for taking up genre subjects are clear: his predilection for pictorial naturalism and his likely association with Crespi who simultaneously produced both large-scale history paintings and small-scale genre images, a career model that Venetian art lacked.

Pietro Longhi began as a history painter, first studying with Balestra, who advised him to study with Crespi. When exactly Longhi's Bolognese sojourn took place is unclear, although evidence seems to point to the 1720s. Back in Venice he received important public and private commissions, including an altarpiece for the church of S. Pellegrino, which he painted around 1730–31, and the fresco of the *Fall of the Giants* which he executed in 1734 over the main stairwell of Palazzo Sagredo. An early drawing by Longhi shows two figures, one made in preparation for the altarpiece and the other a peasant woman. Although it is unclear which was drawn first, the sheet gives every reason to surmise that Longhi took up genre painting even as he painted in the grand manner. The examples were there in the careers of both Crespi and Piazzetta.

But what motivated Longhi to forsake large-scale narratives and devote himself almost exclusively to genre? Today the general opinion holds that he knew his talents were meager. Nevertheless, the flourishing art market for genre imagery must have also played a role. Crespi's art was enjoying success in Venice; in 1736 his *Sleeping Shepherdess Tickled by a Straw* was purchased by the cultivated Anton Maria Zanetti, who had the Venetian painter Giuseppe Camerata make a print of it the following year. Engravings after paintings by Watteau were rapidly becoming known in the city, and just before 1740, the Frenchman Charles-Joseph Flipart and the German Joseph Wagner, two printmakers, arrived from Northern Europe probably carrying packets of prints of genre scenes. Thus, shortly after he appeared on the scene as an artist in the grand manner, Longhi radically altered his professional path. Just as Marco Ricci turned from figurative painting to landscape, Carlevarijs gave up perspectives for cityscapes, Carriera dropped snuffboxes for pastels, and Canaletto abandoned stage scenery for *vedute*, so Longhi abandoned altarpieces for genre.

La polenta, one of Longhi's earliest essays in genre, is typical of the type of peasant scene he painted throughout his long career until he died in 1785. Although somber in color, the picture is sprightly in humor, and flaunts the same kind of sexual message read in Piazzetta's pendants. There can be little doubt about the meaning of a scene in which a gesturing woman firmly grips a conspicuous rod while a smirking and buxom lass playfully discharges a mound of polenta for a youth as another man knowingly tries to stir him with a serenade. Ribald humor like this fills many of Longhi's images of lower-class life, and perhaps reflects the presence of bawdy Flemish paintings in Venetian private collections at the time; both Smith and Schulenburg owned such works. The two men also bought genre paintings by local artists: Smith owned at least three canvases by Longhi, and Schulenburg commissioned no fewer than six from Piazzetta.

Because Longhi and Piazzetta offer contrasting images of peasant life, it is worth comparing their works to understand the alternatives that patrons like Smith and Schulenburg found available. Longhi was a miniaturist, not only because of the small size of the canvases he chose to use, but also because his peasants are dainty and charming. In contrast, Piazzetta interpreted human experience, even when contemporary and rural rather than historical and noble, in a grand manner. His protagonist in *The Fortune-Teller* fills the canvas and towers over her companions while looming over the viewer (see p. 597). In describing her, Piazzetta employed a rich range of browns, beiges, and grays. Longhi's colors too are somber, but he sets earth tones with bright hues, using yellow for polenta and a golden tone for the interior of the pot. But if his chromatic range is wider, his colorism is more restricted than Piazzetta's.

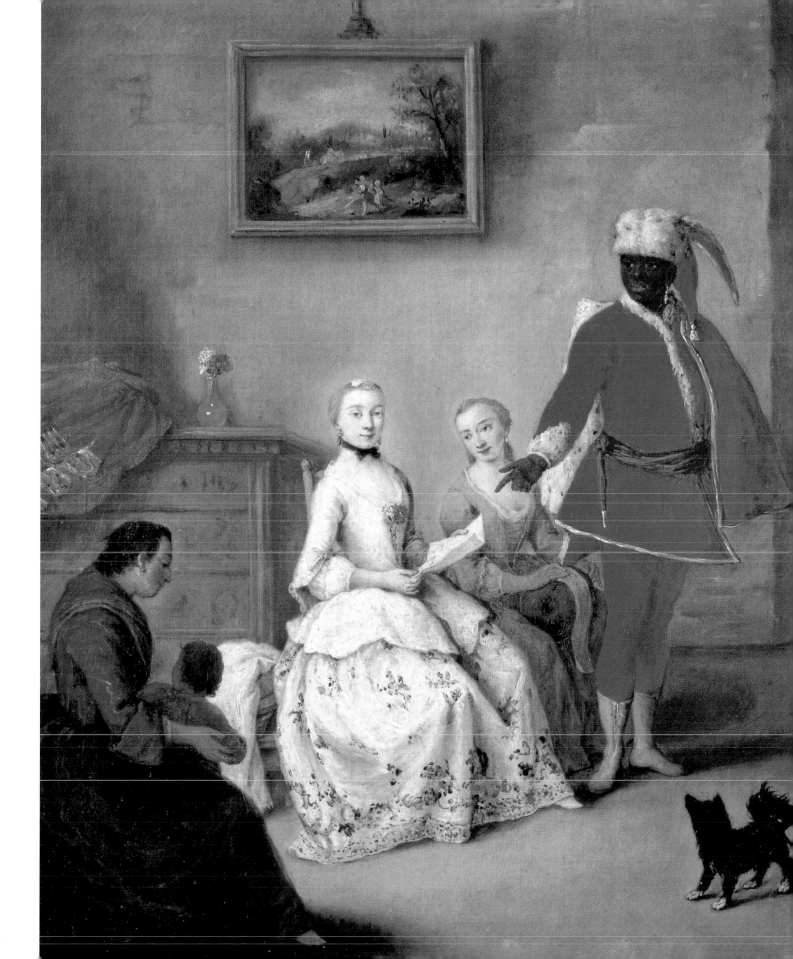

The Rhinoceros Exhibition, Pietro Longhi. Ca' Rezzonico, formerly Morosini collection. The painting bears the inscription: "True likeness of a rhinoceros brought to Venice in 1751, made by the hand of Pietro Longhi on commission of the N.O. Giovanni Grimani of the Servi, patrician of Venice."

emergence onto the market around 1735–40 prompt the older Piazzetta to shift to a larger format than he had previously used and to devise a less anecdotal and more inventive poetic image of peasants and country folk? If so, then Longhi affected Venetian painting in ways that have been only partially understood.

The directness of Longhi's scenes of peasant folk contrasts with the subtlety of his depictions of patricians. In *The Concert*, of 1741, six men amuse themselves in a salon decorated with sumptuous fabrics and an ornate chandelier (see p. 686). A partially visible portrait of a procurator of S. Marco hangs on the wall. Wearing an informal bonnet and *robe de chambre*, the palace's owner participates in a string trio, an impromptu performance which is probably part of a hastily assembled divertissement. Three astutely depicted churchmen, differentiated by age, rank, and—does one credit Longhi with too much?—intelligence, play a game of cards. Are the six men alone? Do the musicians fiddle just for themselves? The light streaming in from the right and the visually fragmented portrait impel us to suppose that the room extends beyond the picture frame, and the pup and the delicate white material on the stool imply the presence of a woman. Is the mistress of the palace on the right and enjoying the music-making with some friends? If so, then they, like us, are delighting in the pleasures of her patrician salon. Candid and unpretentious, such a simply annotated painting of social exposition had never before appeared in Venetian art.

Longhi's style did not change during the half-century he painted, but his investigation of Venetian life and social mores considerably increased in scope. Beyond rustic amusements and aristocratic pleasures, he depicted carnival games and escapades, group portraits, hunting excursions, and scenes of both aristocratic love and religious devotion. His range is impressive. Some of his most colorful works are *mascherate*, or scenes of Venice during carnival, the period preceding Lent. One charming work, *The Ridotto*, is also an incisive statement on the decorum of the holiday season. A man wearing the white *larva* [mask] and black *bautta* [domino] of carnival courts a sumptuously gowned lady who, having removed her own mask, lets drop her guard and consents to her partner's attentions. Is their flirtation only a game? The dog, a traditional reference to fidelity, implies by its sleeping state that their liaison goes beyond the bounds of propriety. Longhi contrasts the pair with another couple visible in the doorway who set foot into the room. The card game on the right makes a still more penetrating and biting comment on the protagonists, for the banker holding the heavy

Although neither *La polenta* nor *The Fortune-Teller* tells a story, action dominates each painting. Longhi's work delights and titillates, in part because the incident he portrays is so easily understood. Piazzetta's is not; indeed the scene has been very differently elucidated over the last half century. The size of *The Fortune-Teller* is unusual in the history of the Italian genre tradition. None of the gestures or the iconographic symbols is open to certain interpretation, the relationships of the protagonists are ambiguous, and the setting lacks precision. This very lack of explicitness is critical, for in marked contrast to Longhi's unabashed sexual allusions, Piazzetta's genre paintings tease viewers. Another point must be raised vis-à-vis the two artists: did Longhi's successful

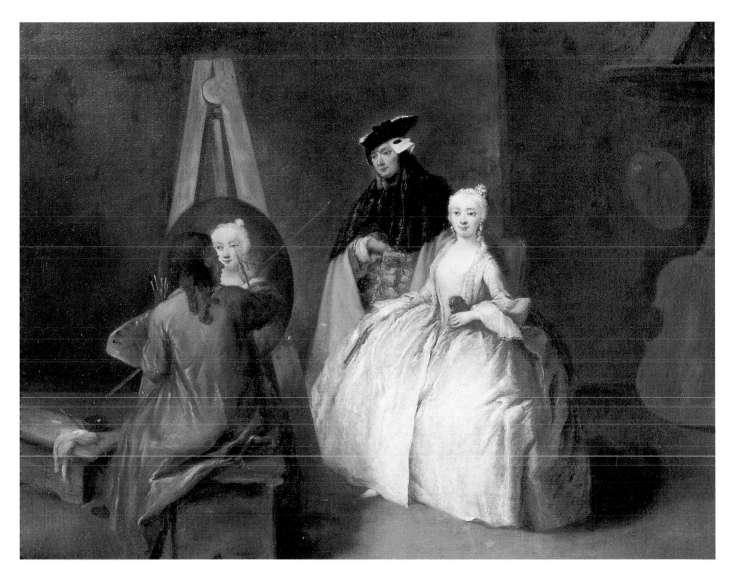

bag of money hints that the stakes are high. Two *popolane* [lower-class women] in brightly colored gowns embellish the scene while they survey both us and their patrician betters through a *moretta* [carnival mask].

Pietro Longhi and Aristocratic Portraits

Besides depicting the pleasures of Venice's ruling class, Longhi portrayed the patricians themselves, not in bust-length portraits devoid of settings like those of Carriera, but in full-length poses within the interiors of noble palaces. His *Sagredo Family* depicts Cecilia Grimani Sagredo, her two daughters

and three grandchildren, and a manservant. Cecilia sits on the left wearing a gown of a beautifully burnished gold color; Caterina Barbarigo, her firstborn, is on the right near her own two daughters; Marina Pisani, Cecilia's second child, is in the middle of the group directly behind her son. This formal portrait was only one of a number of assignments Longhi discharged for the Sagredo, a family whose history in the city could be traced back to the ninth century. He had earlier frescoed the *Fall of the Giants* over the family's newly redesigned staircase for Gherardo Sagredo, Cecilia's husband and heir to the most celebrated art collection in early eighteenth-century Venice. Cecilia patronized Longhi several more times after her husband's death in 1738: she commissioned

The Artist's Studio, Pietro Longhi, 1740–45. Ca' Rezzonico, formerly Teodoro Correr collection.

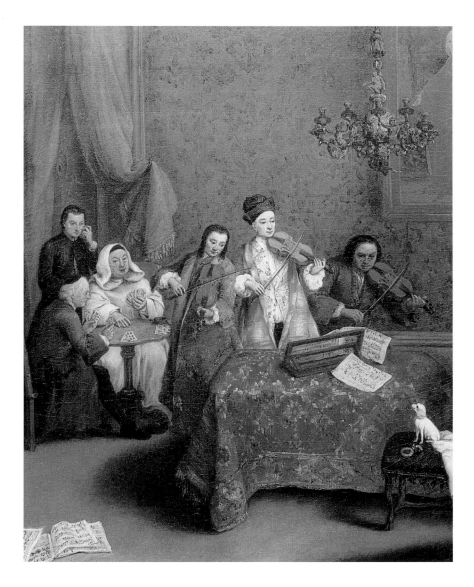

cycle, convey the essence of the artist's appeal to patricians: small gestures, prosaic items, impersonal glances, and the judicious use of light call attention to their values. In the *Sagredo Family* the Pisani boy carries a sword which, tiny as it is, it proclaims his standing as the future head of the Pisani household. Marina's gesture toward her son embodies her maternal pride. The little girls, in contrast, lack externally defining objects, and Caterina is totally without movement. A plainly dressed servant ready to serve coffee stands behind the family, the only figure in the painting to do something useful.

Longhi similarly distinguishes between social classes in the *Arrival of the Lord*, in which light insulates Gregorio from his subordinates just as Cecilia and her heirs are separated from their servant. Gregorio's authority is seen in the peasants' actions, bending or doffing a hat or simply toiling. But although Longhi grants his patrons courtly precedence, he betrays it with accompanying hints of skepticism: the Sagredo servant minds his place as he gingerly steps into Cecilia's presence, but his slightly unsure glance contrasts with the bearing and aristocratic poise of the three noblewomen. Likewise, the subservient looks, attitudes, and deportment of the four peasants welcoming Gregorio to his hunting lodge displace his haughty air of command. Do Gregorio's privileges unfairly yoke these men into subservience? Does the aloofness of the elite depend generally on the subjugation of their followers? Longhi's Venetian theater of patricians and underlings is a far cry from the rumbling world Beaumarchais would soon introduce to Paris in the *Barber of Seville* and the *Marriage of Figaro*. His humble brush plainly proposed, nonetheless, that Gregorio Barbarigo and Cecilia Sagredo, like the Count and Countess Almaviva in Spain, depended on the efficiency of servants like Figaro and Susanna to regulate their daily lives.

Longhi's vision of peasant and patrician life in Venice encourages a comparison with Carlo Goldoni's contemporary comedies for the stage, especially since the playwright himself recognized a link. Both artists looked through the same lens of reality, but a chasm separates the writer's fully realized characters from the painter's more anecdotal figures. Associations have been drawn, too, between Longhi and Chardin in France and Hogarth in England. Longhi's reliance on partially visible objects to suggest, as in *The Concert*, a world beyond the canvas is close to Chardin's ability to suggest human presence and space outside the painted scene. And Longhi's practice of making series like the hunting scenes for Gregorio Barbarigo is akin to Hogarth's cycles such as his "progresses." But

The Concert, Pietro Longhi, signed and dated 1741. Venice, Gallerie dell'Accademia, formerly Contarini collection. The painting, which demonstrates the scrupulous attention to detail typical of the artist as well as his taste for lively chromatism, shows the almost improvised amusement of the nobles in a salon decorated with sumptuous fabrics and an elaborate chandelier.

an altar painting from him and charged him to draw up an inventory of the family art collection with estimates of values. Her daughters and their husbands employed Longhi, too. Around 1740 he portrayed Caterina Barbarigo and Marina Pisani in *The Sagredo Sisters* (London, National Gallery), and he painted the famous *Elephant* (Vicenza, Banco Ambrosiano Veneto) for Marina alone. Marina's son, Almorò, frequented Longhi's academy of art in Palazzo Pisani, and in the 1760s the artist executed a series of hunting scenes (Venice, Galleria Querini Stampalia) for Caterina's husband, Gregorio Barbarigo.

Cecilia's *Sagredo Family* and Gregorio's *Arrival of the Lord*, the opening "bugle call" of that hunting

despite these parallels, noteworthy distinctions abound. The most prominent is the way in which Longhi's figures play before the viewer. They pose for us. Their world is a parade ground, and they want to be admired against it. Chardin instead fully dramatizes his scenes, locking his figures psychologically into their environment, while Hogarth engages his protagonists in dramatic performances. Furthermore, both Chardin and Hogarth were more accomplished than Longhi. Their figures are better drawn than his, and their brushwork oozes a creamy richness lacking in his. It must be said, however, that few painters delight, charm, and intrigue the modern audience as does the Venetian.

View Painting

By the time the Settecento reached its midpoint, the new genres were firmly established on the art market in Venice. Simultaneously, the tradition of history painting receded. After Piazzetta's death in 1754 and Tiepolo's departure for Spain in 1762, no great altarpiece or monumental decorative cycle of first quality was again produced. The taste of the buying public was changing, and so perhaps were the painters' own predilections. For even as the family workshop persisted as the basis for artistic production, its focus altered. While the successors of Tintoretto and Veronese had followed in the footsteps of their elders, now the junior members of thriving workshops like those of the Guardi and Tiepolo families willingly took up the minor genres once they reached adulthood. History painting was moribund by 1760, whereas view painting and genre thrived in the city until Napoleon toppled the State in 1797.

Michele Marieschi

Views were the most popular of all the new subjects. Following Carlevarijs's debut and Canaletto's early success, Michele Marieschi started to win recognition, but his career lasted only from about 1735 until his death eight years later. Although his early training is unknown, his personal association with Gaspare Diziani may point to an apprenticeship with that artist. Like Canaletto, Marieschi began as a set-designer, and traces of that experience are to be found in his designs of 1735 for the funeral in Fano of Maria Clementina Sobieski, Queen of Poland. He was inscribed in the Venetian *fraglia* [painters' gild] in 1736, and then, like Piazzetta and Giannantonio Guardi, worked for Marshall von der Schulenburg. In 1741, five years after Canaletto and Visentini's album appeared, Marieschi published twenty-one etchings of city views under the title

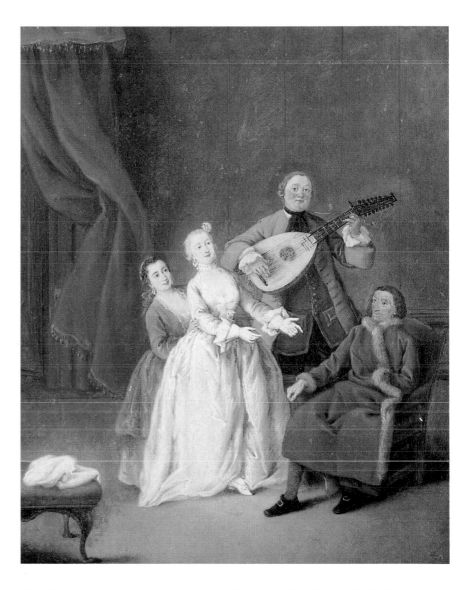

Magnificentiores selectioresque urbis venetiarum prospectus [The finest and most select views of the city of Venice].

Despite the contemporaneity of their two careers, Marieschi and Canaletto painted very differently from one another. While the latter's brushwork is thick, Marieschi applied paint loosely and in a more liquid fashion. He appropriated, however, many of the viewpoints Canaletto had devised. An excellent example of this is seen by comparing Marieschi's *Grand Canal at the Entrance into Cannaregio* with a similar view by Canaletto of the early 1730s. The two scenes both focus on the impressive bell tower of the church of S. Geremia and the adjacent Palazzo Labia, but whereas Canaletto situated the viewer directly

A Little Concert en Famille, Pietro Longhi, c. 1752. Ca' Rezzonico, formerly Venice, Morosini collection. The pleasant and aristocratic pastime of a family group is represented here in a genuine and spontaneous manner.

ON THE FOLLOWING PAGES:
Capriccio with Gothic Architecture and Obelisk, Michele Marieschi. Venice, Gallerie dell'Accademia. In this composition, which was repeated several times by the artist, an imaginary obelisk rises in front of a Gothic building—the Palazzo Ducale still under construction—against the background of a landscape evoked by loose brush strokes.

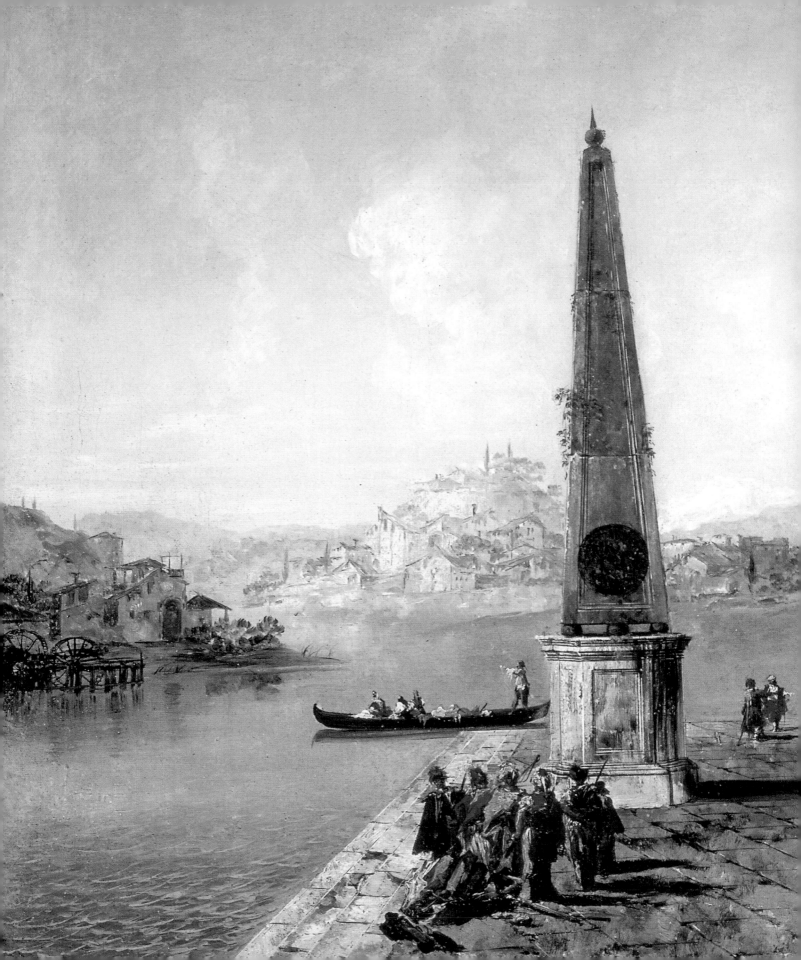

Rape of Europa, Francesco Zuccarelli. Venice, Gallerie dell'Accademia. Painted for the Pisani family who still owned it at the end of the 18th century in their villa at Strà. The abduction is represented in an idyllic setting, enhanced by the green of the lawns and the blue of the water, in the typical tonalities of Zuccarelli.

across from the Ponte delle Guglie, regularizing Venice's urban fabric so that the two canals appear to intersect at a regular ninety-degree angle, Marieschi located the viewer opposite the sharp corner where the two embankments cut into each other. As a result, the city appears to flare outward, eccentrically flying off in opposing directions. Every boat, roofline, and window molding furthers this perspectival stretch. Marieschi's buildings are smaller than Canaletto's in relation to the size of their canvases, and sky and water occupy more of his composition.

Marieschi adapted his unorthodox conception of reality to excellent advantage in his charming capriccios, the fanciful views popular in Venetian eighteenth-century art. Both Carlevarijs and Ricci had already painted a number of works in which real and unreal monuments are unexpectedly grouped with buildings and ruins of classical, medieval, or Renaissance design. Canaletto, too, had produced his own imaginary views. Marieschi built on these prototypes, for example in a pair of pendants in which he juxtaposed ruined structures in landscape and urban settings. A ruined classical arch serving as an entrance to an island goat-pen in one work is set against a fantastic obelisk before partially built portions of the Palazzo Ducale in the other painting (see pp. 688–689). Curving tree trunks contrast with straight architectural lines, and weary goatherds rest while turbaned Orientals chat. A body of water recalling the Venetian lagoon separates the sharply foreshortened foreground in each scene from a distant shoreline, where a quaint arrangement of rustic houses catches the sunlight. In arranging possible realities and frivolous fancies into scenic confections, Marieschi offered a pleasing pictorial alternative to the harsh reality of city existence.

Francesco Zuccarelli and Giuseppe Zais

Francesco Zuccarelli and Giuseppe Zais, contemporaries of Marieschi, painted landscapes equivalent to his more urbanized capriccios. Neither of the two painters was Venetian by birth (Zuccarelli was Tuscan, and Zais was born in Belluno), but each built a successful career in Venice after the deaths of Ricci and Marieschi and during the ten years or so that Canaletto worked in England (1746–61). Benefiting from the partial vacuum in the local production of landscapes and imaginary views, Zuccarelli enjoyed the patronage of Schulenburg and Smith, while Zais eventually profited from the favors of the prestigious Pisani family who offered him work in their villa at Strà. Beginning around mid-century, the two depicted diminutive figures frolicking amidst classical monuments, aristocrats playing fashionable garden games, well-dressed peasants assuming elegant poses, laun-dresses willingly doing the wash, and cowherds and shepherdesses grazing their animals while enjoying the fresh air in cheery countrysides (see pp. 690–694).

Antonio Canaletto and Bernardo Bellotto: Landscapes and Capriccios

Besides accommodating Marieschi's brief career and the appearance of Zuccarelli and Zais, the early 1740s in Venice witnessed Canaletto's exploration of landscape painting and his return to the production of capriccios. Several circumstances explain the enlargement of his pictorial repertory. The War of the Austrian Succession, which broke out in 1740, made continental tourism so dangerous for a while that Canaletto's English clientele, the source of his profits,

Bacchanal, Francesco Zuccarelli. Venice, Gallerie dell'Accademia. As in the preceding work, the myth taken from the repertory of classical antiquity is treated in an idyllic and delicate spirit, almost like a country feast.

Landscape with River, Bridge, and Herds, Giuseppe Zais. Venice, Gallerie dell'Accademia. This type of genre piece was very much in fashion in Venice. Here the shepherds and herdsmen are taking cattle and sheep to pasture while they enjoy the country air.

began to disappear, while Marieschi's achievements possibly threatened his economic security. Perhaps he felt challenged, too, by the artistic debut of the young Bernardo Bellotto, his sister's son. Their work around 1740 suggests that uncle and nephew made excursions together into the countryside near Padua and along the Brenta canal, the younger man picking up tips from his uncle and Canaletto himself learning new ways of composing views and capriccios. An excellent example of Canaletto's mature style is the *Caprice View of an Island, with a Pavilion and a Church* (St. Louis Art Museum). Several monuments, including a city gateway similar to several in Padua, define a zigzagging line wending its way through a convincingly conceived space lit by a credible warm afternoon sun. Little *macchiette* of workaday men, women, and children suggest an actual place, promoting the authenticity of the scene. Although it has sometimes been attributed to the young Bellotto because of its brushwork, the painting mirrors a sophisticated conception of pictorial invention that must speak the mind of a mature painter, not of a beginner. The work nonetheless pinpoints how the two artists' styles overlapped around 1740.

Despite Bellotto's youth, his native talent and excellent training produced wonderful views of both city and countryside in the early 1740s. *Rio dei Mendicanti and the Scuola di S. Marco* (see pp. 694–695) and the landscape view of the countryside at Gazzada, near Varese, identify both his early and fruitful apprenticeship under Canaletto and his striving for artistic independence. The dark and angular shadows hitting bright surfaces and the meticulously rendered detail—the stonework along the embankment in the first view and the cottage in the foreground of the second—testify to Bellotto's eagerness to intensify his uncle's style. His individuality emerges in the broad circular sweep of the Gazzada landscape, in its cold palette, and in its stiff, overly large figures.

Still young in the 1740s, Bellotto was possibly anxious for adventure. He traveled west to Turin and Milan and south to Florence, Lucca, and Rome, painting views and capriccios based on the buildings in those cities. This expedition influenced Canaletto, for it was the nephew's sojourn in Rome that likely stimulated the older artist to portray that city's ancient sites. Between 1743 and 1745, just before their careers drew them apart forever, each produced a number of capriccios whose appeal is based on fanciful juxtapositions of known buildings and imaginary monuments. Working exclusively for Smith, who became Britain's consul in Venice in 1744, Canaletto painted thirteen overdoors destined for the Englishman's palace on the Grand Canal. Some of the paintings were conceived in tribute to Andrea Palladio. The most remarkable is the

The Swing, Giuseppe Zais.
Venice, Gallerie
dell'Accademia. The
delightful scene belongs to
a series of four that portray
scenes of aristocratic life
in a villa.

Rio dei Mendicanti and the Scuola di S. Marco, Bernardo Bellotto, c. 1740. The view of Venice is remarkable for its meticulous detail and brooding shadows, influenced by the artist's famous uncle, Antonio Canaletto.

Capriccio of a Palladian Design for the Rialto Bridge in which Palladio's abortive project for the sole bridge to span the Grand Canal until the nineteenth century commandingly assumes center stage. Substituting the scheme represented in Palladio's *Quattro libri dell'architettura* of 1570 for Antonio da Ponte's prosaic structure begun in 1588 and still standing today, Canaletto pictorially ennobled Venice's hurly-burly commercial center with a massive Roman

world] in his *Roman Caprice with the Capitoline Hill* in which the modern Christian city proudly confronts the pagan and ruined capital of antiquity. Peasants and beggars defining the foreground contrast with elegantly dressed figures climbing toward Michelangelo's Renaissance complex, while a mix of classes ascends the staircase on the far left to reach the church of S. Maria in Aracoeli. The medieval church, the two Capitoline palaces, and a group of simple dwellings

Washerwomen, Antonio Visentini. Palazzo Contarini-Fasan, 1739–40. The work belongs to a cycle of eight large perspective views that derive from sketches of theatrical stage design. The series is striking for its architectural complexity, which provides an extraordinary background to ordinary daily life and amusement.

portico and a pair of *tempietti* [small temples], one at either end. The painting exalts Palladio's severely geometrical shapes by crisply defining the brightly lit forms in relation to Venice's clear blue sky, but setting them against the dark canal below.

Bellotto, like his uncle, also drew on urban designs for imaginary views, reordering Rome and Padua in surprising ways. Whereas Canaletto honored Venetian tradition in his overdoors for Smith, Bellotto upheld Rome's self-affirmation as *caput mundi* [capital of the

triumph in sunlight beyond the dark archway. Bellotto replaced the statue of Marcus Aurelius and his steed, the rightful guardians of the Capitoline, with one of the ancient sculpted Dioscuri (Castor or Pollux) and his horse, in reality found on the Quirinal hill. The young painter humorously recreated the emperor at the bottom of the ramp, transforming him however into a visitor from eastern Europe. Recalling actual monuments and historical designs but placing them in unexpected and even disconcerting arrangements,

Bellotto startles viewers with a new reality. The tension between persuasive reality and fanciful invention was a novel and brilliant idea in the genre of capriccios. Issuing from the Canaletto-Bellotto alliance, the *veduta ideata* [imaginary view] can be defined as an apparently real view of an imaginary world.

Notwithstanding the supportive patronage of consul Smith, uncle and nephew each left Venice to seek lucrative commissions elsewhere, Canaletto

Canaletto in London

While working abroad Canaletto produced spectacular panoramic views of London and the English countryside as well as unusual capriccios and *vedute ideate*. His arrangements of material reality during this mature period are perhaps even more sophisticated and satisfying than those of his youth. The view of *Greenwich Hospital from the North Bank of the Thames River* indicates his ability to

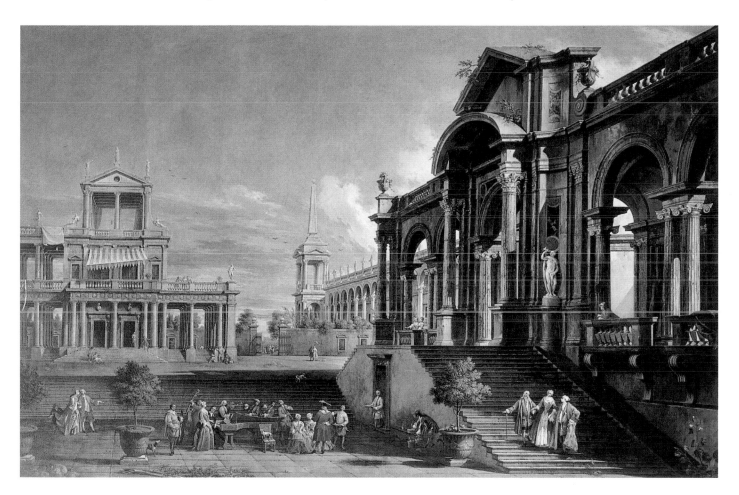

departing for London in 1746 and Bellotto for Dresden in 1747. The older painter worked successfully in England until 1755, probably going home for a brief visit in 1752–53. The younger man, in contrast, spent the rest of his life in east-central Europe, working in Dresden until 1758, when he went to Vienna, where he was employed at the court of Empress Maria Theresa. In 1761 he returned to Dresden and briefly visited Munich; he then lived and worked in Warsaw from 1766 until his death in 1780.

picture the broad horizons and pale light of England. The composition masterfully juxtaposes the broad expanse of the river against the deep recession of the building complex beyond. The brightly lit facades of the royal hospital proclaim Britain's maritime power and suggest the nation's capacity to care for its wounded. Small figures depicted in deep red enliven the dull blue of the Thames, which the artist contrasted with the paler shades of the sky. The landscape on the horizon repeats the green of the

Concert in a Villa, Antonio Visentini. Palazzo Contarini-Fasan. A complicated exercise in architectural perspective provides a setting for musical entertainment, one of the most pleasant pastimes of the aristocracy of the period. On the following pages: detail.

foreground embankment but in a lighter tone. Though Canaletto's tight application of paint, visible in short and sharp curlicues or twirls of brushwork, may be less pictorially seductive than his earlier, more richly laden application of oils, the work demonstrates his sure technical control even in old age and reaffirms his evidently passionate commitment to record the details of day-to-day existence.

Capriccio of a Colonnade and the Courtyard of a Palace as his reception piece in 1765 (see p. 675). The scene offers the same mix of finely dressed patricians and humble citizens as his actual views and evokes Venetian daily life, the more so since the architecture recalls an actual site, the courtyard of the Ca' d'Oro. Hanging lanterns, massive drapery, a ponderous coat of arms, a lavish urn, and an elegant wellhead further the impression of reality.

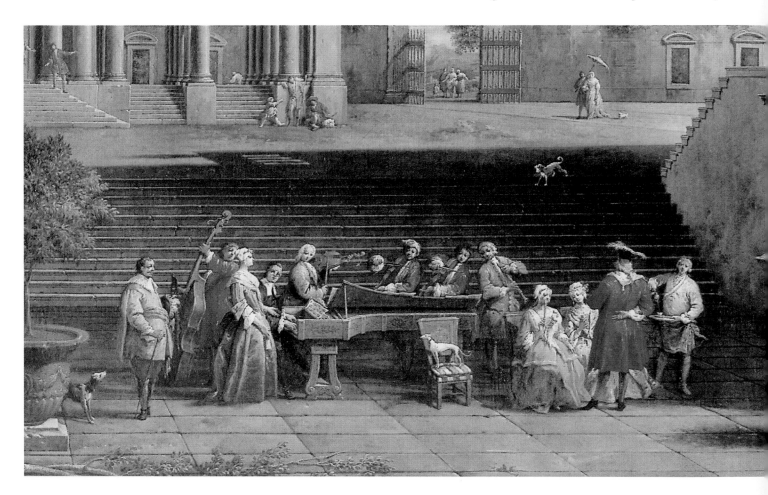

Upon his return to Venice, Canaletto was admitted into the Academy of Painting and Sculpture in 1763. Piazzetta and Tiepolo had been the first presidents, and although they were both dead by that date, Canaletto must have been proud of his membership of the official body. Besides acknowledging his own achievements, it also distinguished architectural painting among the hierarchy of pictorial categories deserving public recognition, a not unimportant event in the history of art. He submitted the

Thus Canaletto concluded his career with a painting that charmingly grafted the unfamiliar onto the everyday. Nine years after his death in 1768, this work was exhibited in Piazza S. Marco, and Josef Wagner produced an engraving after it in 1779. The uncanny fusion of reality and fancy that distinguishes Canaletto's best imaginary views still pleased the public.

Bernardo Bellotto in Germany, Austria, and Poland

Bellotto's almost forty-year career in Germany, Austria, and Poland rightly belongs to the history of those Northern centers, but his achievements cannot be severed from a narrative of the school that trained him. Upon reaching Dresden, he set to work for Augustus III, king of Poland, Elector of Saxony, and

of the scene, just to the left of center, is the Hofkirche designed by Gaetano Chiaveri, a Roman architect who had previously worked for Peter the Great and Catherine the Great in St. Petersburg, and who had been commissioned in 1738 to build a new Roman Catholic church in Dresden for the Polish king. This view also recalls the man behind Bellotto's invitation to work in Germany, for on the far left can be seen a complex of sunlit buildings belonging to Count

a devoted patron of the arts. One of Bellotto's first undertakings was the *View of Dresden from the Right Bank of the Elbe River with the Frauenkirche and Hofkirche*, a painting that points to the rich cultural milieu that Bellotto found in Saxony. The view itself was taken from the home of Felicita Sartori, a portraitist who had studied with Rosalba Carriera in Venice and who had been residing in Dresden since 1741, when she married one of Augustus's councillors. Defining the middle ground

Heinrich von Brühl, director of the royal art collections and Augustus's first minister from 1746. It was Brühl's decision to attract Italian painters to the Saxon court that had originally brought Bellotto to Dresden.

The *View of Dresden* is characteristic of the splendid quality and solid craftsmanship distinguishing Bellotto's art throughout the almost twenty-year period (1747–66) of his German and Viennese residencies. Using sharply drawn lines,

alternating areas of light and dark, figural silhouettes, and sunlit reflections in the water, he constructed a convincing spatial recession from the lower left-hand corner of the painting to just below the central horizontal axis of the canvas at its far right side. He then redirected the viewer's attention back to the left, to Dresden's old city, over the contrasting bright and dark arches and piers

The artist's residence coincided with the cultural renaissance Poland was enjoying under Stanislaus's enlightened policies. In capturing life along the Vistula river and in Warsaw, Bellotto intensified the sharp contrasts between deep shadow and bright sunlight that had characterized his earlier work. He devoted much of his time, too, to architectural capriccios, offering his new patrons his artful

The Ridotto, Francesco Guardi. Ca' Rezzonico. Inspired by the work of the same period by Pietro Longhi, the painting is set in the great hall of the Ridotto in Palazzo Dandolo at S. Moisè.

supporting the Augustusbrücke and toward the Hofkirche. Like his uncle, Bellotto conveyed the political and civic connotations that buildings enjoyed in cities: just as the bell tower of S. Marco heralds Venice's historical independence in Canaletto's *Bucintoro Returning to the Molo on Ascension Day*, so the strategically positioned Hofkirche here proclaims Augustus's recent conversion from the Protestantism of his Wettin ancestors to the Roman Catholicism of his new subjects to the east.

In late 1766 Bellotto journeyed to Warsaw. He had hoped eventually to reach St. Petersburg and work for Empress Catherine II but he stayed permanently in Warsaw at the urging of the recently crowned king, Stanislaus II Augustus Poniatowski.

command of perspective and the same mixture of reality and fantasy he had been practicing for more than two decades. His *Imaginary View with Self-Portrait*, the first version of which he had painted in Dresden, demonstrates these well-honed skills. Bellotto wears the robes of a Venetian procurator—a liberty of dress he could hardly have allowed himself in Venice—and assumes the formal pose of official portraits of the period. Attended by a pair of servants or bureaucrats, the well-fed artist stands in a luminous space within a portico beyond which a monumental triumphal arch enframes a fantastic view of Jacopo Sansovino's Libreria. A reference to Horace's *Ars Poetica* appears on a poster attached to a nearby monumental column.

Perspective Painting: Antonio Visentini, Francesco Battaglioli, Girolamo Mengozzi-Colonna, and Giambattista Piranesi

Having already lost Carlevarijs in 1730 and Marieschi in 1743, *vedutismo* was mortally wounded when Canaletto and Bellotto withdrew from the city in 1746–47. By 1750 the tradition was at an impasse. This grave situation can also be ascribed to the genre's lack of a theoretical artistic foundation. Based on quotidian reality, view painting could not claim a conceptual or intellectual base. It reached a nadir in its fortunes at the very moment the pictorial establishment of Venice founded an academy in the city. Canaletto's submission to the academy of the *Capriccio of a Colonnade and the Courtyard of a Palace*, an exercise in Albertian perspective with an overlay of architectural sophistication, demonstrates that theory and technical expertise were seen as the primary bases for artistic creation by academic painters (see p. 675). In presenting the work, Canaletto essentially concurred with his colleagues that perspectival studies were worthy of formal recognition.

Well-honed skills in perspective had constituted the foundations of Canaletto's and Marieschi's careers as scenographers and of Carlevarijs's as a mathematician, and they eventually made possible their achievements as view painters. Just after mid-century, perspective painting became an autonomous form of pictorial expression and soon constituted the basis for an independent field of artistic endeavor in the Venetian academy itself. Antonio Visentini and Francesco Battaglioli taught perspective as a subject in the academy and painted perspective views of impressive architectural complexes enlivened with stories from classical drama or imaginary vistas like Visentini's charming scene of designers concentrating on their professional endeavors (see pp. 696–699). Such exercises in spatial illusionism were not contrived only by academicians. The Ferrarese Girolamo Mengozzi-Colonna, a specialist in *quadratura* [perspective painting], constructed the dizzying spatial surrounds for Tiepolo's *Transportation of the Holy House* on the ceiling of the church of the Scalzi and the brilliant *trompe l'oeil* scenography for the Antony and Cleopatra decorations in the *salone* of Palazzo Labia, both fresco projects of the 1740s. By dramatically enframing Christian legend in the first project and ancient history in the second, Mengozzi-Colonna's work illustrates the advantages of perspective beyond the specialized category of architectural painting.

Giambattista Piranesi, from the Venetian mainland, used his training in perspective to produce prints and drawings of complex ensembles of real or imaginary buildings that recreate the splendor of urban grandeur. Working almost his entire adult life in Rome, he conceived of architectural space as a way to evoke powerful emotional responses.

Francesco Guardi

The absence of Canaletto and Bellotto from Venice around 1750 may explain the decision by Francesco Guardi to begin painting cityscapes shortly thereafter. Francesco had been trained by his older brother Giannantonio, who enjoyed a successful career copying famous works by other artists as well as producing independent altarpieces for provincial churches. Until his brother's death in 1761, Francesco painted cabinet pictures, some religious in theme and others of genre subjects (see pp. 700, 702–703). He played a subordinate role in the family studio, but the year Giannantonio died, Francesco's name was inscribed on the lists of the *fraglia*. Guardi began reproducing the same sites that his senior colleague had represented for over thirty years. Unexpectedly, however, he portrayed them not in Canaletto's mature style but in his youthful and dramatic manner. Guardi painted *Piazza S. Marco Looking Toward the Basilica* around 1760, that is, some time after he began to produce views. This work captures his early dependence upon Canaletto's vision, but it also demonstrates his own search for a personal idiom. Guardi repeated the same vista that the older painter had represented several times, offering a similarly bright and cloud-filled sky and using an almost identical disposition of light and dark, but he intensified the shadows so that they are close in type to those of Canaletto's earliest canvases. Guardi's application of paint, however, is looser, draperies are more broken in outline, shadows less consistently contoured, and building surfaces more blemished.

The contrasts between the two artists' views of the piazza are such that viewers might mistakenly assume that the city around 1760 was less physically sturdy than the city a generation earlier. But Venice's reality appears in neither the cityscapes of Guardi nor those of Canaletto, just as the Roman countryside cannot be objectively grasped through the landscapes of Claude Lorrain or Nicolas Poussin. Nonetheless, Guardi's apparently less impersonal hold on visual facts dissociates his views from Canaletto's crisper focus on daily life. Indeed, a work like the *Basin of S. Marco and S. Giorgio Maggiore* is captivating for its very avoidance of solid existence: Palladio's church and its monastery appear to float

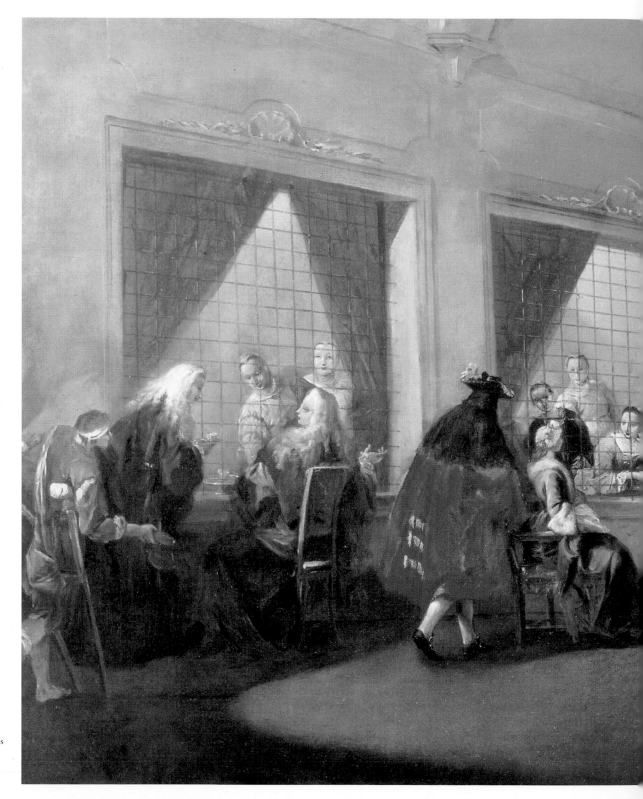

The Parlor, Francesco Guardi. Ca' Rezzonico. This amusing genre scene is set in the nuns' parlor of S. Zaccaria.

ON THE FOLLOWING PAGES:
Doge on the Bucintoro at S. Nicolò del Lido, Francesco Guardi. Paris, Louvre. The painting belongs to the series of 12 canvases depicting ducal ceremonies painted in honour of Doge Alvise IV Mocenigo.

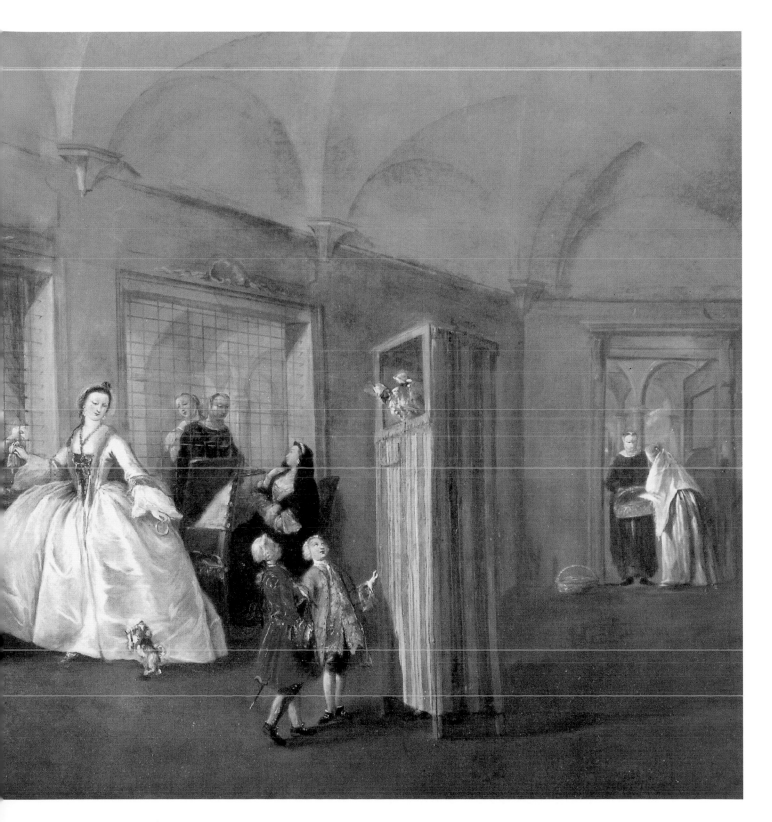

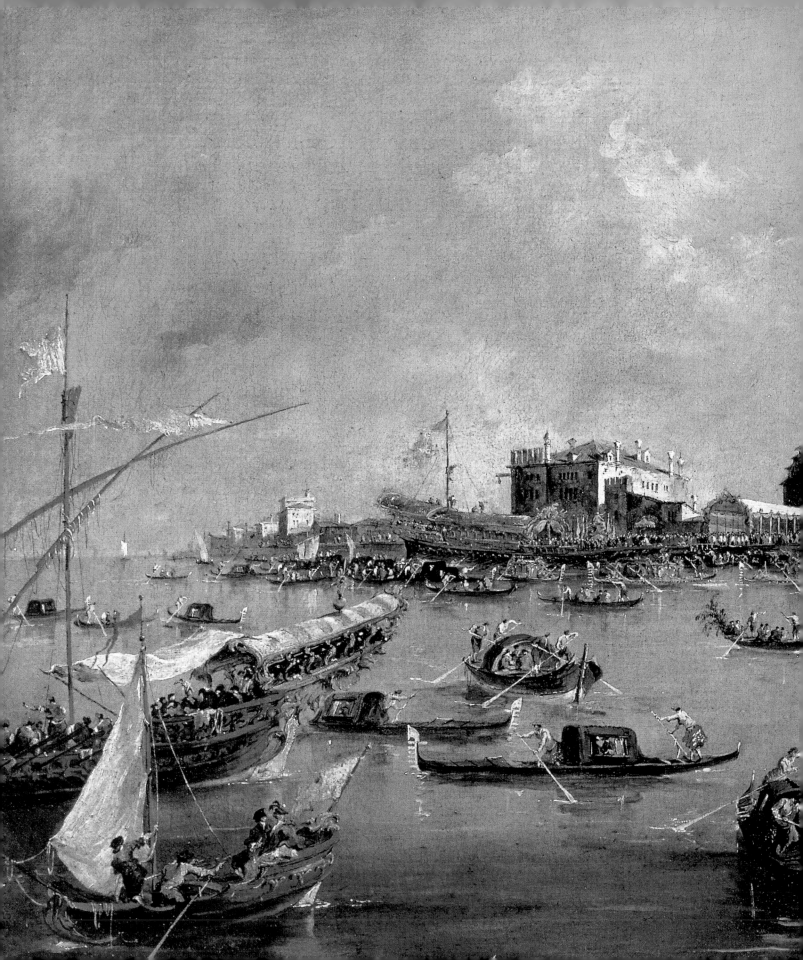

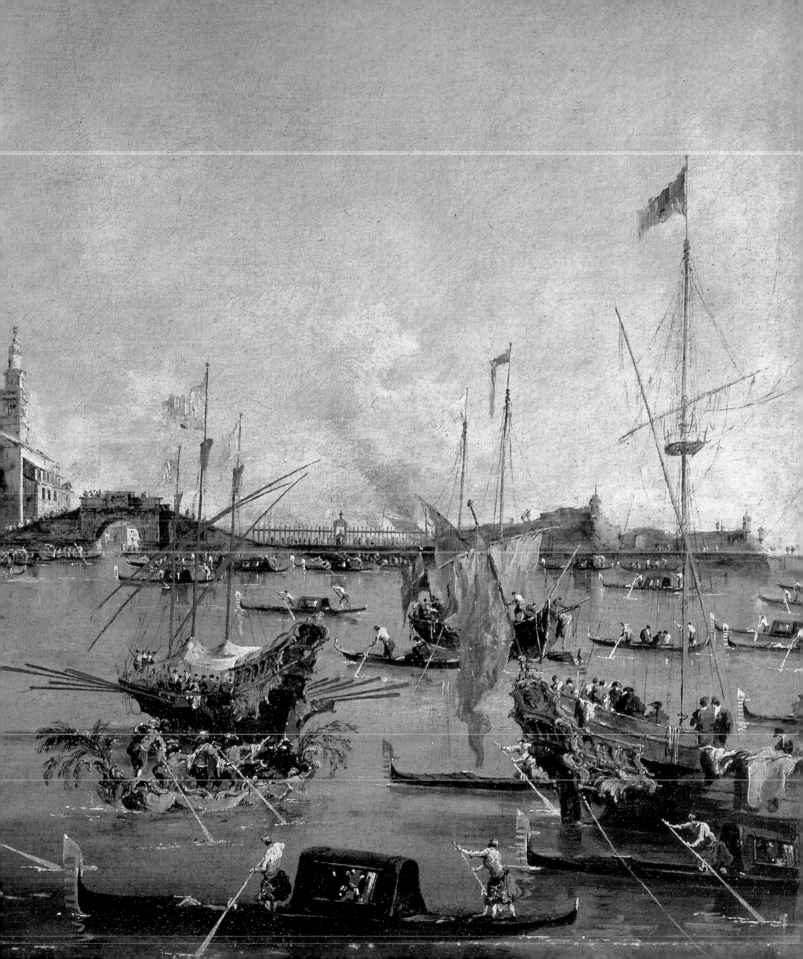

like boats on water, and little *macchiette* dart fleetingly through contrasting pockets of light and shadow that seem to have been smudged onto the canvas surface. The oblique sail in the right foreground is more substantial than the shadowy bell tower in the left distance, and sky and water lose their individuality through a fusion of blue tones.

Fire at S. Marcuola is quite a different work from the *Basin of S. Marco*, for in contrast to the ordinariness of daily activity in the latter work, Guardi captured in the former the terror of an actual fire of 27 November 1789. Tiny figures atop burning buildings desperately seek to quench flames that rage furiously out of control, while a crowd of helpless Venetians witnesses the destruction of their homes. The uniqueness of this frightening urban experience contrasts with the entire view-painting tradition that preceded it, for Guardi's scene disavows the urban tranquillity that Carlevarijs, Marieschi, and Canaletto neatly realized in their conceptions.

Guardi came into his own after the deaths of his older brother and Canaletto, when he was well into his mid-fifties. He subsequently worked for a number of prosperous Venetians and produced for the State three series of government festivities: the *Ducal Ceremonies*, twelve canvases based upon either drawings by or prints after Canaletto (see pp. 704–705); six paintings recording the celebrations held in 1782 for the future Tsar Paul I of Russia and his wife Maria Teodorowna; and four works commemorating Pope Pius VI's visit to Venice in that same year. Despite the negligible position in European affairs of Venice at mid-century and later, the weakened economy, and the decline of the patriciate, these almost two dozen paintings— comprising nearly equal numbers of exterior and interior views—convincingly depict a happy and prosperous city. Typical is Guardi's captivating account of the extravagant concert Venice offered the Russian tsarevitch and his consort who were traveling incognito as the "count and countess of the north." Surely inspired that January evening by the candlelight reflected in the mirrors and the silver chandeliers of the Casino dei Filarmonici, the shimmering silks and satins of the noblewomen, the bright collars of the eighty-two female musicians (the *figlie del coro* from the city's four *ospedali*), even the sparkling gold-trimmed covers of the librettos given to members of the audience, the painter interpreted the splendid gathering as a moment of ephemeral beauty.

Beyond the sumptuous entertainments of the privileged, Guardi also found poetry in the labors of the poor. Inaugurating a totally new type of imaginary view, he painted seaside landscapes in which rustic dwellings stand next to Roman ruins

and in which the desolation of decaying grandeur overwhelms the quiet lives of anonymous workers intent upon their modest tasks. A few of these canvases, such as the three that formerly decorated a room in the castle of Colloredo near Udine (New York, Metropolitan Museum of Art), are grand in scale, but most are small and jewel-like in their delicacy and refinement. In *Lagunar Caprice*, figures travel across open stretches of land and bend over their work. Paradoxically they move with dancelike rhythms that belie their dreary reality. It is difficult today not to read into Guardi's grandiose but crumbling structure a metaphor for the Republic's own degeneration but it is more likely that these tiny scenes of imaginary sites were, for the artist, probably considered as pictorial foils to his panoramic scenes of reality. The viewer is still left wondering about the many faceless *macchiette* in the capriccios, tiny figures depicted as lonely shapes in forsaken corners of the world. Despite the official commissions he enjoyed late in his career, Guardi's vision was that of an outsider.

Aristocratic Portraiture

The anonymous Venetian laborers who enliven Guardi's late works stand at the opposite end of the social scale from the patricians limned in establishment portraiture in the paintings of Nicolò Cassana, Pietro Uberti, Giuseppe Nogari, and Bartolomeo Nazari, and his son Nazario Nazari, all of whom continued the old formulas of earlier painters like Bombelli. Typical is Uberti's *Portrait of Gherardo Sagredo*, dating from after 1718, when Sagredo was named procurator of S. Marco. The distinguished patron and collector, posed against a setting that refers to his cultural distinction, wears the robes of office and a fashionable peruke. Whatever polish such a formal image may display, its inadequacies are more than apparent when compared to Tiepolo's *Portrait of Daniele IV Dolfin*, the great history painter's singular effort in full-length portraiture (see p. 707). Tiepolo dressed the dead hero in robes of state and furnished him with a baton and admiral's hat to commemorate his patriotic services to the Republic, and he alluded specifically to the man's personal sacrifice—a damaged hand at the battle of Metellino—through the ghostly white glove starkly projecting from a field of crimson reds near the painting's center. But what most distinguishes this portrait from similar essays by Uberti and other painters of the period is Dolfin's uniquely authoritative air, conveyed by the work's dramatically raked viewpoint and impressively deep

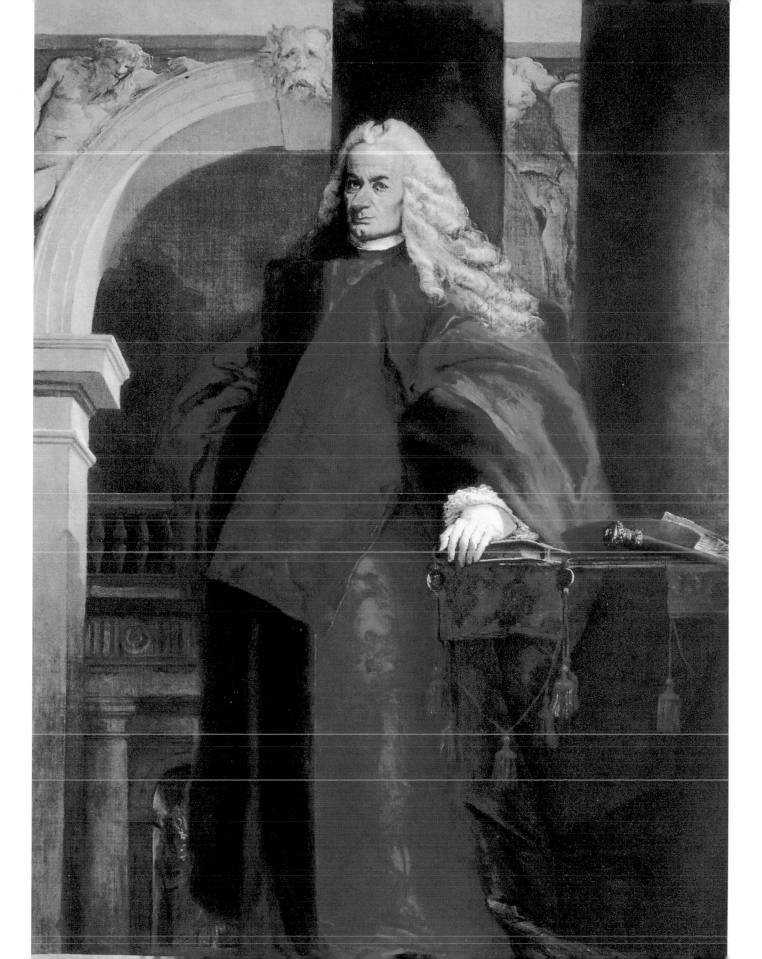

Portrait of Giambattista Piazzetta, Alessandro Longhi. Ca' Rezzonico. In 1760 Longhi published a collection of portraits of famous Venetian artists consisting of a biography accompanied by a portrait etching of each.

space. In honoring the admiral, Tiepolo celebrated the fame of the Dolfin family, one that had supported him since the first decade of his career.

Alessandro Longhi

Official portraits like Uberti's and Tiepolo's stand in contrast to the less formal representations that Alessandro Longhi, son of the successful genre painter, began to paint in the 1760s. Trained by Nogari, one of whose specialties was "heads" in a Rembrandtesque style, the younger Longhi often worked in the Bombelli-Uberti mold. He enlivened his portrayals with sharp interpretations of character, producing full-length portraits like those of Antonio Renier (Padua, Musei Civici) and Pietro Vittore Pisani (Venice, private collection), as well as group portraits such as the *Three Avogadori* [magistrates] in the Palazzo Ducale and the *Family of Luigi Pisani* (Venice, Gallerie dell'Accademia). In 1760 he published the *Raccolta di ritratti* [Collection of portraits], a collection of portraits of famous Venetian artists. He then reissued this compilation in 1762 with a collection of biographies, the *Compendio delle vite dei pittori veneziani* [Collection of the lives of Venetian painters], which faces each life with a seemingly artless etching within an elaborate rocaille frame.

On 16 August 1760, at the outdoor exhibition held annually on the feast day of St. Roch, Longhi caught the public eye with a portrait of an innkeeper, so unusual a contribution and so convincing that

Gasparo Gozzi noted in the *Gazzetta Veneta* that it was a *nuova maniera* [new style]. The enthusiasm accorded Beaumarchais in Paris in the 1780s for his untraditional *Marriage of Figaro*, an excitement echoed in the jubilant reception in Vienna of the operatic version of the comedy, corroborates that taste was changing not only in the pictorial arts but also in much of Europe's cultural milieu. Although the politically conservative old guard of Venice did not alter, Longhi's close observation of nature, his attention to reality, and his honest portrayal of visual phenomena endorsed the values of the Enlightenment.

Nowhere did Alessandro Longhi realize this better than in his *Portrait of Carlo Goldoni*, executed shortly before Goldoni definitively left Venice for Paris in 1762. The painter and the dramatist were friends, and each often dispensed with the traditional trappings of high art. When he produced Goldoni's portrait, Longhi depicted the writer with the tools of his trade while he exchanges a familiar glance with the observer. Projecting an air of polished insouciance, Goldoni's hand effortlessly gestures, the exquisite lace at his neck and wrists trails, and the pages of his book matter-of-factly fall open.

Domenico and Lorenzo Tiepolo

Candid portrayal, exquisite grace, and picturesque genre describe the work of Venice's last noteworthy painter of the era, Giandomenico (Domenico) Tiepolo. Son, pupil, collaborator, and heir of the great Giambattista, Domenico was trained by his father in the family workshop from about 1737 to 1747. He made a public debut in the Oratory of the Crucifix attached to the church of S. Polo with an impressive series of fourteen canvases, one bearing the date 1747, narrating the *via crucis* [way of the cross]. Very different from his father's heroic interpretations of Christian narrative, Domenico's stories of the Passion focus on the particular and the homespun. Thus, despite its noble setting of monumental columns and ancient sarcophagus, *Christ Consoling the Weeping Women*, station VIII of the *via crucis*, depicts an all too fragile Savior tenderly caring for his afflicted followers, portraitlike in their individuality.

The S. Polo cycle pinpoints a further and significant distinction between the art of Giambattista and that of his son. Domenico had a predilection for working in cycles, telling a story or affecting an ambience through the accumulation and variation of anecdote across a number of scenes. Two years after his success at the Oratory of the Crucifix, he engraved the *via crucis* series. He later narrated

the adventures of Punchinello in the 104 sheets of the *Divertimenti per li regazzi* [Diversions for children], portrayed the foibles of a cross-section of society in drawings called *Scenes of Contemporary Life*, and recounted the journey of the Holy Family in twenty-five etchings, *Idee pittoresche sopra la fugga in Egitto* [Picturesque ideas on the flight to Egypt]. He frescoed more than a dozen scenes of rustic and oriental life in the *foresteria* [guest house] of Villa Valmarana, the family villa outside Vicenza, etched sixty heads after his father's paintings and designs, drew about one hundred scenes of the eccentric doings of fauns, satyrs, centaurs, and nymphs, and decorated the family villa with, among other subjects, the antics of Punchinello.

However, Domenico displayed a strong affinity with his father's style, particularly in his history paintings. A good case in point is the *Consilium in Arena*, which mixes ceremonial elements with genre and portraiture. Some of the brushwork of this fascinating record of judicial dispute echoes Giambattista, but the dry, cutting shadow on the far wall, the anecdotal elements in the foreground, and the simplified elucidation of figures all argue for Domenico's authorship. Yet the documents show that the commission was Giambattista's. Collaboration often governed the output of father and son, and when overwhelmed by commitments, Giambattista must have turned over some of his duties to the faithful Domenico, handing him responsibility for the execution of a work like the *Consilium in Arena* after reserving the right, perhaps, to design it and emend its details in order to fulfil his contractual obligations.

In late 1751 Domenico accompanied his father to Würzburg, where they formed a prolific partnership for two years, serving Karl Philip von Greiffenklau, the prince-bishop, and other patrons. Domenico worked independently as a printer, and produced for Greiffenklau the *Idee pittoresche sopra la fugga in Egitto*. The success of the series is owed in part to Domenico's talent in etching, but also, to a greater degree, to his fertile artistic imagination and his vision of the Christ child's humanity and his parents' earthly tribulations.

Returning home from Würzburg at the end of 1753, aged twenty-five, Domenico continued to develop his talents, depicting the rural pastimes and leisurely rhythms of the Veneto. In 1757, as his father painted the walls of Villa Valmarana with narratives from Greek, Latin, and Italian epic poetry, he portrayed rustic peasants and oriental merchants in the *foresteria*. The *Peasants' Meal* is one of the most attractive of Domenico's frescoes there (see p. 710). Although he conceived the farm laborers as serious

figures, the pictorial charm of the painting distinguishes it from the forlorn and stark mealtime scenes visualized by Louis Le Nain in seventeenth-century France and by Giacomo Ceruti in early eighteenth-century Bergamo. At the center of the bountiful autumnal scene, a new tendril lyrically curls upward, its exquisite grace forming an ironic counterweight to the heavy belly of the pregnant woman, while the succulent squash hanging on the vine comments wittily on the plump infant perched

Portrait of Dr. Pietro Pellegrini, Alessandro Longhi. Venice, Ateneo Veneto. The professionalism of the doctor is brutally exposed through the open book of human anatomy on the table alongside parts of a human skeleton.

Peasants' Meal, Giandomenico Tiepolo, fresco, 1757. Vicenza, Villa Valmarana ai Nani. Farmhands like those represented played a major part in creating the wealth of Renaissance Venice, but they rarely appeared in painting of that period. The artist's unusual portrayal of them illustrates the wide focus of 18th-century culture.

on his father's knee. The fresco is a lightly veiled quip, a subtle parody even, of *Sarah and the Angel*, painted by Giambattista Tiepolo in the gallery of the archbishop's palace in Udine a generation earlier (see p. 587). Giving his scene of peasant fecundity the same roofless lean-to, its door still ajar, that his father had used to set the story of Sarah's unexpected pregnancy in Genesis, Domenico transformed the biblical meeting of the matriarch with an angel into a rustic picnic for peasants As in the *Divertimenti per li regazzi*, Domenico displays a singular talent to restate and refract his father's motifs with such adroitness as to turn meanings upside down,

transforming high art into genre, historical narrative into contemporary incident, even tragedy into comedy.

Farmhands like those in the *Peasants' Meal* had played a major part in creating the wealth of Renaissance Venice, but rarely appeared in painting of that period. Domenico's kindly and unusual portrayal of them at the Villa Valmarana illustrates once again the wide focus of eighteenth-century culture. The same may be said of his *Burchiello*, which reveals his interest in yet another historically vital aspect of Venetian life and economy, maritime trade. As his Valmarana frescoes substituted rustic

chores and repose for the cultivated rituals of rural life, so the *Burchiello* replaces the great mercantile enterprises of Adriatic shipping with ferry transport and small-time bartering. A rolled-up oriental carpet is loaded onto a large barge as a monk converses with its captain. With consummate skill Domenico contrasts the public vessel with the privately owned gondola alongside, and plays the colorful rungs of a red ladder off the silvery forms of the prow to the right. He astutely juxtaposes disparate motifs along similar diagonal axes: the bright oar resting against its rowlock, the dark pole thrust by the straining boatman, the rod lying in its rudder, and the pipe in the steersman's hand. In his simple but artfully composed painting Domenico at once captured the unhurried rhythms of traffic on the waters connecting Venice with Padua and accented the commerce that had once made the city a great power.

The abundance of small-scale works like the *Burchiello* and the *Consilium in Arena* and monumental projects such as those in Würzburg and Villa Valmarana encouraged the Tiepolo workshop to enlist Lorenzo, another son. Lorenzo chose portraiture as his field of activity, both in Venice and in Spain, where he stayed after his father's death in 1770 and Domenico's almost immediate return home. In 1757, the same year as the Valmarana commission, he produced a wonderfully delicate portrait of his mother. Appropriating Rosalba Carriera's technique of pastel on paper and conforming to her bias for both intimacy and elegance, he depicted Cecilia Guardi Tiepolo wearing furs, fine lace ruffs, and a bonnet, paying special attention to the dazzling jeweled ornaments in her hair, on her ears, hand, and wrist, and around her neck. Lorenzo depicted his mother as a patrician and allotted her the quintessential token of aristocratic ladies, a fan. The Tiepolo family's collective pockets were indeed bulging by 1757, and the tangible signs of their wealth consisted not only in the expensive gifts Giambattista obviously showered on his wife, but also in the increasingly larger houses they occupied over the years and in the country villa in Zianigo, near Mirano, which he purchased for the family that same year.

Domenico started frescoing the villa shortly thereafter, and pursued that work until late into the 1790s. Here, free to let his fantasy drift as it could not in the splendid villas he and his father had decorated for others, Domenico depicted a wide range of subject-matter, from time-honored histories to elegant city folk on country outings and zany punchinellos at play (see pp. 616, 617). Many of the paintings reflect Giambattista's lessons, which Domenico reworked as he had in the *Peasants' Meal*.

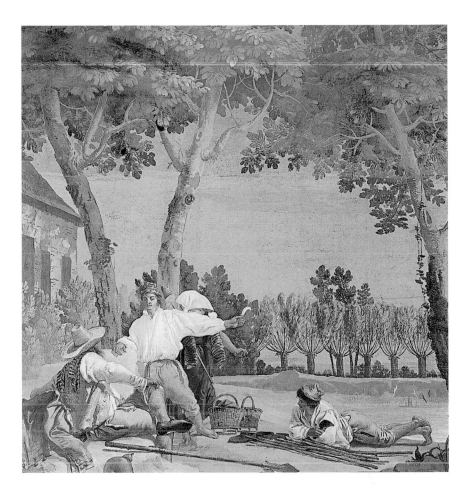

The Peasants' Rest, Giandomenico Tiepolo, fresco. Vicenza, Villa Valmarana ai Nani.

Gently mocking his father's noble ceiling paintings in which idealized personifications or heroes soar in fictive heavens within illusionistically opened vaults to symbolize lofty sentiments or enact celebrated deeds, Domenico frescoed in one of the rooms the antics of two masked clowns playing on a hanging rope while two of their companions sit to the side.

In his final years Domenico worked exclusively for himself. Like many colleagues who had preceded him, he refused to cater to the market. But in envisioning a private realm of fancy, he went even further, ignoring the world outside his windows. Indeed, when he completed his villa decoration, that world was no longer the one into which he had been born. The artist had, in effect, become his own patron.

William Barcham

Glossary

aedicula A niche for a statue in Roman temples; a small burial chapel in the Middle Ages; in architecture, the frame of a window consisting of columns supporting a pediment. Many tombs and altars are built in the form of an *aedicula*.

albergo In a *scuola grande*, the small meeting room on the *piano nobile* used for the meetings of the governing body, the Banca.

all'antica Literally, "after the Antique" (Italian). Term used to describe a work of art based on a classical model.

altar A raised structure dedicated to an act of worship. In antiquity, the main altar was located in front or at the side of the temple. Christian altars, used since the third century for prayers and the Eucharist, occupy a particular position within the church, which has been the apse since the Middle Ages. The basic Christian altar consists of the mensa (rectangular slab) and its supports. Four types developed: the table altar, the box-shaped altar (hollow-centered entrance to the reliquary below), the block altar (thick supports), and the sarcophagus altar (with a sarcophagus underneath). Artistic decoration was at first limited to ornamental coverings (see antependium); eventually altarpieces, sometimes with painted wings, were introduced. The winged altarpiece (polyptych, triptych) developed during the Medieval period. It could be closed to differentiate between ordinary and holy or feast days. Later, the reverse (outer) side was also painted. In the late 16th century, altars without moving panels and bearing sculptural decoration became the norm.

altarpiece An altar painting in the center of the retable, frequently surrounded by architectural embellishments and stone or wooden figures. From the 14th to the 16th century, altarpieces were one of the most important commissions in European art.

anastasis Literally, "resurrection" (Greek). The Harrowing of Hell, a scene frequently portrayed by Byzantine art: Christ descending into Limbo, the abode of souls who are neither in Heaven nor in Hell, breaking open the gate to Hell, and bringing out the chosen souls into the light.

andata A religious outing by the doge and his retinue to selected city churches on specific feast days, such as the Feast of St. Stephen.

antependium The hanging or frontal of an altar, usually richly decorated.

archangels The eighth highest of the nine orders of angels. Of the four archangels of ancient Hebrew tradition, Michael, Gabriel, and Raphael are the best known; each has set functions. The Book of Tobit (12:15) refers to seven archangels, but only Raphael is given a name. See Gabriel, Michael, Raphael. The joint feast day of the archangels is 29 September.

archivolt A continuous molding framing the face of an arch. In Greek and Roman architecture, decorated archivolts were often used on triumphal arches and city gates; in Romanesque and Gothic portals, archivolts formed a link with the upper parts of the wall and were often decorated with sculpture.

androne The atrium, or entrance, to a palazzo, also known as the *entrada*. In the Medieval period, the space functioned mainly as a hallway and link to other parts of the dwelling, but by the 18th century the *androne* had developed into an elaborately decorated gallery for the display of art.

arte chiusa This principle was the primary means available to the gilds to protect Venetian artisans from foreign competition: anyone not inscribed in the gild was not permitted to practice his craft, or to make or sell articles in Venice.

Arte dei Depentori The painters' gild. The statutes (*capitolari* in Italian, *mariegola* in Venetian) of the Arte dei Depentori date from 1271, making it probably the oldest painters' gild in Italy. Members' duties to the State as well as to the gild were enumerated in the regulations. Each member, therefore, in swearing to uphold the statutes of his gild, simultaneously swore allegiance to the State. The *mariegola* also established the pattern and practice of an artist's career, maintained professional standards, and controlled, as an extension of the State, the working conditions and schedules of the workshops, assuring a broad distribution of available work by limiting the number of apprentices and assistants.

atlantes Plural of *atlas* and named after Atlas, the giant of Greek mythology. In architecture, the full- or half-length male figures, in the round or in high relief, which are used instead of columns to support an entablature. Also called telamones, they are the male equivalent of caryatids.

atrium Originally the open central court of a Roman house; later, the colonnaded forecourt of an Early Christian church.

attic A storey above the main entablature, frequently decorated or inscribed, and used to conceal the roof line. In antiquity, it was used on city gates and triumphal arches; in Renaissance and Baroque architecture, on churches and secular buildings.

Augustinian Order of monks following the rule of St. Augustine (354–430). It was influenced by Renaissance humanism, and many members joined the early Reformation movement instigated by their brother Martin Luther. The order also took on an increasing teaching role.

baptistery A small building separate from the main church in which the rite of baptism was performed. Often dedicated to St. John the Baptist, it was usually circular or octagonal in shape. In the late Middle Ages, the practice of full submersion during baptism ceased; from then on, a font on the main church was used.

Baroque A style of art and architecture that dominated Europe during the 17th century and well into the 18th. It was a dramatic and dynamic blending of the arts of sculpture, painting, and architecture, a style that used illusionism, realism, and ornamental forms to achieve its aims and effects. Illusionistic frescoed ceilings, designed to blend with the actual carved cornices and moldings surrounding them, are characteristic of the Italian Baroque.

basilica The Christian basilica used the Roman architectural basilica form for a community meeting place and church. The basic shape is a rectangular hall church with a nave flanked by two to four narrower and lower side aisles. Light entered through windows in the side aisles and at the top of the nave walls. The longitudinal nave led to an apse, usually in the east. Later, variations were added, such as transept, narthex, choir, and crypt.

bay A division of a building, either inside or outside, which is created by supporting members such as walls, columns, and buttresses.

Beatitudes In art, personifications of the qualities enumerated in Matthew 5:3–12, including Sorrow, Gentleness, Mercy, and Purity.

Byzantine Relating to the art, architecture, and civilization of Byzantium, the Christian empire that succeeded the Eastern Roman Empire. The Byzantine Empire endured for more than 1000 years, from A.D. 330, when Constantine made Byzantium – renamed Constantinople – his capital, to 1453, when was Constantinople conquered by the Ottoman Turks. The arts and architectural forms of Byzantium were important influences on production and construction in medieval Italy, especially in Venice, Ravenna, and Sicily; superb examples are found in the mosaic decoration of S. Marco.

campanile A bell tower, usually detached from the church.

capitolari, see Arte dei Depentori.

capriccios, caprices Painted views of landscape combined with architecture in which the individual elements are realistically depicted but combined in a fanciful way; the flowering of this type of painting occurred in 18th-century Venice.

a carena di nave Literally, "in the form of a ship's keep." The term is used to describe the wooden ceilings used in some church interiors, such as that of S. Stefano, a splendid Mendicant church from the Trecento.

Carmelites Originating in Palestine, this contemplative order spread into Europe in the 13th century and became one of the three great mendicant orders. See also Dominicans, Franciscans.

casa da stazio A noble residence, today frequently termed *palazzo*. In Venetian sources of the Medieval and Renaissance periods, such residences were merely called *case*, abbreviated to *Ca'*. In inventories and property transactions a palace was known simply as a *casa da stazio*. The only true *palazzo* was the Palazzo Ducale; any resident with adequate wealth could own or occupy a *casa da stanzio*.

casino This private area of comfort and intimacy was designed for entertainments, in the later 17th and 18th centuries, and in Venice was often located on the mezzanine floor of a palazzo, in contrast to its development as a small outbuilding in the grounds of a country villa. Its decoration tended to follow the French model of "grace" and "loveliness."

cathedral A church which contains a *cathedra*, the throne of a bishop.

central-plan church A church with four arms of equal length; also a church with a circular or polygonal plan; see Greek-cross plan.

chancel, see choir.

chapter house A large room within, or a building attached to, a monastery or bishop's palace, used for meetings of the governing body (chapter).

chiaroscuro Literally, "light-dark" (Italian). In painting, drawing, and the graphic arts, the technique of modeling form by almost imperceptible gradations of light and dark to create an illusion of space and depth around figures and objects. Chiaroscuro is often used to add to the dramatic atmosphere of a painting.

choir A term borrowed from ancient Greek theater, used for that part of the Christian church reserved for clergy and singers; the area extends from the crossing to the high altar.

choir screen Frequently decorated with sculpture, it separates the choir from the nave or from the transept. In an Eastern church, the screen is covered with icons and is called an iconostasis.

chrysa bullon A byzantine charter with an imperial seal.

ciborium A canopy, or baldachin, supported by columns over an altar.

Cinquecento Literally "five hundred" (Italian). The period 1500–1599 in Italian art.

clipeus (*pl. clipei*) A round bronze shield; an oval-shaped medallion used as a decorative element in architecture.

codex (pl. codices) Handwritten manuscript in book form, as opposed to a text written on a scroll.

colorito The active use of color in painting as a structural and expressive element, pioneered by Titian. Tintoretto was said to have inscribed on the wall of his studio: "The drawing [*disegno*] of Michelangelo and the coloring [*colorito*] of Titian."

Colossal order Architectural order whose columns or pilasters rise through more than one storey.

commedia dell'arte Italian comedy of the 16th, 17th, and 18th centuries, improvised from stock situations and characters, such as Punchinello (compare Punch of Punch and Judy).

Composite order Architectural order that combines Ionic and Corinthian elements.

condottiere A mercenary captain.

Corinthian order Architectural order with unfluted columns and capitals representing an acanthus growing in a basket.

Council of Trent, see Counter-, or Catholic, Reformation.

Counter-, or Catholic, Reformation Action led by the Roman Catholic Church and Roman Catholic rulers to counter the influence of the Protestant Reformation. The Jesuits, who held influential positions in universities and schools, and commissioned many magnificent churches, were the leaders of the Catholic Reform, the principles of which were established at the Council of Trent (1545–63).

crossing The part of a church where the nave and transept intersect. If the nave and the transept are of equal length, the result is a central ground plan.

cupola, see dome.

da mar entrance The entrance "from the sea" (more usually, from the canal) to a church or other Venetian building.

diptych A pair of hinged panels, made of wood, ivory, or metal, with their surfaces painted or carved or otherwise prepared for receiving decoration or text.

disegno Literally, "drawing" (Italian). In the delineation of forms on a flat surface, the linear element predominates. See, in contrast, colorito.

doge The chief magistrate of the Republic of Venice, the doge ruled in conjunction with a patrician council, membership of which was restricted to a limited number of families until the 17th century, when the Republic needed to find new financial resources and allowed wealthy merchants to buy their way into the ruling class.

dome (also cupola) An evenly curved vault on a circular, elliptical, or polygonal base. In cross-section it can have any of the configurations of an arch. There is frequently an oculus or lantern at the highest point to admit light.

Dominicans Order of mendicant monks founded by St. Dominic in Toulouse in 1216, to spread the faith by preaching and teaching. The Dominicans were the most influential medieval order and were put in charge of the Inquisition.

Doric order Architectural order with fluted columns and capitals having a flat abacus.

dossal An ornamental cloth hung behind an altar.

drum Cylindrical wall that supports a dome; also a segment of a column shaft.

Early Christian The term is a chronological rather than a stylistic one, referring to art and architecture produced by and for Christians prior to the final religious division between the Western Catholic and Eastern Orthodox churches – approximately up to A.D. 500. Besides church buildings, work includes painted and mosaic decoration for places of worship, decorated tombs, carved sarcophagi, and intricately worked objects of wood, metal, and ivory.

entablature Everything above the level of the columns in classical architectural orders: architrave, frieze, and cornice.

entrada Atrium or entrance; see androne.

Epistolary A lectionary (list of liturgical lessons) containing a group of liturgical epistles.

Eucharist The sacrament of Holy Communion, a religious celebration that commemorates the Last Supper.

Evangelists The apostles Matthew, Mark, Luke, and John, traditionally believed to be the authors of the first four books of the New Testament, the Gospels, which relate the life of Christ. They are usually depicted with their respective symbols (inspired either by the vision of Ezekiel in the Old Testament or by the beasts surrounding the throne of the Lamb in Revelation): Matthew, winged man or angel; Mark, winged lion; Luke, winged ox; and John, an eagle.

extrados External part of an arch or a vault.

facade The main elevation of a building; sometimes also one of its subsidiary elevations.

fondaco Trading station, e.g., the Fondaco dei Turchi.

forma urbis Literally, the "shape of the city" (Latin).

Franciscans Order of mendicant monks founded by St. Francis of Assisi in 1223. Their mission was to imitate the life of Christ through asceticism and poverty and to attend to the spiritual needs of the poor.

fresco Literally, "fresh" (Italian), referring to "fresh plaster" (*fresco intonaco*). Wall painting in which mineral or earth pigments are suspended in water and painted onto wet lime or gypsum plaster; the pigments unite with the plaster as they dry.

frieze The part of the entablature between the architrave and the cornice, sometimes decorated with relief sculpture; also any relief or painting used decoratively in a long horizontal format.

Futurism A revolutionary movement in the arts that began in Italy in 1909; its adherents were especially interested in expressing movement and time, as well as space. As an organized movement, it did not survive the First World War, but it was an important influence in the development of 20th-century art (notably Dada and Surrealism).

Gabriel (archangel) Like the other archangels, he appears several times in the Old Testament. Christian iconography depicts him carrying a lily as the angel of the Annunciation to the Virgin and holding a raised trumpet as the herald of the Last Judgment. See archangel.

giovani One of two anticlerical parties within the patriciate, consisting of the younger members whose unyielding attitude favored no compromise with Rome (after the Council of Trent); see also vecchi.

Giustizia Vecchia Established in 1173, this office of the Venetian government, with three magistrates, was charged with supervising the activities of the gilds.

Golden Legend The *Legenda Aurea*, a collection of legends about saints, taken from written and oral sources by Jacobus da Voragine (13th century), archbishop of Genoa; one of the most important sources for artists' pictures of saints.

Gothic The term now used to describe medieval art from the end of the Romanesque period (mid-12th century) to the beginning of the Renaissance. The word was coined by Vasari and used to deride the immediate predecessors of the Renaissance as "goths," or barbarians. The Gothic cathedral was a particularly important architectural development. The separate areas of Romanesque churches were united and the entire structure became taller. Other features are the pointed arch, rib vault, and flying buttress. Gothic sculpture was mainly used as architectural ornament, and Gothic painting – with some notable exceptions – was mostly restricted to altarpieces and stained glass.

Greek-cross plan A church with four arms of equal length; also called a central-plan church.

grotteschi A kind of ornament derived by Renaissance architects and artists from ancient Roman decoration, which they discovered c. 1520 in the subterranean ruins of Nero's "Golden House" in Rome; hence its name, from the Italian word for "cave" (*grotto*). The ornament, which could be painted, carved, or made of stucco, usually consisted of curvilinear plant forms twisting around fantastic human and animal figures.

icon Literally, "likeness" (Greek). A small, portable painting by a Greek or Russian Orthodox believer on panel, generally of a religious subject, usually Christ, the Virgin Mary, or a saint. The iconography of the subject was strictly prescribed by tradition, using an equally strict pattern of representation. Used both as church ornament and private devotional pictures. See also choir screen.

iconography Originally the study and identification of classical portraits. In art history, the term refers to the systematic investigation of the subject matter and symbolism of images as opposed to their style; this requires research into literary, philosophical, historical, and theological sources.

iconostasis Screenlike partition that separates the sanctuary from the nave in an Eastern church; see also choir screen.

imaginarius In the creation of mosaics, there were two different masters, each of whom played an important part:

the *imaginarius* [creative artist] and the *tessellarius* [tessellation artist]. It was the function of the *tessellarius* to translate into mosaic the images provided by the *imaginarius*, "painting" them using small stones and pieces of glass, interpreting their themes with images that were not merely mechanical translations. While there may have been only one *imaginarius* on a given project, it is likely that a number of *tessellarii* would have worked on his images.

imago urbis Literally, "image of the city" (Latin). Throughout its history, the city of Venice capitalized on its image, at times was more glorious than the actuality.

incipit The first words in a text of a medieval manuscript or an early printed book.

intarsia A type of decorative wooden inlay used for the ornamentation of furniture, such as choir stalls, and the paneling of rooms. Woods of different colors and grains were utilized to produce not only foliate and geometric patterns, but also complex figurative scenes with deep perspective.

intrados The inner face of an arch.

Ionic order Architectural order with slender, unfluted columns and capitals having symmetrical volutes.

Jesuits Roman Catholic teaching order founded by St. Ignatius Loyola in 1534 for the express purpose of fighting heresy. It was the Jesuits' intention to spread the faith by missionary work and education and to this end, they published numerous theological books and scientific studies.

Late Antique A chronological rather than a stylistic term, it denotes work in the classical tradition made by and for non-Christians from about A.D. 200 through about A.D. 500.

Latin-cross plan Church plan in the form of a cross, with three short arms and one long arm.

loggia An exterior arcaded gallery, a *loggia* can be located on the ground or upper floor, or on a sequence of floors.

macchietta Sketch, in a drawing or painting, that describes only the essential characteristics of the subject; from *macchia* (Italian), meaning "sketch" or "outline," (literally, "little spots or stains").

maniera greca Literally, "Greek manner" (Italian). Term to describe Byzantine-influenced works of art, especially painting and mosaic.

Mannerism Term describing European art in the period between the Renaissance and the Baroque, c. 1520–1620. To an extent, it can be explained as a consequence of the Counter-, or Catholic, Reformation, and the destruction of the High Renaissance's anthropocentric view of the world by radical social restructuring and political events. Mannerism is typified by stylistic trickery and a liking for bizarre effects: elongated bodies and anatomically impossible positions, complicated compositions, irrational and theatrical lighting, and a use of color that is no longer restricted to the object it represents. Venetian Mannerists include Palma the Younger, Leonardo Corona, Andrea Vicentino, Sante Peranda, and Antonio Vassilacchi (known as Aliense).

mariegola, see Arte dei Depentori.

mendicant orders Religious orders that exist solely through begging for alms. They came into existence during the 13th century as a reaction against the growing secularization of the Church. Mendicants saw their mission as connecting monastic life with spiritual work in the outside world, including ministering to the spiritual needs of the poor, fighting heresy, teaching in universities, and engaging in missionary work. See also Dominicans, Franciscans.

Michael (archangel) The conqueror of Satan, he is represented in art as the warrior archangel, holding a sword. His feast day (29 September) was important in the liturgical calendar of the Eastern (Orthodox) Church. See also archangels.

mosaic A design, figurative or nonfigurative, made by attaching small pieces of hard colored substances – e.g., marble, glass – via plaster or concrete to a base. See *imaginarius*.

Nabis The Symbolist followers of Gauguin; the word comes from the Hebrew word for "prophet." Their credo, penned by Maurice Denis and adopted by "modern" 20th-century painters, was the statement "A picture – before being a war horse, a female nude, or some anecdote – is essentially a flat surface covered with colors in a particular order."

narthex The transverse vestibule leading into the main body of an Early Christian or Byzantine church.

Neoclassicism An artistic style of the late 18th and early 19th centuries influenced by classical art in style and subject matter. Among the finest Neoclassical artists are the painter Jacques-Louis David and the sculptor Antonio Canova.

ogee A molding with a profile in a continuous, double-curved line; *ogee* is often used interchangeably with *cyma*.

orant In Christian art, a figure standing with raised arms outspread in a gesture of prayer.

orders, religious: see Augustinian, Carmelites, Dominicans, Franciscans, Jesuits, Theatines.

orders, architectural: a system devised by Vitruvius, the Roman architectural historian, to categorize already existing architectural elements; see Composite, Corinthian, Doric, Ionic.

Ottocento Literally, "eight hundred" (Italian). The period 1800–1899 in Italian art.

Palaeologus The Greek dynasty that rules the Byzantine Empire from 1261 until its final conquest by the Ottoman Turks in 1453.

palazzo, see *casa da stazio*.

patera (pl *paterae, patere*) Round ornamental reliefs of stone or marble used on facades, e.g., on the canal facade of the Fondaco dei Turchi and other residential buildings. Many have animal subjects and are thought to be derived from the *clipeus* with animals, used on fabrics produced in Constantinople.

pendentive, see spandrel.

pergula In an Early Christian church, parallel rows of columns connected by an architrave, located at the intersection of the nave and transept.

piano nobile The main floor of a large building such as a palazzo, containing the reception rooms, usually the storey above the ground floor. Some Venetian palazzi had more than one *piano nobile*.

Pietà A representation of the body of Christ lying in the lap of his grieving mother. The scene is called a "Lamentation" when a specific narrative moment after the Crucifixion, with several persons present, is represented.

pinnacle Gothic architectural ornament of a narrow, pointed pyramidal form crowning an architectural member such as a buttress. Its lower portion is often decorated with tracery.

pluteus (pl. plutei) Slab(s) of stone or marble, usually decorated in relief and used as an enclosure.

polyptych A painting made up of more than three panels fastened together.

portego Though sparsely furnished, the *portego* was the place for the display of arms and trophies, as well as family portraits; it was the room that provided the setting for ceremonial occasions such as wedding feasts and parties. See also sala.

presbytery The raised part of a church reserved for the clergy; also called Chancel.

proto (pl. proti) Protomagister, master builder, master of works. For major civic undertakings such as the ongoing work on the Palazzo Ducale or the project for the new Rialto bridge, the appointment was made by the Procuratori de Supra who designated prominent architects such as Bartolomeo Bon and Jacopo Sansovino.

puteal Well-head, often decorated with reliefs.

quadratura Scenographic perspective painting.

quatrefoil A four-lobed decorative motif, especially a four-lobed shape in Gothic tracery.

Quattrocento Literally, "four hundred" (Italian). The period 1400–1499 in Italian art, the time of the early Renaissance and into the High Renaissance.

Raphael (archangel) Prominent in the Book of Tobit, he is the friend and companion of Tobias, the healer of Tobit, and the rescuer of Sara from Asmodeus. See also archangel.

Realism A movement in 19th-century painting that eschewed the idealized subjects of Romantic and Neoclassical painting and instead attempted to provide a true-to-life rendering of everyday reality.

relief A composition or design made so that the forms project from a flat surface. The degree of projection is indicated by terms such as high relief (deeply carved sculpture almost detached from its support) and low relief (figures projecting less than half their true depth from the background).

reliquary A container for the sacred relics of a saint.

renovatio urbis Literally, "renewal of the city" (Latin).

retable The rear wall of an altar, decorated with paintings and sculptures.

ridotto, see *casino*.

Rococo An 18th-century style of art and interior design, particularly during the reign of the French king Louis XV, characterized by a light and delicate treatment of the curvilinear forms of the Italian Baroque. The work of Giambattista Tiepolo – with his enormous, airy, and flamboyant compositions – is considered a prime example of this style in Italy.

Romanesque Term describing the art and architecture of Western Europe from the end of the 8th century until the 13th century. It is divided into Early Romanesque (until c. 1080), High Romanesque (until c. 1150), and Late Romanesque (until c. 1240). (The last ran parallel to Early Gothic in France.) Features of ecclesiastical buildings are the heavy, massive proportions of all the architectural elements.

sacra conversazione A representation of the Virgin and Child surrounded by saints, all of whom seem engaged in some kind of dialogue, or at least aware of one another's presence, within a unified physical space.

sala, salone In the medieval period, a large reception room located on each main living storey and lit by multilight windows at either end; the *salone* was itself often called the portego.

salizzada Main street of a parish in Venice. Literally, paved street as originally only mainstreets were paved.

scuola grande There were two principal kinds of *scuole* in medieval and early modern Venice: the *scuola grande*, or great citizens' confraternity, and the simpler version known as the scuola piccola. All the *scuole grandi* and most of the *scuole piccole* were situated near, or attached to, a church or religious house, alluding to their transitional status between religious and secular culture. In its simplest terms the *scuola grande* was a larger version of the *scuola piccola*: a barnlike rectangular structure with two halls one above the other, linked by a staircase; the main exception was that an additional smaller meeting room, known as the *albergo*, was needed on the *piano nobile* for the meetings of the governing body. See also scuola piccola.

scuola piccola There were three principal types: the artisans' gild, the headquarters of a particular trade or craft; the gild for foreign residents, such as Greeks, Albanians, or Dalmatians; and the devotional confraternity, whose members were dedicated to the veneration of a particular saint or cult. See also *scuola grande*.

Seicento Literally, "six hundred" (Italian). The period 1600–1699 in Italian art.

Settecento Literally, "seven hundred" (Italian). The period 1700–1799 in Italian art.

sopraporta Literally, "overdoor" (Italian). Decorative painting, frequently landscapes or *vedute ideate*, painted for the space above interior doorways, especially in grand residences and public reception rooms.

sotto in sù Literally, "from below upward" (Italian). A ceiling painting intended to be viewed from directly underneath. Frescoed ceilings with extreme foreshortening of figures in space, so that they appeared suspended rather than attached to a picture plane, are characteristic of Italian Baroque painting, e.g., Sebastiano Ricci's *Glorification of the Arts and Sciences* for the ceiling of the library of the Patriarcal Seminary in Venice or Giambattista Tiepolo's ceiling for the Kaisersaal in Würzburg.

spandrel The triangular area of stonework on the outer curve of an arch.

specchiatura A decorative pattern in a small, depressed area, generally found on furniture, doors, or similar objects.

stucco (*stucchi* in Italian) Decorative sculpture, usually in relief, made of a fine plaster. Elaborate stucco cornices and moldings went hand in hand with the vast wall and ceiling frescoes of the Venetian Baroque, as in Tiepolo's Antony and Cleopatra cycle in Palazzo Labia.

synthronon In Byzantine churches, the seating of the bishop and his presbyters, located behind the altar: usually a semicircular row of seats with the bishop's throne in the middle.

telamones, see atlantes.

teleri Paintings on canvas. Such paintings could be relatively small and portable or vast and attached to the wall surface, such as the cycle by Titian for the Scuola Grande di S. Giovanni Evangelista, that by Carpaccio for the Scuola di S. Orsola, or that by Tintoretto for the Scuola Grande di S. Rocco.

tenebrism A 17th–18th–century style of painting in which the dramatic possibilities of chiaroscuro are emphasized in the direction of the dark and mysterious.

tessera (pl. tesserae) One of thousands of tiny pieces of colored glass (including gold-backed glass), marble, or stone needed to compose a mosaic.

tessellarius, see *imaginarius*.

tetrastyle porch A porch with four columns supporting the entablature and projecting in front of the facade wall.

Theatines Founded in the 16th century in Rome, the order's aim was to reform the Church from within. Members were supposed to do charitable acts and to develop their own spiritual lives.

transept The section of a church that lies perpendicular to the main axis of the nave.

translatio Literally, "transferring, transporting" (Latin). Used to refer to the transporting of the remains of St. Mark from Alexandria to Venice.

Trecento Literally, "three hundred" (Italian). The period 1300–1399 in Italian art.

trefoil arch An arch with tracery in the shape of the three lobes of a clover leaf.

triptych A set of three hinged panels, made of wood, ivory, or metal, with their surfaces painted or carved; usually a painting made up of three panels consisting of two smaller wings flanking a larger central composition.

trompe l'oeil Literally, "deceive the eye" (French). The term is applied to painting that is so realistic that it fools the viewer into believing that the painted objects or scenes are real.

vecchi One of two anticlerical factions within the patriciate, consisting of the older members, who favored compromising with Rome (after the Council of Trent). See also *giovani*.

veduta ideata An imaginary painted scene made up of architectural and landscape elements that look "real" but do not actually exist in the configuration depicted.

virtues and vices There are three theological virtues: Faith, Hope, and Charity; and four cardinal virtues: Prudence, Justice, Fortitude, and Temperance. The seven virtues are often represented allegorically with the seven vices: Pride, Covetousness, Lust, Envy, Gluttony, Anger, and Sloth.

Bibliography

PRIMARY SOURCES

ARETINO, P., *Lettere sull'arte di Pietro Aretino*, ed. E. Camesasca, commentary by F. Pertile, 3 vols., Milan 1957–60.

BARZONI, V., *Lettera sopra il monumento di Angelo Emo scolpito da Canova*, Venice 1795.
——*Lettera sopra la Psiche di Canova*, Venice 1795.
BOSCHINI, M., *Le minere della pittura*, Venice 1664.
——*Le ricche minere della pittura veneziana*, Venice 1674.
——*La carta del navegar pitoresco con la "Breve instruzione" premessa alle Ricche minere della pittura veneziana*, ed. A. Pallucchini, Venice-Rome 1966.

CANOVA, A., *Scritti*, I, ed. H. Honour, Rome 1994.
CARTARI, V., *Imagini delli dei de gl'antichi*, Venice 1647.
CASOLA, P., *Viaggio a Gerusalemme* [1494], Milan 1855.
CORYAT, T., *Crudities*, 2 vols., Glasgow 1905.

DA CANAL, V., *Vita di Gregorio Lazzarini scritta da Vincenzo Da Canal P.V.* [1732], ed. G. Moschini, Venice 1809.
——*Della maniera del dipingere moderno* [c. 1730], Venice 1810.
DA CANALE, M., *Les Estoires de Venise, cronaca veneziana in lingua francese dalle origini al 1275*, ed. A. Limentani, Florence 1972.
DE BROSSES, C., *Lettres familières de l'Italie* [1739], Paris 1931.
DELFICO, D. [S. BETTINELLI], *Lettere su le belle arti*, Venice 1793.
Descrizione degli spettacoli, e feste datesi in Venezia per l'occasione della venuta delle...il Granduca e la Granduchessa di Moscovia, Venice 1782.
DEZALLIER D'ARGENVILLE, A.J., *Abrégé de la vie des plus fameux peintres*, Paris 1762.
DOLCE, L., "Dialogo della pittura intitolato l'Aretino" [1557], in *Trattati d'arte del Cinquecento*, I, ed. P. Barocchi, Bari 1960.

Elenco degli oggetti della Galleria di Daniele Farsetti, Venice 1778.

FACIO, B., *De viris illustribus*, 1971.
Forestiere illuminato intorno le cose più rare...della Città di Venezia, Venice 1740.
FRANCO, F., *Habiti delle donne veneziane*, Venice 1610.

GOETHE, J.W., *Italian Journey*, ed. T.P. Saine and J.L. Sammons, trans. R.R. Heitner, Princeton, N.J.-Chichester 1994.
GOLDONI, C., *Componimenti poetici per le felicissime Nozze di Sua Eccellenza il Signor Giovanni Grimani e la Signora Catterina Contarini*, Venice 1750.
GUARIENTO, P., ed., *Abecedario pittorico del M.R.P. Pellegrino Antonio Orlandi Bolognese contenente le notizie de' Professori di Pittura, Scoltura, ed Architettura*, Venice 1753.
Guerre in ottava rima, IV, *Guerre contro i Turchi (1453–1570)*, ed. M. Beer and C.Ivaldi, Modena 1988.

LACOMBE, *Dizionario portatile delle belle arti*, Bassano 1758.
LANZI, *Storia pittorica della Italia*, ed. M. Capucci, 3 vols., Florence 1968–74.
LONGHI, A., *Compendio delle vite de' Pittori veneziani istorici più rinomati del presente secolo con suoi ritratti*, Venice 1762.
LOTTO, L., *Il Libro di spese diverse con aggiunta di lettere e d'altri documenti*, ed. P. Zampetti, Venice-Rome 1969.
LUCCHESI, P., *Degli archi e delle volte, e regole generali dell'architettura civile. Opera e studio dello architetto ed ingegnere Tommaso Temanza* [1733], Venice 1811.

MAGALOTTI, L., *Diario di Francia dell'anno 1688*, Palermo 1991.
MANCINI, G., *Considerazioni sulla pittura 1619-21*, ed. A. Marucchi and L. Salerno, 2 vols., Rome 1956–57.
MEMMO, A., *Elementi di architettura lodoliana o sia l'arte di fabbricare con solidità scientifica e con eleganza non capricciosa*, Rome 1786.
MONTESQUIEU, Charles le Secondat, *Oeuvres complètes de Montesquieu*, ed. A. Masson, 3 vols., Paris 1950.

"N.N.," "Lettera del Co. N.N. a Madama la Marchesa di N.N. a Paris, in cui si dà conto delle solenni pompe nuziali vedute nel palazzo di S.E. il Signor Co. Manin in Venezia," *Galleria di Minerva*, Venice 1708.
Notizie tratte dai Notatori e dai Annali del N.H. Pietro Gradenigo, ed. L. Livan, Padua 1942.

Orazione in lode di S.E. il Signor Cavalier Luigi Pisani Procurator di San Marco, Venice 1711.

PACIFICO, P.A., *Cronica veneta, sacra e profana*, Venice 1697.
PALLADIO, A., *I quattro libri dell'architettura*, Venice 1570.

PASTORELLO, E., *Chronica per extensum descripta*, in *Rerum Italicarum Scriptores*, XII.1, Bologna 1938–58.
PINO, P., "Dialogo di pittura" [1548], in *Trattati d'arte del Cinquecento*, I, ed. P. Barocchi, Bari 1960.
POLENI, G., *Exercitationes Vitruvianae, primae, secundae et tertiae*, Padua 1739–41.

RIDOLFI, C., *Le maraviglie dell'arte*, Venice 1648, ed. D. von Hadeln, 2 vols., Berlin 1914–24.
RIPA, C., *Iconologia overo Descrittione di diverse Imagini*, Rome 1603.
Rosalba Carriera. Lettere. Diari. Frammenti, 2 vols., ed. B. Sani, Florence 1985.

SABELLICO, M.A., *Del sito di Venezia città*, Venice 1957.
SANDRART von, J., *Academie der Bau-, Bild- und Malerei-Kunste*, ed. A.R. Peltzer, Munich 1925.
SANSOVINO, F., *Venetia città nobilissima et singolare*, Venice 1581.
——*Venetia città nobilissima et singolare...ampliata dal M.R.D. Giovanni Stringa*, Venice 1604.
——*Venetia città nobilissima et singolare...con aggiunta...da Giustiniano Martinioni*, Venice 1663.
SANUDO, M., *De origine, situ et magistratibus urbis Venetae ovvero La città di Venetia*, Milan 1980.
SAVONAROLA, M., *Libellus de magnificis ornamentis Regie Civitatis Padue*, in *Rerum Italicarum Scriptores*, XIV.15, Città di Castello 1902.
SCAMOZZI, V., *Dell'idea dell'architettura universale*, Venice 1615.

TADINI, F., *Le sculture e le pitture di Antonio Canova pubblicate fino a quest'anno 1795*, Venice 1796.
TEMANZA, T., *Vita di Andrea Palladio*, Venice 1762.
——*Vite de' più celebri architetti, e scultori veneziani che fiorirono nel secolo decimosesto*, Venice 1778.
——*Antica pianta dell'Inclita città di Venezia delineata circa la metà del XII secolo ed ora per la prima volta pubblicata ed illustrata*, Venice 1781.
——*Zibaldon*, ed. N. Ivanoff, Rome 1963.

VASARI, G., *Le vite de' più eccellenti pittori, scultori ed architettori* [1568], ed. G. Milanesi, 9 vols., Florence 1906.
——*Vita di Jacopo Tatti detto il Sansovino*, Florence 1913.
VISENTINI, A., *Osservazioni di Antonio Visentini architetto veneto*, Venice 1771.

WYNNE ROSENBERG, G., *Del soggiorno dei conti del Nord a Venezia in gennaro del MDCCLXXXII*, Venice 1782.

ZANETTI, A.M., *Della pittura veneziana e delle opere pubbliche de' veneziani maestri*, Venice 1771.
——*Descrizione di tutte le pubbliche pitture della Città di Venezia e isole circonvicine*, Venice 1733.
ZUCCARI, F., *Lamento della pittura*, Florence 1605.

SECONDARY SOURCES

19TH-CENTURY PUBLICATIONS

ALBRIZZI TEOTOCHI, I., *Opere di scultura e di plastica di Antonio Canova*, Florence 1809.
——*Opere di scultura e di plastica di Antonio Canova*, 4 vols., Pisa 1821–24.
ALGAROTTI, F., *Saggi sull'architettura e sulla pittura*, Milan 1831.

La basilica di San Marco in Venezia illustrata nella storia e nell'arte, Venice 1881–88.
BARZONI, V., *L'Ebe di Canova posseduta dal conte Giuseppe Albrizzi*, Venice 1800.
BELTRAME, F., *Cenni illustrativi del monumento a Tiziano Vecellio in Venezia e notizie intorno al fu...Luigi Zandomeneghi*, Venice 1852.
Biblioteca Canoviana ossia Raccolta delle migliori prose, e de' più scelti componimenti poetici sulla vita, sulle opere ed in morte di Antonio Canova, 4 vols., Venice 1823–24.
BINI, T., *I Lucchesi a Venezia*, Lucca 1853.
BOITO, C., *Gite di un artista*, Milan 1884.
BOTTARI, G., TICOZZI, S., *Raccolta di lettere*, Milan 1822–25.

CATTANEO, R., *L'architettura in Italia dal secolo VI al mille circa*, Venice 1888.
CICOGNA, E., *Saggio di bibliografia veneziana*, Venice 1847.
CICOGNARA, L., *Biografia di Antonio Canova*, Venice 1823.
——"Della istituzione delle Accademie di Belle Arti in Europa," *Antologia*, XXI, 1826.
——*Omaggio delle provincie venete alla Maestà di Carolina Augusta Imperatrice d'Austria*, Venice 1818.
——*Orazione in morte del march. Antonio Canova letta il giorno delle esequie nella sala dell'Accademia di Belle Arti*, Venice 1822.
——*Storia della scultura dal suo risorgimento in Italia fino al secolo di Canova*, 7 vols. Prato 1824.

CICOGNARA, L., DIEDO, A., SELVA, G., *Le fabbriche più cospicue di Venezia*, Venice 1815–20.
CONTARINI, A., *Pantheon veneto ossia iscrizioni erette con busti nel Ducale Palazzo a celebri italiani con analoghe biografie*, Venice 1866.

DANDOLO, G., *La caduta della Repubblica di Venezia*, Venice 1855.
Descrizione della statua di un Pugilatore eseguita in Roma dal celebre scultore Sig. Antonio Canova, Venice 1802.
D'ESTE, A., *Memorie di Antonio Canova*, Florence 1864.
Discorsi ed Atti dell'Accademia di Belle Arti di Venezia, Venice 1807–88.

Elenco degli oggetti d'arte ammessi all'esposizione nelle sale dell'I.R. Accademia di Belle Arti in Venezia, Venice 1838–64.
Esposizione Nazionale Artistica Venezia 1887, Venice 1887.

FAPANNI, F., *Intorno l'architetto Baldassare Longhena*, Venice 1874.
FONTANA, G., *Cento palazzi di Venezia*, Venice 1865.

JUSTI, C., "Ein Denkmal venezianischer Bildnisplastik im fernen Westen," *Zeitschrift für bildende Kunst*, Neue Folge, II, 1891.

LEVI, C.A., *Il pittore veneziano Pompeo Marino Molmenti (1819–1894)*, Rome 1895.
LOCATELLI, T., *L'Appendice della Gazzetta di Venezia. Prose scelte*, Venice 1837–80.
LORENZI, G., *Monumenti per servire alla storia del Palazzo Ducale di Venezia*, Venice 1868.

MALAMANI, V., "Isabella Teotochi Albrizzi, i suoi amici e il suo tempo," *Nuova Rivista*, II, 1882.
——*Memorie del Conte Leopoldo Cicognara tratte dai documenti originali*, Venice 1888.
——*Un'amicizia di Antonio Canova. Lettere di lui al Conte Leopoldo Cicognara*, Città di Castello 1890.
MARIETTE, P.J., *Abecedario et autres notes inédits de cet amateur sur les arts et les artistes*, 6 vols., Paris 1851–60.
MICHIEL, M., *Notizia d'opere di disegno*, ed. D.J. Morelli, Bologna 1884.
MISSIRINI, M., *Del Tempio eretto in Possagno da Antonio Canova*, Venice 1833.
——*Della vita di Antonio Canova libri quattro*, Prato 1824.
MOLMENTI, P., *La storia di Venezia nella vita privata*, 2nd. edn., Bergamo 1927–29 (1st. edn. Turin 1880).
MOLMENTI, P.G., "Delendae Venetiae," *Nuova Antologia*, 1 Feb. 1887.

——*Acque-Forti dei Tiepolo*, Venice 1896.
MONTICOLO, G., "Il capitolare dell'arte dei pittori a Venezia," *Nuovo Archivio veneto*, II, 1891.
MORELLI, I., *Descrizione delle feste celebrate in Venezia per la venuta di S.M.I.R. Napoleone il Massimo*, Venice 1808.
MOSCHINI, G.A., *Della letteratura veneziana del sec. XVIII fino a' nostri giorni*, Venice 1806–08.
——*Guida per la città di Venezia*, Venice 1815.
MUTINELLI, F., *Annali delle Provincie venete dall'anno 1801 al 1840*, Venice 1843.
——*Dell'avvenimento di S.M.I.R.A. Ferdinando I d'Austria in Venezia e delle civiche solennità d'allora*, Venice 1838.

NANI MOCENIGO, F., *Artisti veneziani del secolo XIX. Note e appunti*, Venice 1898.
NEGRI, F., *Notizie intorno alla persona e all'opere di Tommaso Temanza architetto veneziano*, Venice 1830.
NEUMAYR, A., *Il pittore ritrattista*, Venice 1834.
——*Illustrazione del Prato della Valle ossia Piazza delle Statue di Padova*, Padua 1807.
NOVELLI, P.A., *Memorie della vita di Pier Antonio Novelli scritte da lui medesimo*, Padua 1834.

Opera ornamentale di Giuseppe Borsato, Venice 1831.

PAOLETTI, P., *L'architettura e la scultura del Rinascimento a Venezia*, Venice 1893.
PERCIER, C., FONTAINE, P.F.L., *Raccolta di decorazioni interne...con notevoli giunte di Giuseppe Borsato*, ed. F. Zanotto, Venice 1843.

QUATREMERE DE QUINCY, A.C., *Canova et ses ouvrages*, Paris 1834.

RUSKIN, J., *The Stones of Venice*, 3 vols., London 1851–86.

SACCARDO, P., *Les mosaïques de Saint Marc à Venise*, Venice 1896.
SAGREDO, A., *Intorno al monumento da innalzarsi in Venezia per volere di Sua Maestà l'Imperatore Ferdinando I e nostro alla memoria di Tiziano*, Milan 1839.
——*Sulle consorterie delle arti edificative in Venezia*, Venice 1854–56.
SCOLARI, F., *La chiesa di Santa Maria del Pianto*, Venice 1851.
SELVATICO, P., *Arte e artisti. Studi e racconti*, Padua 1863.
——*Considerazioni sullo stato presente della pittura storica in Italia*, Milan 1837.
——*Sull'architettura e sulla scultura a Venezia*, Milan 1847.
——*Sull'educazione del pittore storico odierno italiano. Pensieri*, Padua 1842.
SELVATICO, P., LAZZARI, V., *Guida di Venezia e delle isole circonvicine*, Venice 1852.

SERNAGIOTTO, L., *Natale e Felice Schiavoni. Vita, opere, tempi*, Venice 1881.
SEUME, J.G., *Spaziergang nach Syrakus*, Brunswick-Leipzig 1803.
SORANZO, G., *Bibliografia veneziana*, Venice 1885.

TIKKANEN, J.J., *Die Genesismosaiken von S. Marco in Venedig und ihr Verhältnis zu den Miniaturen der Cottonbibel*, Helsinki 1889.

URBANI DE GHELTOF, G.M., *Tiepolo e la sua famiglia*, Venice 1879.

Venezia e le sue lagune, Venice 1847.

ZANETTI, V., *Degli studi delle opere e della vita del pittore Sebastiano Santi*, Venice 1871.
ZANOTTO, F., *Il Palazzo Ducale di Venezia*, Venice 1853.
——*Storia della pittura veneziana*, Venice 1837.

20TH-CENTURY PUBLICATIONS

ACKERMAN, J.S., "L'architettura religiosa veneta in rapporto a quella toscana del Rinascimento," *Bollettino del Centro Internazionale di Studi di Architettura Andrea Palladio*, XIX, 1977.
AGAZZI, M., *Platea sancti Marci. I luoghi marciani dall'XI al XIII secolo e la formazione della piazza*, Venice 1991.
The Age of Bruegel. Netherlandish Drawings in the Sixteenth Century, exhib. cat., ed. J.O. Hand *et al.*, London 1968.
AIKEMA, B., "Diamantini e Molinari in Palazzo Gritti-Badoer a Venezia," *Arte Veneta*, XXXIX, 1985.
——"L'immagine della 'Carità' veneziana," in B. Aikema and D. Meijers, *Nel regno dei poveri. Arte e storia dei grandi ospedali veneziani in età moderna 1474–1797*, Venice 1988.
——"Le decorazioni di Palazzo Barbaro-Curtis a Venezia fino alla metà del Settecento," *Arte veneta*, XLI, 1987.
——"Nicolò Bambini e Giambattista Tiepolo nel salone di Palazzo Sandi," *Arte veneta*, XL, 1986.
——"Patronage in late baroque Venice. The Zenobio," *Mededelingen van het Nederlands Instituut te Rome*, XLI, 1979.
——*Pietro della Vecchia and the Heritage of the Renaissance in Venice*, Florence 1990.
——"Pietro della Vecchia, a profile," *Saggi e memorie di storia dell'arte*, XIV, 1984.
AIKEMA, B., MEIJERS, D., *Nel regno dei poveri. Arte e storia dei grandi ospedali veneziani in età moderna 1474–1797*, Venice 1989.
ALBERICI, C., *Il mobile veneto*, Milan 1980.
Alberto Martini, exhib. cat., ed. M. Lorandi, Milan 1985.
Alessandro Milesi, exhib. cat., ed. G. Perocco, Venice 1959.

ALGERI, G., "L'attività di Michelino da Besozzo in Veneto," *Arte cristiana*, 1987.
Alle origini di Canova. Le terrecotte della collezione Farsetti, exhib. cat., Venice 1991.
ALPERS, S., BAXANDALL, M., *Tiepolo and the Pictorial Intelligence*, New Haven-London 1994.
Alte Pinakothek, München, Erläuterungen zu den ausgestellten Gemälden, Munich 1983.
Ambienti di dimore medievali a Verona, ed. F. Doglioni, Venice 1987.
ANDREESCU, I., "Torcello I. Le Christ inconnu II. Anastasis et Jugement Dernier: têtes vraies, têtes fausses," *Dumbarton Oaks Papers*, XXVI, 1972.
——"Torcello III. La chronologie relative des mosaïques pariètales," *Dumbarton Oaks Papers*, XXX, 1976.
ANELLI, L., *Pietro Bellotti 1625–1700*, essays by A. Bononi, I. Lechi and J. Rosengarten, Brescia 1996.
ANGELINI, L., *Le opere in Venezia di Mauro Codussi*, Milan 1945.
Anni Trenta. Arte e cultura in Italia, Milan 1982.
ANTONIAZZI ROSSI, E., "Addenda: la data di morte di Johann Liss," *Arte veneta*, XXIX, 1975.
Antonio Canova, exhib. cat., ed. G. Pavanello and G. Romanelli, Venice 1992.
ARBAN, A., *L'attività padovana di Pier Antonio Novelli*, Arte veneta, 1970.
ARCAIS, F., D', *Guariento*, Venice 1965.
——"La personalità del Guariento nella cultura figurativa del Trecento padovano," in *Da Giotto a Mantegna*, exhib. cat., ed. L. Grossato, Milan 1974.
——"Venezia," in *La pittura nel Veneto. Il Trecento*, I, Milan 1992.
ARGAN, G.C., *Antonio Canova*, ed. E. Debenedetti, Rome 1969.
ARNALDI, L., CAPO, G., "I cronisti di Venezia e della Marca Trevigiana," in *Storia della cultura veneta*, II, Vicenza 1976.
ARNOLD, D., ARNOLD, E., "Russians in Venice: the visit of the 'Conti del Nord' in 1782," in *Slavonic and Western Music. Essays for Gerald Abraham*, ed. M.H. Brown and R.J. Wiley, Oxford 1985.
ARSLAN, E., *Venezia gotica*, 1986 (1st. edn. 1970).
The Art of Paolo Veronese 1528–1588, ed. W.R. Rearick, Cambridge 1988.
Art vénitien en Suisse et au Liechtenstein, exhib. cat., ed. M. Natale, Milan 1978.
Arte d'Europa tra due secoli: 1895–1914. Trieste, Venezia e le Biennali, exhib. cat., ed. M. Masau Dan and G. Pavanello, Milan 1995.
Arte Neoclassica, Atti del Convegno (12–14 October 1957), Venice–Rome 1964.
Asterischi d'archivio per il '700 veneziano, *Notizie da Palazzo Albani*, II, 1973.
Arte a Venezia, exhib. cat., ed. G. Mariacher, 1971.
Astolfo de Maria 1891–1946, exhib. cat., ed. G. Dal Canton, Milan 1996.
AUGUSTI, A., "La scoperta e il restauro di un crocifisso duecentesco ai Frari," *Quaderno n. 17 della S. BB. AA. SS. di Venezia – Restauri a Venezia*, Venice 1993.

AURIGEMMA, M.G., "Addenda et corrigenda a Saraceni," *Arte/Documento*, VIII, 1994.

AVON CAFFI, G., *Ippolito Caffi 1809-1866*, Padua 1967.

BALDAUF-BERDES, J.L., *Women Musicians of Venice. Musical Foundations 1525-1855*, Oxford 1996.

BANO, D., "La riflessione economica: dai problemi dell'agricoltura e della moneta all'economia come un tutto," in *Storia della cultura veneta. Il Settecento*, ed. G. Arnaldi and M. Pastore Stocchi, V.2, Vicenza 1986.

BARBANTINI, N., *Il ritratto veneziano dell'Ottocento*, exhib. cat., Venice 1923.

——"La mostra del ritratto veneziano dell'Ottocento," *Rivista di Venezia*, Sept. 1923.

BARCHAM, W., "Canaletto and a commission from consul Smith," *Art Bulletin*, LIX, 1977.

——"Giambattista Tiepolo's ceiling for S. Maria di Nazareth in Venice: legends, traditions, and devotions," *Art Bulletin*, LXI, 1979.

——*The Imaginary View Scenes of Antonio Canaletto*, New York 1977.

——*The Religious Paintings of Giambattista Tiepolo*, Oxford 1989.

——*Tiepolo*, New York 1992.

——"Two views by Bernardo Bellotto: *View of Dresden with the Frauenkirche at Left* and *View of Dresden with the Hofkirche at Right*," *North Carolina Museum of Art Bulletin*, XV, 1991.

BARDON, F., "La peinture narrative de Carpaccio dans le cycle de Ste Ursule," *Atti dell'Istituto veneto di scienze, lettere ed arti*, XXXIX, 1985.

BARRAL, X., ALTET, I., *Les mosaïques de pavement médiévales de Venise, Murano, Torcello*, Paris 1985.

BARZAZI, A., "Documenti sulla protezione accordata dalla Serenissima Signoria a Bernardo Strozzi: il contributo di Fra' Fulgenzio Micanzio," *Atti dell'Istituto veneto di scienze, lettere e arti*, CXL, 1981-82.

BASSI, E., *Antonio Canova*, Bergamo 1943.

——*Architettura del Sei e Settecento a Venezia*, Naples 1962.

——"Baldassare Longhena e l'architettura del Seicento a Venezia," *Bollettino del Centro Internazionale di Studi di Architettura Andrea Palladio*, XXIII, 1981.

——"Episodi dell'architettura veneta nell'opera di Antonio Gaspari," *Saggi e memorie dell'arte*, III, 1963.

——"Episodi dell'edilizia veneziana nei secoli XVII e XVIII: Palazzo Pesaro," *Critica d'arte*, VI, 1959.

——*Giannantonio Selva architetto veneziano*, Padua 1936.

——"Gli architetti dell'Ospedaletto," *Arte veneta*, VIII, 1953.

——*Il Museo Civico di Bassano: i disegni di Antonio Canova*, Venice 1959.

——*La Gipsoteca di Possagno: sculture e dipinti di Antonio Canova*, Venice 1957.

——*La R. Accademia di Belle Arti di Venezia*, Florence 1941.

——*L'Accademia di Belle Arti di Venezia nel suo bicentenario 1750-1950*, exhib. cat., Venice 1950.

——"L'architetto Francesco Lazzari (1791-1871)," *Rivista di Venezia*, June 1934.

——"L'architettura," in *Storia di Venezia. L'arte*, ed. R. Pallucchini, II, Venice-Rome 1995.

——"L'edilizia veneziana nei secoli XVII e XVIII. Il restauro dei palazzi," *Critica d'arte*, Jan.-Feb. 1957.

——*Palazzi di Venezia*, Venice 1976.

——*Palazzi di Venezia: Admiranda Urbis Venetae*, Venice 1980.

BAZZONI, R., *60 anni della Biennale di Venezia*, Venice 1962.

BECHERUCCI, L., "La bottega pisana di Andrea da Pontedera," *Mitteilungen des Kunsthistorischen Institutes in Florenz*, XI, 1965.

BELLAVITIS, G., ROMANELLI, G., *Le città nella storia d'Italia. Venezia*, Rome-Bari 1985.

——*Venezia*, Bari 1985.

BELLINATI, C., "Le tavolette del Semitecolo (1367) nella Pinacoteca dei Canonici di Padova," *Atti e memorie dell'accademia patavina di scienze, lettere ed arti*, CIV, 1992.

BELLINATI, C., BETTINI, S., *L'Epistolario miniato di Giovanni da Gaibana*, Vicenza 1968.

BELLOSI, L., *La pecora di Giotto*, Turin 1985.

BELTRAMI, D., *Storia della popolazione di Venezia dalla fine del secolo XVI alla caduta della Repubblica*, Padua 1954.

BELTRAMI, L., *La "Ca' del Duca" sul Canal Grande ed altre reminiscenze sforzesche in Venezia*, Milan 1900.

BÉNÉDITE, L., *Storia della pittura nel secolo XIX*, Milan 1915.

BERENGO, M., *La società veneta alla fine del Settecento*, Florence 1956.

BERNABEI, F., "Critica, storia e tutela delle arti," in *Storia della cultura veneta. Dall'età napoleonica alla prima guerra mondiale*, VI, Vicenza 1986.

——"Cultura artistica e critica d'arte. Marco Boschini," in *Storia della cultura veneta. Il Seicento*, IV.1, Vicenza 1983.

—— "La letteratura artistica," in *Storia della cultura veneta. Il Settecento*, ed. G. Arnaldi and M. Pastore Stocchi, V.1, Vicenza 1985.

——*Pietro Selvatico nella critica e nella storia delle arti figurative dell'Ottocento*, Vicenza 1974.

Bernardo Bellotto, Verona e le città europee, exhib. cat., ed. S. Marinelli, Milan 1990.

BERTACCHI, L., "Architettura e mosaico," in *Da Aquileia a Venezia*, ed. B. Forlati Tamaro *et al.*, Milan 1980.

BERTELLI, C., "Dietro la pittura italiana: Bisanzio," in *La Pittura in Italia. Il Duecento e il Trecento*, ed. E. Castelnuovo, II, Milan 1986.

BETTAGNO, A., "Un soffitto ritrovato di Palazzo Pisani," *Arte veneta*, XXIX, 1975.

BETTINI, S., "Appunti di storia della pittura veneta nel Medioevo, I," *Arte veneta*, XX, 1966.

——"Appunti di storia della pittura veneta nel Medioevo, II," *Arte veneta*, XXI, 1967.

——*La pittura di icone cretese-veneziana e i Madonneri*, Padua 1933.

——*L'architettura di San Marco (origini e significato)*, Padua 1946.

——"L'architettura esarcale," *Bollettino del Centro Internazionale di Studi di Architettura Andrea Palladio*, VIII, 1966.

——*Mosaici antichi di San Marco a Venezia*, Bergamo 1944.

——*Pitture cretesi e veneziane, slave e italiane, del Museo Nazionale di Ravenna*, Ravenna 1940.

——introduction, in *Venezia e Bisanzio*, exhib. cat., Venice 1974.

——*Venezia: nascita di una città*, Milan 1978.

BEVILACQUA, P., *Venezia e le acque: una metafora planetaria*, Rome 1995.

BIADENE, S., "Catalogo delle opere," in *Longhena*, exhib. cat., Milan 1982. *Biblioteca Marciana, Venezia*, ed. M. Zorzi, Florence 1988.

BIGGI, M.I., "I disegni di G. Selva per il teatro della Fenice di Venezia," *Neoclassico*, VI, 1994.

BINION, A., "From Schulenburg's gallery and records," *Burlington Magazine*, CXII, 1970.

BINION, A., *La Galleria scomparsa del maresciallo von der Schulenburg*, Milan 1990.

Boccioni a Venezia; dagli anni romani alla mostra d'estate a Ca' Pesaro: momenti della stagione futurista, exhib. cat., ed. E. Coen, L. Magagnato and G. Perocco, Milan 1985.

BISOGNI, F., "Un polittico di Cristoforo Cortese ad Altidona," *Arte illustrata*, LIII, 1973.

BISTORT, G., *Il magistrato alle pompe della Repubblica di Venezia*, Bologna 1969.

BOLOGNA, F., *Francesco Solimena*, Naples 1958.

BONICATTI, M., "Precedenti storici di Francesco Guardi nella tradizione settecentesca del 'Capriccio'," *Problemi guardeschi*, Atti del Convegno di studi promosso dalla mostra dei Guardi (Venice, 13-14 Sept. 1965), Venice 1966.

BONORA, E., "Algarotti, Francesco," *Dizionario Biografico degli Italiani*, Rome 1960.

BORTOLAN, G., "Asterischi d'archivio per il '700 veneziano," *Notizie da Palazzo Albani*, II, 1973.

——"Santa Maria Formosa nel '700," *Bollettino dei Musei Civici Veneziani*, XVIII, 1973.

BOUCHER, B., *The Sculpture of Jacopo Sansovino*, 2 vols., New Haven-London 1991.

BOUCHER, B., RADCLIFFE, A., "Sculpture," in *The Genius of Venice 1500-1600*, exhib. cat., London 1983.

BRAND, H.G., *Die Grabmonumente Pietro Lombardos. Studien zum venezianischen Wandgrabmal des späten Quattrocento*, Augsburg 1977.

BRATTI, R., "Antonio Canova nella sua vita artistica privata (da un carteggio inedito)," *Nuovo Archivio Veneto*, April-June 1917.

BRIGANTI, G.B, *Pietro da Cortona o della pittura barocca*, Florence 1982.

BRIZIO, A.M., *Ottocento e Novecento*, Turin 1962.

BROGLIO D'AJANO, R., "L'industria della seta a Venezia," in *Storia dell'economia italiana*, ed. C.M. Cipolla, I, Turin 1959.

BROWN, P. FORTINI, *Venetian Narrative Painting in the Age of Carpaccio*, New Haven-London 1988.

BRUNETTI, M., *Da Campoformio a Vittorio Veneto. Guida al Museo del Risorgimento*, Venice 1951.

——"Un eccezionale collegio peritale: Piazzetta, Tiepolo, Longhi," *Arte veneta*, V, 1951.

BRUSATIN, M., *Venezia nel Settecento. Stato, architettura, territorio*, Turin 1980.

BRUSATIN, M., PAVANELLO, G., *Il Teatro La Fenice. I progetti, l'architettura, le decorazioni*, Venice 1987.

BUCCI, C.A., "Pietra Porto in due pale di Bartolomeo Montagna," in *Venezia Cinquecento*, I, 1991.

BUCHWALD, H.H., "Eleventh-century Corinthian-palmette capitals in the region of Aquileia," *Art Bulletin*, XLVIII, 1966.

——"The carved stone ornament of the high Middle Ages in San Marco, Venice," *Jahrbuch der Österreichischen Byzantinischen Gesellschaft*, XI-XII, 1962-63, XIII, 1964.

BUSH, V., *Colossal Sculpture of the Cinquecento*, New York 1976.

BUSS, C., "Problemi di datazione e attribuzione: approccio interdisciplinare," in *Tessuti serici italiani 1450-1530*, Milan 1983.

BYAM SHAW, J., *The Drawings of Domenico Tiepolo*, Boston 1962.

La caduta di Costantinopoli, ed. A. Pertusi, I, *Le testimonianze dei contemporanei*, II, *L'eco nel mondo*, Milan 1976.

Cagnaccio di San Pietro, exhib. cat., Milan 1991.

CAILLEUX, J., "Centaurs, fauns, female fauns, and satyrs among the drawings of Domenico Tiepolo," *Burlington Magazine*, CXVI, 1974.

——"Un portrait de Watteau per Rosalba Carriera," in *Miscellanea J.Q. Van Regteren Altena*, Amsterdam 1969.

CAIZZI, B., *Industria e commercio della Repubblica veneta nel XVIII secolo*, Milan 1965.

CALVESI, M., "La 'morte di bacio'. Saggio sull'ermetismo di Giorgione," *Storia dell'arte*, VII-VIII, 1970.

CAMESASCA, E., *L'opera completa del Bellotto*, Milan 1974.

Canaletto e Visentini: Venezia e London, exhib. cat., ed. D. Succi, Gorizia 1986.

Canaletto, exhib. cat., ed. K. Baetjer and J.G. Links, New York 1989.

Canaletto. Disegni, Dipinti, Incisioni, exhib. cat., ed. A. Bettagno, Vicenza 1982.

Canaletto. Paintings and Drawings, exhib. cat., London 1980.

Canova e l'incisione, exhib. cat., ed. G. Pezzini Bernini and F. Fiorani, Bassano del Grappa 1993.

I capitolari delle arti veneziane...dalle origini al MCCCXXX, I-II, ed. G. Monticolo, III, ed. G. Monticolo and E. Besta, Rome 1896-1914.

CARAMEL, L., ed., *Arte in Italia 1945-1960*, Milan 1994.

CARILE, A., "Aspetti della cronachistica veneziana nei secoli XIII e XIV," in *La storiografia veneziana fino al secolo XVI*.

Aspetti e problemi, ed. A. Pertusi, Florence 1980.
Casorati, exhib. cat., ed. M.M. Lamberti, Milan 1989.
CASSINI, G., *Piante e vedute prospettiche di Venezia (1479–1855)*, Venice 1971.
CASTEELS, M. [M.C.], in *La sculpture au siècle de Rubens*, Brussels 1977.
CASTELNUOVO, E., *Un pittore italiano alla corte d'Avignone*, Turin 1962.
CATTIN, G., MARIANI CANOVA, G., MARCON, S., *Musica e liturgia a San Marco*, Venice 1990–92.
CERIANA, M., "Due esercizi di lettura: la Cappella Moro in San Giobbe e le fabbriche dei Gussoni a Venezia," *Annali di architettura*, IV–V, 1992–93.
CESARO, B., "Scenografie di Giuseppe Borsato," *Neoclassico*, III, 1993.
CHADWICK, O., *The Popes and European Revolution*, Oxford 1981.
Chardin, exhib. cat., ed. P. Rosenberg, Cleveland, Ohio 1979.
CHATZIDAKIS, M., GRABAR, A., *La pittura bizantina e dell'alto Medioevo*, Verona-Amsterdam 1965.
CHIAPPINI DI SORIO, I., "Appunti per la storia dell'arte veneta: Jacobello ed Ercole del Fiore," *Arte/Documento*, III, 1989.
——"Il tessuto d'arte," in *Storia di Venezia. Temi. L'Arte*, Rome 1995.
——*L'arte della tessitura serica a Venezia*, Venice 1989.
——*Palazzo Pisani Moretta*, Parma 1983.
——"Note e appunti su Jacobello del Fiore," *Notizie da Palazzo Albani*, II, 1973.
CHIARI MORETTO WIEL, M.A., GALLO, A., MERKEL, E., *Chiesa di Santo Stefano. Arte e devozione*, Venice.
CHRISTIANSEN, K., *Gentile da Fabriano*, London 1982.
——"La pittura a Venezia e in Veneto nel primo Quattrocento," in *La Pittura in Italia. Il Quattrocento*, ed. F. Zeri, I, rev. edn., Milan 1987.
CIARTOSO LORENZETTI, M., "Di uno scomparso politico di Giusto Padovano," *L'Arte*, XXX, 1927.
——"Stucchi veneziani del Settecento," *Le Tre Venezie*, July 1939.
Cima da Conegliano, Atti del Convegno Internazionale di Studi Conegliano 1993, 2 vols., ed. P. Humphry and A. Gentili, in *Venezia Cinquecento*, IV, 1994.
CIRIACONO, S., "L'idraulica veneta: scienza, agricoltura e difesa del territorio dalla prima alla seconda rivoluzione scientifica," in *Storia della cultura veneta. Il Settecento*, ed. G. Arnaldi and M. Pastore Stocchi, V.2, Vicenza 1986.
Civiltà di Napoli, exhib. cat., 2 vols., Florence 1979.
La civiltà veneziana nell'età romantica, Florence 1961.
CLEGG, J., *Ruskin in Venice*, London 1981.
COCCHETTI PRATESI, L., "Contributi alla scultura veneziana del '200," *Commentari*, XII, 1961.
COGGIOLA, G., *Di un'opera del Canova destinata alla Marciana*, Perugia 1906.
COLETTI, L., "La fortuna del Canova," *Bollettino del Reale Istituto di Archeologia e Storia dell'Arte in Roma*, I, 1927.
——*I primitivi. I padani*, Novara 1947.
——*Pittura veneta del Quattrocento*, Novara 1953.

COMANDUCCI, A.M, *I pittori italiani dell'Ottocento*, Milan 1934.
CONCINA, E., *L'Arsenale della Repubblica di Venezia*, Milan 1984.
——*Le chiese di Venezia: l'arte e la storia*, Udine 1995.
CONNELL, S., *The Employment of Sculptors and Stonemasons in Venice in the Fifteenth Century*, New York–London 1988.
CONSTABLE, W.G., "Some unpublished Canalettos," *Burlington Magazine*, XLII, 1923.
CONSTABLE, W.G., LINKS, J.G., *Canaletto*, 2 vols., Oxford 1976.
CORBOZ, A., *Canaletto: una Venezia immaginaria*, 2 vols., Milan 1985.
COWAN, A., "New families in the Venetian patriciate, 1646–1718," *Archivio veneto*, XXXI, 1985.
COZZI, E., "Vicenza," in *La pittura nel Veneto. Il Quattrocento*, ed. F. Zeri, rev. edn., I, Milan 1989.
COZZI, G., "La venuta di Alessandro III a Venezia nel dibattito religioso e politico tra il '500 e il '600," *Ateneo veneto*, XV, 1977.
CRACCO, C., "La cultura giuridico-politica nella Venezia della 'serrata'," in *Storia della cultura veneta*, II, Vicenza 1976.
CRISTINELLI, G., *Baldassare Longhena architetto del Seicento a Venezia*, Venice 1972.
Cronaca 1947–1967, exhib. cat., ed. F. Bizzotto, D. Marangon and T. Toniato, Venice 1984.
CROUZET-PAVAN, É., "Sopra le acque salse:" *espaces, pouvoir et société à Venise à la fin du Moyen Âge*, Rome 1992.
CUOGHI COSTANTINI, M., "Le linceul du bienheureux Giacomo Salomoni," *Bulletin du CIETA*, LXX, Lyons, 1992.
CUPPINI, L., "Una croce stazionale di Lorenzo Veneziano," *Commentari*, IX, 1958.
CUPPINI, M.T., *Pitture murali restaurate*, exhib. cat., Verona 1978.

DA MOSTO, A., *I Dogi di Venezia nella vita pubblica e privata*, Milan [1966].
——"Interni secenteschi di palazzi veneziani," *Rivista di Venezia*, July 1932.
——*La facciata della chiesa di San Nicolò da Tolentino*, Venice 1914.
DA PORTOGRUARO, D., "L'isola di San Clemente," *Rivista di Venezia*, Dec. 1934.
DA POZZO, G., "Tra cultura e avventura: dall'Algarotti al Da Ponte," in *Storia della cultura veneta. Il Settecento*, ed. G. Arnaldi and M. Pastore Stocchi, V.1, Vicenza 1985.
Da Tiziano a El Greco. Per la storia del manierismo a Venezia 1540–1590, ed. R. Pallucchini et al., Milan 1981.
DAL CANTON, G., "Arte a Venezia: 1946–1956," in D. Rosand, ed., *Interpretazioni veneziane. Studi di storia dell'arte in onore di Michelangelo Muraro*, Venice 1984.
——"La pittura del primo Novecento nel Veneto (1900–1945)," in C. Pirovano, ed., *La pittura in Italia. Il Novecento*, I, 1900–1945, Milan 1992.
DAL MAS, G., *Giovanni De Min 1786–1859*, Belluno 1992.
DAL POZZOLO, E.M., "Il lauro di Laura e delle 'maritate venetiane'," *Mitteilungen*

des Kunst-historischen Institutes in Florenz, XXXVII, 1993.
DALMATINAC, J.M., *Radovi Instituta za povijest umjetnosti*, III–VI, 1979–82.
DAMIGELLA, A.M., *La pittura simbolista in Italia 1885–1900*, Turin 1981.
DANIELS, J., *L'opera completa di Sebastiano Ricci*, Milan 1976.
——*Sebastiano Ricci*, Hove 1976.
DAVANZO POLI, D., *I mestieri della moda a Venezia nei secoli XIII–XVIII*, 3 vols., Venice 1984–88.
DAVANZO POLI, D., MORONATO, S., *Le stoffe dei veneziani*, Venice 1994.
DAVIS, C., "Alari from the shop of 'Andrea dai bronzi': a notice for Andrea Bresciano," *Arte veneta*, XXX, 1976.
——"Jacopo Sansovino's 'Loggetta di San Marco' and two problems of iconography," *Mitteilungen des Kunsthistorischen Institutes in Florenz*, XXIX, 1985.
DE ANGELIS D'OSSAT, G., "Venezia e l'architettura del primo Rinascimento," in *Umanesimo europeo e umanesimo veneziano*, ed. V. Branca, Florence 1963.
DE GRAZIA, D., GARBERSON, E., *Italian Paintings of the Seventeenth and Eighteenth Centuries. The Collection of the National Gallery of Art*, New York–Oxford 1996.
DE MARCHI, A., *Gentile da Fabriano: un viaggio nella pittura italiana alla fine del Gotico*, Milan 1992.
——"Per un riesame della pittura tardogotica a Venezia: Nicolò del Paradiso e il suo contesto adriatico," *Bollettino d'arte*, XLIV–XLV, 1987.
DE VINCENTI, M., "Antonio Tarsia," MA thesis, Venice University, 1993.
DE VITO, G., "Il viaggio di lavoro di Luca Giordano a Venezia e alcune motivazioni per la scelta riberesca," in *Ricerche sul 600 napoletano. Saggi e documenti per la storia dell'arte dedicato a Luca Giordano*, Milan 1991.
DEICHMANN, F.W., KRAMER, J., PESCHLOW, U., *Corpus der Kapitelle der Kirche von San Marco in Venedig*, Wiesbaden 1981.
DELLWING, H., *Studien zur Baukunst der Bettelorden in Venedig*, Munich 1970.
DEMUS, O., "Bisanzio e la pittura a mosaic del Duecento a Venezia," in *Venezia e l'Oriente fra tardo Medioevo e Rinascimento*, Florence 1966.
——*The Church of San Marco in Venice. History, Architecture, Sculpture*, Washington, D.C. 1960.
——*The Mosaics of San Marco in Venice*, Chicago–London 1984.
Der Himmel auf Erden, Tiepolo in Würzburg, exhib. cat., ed. P.O. Krückmann, Munich–New York 1996.
DEROSAS, R., "La crisi del patriziato come crisi del sistema familiare: i Foscarini ai Carmini nel secondo Settecento," in *Studi veneti offerti a Gaetano Cozzi*, Venice 1992.
DEVOTI, D., *L'arte del tessuto in Europa*, Milan 1974.
Dietro i palazzi. Tre secoli di architettura minore a Venezia 1492–1803, exhib. cat., ed. G. Gianighian and P. Pavanini, Venice 1984.
DI MARTINO, E., *La Biennale di Venezia 1895–1995: cento anni di arte e cultura*, Milan 1995.

——*L'Opera Bevilacqua La Masa*, 2nd. edn., 1994 (1st. edn. Venice 1984).
DINI, B., "L'industria serica in Italia. Secc. XIII–XV," in *La seta in Europa. Secc. XIII–XX*, ed. S. Cavaciocchi, Florence 1993.
DINI, F., *Federico Zandomeneghi. La vita e le opere*, Florence 1989.
DIRUF, H., *Paläste Venedigs vor 1500: Baugeschichtliche Untersuchungen zur Venezianischen Palastarchitektur im 15. Jahrhundert*, Munich 1990.
Disegni del Canova dal Museo Civico di Bassano, exhib. cat., Milan 1982.
"Dizionario biografico degli artisti," in *La pittura in Italia. Il Duecento e il Trecento*, ed. E. Castelnuovo, II, Milan 1986.
"Dizionario biografico degli artisti," in *La pittura nel Veneto. Il Trecento*, ed. M. Lucco, II, Milan 1992.
Domenico Fetti 1588/89–1623, exhib. cat., ed. E.A. Safarik, Milan 1996.
Domenico Tiepolo's Punchinello Drawings, exhib. cat., ed. M.E. Vetrocq, Indiana 1979.
DONZELLI, C., PILO, G.M., *I pittori del Seicento veneto*, Florence 1967.
DORIGO, W., "Chiese venetiche altomedievali ad absidi inscritte," *XLII Corso di cultura sull'arte ravennate e bizantina*, Ravenna 1995.
——"Croci petrinee e laterizie medievali in esterni: Ravenna, Pomposa, Venezia," in *Bisanzio e l'Occidente: arte, archeologia, storia. Studi in onore di Fernanda de' Maffei*, Rome 1996.
——"I capitelli veneziani nel corpus dei capitelli adriatici di ispirazione corinzia del secolo XI," *Prijateljev Zbornik*, I, Split 1992.
——"I mosaici medievali di San Marco nella storia della basilica," in *San Marco. I mosaici. La storia. L'illuminazione*, Milan 1990.
——"Il girale fitomorfico abitato nella plastica veneziana dei secoli XI–XIV," in *Majstor Radovan i njegovo doba*, Trogir 1994.
——"La prima San Marco e il problema della \forma gerosolimitana'," *Arte/Documento*, VI, Venice 1992.
——"L'architettura della basilica patriarcale di Aquileia," *Antichità altoadriatiche*, XXXVIII, Udine 1992.
——"Le espressioni d'arte: gli edifici," in *Storia di Venezia dalle origini alla caduta della Serenissima*, II, *L'età del Comune*, Rome 1995.
——*L'edilizia abitativa nella "Civitas Rivoalti" e nella Civitas Veneciarum" (secoli XI–XIII)*, Venice 1993.
——"Lo stato della discussione storico-archeologica dopo i nuovi lavori nella cripta di San Marco," in *San Marco. La cripta. Il restauro*, Milan 1993.
——"Una discussione e nuove precisazioni sulla capella sancti Marci nel IX–X secolo," *Venezia Arti*, VII, 1993.
——"Una nuova lettura delle sculture del portale centrale di San Marco," *Venezia Arti*, II, 1988.
——*Venezia: origini, fondamenti, ipotesi, metodi*, Milan 1983.
——*Venezie sepolte nella terra del Piave*. *Drawing in England from Hilliard to Hogarth*, exhib. cat., ed. L. Stainton and C. White, London 1987.
Duemila anni fra il dolce e il salso, Rome 1994.

EMILIANI, A., "Gotico Internazionale," in *Enciclopedia Universale dell'Arte*, VI, Venice–Rome 1958.
Etchings by the Tiepolo, exhib. cat., ed. E. Dee, Ottawa 1976.
EVANGELISTA, R., "Notizie di archivio sullo scultore Tomaso Ruer," *Ateneo veneto*, VIII, 1970.
EWALD, G., *Johann Carl Loth 1632–1698*, Amsterdam 1965.

FABBIANI, L., *La fondazione monastica di San Nicolò di Lido (1053–1628)*, Venice [1989].
FAGIOLO DELL'ARCO, M., *Barocco e Rococò*, Verona 1978.
FANTELLI, P.L., "Nicolò Renieri 'pittor fiamengo'," *Saggi e memorie di storia dell'arte*, IX, 1974.
FAVARETTO, I., *Arte antica e cultura antiquaria nelle collezioni venete al tempo della Serenissima*, Rome 1990.
FAVARO, E., *L'arte dei pittori in Venezia e i suoi statuti*, Florence 1975.
FEDI, F., *L'ideologia del bello. Leopoldo Cicognara e il classicismo fra Settecento e Ottocento*, Milan 1990.
FERRARI, O., SCAVIZZI, G., *Luca Giordano. L'opera completa*, 2 vols., Milan 1992.
FERSUOCH, L., *San Leonardo in Fossa Mala e altre fondazioni medievali lagunari*, Rome 1995.
FINLAY, R., *Politics in Renaissance Venice*, New Brunswick 1980.
FIOCCO, G., "Aggiunte di Francesco Maria Tassis alla guida di Venezia di Antonio Maria Zanetti," *Rivista di Venezia*, VI, 1927.
——"Baldassare Longhena," in *Barocco europeo e barocco veneziano*, ed. V. Branca, Florence 1962.
——*Giambattista Crosato*, Padua 1944.
——*La pittura veneziana del Seicento e del Settecento*, Verona 1929.
——"Palazzo Pesaro," *Rivista di Venezia*, Nov. 1925.
FLEMING, J.V., *From Bonaventure to Bellini. An Essay in Franciscan Exegesis*, Princeton, N.J. 1982.
FOGOLARI, G., "Domenico Pellegrini ritrattista veneziano," *L'Arte*, I, 1909.
——"Mostra di ritratto veneziano dell'Ottocento," *Emporium*, Oct. 1923.
FOLENA, G., *Lingue e culture nel Veneto medievale*, Padua 1990.
FONTANA, A., "La verità delle maschere," in *Venezia e lo spazio scenico*, exhib. cat., Venice 1979.
FONTANA, G., *Venezia monumentale. I palazzi*, ed. L. Moretti, Venice 1967.
FORSSMAN, E., *Venedig in der Kunst und im Kunsturteil des 19. Jahrhunderts*, Stockholm 1971.
FOSSATI, P., "Pittura e scultura fra le due guerre," in *Il Novecento*, Turin 1982 (*Storia dell'arte italiana*, VII).
Francesco Guardi: vedute, capricci, feste, exhib. cat., ed. A. Bettagno, Milan 1993.
FRANK, M., "Baldassare Longhena e il Palazzo Basadonna a San Trovaso," *Annali di architettura*, II, 1990.
FRANZINA, E., *Venezia*, Bari 1986.
FRANZOI, U., DI STEFANO, D., *Le chiese di Venezia*, Venice 1975.

FRANZOI, U., PIGNATTI, T., WOLTERS, W., *Il Palazzo Ducale di Venezia*, Treviso 1990.
FURLAN, C., *Il Pordenone*, Milan l988.

GALLI ROSSO, C., "Un pittore francese a Venezia: Jean Raoux," *Arte veneta*, XLIII, 1989–90.
GALLO, R., *I Pisani e i palazzi di Santo Stefano e di Strà*, Venice 1944.
——"La loggia e la facciata della chiesa di San Basso e Baldassare Longhena," *Atti dell'Istituto veneto di scienze, lettere e arti*, CXXI, 1958–59.
——"L'architettura di transizione dal Gotico al Rinascimento e Bartolomeo Bon," *Atti dell'Istituto veneto di scienze, lettere e arti*, CXX, 1961–62.
GARGAN, L., "Oliviero Forzetta e la nascita del collezionismo nel Veneto," in *La pittura nel Veneto. Il Trecento*, II, Milan 1992.
GARRISON, E.B., "A giant Venetian Bible of the earlier thirteenth century," in *Scritti di storia dell'arte in onore di M. Salmi*, Rome 1961.
——*Italian Romanesque Panel Painting*, Florence 1949.
GATTI, I., *Santa Maria Gloriosa dei Frari. Storia di una presenza francescana a Venezia*, Venice 1992.
GEALT, A., *Domenico Tiepolo. Punchinello Drawings*, London 1986.
GEMIN, M., PEDROCCO, F., *Giambattista Tiepolo. I Dipinti. Opera Completa*, Venice 1993.
The Genius of Venice, exhib. cat., ed. J. Martineau and C. Hope, London 1983.
Genova nell'età barocca, exhib. cat., ed. E. Gavazza and G. Rotondi Terminiello, Genova 1992.
GENTILI, A., *Carpaccio, i Turchi, gli Ebrei*, Venice 1995.
——with M. Lattanzi and F. Polignano, *I giardini di contemplazione. Lorenzo Lotto, 1503/1512*, Rome 1985.
——"Giorgione non finito, finito, indefinito," in *Studi per Pietro Zampetti*, ed. R. Varese, Ancona 1993.
GENTILI, A., BERTINI, C., *Sebastiano del Piombo. La Pala di San Giovanni Crisostomo*, Venice 1985.
GENTILI, A., POLIGNANO, F., "Vittore Carpaccio. Due dame veneziane," in *Carpaccio, Bellini, Tura, Antonello e altri restauri quattrocenteschi della Pinacoteca del Museo Correr*, exhib. cat., ed. A. Dorigato, Milan 1993.
GENTILI, A., TORELLA, F., *Giovanni Bellini. Il polittico di San Vincenzo Ferrer*, Venice 1985.
GHIO, L., BACCHESCHI, E., "Antonio Balestra," in *I pittori bergamaschi. Il Settecento*, II, Bergamo 1989.
Giambattista Piazzetta. Il suo tempo, la sua scuola, exhib. cat., Venice 1983.
Giambattista Tiepolo, Master of the Oil Sketch, exhib. cat., ed. B. Brown, Milan 1993.
Giambattista Tiepolo 1696–1996, exhib. cat., Milan 1996.
GIANIGHIAN, G., *Dal Medioevo al tardo Rinascimento: ricerche di storia del costruire a Venezia*, Venice 1994.

GIANIGHIAN, G., PAVANINI, P., *Dietro i palazzi. Tre secoli di architettura minore a Venezia, 1492–1803*, Venice 1984.
Giovanni Bellini, 1500/1515, ed. A. Gentili, in *Venezia Cinquecento*, I.2, 1991.
GIRARDI, G., "San Moisè profeta a Venezia: da un impianto bizantino all'attuale configurazione ad aula unica," *Bollettino d'arte*, LXXV, 1990.
Giuseppe Maria Crespi and the Emergence of Genre Painting in Italy, exhib. cat., ed. F.T. Worth, Florence 1986.
The Glory of Venice, exhib. cat., ed. J. Martineau and A. Robison, New Haven–London 1994.
GOFFEN, R., *Devozione e committenza*, Venice 1991.
——*Giovanni Bellini*, New Haven–London 1989.
——"Paolo Veneziano e Andrea Dandolo. Una nuova lettura della Pala feriale," in H.R. Hahnloser, ed., *Il Tesoro di San Marco*, I, *La Pala d'Oro*, Venice 1994.
——*Piety and Patronage in Renaissance Venice. Bellini, Titian, and the Franciscans*, New Haven–London 1986.
GOI, P., "Sculture settecentesche nella chiesa dei Gesuiti a Venezia," in *I Gesuiti a Venezia. Momenti e problemi di storia veneziana della Compagnia di Gesù*, Atti del convegno di studi 1990, Padua 1994.
GOLDNER, G., "Niccol Ú- Lamberti and the Gothic sculpture of S. Marco in Venice," *Gazette des Beaux-Arts*, LXXXIX, 1977.
——"The decoration of the main facade window of San Marco in Venice," *Mitteilungen des Kunsthistorischen Institutes in Florenz*, XXI, 1977.
GOMBOSI, G., "Il più antico ciclo di mosaici di San Marco," *Dedalo*, XIII, 1933.
GONZALEZ-PALACIOS, A., "L'Album del Conte Cicognara, *Comma*, Aug.–Sept. 1970.
GOSS, P., "Parma-Venice-Trogir: hypothetical peregrinations of a thirteenth-century Adriatic sculptor," *Arte veneta*, XXXIV, 1980.
GOY, R.J., *The House of Gold: Building a Palace in Medieval Venice*, Cambridge 1992.
——*Venetian Vernacular Architecture: Traditional Housing in the Venetian Lagoon*, Cambridge 1989.
——"To the glory of God: building the church of S. Maria della Carità, Venice 1441–54," *Architectural History*, XXXVII, 1994.
GRANDESSO, E., *Portali medievali di Venezia*, Venice 1988.
GUADAGNINO LENCI, L., Per Giovanni Poleni. Note e appunti per una revisione critica," *Atti dell'Istituto veneto di scienze, lettere e arti*, CXXXIV, 1975–76.
GUERRIERO, S., "I rilievi marmorei della Cappella del Rosario ai Santi Giovanni e Paolo," *Saggi e memorie di storia dell'arte*, XIX, 1994.
——"Profilo di Alvise Tagliapietra," *Arte veneta*, XLVII, 1995.
Guglielmo Ciardi, exhib. cat., ed. L. Menegazzi, Treviso 1977.
Guglielmo Ciardi (1842–1917). Dipinti e disegni dalle collezioni di Ca' Pesaro, exhib. cat., ed. F. Scotton, Venice 1988.
Guido Cadorin 1892–1976, exhib. cat., Milan 1987

GUIDOTTI, F., "Il mestiere del 'dipintore' nell'Italia due-trecentesca," in *La Pittura in Italia. Il Duecento e il Trecento*, ed. E. Castelnuovo, II, Milan 1986.
GUIOTTO, M., "Vicende storiche e restauro della Villa Tiepolo a Zianigo di Mirano," *Ateneo veneto*, XIV, 1976.

HAHNLOSER, H.R., ed., *Il tesoro di San Marco* (I, *La Pala d'Oro*, Venice 1994 [1st. edn. Florence 1965], II, *Il tesoro e il museo*, Florence 1971).
HANNEGAN, B., "Antonio Zanchi and the ceiling of the salone of the Palazzo Barbaro Curtis," *Arte veneta*, XXXVII, 1983.
——*Venetian Ceiling Painting 1665–1730*, Ann Arbor, Michigan 1988.
HASKELL, F., "Francesco Guardi as a vedutista and some of his patrons," *Journal of the Warburg and Courtauld Institutes*, XXIII, 1960.
——*Patrons and Painters. Art and Society in Baroque Italy*, New Haven–London 1980.
——"Stefano Conti, patron of Canaletto and others," *Burlington Magazine*, XCVIII, 1956.
——"Su Francesco Guardi vedutista e alcuni suoi clienti," in *Francesco Guardi: vedute, capricci, feste*, exhib. cat., Venice 1993.
Hayez, exhib. cat. ed. M.C. Gozzoli and F. Mazzocca, Milan 1983.
HEIMBURGER, M., "Bernardo Keilhau a Venezia," *Arte veneta*, XXXIX, 1985.
——*Bernardo Keilhau detto Monsù Bernardo*, Rome 1988.
HELD, J., *The Oil Sketches of Peter Paul Rubens*, 2 vols., Princeton, 1978.
HENNESSEY, L.G., "Jacopo Amigoni (c. 1685–1752): an artistic biography with a catalogue of his Venetian paintings," PhD thesis, University of Kansas 1983.
HIBBARD, H.H, *Bernini*, Baltimore 1966.
HIRTHE, T., "Mauro Codussi als architekt des Dogen-palastes," *Arte veneta*, XXXVI, 1982.
HOCHMANN, M., *Peintres et commanditaires à Venise (1540–1628)* (Collection de l'École française de Rome, 155), Rome 1992.
HOWARD, D., "Giambattista Tiepolo's frescos for the church of the Pietà in Venice," *Oxford Art Journal*, IX, 1986.
——*Jacopo Sansovino: Architecture and Patronage in Renaissance Venice*, New Haven–London 1976.
——"Pietro Foscarini e l'altar maggiore della chiesa della Pietà a Venezia," *Arte veneta*, XLV, 1993.
——*The Architectural History of Venice*, London 1980.
——"Venice and Islam in the middle ages: some observations on the question of architectural influence," *Architectural History*, XXXIV, 1991.
HUBERT, G., *La sculpture dans l'Italie napoléonienne*, Paris 1964.
HUMFREY, P., *Cima da Conegliano*, Cambridge 1983.
——"Pittura e devozione: la tradizione narrativa quattrocentesca," in *La pittura nel Veneto. Il Quattrocento*, ed. F. Zeri, rev. edn., I, Milan 1989.

——*The Altarpiece in Renaissance Venice*, New Haven–London 1993.
HUSE, N., "Über ein Hauptwerk der venezianischen Skulptur des 13. Jahrhunderts," *Pantheon*, XXVI, 1968.
HUSE, N., WOLTERS, W., *The Art of Renaissance Venice*, Chicago 1990.
HUTTINGER, E., "Immagini e interpretazioni della Venezia dell '800," *Paragone*, CCLXXI, 1972.

Illuminismo e architettura del '700 veneto, exhib. cat., ed. M. Brusatin, Resana di Treviso 1969.
Ippolito Caffi. Viaggio in Oriente 1843–44, exhib. cat., ed. F. Scotton, Venice 1988.
ISERMEYER, C.A., *Das Reiterdenkmal des Colleoni*, Stuttgart 1963.
IVANOFF, N., "Gian Francesco Loredan e l'ambiente artistico a Venezia nel Seicento," *Ateneo veneto*, 1965.
——"La decorazione della Biblioteca di San Giorgio Maggiore," in *Le biblioteche del monastero di San Giorgio Maggiore*, Florence 1976.
——"Leopoldo Cicognara e il gusto dei Primitivi," *Critica d'arte*, Jan.–Feb. 1957.
——"Mons_ Bernardo e altri collaboratori del Longhena," *Arte veneta*, II, 1948.
——"Sebastiano Mazzoni," *Saggi e memorie di storia dell'arte*, II, 1958–59.
——"Un amico e seguace del Canova: Luigi Zandomeneghi (1778–1850)," *Ateneo veneto*, May–July 1941.
——"Una ignota opera del Longhena. L'altar maggiore dei Tolentini," *Ateneo veneto*, CXXXVI, 1945.

Jacopo Bassano, exhib. cat., ed. B.L. Brown and P. Marini, Bologna 1992.
Jacopo Tintoretto. Ritratti, ed. P. Rossi et al., Milan 1994.
JAFFÉ, M., *Rubens. Catalogo completo*, Milan 1989.
JESTAZ, B., *La Chapelle Zen à Saint-Marc de Venise: d'Antonio à Tullio Lombardo*, Wiesbaden 1986.
——"Requiem pour Alessandro Leopardi," *Revue de l'Art*, LV, 1982.
Johann Liss, exhib. cat., ed. B. Bushart and S.E. Lee, Augsburg 1975.
JULIER, J., *Venezia nella cultura artistica tedesca dell'Ottocento* (Centro Tedesco di Studi Veneziani, Quaderni 22A), Venice 1982.

KAFTAL, G., *Iconography of the Saints in the Painting of North-East Italy*, Florence 1978.
KAUFMANN, E., *L'architettura dell'illuminismo*, Turin 1966 (1st. edn. 1955).
KIESLINGER, F., "Le transenne della Basilica di San Marco del secolo XIII," *Ateneo veneto*, CXXXV, 1944.
KNOX, G., "'Philosopher Portraits' by Giambattista, Domenico and Lorenzo Tiepolo," *Burlington Magazine*, CXVII, 1975.
——*Anthony and Cleopatra in Russia. A Problem in the Editing of Tiepolo Drawings*, New York–London 1979.

——*Antonio Pellegrini 1675–1741*, Oxford 1995.
——"Ca' Sandi: la forza della eloquenza," *Arte/Documento*, VII, 1993.
——"Consul Smith's villa at Mogliano, Antonio Visentini and Francesco Zuccarelli," *Apollo*, CXLIII, 1996.
——"Forum: the Cavaliere Celesti and the decoration of Ca' Erizzo alla Maddalena," *Drawings*, XI, 1989.
——*Francesco Guardi as an Apprentice in the Studio of Giambattista Tiepolo*, 5 vols., ed. R.C. Rosbottom, Madison, Wisconsin 1976.
——*Giambattista Piazzetta 1682–1754*, Oxford 1992.
——*Giannantonio Pellegrini*, Oxford 1994.
——"Pagani, Pellegrini and Piazzetta from Ca' Corner to 'The Elms'," *Apollo*, Nov. 1979.
——"Some notes on large paintings depicting scenes from antique history by Ricci, Piazzetta, Bambini and Tiepolo," in *Atti del congresso internazionale di studi su Sebastiano Ricci e il suo tempo*, Milan [1976].
——"The Tasso cycles of Giambattista Tiepolo and Giannantonio Guardi," *Museum Studies*, IX, 1978.
——"The Tombs of Famous Englishmen as described in the letters of Owen McSwiney to the Duke of Richmond," *Arte veneta*, XXXVII, 1983.
——"Tiepolo triumphant. The Roman history cycles of Ca' Dolfin, Venice," *Apollo*, Nov. 1991.
KOZAKIEWICZ, S., *Bernardo Bellotto*, Recklinghausen 1972.
KULTZEN, R., *Alte Pinakothek*, V, *Italienische Malerei*, Munich 1975.

LACCHIN, E., *Di Francesco Pianta junior*, Venice 1930.
LAMBERTI, M.M., "1870–1915: i mutamenti del mercato e le ricerche degli artisti," in *Il Novecento*, Turin 1982 (*Storia dell'arte italiana*, VII).
LASAREV, V., "Maestro Paolo e la pittura veneziana del suo tempo," *Arte veneta*, VIII, 1954.
——review of R. Pallucchini, *La pittura veneziana del Trecento*, *Art Bulletin*, XLVIII, 1966.
LATTANZI, M., COLTELLACCI, S., *Giovanni Bellini. Pala dei Santi Girolamo, Ludovico e Cristoforo*, Venice 1985.
LAVAGNINO, E., *L'arte moderna. Dai neoclassici ai contemporanei*, Turin 1956.
LAZAREV, V., *Storia della pittura bizantina*, Turin 1967.
LAZZARINI, L., "'Dux ille Danduleus.' Andrea Dandolo e la cultura veneziana a metà del Trecento," *Civiltà veneziana*, Florence 1976.
——*Paolo de' Bernardo e i primordi dell'Umanesimo a Venezia*, Geneva 1930.
Le siècle de Rubens, exhib. cat., Brussels 1965.
Le siècle de Titien: L'âge d'or de la peinture à Venise, ed. M. Laclotte, Paris 1993.
Le Venezie possibili. Da Palladio a Le Corbusier, exhib. cat., ed. L. Puppi and G. Romanelli, Milan 1985.
LEVEY, M., *Giambattista Tiepolo*, New Haven–London 1986.

——*National Gallery Catalogues. The Seventeenth- and Eighteenth-Century Italian Schools*, London 1971.
——*Painting in Eighteenth-Century Venice*, New Haven–London 1994 (1st. edn. 1980).
LEVI, C.A., *Le collezioni d'arte e d'antichità dal secolo XIV ai nostri giorni*, Venice 1900.
LEWIS, D., *The Late Baroque Churches in Venice*, New York 1979.
I libri di San Marco. I manoscritti liturgici della basilica marciana, exhib. cat., ed. S. Marcon, Venice 1995.
LICHT, F., *Canova*, New York 1983.
LIEBERMAN, R., "Real architecture, imaginary history: the Arsenale gate as Venetian mythology," *Journal of the Warburg and Courtauld Institutes*, LV, 1991.
LIMENTANI, A., "Martin da Canal e \Les Estoires de Venise'," in *Storia della cultura veneta*, I, Vicenza 1976.
LINKS, J.G., *Canaletto and His Patrons*, New York 1977.
LOGU, G. DE, *Pittura italiana dell'Ottocento*, Bergamo 1955.
Longhena, exhib. cat., ed. L. Puppi, G. Romanelli, S. Biadene, Milan 1982.
LONGHI, R., "Calepino veneziano," *Arte veneta*, I, 1947.
——"Un ignoto corrispondente del Lanzi sulla Galleria di Pommersfelden (scherzo 1922)," *Proporzioni*, 1922 (repr. *Scritti giovanili 1912–1922*, Florence 1961).
LORENZETTI, G., *Ca' Rezzonico*, Venice 1936.
——"Il Palazzo Merati e i suoi stucchi," *Rivista di Venezia*, July 1931.
——*Venezia ed il suo estuario*, Venice 1926 (and later edns.).
LORENZONI, G., "Venezia medievale tra Oriente e Occidente," in *Storia dell'arte italiana*, II.I, *Dal Medioevo al Quattrocento*, Turin 1983.
Luca Carlevarijs e la veduta veneziana del Settecento, exhib. cat., ed. I. Reale and D. Succi, Milan 1994.
LUCCO, M., "Pittura del Trecento a Venezia," in *La pittura in Italia. Il Duecento e il Trecento*, ed. E. Castelnuovo, I, Milan 1986.
——"Venezia 1400–1430," in *La pittura nel Veneto. Il Quattrocento*, ed. F. Zeri, I, rev. edn., Milan 1989.
——*Sebastiano del Piombo*, Milan 1990.
Luigi Nono, exhib. cat., ed. G. Granzotto, Sacile 1990.
LUZIO, A., *La galleria dei Gonzaga venduta all'Inghilterra nel 1627–28*, Milan 1913.

MACCHIONI, S., GANGENI, G., "Danese Cattaneo," *Dizionario biografico degli Italiani*, XXII, Rome 1979.
MAEK-GüRARD, M., "Die 'Milanexi' in Venedig. Ein Beitrag zur Entwicklungsgeschichte der Lombardi-Werkstatt," *Wallraf-Richartz-Jahrbuch*, XLI, 1980.
MAGANI, F., *G.B. Bison*, Soncino 1993.
——*Giuseppe Bernardino Bison a Ceggia. Gli affreschi dell'oratorio "Bragadin,"* Ceggia 1994.
——"Luigi Minisini: gli ideali del vero," *Neoclassico*, II, 1992.
——"Teodoro Matteini amico di Giovanni De Lazara, ovvero lo studio dei 'Primitivi'

attraverso il recupero di Andrea Mantegna," *Atti dell'Istituto veneto di scienze, lettere ed arti*, CLI, 1992–93.
MAGRINI, M., *Francesco Fontebasso (1707–1769)*, Vicenza 1988.
——"Il Fontebasso nei palazzi veneziani," *Arte veneta*, XXVIII, 1974.
MAHON, D., "When did Francesco Guardi become a 'vedutista'?," *Burlington Magazine*, CX, 1968.
MALAMANI, V., *Canova*, Milan 1911.
MALTESE, C., *Storia dell'arte in Italia 1785–1943*, Turin 1960.
MANGINI, N., *I teatri di Venezia*, Milan 1974.
Manners and Morals, Hogarth and British Painting 1700–1760, exhib. cat., London 1987.
MARANGON, D., *Spazialismo: protagonisti, idee, iniziative*, Treviso 1993.
MARANGONI, L., *Ettore Tito*, Venice 1945.
Marco Ricci e il paesaggio veneto del Settecento, exhib. cat., ed. D. Succi and A. Delnieri, Milan 1993.
MARCON, S., "I codici medievali di San Cipriano di Murano," in *Il codice miniato. Atti del III congresso di storia della miniatura*, ed. M. Ceccanti and M.C. Castelli, Florence 1992.
MARETTO, P., *La casa veneziana nella storia della città dalle origini all'Ottocento*, Venice 1986.
MARETTO, P., MURATORI, S., *L'edilizia gotica veneziana*, Rome 1961.
MARIACHER, G., "Croci dipinte veneziane del Trecento," in *Scritti di storia dell'arte in onore di Lionello Venturi*, Rome 1956.
——"Il continuatore di Longhena a Palazzo Pesaro," *Ateneo veneto*, I, 1951.
——"L'arte dello stucco a Venezia nel 1700. Palazzo Sagredo a Santa Sofia," *Giornale economico*, IV, 1961.
——"L'arte dello stucco a Venezia nel 1700. Palazzo Zenobio ai Carmini," *Giornale economico*, IV, 1961.
——"Stuccatori ticinesi a Venezia tra la fine del '600 e la metà del '700," in *Arte e artisti dei laghi lombardi*, II, *Gli stuccatori dal barocco al rococ Ú-*, Como 1964.
MARIANI CANOVA, G., "La miniatura nei libri liturgici marciani," in G. Cattin, *Musica e liturgia a San Marco*, I, Venice 1990.
——*La miniatura veneta del Rinascimento, 1450–1500*, Venice 1969.
——"Miniatura e pittura in età tardogotica (1400–1440)," in *La pittura nel Veneto. Il Quattrocento*, ed. F. Zeri, I, rev. edn., Milan 1989.
MARINI, E., *Venezia antica e moderna*, Venice 1905.
Mario Cavaglieri. Gli anni brillanti. Dipinti 1912–1922, exhib. cat., ed. R. Monti and V. Vareilles, Milan 1993.
Mario Deluigi, exhib. cat., ed. G. Mazzariol, Venice 1966.
Mario Deluigi 1901–1978, exhib. cat., ed. L.B. Barbero and C. De Luigi Bianchi, Milan 1991.
Mario de Maria. Nell'atelier del pittore delle lune, exhib. cat., ed. J. Schulz, Milan 1983.
MARIUZ, A., "Capricci veneziani del Settecento," *Arte veneta*, XLII, 1988.

——"Due bambini di casa Pisani ritratti da Domenico Pellegrini," in *Per Maria Cionini Visani. Scritti di amici*, Turin 1977.
——*Giandomenico Tiepolo*, Venice 1971.
——"La Magnifica Sala' di Palazzo Dolfin a Venezia: gli affreschi di Nicolò Bambini e Antonio Felice Ferrari," *Arte veneta*, XXXV, 1981.
——*L'opera completa del Piazzetta*, Milan 1982.
——"Luca Carlevarijs: 'L'ingresso solenne dell'Abate de Pomponne'," *Arte veneta*, XLVI, 1994.
——"Una precisazione sul 'Consilium in Arena' del Museo Civico di Udine," *Arte veneta*, XXVI, 1972.
MARIUZ, A., PAVANELLO, G., "Disegni inediti di Antonio Canova da un taccuino 'Canal'," *Saggi e memorie di storia dell'arte*, XIX, 1994.
——"Le decorazioni del palazzo e della villa dei Baglioni," *Arte veneta*, XLIV, 1993.
MARIUZ, P., "Francesco Gallimberti: dai 'Fasti veneziani' alle 'Carceri sotterraccuee'," in *L'Europa delle corti alla fine dell'antico regime*, ed. C. Mozzarella and G. Venturi, Rome 1991.
MARKHAM SCHULZ, A., *Antonio Rizzo, Sculptor and Architect*, Princeton, N.J. 1983.
——"Bartolomeo di Francesco Bergamasco" in *Interpretazioni veneziane. Studi di storia dell'arte in onore di Michelangelo Muraro*, ed. D. Rosand, Venice 1984.
——"Four new works by Antonio Minello," *Mitteilungen des Kunsthistorischen Institutes in Florenz*, XXXI, 1987.
——*Giambattista and Lorenzo Bregno. Venetian Sculpture in the High Renaissance*, Cambridge 1991.
——"Giovanni Buora lapicida," *Arte lombarda*, LXVI, 1983.
——"In pursuit of the real Bartolomeo Buon," *Art Bulletin*, 1974.
——*Niccolò di Giovanni Fiorentino and Venetian Sculpture of the Early Renaissance*, New York 1978.
——"Paolo Stella Milanese," *Mitteilungen des Kunsthistorischen Institutes in Florenz*, XXIX, 1985.
——"The sculpture of Giovanni and Bartolomeo Buon and their workshop," *Transactions of the American Philosophical Society*, LXVIII, 1978.
MARTIN, T., *Alessandro Vittoria and the Portrait Bust in Renaissance Venice* (forthcoming).
MARTINI, E., "I dipinti di Francesco Fontebasso a Palazzo Duodo," *Notizie da Palazzo Albani*, I, 1973.
——*La pittura del Settecento veneto*, Udine 1982 (1st. edn. 1964).
——"Novità per Jacopo Guarana," *Labyrinthos*, VI, 1987.
MARX, B., *Venezia-altera Roma? Ipotesi sull'umanesimo veneziano* (Centro tedesco di studi veneziani, Quaderni, 10), Venice, 1978.
MASCHIO, R., "Giorgio Fossati trattatista. Un divulgatore della cultura architettonica europea alle origini del Neoclassicismo," *Arte lombarda*, CV–CVII, 1980.
MASSARI, A., *Giorgio Massari architetto veneziano del Settecento*, Vicenza 1971.

MASON, S., "La pittura del Seicento a Venezia," in *Antonio Carneo nella pittura veneziana del Seicento*, exhib. cat., ed. C. Furlan, Milan 1995.
MASON RINALDI, S., *Palma il Giovane. L'opera completa*, Milan 1984.
MAZZA, B., "Le vicende dei 'Tombeaux des Princes': matrici, storia e fortuna della serie McSwiney tra Bologna e Venezia," *Saggi e memorie di storia dell'arte*, X, 1976.
MAZZARIOL, G., DORIGATO, A., *Interni veneziani*, Cittadella 1989.
MAZZOCCA, F., *Hayez*, Milan 1994.
McANDREW, J., *Venetian Architecture of the Early Renaissance*, Cambridge, Mass. 1980.
McHAM, S.B., *The Chapel of St. Anthony at the Santo and the Development of Venetian Renaissance Sculpture*, Cambridge 1994.
MEISS, M., "The Madonna of Humility," *Art Bulletin*, 1936.
MELLER, P., "Marmi e bronzi di Simone Bianco," *Mitteilungen des Kunsthistorischen Intitutes in Florenz*, XXI, 1977.
MENATO, G., "Contributi a Luigi Dorigny," *Arte veneta*, XXI, 1967.
MENEGAZZI, L., "Guglielmo Ciardi, Soncino 1993.
MERKEL, E., "Gli affreschi dell' 'andito Foscari' a San Marco," *Quaderni della Soprintendenza ai Beni Artistici e Storici di Venice*, VII, 1978.
——"I maestri della 'Crocifissione' della chiesa di San Nicolò dei Mendicoli," *Quaderni della Soprintendenza ai Beni Artistici e Storici di Venice*, VII, 1978.
——"La pittura del Gotico internazionale," in *Storia di Venezia. L'Arte*, Rome 1994.
——"Venezia 1430–1450," in *La pittura nel Veneto. Il Quattrocento*, ed. F. Zeri, I, rev. edn., Milan 1989.
Michelangelo Grigoletti e il suo tempo, exhib. cat., ed. G.M. Pilo, Milan 1971.
MOENCH SHERER, E., "Verona," in *La pittura nel Veneto. Il Quattrocento*, ed. F. Zeri, I, rev. edn., Milan 1989.
MOLÀ, L., *La comunità dei lucchesi a Venezia. Immigrazione e industria della seta nel tardo Medioevo*, Venice 1994.
MOLMENTI, P., *La pittura veneziana*, Florence 1903.
MORASSI, A., *A Complete Catalogue of the Paintings of G.B. Tiepolo*, London 1962.
——*Guardi. I dipinti*, 2 vols., Milan 1973.
MORETTI, L., "Ambienti dogali," in *I Dogi*, Milan 1982.
——"Antonio Molinari rivisitato," *Arte veneta*, XXXIII, 1979.
——"Documenti e appunti su Sebastiano Ricci (con qualche cenno su altri pittori del Settecento)," *Saggi e memorie di storia dell'arte*, II, 1978.
——"I Pisani di Santo Stefano e le opere d'arte del loro palazzo," in *Il conservatorio di musica Benedetto Marcello di Venezia*, Venice 1977.
——"La data degli apostoli della chiesa di San Stae," *Arte veneta*, XXVII, 1973.
——"Nuovi documenti sul Ponzone e sul Forabosco," *Arte veneta*, XL, 1986.
MOROZZO DELLA ROCCA, R., TIEPOLO, M.F., "Cronologia veneziana dal 1300 al 1600," in *Storia della civiltà*

veneziana, II, *Autunno del Medioevo e Rinascimento*, Venice 1979.
MORTARI, L., *Bernardo Strozzi*, Rome 1966.
MOSCHINI, V., "Sculture ignote di Enrico Meyring e di Giacomo Piazzetta," *Arte veneta*, XVIII, 1964.
MOSCHINI MARCONI, S., *Gallerie dell'Accademia di Venezia*, I, Rome 1955.
——*Gallerie dell'Accademia di Venezia. Opere d'arte dei secoli XVII, XVIII, XIX*, Rome 1970.
Mostra Canoviana, exhib. cat., ed. L. Coletti, Treviso 1957.
Mostra dei Guardi, exhib. cat., ed. P. Zampetti, Venice 1965.
MUNMAN, R., "Giovanni Buora, the 'missing' sculpture," *Arte veneta*, XXX, 1976.
——"The sculpture of Giovanni Buora: a supplement," *Arte veneta*, XXXIII, 1979.
MURARO, M., "Antichi affreschi veneziani," *Le meraviglie del passato*, Milan 1954.
——*Il "Libro secondo" di Francesco e Jacopo dal Ponte*, Bassano del Grappa 1992.
——"La scala senza giganti," in *De artibus opuscula XL. Essays in Honor of Erwin Panofsky*, ed. M. Meiss, I, New York 1961.
——*La vita nelle pietre. Scultura marciana e civiltà veneziana del Duecento*, Venice 1985.
MURARO, M., "Le arti," in *Componenti storico-artistiche e culturali a Venezia nei secoli XIII e XIV*, Venice 1981.
——"Maestro Marco e Maestro Paolo da Venezia," in *Studi di storia dell'arte in onore di Antonio Morassi*, Venice 1971.
——*Nuova guida di Venezia e delle sue isole*, Florence 1953.
——*Palazzo Contarini a S. Beneto*, Venice 1970.
——*Paolo da Venezia*, Milan 1969.
——*Pitture murali nel Veneto e tecnica dell'affresco*, exhib. cat., Venice 1960.
MURARO, M., ROSAND, D., *Tiziano e la silografia veneziana del Cinquecento*, Vicenza 1976.
Museo di Torcello. Sezione medievale e moderna, Venice 1978.

NANI MOCENIGO, F., *Della letteratura veneziana nel secolo XIX*, Venice 1916.
NAVA CELLINI, A., "La scultura del Seicento," in *Storia dell'arte italiana*, Turin 1982.
NEGRI, A., *Il Realismo. Dagli anni Trenta agli anni Ottanta*, Bari 1994.
NEPI SCIRÈ, G., *Gallerie dell'Accademia*, Venice 1991.
NICODEMI, G., *Francesco Hayez*, Milan 1962.
NICOLSON, B., KERSLAKE, J., *The Treasures of the Foundling Hospital*, London 1982.
NIERO, A., "Censimento delle Pale nell'area lagunare," in H.R. Hahnloser, ed., *Il tesoro di San Marco*, I, *La Pala d'Oro*, Venice 1994.
——*San Giacomo dell'Orio*, Venice 1990.
NOÉ, E., "Rezzonicorum Cineres. Ricerche sulla collezione Rezzonico," *Rivista dell'Istituto Nazionale d'Archeologia e Storia dell'Arte*, III, 1980.

NORWICH, J.J., *A History of Venice*, New York 1989.

Odorico Politi, exhib. cat., ed. G. Comelli, Udine 1947.
OLIVATO, L., "Storia di un'avventura edilizia a Venezia tra il Seicento e il Settecento. Palazzo Cornaro della Regina," *Antichità Viva*, XX, 1973.
OLIVATO PUPPI, L., PUPPI, L., *Mauro Codussi*, Milan 1977.
OTTANI CAVINA, A., *Carlo Saraceni*, Milan 1968.
Ottant'anni di allestimenti alla Biennale, exhib. cat., ed. G. Romanelli, Venice 1977.
L'800 a Venezia. Aspetti della pittura dell'800 a Venezia, exhib. cat., Venice 1977.

PADOA RIZZO, A., "Cristoforo Cortese," in *Dizionario biografico degli italiani*, XXIX, Rome 1983.
PADOAN URBAN, L., "Catalogo delle opere di Giambattista Canal (1745–1825)," *Atti dell'Istituto veneto di scienze, lettere ed arti*, CXXVIII, 1970.
——*La decorazione del Bevilacqua alle Procuratie Vecchie*," *Arte veneta*, XXII, 1970.
PADOVANI, S., "Una nuova proposta per Zanino di Pietro," *Paragone*, XXXVI, 1985.
The Painted Page. Italian Renaissance Book Illumination. 1450–1550, ed. J.J.G. Alexander, London–Munich 1995.
Painters of Venice. The Story of the Venetian "vedute," exhib. cat., B. Aikema and B. Baker, Amsterdam 1990.
La pala ricostituita. L'Incoronazione della Vergine e la cimasa vaticana di Giovanni Bellini. Indagini e restauri, exhib. cat., ed. M.R. Valazzi, Venice 1988.
PALLUCCHINI, A., *L'opera completa di Giambattista Tiepolo*, Milan 1968.
PALLUCCHINI, R., *La Galleria Internazionale d'Arte Moderna della Città di Venezia. Catalogo*, Venice 1938.
——*La pittura nel Veneto. Il Settecento*, Milan 1995 (first pub. as *La pittura veneziana del Settecento*, Venice–Rome 1960).
——*La pittura veneziana del Seicento*, 2 vols., Milan 1981.
——*La pittura veneziana del Trecento*, Venice–Rome 1964.
——*Nota per Paolo Veneziano*," in *Scritti di storia dell'arte in onore di Lionello Venturi*, Rome 1956.
PALLUCCHINI, R., ROSSI, P., *Tintoretto. Le opere sacre e profane*, 2 vols., Milan 1982.
Palma il Giovane 1548–1628: Disegni e dipinti, ed. S. Mason Rinaldi, Milan 1990.
PALUMBO-FOSSATI, C., *Gli architetti del Seicento Antonio e Giuseppe Sardi e il loro ambiente*, Bellinzona 1988.
PALUDETTI, G., *Giovanni De Min*, Udine 1959.
PANOFSKY, E., "The history of the theory of proportion as a reflection of the history of styles," in *Meaning in the Visual Arts*, New York 1955.
PANZEVI, L., "Ai Frari un ascetico Crocifisso umbro," *Giornale dell'Arte*, CII, 1992.

PAOLILLO, D.R., DALLA SANTA, C., *Il Palazzo Dolfin Manin a Rialto*, Venice 1970.

Paolo Veronese: disegni e dipinti, ed. A. Bettagno, Vicenza 1988.

PARISET, F.G, *Georges de la Tour*, Paris 1948.

PAVAN, M., "Antonio Canova," in *Dizionario biografico degli Italiani*, XVIII, Rome 1975.

PAVANELLO, G., "Antonio Balestra a Venezia: la pala dei Santi Biagio e Cataldo e il suo intervento a Ca' Savorgnan," *Arte veneta*, XXXIII, 1979.

——"Antonio Canova: i bassorilievi 'Rezzonico'," *Bollettino del Museo Civico di Padova*, LXXIII, 1984.

——"Antonio d'Este amico di Canova, scultore," *Antologia di Belle Arti*, XXXV–XXXVIII, 1990.

——"Collezioni di gessi canoviani in età neoclassica: Padova," *Arte in Friuli Arte a Trieste*, XII–XIII, 1993.

——"Collezionismo di gessi canoviani in età neoclassica: Venezia," *Arte in Friuli Arte a Trieste*, XV, 1995.

——"Costantino Cedini (1741–1811)," *Bollettino del Museo Civico di Padova*, LXI, 1972.

——"Decorazioni settecentesche in due palazzi veneziani," *Antichità Viva*, XV, 1976.

——"Federico Zandomeneghi tra Venezia e Firenze," in *Federico Zandomeneghi. Un veneziano a Paris*, exhib. cat., Milan 1988.

——"Francesco Bagnara, Davide Rossi, Luigi Zandomeneghi alla villa Comello di Mottinello Nuovo," *Antichità viva*, XII, 1973.

——"Giovanni Scajario pittore tiepolesco," *Arte veneta*, XXXII, 1978.

——"Giovanni Volpato incisore a Bassano e a Roma," *Arte veneta*, XLII, 1988.

——"Hayez frescante neoclassico," *Arte veneta*, XXXI, 1977.

——"I disegni di Giovanni Carlo Bevilacqua del Museo Correr," *Bollettino dei Musei Civici Veneziani*, I–II, 1973.

——"Il 'Parnaso Veneto' di Francesco Hayez," *Neoclassico*, I, 1992.

——"L'ornatissimo" Pedrocchi, in *Il Caffè Pedrocchi in Padova. Un luogo per la società civile*, ed. B. Mazza, Padua 1984.

——"La decorazione dei palazzi veneziani negli anni del dominio austriaco (1814–1866)," in *Il Veneto e l'Austria. Vita e cultura artistica nelle città venete 1814–1866*, exhib. cat., Milan 1989.

——"La decorazione del Palazzo Reale di Venezia," *Bollettino dei Musei Civici Veneziani*, I–II, 1976.

——"La decorazione neoclassica a Padova," *Antologia di Belle Arti*, XIII–XIV, 1980.

——"La decorazione neoclassica nei palazzi veneziani," in *Venezia nell'età di Canova 1780–1830*, exhib. cat., Venice 1978.

——"La pittura dell'Ottocento a Venezia," in *La pittura in Italia. L'Ottocento*, Milan 1990.

——"L'autobiografia e il catalogo delle opere di Giovanni Carlo Bevilacqua," *Atti dell'Istituto veneto di scienze, lettere ed arti*, 1972.

——"Le decorazioni di Palazzo Grassi," in *Palazzo Grassi*, Venice 1986.

——"Le decorazioni settecentesche di Palazzo Soranzo Piovene," in *Il Palazzo Soranzo-Piovene di Venezia*, Venice 1994.

——"L'opera completa del Canova," Milan 1976.

——"L'Ottocento," in *Gli affreschi nelle ville venete dal Seicento all'Ottocento*, Venice 1978.

——"Per Gaspare Diziani decoratore," *Arte veneta*, XXXV, 1981.

——"Un 'copia-lettere' di Giovanni Antolini 'Regio architetto' a Venezia," *Arte in Friuli Arte a Venezia*, XI, 1989.

PEDROCCO, F., *Giandomenico Tiepolo a Zianigo*, Villorba 1988.

——"L'Oratorio del Crocifisso nella chiesa di San Polo," *Arte veneta*, XLIII, 1989–90.

PEDROCCO, F., MONTECUCCOLI DEGLI ERRI, F., *Antonio Guardi*, Milan 1992.

PELLEGRITI, R., "La chiesa dell'Ospedale di San Lazzaro dei Mendicanti," *Arte veneta*, XLIII, 1989–90.

PEROCCO, G., *Ca' Pesaro. La Galleria d'Arte Moderna di Venezia*, Bergamo 1959.

——"Il momento della pittura veneziana negli anni venti," in *Eugenio da Venezia. La donazione Querini Stampalia*, exhib. cat., Milan 1990.

——*Ippolito Caffi 1809–1866*, exhib. cat., Venice 1979.

——*Ippolito Caffi*, exhib. cat., Venice 1966.

——*La pittura veneta dell'Ottocento*, Milan 1967.

——*Le origini dell'arte moderna a Venezia (1908–1920)*, Treviso 1972 (1st. edn. Turin 1965).

——*Luigi Nono*, exhib. cat., Venice 1964.

——*Mostra dei pittori veneziani dell'Ottocento*, exhib. cat., Venice 1962.

PEROCCO, G., SALVADORI, A., *Civiltà di Venezia*, III, Venice 1976.

PERRY, M., "Antonio Sanquirico, art merchant of Venice," *Labyrinthos*, I, 1982.

PESARO, C., "Michele Giambono," *Saggi e memorie di storia dell'arte*, XVIII, 1992.

——"Un'ipotesi sulle date di partecipazione di tre artisti veneziani alla decorazione della sala del Maggior Consiglio nella prima metà del Quattrocento," *Bollettino dei Musei Civici Veneziani*, XXIII, 1978.

Pietro Longhi, exhib. cat., ed. A. Mariuz, G. Pavanello and G. Romanelli, Milan 1993.

PIGNATTI, T., *Giorgione*, trans. C. Whitfield, London 1969.

——*Il Museo Correr di Venezia. Dipinti del XVII e XVIII secolo*, Venice 1960.

——*Le scuole di Venezia*, Milan 1981.

——*Longhi*, London 1969.

——*L'opera completa di Pietro Longhi*, Milan 1974.

——*Origini della pittura veneziana*, Bergamo 1961.

——"Pittori veneti dell'Ottocento da Canova a Favretto," in *Studia Ghisleriana*, serie II, I, 1950.

——*Veronese. L'opera completa*, 2 vols., Venice 1976.

PIGNATTI, T., PEDROCCO, F., *Veronese*, 2 vols., Milan 1995.

PIGNATTI, T., PEDROCCO, F., MARTINELLI PEDROCCO, E., *Palazzo Labia a Venezia*, Turin 1982.

PILO, G.M., "Due ritratti di Alvise Pisani di Domenico Pellegrini," *Paragone*, July 1965.

——"Francesco Zugno," *Saggi e memorie di storia dell'arte*, II, 1959.

——*Pittura dell'Ottocento a Bassano*, exhib. cat., Bassano del Grappa 1961.

PINCUS, D., *The Arco Foscari. The Building of a Triumphal Gateway in Fifteenth-Century Venice*, New York–London 1976.

PINTO, S., "La promozione delle arti negli Stati italiani dall'età delle riforme all'Unità," in *Storia dell'arte italiana, Settecento e Ottocento*, Turin 1982.

PIPERATA, C., *Giuseppe Bernardino Bison*, Padua 1940.

PIROVANO, C., ed., *La pittura in Italia. Il Novecento*, 2 vols., Milan 1993.

——ed., *Scultura italiana del Novecento*, Milan 1991.

PISTELLATO, P., "Venezia nella pittura simbolista di area veneta fra '800 e '900," PhD thesis, Universities of Venice-Padua-Trieste, 1991.

PITTALUGA, M., *Il pittore Ippolito Caffi*, Vicenza 1971.

La pittura del Seicento a Venezia, exhib. cat., ed. P. Zampetti, G. Mariacher and G.M. Pilo, Venice 1959.

La pittura nel Veneto. Il Quattrocento, 2 vols., ed. F. Zeri, Milan 1989.

PLANISCIG, L., *Venezianische Bildhauer der Renaissance*, Vienna 1921.

PODREIDER, F., *Storia dei tessuti d'arte in Italia*, Bergamo 1928.

POHLAND, W., "Antonio Rizzo," *Jahrbuch der Berliner Museen*, XIII, 1971.

POLACCO, R., "I bassorilievi marmorei duecenteschi raffiguranti il Cristo e gli Evangelisti sulla facciata settentrionale della basilica di San Marco," *Arte veneta*, XXXII, 1978.

——*La cattedrale di Torcello*, Venice-Treviso 1984.

——"Le colonne del ciborio di San Marco," *Venezia Arti*, 1987.

——"San Marco e le sue sculture nel Duecento," in *Interpretazioni veneziane. Studi di storia dell'arte in onore di M. Muraro*, ed. D. Rosand, Venice 1984.

——*San Marco: la Basilica d'oro*, Milan 1991.

——"Una nuova lettura della Pala d'Oro," *Venezia Arti*, 1987.

——"Una nuova lettura della Pala d'Oro. Gli smalti, le oreficerie e il ciborio," in M. Polazzo, *Antonio Balestra, pittore veronese del Settecento*, Verona 1990.

POLIGNANO, F., "Ritratto e sistema simbolico nelle 'Dame' di Vittore Carpaccio," in *Il ritratto e la memoria. Materiali 3*, ed. A. Gentili, P. Morel and C. Cieri Via, Rome 1993.

POMIAN, K., *Collezionisti, amatori e curiosi. Paris-Venezia XVI–XVIII secolo*, 1987, Milan 1989.

POPE-HENNESSY, J., *Italian High Renaissance and Baroque Sculpture*, London 1983.

POSNER, D., "Pietro da Cortona, Pittoni, and the plight of Polyxena," *Art Bulletin*, LXXIII, 1991.

POSPISIL, M., POSPISIL, F., *Guglielmo Ciardi*, Florence 1947.

PRAZ, M., *Le bizzarre sculture di Francesco Pianta*, 1959, repr. in *Il giardino dei sensi. Studi sul manierismo e il barocco*, Vicenza 1975.

PREDAVAL, G., *Pietro Fragiacomo*, Milan 1945.

PRETO, P., "L'illuminismo veneto," in *Storia della cultura veneta, Il Settecento*, ed. G. Arnaldi and M. Pastore Stocchi, V.1, Vicenza 1985.

PREVITALI, G., "Alcune opere fuori contesto. Il caso di Marco Romano," *Bollettino d'Arte*, LXVII, 1983.

PRIJATELJ, K., "Neobjelodanjena slika iz Kruga Paolo Veneziano u Splitu [Un dipinto inedito della cerchia di Paolo Veneziano a Spalato]," *Prilozi Povijesti umijetuosti u Dalmaciji*, XXVI, 1986–87.

Il primo '800 italiano. La pittura tra passato e futuro, exhib. cat., Milan 1992.

PULLAN, B., *Rich and Poor in Renaissance Venice*, Oxford 1971.

PUPPI, L., "'Venecia de cristal y crepusculo'," in *Nel mito di Venezia. Autocoscienza urbana e costruzione delle immagini: saggi di lettura*, Venice 1994.

——"La vera origine della famiglia Longhena e Melchisedec tagliapietra," in *Miscellanea di studi in onore di Gino Barbieri*, Verona 1983.

——"Sulla storia del collezionismo a Venezia nel '600," *Arte veneta*, XIX, 1965.

RAGGHIANTI, C.L., "Studi sul Canova," *Critica d'arte*, July–Aug. 1957.

RAHTGENS, H., *S. Donato zu Murano und ihr ähnliche venezianische Bauten*, Berlin 1903.

Rare Etchings by Giovanni Battista and Giovanni Domenico Tiepolo, exhib. cat., ed. H.D. Russell, Washington, DC 1971.

RAVÀ, A., "Appartamenti e arredi veneziani del Settecento, I. Il Ridotto della Procuratessa Venier," *Dedalo*, II, 1921–29.

RAVEGNANI, G., *La biblioteca del monastero di San Giorgio Maggiore a Venezia*, Venice 1976.

RAVELLI, L., "Un pittore partenopeo a Bergamo: Nicola Malinconico e le sue 'Historiae Sacrae' per Santa Maria Maggiore," *Atti dell'Ateneo di scienze, lettere ed arti*, XLVIII, 1988.

REALE, I., "Odorico Politi," *Antologia di Belle Arti*, XII–XIII, 1990.

Realismo magico, Pittura e scultura in Italia 1919–1925, exhib. cat., ed. M. Fagiolo Dell'Arco, Milan 1988.

Renaissance Master Bronzes from the Collection of the Kunsthistorisches Museum, exhib. cat., ed. M. Liethe-Jasper, Vienna-Washington, D.C. 1986.

"Renovatio Urbis". Venezia nell'età di Andrea Gritti (1523–1538), ed. M. Tafuri, Rome 1984.

RENZI, L., "Il Francese come lingua letteraria e il franco-lombardo. L'epica carolingia nel Veneto," in *Storia della cultura veneta*, I, Vicenza 1976.

RICCOBONI, A., "Antonio Zanchi (1631–1722)," *Acropoli*, II, 1961–62.

RICCOMINI, E., "Opere veneziane di Giuseppe Maria Mazza," *Arte veneta*, XXI, 1967.

RIZZI, A., *Atlante di storia dell'arte nel Friuli Venezia Giulia*, Udine 1979.

——*Cento disegni del Bison*, exhib. cat., Udine 1962.

——*Lattanzio Querena a Venezia e nel suo entroterra*, Martellago 1989.
——*Luca Carlevarijs*, Venice 1967.
——*Scultura esterna a Venezia*, Venice 1987.
——*Vere da pozzo di Venezia*, Venice 1981.
——"Arte nel Veneto negli anni venti e trenta," in *Pittura a Treviso tra le due guerre*, exhib. cat., ed. M. Goldin, Treviso 1990.
RIZZI, P., DI MARTINO, E., *Storia della Biennale 1895–1982*, Milan 1982.
ROECK, B., *Arte per l'anima, arte per lo stato. Un doge del tardo Quattrocento ed i segni delle immagini* (Centro tedesco di Studi veneziani. Quaderni, 40), Venice 1991.
RÖLL, J., *Giovanni Dalmata*, Worms 1994.
ROMANELLI, G., *Ca' Corner della Ca' Grande: Architettura e committenza nella Venezia del Cinquecento*, Venice 1993.
——"Canaletto e Visentini, due operatori del club Smith," in *Canaletto e Visentini tra Venezia e London*, exhib. cat., ed. D. Succi, Cittadella 1986.
——"Due progetti di un arco per Napoleone," *Arte veneta*, XXVII, 1973.
——"Il contributo tedesco alle prime Biennali veneziane," in *Incontri italo-tedeschi al volgersi del diciannovesimo secolo* (Centro tedesco di studi veneziani. Quaderni, 22A) Venice 1982.
——"Lorenzo Urbani architetto veneziano," *Antichità viva*, I, 1974.
——"L'Ottocento: dall'Accademia alla Biennale," in *Veneto*, Milan 1977.
——"Per G.A. Selva urbanista: inediti sui giardini di Castello," *Arte veneta*, XXVI, 1972.
——"Per Giuseppe Borsato: una economica dipintura del teatro La Fenice nel 1808; e origini della loggia imperiale," *Atti dell'Istituto veneto di scienze, lettere ed arti*, CXXXIII, 1975.
——"Storia e mitologia nel casino degli Erizzo: la stagione neoclassica," in *Palazzo Ziani. Storia, architettura, decorazioni*, Venice 1994.
——*Tintoretto. La Scuola Grande di San Rocco*, Milan 1994.
——*Tra gotico e neogotico. Palazzo Cavalli Franchetti a San Vidal*, Venice 1989.
——*Venezia Ottocento: Materiali per una storia architettonica e urbanistica della città nel secolo XIX*, Rome 1977.
ROMANELLI, G., BIADENE, S., *Venezia piante e vedute. Catalogo del fondo cartografico a stampa del Museo Correr*, Venice 1982.
ROMANO, S., *La Porta della Carta. I restauri*, Venice 1979.
——"Palazzi veneziani: scoperte. Un ciclo di Niccolò Bambini nel palazzetto Zane a Venezia," *Ricerche di storia dell'arte*, XVII, 1982.
ROSAND, D., *Painting in Sixteenth-Century Venice. Titian, Veronese, Tintoretto*, Cambridge–New York 1997 (1st. edn. 1982).
——*Tiziano*, Milan 1983.
ROSSI, P., "'Claudius Perreau Parisinus' a Venezia," *Arte veneta*, XLIII, 1989–90.
——"Appunti sull'attività veneziana di Clemente Molli," *Venezia Arti*, III, 1989.

——"Bernardo Falconi collaboratore del Longhena negli altari dei Santi Giovanni e Paolo e di San Pietro di Castello," in *Scritti in onore di Elena Bassi. Studi sul Neoclassicismo e sull'architettura veneziana*, ed. A. Bettagno, Venice 1995.
——"Due aggiunte al catalogo delle opere veneziane di Bernardo Falconi," in *Per Giuseppe Mazzariol* (Quaderni di Venezia Arti, I), Rome 1992.
——*Francesco Maffei*, Milan 1991.
——*Girolamo Campagna*, Verona 1968.
——"I 'marmi loquaci' del monumento Pesaro ai Frari," *Venezia Arti*, IV, 1990.
——"Il monumento a Girolamo Cavazza," in L. Moretti, A. Niero and P. Rossi, *La chiesa del Tintoretto. Madonna dell'Orto*, Venice 1994.
——"La decorazione scultorea dell'altar maggiore della chiesa di San Cassiano," *Arte veneta*, XLVI, 1994.
——"La scultura veneziana del Seicento e del Settecento. Nota per la datazione delle sculture di Enrico Merengo e Giovanni Comin dell'altare di Barcola," *Venezia Arti*, IV, 1990.
——"La scultura veneziana del Seicento," in *Storia di Venezia*, Venice 1995.
——"Per il catalogo di Enrico Merengo," *Arte/Documento*, V, 1993.
——"Ritratti funebri e commemorativi di Enrico Merengo," *Venezia Arti*, VIII, 1994.
——*Tintoretto: I ritratti*, Venice 1974.
——"Michele Fabris (also called Ongaro)," *Dizionario biografico degli Italiani*, XLIII, Rome 1993.
——"Bernardo Falconi," *Dizionario biografico degli Italiani*, Rome 1994.
ROSSI BORTOLATO, L., *L'opera completa di Francesco Guardi*, Milan 1974.
ROSSI SCARPA, G., "I mosaici del secolo XIV nel Battistero e nella Cappella di Sant'Isidoro," in *San Marco. La basilica d'oro*, Milan 1991.
ROTONDI BRIASCO, P., *Filippo Parodi* (Quaderni dell'Istituto di Storia dell'Arte, Università di Genova, III), Genoa 1962.
RUBIN DE CERVIN, A., "Un palais romantique à Venise," *L'Oeil*, Jan. 1966.
RUGGERI, U., "Alessandro Varotari detto il Padovanino," *Saggi e memorie di storia dell'arte*, XVI, 1988.
——*Pietro e Marco Liberi, pittori nella Venezia del Seicento*, Rimini 1996.
RYKWERT, J., *The First Moderns. The Architecture of the Eighteenth Century*, Cambridge, Mass.–London 1980.
RYLANDS, P., *Palma il Vecchio*, Cambridge 1992.

SAFARIK, E.A., *Fetti*, Milan 1990.
——"La mostra di Johann Liss," *Arte veneta*, XXIX, 1975.
——"Per la pittura veneziana del Seicento. Sebastiano Mazzoni," *Arte veneta*, XXVIII, 1974.
——"Pietro Negri," *Saggi e memorie di storia dell'arte*, XI, 1978.
——"Riflessioni su *La pittura veneziana del Seicento* di Rodolfo Pallucchini," *Arte veneta*, XXXV, 1981.
SAFARIK, E.A., MILANTONI, G., "La pittura del Seicento a Venezia," in *La pittura in Italia. Il Seicento*, ed. M. Gregori and E. Schleier, 2 vols., Milan 1989.

SALMI, M., *L'abbazia di Pomposa*, Milan 1936, 1966.
SALVINI, R., "Giotto," in *Bibliografie e Cataloghi*, IV, 1970 (1st. edn. 1938).
SANDBERG VAVALÀ, E., "Maestro Paolo Veneziano," *Burlington Magazine*, LII, 1930.
SANI, B., *Rosalba Carriera*, Turin 1988.
SANTANGELO, A., *Tessuti d'arte italiani*, Milan 1951.
SANTINI, C., "Un'antologia pittorica del primo Trecento nella chiesa di San Francesco di Udine," *Arte cristiana*, LXXXII, 1994.
SAVINI BRANCA, S., *Il collezionismo veneziano nel '600*, Padua 1965.
SCARFÀ, S., "L'attività pittorica di Gaetano Zompini," *Venezia Arti*, VIII, 1994.
SCARPA SONINO, A., *Jacopo Amigoni*, Soncino 1994.
——*Marco Ricci*, Milan 1991.
SCATTOLIN, G.. *Contributo allo studio dell'architettura civile veneziana dal IX al XIII secolo. Le case-fondaco sul Canal Grande*, Venice 1961.
Scenografi veneziani dell'Ottocento, exhib. cat., ed. G. Damerini, Venice 1962.
SCHLEGEL, U., "Simone Bianco und die venezianische Malerei," *Mitteilungen des Kunsthistorischen Institutes in Florenz*, XXIII, 1979.
SCHMIDT, O.E., *Minister Graf Brühl und Karl Heinrich von Heinecken (1733–1763)*, Leipzig-Berlin 1921.
SCHULLER, M., *Die Ecke des Dogenpalasts. Ein Vorbericht zur Architektur Filippo Calendarios* (Forschungsforum, Berichte aus der Otto-Friedrich-Universität Bamberg, fasc. I), 1989.
SCHULZ, J., "La piazza medievale di San Marco," *Annali di architettura*, IV–V, 1992.
——"The houses of the Dandolo. A family compound in medieval Venice," *Journal of the Society of Architectural Historians*, LII, 1993.
——"The printed plans and panoramic views of Venice (1486–1797)," *Saggi e memorie di storia dell'arte*, VII, 1970.
——"Urbanism in medieval Venice," in A. Molho, ed., *City States in Classical Antiquity and Medieval Italy*, Stuttgart 1991.
Il secondo '800 italiano. Le poetiche del vero, exhib. cat., Milan 1988.
SELLA, D., *Commercio e industria a Venezia nel secolo XVII*, Venice–Rome 1961.
SEMENZATO, C., *La scultura veneta del Seicento e del Settecento*, Venice 1966.
——*L'architettura di Baldassare Longhena*, Padua 1954.
SETTIS, S., *La "Tempesta" interpretata. Giorgione, i committenti, il soggetto*, Turin 1978.
SINDING LARSEN, S., *Christ in the Council Hall. Studies in the Religious Iconography of the Venetian Republic*, Rome 1974.
SIRÈN, O., *Dessins et tableaux de la Renaissance italienne dans les collections de la Suède*, Stoccolma 1902.
SKERL DEL CONTE, S., "Stefano Plebano da S. Agnese e le storie di Tommaso Becket," *Arte in Friuli Arte a Trieste*, XI, 1989.

SOHM, P., "A new document on Giambattista Tiepolo's Santa Fosca residence," *Arte veneta*, XL, 1986.
——"Pietro Longhi and Carlo Goldoni: relations between painting and theater," *Zeitschrift für Kunstgeschichte*, XLV, 1982.
——*The Critical Reception of Paolo Veronese in Eighteenth-Century Italy. The Example of Giambattista Tiepolo as Veronese Redivivus*, Sigmaringen 1990.
——*The Scuola Grande di San Marco 1437–1550*, New York–London 1982.
——"Unknown epithalamia as sources for G.B. Tiepolo's iconography and style," *Arte veneta*, XXXVII, 1983.
Spazialismo a Venezia, exhib. cat., Milan 1987.
SPENCER, J., "The Ca' del Duca in Venice and Benedetto Ferrini," *Journal of the Society of Architectural Historians*, XXIX, 1970.
SPIAZZI, A.M., "Padova," in *La pittura nel Veneto. Il Trecento*, ed. M. Lucco, I, Milan 1992.
Splendori del Settecento veneziano, exhib. cat., Milan 1995.
SPONZA, S., "Il monumento al doge Marco Corner ai Santi Giovanni e Paolo restaurato: osservazioni e proposte," *Ateneo veneto*, XXV, 1987.
——"Pittura e scultura a Venezia nel Trecento: divergenze e convergenze," in *La pittura nel Veneto, Il Trecento*, ed. M. Lucco, II, Milan 1992.
STEDMAN SHEARD, W., "Antonio Lombardo's reliefs for Alfonso d'Este's studio di marmi: their significance and impact on Titian," in *Titian 500* (Proceedings of symposium, National Gallery of Art, Washington, D.C., 25–27 Oct. 1990), ed. J. Manca, Hanover, New Hampshire–London 1993.
——"The birth of monumental classicising reliefs in Venice on the facade of the Scuola di San Marco," in *Interpretazioni veneziane. Studi di storia dell'arte in onore di Michelangelo Muraro*, ed. D. Rosand, Venice 1984.
——"The tomb of Doge Andrea Vendramin in Venice by Tullio Lombardo," PhD thesis, Yale University 1971.
STEFANI MANTOVANELLI, M., *Giovanni Battista Langetti*, *Saggi e memorie di storia dell'arte*, XVII, 1990.
STEINBERG, L., *The Sexuality of Christ in Renaissance Art and in Modern Oblivion*, New York 1983.
Storia della cultura veneta: Dall'età napoleonica alla prima guerra mondiale, VI, ed. G. Arnaldi and M. Pastore Stocchi, Vicenza 1986.
Storia della cultura veneta. Il Settecento, V, 2 vols., ed. G. Arnaldi and M. Pastore Stocchi, Vicenza 1985–86.
STRINGA, N., *Giuseppe De Fabris. Uno scultore dell'Ottocento*, Milan 1994.
Studi canoviani. Quaderni sul Neoclassico, I–II, Rome 1973.
Bernardo Strozzi. Genova 1581/82-Venezia 1644, exhib. cat., ed. E. Gavazza, G. Nepi Scirè, and G. Rotondi Terminiello, Milan 1995.
SUCCI, D., *Gli inizi vedutistici di Francesco Guardi, con cenni sui capricci. Guardi, metamorfosi dell'immagine*, exhib. cat., Venice 1987.

SWIECHOWSKI, Z., RIZZI, A., HAMANN MACLEAN, R., *Romanische Reliefs von venezianischen Fassaden (Patere e formelle)*, Wiesbaden 1982.

SWOBODA, K.M., "Palazzi antichi e medioevali," *Bollettino del Centro di Studi per la Storia dell'Architettura*, XI, 1957.

——*Römische und romanische Paläste*, 1969 (1st. edn., Vienna 1918).

TABURET-DELAHAYE, E., *I gioielli della Pala d'oro*, in H.R. Hahnloser, ed., *Il tesoro di San Marco*, I, *La Pala d'Oro*, Venice 1994.

TAFURI, M., "La 'nuova Costantinopoli'. La rappresentazione della 'renovatio' nella Venezia dell'Umanesimo," *Rassegna*, IX, 1982.

——*Venezia e il Rinascimento*, Turin 1985.

Il teatro patriottico, ed. C. De Michelis, Padua 1966.

TEMPESTINI, A., *Giovanni Bellini*, Florence 1992.

TENENTI, A., "Venezia e il Veneto nelle pagine dei viaggiatori stranieri (1650-1790)," in *Storia della cultura veneta. Il Settecento*, ed. G. Arnaldi and M. Pastore Stocchi, V.1, Vicenza 1985.

Tessuti serici italiani dal 1450 al 1530, Milan 1983.

TESTI, L., *La storia della pittura veneziana*, I, Bergamo 1909.

I Tiepolo e il Settecento vicentino, exhib. cat., Milan 1990.

I Tiepolo, virtuosismo e ironia, exhib. cat., ed. D. Succi, Turin 1988.

Tiepolo, tecnica e immaginazione, exhib. cat., ed. G. Knox, Venice 1979.

TIGLER, G., "Il portale maggiore di San Marco a Venezia," PhD thesis, Venice University 1993.

——entry 131, exhib. cat., *Omaggio a San Marco, Venezia 1994-95*, Milan 1994.

TIMOFIEWITSCH, W., *Girolamo Campagna. Studien zur venezianischen Plastik um das Jahr 1600*, Munich 1972.

——*La chiesa del Redentore*, Vicenza 1969.

——"Quellen und Forschungen zum Prunkgrab des Dogen Marino Grimani in San Giuseppe di Castello zu Venedig," *Mitteilungen des Kunsthistorischen Institutes in Florenz*, Dec. 1963.

Tiziano, exhib. cat., Venice 1990.

TOESCA, P., *Il Trecento*, Turin 1951.

TOLEDANO, R., *Michele Marieschi. L'opera completa*, Milan 1988.

TOMASSONI, I., *Arte dopo il 1945. Italia*, Milan 1971.

TONIATO, T., ed., *Modernità allo specchio. Arte a Venezia (1860–1960)*, Venice 1995.

TORCELLAN, G.F., *Andrea Memmo*, Venice–Rome 1963.

TORSELLO, P., "Il neoclassico nella Piazza. L'Ala napoleonica e il Patriarcato," in *La Piazza San Marco...*, Venice 1970.

TRAMONTIN, S., FEDALTO, G., *Santi e beati vissuti a Venezia*, Venice 1971.

TRINCANATO, E., *Venezia minore*, Venice 1948.

TUCCI, U., "I primi viaggiatori e l'opera di Marco Polo," in *Storia della cultura veneta*, I, Vicenza 1976.

——"Miti e realtà di Venezia negli scritti degli economisti," in *Storia della vultura veneta. Il Settecento*, ed. G. Arnaldi and M. Pastore Stocchi, V.1, Vicenza 1986.

Una città e il suo museo. Un secolo e mezzo di collezioni civiche veneziane, Venice 1988.

VALLE, P., *Tommaso Temanza e l'architettura civile. Venezia e il Settecento: diffusione e funzionalizzazione dell'architettura*, Rome 1989.

L.VEDOVATO, *La villa Farsetti a Santa Maria di Sala*, Santa Maria di Sala 1994.

Venedigs Ruhm im Norden: die grosser venezianischen Maler des 18. Jahrhunderts, ihre Auftraggeber, und ihre Sammler, ed. M. Trudzinski and B. Schülicke, exhib. cat., Düsseldorf 1991.

Venetian Seventeenth-Century Painting, exhib. cat., ed. H. Potterton, London 1979.

Il Veneto e l'Austria. Vita e cultura artistica nelle città venete 1814–1866, exhib. cat., Milan 1989.

Venezia e la Biennale. I percorsi del gusto, exhib. cat., Milan 1995.

Venezia: gli anni di Ca' Pesaro, 1908-1920, exhib. cat., ed. C. Alessandri, G. Romanelli and F. Scotton, Milan 1987.

Venezia e Bisanzio, exhib. cat., entries 74, 82 (L. Moretti), 60-62, 70 (M. Muraro), 66 (F. Zuliani).

Venezia nell'età di Canova 1780-1830, exhib. cat., ed. E. Bassi et al., Venice 1978.

Venezia nell'Ottocento: Immagini e mito, exhib. cat., ed. G. Pavanello and G. Romanelli, Milan 1983.

Venezia e lo spazio scenico, exhib. cat., ed. M. Brusatin and A. De Poli, Venice 1979.

Venezia e i Turchi. Scontri e confronti di due civiltà, Milan 1985.

Venezia nell'Unità d'Italia, Florence 1962.

Venezia-Vienna, ed. G. Romanelli, Milan 1983.

VENTURI, A., *Storia dell'arte italiana*, V, *La pittura del Trecento e le sue origini*, Milan 1907.

——*Storia dell'arte italiana*, X.3, *La scultura del Cinquecento*, Milan 1937.

VIO, G., "Il Longhena e la chiesa di Sant'Antonin a Venezia," *Arte veneta*, XXIX, 1976.

——"L'altare di San Lorenzo Giustiniani in San Pietro di Castello," *Arte veneta*, XXXV, 1981.

——"Per la datazione del *telero* del Forabosco a Malamocco," *Arte veneta*, XXXVIII, 1984.

Virgilio Guidi. Opere astratte, exhib. cat., ed. M. Apa and T. Toniato, Milan 1989.

VIVIAN, F., *Il console Smith, mercante e collezionista*, Vicenza 1971.

WALKER, J., *Bellini and Titian at Ferrara*, London 1956.

WEITZMANN, "The Genesis mosaics of San Marco and the Cotton Genesis miniatures," in O.Demus, ed., *The Mosaics of San Marco in Venice*, Chicago–London 1984.

WETHEY, H.E., *The Paintings of Titian*, 3 vols., London 1969-75.

WILDENSTEIN, G., *Chardin*, Zurigo 1963.

WIROBSZ, A., "L'attività edilizia a Venezia nel XIV e XV secolo," *Studi veneziani*, VII, 1965.

WITTKOWER, R., *Arte e architettura in Italia, 1600-1750*, Turin 1972.

——"Santa Maria della Salute," *Saggi e memorie di storia dell'arte*, III, 1963.

WOLTERS, W., *Der Bildenschmuck des Dogenpalastes*, Wiesbaden 1983.

——*La scultura veneziana gotica (1300-1460)*, Venice 1976.

——"La scultura," in U. Franzoi, T. Pignatti and W. Wolters, *Il Palazzo Ducale di Venezia*, Treviso 1990.

——*Storia e politica nei dipinti di Palazzo Ducale*, Venice 1987.

ZAMPETTI, I., et al., *Antonio Zanchi*, Bergamo 1988.

ZAMPETTI, P., "Antonio Zanchi," in *I pittori bergamaschi. Il Seicento*, IV, Bergamo 1987.

ZANOTTO, F., *Venezia monumentale. I Palazzi*, ed. L. Moretti, Venice 1967.

ZAVA BOCCAZZI, F., "Gli affreschi del Bison," *Arte veneta*, XXII, 1968.

——"I veneti della Galleria Conti di Lucca (1704-1707)," *Saggi e memorie di storia dell'arte*, XVII, 1990.

——"Il Settecento," in *Gli affreschi nelle ville venete dal Seicento all'Ottocento*, Venice 1978.

——*La basilica dei Santi Giovanni e Paolo in Venezia*, Venice 1965.

——"Nuovi paesaggi e pitture di genere del Bison," *Arte veneta*, XXV, 1971.

——"Per la grafica del Bison," *Arte veneta*, XXVII, 1973.

——*Pittoni*, Venice 1979.

ZERI, F., GARDNER, E.E., *Italian Paintings. A Catalogue of the Collection of the Metropolitan Museum of Art. Venetian School*, Vicenza 1973.

ZORZI, A., *I palazzi veneziani*, Udine 1989.

——*Venezia austriaca*, Bari 1985.

——*Venezia scomparsa*, Milan 1977 (1st. edn. 1972).

ZORZI, L., *Carpaccio e la rappresentazione di Sant'Orsola*, Turin 1988.

ZORZI, M., "La circolazione del libro. Le biblioteche. La stampa," in *Storia di Venezia*, V, Rome 1997.

ZOVATTO, P.L., *Caorle, Portogruaro, Concordia, Summaga, Sesto al Reghena*, Bologna 1971.

——"Monumenti paleocristiani di Grado," in G. Brusin and P.L. Zovatto, ed., *Monumenti paleocristiani di Aquileia e di Grado*, Udine 1957.

ZUCCHETTA, E., *Antichi ridotti veneziani*, Rome 1988.

ZUGNI TAURO, A.P., *Gaspare Diziani*, Venice 1971.

ZULIANI, F., "I marmi di San Marco," *Altomedioevo*, II, 1970.

——"Il Duecento a Venezia," in *La Pittura in Italia. Il Duecento e il Trecento*, ed. E. Castelnuovo, I, Milan 1986.

——"Il Maestro dell'Incoronazione della Vergine," in *Da Giotto al Tardogotico*, exhib. cat. ed. L. Grossato, Padua 1989.

Page numbers in italics denote illustrations / illustrated text. Entries in *italics* denote art works, texts and Italian terms.

Photographic Sources

Böhm: 14, 15 (top), 17 (top), 22 (left), 25 (top), 37 (bottom), 39, 55–56, 60, 113, 126, 136–137, 145, 200, 202–203, 206–207, 216 (right), 238, 268, 278, 290 (left), 293, 303, 304, 349, 350, 351, 424, 430, 432, 434, 445, 448, 454, 455, 473, 474, 475, 483, 488–489, 532, 554–555, 626, 643, 644, 646, 654, 655, 659, 661.

Cameraphoto – Arte: 16 (bottom), 21, 22–23, 24, 25 (bottom), 26, 27, 28–29, 30, 31, 32, 40, 41, 42, 44, 47, 48, 53, 58–59, 62, 63, 64–65, 66, 67, 68, 69 (top), 70–71, 72, 73, 78, 79, 81, 83, 84–85, 86, 87, 94–95, 100, 103, 107, 109, 112, 114, 116, 117, 118, 119, 120, 121, 122, 123, 124, 125, 128, 129, 131, 133, 135 (right), 138, 139, 140, 141, 144, 147, 148, 150–151, 153, 157, 158–159, 161, 163, 164, 165, 168–169, 172, 173, 174, 176, 177, 178, 179, 180, 183, 184, 188, 189, 192, 193, 194, 195, 197, 199, 201, 204 (left), 208 (left), 208–209, 211, 214, 216 (left), 217, 222, 230, 231, 233, 234, 235, 236–237, 239, 242, 243, 244, 246, 247, 248–249, 251, 252, 255, 256, 257, 258, 259, 262, 269, 270–271, 272, 273, 276, 277, 282, 283, 286 (top), 288 (top), 290 (top right), 291, 299, 301, 305, 306–307, 308, 309, 310–311, 315, 316–317, 318, 320, 322 (left), 322–323, 324–325, 326, 327, 328, 332, 333, 334, 337, 338, 342, 343, 344 (top), 345, 346, 347, 353, 354–355, 356, 357, 358, 359, 360, 361, 362–363, 364, 366–367, 368, 370, 371, 372, 374–375, 376–377, 378–379, 380, 382, 383, 384–385, 386, 387, 388–389, 390, 391, 392, 393, 394, 395, 396, 397, 398, 399, 403, 408, 409, 412, 414–415, 416, 417, 422, 426, 427, 428, 429, 433, 436, 438, 439, 440, 444, 446, 447, 449, 451, 452–453, 456, 457, 458, 459, 460–461, 462, 463, 464, 465, 466, 467, 468–469, 470, 471, 472, 481, 482, 484, 485, 486, 487, 490, 494–495, 500, 501, 502–503, 504 (left), 504–505, 509, 518, 519, 520–521, 528, 529, 530–531, 533, 540, 542–543, 548, 549, 553, 558, 564–565, 572–573, 575, 577, 579, 580–581, 583, 584, 585, 588, 589, 590, 592, 593, 594–595, 597, 600–601, 602–603, 606–607, 610, 611, 619, 622, 623 (top right), 627, 628–629, 632 (bottom), 633, 634, 638–639, 640, 645, 653, 656, 658, 666, 668/669, 672, 674, 680–681, 686, 704–705, 709.

Ciol: 8, 9, 10, 33, 35.

Huber: 2, 74–75, 97, 99, 143.

Magliani: 162, 224 (bottom), 236 (left), 240, 241, 261, 263, 340, 574, 582, 587, 600 (left), 605, 608, 667, 683, 684, 685, 687, 702–703.

Magnus archives: 7 (Gaddi), 11 (Gaddi), 15 (bottom – Cameraphoto), 16 (top – Cameraphoto), 17 (bottom – Cameraphoto), 18 (Cameraphoto), 19, 36 (Cameraphoto), 37 (top – Cameraphoto), 38, 43, 45, 46 (Cameraphoto), 49 (Gaddi), 50 (Cameraphoto), 51 (Cameraphoto), 54, 57, 69 (bottom – Cameraphoto), 80 (Magliani), 82 (Magliani), 88, 90, 91 (top), 92 (Cameraphoto), 93, 101 (Cameraphoto), 104, 105 (Cameraphoto), 106, 108, 110, 111, 115 (Cameraphoto), 127 (Magliani), 130 (Cameraphoto), 134 (Magliani), 135 (left – Cameraphoto), 142, 146 (Cameraphoto), 152, 154–155 (Cameraphoto), 160 (Magliani), 166 (Cameraphoto), 167 (Cameraphoto), 170 (Cameraphoto), 171 (Magliani), 175 (Cameraphoto), 181 (Cameraphoto), 185, 186–187 (Cameraphoto), 190–191, 196 (Cameraphoto), 198 (Magliani), 204–205 (Cameraphoto), 215 (Cameraphoto), 218 (Cameraphoto), 219 (Cameraphoto), 220 (Cameraphoto), 221 (Cameraphoto), 226, 227, 228, 229, 250 (Magliani), 253 (Magliani), 260 (Magliani), 280, 281 (Magliani), 284–285 (Cameraphoto), 286 (bottom – Cameraphoto), 287 (Cameraphoto), 288 (bottom), 289 (Cameraphoto), 292, 294, 296 (Böhm), 298 (Cameraphoto), 300 (top – Cameraphoto), 300 (bottom), 302 (Magliani), 312 (Cameraphoto), 313 (Cameraphoto), 319 (Cameraphoto), 321 (Cameraphoto), 329, 330, 331, 335 (Cameraphoto), 344 (bottom – Cameraphoto), 373 (Cameraphoto), 401, 402 (Cameraphoto), 404–405 (Cameraphoto), 407 (Cameraphoto), 410 (Cameraphoto), 411 (Cameraphoto), 413 (Cameraphoto), 419 (Cameraphoto), 420 (Cameraphoto), 421 (Cameraphoto), 425 (Cameraphoto), 431 (Cameraphoto), 435 (Cameraphoto), 437 (Cameraphoto), 441 (Cameraphoto), 442 (Cameraphoto), 443 (Cameraphoto), 478, 479, 491 (Cameraphoto), 496 (Cameraphoto), 498–499 (Cameraphoto), 508, 512–513, 514 (Cameraphoto), 515 (Cameraphoto), 516 (Cameraphoto), 517 (Cameraphoto), 522, 524–525 (Cameraphoto), 527, 534, 535, 536, 537, 538–539, 541 (Cameraphoto), 542 (left), 544 (Cameraphoto), 545 (Cameraphoto), 546 (Cameraphoto), 547 (Cameraphoto), 550–551 (Cameraphoto), 552 (Cameraphoto), 556–557 (Cameraphoto), 559 (Magliani), 560 (Cameraphoto), 567 (Cameraphoto), 569 (Cameraphoto), 576 (Cameraphoto), 586 (Cameraphoto), 591, 596 (Cameraphoto), 604 (Magliani), 609, 612 (Magliani), 613, 616, 617, 623 (bottom left – Cameraphoto), 624–625 (Cameraphoto), 630, 631, 632 (top – Magliani), 641 (Magliani), 642 (Magliani), 647 (Magliani), 648 (Cameraphoto), 649 (Cameraphoto), 650–651 (Cameraphoto), 652 (Magliani), 662 (Cameraphoto), 663 (Cameraphoto), 665 (Cameraphoto), 670, 671, 673, 675, 676–677 (Cameraphoto), 678, 688–689, 690 (Cameraphoto), 691 (Cameraphoto), 692 (Cameraphoto), 693, 694–695, 696 (Cameraphoto), 697 (Cameraphoto), 698–699 (Cameraphoto), 700, 708 (Magliani), 710, 711.

Marton: 266, 562.

Aquileia, Società per la conservazione della Basilica di Aquileia (foto Andrian): 34.

Berlin, Staatliche Museen zu Berlin – Stiftung Preussischer Kulturbesitz Gemäldegalerie: 511.

Dresden, Staatliche Kunstsammlungen – Gemäldegalerie Alte Meister: 254.

Paris, École des Beaux-Arts: 510, 561 (top).

Paris, Musée du Louvre (Agence Photographique de la Réunion des Musées Nationaux): 224 (top), 225.

Portogruaro, Museo Nazionale Concordiese. By permission of the Ministero per i Beni Culturali e Ambientali, Soprintendenza Archeologica di Padova (foto Peripolli): 12, 13.

Venice, Biblioteca Nazionale Marciana: 102.

Venice, Fondazione Giorgio Cini: 279, 450, 657, 660, 664.

Venice, Fondazione Querini-Stampalia: 492–493, 497, 707.

Venice, Museo Civico Correr: 91 (bottom).

Vienna, Kunsthistorisches Museum: 267, 339.

We are grateful to Deborah Howard, Giuseppe Pavanello, Juergen Schulz, and Wolfgang Wolters for providing us with a number of their illustrations.

Acknowledgments

It is normal practice to place the acknowledgments at the beginning. I have decided to make an exception to the rule: it is only after examining the whole volume that readers will be able to appreciate the many-sided support of individuals and institutions that has contributed to this book.

Without the informed and kind support of Dr. Guido Ceriotti this project could never have been completed. I also owe particular thanks to Professor Andrea Barbaranelii for taking on the onerous task of reconciling stylistic demands with the authors' individual approaches and styles.

Many individuals have kindly allowed us entry to their homes. In particular, I should like to thank Ing. Orazio Bagnasco, Commendatore Sergio Bortoli, Mrs. Patricia Viganò Curtis, Countess Cecilia Falk, Arch. Alessandro Zoppi, Countess Maria Maddalena Franchin, Countess Andriana Foscari, Dr. Maurizio Sammartini, and Count and Countess Arrivabene Valenti Gonzaga. I am also grateful to the Consiglio Nazionale delle Ricerche and Dr. Gianfranco Dallaporta, Avv. Alessandro Manganiello, secretary of the Ateneo Veneto, Dr. Frédéric Bouilleux, secretary of the Italian-French cultural association, the Compagnie Générale des Eaux S.A., Mr. Daniele Campajola, the staff of the Marina Militare and the Museo Storico Navale of Venice, the Cassa di Risparmio di Venezia, and Dr. Franco Campiutti, the Galleria dello Scudo in Verona, the Scuola Grande di San Rocco and their chairman Ing. Erme Farina, and the management of the Caffè Florian.

I should also like to thank the Right Reverend Rector of Turriaco, Don Graziano Marini, president of the Società per la Conservazione della Basilica di Aquileia, the Very Reverend Don Gian Matteo Caputo, head of the Ufficio Beni Cultural della Curia Patriarcale of Venice, the Procuratia di San Marco, the staff of the basilica of San Marco, all the Venice priests who have helped in the production of this book, the Fondazione Giorgio Cini, and the Peggy Guggenheim Collection, particularly Dr. Claudia Rech. I am indebted to Arch. Umberto Franzoi for the illustrations he has so kindly made available. My thanks also go to all the local Soprintenze and museums, galleries, and libraries that have assisted us and allowed us to take photographs.

Many others have played a part in this surprisingly long and difficult task. It is impossible to list each, but to all we are deepy grateful. Finally, I should like to express my thanks to Dr. Franca Lugato, Professor Giandomenico Romanelli's efficient and helpful assistant, Dr. Elena Cimenti, for some of the translations, and Alessandro Gaggiato of the Böhm Archive for his great personal kindness.